ISBN 978-1-5277-6742-3
PIBN 10889476

1 MONTH OF
FREE
READING

at

www.ForgottenBooks.com

By purchasing this book you are eligible for one month membership to ForgottenBooks.com, giving you unlimited access to our entire collection of over 1,000,000 titles via our web site and mobile apps.

To claim your free month visit:
www.forgottenbooks.com/free889476

English
Français
Deutsche
Italiano
Español
Português

www.forgottenbooks.com

Mythology Photography **Fiction**
Fishing Christianity **Art** Cooking
Essays Buddhism Freemasonry
Medicine **Biology** Music **Ancient
Egypt** Evolution Carpentry Physics
Dance Geology **Mathematics** Fitness
Shakespeare **Folklore** Yoga Marketing
Confidence Immortality Biographies
Poetry **Psychology** Witchcraft
Electronics Chemistry History **Law**
Accounting **Philosophy** Anthropology
Alchemy Drama Quantum Mechanics
Atheism Sexual Health **Ancient History**
Entrepreneurship Languages Sport
Paleontology Needlework Islam
Metaphysics Investment Archaeology
Parenting Statistics Criminology
Motivational

CLEAR TYPE

A FEW SUGGESTIONS CONCERNING

TYPE, LETTERS, BOOKS

AND

HAND-WRITING

BY

S. MILLETT THOMPSON

The Riverside Press

1907

IN GENERAL.

Any marked separation of the literary and the common language should be avoided; while time, space and economy demand that AMERICAN shall be continually compacting. A favorable result is possible only by way of an absolute exactness, terse, and which all may understand alike.

It appears that the vernacular alone is, and ever will be, a wrecking; that linguistics alone is, and doubtless ever will be, a quarrel, — and our good AMERICAN is forced to run a stormy course with both of them, and also between the purgatory of an indeterminate spelling (as yet no law) and the hades of general phonetics void of law, rule or reason.

In its uses with pen, pencil and type, and largely in the reading also, the language is so far in strictly mechanical operations as to appeal to an inventor; in any plans with reference to it, however, a person should seek to better build, as well as to remove.

In print the first move necessarily concerns body type — lower case type. And the style of type most in use — that used in the 'common print' found in Newspaper editorial columns, in Magazines and Books — produces a dull and greyish mass, — like a snow-field blown with sand, — indistinct, and also semi-veiled with ceriphs, scrolls, and finical projections on the letters.

Convention seems to have settled upon this style of type; and the chief aim should be to reduce space in its use, and also to make both letters and words more marked, sharper and clearer.

Of course I have made designs for changes in letters; but these pages are not the proper place for such designs, though I indicate some features of Clear Type.

LINES.

Persons read by the tops of the printed lines, — the eyes being far less concerned with the body or base of such lines; thus Clear Type follows the well known ways of common custom.

WORDS.

If the changes that are suggested in these pages are ever adopted at all, their adoption will be gradual, and possible only because the language is kept alive — dead and dying languages never change for the better.

Words and letters are only signs; but the burdening or beclouding either of them by use of the fifty or more different — diacritical — marks, in order to preserve the nice old lingual tones or odd elementary sounds, in our polyglot land, is a wasted endeavor, — the common people will not, cannot, learn them, and scholars will neither endure the waste and bother of writing them, nor attempt to speak by them — and would not be understood if they did.

ABBREVIATIONS.

In common writing the work of abbreviating comes first upon the many thousands of prefixes and suffixes:

The endings -able, and -ible, may often be written -al; and be very good, even if the a were pronounced as broad as in -ahl.

Similarly -ing may be written -en; and if so pronounced, be a decided improvement upon the too common " -in," or mere " -n."

Also -tion may often be written -ton; and -sion be written -son, and still be well understood.

The -ion in two syllables is far weaker than if pronounced as -yon.

One s is enough to write in -ness, and -less; and one l in -lly; while -us is often quite enough for -ous.

These endings are on about 6,000 words, among which choices may be readily taken. Of course a complete plan of abbreviating would not stop at these little affairs.

LETTERS.

No new letters should be added to the Alphabet now in use — there are already too many.

As an *ideal* advantage in writing, and often in print also — avoiding general phonetics — the letter c might well be used as a sharp sibilant only; s as a soft sibilant; and z for all buzzing sounds.

Also f for all f-sounds, excepting in words of Greek or Latin origin having ph; g always hard; j for all soft sounds of g; k for all k-sounds — a most conspicuous letter, and especially desirable to replace hard c, and hard ch, — since c now demands half a dozen rules, and is easily mistaken for a, e, or o.

Then q — as now followed by u, is not so desirable for clearness as kw; for u is readily mistaken for n, or a, and q is a descending letter.

The conical v, and rounded u, are now distinctly separated in all good and high-class AMERICAN.

FIRST CHANGE.

This first change, in letter forms, alone — in its three parts — made in common print, would certainly shorten words — lines, columns, pages and books — by a total of $\frac{1}{10}$ = 10 per cent — and demonstrably more, even if letters were a trifle farther apart in words; and all that, too, with actual gain in distinctness.

The above result with the space between words narrowed to the average width of one letter, would do away with much very fine print — the worst eye-destroyer in the universe of letters.[1]

[1] Note : — No change in the height of letters is here considered — their tallness aids the eye. In order to be clearly understood, I have had these pages printed in the "common type" — 11-point size — referred to on page 2; and the Notes with type three points smaller — 8-point size, — the smallest type that should ever be used in a publication for students, or for general use.

VOWELS.

The vowels: a, e, i, o, u, and y now treated as a vowel, are long, short, flat, open, hard, soft, and often interchangeable in values; and there is nothing now in any of them to decide anything. You must turn away from each vowel, and read four to eight rules in order to learn how to use it — and thus go hunting for near forty rules to cover all the vowels. As a partial remedy:

First: In common print the long sound of each vowel should be fixed by a small, but clear, mark at the top.

Second: All vowel sounds not thus fixed should be short; and no vowels to have any other mark whatever.[1]

[1] Note:—No consonant to be marked at all. All sounds of a, not long, to be drawn so far as possible toward broad a, as heard in ah, father, or a-final; thus avoiding the flat, *cat-bird*, drawled-out a — as heard in fair — with its low-bred, nasal twang.

HAND–WRITING — SCRIPT.

Our first aim in these pages is to shorten, reduce, the hand-labor in writing — printing to follow. There are only twenty-six letters; and an illegible hand-writing should be regarded as inexcusable.

In hand-writing to indicate the long sound of a vowel, merely prolong the final stroke — omitting the usual dot over i:

These letters were designed by me in 1875.

The short sounds of the vowels, being very difficult to spell or to pronounce alone, are usually only compared; their values, in actual use, will be made clearer by having the long vowel sounds definitely fixed, while also the consonants in words with short vowels will be strengthened.

Note:—A word is only a sign; and its mere form, or "looks," is a matter of very minor consideration — thousands of now good words must once have seemed very queer.

[14]

RESULTS.

Silent letters, doubled consonants, digraphs, and final e removed; the long, and consequently most of the short vowels made certain; spelling of words brought largely under a good and firm law, — and, between matter and space, nearly $\frac{3}{10} = 30$ per cent — can be saved from present methods, and all without the use of any small type.

At the least a fifty-column newspaper becomes forty columns and less; and a five hundred page book is brought to less than four hundred pages.

Then to the writer, editor, printer, proof reader, reviewer, and type-writer, is brought a saving of nearly one hour's work in every ten; and to the scholar, student, teacher — and to every reader — is brought unnumbered hours of gain — not to mention the less burdened eyes of all persons concerned.

Against all this positive saving and gain, comes no actual loss whatever.

READING LIST FOR RHETORIC I.

**One group is to be read each fortnight. The studer
read one story, one essay, and two poems.**

SHORT STORY	ESSAY	POETRY
1. Stevenson	Ruskin	Burns
2. Harte	Lamb	Lowell
3. Wharton	G. W. Curtis	Byron
4. Kipling	Huxley	Lanier
5. Garland	Repplier	Keats
6. Poe	Stevenson	Tennyson
7. Matthews	Morley	Pope
8. Parker	Lowell	Shakespeare
9. Bunner	Birrel	Arnold
10. Stockton	Macaulay	Scott
11. Hopkinson Smith	Carlyle	Cowper
12. Jewett	Burroughs	Shelley
13. Aldrich	Stephen	Poe
14. James	Benson	Gray
15. Hawthorne	Crothers	Browning
16. Hale	G. L. Dickinson	Rossetti
17. Wm. A. White	Thoreau	Milton
18. Page	Holmes	Swinburne
19. Van Dyke	Arnold	Whittier
20. Wilkins	Lang	Wordsworth
21. W. W. Jacobs	Emerson	Kipling

In addition the student is required to read as follows

First Semester: One novel.

Second Semester:

1. (a) A biography, or (b) An autobiography.

2. A volume of essays by a single author, or any volu
 history, science, etc., which the instructor shall
 equivalent to the volume of essays.

These books are to be selected by the student. The ch
to be ratified by the instructor. The selection should be
early in the semester.

Explanation:—784 is the file-number of the studer
cates the number of his file in the Theme Room; 19 is
of the theme; 1 is the number of the page. The next
same theme should be numbered 19-2, 19-3, etc.

CORRECTIONS.

1. Credit will be given only when all the themes whic
 assigned are properly corrected and on file with
 Clerk.

2. The student is expected to purchase a filing-case fo
 and leave it with the Theme Clerk. Corrected th
 be kept on file and should not be removed without
 mission. If a student removes any theme from
 should leave a note in the file explaining when an
 authority it has been taken.

gr.—Ungrammatical.

kp.—Out of keeping with style of essay.

l. c.—Lower case. Do not capitalize.

p.—Punctuation.

pos.—Position of words.

rep.—Repetition.

sen.—Sentence structure faulty.

seq.—Sequence of sentences or paragraphs.

sl.—Slang.

sp.—Spelling.

taut.—Tautology.

tense seq.—Sequence of tenses.

tr.—Transpose words indicated.

trite.—Hackneyed or commonplace expression.

U.—Sentence or paragraph unity.

wd.—Word not well chosen.

8.—Omit.

?.—Truth or accuracy questionable.

1, 2, 3, 4, etc.—Rearrange in conformity with number:

X or *!!*—Error obvious.

¯_∧_ —Word or words omitted.

¶.—Paragraph.

No ¶.—Do not paragraph.

||*cnst.*—Parallel construction.

PLAGIARISM.

The themes assigned, unless it is explicitly stated that are exercises in selection or re-organization, are supposed to be original work of the student. Whenever he has occasion to m use of the language of another, even if only a single phrase, should denote the fact by quotation marks. The borrowing ideas from another should be indicated by marginal or footn references to the original. Failure to observe these rules scru lously will be regarded as cheating; and the penalty of suspens from the University will be invoked.

X. 15: 3-07; 1909:

UNIVERSITY OF ILLINOIS

COLLEGE OF ENGINEERING

SUMMER READING

All students in the College of Engineering, except college graduates, are required to do a certain amount of reading of a non-professional character during the summer vacation following the first and the second school year. The books read are to be selected by the student from the lists given on the second and fourth pages of this pamphlet. In these lists each title is preceded by a number showing the credit allowed for it; and each student is expected to read carefully as many books as will give a total credit of at least 100 points. A statement of the works read during the summer will be required at the beginning of the succeeding school year on a blank which may be obtained at the office of the Dean of the College of Engineering.

It is desired to impress upon the student the fact that an acquaintance with literature, history, and general science will not only increase his general usefulness and his individual enjoyment, but will also be of much practical importance to him as a professional man in his social and business relations. It is hoped that the value of such reading will be so evident that each student will do as much more than the required amount as his opportunities will permit. As an aid in this direction a supplementary list of recommended books is given on page 7. The books contained in all three lists have been selected for their value from the point of view of general training, but the attempt has been made to include only readable and attractive

POETICAL SELECTIONS FOR FRESHMEN

SELECTIONS FROM PALGRAVES GOLDEN TREASURY

(The first Roman numerical refers in each case to the original edition, that in parenthesis to the revised edition.)

XLV (LXIV). Fiddele. LI (LXII). Cupid and Campaspe. (LV (LXXVII), This Life, which Seems so Fair. LVI (LXXVIII), Soul and Body. LXIII (LXXXVI), Song for Saint Cecilia's Day, 1687. LXVII (XC), On the Tombs in Westminster Abbey. LXIX (XCII), Death, the Leveler. LXXI (XCIV), On His Blindness. LXXIII (XCVI), The Noble Nature. LXXXIII (CIX), To Lucasta, on Going to the Wars. CI (CXXIX), Encouragements to a Lover. CIII (CXXXI), The Manly Heart. CX (CXL). To Daffodils. CXII (CXLIV), L'Allegro. CXIII (CXLV), II Penseroso. CXVI (CLI), Alexander's Feast. CXLI (CLXXVIII), The Passions. CXLVII (CLXXXVII), Elegy Written in a Country Churchyard. CL (CXC), O, My Love's like a Red, Red Rose. CLI (CXCII), Highland Mary. CLII (CXCII), Auld Robin Gray. CLVII (CXCVIII), The Land o' the Leal. CLXV (CCVII), Life! I know not what thou art. CLXXXI (CCXXV). Lord Ullin's Daughter. CLXXXII (CCXXVII), Jock o' Hazeldean. CCV, (CCXLIX), a Wet Sheet and a Flowing Sea. CCVII (CCLI), Battle of the Baltic. CCXV (CCLIX), Hohenlinden. CCXVI (CCLX), After Blenheim. CCXVIII (CCLXII), The Burial of Sir John Moore. CCXXIV (CCLXVIII), Past and Present. CCXXV (CCLXIX), The Light of Other Days. CCXXIX (CCLXXII), The Mermaid Tavern. (CCXXXI CCLXXIV), The Bridge of Sighs. CCXLI (CCLXXXVI), To a Skylark. CCXLVI (CCXCIII), Ozymandias of Egypt. CCL (CCXCVIII), The Reaper. CCLIII (CCCI), The Daffodils. CCLV (CCCIII), Ode to Autumn. CCLXXVIII (CCCXXVI), The World is too much with us. CCLXXXVIII (CCCXXXVIII), Ode on Intimations of Immortality.

SELECTIONS FROM HENLEY'S LYRA HEROICA.

I. Agincourt. p. 1. II. Lord of Himself, p. 11. X. The King of Kings, p. 20. XIX. Going to the Wars, p. 32. XXV. Chevy Chase, p. 47. XXIX. Kinmount Willie, p. 66. XXX. The Honor of Bristol, p. 78. Helen of Kirkconnel, p. 77. XXXV. Boadicea, p. 86. XLVII. Venice, p. 100. LIV. Lochinvar, p. 112. LVI. The Chase, p. 121. LVIII. Pibroch, p. 139. LXX. A Sea-Song. p. 144. LXXIII. The Storming of Corinth, p. 151. LXXV. Friendship, p. 164. LXXX. The Old Navy, p. 174. LXXXII. The Pilgrim Fathers, p. 177. LXXXIV. Horatius, p. 179. LXXXV. The Armada, p. 200. XCIV. A Ballad of the Fleet, p. 222. XCVII. The Red Thread of Honor, p. 244. CVIII. The Death of Sohrab, p. 267. CXXV. A Ballad of East and West, p. 327.

SELECTIONS FROM WHITTIER'S POEMS.

Massachusetts to Virginia. The Fisherman. Ichabod. The Barefoot Boy. Maud Muller. Skipper Ireson's Ride. Barbara Frietchie. Snowbound. Laus Deo. Mary Garvin. The River Path. The Changeling.

LIST FOR SOPHOMORES.

HISTORY

15. Fiske, John: The Critical Period of American History.
10. Franklin, Benjamin; Autobiography.
5. Mahan, A. T.: The Problem of Asia.
10. Mombert, J. I.: A Short History of the Crusades.
50. Motley, J. L.: The Rise of the Dutch Republic. (3 vol
25. Parkman, Francis: Montcalm and Wolfe. (2 vols.)
10. Smith, Goldwin: Three English Statesman.

FICTION

10. Hawthorne, Nathaniel: The House of Seven Gables.
20. Kingsley, Charles: Westward Ho! or Hypatia.
20. Reade, Charles: The Cloister and the Hearth.
20. Scott, Walter: The Heart of Midlothian, or Waverly.
20. Thackeray, W. M.; Vanity Fair, or The Newcomes.

POETRY

10. Bryant, W. C.: Homer's Iliad. Books I, VI, X, XV
 XVII, XIX, XXII, XXIII, XXI
5. Longfellow, H. W.: Poems. Selections (see page 5).
5. Macaulay, T. B.: Lays of Ancient Rome.
5. Pope, Alexander: Essay on Man.
10. Repplier: Book of Famous Verse. Selections (see page
10. Shakespeare: King Lear, or Twelfth Night.

SCIENCE

5. Frankland, Mr. and Mrs. Percy: Pasteur.
20. Leconte, Joseph: Evolution and its Relation to Religio
 Thought.
10. Marshall, A. M.: Lectures on the Darwinian Theory.
15. Newcomb, Simon: Astronomy for Everybody.
5. Tyndall, John: Faraday as a Discoverer.

POETICAL SELECTIONS FOR SOPHOMORES

PUBLISHERS AND PRICES

Freshman List

Book	Publisher	Net Price	Post ag
Bulwer-Lytton's Last Days of Pompeii. T. Y. Crowell		$.45	$.1
Conn's Story of German Life. Appleton & Co...		.35	.0
De Quincy's Joan of Arc. Sibley & Ducker......		.35	.0
Dicken's Tale of Two Cities. Ginn & Co........		.50	.1
Fiske's American Revolution. Houghton, Mifflin Co		3.00	.45
Frankland's Bacteria in Daily Life. Longman, Green & Co		1.58	.17
Froude's English Seamen. Scribner.............		1.10	.15
Henley's Lyra Heroica. Scribner...............		.95	.20
Macaulay's England in 1685. Ginn & Co.........		.25	.04
Palgrave's Golden Treasury. T. Y. Crowell......		.45	.15
Parkman's Oregon Trail. Little, Brown & Co...		.75	.15
Scott's Lady of the Lake. Ginn & Co............		.35	.05
Scott's Lay of the Last Minstrel. Ginn & Co....		.30	.05
Scott's Rob Roy. Houghton, Mifflin & Co. Macmillan Co (Dyreburg ed.)		.95	.20
Shakespeare's Othello or Henry V. D. C. Heath		.25	.04
Stevenson's Kidnapped. T. Y. Crowell.........		.45	.12
Turner's Eginhard's Life of Charlemagne. American Book Co		.30	.05
Tylor's Anthropology. D. Appleton & Co......		1.50	.15
Whittier's Poems. Houghton, Mifflin & Co		1.10	.20

Sophomore List

Book	Publisher	Net Price	Post ag
Bryant's Homer's Iliad. Houghton, Mifflin & Co.		1.00	.20
Fiske's Critical Period of American History. Houghton, Mifflin & Co		1.50	.20
Frankland's Pasteur. Macmillan Co.............		1.25	.10
Franklin's Autobiography. American Book Co..		.35	.08

Hawthorne's House of Seven Gables. Houghton Mifflin Co........50	.10
Kingsley's Westward Ho! T. Y. Crowell........	.45	.15
Longfellow's Poems. Houghton, Mifflin & Co...	1.10	.20
Macaulay's Lays of Ancient Rome. Silver, Burdett & Co....................................	.35	.06
Mahan's Problem of Asia. Little, Brown & Co.	1.50	.20
Marshall's Lectures on the Darwinian Theory. Macmillan Co................................	1.69	.12
Mombert's Short History of Crusades. D. Appleton & Co....................................	1.10	.15
Motley's Rise of Dutch Republic. Harper.......	4.50	.50
Newcomb's Astronomy for Everybody. McClure & Co..............	2.00	.16
Parkman's Montcalm and Wolfe. Little, Brown & Co................................	2.25	.45
Pope's Essay on Man. Silver, Burdett & Co.....	.30	.05
Reade's Cloister and the Hearth. T. Y. Crowell.	.45	.15
Repplier's Book of Famous Verse. Houghton, Mifflin & Co75	.10
Scott's Heart of Midlothian. Macmillan (Dyreburg Edition).....................................	.95	.20
Shakespeare's King Lear or Twelfth Night. American Book Co....25	.05
Smith's Three English Statesmen. Macmillan Co	1.10	.15
Thackeray's Vanity Fair. T. Y. Crowell........	.45	.15
Tyndall's Faraday as a Discoverer. D. Appleton & Co.....................75	.10

SUPPLEMENTARY LIST

The following list of books has been prepared with the pı ıose of bringing to the attention of the student a small numl ıf works suitable to serve as supplementary reading to th(ıontained in the preceding lists. It is believed that all t ıooks are not only profitable, but also interesting.

FICTION

3alzac, Honore De (Miss Wormeley's translation): The Choua̱
 Modeste Mignon.
Ɔickens, Charles: The Cricket on the Hearth.
Ɔumas, A., "pere": The Three Guardsmen.
Ƨliot, George: Adam Bede. Mill on the Floss
̧askell, Mrs.: Mary Barton.
Ɩugo, Victor: Les Miserables.
Ƙingsley, Charles: Hypatia.
Ɍhackeray, W. M.: Henry Esmond.

 The preceding works are standard novels, chosen as representative an(
articularly adapted to this list. The following are entertaining books, no̧
f especial literary merit but worth reading for one reason or another.

3rown, Miss Alice: King's End.
Ɔable, G. W.: Old Creole Days.
Ɔrawford, F. Marion: A Roman Singer. Saracinesca.
Ɔavis, Mrs. M. E. M.: In War Times at La Rose Blanche.
̄ewett, Miss Sarah Orne: Country of the Pointed Firs.
Ƙipling, Rudyard: Life's Handicap. Soldiers Three. The Jı
 gle Books.
Ɯason, A. E. W.: The Four Feathers.
Ɯitchell, S. W.: Hugh Wynne.
̄age, T. N.: In Old Virginia.
Ɋ.: The Splendid Spur. The Blue Pavilion
3tevenson, R. L.: The Wrecker. David Balfour.
Ɯilkins, Miss Mary E.: A Humble Romance.

HISTORY

̄iske, J.: The Discovery of America.
 The Beginnings of New England.

Gibbins, H. de B.: The Industrial History of England.
Green, J. R. (Editor): Reading from English History.
Parkman, F.: The Jesuits in North America.
La Salle and the Discovery of the Great West.
Conspiracy of Pontiac.
Wilson, Woodrow: History of the United States.

BIOGRAPHY OF STATESMEN

Harrison, F.: Cromwell.
Hosmer, J. K.: Samuel Adams.
Johnston, R. M.: Napoleon.
Lord Roseberry: William Pitt.
Morley, John: Chatham. Walpole. Burke.
Morse, J. T.: Thomas Jefferson. Abraham Lincoln.
Schurz, Carl: Henry Clay.

POLITICS

Bryce, James: American Commonwealth.
Douglas, R. K.: China.
Goodnow, F. J.: Municipal Problems.
Morison, George S.: The New Epoch.
Morris, Charles: Our Island Empire.
Parsons, W. B.: An American Engineer in China.
Porritt, E.: The Englishman at Home.
Ransome, Stafford: Japan in Transition.
Shaw, A.: Municipal Government in Great Britian.
Skrine, F. H.: The Expansion of Russia (1815-1900).
Wells, D. A.: Recent Economic Changes.
Wilcox, D. F.: Study of City Government.

SCIENCE

Ball, Sir R. S.: Time and Tide.
Ball, W. W. R.: A Primer of the History of Mathematics.
Cajori, F.: A History of Physics.
Darwin, C.: Insectivorous Plants.
Formation of Vegetable Mould through the Action
of Worms.
Duncan, R. K.: The New Knowledge. (A Popular account of
the new Physics and the new Chemistry in
their relation to the new thories of matter).

Gaye, Selina: The Great World's Farm.
Helmholtz, H. von,: Popular Scientific Lectures.
Huxley, T. H.: Disclosures Biological and Geological.
 Physiography: an Introduction to the Study
 Nature.
Langley, S. P.: The New Astronomy.
Lubbock, J.: The Scenery of Switzerland.
McKendrick and Snodgrass: Physiology of the Senses.
Newcomb, Simon: The Stars. A Study of the Universe.
Ramsay, W.: Gases of the Atmosphere.
Russell, I. C.: Glaciers of North America.
 Lakes of North America.
 Volcanoes.
Sedgwick, W. T.: Principles of Sanitary Science and Publi
 Health.
Tait, P. G.: Recent Advances in Physical Science.
Thompson, S. P.: Light, Visible and Invisible.
Thomson, J. A.: Study of Animal Life.
Tyndall, J.: Fragments of Science.
Wallace, A. R.: Darwinism.
Williams, H. S.: The Story of Nineteenth Century Science.
Woodhead, G. S.: Bacteria and Their Products.

BIOGRAPHY OF SCIENTIFIC MEN

Aggassiz, Mrs. E. C.: Louis Agassiz.
Brewster, Sir David: Life of Sir Isaac Newton.
Clerke, Miss A. M.: The Herschels and Modern Astronomy.
Glazebrook, R. T.: James Clerk Maxwell.
Huxley, Leonard: Life and Letters of Thomas Henry Huxley.
Muir, Pattison: Heroes of Science: Chemists.
Thorpe, T. E.: Essays in Historical Chemistry.

ENGINEERING

Church, W. C.: Life of John Ericsson.
Harcourt, L. F. Vernon: Achievements in Engineering.
Nasmyth, James: Autobiography.
Smiles, S.: Lives of George and Robert Stephenson, and of
 Boulton and Watt, in "Lives of the Engineers".
Vose, G. L.: Loamni Baldwin ("The Father of American Civil
 Engineering").

ART AND ARTISTS

Brown, Horatio: Venetian Sketches. Life on the Lagoons.
Clement, Mrs. C. E.: Italian Painters.
Grimm, H.: Michel Angelo. Raphael.
Oliphant, Mrs.: The Makers of Venice.
 The Makers of Florence.
Richter, J. P.: Leonardo da Venci.
Statham: Architecture for General Readers.
Taft, Lorado: American Sculpture

AMERICAN IGNORANCE OF ORIENTAL LANGUAGES

There is no world problem that looms up so large as the coming relations between the East and the West. It is above all and beyond all the greatest problem that ever confronted the human race. It is one that involves profound changes not only in diplomacy but in popular thinking. It affects as no other problem ever has the action of governments and of the peoples under those governments. And it looks as though the burden of the solution of this magnificently great problem, so far as the West is concerned, must fall mainly upon the United States government and the people of our Great Republic.

In helping on the right and righteous solution of the many problems that arise from the coming together of the great East and the great West, I desire to submit just one line of practical aid in knowing and understanding one another.

It is by knowing the other's language. One can faintly imagine the fearful responsibility of Ii Kamon no Kami, the Premier of the Shogunate, when Commodore Perry came. He had to make some kind of a humiliating treaty with those "Western barbarians" of whose language and intentions he could know nothing, or else involve his country in a disastrous war. The dilemma forced from him this lamentation:—

> "Nothing is worse than a barrier to the
> Communication of thought."

It is just this vast vague barrier that exists between the East and the West, and that constitutes a standing peril—ignorance of the other's language. Here are two historic civilizations with different political, social, religious evolutions, and with languages and customs widely alien to each other. These millions upon millions of human beings in the two

3

hemispheres have been brought into close contact by commerce, by diplomacy, by the missionary work movement, and by the press that now every morning gathers up all the significant events of the nations into one column of news.

This whole world of human beings is now in closer geographical and intellectual touch with each and every part of itself than any one nation was with itself a hundred years ago. And yet collossal misunderstandings have arisen between these two halves that have bred ill will and suspicions and wars, until now, in spite of the Hague and other peace movements, statesmen and scholars are found who allow themselves to go on record as predicting that a bigger war than the world has ever seen, one that "will shake the earth," is inevitable between the yellows and the whites.

Now the first great duty of both sides is to get into proper shape to understand each other, and there is no other way of knowing each other more essential than that of knowing the other's language.

This Association of International Conciliation has for one of its aims "To encourage the study of foreign languages." This is absolutely imperative, and it is just here that the United States is absolutely weak. We are comparatively rich in peace movements; in our power to push arbitration; in gifted and sympathetic statesmen; in misisonary work; in our "American Diplomacy in the Orient," as the Honorable J. W. Foster has shown; and in our generous welcome of Eastern students to our universities. But we are almost helpless when it comes to first hand knowledge of the East through the languages thereof.

And it is this almost universal ignorance on our part of the language and literature and history and ideals of Japan, that made possible that wave of suspicion and distrust that so largely captured the attention of both our government and our people for over a year. Had our government's military attachés in Manchuria, our naval officers on duty in the East, our

war correspondents, our secret service men, our consular and commercial agents, and our diplomatic agents, as a rule been conversant with the Japanese language, the margin for misunderstandings would have been greatly narrowed. And then, had each of our representative papers and magazines even one writer capable of translating at sight Japanese papers and giving their important contents to the public, they could have spoken with authority and prevented the larger part of the wretched stuff too many of our papers printed about Japan and her intentions. I do not claim that all misunderstandings would thus be avoided, but I do fearlessly assert that until we have : large body of competent Oriental linguists connected with our press we are shamefully helpless to prevent the spread of all kinds of mischievous misunderstandings and even of intentional falsehoods.

Let me give one illustration that I have already published elsewhere. About a year ago, a correspondent of a New York paper in Hawaii learned that the Japanese there at a great gathering on one of their national holidays listened with profound attention to the reading of some Imperial Rescript, and he managed to get this sentence:—"In case of emergency give yourselves courageously to the State." He at once wired his paper that the ex-soldiers of Japan had just received an order from their Emperor to be ready for any emergency, and that this could have no other meaning than getting ready for an attack on the United States! When this was duly and impressively published, the New York paper was informed by a lady who had long lived in Japan as a teacher in one of the highest schools for girls in Japan, that this Rescript was promulgated in 1891 for especial use in educational work, that it is read on national holidays in all the schools of the Empire, including mission schools, and that in a place like Hawaii where are some 60,000 Japanese laborers, it is a most natural thing to have this moral Rescript read. Yet her letter of explanation never appeared in the paper.

5

Among our press writers of the last year, while of course there were multitudes who took no stock in the war agitation against Japan, and hundreds who wrote with deep sincerity against the jingoes, yet they were almost powerless to prevent the evil thinking which the sensational press inspired by such heavy headlines as these:—"Japan Made Warlike Threat to Act Against California"; "The Yellow Peril, Its Headquarters on this Continent"; "Japan a Menace to American Civilization"; "Says War of Races Will Shake the Earth."

No matter how much our Taft and Wright and O'Brien—men who knew—said war was "unthinkable" and "not even respectable nonsense," these and similar headlines were kept up with such persistency that many honest minds were bewildered. One paper at last said:—"We wish it were possible to find the fountain of falsehoods and guesses worse than falsehood from which the press of the world is kept misinformed as to the actual relations between this country and Japan."

Well, it seems to me that one fountain of these falsehoods is the almost absolute inability of our press to get at facts first hand, because of the ignorance on the part of our influential writers of the language of Japan. Our government is slowly waking up to the need of a body of trained interpreters, and six students were appointed last year to study under our Embassy in Tokyo. Our military department also, I believe, is represented by a few officers who are studying Japanese. I wonder how many, or rather how few, of the hundreds of officers of our fleet who were so splendidly welcomed and entertained in Japan, could carry on a conversation with their accomplished hosts.

Our government has only a few trained Japanese interpreters of whose work we may justly be proud. But a great and neighboring nation like ours, upon whom rests the exceedingly difficult and delicate responsibility of exactly understanding every depart-

This is admirable, but any one can see that it is one sided. There is just as much need, in view of pressing twentieth century problems, for us to have post-graduate students at work in eastern universities, as for the East to have her choice young men in western universities.

Both as a government and as a people we are far behind Japan in this essential step towards mutual understanding. She has for decades called the United States her teacher; and the wide welcome we have given her students in all our institutions, and the inspiration our political and educational and commercial systems has given her, make us somewhat worthy of the high appellation of teacher. But has not the time come for us to return the compliment and take Japan for our teacher? I affirm unhesitatingly that *there is no government and people in the world that understands all the nations as well as Japan does.*

Just as soon as she began to get on her feet after the shock of forced treaties with "Western barbarians," she set herself the task of learning everything possible about other peoples. The significant words of the Imperial Oath taken at the Restoration, —"WE SHALL SEEK FOR KNOWLEDGE THROUGHOUT THE WHOLE WORLD"—has been a ceaseless inspiration to this open minded people. The government has sent year after year, and still keeps it up, her choicest students and officials to every nation to study it in every department of social, political, commercial, and moral life, and then to bring back the knowledge gained for the use of the government and for the education of the people.

But we of the Great Republic, with our inexhaustible resources and institutions, and with our world language into which is translated pretty much all the wisdom of all times and places, we seem so satisfied with our own priceless intellectual treasures that we are apt to be dominated by the thought, "We are IT. If you want to learn anything come to us and we will teach you. If you have anything worth knowing,

8

bring it along and translate it into English, and then we will examine it at our convenience."

This thought unconsciously controls much of our attitude towards the East. We have been thoughtlessly, if not cruelly, taught to think of the peoples of the East as "heathen," and we give little credit to their civilization of millenniums. We have a tendency to think of them as immoral, counting of little value their morality that has conserved them for ages, elements of which morality we may well incorporate into our Christian civilization. We have hardly taken the trouble to ask what is the secret of their persistence and power, unless startling success in war has forced us to begin to inquire.

This attitude is apparent wherever we meet Orientals. We expect them to use our language whether in their own country or in ours. We show them plainly that we have no interest in their language. We indulge in fatherly admiration of their use of English, never raising the question whether we have any obligation to learn to speak their language, nor feeling anything of shame in our attitude of lofty superiority.

This came out in the welcome meeting given by the Japan Society in New York to Baron Takahira, on his appointment to the United States as Ambassador. At this meeting of over three hundred ladies and gentlemen of both nationalities, the Baron made an able address in English on the relations between Japan and the United States. Then Senator Depew was called upon for a speech, and among other things he said, "It is astonishing to hear this statesman from distant Japan addressing us in stately language fit for our senatorial hall." I wished he had gone on from admiration of the Ambassador's English to the humiliation we ought to feel in view of the fact that we never have had, with the exception of one regular interpreter in our Legation, an officer in diplomatic or consular service in Japan who could address in

scholarly Japanese a company of ladies and gentlemen such as welcomed the Baron.

I happened to be present at the reception tendered by the Japanese residing in New York to Baron Sakatani in the spring of 1908. There was present about an equal number of Americans and Japanese. Of the five after dinner speeches by Dr. J. Takamine, Baron Takahira, Baron Sakatani, the Consul General, and a prominent banker, all but the Banker's were in English, out of respect to their American guests. I could not but think that had a similar welcome been given in Yokohama by American merchants and officials residing there, out of five speeches by Americans to their Japanese guests, there would be just five in English.

To go on with this comparison, it may be said that of the thirty Honorary Commercial Commissioners from the Pacific Coast who visited Japan last fall, not one could speak Japanese. English speaking Japanese met them and accompanied them everywhere. Even in the interior towns there were officials and business men who welcomed them in English, as this sentence from their official report shows;—"Everywhere we journeyed, in the villages and towns as well as in the cities, delegations of prominent officials and business men delivered addresses to us, a number of them being in English." The representatives of the Japanese Chambers of Commerce will return this friendly call in the near future. And I wonder how many of our officials and business men will welcome them in Japanese, and show them what they want to see with explanations in their native tongue. In all probability every member of the coming Japanese commissioners will speak English to some degree, some of them with as perfect a swing as Baron Takahira or Dr. Takamine.

It is announced that an exchange of editors is planned between Japan and the United States. We may safely say that, among the American editors who are to visit Japan, there will not be one who can read what the morning papers will say about them and the

editorials that give the safe clue to public opinion. While among the Japanese editors who are to visit America there will not be one who cannot carry on a conversation in English and read our papers. And several of them doubtless will leave valuable impressions on large and appreciative audiences in our cities as well as original articles in our principal magazines.

Now any one who thinks that the historic friendship between these two great and ambitious peoples is perfectly safe under this one-sided intercourse is, I fear, blind to the trend of world movements. It is well to have international visits, for they help to change wrong opinions. As the able Chairman of the Commissioners of the Pacific Coast says in his frank report:—"Before visiting the Empire of Japan none of us had the slightest conception of the sentiments which the people of that country bear to our people. . . . The people of the United States ought to be proud of the friends they have in the Far East." And then the Report ends with a Resolution that amounts to a discovery:—

"That the friendship and good will of the people of the Empire of Japan towards the citizens of the United States is unquestioned."

Thousands of tourists visit Japan, among whom are some of our choicest scholars and officials and correspondents, yet they have to get their facts through interpreters. I do not deny that one can get at facts and the right interpretation of them without the knowledge of the language, for some of our ablest diplomats and authors are of that class. But I do not hesitate to say that the peaceful development of international relations and real friendship between the peoples that control the Pacific, are always exposed, in times of excitement, to gross misunderstandings, which when exaggerated become a huge wave of distrust, thus giving jingoes and demagogues their chance to inflame the unthinking and to flourish their senseless war talk.

I have spoken mainly of Japan, for the people of this land are our neighbors, whose friendship we must strengthen by intellectual sympathy as well as by commerce, if we would have their invaluable aid in solving present and coming world problems. It is the growing belief that something large must be undertaken as soon as possible for international education. For instance, in the Prime Minister's address before that "forever memorable" Seventeenth Universal Peace Congress held in London, July, 1908, he said with all the emphasis possible:—

"I have said it before, but I would say it again—*the main thing is that nations should get to know and understand one another.*"

To this should be added that governments, universities, churches, chambers of commerce, should have some definite plan of raising up a body of sympathetic scholars, who shall be first hand interpreters of one nation to the other. If it is important that a hundred American students should be sent to Oxford in order that Americans may be better prepared to understand the mother country with the same language, the same religion, the same political institutions, and the same family life, how much more necessary is it that our universities should have at least as many students in Japanese universities, who would return to be interpreters of the life and spirit of the people, and who would become educators, ministers, judges, and congressmen who know and are able to make others know the truth about this nation with such a different history, such a different moral and religious evolution.

Arbitration treaties, interchange of professors, international visits, the purification of international law, peace societies, the Hague tribunal, the limitation of armaments—all these are splendid manifestations of the coming spirit of the world, but they will never become the mighty influence they ought to be until the nations make it a fundamental duty each to have its own body of scholarly linguists whose great busi-

12

ness it shall be "to get the nations to know and understand one another."

What I have said applies with even more force when Great China with her four hundred millions is taken into consideration. For nearly a century we have been facing this wonderfully great and dangerous problem of intercourse with China. Apart from the missionary movement, the main American thought seems to be that Chinese students should come to the United States in large numbers to study in our institutions and thus take back our civilization to China. Everybody welcomes the thought of having that returned indemnity surplus spent in educating scores and hundreds of Chinese students in our land.

Mr. Taft is made to say in a New York paper:— "Frankness compels me to say that China should send more young men to study conditions here, and work for the improvement of their country. I have often met Chinese students at Yale and wished more like them would come here. I think Chinese educated in the United States greatly benefit China."

I do not believe that Mr. Taft is so one-sided as these words imply, yet we must confess that this is the American idea. I would like to add to the above quotation these words:—I think American students, with post-graduate training in China, would greatly benefit America. When a sufficient number of our statesmen, our university heads, and our world merchants begin to think of this necessity, we shall have begun one practical step in carrying out Prime Minister Asquith's earnest appeal that nations get to know and understand one another.

We Americans are not the only ones who have this one-sidedness towards the East. There is a plan in England to have a large number of Japanese go to Oxford. And as to France, my morning paper announces that Mr. Albert Kahn, the eminent French financier, on his visit to Japan, donated $10,000 to the university to found scholarships for promoting the

visits of Japanese to Europe. All of which is most commendable, and such international kindness will certainly bear good fruit. When, however, we add that there are probably a thousand Japanese who know the English or French language where there is one Englishman or Frenchman who knows Japanese, we are simply stating that the necessity is on us to have a movement of students towards the East.

If it be true that Japan knows all the nations better than any other nation does, then we might well recognize Japan as the teacher of nations in the art of knowing and understanding one another. If Japan had not had thousands of scholars educated in America, among her military and civil officers, on her daily press, among her educators, scattered all through the the country, men who know and trust the real heart of America, and so were able to refute the slanders and insinuations of our agitators, and also to prevent the influence of a similar class in Japan, that delightful welcome of the Commissioners from the Pacific, and that amazing welcome of our fleet would have been impossible. And it would have been impossible for Premier Marquis Katsura to have said as he did with emphasis on November fourth, "I have never doubted the sincere friendship of the United States. . . . *In Japan both government and people are absosolutely one in their friendship for the United States, and belief in your friendship for us.*"

It is this vast barrier of ignorance of the languages and therefore of the heart of the peoples of the East that constitutes a standing peril to international good will. The remedying of this ignorance is one of the most pressing steps to be taken in order that the millions of the East and the millions of the West may come together on lines of mutual friendship.

J. H. DE FOREST

Sendai, Japan.

14

JOURNALISM AND INTERNATIONAL AFFAIRS

It is a truism in all lands where the press is reasonably free, that the responsibility of journalism in international affairs is weighty. But it is in the nature of a truism to be trite and of triteness to be vague and of vagueness to be misleading. Let us examine the matter a little closely.

In the first place, journalism, like every modern institution, is very complex, differing in different lands, in different parts of the same land, and at different periods of its own evolution. Great Britain and Japan are allies. The statesmen of each nation recognize that it has vital interests in common with the other, and they have bound the two, for a fixed term, to pursue these jointly, even by armed force. France and Russia are in like case. In carrying out the purposes of these alliances, or in hindering them, the journalism of the several countries may have a considerable influence. The matter has but to be mentioned to suggest the marked variation in the agencies that must thus be called in play and in the way that they will work. We need not, however, go so far afield for evidence that journalism differs under different skies, even when the language is the same. That of the United States is very unlike that of England, and we see appreciable dissimilarity in the journalism of the East, the West and the South of the United States, and in the journalism of to-day in each of these regions compared with that of even two

3

decades since. The institution, if we may so call it, is as *ondoyant et divers* as the personality of Michel de Montaigne.

Yet the complex thing we call journalism—British, German, French, American, what not—exists. The image the name calls up in our minds has a basis in fact. Journalism has generally two functions in which every journal, in different fashion or degree, shares—to furnish information and to comment thereon. As it is in the exercise of these functions that they find a common part in the affairs of the community, so it is for the way they exercise them that they have their common responsibility. In general terms it is easy enough to state that responsibility. It requires that information shall be full and accurate, and that comment shall be fair, temperate, and as wise as the journalist shall be able to make it. But this is almost as indefinite as to say that journalists should be gentlemen by nature and breeding, besides being thoroughly trained in a difficult and intricate profession. Look a little nearer at the functions to which the journalist is called.

First as to furnishing information. Not many years ago this was the field in which energy, capital, ambition, talent were most concentrated, and in this field the competition was so strenuous and costly that only the wealthier and stronger journals entered it. While there is still ample room for ingenious and vigorous competition, among those who care to take part in it, the more important, at any rate the more salient, facts in the daily life of mankind are now

accessible practically to the great body of the newspapers in English-speaking lands, and in less degree, but with pretty liberal fulness, to newspapers in other lands. This has been brought about by the organization of news-collecting associations—Reuter in England, Havas in France, Wolff in Germany, the Associated Press, the United Press, Laffan's in the United States—which are expected to cover, and in fact generally do cover, the news of all parts of the world. These associations have their agents, usually fairly trained, sometimes men of exceptional character and equipment, not only in all the capitals, but in all the chief cities and in the newspaper offices of the minor centres, so that it is practically impossible that any event of obvious interest shall pass undiscovered and unreported. The result is that on thousands of editors' desks in every quarter of the globe each day there are laid, ready for printing if desired, reports of the news of the preceding twenty-four hours in all other quarters of the globe. For the great mass of newspapers the task of news-collecting, so far as concerns foreign lands, or their own land beyond the neighborhood of each, has been abolished. The question of how to get the news has been replaced by the question of what choice to make from the vast heap daily at hand.

For most journalists, then, in the chief countries, the responsibility in international affairs hardly relates to fullness or accuracy of the news they collect. The news they get is about as full and accurate as can be had. No private effort, save by papers of great

5

capital, and a highly organized staff, under expert and daring direction, can seriously amend the work of the news associations in these regards. What remains for most is the choice of news accessible, the form of its presentation and the comment on it. What responsibility attaches to this function? For the great papers, for those that can afford to maintain their editors-resident, so to call them, at the centres of affairs, who know—and sometimes share—the under-currents of sentiment and interest that influence political action, there is clearly a responsibility that the least sensitive might well feel. What is that which rests on the multitude of active, keen, generally intelligent and right-minded men who administer probably nine-tenths of the sixty-thousand newspapers of the modern world? It is not easy clearly to define it, but it is unmistakable and it is considerable.

Primarily it relates to their influence on what is known as public opinion, but what is in reality chiefly public sentiment. As to international affairs there hardly exists in the public mind anything that fairly or accurately can be called opinion. A very small part of any community, of even the best-taught and, in ordinary matters, the most intelligent, can, and a still smaller number do, *think*, on foreign affairs. One of the wittiest and wisest of journalists, Walter Bagehot, was wont to say that if you wished to test the value of public opinion, ask your butler what he thinks of proportional representation. Of course, generally he does not and cannot think about it at all. Foreign affairs are of necessity not understanded of

6

the people because there is not room in their minds and lives for the unfamiliar and often difficult facts from which an understanding can alone be secured. It was reported in February of this year when Mr. Elihu Root retired from the State Department at Washington, that he had negotiated twenty-four treaties providing specifically or generally for the arbitration of international differences arising between the United States and other nations. Unquestionably that was a substantial service to his country and to mankind, rendered by years of patient, enlightened and tactful effort. How many of the people of the United States, how many of the members of the Legislature of the State of New York, who have just voted for Mr. Root as United States Senator, could mention one in ten of these treaties or could define the general principles by which the American Government has been guided in making them? But if opinion, drawn from adequate study of authenticated facts, is too difficult and tedious of acquirement, there is no lack of sentiment regarding international affairs. It is in relation to this sentiment, to its creation, guidance, restraint or stimulation, that the responsibility of journalists arises.

"Responsible" government is a relatively modern phrase, describing, not too nicely, a modern thing. In practice it is government of a nation by agents who can, more or less clumsily, be changed if their conduct do not satisfy the majority of that portion of the people who have a voice in their selection. The change is not necessarily the result of deliberation

7

and it may not be due to the electors' opinion of the general conduct of the agents, or of their conduct as to matters of serious or lasting interest. It may be due to a transient outburst of passion, and may be reversed in another outburst in the opposite direction. Such things happen so often that it would not be far amiss to call the modern system in many instances rather responsive than responsible government. It is with the sentiment which, when aroused, controls at such crises that journalism has to deal, and from this fact its reponsibility arises. The most serious situations are presented not in domestic but in international matters, because in domestic matters readers have more, and more trustworthy, information as to men and measures, do not so easily deceive themselves nor are so readily misled. Moreover in international matters the minds of the mass of men are excited by a strong tendency towards personification. That is to say, they conceive of a foreign nation as an individual, with individual virtues and vices, particularly vices. Even the wisest yield unduly to this. Grave historical writers have a besetting habit of speaking of Germany, France, Great Britain, America, as "she," as a being who can hate and love, plot and fight, can give or take gratitude, resentment and all the intricate category of attributes or feelings that lead to friendship or quarrel in personal intercourse. The tendency is simplified and becomes more intense in the minds of the mass in any nation. It is very tenacious, it is wayward and incalculable in its manifestations, and is sometimes full of peril. The jour-

nalist ought clearly to keep it in mind and to shape his conduct with reference to it.

The chief responsibility of a journalist, then, in international affairs is for the influence he may exert on the feelings of his readers and so on the general sentiment on which so much depends. This influence is exerted, first, by the choice he makes from the mass of news accessible to him. That choice is not really very wide. He must in practice take that most interesting to his readers. It is an elusive despotism that dictates this, but it is indisputable. There is, however, wide discretion as to form. The same news can be presented in a manner to excite or to prevent excitement. The sensible and practical rule is always, so far as possible, to give peace the benefit of the doubt, so to address readers as to keep them cool, and fair, and rational. So far as concerns the text of the news as furnished by the press associations, this rule is generally followed. There is not much temptation for the agents of the associations to depart from it. They are not likely to be goaded by any feeling of rivalry to make their dispatches more impressive, attractive, in a word, sensational. Their interest, as well as their instructions and their duty, can best be obeyed by clear and uncolored presentation of the facts they have obtained. When their reports reach the newspaper offices, however, a different set of conditions is sometimes encountered. The temptation to depart from the rule, to make the news striking, to give to it a form that will catch the eye and stir the feelings of readers to whom the same news may be

9

a very large total circulation. They are usually read more deliberately, with closer attention, and enter more intimately into the minds and the lives of their readers. Their interpretation of current events may not carry more weight, but they make a more continuous and probably a more effective impression. On the whole, the contents of these papers correspond to this view of their function. They are less ephemeral and sensational. It was these journals that Dr. Nicholas Murray Butler, President of Columbia University, largely had in mind when he said, in one of his addresses before the University of Copenhagen, in 1908: "At its best, or even in its average state, the American newspaper is conducted with sobriety and with a due sense of responsibility as an institution powerful for good or evil in a democratic community." Among the larger papers also, especially in the matter of editorial discussion, this judgment is deserved, the exceptions being more conspicuous than numerous or influential. Undoubtedly the press in America, as elsewhere, falls short of the best in this regard, but it is advancing. Those of us who, ardently attached to the cause of just peace, find the advance slow, may comfort ourselves with the ancient saying: "Time respects only that which Time has wrought."

EDWARD CARY

6

The Principles of Style

TOPICS AND REFERENCES

WITH A

PREFATORY ESSAY

BY

FRED N. SCOTT, PH. D.

Assistant-Professor of Rhetoric in the University of Michigan

ANN ARBOR

REGISTER PUBLISHING COMPANY

The Inland Press

1890

PREFACE.

The contents of this pamphlet, with the exception of the Prefatory Essay, are taken from a note-book which the writer compiled for the benefit of his class in the Principles of Style. In the main, therefore, the references do not go beyond the resources of the University Library, though occasional note has been made of works which, it is hoped, the Library may soon possess. Books that are accessible to students of the University of Michigan are indicated in the Bibliographical Index by the affixed shelf number enclosed in brackets, thus [2. 7. 4. 5.]. The Prefatory Essay is not intended to be an original contribution to the theory of Style, but simply to make plain to other instructors who may care to use the references, the writer's purpose in compiling them.

FRED N. SCOTT.

ANN ARBOR. MICHIGAN. November. 1890.

CONTENTS.

CORRECTIONS.

Page 14, l. 6, *for* ecrite *read* écrite.

" 16, l. 20, *for* Microcosmos *read* Microcosmus.

" 19, l. 30, *for* student's *read* students.

" 20, l. 14, *for* problémes *read* problèmes.

" 22, l. 28, *for* rythm *read* rhythm.

" 22, l. 28, *for* Deutschen sprache *read* deutschen Sprache.

" 36, l. 5, *for* Prof. *read* Profs.

" 39, l. 20, *for* ecrivain *read* écrivain.

" 30, l. 19, *for* 30 *read* 27.

" 31, l. 3, *for* longeurs *read* longueurs.

PREFATORY ESSAY.

If we use the term Rhetoric in its broadest sense to mean the principles and practice of literary effect, there are three ways in which the subject may be profitably studied. The student may, in the first place, try to get from the reading of a text-book practical instruction in writing essays. That is, he may commit to memory rules and hints to be applied in the construction of 'compositions'—artificial things which generally sustain to the real things he will be called upon to produce in after life,—letters, editorials, sermons, harangues, stories, sketches, and occasionally essays properly so-called — the same relation that five-finger exercises sustain to symphonies and sonatas. These practical helps he will find given him by the text-books in the form, generally, of abstract and arbitrary rules—"Thou shalt" do this or avoid that. The reasons for the rule may or may not be given, but in either case the student is not at a stage to profit much by them. The rule in all its bareness and blatant practicality is exactly what he needs and about all he is likely to get. "Short sentences should follow long ones," "Particular terms are more forcible than general terms"—a few dogmas of this

Three ways of studying Rhetoric.

1. As a guide to composition.

Abstract rules.

sort must be worked into the student's raw
wincing memory by main strength and
habit of using them reduced to automa
long before, in most cases, the student can
more than a vague glimmering of the rea
that underlie them. This does not mean
the Rhetoric or the instructor should cor
the truth that every rule has a reason bac
it. On the contrary, that fact cannot be
often dinned in the student's ears. He will
be able, probably, to recall very much about
reason and what he thinks he recalls wil
absurdly wrong; but some day he will rem
ber that there *is* a reason and perhaps be
ous to know something about it. If that
ever comes, or is brought about by arti
means, then the student is prepared to prof
a second method of studying rhetoric.

Search for a principle. This consists in a search for some funda
tal principle, the various special applicatio
which furnish the rational explanation of
rules before mentioned. I say 'search' bec
although the illuminating principle itse
usually flaring at the very entrance of the
the student rarely takes it with him i
exploration of the interior. As a general
it is not until he has accepted any numl
corollaries as fundamental and unrelated
ciples that he begins to suspect the exis
of a larger principle from which the corol
are derived. The verification of this sus
and the discovery that the larger princi

that annoying formula which the instructor has been harping on ever since the first lesson was assigned, mark a decided advance in intellectual development. Henceforth, some interest, it may be expected, will be shown in the subject not only for its utility as a guide to practical composition, but for its value as an organized system of facts worth knowing. In short, the study of Rhetoric as a science is now fairly begun. It need not be inferred, however, because the scientific interest increases, that the practical value of the study must at the same time diminish. Rather, practical applications are now unfolded in terms which the student, in his unenlightened state, could not be expected to understand. "Follow the order which corresponds to the self-movement of the subject." Admirable! But a student will have torn his palms on division, definition, amplification and the like for months, before he sets foot on that good eminence. So with the instructions, such as can be given, for the adjustment of matters of sentential stress and rhythm, and for the internal structure of the paragraph. So with the whole question of the order of precedence of the various kinds of subordinate clauses.

2. Science of Rhetoric.

New meanings in old words.

At this stage, rhetorical instruction, it is generally held, reaches its limit. At any rate, if it goes beyond this point it ceases to be a science. It passes the knife-edge boundary which a carefully-worded definition will nicely set about

Ultima Thule.

each individual department of knowledge, s
it henceforward wanders distracted in the m
ancholy and dim land of Aesthetics

> Quivi sospiri, pianti, ed alti guai
> Resonavan per l'aer senza stelle.

Or if haply it flies shrieking from this limbo
Lost Ideas, it may be unlucky enough to ,
over into the adjoining territory of Literat
among dramas, epics, novels and other

> Gorgons, and hydras, and chimaeras dire.

"Step over this line" says the rhetoric-mal
scratching in the accumulated dust of ag
"and you get into the region of the vag
Rhetoric cannot account for the finer effect
literature. There is an indescribable bloon
charm"—and so on. We all believe in the ir
scribable bloom and charm, though it mus
confessed the formula is getting rather t
some; but is it true that any exact line of d
sion can be drawn between the vague and
definite? To the average student, everytl
is vague at first. The bloom that goes with
substitution of a particular for a general t
is to his mind not less indescribable than is
dying fall of a line of Keats to the presume
more piercing intelligence of the instruc
After a time, if he is diligent, the student m
orizes a reason for this particular kinc
bloom, and later, if he is fortunate, he
some idea of what the reason means. He
on in this way from beginning to end of
study, at every step clearing up vaguene

and learning to describe blooms and charms.
This process comes to an end, not, in most
cases, because the truly Indescribable blocks
the way, but because the last page of the Rhet-
oric has been recited and review has begun.
The acquisition of ever clearer knowledge
might go on for a life-time, and in very many
cases, let us hope, it actually does so. Of
course a text-book must end somewhere and
have at least a semblance of completeness and
finality or it will be unfavorably reviewed by
the journals. Suppose then, we call the kind
of rhetoric commonly taught from text-books
in our High Schools and Universities, the
Lower Rhetoric (not meaning thereby to de-
preciate it but simply to give it a convenient
handle), and suppose again that we embrace
all further incursions into the vague and all
further strivings to describe blooms and charms,
under the name of Higher Rhetoric.

*The tether
of the text-
book.*

Now the student, as he passes from the
Lower to the Higher treatment, while he will
not be made aware of any absolute breach
of continuity between the two, will yet feel
a growing sense of otherness. For one thing,
he will find that his instruction calls for the
exercise of certain mental functions in higher
degree than was formerly the case. Imagina-
tion and Feeling, which had little employment
while the Lower Rhetoric was in progress, are
now required at every step. The student is not
argued with so much as appealed to to feel as his

*1. The High-
er Rhetoric.*

instructor does, or frankly to differ with hi
If he respond tardily to the appeal, his advan

*Appeal to
Feeling.*

ment is slow and hesitating. Further, just
when he entered upon the study of the Scien
of Rhetoric, he must learn a new vocabulary,
rather learn to attach new meanings to
words and phrases. But what meaning? Tha
something he cannot learn from the diction

*Cultivation
of a sense for
literary val-
ues.*

He must come to feel the thing itself before
can feel any value in the symbol of the thi
And almost his only hope, if the feeling ha
fire, is to read, to read: to go through crise
wild, blind enthusiasm for the worst passage
Macaulay, Scott and Ruskin; to linger in si
sentimentality over syrupy lines of Rossetti
Swinburne; to explode with admiration at
metaphors in Dickens, Lowell and Holi
If the good passages can be admired, so m
the better; but unless there is sincere lov
hate for something the work had better
abandoned.

One aim of the Higher Rhetoric then is
cultivation of a sense for values in literat
but if we consider carefully we shall see
this is only one phase of a more general
cess, namely, an advance toward concretei
—concreteness in all the student's concept

*Return to
nature.*

Some vague feeling of rightness there i
have been at the very beginning of the st
else the student could not have applied even
simplest precept. What is being accompli
now is the emancipation of this feeling, gi

it a chance to grow out from under the memor-
ized abstract rule, to grow away from it appar-
ently at first, but really, as will later turn out to
be the case, to grow into it and give it meaning
and vitality. All the new sap of feeling and
imagination that collects with the study of
the Higher Rhetoric, should flow back into *Abstrac-*
the hard abstractions of the Lower to give *tions made concrete.*
them richness and ease. The student's prac-
tice—his paragraphing, the management of
the rhythm of his prose, even his cap-
italizing, spelling and punctuation—ought to
come more easily and naturally to him through
this infusion of life into dry bones. And as for
the grasp of principles, he will probably come
to wonder whether, before, he ever had hold of
any principles at all, so vividly does he now
realize for the first time that whatever is not a
piece of his own personality can be nothing but *Shadows,*
an insular—a paste-board box to hold abstrac- *not substan-*
tions. *tial things.*

A piece of his own personality!—that, after
all, is, in the Higher Rhetoric, the only kind of
goods worth having. If we say cultivation of
taste, what should we mean but holding on
steadfastly and sincerely to what takes hold on
us—satisfies, that is, what of personality we *Growth of*
have achieved up to that point in our develop- *personality.*
ment, and striving to grow in grace and knowl-
edge so that more things may take hold on us?
Or if we say that a writer must obey the Laws
of Composition, what should we mean but that

he is to make these laws a part of his own ṛ
sonality and then utter himself? Or if finɛ
we say that such and such compositions
masterpieces of style, what can or ought we

*The Secret
of Style.* mean but that they are the perfect express
of personalities worth expressing?

To develop this rational and sensitive pers
ality is, then, the object of the Higher Rheto
no matter whether the student's aim be to ṛ
duce good literature, to appreciate that produ
by others, or simply to learn the laws and pı
ciples of good writing. To that end three li

Feeling of progress will converge: the cultivation o
and sense for literary values by wide reading,
Reason study of Rhetoric as a science, and the union
united feeling and knowledge through practice. A
by Practice in practice I would include not composit
in alone, but the equally indispensable discipl
Composition of criticism, provided only the criticism be ᴢ
and in mere notes of appreciation or mere compilat
Criticism. of statistics—both are good in their way—l
an earnest attempt to get at the rational ɛ
ment of what we feel to be good.

*Object of
the course.* The object of the course for which this ref
ence-book has been prepared, is to furnish ṭ
student with all legitimate help on his way
a better understanding of the Higher Rhetoı
The course has been called the Principles
Style, because Style is a word which, when us
in its broadest sense and not as the compleme
of Invention, comes near to summing up thϲ

concrete elements of good literature with which
the Higher Rhetoric is concerned. The method
of instruction might, of course, be varied infi-
nitely, but the topics and references here given
have been arranged to accord with the following
programme:

1. *Lectures* of a suggestive character designed
to relate the familiar rules of the Lower Rhe-
toric to some of the primary facts of Logic,
Psychology and Aesthetics, and to a lay a more
philosophical foundation for the student's own
investigations. Among the topics which call
for this treatment may be mentioned, the Defi-
nition and Kinds of Literature, the Relations
of Prose and Poetry, the Nature of Language,
etc.

Programme of the Course: 1. Lectures.

2. *Personal research* of three kinds:

2. Personal research.

(a) The examination of essays in criticism to
discover upon what basis famous critics have
founded their judgments of literature. This
has been found profitable on three accounts: it
is interesting work; it brings the student into
personal relations with an excellent class of lit-
erature; it presents him with the principle in a
concrete form. The results of the research may
be presented to the class in the form of papers
or verbal reports and the value of the princi-
ples form the subject of a general discussion.

(b) The reading of special treatises upon
style. The selection of the treatises must of
course depend largely on the number of hours
that the course occupies and the more or less

elementary character of the work. The m
object is to get out of the groove of the regu
text-book, to see, for example, what Spencer h
self said about Style instead of taking u
trust what some third person thinks he ough
have said. ·The results of this investigat
may also be presented in brief papers or ver
reports and should, if possible, be vigorou
discussed by the class.

(c) Essays on special topics. Each mem
of the class may be assigned a particular to
to work up into a thesis, the latter to be
greater or less length according to the grad
work that is being done and the time devo
to the course.

s. Study of Specimens of Style. 3. *Study of specimens of style* to verify
principles. For class-room purposes Sai
bury's Specimens of English Prose Style
Genung's Handbook of Rhetorical Analysis
exactly answer the purpose. Prose selecti
are of course to be preferred for the m
elementary work. Genung's Handbook c
tains valuable suggestions for methods of
struction, but, as in all other things, the
structor must here hew out his own method.
the members of the class can be encourage
read through the works from which the se
tions are taken, so much the better.

Arrangement of the references. The material which follows has been arran
in the order: (a) References to accompany
lectures; (b) Specimen critiques; (c) Topics
individual research; (d) Bibliographical inc

The lists are intended to be suggestive merely, and in consequence, no high degree of comprehensiveness has been aimed at. As not all the works mentioned are, very obviously, of the same degree of abstruseness, some pains has been taken to discriminate between them by means of brief commentaries or characterisations, which, it is hoped, will not be mistaken for critical judgments. A few suggestions have been added for the benefit of more advanced students.

Two classes of topics have been discriminated, although one naturally passes into the other: (a) Those of an elementary and more or less technical character, demanding little more than patience and accuracy, but yet affording a discipline not without its value; (b) Those requiring considerable exercise of independent thinking. The number may be increased indefinitely by substituting other authors, increasing or narrowing the scope of the field of inquiry, etc.

TOPICS AND REFERENCES.

i. ORIENTATION.

Certain fundamental questions concerning the relations of Style to other facts of knowledge are sure to arise at the very beginning of the course, and, unless at once disposed of, to recur at intervals in an increasingly annoying aspect. The approach to them will be easy if the student has had a thorough grounding in Psychology, but they can be satisfactorily answered only in the light of some elementary principles of Philology and Aesthetics; and although these principles, as before suggested, are to be given by lecture, the instruction may profitably be supplemented by outside reading in some of the following references.

1. DEFINITION AND CLASSIFICATION OF LITERATURE.

MATTHEW ARNOLD. Discourses in America.*
> P. 72-137 Literature and Science. See p. 90 for a distinction between Literature and Belles-lettres.

BROOKE. English Literature.
> P. 1 Definition of Literature.

BURT. Some Relations between Philosophy and Literature.

CARLYLE. On Heroes.
> See p. 151 for a characterization of Literature.

DE QUINCEY. Works.
> For De Quincey's distinction between the Literature of Knowledge and the Literature of Power, see his essay on Pope and Letter III of his Letters to a Young Man.

* For full bibliography and shelf number to this, as to all other references, see Bibliographical Index.

DOWDEN.　Transcripts and Studies.

See p. 237-240 of the essay on the Interpretation of Literature.

GAUCKLER.　Le Beau.

P. 178-182. Gauckler's term for Literature in general is *L'art de la Par* which he considers under three heads: *La Poesie, L'art oratoire* i *La Prose ecrite.*

HUNT.　Studies in Literature and Style.

See p. 7 for definition of Literature.

LAURIE.　Lectures on Language.

P. 81-104.

LEWES.　Principles of Success in Literature.

P. 1-23.

MORLEY AND TYLER.　Manual.

P. 1.

JOHN MORLEY.　On the Study of Literature.

See p. 38-39 for several definitions of Literature, p. 40 for Morley's o definition.

JOHN MORLEY.　Voltaire.

A definition and characterization of Literature will be found on p. 13-15.

NETTLESHIP.　The Moral Influence of Literature.

NEWMAN.　The Idea of a University.

P. 268-294.

POSNETT.　Comparative Literature.

Chap. 1.

STE. BEUVE.　Causeries de Lundi.

V. 3, p. 38-55 Definition of a Classic.

SCHERR.　Allgemeine Geschichte der Literatur.

V. 1, p. 1-2.

TAINE.　History of Literature.

Introduction.

THIRLWALL.　Essays, Speeches and Sermons.

P. 284-311. The present State of Relations between Science and Literatur

BASCOM.　Philosophy of English Literature.

VINET.　Outlines of Philosophy and Literature.

P. 457-481.

BAGEHOT.　Literary Studies.

A plea for the introduction of the term *literatesque* to mean what is avai able for purposes of literary art, will be found in Vol. 2, p. 341.

NOTES.

ARNOLD. For Arnold's lecture, if duplicates are needed, see 19th C. 12:216, Pop. Sci. Mo. 21:737. The lecture by Huxley to which Arnold's lecture is in part an answer, may be found in Nature 22:545 or Pop. Sci. Mo. 18:159. Huxley touches on the same theme, but with somewhat more liberality toward letters, in his Liverpool lecture, an abstract of which is published in Nature 27:396. The lecture in full appeared in Lond. Jl. Educa., March, 1883. See also Brackett's Relation of Modern Science to Literature in Pop. Sci. Mo. 15:166. Arnold's essay in Macm. 19:304 on the Modern Element in Literature has at the beginning a few paragraphs on the Nature of Literature.

MORLEY. Morley's lecture on the Study of Literature was reprinted in the Critic 7:169.

STE. BEUVE. The definition of a classic will be found translated in Morley's Study of Literature, p. 38-39.

Of the references given above, ARNOLD, DE QUINCEY, JOHN MORLEY, NETTLESHIP, NEWMAN AND THIRLWALL, are best adapted for assigned readings of a popular character. BROOKE, HUNT, MORLEY and TYLER, CARLYLE and STE. BEUVE, contain each only a paragraph or two bearing directly on the topic. BURT, GAUCKLER, VINET and SCHERR are philosophical though not violently so; TAINE and POSNETT scientific. LAURIE and LEWES are not concerned so much with defining literature as the one in pointing out its educational value and the other the conditions necessary to the successful pursuit of literature as a profession.

For advanced students, more technical and profound treatments of the subject may be sought in Gerber's Die Sprache als Kunst, V. 1, p. 43–122, Paul's Grundriss d. Germ. Philol., Methodenlehre, p. 216, et seq., Hegel's Aes-

3

thetik, V. 3, p. 220–282. The relation of literature to other arts is a profitable line of research.

2. RELATIONS OF THOUGHT AND LANGUAGE.

ENCYCL. BRIT. 9th ed. "Philology" by W. D. White
See esp. p. 766, *et seq.*

WHITNEY. Language and the Study of Language.
P. 403–420.

WHITNEY. Life and Growth of Language.
P. 1–31.

PAUL. Principles of Language.
Esp. Introd. and p. 1–19.

DEWEY. Psychology.
P. 3, 211–213.

SULLY. Outlines of Psychology.
P. 337–351.

PEILE. Philology.
Chap. 8.

HAMILTON. Lectures on Metaphysics and Logic.
P. 98–99, 432–439.

LOTZE. Microcosmos.
Vol. 1, p. 618–639.

JAMES. Psychology.
Vol. 1. p. 236, 241, 245, 251–261–283.

VICTOR EGGER. La Parole Intérieure.

BRUCHMANN, K. Psychol. Studien.
II Teil.

BALLET. La Parole Intérieure.

WEIL. Order of Words.

MAX MUELLER. The Science of Thought.

MAX MUELLER. On the Science of Thought.
See esp. p. 34–61.

EARLE. Philology of the English Tongue.
See Chap. 5 on Symbolic and Presentive Words.

LEWES. Problems of Life and Mind. 3d Ser.
See Problem 4, Chap. 5, for a comparison of words to Algebraic Symbo

D. J. HILL. Science of Rhetoric.
P. 19-33.
REV. PHILOS. 22:1 De la parole. Stricker.

NOTES.

MAX MUELLER. For further discussion of Mueller's theory see 19th Cent. 23:569, 743; Nature 36:249, 37:323, 364, 412; Contemp. 54:475, 806; Princeton Rev. 1881 (Vol. 1) p. 108. The same subject is also briefly treated by Romanes in his Mental Evolution in Man, p. 81-83.

The best works for popular reading are doubtless WHITNEY, PEILE and EARLE. The article in the Encyclopædia Britannica is more concise and harder for most students to comprehend. The work of Max Mueller first mentioned is rather bewildering to the non-philological student, but the second, a book made up of letters published in the Open Court, is of a more popular character. Of the psychologies, DEWEY is brief but very suggestive; SULLY more detailed; JAMES a mine of valuable information for those who are sufficiently advanced to appreciate him. PAUL is admirable, but requires considerable familiarity with the terminology and history of Philology. HAMILTON's forcible illustrations make his explanations clear for most readers. The chapter in LOTZE is for those who have done considerable philosophical reading. VICTOR EGGER and WEIL are pieces of brilliant research, one dealing with the relation of the word to the thought, the other with the relation of the order of words to the order of thoughts.

3. POETRY AND PROSE.

BAIN. On Teaching English.
Chap. I.
ENCYCL. BRIT. 9th ed. 'Poetry' by T. Watts.
See cap. p. 261-263.

COLERIDGE. Complete Works. Vol. 4.

The famous statement of the antithesis of poetry and science occ
 Vol. 4 in the introductory essay on Definition of Poetry. Se
 pages 387–388 on the Wonderfulness of Prose.

ABBOTT AND SEELEY. English Lessons.

See p. 54–104, 145–151.

MASSON. Essays.

See p. 447–475 on Prose and Verse.

PATER. Appreciations.

P. 1–13.

SAINTSBURY. Specimens of English Prose Style.

In the Introduction Saintsbury has some curious reflections on the m
 movement of prose.

POSNETT. Comparative Literature.

See p. 49–52 and the foot-note on p. 51–52.

BASCOM. Aesthetics.

See the opening paragraph of Chap. 7.

VINET. Outlines of Philosophy and Literature.

See p. 544 and the paragraph on Rhythmical Unity, p. 492.

GENUNG. Practical Rhetoric.

See p. 48–84 for contrasts of poetic and prose diction.

GUMMERE. Hand-book of Poetics.

P. 84, 157.

WALTER. Lessing on Poetry and Painting.

P. 5–9.

SPENCER. Philosophy of Style.

In § iv Spencer attempts an explanation of the Superiority of Poe
 Prose.

MASSON. De Quincey (Engl. Men of L.).

See p. 190–198 on De Quincey's Prose-poetry.

D. J. HILL. Science of Rhetoric.

P. 33–37.

CONTEMP. 47: 548 On Style in Literature. R. L. F
enson.

P. 552–556.

WHATELY. Elements of Rhetoric.

Part III, Ch. 3, § 3–4.

of prose and poetry, Vol. 3, p. 220–282, should be know⟩
first hand. Most of the systematic German treatises
Poetics, as those of Viehoff, Wackernagel, Gottsc⟩
Kleinpaul, and Wilh. Scherer. either throw light on
question or succeed in making the darkness visible.

4. RHYTHM AND METRE.

SPENCER. First Principles.
Chapter on Rhythm.

KAWCZYNSKI. Essai comparatif sur l'origine et l'hist
des rythmes.

HELMHOLTZ. Sensations of Tone.

HAUPTMANN. The Nature of Harmony and Metre.

CHARLES HENRY. Rapporteur Esthétique.

GUYAU. Problémes de l'esthétique contemporaine.
P. 178–223. See especially p. 178–182 on the Rhythm of Language a
Origin.

GUMMERE. Poetics.
Part III Metre.

SULLY. Outlines of Psychology.

DEWEY. Psychology.
P. 58–68, 185-187 Rhythm.

GENUNG. Practical Rhetoric.
See p. 169–171 for the Rhythm of Prose.

MINTO. Manual of English Prose Literature.
P. 24.

T. A. ARNOLD. Manual of English Literature.
See the Appendix on English Metres.

MOD. LANG. NOTES, 4:97. Certain considerations t⟨
ing the Structure of English Verse. W. H. Browne.

SYLVESTER. The Laws of Verse.

LANIER. Science of English Verse.

ABBOTT and SEELEY. English Lessons.
P. 145-221.

EVERETT. A System of English Versification.

RUSKIN. Elements of English Prosody.

FORTN. 22:767. The Blank Verse of Milton. J. A. Sy-

·SYMONDS. Sketches and Studies in Italy.
On Blank Verse.

MAYOR. English Metres.

JEBBIN. Papers, Literary, etc.
See Vol. 1, p. 149-170, for a theory of Rhythm in English Verse.

GUEST. History of English Rhythms.

SCHIPPER. Englische Metrik.

CONTEMP. 47:548. On Style in Literature. R. L. Ste-
venson.
See p. 548-558 on the Rhythm of the Phrase.

SPENCER. Philosophy of Style.
See § iv, in which Spencer offers an explanation of the effect of rhythm in
poetry.

DUHER. Ueber Metrik und Rhythmik.

GURNEY. Power of Sound.
Chap. 7, and Chap. 19 on The Sound Element in Verse. See also appendix D.

ENCYCL. BRIT. 9th ed. 'Poetry' by T. Watts.

DE MILLE. Elements of Rhetoric.
P. 776-788.

BAIN. Rhetoric.
P. 589-594.

MARSH. Lectures on the English Language.
Lect. xxiv Accentuation.

SCHMIDT. Introduction to Rhythmic and Metric.

BULWER. Caxtoniana.
Rhythm of Prose.

KAME. Works.
Vol. 2, p. 349-402.

REV. PHILOS. 28:356 Le Contraste, le Rhythme, la
Mesure. Ch. Henry.

NOTES.

Some notion of the general character of rhythm and th
part it plays in nature may be gained from the chapter i
SPENCER, which no one will have any difficulty in under
standing. The psychology of rhythm is treated b
DEWEY and SULLY. HELMHOLTZ, the great authority o
musical rhythm as on all other matters pertaining t
tones, is formidable both for bulk .and for complexity
HAUPTMANN is of truly German profundity, not to b
understood without great travail of spirit, but well wort
the labor. HENRY has made some curious discoverie
with regard to the psycho-physical aspects of rhythi
and their mathematical equivalents. GURNEY is a stor
house of interesting information and always intelligibl

On the vexed subject of metre, the standard works al
GUEST, LANIER, MAYOR and SCHIPPER. GUMMERE :
intended for class-room use, but embodies the latest scien
tific research. T. A. ARNOLD, ABBOTT and SEELEY al
useful brief compends. SYLVESTER is a conglomerate (
translation, comment and digression, but contains a fe
interesting observations on metre from a mathematica
point of view, obscured by a preposterous terminolog
The articles by BROWNE (Mod. Lang. Notes), JENKIN, an
SYMONDS are adapted to the needs of the non-technica
student. A statement of the controversy over the variot
theories of metre may be found in the opening chapter (
MAYOR.

The rythm of prose is a subject that still awaits careft
investigation. GENUNG and MINTO contain useful hin
from the practical stand-point. A few pages full of su
gestion are to be found in GUYAU, who is always readabl
and a very deft handling of the subject in STEVENSON

II

WHATELY. Elements of Rhetoric.
Part III, Ch. 2, § 5 Words Considered as Sounds.
BAIN. Rhetoric.
P. 110–120.
MARSH. Lectures on the English Language.
See Lects. xxiii–xxv on Rhyme, Alliteration and Assonance.
CONDILLAC. Oeuvres.
Vol. 7, p. 429 Dissertation sur l'harmonie du Style.

NOTES.

Most of the systematic treatises referred to under Met
and Rhythm have something to say also about the qua
tative value of words and word-combinations, but no ve
satisfactory treatment of the subject is as yet availabl
The best, LANIER'S, is hurried and desultory. LONGRID(
has brought together most of the traditional (and fancifu
ideas upon the emotional value of consonant-combin
tions and long and short vowels. CAMPBELL, KAMES ar
BLAIR are mostly concerned with the concord of soun
and sense. The student will find in them the well-wor
examples retained in most modern text-books. GUMMERE
treatment is brief but meaty. SPENCER'S theory of tl
physiological effect of rhyme and rhythm has been gene
ally adopted. See, however, the note on p. 441 of Gu
ney's Power of Sound. The *Schulprogramme* of DUEE
and GRABOW are excellent, especially that of the latte
which is a special investigation into the musical elemen
of German speech. Some interesting notes on the cha
acter of rhyme-words in English will be found in Pro
A. S. Cook's article on English Rimes, Mod. Lang. Not(
3: 209.

principle of economy, has been pretty generally follow
in particular by GENUNG and D. J. HILL. GUMMEB
research into the historical relations of Metaphor ɛ
Simile may be found in his thesis on The Anglo-Sa:
Metaphor. The articles in Mod. Lang. Notes by Pɪ
Bradley and Fruit will be found suggestive.

7. THE LOGICAL STRUCTURE.

RENTON. Logic of Style.
Chap. III Of Quantity.

WHATELY. Elements of Rhetoric.
Part I.

BAIN. Rhetoric.
Part I, Ch. 5.

MINTO. Manual of English Prose Literature.
P. 3-11.

CAMPBELL. Philosophy of Rhetoric.
Book III, Chap. 5, § 2 on the manner of using the Connectives in coml
Sentences

GENUNG. Practical Rhetoric.
P. 176 179, 193 214, 245 248.

CONTEMP. 47:548. On Style in Literature. R. L.
venson.
P. 549 553 The Web.

PATER. Appreciations.
See the remarks on logical coherence on p. 18 21.

NOTES.

It would be easy to multiply references under this
since almost every rhetoric has something to say ɛ
sentential or paragraph structure, or about the logica
cedures of Invention so-called. The ablest handling ɛ
subject is that of RENTON, which few undergraduate re
are prepared to understand. GENUNG's treatment ɛ
paragraph is in every way admirable.

6. STEPHEN. Johnson. [Eng. M. of L.].
 Chap. 6.

7. WARNER. W. Irving. [Am. M. of L.].
 Chap. 10.

8. COURTHOPE. Addison. [Eng. M. of L.].
 Chap. 9.

9. TRAILL. Sterne. [Eng. M. of L.].
 Chap. 10.

10. JOHNSON. Lives of the Poets.
 (a) Dryden, (b) Pope, (c) Milton, (d) Cowley, (e) Waller, (f) Addison
 Swift.

11. MORISON. Macaulay. [Eng. M. of L].
 Chap. 2.

12. GOSSE. From Shakespeare to Pope.
 (a) P. 1-36 Poetry a the Death of Shakespeare, (b) p. 155-189, The Rea

13. STEDMAN. Poets of America.
 See references in the Index under 'Style.'

14. STEDMAN. Victorian Poets.
 (a) Chap. 2, (b) Chap. 3, (c) Chap. 4, (d) Chap. 5, (e) Chap. 9.

15. STEPHEN. Hours in a Library. First Series.
 Essay on De Quincey.

16. MASSON. De Quincey. [Eng. M. of L.].
 Chap. 11.

17. MATTHEW ARNOLD. Mixed Essays.
 P. 189 204 A Guide to English Literature.

18. SWINBURNE. Essays and Studies.
 P. 123-183 Matthew Arnold's New Poems.

19. BAGEHOT. Literary Studies.
 Vol. 2 Essay on Gibbon, p. 31-33

20. MORLEY. Burke. [Eng. M. of L.].
 Chap. 10.

21. NICHOL. Byron. [Eng. M. of L.].
 Chap. 11.

22. STEVENSON. Men and Books.
 P. 91 128 Walt Whitman.

23. BURKE. Select Works.
 Vol. 1. Introduction by E. J. Payne.

24. Forth. 25:494 Macaulay. J. Morley.

25. Pater. Appreciations.

(a) Wordsworth, (b) Lamb, (c) Browne.

26. Fraser. 55:249. Literary Style. W. Forsyth.

iii. TREATISES ON STYLE.

1. Essays.

Lewes. Principles of Success in Literature.

Spencer. Philosophy of Style.

Buffon. Discours sur le Style.

De Quincey. Essay on Style and Essay on Rhetoric.

Coleridge. Complete Works.

Vol. 4. p. 287-343. On Style.

Pater. Appreciations.

Essay on Style.

Contemp. 47:548. Style. R. L. Stevenson.

See the same article in Critic, 6: 189, 199, 213.

Higginson. Atlantic Essays.

P. 29-67, Literature as an Art.

Joubert. Pensées.

Vol. 2. p. 273-300 Du Style, p. 301-341 Des Qualités de l'ecrivain.

Long. An Old Man's Thoughts.

P. 79-103 style.

Minto. Manual of English Prose Literature.

Introduction.

Newman. The Idea of a University.

Lecture on Literature.

Burton. The Logic of Style.

Saintsbury. Specimens of English Prose Style.

Introductory Essay.

Forth. 25:243. Modern English Prose. G. Saintsbury.

Royal Irish Acad. Trans. 5:39-92. On Style in writing. R. Burrowes.

DRAKE. Essays illustrative of the Tatler, Sp tator and Guardian.

Vol. 2, p. 1-116 On the Progress and Merits of English Style.

MACM. 37:78. Style. T. H. Wright.

The same article may be found in Pop. Sci. Mo. 12: 340.

HIGGINSON. Hints on Writing and Speech-making.

BULWER. Caxtoniana.

SCHOPENHAUER. Sæmmtliche Werke.

V. 6, p. 536-581, Ueber Schrift-stellerei und Stil.

ZEITSCH. F. VOELKERPSYCHOL. 4:465. Zur Stylis H. Steinthal.

STEDMAN. Victorian Poets.

Introduction.

HUNT. English Prose.

Part II.

NOTES.

BUFFON'S discourse should be read by all because of historical importance. His definition of style has alrea been spoken of, p. 30. What does he mean by it, and w does he prefer general to particular terms?

Everyone should know SPENCER at first hand, and in t same connection should be read the article by WRIG (Macm. 37:78). WRIGHT offers a justification of SPENCE somewhat startling conclusions concerning the ideal styl. See also Gurney's Power of Sound, p. 441 note. LEW who is admirably clear, vigorous and comprehensive, I availed himself of SPENCER's theory of Economy, t offers a criticism of it at the beginning of the section Sequence. LEWES's three principles of Vision, Sincer. and Beauty are easily grasped by students and frequent stick in their memories when other and more conve tional precepts leave no trace.

DE QUINCEY'S long and rambling essay on Style and I

shorter essay on Rhetoric have been so rifled by rhetoric-makers that they seem, like Hamlet, full of stale quotations. The student may skip, with profit, the *longeurs* on Isocrates and the Athenian orators, in the essay on Style. Renton is probably right in saying that DE QUINCEY marks an epoch in the history of Rhetoric second in importance to that made by Aristotle, and is equally just when he says further that DE QUINCEY'S contribution would have been much greater had his philosophical basis been sounder.

Lowe has nothing particularly new to say, but says it with a charming garrulity. DRAKE deals mainly with Addison and Addisonianism. JOUBERT is a string of verbal brilliants not less meaningful than brilliant. NEWMAN'S Lecture on Literature restates delightfully some of the simple truths of the text-books. SAINTSBURY'S Introduction is mainly historical, showing the evolution of modern sentence- and paragraph-structure. It contains interesting remarks on prose rhythm. His article in Fortn. 25:243 briefly outlines the principles of style, then criticises Froude, Swinburne, J. R. Green and others. HIGGINSON'S essays are for young men with literary aspirations. That on Literature as an Art is excellent. The essay by BURROWES in the Royal Irish Acad. Trans. is old-fashioned but not without merit.

RENTON'S book is probably the best thing in existence on the Logic of Style, but the author's fondness for logical subtleties and obscure semi-humorous metaphors makes it, for beginners, unnecessarily hard and dark.

The Introduction to MINTO'S Manual is sometimes used as a text-book and taken in connection with the rest of the work, it should answer that purpose well, as far as it goes. The author does not make much effort, however,—perhaps

4

that did not lie within his purpose—to help the studer out of the conventional ruts.

The most important recent contributions of a popul character to the theory of Style, are the essays of STEVE son (Contemp. 47) and PATER. The former is most concerned with technical points. The latter works fro a philosophical basis. In connection with STEVENS should be read ARCHER'S essay in CRITIC, Vol. 8. Fla bert's Letters will be asked for by those who read PATE

A few paragraphs on style with a comment on Buffor definition (misquoted) will be found in Stephen's Hou in a Library, 2d series, p. 201. Brockhaus's Conve sations-Lexicon contains a brief but suggestive arti on "Stil," mostly taken from Rumohr. Milton's compa son of poetry and rhetoric, often quoted (or rather m quoted) as a canon of style, will be found in his Tracti on Education. See the use made of it by STEDMAN in 1 Introduction to his Victorian Poets. Chap. 18 of Hosme History of German Literature discusses German St interestingly. Ruskin and Arnold, the first in Vol. 3 Modern Painters, the second in his essays on Translati Homer, have touched on the characters of the "gre style." See, for these references, Cook's Touchstones Poetry, which contains also Ruskin's rules from Ficti Fair and Foul. Bourget writes subtilely on style in essays on Flaubert and the brothers de Goncourt, in Ess de Psychol., pp. 156–173, and Nouveaux Essais, pp. 1 198. Wordsworth's Prefaces are of interest in the (cussion of poetic diction.

Of the older English treatises, it is perhaps unnecess to do more than mention Jonson's Discoveries, Sidn Apologie for Poetrie, Webbe's Discourse, Puttenham's .

of Poesie, Constable's Reflections on Accuracy of Style, and Pope's Essay on Criticism. The list might be extended indefinitely, but would be of value only to the specialist.

The advanced student may consult, for artistic style in general, Veron's Aesthetics, references under Style in the index; Vischer's Aesthetik, references under Styl, Stylgegensatz, Stylgesetz and Stylisirung; Von Hartmann's Aesthetik, Vol. 2, references under Stil. On literary style especially, see Richter's Aesthetik, Vol. 2, p. 601–656, the article by STEINTHAL in the Zeitsch. f. Völkerps. 4:465, and SCHOPENHAUER's treatise referred to above.

Those who are taking up the historical development of stylistic theory will wish to consult most of the following works: Aristotle's Poetics; The Treatise on the Sublime by Longinus; Horace's Ars Poetica; Cicero's De Inventione Rhetorica, De Oratore, Brutus, Orator, Topica and De Partitione Oratoria; Quintilian's Institutes; Dante's De vulgari eloquio; Bembo's Le prose; Vida's De Arte poetica; Boileau's L'Art poétique, and Voltaire's article on Style in the Encyclopædia (Oeuvres, Vol. 20).

2. RHETORICS.

ARISTOTLE. Rhetoric.

QUINTILIAN. Institutes.

HOBBES. English Works.

V. & p. 513, The Art of Rhetoric. The preceding portion of the Whole Art of Rhetoric, p. 420–512, is an abridgment of Aristotle.

CAMPBELL. Philosophy of Rhetoric.

KAMES. Elements of Criticism.

BLAIR. Lectures on Rhetoric and Belles Lettres.

WHATELY. Elements of Rhetoric.

HART. Composition and Rhetoric.

A. S. HILL. Principles of Rhetoric.
D. J. HILL. Science of Rhetoric.
GENUNG. Practical Rhetoric.
BASCOM. Philosophy of Rhetoric.

NOTES.

The above list is designed to point out for the student a few systematic treatises on Rhetoric which are important for their historical influence, for their breadth of treat ment, or for both reasons together. ARISTOTLE is, of course, the first great authority. Changes in modes of life thought, and verbal communication have done little to destroy the practical value of his precepts, while for an understanding of the theory he is simply indispensable The difficulty of understanding the Rhetoric is com monly overrated. Most of it is intelligible even to beginners. The English trio, CAMPBELL, KAMES and BLAIR, are much talked about, but little read. As prac tical guides they point the way to that 'proper' kind o style which is elegantly impersonal and sickeningly correct but as repositories of information upon special topics they will amply repay frequent consultation if not consecutive perusal. CAMPBELL is undoubtedly the most sensible and original of the three. The student's reading of them wil be far more profitable if he first gets some notion of the philosophical and psychological tenets of the Scottish School. On Kames in particular see Schasler's Kritische Geschichte der Aesthetik, Vol. 1, p. 295. For special stu dents Cope's Introduction to Aristotle's Rhetoric, Spen gel's Studium der Rhetorik bei den Alten, and Volkmann's Rhetorik der Griechen und Römer will be found of grea

critical value. See also the closing chapter of Vischer's
Aesthetik and the brief essay by Schopenhauer in The
World as Will and Idea, Vol. 3.

iv. TOPICS FOR PERSONAL RESEARCH.

1. TECHNICAL.

1. Analysis of paragraph-structure.
See Genung's Practical Rhetoric, p. 193-219.

(a) Macaulay.

(b) Dryden.

(c) Sir Philip Sidney.

(d) Lamb.

(e) Gibbon.

(f) Locke.

(g) Spencer.

(h) Burke.

(i) Freeman.

(j) Froude.

2. Character of the sentential cadence.
See Genung's Practical Rhetoric, p. 171, Longridge's English Writers, Part
2, p. 17-18.

(a) Macaulay.

(b) Ruskin.

(c) Thackeray.

(d) Milton.

**5. Proportion of words of Saxon to words of Latin
derivation.**

(a) Macaulay.

(b) Johnson.

(c) Bunyan.

(d) More.

(e) Dryden.

(f) Matthew Arnold.

6. Use of *will* and *shall, would* and *should.*

See White's Words and their Uses, p. 265; Head's Shall and Wl
[2. 12. 1. 5.]

(a) Bunyan.

(b) Lamb.

(c) Goldsmith.

(d) Addison.

7. Use of alliteration and assonance in prose.

See Contemp. 47:556–561.

(a) Macaulay.

(b) Ruskin.

(c) Thackeray.

(d) Milton.

(e) Sir Thomas Browne.

(f) Carlyle.

(g) Newman.

(h) Pater.

8. Archaisms and the use made of them.

(a) Lamb.

(b) Helps.

9. Newly-coined words and the use made of them.

(a) Carlyle.

(b) Lowell.

(c) Dickens.

10. Examples of poetic diction in prose writing.

See Genung's Practical Rhetoric, p. 48–76. Abbott and Seeley's E
Lessons, p. 54–104.

(a) Burke.

(b) Carlyle.

(c) Hawthorne.

(d) Ruskin.

11. **C**ases of inverted order and reasons for them.

See Genung's Practical Rhetoric, p. 60, 165-169.

(a) Ruskin.

(b) Thackeray.

(c) De Quincey.

(d) Dickens.

(e) Scott.

12. **I**rrelevant clauses.

Genung's Practical Rhetoric, p. 176-178. Minto's Manual, p. 10. D. J. Hill's Science of Rhetoric, p. 195-196.

13. Devices for showing the connection between sentences.

Genung's Practical Rhetoric, p. 196-207.

(a) Carlyle.

(b) Newman.

(c) De Quincey.

14. Devices for showing the connection between paragraphs.

(a) Macaulay.

(b) De Quincey.

15. Classification and statistics of the various kinds of figures employed.

See preceding references on figures.

(a) Burke.

(b) Johnson.

(c) George Eliot.

16. Sources of similitudes.

See Minto's Manual, p. 56-68.

17. Discrimination of synonyms employed.
 (a) Arnold.
 (b) De Quincey.
 (c) Sir Thomas Browne.

18. Violations of 'parallel construction.'
 See Genung's Practical Rhetoric, p. 208.
 (a) Boswell.
 (b) Froude.
 (c) J. R. Green.

19. Methods and devices of description.
 See Genung's Practical Rhetoric, p. 328-353.
 (a) Ruskin.
 (b) Dickens.
 (c) Howells.
 (d) Bulwer.

20. Examples of melody and harmony, and means which the effects are secured.
 See preceding references on tone-color and harmony, and appendi Bain's Rhetoric.
 (a) Hawthorne.
 (b) Burroughs.
 (c) Irving.
 (d) Pater.

21. Examples of harshness and explanation of this eff
 (a) Locke.
 (b) Bacon.
 (c) Dryden.
 (d) Browning.
 (e) George Meredith.

22. Rewrite paragraphs from (a) Macaulay and (Emerson combining the short sentences into longer or

23. Rewrite passages from Bunyan, substituting mod

phraseology and using a larger proportion of Latinisms.

24. Rewrite paragraphs of Gibbon that describe trivial scenes or events, modifying the rhythm and language to suit the subject.

25. Turn passages of William Morris into the vernacular.

26. Figures of fancy and figures of imagination.

See Dewey's Psychology, p. 195-196, Ruskin's Modern Painters, Vol. 2, p. 187-204.

(a) Dickens.

(b) Lowell.

(c) Holmes.

27. Arrangement of dynamic stress.

See Genung's Practical Rhetoric, p. 181-194.

(a) Morley.

(b) Motley.

(c) Landor.

28. Reasons for order of subordinate clauses.

See Spencer's Philosophy of Style, Lewes's Principles of Success, Chap. III.

(a) George Eliot.

(b) Webster.

(c) Stevenson.

(d) Huxley.

2. FOR MORE ADVANCED WORK.

1. Value of 'adaptation' as a fundamental principle of Rhetoric.

See Mod. Lang. Notes, 5; 209-211, Campbell's Philosophy of Rhetoric, Book 1, Chap. 1, Genung's Practical Rhetoric, p. 1. See preceding references on Rhetoric.

2. Classification of figures.

See preceding references on figures.

3. Value of the distinction between figures and tropes.

4. Origin and psychological explanation of figurative

4. Meaning of Buffon's definition of Style.

Mod. Lang. Notes, 5:179-180, Saintsbury's French Literature.

5. Thackeray's Esmond as an imitation of the style o the time portrayed.

6. Teutonisms in Carlyle.

7. Comparison of Latin and English sentence-structur and rhythm.

See Weil's Order of Words.

8. Characteristics of Shakespeare's prose.

9. Value of the principle of Economy as the fundament principle of Style.

See preceding references on Style.

10. General changes in the scope and character of Rh toric due to (a) the invention of printing, (b) the rise i importance of the newspaper.

11. Relation of Rhetoric to Logic and Aesthetics.

BIBLIOGRAPHICAL INDEX.

Abbott, E. A., and Seeley, J. R. English Lessons for English People. Boston: 1872. [2. 12. 3. 4.]

Adams, J. Q. Lectures on Rhetoric and Oratory. [2. 12. 3. 4.]

Archer, W. See Critic.

Aristotle. De Arte Poetica, [Vahlen's Text] with Trans. by E. R. Wharton. Oxford: 1883. [2. 7. 3. 7.]

—— The Rhetoric. Trans. ... by J. E. C. Welldon. Lond: 1886. [Catal. R.]

Arnold, M. Discourses in America. Lond: 1885. [2. 7. 5. 4.]

Arnold, M. Essays in Criticism. Boston: 1869. [2. 7. 5. 4.]

Arnold, T. A. A Manual of English Literature, historical and critical. With an appendix on English metres. Am. Ed. Rev. Boston: 1882. [2. 7. 3. 5.]

Bagehot, W. Literary Studies. Ed. by R. H. Hutton. 2 v. Lond: 1879. [2. 7. 4. 5.]

Bain, Alex. On Teaching English. With detailed examples, and an Enquiry into the Definition of Poetry. Lond: 1887. [2. 12. 3. 4.]

—— English Composition and Rhetoric. N. Y.: 1871. [2. 12. 3. 4.]

Ballet. Le Langage Intérieur. Paris: 1886.

Bascom, J. Aesthetics; or, the Science of Beauty. N. Y: 1886.

———— Philosophy of Rhetoric. N. Y.

Biese, A. Das Metaphorische in der dichterischen Phantasie. Berlin: 1889.

Blair, H. Lectures on Rhetoric and Belles Lettres. Phila: 1886. [2. 12. 3. 4.]

Boileau-Déspreaux, N. Oeuvres Complètes. ... Publ. par P. Chéron. Paris: 1875. [3. 6. 5. 3.]

Bourget, P. Essais de Psychologie Contemporaine. 4e. ed. Paris: 1885. [3. 7. 5. 6.]

———— Nouveaux Essais de Psychologie Contemporaine. Paris: 1886. [3. 7. 5. 6.]

Brooke, S. A. English Literature. [Lit. Primers.] New ed. Lond: 1878. [2. 7. 3. 5.]

Bruchmann, K. Psychologische Studien zur Sprachgeschichte. Leipzig: 1888.

Buffon, G. L. L., Comte de. Discours sur le Style, suivi d'extraits choisis. Notes d'Antoine Rondelet. Paris: 1883.

Bulwer. Caxtoniana. Lond: 1863.

Burt, B. C. Some Relations between Philosophy and Literature. Univ. of Mich. Philos. Papers, No. 4.

Carlyle, Th. On Heroes, Hero-Worship and the Heroic. N. Y: 1846. [2. 8. 5. 3.]

Coleridge, S. T. Complete Works. Ed. by Prof. Shedd. 7v. N. Y: 1853-4. [2. 9. 3. 3.]

Colvin, S. Selections from the Writings of W. S. Landor. Lond: 1882. [2. 9. 2. 5.]

Condillac, E. B. Oeuvres. 10v. Paris: 1798. [3. 14. 5. 4.]

Constable, J. Reflections upon Accuracy of Style. Lond: 1734. [2. 12. 3. 5.]

Contemp. 47:548. On Style in Literature. R. L. Stevenson. [Same art. in Critic 6:189, 199, 213.]

Cook, A. S. The Touchstones of Poetry. Selected from the Writings of Matthew Arnold and John Ruskin; with Introd. by A. S. Cook. San Fran: 1889. [2. 7. 4. 8.]

Cope, E. M. An Introduction to Aristotle's Rhetoric. Lond: 1867. [3. 3. 3. 6.]

Critic 8:7, 19, 57. R. L. Stevenson: His Style and Thought. W. Archer.

De Mille, J. Elements of Rhetoric. N. Y: 1878. [2. 12. 3. 4.]

De Quincey, Thos. The Collected Writings. New and Enlgd. ed. by D. Masson. Lond: 1890. [2. 9. 1. 6.]

Dewey, J. Psychology. N. Y: 1890.

Drake, N. Essays, Biographical, Critical and Historical ... illustrative of the Tatler, Spectator and Guardian. 2d. ed. Lond: 1814. [2. 9. 4. 4.]

Egger, V. La Parole Intérieure. Paris: 1881.

Encycl. Brit. 9th. ed. 'Poetry' by Th. Watts.

——— 'Philology' by W. D. Whitney.

English Men of Letters:

Colvin, S. Landor. [2. 9. 2. 5.]
Courthope, W. J. Addison. [2. 10. 2. 7.]
Masson, D. De Quincey. [2. 9. 1. 6.]
Morison, J. C. Macaulay. [2. 7. 4. 4.]
Morley, J. Burke. [2. 9. 5. 5.]
Nichol, J. Byron. [2. 9. 1. 5.]
Saintsbury, G. Dryden. [2. 10. 1. 7.]
Stephen, L. Johnson. [2. 10. 1. 4.]
Traill, H. D. Sterne. [2. 10. 1. 3.]
Trollope, A. Thackeray. [2. 8. 3. 4.]

Flaubert, G. Correspondance. Paris: 1887.

—— Lettres à G. Sand. Paris: 1884.

Fortn. 25: 234. Modern English Prose. G. Saints-.
bury.

Gauckler, Ph. Le Beau et son Histoire. Paris: 1873.

Gayley, C. M., and F. N. Scott. A Guide to the Litera-
ture of Aesthetics. Univ. of Cal: 1890.

Genung, J. F. The Practical Elements of Rhetoric.
Boston: 1887. [2, 12. 3. 6.]

Gerber, G. Die Sprache als Kunst. 2v. Bromberg:
1871. [3. 1. 1. 3.]

Gosse, E. From Shakespeare to Pope. Lond: 1885.
[2. 7. 4. 7.]

Gottschall, R. Poetik. 3te. aufl. 2v. in 1. Breslau: 1873.

Grabow, A. Ueber Musik in der deutschen Sprache.
Lemgo: 1876.

Gray, Th. Works in Prose and Verse. Ed. by E.
Gosse. 4v. Lond: 1884. [2. 10. 1. 3.]

Grundriss der Germanischen Philologie. Hrsg. von. H.
Paul. 1 Lief. Methodenlehre von H. Paul. Strassburg:
1889.

Gummere, F. B. A Handbook of Poetics. Boston:
1885. [2. 12. 1. 4.]

Gurney, Edm. The Power of Sound. Lond: 1880.
[3. 16. 4. 5.]

Guyau, Ch. Les Problèmes de l'esthétique contempo-
raine. Paris: 1884.

Hamilton, Sir Wm. Lectures on Metaphysics and Logic.
2v. Boston: 1860. [3. 15. 1. 6.]

Hartmann, E. von. Ausgewählte Werke. 2 Syst. Theil
der Aesthetik. Berlin: 1887. [3. 16. 1. 5.]

Hauptmann, M. The Nature of Harmony and Metre.

Trans. and Ed. by W. E. Heathcote. N. Y: 1888.
[3. 16. 4. 6.]

Hegel, G. W. F. Werke. 18v. Berlin: 1833–48. [3. 14. 5. 7.] Bd. 10, Th. 1–3 Aesthetik.

Helmholtz, H. L. F. Sensations of Tone as a Psychological Basis for the Theory of Music. Trans. and Ed. by A. J. Ellis. Lond: 1875. [4. 5. 4. 7.]

Henry, Ch. Rapporteur Esthétique. Paris: 1888.

Higginson, T. W. Atlantic Essays. Boston: 1871. [2. 6. 5. 6.]

Hill, D. J. The Science of Rhetoric. N. Y: 1886. [2. 12. 3. 4.]

Hill, A. S. The Principles of Rhetoric and their Application. N. Y: 1878.

Hobbes, Th. English Works. Lond: 1840. [3. 14. 4. 5.]

Horace. Works. Trans. by C. Smart. Bohn ed. Lond: 1858. [3. 5. 1. 6.]

Hosmer, J. K. A Short History of German Literature. St. Louis: 1879. [3. 8. 2. 4.]

Hunt, T. W. Representative English Prose and Prose Writers. N. Y: 1887. [2. 7. 4. 7.]

Hunt, T. W. Studies in Literature and Style. N. Y: 1890. [2. 7. 4. 8.]

James, W. The Principles of Psychology. N. Y: 1890.

Johnson, S. Works. 11 v. Oxford: 1825. [2. 10. 1. 4.]

Jonson, Ben. Works. Ed. by Gifford. 9 v. Lond: 1875. [2. 14. 2. 7.]

Joubert, J. Pensées . . . précédées d'une notice . . . par P. de Raynal. 2 v. Paris: 1877–80. [3. 7. 2. 4.]

Kames, Lord. Elements of Criticism. N. Y: 1838. [3. 12. 3. 5.]

Kawczynski, M. Essai comparatif sur l'origine et l'hi
toire des rythmes. Paris: 1889.

Laurie, S. S. Lectures on Language and Linguisti
Method in the School. Cambridge: 1890. [5. 6. 5. 5.]

Lessing, G. E. Selected Prose Works. Trans. by Bea
ley and Zimmern. Bohn ed. Lond: 1879. [3. 8. 5. 4

Lewes, G. H. The Principles of Success in Literatur
Repr. by A. S. Cook. San Francisco: 1885. [2. 7. 3. 7.
[Same in Fortn. 1: 85, 185, 572, 697; 2: 257, 689.]

——— Problems of Life and Mind. 3d Ser. 2 ·
Boston: 1879–80. [3. 15. 2. 5.]

Long, Geo. An Old Man's Thoughts about Man
Things. 2d ed. Lond: 1872. [2. 6. 5. 7.]

Longinus, Dionysius. On the Sublime. Trans. fro
the Greek, with notes, by Wm. Smith. 5th ed. Lon(
1800. [2. 12. 3. 5.]

Longridge, C. C. The Formation of English Writer
3d ed. 3 v. Lond. [2. 12. 3. 6].

Lord, D. N. Characteristics and Laws of Figurativ
Language. N. Y: 1854. [2. 12. 3. 5.]

Lotze, H. Microcosmus. Trans. by E. Hamilton an
E. E. C. Jones. 2 v. Edinb.: 1885. [3. 15. 2. 3.]

Marmontel, J. F. Eléments de Littérature. 3v. Paris
1846. [3. 7. 2. 2.]

Marsh, G. P. Lectures on the English Language. 1
Ser. 4th Ed. N. Y: 1863. [2. 12. 2. 4.]

Masson, D. Essays Biographical and Critical. Camb
1856. [2. 7. 4. 5.]

Mayor, J. B. Chapters on English Metre. Lond: 188(
[2. 12. 1. 4.]

Minto, W. Manual of English Prose Literature. Bos
ton: 1889. [2. 7. 3. 5.]

1

Peile, J. Philology. (Lit Primers.) Lond: 1877. [
1. 1. 6.]

Posnett, H. M. Comparative Literature. N. Y: 188
[2. 7. 1. 1.]

Puttenham, Geo. The Arte of English Poesie. Eng
Reprints ... ed. by E. Arber. Lond: 1869. [2. 10. 5. 6.

Quintilian. The Institutes of Oratory. Trans. by J. 1
Watson. Bohn Libr. 2v. Lond: 1882. [3. 5. 4. 3.]

Renton, W. The Logic of Style, being an Introductic
to Critical Science. Lond: 1874. [2. 12. 3. 4.]

Rev. Philos. 22:1. De la Parole et des sons intérieur
Stricker.

——— 28:356. Le Contraste, le Rythme, la Mesur
Ch. Henry.

Richter, Jean Paul. Vorschule der Aesthetik. 3
Stuttgart: 1813. [3. 16. 1. 5.]

Royal Irish Acad. Trans. v. 5. p. 39–92. R. Bu
rowes. On Style in Writing. [4. 1. 3.]

Ruskin, J. Elements of English Prosody. Orpingto:
1880.

——— Modern Painters. 5v. Orpington: 1887. [
17. 3. 4.]

——— On the Old Road. 3v. Orpington: 1885. [
17. 3. 2.] Vol. 2 Fiction, Fair and Foul. Esp. p. 8
Same in 19th C. 8:401.

Sainte-Beuve, C. A. Causeries de Lundi. 3e ed. 15
Paris: 1857–62. [3. 7. 5. 2.]

Saintsbury, G. W. Specimens of English Prose Sty
...with an Introductory Essay. London: 1884. [2.
1. 6.]

Scherr, Joh. Allgemeine Geschichte der Literatur. 2
Stuttgart: 1881–82. [Dorsch L.]

Schipper, J. Euglische Metrik. 2v. Bonn: 1881–88. [2. 12. 1. 4.]

Schmidt, J. H. H. Introduction to the Rhythmic'and Metric of the Classical Languages. Trans. by J. W. White. Boston: 1878. [3. 2. 1. 7.]

Schopenhauer, A. Sammtliche Werke. 6v. Leipzig: 1877. [3. 15. 1. 5.]

—— The World as Will and Idea. Trans. by R. B. Haldane and J. Kemp. 3v. Lond: 1883. [3. 15. 1. 5.]

Shairp, J. C. Aspects of Poetry. Boston: 1882. [2. 8. 1. 7.]

Sidney, Sir Ph. An Apologie for Poetrie. Engl. Reprints ... ed. by E. Arber. Lond: 1868. [2. 10. 5. 6.]

Spencer, Herbert. First Principles. Lond: 1862. [3. 15. 2. 6.]

—— Essays: Moral, Political and Aesthetic. N. Y: 1873. [3. 15. 2. 6.] Essay on Style.

Spengel, L. Ueber das Studium der Rhetorik bei den Alten. Muenchen: 1842. [2. 12. 3. 4.]

Stael, Mme. de. De la Littérature. Paris: 1845. [3. 7. 2. 5.]

Stedman, E. C. Poets of America. Boston: 1885. [2. 7. 4. 7.]

—— Victorian Poets. Boston: 1879. [2. 7. 4. 7.]

Stephen, L. Hours in a Library. Ser. 1–3. [2. 7. 4. 7.]

Stevenson, R. L. See Contemp.

Sully, Jas. Outlines of Psychology. Lond: 1884. [3. 15. 4. 1.]

Swinburne, A. C. Essays and Studies. Lond: 1875. [2. 7. 5. 6.]

Sylvester, J. J. The Laws of Verse. Lond: 1870.
[2. 12. 1. 4.]

Symonds, J. A. Sketches and Studies in Italy. Lond:
1879. [3. 16. 1. 6.]

Taine, H. A. History of English Literature. Trans.
by H. Van Laun. Lond: 1883. 3v. [2. 7. 3. 4.]

Thirlwall, C., Bishop. Essays, Speeches and Sermons.
Ed. by J. J. S. Perowne. Lond: 1880. [1. 8. 3. 5.]

Venables, E. John Bunyan. Great Writers Series.
Lond: 1888. [2. 10. 3. 4.]

Viehoff, H. Die Poetik auf. d. Grundlage d. Erfah-
rungsseelenlehre. Trier: 1888.

Vinet, Alex. Outlines of Philosophy and Literature.
2d ed. Lond: 1867. [3. 15. 3. 7.]

Vischer, F. T. Aesthetik oder Wissenschaft des Schö-
nen. 3v. Reutlingen: 1846. [3. 16. 1. 5.]

Volkmann, R. Die Rhetorik der Griechen und Römer.
Berlin: 1872. [2. 12. 3. 5.]

Voltaire, F. M. A. de. Oeuvres Complètes. 50v. Paris:
1877–83. [3. 7. 1.]

Wackernagel, W. Poetik, Rhetorik und Stilistik.
Halle: 1873.

Walter, E. L. Lessing on the Boundaries of Poetry and
Painting. Ann Arbor: 1888. [3. 8. 5. 4.]

Warner, C. D. Washington Irving. Am. Men of Let-
ters Series. Boston: 1882. [2. 9. 2. 2.]

. Webbe, Wm. A Discourse of English Poetrie. Engl.
Reprints ... ed. by E. Arber. Lond: 1870. [2. 10.
5. 6.]

Weil, H. The Order of Words in the Ancient Lan-
guages compared with that of the Modern Languages.
Trans. by C. W. Super. Boston: 1887.

Whitney, W. D. Language and the Study of Language.
N. Y: 1867. [3. 1. 1. 5.]
———— Life and Growth of Language. N. Y: 1877.
[3. 1. 1. 4.]
Zeitsch. f. Völkerpsychologie. 4:465. Zur Stylistik.
H. Steinthal.
———— 6:285. Poesie und Prosa. H. Steinthal.

Ὁμιλεῖτε Ἑλληνικά;

Do You Speak Greek?

A GREEK PRIMER AND FITTING BOOK,

COLLOQUIAL AND NOVEL.

Prepared and Published by

SOCIETAS RUGBIANA COLLOQUII LATINI GRÆCIQUE.

Rugby Academy, 1415 Locust Street,

Philadelphia, U. S. A.

1894.

GREEK.

To the Friends and Patrons of Classical Learning,

GREETING:

Great truths always strike us by their simplicity and directness. The egg of Columbus, the sphericity of the earth, the axioms of geometry, and similar truths, are examples of this great principle. In his search after truth, man often misses his way, to wander in barren deserts, until a redeeming thought guides his steps out of the jungle of error back to the light of truth. "New departures" and "reforms" are but returning from complicated error to simple truth.

When the SOCIETAS RUGBIANA COLLOQUII LATINI GRÆCIQUE, established for the purpose of introducing and propagating the *colloquial* method in teaching Latin and Greek, steps before the cultured public with the first *Course* of its periodical,—the TUSCULUM,—it proclaims a movement for a *total* reform in the field of classical studies, and exhibits a method of teaching, and learning, which rivals in simplicity any of those employed so successfully in the modern languages.

All who are familiar with modern classical teaching and learning, feel in their inmost heart that reform is urgently needed; yet at the word "reform" a whole chain of inquiries will arise, which may be grouped in the following classes:

(*a*) *Are the Classical languages worth teaching at all?*
(*b*) *What are the faults of modern methods?*
(*c*) *What can a reform bring about, and by what methods?*
Let it be allowed us to consider these questions separately.

(*a*) ARE THE CLASSICAL LANGUAGES WORTH TEACHING AT ALL?

This question requires but a brief answer. All modern civilization is based on Roman and Hellenic. Most of our civilized tongues, as French, Italian, Spanish, Portuguese, etc., are either entirely Latin with some Greek elements, or, as in English and

other Germanic tongues, their intellectual and moral part is Latin and Greek. No person of English, French, or German birth can understand his own vernacular unless familiar with Latin.

Science, art, industry, the trades and professions, are so entirely Latin and Greek in their technical terms, that one could much more easily dispense with English, French, and German, than with Latin and Greek. Greek and Latin philosophy, oratory, poetry, history, mythology, idealism, architecture, sculpture, and all that is sublime in them, are still the originals and models for our imitation. Hence, the entire civilized world looks up to these models, and spends ages of time, millions of money, to maintain these most perfect forms of human speech, because they are worthy of being taught.

(b) What are the Faults of Modern Methods?

The faults of modern methods are manifold, namely :

1. Overvaluing the book-language of particular authors, discriminated one from another ; flowery, rhetorical, and poetical Latin and Greek are considered *the* language, while the real, *spoken* language is unjustly disparaged, if not despised as *unclassical*. Even single words are banished, simply because they may not occur in the comparatively few books which have come down to us. By this injustice the *body* of the language is ignored, while its adornments are unduly extolled. This fault leads to another, *viz.:*

2. Institutions do not teach *Latin* and *Greek*, but Cæsar-Latin, Cicero-Latin, Xenophon-Greek, Homer-Greek, etc., out of which fragments, of course, no living language can be constructed ; therefore, no Latin and no Greek is known. Consequently,

3. As teachers are unable to speak either Latin or Greek, recourse is had to abstract philological speculations, learned comparison of Sanscrit with Greek, scientific dissertations on lost manuscripts, critical notes on peculiarities of authors and phrases, deep researches into philological causes, spelling reforms, and the like, while the language itself remains dead.

4. Extracts from particular authors are read with the eye without the utterance of a Latin or Greek sentence, by merely reciting the English equivalent of the given text, or translating—and thereby transferring English ideas and expressions—into Latin and Greek. Hence, there is no "reading the Classics," and profiting by the delight and instruction they afford ; but the work remains a painful, repulsive drudgery to students and teachers

alike. Translating and retranslating extracts from authors, instead of *reading* their complete works, cannot be the object of "classical" education. As things stand, students may remember a few phrases from Cæsar or from Xenophon, but they cannot ask for even a glass of water in either Latin or Greek.

SPECIAL DIRECTIONS.

1. The RUGBIANA method of mastering its lessons is unique. Each pupil (or leader of a class or circle), with pencil or crayon in hand, sketches the illustrations, one after the other, while *simultaneously the equivalent Latin or Greek word is pronounced aloud;* and the COLLOQUIAL part must be repeated until, with the thought of •, —, ○, etc., the equivalent Latin or Greek sentences rise instinctively to the lips and roll naturally from the tongue. Let not him who fails to follow literally these directions, accuse the Societas of his certain failure; since "*Repetitio est mater studiorum,*" and this "*repetitio*" must be *viva voce*. *Silent* language-work is largely *somnolent*, and as inefficient as rules for learning to swim; but as if by magic, through this practice, that which at first was Latin or Greek and foreign will become merely an *extension of our mother-tongue*.

2. The Rugbian teacher thus must *speak* Latin or Greek fluently and correctly, without hesitation, and use no other language in the class. His instruction is *oral* and *colloquial;* his pronunciation, ancient Roman and modern Greek. Students making use of this method for self-instruction, must read and re-read the Latin text *aloud* until perfect fluency is gained in uttering each and every word.

3. The heart and secret of the remarkable success obtained by the RUGBIANA method is, that the *idea* is first given; then, the *symbol of expression*. And teachers, particularly, must be doubly on their guard that they do not lapse into the diametrically opposite and unnatural course of requiring the pupil to guess or conjecture the meaning *from* the language. Unusual care must be taken by the teacher's position, motions, accents, illustrations, and board-work, to spare the class the humiliation and discouragement of uncertainty. Never, *under any circumstances*, must the pupil be appealed to until, in addition to the above, the *teacher* has distinctly asked and answered the question. Then, let him encourage the voluble repetition of the same by the class and individuals.

TABLE OF CONTENTS.

* Italics indicate illustrations.

'Ελληνικὸν 'Αλφάβητον.
Greek Alphabet.

Character.		Pronunciation.	Character.		Pronunciation.
Α	α	ah	Ν	ν	n
Β	β ϐ	v	Ξ	ξ	ks
Γ	γ[1]		Ο	ο	o
Δ	δ	th in the	Π	π	p
Ε	ε	ě	Ρ	ρ	r
Ζ	ζ	z	Σ	σ ς	s
Η	η	ee	Τ	τ	t
Θ	θ ϑ	th in thing	Υ	υ	ee
Ι	ι	ee	Φ	φ	ph
Κ	κ	k	Χ	χ[2]	
Λ	λ	l	Ψ	ψ	ps
Μ	μ	m	Ω	ω	o

[1] Γ, before α, ο, ου, has the initial sound of *w* in *wool*, but like *y* in *yes* before ε, ι; γγ, γκ, like *ng* in *angel*. [2] Χ pronounced like *wh* in *who* before α, ο, ου, but like *he* before ε, ι.

Δίφθογγοι.—DIPHTHONGS.

αι as ε.

ει, οι, as η.

ου, as *oo* in *moon*.

αυ, ευ, as αφ. εφ; but as αϐ, εϐ, before vowels or β, γ, δ, ζ. λ, μ, ν, ρ.

Πνεύματα.—BREATHINGS.

Over an initial vowel or diphthong[1] stands a ['] ψιλή or a ['] δασεῖα, but wholly silent in pronunciation.

Χρόνος.—QUANTITY.

The vowels (τὰ φωνήεντα) ε, υ, are always short (βραχέα); η, ω, always long (μακρά); α, ι, υ, sometimes short, sometimes long. All diphthongs are long, except αι, οι, at the end of a word.

Τόνοι.—ACCENTS.

The last syllable of a word is called the *ultima;* the next, *penult;* and the third from the last, *antepenult.*

The accented syllables are marked by ['] or ['] or [˘]. The ['] ὀξεῖα stands on one of the last three syllables of a word; on the antepenult, only when the ultima is short, as ἄνθρωπος, *man;* on the ultima, when the word is at the end of a sentence, as, τέκνον καλόν, *a good child,* otherwise it is replaced by the ['] βαρεῖα, as, καλὸν τέκνον. The [˘] περισπωμένη stands on either the penult or the ultima; on the penult, only when the ultima is short, as, δῶρον, gift.

Στιγματισμός.—PUNCTUATION.

The [,] κόμμα, comma, and the [.] τελεία,[2] period, are as in English. The [·] ἄνω τελεία, colon or semicolon, is above the line. The [;] ἐρωτηματικόν,[3] interrogation mark, is the English semicolon. The [!] ἐπιφωνηματικόν,[3] mark of exclamation, is the same as in English.

[1] A breathing, or accent, stands over the *second* vowel of a diphthong. [2] στιγμή understood. [3] σημεῖον understood.

Μάθημα Πρῶτον.
Lesson First.

A

•

Στιγμή.
Στιγμή μικρά.

B

●

Στιγμή.
Στιγμή μεγάλη.

A

Ἡ στιγμή αὕτη.

B

●

Ἡ στιγμή ἐκείνη.

Ἡ στιγμὴ αὕτη [•] εἶνε[1] μικρά· ἡ στιγμὴ ἐκείνη [●] εἶνε μεγάλη.—Τίς στιγμὴ εἶνε μικρά; Ἡ στιγμὴ αὕτη εἶνε μικρά, ἐκείνη εἶνε μεγάλη.—Εἶνε ἡ στιγμὴ αὕτη Α; Μάλιστα,[2] ἡ στιγμὴ αὕτη εἶνε Α.—Τίς στιγμὴ εἶνε μεγάλη; Ἡ στιγμὴ Β εἶνε μεγάλη.—Εἶνε ἡ στιγμὴ αὕτη [•] μεγάλη; Ὄχι,[3] ἡ στιγμὴ αὕτη δὲν[4] εἶνε μεγάλη, εἶνε μικρά.—Εἶνε ἡ στιγμὴ ἐκείνη μικρὰ ἢ[5] μεγάλη; Ἡ στιγμὴ ἐκείνη δὲν εἶνε μικρά, εἶνε μεγάλη.

A

Γραμμή.
Γραμμὴ βραχεῖα.

B

Γραμμή.
Γραμμὴ μακρά.

Ἡ γραμμὴ αὕτη. *Ἡ γραμμὴ ἐκείνη.*

Ἡ γραμμὴ αὕτη εἶνε βραχεῖα, ἡ γραμμὴ ἐκείνη εἶνε μακρά.—Εἶνε ἡ γραμμὴ Α βραχεῖα; Μάλιστα, ἡ γραμμὴ Α εἶνε βραχεῖα.—Τίς γραμμὴ εἶνε μακρά; Ἡ γραμμὴ Β εἶνε μακρά.—Τίς εἶνε βραχεῖα; Ἡ γραμμὴ αὕτη [——] εἶνε βραχεῖα.—Εἶνε ἡ γραμμὴ αὕτη [————] βραχεῖα; Ὄχι, ἡ γραμμὴ αὕτη δὲν εἶνε βραχεῖα, εἶνε μακρά.

[1]Attic ἐστί. [2]Also, ναί, yes; ναὶ ἢ ὄχι, yes or no. [3]Attic οὔ.

Γ ⌐

Γραμμὴ λεπτὴ καὶ εὐθεῖα. *Γ. παχεῖα καὶ καμπύλη.*

Τί[1] *γραμμὴ εἶνε ἡ Γ; 'Η Γ εἶνε λεπτὴ καὶ εὐθεῖα.—Εἶνε καὶ*[2] *ἡ ⌐ λεπτὴ καὶ εὐθεῖα; Ὄχι, ἡ ⌐ δὲν εἶνε οὔτε λεπτὴ οὔτε εὐθεῖα, εἶνε παχεῖα καὶ καμπύλη.*

Οὗτος [o] *ὁ κύκλος εἶνε μικρός.* 'Εκεῖνος [O] *ὁ κύκλος εἶνε μέγας.—Αῦτη* [●] *ἡ σφαῖρα εἶνε μικρά.* 'Εκείνη [⬤] *ἡ σφαῖρα εἶνε μεγάλη.—Τοῦτο* [□] *τὸ τετράγωνον εἶνε μικρόν.* 'Εκεῖνο [☐] *τὸ τετράγωνον εἶνε μέγα.—'Η σφαῖρα εἶνε στρογγύλη. Τὸ τετράγωνον δὲν εἶνε στρογγύλον. 'Η σφαῖρα δὲν εἶνε τετράγωνος. Εἶνε ὁ κύκλος τετράγωνος; Ὄχι. Τί εἶνε; 'Ο κύκλος εἶνε γραμμὴ καμπύλη.—Τί εἶνε τοῦτο* [——] *τετράγωνον ἢ κύκλος;* 'Εκεῖνο δὲν *εἶνε οὔτε τετράγωνον οὔτε κύκλος, εἶνε γραμμή.*

Τὸ ἄρθρον.—THE ARTICLE.

'Η ἑλληνικὴ γλῶσσα ἔχει τρία ἄρθρα, ἀρσενικὸν, ὁ· θηλυκὸν, ἡ· οὐδέτερον, τό.—(The Greek language has three articles: masculine, *ὁ* ; feminine, *ἡ* ; neuter, *τό*.)

Τὸ Γένος.—GENDER.

'Ονόματα λήγοντα εἰς, ος, εἶνε[3] *γένους ἀρσενικοῦ*[4]· *εἰς α ἢ η, θηλυκοῦ· εἰς ον, οὐδετέρου.*—(Nouns ending in *ος* are of masculine gender; in *α* or *η*, of feminine gender; in *ον*, of neuter gender.)

Τὸ ἐπίθετον συμφωνεῖ μετὰ τοῦ ὀνόματος κατὰ γένος, ἀριθμὸν καὶ πτῶσιν.—(The adjective agrees with its noun in gender, number, and case.)

[1] *Τί*, abbreviated from *τίνος εἴδους*, *of what kind?*
[2] *Καί*, *and*, here means *also.*
[3] Attic *εἰσί*, which is also used to-day, but not after *δέν.*
[4] *'Ολίγα τινὰ ἐξαιροῦνται.*—(A few are excepted.)

Σχηματισμὸς τοῦ Πληθυντικοῦ Ἀριθμοῦ.

Formation of the Plural Number.

Τὰ ἄρθρα, τὰ ὀνόματα, τὰ ἐπίθετα καὶ αἱ ἀντωνυμίαι σχηματίζουσι τὴν πληθυντικὴν ὀνομαστικὴν ὡς ἑξῆς.—(The articles, the nouns, the adjectives, and the pronouns form their nominative plural as follows.)

Ἄρθρα.

Ἀριθμὸς ἑνικός (SING.)			Ἀριθμὸς Πληθυντικός (PLUR.)		
Ἀρσενικόν.	Θηλυκόν.	Οὐδέτερον.	Ἀρσενικόν.	Θηλυκόν.	Οὐδέτερον.
(m.)	(f.)	(n.)	(m.)	(f.)	(n.)
ὁ	ἡ	τό	οἱ	αἱ	τά

Ὀνόματα.

κύκλος	γραμμή	τετράγωνον	κύκλοι	γραμμαί	τετράγωνα

Ἐπίθετα.

μικρός	μικρά	μικρόν	μικροί	μικραί	μικρά
λεπτός	λεπτή	λεπτόν	λεπτοί	λεπταί	λεπτά
πρῶτος	πρώτη	πρῶτον	πρῶτοι	πρῶται	πρῶτα
δεύτερος	δευτέρα	δεύτερον	δεύτεροι	δεύτεραι	δεύτερα

Ἄλλα (OTHER) Ἐπίθετα.

βραχύς	βραχεῖα	βραχύ	βραχεῖς	βραχεῖαι	βραχέα
μέγας	μεγάλη	μέγα	μεγάλοι	μεγάλαι	μεγάλα

Εὐθύς and παχύς are formed like βραχύς.

Ἀντωνυμίαι.

οὗτος	αὕτη	τοῦτο	οὗτοι	αὗται	ταῦτα
ἐκεῖνος	ἐκείνη	ἐκεῖνο	ἐκεῖνοι	ἐκεῖναι	ἐκεῖνα
τίς	τίς	τί	τίνες	τίνες	τίνα

Ἀριθμητικά.—NUMERALS.

εἷς	μία	ἓν	=one.
δύο	δύο	δύο	=two.
τρεῖς	τρεῖς	τρία	=three.
τέσσαρες	τέσσαρες	τέσσαρα	=four.

Ἑνικός.	Πληθυντικός.
πόσος ⎫	πόσοι ⎫
πόση ⎬ how much?	πόσαι ⎬ how many?
πόσον ⎭	πόσα ⎭

Μάθημα Τρίτον.

Αὗται ═══ αἱ δύο γραμμαὶ εἶνε παράλληλοι καὶ βραχεῖαι. Δύο παράλληλοι γραμμαὶ καὶ δύο μικροί, πλάγιοι κύκλοι εἶνε ▭ κύλινδρος. Κύλινδρος καὶ — αἰχμὴ εἶνε —— μολυβδοκόνδυλον. Κύλινδρος κάθετος καὶ γραμμὴ βραχεῖα εἶνε ‖ λαμπάς. Δύο παράλληλοι, μακραὶ γραμμαὶ καὶ κύκλοι εἶνε ——o ῥάβδος· ῥάβδος δὲ βραχεῖα εἶνε βακτηρία.

Ἐνταῦθα εἶνε τρεῖς γραμμαί. Ἡ πρώτη εἶνε εὐθεῖα καὶ παχεῖα· ἡ δευτέρα εἶνε λεπτὴ καὶ καμπύλη· ἡ δὲ τρίτη εἶνε εὐθεῖα καὶ λεπτή. Ἡ δευτέρα γραμμή, ἡ ὁποία[1] εἶνε καμπύλη, εἶνε μεταξὺ τῆς πρώτης καὶ τρίτης, μεταξὺ τῆς παχείας καὶ λεπτῆς. Ἡ πρώτη, παχεῖα γραμμὴ εἶνε ὑπεράνω[2] τῆς δευτέρας, καμπύλης γραμμῆς. Ἡ καμπύλη γραμμὴ εἶνε ὑποκάτω[3] τῆς πρώτης παχείας γραμμῆς, καὶ ὑπεράνω τῆς τρίτης λεπτῆς γραμμῆς.

Ἡ παχεῖα γραμμὴ εἶνε μεταξὺ δύο μεγάλων στιγμῶν. Ἡ καμπύλη γραμμὴ εἶνε μεταξὺ δύο μικρῶν κύκλων. Τρεῖς μικραὶ στιγμαὶ εἶνε ὑπεράνω τῆς καμπύλης καὶ παχείας γραμμῆς. Ἡ καμπύλη καὶ παχεῖα γραμμὴ εἶνε ὑποκάτω τριῶν μικρῶν στιγμῶν, καὶ ὑπεράνω τριῶν μικρῶν κύκλων. Τρεῖς δὲ μικροὶ κύκλοι εἶνε ὑποκάτω τῆς παχείας, καμπύλης γραμμῆς.

Δύο πλάγιαι γραμμαὶ ἐπὶ μιᾶς ὁριζοντίου σχηματίζουσι τρίγωνον △. Τὸ τρίγωνον ἔχει τρεῖς γωνίας καὶ τρεῖς πλευράς· ἡ γραμμὴ μεταξὺ τῶν γραμμάτων, α καὶ β, εἶνε ἡ πλευρὰ αβ, ἀπέναντι τῆς ὁποίας εἶνε ἡ γωνία αγβ.

Τὸ τρίγωνον △ □ εἶνε πλησίον τοῦ τετραγώνου, τὸ τετράγωνον εἶνε πλησίον τοῦ τριγώνου. Τὸ τρίγωνον △○ εἶνε πλησίον τοῦ κύκλου, ὁ κύκλος εἶνε πλησίον τοῦ τριγώνου.

Τὸ τρίγωνον τοῦτο △ ὑπεράνω ποῦ τετραγώνου ἐκείνου σχηματίζει οἰκίαν· τοῦτο 🏠 εἶνε οἰκία. Ἡ οἰκία αὕτη ▭ εἶνε πλατεῖα, ἐκείνη δὲ 🏠 ὑψηλή· Ἡ πλατεῖα οἰκία εἶνε χαμηλή, ἡ δὲ ὑψηλὴ δὲν εἶνε 🏠 πλατεῖα, ἀλλὰ στενή. Τὰ μικρὰ ταῦτα ▦

[1] Attic ἥ, from the relative pronoun ὅς, ἥ, ὅ. [2] Attic ὑπέρ.
[3] ὑπό, also used to-day.

εἶνε παράθυρα, τὸ δὲ ἐπίμηκες τετράγωνον ▯ εἶνε θύρα. Τὸ τρίγωνον ὑπεράνω τῆς οἰκίας εἶνε στέγη, τὰ δὲ μικρὰ τετράγωνα ▤ ὑπεράνω τῆς στέγης εἶνε καπνοδόχαι (ἡ καπνοδόχη). Τὸ τετράγωνον τοῦτο 🛏 εἶνε τράπεζα· ἀλλ' ἐκεῖνο 🛏 εἶνε κάθισμα.

Μικρὰ οἰκία εἶνε καλύβη, μεγάλη δὲ οἰκία, ἡ ὁποία ἔχει πλατέα καὶ ὑψηλὰ παράθυρα, πλατείας θύρας, ὑψηλὴν καὶ πλατεῖαν στέγην, καὶ μεγάλας καπνοδόχας εἶνε ἀνάκτορον.

Μεγάλαι θύραι ἔχουσι δύο φύλλα, τοιαῦται δὲ θύραι (αἱ ὁποῖαι ἔχουσι δύο φύλλα) εἶνε ἐξώθυραι. Μεγάλαι δ' ἐξώθυραι εἶνε πύλαι.

Σκόλιον

Ἐν τούτῳ τῷ μαθήματι εἰσάγονται δύο ἄλλαι πτώσεις, ἡ γενικὴ καὶ ἡ αἰτιατικὴ τοῦ τε ἑνικοῦ καὶ πληθυντικοῦ ἀριθμοῦ.—(In this lesson are introduced two other cases, the genitive and the accusative of both the singular and plural numbers.)

Ἀρσενικά. (Masculine.)

Ἑνικός. (Sing.)	Πληθυντικός. (Plur.)
Γενική. (Gen.) Τούτου τοῦ μεγάλου κύκλου.	(Gen.) Τούτων τῶν μεγάλων κύκλων.
Αἰτιατική. (Ac.) Τοῦτον τὸν μέγαν κύκλον.	(Ac.) Τούτους τοὺς μεγάλους κύκλους.

Θηλυκά. (Feminine.)

Γεν. (Gen.) Ταύτης τῆς μικρᾶς οἰκίας.	(Gen.) Τούτων τῶν μικρῶν οἰκιῶν.
Αἰτ. (Ac.) Ταύτην τὴν μικρὰν οἰκίαν.	(Ac.) Ταύτας τὰς μικρὰς οἰκίας.

Οὐδέτερα. (Neuter.)

Γεν. (Gen.) Τούτου τοῦ πλατέος ἀνακτόρου.	(Gen.) Τούτων τῶν πλατέων ἀνακτόρων.
Αἰτ. (Ac.) Τοῦτο τὸ πλατὺ ἀνάκτορον.	(Ac.) Ταῦτα τὰ πλατέα ἀνάκτορα.

Ἀριθμητικά.

	(Ἀρ.)	(Θηλ.)	(Οὐδ.)	(Ἀρ.)	(Θηλ.)	(Οὐδ.)
Γενική.	ἑνός,	μιᾶς,	ἑνός.	τριῶν,	τριῶν,	τριῶν.
Αἰτιατική.	ἕνα,	μίαν,	ἕν.	τρεῖς,	τρεῖς,	τρία.
	δύο	(the same in all cases.)		τεσσάρων,	τεσσάρων,	τεσσάρων.
				τέσσαρας,	τέσσαρας,	τέσσαρα.

Τὰ ἐπίθετα δὲν συμφωνοῦσι πάντοτε μετὰ τῶν ὀνομάτων ὡς πρὸς τὰς καταλήξεις · ἄλλοτε τὰ ὀνόματα καὶ ἄλλοτε τὰ ἐπίθετα, ἢ εἶνε ἀνώμαλα (ὅρα : μέγαν), ἢ κλίνονται κατὰ διαφόρους κλίσεις (ὅρα : πλατύ). (Adjectives do not agree always with their nouns as to their endings ; sometimes the nouns and sometimes the adjectives are either irregular [see : μέγαν], or follow different declensions [see : πλατύ].)

Αἱ (καταχρηστικῶς καλούμεναι) προθέσεις, μεταξύ, πλησίον. ἐνέναντι, ὑπεράνω καὶ ὑποκάτω, συντάσσονται μετὰ γενικῆς. (The [improperly called] prepositions μεταξύ, πλησίον, etc., are construed with the genitive.)

Ἐνταῦθα, σημαίνει (means) here.

Ἡ πρόθεσις, ἐπί, μετὰ γενικῆς συντασσομένη, σημαίνει upon, οἷον (as) · τὸ μολυβδοκόνδυλον εἶνε ἐπὶ τῆς τραπέζης. (The lead-pencil is upon the table.)

Ἔχει (has), ἔχουσι (have), σχηματίζουσι (form), εἶνε ῥήματα · τὸ πρῶτον εἶνε προσώπου τρίτου, ἀριθμοῦ ἑνικοῦ · τὸ δὲ δεύτερον καὶ τρίτον, τρίτου πληθυντικοῦ. (Ἔχει, ἔχουσι, σχηματίζουσι, are verbs ; the 1st is of the third person singular ; but the 2d and 3d of third plural.)

Ἡ ἀναφορικὴ (relative) ἀντωνυμία, ὁ ὁποῖος, Attic ὅς, ἥ, ὅ, (who, which), κλίνεται οὕτως (is declined thus).

Ἑνικός.

	(Ἀρ.)	(Θηλ.)	(Οὐδ.)
Ὀν.	ὁ ὁποῖος,	ἡ ὁποία,	τὸ ὁποῖον.
Γεν.	τοῦ ὁποίου,	τῆς ὁποίας,	τοῦ ὁποίου.
Αἰτ.	τὸν ὁποῖον,	τὴν ὁποίαν,	τὸ ὁποῖον.

Πληθυντικός.

	(Ἀρ.)	(Θηλ.)	(Οὐδ.)
οἱ ὁποῖοι,	αἱ ὁποῖαι,	τὰ ὁποῖα.	
τῶν ὁποίων,	τῶν ὁποίων,	τῶν ὁποίων.	
τοὺς ὁποίους,	τὰς ὁποίας,	τὰ ὁποῖα.	

ἐπιμήκης (Ἀρ.), ἐπιμήκης (Θηλ.), ἐπίμηκες (Οὐδ.), oblong.

Μάθημα Τέταρτον.

Ἐνταῦθα ◯ εἶνε δύο κύκλοι. Δύο κύκλοι καὶ ἀκτῖνες κάμνουσι[1] ✸ τροχόν. Ἐπίμηκες τετράγωνον ὑπεράνω τεσσάρων τροχῶν καὶ ῥυμὸς κάμνουσι ▭ ἅμαξαν. Ἡ ἅμαξα αὕτη ▭ ἔχει σκέπην (στέγην) καὶ δύο ῥυμούς. Ἅμαξα, ἡ ὁποία δὲν ἔχει σκέπην οὐδὲ (nor) τέσσαρας τροχούς, ἀλλὰ μόνον δύο, εἶνε ▭ κάρρον. Ἀμάξιον δὲ, τὸ ὁποῖον ἔχει ἕνα μόνον τροχὸν καὶ δύο λαβὰς, εἶνε ▭ χειράμαξα.

Μέγας τροχὸς, ὁ ὁποῖος εἶνε πλησίον οἰκίας, καὶ οἰκία κάμνουσι μύλον ἢ ὑδρόμυλον. Τὸ ὕδωρ κινεῖ τὸν τροχὸν, ὁ δὲ τροχὸς κινεῖ τὸν μύλον.

Ἐνταῦθα εἶνε ▭ οἰκία, ἡ ὁποία ἔχει ὑψηλὴν καπνοδόχην· τοιαύτη οἰκία εἶνε ▭ ἐργοστάσιον. Ἀλλ' αὕτη ▭ ἡ οἰκία εἶνε πύργος. Πύργος εἶνε οἰκία ὑψηλὴ καὶ στενὴ, ἡ ▭ ὁποία ἔχει στέγην ὀξεῖαν. Δὲν εἶνε καὶ τὸ μολυβδοκόνδυλον ὀξύ; Μάλιστα, καὶ τὸ μολυβδοκόνδυλον ἔχει αἰχμήν.

Τοῦτο ▭ εἶνε μάχαιρα. Καὶ τοῦτο ▭ εἶνε μάχαιρα. Ἡ πρώτη μάχαιρα εἶνε ὀξεῖα, ἡ δὲ δευτέρα δὲν ἔχει αἰχμήν. Ἀμφότεραι αἱ μάχαιραι ἔχουσι σπάθας καὶ λαβάς. Ἡ σπάθη τῆς πρώτης μαχαίρας εἶνε ὀξεῖα· ἡ σπάθη ὅμως (however) τῆς δευτέρας μαχαίρας δὲν εἶνε ὀξεῖα, εἶνε ἀμβλεῖα. Αἱ σπάθαι ἀμφοτέρων τῶν μαχαιρῶν εἶνε ὀξεῖαι. Ἡ λαβὴ τῆς πρώτης μαχαίρας εἶνε κυρτὴ, ἡ δὲ τῆς δευτέρας εὐθεῖα. Ἡ μάχαιρα εἶνε ἐργαλεῖον (tool) ὀξύ. Ἡ μάχαιρα, ἡ ὁποία δὲν εἶνε ὀξεῖα, εἶνε ἀμβλεῖα.

Τὸ μαχαίριον (μικρὰ μάχαιρα) κόπτει. Τὸ ὀξὺ μαχαίριον κόπτει, τὸ ἀμβλὺ δὲν κόπτει. Τί κάμνεις; κόπτω τὸ μολυβδοκόνδυλον. Ὄχι, δὲν κόπτεις, ἀλλ' ὀξύνεις τὸ μολυβδοκόνδυλον. Ὀξύνομεν τὸ μολυβδοκόνδυλον διὰ τοῦ μαχαιρίου.

Σχόλιον.

Ἀκτῖνες, ἡ ἀκτίς (the ray), γενική : τῆς ἀκτῖνος. Ἀκτιν, εἶνε ἡ ῥίζα (the root) · ες, εἶνε ἡ κατάληξις τῆς πληθυντικῆς ὀνομαστικῆς.

[1] Attic ποιοῦσι.

ὥρα 6ⁿ. μεσημβρία ὥρα 6ⁿ.
ἑσπέρα. ὥρα δωδεκάτη πρωΐ.
 (12ⁿ.)

◇ Δύσις. Ἀνατολή. ◇
δύει. ἀνατέλλει.

Ὁ ἥλιος ἀνατέλλει ἐν τῇ Ἀνατολῇ τὸ πρωΐ, τῇ ἕκτῃ ὥρᾳ, καὶ ἀναβαίνει ἐν τῷ οὐρανῷ. Ὅταν ὁ ἥλιος εἶνε ἐν τῷ μέσῳ τοῦ οὐρανοῦ, εἶνε μεσημβρία. Μετὰ τὴν δωδεκάτην ὥραν ὁ ἥλιος καταβαίνει καὶ τὴν ἑσπέραν, τῇ ἕκτῃ ὥρᾳ, δύει ἐν τῇ Δύσει. Ἀπὸ τῆς Ἀνατολῆς τοῦ ἡλίου μέχρι τῆς Δύσεως αὐτοῦ εἶνε ἡμέρα. Ἀπὸ τῆς ἕκτης πρωϊνῆς ὥρας μέχρι τῆς δωδεκάτης εἶνε πρὸ μεσημβρίας (π. μ.)· ἀπὸ δὲ τῆς δωδεκάτης μέχρι τῆς ἑσπέρας εἶνε μετὰ μεσημβρίαν (μ. μ.). Τά τέσσαρα σημεῖα τοῦ οὐρανοῦ εἶνε ἡ Ἀνατολὴ, ἡ Μεσημβρία ἢ Νότος, ἡ Δύσις καὶ ὁ Βορρᾶς.

Ἡ σελήνη ἔχει τέσσαρας φάσεις· ἡ πρώτη φάσις εἶνε ☽ τὸ πρῶτον τέταρτον· ἡ δευτέρα φάσις ◑ εἶνε ἡμισέληνος (ἡ)· ἔπειτα αὐξάνει καὶ εἶνε ἡ τρίτη φάσις, δηλαδὴ, τὸ τελευταῖον τέταρτον = (δευτέρα with colors reversed)· μετὰ δὲ ταῦτα εἶνε ◯ πανσέληνος (ἡ). Ταχέως ἡ σελήνη μειοῦται καὶ, ὅταν δὲν ἔχῃ ἀκτῖνας οὐδὲ φέγγῃ, εἶνε νουμηνία ἢ νέα σελήνη.

Ὅταν ὁ ἥλιος δὲν ἦνε ἐν τῷ οὐρανῷ, εἶνε νύξ (ἡ). Ὅταν ἡ σελήνη δὲν φέγγῃ, εἶνε σκότος (τό). Ἡ ἡμέρα εἶνε φωτεινή, ἡ νύξ σκοτεινή. Τὸ φῶς τοῦ ἡλίου εἶνε λαμπρὸν, τὸ τῆς σελήνης ὠχρόν (pale). Ὁ ἥλιος λάμπει· ἡ σελήνη φέγγει· οἱ ἀστέρες λαμπυρίζουσι. Πότε λάμπει ὁ ἥλιος; ὁ ἥλιος λάμπει τὴν ἡμέραν. Πότε φέγγει ἡ σελήνη; Ἡ σελήνη φέγγει τὴν νύκτα.

Σκόλιον.

Αἱ κλίσεις. — THE DECLENSIONS.

Τὰ ὀνόματα καὶ τὰ ἐπίθετα κλίνονται κατὰ τρεῖς διαφόρους τρόπους (ways), ἢ κλίσεις.

Ἡ πρώτη κλίσις περιέχει (contains) ὀνόματα ἀρσενικὰ λήγοντα ἐν τῇ ὀνομαστικῇ ἑνικῇ εἰς, ας, ἡ, ης, οἷον (as)· ὁ νεανίας, young

Πληθυντικός.

| | 'Αρσ. Θηλ. | | 'Αρσ. Θηλ. | Ούδ. | | 'Αρσ. Θηλ. | Ούδ. |
|---|---|---|---|---|---|---|---|---|
| Όν. | αι | | οι | α | | ες | α |
| Γεν. | ων | | ων | ων | | ων | ων |
| Δοτ. | αις | | ɔις | οις | | σι | σι |
| Αἰτ. | ας | | ους | α | | ας | α |
| Κλ.² | αι | | οι | α | | ες | |

1. περί, πρόθεσις, μετ' αἰτιατικῆς σημαίνει, around· μετὰ γενικῆς, concerning.

2. ἐν, in, πάντοτε (always) μετὰ δοτικῆς.

3. αὐτός, αὐτή, αὐτό, he, she, it.

4. ἀκέραιος ('Αρσ. Θηλ.), or, (Ούδ.), entire.

5. ἡμικύκλιον, ἡμι (ἥμισυ, half).

6. ὁ ἀστήρ, τοῦ ἀστέρος.

7. τὸ πρωΐ, morning, εἶνε ἄκλιτον (undeclined).

8. ἀνατέλλει, ἀναβαίνει, καταβαίνει· ἀνά, up· κατά, down· τέλλει, rises· βαίνει, goes.

9. Ἡ δύσις, west, κλίνεται οὕτω· ('Εν.) δύσις, δύσεως, δύσει, δύσιν. (Πλ.) δύσεις, δύσεων, δύσεσι, δύσεις.

10. μετά, πρόθεσις, μετὰ γενικῆς, with· μετὰ αἰτιατικῆς, after.

11. ἀπό, πρόθεσις, μετὰ γενικῆς, from.

12. μέχρι, πρόθεσις, μετὰ γενικῆς. up to, until.

13. πρό, πρόθεσις, μετὰ γενικῆς, before.

14. ὁ Βορρᾶς, τοῦ Βορρᾶ. τῷ Βορρᾷ, τὸν Βορρᾶν.

15. Ἡ φάσις, κλίνεται ὡς (as) ἡ δύσις.

16. ἡ ἡμισέληνος, ἡμι = half.

17. ἔπειτα, then.

18. αὐξάνει, it waxes.

19. δηλαδή, that is.

20. τελευταῖος, τελευταία, τελευταῖον, last.

21. μετὰ ταῦτα, after this.

22. δέ, but, οὐδέποτε τίθεται ἐν ἀρχῇ προτάσεως (it is never placed at the beginning of a sentence).

Ὁ τροχὸς τοῦ μύλου κινεῖται (is moved) ὑπὸ τοῦ ὕδατος· οἱ μικροὶ (small) τροχοὶ τοῦ μύλου κινοῦνται ὑπὸ τοῦ μεγάλου ὑδροτρόχου. Ὑπὸ τίνος κινοῦνται οἱ τοῦ μύλου τροχοί; ὑπὸ τοῦ ὑδροτρόχου. Ὑπὸ τίνος κινεῖται ἡ ἅμαξα; ἡ ἅμαξα κινεῖται ὑπὸ τοῦ ἵππου· ὑπὸ τίνος κινεῖται ὁ ἵππος; ὁ ἵππος κινεῖ ἑαυτόν (himself).

Κινεῖται ἡ σελήνη, ἡ γῆ καὶ ὁ ἥλιος; μάλιστα, κινεῖνται. Δὲν εἶναι ἡ σελήνη δορυφόρος τῆς γῆς, καὶ ἡ σελήνη κινεῖται ὑπὸ τῆς γῆς; μάλιστα, ἡ γῆ κινεῖ τὴν σελήνην. Ὑπὸ τίνος κινεῖται ἡ γῆ; αὐτὴ κινεῖται ὑπὸ τοῦ ἡλίου. Τί κινεῖ τὸν ἥλιον; ὁ θεός. Εἶναι ἡ γῆ δορυφόρος τοῦ ἡλίου; ὄχι, εἶναι πλανήτης. Πόσοι πλανῆται ὑπάρχουσιν; ὑπάρχουσιν ὀκτὼ πλανῆται. Τί εἶναι τὰ τῶν πλανητῶν ὀνόματα; (ἤ, πῶς ὀνομάζονται οἱ πλανῆται); ἰδοῦ τὰ τῶν πλανητῶν ὀνόματα· ὁ Ἑρμῆς, ἡ Ἀφροδίτη, ἡ Γῆ, ὁ Ἄρης, ὁ Ζεύς, ὁ Χρόνος, ὁ Οὐρανός, καὶ ὁ Ποσειδῶν· ταῦτα εἶναι πάντα πλανῆται οἵτινες περὶ τοῦ ἡλίου καὶ ὑπὸ τοῦ ἡλίου κινοῦνται ἐν τῷ οὐρανῷ.

Οἰκοῦσιν καὶ ἐν τῷ ὕδατι ζῶα; μάλιστα, οἱ ἰχθύες οἰκοῦσιν ἐν τῷ ὕδατι· πόσους πόδας ἔχουσιν; οἱ ἰθύες δὲν ἔχουσιν πόδας· πῶς κινοῦσιν; κολυμβῶσιν. Εἶναι ὁ ἰχθὺς ἐν τῷ ὕδατι ἡμέραν καὶ νύκτα; βεβαίως (certainly), εἶναι πάντοτε (always) ἐν τῷ ὕδατι, δὲν ἐξέρχεταί ποτε.

Σκόλιον.

Ὑπάρχουσιν εἰς τὴν Ἑλληνικὴν ἐννέα μέρη τοῦ λόγου, δηλαδή· τὸ ἄρθρον, τὸ ἐπίθητον, τὸ ὄνομα, ἡ ἀντωνυμία, τὸ ῥῆμα, τὸ ἐπίρρημα, ὁ σύνδυσμος, ὁ πρόθεσις, τὸ ἐπιφώνημα. (There are in Greek nine parts of speech, viz.: the article, adjective, noun, pronoun, verb, adverb, conjunction, preposition, interjection.)

Ἡ κλίσις τοῦ ἄρθρου.

	Ἐνικός.			Πληθυντικός.		
	Ἀρσ.	Θηλ.	Οὐδ.	Ἀρσ.	Θηλ.	Οὐδ.
Ὀν.	ὁ	ἡ	τό	οἱ	αἱ	τά
Γεν.	τοῦ	τῆς	τοῦ	τῶν	τῶν	τῶν
Δοτ.	τῷ	τῇ	τῷ	τοῖς	ταῖς	τοῖς
Αἰτ.	τόν	τήν	τό	τούς	τάς	τά

17. Πόσοι, -οι, ᾱ, η, ον, κτλ, καθὼς τὸ ἄνω ἄρθρον · ἀντωνυμιακὸν ἐπίθετον (pronominal adj.), *how many* planets are there?

18. Ἰδού, ἐπιφώνημα, voilà, behold, *here are.*

19. Ταῦτα, ἄντων. δεικτική (pronoun demons.), οὗτος, αὗται, τοῦτο · τούτου, ταύτης, κτλ, σελ. ι´ (10) καὶ ιι´, this.

20. Ἰχθύς, ύος, όν. τρίτης ἀρσ., fish.

21. Κολυμβῶσιν, ῥῆ. συνηρημένον τρίτου πληθ. τῆς ὁριστικῆς (3 pl. Indic.), they swim.

At this point there should be a thorough review and mastery of the various grammatical forms and terms already given. Thus, on pp. 3, 4, are some fifteen ; p. 6, twelve ; p. 8, the plurals of the old and some new ones ; pp. 10–16, a score more, *including the essentials of the entire declension.* In the present lesson references to the preceding, in full and abbreviated, have been employed, but henceforth the abbreviations should suffice, or merely the terminations after the different parts of speech having inflection.

Μάθημα Ἕβδομον.

Ἔχομεν ἐνταῦθα (we have here) δύο μακρὰς καὶ παραλλήλους γραμμάς · ἡ γραμμὴ Α εἶναι τόσον (so) μακρὰ ὅσον (as) ἡ γρ. Β · πρὸς τούτοις (moreover) ἡ γρ. Β εἶναι τόσον μ. ὅ. ἡ γρ. Α. ○Α—○Β. Πόσον (how) μέγας εἶναι ὁ κύκλος Α ; ὁ κύκλος Α εἶναι τόσον μέγας ὅσον ὁ Β. Καὶ ὁ Β ;

Α --------------	Δ ▬▬▬
Β ▬▬▬▬▬▬▬▬	Ε ▬▬
Γ ▬▬▬▬▬▬▬▬	Ζ —

Εἶναι ἡ γρ. Α τόσον μακρὰ ὅσον ἡ γρ. Β ; ἡ γρ. Α δὲν εἶναι, κτλ, ἀλλὰ ἡ γρ. Β εἶναι μακροτέρα τῆς γραμμῆς Α (ἤ, μακρ. ἀπὸ (παρὰ) τὴν γρ. Α). Εἶναι ἡ Ζ τόσον μακρὰ ὅσον Ε ; αὐτὴ (it) δὲν εἶναι κτλ, ἀλλ᾽ εἶναι βραχυτέρα τῆς γραμμῆς Ε (ἤ, βραχ. παρὰ τὴν γραμμὴν Ε). Εἶναι Β τ. μ. ὅ. Γ ; ὄχ᾽, ἡ γὰρ (for the) Γ εἶναι ἡ μακροτάτη μεταξὺ ὅλων τῶν ἓξ γραμμῶν. Ποῖά ἐστι βραχυτέρα

τῆς Δ; Ε καὶ Ζ εἶναι ἀμφότεραι μακρότεραι τῆς Δ. Ποῖά ἐστι ἡ βραχίστη (ἡ, ἡ βραχυτέρα) ἐκ τῶν ἕξ; ἡ μακροτέρα καὶ ἡ πυκνοτέρα;

Ἡ γῆ δὲν εἶναι τόσον μεγάλη ὅσον ὁ ἥλιος· ὁ ἥλιος εἶναι μείζων (μεγαλίτερος) τοῦ Ἑρμοῦ (ἡ, μεγαλ. παρὰ τὸν Ἑρμήν), τῆς Ἀφροδίτης, τῆς Γῆς καὶ τῶν ἄλλων πλανητῶν· ὁ ἥλιος εἶναι τὸ μέγιστον σῶμα (body) ἐξ ὅλων τούτων. Ὑπάρχουσι τόσοι ἥλιοι ὅσαι πλανήται; ὄχι, ὑπάρχει εἷς μόνον (only) ἥλιος.

Τί (ποῖον) εἶναι μακρότερον, ἡ λαμπὰς (ὁ λύχνος) ἡ ἡ ῥάβδος; ἡ ῥάβδος εἶναι μικροτέρα τῆς λαμπάδος, ἡ δὲ λαμπὰς βραχίων (βραχυτέρα) τῆς ῥάβδου. Εἶναι παλάτιόν τι μεῖζον (larger) καλύβης τινός; Τί εἶναι ὑψηλότερον, ἡ καπνοδόχη ἡ ἡ στέγη τῆς οἰκίας; εἶναι ἡ στέγη χαμηλοτέρα (lower); Τί εἶναι μεῖον (smaller, μικρότερον), μία στιγμὴ ἡ εἷς κύκλος;

Σχόλιον.

Ἡ τῆς ἰσότητος σύγκρισις γίνεται διὰ τοῦ τόσος, -η, ον— ὅσος, -η, -ον, so-as. (The comparison of equality is made by the (word) τόσος, etc.)

Ἡ τῆς ὑπεροχῆς τε καὶ ἐλαττώσεως σύγκρισις γίνεται διὰ τοῦ τοῦ ἐπιθέτου συγκριτικοῦ μετὰ τῆς Γεν. (ἡ, ἀπό ἡ παρά μετὰ τῆς Αἰτ). (The comparison of both superiority and inferiority is made by the comparative of the Adjec. with the G. [or, ἀπό or παρά with the Ac.].)

Τὸ μὲν ὑπερθετικὸν ἀπόλυτον γίνεται διὰ τοῦ τοῦ ἐπιθέτου θετικοῦ προηγουμένου ὑπὸ τοῦ ἐπιρρήματος πολύ, λίαν, κτλ, τὸ δὲ ἀναφορικὸν διὰ τοῦ ὑπερθετικοῦ, παραδείγματος χάριν· ἡ πολὺ (very) μεγάλη πόλις· ἡ μεγίστη πόλις. (The absolute superlative is formed by the positive of the adj. preceded by the advb. πολύ, λίαν, etc., and the relative (superlative) by the superlative (of the adj.), for example: the *very large* city; the *largest* city.)

1. Τόσος—ὅσος. When *so-as* modify an adj., as, "so great." they are *advbs.* and in the neu. indeclinable, τόσον —ὅσον; elsewhere they must agree with their nouns like

adjs. in gender, number, case. *After* the comparative the construction can be, (*a*), ἤ, than, with same case after as before it ; (*b*), the G.; (*c*), ἀπό or παρά with Ac. Find examples in the lesson.

2. The regular terminations for Comparison are, (*a*), -τερος, -ρα, -ρον· τατος, -τη, -τον· but, (*b*), -ίων, -ιον, G. -ἰονος, κτλ, occur with a few adjs. in ancient Greek where the modern inclines to follow the rule: thus, (*a*), Ὑψηλός, -λότερος, λότατος· Χαμηλός, κτλ· (*b*), βραχύς, βραχίων (βραχί-τερος), βράχιστος (βραχύτατος)· μέγας, μείζων (μεγαλίτερος), μέγιστος (μεγαλίτατος).

3. Adjectives having ε, ι, ρ before the final α, retain the ᾱ in the fem.; others become η ; hence the accent is different from the masc. and neuter.

4. Distinguish εἰς, into, πρόθεσις, from εἷς, one, ἀριθ-μητικόν.

5. Λαμπάς (ὅρα μάθ. τρίτον.), ὄν. θηλ. τῆς τρίτης· -πάς, πάδος, κτλ.

6. Ῥάβδος, ου, εἶναι ἀνωμάλως τοῦ θηλ. τῆς δευτέρας· ἄλλα (others) εἶναι, ἡ ἤπειρος, continent· ἡ νῆσος, island· ἡ νίσος, sickness· ἡ ὁδός, road· ἡ τάφρος, ditch.

7. Εἷς, μία, ἕν· ἑνός, μιᾶς, κτλ, ἀριθμητικόν (numeral) can be used for *a* or *an*, or the noun stand alone, or be followed by τὶς, τὶ: thus, ἕν παλάτιον, παλάτιον, παλάτιόν τι, all mean, *a* palace, but the first is most colloquial (modern) Greek.

Μάθημα Ὄγδοον.

[Γεωγραφικὸς χάρτης τῆς ἠπείρου.]

Ἐκεῖνο (that) τὸ μέγα ὕδωρ μεταξὺ Ἀμερικῆς (-ή, θηλ.) καὶ Εὐρώπης (-η) εἶναι Ἀτλαντικὴ θάλασσα (ης), ἡ Ἀτλαντικὸς ὠκεανός (οἱ, ἀρσ.). Τί εἶναι ὁ μέγιστος ὠκεανός; ἐκεῖνος ὅστις (ὁ ὁποῖος)

Ἐν τῷ μέσῳ δύο βουνῶν εἶναι μία κοιλάς (άδος, θηλ.), ἥτις μεταξὺ ὑψηλοτέρων βουνῶν εἶναι βαθέα· ποταμός τις δὲν εἶναι τόσον βαθὺς ὅσον ὁ ὠκεανὸς· ὁ Εἰρηνικὸς ὠκεανὸς εἶναι ὁ βαθύτατος.

<div align="center">Σχόλιον.

Ἡ πρώτη κλίσις.</div>

Ὀνο.	ἡ τιμή,	οἰκία,	θάλασσᾰ·	ὁ πολίτης,	ταμίας	
Γεν.	τῆς τιμῆς,	οἰκίας,	θαλάσσης·	τοῦ πολίτου,	ταμίου	
Δοτ.	τῇ τιμῇ,	οἰκίᾳ,	θαλάσσῃ·	τῷ πολίτῃ,	ταμίᾳ	
Αἰτ.	τὴν τιμήν,	οἰκίαν,	θάλασσᾰν·	τὸν πολίτην,	ταμίαν	

<div align="center">-αι
-ῶν (for άων)
-αις
-ας</div>

Notice (a), the *plural* terminations are the same for all nouns; (b), the singular feminines have three and masculines, which add s, two forms; (c), the accent, according to the rule for substantives, remains on the same syllable as in N., *except* that the G. plu. is always circumflexed (because contracted), and the third class, called "recessives," has the accent as far as possible (three places) from the ultima; (d), *ultimate* accents are circumflex only in G. and D.; (e), long accented ·*penults* take the long (circumflex) accent only when the ultima is short.

1. Ἀ-κίνητον == alpha privative, Eng. "un" or "non," and as equally common in Greek should be fixed in mind once for all.

2. Οὗτος ὁ π. Demonstrative and possessive pronouns require the article, this *the* river; demonstratives must stand as here or after the noun, *never* between art. and n. unless an adjective also modifies the noun, when they may stand before the noun, as, ὁ μέγας οὗτος π. But possessives stand between art. and noun, as, ὁ ἐμὸς ἵππος, (the) my horse; this is called the "attributive," the other the "predicate" position.

3. Ἥ-τις, compound relative, *which*, with both parts declined, the first nearly like the def. article: ὅς, ἥ, ὅ· οὗ, ἧς, κτλ· the second like a word of the 3d decl.: τίς, τίς, τί· τινός, τινός, τινός· τινί, κτλ.

4. Περί-κυκλο. = about (en)-circled.

5. Ἐφ', ὑφ', ἀφ' = ἐπί, ὑπό, ἀπό. Before a vowel of the following word the final vowel of prepositions is elided (except περί, πρό), and if this brings a "mute" before the rough breathing, the mute is changed to its aspirate; the nine "mutes" are: "labials," π, β, φ· "linguals," τ, δ, θ· "palatals," κ, γ, χ.

6. Ἐν-όνεται, un(one)-ited.

7. Παρα-θαλ., beside-sea, sea-side.

8. Τοι-αῦται, *such* as.

9. Μυχοί κ. ῥύ., creeks and brooks.

10. Ὁμαλή, level; περίσ., rolling and high.

11. Μεταξύ, between, πρόθεσις μετὰ τῆς, Γεν.

12. Βαθέα· βαθύς, βαθεῖα, βαθύ· βαθέος, βαθείας· βαθεῖ, βαθείᾳ, κτλ., deep.

Μάθημα Ἔννατον.

Τοῦτο εἶναι δένδρον· δένδρον τι εἶναι φυτόν, διότι πᾶν ὅ τι φύει ἐκ τῆς γῆς εἶναι φυτόν. Τὸ δένδρον στέκεται ἐν τῇ γῇ διότι αἱ ῥίζαι του ὑπὸ τὸ χῶμα (ground) τὸ κρατοῦσι εἰς θέσιν· Ὑπὲρ τὰς ῥίζας καὶ ἐπὶ τοῦ χώματος (τῆς γῆς) εἶναι τὸ στέλεχος (trunk) τοῦ δένδρου. Ἐπὶ (ἐπάνω) τοῦ στελέχους εἶναι αἱ κλάδαι καὶ κλόναι ἐπὶ τῶν ὁποίων εἶναι τὰ φύλλα. Δένδρον δὲν ἔχει μόνον ἕνα φύλλον, οὔτε δύο οὔτε τρία ἀλλὰ πολλά· ἕν, δύο, τρία δὲν εἶναι πολλά, μία χιλιάδα εἶναι πολλά· ἕν, δύο, τρία εἶναι, τῷ ὄντι, ὀλίγα· ἕν δένδρον ἔχει πολλὰς χιλιάδας φύλλων. Πολλὰ δένδρα εἰς μίαν θέσιν (ἐν μιᾷ θέσει) σχηματίζουσι (form) δάσος τι ░░░░, ἤ, δενδρότοπον· μέγα δάσος εἶναι δρυμών (ὦνος, ὁ, forest).

Μεταξὺ τῶν φύλλων τῶν δένδρων κατοικοῦσι πτηνά ⬥· ταῦτα τὰ πτηνὰ εἶναι ζῶα ἅ ἔχουσι δύο πόδας καὶ δύο πτέρυγας καὶ εἶναι

περικεκαλυμένα μὲ πτερά. Αὐτὰ κάμνουσιν ἢ κτίζουσι φωλεὰς ἐν τῷ μέσῳ τῶν φύλλων, καὶ εἰς φωλεὰς ἀφίνουσιν αὐγά 🥚, καὶ ἐκ τῶν αὐγῶν κλώσσουσι μικρότερα πτηνά, τουτέστιν, νεοσσούς (chicks).

Ὁμαλὴ γῆ μὲ ῥεῖθρον εἶναι λιβάδιον (λειμών, meadow)· ἐν τῷ λειμῶνι πολλὰ μικρὰ καὶ τρυφερὰ (tender) φυτὰ αὐξάνουσιν (grow)· αὐτὰ (these) εἶναι χορταρικά (herbage).

Ὁ ἵππος διαβαίνει ἐκεῖ καὶ ἄλλα οἰκιακὰ ζῶα ὡς βῶδες καὶ ἀγελάδες. 🐂 Ἀμφότερα ζῶα, ὁ βοῦς καὶ ἡ ἀγελὰς ἔχουσι κέρατα ἐπὶ τῆς κεφαλῆς των, καὶ ὀνομάζονται κερατοφόρα (cornifera). Μικροὶ ἵπποι ὀνομάζονται πῶλοι ἢ πουλάρια, ὁποίων ὁ πατὴρ ὀνομάζεται ὁ ἵππος καὶ ἡ μήτηρ ἡ φοράδα· οἱ δὲ μικροὶ βόες καὶ ἀγελάδες εἶναι μόσχοι, ἢ, δαμάλια. Πολλοὶ βόες καὶ ἀγελάδες εἶναι ἀγέλη (herd), καὶ διάφοραι ἀγέλαι βοῶν καὶ ἀγελάδων σχηματίζουσιν κοπάδιον (drove)· καὶ ἀγέλαι ἵππων καὶ βοσκημάτων τρόγουσιν χόρτον ἐντὸς (in) τοῦ λεμῶνος.

Ἡ θέσις ἥτις καλύπτεται ὑπὸ χόρτου εἰς τήν ὁποῖαν αἱ ἀγέλαι θρέφονται εἶναι ἡ βοσκή 🌾, ὅπου ὑπάρχουσιν καὶ ζῶα ἐν τοῖς 🌲 δάσεσι, τοιαῦτα ὡς, λέοντες, τίγρες, ἄρκται (-η, bear) καὶ 🐺 λύκοι· ταῦτα δὲ εἶναι θηρία, ἢ, ἄγρια ζῶα, ἐνῷ (while) οἱ ἵπποι καὶ κερατοφόρα ζῶα εἶναι βοσκήματα. Ἀγέλαι μετὰ τὴν θρεφὴν τοῦ χόρτου ὑπάγουσιν εἰς τὸ ῥυάκιον (brook) καὶ πίνουσι τὸ ὕδωρ, καὶ περὶ τῆς μεσημβρίας συνάγονται ὑπὸ τὴν τῶν δένδρων σκιὰν (shade) καὶ πέρουσι (pass) τὸ μεσημεριανόν. ☀️

Σχόλιον.

Ἡ δευτέρα κλίσις

εἶναι εὔκολος (easy) περιεχοῦσα (containing) ὀνόματα τοῦ ἀρσενικοῦ καὶ οὐδετέρου (καὶ ὀλίγα θηλικοῦ, ὅρα σελ. κβʹ, 6), δηλαδή·

	Ἑνικός.		Πληθυντικός.	
Ὀνο.	ὁ ἵππος·	τὸ δένδρον	οἱ ἵπποι·	τὰ δένδρα
Γεν.	τοῦ ἵππου·	τοῦ δένδρου	τῶν ἵππων·	τῶν δένδρων
Δοτ.	τῷ ἵππῳ·	τῷ δένδρῳ	τοῖς ἵπποις·	τοῖς δένδροις
Αἰτ.	τὸν ἵππον·	τὸ δένδρον	τοὺς ἵππους·	τὰ δένδρα

Τὸ ἄρθρον ὁ ἡ τό (ἡ ἡ) θὰ δείξῃ (will show) τὸ γένος.

1. Φυ-τόν, τό, growth, *plant*. Τίνος κλίσεως; πῶς κλίνεται;

2. Γῆ, ἡ, πῶς κλίνεται; ὅρα σελ. κδ´ (p. 24): ge-ology.

3. Τὸ κράτ., hold it in place.

4. Ὑπερ (*super*-ior) πρόθεσις μετὰ Γεν., for, καὶ Αἰτ., above.

5. Τὸ στέλεχος, έχους, έχει· έχῃ, έχων, έχεσι· ὄν. τῆς τρίτης.

6. Πτηνά (-όν, τό), τί κλίσεως;

7. Πτέρυξ, ἡ, υγος, κτλ, σελ. ιέ, "τρίτη κλίσις," wing.

8. Μὲ πτερά, or Attic μετὰ πτερῶν, τῆς δευτέρας οὐδ., *with* feathers.

9. Οἰκια-κά, ἐπίθετον, -κός, κή, κόν· κοῦ, κῆς, κτλ., σελ. ιη´, *house*-hold, *dom*-estic animals as oxen and cows.

10. Θρέφονται and θρεφήν, ὄν. καὶ ῥῆ., feed,

11. Μεσημβρίας = μέσ(ος)- ἡμέρα, mid-day.

Μάθημα Δέκατον.

ὁ ἀνήρ.　　ἡ γυνή.

ὁ ἄνθρωπος.

Ο ἄνθρωπός ἐστι δίποδον ζῶον ὅτι (which) ἔχει νοῦν καὶ λόγον. Οὗτος ὁ ἄνθρωπός ἐστι ἀνήρ, ἐκεῖνος ὁ ἄνθρωπός ἐστι γυνή. Ὁ ἀνὴρ ὅστις ἔχει γυναῖκα εἶναι ἔγγαμος; ἡ δὲ γυνὴ ἥτις ἔχει ἄνδρα εἶναι ὑπανδρευμένη· ὁ ἔγγαμος ἀνὴρ καὶ ἡ ἐπανδρευμένη γυνὴ εἶναι ἐπανδρευμένοι ἄνθρωποι, καὶ ἀμφότεροι εἶναι ἑνωμένοι εἰς γάμον.

Ἔγγαμοι ἄνθρωποι ἔχουσι μικροὺς ἄνδρας καὶ μικρὰς γυναῖκας· οἱ μικροὶ ἄνδρες εἶναι παιδία 🙎, αἱ δὲ μικραὶ γυναῖκες εἶναι κοράσια 🙎🙎· ἀμφότεροι εἶναι τὰ τέκνα, ἢ τὰ γένη. Ὁ ἄνθρωπος ὅστις ἔχει τὰ τέκνα εἶναι ὁ πατήρ, ἡ δὲ γυνὴ ἥτις ἔχει τὰ τέκνα εἶναι ἡ μήτηρ· ὁ πατὴρ καὶ ἡ μήτηρ τῶν παιδίων καὶ τῶν κορασίων εἶναι οἱ γονεῖς· ὁ πατὴρ εἶναι οἰκοκύρης τῆς οἰκογενείας, ἡ δὲ μήτηρ εἶναι οἰκοκυρὰ τῆς οἰκογενείας.

Οἱ υἱοὶ καὶ αἱ θυγατέρες ἑνὸς πατρὸς καὶ μιᾶς μητρός εἰσιν οἱ ἀδελφοὶ καὶ αἱ ἀδελφαί. Τὸ μικρὸν παιδίον εἶναι ἀγοράκιον, τὸ μικρὸν κοράσιον εἶναι παιδίσκη· τὸ δὲ μικρότερον τέκνον εἶναι τὸ νήπιον, ἢ τὸ βρέφος. Τὸ νήπιον αὐξάνει καὶ γίνεται ὁ παῖς· ὁ παῖς μεγαλόνει ἕως οὗ (until) γίνη νεανίας ἢ νεανίς, καὶ τότε εἶναι νέος ἄνθρωπος· ὁ ἀνὴρ ἐν ὅσῳ ἡλικιόνεται ταχέως (quickly) γίνεται γέρων, ἡ δὲ γυνὴ γραῖα (γερόντισσα)· τέλος (finally) ἐν προβεβηκείᾳ (advanced) ἡλικίᾳ θνήσκουσιν· ὁ θάνατός ἐστι τὸ ἔσχατον ὅρος (σύνορον) ἀνθρωπίνης ζωῆς.

Τὸ νεκρὸν σῶμα ἀνθρωπίνης ὑπάρξεως καλεῖται (is called) πτῶμα, ὃ μετὰ δύο ἢ τρεῖς ἡμέρας θέτεται εἰς σορόν ⊏⊐· ἡ θέσις εἰς τὴν ὁποίαν οἱ ἄνθρωποι θέτουσι τοὺς νεκροὺς αὐτῶν εἶναι τάφος ἢ μνῆμα ⟋🏛⟍· ἡ δὲ θέσις ἐν τῇ ὁποίᾳ εἶναι ὅλα τὰ μνήματα (οἱ τάφοι) εἶναι κοιμητήριον ἢ νεκροταφεῖον. ⟋🏛🏛⟍ Ὅταν ὁ πατὴρ οἰκογενείας τινὸς θνήσκει, τὰ τέκνα του γίνονται ὀρφανὰ καὶ ἡ μήτηρ τῆς οἰκογενείας χήρα. Ἐὰν δὲ ἡ μήτηρ ἀποθάνῃ καὶ ὁ πατὴρ νυμφεύεται δευτέραν σύζυγον, αὐτὴ δὲν εἶναι ἡ ἑαυτῶν μήτηρ ἀλλὰ ἡ μητρυιά. Πάντες οἱ ἄνθρωποι θνήσκουσι διότι εἶναι θνητοί. ἅπαντες εἶναι γεγενημένοι (begotten) ὑπὸ πατρὸς καὶ μητρός· ὅλος ὁ λαὸς εἰς ὁλόκληρον τὸν κόσμον (ἐν τῇ οἰκουμένῃ) σχηματίζει (form) τὸ ἀνθρώπινον γένος· πάντες οἱ ἄνθρωποί εἰσιν ἀδελφοί, τὸ γένος (off-spring) τῶν ἀνθρώπων· πολλαὶ οἰκογένειαι σχηματίζουσι γενεάν, πολλὰ πρόσωπα λαόν, καὶ οἱ κάτοικοι (inhabitants) μόνης ἐπαρχίας ἓν ἔθνος.

Σχόλιον.

Ἡ τρίτη κλίσις

περιέχει πέντε εἴδη ὀνομάτων ληγόντων ὡς πρὸς τὴν ῥίζαν ὡς ἑξῆς· εἰς (α) ἄφωνον (mute, ὅρα σελ. κε΄, 5)· (β) ἡμιφωνῆεν (λ, μ, ν, ρ)· (γ) σ· (δ) ϝ· (ε) υ, ι. Ἐνταῦθα δὲ εὑρίσκονται ὅλα τὰ τρία γένη. Ὅρα τὰς καταλήξεις, σελ. ιέ.

(α) ὁ φύλαξ, ακος, κτλ. —ἡ ὄρνις, νιθος· —τὸ μάθημα ήματος.

(β) ὁ ῥήτωρ, τορος· —ἡ ῥίς, ῥινός· —τὸ πέρας, πέρατος.

(γ) ὁ ἀληθής, θοῦς, θεῖ, θῆ· θεῖς, θῶν, θέσι, θεῖς· —τὸ γένος, νους.

(δ) ὁ βασιλεύς, λέως, λᾶ, λέα· λεῖς, λέων, λεῦσι, λέας.

(ε)ὁ ἰχθύς, θύος, κτλ· —ἡ πόλις, λεως, λει, λιν· λεις, λεων, λεσι, λεις· —τὸ ἄστυ, τεος, τει· τη, τεων, τεσι.

The few "syncopated," "contracted," and otherwise irregular nouns will we treated as they occur; thus, πατήρ, (πατέρος) πατρός, (πατέρι) πατρί, πατέρα· τέρες, τέρων, τράσι, τέρας. So μήτηρ, θυγάτηρ· ἀνήρ, ἀνδρός, inserts δ.

1. Δί(ς)-ποδον, bi(s)-ped.

2. Νοῦν, ὄν. τῆς δευτέρας, συνῃρημένον, (νόος) νοῦς, (νόου) νοῦ, κτλ., mind and reason.

3. Ἔγγαμος, ου, ἐν-γαμος, in-wedlock, married.

4. Ἔπανδ., ἐπί-ανήρ, by-(a) man, married.

5. Ἀμφότερος, -έρα, -ερον, ἐπίθετον, both.

6. Γονεύς, έως (ὅρα "(δ)" ἄνω), parent.

7. Οἰκο-κύρης, -κυρά, -γένεια, house-master, -mistress, -generation (family).

8. Ἀγοράκιον· παιδίσκη, little boy; little girl.

9. Νήπιον, non-speaking, in-fant, βρέφος, ους.

10. Αὐξάνω, κτλ., grows and becomes the boy—youth —young man; matures—old man—old woman; they die; death—the farthest bound of human life.

11. Τὸ νεκρόν, κτλ., the dead body of a human being.

12. Θέ-σις, εως· θέ-τεται, place; is placed.

13. Κοιμη-τήριον = ceme-tery = sleeping-place.

14. Νυμφ. (nymph) marries.

15. Ἡ ἑαυ., their own mother.

16. Ὅλος, κτλ., the whole of the people in the whole of the world.

17. Πάντες, κτλ., all men are brothers. Πᾶς, πᾶσα, πᾶν· παντός, πάσης, στλ.

18. Πολλά, κτλ., many f. form a race, m. persons a people—of a single region one nation.

A thorough review should now be made of declension in this order: pp. 18, 14, 15, 16, 24, 26, 28, 8, 10, 11. If this is done well, the most of the substantive parts, especially when the article occurs, can be recognized and located as to gender, declension, and case, at a glance.

Μάθημα Ἑνδέκατον.

Ἡ καλύβη ἵσταται ἐν μέσῳ δένδρων καὶ ὀπωροκηπίων (-ον, τό, orchard). Περὶ τὴν καλύβην εἶναι ἀγρὸς (ὁ, field) ἐν ᾧ βόες (βῶδες), ἀγελάδες καὶ ἵπποι θρέφονται. Πρὸ τῆς καλύβης πτηνὰ (-όν, fowl) οἰκιακά, οἷον ὄρνιθες (-νις, νιθος, ἡ, hen) σὺν νεοσσοῖς, ὄρνιθες τῆς Ἰνδίας καὶ ἀλέκτορες Γάλλοι ζητοῦσι τὸν σπόρον (-ος, ὁ, grain). Ἐγγὺς (πλησίον) τῆς καλύβης εἶναι ποταμὸς ἐν ᾧ χῆνες (χήν, χηνός, ἡ, goose) καὶ νῆσσαι (-α, ης, ἡ, duck), πτηνὰ ὑδρόβια (-ιος, -ιον, aquatic) ἁλιεύουσιν (fish).

Μικρὰ οἰκογένεια κατοικεῖ τὴν καλύβην, καὶ κοράσιόν τι (girl) ἐξέρχεται διὰ τῆς θύρας φέρον (bearing) κόφινον (-ος, ὁ, basket)· ἐκ τοῦ κοφίνου σκορπίζει τὸν σπόρον ἐπὶ τὴν γῆν· οἱ νεοσσοὶ κακαρίζοντες (peeping) καὶ συνπετόμενοι (flying together) τοὺς σπόρους ἀπὸ τοῦ δαπέδου (-ον, ground) συλλέγουσιν.

Ἡ οἰκογένεια ἥτις ἐνοικεῖ ταύτην τὴν καλύβην εἶναι χωριανοί· λειβάδια, ἀγροί, ῥύακες, δένδρα, ποίμνια καὶ καλύβαι εἶναι ἐξοχή, καὶ οἱ ἄνθρωποι κατοικοῦντες ἐν τῇ ἐξοχῇ εἶναι χωριανοί. Ὅταν εἶναι πολλαὶ οἰκίαι ὁμοῦ, οἰκία πλησίον οἰκίας, εἶναι κώμη (town), καὶ μεγάλη κώμη, πόλις (city). Οἱ ἐνοικοῦντες ἐν ταῖς πόλεσι δὲν εἶναι χωριανοὶ διότι δὲν ἐνοικοῦσιν ἐν χωρίῳ, ἀλλὰ πολῖται μεγάλων κωμῶν. Πάντες οἱ πολῖται (citizens) δὲν ἔχουσι τὰς ἑαυτῶν οἰκίας, κατοικοῦσι καὶ αὐτὰς ἀνηκούσας (belonging to) ἄλλοις· ὁ κατοικῶν τὴν ἑαυτοῦ οἰκίαν εἶναι οἰκοκύρης, ὁ δὲ τὴν τοῦ ἄλλου, ἐνοικιαστής· οἱ μὲν πλούσιοι κατοικοῦσιν ἀνάκτορα, οἱ δὲ πτωχοί, καλύβας. Ἀγροί, δάσοι, ὄρη, ποταμοί, κῶμαι, πόλεις σχηματίζουσι τὴν κατοικίαν ἢ πατρίδα (-τρίς, ἡ, fatherland) ἣν τὸ ἔθνος (ους, τό, nation) κατέχει· αἱ χῶραι ἀπὸ τοῦ Ἀτλαντικοῦ ἕως τοῦ Εἰρηνικοῦ, καὶ ἀπὸ τῶν ὁρῶν τῆς Βριτανικῆς Ἀμερικῆς ἕως τοῦ Μεξικοῦ εἶναι ἡ πατρὶς τῶν Ἀμερικανῶν. Τεσσαράκοντα τέσσαρα (44) πολιτεῖαι καὶ ἐξ ἐπαρχίαι ἡνωμέναι καὶ ποιοῦσαι ἓν πολιτικὸν ἔθνος, εἶναι, "Αἱ Ἡνωμέναι Πολιτεῖαι." Πάντα τὰ ἔθνη τῆς γῆς, ὁλόκληρος ἡ γῆ αὐτὴ καὶ ὅλα τὰ ἐν αὐτῇ, οἱ πλανῆται, ὁ ἥλιος, καὶ

πάντες οἱ ἀστέρες,—ἐν ἑνὶ λόγῳ (ἑλόντι εἰπεῖν), πᾶν ὅτι ὑπάρχει εἶναι ὁ Κόσμος ἢ τὸ Πᾶν.

Σχόλιον.

Τὸ Ῥῆμα

τῆς νέας Ἑλληνικῆς καίπερ ἁπλούστερον διατηρεῖ (altho simpler retaius) ὅμως ἐν πολλοῖς τὸν τύπον τῆς ἀρχαίας· εἶναι,—

Ἡ Φωνή, ἐνεργητική, παθητική· (Voice, Act., Pass.)

Ὁ χρόνος, ἐνεστώς, παρατατικός, μέλλων (πρῶτος καὶ δεύτερος), ἀόριστος, παρακείμενος, ὑπερσυντελικός· (Tense, Pres., Impf., Fut., Aorist, Pf., Plupf.)

Ἡ Ἔγκλισις, ὁριστική, ὑποτακτική, ὑποθετική (πρώτη καὶ δευτέρα), προστακτική, ἀπαρέμφατος, μετοχή· (Mood, Indic., Subj., Conditional, Impv., Infin., Ptcpl.)

Ὁ Ἀριθμός, ἑνικός, πληθυντικός. (Number.)

Τὸ Πρόσωπον, πρῶτον, δεύτερον, τρίτον. (Person.)

Ὅπως μάθῃ τις νὰ σχηματίζει καλῶς τὰ ῥήματα, πρέπει νὰ ἐκμάθῃ (one must learn by heart) πρῶτον τὸν ἐνεστῶτα κ.ὶ τὸν ἀόριστον ἐνεργητικὸν καὶ παθητικὸν τῆς ὁριστικῆς καὶ ὑποτακτικῆς, οἷον·

Λύ-ω (I loose), -εις, -ει· -ομεν, -ετε, -ουσι(ν).

Λύ-ομαι (I am loosed), ῃ, εται· όμεθα, εστε, ονται.

Νὰ λύ-ω (to loose now), ῃς, ῃ· ωμεν, ητε, ωσι(ν).

Νὰ λύ-ωμαι (to be loosed now), ῃ, ηται· ώμεθα, ησθι, ωνται, = Attic infinitives, λύειν, λύεσθαι.

Ἔλυ-σα (I loosed), σας, σε· σαμεν, σατε, σαν·

Ἐλυ-σάμην (I h'd b'n l'sed), σω, σατο· σάμεθα, σασθε, σαντο.

Νὰ λύ-σω (to loose), σῃς, σῃ· σωμεν, σητε, σωσι(ν).

Νὰ λύ-σωμαι (t. b. l'sed), σῃ, σηται· σώμεθα, σασθε, σωνται. = Attic infins., λῦσαι, λύσασθαι.

1. Ὀρν. τῆς Ἰ, Guinea hens and turkeys.

2. Φέρον, μετοχὴ τοῦ ἐνεστῶτος οὐδετέρου (ptcpl. pres. neu.), ἐκ τοῦ φέρω (fero), to bear, συντασσομένη μετὰ τοῦ κοράσιον. Ὅρα καὶ κακαρίζ. καὶ συμπετόμεναι. Συλ-λεγ., col-lect.

3. Χωρ(ὰ)-ιανοί, country-folks· ἐξοχή, country.

4. Ὁ μὲν κ., the one occupying, . . . but the one, etc.

5. Οἱ μὲν πλ.—οἱ δὲ πτωχοί, the rich,—the poor.

6. Τὸ Πᾶν, the Universe.

Μάθημα Δωδέκατον.

Τὰ Ἀριθμητικά.

Ἀπόλυτα Cardinals		Τακτικά Ordinals	Ἀριθμητικὰ Ἐπιρρήματα Numeral Adverbs
1	α΄ εἷς, μία, ἕν	πρῶτος, -η, -ον	ἅπαξ, once
2	β΄ δύο	δεύτερος, -α, -ον	δίς, twice
3	γ΄ τρεῖς, τρία	τρίτος, -η, -ον	τρίς, three times
4	δ΄ τέσσαρες, -ρα	τέταρτος, -η, -ον	τετράκις, four times
5	ε΄ πέντε	πέμπτος, κτλ.	πεντάκις, five times
6	ϛ΄ ἕξ	ἕκτος	εἰκοσάκις, twenty times
7	ζ΄ ἑπτά	ἕβδομος	ἑκατοντάκις, 100 times
8	η΄ ὀκτώ	ὄγδοος	χιλιάκις, 1000 times
9	θ΄ ἐννέα	ἔννατος	
10	ι΄ δέκα	δέκατος	Ἀριθμοὶ Ἀνάλογοι
11	ια΄ ἕνδεκα	ἑνδέκατος	ἁπλοῦς, single
12	ιβ΄ δώδεκα	δωδέκατος	διπλοῦς, double
13	ιγ΄ δεκατρία, κτλ.	δέκατος τρίτος	τριπλοῦς, triple
20	κ΄ εἴκοσι	εἰκοστός	τετραπλοῦς, quadruple
21	κα΄ εἰκοσιέν	εἰκοστὸς πρῶτος	πενταπλοῦς, five-fold
30	γ΄ τριάκοντα	τριακοστός	εἰκοσαπλοῦς
40	μ΄ τεσσαράκοντα	τεσσαρακοστός	ἑκατονταπλοῦς
50	ν΄ πεντήκοντα	πεντηκοστός	χιλιαπλοῦς
60	ξ΄ ἑξήκοντα	ἑξηκοστός	
70	ο΄ ἑβδομήκοντα	ἑβδομηκοστός	Ἀριθμοὶ Ἀφῃρημένοι
80	π΄ ὀγδοήκοντα	ὀγδοηκοστός	ἡ μονάς, the unit
90	ꝑ ἐννενήκοντα	ἐννενηκοστός	αἱ μονάδες, the units
100	ρ΄ ἑκατόν	ἑκατοστός	ἡ δυάς, the couple
200	σ΄ διακόσια	διακοσιοστός	αἱ δεκάδες, the tens
300	τ΄ τριακόσια	τριακοσιοστός	αἱ ἑκατοντάδες, the hun-
400	υ΄ τετρακόσια	τετρακοσιοστός	dreds
500	φ΄ πεντακόσια	πεντακοσιοστός	ἡ δωδεκάς, the dozen
600	χ΄ ἑξακόσια	ἑξακοσιοστός	ἡ εἰκοσάς, the score
700	ψ΄ ἑπτακόσια	ἑπτακοσιοστός	Ἀριθμοὶ Κλασματικοί
800	ω΄ ὀκτακόσια	ὀκτακοσιοστός	τὸ ἥμισυ, ½
900	ϡ΄ ἐννεακόσια	ἐννεακοσιοστός	τὸ τρίτον, ⅓, κτλ.
1,000	͵α χίλια	χιλιοστός	δύο τρίτα, ⅔
2,000	͵β δύο χιλιάδες	δισχιλιοστός	τρία τέταρτα, ¾
	ἓν ἑκατομμύριον	ἑκατομμυριοστός	ἓν καὶ ἥμισυ, 1½

Only 1, 3, 4 (and in Attic 200 upwards) are declined ; all the Ordinals as Adjectives have their proper declension.

Ἡ ἡμέρα καὶ ἡ νὺξ σύγκεινται ἀπὸ (consist of) 24 ὡρῶν· μία ὥρα ἀπὸ 60 λεπτῶν (-όν), καὶ τοῦτο ἀπὸ 60 δευτέρων (-ρος, ρα, ρον)· 7 ἡμέραι κάμνουσιν μίαν ἑβδομάδα (-μάς, ἡ), δηλαδή· Κυριακή (full form, ἡ Κυριακὴ ἡμέρα, the Lord's day), Δευτέρα, Τρίτη, Τετάρτη, Πέμπτη, Παρασκευή, Σάββατον (τό). Σήμερον (to-day) εἶναι Παρασκευή, χθὲς ἦτο (ἦν) Πέμπτη, προχθές, Τετάρτη, καὶ ἡ ἡμέρα πρὸ ταύτης, Τρίτη· αὔριον θὰ ἦναι τὸ Σάββατον, καὶ μεθαύριον ἡ Κυριακή. Πόσαι ἡμέραι ποιοῦσι μῆνα (μήν, μηνός, ὁ); πόσοι μῆνες τὸ ἔτος; πόσαι ἡμέραι;

Οἱ ἄνθρωποι ἐργάζονται 6 ἡμέρας καὶ μίαν, τὴν Κυριακήν, ἀπέχουσιν ἀπὸ ἔργου καὶ ἀναπαύονται. Τίς ἡμέρα τοῦ μηνὸς εἶναι σήμερον; Τί μάθημά ἐστι τοῦτο; Αἱ μῆνες τοῦ ἔτους εἶναι· Ἰανουάριος, Φεβρουάριος, Μάρτιος, Ἀπρίλιος, Μάϊος, Ἰούνιος, Ἰούλιος, Αὔγουστος, Σεπτέμβριος, Ὀκτώβριος, Νοέμβριος, Δεκέμβριος.

Αἱ 4 ὧραι τοῦ ἔτους εἶναι, τὸ ἔαρ (ἔαρος); τὸ θέρος (ους), τὸ φθινόπωρον (ου), ὁ χειμών (μῶνος). Ἡ πρώτη ὥρα, τὸ ἔαρ, ἐκτείνει (extends) ἀπὸ τῆς εἰκοστῆς πρώτης Μαρτίου ἕως τῆς 21ης Ἰουνίου· ἡ 2α ἀπὸ, κτλ., ἕως τῆς 21ης Σεπτεμβρίου· ἡ 3η ἀπὸ, κτλ., ἕως τῆς 21ης Δεκεμβρίου· ἀπὸ ταύτης ἕως τῆς 21ης Μαρτίου εἶναι ὁ χειμών, ὅτε ὁ καιρὸς εἶναι πολὺ ψυχρός, οὐδὲ ζεστός, καὶ αἱ ἡμέραι δὲν εἶναι μακραὶ ὡς ἐν τῷ θέρει, ἀλλὰ βραχεῖαι.

Σχόλιον.

1. Μόνον εἷς, τρεῖς καὶ τέσσαρες κλίνονται, οιον σελὶς ή΄, ι΄. ἡ Δοτικὴ τοῦ εἷς, εἶναι, ἑνί, μιᾷ, ἑνί· τοῦ τρεῖς, τρισί· τοῦ τέσσαρες, τέσσαρσι.

2. Δύο ὥρας καὶ ἡμίσειαν, two hours and a half

3. Πληρόνει ὀκτὼ τοῖς ἑκατόν, he pays 8 per cent.

4. Χίλια ὀκτακόσια ἐννενήκοντα τρία, 1893.

5. Ἀνὰ εἷς, one by one· ἀνὰ τέσσαρις, by fours, κτλ.

Ὁ Μέλλων ἐστί διαρκὴς (= continued or repeated action) ἢ στιγμιαῖος (= action undefined), καὶ εἰς τὴν Νέαν σχηματίζεται (in Mod. G. is formed) ἐκ τοῦ θά καὶ τῆς ὑποτακτικῆς (σελ. 31), ἢ, ἐκ τοῦ θέλω καὶ τῆς ἀπαρεμφάτου τοῦ ἐνεστῶτος τε

καὶ Ἀορίστου, οἶον· Ἐνεργητική—θὰ λύω, ῃς, κτλ. ἢ θέλω λύει (ν),
I shall loose, habitually· θὰ λύσω, σῃς, κτλ. ἢ θέλω λύσει,
I shall loose. Παθητική—θὰ λύωμαι ἢ θέλω λύεσθαι, ἤ, θὰ
λυθῶ ἢ θέλω λυθῇ.

Ὁμοίως ἡ Ὑποθετικὴ (Εὐκτική) σχηματίζεται ἐκ τοῦ θ ά καὶ τῆς
π α ρ α τ α τ ι κ ῆ ς ἢ τῆς π α ρ α τ α τ ι κ ῆ ς τοῦ θ έ λ ω καὶ τῆς ἀ π α ρ-
ε μ φ ά τ ο υ, οἶον· Ἐνεργητική—θὰ ἔλυ-ον, ἐς, ε, ομεν, ετε, ον, ἢ
ἤθελον λύει, I should (or would) be loosing, ἤ, [θὰ ἔλυσα] ἢ
ἤθελον λύσει, I should loose. Παθητική—θὰ ἐλυόμην ἢ ἤθελον
λύεσθαι, ἤ, θὰ ἐλύθην ἢ ἤθελον λυθῇ.

Μάθημα Δέκατον Τρίτον.

🙂 Τοῦτο τὸ σχῆμα εἶναι ἀνθρωπίνη κεφαλή· ἡ κόμη καλύπτει
τὴν κορυφὴν τῆς κεφαλῆς· ὁ νεανίας ἔχει πλείονα κόμην τοῦ γέρον-
τος· οἱ μὴ ἔχοντες κόμην εἶναι φαλακροί. Τὸ ἔμπροσθεν μέρος
δὲν καλύπτεται ὑπὸ τριχῶν ἀλλὰ τὸ ὄπισθεν, καὶ τὸ λεῖον μέρος
δεῖναι τ πρόσωπον οὗ τὸ ἄνω μέρος πλησίον τῆς κόμης ἐστὶ τὸ
μέτωπον ὑπὸ ὃ οἱ ὀφθαλμοί εἰσιν. ✱✱ Τὰ βλέφαρα ἔχουσι βλε-
φαρίδας (ματόκλαδα), ὑπὲρ δὲ τῶν βλεφάρων εἶναι αἱ ὀφρύες. Ἡ
ῥὶς ἔχουσα δύο ῥώθονα εἶναι μεταξὺ τῶν δύο ὀφθαλμῶν. Ἐπὶ τῶν
πλαγίων τῆς κεφαλῆς εἰσι δύο κρόταφοι, ὄπισθεν δὲ αὐτῶν δύο ὦτα. 👂👂
Ὑπὸ τὴν ῥῖνά εἰσι τὰ χείλη, τὸ ἄνω καὶ τὸ κάτω· τὸ ἄνω τῶν ἀρσε-
νικῶν καλύπτεται ὑπὸ τριχῶν, ἡ μύσταξ (ακος). Μεταξὺ τῶν χει-
λῶν ἐστι τὸ στόμα ἐν ᾧ εἰσι δύο σειραὶ ὀδόντων τεθειμένων ἐν τοῖς
οὔλοις· κατόπιν τῶν ὀδόντων καὶ τῶν οὔλων εἶναι ἡ ὑπερῴα, καὶ
πλησίον, ἡ γλῶσσα. Ὑπὸ τὸ κάτω χεῖλος εἶναι ὁ πώγων καὶ τὸ
γένειον· μεταξὺ τοῦ πώγονος καὶ τῶν ὤτων εἶναι τὰ γνάθα, μεταξὺ
δὲ τούτων τε καὶ τῆς ῥινός εἰσιν αἱ παρειαί. Ἡ κεφαλὴ ἵσταται ὑπὲρ
τοῦ τραχήλου, οὗτος δὲ μεταξὺ τῶν δύο ὤμων, ἐξ ὧν ἐξέρχονται (φύου-
σιν) οἱ δύο βραχίονες μετὰ τῶν ἀγκώνων καὶ τῶν περιχειρίδων. Ὁ μὲν
βραχίων εἶναι ὁ δεξιός, ὁ δέ, ὁ ἀριστερός· οἱ βραχίονες λήγουσιν εἰς
τὰς χεῖρας ὧν ἑκάστη ἔχει παλάμην καὶ πέντε δακτύλους ὧν αἱ ἄκραι
προφυλάττονται ὑπὸ ὀνύχων. Οἱ δάκτυλοί εἰσιν· ὁ ἀντίχειρ, ὁ

δείκτης (λιχανός), ὁ μέσος, ὁ παράμεσος, ὁ μικρός. Τὸ ἔμπροσθεν μέρος τοῦ ἀνθρωπίνου σώματος καλεῖται τὸ στῆθος, τὸ δὲ ὅπισθεν, ἡ ῥάχις (εως)· εἶναι καὶ δύο πλευραί· ὑποκάτω εἶναι ὁ στόμαχος καὶ ἐγκοιλία.

Ὁ ἄνθρωπος ἵσταται ἐπὶ δύο κνημῶν ὦν τὸ ἄνω μέρος ὀνομάζεται ὁ μηρός, καὶ οὗτος τελεόνει εἰς τὸ γόνυ (νατος) ὅτι εἶναι εὔκαμπτον· ὑπὸ τοῦτο εὑρίσκεται ἡ κνήμη, ἡ γαστροκνήμη, οἱ σφυροί, οἱ πόδες ἔχοντες πέντε δακτύλους τοῦ ποδός, ὄπισθεν εἶναι ἡ πτέρνα, ὑποκάτω δέ, ὁ πάτος.

Σχόλιον.

Ο μαθητὴς νῦν ἤθελε δυνηθῆ νὰ διακρίνῃ (the pupil now should be able to distinguish) τὰ ἄρθρα, τὰ ἐπίθετα καὶ τὰ ὀνόματα ὡς πρὸς τὴν κλίσιν τε καὶ πτῶσιν, ὡσαύτως πολλὰ μέρη τῶν ῥημάτων.

Καλύπτ-ω, cover· κορυφή (declen. pp. 24 and 15), crown· νεανίας (p. 24), young man· ὁ γέρων, οντος (28 β), old man· οἱ μὴ ἔχ., those (the ones) not having: the Grk. negative with Indic. is οὐ(κ), elsewhere μή· κόμη, hair of head· ἡ θρίξ, τριχός (28 a, β), hair generally· ἔμπροσθεν, front· λεῖος, -α, -ον, smooth· οὗ, ὅς, ἥ, ὅ (11, 18)· βλέφαρον (26), eyelid, ἡ βλεφαρίς, ρίδος (28 a), eyelash, ὀφρύς, ρύος (29 ε) eyebrow· ῥίς, ῥινός (28 β), nose· ῥώθων, -θωνος, nose, plu., τὰ ῥ., nostrils· τὸ πλάγιον, side· ὁ κρόταφος, temple· τὸ οὖς, ὠτός (28 β), ear· τὸ χεῖλος (28 γ), λους, lip· ἡ σειρά, series, row· ὁ ὀδούς, δόντος, tooth· τὰ οὖλα (26), the gums· ὑπ. κ. γλῶ., palate and tongue· chin, beard, jaw, cheek· ὁ τράχηλος, neck· ὁ ὦμος, shoulder· ὁ βραχίων, ονος, arm· ὁ ἀγκών, ῶνος, elbow· τὸ περιχείριδον (26), wrist· ὁ μέν . . ὁ δέ, the one . . the other· ἡ χείρ, ῥός, hand· palm, finger, end· ὁ ὄνυξ, υκος, nail· προ-φυλάττ-ω fore-guard· thumb, index, middle, beside-middle, little· chest, back, side. stomach, bowels· leg, thigh, knee, flexible, calf, ankle, heel, sole· τελεόν-ω, end· εὑρίσκ-ω, find.

Ὁ Παρατατικὸς σχηματίζεται,—

Ἐνεργ.—ἔ-λυ-ον, ες, ε, ομεν, ετε, ον.
Παθη.—ἐ-λυ-όμην, ου, ετο, όμεθα, εσθε, οντο.

Ὁ Ἀόριστος σχηματίζεται,—

Ἐνεργ.—ἔ-λυ-σα, σας, σε, σαμεν, σατε, σαν.
Παθη.—ἐ-λυ-σάμην, σω, σατο, σάμεθα, σασθε, σαντο.

Αὔξησις.—Augment.

Τὰ μὲν ἀπὸ συμφώνου ἀρχόμενα ῥήματα εἰς τὸν παρατατικὸν καὶ ἀόριστον τῆς ὁριστικῆς λαμβάνουσιν ἐν τῇ ἀρχῇ ἓν ε ὃ λέγεται αὔξησις συλλαβική (ρ δὲ διπλασιάζεται, ὡς, ῥέω, ἔρρεον, ἔρρευσα)· τὰ δὲ ἀπὸ φωνήεντος, τρέπουσι τὸ ἀρκτικὸν φωνῆεν, καὶ λέγεται αὔξησις χρονική, ὡς ἑξῆς·

α εἰς η ὡς ἀκούω, ἤκουον
ε " η " ἐλπίζω, ἤλπιζον (ἔχω, εἶχον)
ο " ω " ὁπλίζω, ὤπλιζον
αι " ῃ " αἰσθάνομαι, ᾐσθανόμην
οι " ῳ " οἰκτείρω, ᾤκτειρον
αυ " ηυ " αὐξάνω, ηὔξανον
ευ " ηυ " εὔχομαι, ηὐχόμην

Τὰ ἐκ προθέσεων σύνθετα ῥήματα αὐξάνουσι μετὰ τὴν πρόθεσιν, ἀποβολῇ τοῦ λήγοντος φωνήεντος (πλὴν τῶν περί καὶ πρό), ὡς, ἀντι-γράφω, ἀντ-έγραφον.

From this point the *Notes* will continue to be in literary modern Greek, translated when necessary ; the *Lessons* will be the First Book of the Anabasis in Subject, Vocabulary, and Construction, but greatly simplified, with corresponding English exercises. Thus the teacher's terror—the gulf separating the Primer and Classical Author—will be bridged, while the living language already acquired will be retained.

Μάθημα Δέκατον Τέταρτον.

Δαρεῖος βασιλεὺς τῶν Περσικῶν, γίγνεται ὁ πατὴρ παίδων δύο, ὧν ὁ μὲν πρεσβύτερος ἦν Ἀρταξέρξης, νεώτερος δὲ Κῦρος· ἡ δὲ μήτηρ αὐτῶν Παρύσατις. Ἐπεὶ δὲ Δαρεῖος ᾐσθάνει (ἦν ἀ-σθενής) καὶ ὑπ-ώπτευε τὴν τελευτὴν τοῦ βίου, βούλεται τοὺς παῖδας παρ-εῖναι, καὶ μεταπέμπεται Κῦρον ἀπὸ τῆς ἀρχῆς τῆς ἐν τῇ Ἀσίᾳ ὅπου ἦν σατρά-της, ἢ ἄρχων, καὶ στρατηγός· ἀνα-βαίνει οὖν λαβὼν σὺν ἑαυτῷ, ὡς φίλον, ἄλλον σατράπην, Τισσαφέρνην, καὶ ὡς φύλακας, τριακοσίους ὁπλίτας ἢ στρατιώτας ὧν ὁ ἄρχων ἦν Ξενίας. Μετὰ τὴν Δαρείου θάνατον Ἀρταξέρξης γίγνεται βασιλεὺς καὶ συλ-λαμβάνει Κῦρον ὅτι Τισσαφέρνης δια-βάλλει αὐτὸν πρὸς τὸν βασιλέα, λέγων, "Κῦρος ἐπι-βουλεύει σοι"· ἡ δὲ μήτηρ αὐτὸν ἀπο-πέμπει ἐπὶ τὴν ἀρχήν· ὁ δὲ Κῦρος χαλεπαίνει καὶ βουλεύεται ὅπως βασιλεύσει, ἐὰν δύνηται, καὶ ἀθροίζει δύναμιν τῶν Ἑλλήνων καὶ τῶν βαρβάρων· ὧδε οὖν ἐ-ποιεῖτο τὴν συλ-λογήν· ἦσαν ἐν ταῖς πόλεσι φυλακαὶ ἐκ τῆς Ἑλ-λάδος οὓς ἐ-μίσθωσαν καὶ ἐ-πολιόρκει τὴν πόλιν Μίλητον· αὕτη ἦν πρόφασις αὐτῷ, ὥστε ὁ ἀδελφὸς τὴν πρὸς ἑαυτὸν ἐπι-βουλὴν οὐκ ᾐσθάνετο. Ἄλλο δὲ στράτευμα αὐτῷ συν-ελίγετο ἐν Χερρονήσῳ τόνδε τὸν τρόπον. Κλέαρχος ἦν Λακεδαιμόνιος φυγάς, φίλος δὲ Κύρῳ· ὥστε λαμβάνει ἀπὸ Κύρου μυρίους δαρεικοὺς καὶ ἀπὸ τοῦ χρυ-σίου μισθοῖ στρατιώτας. Ἀρίστιππος δὲ, ὁ Θετταλός, Κύρῳ φίλος ὤν, πιεζόμενος ὑπὸ τῶν οἴκοι ἔρχεται πρὸς Κῦρον καὶ αἰτεῖ αὐτὸν δισ-χιλίους ξίνους (στρατιώτας) καὶ μισθὸν τριῶν μηνῶν· ὁ δὲ Κῦρος δίδωσιν αὐτῷ τετρα-κις-χιλίους· οὕτω δ᾽ αὖ τὸ ἐν Θετταλίᾳ στρά-τευμα αὐτῷ ἀθροίζεται. Τοῦτον τὸν τρόπον καὶ ἄλλοι τρεῖς φίλοι, Πρόξενος, Σοφαίνετος, Σωκράτης, αὐτῷ συλ-λέγουσι στρατιώτας.

Σχόλιον.

Πάντα τὰ κζ΄ ῥήματα τοῦ α΄ κεφαλαίου θὰ εὑρεθῶσι κάτω μετὰ μερῶν καὶ σημασίας (will be found below with parts and meaning).

Δαρ. (26) Darius· βασι. (29), king· Περσικός, Persian· πατήρ (29), father· παῖς, παιδός (28 β), child, *boy* or girl·

πρεσβ. . . . νεώτ. = συνκριτικά (comparatives, 22, 2) τοῦ πρέσβυς, old (presby-tery) καὶ νίος, a, ον (17, 25) new, *young* (= νεϝος, *novus*), (νε)ω διότι τὸ προηγούμενον φωνῆεν ε εἶναι βραχύ (bc. preced. vwl. short)· μέν . . . δέ (16, 22) = μόρια (particles) σημαίνοντα now, *indeed*, on the one hand . . . then, *but*, on the other hand· ὧν (11) κλίνεται ὡς τὸ ἄρθρον (18), ὅς, ἥ, ὅ, οὗ, κτλ., ἡ γενικὴ κτητική (G. poss.)· ἦν = παρατατικὸς τοῦ εἰμί (e-*sum*, am)· Ἀρταξ. (24)· μήτηρ (29) *mater*· αὐτός, ή, όν = ἀντωνυμία ὁριστικὴ ἢ ἐπαναληπτική (distinctive or repetitive), self, same, his, hers, etc. Παρύσ. (28 a)· ἐπεὶ δέ, and when· ἀ-σθένος (19, 9, 10; 24 η), in-firm, *sick*· τελευ., terminus, *end*· βίου (bio-graphy), life· βούλ. (*vol-o*), wil-l, *wish*· παρά, by, beside· μετά, a-midst, *after*· πεμπ., *middle* voice = for *himself*· ἀπό, ἐξ . . . ἐπί, εἰς, from (without and within) . . . to (outside and inside)· τῆς ἀ. τ., the province the (one)· σατρ., Περσικὴ λέξις, satrap· στρατ(ός)-ἀγός, army-leader (cf. λοχ(ος)αγός, captain)· ἀνά . . . κατά, up . . . down· λαβών, οὖσα, όν, όντος, κτλ. (28 a) taking· σύν, *cum*, *with*, w. help of· ἐ-αυτῷ, him-self· Τισ. (28 γ)· φύλα(κς)ξ (26 a), guard· τρια-κ. (32)· ὁπλί-της, armor-er, hoplite-soldier· Ξεν. (24)· θάν., thanat-opsis, *death*-vision· the of D. death, εἶναι ἡ Ἑλληνικὴ τάξις = "attributive" position of the G.· συλ-λ. = σύν-λ., ar-rests· δια-β., across(apart)-throws, slanders· (cf. Eng. ball, thing thrown)· πρό . . . πρός = πορ, (be)for(e) . . . for(e)-wards, *to*-wards· ἐπ-ί, up-on, *against*· σοί, ἀντωνυμία β' προσωπική (2d pers. pro.), thou, κλίνεται, σύ, σοῦ, σοί, σέ, ὑμεῖς, ὑμῶν, ὑμῖν, ὑμᾶς· δοτική μετὰ τῆς ἐπί· ὅ-πως, some-*how*, how-that· ἐ(ι)-άν *if*-possible, πάντοτε μετὰ τῆς ὑποκειμένης = "if shall"· βασ. = θὰ βασι-λεύσῃ (34)· δύναμις (29 ε, dynamite), force· Ἕλλην (28 a), Hellen-ic, *Greek*· βαρ-βάρ. (blab-blab-ers, *i. e.*, unable to speak Greek)· ὧδε, thus(ly), as follows· οὖν, then, truly, *therefore*· συλ-λ., col-lection· πόλ-ις (29 ε, pol-itics), city· Ἑλλά(δ)ς (28 a), Greece· μισθός, hire· πόλις-ἕρκος, city-hedge, *besiege*· αὕτη (8), this· πρό-φασις, fore-phase,

præ-text· ὥσ-τε so-that (= result, always)· ἀ-δελφ(ός), same-mother, *brother·* ἦσθ. = ε-αισθ. (æsthetic), perceived· Ἄλλω . . . and another army was collected for him in Ch in the fol. manner· φυγά(δ)ς (28 *a*), *fug*ítive· φίλ., friend· μυρ., *myr*ι-ad, ten thous.· δρ. (cf. Δαρεῖος, *dara*, king) νόμισμα χρυσοῦν = $3.50· πιεζ., hard pressed· ὑπό by (= agent w. passives)· οἴκο-ι, at-home· αἰτέ-ω (19, 9, 10), asks, w. double ac.· ξένος, foreíγn (troops)· δἰ-δο-σιν = ἀναδιπλασιασμός-ῥίζα-κατάλεξις (redup.-root-ending), he gives (*do*-nates)· οὕτω δὲ αὖ, and thus again.

1. The young boy. 2. The two youngest boys. 3. Their father, the king, is sick. 4. The mother wishes Darius to be present. 5. The soldier sends for his general as a friend. 6. The death of the soldiers happened after that (τόν) of their leader. 7. The generals, friends of Cyrus, are angry and accuse Tissaphernes. 8. A levy of soldiers was made in this city for the son of Parysatis.

Τὰ ῥήματα εἰς αω, εω, οω, ενω, αζω, ιζω, αινω, υνω εἶναι ὁμαλά.

1. Γίγνομαι, γενήσομαι, ἐγενόμην, γέγονα, γεγένημαι, ἐγενήθην,
2. Ἀσθενέω, ἀσθενήσω, ἠσθένησα, κτλ., be ill. [become.
3. Ὑποπτεύω, ὑποπτεύσω, ὑπώπτευσα, κτλ., suspect.
4. Βούλομαι, βουλήσομαι, βεβούλημαι, ἐβουλήθην, wish.
5. Πάρειμι, παρέσομαι, be present.
6. Τυγχάνω, τεύξομαι, ἔτυχον, τέτευχα, τέτευγμαι, ἐτεύχθην, happen.
7. Πέμπω, πέμψω, ἔπεμψα, πέπομφα, πέπεμμαι, ἐπέμφθην, send.
8. Ποιέω, ποιήσω, ἐποίησα, πεποίηκα, πεποίημαι, ἐποιήθην, make.
9. Δείκνυμι, δείξω, ἔδειξα, δέδειχα, δέδειγμαι, ἐδείχθην, show.
10. Ἀθροίζω, ἀθροίσω, ἤθροισα, κτλ., collect.
11. Βαίνω, βήσομαι, ἔβην, βέβηκα, go.
12. Λαμβάνω, λήψομαι, ἔλαβον, εἴληφα, εἴλημμαι, ἐλήφθην, take.
13. Ἔχω, ἕξω ἢ σχήσω, ἔσχον, ἔσχηκα, ἔσχημαι, ἐσχέθην, have.
14. Ἄρχω, ἄρξω, ἦρξα, ἦρχα, ἦργμαι, ἤρχθην, lead.
15. Τελευτάω, τελευτήσω, ἐτελεύτησα, κτλ., end.
16. Ἵστημι, στήσω, ἔστησα, ἕστηκα, ἕσταμαι, ἐστάθην, stand.
17. Βάλλω, βαλῶ, ἔβαλον, βέβληκα, βέβλημαι, ἐβλήθην, throw.
18. Βουλεύω, βουλεύσω, ἐβούλευσα, plan.
19. Πείθω, πείσω, ἔπεισα, πέπεικα, πέπεισμαι, ἐπείσθην, persuade.
20. Κτείνω, κτενῶ, ἔκτανον, ἔκτονα, kill.

21. Αἰτέω, αἰτήσω, ῄτησα, ask for.
22. Ἔρχομαι, εἶμι (ἐλεύσομαι), ἦλθον, ἐλήλυθα, go.
23. Κινδυνεύω, κινδυνεύσω, ἐκινδύνευσα, incur danger.
24. Ἀτιμάζω, ἀτιμάσω, ἠτίμησα, dishonor.
25. Δύναμαι, δυνήσομαι, δεδύνημαι, ἐδυνήθην, be able.
26. Βασιλεύω, βασιλεύσω, ἐβασίλευσα, be king.
27. Φιλέω, φιλήσω, ἐφίλησα, πεφίληκα, love.
28. Ἀφικνέομαι, ἀφίξομαι, ἀφικόμην, ἀφῖγμαι, arrive.
29. Τίθημι, θήσω, ἔθηκα, τέθεικα, τέθειμαι, ἐτέθην, put.
30. Μέλω, μελήσω, ἐμέλησα, μεμέληκα, care.
31. Πολεμέω, πολεμήσω, ἐπολέμησα, war.
32. Κρύπτω, κρύψω, ἔκρυψα, κέκρυμμαι, ἐκρύφθην, hide.
33. Ἀγγέλλω, ἀγγελῶ, ἤγγειλα, ἤγγελκα, ἤγγελμαι, ἠγγέλθην,
34. Δίδωμι, δώσω, ἔδωκα, δέδωκα, δέδομαι, ἐδόθην, give. [announce.
35. Αἰσθάνομαι, αἰσθήσομαι, ᾐσθόμην, ᾔσθημαι, perceive.
36. Φεύγω, φεύξομαι, ἔφυγον, πέφευγα, πέφυγμαι, flee. .
37. Λέγω, λέξω, ἔλεξα, εἴλοχα, εἴλεγμαι, ἐλέγην, gather.
38. Πολιορκέω, πολιορκήσω, ἐπολιόρκησα, besiege.
39. Πειράω, πειράσω, ἐπείρασα, try.
40. Ἄγω, ἄξω, ἤγαγον, ἦχα, ἦγμαι, ἤχθην, lead.
41. Πίπτω, πεσοῦμαι, ἔπεσον, πέπτωκα, fall.
42. Ἀξιόω, ἀξιώσω, ἠξίωσα, κτλ., claim.
43. Πράττω, πράξω, ἔπραξα, πέπραχα, πέπραγμαι, ἐπράχθην, do.
44. Νομίζω, νομίσω, ἐνόμισα, νενόμικα, νενόμισμαι, suppose.
45. Δαπανάω, δαπανήσω, ἐδαπάνησα, spend.
46 Ἄχθομαι, ἀχθέσομαι, ἤχθημαι, ἠχθέσθην, be vexed.
47. Ἄγαμαι, ἀγάσομαι, ἠγάσθην, admire.
48. Ὁρμάω, ὁρμήσω, ὥρμησα, rush.
49. Οἰκέω, οἰκήσω, ᾤκησα, dwell.
50. Ὠφελέω, ὠφελήσω, ὠφέλησα, aid.
51. Τρέφω, θρέψω, ἔθρεψα, τέτροφα, -έθραμμαι, ἐτράφην, nourish.
52. Λανθάνω, λήσω, ἔλαθον, λέληθα, λέλησμαι, ἐλάθην, be hid.
53. Πιέζω, πιέσω, ἐπίεσα, press.
54. Δέω, δεήσω, ἐδέησα, δεδέηκα, δεδέημαι, ἐδεήθην, need.
55. Λύω, λύσω, ἔλυσα, λέλυκα, λέλυμαι, ἐλύθην, loose.
56. Κελεύω, κελεύσω, ἐκέλευσα, command.
57. Στρατεύω, στρατεύσω, ἐστράτευσα, make war.

Μάθημα Δέκατον Πέμπτον.

Ἀνάβασις 1, 2.

Ἐπεὶ δ᾽ ἤδη αὐτῷ ἐ-δόκει πορεύεσθαι ἄνω, τὴν μὲν πρόφασιν ἐ-ποιεῖτο ὅτι βούλεται ἐκ-βαλεῖν τοὺς Πισίδας ἐκ τῆς χώρας· καὶ ἀθροίζει ὡς ἐπὶ τούτους τό τε Βαρβαρικὸν καὶ τὸ Ἑλληνικὸν στρά-τευμα. Ἐνταῦθα καὶ παρ-αγγέλλει τῷ τε Κλεάρχῳ ἥκειν λαβόντι ὅσον στράτευμα ἦν αὐτῷ, καὶ τῷ Ἀριστίππῳ ἀπο-πέμψαι ὃ στράτευμα ἦν αὐτῷ, καὶ Ξενίᾳ ἥκειν ἔχοντι τοὺς ἄνδρας πλὴν ὁπόσοι ἱκανοὶ ἦσαν τὰς ἀκροπόλεις φυλάττειν· ἐ-κάλεσε δὲ καὶ τοὺς Μίλητον πολιορκοῦντας καὶ τοὺς φυγάδας, ὑπο-σχόμενος αὐτοῖς μὴ πρόσθεν παύσεσθαι πρὶν αὐτοὺς κατ-αγάγοι οἴκαδε, καὶ ἐ-πίστευον αὐτῷ. Ξενίας μὲν δὴ τοὺς ἐκ τῶν πόλεων λαβὼν ὁπλίτας τετρακισχιλίους, παρ-ε-γένετο εἰς Σάρδεις, Πρόξενος δὲ παρ-ῆν ἔχων ὁπλίτας μὲν πεν-τακοσίους καὶ χιλίους, γυμνῆτας δὲ πεντακοσίους, Σοφαίνετος δὲ ἔχων ὁπλίτας χιλίους, Σωκράτης δὲ ἔχων ὁπλίτας πεντακοσίους, Πασίων δὲ ἔχων τριακοσίους μὲν ὁπλίτας, τριακοσίους δὲ πελταστάς· οὗτοι εἰς Σάρδεις αὐτῷ ἀφίκοντο. Τισσαφέρνης δὲ πορεύεται πρὸς βασιλέα ᾗ ὁδῷ ἐ-δύνατο τάχιστα, καὶ βασιλεὺς δὴ ἐπεὶ ἤκουσε (ἀπὸ) Τισσαφέρνους τὸν Κύρου στόλον, ἀντι-παρ-ε-σκευάζετο.

Κῦρος δὲ ἔχων οὓς εἴρηκα ὡρμᾶτο ἀπὸ Σάρδεων· καὶ ἐξ-ελαύνει διὰ τῆς Λυδίας σταθμοὺς τρεῖς, παρασάγγας εἴκοσι καὶ δύο ἐπὶ τὸν Μαίανδρον ποταμόν, οὗ τὸ εὖρος ἦν δύο πλέθρα· γέφυρα δὲ ἐπ-ῆν αὐτῷ ἐ-ζευγμένη πλοίοις ἑπτά· τοῦτον διαβὰς ἐξελαύνει διὰ Φρυγίας εἰς Κολοσσάς, πόλιν οἰκουμένην, εὐδαίμονα καὶ μεγάλην· ἐνταῦθα ἔ-μεινεν ἡμέρας ἑπτά, καὶ ἧκε Μένων ὁπλίτας ἔχων χιλίους καὶ πελ-ταστὰς πεντακοσίους· ἐντεῦθεν ἐξελαύνει εἰς Κελαινάς, ὅπου Κύρῳ βασίλεια ἦν καὶ παράδεισος μέγας καὶ πλήρης ἀγρίων θηρίων, ἃ ἐ-θήρευεν ἀφ᾽ ἵππου, ὁπότε βούλοιτο γυμνάσαι ἑαυτόν τε καὶ τοὺς ἵππους· ἐνταῦθά ἐστι καὶ μεγάλου βασιλέως βασίλεια ἐπὶ ταῖς πηγαῖς τοῦ Μαρσύου ποταμοῦ, ὅπου Ἀπόλλων λέγεται ἐκ-δεῖραι Μαρσύαν, νικήσας αὐτὸν ἐρίζοντα ἑαυτῷ περὶ μουσικῆς, καὶ τὸ δέρμα κρεμάσαι ἐν τῷ ἄντρῳ ὅθεν αἱ πηγαί· ἐνταῦθα Ξέρξης ἀπ-ε-χώρει ἐκ

τῆς Ἑλλάδος ἡττηθεὶς ἐν τῇ Σαλαμῖνος μάχῃ, ᾠκο-δόμησε δὲ ταῦτά τε τὰ βασίλεια καὶ τὴν Κελαινῶν ἀκρόπολιν. Ἐνταῦθα ἔμεινε Κῦρος ἡμέρας τριάκοντα, καὶ ἧκε Κλέαρχος ὁ Λακεδαιμόνιος φυγὰς ἔχων ὁπλίτας χιλίους καὶ Θρᾷκας πελταστὰς ὀκτακοσίους καὶ Κρῆτας τοξότας διακοσίους· ἅμα δὲ καὶ Σῶσις καὶ Σοφαίνετος ἔχοντες ὁπλίτας τριακοσίους καὶ χιλίους. Ἐντεῦθεν ἐξελαύνει εἰς Πλτας, καὶ Κεραμῶν ἀγοράν, καὶ Καΰστρου πεδίον, ὅπου οἱ στρατιῶται ἀπ-ῄτουν τὸν μισθόν· Κῦρος δὲ ἐλπίδας λέγων δι-ῆγε αὐτοὺς καὶ δῆλος ἦν ἀνιώμενος, οὐ γὰρ ἦν πρὸς τοῦ Κύρου τρόπου, εἰ δύναται, μὴ ἀπο-διδόναι· ἀλλὰ ἀφ-ικνεῖται Ἐπύαξα ἡ Συεννέσεως γυνή, τοῦ Κιλίκων βασιλέως, καὶ Κύρῳ ἔ-δωκε χρήματα πολλά, ὥστε ἀπ-έ-δωκε τῷ στρα-τεύματι μισθὸν τεττάρων μηνῶν. Ἐντεῦθεν ἐξελαύνεν εἰς Θύμβριον, ὅπου ἦν παρὰ τῇ ὁδῷ ἡ Μίδου κρήνη, καὶ εἰς Τυριαῖον, ὅπου ποιεῖται ἐξέτασιν τοῦ στρατεύματος, βουλόμενος ἐπι-δεῖξαι αὐτὸ τῇ Κιλίσσᾳ· ἐπειδὴ δὲ πάντας παρ-ήλασε, ἐ-κέλευσε τοὺς Ἕλληνας προ-βαλέσθαι τὰ ὅπλα καὶ ἐπι-χωρῆσαι ὅλην τὴν φάλαγγα, καὶ ἥσθη ἰδὼν τὸν τῶν βαρβάρων φόβον. Ἐντεῦθεν ἐξελαύνει διὰ Λυκαονίας καὶ Καππαδο-κίας εἰς τὴν Κιλικίαν διὰ τῆς εἰσβολῆς, ἀνα-βὰς ἐπὶ τὰ ὄρη, Συεννέ-σεως οὐ κωλύοντος, καὶ κατ-έ-βαινεν εἰς πεδίον μέγα, καλόν, ἐπίρρυ-τον καὶ σύμπλεων δένδρων καὶ ἀμπέλων, ἕως ἀφ-ίκετο εἰς Ταρσούς· ἐνταῦθα ἦν τὰ βασίλεια Συεννέσεως καὶ Ἐπυάξας, ἃ οἱ στρατιῶται δι-ήρπασαν, ὀργιζόμενοι διὰ τὸν ὄλεθρον τῶν Μένωνος συ-στρατιωτῶν ἐν τῇ ὑπερβολῇ τῶν ὀρέων· Κῦρος δὲ ἐπεὶ εἰσ-ήλασεν εἰς τὴν πόλιν, μετ-ε-πέμπετο Συέννεσιν, ἐ-δέχετο μὲν αὐτοῦ πολλὰ χρήματα εἰς τὸ στράτευμα, ἔδωκε δὲ αὐτῷ ἵππον, στρεπτὸν χρυσοῦν, ψέλια, ἀκινάκην, στολήν, τὴν χώραν καὶ τὰ ἀνδράποδα.

Σχόλιον.

τὰ να΄ ῥήματα εἶναι κάτω.

Αὐτῷ ἐδόκει . . . to him it seemed (good, ἀγαθόν) to march up, *i.e.*, ἀπὸ τῆς θαλάσσης· τὴν μὲν πρ. . . . he made it his pretext indeed that . . . τῇ δὲ ἀληθείᾳ ἐπὶ βασιλέα ἐπο-ρεύετο· ἔπ. καί . . . and-also (καί) then he sends word

along to both (τε)· λαβόντι, μετοχὴ τοῦ δευτέρου ἀορίστου καὶ συμφωνεῖ μετὰ τοῦ Κλ., ὅρα ῥῆμα 12· ὅσον . . . what army was to him· ἔχοντι, ὡς λαβόντι, ῥῆμα 13· ἀνδ. (27, 29)· πλὴν . . . except how many able were to guard the citadels· πολιορκ., μετοχὴ τοῦ ἐνεστῶτος, καὶ συμφωνεῖ μετὰ τοῦ "στρατιώτας" ἐννουμ.νου (understood)· μὴ πρόσθεν, not before, πρὶν, until = not sooner to stop than· γυμνῆτας, naked, light-armed troops· πελτ. troops with small shield· τετρακισ. (32)· ᾗ ὁδῷ . . . by what way he could most quickly· ἀντιπ., entered upon counter preparations for himself· ἀρηκα, ῥῆμα 69· ὡρμ., αὔξησις (36) ἐξελαύνει, used w. the gen'l, παρειάσθαι w. the troops· ποῦς, 1 (plus) foot ; πλέθρον, 101 (plus) ft. ; στάδιον, 606 (plus) ft. ; παρασάγγης, 3.5 miles ; σταθμός, a day's march· εὖρος, width ; μῆκος, length ; ὕψος, height· ἔζευγ, yoked (controlled) by seven boats· πόλιν . . . a city populous, prosperous, and large· ἔμειναν, ῥῆμα 72· ἡμί., days seven ; time in which, G. ; t. at which, D., t. during which Ac. · ὅπου . . . where to K. a palace was· Κύρῳ, δοτικὴ κτιτική (D. poss.)· παρδ., τίς Αγγλικὴ λέξις ;· πλήρης, full of wild beasts· ὁ τόνος τοῦ ἐπιθίτου πλήρης εἶναι ἀνώμαλος, διότι πᾶν ἄλλον λῆγον εἰς ης ὀξύνεται· θηρ. (fer-ocious, deer), beast· ἀφ' ἵ. (25,5) on (from) horseback ; thus only with hunting and fighting, where the weapons come from the horse· ἐπὶ τ. πηγ., upon (over) the springs· λεγ. ἐκδ., is said to have flayed M., when he had conquered him contending with him about music· ἐκδ., ῥῆμα 77, τὸ ἀπαρέμφατον τοῦ α'. ἀορίστου· καὶ τ. δ., and the (his) hide (skin, epi-dermis) to have hung up in the cave whence (are) the springs· ἀπή. = ἀπό-αἰτίω· διή. = διά-έγω· δῆλος, evident(ly) was (being) troubled· πρὸς τ., consonant w. C.'s character· ἀπέδ., off-gave, paid· μισθ., pay of four months (μήν, μηνός)· κρήνη, fountain· ἐξέτ., review· ἀναδὴ δὲ, and when he had ridden along by all· προβ., to throw forward (charge) their arms· ἤσθη, ῥῆμα 97· ἰδών, ῥῆμα 95. μετοχὴ τοῦ ἀο. · φοβ., the B.'s fear· ἀσβ. entrance, pass· ἀναβ., ῥῆμα 11· μετοχὴ τοῦ ἀο. · ὄρη (ὄρος, -ους, τό,

28 γ), mountains· πεδίον, plain, large, beautiful, well-watered and full of trees and vines until he arrived at Tarsus· σύμπλεων, -ον, ἐπίθετον· δι-ήρ. = διά- ἁρπάζω, ῥῆμα 99· ὄλεθρον,· destruction· συ(ν)-στρατ., com-rades, fellow-soldiers· ὑπερ-β., over-throwing, *crossing*· εἰσήλ., ῥῆμα 70· στρεπτόν . . . chain golden, bracelets, dagger, robe, his country (unravaged), and his slaves (returned).

1. He wishes to make a pretext. 2. He sends-for his (τὸ) army to march to Sardis. 3. These soldiers are sufficient to guard all the cities. 4. Proxenus came with hoplites, but Tissaphernes proceeded to the King. 5. The Meander River is five plethra wide where the bridge crosses it. 6. Both the King and Cyrus had palaces and parks. 7. The generals and soldiers marched over many mountains and through great plains. 8. Cyrus gives the soldiers ten months' pay. 9. Kings can give money, horses, chains, and slaves.

58. Δοκέω, δόξω, ἔδοξα, δίδογμαι, ἐδόχθην, seem.
59. Πορεύομαι, πορεύσομαι, πεπόρευμαι, ἐπορεύθην, march.
60. Ἥκω, ἥξω, have arrived.
61. Ἀλλάσσω, ἀλλάξω, ἤλλαξα, -αχα, -αγμαι, -άχθην, change.
62. Φυλάσσω, φυλάξω, ἐφύλαξα, κτλ., guard.
63. Καλέω, καλῶ, ἐκάλεσα, κέκληκα, κέκλημαι, ἐκλήθην, call.
64. Παύω, παύσω, ἔπαυσα, κτλ., stop.
65. Πιστεύω, πιστεύσω, ἐπίστευσα, trust.
66. Νοέω, νοήσω, ἐνόησα, perceive. [sider.
67. Ἡγέομαι, ἡγήσομαι, ἡγησάμην, ἥγημαι, ἡγήθην, lead, con-
68. Παρα-σκευάζω, -σκευάσω, -σκεύασα, prepare.
69. Φημί, φήσω ἢ ἐρῶ, εἶπον, εἴρηκα, εἴρημαι, ἐρρήθην, declare.
70. Ἐλαύνω, ἐλῶ, ἤλασα, ἐλήλακα, ἐλήλαμαι, ἠλάθην, march.
71. Ζεύγνυμι, ζεύξω, ἔζευξα, ἔζευγμαι, ἐζύγην, yoke.
72. Μένω, μενῶ, ἔμεινα, μεμένηκα, remain.
73. Θηρεύω, θηρεύσω, ἐθήρευσα, hunt.
74. Ῥέω, ῥεύσομαι ἢ ῥυήσομαι, ἐρρύηκα, ἐρρύην, flow.
75. Γυμνάζω, γυμνάσω, ἐγύμνασα, exercise.

76. Λέγω, λέξω, ἔλεξα, εἴρηκα, λέλεγμαι, ἐλέχθην, say.
77. Δέρω, δερῶ, ἔδειρα, δέδαρμαι, ἐδάρην, flay.
78. Ἐρίζω, ἐρίσω, ἤρισα, strive.
79. Νικάω, νικήσω, ἐνίκησα, conquer.
80. Κρεμάννυμι, κρεμῶ, ἐκρέμασα, ἐκρεμάσθην, hang up.
81. Ἡττάομαι, ἡττήσομαι, ἥττημαι, ἡττήθην, be defeated.
82. Χωρέω, χωρήσω, ἐχώρησα, retire.
83. Οἰκοδομέω, οἰκοδομήσω, ᾠκοδόμησα, build.
84. Θύω, θύσω, ἔθυσα, τέθυκα, sacrifice.
85. Θεωρέω, θεωρήσω, ἐθεώρησα, view.
86. Ὀφείλω, ὀφειλήσω, ὠφείλησα ἢ ὤφελον, ὠφείληκα, owe.
87. Εἶμι (Impf., ᾔειν ἢ ᾖα), go.
88. Ἀνιάω, ἀνιάσω, ἠνίασα, ἠνιάθην, be troubled.
89. Κεράννυμι, (κεράσω), ἐκέρασα, mix.
90. Τάσσω, τάξω, ἔταξα, arrange.
91. Καλύπτω, καλύψω, ἐκάλυψα, cover. [proclaim.
92. Προ-αγορεύω, -εύσω, -ευσα, -ευκα· ἢ, -ερῶ, -εῖπον, εἴρηκα,
93. Σαλπίγγω, σαλπίγξω, ἐσάλπιγξα, trumpet.
94. Λείπω, λείψω, ἔλιπον, λέλοιφα, λέλειμμαι, ἐλείφθην, leave.
95. Ὁράω, ὄψομαι, εἶδον, ἑώρακα, ἑώραμαι ἢ ὦμμαι, ὤφθην, see.
96. Θαυμάζω, θαυμάσομαι, ἐθαύμασα, wonder, admire.
97. Ἥδομαι, ἡσθήσομαι, ἥσθην, be glad.
98. Τρέπω, τρέψω, ἔτρεψα, τέτροφα, τέτραμμαι, ἐτράπην, turn.
99. Ἁρπάζω, ἁρπάσω, ἥρπασα, plunder.
100. Κωλύω, κωλύσω, ἐκώλυσα, hinder.
101. Πλέω, πλεύσομαι, ἔπλευσα, sail. [bear.
102. Φέρω, οἴσω, ἤνεγκον (-κα), ἐνήνοχα, ἐνήνεγμαι, ἠνέχθην,
103. Ὄλλυμι, ὀλῶ, ὤλεσα (ὠλόμην), ὀλώλεκα, ὄλωλα, destroy.
104. Κόπτω, κόψω, ἔκοψα, κέκοφα, κέκομμαι, ἐκόπην, cut.
105. Εὑρίσκω, εὑρήσω, ηὗρον, find.
106. Πλανάομαι, πλανήσομαι, πεπλάνημαι, ἐπλανήθην, wander.
107. Ὀργίζω, ὀργίσω, ὤργισα, enrage.
108. Ἐθέλω (θέλω), ἐθελήσω, ἠθέλησα, wish.

Ἀναδιπλασιασμός.—Reduplication.

Οἱ τετελεσμένοι χρόνοι ἀρχόμενοι ἀπὸ ἀπλοῦ συμφώνου, πλὴν τοῦ ρ, ἢ ἀπὸ δύο συμφώνων, ἀφώνου καὶ λιγρόν, ἐπαναλαμβάνουσι τὸ ἀρχικὸν σύμφωνον μετὰ τοῦ ε· ἄλλως εἶναι ἐν γένει ὡς ἡ αὔξησις.

Μάθημα Δέκατον Ἕκτον.

Ἀνάβασις 1, 3.

Ἐνταῦθα ἔμεινε Κῦρος καὶ ἡ στρατιὰ ἡμέρας εἴκοσιν· οἱ γὰρ στρατιῶται οὐκ ἔ-φασαν ἰέναι τοῦ πρόσω· ὑπ-ώπτευον γὰρ ἤδη ἐπὶ βασιλέα ἰέναι· μισθωθῆναι δὲ οὐκ ἐπὶ τούτῳ ἔφασαν. Κλέαρχος δὲ πρῶτος ἐ-βιάζετο τοὺς ἑαυτοῦ στρατιώτας ἰέναι· οἱ δὲ (στρατιῶται) ἔ-βαλλον αὐτόν τε καὶ τὰ ὑποζύγια αὐτοῦ, ὥστε Κλέαρχος τότε μικρὸν ἐξ-έ-φυγε κατα-πετρωθῆναι· ἐπεὶ δὲ ἔ-γνω ὅτι οὐ δυνήσεται βιάσασθαι αὐτούς, συν-ήγαγεν ἐκκλησίαν τῶν ἑαυτοῦ στρατιωτῶν, καὶ πρῶτον μὲν ἐ-δάκρυε πολὺν χρόνον, οἱ δὲ ὁρῶντες ἐ-θαύμαζον καὶ ἐ-σιώπων, εἶτα ἔλεξε τοιά-δε. "Ἄνδρες στρατιῶται, μὴ θαυμάζετε ὅτι χαλεπῶς φέρω, Κῦρος γὰρ ἐμοὶ ἐ-γένετο ξένος καί με ἐ-τίμησε καὶ ἐμοὶ ἔ-δωκε μυρίους δαρεικούς, οὓς ἐγὼ οὐ καθ-ηδυ-πάθησα, ἀλλὰ πρῶτον μὲν πρὸς Θρᾷκας ἐ-πολέμησα καὶ ἐ-τιμωρούμην μεθ' ὑμῶν αὐτοὺς βουλομένους ἀφαιρεῖσθαι τοὺς Ἕλληνας τὴν γῆν. Ἐπεὶ δὲ Κῦρος ἐ-κάλει, ἦλθον ἵνα ὠφελοίην αὐτὸν ἀνθ' ὧν εὖ ἔπαθον ὑπ' ἐκείνου· νῦν δέ μοι ἀνάγκη ἐστὶ ἢ τῇ Κύρου φιλίᾳ χρῆσθαι ἢ ψεύσασθαι αὐτὸν καὶ ἰέναι μεθ' ὑμῶν, καὶ οἶδα ὅτι αἱρήσομαι ὑμᾶς καὶ ἕψομαι ὑμῖν· σὺν μὲν ὑμῖν οἴομαι εἶναι τίμιος, χωρὶς δὲ ὑμῶν οὐχ ἱκανὸς εἶναι ἐχθρὸν ἀλέξασθαι." Οἱ δὲ στρατιῶται ἀκούσαντες, ἐπ-ήνεσαν καὶ πολλοὶ ἄλλοι ἐ-στρατο-πεδεύσαντο παρὰ Κλεάρχῳ. Κῦρος δ' ἀ-πορῶν τε καὶ λυπούμενος μετ-ε-πέμπετο Κλέαρχον, ὃς αὐτῷ μὲν ἔ-λεγε θαρρεῖν, τοῖς δὲ στρατιώταις ὅτι Κῦρος οὐκ ἔστι ἔτι μισθοδότης καὶ νομίζει ἀ-δικεῖσθαι ὑπ' αὐτῶν· αὐτὸς δὲ αἰσχύνεται καὶ δέδιε μὴ Κῦρος δίκην ἐπι-θῇ· ὥστε οὐκ ἔστι ὥρα καθ-εύδειν ἀλλὰ βουλεύεσθαι ὅ τι χρὴ ποιεῖν, καὶ σκέπεσθαι ὅπως τὰ ἐπιτήδεια ἕξουσιν· "ὁ δ' ἀνὴρ πολλοῦ μὲν ἄξιος φίλος ᾧ ἂν φίλος ᾖ, χαλεπώτατος δ' ἐχθρὸς ᾧ ἂν πολέμιος ᾖ, ἔχει δὲ δύναμιν καὶ πεζὴν καὶ ἱππικὴν καὶ ναυτικὴν ἣν πάντες ὁμοίως ὁρῶμέν τε καὶ ἐπι-στάμεθα· καὶ γὰρ δοκοῦμέν μοι οὐδὲ πόρρω αὐτοῦ καθ-ῆσθαι· ὥστε ὥρα λέγειν ὅτι τις γιγνώσκει ἄριστον εἶναι." Ἐκ δὲ τούτου ἀν-ίσταντο οἱ μὲν ἐκ τοῦ αὐτομάτου, οἱ δὲ καὶ ὑπ' ἐκείνου ἐγ-κέλευστοι· εἰς δὲ δὴ εἶπε

προσ-ποιούμενος σπεύδειν ὡς τάχιστα πορεύεσθαι εἰς τὴν Ἑλλάδα,
ἄλλους στρατηγοὺς ἑλέσθαι, τὰ ἐπιτήδει' ἀγοράζεσθαι, καὶ Κῦρον
αἰτεῖν πλοῖα καὶ ἡγεμόνα, πέμψαι δὲ καὶ τοὺς προ-κατα-ληψομένους
τὰ ἄκρα.

Μετὰ δὲ τοῦτον Κλέαρχος εἶπεν ὧδε· "Μηδεὶς ὑμῶν λεγέτω
ὅτι ἐγὼ στρατηγήσω ταύτην τὴν στρατηγίαν· ἀλλὰ πείσομαι τῷ
ἀνδρὶ ὃν ἂν ἕλησθε ἵνα εἰδῆτέ ὅτι ἐπίσταμαι καὶ ἄρχεσθαι ὥς τις καὶ
ἄλλος ἀνθρώπων." Μετὰ τοῦτον ἄλλος ἀν-έ-στη, ἐπι-δεικνὺς μὲν
τὴν εὐήθειαν τοῦ τὰ πλοῖα αἰτεῖν κελεύοντος, ὡς δὲ εὔηθες εἴη ἡγε-
μόνα αἰτεῖν παρὰ τούτου ᾧ τὴν πρᾶξιν ἐ-λυμαίνοντο· "ἐγὼ γὰρ
ὀκνοίην ἐμ-βαίνειν εἰς τὰ πλοῖα ἃ ἡμῖν δοίη, μὴ ἡμᾶς αὐταῖς ταῖς
τριήρεσι κατα-δύσῃ· φοβοίμην δ' ἂν ἕπεσθαι τῷ ἡγεμόνι ᾧ δοίη·
βουλοίμην δ' ἄν, ἀπ-ελθὼν Κῦρον λαθεῖν, ὃ οὐ δυνατόν ἐστιν· ἀλλ'
ἐγώ φημι ταῦτα πάντα φλυαρίας εἶναι· δοκεῖ δέ μοι ἄνδρας ἐλθόντας
σὺν Κλεάρχῳ πρὸς Κῦρον ἐρωτᾶν αὐτὸν τί βούλεται ἡμῖν χρῆσθαι,
καὶ ἐὰν μὲν ᾖ ἡ πρᾶξις ᾖ παραπλησία τῇ πρόσθεν, ἕπεσθαι· ἐὰν δὲ
ἡ πρᾶξις μείζων φαίνηται, ἀξιοῦν ἢ αὐτὸν πείσαντα ἀπ-άγειν ἡμᾶς,
ἢ πεισθέντα ὑφ' ἡμῶν, ἡμᾶς φιλικῶς ἀφιέναι." Ἔδοξε ταῦτα
καὶ ἄνδρες ἑλόμενοι σὺν Κλεάρχῳ πέμπουσιν αὐτοὺς οἳ ἠρώτων Κῦρον
τὰ δόξαντα τῇ στρατιᾷ. Ὁ δ' ἀπ-ε-κρίνατο ὅτι ἀκούει Ἀβροκόμαν,
ἐχθρὸν ἄνδρα, ἐπὶ τῷ Εὐφράτῃ ποταμῷ εἶναι, πρὸς δὲ τοῦτον βού-
λεσθαι ἐλθεῖν· ἐὰν δὲ φεύγῃ, ἡμεῖς ἐκεῖ πρὸς ταῦτα βουλευσό-
μεθα. Ἀκούσαντες δὲ ταῦτα οἱ αἱρετοὶ ἀν-αγγέλλουσι τοῖς στρατιώ-
ταις· τοῖς δὲ ὑποψία μὲν ἦν ὅτι ἄγει πρὸς βασιλέα, ὅμως δ' ἐ-δόκει
ἕπεσθαι· προσ-αιτοῦσι δὲ μισθόν (πλείονα), Κῦρος δὲ ὑπ-ισχνεῖται
ἡμιόλιον πᾶσι· δώσειν, ἀντὶ δαρεικοῦ τρία ἡμιδαρεικὰ τοῦ μηνὸς
ἑκάστῳ τῷ στρατιώτῃ· ὅτι δὲ ἐπὶ βασιλέα ἄγοι οὐδὲ ἐνταῦθα οὐδεὶς
ἤκουσεν.

Σχόλιον.

Οὐκ ἐφ., refused to go into the forward (place), *to ad-
vance*· ἔφασαν, παρατατικὸς τοῦ ῥή. 69, ἔφην, -ης, -η, -αμεν, -ατε,
-ασαν· ἰέναι, ἀπαρέμφατον τοῦ ἐνεστῶτος τοῦ ῥή. 87· μισθωθ.,

ἀπαρέμφατον τοῦ ἀο. παθητικοῦ, to have been hired · ἐπὶ τούτῳ,
for this (purpose) · ἐβιάζ., tried (started) to compel · ἔβαλ.,
began to throw (stones) at · μικρὸν, scarcely (a little) es-
caped being stoned to death · ἔγνω, ῥῆ. 112, ἀό. δεύτερος τοῦ
ἐνικοῦ τρίτου, ἔγνων, -νως, -νω, he *knew* · συνήγ., ῥῆ. 40 = 'Ατ-
τικὸς ἀναδιπλασιασμός = αγ-αγ-εν · ἐκκλη. (ecclesiastic), = ἐκ-
καλέω, called out, *assembly* · πολ. χρ., αἰτιατικὴ τοῦ πόσου, ex-
tent of *time* and space expressed by Ac., much time · ἐσιώ.,
παρατατικὸς τοῦ συνῃρημένου ῥή. 114 = ἐ-σιώπα-ον, they kept
silent · ἀνδ. στρατ., fellow soldiers · μὴ θαυμ., don't wonder
that hardly I hear, that *I am troubled* · ξένος, (stranger)
guest-friend · ἐτιμω., punished those wishing to deprive the
Greeks of their land · ἦλθον, ῥῆ. 22 · ὠφελ., εὐτικὴ μετὰ τοῦ
ἵνα, in order that I might aid him in place of what I had
suffered well by him · ἀνάγκη, it is necessary for me either
to use the friendship of Cyrus or to be false to him · χωρὶς,
apart from you · ὑμῶν, ἀντωνυμία β'. προσωπικοῦ, σύ, σοῦ, σοί,
σέ, ὑμεῖς, ὑμῶν, ὑμῖν, ὑμᾶς, you · οὐ(χ) ἱκ., not able to repel a
foe · οὐ(κ)-ἔτι, not-yet, *no longer* · μισθό(ς)-δό-της, pay-giv-er,
pay-master · δίκην ἐπ. punishment will in-flict · τὰ ἐπι., the
suitable (things), *provisions* · πολλοῦ ἄξ., worth much · χαλ.
ἐχθ., most harsh (bitter) personal enemy (to him) with
whom he is at war (πολέ.) · δύν., force, both foot, horse,
naval · οὐδὲ παρ., not at all far from him · ἐκ τούτου, from
this (time, χρόνου), *thereupon* · ἐγκέλ, set on · εἷς δὲ δὴ, and
one in particular · πλοῖα (πλέω, to sail), sailing (things),
vessels · τὰ ἄκρα (*acer*, sharp) the heights · μή-δ(έ)-εῖς (not-
even-one), don't let any of you say · ὥς τις, as any other
of men · εὐ-ήθ., (too) good-disposition, *silliness* · μὴ ἡμᾶς,
lest he sink us, triremes and all · βουλ., but I should pre-
fer,="potential" optative · Κῦ. λαθ , to conceal it from C. ·
ἀλλ', but I declare all this to be (of) nonsense · τί βούλε.,
for what he wants to use us, and if the matter shall be simi-
lar (παραπλ.) to the former · πείσ. . . . πεισθ., having persuad-
ed . . . h. been p. · ἔδοξ, these (things) seemed (good), *this
was voted* · ὑποψ., suspicion · ἡμιολ., one-half more to all, in-
stead of a daric three half darics per month to each soldier.

1. Can you tell me who Clearchus was? 2. Certainly (βεβαίως), he was a Lacedemonian exile and the best general of the Anabasis Greeks. 3. Who first hired these soldiers? I don't know. 4. Did the soldiers then have a vote in the assembly? 5. What is the difference (διαφορά) between οὐ and μή? (See page 35.) 6. The "former matter" was the going up of Cyrus at the death of his father. 7. It was true that Abrocomas was at the Euphrates at that time, but he fled to the King.

109. Μισθόω, μισθώσω, ἐμίσθωσα, hire.
110. Βιάζω, βιάσω, ἐβίασα, force.
111. Κατα-πετρόω, πετρώσω, ἐπέτρωσα, stone (to death).
112. Γιγνώσκω, γνώσομαι, ἔγνων, ἔγνωκα, ἔγνωσμαι, ἐγνώσθην,
113. Δακρύω, δακρύσω, ἐδάκυσα, weep. [know.
114. Σιωπάω, σιωπήσω, ἐσιώπησα, be silent.
115. Τιμάω, τιμήσω, ἐτίμησα, honor.
116. Καθ-ηδυ-παθέω, παθήσω, ἐπάθησα, spend in luxury.
117. Τιμωρέω, τιμωρήσω, ἐτιμώρησα, avenge; middle, *punish*.
118. Ἀφ-αιρέω, αἱρήσω, εἷλον, ᾕρηκα, ᾕρημαι, ᾑρέθην, deprive of.
119. Πάσχω, πείσομαι, ἔπαθον, πέπονθα, suffer.
120. Χράομαι, χρήσομαι, ἐχρησάμην, κέχρημαι, ἐχρήσθην, use.
121. Ψεύδω, ψεύσω, ἔψευσα, deceive.
122. Οἶδα, εἴσομαι, know.
123. Ἕπομαι, ἕψομαι, ἑσπόμην, follow.
124. Οἴομαι, οἰήσομαι, ᾠήθην, think.
125. Ἀλέξω, ἀλέξομαι, ἠλεξάμην, repel.
126. Ἀκούω, ἀκούσομαι, ἤκουσα, ἀκήκοα, ἠκούσθην, hear.
127. Ἐπ-αινέω, αἰνέσω, ᾔνεσα, praise. [paign.
128. Στρατο-πεδεύομαι, πεδεύσομαι, ἐπεδευσάμην, make a cam-
129. Ἀ-πορέω, πορήσω, ἐπόρησα, perplexed.
130. Λυπέω, λυπήσω, ἐλύπησα, grieve.
131. Θαρρέω, θαρρήσω, ἐθάρρησα, be courageous.
132. Αἰσχύνω, αἰσχυνῶ, ᾔσχυνα, ᾐσχύνθην, shame.
133. Δείδω, δείσομαι, ἔδεισα, δέδοικα (ἤ) δέδια, fear.
134. Καθ-εύδω, εὐδήσω, lie asleep.
135. Χρή, χρήσει, ἔχρησε, it is necessary.

and without· παρ-έλ., ῥῆ. 22· ᾤετο, ῥῆ. 124, παρατατ.·
ἐμβ, ἐν-βαίνω, ῥῆ. 11, μετοχὴ β΄. δο.· φιλο-τ., loving-honor
(τιμάω, τιμήσω, ἐτίμησα, honor)· εἶα (ἐάω, ἐάσω, εἴασα), =
ἐ-έα-ε, παρατατικός, was allowing· Ἀπολ., ῥῆ. 94, παρακεί-
μενος μετὰ τοῦ ἀναδιπ., σελ. 45, have left us, but by (μὰ)
the gods, not I, at least (γε), will pursue them· διώξω
(διώκω, -ώξω, -ωξα, pursue)· ἰ-όντων, ῥῆ. 87, let them go·
εἰδότες (οἶδα, εἴσομαι, know) μετοχὴ τοῦ β.΄ παράκειμ., κλίνεται,
εἰδώς, εἰδυῖα, εἰδός, εἰδότος, εἰδυίας, κτλ., knowing· κακ., σελ.
22, 2, κακός, bad· ἀρετήν (virtus), goodness· ἥδιον, more
pleasantly and cheerfully marched on with him· ἐχαλ.
(χαλεπαίνω, -πανῶ, -πανα, angry)· ἐὰν, unless someone shall
give to them money· ὑπέσ (ὑπίσχομαι, ὑποσχήσομαι, ὑπεσχό-
μην, promise)· οἱ περὶ Μ., those about M., *Menon and his
men·* ἦσθ., ῥῆ. 97· ὄντες, ῥῆ. 5, μετοχὴ τοῦ ἐνεστῶτος, ὤν,
οὖσα, ὄν, ὄντος, οὔσης, κτλ., being· εὐχ., wished him success
(εὐ-τυχέω, εὐ-τυχήσω, ηὐ-τύχησα, succeed).

1. How many days did Cyrus remain at the Psarus
River? 2. Two steep walls reaching down to the sea
were between Cilicia and Syria. 3. A thousand hoplites
were said to be guarding this pass. 4. Abrocomas and
his men left the route open by marching to the great
King at Babylon. 5. Generals and soldiers praise the
good character and magnanimity of Cyrus. 6. I now
praise you, but you shall soon praise me.

Ἀντωνυμίαι.—Pronouns.

Αἱ ἀντωνυμίαι εἶναι δώδεκα εἰδῶν.

α΄. Προσωπική.—Personal, I, thou, etc.

	Ἑνικὸς Ἀριθμός.			Πληθυντικὸς Ἀριθμός.		
	α΄.	β΄.	γ΄.	α΄.	β΄.	γ΄.
Ὀνομ.	ἐγώ	σύ	(—)ὁ δέ, ἡ δέ	ἡμεῖς	ὑμεῖς	(σφεῖς) οἱ δέ, αἱ δέ
Γεν.	ἐμοῦ, μου	σοῦ	(οὗ) αὐτοῦ, τῆς	ἡμῶν	ὑμῶν	(σφῶν) αὐτῶν
Δοτ.	ἐμοί, μοι	σοί	(οἷ) αὐτῷ, τῇ	ἡμῖν	ὑμῖν	(σφίσι) αὐτοῖς, ταῖς
Αἰτ.	ἐμέ, με	σέ	(ἕ) αὐτόν, τήν	ἡμᾶς	ὑμᾶς	(σφᾶς) αὐτούς, τάς

β΄. Κτητική.—Possessive, my, thy, etc.

	α΄.	β΄.	γ΄.
Ἑνικ.	ἐμός, ή, όν	σός, ή, όν	αὐτοῦ, τῆς, τοῦ
Πληθ.	ἡμέτερος, τέρα, τερον	ὑμέτερος, τέρα, τερον	αὐτῶν

Κλίνονται δὲ ὁμαλῶς ὡς ἐπίθετα τριγενῆ καὶ τρικατάληκτα.

γ. Αὐτοπαθής.—Reflexive, of myself, etc.

Γεν.	ἐμαυτοῦ, τῆς	σεαυτοῦ, τῆς	ἑαυτοῦ, τῆς
Δοτ.	ἐμαυτῷ, τῇ	σεαυτῷ, τῇ	ἑαυτῷ, τῇ
Αἰτ.	ἐμαυτόν, τήν	σεαυτόν, τήν	ἑαυτόν, τήν
Γεν.	ἡμῶν αὐτῶν	ὑμῶν αὐτῶν	σφῶν αὐτῶν
Δοτ.	ἡμῖν αὐτοῖς, ταῖς	ὑμῖν αὐτοῖς, ταῖς	σφίσιν αὐτοῖς, ταῖς
Αἰτ.	ἡμᾶς αὐτούς, τάς	ὑμᾶς αὐτούς, τάς	σφᾶς αὐτούς, τάς

δ. Ἀλληλοπαθής.—Reciprocal, each other.

Πληθ.—Γεν., ἀλλήλων· Δοτ., λοις, λαις, λοις· Αἰτ., λους, λας, λα.

ε΄. Ὁριστική.—Definitive, self-same.

αὐτός, ή, ό· οὗ, ἧς, οῦ· ᾧ, ῇ, κτλ.

ϛ΄. Δεικτική.—Demonstrative, this, that.

1. { Ἑνικ. οὗτος, αὕτη, τοῦτο· τούτου, ης, ο, κτλ., this.
{ Πληθ. οὗτοι, αὗται, ταῦτα· τούτων, κτλ., these.

2. { Ἑνικ. ἐκεῖνος, η, ο· ου, ης, ου, κτλ., that.
{ Πληθ. ἐκεῖνοι, αι, α· ων, κτλ., those.

3. { Ἑνικ. ὅδε, ἥδε, τόδε· τοῦδε, τῆσδε, τοῦδε, κτλ., this here.
{ Πληθ. οἵδε, αἵδε, τάδε· τῶνδε, κτλ., these following.

ζ. Ἀναφορική.—Relative, who, which.

Ἑνικ. ὅς, ἥ, ὅ· οὗ, ἧς, οὗ, κτλ. Πληθ. οἵ, αἵ, ἅ· ὧν, κτλ.

η΄. Ἐρωτηματική.—Interrogative, who? what?

Ἑνικ. τίς, τίς, τί· τίνος, τίνος, τίνος· τίνι, κτλ.
Πληθ. τίνες, τίνες, τίνα· τίνων, κτλ.

θ΄ Ἀόριστος.—Indefinite, some, a; so and so.

1. τὶς, τὶ· τινός, τινός, τινός· τινί, κτλ.
2. ὁ, ἡ, τὸ δεῖνα· τοῦ, τῆς δεῖνος, κτλ.

ι΄. Ἀοριστολογική.—Indefinite Relative, whoever.

παράγεται ἐκ ζ΄. καὶ θ΄.· ὅστις, ἥτις, ὅτι, κτλ.

ια΄. Ἐπιμεριστική.—Distributive.

1. ἄλλος, λη, λο· λου, λης, κτλ., another (besides).
2. ἕτερος, ἑρα, ερον· ἑρου, ἑρης, κτλ., another (of two).
3. ἑκάτερος, ἑρα, ερον· ἑρου, ἑρης, κτλ., each (of two).
4. ἕκαστος, τη, το· του, της, κτλ., each (of several).

ιβ΄. Συσχετική.—Correlative.

	Ἐρωτηματική. Interrogative.	Ἀοριστική. Indefinite.	Δεικτική. Demonstrative.	Ἀναφορική. Relative.
Simple	τίς, τί; which? what?	τὶς some	ὅδε, this (here) οὗτος, this, that	ὅς, ὅστις who, which
Comparative	πότερος which of two?	πότερος one of two	ἕτερος, the one or the other of two	ὁπότερος which of two
Quantity or Number	πόσος, how much? many?	ποσό, of some 1 in. or number	(τόσος) so ὅδε τοσόδε mh, τοσοῦτος many	ὅσος, ὁπόσος of which quan., num. (as much, many) as
Quality	ποῖος, of what sort?	ποιός, of some sort	(τοῖος), such ὅδε τοιόσδε τοιοῦτος	οἷος, ὁποῖος of which sort (such) as
Age or Size	πηλίκος how old? how large?	πηλίκος of some age, size	(τηλίκος) τηλικόσδε τηλικοῦτος { so old, large	ἡλίκος, ὁπηλίκος of which age, size, (as old, large) as

Μάθημα Δέκατον Ὄγδοον.

Ἀνάβασις Ι, 5.

Ἐντεῦθεν ἐξελαύνει διὰ τῆς Ἀραβίας, τὸν Εὐφράτην ποταμὸν ἐν δεξιᾷ ἔχων, σταθμοὺς ἐρήμους πέντε, παρασάγγας τριάκοντα καὶ πέντε· ἐν τούτῳ δὲ τῷ τόπῳ ἦν μὲν ἡ γῆ πεδίον ἅπαν ὁμαλὲς ὥσπερ θάλαττα, ἀψινθίου δὲ πλῆρες· εἰ δέ τι καὶ ἄλλο ἐνῆν ὕλης ἢ καλάμου, ἅπαντα ἦσαν εὐώδη ὥσπερ ἀρώματα· δένδρον δ' οὐδὲν ἐνῆν, θηρία δὲ παντοῖα, πλεῖστοι ὄνοι ἄγριοι, πολλοὶ δὲ μεγάλοι στρουθοὶ καὶ ὠτίδες καὶ δορκάδες· ταῦτα δὲ τὰ θηρία οἱ ἱππεῖς ἐνίοτε ἐδίωκον, τὰ δὲ κρέα τῶν ἁλισκομένων ἦν παραπλήσια τοῖς ἐλαφείοις· στρουθὸν δὲ οὐδεὶς ἔλαβεν, τὰς δὲ ὠτίδας ἄν τις ταχὺ ἀνιστῇ, ἔστι (δυνατὸν) λαμβάνειν. Πορευόμενοι δὲ ἀφικνοῦνται ἐπὶ τὸν Μάσκαν ποταμόν, τὸ εὖρος πλέθρου, ὅπου ἦν μεγάλη πόλις· ἐνταῦθα ἔμειναν ἡμέρας τρεῖς καὶ ἐπεσιτίσαντο. Ἐντεῦθεν ἐξελαύνει ἐπὶ Πύλας, ἐν τούτοις δὲ τοῖς σταθμοῖς πολλὰ τῶν ὑποζυγίων ἀπώλετο ὑπὸ λιμοῦ, οὐ γὰρ ἦν χόρτος, τὸ δὲ στράτευμα ὁ σῖτος ἐπέλιπε· ἦν δὲ τούτων τῶν σταθμῶν οὓς πάνυ μακροὺς ἤλαυνεν, ὁπότε βούλοιτο ἢ πρὸς ὕδωρ ἢ πρὸς χιλὸν διατελέσαι· ἐπεὶ δ' ἐδόκουν αὐτῷ σχολαίως ποιεῖν, ὥσπερ ὀργῇ Κῦρος ἐκέλευσε τοὺς περὶ αὐτὸν Πέρσας συν-επι-σπεῦσαι τὰς ἁμάξας· ἔνθα δὴ ἵετο (ἑαυτοὺς) ὥσπερ ἂν δράμοι τις περὶ νίκης, ἔχοντες τούς τε πολυτελεῖς χιτῶνας καὶ τὰς ποικίλας ἀναξυρίδας, ἔνιοι δὲ καὶ στρεπτοὺς περὶ τοῖς τραχήλοις καὶ ψέλια περὶ ταῖς χερσίν· τὸ δὲ σύμπαν δῆλος ἦν Κῦρος σπεύδων πᾶσαν τὴν ὁδόν. Πέραν δὲ τοῦ Εὐφράτου ποταμοῦ ἦν πόλις εὐδαίμων καὶ μεγάλη, ὄνομα δὲ Χαρμάνδη· ἐκ ταύτης οἱ στρατιῶται ἠγόραζον τὰ ἐπιτήδεια, διαβαίνοντες διφθέραις αἷς ἐπίμπλασαν χόρτου κούφου. Ἐνταῦθα δὲ ἀμφιλεξάντων τι τῶν τε Μένωνος στρατιωτῶν καὶ τῶν Κλεάρχου, Κλέαρχος τὸν Μένωνος πληγὰς ἐνέβαλεν· τῇ δὲ αὐτῇ ἡμέρᾳ ἀφιππεύσας ἐπὶ τὴν ἑαυτοῦ σκηνὴν διὰ Μένωνος στρατεύματος, στρατιώτης δὲ ἦσι τῇ ἀξίνῃ, ἄλλος δὲ λίθῳ καὶ ἄλλος, εἶτα πολλοί, κραυγῆς γενομένης· ὁ δὲ καταφεύγει εἰς τὸ ἑαυτοῦ στράτευμα καὶ εὐθὺς παραγγέλλει εἰς τὰ ὅπλα καὶ ἤλαυνεν ἐπὶ τοὺς Μένωνος ὥστε καὶ

ἐκείνους τρέχειν ἐπὶ τὰ ὅπλα· ὁ δὲ Πρόξενος εὐθὺς εἰς τὸ μέσον
ἀμφοτέρων ἄγων ἔθετο τὰ ὅπλα καὶ ἐδεῖτο τοῦ Κλεάρχου μὴ ποιεῖν
ταῦτα· ἐν τούτῳ δὲ ἐπῄει καὶ Κῦρος καὶ ἐπύθετο τὸ πρᾶγμα· λαβὼν
δὲ τὰ παλτὰ εἰς τὰς χεῖρας ἧκεν σὺν τοῖς πιστοῖς ἐλαύνων εἰς τὸ
μέσον καὶ ἔλεξε τάδε· "Κλέαρχε καὶ Πρόξενε καὶ οἱ παρόντες
Ἕλληνες, οὐκ ἴστε ὅ τι ποιεῖτε· εἰ γάρ τινα μάχην ἀλλήλοις συνά-
ψετε, νομίζετε ἐν τῇδε τῇ ἡμέρᾳ ἐμέ τε κατα-κεκόψεσθαι καὶ ὑμᾶς οὐ
πολὺ ἐμοῦ ὕστερον.' Ἀκούσας ταῦτα ὁ Κλέαρχος ἐν ἑαυτῷ ἐγέ-
νετο, καὶ παυσάμενοι ἀμφότεροι κατὰ χώραν ἔθεντο τὰ ὅπλα.

Σχόλιον.

Ἐρήμ., ἐπίθετον τοῦ δευτέρου, desert· ὁμαλής, -ες, ἐπίθετον
τῆς τρίτης (28 γ), smooth, level; in this place the ground
(γῆ) was a plain wholly level like a sea· ἀψινθ., of worm-
wood full· εἰ δέ τι—and if there was anything else in (it)
of shrub or reed, all were fragrant like spices· παντοῖα,
all kinds, the most, wild asses, but many ostriches (μεγ.
στρ.) and bustards (ὠτίς, ἶδος) and gazelles (δορκάς, άδος)·
ἱππ-εύς, horse-man· ἐνί., sometimes· κρέας, (κρέαος) κρέως,
κρέαι· κρέα (car-nal), flesh· τῶν ἁλισκ., of those captured,
μετοχὴ τοῦ ἐνεστῶτος εὑρισκομένη κατὰ τὴν πληθυντικὴν γενικήν·
παραπλ., similar to deer, venison· ἐπι-σίτ., provisioned up·
ἀπ-ώλ. ῥῆ. 103, perished by hunger· χόρτος, grass, fodder·
ἐπ-ε-λ. ῥῆ. 94· ἦν δὲ, and there were (some) of these
stages which very long he marched, when he wished·
δια-τελέω (ἔσω, εσα, thro-to-the-end), reach· σχολ., in a
school manner, leisurely· ὀργῇ, anger· συν-επ, help-hasten-
on· ἵημι (ἥσω, ἧκα, εἷκα, εἷμαι, εἵθην) send· δράμοι, εὐτική τοῦ
β΄ ἀορίστου τοῦ τρέχω (δραμοῦμαι, ἔδραμον, run), as one would
run for victory (in a race)· πολυτ., costly tunics,—flannel
shirts worn next to the skin· ποικ., vari-colored trousers,
and some also chains around their necks and bracelets on
their (hands) wrists· τὸ δὲ σύμπ., and wholly, = ῥηματικὴ
αἰτιατικὴ φράσις· πέραν, across· διφθέρα, ας (δέφω, to tan)
skin· ἐπι-πίμπλημι (πλήσω, ἔπλησα, πέπλεκα, πέπλη(σ)μαι,
ἐπλήθην), fill· χόρτ., grass, light· ἀμφι-λ., dis-puting about

something, γενική ἀπόλυτος· πληγ., blows inflicted· τῇ δὲ
αὐτ., on the *same* day, p. 43, middle· ἀπο-ιππεύω (-εύσω,
-ευσα), ride (on *horse*back)· ἵησι, throws *with* his ax (at
him)· κραυ., a cry being raised· τρέχ., ἀπαρέμφατον συντασ-
σόμενον μετὰ τοῦ ὥστε· ἔθετο, placed, stood under arms and
begged K. not to do this· ἐπῄει (ἔπειμι, 87), came up K.,
too, and learned of the affair (πυνθάνομαι, πεύσομαι, ἐπυθό-
μην, πέπυσμαι, learn by inquiry)· πάλτα, taking his javelins
in his hands he came with his faithful (followers) dashing
in between (them) and said this (which follows)· οὐκ ἴστε
(οἶδα), you don't know what you are doing· συν-άπτω,
con-join· κατακ., I *shall have been* cut down, Fut. Pf. for
emphasis· ἑαυτῷ came to himself, to his senses· κατὰ χωρ.,
put back their arms into (their) place.

1. What verb do we use (μεταχειρίζομαι) in Greek
when the general "marches," and what when his (αὐτοῦ)
troops? 2. Which of the wild animals could the horsemen
catch? 3. The Greeks could get across the Euphrates
River so as to furnish-themselves-with-provisions. 4.
Dry grass is lighter (ἐλαφρός) than water. 5. The Greeks
and Persians wore (φέρω) woolen shirts like ours. 6. The
bad boy throws stones at houses, birds, and people. 7.
We know what we are doing in studying (μελετάω) Greek.

Μάθημα Δέκατον Ἔννατον.

Ἀνάβασις 1, 6, 7.

Ἐντεῦθεν τῶν προϊόντων, ἐφαίνετο ἴχνη ἵππων καὶ ἀνδρῶν οἱ
ἔκαον καὶ χιλὸν καὶ πᾶν ἄλλο χρήσιμον. Ὀρόντας δὲ, Πέρσης ἀνήρ,
Κύρῳ εἶπεν, εἰ αὐτῷ δοίη ἱππέας χιλίους κωλύσειε τοῦ κάειν· ὁ δὲ
Κῦρος ἐκέλευσεν αὐτὸν λαμβάνειν μέρος παρ' ἑκάστου τῶν ἡγεμόνων·
ὁ δ' Ὀρόντας ἔγραψεν ἐπιστολὴν παρὰ βασιλέα ὅτι ἥξοι ἔχων ἱππέας
ὡς ἂν δύνηται πλείστους, ἀλλὰ φράσαι τοῖς ἑαυτοῦ ἱππεῦσιν ὡς
φίλον αὐτὸν ὑποδέχεσθαι, καὶ ἔδωκε ταύτην τὴν ἐπιστολὴν πιστῷ
ἀνδρί, ὡς ᾤετο· ·ὁ δὲ λαβὼν Κύρῳ ἔδωκεν· ἀναγνοὺς δὲ αὐτὴν ὁ

Κῦρος συνέλαβεν Ὀρόνταν καὶ συνεκάλησεν εἰς τὴν ἑαυτοῦ σκηνὴν Πέρσας τοὺς ἀρίστους τῶν περὶ αὐτὸν ἑπτά, καὶ τοὺς τῶν Ἑλλήνων στρατηγοὺς ἐκέλευεν ὁπλίτας ἀγαγεῖν, τούτους δὲ θέσθαι τὰ ὅπλα περὶ τὴν ἑαυτοῦ σκηνήν· Κλέαρχον δὲ καὶ εἴσω παρεκάλεσε ὡς σύμβουλον· οὗτος δ᾽ ἔφη Κῦρον ἄρχειν τοῦ λόγου ὧδε. ''Παρεκάλεσα ὑμᾶς, ἄνδρες φίλοι, ὅπως σὺν ὑμῖν βουλευόμενος ὅτι δίκαιόν ἐστι καὶ πρὸς θεῶν καὶ πρὸς ἀνθρώπων, τοῦτο πράξω περὶ Ὀρόντου τουτουί.'' Μετὰ ταῦτα ἔφη· ''ὦ Ὀρόντα, ἔστιν ὅτι σε ἠδίκησα;'' ἀπεκρίνατο ὅτι οὔ· ἠρώτησεν Κῦρος αὐτόν· ''ὁμολογεῖς οὖν περὶ ἐμὲ ἄδικος γεγενῆσθαι;'' ''ἦ γὰρ ἀνάγκη,'' ἔφη Ὀρόντας, ''καὶ οὐδ᾽ εἰ γενοίμην πιστός, σοί γ᾽ ἄν ποτε ἔτι δόξαιμι.'' Μετὰ ταῦτα κελεύοντος Κύρου ἔλαβον τῆς ζώνης τὸν Ὀρόνταν ἐπὶ θανάτῳ.

Ἐντεῦθεν ἐξελαύνει διὰ τῆς Βαβυλωνίας· ἐν δὲ τῷ τρίτῳ σταθμῷ Κῦρος ποιεῖται ἐξέτασιν τῶν Ἑλλήνων καὶ τῶν βαρβάρων ἐν τῷ πεδίῳ περὶ μέσας νύκτας, ἐδόκει γὰρ εἰς τὴν ἐπιοῦσαν ἕω ἥξειν βασιλέα σὺν τῷ στρατεύματι· Κῦρος δὲ συγκαλέσας τοὺς στρατηγοὺς καὶ λοχαγοὺς τῶν Ἑλλήνων συνεβουλεύετό τε πῶς ἂν τὴν μάχην ποιοῖτο καὶ αὐτὸς παρῄνει θαρρύνων· οἱ δὲ ἀκούσαντες αὐτοί τε ἦσαν πολὺ προθυμότεροι καὶ τοῖς ἄλλοις ἐξήγγελλον· παρεκελεύοντο δὲ αὐτῷ μὴ μάχεσθαι ἀλλ᾽ ὄπισθεν ἑαυτῶν τάττεσθαι. Ἐνταῦθα δὴ ἀριθμὸς τῶν μὲν Ἑλλήνων ἐγένετο ἀσπὶς μυρία καὶ τετρακοσία, πελτασταὶ δὲ δισχίλιοι καὶ πεντακόσιοι, τῶν δὲ μετὰ Κύρου βαρβάρων δέκα μυριάδες καὶ ἅρματα δρεπανηφόρα ἀμφὶ τὰ εἴκοσι. Τῶν δὲ πολεμίων ἐλέγοντο εἶναι ἑκατὸν καὶ εἴκοσι μυριάδες καὶ ἅρματα δρεπανηφόρα διακόσια, καὶ ἑξακισχίλιοι ἱππεῖς. Ἐντεῦθεν δὲ Κῦρος ἐξελαύνει σταθμὸν ἕνα ἔχων καὶ τὸ Ἑλληνικὸν καὶ τὸ βαρβαρικὸν στράτευμα συντεταγμένον, ᾤετο γὰρ ταύτῃ τῇ ἡμέρᾳ μαχεῖσθαι βασιλέα, κατὰ γὰρ μέσον τὸν σταθμὸν τοῦτον ἦν τάφρος βαθεῖα, ἀλλὰ Κῦρός τε καὶ τὸ στράτευμα παρῆλθε καὶ ἐγένετο εἴσω τῆς τάφρου· ἐπεὶ δ᾽ ἐπὶ τῇ τάφρῳ οὐκ ἐκώλυε βασιλεὺς τὸ Κύρου στράτευμα διαβαίνειν, ἔδοξε καὶ Κύρῳ καὶ τοῖς ἄλλοις ἀπεγνωκέναι τοῦ μάχεσθαι· ὥστε τῇ ὑστεραίᾳ Κῦρος ἐπορεύετο ἠμελημένως μᾶλλον.

Σχόλιον.

Τῶν προ-ι-όντων, ῥῆ. 87, γενικὴ ἀπόλυτος, as they are advancing· ἰ-φαίν., ῥῆ. 148, in pass., be shown, *appear·* ἴχνος, ους, τὸ (28 γ), track· ἴκαιον (καίω, καύσω, ἴκαυσα), *cauterize, burn,* grass and every other useful (thing)· δοίη, ῥῆ. 34, = optative (εὐκτικὴ) 2 ao. of a "μι" verb, which mod. Greek has lost, σχηματίζεται δι, δοίην, ης, η, οἷμεν, οἷτε, οἷεν, if he *would give* to him a thousand horsemen he would stop (them) from the burning (κωλύω, ύσω, υσα, hinder), εὐκτικὴ ἀο. ῥήματος εἰς "ω," σχηματίζεται δέ, κωλύσαιμι, (σαις) σειας, (σαι) σειε, σαιμεν, σαιτε, (σαιεν) σειαν· μέρος, ους, *part* from each of the leaders· ἤξοι, ῥῆ. 60, εὐκτικὴ τοῦ μέλλοντος, would come· ὡς——πλείσ., as ever he can (the) most, as many as possible· φράσαι (φράζω, σω, σα, tell), ἀπαρίμφ. τοῦ ἀο.· ὑποδέχ. (ὑπο-δέχομαι, δέξομαι, ἐδεξάμην, δ.δεγμαι, ἰδέχθην), receive under one's protection, ἀπαρίμφ. τοῦ ἀο.· πιστῷ, faithful· ᾤετο, ῥῆ. 124, παρατατικὸς τρίτου ἐνικ. προσώπ.· ἀαγ., ῥῆ. 112 (ἀνα-γιγν., read), μετοχὴ τοῦ β. ἀο. συντασσομένη μετὰ τοῦ Κῦρος· συν-ἐ-λ., arrested· συν-ι-κάλ., called together· ἀρίσ. ὑπερθετικὸς (superlative) τοῦ ἀγαθός· good· θέσθαι, ῥῆ. 29, stand under arms· σύμβον., counselor· ἀρχ., began his speech thus· ὅτι, what is just before both gods and men· τουτου-ί, this-here· ἐστιν, is there anything in which I have wronged you? He answered that (there was) not (οὔ)· ἀπεκρ., ῥῆ. 149, ἀο. τοῦ μέσου· ἠρώτ. ῥῆ. 147, ἀο. τοῦ γ′. ἐνικ. πρόσωπ.· ὁμολ. (ὁμολογέω, ήσω, ησα, acknowledge), you acknowledge then concerning me to have been unjust? Yes, for it is a necessity, said O., and not even if I should become faithful, to you at least should I ever again seem (so)· κελεύ., γεν. ἀπόλυτος· ζώνης, zone, girdle; they took O. by the belt for (as a sign of) death· ῥήματα σημαίνοντα τὸ μέρος ἐξ οὗ κρατοῦμεν (the part taken hold of) συντάσσονται μετ᾽ αἰτιατ. καὶ γεν.· ἐξέτ., examination, *review·* ἐπιοῦ., the coming dawn (ἕως, ἔω, ἄμ, ἕω, east, δευτ. κλίσ. Ἀττικῆς· παρήνει (παρά-αινέω, έσω, εσα), exhorted, encouraging (θαρρύνω, υνῶ, υνα)· πρόθυμος (-ότερος, ότατος), fore-

minded, *zealous*· ἐξ-ήγ. (ἀγγέλλω, ῥῆ. 33), re-port· παρ-ε-
κελ., ex-hort· ὄπισθεν, behind· τάττ. (= τάσσ., ῥῆ. 90)·
ἀσπίς, *shield* (bearers)· δρεπ. scythe-bearing· συν-τεταγ., in
battle array· τάφ. βοθ., ditch deep· ἀπ-ε-γνω-κ., ἀπαρέμφα-
τον τοῦ παρακειμένου τοῦ ἀπο-γιγνώσκω (ῥῆ. 112), renounced the
(idea) of fighting· ἠμελη., ἐπίρρημα, carelessly· μᾶλλον,
ἐπίρρημα τοῦ συγκριτικοῦ βαθμοῦ (in comp. degree) ἐκ τοῦ
μάλα, much, ὑπερθετ., μάλιστα.

1. Orontas plotted against Cyrus and wrote a letter
to the King. 2. This he gave to a soldier who he sup-
posed was faithful to himself. 3. But Cyrus received and
read the letter and arrested Orontas. 4. The trial (ἡ δίκη)
was held in Cyrus' tent and Clearchus was one of the ad-
visers. 5. Cyrus asked Orontas if he had ever been
wronged, and Orontas answered that he must confess he
himself had been the unjust (party). 6. Thereupon at
Cyrus' order Orontas was led off to execution.

Μάθημα Εἰκαστόν.

Ἀνάβασις 1, 8.

Καὶ ἤδη τε ἦν ἀμφὶ ἀγορὰν πλήθουσαν καὶ πλησίον ἦν ὁ σταθ-
μὸς ἔνθα ἔμελλε καταλύειν, ἡνίκα Πατηγύας, ἀνὴρ Πέρσης τῶν ἀμφὶ
Κῦρον πιστῶν, προφαίνεται ἐλαύνων ἀνὰ κράτος ἱδροῦντι τῷ ἵππῳ,
καὶ εὐθὺς πᾶσιν οἷς ἐνετύγχανεν ἐβόα ὅτι βασιλεὺς σὺν στρατεύματι
πολλῷ προσέρχεται ὡς εἰς μάχην παρεσκευασμένος· ἔνθα δὴ πολὺς
τάραχος ἐγένετο, αὐτίκα γὰρ ἐδόκουν οἱ Ἕλληνες καὶ πάντες δὲ ἀτάκ-
τοις ἑαυτοῖς ἐπιπεσεῖσθαι. Κῦρός τε καταπηδήσας ἀπὸ τοῦ ἅρματος
τὸν θώρακα ἐνέδυ καὶ ἀναβὰς ἐπὶ τὸν ἵππον τὰ παλτὰ εἰς τὰς χεῖρας
ἔλαβεν, τοῖς τε ἄλλοις πᾶσι παρήγγελλεν ἐξοπλίζεσθαι καὶ καθίσ-
τασθαι εἰς τὴν ἑαυτοῦ τάξιν ἕκαστον. Ἔνθα δὴ σὺν πολλῇ σπουδῇ
καθίσταντο, Κλέαρχος μὲν τὰ δεξιὰ τοῦ κέρατος ἔχων πρὸς τῷ Εὐ-
φράτῃ ποταμῷ, Πρόξενος δὲ ἐχόμενος, οἱ δ᾽ ἄλλοι μετὰ τοῦτον,
Μένων δὲ καὶ τὸ στράτευμα τὸ εὐώνυμον κέρας ἔσχε τοῦ Ἑλληνικοῦ·
τοῦ δὲ βαρβαρικοῦ ἱππεῖς μὲν Παφλαγόνες εἰς χιλίους παρὰ Κλέαρ-

χον ἔστησαν ἐν τῷ δεξιῷ καὶ τὸ Ἑλληνικὸν πελταστικόν, ἐν δὲ τῷ εὐωνύμῳ Ἀριαῖός τε ὁ Κύρου ὕπαρχος καὶ τὸ ἄλλο βαρβαρικόν· Κῦρος δὲ καὶ οἱ ἱππεῖς ὡπλίσθησαν θώραξι καὶ κράνεσι πάντες πλὴν Κύρου. Καὶ ἤδη τε ἦν μέσον ἡμέρας καὶ οὔπω καταφανεῖς ἦσαν οἱ πολέμιοι, ἡνίκα δὲ δείλη ἐγίγνετο ἐφάνη κονιορτὸς ὥσπερ νεφέλη λευκή, ὕστερον ὥσπερ μελανία τις ἐν τῷ πεδίῳ ἐπὶ πολύ, τάχα δὴ καὶ χαλκός τις ἤστραπτε καὶ αἱ λόγχαι καὶ αἱ τάξεις καταφανεῖς ἐγίγνοντο· καὶ ἦσαν ἱππεῖς καὶ τοξόται, πρὸ δὲ αὐτῶν ἅρματα, τὰ δρεπανηφόρα καλούμενα· πάντες δὲ σιγῇ, ἐν ἴσῳ καὶ βραδέως προσῇσαν, ἀλλ᾽ ἐν τούτῳ τῷ καιρῷ τὸ Ἑλληνικὸν στράτευμα ἔτι ἐν τῷ αὐτῷ τόπῳ μένον συνετάττετο ἐκ τῶν ἔτι προσιόντων. Κῦρος δὲ θορύβου ἤκουσε διὰ τῶν τάξεων ἰόντος, καὶ ἤρετο τίς ὁ θόρυβος εἴη· ὁ δὲ Κλέαρχος εἶπεν ὅτι τὸ σύνθημα παρέρχεται δεύτερον ἤδη, "Ζεὺς Σωτὴρ καὶ Νίκη·" καὶ οὐκέτι τρία ἢ τέτταρα στάδια διεῖχον αἱ φάλαγγες ἀπ᾽ ἀλλήλων ἡνίκα ἐπαιάνιζόν τε οἱ Ἕλληνες καὶ προήρχοντο ἀντίοι ἰέναι τοῖς πολεμίοις, πρὶν δὲ τόξευμα ἐξικνεῖσθαι ἐκκλίνουσιν οἱ βάρβαροι καὶ φεύγουσι. Κῦρος δ᾽ ὁρῶν τοὺς Ἕλληνας νικῶντας τὸ καθ᾽ αὑτούς, ἐπεμελεῖτο ὅ τι ποιήσει βασιλεὺς τότε μέσον ἔχων τοῦ ἑαυτοῦ στρατεύματος, οὗ ὅμως ἐγίνετο ἔξω τοῦ Κύρου εὐωνύμου κέρατος· ἐπεὶ δ᾽ οὐδεὶς αὐτῷ ἐμάχετο, ἐπέκαμπτεν ὡς εἰς κύκλωσιν· ἔνθα δὴ Κῦρος δείσας μὴ ὄπισθεν γενόμενος κατακόψῃ τὸ Ἑλληνικὸν ἐλαύνει ἀντίος, καὶ ἐμβαλὼν σὺν τοῖς ἑξακοσίοις νικᾷ τοὺς πρὸ βασιλέως τεταγμένους καὶ εἰς φυγὴν ἔτρεψε τοὺς ἑξακισχιλίους καὶ ἀποκτεῖναι λέγεται αὐτὸς τῇ ἑαυτοῦ χειρὶ Ἀρταγέρσην τὸν ἄρχοντα αὐτῶν· ὡς δ᾽ ἡ τροπὴ ἐγένετο διασπείρονται καὶ οἱ Κύρου ἑξακόσιοι εἰς τὸ διώκειν ὁρμήσαντες πλὴν πάνυ ὀλίγοι ἀμφ᾽ αὐτὸν κατελείφθησαν, σχεδὸν οἱ ὁμοτράπεζοι καλούμενοι· σὺν τούτοις δὲ ὢν καθορᾷ βασιλέα καὶ τὸ ἀμφ᾽ ἐκεῖνον στῖφος, καὶ εὐθὺς οὐκ ἠνέσχετο, ἀλλ᾽ εἰπών, "Τὸν ἄνδρα ὁρῶ," ἵετο ἐπ᾽ αὐτὸν καὶ παίει κατὰ τὸ στέρνον καὶ τιτρώσκει διὰ τοῦ θώρακος, ὡς φησι Κτησίας ὁ ἰατρὸς καὶ ἰᾶσθαι αὐτὸς τὸ τραῦμά φησι· Κῦρον δὲ παίοντα αὐτὸν ἀκοντίζει τις παλτῷ ὑπὸ τὸν ὀφθαλμὸν βιαίως, καὶ Κῦρος αὐτός τε ἀπέθανεν, καὶ ὀκτὼ οἱ ἄριστοι τῶν περὶ αὐτὸν ἔκειντο ἐπ᾽ αὐτῷ.

Σχόλιον.

'Aγο. πλή., full market (time), *towards noon*· ἐ-μελλε
κατ., was about to, intended to, halt (μέλλω, ήσω, ησα· λύω,
λύσω, ἔλυσα, λέλυκα, λέλυμαι, ἐλύθην, loose)· ἡνίκα, when·
προφαίν., appears· ἀνὰ κρ., up to strength, *at full speed*·
ἰδρ., μετοχὴ τοῦ ῥή. ἰδρόω (ώσω, ωσα), sweat, κλίνεται, ἰδρῶν,
οἶντος, οὖντι, συντάσσεται δὲ μετὰ τοῦ ἵππῳ, with his horse in
a lather· ἐν-ε-τυγ., ῥῆ. 6, happen upon, meet· ἐ-βόα, (βοάω,
ήτω, ησα, shout, bawl), παρατατικός· παρ-ε-σκ., prepared·
τάρ., confusion· ἀ-τάκ., dis-order· ἐπι-π., ῥῆ. 41, fall upon·
κατα-π. (πηδάω, ήσομαι, ησα, leap), leap down, μετοχὴ τοῦ
ἀο.· ἐν-έδυ (δύω, δύσω, ἔδυσα, enter, put on), ἔδυν, ἔδυς, ἔδυ,
put on his cuirass· πάλτα, javelins· ἐξ-οπ. (ὁπλίζω, ίσω,
ισα, arm), each one to arm himself and take position
in his own division· σπουδῇ, with speed· τὰ δεξ., the
right (parts) of the wing· ἐχόμ., having (himself), be-
ing next· εὐ-ών. (well-named, ὄνομα), left· ὑπ-αρ., sub-
ordinate, *lieutenant*· helmets (κράνος, τό)· καταφ., in
sight· δείλη, late· κονι-ορ., dust-arising, *dust cloud*· νεφ.,
cloud· λευ., white· μελ., something black on the plain
afar· τάχα, quickly then also something of brass gleamed
(ἀστράπτω, άψω, αψα)· λογχ., spears· τοξ., bowmen· σιγῇ,
silently in equal (line) and also slowly they advanced
ῥῆ. 87)· τόπῳ, in the same place remaining were forming
from those (troops) yet coming up· θορύ., noise going
through the ranks· συνθ., watchword· Ζεὺς, Zeus Saviour
and Victory· διεῖχ., were apart· ἐ-παι. (παιανίζω, ίσω, ισα,
sing pæan), began their war-song and then advanced to
meet the enemy hand to hand (ἀντίοι)· τοξ. ἐξ., but before
they got within a bow (shot)· ἐκκλ. (κλίνω, κλινῶ, ἔκλινα, in-
cline), give way· τὸ καθ, the (part) opposite them· ἐπ-έ-
καμπ. (κάμπω, κάμψω, ἔκαμψα, bend), began to wheel around
into a circle· δείσας, ῥῆ. 133, μετοχὴ τοῦ ἀο.· ἐμβαλ., charg-
ing in· ἐ-τρεψε, ῥῆ. 98· τροπὴ, flight· διασπείρ. (σπείρω, ερῶ,
ειρα, sow, scatter), were dispersed· κατ-ε-λείφ., ῥῆ. 94, ἀο.
παθητικός· σχεδὸν, nearly his so-called table companions·

καθ-ορᾷ, sees· στῖφος, compact body· ἡνίσχ. (ἀνὰ-ἔχω, up-
hold), restrain himself· στέρνον, chest· τιτρώ. (τι-τρώσκω,
ώσω, ωσα, wound)· ἰατρός, physician· ἰᾶσθαι (ἰάω, ἰάσω, ἰασα,
heal)· τραῦμα, wound· παίοντα (παίω, παίσω, ἔπαισα, strike),
μετοχὴ τοῦ ἐν:στῶτος τῆς ἐνικῆς αἰτιατικῆς συντασσομένη μετὰ τοῦ
Κῦρον· ἀκοντίζα (ἀκοντίζω, ίσω, ισα, spear)· ὀφθαλ., eye·
βιαίως, violently· ἔκειτο (κεῖμαι, κείσομαι, lie), also eight,
the noblest of his circle, lay dead upon him.

1. Thus we have read of the upward march of Cyrus
and his army. 2. We see that if he had restrained him-
self he would have been king of the vast realm of Persia.
3. We wonder if this would have changed history. 4.
Xenophon has given four pages, Chapter IX, to a de-
scription of his character. 5. He says he was, after
Cyrus the Great, at once most kingly and commanding.
6. As a man and as a ruler he was equally kind to friends,
and severe to evildoers and foes. 7. Yet those who be-
came reconciled could rely with full confidence on his
integrity.

<div align="center">ΤΕΛΟΣ.</div>

'Ονόματα.

Πρώτη Κλίσις.

	Θηλυκά.			'Αρσενικά.		Πληθυν.
Ονο.	τιμή	οἰκία	θάλασσᾰ	πολίτης	νεανίας	-αι̮
Γεν.	τιμῆς	οἰκίας	θαλάσσης	πολίτου	νεανίου	-ῶν (άων)
Δοτ.	τιμῇ	οἰκίᾳ	θαλάσσῃ	πολίτῃ	νεανίᾳ	-αῖς
Αἰτ.	τιμήν	οἰκίᾱν	θάλασσᾰν	πολίτην	νεανίᾱν	-ᾱς (ανς)
Κλη.	τιμή	οἰκία	θάλασσᾰ	πολῖτᾰ	νεανία	-αι̮
	honor	house	sea	citizen	youth	

Δυϊκὸς 'Αριθμός = 'Ον., Αἰτ., Κλη., -ᾱ · Γεν., Δοτ., -αῖν

Δευτέρα Κλίσις.

'Αρσ.	Θη.	Οὐδ.	Συνῃρημένον.		'Αττικόν.
ἵππος	ὁδός	δῶρον	νόος, νοῦς		νεώς
ἵππου	ὁδοῦ	δώρου	νόου, νοῦ		νεώ
ἵππῳ	ὁδῷ	δώρῳ	νόῳ, νῷ		νεῴ
ἵππον	ὁδόν	δῶρον	νόον, νοῦν		νεών
ἵππε	ὁδέ	δῶρον	νόε, νοῦ		νεώς
ἵπποι	ὁδοί	δῶρᾰ	νόοι, νοῖ		νεῴ
ἵππων	ὁδῶν	δώρων	νόων, νῶν		νεών
ἵπποις	ὁδοῖς	δώροις	νόοις, νοῖς		νεῴς
ἵππους	ὁδούς	δῶρᾰ	νόους, νοῦς		νεώς
ἵπποι	ὁδοί	δῶρᾰ	νόοι, νοῖ		νεῴ
horse	road	gift	mind		temple

Δυϊκὸς 'Αριθ. = 'Ον., Αἰτ., Κλη., -ω · Γεν., Δοτ., -οιν

Τρίτη Κλίσις.

'Αρσ.	Θηλ.	'Αρσ.	'Αρσ.	'Αρσ.	Θηλ.	Οὐδ.
φύλᾰξ	ἐλπίς	μήν	πατήρ	βασιλεύς	πόλῑς	γένος
φύλακος	ἐλπίδος	μηνός	πατρός	βασιλέως	πόλεως	γένους
φύλακῐ	ἐλπίδῐ	μηνί	πατρί	βασιλεῖ	πόλει	γένει
φύλακᾰ	ἐλπίδᾰ	μῆνᾰ	πατέρᾰ	βασιλέα	πόλῑν	γένος
φύλᾰξ	ἐλπί	μήν	πάτερ	βασιλεῦ	πόλῐ	γένος
φύλακες	ἐλπίδες	μῆνες	πατέρες	βασιλεῖς	πόλεις	γένη
φυλάκων	ἐλπίδων	μηνῶν	πατέρων	βασιλέων	πόλεων	γενῶν
φύλαξῐ	ἐλπίσῐ	μησί	πατράσῐ	βασιλεῦσι	πόλεσι	γένεσι
φύλακᾰς	ἐλπίδᾰς	μῆνᾰς	πατέρᾰς	βασιλέᾱς	πόλεις	γένη
φύλακες	ἐλπίδες	μῆνες	πατέρες	βασιλεῖς	πόλεις	γένη
guard	hope	month	father	king	city	race

Δυϊκὸς 'Αριθ. = 'Ον., Αἰτ., Κλη., -ε · Γεν., Δοτ., -οιν

Ἐπίθετα.

α΄. Πρώτη καὶ Δευτέρα Κλίσις.

Θηλ.	Ἀρσ.	Οὐδ.	Θηλ.	Ἀρσ.	Οὐδ.
ἀγαθή	ἀγαθός	ἀγαθόν	φιλία	φίλιος	φίλιον
ἀγαθῆς		ἀγαθοῦ	φιλίας		φιλίου
	κτλ.			κτλ.	

β΄. Πρώτη καὶ Τρίτη Κλίσις.

γ΄. Τρίτη Κλίσις.

Θηλ.	Ἀρσ.	Οὐδ.	Ἀρσ. καὶ Θηλ.	Οὐδ.	Ἀρσ. καὶ Θηλ.	Οὐδ.
ἡδεῖα	ἡδύς	ἡδύ	ἀληθής	ἀληθές	εὐδαίμων	εὔδαιμον
ἡδείας	ἡδέος		ἀληθοῦς		εὐδαίμονος	
ἡδείᾳ	ἡδεῖ		ἀληθεῖ		εὐδαίμονι	
ἡδεῖαν	ἡδύν	ἡδύ	ἀληθῆ	ἀληθές	εὐδαίμονα	εὔδαιμον
ἡδεῖα		ἡδύ		ἀληθές		εὔδαιμον
ἡδεῖαι	ἡδεῖς	ἡδέα	ἀληθεῖς	ἀληθῆ	εὐδαίμονες	εὐδαίμονα
ἡδειῶν	ἡδέων		ἀληθῶν		εὐδαιμόνων	
ἡδείαις	ἡδέσι		ἀληθέσι		εὐδαίμοσι	
ἡδείας	ἡδεῖς	ἡδέα	ἀληθεῖς	ἀληθῆ	εὐδαίμονες	εὐδαίμονα
ἡδεῖαι	ἡδεῖς	ἡδέα	ἀληθεῖς	ἀληθῆ	εὐδαίμονες	εὐδαίμονα

δ΄. Συνκριτικόν.

ε΄. Συνῃρημένα.

Ἀρσ. καὶ Θηλ.	Οὐδ.	Θηλ.	Ἀρσ.	Οὐδ.
μείζων	μεῖζον	χρυσῆ	χρυσοῦς	χρυσοῦν
-ονος, κτλ.		χρυσῆς		χρυσοῦ
μείζονες (μείζους)	μείζονα (μείζω)	χρυσαῖ	χρυσοῖ	χρυσᾶ
-όνων, κτλ.			χρυσῶν, κτλ.	

στ΄. Μετοχιί καὶ Στελίχη εἰς -ντ.

Θηλ.	Ἀρσ.	Οὐδ.	Θηλ.	Ἀρσ.	Οὐδ.
λύουσα	λύων	λῦον	πᾶσα	πᾶς	πᾶν
λυούσης		λύοντος	πάσης		παντός

ζ΄. Ἀνώμαλα.

Θηλ.	Ἀρσ.	Οὐδ.	Θηλ.	Ἀρσ.	Οὐδ.
μεγάλη	μέγας	μέγα	πολλή	πολύς	πολύ
μεγάλης		μεγάλου	πολλῆς		παλλοῦ
μεγάλῃ		μεγάλῳ	πολλῇ		πολλῷ
μεγάλην	μέγαν	μέγα	πολλήν	πολύν	πολύ
μεγάλη		μέγα	πολλή		πολύ
μεγάλαι	μεγάλοι	μεγάλα	πολλαί	πολλοί	πολλά
μεγάλων, κτλ.		μεγάλων			πολλῶν, κτλ.

Ἀριθμητικά, ὅρα σ. 32.　　　Ἀντωνυμίαι, ὅρα σ. 52–54.

Τύπος τῶν Βαρυτόνων Ῥημάτων.

		Ἐνεστώς		Παρατατικός		Ἀόριστος β		Μέλλων	
		ἐνεργ.	παθητ.	ἐνεργ.	παθητ.	ἐνεργ.	μέσης.	ἐνεργ.	μέσης.
Ὁρισ-τική	1	λύω	λύομαι	ἔλυον	ἐλυόμην	ἔβαλον*	ἐβαλόμην	λύσω	λύσομαι
	2	λύεις	λύει, -ῃ	ἔλυες	ἐλύου	ἔβαλες	ἐβάλου	λύσεις	λύσει, ῃ
	3	λύει	λύεται	ἔλυε	ἐλύετο	ἔβαλε	ἐβάλετο	λύσει	λύσεται
	1	λύομεν	λυόμεθα	ἐλύομεν	ἐλυόμεθα	ἐβάλομεν	ἐβαλόμεθα	λύσομεν	λυσόμεθα
	2	λύετε	λύεσθε	ἐλύετε	ἐλύεσθε	ἐβάλετε	ἐβάλεσθε	λύσετε	λύσεσθε
	3	λύουσι	λύονται	ἔλυον	ἐλύοντο	ἔβαλον	ἐβάλοντο	λύσουσι	λύσονται
Ὑπο-τακ-τική	1	λύω	λύωμαι						
	2	λύῃς	λύῃ						
	3	λύῃ	λύηται	ὡς ἐνεστώς, κτλ.		ὡς ἐνεστώς, κτλ.		λείπεται	
	1	λύωμεν	λυώμεθα						
	2	λύητε	λύησθε						
	3	λύωσι	λύωνται						
Εὐ-κτική	1	λύοιμι	λυοίμην					λύσοιμι	λυσοίμην
	2	λύοις	λύοιο					λύσοις	λύσοιο
	3	λύοι	λύοιτο					λύσοι	λύσοιτο
	1	λύοιμεν	λυοίμεθα					λύσοιμεν	λυσοίμεθα
	2	λύοιτε	λύοισθε					λύσοιτε	λύσοισθε
	3	λύοιεν	λύοιντο					λύσοιεν	λύσοιντο
Προσ-τακ-τική	2	λῦε	λύου						
	3	λυέτω	λυέσθω					λείπεται	
	2	λύετε	λύεσθε						
	3	λυέτωσαν	λυέσθωσαν						

		Ἀόριστος ἐνεργ.	Ἀόριστος μέσ.	Παρακείμενος ἐνεργ.	Παρακείμενος παθητ.	Ὑπερσυντελικός ἐνεργ.	Ὑπερσυντελικός παθητ.	Ἀόριστος παθητ.
Ὁριστική	1	ἔλυσα	ἐλυσάμην	λέλυκα	λέλυμαι	ἐλελύκειν, ἢ ἐλελύκη	ἐλελύμην	ἐλύθην
	2	ἔλυσας	ἐλύσω	λέλυκας	λέλυσαι	ἐλελύκεις, -ης	ἐλέλυσο	ἐλύθης
	3	ἔλυσε	ἐλύσατο	λέλυκε	λέλυται	ἐλελύκει	ἐλέλυτο	ἐλύθη
	1	ἐλύσαμεν	ἐλυσάμεθα	λελύκαμεν	λελύμεθα	ἐλελύκειμεν	ἐλελύμεθα	ἐλύθημεν
	2	ἐλύσατε	ἐλύσασθε	λελύκατε	λέλυσθε	ἐλελύκειτε	ἐλέλυσθε	ἐλύθητε
	3	ἔλυσαν	ἐλύσαντο	λελύκασι	λέλυνται	ἐλελύκεισαν	ἐλέλυντο	ἐλύθησαν
Ὑποτακτική	1	λύσω	λύσωμαι	λελύκω	λελυμένος ὦ			λυθῶ
	2	λύσῃς	λύσῃ	λελύκῃς	" ᾖς			λυθῇς
	3	λύσῃ	λύσηται	λελύκῃ	" ᾖ			λυθῇ
	1	λύσωμεν	λυσώμεθα	λελύκωμεν	λελυμένοι ὦμεν	ὡς παρακείμενος, κτλ.		λυθῶμεν
	2	λύσητε	λύσησθε	λελύκητε	" ἦτε			λυθῆτε
	3	λύσωσι	λύσωνται	λελύκωσι	" ὦσι			λυθῶσι
Εὐκτική	1	λύσαιμι	λυσαίμην	λελύκοιμι	λελυμένος εἴην			λυθείην
	2	λύσαις	λύσαιο	λελύκοις	" εἴης			λυθείης
	3	λύσαι	λύσαιτο	λελύκοι	" εἴη			λυθείη
	1	λύσαιμεν	λυσαίμεθα	λελύκοιμεν	λελυμένοι εἶμεν			λυθεῖμεν
	2	λύσαιτε	λύσαισθε	λελύκοιτε	" εἶτε			λυθεῖτε
	3	λύσαιεν	λύσαιντο	λελύκοιεν	" εἶεν			λυθεῖεν
Προστακτική	2	λῦσον	λῦσαι	λέλυκε	λέλυσο			λύθητι
	3	λυσάτω	λυσάσθω	λελυκέτω	λελύσθω			λυθήτω
	2	λύσατε	λύσασθε	λελύκετε	λέλυσθε			λύθητε
	3	λυσάτωσαν	λυσάσθωσαν	λελυκόντων	λελύσθων			λυθέντων
				λελυκέτωσαν	λελύσθωσαν			λυθήτωσαν
Ἀπαρ.		λῦσαι	λύσασθαι	λελυκέναι	λελύσθαι			λυθῆναι
Μετοχή		λύσας	λυσάμενος	λελυκώς	λελυμένος			λυθείς

Τύπος τῶν εἰς μι Ῥημάτων. Ἀόριστος β΄.

	Ἐνεστώς ἐνεργ.	Ἐνεστώς παθητ.	Ἀόρ. β΄ ἐνεργ.	Ἀόρ. β΄ μέση	Ἐνεστώς ἐνεργ.	Ἐνεστώς παθητ.
Ὁρισ- 1	ἵστημι	ἵσταμαι	ἔστην	ἐπριάμην	τίθημι	τίθεμαι
τική 2	ἵστης	ἵστασαι	ἔστης	ἐπρίω	τίθης	τίθεσαι
3	ἵστησι	ἵσταται	ἔστη	ἐπρίατο	τίθησι	τίθεται
1	ἵσταμεν	ἱστάμεθα	ἔστημεν	ἐπριάμεθα	τίθεμεν	τιθέμεθα
2	ἵστατε	ἵστασθε	ἔστητε	ἐπρίασθε	τίθετε	τίθεσθε
3	ἱστᾶσι	ἵστανται	ἔστησαν	ἐπρίαντο	τιθέασι	τίθενται
Ὑπο- 1	ἱστῶ	ἱστῶμαι	στῶ	πρίωμαι	τιθῶ	τιθῶμαι
τακ- 2	ἱστῇς	ἱστῇ	στῇς	πρίῃ	τιθῇς	τιθῇ
τική 3	ἱστῇ	ἱστῆται	στῇ	πρίηται	τιθῇ	τιθῆται
1	ἱστῶμεν	ἱστώμεθα	στῶμεν	πριώμεθα	τιθῶμεν	τιθώμεθα
2	ἱστῆτε	ἱστᾶσθε	στῆτε	πρίησθε	τιθῆτε	τιθῆσθε
3	ἱστῶσι	ἱστῶνται	στῶσι	πρίωνται	τιθῶσι	τιθῶνται
Εὐκ- 1	ἱσταίην	ἱσταίμην	σταίην	πριαίμην	τιθείην	τιθείμην
τική 2	ἱσταίης	ἱσταῖο	σταίης	πρίαιο	τιθείης	τιθεῖο
3	ἱσταίη	ἱσταῖτο	σταίη	πρίαιτο	τιθείη	τιθεῖτο
1	ἱσταῖμεν	ἱσταίμεθα	σταῖμεν	πριαίμεθα	τιθεῖμεν	τιθείμεθα
2	ἱσταῖτε	ἱσταῖσθε	σταῖτε	πρίαισθε	τιθεῖτε	τιθεῖσθε
3	ἱσταῖεν	ἱσταῖντο	σταῖεν	πρίαιντο	τιθεῖεν	τιθεῖντο
Προσ- 2	ἵστη	ἵστασο	στῆθι	πρίω	τίθει	τίθεσο
τακ- 2	ἵστατε	ἵστασθε	στῆτε	πρίασθε	τίθετε	τίθεσθε
τική 3	ἱστάτω	ἱστάσθω	στήτω	πριάσθω	τιθέτω	τιθέσθω
3	ἱστάτων	ἱστάσθων	στάντων	πριάσθων	τιθέτων	τιθέσθων
3	ἱστάτωσαν	ἱστάσθωσαν	στήτωσαν	πριάσθωσαν	τιθέτωσαν	τιθέσθωσαν
Ἀπαρέ.	ἱστάναι	ἵστασθαι	στῆναι	πρίασθαι	τιθέναι	τίθεσθαι
Μετοχή	ἱστάς	ἱστάμενος	στάς	πριάμενος	τιθείς	τιθέμενος

	Ἀόριστος β΄ ἐνεργ.	Ἀόριστος β΄ μέσ.	Ἐνεστώς ἐνεργ.	Ἐνεστώς παθητ.	Ἀόριστος β΄ ἐνεργ.	Ἀόριστος β΄ μέσ.	Παρατατικός ἐνεργ.	Παρατατικός παθητ.
Ὁριστική 1	(ἔθην)	ἐθέμην	δίδωμι	δίδομαι	(ἔδων)	ἐδόμην	ἵστην	ἱστάμην
2	(ἔθης)	ἔθου	δίδως	δίδοσαι	(ἔδως)	ἔδου	ἵστης	ἵστασο
3	(ἔθη)	ἔθετο	δίδωσι	δίδοται	(ἔδω)	ἔδοτο	ἵστη	ἵστατο
1	ἔθεμεν	ἐθέμεθα	δίδομεν	διδόμεθα	ἔδομεν	ἐδόμεθα	ἵσταμεν	ἱστάμεθα
2	ἔθετε	ἔθεσθε	δίδοτε	δίδοσθε	ἔδοτε	ἔδοσθε	ἵστατε	ἵστασθε
3	ἔθεσαν	ἔθεντο	διδόασι	δίδονται	ἔδοσαν	ἔδοντο	ἵστασαν	ἵσταντο
Ὑποτακτική 1	θῶ	θῶμαι	διδῶ	διδῶμαι	δῶ	δῶμαι	ἐτίθην	ἐτιθέμην
2	θῇς	θῇ	διδῷς	διδῷ	δῷς	δῷ	ἐτίθεις	ἐτίθεσο
3	θῇ	θῆται	διδῷ	διδῶται	δῷ	δῶται	ἐτίθει	ἐτίθετο
1	θῶμεν	θώμεθα	διδῶμεν	διδώμεθα	δῶμεν	δώμεθα	ἐτίθεμεν	ἐτιθέμεθα
2	θῆτε	θῆσθε	διδῶτε	διδῶσθε	δῶτε	δῶσθε	ἐτίθετε	ἐτίθεσθε
3	θῶσι	θῶνται	διδῶσι	διδῶνται	δῶσι	δῶνται	ἐτίθεσαν	ἐτίθεντο
Εὐκτική 1	θείην	θείμην	διδοίην	διδοίμην	δοίην	δοίμην	ἐδίδων	ἐδιδόμην
2	θείης	θεῖο	διδοίης	διδοῖο	δοίης	δοῖο	ἐδίδους	ἐδίδοσο
3	θείη	θεῖτο	διδοίη	διδοῖτο	δοίη	δοῖτο	ἐδίδου	ἐδίδοτο
1	θεῖμεν	θείμεθα	διδοῖμεν	διδοίμεθα	δοῖμεν	δοίμεθα	ἐδίδομεν	ἐδιδόμεθα
2	θεῖτε	θεῖσθε	διδοῖτε	διδοῖσθε	δοῖτε	δοῖσθε	ἐδίδοτε	ἐδίδοσθε
3	θεῖεν	θεῖντο	διδοῖεν	διδοῖντο	δοῖεν	δοῖντο	ἐδίδοσαν	ἐδίδοντο
Προστακτική 2	θές	θοῦ	δίδου	δίδοσο	δός	δοῦ		
3	θέτω	θέσθω	διδότω	διδόσθω	δότω	δόσθω		
2	θέτων	θέσθων	διδόντων	διδόσθων	δόντων	δόσθων		
3	θέτωσαν	θέσθωσαν	διδότωσαν	διδόσθωσαν	δότωσαν	δόσθωσαν		
Ἀπαρέμ.	θεῖναι	θέσθαι	διδόναι	δίδοσθαι	δοῦναι	δόσθαι		
Μετοχή	θείς	θέμενος	διδούς	διδόμενος	δούς	δόμενος		

Ὁ Δυϊκὸς καταλήγει, Ἐνεργητική, 2 τον, 3 τον· 2 τον, 3 την· Παθητική, 2 σθον, 3 σθον· 2 σθον, 3 σθην.

Τύπος τῶν Περισπωμένων Ῥημάτων.

Ἐνεστώς

	ἐνεργ.	παθητ.	ἐνεργ.	παθητ.	ἐνεργ.	παθητ.
Ὁριστική 1	τιμῶ	τιμῶμαι	φιλῶ	φιλοῦμαι	δηλῶ	δηλοῦμαι
2	τιμᾷς	τιμᾷ	φιλεῖς	φιλεῖ	δηλοῖς	δηλοῖ
3	τιμᾷ	τιμᾶται	φιλεῖ	φιλεῖται	δηλοῖ	δηλοῦται
1	τιμῶμεν	τιμώμεθα	φιλοῦμεν	φιλούμεθα	δηλοῦμεν	δηλούμεθα
2	τιμᾶτε	τιμᾶσθε	φιλεῖτε	φιλεῖσθε	δηλοῦτε	δηλοῦσθε
3	τιμῶσι	τιμῶνται	φιλοῦσι	φιλοῦνται	δηλοῦσι	δηλοῦνται
Ὑποτακτική 1	τιμῶ	τιμῶμαι	φιλῶ	φιλῶμαι	δηλῶ	δηλῶμαι
2	τιμᾷς	τιμᾷ	φιλῇς	φιλῇ	δηλοῖς	δηλοῖ
3	τιμᾷ	τιμᾶται	φιλῇ	φιλῆται	δηλοῖ	δηλῶται
1	τιμῶμεν	τιμώμεθα	φιλῶμεν	φιλώμεθα	δηλῶμεν	δηλώμεθα
2	τιμᾶτε	τιμᾶσθε	φιλῆτε	φιλῆσθε	δηλῶτε	δηλῶσθε
3	τιμῶσι	τιμῶνται	φιλῶσι	φιλῶνται	δηλῶσι	δηλῶνται
Εὐκτική 1	τιμῴην	τιμῴμην	φιλοίην	φιλοίμην	δηλοίην,	δηλοίμην,
2	τιμῴης	τιμῷο	φιλοίης	φιλοῖο	κτλ.	κτλ.
3	τιμῴη	τιμῷτο	φιλοίη	φιλοῖτο		
1	τιμῷμεν	τιμῴμεθα	φιλοῖμεν	φιλούμεθα		
2	τιμῷτε	τιμῷσθε	φιλοῖτε	φιλοῖσθε		
3	τιμῷεν	τιμῷντο	φιλοῖεν	φιλοῖντο		
Προστακτική 2	τίμα	τιμῶ	φίλει	φιλοῦ	δήλου	δηλοῦ
3	τιμάτω	τιμάσθω	φιλείτω	φιλείσθω	δηλούτω	δηλούσθω
2	τιμᾶτε	τιμᾶσθε	φιλεῖτε	φιλεῖσθε	δηλοῦτε	δηλοῦσθε
3	τιμώντων	τιμάσθων	φιλούντων	φιλείσθων	δηλούντων	δηλούσθων
Ἀπαρέ.	τιμᾶν	τιμᾶσθαι	φιλεῖν	φιλεῖσθαι	δηλοῦν	δηλοῦσθαι
Μετοχή	τιμῶν	τιμώμενος	φιλῶν	φιλούμενος	δηλῶν	δηλούμενος

Παρατατικός

	ἐνεργ.	παθητ.
1	ἐτίμων	ἐτιμώμην
2	ἐτίμας	ἐτιμῶ
3	ἐτίμα	ἐτιμᾶτο
1	ἐτιμῶμεν	ἐτιμώμεθα
2	ἐτιμᾶτε	ἐτιμᾶσθε
3	ἐτίμων	ἐτιμῶντο
1	ἐφίλουν	ἐφιλούμην
2	ἐφίλεις	ἐφιλοῦ
3	ἐφίλει	ἐφιλεῖτο
1	ἐφιλοῦμεν	ἐφιλούμεθα
2	ἐφιλεῖτε	ἐφιλεῖσθε
3	ἐφίλουν	ἐφιλοῦντο
1	ἐδήλουν	ἐδηλούμην
2	ἐδήλους	ἐδηλοῖο
3	ἐδήλου	ἐδηλοῖτο
1	ἐδηλοῦμεν	ἐδηλούμεθα
2	ἐδηλοῦτε	ἐδηλοῦσθε
3	ἐδήλουν	ἐδηλοῦντο

Κανόνες τῆς Συναιρέσεως.

Τὰ συνηρημένα ῥήματα ἔχουσι χαρακτῆρα α, ε, ο, συναιροῦνται δὲ ἐν τῷ Ἐνεστῶτι καὶ Παρατατικῷ ὡς ἑξῆς· ἡ ο-φωνὴ ὅπου εὑρίσκεται γίνεται ω· τῶν δὲ α- καὶ ε-φωνῶν γίνεται ἡ πρώτη μακρά· ἀλλά, τὸ ο μετὰ τοῦ ο καὶ ε γίνεται ου, καὶ τὸ ε μετὰ τοῦ ε, ει, πλὴν πρὸ τῶν μικρῶν φωνηέντων καὶ διφθόγγων ἀποβάλλεται.

'Ανώμαλα Εἰς μι 'Ρήματα.

		εἰμί (ἐσ), be			εἶμι (ἰ), go		ἵημι (ἑ), send			φημί (φα), say		οἶδα (ϝιδ), know
		ἐνεστ.	παρατ.	μέλλων	ἐνεστὼς	παρατ.	ἐνεστὼς	παρατ.	ἀορίστος β'.	ἐνεστ.	παρατ.	ἐνεστ. παρατ.
Ὁριστ-	1	εἰμί	ἦ, ἦν	ἔσομαι	εἶμι	ᾔειν·ᾖα·ᾔα	ἵημι	ἵην	ἧκα	φημί	ἔφην	οἶδα ᾔδην
ική	2	εἶ	ἦσθα	ἔσῃ, ἔσει	εἶ	ᾔεις	ἵης	ἵεις	ἧκας	φῂς	ἔφησθα	οἶσθα ᾔδησθα
	3	ἐστί	ἦν	ἔσται	εἶσι	ᾔει	ἵησι	ἵει	ἧκε	φησί	ἔφη	οἶδε ᾔδει(ν)
	1	ἐσμέν	ἦμεν	ἐσόμεθα	ἴμεν	ᾖμεν	ἵεμεν	ἵεμεν	εἷμεν	φαμέν	ἔφαμεν	ἴσμεν ᾖσμεν
	2	ἐστέ	ἦτε	ἔσεσθε	ἴτε	ᾖτε	ἵετε	ἵετε	εἷτε	φατέ	ἔφατε	ἴστε ᾖστε
	3	εἰσί	ἦσαν	ἔσονται	ἴασι	ᾖσαν	ἱᾶσι	ἵεσαν	εἷσαν	φασί	ἔφασαν	ἴσασι ᾖσαν
Ὑπο- τακ- τική	1	ὦ			ἰῶ		ἰῶ		ὦ	φῶ		εἰδῶ
	2	ᾖς			ἰῇς		ἰῇς		ᾖς	φῇς		εἰδῇς
	3	ᾖ			ἰῇ		ἰῇ		ᾖ	φῇ		εἰδῇ
		κτλ.			κτλ.		κτλ.		κτλ.	κτλ.		κτλ.
Εὐκ- τική	1	εἴην		ἐσοίμην	ἰοίην		ἰείην		εἵην	φαίην		εἰδείην
	2	εἴης		ἔσοιο	ἰοίης		ἰείης		εἵης	φαίης		εἰδείης
	3	εἴη		ἔσοιτο	ἰοίη		ἰείη		εἵη	φαίη		εἰδείη
		κτλ.			κτλ.		κτλ.		κτλ.	κτλ.		κτλ.
Προσ- τακ- τική	2	ἴσθι			ἴθι		ἵει		ἕς	φαθί		ἴσθι
	3	ἔστω			ἴτω		ἱέτω		ἕτω	φάτω		ἴστω
	3	ὄντων			ἰόντων		ἱέντων		ἕντων	φάντων		ἴστων
Ἀπαρέ- μφατον		εἶναι		ἔσεσθαι	ἰέναι		ἱέναι		εἷναι	φάναι		εἰδέναι
Μετοχή		ὤν		ἐσόμενος	ἰών		ἱείς		εἵς	φάς		εἰδώς

(εἰμί (ἐσ) ... ὡς Λείπεται ἐνεστ. κτλ.)

Προθέσεις.—Prepositions.*

English (Latin) equivalent.	Genitive, *whence* case; source, agency.	Dative, *where* case; nearness, likeness, means, accom'mnt.	Accusative, *whither* case; motion, extent.	Summary.
1 ἀντί instead	*in place of.*			4 w. Genitive, ἀντί, ἀπό, ἐξ, πρό.
2 ἀπό (ab) off	*away from;* place, time, source.			2 w. Dative, ἐν, σύν.
3 ἐξ (ex) out	*out of;* place.		[from]	2 w. Accusative, ἀνά, εἰς [ἀπό, μέ].
4 πρό (pro) (be)fore	*before;* place, time.			5 w. Gen. and Ac., ἀμφί, διά, κατά, μετά, ὑπέρ.
1 ἐν (in) in		*in;* place, time, fig'tive		5 w. Gen., Dat. and Ac., ἐπί, παρά, περί, πρός, ὑπό.
2 σύν (cum) with		*with, w. aid of.*		20 Adverbs w. Gen., as in list.
1 ἀνά (up)on			*up along;* place, time, distrib.	1 w. Ac., ὡς.
2 εἰς (in) int(o)			*into;* place, number.	

Preposition	with Genitive	with Dative	with Accusative
1 ἀμφί (ambo) about?	concerning; (mostly poetic.)		about; place, time, number.
2 διά (dia) thro	through; place, time, means.		on account of; place, time, agency [ing to.
3 κατά down	down, upon, under; place.		down along, accord-place, time, distrib.
4 μετά [-] (a)mid	with; company, union.		after, into midst of, over, beyond [with]. place, time.
5 ὑπέρ (super) over	over, in behalf of; place, person.		over, against, be-[yond; place, number.
1 ἐπί up(on)	upon; place, time, reference.	at, by, upon: [pose. place, cause, pur-[beside, at;	towards, upon; place, time, object.
2 παρά by	from (beside); person or thing.	beside, at; person or thing.	(beside).[parison place, cause, com-[around;
3 περί about	concerning; person or thing.	about; place, cause.	person or thing.
4 πρός for(ward)s	from, by, before, twrds; person or place.	at, besides; person, place.	twrds, according to; person, place.
5 ὑπό (sub) under	by, under; agent, cause, place.	under; (poetic.)	under; place, time, con-dition.

Ἐπιρρηματικαὶ Προθέσεις. Adverbial Prepositions.

- ἄνευ, without.
- ἄνω, above.
- ἀντιπέρας, } opposite.
- ἀπέναντι, }
- ἄτερ, without.
- ἄχρι, }
- μέχρι, } until.
- ἕως, }
- εἴσω, within.
- ἔμπροσθεν, before.
- ἐναντίον, facing.
- ἕνεκα, on account of.
- ἐντός, within.
- ἐνώπιον, in presence of.
- ἔξω, without.
- κάτω, adown.
- μεταξύ, between.
- ὀπίσω, behind.
- πέραν, across.
- πλήν, except.
- πλησίον, near.
- ὡς, to (persons). w. Ac.

* Best prose usage; brackets Modern Greek only. ¹ Both sides. ² All sides.

Ἐπιρρήματα.

1. Χρονικόν (temporal), νῦν, now.
2. Τοπικόν (local), ἄνω, up.
3. Τροπικόν (descriptive), εὖ, κακῶς, well, ill.
4. Ποσότητος (definitive), ἅπαξ, δίς, once, twice.
5. Ἐπιτατικόν (intensive), λίαν, ἄγυιν, exceedingly.
6. Παραθετικόν (comparative), μᾶλλον, more than.
7. Ἀθροιστικόν (collective), ἅμα, together with.
8. Ἀρνητικόν (negative), οὐ, μή, no.
9. Ὁμοτικόν (adjurative), νή, μά, by.
10. Βεβαιωτικόν (emphatic), ναί, πάντως, yea, wholly.
11. Ἐπεξηγηματικόν (explanatory), ἤτοι, οἷον, that is.
12. Εἰκαστικόν (conjectural), ἴσως, τάχα, possibly.
13. Δυσκολίας (dubitive), μόλις, scarcely.
14. Ἐξαιρετικόν (exceptive), πλήν, except.
15. Δυνητικόν (potential), ἄν, if, possibly.
16. Ἐρωτηματικόν (interrogative), ἆρα, μῶν, is it? eh?
17. Εὐτικόν (optative), εἴθα, would that!
18. Παρακελευσματικόν (hortative), ἄγε, come!
19. Δεικτικόν (indicative), ἰδού, see!
20. Συγκαταθετικόν (confirmative), εἶεν, so be it.

———

Σύνδεσμοι.

1. Συμπλεκτικός (copulative), καί, τέ, and.
2. Ἀντιθετικός (contrasting), μέν, δέ, now, but.
3. Ἐναντιωματικός (adversative), δέ, ἀλλά, but.
4. Διαζευτικός (disjunctive), ἤ, εἴτε, either, or.
5. Ὑποθετικός (conditional), εἰ, if.
6. Αἰτιολογικός (causal), γάρ, ὅτι, ἐπεί, for.
7. Τελικός (final), ἵνα, ὡς, ὅπως, μή, in order that.
8. Συλλογιστικός (illative), οὖν, ἄρα, therefore.
9. Ἀπορηματικός (interrogative), ἤ, ἆρα, really? eh?
10. Χρονικός (temporal), ὅτε, πρίν, when, before.
11. Εἰδικός (demonstrative), ὅτι, ὡς, that.
12. Ὁμοιωματικός (comparative), ὡς, as.
13. Ἐλαττωτικός (concessive), γέ, γοῦν, at least.
14. Βεβαιωτικός (emphatic), δή, πέρ, indeed.

Ἐπιφωνήματα.

α΄. Τὸ κλητικόν, address or hailing, ὦ, O! ho there!

β΄. Τὸ θαυμαστικόν, surprise, ὤ, O! oh!

γ΄. Τὸ ἐκπληκτικόν, amazement, ἆ, what!

δ΄. Τὰ σημαίνοντα λύπην, πόνον, ἀγανάκτησιν, indicating grief, pain, anger, ἰού, οὐαί, οἰμοί, παπαῖ, βαβαί, φεῦ, oh! alas! be gone!

ε΄. Τὰ ἐνθουσιαστικά, enthusiasm, εὐοῖ, εὖγε, all hail! bravo!

στ΄. Τὰ γελαστικά, laughter or ridicule, ἅ, ἅ, χὰ χά, ha ha!

SPECIMENS OF PROSE.

There is a general impression in England, that the people of the United States are inimical to the parent country. It is one of the errors which have been diligently propagated by designing writers. There is, doubtless, considerable political hostility, and a general soreness at the illiberality of the English press; but, generally speaking, the prepossessions of the people are strongly in favor of England. Indeed, at one time, they amounted, in many parts of the Union, to an absurd degree of bigotry. The bare name of Englishman was a passport to the confidence and hospitality of every family, and too often gave a transient currency to the worthless and the ungrateful. Throughout the country there was something of enthusiasm connected with the idea of England. We looked to it with a hallowed feeling of tenderness and veneration, as the land of our forefathers— the august repository of the monuments and antiquities of our race—the birthplace and mausoleum of the sages and heroes of our paternal history. After our own country, there was none in whose glory we more delighted—none whose good opinion we were more anxious to possess—none towards which our hearts yearned with such throbbings of warm consanguinity. Even during the late war, whenever there was the least opportunity for kind feelings to spring forth, it was the delight of the generous spirits of our country to show that, in the midst of hostilities, they still kept alive the sparks of future friendship.—IRVING: *Sketch-Book*.

The Puritans espoused the cause of civil liberty mainly because it was the cause of religion. There was another party, by no means numerous, but distinguished by learning and ability, which cooperated with them on every different principles. We speak of those whom Cromwell was accustomed to call the Heathens; men who were, in the phraseology of that time, doubting Thomases or careless Gallios with regard to religious subjects, but passionate worshippers of freedom. Heated by the study of ancient literature, they set up their country as their idol, and proposed to themselves the heroes of Plutarch as their examples. They seem to have borne some resemblance to the Brissotines of the

French Revolution. But it is not very easy to draw the line of distinction between them and their devout associates, whose tone and manner they sometimes found it convenient to affect, and sometimes, it is probable, imperceptibly adopted.—MACAULAY: *Essay on Milton.*

To the student of political history, and to the English student above all others, the conversion of the Roman Republic into a military empire commands a peculiar interest. Notwithstanding many differences, the English and the Romans essentially resemble one another. The early Romans possessed the faculty of self-government beyond any people of whom we have historical knowledge, with the one exception of ourselves. In virtue of their temporal freedom, they became the most powerful nation in the known world; and their liberties perished only when Rome became the mistress of the conquered races to whom she was unable or unwilling to extend her privileges. If England was similarly supreme, if all rival powers were eclipsed by her or laid under her feet, the Imperial tendencies, which are as strongly marked in us as our love of liberty, might lead us over the same course to the same end.

FROUDE: *Cæsar; A Sketch.*

You would think it strange if I called Burns the most gifted British soul we had in all that century of his: and yet I believe the day is coming when there will be little danger in saying so. His writings, all that he *did* under such obstructions, are only a poor fragment of him. Professor Stewart remarked very justly, what, indeed, is true of all Poets good for much, that his poetry was not any particular faculty, but the general result of a naturally vigorous original mind expressing itself in that way. Burns's gifts, expressed in conversation, are the theme of all that ever heard him. All kinds of gifts: from the gracefulest utterances of courtesy, to the highest fire of passionate speech; loud floods of mirth, soft wailings of affection, laconic emphasis, clear, piercing insight; all was in him. Witty duchesses celebrated him as a man whose speech "led them off their feet." This is beautiful; but still more beautiful that which Mr. Lockhart has recorded, which I have more than once alluded to. How the waiters and ostlers at inns would get out of bed, and come crowding to hear this man speak! Waiters and ostlers:—they too were men, and here was a man! I have heard much about his speech; but one of the best things I ever heard of it was, last year, from a venerable

gentleman long familiar with him. That it was speech distinguished by always *having something in it.* "He spoke rather little than much," this old man told me; "sat rather silent in those early days, as in the company of persons above him; and always when he did speak, it was to throw new light on the matter." I know not why any one should ever speak otherwise!—But if we look at his general force of soul, his healthy *robustness* every way, the rugged downrightness, penetration, generous valor and manfulness that was in him,—when shall we readily find a better-gifted man?

—CARLYLE: *Heroes and HeroWor-ship.*

It was after the Revolution. Manufacturers, trade, all business was flat on its back. A silver dollar was worth seventy-five; corn was seventy-five dollars a bushel, board five hundred dollars a week. Landed property was worthless, and the taxes were something awful. So the general dissatisfaction turned on the courts and was going to prevent collections. Grandfather Cobb was a judge of the probate court; and when he heard that a mob was howling in front of the court-house, he put on his old Continental regimentals, the old buff and blue, and marched out alone. "Away with your whining!" says he. "If I can't hold this court in peace, I will hold it in blood; if I can't sit as a judge, I will die as a general!" Though he was one man to hundreds, he drew a line in the green, and told the mob that he would shoot with his own hand the first man that crossed. He was too many for the crowd, standing there in his old uniform in which they knew he had fought for them; and they only muttered, and after a while dispersed. They came again the next term of court; but he had his militia and his cannon all ready for them, then; and this time when they got their answer they took it, went off, and never came back.

—OCTAVE THANET: *A Son of the Revolution.*

Is there a penny-post, do you think, in the world to come? Do people there write for autographs to those who have gained a little notoriety? Do women there send letters asking for money? Do boys persecute literary men with requests for a course of reading? Are there offices in that sphere which are coveted, and to obtain which men are pestered to write letters of recommendation?

—*Letter of William Cullen Bryant.*

Do you remember the brown suit which you made to hang upon you, till all your friends cried shame upon you,

it grew so threadbare, and all because of that folio Beaumont and Fletcher, which you dragged home late at night from Barker's in Covent Garden? Do you remember how we eyed it for weeks before we could make up our minds to the purchase, and had not come to a determination till it was near ten o'clock of the Saturday night, when you set off from Islington fearing you should be too late—and when the old bookseller, with some grumbling. opened his shop, and by the twinkling taper (for he was setting bedwards), lighted out the relic from his dusty treasures, and when you lugged it home, wishing it were twice as cumbersome, and when you presented it to me, and when we were exploring the perfectness of it (*collating*, you called it), and while I was repairing some of the loose leaves with paste, which your impatience would not suffer to be left till daybreak—was there no pleasure in being a poor man? or can those neat black clothes which you wear now, and are so careful to keep brushed, since we have become rich and financial, give you half the honest vanity with which you flaunted it about in that overworn suit—your old corbeau—for four or five weeks longer than you should have done, to pascify your conscience for the mighty sum of fifteen or sixteen shillings, was it?—a great affair you thought it then—which you had lavished on the old folio? Now you can afford to buy any book that pleases you, but I do not see that you ever bring me home any nice old purchases now.

—LAMB: *Essy on Old China.*

Nothing strikes one more, in the race of life, than to see how many give out in the first half of the course. "Commencement day" always reminds me of the the start for the "Derby," when the beautiful high-bred three-year-olds of the season are brought up for trial. That day is the start, and life is the race . . . This is the start, and here they are, —coats bright as silk, and manes as smooth as *eau lustrale* can make them. Some of the best of colts are pranced round, a few minutes each, to show their paces. What is that old gentlemen crying about? and the old lady by him, and the three girls, what are they all covering their eyes for? Oh, that is *their* colt which has just been trotted up the stage. Do they really think those little thin legs can do anything in such a slashing sweepstakes as is coming off in these next forty years? . . .

Fifty years. Race over. All that are on the course are coming in at a walk; no more running. Who is ahead?

Ahead? What! and the winning post a slab of white or gray stone standing out from that turf where there is no more jockeying or straining for victory! Well, the world marks their places in its betting-book; but be sure that these matter very little, if they have run as well as they know how!

—HOLMES: *Autocrat.*

In my poor mind it is most sweet to muse
Upon the days gone by; to act in thought
Past seasons o'er, and be again a child;
To sit in fancy on the turf-clad slope,
Down which the child would roll; to pluck gay flowers,
Make posies in the sun, which the child's hand
(Childhood offended soon, soon reconciled),
Would throw away, and strait take up again,
Then fling them to the winds, and o'er the lawn
Bound with so playful and so light a foot,
That the pressed daisy scarce declined her head.

—CHARLES LAMB.

The young prince Hamlet was not happy at Elsinore. It was not because he missed the gay student-life of Wittenberg, and that the little Danish court was intolerably dull. It was not because the didactic lord chamberlain bored him with long speeches, or that the lord chamberlain's daughter was become a shade wearisome. Hamlet had more serious cues for unhappiness. He had been summoned suddenly from Wittenberg to attend his father's funeral; close upon this and while his grief was green, his mother had married with his uncle Claudius, whom Hamlet had never liked. The indecorous haste of these nuptials—they took place within two months after the king's death, the funeral baked meats, as Hamlet cursorily remarked, furnishing forth the marriage-tables—struck the young prince aghast. He had loved the queen, his mother, and had nearly idolized the late king; but now he forgot to lament the death of the one in contemplating the life of the other. The billing and cooing of the newly-married couple filled him with horror. Anger, shame, pity, and despair seized upon him by turns. He fell into a forlorn condition, forsaking his books, eating little save of the chameleon's dish, the air, drinking deep of Rhenish, letting his long, black locks go unkempt, and neglecting his dress—he who had hitherto been "the glass of fashion and the mould of form," as Ophelia had prettily said of him. Often for half the night he would wander along the ramparts of the castle, at the imminent risk of tumbling off, gazing

seaward and muttering strangely to himself, and evolving
frightful spectres out of the shadows cast by the turrets.
Sometimes he lapsed into a gentle melancholy: but not sel-
dom his mood was ferocious, and at such times the conver-
sational Polonius, with a discretion that did him credit,
steered clear of my lord Hamlet. He turned no more grace-
ful compliments for Ophelia. The thought of marrying her,
if he had ever seriously thought of it, was gone now. He
rather ruthlessly advised her to go into a nunnery. His
mother had sickened him of women. It was of her he spoke
the notable words, "Frailty, thy name is woman!" which,
some time afterwards, an amiable French gentleman had
neatly engraved on the hearthstone of his wife, who had long
been an invalid. Even the king and queen did not escape
Hamlet in his distempered movements. Passing his mother
in a corridor or on a staircase of the palace, he would sud-
denly plant a verbal dagger in her heart; and frequently, in
full court, he would deal the king such a cutting reply as
caused him to blanch, and gnaw his lip.

A tree is an underground creature, with its tail in the
air. All its intelligence is in its roots. All the senses it has
are in its roots. Think what sagacity it shows in its search
after food and drink! Somehow or other, the rootlets, which
are its tentacles, find out that there is a brook at a moderate
distance from the trunk of the tree, and they make for it
with all their might. They find every crack in the rocks
where there are a few grains of the nourishing substance
they care for, and insinuate themselves into its deepest re-
cesses. When spring and summer come, they let their tails
grow, and delight in whisking them about in the wind, or
letting them be whisked about by it; for these tails are poor
passive things, with very little will of their own, and bend in
whatever direction the wind chooses to make them. The
leave makes a deal of noise whispering. I have sometimes
thought I could understand them, as they talk with each
other, and that they seemed to think they made the wind as
they wagged forward and back. Remember what I say. The
next time you see a tree waving in the wind, recollect that
it is the tail of a great underground, many-armed, polypus-
like creature, which is as proud of its caudal appendage, es-
pecially in summer-time, as a peacock of his gorgeous ex-
panse of plumage.—HOLMES: *Over the Teacups.*

We will try to make some small piece of English
ground beautiful, peaceful, and fruitful. *We will have no*

steam engines upon it, and no railroads; we will have no un-
tended or unthought-of creatures on it; none wretched, but
the sick; *none idle,* but the dead. *We will have no liberty*
upon it; but instant obedience to know law, and appointed
persons; *no equality upon in;* but recognition of every bet-
terness that we can find, and reprobation of every worseness.
When we want to go anywhere, we will go there quietly and
safely, *not at forty miles an hour in the risk of our lives;*
when we want to carry anything anywhere, we will carry it
either on the backs of beasts, or on our own, or in carts, or
in boats; we will have plenty of flowers and vegetables in
our gardens, plenty of corn and grass in our fields,—and few
bricks. We will have some music and poetry; the children
shall learn to dance to it, and sing it; perhaps some of the
old people, in the time, may also. We will have some art,
moreover; we will at least try if, like the Greeks, we can't
make some pots.—RUSKIN: *Fors Clavigera,* Letter V.

◢ The effect of historical reading is analogous, in many
respects, to that produced by foreign travel. The student,
like the tourist, is transported into a new state of society.
He sees new fashions. He hears new modes of expression.
His mind is enlarged by contemplating the wide diversities
of laws, of morals, and of manners. But men may travel
far, and return with minds as contracted as if they had never
stirred from their own market-town. In the same manner,
men may know the dates of many battles and the genealogies
of many royal houses, and yet be no wiser. Most people
look at past times as princes look at foreign countries. More
than one illustrious stranger has landed on our island amidst
the shouts of a mob, has dined with the King, has hunted
with the master of the stag-hounds, has seen the Guards re-
viewed, and a Knight of the Garter installed, has cantered
along Regent Street, has visited St. Paul's, and noted down
its dimensions; and has then departed, thinking that he has
seen England. He has, in fact, seen a few public buildings,
public men, and public ceremonies. But of the vast and
complex system of society, of the fine shades of national
character, of the practical operation of the government and
laws, he knows nothing. He who would understand these
things rightly must not confine his observations to palaces
and solemn days. He must see ordinary men as they appear
in their ordinary business and in their ordinary pleasures.
He must mingle in the crowds of the exchange and the coffee-
house. He must obtain admittance to the convivial table
and the domestic hearth. He must bear with vulgar ex-

pressions. He must not shrink from exploring even the re-
treats of misery. He who wishes to understand the condition
of mankind in former ages must proceed on the same prin-
ciple. If he attends only to public transactions, to wars,
congresses, and debates, his studies will be as unprofitable
as the travels of those imperial, royal, and serene sovereigns
who form their judgment of our island from having gone in
state to a few fine sights and from having held formal con-
ferences with a few great officers.—MACAULAY: *Essay on
History.*

The courage we desire and prize is not the courage to
die decently, but to live manfully. This, when by God's
grace it has been given, lies deep in the soul; like genial
heat, fosters all other virtues and gifts; without it they could
not live. In spite of our innumerable Waterloos and Pe-
teloos, and such campaigning as there has been, this courage
we allude to, and call the only true one, is perhaps rare in
in these last ages than it has been in any other since the
Saxon Invasion under Hengist. Altogether extinct it can
never be among men; otherwise the species man were no
longer for this world: here and there, in all times, under
various guises, men are sent hither not only to demonstrate
but exhibit, and testify, as from heart to heart, that it is
still possible, still practicable.

—CARLYLE: *Boswell's Life of Johnson.*

In whatsoever light we examine the characteristics of
the Laureate's genius, the complete and even balance of his
poetry is from first to last conspicuous. It exhibits that just
combination of lyrical elements which makes a symphony,
wherein it is difficult to say what quality predominates. Re-
viewing minor poets, we think this one attractive for the
wild flavor of his unstudied verse; another, for the gush and
music of his songs; a third, for idyllic sweetness or tragic
power; but in Tennyson we have the strong repose of art,
whereof—as of the perfection of nature—the world is slow to
tire. It has become conventional, but remember that noth-
ing endures to the point of conventionalism which is not
based upon lasting rules; that it once was new and refresh,
ing, and is sure, in future days, to regain the early charm.

—STEADMAN: *Victorian Post.*

I made a laughable mistake this morning in giving
alms. A man stood on the shady side of the street with his
hat in his hand, and as I passed he gave me a piteous look,

though he said nothing. He had such a woe-begone face and such a threadbare coat, that I at once took him for one of those mendicants who bear the title of *proveri vergognosi* —bashful beggars; persons whom pinching want compels to receive the stranger's charity, though pride restsains them from asking it. Moved with compassion, I threw into the hat the little I had to give; when, instead of thanking me with a blessing, my man with the threadbare coat showered upon me the most sonorous maledictions of his native tongue, and, emptying his greasy hat upon the pavement, drew it down over his ears with both hands, and stalked away with all the dignity of a Roman senator in the best days of the republic,—to the infinite amusenent of a green-grocer, who stood at his shop-door bursting with laughter. No time was given me for an apology; but I resolved to be for the future more discriminating in my charities, and not to take for a beggar every poor gentleman who chose to stand in the shade with his hat in his hand on a hot summer's day.—LONGFELLOW: *Outre-Mer.*

I pray you, O excellent wife, not to cumber yourself and me to get a rich dinner for this man or this woman who has alighted at our gate, nor a bed-chamber made ready at too great a cost. These things, if they are curious in them, they can get for a dollar at any village. But let this stranger, if he will, in your looks, in your accent and behavior, read your heart and earnestness, your thought and will,—which he cannot buy at any price in any village or city, and which he may well travel fifty miles, and dine sparely and sleep hard, in order to behold. Certainly let the board be spread, and let the bed be dressed for the traveler, but let not the emphasis of hospitality lie in these things. Honor to the house where they are simple to the verge of hardship, so that there the intellect is awake and reads the law of the universe, the soul worships truth and love, honor and courtesy flow into all deeds.—EMERSON: *Domestic Life.*

4. It has been justly observed that Shakespeare shows much judgment in the naming of his plays. From this observation, however, several critics, as Gildon and Schlegel, have excepted the play in hand, pronouncing the title a misnomer, on the ground that Brutus, and not Cæsar, is the hero of it. It is indeed true that Brutus is the hero; nevertheless I must insist upon it that the play is rightly named, inasmuch as Cæsar is not only the subject, but also he governing power of it throughout. He is the centre and

spring-head of the entire action, giving law and shape
to everything that is said and done. This is manifestly
true in what occurs before his death; and it is true in a still
deeper sense afterwards, since his genius then becomes the
Nemesis or retributive Providence presiding over the whole
course of the drama.—HUDSON: *Introduction to school edi-
tion of Shakespeare's Julius Cæsar.*

 5. We are accustomed to call Washington the "Fath-
er of his country." It would be useless, if one desired to
do so, to dispute his right to the title. He and no other
will bear it through the ages. He established our country's
freedom with the sword, then guided its course during the
first critical years of its independent existence. No one can
know the figure without feeling how real is its greatness. It
is impossible to see how, without Washington, the nation
could have ever been. His name is and should be greatest.
But after all is "Father of America" the best title for Wash-
ington? Where and what was Washington during those
long preliminary years while the nation was taking form
. . . ? A quiet planter, who in youth as a surveyor had
come to know the woods; who in his young manhood had
led bodies of provincials with some efficiency in certain un-
successful military expeditions; who in maturity had sat,
for the most part in silence, among his talking colleagues in
the House of Burgesses, with scarcely a suggestion to make
in all the sharp debate, while the new nation was shaping.
There is another character in our history to whom was once
given the title, "Father of America,"—a man to a large
extent forgotten, his reputation overlaid by that of those
who followed him,—no other than this man of the town-
meeting, Samuel Adams. As far as the GENESIS of America
is concerned, Samuel Adams can more properly be called
the "Father of America" than Washington.—HOSMER:
Samuel Adams.

 Every traveller going south from St. Louis can recall
the average Arkansas village in winter. Little strings of
houses spread raggedly on both sides of the rails. A few
wee shops, that are likely to have a mock rectangle of façade
stuck against a triangle of roof, in the manner of chil-
dren's card houses, parade a draggled stock of haberdashery
and groceries. To right or left a mill buzzes, its newness
attested by the raw tints of the weather boarding. There is
no horizon; there seldom *is* a horizon in Arkansas,—it is
cut off by the forest. Pools of water reflect the straight

black lines of tree trunks and the crooked lines of bare houghs, while a muddy road winds through the vista. Generally there are a few lean cattle to stare in a dejected fashion at the train, and some fat black swine to root among the sodden grasses. Bales of cotton are piled on the railway platform, and serve as seats for half a dozen listless men in high boots and soft hats. Occasionally a woman, who has not had time to brush her hair, calls shrilly to some child who is trying to have pneumonia by sitting on the ground. No one seems to have anything to do, yet everyone looks tired, and the passenger in the Pullman wonders how people live in "such a hole."—Octave Thanet.

Many distinguished Englishmen have had some favorite physical amusement that we associate with their names. It is almost a part of an Englishman's nature to select a physical pursuit and make it especially his own. His countrymen like him the better for having a taste of this kind. Mr. Gladstone's practiced skill in tree-felling is a help to his popularity. The readers of Wordsworth, Scott, and Byron all remember that the first was a pedestrian, the second a keen sportsman, and the third the best swimmer of his time. The readers of Keats are sorry for the ill health that spoiled the latter years of his short life, but they remember with satisfaction that the ethereal poet was once muscular enough to administer "a severe drubbing to a butcher whom he caught beating a little boy, to the enthusiastic admiration of a crowd of bystanders." Shelley's name is associated forever with his love of boating, and its disastrous ending. In our own day, when we learn something about the private life of our celebrated contemporaries, we have a satisfaction in knowing that they enjoyed some physical recreation, as, for example, that Tyndall is a mountaineer, Millais a grouse-shooter, John Bright a salmon-fisher; and it is characteristic of the inveteracy of English physical habits that Mr. Fawcett should have gone on riding and skating after he was blind, and that Anthony Trollope was still passionately fond of fox-hunting when he was old and heavy and could hardly see. The English have such a respect for physical energy that they still remember with pleasure how Palmerston hunted in his old age, and how. almost to the last, he would go down to Epsom on horseback. There was a little difficulty about getting him into the saddle, but, once there, he was safe to the end of his journey.—Hamerton: *French and English.*

ing was I roused at two o'clock to go and see its sudden victims, for then is its hour and power. One morning a sailor came to say I must go three miles down the river to a village where it had broken out in great fury. Off I set. We rowed in silence down the dark river, passing the huge hulks, and hearing the restless convicts turning in their beds in their chains. The men rowed with all their might: they had too many dying or dead at home to have the heart to speak to me. We got near the place; it was very dark, but I saw a crowd of men and women on the shore, at the landing-place. They were all shouting for the doctor; the shrill cries of the women and the deep voices of the men coming across the water to me. We were near the shore, when I saw a big old man, his hat off, his hair gray, his head bald; he said nothing, but turning them all off with his arm, he plunged into the sea, and before I knew where I was, he had me in his arms. I was helpless as an infant. He waded out with me, carrying me high up in his left arm, and with his right leveling every man or woman who stood in his way.

It was Big Joe carrying me to see his grandson, little Joe; and he bore me off to the poor convulsed boy, and dared me to leave him till he was better. He did get better, but Big Joe was dead that night. He had the disease on him when he carried me away from the boat, but his heart was set upon his boy. I never can forget that night, and how important a thing it was to be able to relieve suffering, and how much Old Joe was in earnest about having the doctor.—JOHN BROWN: *Horæ Subsecivæ*, 1, p. 393.

The circle of human nature is not complete without the arc of feeling and emotion. The lillies of the field have a value for us beyond their botanical ones.—a certain lightening of the heart accompanies the declaration that, "Solomon in all his glory was not arrayed like one of these." The sound of the village bell which comes mellowed from the valley to the traveller upon the hill has a value beyond its acoustical one. The setting sun when it mantles with the bloom of roses the alpine snows has a value beyond its optical one. The starry heavens, as you know, had for Immanuel Kant a value beyond their astronomical one. Round about the intellect sweeps the horizon of emotions from which all our noblest impulses are derived. I think it very desirable to keep this horizon open; not to permit either priest or philosopher to draw down his shutters between you and it. And here the dead languages, which are sure to be

beaten by science in the purely intellectual fight, have an irresistible claim. They supplement the work of science by exalting and refining the æsthetic faculty, and must on this account be cherished by all who desire to see human culture complete. There must be a reason for the fascination which these languages have so long exercised upon the most powerful and elevated minds,—a fascination which will probably continue for men of Greek and Roman mould to the end of time.—TYNDALL: *Addresses.*

The sounds which the ocean makes must be very significant and interesting to those who live near it. When I was leaving the shore at this place the next summer, and had got a quarter of a mile distant, ascending a hill, I was startled by a sudden sound from the sea, as if a large steamer were letting off steam by the shore, so that I caught my breath and felt my blood run cold for an instant, and I turned about, expecting to see one of the Atlantic steamers thus far out of her course; but there was nothing unusual to be seen. There was a low bank at the entrance of the Hollow, between me and the ocean, and suspecting that I might have risen into another stratum of air in ascending the hill, —which had wafted to me only the ordinary roar of the sea, —I immediately descended again, to see if I lost hearing of it; but, without regard to my ascending or descending, it died away in a minute or two, and yet there was scarcely any wind all the while. The old man said that this was what they called the "rut," a peculiar roar of the sea before the wind changes, which, however, he could not account for. He thought that he could tell all about the weather from the sounds which the sea made.—THOREAU: *Cape Cod.*

Of ghosts I have seldom dreamed, so far as I can remember; in fact I have never dreamed of the kind of ghosts that we are all more or less afraid of, though I have dreamed rather often of the spirits of departed friends. But I once dreamed of dying, and the reader, who has never died yet, may be interested to know what it is like. According to this experience of mine, which I do not claim is typical, it is like a fire kindling in an air-tight stove with paper and shavings; the gathering smoke and gases suddenly burst into flame, and puff the door out, and all is over.—W. D. HOWELL'S: *Harper's Magazine,* 90: 840.

The vast results obtained by science are won by no mystical faculties, by no mental processes, other than those

which are practised by every one of us in the humblest and meanest affairs of life. A detective policeman discovers a burglar from the marks made by his shoe, by a mental process identical with that by which Cuvier restored the extinct animals of Montmartre from fragments of their bones. Nor does that process of induction and deduction by which a lady, finding a stain of a particular kind upon her dress, concludes that somebody has upset the inkstand thereon, differ in any way from that by which Adams and Leverrier discovered a new planet. The man of science, in fact, simply uses with scrupulous exactness the methods which we all habitually and at every moment use carelessly.—HUXLEY: *Lay Sermons.*

It is astonishing how much of the interesting history of the human race has had for its scene the shores of the Mediterranean. Egypt is there. There is Greece. Xerxes, Darius, Solomon, Cæsar, Hannibal, knew no extended sea but the Mediterranean. The mighty armies of Persia, and the smaller but invincible bands of the Grecians, passed its tributaries. Pompey fled across it—the fleets of Rome and Carthage sustained their deadly struggles upon its waters; and, until the discovery of the passage round the Cape of Good Hope, the commerce of the world passed through the ports of the Mediterranean. If we go back to ancient ages, we find the Phœnician sailors—the first who ventured upon the unstable element—slowly and fearfully steering their little barks along the shores of this sea; and if we come down to modern times, we see the men of war of every nation proudly ploughing its waves, or riding at anchor in its harbors. There is not a region upon the face of the earth so associated with the recollection of all that is interesting in the history of our race, as the shores of the Mediterranean sea.

The objects of which science treats are of two different kinds. They may be *things*, or they may be *processes*. If we were arranging fossil specimens or shells or minerals, or if we were experimenting in the physical laboratory with the wedge and the inclined plane and falling bodies, we should be handling *things*. Things are, for all practical purposes, lasting and unchanging; they *are* there, on the table before us, and they do not altar as we look at them. On the other hand, if we were watching the course of a chemical change as it occurred in the test tube, or observing the growth of a tadpole into a frog, we should be dealing with *processes*.

Processes are always changing; they are different now from what they were a moment ago and from what they will be a moment later; they *go on* there, in the test tube or the aquarium before us.—TITCHENER: *Primer of Phychology.*

"Disorders of intellect," answered Imlac, "happen much more often than superficial observers will easily believe. Perhaps, if we speak with rigorous exactness, no human mind is in its right state. There is no man whose imagination does not sometimes predominate over his reason, who can regulate his attention wholly by his will, and whose ideas will come and go at his command. No man will be found in whose mind airy notions do not sometimes tyrannize, and force him to hope or fear beyond the limits of sober probability. All power of fancy over reason is a degree of insanity; but while this power is such as we can control and repress, it is not visible to others, nor considered as any depravation of the mental faculties: it is not pronounced madness, but when it becomes ungovernable and apparently influences speech or action."—JOHNSON: *Rasselas.*

In my schoolhouse, I seem to see the square most readily in the Scotch mist which so often filled it, loosening the stones and choking the drains. There was then no rattle of rain against my window sill, nor dancing of diamond drops on the roofs, but blobs of water grew on the panes of glass to reel heavily down them. Then the sodden square would have shed abundant tears if you could have taken it in your hands and wrung it like a dripping cloth. At such a time the square would be empty but for one vegetable-cart left in the care of a lean colly, which, tied to the wheel, whined and shivered underneath. Pools of water gathered in the coarse sacks that have been spread over the potatoes and bundles of greens, which turn to manure in their lidless barrels. The eyes of the whimpering dog never leave a black close over which hangs the sign of the Bull, probably the refuge of the hawker. At long intervals a farmer's gig rumbles over the bumpy, ill-paved square, or a native, with his head buried in his coat, peeps out-of-doors, skurries across the way, and vanishes. Most of the leading shops are here, and the decorous draper ventures a few yards from the pavement to scan the sky, or note the effect of his new arrangement in scarfs. Planted against his door is the butcher, Henders Todd, white-aproned, and with a knife in his hand, gazing interestedly at the draper,

for a mere man may look at an elder. The tinsmith brings out his steps, and mounting them, stealthily removes the sauce-pans and pepper-pots that dangle on a wire above his sign-board. Pulling to his door he shuts out the foggy light that showed in his solder-strewn workshop. The square is deserted again. A bundle of sloppy parsley slips from the hawkers cart and topples over the wheel in driblets. The puddles in the sacks overflow and run together. The dog has twisted his chain round a barrel, and yelps sharply. As if in response comes a rush of other dogs. A terrified fox terrier tears across the square with half a score of mongrels, the butcher's mastiff and some collies at his heels; he is doubtless a stranger who has insulted them by his glossy coat. For two seconds the square shakes to an invasion of dogs, and then, again, there is only one dog in sight.—BARRIE: *Auld Licht Idylls.*

I was thinking, Young Ladies and Gentlemen, as I sat here this morning, that life is almost wholly made up of margins. The bulk itself of almost anything is not what tells; that exists anyway. That is expected. That is not what gives the profit or makes the distinguishing difference. The grocer cares little for the great bulk of the price of his tea. It is the few cents between the cost and the selling price, which he calls the "margin," that particularly interests him, "Is this to be great or small?" is the thing of importance. Millions of dollars change hands in our great marts of trade just on the question of margins. This same thing is all-important in the subject of thought. One mind is not greater than another, perhaps, in the great bulk of its contents: but its margin is greater, that's all, I may know just as much as you do about the general details of a subject, but you can go just a little farther than I can. You have a greater margin than I. You can tell me of some single thought just beyond where I have gone. Your margin has got me. I must succumb to your superiority.

A good way to carry out the same idea, and better rllustrate it, is by globes. Did you ever see globes whose only difference was that one had half an inch larger diameter than the other? This larger one, although there is so little difference, will entirely enclose the other, and have a quarter of an inch in every direction to spare besides. Let these globes be minds, with a living principle of some kind at their centers, which throws out its little tentacle-like arms in every direction as radii to explore for knowledge.

The one goes a certain distance and stops. It can reach no farther. It has come to a standstill. It has reached its maximum of knowledge in that direction. The other sends its arms out, and can reach just a quarter of an inch farther. So far as the first mind is able to tell, the other has gone infinitely farther than it can reach. It goes out to its farthest limit and must stop; the other tells him things he did not know before. Many minds you may consider wonderful in their capacity. They may be able to go only a quarter of an inch beyond you. What an incentive this should be for any young man to work, to make this margin as great as, if not greater than, the margin of his fellows.

I recall a good illustration of this when I was in college. A certain young man was leading the class in Latin. I thought I was studying hard. I couldn't see how he got the start of us all so. To us he seemed to have an infinite knowledge. He knew more than we did. Finally, one day, I asked him when he learned his Latin lesson. "At night," he replied. I learned mine at the same time. His window was not far from mine, and I could see him from my own. I had finished my lesson the next night as well as usual, and, feeling sleepy, was about to go to bed. I happened to saunter to my window, and there I saw my classmate still bending diligently over his book. "There's where he gets the margin on me," I thought. "But he shall not have it for once," I resolved. "I will study just a little longer than he does to-night." So I took my books again, and, opening to the lesson, went to work with renewed vigor. I watched for the light to go out in my classmate's room. In fifteen minutes it was all dark. "There is his margin," I thought. It was fifteen minutes more time. It was hunting out fifteen minutes more of rules and root-derivatives. How often, when a lesson is well prepared, just five minutes spent in perfecting it will make one the best in the class. The margin in such a case as that is very small, but it is all-important. The world is made up of little things.—*General Garfield.*

When I am in a serious humor, I very often walk by myself in Westminster-abbey: when the gloominess of the place, and the use to which it is applied, with the solemnity of the building, and the condition of the people who lie in it, are apt to fill the mind with a kind of melancholy, or rather thoughtfulness, that is not disagreeable. I yesterday passed a whole afternoon in the church-yard, the cloisters, and the church, amusing myself with the tombstones and

inscriptions that I met with in those several regions of the dead. Most of them recorded nothing else of the buried person, but he was born upon one day, and died upon another, the whole history of his life being comprehended in those two circumstances that are common to all mankind. I could not but look upon these registers of existence, whether of brass or marble, as a kind of satire upon the departed persons; who had left no other memorial of them, but that they were born, and that they died. They put me in mind of several persons mentioned in the battles of heroic poems, who have sounding names given them, for no other reason but that they may be killed, and are celebrated for nothing but being knocked on the head.

Glaucumque, Medontaque, Thersilochumque.—VIRGIL.
(Glaucus, and Medon, and Thersilochus.)

The life of these men is finely described in holy writ by "the path of an arrow," which is immediately closed up and lost.

Upon my going into the church, I entertained myself with the digging of a grave; and saw in every shovelful of it that was thrown up, the fragment of a bone or skull intermixed with a kind of fresh mouldering earth that some time or other had a place in the composition of a human body. Upon this I began to consider with myself what innumerable multitudes of people lay confused together under the pavement of that ancient cathedral; how men and women, friends and enemies, priests and soldiers, monks and prebendaries, were crumbled among one another, and blended together in the same common mass; how beauty, strength, and youth, with old age, weakness, and deformity, lay undistinguished in the same promiscuous heap of matter.

After having thus surveyed the great magazine of mortality, as it were, in the lump, I examined it more particularly by the accounts which I found on several of the monuments which are raised in every quarter of that ancient fabric. Some of them were covered with such extravagant epitaphs, that if it were possible for the dead person to be acquainted with them, he would blush at the praises which his friends had bestowed upon him. There are others so excessively modest, that they deliver the character of the person departed in Greek or Hebrew, and by that means are not understood once in a twelvemonth. In a poetical quarter, I found there were poets who had no monuments, and monuments which had no poets. I observed, indeed, that the present war had filled the church with many of

these uninhabited monuments, which had been erected to the memory of persons whose bodies were perhaps buried in the plains of Blenheim, or in the bosom of the ocean.

I could not be but very much delighted with several modern epitaphs, which were written with great elegance of expression and justness of thought, and therefore do honor to the living as well as the dead. As a foreigner is very apt to conceive an idea of the ignorance or politeness of a nation from the turn of their public monuments and inscriptions, they should be submitted to men of learning and genius before they are put in execution. Sir Cloudesly Shovel's monument has very often given me great offence. Instead of the brave rough English admiral, which was the distinguishing character of that plain, gallant man, he is represented on his tomb by the figure of a beau, dressed in a long periwig, and reposing himself upon velvet cushions, under a canopy of state. The inscription is answerable to the monument; for instead of celebrating the many remarkable actions he had performed in the service of his country, it acquaints us only with the manner of his death, in which it was impossible for him to | reap any honor. The Dutch, whom we are apt to despise for want of genius, show an infinitely greater taste of antiquity and politeness in their buildings and works of this nature than what we meet with in those of our own country. The monuments of their admirals, which have been erected at the public expense, represent them like themselves, and are adorned with rostral crowns and naval ornaments, with beautiful festoons of seaweeds, shells, and coral.

But to return to our subject. I have left the repository of our English kings for the contemplation of another day, when I shall find my mind disposed to so serious an amusement. I know that entertainments of this nature are apt to raise dark and dismal thoughts in timorous minds and gloomy imaginations; but for my own part, though I am always serious, I do not know what it is to be melancholy; and can therefore take a view of nature in her deep and solemn scenes with the same pleasure as in here most gay and delightful ones. By this means I can improve myself with those objects which others consider with terror. When I look upon the tombs of the great, every emotion of envy dies within me; when I read the epitaphs of the beautiful, every inordinate desire goes out; when I meet with the grief of parents upon a tombstone, my heart melts with compassion; when I see the tomb of the parents themselves,

I consider the vanity of grieving for those whom we must quickly follow. When I see kings lying by those who deposed them, when I consider rival wits placed side by side, or the holy men that divided the world with their contests and disputes, I reflect with sorrow and astonishment on the little competitious, factions, and debates of mankind, When I read the several dates of the tombs, of some that died yesterday, and of some of six hundred years ago, I consider that great day when we shall all of us be contemporaries, and make our appearance together.—ADDISON: *The Spectator*, No. 26.

In the season of hot weather in the central part of the Mississippi Valley, there often come successions of days when the atmosphere is not stirred by the winds, but remains as still as the air of a cave. Despite the steady gain in the heat, the sky stays cloudless, or at most is flecked by those light clouds that lie five miles or more above the surface of the earth. All nature seems cowed beneath the fervent heat, yet there is nothing of distinct portent in earth or air. At last, towards evening, there may be seen a sudden curdling of the western sky; in a few minutes the clouds gather, coming from nowhere, growing at once in the lurid air. In less than half an hour the forces of the storm are organized, and its dreadful advance begins. If we were just beneath the gathering clouds we would find that the air over a space a mile or so in diameter was spinning around in a great whirlpool, and while the revolving mass slowly advanced, the central part moved rapidly upwards. Beginning slowly, all the movements of the storm, the whirling action, the vertical streaming of the air, its onward movement, all gain speed of motion with astonishing rapidity. In a minute or two some cubic miles of air are in a state of intense gyratory movement, mounting upwards as violently as the gases over a volcano. To replace the strong whirling uprush, there is an indraught from every side towards the center of the whirlwind; and as this center moves quickly forward, the rush of air is strongest from behind towards the advancing hurricane. The rate at which the storm goes forward is variable, though it is generally as much as forty to one hundred miles an hour; but this is not the measure of its destructive power. The rending effect of the storm is much greater than would be given by a simple blast of air moving at this speed. Much of this peculiar capacity for destruction may perhaps be due to the gyratory motion of the wind in the storm center, which on one side

of the whirlwind adds the speed arising from its circular movement to the translatory velocity of the whirlwind itself. Some of the records tell us that houses with closed windows have been known to burst apart, as if from an explosion of gunpowder, while others, that had their doors and windows open, remained essentially unharmed. It has been conjectured that this action may be due to a sudden rarefaction of air on the outside of the building; but this cause cannot be sufficient to produce such effects, and if such explosions occur the cause must be looked for elsewhere. After the storm is once developed, it seems very quickly to acquire its maximum of destructive power and its speed of translation. At the outset and during the period of most efficient action, the strip of country affected is generally very narrow, not often exceeding a mile in width; as the storm advances the path seems gradually to grow wider, and the gyratory movement as well as the translatory motion of the meteor less considerable, until at last it fades into an ordinary thunder storm, or dies into a calm, Through the whole course of the hurricane, and especially during its closing stages, there is generally more or less rain and hail.—*Atlantic,* 40: 331.

We would speak first of the Puritans, the most remarkable body of men, perhaps, which the world has ever produced. The odious and ridiculous parts of their character lie on the surface. He that runs may read them; nor have there been wanting attentive and malicious observers to point them out. For many years after the Restoration, they were the theme of unmeasured invective and derision. They were exposed to the utmost licentiousness of the press and of the stage, at the time when the press and the stage were most licentious. They were not men of letters; they were, as a body, unpopular; they could not defend themselves; and the public would not take them under its protection. They were therefore abandoned, without reserve, to the tender mercies of the satirists and dramatists. The ostentatious simplicity of their dress, their sour aspect, their nasal twang, their stiff posture, their long graces, their Hebrew names, the Scriptural phrases which they introduced on every occasion, their contempt of human learning, their detestation of polite !amusements, were indeed fair game for the laughers. But it is not from the laughers alone that the philosophy of history is to be learnt. And he who approaches this subject should carefully guard against the in-

fluence of that potent ridicule, which has already misled so many excellent writers.

"Ecco il fonte del riso, ed ecco il rio
Che mortali perigli in se contiene:
Hor qui tener a fren nostro a desio,
Ed esser cauti molto a noi conviene."

Those who roused the people to resistance—who directed their measures through a long series of eventful years —who formed, out of the most unpromising materials, the finest army that Europe had ever seen—who trampled down king, church, and aristocracy—who, in the short intervals of domestic sedition and rebellion, made the name of England terrible to every nation on the earth, were no vulgar fanatics. Most of their absurdities were mere external badges, like the signs of freemasonry or the dress of frairs. We regret that a body, to whose courage and talents mankind has owed inestimable obligations, had not the lofty elegance which distinguished some of the adherents of Charles I., or the easy breeding for which the court of Charles II. was celebrated. But, if we must make our choice, we shall, like Bassanio in the play, turn from the specious caskets, which contain only the death's head and the fool's head, and fix our choice on the plain leaden chest which conceals the treasure.

The Puritans were men whose minds had derived a peculiar character from the daily contemplation of superior beings and external interests. Not content with acknowledging, in general terms, an overruling Providence, they habitually ascribed every event to the will of the Great Being, for whose power nothing was too vast, for whose inspection nothing was too minute. To know him, to serve him, to enjoy him, was with them the great end of existence. They rejected with contempt the ceremonious homage which other sects substituted for the pure worship of the soul. Instead of catching occasional glimpses of the Deity through an obscuring veil, they aspired to gaze full on the intolerable brightness, and to commune with him face to face. Hence originated their contempt for terrestrial distinctions. The difference between the greatest and meanest of mankind seemed to vanish, when compared with the boundless interval which separated the whole race from him on whom their own eyes were constantly fixed. They recognized no title to superiority but his favor; and, confident of that favor, they despised all the accomplishments and all the dignities of the world. If they were unacquainted with the works of philosophers and poets, they were deeply read in the oracles of God. If their names were not found in the

registers of heralds, they felt assured that they were recorded in the Book of Life. If their steps were not accompanied by a splendid train of menials, legions of ministering angels had charge over them. Their palaces were houses not made with hands: their diadems, crowns of glory which should never fade away! On the rich and the eloquent, on nobles and priests, they looked down with contempt: for they esteemed themselves rich in a more precious treasure, and eloquent in a more sublime language—nobles by the right of an earlier creation, and priests by the imposition of a mightier hand. The very meanest of them was a being to whose fate a mysterious and terrible importance belonged —on whose slightest actions the spirits of light and darkness looked with anxious interest—who had been destined, before heaven and earth were created, to enjoy a felicity which should continue when heaven and earth should have passed away. Events which short-sighted politicians ascribed to earthly causes had been ordained on his account. For his sake empires had risen, and flourished, and decayed. For his sake the Almighty had proclaimed his will by the pen of the evangelist, and the harp of the prophet. He had been rescued by no common deliverer from the grasp of no common foe. He had been ransomed by the sweat of no vulgar agony, by the blood of no earthly sacrifice. It was for him that the sun had been darkened, that the rocks had been rent, that the dead had arisen, that all nature had shuddered at the sufferings of her expiring God!

Thus the Puritan was made up of two different men, the one all self-abasement, penitence, gratitude, passion; the other proud, calm, inflexible, sagacious. He prostrated himself in the dust before his Maker; but he set his foot on the neck of his king. In his devotional retirement, he prayed with convulsions, and groans, and tears. He was half maddened by glorious or terrible illusions. He heard the lyres of angels, or the tempting whispers of fiends. He caught a gleam of the Beatific Vision, or woke screaming from the dreams of everlasting fire. Like Vane, he thought himself intrusted with the scepter of the millennial year. Like Fleetwood, he cried in the bitterness of his soul that God had hid his face from him. But when he took his seat in the council or girt on his sword for war, these tempestuous workings of the soul had left no perceptible trace behind them. People who saw nothing of the godly but their uncouth visages, and heard nothing from them but their groans and their whining hymns, might laugh at them.

But those had little reason to laugh who encountered them in the hall of debate, or in the field of battle. These fanatics brought to civil and military affairs a coolness of judgment and an immutability of purpose which some writers have thought inconsistent with their religious zeal, but which were in fact the necessary effects of it. The intensity of their feelings on one subject made them tranquil on every other. One overpowering sentiment had subjected to itself pity and hatred, ambition and fear. Death had lost its terrors and pleasure its charms. They had their smiles and their tears, their raptures and their sorrows, but not for the things of this world. Enthusiasm had made them Stoics, had cleared their minds from every vulgar passion and prejudice, and raised them above the influence of danger and of corruption. It sometimes might lead them to pursue unwise ends, but never to choose unwise means. They went through the world like Sir Artegale's iron man Talus with his flail, crushing and trampling down oppressors, mingling with human beings, but having neither part nor lot in human infirmities; insensible to fatigue, to pleasure, and to pain, not to be pierced by any weapon, not to be withstood by any barrier.

Such we believe to have been the character of the Puritans. We perceive the absurdity of their manners. We dislike the sullen gloom of their domestic habits. We acknowledge that the tone of their minds was often injured by straining after things too high for mortal reach. And we know that, in spite of their hatred of Popery. they too often fell into the worst vices of that bad system, intolerance and extravagant austerity—that they had their anchorites and their crusades. their Dunstans and their De Montforts, their Dominics and their Escobars. Yet when all circumstances are taken into consideration, we do not hesitate to pronounce them a brave, a wise, an honest, and a useful body.—MACAULAY: *Essay on Milton.*

Let us ask ourselves, what is education? Above all things, what is our ideal of a thoroughly liberal education? —of that education which, if we could begin life again, we would give ourselves—of that education which, if we could mould the fates to our own will, we would give our children. Well, I know not what may be your conceptions upon this matter, but I will tell you mine, and I hope I shall find that our views are not very discrepant.

Suppose it were perfectly certain that the life and for-

tune of every one of us would, one day or other, depend upon his winning or loosing a game of chess. Don't you think that we should all consider it to be a primary duty to learn at least the names and the moves of the pieces; to have a notion of a gambit, and a keen eye for all the means of giving and getting out of a check? Do you not think that we should look with a disapprobation amounting to scorn, upon the father who allowed his son, or the state which allowed its members, to grow up without knowing a pawn from a knight?

Yet it is a very plain and elementary truth, that the life, the fortune, and the happiness of every one of us, and, more or less, of those who are connected with us, do depend upon our knowledge sometimes of the rules of a game infinitely more difficult and complicated than chess. It is a game which has been played for untold ages, every man and woman of us being one of the two players in a game of his or her own. The chess-board is the world, the pieces are phenomena of the unievrse, the rules of the game are what we call the laws of Nature. The player on the other side is hidden from us. We know that his play is always fair, just, and patient. But also we know, to our cost, that he never overlooks a mistake, or makes the smallest allowance for ignorance. To the man who plays well, the highest stakes are paid, with that sort of overflowing generosity with which the strong shows delight in strength. And one who plays ill is checkmated—without haste, but without remorse.

My metaphor will remind some of you of the famous picture in which Retzsch has depicted Satan playing at chess with man for his soul. Substitute for the mocking fiend in that picture, a calm, strong angel who is playing for love, as we say, and would rather lose than win—and I should accept it as an image of human life.

Well, what I mean by Education is learning the rules of this mighty game. In other words, education is the instruction of the intellect in the laws of Nature, under which name I include not merely things and their forces, but men and their ways; and the fashioning of the affections and of the will into an earnest and loving desire to move in harmony with those laws. For me, education means neither more nor less than this. Anything which professes to call itself education must be tried by this standard, and if it fails to stand the test, I will not call it education, whatever may be the force of authority, or of numbers, upon the other side.

It is important to remember that, in strictness, there is no such thing as an uneducated man. Take an extreme case. Suppose that an adult man, in the full vigor of his faculties, could be suddenly placed in the world, as Adam is said to have been, and then left to do as he best might. How long would he be left uneducated? Not five minutes. Nature would begin to teach him, through the eye, the ear, the touch, the properties of objects. Pain and pleasure would be at his elbow telling him to do this and avoid that; and by slow degrees the man would receive an education, which, if narrow, would be thorough, real, and adequate to his circumstances, though there would be no extras and very few accomplishments.

And if to this solitary man entered a second Adam, or, better still, an Eve, a new and greater world, that of social or moral phenomena, would be revealed. Joys and woes, compared with which all others might seem but faint shadows, would spring from the new relations. Happiness and sorrow would take the place of the coarser monitors, pleasure and pain; but conduct would still be shaped by the observation of the natural consequences of actions; or, in other words, by the laws of the nature of man.

To every one of us the world was once as fresh and new as to Adam. And then, long before we were susceptible of any other mode of instruction, Nature took us in hand, and every minute of waking life brought its educational influence, shaping our actions into rough accordance with Nature's laws, so that we might not be ended untimely by too gross disobedience. Nor should I speak of this process of education as past, for any one, be he as old as he may. For every man, the world is as fresh as it was at the first day, and as full of untold novelties for him who has the eyes to see them. And Nature is still continuing her patient education of us in that great university, the universe, of which we are all members—Nature having no Test-Acts.

Those who take honors in Nature's university, who learn the laws which govern men and things and obey them, are the really great and successful men in this world. The great mass of mankind are the "Poll," who pick up just enough to get through without much discredit. Those who won't learn at all are plucked; and then you can't come up again. Nature's pluck means extermination.

Thus the question of compulsory education is settled so far as Nature is concerned. Her bill on that question was framed and passed long ago. But, like all compulsory

legislation, that of Nature is harsh and wasteful in its operation. Ignorance is visited as sharply as wilful disobedience—incapacity meets with the same punishment as crime. Nature's discipline is not even a word and a blow, and the blow first; but the blow without the word. It is left you to find out why your ears are boxed.

The object of what we commonly call education—that education in which man intervenes and which I shall distinguish as artificial education—is to make good these defects in Nature's methods; to prepare the child to receive Nature's education, neither incapably nor ignorantly, nor with wilful disobedience; and to understand the preliminary symptoms of her displeasure, without waiting for the box on the ear. In short, all artificial education ought to be an anticipation of natural education, which has not only prepared a man to escape the great evils of disobedience to natural laws, but has trained him to appreciate and to seize upon the rewards, which Nature scatters with as free a hand as her penalties.

That man, I think, has had a liberal education, who has been so trained in youth that his body is the ready servant of his will, and does with ease and pleasure all the work that, as a mechanism, it is capable of; whose intellect is a clear, cold, logic engine, with all its parts of equal strength, and in smooth working order; ready, like a steam engine, to be turned to any kind of work, and spin the gossamers as well as forge the anchors of the mind; whose mind is stored with a knowledge of the great and fundamental truths of Nature and of the laws of her operations; one who, no stunted ascetic, is full of life and fire, but whose passions are trained to come to heel by a vigorous will, the servant of a tender conscience; who has learned to love all beauty, whether of Nature or of art, to hate all vileness, and to respect others as himself.

Such an one, and no other, I conceive, has had a liberal education; for he is, as completely as a man can be, in harmony with Nature. He will make the best of her, and she of him. They will get on together rarely; she is his ever beneficent mother: he as her mouth-piece. her conscious self, her minister and interpreter.—HUXLEY: *Lay Sermon, Addresses. and Reviews.*

A professional life of Robert Stevenson has been already given to the world by his son David, and to that I would refer those interested in such matters. But my own

design, which is to represent the man, would be very ill carried out if I suffered myself or my reader to forget that he was, first of all and last of all, an engineer. His chief claim to the style of a mechanical inventor is on account of the Jib or Balance Crane of the Bell Rock, which are beautiful contrivances. But the great merit of this engineer was not in the field of engines. He was above all things a projector of works in the face of nature, and a modifier of nature itself. A road to be made, a tower to be built, a harbor to be constructed, a river to be trained and guided in its channel—these were the problems with which his mind was continually occupied; and for these and similar ends he travelled the world for more than half a century. like an artist, note-book in hand.

He once stood and looked on at the emptying of a certain oil-tube; he did so watch in hand, and accurately timed the operation; and in so doing offered the perfect type of his profession. The fact acquired might never be of use: it was acquired: another link in the world's huge chain of progress was brought down to figures and placed at the service of the engineer. "The very term mensuration sounds *engineer-like*," I find him writing; and in truth what the engineer most properly deals with is that which can be measured, weighed, and numbered. The time of any operation in hours and minutes, its cost in pounds, shillings, and pence, the strain upon a given point in foot-pounds—these are his conquests, with which he must continually furnish his mind, and which, after he has acquired them, he must continually apply and exercise. They must be not only entries in note-books, to be hurriedly consulted; in the actor's phrase, he must be *stale* in them; in a word of my grandfather's, they must be "fixed in the mind like the ten fingers and ten toes."

These are the certainties of the engineer; so far he finds a solid footing and clear views. But the province of formulas and constants is restricted. Even the mechanical engineer comes at last to the end of his figures, and must stand up, a practical man, face to face with the discrepancies of nature and the hiatuses of theory. After the machine is finished, and the steam turned on, the next is to drive it; and experience and an exquisite sympathy must teach him where a weight should be applied or a nut loosened. With the civil engineer, more properly so called (if anything can be proper with this awkward coinage), the obligation starts with the beginning. He is always the

practical man. The rains, the winds, and the waves, the complexity and the fitfulness of nature, are always before him. He has to deal with the unpredictable, with those forces, (in Smeaton's phrase) that "are subject to no calculation"; and still he must predict, still calculate them, at his peril. His work is not yet in being, and he must foresee its influence: how it shall deflect the tide, exaggerate the waves, dam back the rain water, or attract the thunderbolt. He visits a piece of sea-board: and from the inclination and soil of the beach, from the weeds and shell-fish, from the configuration of the coast and the depth of soundings outside, he must induce what magnitude of waves is to be looked for. He visits a river, its summer water babbling on shallows; and he must not only read, in a thousand indications, the measure of winter freshets, but be able to predict the violence of occasional great floods. Nay, and more; he must not only consider that which is, but that which may be. Thus I find my grandfather writing, in a report on the North Esk Bridge: "A less waterway might have sufficed, but *the valley may come to be meliorated by drainage.*" One field drained after another through all that confluence of vales, and we come to a time when they shall precipitate, by so much a more copious and transient flood, as the gush of the flowing drain pipe is superior to the leakage of a peat.

It is plain there is here but a restricted use for formulas. In this sort of practice, the engineer has needs of some transcendental sense. Smeaton, the pioneer, bade him obey his "feelings"; my father, "that power of estimating obscure forces which supplies a coefficient of its own to every rule." The rules must be everywhere indeed; but they must everywhere be modified by this transcendental coefficient, everywhere bent to the impression of the trained eye and the *feelings* of the engineer. A sentiment of physical laws and of the scale of nature, which shall have been strong in the beginning and progressively fortified by observation, must be his guide in the last recourse. I had the most opportunity to observe my father. He would pass hours on the beach, brooding over the waves, counting them, noting their least deflection, noting when they broke. On Tweedside, or by Lyne or Manor, we have spent together whole afternoons; to me, at the time, extremely wearisome; to him, as I am now sorry to think, bitterly mortifying. The river was to me a pretty and various spectacle; I could not see—I could not be made to see—it otherwise. To my father it was a chequer-board of lively forces, which

he traced from pool to shallow with minute appreciation and enduring interest. "That bank has been undercut," he might say; "why? Suppose you were to put a groin out here, would not the *filum fluminis* be cast abruptly off across the channel? and where would it impinge upon the other shore? and what would be the result? Or suppose you were to blast that boulder, what would happen? Follow it—use the eyes God has given you—can you not see that a great deal of land would be reclaimed upon this side?" It was to me like school in holidays; but to him, until I had worn him out with my invincible triviality, a delight. Thus he pored over the engineer's voluminous handybook of nature; thus must, too, have pored my grandfather and uncles.

But it is of the essence of this knowledge, or this knack of mind, to be largely incommunicable. "It cannot be imparted to another," says my father. The verbal casting-net is thrown in vain over these evanescent, inferential relations. Hence the insignificance of much engineering literature. So far as the science can be reduced to formulas or diagrams, the book is to the point; so far as the art depends upon intimate study of the ways of nature, the author's words will too often be found vapid. This fact— that engineering looks one way, and literature another—was what my grandfather overlooked. All his life long, his pen was in his hand, piling up a treasury of knowledge, preparing himself against all possible contingencies. Scarce anything fell under his notice but he perceived in it some relation to his work, and chronicled it in the pages of his journal in his always lucid, but sometimes inexact and wordy, style. The Traveling Diary (so he called it) was kept in fascicles of ruled paper, which were at last bound up, rudely indexed, and put by for future reference. Such volumes as have reached me contain a surprising medley: the whole details of his employment in the Northern Lights and his general practice; the whole biography of an enthusiastic engineer. Much of it is useful and curious; much merely otiose; and much can only be described as an attempt to impart that which cannot be imparted in words. Of such are his repeated and heroic descriptions of reefs; monuments of misdirected energy, which leave upon the mind of the reader no effect but that of a multiplicity of words and the suggested vignette of a lusty old gentleman scrambling among tangle. It is to be remembered that he came to engineering while yet it was in the egg and without a library, and

that he saw the bounds of that profession widen daily. He saw iron ships, steamers, and the locomotive engine, introduced. He lived to travel from Glasgow to Edinburgh in the inside of a forenoon, and to remember that he himself had "often been twelve hours upon the journey, and his grandfather (Lillie) two days"! The profession was still but in its second generation, and had already broken down the barriers of time and space. Who should set a limit for its future encroachments? And hence, with a kind of sanguine pedantry, he pursued his design of "keeping up with the day" and posting himself and his family on every mortal subject. Of this unpractical idealism we shall meet with many instances; there was not a trade, and scarce an accomplishment, but he thought it should form part of the outfit of an engineer; and not content with keeping an encyclopædic diary himself, he would fain have set all his sons to work continuing and extending it. They were more happily inspired. My father's engineering pocket-book was not a bulky volume; with its store of pregnant notes and vital formulas, it served him through life, and was not filled when he came to die. As for Robert Stevenson and the Travelling Diary, I should be ungrateful to complain, for it has supplied me with many lively traits for this and subsequent chapters; but I must still remember much of the period of my study there as a sojourn in the Valley of the Shadow.

The duty of the engineer is two-fold—to design the work, and to see the work done. We have seen already something of the vociferous thoroughness of the man, upon the cleaning of lamps and the polishing of reflectors. In building, in road-making, in the construction of bridges, in every detail and byway of his employments, he pursued the same ideal. Perfection (with a capital P and violently under-scored) was his design. A crack for a penknife, the waste of "six-and-thirty shillings," "the loss of a day or a tide," in each of these he saw and was revolted by the finger of the sloven; and to spirits as intense as his, and immersed in vital undertakings, the slovenly is the dishonest, and wasted time is instantly translated into lives endangered. On this consistent idealism there is but one thing that now and then trenches with a touch of incongruity, and that is his love of the picturesque. As when he laid out a road on Hogarth's line of beauty; bade a foreman be careful, in quarrying, not "to disfigure the island"; or regretted in a report that "the great stone, called the *Devil in the*

Hole. was blasted or broken down to make road-metal, and for other purposes of the work."—*Reprinted by permission from* STEVENSON'S *Records of a Family of Engineers*, copyrighted 1897.—*Scribners.*

ADVENTURE OF THE LITTLE ANTIQUARY.

My friend, the doctor, was a thorough antiquary,—a little rusty, musty old fellow, always groping among ruins. He relished a building as you Englishmen relish cheese,—the more mouldy and crumbling it was, the more it suited his taste. A shell of an old nameless temple, or the cracked walls of a broken-down ampitheatre, would throw him into raptures, and he took more delight in these crusts and cheese-parings of antiquity than in the best-conditioned modern palaces.

He was a curious collector of coins also, and had just gained an accession of wealth that almost turned his brains. He had picked up, for instance, several Roman Consulars, half a Roman As, two Punics, which had doubtless belonged to the soldiers of Hannibal, having been found on the very spot where they had camped among the Appennines. He had, moreover, one Samnite, struck after the Social War, and a Philistis, a queen that never existed; but above all, he valued himself upon a coin, indescribable to any but the initiated in these matters, bearing a cross on one side, and a Pegasus on the other and which, by some antiquarian logic, the little man adduced as an historical document illustrating the process of Christianity. All these precious coins he carried about him in a leathern purse, buried deep in a pocket of his little black breeches.

The last maggot he had taken into his brain was to hunt after the ancient cities of the Pelasgi, which are said to exist to this day among the mountains of the Abruzzi, but about which a singular degree of obscurity prevails. He had made many discoveries concerning them, and had recorded a great many valuable notes and memorandums on the subject, in a voluminous book which he always carried about with him, either for the purpose of frequent reference, or through fear lest the precious document should fall into the hands of brother antiquaries. He had, therefore, a large pocket in the skirt of his coat, where he bore about this inestimable tome, banging against his rear as he walked.

Thus heavily laden with the spoils of antiquity, the good little man, during a sojourn at Terracina, mounted one day the rocky cliffs whic overhang the town, to visit the

castle of Theodoric. He was groping about the ruins, towards the hour of sunset, buried in his reflections, his wits no doubt woolgathering among the Goths and Romans, when he heard footsteps behind him.

He turned, and beheld five or six young fellows, of rough, saucy demeanor, clad in a singular manner, half pleasant, half huntsman, with carbines in their hands. Their whole appearance and carriage left him no doubt into what company he had fallen.

The doctor was a feeble little man, poor in look, and and poorer in purse. He had but little gold or silver to be robbed of, but then he had his curious ancient coin in his breeches pocket. He had, moreover, certain other valuables, such as an old silver watch, thick as a turnip, with figures on it large enough for a clock, and a set of seals at the end of a steel chain, dangling half way down to his knees. All these were of precious esteem, being family relics. He had also a seal ring, a veritable antique *itaglio*, that covered half his knuckles. It was a Venus, which the old man almost worshiped with zeal of a voluptuary. But what he most valued was his inestimable collection of hints relative to the Pelasgian cities, which he would gladly have given all the money in his pocket to have had safe at the bottom of his trunk in Terracina.

However, he plucked up a stout heart, at least as stout a heart as he could, seeing that he was but a puny little man at the best of times. So he wished the hunters a *buon giorno*. They returned his salutation, giving the old gentleman a social slap on the back that made his heart leap into his throat.

They fell into conversation, and walked for some time together among the heights, the doctor wishing them all the while at the bottom of the crater Vesuvius. At length they came to a small *osteria* on the mountain, where they proposed to enter and have a cup of wine together. The doctor consented, though he would as soon have been invited to drink hemlock.

One of the gang remained sentinel at the door; the others swaggered into the house, stood their guns in the corner of the room, and each drawing a pistol or stilleto out of his belt, laid it upon the table. They now drew benches round the board, called lustily for wine, and hailing the doctor as though he had been a boon companion of long standing, insisting upon his sitting down and making merry.

The worthy man complied with forced grimace, but

with fear and trembling, sitting uneasily on the edge of his chair, eyeing ruefully the black-muzzled pistols, and cold, naked stilettos, and supping down heartburn with every drop of liquor. His new comrades, however, pushed the bottle bravely, and plied him vigorously. They sang, they laughed, told excellent stories of their robberies and combats, mingled with many ruffian jokes, and the little doctor was fain to laugh at all their cutthroat pleasantries, though his heart was dying away at the very bottom of his bosom.

By their own account, they were young men from the villages, who had recently taken up this line of life out of the wild caprice of youth. They talked of their murderous exploits as a sportsman talks of his amusements; to shoot down a traveller seemed of little more consequence to them than to shoot a hare. They spoke with rapture of the glorious roving life they led,—free as birds, here to-day, gone to-morrow, ranging the forests, climbing the rocks, scouring the valleys, the world their own wherever they could lay hold of it, full purses, merry companions, pretty women. The little antiquary got fuddled with their talk and their wine, for they did not spare bumpers. He half forgot his fears, his seal ring, and his family watch; even the treatise on the Pelasgian cities, which was warming under him, for a time faded from his memory in the glowing picture that they drew. He declares that he no longer wonders at the prevalence of this robber mania among the mountains, for he felt at the time that, had he been a young man and a strong man, and had there been no danger of the galleys in the background, he should have been half tempted himself to turn bandit.

At length the hour of separating arrived. The doctor was suddenly called to himself and his fears by seeing the robbers resume their weapons. He now quaked for his valuables, and, above all, for his antiquarian treatise. He endeavored, however, to look cool and unconcerned, and drew from out his deep pocket a long, lank, leathern purse, far gone into consumption, at the bottom of which a few coins chinked with the trembling of his hand.

The chief of the party observed his movement, and laying his hand upon the antiquary's shoulder, "Harkee! *Signor Dottore!*" said he, "we have drunk together as friends and comrades; let us part as such. We understand you. We know who and what you are, for we know who everybody is that sleeps at Terracina, or that puts foot upon the road. You are a rich man, but you carry all your

wealth in your head. We cannot get at it, and we should not know what to do with it if we could. I see you are uneasy about your ring; but don't worry yourself, it is not worth taking. You think it an antique, but it's a counterfeit—a mere sham."

Here the ire of the antiquary rose; the doctor forgot himself in his zeal for the character of his ring. Heaven and earth! his Venus a sham? Had they pronounced the wife of his bosom "no better than she should be," he could not have been more indignant. He fired up in vindication of his *intaglio*.

"Nay, nay," continued the robber, "we have no time to dispute about it; value it as you please. Come, you're a brave little old *signor*. One more cup of wine, and we'll pay the reckoning. No compliments; you shall not pay a grain; you are our guest. I insist upon it. So now make the best of your way back to Terracina; it's growing late. *Buono viaggio!* And harkee, take care how you wander among these mountains; you may not always fall into such good company."

They shouldered their guns, sprang gayly up the rocks, and little doctor hobbled back to Terracina, rejoicing that the robbers had left his watch, his coins, and his treatise unmolested, but still indignant that they should have pronounced his Venus an imposter.—WASHINGTON IRVING.

AMERICANISM—AN ATTEMPT AT A DEFINITION.

There are many words in circulation among us which we understand fairly well, which we use ourselves, and which we should, however, find it difficult to define. I think that *Americanism* is one of these words; and I think also it is well for us to inquire into the exact meaning of this word, which is often most carelessly employed. More than once of late have we heard a public man praised for his "aggressive Americanism," and occasionally we have seen a man of letters denounced for his "lack of Americanism." Now what does the word really mean when it is thus used?

It means, first of all, a love for this country of ours, an appreciation of the institutions of this nation, a pride in the history of this people to which we belong. And to this extent *Americanism* is simply another word for *patriotism*. But it means also, I think, more than this: it means

a frank acceptance of the principles which underlie our government here in the United States. It means, therefore, a faith in our fellow-man, a belief in liberty and in equality. It implies, further, so it seems to me, a confidence in the future of this country, a confidence in its destiny, a buoyant hopefulness that the right will surely prevail.

In so far as Americanism is merely patriotism, it is a very good thing. The man who does not think his own country the finest in the world is either a pretty poor sort of a man or else he has a pretty poor sort of a county. If any people have not patriotism enough to make them willing to die that the nation may live, then that people will soon be pushed aside in the struggle of life, and that nation will be trampled upon and crushed; probably it will be conquered and absorbed by some race of a stronger fiber and of a sterner stock. Perhaps it is difficult to declare precisely which is the more pernicious citizen of a republic when there is danger of war with another nation—the man who wants to fight, right or wrong, or the the man who does not want to fight, right or wrong; the hot-headed fellow who would plunge the country into a deadly struggle without first exhausting every possible chance to obtain an honorable peace, or the coldb-looded person who would willingly give up anything and everything, including honor itself, sooner than risk the loss of money which every war surely entails. "My country, right or wrong'" is a good motto only when we add to it, "and if she is in the wrong, I'll help to put her in the right." To shrink absolutely from a fight where honor is really at stake, this is the act of a coward. To rush violently into a quarrel when war can be avoided without the sacrifice of things dearer than life, this is the act of a fool.

True patriotism is quiet, simple, dignified; it is not blatant, verbose, vociferous. The noisy shriekers who go about with a chip on their shoulders and cry aloud for war upon the slightest provocation belong to the class contemptuously known as "Jingoes." They may be patriotic,—and as a fact they often are,—but their patriotism is too frothy, too hysteric, too unintelligent, to inspire confidence. True patriotism is not swift to resent an insult, on the contrary, it is slow to take offence, slow to believe that an insult could have been intended. True patriotism, believing fully in the honesty of its own acts, assumes also that others are acting with the same honesty. True patriotism, having a solid pride in the power and resources of our country, doubts

always the likelihood of any other nation being willing carelessly to arouse our enmity.

In so far, therefore, as Americanism is merely patriotism it is a very good thing, as I have tried to point out. But Americanism is something more than patriotism. It calls not only for love of our common country, but also for respect for our fellow-man. It implies an actual acceptance of equality as a fact. It means a willingness always to act on the theory, not that "I'm as good as the other man," but that "the other man is as good as I am." It means leveling up rather than leveling down. It means a regard for law, and a desire to gain our wishes and to advance our ideas always decently and in order, and with deference to the wishes and the ideas of others. It leads a man always to acknowledge the good faith of those with whom he is contending, whether the contest is one of sport or of politics. It prevents a man from declaring, or even from thinking, that all the right is on his side, and that all the honest people in the country are necessarily of his opinion.

And, further, it seems to me that true Americanism has faith and hope. It believes the world is getting better, if not year by year, at least century by century; and it believes also that in this steady improvement of the condition of mankind these United States are destined to do their full share. It holds that, bad as many things may seem to be to-day, they were worse yesterday, and they will be better to-morrow. However dark the outlook for any given cause may be at any moment, the man imbued with the true spirit of Americanism never abandons hope and never relaxes effort; he feels sure that everything comes to him who waits. He knows that all reforms are inevitable in the long run; and that if they do not finally establish themselves it is because they are not really reforms, tho for a time they may have seemed to be.

And a knowledge of the history of the American people will supply ample reasons for this faith in the future. The sin of negro-slavery never seemed to be more secure from overthrow than it did in the ten years before it was finally abolished. A study of the political methods of the past will show that there has been immense improvement in many respects; and it is perhaps in our political methods that we Americans are most open to censure. That there was no deterioration of the moral stamina of the whole people during the first century of the American republic any student can make sure of by comparing the spirit which ani-

mated the inhabitants of the thirteen colonies during the
Revolution with the spirit which animated the population of
the northern states (and of the southern no less) during the
civil war. We are accustomed to sing the praises of our
grandfathers who won our independence, and very properly;
but our grandchildren will have also to sing the praises of
our fathers who stood up against one another for four years
of the hardest fighting the world has ever seen, bearing the
burdens of a protracted struggle with an uncomplaining
cheerfulness which was not a characteristic of the earlier war.

True Americanism is sturdy but modest. It is as far
removed from "Jingoism" in times of trouble as it is from
"Spread-Eagleism" in times of peace. It is neither vain-
glorious nor boastful. It knows that the world was not created
in 1492, and that July 4, 1776, is not the most important date
in the whole history of mankind. It does not overestimate
the contribution which America has made to the rest of the
world, nor does it underestimate this contribution. True
Americanism, as I have said, has a pride in the past of this
great country of ours, and a faith in the future; but none the
less it is not so foolish as to think that all is perfection on
this side of the Atlantic, and that all is imperfection on the
other side.

It knows that some things are better here than any-
where else in the world, that some things are no better, and
that some things are not so good in America as they are in
Europe. For example, probably the institutions of the nation
fit the needs of the population with less friction here in the
United States than in any other country in the world. But
probably, also, there is no other one of the great nations of
the world in which the government of the large cities is so
wasteful and so negligent.

True Americanism recognizes the fact that America
is the heir of the ages, and that it is for us to profit as best
we can by the experience of Europe, not copying servilely
what has been successful in the old world, but modifying
what we borrow in accord with our own needs and our own
conditions. It knows, and it has no hesitation in declaring,
that we must always be the judges ourselves as to whether
or not we shall follow the example of Europe. Many times
we have refused to walk in the path of European precedent,
preferring very properly to blaze out a track for ourselves.
More often than not this independence was wise, but now
and again it was unwise.

Finally, one more quality of true Americanism must

be pointed out. It is not sectional. It does not dislike an idea, a man, or a political party because that idea, that man, or that party comes from a certain part of the country. It permits a man to have a healthy pride in being a son of Virginia, a citizen of New York, a native of Massachusetts, but only on condition that he has a pride still stronger that he is an American, a citizen of the United States. True Americanism is never sectional. It knows no north and no south, no east and no west. And as it has no sectional likes and dislikes, so it has no international likes and dislikes. It never puts itself in the attitude of the Englishman who said, "I've no prejudices, thank Heaven, but I do hate a Frenchman!" It frowns upon all appeals to the former allegiance of naturalized citizens of this country; and it thinks that it ought to be enough for any man to be an American without the aid of the hyphen which makes him a British-American, an Irish-American, or a German-American.

True Americanism, to conclude, feels that a land which bred Washington and Franklin in the last century, and Emerson and Lincoln in this century, and which opens its schools wide to give every boy the chance to model himself on these great men, is a land deserving of Lowell's praise as "a good country to live in, a good country to live for, and a good country to die for."—*Reprinted by permission from* BRANDER MATTHEWS: Parts of speech (copyrighted.)

— Rede von —

Carl Schurz.

Gehalten am 5. September 1896 in Chicago.

„Du sollst nur einen Gott anbeten, den Gott der Wahrheit, der Ehre und der Rechtschaffenheit, und ihm allein sollst Du dienen“.

Mitbürger! Ich bin aus dem Osten nach dem Westen gekommen, um zu Ihnen über ehrliches Geld zu sprechen. Ich bilde mir nicht ein, in „Feindesland“ zu sein. Für mich giebt es kein Feindesland innerhalb der Grenzen dieser Republik. Wo immer ich unter Amerikanern bin, bin ich unter Mitbürgern und Freunden, die auf's Engste mit einander durch gemeinsame Interessen und einen gemeinschaftlichen Patriotismus verbunden sind. In diesem Geiste werde ich die Tagesfrage besprechen, und ich werde mich nicht mit schwierigen Finanztheorien abgeben, sondern mit einfachen, nackten Thatsachen rechnen.

Es herrscht stellenweise Unzufriedenheit im Lande, und zwar ist diese Unzufriedenheit theilweise begründet, theilweise aber auch durch künstliche Agitation angefacht. Wer sind die Unzufriedenen? Es sind Farmer, die sich über die niedrigen Preise der landwirthschaftlichen Produkte beklagen; es sind Arbeiter, die über die Schwierigkeit, Arbeit und Verdienst zu finden,

klagen; ferner sind es Leute aller möglichen Berufsarten, die über die allgemeine Stockung im Handel und Wandel und über die Knappheit des Geldes klagen. In gewissen Landestheilen, besonders im Süden und Westen, klagen die Leute darüber, daß zu wenig verfügbares Capital vorhanden und der Zinsfuß ein zu hoher sei. Das Geschrei nach „mehr Geld“ findet allgemeinen Anklang.

Das sind die hauptsächlichsten und faßbarsten Klagen. Außer diesen aber hat sich bei vielen Leuten in Folge der Brandreden von Agitatoren der Gedanke festgesetzt, daß eine wohlorganisirte Verschwörung unter den Geldleuten bestehe, hauptsächlich unter den Bankiers in Amerika und Europa und gestützt durch die Fürsten und Aristokraten der alten Welt, eine Verschwörung, welche den Zweck habe, den Goldstandard überall einzuführen, um das Geld der Welt zu monopolisiren, zu „cornern“, zum Nachtheile der Massen.

Diese Klagen und Befürchtungen haben in der folgenden Erklärung des

Artikel: „Wir erklären, daß das Währungsgesetz von 1873, durch welches das Silber ohne Wissen und Zustimmung des amerikanischen Volkes demonetisirt worden ist, zugleich zu einer Wertherhöhung des Goldes und gleichzeitigen Preiserniedrigung aller vom Volke erzeugten Waaren und Lebensmitteln geführt hat; zu einer starken Vermehrung der Steuerlasten sowohl wie der öffentlichen und privaten Schulden; zur Bereicherung der Geldverleiher hierzulande und im Auslande, zur Lahmlegung der Industrie und zur Verarmung des Volkes."

Man merke wohl, alle diese üblen Folgen werden der Demonetisirung des Silbers zugeschrieben, und zwar der Demonetisirung des Silbers in den Ver. Staaten allein, nicht der Demonetisirung sonstwo. Das hat man gethan, um das vorgeschlagene Heilmittel zu rechtfertigen, nämlich die Freiprägung von Silber in den Ver. Staaten allein, ohne erst auf die Zustimmung anderer Nationen zu warten."

Die Platform wird durch die Freisilber-Redner erläutert, welche uns zu beweisen suchen, daß das Gesetz von 1873, das sie mit Vorliebe „das Verbrechen von 1873" nennen, eine Hälfte des Geldes des Volkes, nämlich das Silber, mit dem nassen Schwamme ausgewischt habe; daß in Folge dessen die übrig bleibende Hälfte unseres Münzgeldes, nämlich das Gold, dieselben Geschäfte thun mußte, die vordem beide, von Gold und Silber, gethan worden sind; daß dadurch das Gold fast die doppelte Kaufkraft gegen früher erlangt hätte, der Golddollar eigentlich zu einem 200 Cents-Dollar geworden sei; daß daher Jeder, welcher für den Markt etwas producire, um die Hälfte des Preises beraubt werde, während Schulden, welche in Gold zahlbar gemacht sind, doppelt schwer drücken, daß dieser Sturz aller Preise eintritt und diese Vermehrung der

immer mehr bedrücke.

Sind alle diese Klagen aber auch begründet? Lassen wir Thatsachen sprechen, die Niemand bestreitet. Daß seit 1873 die Waarenpreise stark gefallen sind, ist wahr. Es frägt sich aber, ob dieses Fallen der Preise durch die sogenannte Demonetisirung des Silbers in Folge des Münzgesetzes von 1873 herbeigeführt worden ist.

Ganz abgesehen von anderen Perioden unserer Geschichte, wie z. B. jener von 1846 bis 1851, weiß Jedermann, daß schon vor 1873 nicht nur die Preise gewisser Farmprodukte bedeutend zurückgingen, Baumwolle fiel z. B. von $1 per Pfund im Jahre 1864 auf 17 Cents per Pfund in 1871, sondern daß auch die Preise vieler Fabrikate gefallen sind. Was aber vor 1873 geschehen ist, kann doch unmöglich durch das verursacht worden sein, was sich erst im Jahre 1873 zugetragen hat. Das ist doch klar! Der Preisrückgang nach 1873 könnte also doch auch andere Ursachen haben.

Noch Etwas ist ebenso unklar. Wenn immer ein Umschlag in den Waaren- und Lebensmittel-Preisen in Folge von Veränderungen von Angebot und Nachfrage eintritt, so werden dadurch nicht alle Artikel gleichmäßig berührt. Weizen kann z. B. im Preise steigen, weil der Vorrath gering ist, während die Baumwolle, von der im Ueberfluß vorhanden ist, im Preise fällt. Wenn aber in Folge einer großen Veränderung in der Kaufkraft des Geldes auch die Waarenpreise in Mitleidenschaft gezogen werden, so muß, besonders wenn diese Veränderung eine plötzliche ist, die Wirkung auf die Waarenpreise auch eine augenfällige und eine verhältnißmäßig gleichmäßige für alle Waaren sein, welche mit dem Gelde gekauft oder verkauft werden. Wenn durch die sogenannte Demonetisirung des Silbers im Jahre 1873 der Golddollar oder vielmehr der nach Gold ge-

...Dollar zu einem 200 Cents-Dollar geworden ist, dann ist er es, wenn überhaupt, plötzlich geworden, und zwar für alle Güter und Waaren zugleich. Er konnte nicht zur selben Zeit ein 200 Cents-Dollar für Weizen und ein 120 Cents-Dollar für Kohlen, ein 180 Cents-Dollar für Baumwolle und ein 100 Cents - Dollar für Mais oder für Schaufeln sein. Niemand kann dem widersprechen.

Nun zu Thatsachen. Das Münzgesetz trat am 12. Februar 1873 in Kraft. Und was war die Wirkung? Weizen, Roggen, Hafer und Mais stiegen im Preise höher, als sie im Jahre 1872 standen, während Baumwolle zurückging. In 1874 fiel Weizen ein wenig, während Mais einen Sprung in die Höhe machte; Baumwolle fiel; Hafer und Roggen stiegen im Preise. Im Jahre 1876 stiegen die Weizenpreise, während Mais, Roggen Hafer und Baumwolle fielen. 1877 stieg Weizen abermals, sogar über den Preis von 1870 hinaus, und erreichte die Höhe von 1871. also einer Zeit, welche lange vor der Gesetzgebung von 1873 lag. Wir sehen also, daß der 200 Cents-Dollar nicht die Wirkung gehabt hat, die ihm die Silberleute andichten. Selbst zugegeben, daß die Silberleute recht hätten, wenn sie sagen, das Währungsgesetz von 1873 sei in aller Heimlichkeit erlassen worden, das Volk habe nichts davon gewußt und deshalb seien auch die Waarenpreise nicht sofort davon beeinflußt worden und seien deshalb stabil geblieben, weil sie in ihrer Unschuld keine Ahnung von den schrecklichen Dingen hatten, die sich zugetragen. Selbst wenn dem so wäre, dann brauchten die Wissenden nur zu schweigen und der Golddollar würde ein ganz ... 100 Cents - Dollar geblieben sein und Niemandem wäre ein ... geträumt worden. Doch, ... bei Leute, es darf nicht unerwähnt werden, daß, als das Gesetz von ... erlassen wurde, wir überhaupt nur Papiergeld im Gebrauch hatten,

...e im Jahre 1891 2, 3 und 4
...s mehr, als im Jahre 1879.

Hätte das Münzgesetz von 1873 die
...raft des Dollars wirklich ver-
mehrt, so würde es diese Wirkung sofort
und gleichmäßig für alle Waarenpreise
offenbart haben. Da es aber diese
Wirkung nicht einmal in den ersten
...Jahren nach seinem Erlasse gezeigt
hat, so ist es absurd, zu behaupten, daß
diese Wirkung erst jetzt, also zwanzig
Jahre nach seiner Inkrafttretung, ver-
spürt wird. Ist das nicht klar?

Sollte jedoch angesichts dieser That-
sachen noch Jemand glauben, daß die
Demonetisirung des Silbers durch das
Gesetz von 1873 auf irgend eine geheim-
nißvolle Weise das Sinken der Preise
verursacht habe, so möchte ich denselben
darauf aufmerksam machen, daß der
Silberdollar schon lange vor 1873 de-
monetisirt war. Nach den Reden un-
serer Freiprägungs = Apostel zu urtheil-
en, muß das amerikanische Volk vor
1873 förmlich in Silberdollars gewatet
haben. Doch, wie steht die Sache in
Wirklichkeit? Präsident Jefferson ließ
im Jahre 1806 die Prägung des Sil-
berdollars einstellen. Von 1783 bis
1878 wurden, — abgesehen von den
Scheidemünzen, die seit 1853 nur im
beschränkten Maße gesetzliches Zahlmit-
tel waren — nur ungefähr 8,000,000
Silberdollars geprägt. Sie waren
so rar, daß man selten einen zu Gesicht
bekam, außer in einem Raritäten=Ge-
schäft als seltene Münzen. Es bestan-
den fortwährend Schwierigkeiten wegen
des gesetzlichen Verhältnisses von Gold
und Silber, da man nie im Stande
war, es festzusetzen, damit beide Me-
talle neben einander in Umlauf blieben.
Das eine Mal wurde das Eine aus dem
Lande getrieben, das andere Mal das
Andere. Inzwischen wurden über
2,000,000,000 Dollars in Goldmünzen
geprägt und seit 1853 war thatsächlich
Gold das einzige Geld mit gesetzlicher
Zahlkraft, das in Umlauf war. Und

gute Zeiten. Dann kam der ...
krieg und fegte unser ganzes Metall-
geld hinweg. An die Stelle dessel...
trat Papiergeld, und in dieser Lage
blieben wir bis 1873, als das so viel-
genannte Gesetz von 1873 erlassen wur-
de. Und welcher Art war denn eigent-
lich dieses Gesetz, das seitdem mit so
großem Geschrei als das „Verbrechen
in 1873" bezeichnet worden ist? Nach
den Aeußerungen der Freiprägungs=
Redner muß es ein Gesetz gewesen sein,
das mit einem Schlage die Hälfte des
unter dem Volke cirkulirenden Geldes
aus der Welt schaffte. Hat es das
wirklich gethan? Keineswegs! Es war
einfach ein Gesetz zur Revidirung unse-
rer Münzgesetze, und verfügte unter An-
derem, daß gewisse Silbermünzen ge-
schlagen werden und bei Bezahlung von
Schulden als gesetzliches Zahlmittel gel-
ten sollten, jedoch nur in beschränktem
Maße. Der „Standard" = Silberdol-
lar, der, seitdem Präsident Jefferson
1806 die Prägung eingestellt hatte, aus
dem Verkehr so gut wie verschwunden
war, wurde in dem Gesetz gar nicht er-
wähnt. Das ist die ganze Geschichte.
Das Gesetz von 1873 schuf daher kei-
neswegs ganz neue Verhältnisse, son-
dern brachte nur die Verhältnisse, welche
seit vielen Jahren bestanden hatten,
wieder zur Geltung. Es vernichtete
nicht nur nicht die Hälfte des Geldes
des Landes, sondern nicht einmal einen
einzigen Dollar.

Das Verbrechen von 1873.

Aber, frägt man, wenn das der Fall
ist, weshalb wurde es denn mit so gro-
ßer Heimlichkeit durchgeschmuggelt?
Haben doch die Silber=Redner seit Jah-
ren dem Volke so lange, bis Millionen
es glaubten, vorgeredet, daß der Sil-
berdollar durch das Gesetz von 1873
von einem schwarzen, corrupten Com-
plott meuchlings beiseite geschafft wor-
den sei. Dieses Märchen ist schon so
oft und so unbestritten widerlegt wor-

ben, daß ich nicht auf Einzelheiten ein=
gehen will. Erst kürzlich hat es Sena=
tor Sherman in der überzeugendsten
Weise gethan. Ich will nur noch hin=
zufügen, daß ich zu jener Zeit ein Mit=
glied des Senats war und daher weiß,
wovon ich spreche; und ich erkläre alle
jene Vorbereiten, daß das Gesetz von 1873
heimlich angenommen worden sei, daß
Senatoren und Repräsentanten gewis=
sermaßen hypnotisirt gewesen seien, so
daß sie nicht wußten, was sie thaten,
daß gewisse Engländer mit einem Hau=
fen Gold in Washington gewesen seien,
um die Demonetisirung des Silbers zu
betreiben, und so weiter, und so weiter,
ganz entschieden als falsch und erlogen.
Ich möchte mich meinen Gegnern gegen=
über einer peinlichen Höflichkeit beflei=
ßigen. Allein als ein gewissenhafter
Kenner unserer zeitgenössischenGeschich=
te bin ich gezwungen zu sagen, daß mir
in den vierzig Jahren, in denen ich die
öffentlichen Angelegenheiten aufmerk=
sam beobachtet habe, niemals eine solch
gewissenlose, schamlose, absichtliche,
freche und riesenhafte Lügerei vorge=
kommen ist, wie bezüglich des Gesetzes
von 1873, seines Ursprungs, seines
Inhalts und seiner Wirkungen.

Wie kam es, daß das Gesetz von 1873
damals nicht die öffentliche Aufmerk=
samkeit in größerem Maße erregte?
Einfach daher, weil Jedermann, der sich
für die Sache interessirte, das Einstel=
len der Prägung des veralteten Silber=
dollars als gesetzliche Anerkennung ei=
ner vollendeten Thatsache, als etwas
Selbstverständliches betrachtete, unge=
fähr wie ein Gesetz, welches verfügen
würde, daß die alten Feuerschloß=Flin=
ten nicht mehr in der Armee gebraucht
werden sollten. Und wie kam es, daß
wenige Jahre später so viel Wesens da=
von gemacht wurde? Auch dafür gab
es eine sehr einfache Ursache. Im
Jahre 1873 war der Marktwerth des
Silbers, wenn auch schon im Weichen
begriffen, noch hoch. Das Silber im
Silberdollar war $1.02 werth. Der
Silberminenbesitzer fühlte sich wohl,

$1.02 nach der Münze zu bringen, um
$1.00 dafür zurückzubekommen. Er
war damals ein enthusiastischer Freund
von Gold. Allein ein paar Jahre spä=
ter war der Marktwerth des Silbers
bedeutend gesunken, und als der Sil=
berminenbesitzer 90 Cents werth Silber
nach der Münzstätte bringen und da=
für $1.00 erhalten konnte, war er mit
Herz und Seele für Silber, und seine
Vorliebe für Silber wuchs, je mehr
Vortheil er aus der Freiprägung ziehen
konnte. Der Silberminenbesitzer ist
ohne Frage ein großer und guterMann,
aber er gehört gerade nicht zu den selbst=
losesten Philanthropen. Er weiß, wo
sein Weizen blüht. Als ihm das Ge=
setz von 1873 lästig wurde, entdeckte er
mit einem Male, daß es ein schändliches
Verbrechen sei, nicht gegen die Berg=
werks=Millionäre, sondern gegen das
gemeine Volk. Noch eine andere Classe
von Leuten schloß sich ihm im Lamenti=
ren an, nämlich Diejenigen, welche für
Inflation unseres uneinlösbaren Pa=
piergeldes gewühlt, sich der Wiederauf=
nahme der Baarzahlung widersetzt hat=
ten und jetzt für den Silberdollar sind,
weil das darin enthaltene Silber im
Markte weniger werth ist, als ein Gold=
dollar, und durch seine Prägung daher
„billiges Geld", wie sie es nennen, ge=
schaffen werden würde. Und dann be=
gann jene lügenhafte Campagne, die,
was schamlosen Betrug anbetrifft, so
viel ich weiß, niemals ihres Gleichen ge=
habt hat.

Man merke wohl, was nun folgte.
Eingeschüchtert durch das wilde Ge=
schrei der Silberminenleute, das bei den
Anhängern von „billigem Geld" ein Echo
fand, erließ der Congreß zwei Gesetze,
eins im Jahre 1878, das andere 1890,
in Folge dessen unser Geldvorrath um
429,000,000 Silberdollars vermehrt
wurde, um fünfzigmal mehr, als je zu=
vor geprägt waren, und außerdem wur=
den noch eine Menge mehr Scheidemün=
zen ausgegeben. Auch unser Papier=
geld=Vorrath wurde bedeutend ver=
mehrt, sodaß, während im Jahre 1878

dem ████, ██ ███████ ███ ███████
██ ██ █████ ██████ █████ ███████
█████, ██ ██████████ ██ ██ ███
██████ █████ ██ $774,000,000 ██
███, ███ ██ ██ Jahre 1893 $2,217,000,-
000 an Gold hatten, also nahezu doppelt so viel; und während 1878 die Cirkulation $18.04 per Kopf der Bevölkerung betrug, sie sich im Jahre 1895 auf $22.96 per Kopf belief. Obgleich wir somit fünfzigmal mehr Silberdollars, und viel mehr Geld von allen Sorten hatten, als dieses Land in den Zeiten des größten Wohlstandes aufweisen konnte, fiel der Werth des Silbers noch fortwährend, ebenso wie die Preise vieler Lebensbedürfnisse, einschließlich der Farmprodukte. Auf welche Beweise stützen nun die Silberfreunde ihre Behauptung, daß die sogenannte Demonetisirung des Silbers die Preise herabgesetzt habe? Nach ihrer Beweisführung war nicht genug Geld da, um die Preise zu halten. Was für Preise? Diejenigen, welche vor 1873 bestanden. Dabei haben wir aber jetzt dreimal so viel Geld, wie in 1873, und eine bedeutend höhere Geld-Cirkulation per Capita. Wo bleibt also die Beweisführung der Silberleute? Einige Silber-Philosophen haben eine noch geheimnißvollere Redewendung erfunden—daß die Preise heruntergegangen seien, weil durch das Gesetz von 1873 das zur endgültigen Einlösung von Papiergeld verwendbare Geld — für welchen Zweck nur Gold verwendbar ist — geschädigt worden sei. Jedoch nach den Statistiken des Schatzamtes hatten wir 1873 nur 25 Millionen Dollars an Metallgeld, einschließlich der Scheidemünzen, während wir jetzt allein über 600 Millionen Dollars an Gold, also mehr als 24 Mal mehr „zur Einlösung verwendbares Geld" haben, als in 1873. Und dennoch sind die Preise niedrig. Wer sich durch solche Thatsachen nicht überzeugen läßt, daß das Fallen der Preise nicht durch irgend welche, durch das Gesetz von 1873 auf unseren Geldvorrath ausgeübte Einflüsse verursacht worden sein

████, ███ ████ ██████ ██████ ███
███, ██ ███ ████ ██ ███████ ████
█████ █████ ████████ ██████ ████
████.

Was aber ist denn die Ursache des Sinkens der Preise gewesen? Ich appellire einfach an Ihren gesunden Menschenverstand. Glauben Sie, daß und jetzt ein Mann mit Hülfe von Maschinen soviel Arbeit zu Stande bringt, als früher zehn oder mehr; wo unsere modernen Transportmittel die Produkte fünfmal so schnell vom Produzenten zum Consumenten befördern, und zwar für den fünften Theil der früheren Kosten, und wo bei Mittheilungen von Ort zu Ort die Zeit gar keine, und die Kosten nur eine sehr kleine Rolle spielen, glauben Sie, daß da das Produkt der menschlichen Arbeit nicht verhältnißmäßig billiger sein sollte? Wäre das nicht der Fall, dann würde die Civilisation in einer ihrer wichtigsten und segensreichsten Funktionen gänzlich erfolglos sein. Denn was bezweckt der erfinderische Geist des Zeitalters, der sich mit praktischen Gegenständen beschäftigt, anders, als Mittel und Wege zu finden und zu eröffnen, durch welche die Lebensbedürfnisse des Menschen besser und leichter erreichbar — das heißt billiger — gemacht werden?

Der Farmer in den Vereinigten Staaten bewillkommnete die Ackerbau-Maschinen, welche ihm das Pflanzen, Aufziehen und Einheimsen seines Getreides erleichterten. Er bewillkommnete die Eisenbahnen, das Dampfboot, die niedrigen Frachtraten, den Telegraphen, welche die Entfernungen zwischen seiner Farm und dem Markt verringerten, sowie auch die Bankeinrichtungen, die für den Umsatz und Verkauf seiner Produkte erforderlich sind. Da jedoch fast allen unseren Farmern dieselben Vortheile zu Gebote standen, so war eine natürliche Folge davon die, daß der Weizenertrag dieses Landes von einem jährlichen Durchschnitt von 312,000,000 Bushels in der Periode von 1870 bis 1880 auf einen jährlichen

Durchschnitt von 475,000,000 Bu-
shels in der Zeit von 1890
—1895 stieg. Aber auch den aus-
ländischen Nationen kamen jene Vor-
theile zu Gute; neue Weizendistrikte
wurden in Rußland, der Argentinischen
Republik und anderswo eröffnet und
nach Bradstreet's, eine sehr zuverlässige
Quelle, nahm die Weizenproduktion der
Welt in der Zeit von 1889 bis 1894
um nicht weniger als 429,000,000
Bushels zu, während die Zunahme des
Weizen-Consums der Welt auf nur
12,000,000 bis 16,000,000 Bushels
per Jahr geschätzt wird. Wenn daher
der Ertrag der Welt in solchem Maße
dem Verbrauch vorausläuft, ist es da
ein Wunder, daß auf dem Weltmarkt,
welcher die Preise für alle exportirenden
Länder regulirt, die Preise herunter-
gehen? Ist das nicht eine weit ver-
nünftigerer Erklärung für das Sinken
der Preise, als daß man es dem soge-
nannten Demonetisirungs-Gesetz von
1873 in die Schuhe schiebt, welches in
Wirklichkeit gar nichts demonetisirte,
auf welches vielmehr eine Vermehrung
unseres Geldvorrathes um beinahe das
Dreifache folgte und welches die Kopf-
rate auf einen weit höheren Punkt
brachte, als sie je zuvor gewesen, und
als sie in irgend einem anderen Lande,
eins ausgenommen, ist? Gerade so
gut könnte man unseren Bürgerkrieg
oder den großen Kometen von 1811 da-
für verantwortlich machen.

Ursachen der Unzufriedenheit.

Erlauben Sie mir hier ein paar
Worte darüber zu sagen, was nach mei-
ner unmaßgeblichen Meinung die wahre
Ursache der Unzufriedenheit, soweit ehr-
liche Leute in Betracht kommen, ist. Die
neuen volkswirthschaftlichenVerhältnis-
nisse, wie sie in unserem Zeitalter etwas
plötzlich durch die riesige Verbesserung
der Productions- und Transportmittel
geschaffen wurden, haben eine große
Zahl nachdenkenderLeute inErstaunen
gesetzt und verwirrt. Sie wurden durch
die natürliche Folge dieserVerhältnisse,
das Heruntergehen der Preise sowohl
der Farm- wie Industrie-Produkte,
und dadurch, daß im Allgemeinen der
Profit auf ein Minimum verringert
wurde, besorgt gemacht. Manche ver-
standen es schwer, ihr Urtheil dieser
neuen Lage der Dinge anzupassen. Sie
wollten in diesem ganzen Wechsel nicht
eine natürliche Entwickelung von dau-
ernder Wirkung sehen und ließen sich
willig zu der Ansicht verleiten, daß dem-
selben irgend etwasUnrechtes zuGrunde
liege, irgend eine Verschwörung der
Reichen, ein Hokus-Pokus, der mit
dem Gelde des Landes getrieben werde,
wie vereinst jedeViehkrankheit aufHexe-
rei zurückgeführt wurde, und wie noch
in diesem Jahrhundert das Auftreten
der Cholera einer Verschwörung der
Juden zur Vergiftung derBrunnen zu-
geschrieben ward. Ehrliche Leute mit
derart verkehrten Ansichten fielen so-
wohl den ebenfalls ehrlichen finanziellen
Quacksalbern, wie den unehrlichen De-
magogen leicht zur Beute. Und so
brachte man ihnen die Ueberzeugung bei,
daß die sogenannte Demonetisation des
Silbers die wahre Ursache ihrer Be-
drängniß sei und daß die Freiprägung
von Silber die einzige Abhülfe sein
würde, während sie bei gründlicher Un-
tersuchung und ruhiger Ueberlegung er-
kannt haben würden, daß die wahre Ur-
sache der Fortschritt der Civilisation in
der Production und im Transport sei,
die wahre Abhülfe jedoch nur darin be-
stehe, daß wir unsere Lebensweise und
Geschäftsmethoden diesem Fortschritt
anpassen. Dies ist durch die Erfahrung
bewiesen. Es giebt heute trotz der nie-
drigen Preise eine große Anzahl erfolg-
reicher Farmer. Sie sind eben Farmer,
die ihr Geschäft verstehen. Andere wie-
der sind nicht erfolgreich. Der Grund
ist folgender: Die erfolgreichen Farmer
haben die sparsamstenProductions-Me-
thoden, die vortheilhaftesten Sorten von
Farmproducten und die sich immer ver-
ändernden Absatzgelegenheiten, wie sie
der Markt bietet, genau studirt, wäh-
rend die politischen Farmer „Coin's Fi-

nancial School" und die Frage studirt
haben, auf welche Weise Freiprägung
ihnen doppelt hohe Preise bringen würde
für das, was sie producirt haben wür-
den, wenn ihre financiellen Studien
nicht so viel von ihrer Zeit und Auf-
merksamkeit in Anspruch genommen
hätten.

Bei aufrichtiger Ueberlegung werden
sie erkennen, daß das von den Freiprä-
gungsleuten befürwortete Mittel, weil
es auf einer falschen Diagnose basirt,
nicht nur nicht helfen, sondern die Ver-
hältnisse, über die sie klagen, noch be-
deutend verschlimmern wird. Sie wür-
den vom Regen in die Traufe kommen.
Das Bryan'sche Mittel erleichtert eine
radikale Aenderung der Grundlage un-
seres Geldsystems. Und was ist das für
ein System? Das Geld der Ver. Staa-
ten besteht aus Goldmünzen, Silber-
münzen und fünf verschiedenen Sorten
von Papiergeld, die alle in Gold einlös-
bar sind oder deren Werth auf irgend
einem Umwege durch Gold garantirt ist.
Außerdem haben wir Nationalbankno-
ten, die von den Banken mit Greenbacks
eingelöst werden müssen, während die
Greenbacks dann wieder mit Gold ein-
lösbar sind. Es ist wahr, daß nominell
einige unserer Papiergeldsorten, die
Greenbacks und die Schatzamtsnoten in
„Coin", das heißt in Gold oder Silber,
je nach dem Gutdünken der Regierung,
einlösbar sind, doch thatsächlich hat man
stets angenommen, daß sie in Gold ein-
gelöst würden, wenn der Besitzer Gold
verlangte. Und diese Annahme ist im
Großen und Ganzen durch das Gesetz
von 1890 bestätigt worden. Dieses Ge-
setz schrieb den Ankauf von vier und ein
halb Millionen Unzen Silber per Mo-
nat und Ausstellung von Schatzamtsno-
ten für dasselbe vor, welch' letztere in
Gold- oder Silbermünzen einlösbar sein
sollen; und in Verbindung damit ent-
hielt das Gesetz die Erklärung, „daß es
ein feststehender politischer Grundsatz
der Ver. Staaten sei, die beiden Metalle
nach dem jetzigen, oder einem anderen

Verhältniß mit einander auf Pari zu
erhalten."

Man verstehe diese Worte recht! Wir
wollen, daß die Ver. Staaten als eine
ehrliche und ehrenhafte Nation dastehen,
und demnach muß diese von der Regie-
rung erlassene Erklärung auch als eine
ehrliche angesehen werden. In ehrlichem
Sinne aber kann diese Erklärung nur
diese eine Bedeutung haben: Die Re-
gierung sagt: „Ich gebe hier Papiergeld
aus, das ich nach meinem Gutdünken
entweder in Gold oder Silber einlösen
werde; sollte jedoch Jemand wegen des
Marktwerthes dieser beiden Metalle ir-
gendwie in Zweifel und besorgt sein, so
gebe ich hiermit die feierliche Erklärung
ab, daß es mein unerschütterlicher
Grundsatz ist, diese beiden Metalle in
Parität zu halten, das heißt, das eine
soll so viel gelten, wie das andere, wenn
auch dessen Marktwerth ein größerer ist.
Ihr könnt daher mein Papiergeld mit
vollem Vertrauen auf meine Ehre und
Rechtschaffenheit annehmen." Ich wie-
derhole nochmals, wenn unsere Regie-
rung eine ehrliche und ehrenhafte ist,
so kann jene Erklärung unmöglich eine
andere Bedeutung haben. Ich bestehe
daher auf meiner Behauptung, daß es
ein heiliges Versprechen seitens der Ver.
Staaten ist, die Kaufkraft des Silber-
dollars auf gleicher Höhe mit der des
Golddollars zu halten und kein Mittel
unversucht zu lassen, dieses Resultat her-
beizuführen. Wer bestreitet, daß jene
Erklärung dies nicht bedeutet, stempelt
die Regierung der Ver. Staaten zu ei-
nem Betrüger, einem Bauernfänger, der
unter falschen Vorspiegelungen Zah-
lungsversprechungen macht.

Auf welche Weise soll die Regierung
der Ver. Staaten dieses Versprechen
einlösen? Es würde für sie eine leichte
Sache sein, wenn das im Silberdollar
enthaltene Silber im Markt ebenso viel
werth wäre, wie das Gold im Golddol-
lar. Doch aus Gründen, die ich später
anführen werde, ist der Marktwerth des
Silbers um etwa 50 Prozent gefallen.

so daß man in dem Silberdollar ent-
haltene Silber im Markt als Waare für
etwas mehr als 50 Cents in Gold lau-
fen kann. Was ist demnach das Pro-
blem, das die Regierung jetzt zu lösen
hat? Gewisse Finanzphilosophen mit
„Fiat"-Ideen sagen: Wenn die Re-
gierung auf den Silberdollar ihren
Stempel gedrückt und ihn zum gesetzli-
chen Zahlmittel gemacht hat, so gab sie
ihm dadurch einen Werth, der so gut ist,
wie der des Golddollars, und damit hat
sie für immer ihre Pflicht erfüllt. Ist
dem so?

Bald nach dem Beginn unseres Bürger-
krieges gab die Regierung die „Green-
backs" aus. Der Greenback-Dollar war
ein Stück Papier, auf welchem das Ver-
sprechen gedruckt war, daß die Regierung
dem Besitzer einen Dollar — das heißt
einen Dollar in Goldmünze, denn an et-
was Anderes dachte kein Mensch — da-
für bezahlen werde. Er erhielt den
Stempel der Regierung und wurde zum
gesetzlichen Zahlmittel, ausgenommen
für auf importirte Waaren, gemacht.
Zuerst, als nur wenige Greenbacks aus-
gegeben waren und man hoffte, daß der
Krieg bald beendet und die Regierung
doch im Stande sein werde, sie einzulö-
sen, wurden sie überall zum vollen Werthe
mit Gold angenommen, obgleich damit
keine Einfuhrzölle bezahlt werden konn-
ten. Als jedoch der Krieg länger dau-
erte und die Menge der Greenbacks größer
und größer wurde, schwand das Ver-
trauen, daß die Regierung bald in der
Lage sein würde, sie einzulösen, und der
Greenback verlor trotz des Regierungs-
stempels und seiner Eigenschaft als ge-
setzliches Zahlmittel an Kaufkraft im
Verhältniß zu Gold. Auf Gold stand
ein Agio und es verschwand aus dem Ver-
kehr. Dieses Goldagio stieg um so höher,
je mehr die Masse der Greenbacks zunahm
und je weiter die Zeit, in der die Regie-
rung die letzteren möglicher Weise werde
einlösen können, in die Ferne gerückt er-
schien. Doch der Bürgerkrieg nahm ein
glückliches Ende, die Ausgabe von Green-
backs wurde eingestellt und ein Gesetz zur

Wiederaufnahme der Baarzahlung er-
lassen. Die Regierung sammelte Gold
und der Greenback schwang sich wieder
auf Pari mit Gold empor. Der Stem-
pel der Regierung und die Eigenschaft als
gesetzliches Zahlmittel hatten ihn weder
vor dem Sinken im Werth bewahrt, noch
sein Wiederemporsteigen zur gleichen
Höhe mit Gold gesichert. Die Werth-
verminderung wurde verursacht durch die
Aussicht auf eine unbegrenzte Zunahme
der Greenback = Zahlungsversprechungen
und die Unsicherheit bezüglich des Ver-
mögens der Regierung, ihren Verpflich-
tungen nachzukommen. Das spätere
Emporsteigen der Greenbacks auf gleicher
Höhe mit Gold hatte seinen Grund in der
Beschränkung der Greenback = Ausgabe
auf ein vernünftiges Quantum, in den
von der Regierung getroffenen Vorberei-
tungen zur Einlösung und in der Rück-
kehr des öffentlichen Vertrauens darauf,
daß die Regierung Willens und im
Stande sei, ihre Versprechungen einzu-
halten.

Wie steht es nun in dieser Beziehung
mit dem Silberdollar? Der Greenback-
Dollar ist eine Bescheinigung dafür, daß
die Regierung dem Besitzer einen Dollar
schuldig ist; das Stück Papier, aus wel-
chem der Greenback gemacht ist, hat keinen
Werth. Unter dem Versprechen der Re-
gierung, den Silberdollar in jeder Weise
auf Pari mit Gold zu halten, ist der Sil-
berdollar thatsächlich auch eine Bescheini-
gung dafür, daß die Vereinigten Staaten
dem Besitzer den Betrag des Unterschiedes
zwischen dem Marktwerth des Metalls
im Silberdollar und im Golddollar, das
heißt 50 Cents, wenn das Metall im Sil-
berdollar für 50 Cents gelauft werden
kann, schuldig ist. Trotz dieses Unter-
schiedes wird der Silberdollar, ebenso
wie der Greenback, in Handelstransaktio-
nen zum gleichen Werth wie Gold ange-
nommen werden, so lange das Volk das
Vertrauen hat, daß die Regierung im
Stande und Willens ist, das Versprechen,
„die beiden Metalle auf Parität zu hal-
ten", einzulösen. Um dieses Versprechen
einhalten zu können, ist es nöthig, die

Cirkulation von ███████ und ███ Silberpapiergeld, ██ welche die Regierung verantwortlich ist, derart zu beschränken und eine so große Reserve an Hand zu haben, daß kein vernünftiger Zweifel über die Fähigkeit der Regierung, ihren Verpflichtungen nachzukommen, bestehen kann. Wir wissen aus Erfahrung, daß, als im Jahre 1893 ein solcher Zweifel auftam, das Gold in großen Mengen aus dem Schatzamt gezogen wurde und der Golddollar nahe daran war, ein Agio zu tragen, d. h. das Gleichgewicht zwischen den beiden Metallen wurde gestört. Es konnte nur dadurch aufrecht erhalten werden, daß der Vermehrung der Silber-Cirkulation ein Ziel gesetzt und die Goldreserve durch den Verkauf von Bonds wieder aufgefüllt wurde. Hätte die Regierung diese nothwendigen Maßregeln nicht getroffen, hätte sie eine Störung des Gleichgewichts der beiden Metalle eintreten lassen, so würde sie ihrer Pflicht vernachlässigt haben. So aber hat Präsident Cleveland diese Pflicht getreulich und muthig erfüllt. Es liegt das Versprechen der Regierung vor, die Kaufkraft des Silberdollars mit derjenigen des Golddollars auf gleicher Höhe zu halten, und jede politische Maßregel der Regierung, welche dieses Versprechen außer Acht läßt oder die Erfüllung desselben erschwert oder unmöglich macht, ist eine die Republik entehrende Politik der Republikation.

Unehrliche Politik der Bryan-Demokraten.

Was also ist die Politik der Bryan-Demokratie? Sie ist in ihrer Platform zum Ausdruck gebracht, in welcher es heißt: „Wir verlangen die freie und unbegrenzte Prägung von Silber und Geld nach dem gegenwärtigen gesetzlichen Verhältniß von 16 zu 1, ohne dafür auf die Hülfe oder die Zustimmung irgend einer anderen Nation zu warten" und zweitens „Wir sind dagegen, daß die Bundesstaaten in Zeiten des Friedens Zinsen tragende Bonds ausgeben." Was bedeutet die Silber-Freiprägung? Sie bedeutet, daß Jedermann, hier oder im Auslande, ██████ der Silber ██████ ███ ███ ██, ██ solle nach den Bundes-████████ bringen und es dort kostenfrei zu Dollar prägen lassen kann; die solcher Weise geprägten Silberdollars sollen ihm gegeben werden und als gesetzliches Geld für die Bezahlung aller öffentlichen oder Privatschulden gelten. Und was versteht man unter „Verhältniß von 16 zu 1"? Darunter versteht man, daß gesetzlich sechszehn Unzen Silbers einer Unze Goldes werth gehalten werden sollen. Haben aber heutzutage 16 Unzen Silbers im Weltmarkte den Werth einer Unze Goldes? Es giebt weder in den Vereinigten Staaten noch irgendwo anders einen vernünftigen Menschen, der heutzutage eine Unze Goldes für 16 Unzen Silbers geben würde. Was würde somit die plötzliche Einführung der Silberfreiprägung bedeuten? Sie würde bedeuten, daß jeder Amerikaner oder Fremdling ganz nach seinem Belieben das Silbercourant vermehren und die öffentlichen Schulden vergrößern könnte, indem er Barrensilber, das 50 Cents werth ist, nach unseren Münzstätten bringt und er dafür einen Silberdollar zurückerhält, der als Mittel Schulden zu bezahlen, etwa doppelt so viel werth sein würde.

Das würde ohne Zweifel ein sehr einträgliches Geschäft für alle diejenigen sein, die Silber nach den Münzstätten bringen können. Wer sind sie aber? Nach dem Geschwätz der Silberleute zu urtheilen, sollte man meinen, daß, sobald nur erst die Silberfreiprägung eingeführt ist, jeder Farmer in seinem Hof eine Privat-Silbergrube, und jeder Arbeiter vielleicht in seiner Küche eine zauberhafte Silberquelle haben werde. Die Täuschung aber würde bald schwinden. Es würde sich herausstellen, daß die Silberkönige die Leute sind, die große Quantitäten Silberbarren besitzen, deren Werth verdoppelt würde. Es sind das die reichen Grubenbesitzer, die zu den bedeutendsten Capitalisten des Landes gehören, die Silberhändler, die Bankiers und Geldwechsler in England und in Europa überhaupt, kurz diejenigen Leute, welche die Popu-

Tisten „Geldmacht" (money power) zu nennen pflegen. Ich will mich hier jeder Conjectur enthalten, wie stark der Andrang des Silbers nach unseren Münzen und damit die Zunahme unseres Silbervorraths sein würde. Es ist gewiß, die Aussicht auf bedeutenden Profit würde bald aufhören, aber auf jeden Fall würde eine unbeschränkte Vermehrung des Silbervorraths stattfinden, und ich behaupte, daß diese unbeschränkte Vermehrung eine der Bedingungen, die erforderlich sind, die beiden Metalle im festgesetzten Werthverhältniß zu erhalten, von Grund aus zerstören würde.

Rückgang der Silberpreise.

Einige der Freisilberleute behaupten nun, daß die Freiprägung die Nachfrage so erhöhen würde, daß wieder die alten Preise erzielt werden". Laßt uns sehen! Wie vorhin gezeigt, hat das Gesetz von 1878 die Nachfrage nicht beschränkt, denn in diesem Lande war schon viel Jahre vorher keine Nachfrage nach Silber vorhanden gewesen. Die Demonetisirung des Silbers in der alten Welt hat die Silbernachfrage wohl beeinträchtigt, aber sie war es durchaus nicht allein, die den Heruntergang im Preise des Silbers verursachte. Das Silber begann — anfänglich nur wenig — schon zwei Jahre vor seiner Demonetisirung im Preise zu sinken. Zwischen 1866 und 1870 belief sich die durchschnittliche Silberproduction der Welt auf jährlich 43,051,583 Unzen, zwischen 1871 und 1875 stieg sie auf 63,317,014 und sie stieg weiter, bis sie in dem Jahre 1895 die Höhe von 174,796,875 erreichte, d. h. viermal größer war, als 30 Jahre vorher. Und die Zunahme der Production wäre noch stärker gewesen, hätte nicht der Fall der Preise die Gewinnung von Silber aus minderwerthigem Erz unprofitabel gemacht.

Ich frage nun jeden vernünftigen Menschen, ob angesichts einer solchen Zunahme der Production irgend ein Product in der Welt seine Preise aufrecht erhalten hätte, selbst wenn die Nachfrage dieselbe geblieben wäre. Welche Wirkung würde somit die Freiprägung in den Ver. Staaten auf den Preis des Silbers ausüben? Wahrscheinlich würde sie zuerst eine Neigung zur Preissteigerung hervorrufen, sobald aber der Preis steigt, wird auch die Silberproduction, deren Kosten beständig gesunken sind, in die Höhe schnellen und den Preis von Neuem herabdrücken. Eine prächtige Illustration dafür bot uns das Gesetz von 1890, welches den jährlichen Ankauf von 54,000,000 Unzen Silber anordnete. Zunächst machte der Preis des Silbers darauf einen Sprung aufwärts, bald aber begann er wieder zu sinken und sank tiefer als je zuvor. Weswegen das geschah? Weil die Silberproduction von 124,000,000 Unzen im Jahre 1890 auf 137,000,000 Unzen in 1891, auf 153,000,000 in 1892 und auf 165,000,000 Unzen im Jahre 1893 gestiegen war. Kann daher wohl ein Zweifel darüber herrschen, daß, selbst wenn die Freiprägung eine Preissteigerung verursachen sollte, der Preis schnell wieder durch die erhöhte Production der Silbergruben heruntergedrückt werden würde? Wie kommt es, daß trotz der jetzigen niedrigen Preise immer noch eine solche enorme Quantität Silber producirt wird? Weil die Silbergewinnung im Großen, selbst bei den jetzigen niedrigen Preisen, noch profitabel ist; wäre sie das nicht, so würde es keine geben. Es ist daher sicher, daß Freiprägung den Preis des Silbers niemals in die Nähe seiner früheren Höhe treiben würde, und daß eine Unze Goldes immer noch weit mehr als 16 Unzen Silbers kaufen können würde.

Wie könnte also unter solchen Umständen das Werthverhältniß der beiden Metalle bei der unbegrenzten Vermehrung der Silbercirculation aufrecht erhalten werden? Es würde das unmöglich sein, außer die alle unsere Obligationen deckende Goldreserve würde ebenfalls unbegrenzt vermehrt. Und wie könnte jene Reserve vermehrt

...chen? Ob es vielleicht kommen mag, war durch Anleihen auf Grund der Ausgabe von Ver. Staaten-Bonds. Da kommt aber die Bryan-Demokratie mit ihrer Platform und erklärt: „Wir sind gegen die Ausgabe von Bundesbonds in Zeiten des Friedens.“ So würde also die Bryan-Demokratie damit, daß sie die Silbercirculation ohne Grenzen vermehrt, und gleichzeitig die einzige Quelle verstopft, aus welcher die Goldreserbe ergänzt werden könnte, es durchaus unmöglich machen, daß die beiden Metalle im vorgeschriebenen Werthverhältniß zu einander gehalten werden. Es ist das eine offene Zurückweisung des in dem Gesetz von 1890 enthaltenen feierlichen Versprechens, und noch mehr Zurückweisungen werden folgen.

Üble Folgen.

Erwägen wir nun, welches die unmittelbaren Folgen sein würden, sollte Bryan zum Präsidenten gewählt werden und auch der Congreß seiner Platform entsprechen. Bryan würde sich selbstverständlich beeilen, sein Freiprägungsgesetz in Wirkung setzen zu lassen, das könnte aber, selbst wenn er eine Extrasitzung des Congresses einberiefe, erst nächsten April oder Mai, das heißt fünf oder sechs Monate nach der Wahl geschehen. Sobald aber am 4. November das Wahlresultat bekannt gegeben ist, würde Jedermann wissen, daß der Gleichwerth von Gold und Silber nicht aufrecht erhalten wird. Sogar Cleveland würde nicht im Stande sein, jenen Gleichwerth bis zum Ablaufe seines Amtstermins aufrecht zu erhalten, denn Niemand würde dann Gold für Bonds ausgeben wollen, die er in Silber eingelöst zu erhalten erwarten muß.

Auch werden die Banken des Landes nicht wieder, wie sie es kürzlich thaten, dem Bundesschatzamte zu Hülfe kommen und ihm Gold liefern, denn sie hätten zu erwarten, daß die „Greenbacks“, die sie für ihr Gold erhielten, mit Silber eingelöst würden.

Und hier lassen Sie mich ein Wort über jene großen Banken einschalten. Einige der Silberzeitungen erklären, daß die Banken nicht aus Patriotismus, sondern aus selbstsüchtigem Interesse der Bundesregierung zur Hülfe kamen. Ist das wahr, nun, so laßt uns Gott danken, daß wir Finanz-Institute haben, die es für ihr Interesse halten, die Regierung zahlungsfähig zu erhalten. Wehe dem Lande, in dem eine Majorität der Bewohner es als in ihrem Interesse liegend erachten sollte, die Regierung bankerott zu machen!

Doch, selbst wenn Bryan gewählt werden sollte, würden die Bankiers vielleicht patriotisch oder weise genug sein, mit ihrem Golde der Regierung wieder zur Hülfe zu kommen, wenn sie nicht wüßten, daß es ganz nutzlos sein würde. Und weßwegen würde es nutzlos sein? Die Erwählung Bryan's würde die Gewißheit ergeben, daß Gold und Silber nicht auf gleichem Fuße gehalten werden, die Personen, welche einlöspflichtige „Greenbacks“ besitzen, würden sich nach dem Golde im Schatzamte drängen und die Goldreserve würde im Handumdrehen erschöpft sein. Gold würde sofort aus dem Umlaufe verschwinden, um aufgespeichert oder exportirt zu werden. Und weßwegen würde es verschwinden? Weil jeder vernünftige Mensch, wenn er Zahlungen zu leisten hat, dieselben lieber in weniger werthvollen Dollars machen und die werthvolleren Golddollars zu profitableren Zwecken zurückbehalten würde. Gold würde somit sehr schnell Prämien bringen und wir würden schon lange, bevor das Freisilberprägungsgesetz durchgeführt werden kann, auf einer Silberbasis stehen. Was aber bedeutet es, auf einer Silberbasis zu stehen? Das Wort „Coin“ wird, wo immer es im Gesetze gebraucht wird, nicht mehr, wie jetzt, Gold bedeuten, sondern einzig Silber. Der „Greenback“ oder die „Treasury Note“, welche in „Coin“ eingelöst werden sollen, werden nicht, wie bisher, mit Gold, sondern mit Silber eingelöst werden. Die

in „Coin" werden — gleich, ob für diesel-
ben Gold wurde, oder ob sie
...... wurden, um für das Schatz-
amt Gold zu beschaffen — Capital und
Zinsen, mit Silber eingelöst werden; es
würde das eine so offenkundige Repu-
diation sein, wie noch nie eine in der
Welt bekannt wurde. Unsere täglichen
Geschäftstransaktionen bei Kauf und
Verkauf, beim Bezahlen und Empfan-
gen der Löhne, würden nicht länger auf
der Basis des Golddollars stehen, der
100 Cents werth ist, sondern auf der
Basis des Silberdollars, der 50 Cents
— oder ungefähr so viel — werth ist,
denn die Regierung würde den Silber-
dollar nicht länger auf dem Werthe des
Golddollars halten. Das ist die Be-
deutung der Silberbasis. Ihre Wir-
kung kann man in den mexikanischen
Verhältnissen studiren.

Nun eine andere Frage. Wer wird
das Gold aus dem Schatzamt erhalten,
wenn Bryan erwählt und ein Ansturm
auf dasselbe gemacht wird? Nicht der
Farmer und auch nicht der Arbeiter,
also die Leute, welche die Populisten ge-
wöhnlich als „das Volk" bezeichnen.
Diese haben keine „Greenbacks", die sie
...... könnten, und wenn sie welche
haben, so würden sie kaum schnell genug
bei der Hand sein. Nein, das Gold des
Schatzamtes würde sofort von den gro-
ßen Bankiers, von den „Wall Street
......" und von anderen Personen,
welche die Populisten die Geldmacht nen-
nen, beschlagnahmt und von denselben
zu möglichst profitablen Zwecken benutzt
werden.

Die Quantität Goldes, das aus der
Circulation verschwinden würde, würde
sich auf etwa $600,000,000 belaufen,
...... Verschwinden einer solchen
Summe würde ein ungeheures Loch in
den Vorrath unseres Courantes reißen.
Etwa ein Drittel desselben würde fort
sein, und die Kaufkraft des Restes würde
um nahezu die Hälfte reducirt sein.
„Aber", sagt der Silbermann, „wir
würden Freisilberprägung haben und je-

nes Loch prompt mit gemünztem Gold
oder Silbercertifikaten zustopfen.
Nicht doch, meine lieben Leute! Das
Gold würde prompt nach der Erwählung
Bryan's verschwinden; die Freisilberprä-
gung würde aber unmöglich vor dem
Ablauf von wenigstens sechs Monaten
eingeführt werden können, und dann
noch würde es viele Monate mehr er-
fordern, jenes $600,000,000 - Loch zu-
zustopfen.

Und was wird mittlerweile geschehen?
Der „St. Louis Globe - Demokrat" be-
richtet, daß Bryan sich vor einiger Zeit
äußerte: „Ich glaube, daß er (nämlich
ein Sieg der Freiprägungs - Bewegung)
eine Panik hervorrufen würde. Aber
das Land ist in beklagenswerther Lage
und extreme Maßregeln werden nöthig
sein, es wieder zur Prosperität zu füh-
ren." Jene Zeitung machte dazu die
sehr treffende Bemerkung: „Offenbar
hat Bryan von dem Arzt gehört, der
seine Patienten stets in Krämpfe brachte,
ehe er ihnen die heilbringende Medicin
verabreichte." Gerade so ist es.

Wie aber würden die Bryan'schen
Krämpfe auftreten? Das plötzliche Ver-
schwinden des Goldes aus der Circula-
tion würde den größten Geldmangel
verursachen, der je dagewesen ist. Ge-
schäftsleute, welche Geld schulden und
gleichzeitig Geld ausstehen haben, wür-
den gezwungen sein, ihre Außenstände
mit allen Mitteln, die zu ihrer Verfü-
gung stehen, zu collectiren. Niemand
würde willens sein, Geld auszuleihen,
außer ihm werden ganz außerordentliche
Sicherheiten geboten. Die Banken
würden es natürlich für ihre Pflicht hal-
ten, sich möglichst stark zu erhalten, sie
würden daher Darlehen kündigen und
ihre Discontos und Vergünstigungen ge-
gen Geschäftsleute mit der größten Vor-
sicht beschränken. Geschäfts - Etablisse-
ments, Fabriken und Handelshäuser
würden unfähig sein, Geld zu beschaffen,
um ihren Verpflichtungen nachkommen
zu können, sie würden zu Hunderten ih-
rer Geldklemme erliegen und zusammen-
stürzen wie eine Ziegelwand. Andere

nichten. Den Operationen vorsichtiger ... auf die engsten Grenzen beschränken, und die Lohnarbeiter würden zu Tausenden ihre Beschäftigung verlieren und auf die Straße gesetzt werden.

Keiner Gesellschaftsklasse würde eine Dosis der vernichtenden Folgen erspart bleiben. Jeder Gläubiger würde von seinen eigenen Gläubigern gedrängt und aus Furcht, daß ihm jeder weitere Tag Aufschub noch größeren Verlust bringen mag, rücksichtslos gegen seinen Schuldner vorgehen. Die prompte Bezahlung aller ausstehenden Rechnungen würde peremptorisch verlangt werden. Unsere Farmer, auf deren Eigenthum Hypotheken lasten, und denen gesagt wurde, daß die Freiprägung ihnen große Erleichterung bringen soll, würden ganz unerwartete Erfahrungen machen. Jede Hypothek würde prompt gekündigt werden. Der Eigenthümer, welcher eine Verlängerung seiner Hypothek wünscht, würde auf taube Ohren stoßen. Wer Geld borgen will, um eine alte Hypothek abzulösen und eine neue zu geben, würde hören, daß die Zeiten nicht danach sind, Geld zu verborgen, außer vielleicht zu ganz exorbitanten Bedingungen. Er mag außerdem entdecken, daß seine Hypothek in Gold zahlbar ist und würde sich das Gold dafür zu der jeweilig herrschenden Prämie verschaffen müssen. Subhastationen würden an der Tagesordnung sein. Der Hypothekenschuldner, welcher sich an die Gerichte wendet, um während der Zeit des Prozesses eine Frist zu erhalten, würde sein Eigenthum mit den Prozeßkosten noch tiefer verschulden. Ueberall Aengstlichkeit, Verlegenheit, Opfer, Verluste, Noth, das würde an der Tagesordnung sein, noch bevor Bryan auf dem Präsidentschaftsstuhl Platz nehmen würde.

Und doch giebt es Personen, die unter diesen Umständen gute Geschäfte machen würden. Es sind das der Sheriff, der Wucherer und die Geldleute, welche die Mittel haben, Grundeigenthum oder Anderes bei Zwangsverkäufen für Spottpreise zu ersteben.

Jener Theil der "Geldmacht" würde durch das Mißgeschick des Volkes gut herrlich gedeihen.

Und mehr noch! Wir haben große Schulden in Europa, nicht als ob Europa uns gezwungen hätte, zu borgen, sondern weil wir Europa ersuchten, uns zu borgen. Unsere Kaufleute und Bankiers schulden große Summen und ein großer Theil unserer Werthpapiere — National-, Staats-, Municipal-Bonds, Bahnaktien, Industriepapiere und sogar Hypotheken auf Stadteigenthum oder Farmen — sind im Besitz von Europäern. Die Eigenthümer solcher Sicherheiten würden über die Aussichten hier ernstlich erschreckt werden, und jene Securitäten würden auf den Markt gebracht und verschleudert werden für was sie bringen mögen. Ein starkes Fallen der Preise hier sowohl als auch im Auslande würde die Folge sein. Das würde in erster Linie diejenigen betreffen, welche mit solchen Werthpapieren handeln. Leute, welche auf ihre Papiere Geld geliehen haben, würden sie aufgeben müssen, weil sie nicht das nöthige Geld aufbringen könnten, ihren Werth zu stützen. Es würde somit zu einem allgemeinen, vernichtenden Krach im Aktien- und Bondsmarkt kommen.

Unsere Silberfreunde mögen sagen, daß sie das nicht kümmert und daß, je mehr Geldwechsler aus der Wall-Street zu Schaden kommen, es desto besser sei. Und thatsächlich, wenn nur die Geldwechsler von der Wall-Street darunter zu leiden hätten, so könnten wir uns leicht trösten. Aber die Bonds des Bundes, der Staaten und Municipien, die Actien unserer Eisenbahnen, Straßenbahnen und industriellen Corporationen sind auch zum großen Theil in den Händen von Bewohnern Amerika's, und zwar nicht allein in denen der großen Capitalisten, sondern auch in denen von Leuten, welche nur über geringe Mittel verfügen, wie der Farmer und der Lohnarbeiter, die ihre Ersparnisse in denselben angelegt haben. Ferner be-

... in den
... Verbindung, Aktienversiche-
rung, ... Geschäften u. Verwaltungs-
wesen. Viele Millionen armer Leute
sind daran betheiligt. Sollte deren
Verlust auch gleichgültig sein? —

Unsere Silberfreunde mögen sagen,
daß, wenn die Europäer dem Silber nicht
trauen und sie aus Furcht unsere Se-
curitäten mit großem Verlust aufgeben,
daß wir dann diese Securitäten austau-
sen und ein glänzendes Geschäft damit
machen können, daß einige davon schließ-
lich doch wieder „gut" sein und einen
hohen Preis erzielen werden, und daß
wir so einen hohen Gewinn an denselben
machen würden. Das ist wahr. Wer
aber wird den Gewinn einstecken? Nicht
der Farmer, nicht der Arbeiter in seiner
Werkstätte, nicht die arbeitenden Massen
des Volks. Nein, es werden das die-
selben Leute sein, die unsere Silber-
freunde so gern als „Goldbugs", als
die reichen Spekulanten, als die Verkör-
perung der „Geldmacht" bezeichnen. Je-
ne Classe von Leuten würde jene Pro-
fite einstreichen und dadurch mächtiger
werden als zuvor. Die Katastrophe, wel-
che die Erwählung Bryan's über die
Wall-Street bringen würde und der Un-
tergang einiger Firmen an der Wall-
Street würde noch durchaus nicht den
Untergang dessen bedeuten, was die Po-
pulisten unter „Wall-Straße" verstehen;
es würde nur das bedeuten, daß einige
große Fische mehrere kleine Fische ver-
schlucken, und daß die großen Fische da-
durch noch größer werden. Es würde
das die sogenannte „Geldmacht" nicht
schwächen, sondern sie noch mehr con-
centriren.

Eine Krisis muß eintreten.

Wie kann ich diese Folgen mit so gro-
ßer Bestimmtheit voraussagen? Weil
sie ihre Schatten bereits vorausgeworfen
haben. Erinnern Sie sich noch der Kri-
sis des Jahres 1893, als das Gespenst
der Silberbasis in Sicht war? Und
auch jetzt schon wieder hat die bloße
Furcht vor der Möglichkeit der Wahl
des Herrn Bryan und vor der Annahme

der Silberbasis zweifelhafte Zustände
unserer Sicherheiten in Europa sowohl
wie hier auf den Markt geworfen. Hun-
derte von Geschäftsaufträgen sind bereits
widerrufen, zahlreiche Fabriken haben
bereits ihren Betrieb ganz oder theil-
weise eingestellt, der Unternehmungsgeist
ist bereits entmuthigt und nahezu ge-
lähmt. Zahlreiche Neuanlagen, die
von Industrie- oder Eisenbahn-Gesell-
schaften geplant waren und dem Volke
im Ganzen zu Gute gekommen sein wür-
den, sind bereits aufgegeben, Tausende
von Arbeitern sind bereits beschäfti-
gungslos geworden, Gold wird bereits
aufgespeichert und große Capitalien wer-
den bereits, um sicher zu gehen, zwecks
Anlage in Europa außer Landes ge-
schickt. Und warum alles dies? Nicht,
wie die Silberleute thörichterweise be-
haupten, weil der gegenwärtige Gold-
„Standard" Geld selten gemacht hat,
denn nach Dutzenden und abermals Du-
tzenden von Millionen liegt das Capi-
tal müßig in Haufen und sehnt sich nach
sicherer Anlage. Nein, fragen Sie die-
jenigen, welche mit den Verhältnissen
vertraut sind, und einstimmig werden sie
Ihnen zur Antwort geben, daß das
Vertrauen gewichen ist, weil sie infolge
der in Aussicht gestellten Veränderung
unseres Werth-„Standard", infolge der
Entwerthung unseres Währungsgeldes,
wie sie uns durch die Silberfreiprä-
gungs-Bewegung droht, ernstliche Ge-
fahr für jeden Dollar fürchten, der in
irgend ein Unternehmen gesteckt wird.
Und wenn dies die Folgen einer bloßen
Furcht vor einer Möglichkeit sind, was
würde die Folge der Thatsache selbst
sein? Die wüste Verwirrung, welche
Herrn Bryan's Wahl, selbst noch vor
seiner Inauguration, über alle Ge-
schäftszweige bringen würde, läßt sich
kaum in ihrer Ausdehnung ausdenken.

Nach fünf oder sechs Monaten einer
solchen verderblichen Krisis würde die
von Herrn Bryan einberufene Extra-
sitzung des Congresses beginnen und
uns Freiprägung geben. Wie Herr
Bryan feierlich in seiner großen New
Yorker Rede versprach, wird uns Wäh-

rung eine wirkliche Doppelwährung und hole Gold in Hülle und Fülle herein, und alles wird lauter Freude und Wonne sein. Doppelwährung? Was ist Doppelwährung? Es ist ein Münzsystem, in welchem die beiden Metalle zusammen in einem gesetzlich bestimmten festen Werthverhältniß für alle Zwecke, zu denen das Geld verwandt wird — dieses Verhältniß ist in unserem Falle 16 zu 1 — circuliren. Es ist klar, daß, wenn wir Doppelwährung haben wollen, Gold ebensowohl wie Silber vorhanden sein muß. Wie ich bereits dargethan habe, wird in der Zeit zwischen Herrn Bryan's Wahl und seiner Extrasitzung des Congresses alles Gold aus dem Verkehr verschwunden sein. Ein Theil desselben ist von Privatleuten aufgespeichert worden, und ein anderer, wahrscheinlich bei Weitem der größere Theil, nach Europa gegangen, wo es nutzbringende Anleihe findet. Es stellt sich somit heraus, daß Herrn Bryan's Wahl dazu dienen wird, die amerikanischen und noch mehr die europäischen „Geldmächte" in den Besitz des meisten Goldes zu setzen, das er für seine Doppelwährung hier benöthigt. Das ist eine der Widerwärtigkeiten, welche die wirklich aufrichtigen europäischen Doppelwährungsleute vorhersahen, als sie ihre weniger aufrichtigen amerikanischen Brüder mit fast pathetischen Worten anflehten, doch ja nicht an Silberfreiprägung in den Vereinigten Staaten allein zu denken, weil dann fast alles Gold nach Europa und alles Silber nach Amerika getrieben werden würde, was somit die Doppelwährung in Europa sowohl wie hier unmöglich machen würde.

Auf welche Weise gedenkt Herr Bryan das Gold von der „Geldmacht" zurückzuerhalten? Jedenfalls muß er eine Gegenleistung bieten. Welche Gegenleistung? Die Münzen werden zwar für Gold sowohl wie für Silber geöffnet sein. Aber wer wird Goldbarren anbieten, um sie in Dollars zum Zwecke der Circulation umprägen zu lassen, wenn er Silberdollars mit derselben „Legal Tender"-Kraft zum halben Preise haben kann. Nur ein ... würde das thun. Natürlich wird ... nur angeboten, wenn der Silberdollar wieder auf dem Gold-„Standard" basirt. Das ist der Haken. Doch Herr Bryan tritt hier mit einer Theorie in die Bresche, die ihresgleichen an „staatsmännischem" Unsinn sucht. Er sagte in seiner New Yorker Rede: „Jeder Käufer, der entschlossen ist, den gesammten Vorrath von einem Artikel zu einem bestimmten Preise zu übernehmen, kann verhindern, daß der Artikel unter seinen Preis sinkt. So kann die Regierung einen Preis für Gold und Silber festsetzen, indem sie eine Nachfrage schafft, welche das Angebot übersteigt." Und ferner: „Wenn auf diese Weise ein Münzpreis festgesetzt ist, so regulirt dieser den Barrenpreis, weil Jeder, der geprägtes Geld wünscht, Barren zu jenem Preise zu Münzen prägen lassen, und Jeder, der Barren wünscht, sie sich verschaffen kann, indem er die Münzen einschmelzen läßt."

Soll dies bedeuten, daß unter dem Freiprägungsgesetz die Regierung Silberbarren auflaufen und einen bestimmten Preis dafür bezahlen wird? Ist dem so, dann weiß Herr Bryan, der große Freiprägungs-Apostel, nicht, was Freiprägung heißt. Lassen Sie uns sein Gedächtniß auffrischen. Freiprägung bedeutet, daß der Eigenthümer von Silberbarren dieselben zur Münze bringen, dort prägen und sich die geprägten Geldstücke, so und so viele Silber-Dollars für so und so viel Gewicht reinen Silbers, zurückerstatten lassen kann. Es bedeutet aber nicht, daß die Regierung bereit ist, den ganzen Silbervorrath zu einem gewissen Preise aufzulaufen." Die Regierung kauft keine einzige Unze davon, sie nimmt bloß die Barren entgegen, versieht sie mit dem Werthstempel und giebt sie zurück. Und was die Preisfestsetzung betrifft, so wird, sobald die Regierung aufhört, den Silber-Dollar auf den Gold-„Standard" zu basiren — wie es bei der Wahl Bryan's der Fall sein würde

— der Silberdollar, nach seiner Kauf-kraft bemessen, nicht einen Cent mehr werth sein, als der Marktwerth des da-rin enthaltenen Silbers beträgt. Wenn der Marktwerth desselben 50 Cents in Gold beträgt und Sie bringen einen Barren zur Münze, der 50 Cents werth ist, so erhalten sie nicht einen Goldbol-lar, sondern einen Silberdollar zurück, der nicht mehr und nicht weniger als 50 Cents in Gold werth ist. Statt Ihre Barren zur Münze zu tragen, können Sie sie auf offenem Markte verkaufen und denselben Erlös dafür erzielen. Ja die Barrenbesitzer werden, falls sie nicht irgend welche besondere Veranlassung haben, ihre Barren zur Münze zu tra-gen, sie auf den Markt bringen und dort verkaufen, wie es in ausgedehntem Maße in sämmtlichen Ländern der Fall ist, in denen Silberfreiprägung besteht. Wa-rum auch nicht? Vielleicht aus dem Grunde nicht, weil sie, wenn sie ihre Barren prägen lassen „Legal Tender"-Dollars dafür bekommen? Nun, wenn sie ihr Silber im Markte verkaufen, er-halten sie ebenfalls „Legal Tender"-Dol-lars. Es wird daher weiter nichts, als eine Frage zufälliger Bequemlichkeit sein, ob sie ihr Silber zur Münze oder auf den Markt bringen. Und im Markte wird aller menschlichen Vernunft und Erfahrung zufolge, der Preis ungeach-tet zeitweiliger Schwankungen im Gro-ßen und Ganzen dem Kostenpreis sehr nahe kommen, zu dem Silber in großen Quantitäten producirt werden kann. Herrn Bryan's seltsame Phantastereien haben daher, wenn er vom Silberan-kauf seitens der Regierung spricht, wo-durch der Preis festgesetzt und eine Nach-frage geschaffen werde, die das Angebot übersteige, nur bewiesen, daß er nicht einmal weiß, was Freiprägung bedeu-tet.

Die Theorie, daß Silberfreiprägung den Silberdollar gleichwerthig mit dem Golddollar machen und die Werthgleich-heit aufrecht erhalten wird, beruht auf nichts weiter, als auf Herrn Bryan's unablässig ausposauntem persönlichen Glauben. Nun macht ja der Glaube allerdings selig. Ich muß jedoch sagen, daß die glaubenskräftigste Person, die ich je traf, ein Mann war, der unver-rückt an dem Glauben festhielt, er sei der römische Papst und könne, wenn er wolle, den Mond vom Firmament her-unterholen. Dieser Mann befand sich unter der Behandlung eines Specia-listen für geistige Absonderlichkeiten.

Jede vernünftige Person wird nun — deß bin ich gewiß — zugeben, daß Silberfreiprägung in den Ver. Staaten allein den Bimetallismus, den gleichen Gebrauch von Gold und Silber als Geld, hier sowohl wie im Auslande un-möglich machen wird. Sie wird Eu-ropa im Gold=Monometallismus be-stärken und uns zum Silber=Monome-tallismus, zur ausschließlichen Be-nutzung von Silber als Geld und von Papiergeld, das auf Silber basirt, ver-dammen. Zweifellos ist dies das wirk-liche Endziel der Silberleute.

Wirkung der Silberfreiprägung.

Lassen Sie uns jetzt kurz betrachten, in welcher Weise Silberfreiprägung die verschiedenen Interessen unseres Volkes in Mitleidenschaft ziehen wird. Der erste Segen, der sich nach den Verhei-ßungen der Silber=Apostel über unser Land ergießen soll, ist ein allgemeines Steigen der Preise. Das heißt, der Silberdollar wird weniger laufen, als es der Golddollar that, und zwar le-diglich aus dem Grunde, weil er nicht so viel werth ist wie der Golddollar. Es liegt auf der Hand, daß die Ver-sprechungen der Bimetallisten — das Steigen des Silbers zu seinem alten Preise auf der einen, und die Zusiche-rung höherer Preise infolge einer Werth-verminderung des Silberdollars auf der anderen Seite — nicht mit einander harmoniren. Das eine oder das an-dere ist offener Betrug. Ein Steigen der Preise als Begleiterscheinung der Entwerthung des Dollars wird sofort beginnen, sobald wir die Goldbasis

theurer werden, Kaffee, Zucker, Thee, Gemüse, Kleidungsstücke, Schuhe und Hüte werden im Preise steigen, kurz jeder Gegenstand, dessen Preis vom Verkäufer erhöht werden kann.

Hohe Preise sind ein zweischneidiges Schwert — überaus angenehm für den Verkäufer, aber im höchsten Grade unangenehm für den Käufer. Sie drücken natürlich am härtesten auf Diejenigen, welche gezwungen sind, am meisten im Verhältnisse zu ihrem Einkommen oder Verdienste einzukaufen. Und wer ist dies? Der arme Mann. Was eine reiche Familie für die wirklichen Lebensbedürfnisse, für unentbehrliche Nahrung, Kleidung und Behausung ausgibt, ist sehr wenig im Vergleiche zu ihrem Einkommen. Der größte Theil ihrer Ausgaben ist für Dinge, die keine Lebensbedürfnisse sind und als Luxusgegenstände bezeichnet werden können, deren Ankauf ohne Beschwerden oder Unannehmlichkeiten ganz unterlassen oder aufgeschoben werden kann. Die arme Familie dagegen, die Familie des Lohnarbeiters, ist gezwungen, einen sehr großen Theil ihres Einkommens von Tag zu Tag für Nahrung, Kleidung, Obdach, Heizung und Beleuchtung auszugeben, Dinge, auf die man — sei es auch nur zeitweilig — nicht ohne große Beschwerden verzichten kann. Von einer Preissteigerung der Lebensbedürfnisse haben daher die armen Leute bei Weitem am meisten zu leiden.

Wer sind die Consumenten?

Hier berühre ich eine der hinterlistigsten Täuschungen, durch die unsere Freiprägungs-Apostel die Wähler hinter's Licht zu führen suchen. Sie sprechen von einer Klasse der "Consumenten", als wenn dies nur reiche Leute wären, die in ihren schönen Wohnungen es sich bequem eingerichtet haben und nichts thun, als "consumiren"; und andererseits von einer Klasse von körperliche Arbeit verrichten und weiter nichts thun als "produciren". Diese Darstellung ist eine niederträchtige Lüge. Die Anzahl der Personen, welche keinerlei, sei es direkt oder indirekt, produktive Beschäftigung haben, ist, Gott sei Dank, hier zu Lande noch sehr gering. Und nicht nur sie sind Consumenten, sondern Jedermann ist es. Ja, noch mehr, der ärmste Tagelöhner ist im Vergleiche zu seinen Mitteln ein weit stärkerer Consument als der reichste Millionär. Und was die Segnungen hoher Preise betrifft, so lasten diese schwer drückend nicht auf den reichen, sondern auf den armen Consumenten, es sei denn, daß ihr Verdienst im Verhältnisse zum Steigen der Preise zunimmt. Ebensowenig sind steigende Preise ein Beweis für ein Aufblühen der Geschäfte, außer wenn jene Preissteigerung aus zunehmendem Verbrauche resultirt. Am allerwenigsten ist jene Behauptung gerechtfertigt, wenn die Steigerung der Preise durch das Herunterdrücken der Kaufkraft des Umlaufgeldes veranlaßt ist.

Lassen Sie mich Ihnen ein praktisches Beispiel geben. Kürzlich las ich in einer Zeitung, welche die Aeußerungen verschiedener Personen über die Silberfrage veröffentlichte, die folgende Bemerkung eines Straßenbahn-Conducteurs: "Ich bin für Bryan und Freisilber; wenn er gewählt wird, giebt es Geld in Menge, es wird mehr circuliren, und dann werden wir etwas davon mit abbekommen. Der Arme! Nun, nehmen wir an, Herr Bryan sei gewählt. Wir befinden uns glücklich auf der Silberbasis. Für den Dollar kauft man Waaren im Werthe von etwa 50 Cents. Der Lohn unseres Straßenbahn-Conducteurs beträgt, setzen wir den Fall, 2 Dollars den Tag. Seine Frau geht zum Materialwaarenhändler und macht dort die Entdeckung, daß Alles, was sie für 10 Cents früher zu kaufen pflegte, jetzt 20 Cents kostet. In klagendem Tone hätt sie dies bem-

...sagt der Händler. „Sie zahlen mir in Silber, 50 Cents am Dollar. Ich ... dieses Geld benutzen, um meine Einkäufe zu machen, und brauche zweimal so viel Dollars wie früher. So müssen wir denn auch meine Kunden den doppelten Preis zahlen, oder ich muß meinen Laden schließen." Weitere Argumente sind müßig. Dieselbe Erfahrung macht ?, wenn sie zum Fleischer, Bäcker, Schuhmacher u. s. w. geht. Unser Straßenbahn-Conducteur kommt zur Einsicht, daß er und seine Familie zwar ... bei strenger Sparsamkeit von 2 Dollars den Tag leben konnten, daß der ... sie aber jetzt an allen Ecken und ... bedroht, wenn mit den zwei Dollars jetzt nur ebenso viel eingekauft werden kann, wie früher mit einem. Er ... sich mit seinen Freunden und ein ... spricht beim Präsidenten der ...gesellschaft vor, um ihn zur ... der Löhne zu veranlassen. ... Löhne? giebt er zur Antwort ... habe schon daran gedacht, daß eine ...schreibung der Löhne sich als nothwendig ...weisen wird. Für unsere ...schen Materialien haben wir jetzt ... Dollars zu bezahlen, wo wir früher nur ... zahlten. Nun erhalten wir immer ... noch unsere 5 Cents Fahrgeld, die in Wirklichkeit nur 2½ Cents werth sind. ... außerdem sind unsere Obligationen, Capital sowie Zinsen, in Gold zahlbar ... wir müssen dieses Gold zur Rate von $2 in Silber für einen Golddollar ... Wie können wir da noch auf die ... kommen? Ich weiß wirklich nicht, ... wir fortfahren können, Ihnen die $2 den Tag zu zahlen?" Die Mitglieder des ... murren und sprechen vom ...

„Streik!" sagt der Präsident. „Die Straßen sind mit Arbeitsleuten überfüllt, die durch die Schließung der Fabriken seit Einführung der Silberfreiprägung beschäftigungslos geworden sind. Tausende von ihnen, Männer mit Familien, würden vor Freude einen ...sprung ma-

chen, wenn man ihnen Geld gewährt gäbe, selbst weniger als $2 den Tag zu verdienen." Die Comitémitglieder sehen sich sprachlos an. Sie wissen, daß Alles, was er sagt, die lautere Wahrheit ist. Die in schönsten Farben ausgemalten Segnungen höherer Preise nach Einführung der Silberfreiprägung beginnen ihnen schrecklich klar zu werden; sie entfernen sich, um eine traurige Erfahrung reicher; und des Conducteurs sorgenüberbürdete Frau fragt ihn, ob es wirklich ein kluger Streich war, für Bryan zu stimmen.

Dasselbe wird den Hunderttausenden von Eisenbahnangestellten in den Ver. Staaten passiren. Es giebt kaum eine einzige Eisenbahn, die nicht durch Gesetz oder durch anderen machtvollen Einfluß verhindert werden wird, ihre Passagepreise oder Frachtraten zu erhöhen. Sie werden daher nicht im Stande sein, die Verluste zu decken, die sie durch die Entwerthung des Geldes erleiden werden, zumal sie genöthigt sind, 60 Prozent ihrer verbrieften Schuld, Capital und Zinsen, in Gold zu bezahlen. Sie werden dem Bankerott zugedrängt und selbst diejenigen von ihnen, welchen es gelingen mag, demselben zu entgehen, werden kaum im Stande sein, ihre Angestellten für die Verluste schadlos zu halten, die denselben durch die Entwerthung ihrer Löhne, durch den Silberdollar entstehen werden.

Die Lohnfrage erörtert.

Wie steht es nun mit den Lohnarbeitern, deren Produkte im Verhältniß zur Entwerthung des Dollars im Preise erhöht werden können? So wie der Dollar im Werthe fällt, erhöhen der Fabrikant und der Kaufmann die Preise ihrer Waaren. Der Arbeiter oder der Clerk wird sich, wenn ihn die hohen Preise der Lebensmittel drängen, um eine entsprechende Lohnerhöhung bewerben. Das Haupt der Fabrik oder des kaufmännischen Geschäftes giebt zu, daß eine Zulage gerechtfertigt sei. „Aber", sagt er, „Ihr seid nicht die einzigen Leute, die bedrängt sind. Den

Werth das Geldes schwankt; wir wissen nur, wie er heute steht, und ganz sicher wissen wir nicht, wie er nächste Woche stehen wird. Die Profite sind überhaupt sehr knapp. Wir kaufen oder verkaufen heute etwas und glauben, dabei einen Gewinn erzielt zu haben. Morgen entdecken wir vielleicht, daß wir bei dem Geschäft verloren. Wir wagen es kaum, einen Contrakt für die Zukunft abzuschließen, denn wir können keine sicheren Berechnungen anstellen. Wir können Euren Lohn wohl ein wenig erhöhen, aber nicht viel. Ihr müßt warten, bis die Verhältnisse sich besser geklärt haben. Außerdem hat diese Freisilberprägung eine schauerliche Confusion in der Geschäftswelt angerichtet und es giebt viele Arbeitslose, die Eure Arbeit für noch geringeren Lohn als Ihr jetzt erhaltet, verrichten würden." Und so muß sich der Lohnarbeiter mit einer geringen Lohnerhöhung zufrieden geben und auf mehr warten, bis ihn die erhöhten Preise der Lebensmittel von neuem bedrängen.

Ist dies nur eine Conjectur? Nein, es ist das die Erfahrung in jedem Lande, das durch den Fluch von Preiserhöhungen betroffen wurde, die durch im Werthe fluktuirendes Geld verursacht wurden. Ich behaupte, daß mir Niemand aus der ganzen Weltgeschichte eine einzige Ausnahme von jener Regel nachweisen kann. Haben wir das nicht während des Bürgerkrieges mit unseren eigenen Augen gesehen? Im Jahre 1862, als unser nicht für den Rücklauf garantirtes Geld im Werthe zu sinken begann, stiegen die Löhne durchschnittlich nur um 3 Procent, während die Preise der Lebensmittel um 18 Prozent stiegen. Im Jahre 1863, als die Löhne um 10½ Procent gestiegen waren, standen die Preise durchschnittlich um 49 Procent höher. Im Jahre 1864 waren die Löhne um 25¾ Procent und die Preise um 90¼ Procent gestiegen; im Jahre 1865 waren die Löhne 43 Procent und die Preise 117 Procent höher als die Löhne und Preise im Goldwerth im Jahre 1861. In anderen Worten die Löhne des Arbeiters hatten mehr als 30 Cents für jeden Dollar an Kaufkraft verloren. In jedem Lande, das an ähnlichen Zuständen leidet, ist das dieselbe Geschichte. Was um alle Welt also berechtigt zu der Annahme, daß jene allgemeine Regel nicht auch für den Fall der Freiprägung gelten würde?

Und was haben die Apostel der Freesilberprägung darauf zu antworten? Man höre Bryan selbst in seiner berühmten New Yorker Rede! „Die Goldwährung", sagt er, „erhöht zwar die Kaufkraft des Dollars, aber sie macht es zugleich schwieriger, den Dollar zu erwerben — die Arbeit ist weniger beständig, Arbeitsverluste sind häufiger und es ist weniger gewiß, daß der Arbeiter wieder Beschäftigung findet." Ja, das ist Alles. Weiß aber Bryan nicht, daß dieses Land in den fünfziger Jahren unter einer Währung, die practisch eine Goldwährung war, seine thätigste und gedeihlichste Periode durchmachte? Weiß er es nicht, daß wir in jüngerer Zeit, als wir zu Species-Zahlungen zurückkehrten, unter der Goldwährung Jahre erfreulicher Prosperität, während deren Jedermann Arbeit hatte, erlebten? Und wünscht er zu erfahren, wo seitdem der Haken lag, und wo er jetzt liegt? Mag er die Arbeitgeber fragen, und fast einstimmig werden sie ihm sagen, daß nicht die jetzige Goldwährung, sondern die zunehmende Gefahr ihres Umsturzes, daß die zunehmende Kühnheit der Freiprägungs-Bewegung, welche die Gemüther der Menschen mit trüben Befürchtungen einer dunklen und unsicheren Zukunft erfüllt, dazu gedient hat, jenen Unternehmungsgeist zu paralysiren, der sonst den Arbeitern Arbeit verschafft. Mag er die Geschichte der Krisis von 1893 studiren! Nicht die Goldwährung, sondern das Mißtrauen gegen Silber hat das Vertrauen untergraben, das sonst den Arbeitern Beschäftigung giebt. Dieses ist die Wahrheit und Herr Bryan würde

wenn wir sehen, wie angebliche Arbeiterführer sich mit den Silberminen-Millionären, den Silber-Politikern und den Rebeltheorien nachjagenden Silber-Philosophen dazu verbinden, den Arbeiter zu einer so äußerst thörichten Handlung, die Selbstvernichtung gleichkommt, zu verführen, so ist wahrlich mehr als guter Grund vorhanden, die Arbeiter vor Verrath in ihren eigenen Reihen zu warnen. Wenn es in der ganzen weiten Welt Jemand giebt, der bis zum letzten Athemzuge dafür kämpfen sollte, daß sein Geld seinen Werth behält, und der gegen seinen schlimmsten Feind, eben jenen Demagogen, der ihn mit trügerischen Währungs-Spitzfindigkeiten zu locken sucht, Front machen sollte, so ist es der Mann, welcher sein Brod im Schweiße seines Angesichts erntet. Ganz besonders ist dieses der Kampf des für seinen Lebensunterhalt Arbeitenden. Wehe ihm, wenn er seine eigene Sache im Stiche läßt!

Schuldner und Gläubiger.

Die Freiprägungs = Leute heucheln besondere Fürsorge für diejenigen, welche sie die „Schuldner = Klasse" nennen. Wer sind diese nun? Unsere Silberfreunde sprechen so, wie wenn durchgängig die Reichen Gläubiger und die Armen Schuldner seien. Stimmt das nun? Ich denke, in meinem eigenen Haushalte bin ich der Schuldner der Köchin, des Stubenmädchens, und auch der Wäscherin, die zwei= oder dreimal im Monat kommt; sie sind meine Gläubiger. Auch sind diese schwerlich Schuldner jemand anders gegenüber, während ich es sein mag, da sie geringen oder gar keinen Credit haben, während ich vielleicht welchen habe. Ich bin deshalb in meinem Hause der einzige Schuldner. Die Beziehungen zwischen dem, der viele Leute beschäftigt, und seinen Angestellten sind im Allgemeinen dieselben. Gewöhnlich kann nur der Arbeitgeber, der Reiche, der einzige Schuldner dabei sein. Die Angestellten sind in der Regel nur Gläubiger, und wenn sie Ersparnisse machen, so mögen sie Gläubiger im weiteren Sinne werden. Sie

hinterlegen ihr Geld in Sparkassen oder legen es in Bauvereinen, in Wohltätig-keitsgesellschaften oder auf Gegenseitig-keit, in Darlehensgesellschaften oder in Lebensversicherungs = Policen an und werden so Kapitalisten in kleinerem Maß-stabe. Der von Leuten mit geringen Mitteln in den Sparkassen unseres Lan-des deponirte Betrag beläuft sich gegen-wärtig auf über 1800 MillionenDollars, das in Baugesellschaften angelegte Kapi-tal auf etwa 900 Millionen und ferner sind in Wohltätigkeitsvereinen mit dem Prinzip der Gegenseitigkeit 365 Millio-nen, in Lebensversicherungen viele hun-dert Millionen angelegt.

Es ist daher die Zahl solcher Gläu-biger, die zu jenen Klassen gehören, wel-che unsere Silberfreunde so oft als „um ihr Leben kämpfende Massen" bezeichnen, eine sehr große. Mit den von ihr Ab-hängigen mag sie etwa 15 bis 20 Mil-lionen Personen zählen. Wer sind nun die Schuldner dieser Gläubiger?

Sparbanken hatten, nach den Berichten für das Jahr 1894, etwa die Hälfte der bei ihnen deponirten Summen auf Grundeigenthums = Hypotheken ausge-liehen und die andere Hälfte in Bonds der Vereinigten Staaten sowie in solchen von Staaten, Counties, Städten und auch in Eisenbahn- und anderen Bonds und Aktien. Was die Lebensversiche-rungs = Gesellschaften so angelegt hatten, erreichte im Verhältniß ungefähr densel-ben Betrag. Anlagen in Grundeigen-thums-Hypotheken werden mit Vorliebe in großen Beträgen gemacht, auf Eigen-thum vergleichsweise reicher Personen oder geschäftlicher Corporationen. So sind die Schuldner jener Gläubiger, die jene „um ihr Leben kämpfenden Massen" darstellen, die Vereinigten Staaten selbst, Staaten, Städte, Eisenbahn- und an-dere Corporationen und Personen, die weit mehr Geld besitzen, als die Gläu-biger. Wir haben da also reiche Schuld-ner die vielen Millionen armer Gläubi-ger Tausende von Millionen Dollars schulden.

Die Silberredner geben sich den An-schein, als ob ihnen das Wohl der arbei-tenden Masse des Volkes in erster Reihe am Herzen liege und Freiprägung haupt-sächlich für den Vortheil dieser Masse eingeführt werden solle. In welcher Weise nun nehmen sie sich die-ser Classe der Bevölkerung an? Da-durch, daß sie uns auf die Silberbasis herabdrücken, bringen sie einfach Tau-sende von Millionen, welche die angeleg-ten Ersparnisse armer Leute bilden, auf etwa 50 Cents pro Dollar herab. Und zu wessen Vortheil geschieht dies? Zum Vortheil der Schuldner dieser armen Leute, welche dadurch etwa 50 Cents am Dollar gewinnen. Wer sind diese Schuldner nun? Abgesehen von den Ver. Staaten, den einzelnen Staaten und den Municipalitäten, sind es Ei-senbahnen und andere Corporationen, sowie mehr oder weniger reiche Leute, welche unsere Silberfreunde angeblich so tief verabscheuen, da sie zu der „Geld-macht" gehörten. Auf diese Weise wird die Silberwährung den armen Gläubi-ger zu Gunsten des reichen Schuldners zur Ader lassen. Hat die arbeitende Masse des Volkes nicht allen Grund da-zu, den Himmel darum anzuflehen, sie von den Freiprägungsfreunden zu er-lösen?

Und was haben diese nun zu ihrer Vertheidigung anzuführen? Ich will hier abermals die Rede von Herrn Bryan citiren, welche er in New York gehalten hat. In derselben sagt er zu-nächst in Bezug auf Versicherungs=Ge-sellschaften: „Da die Gesammtsumme der eingezahlten Prämien diejenige des insgesammt ausgezahlten Geldes über-steigt, so muß ein „steigender Standard" für die Gesellschaften von größerem Vortheil sein, als für die Policeninha-ber." Wie weise! Und damit den Ge-sellschaften dieser Vortheil nicht er-wachse, so schlägt er vor, durch Einfüh-rung der Silberwährung die Policen der Policeninhaber um nahezu die Hälfte zu entwerthen. Aber weiß Herr Bryan nicht, daß die Mehrzahl dieser Ge-

n auf gegenüber.......
......ng ihre betreffen
daher Alles, was den Gesell-
......von Vortheil oder Schaden ist.
......Bankinhaber von Vor-
......Schaden sein muß?
......treff der Sparbanken - Depo-
......er: „Bei der Goldwährung
......Gefahr stetig wachsen, daß die
......Depositoren ihre Einla-
......, weil die Banken nicht
......sind, ihre Bestände flüssig
....... Und zur Abwendung
......räth Herr Bryan eine Po-
......vermittelst der Einführung
......Währung sofort den Werth
......auf 50 Cents auf den
......müßte. Weiter sagt
......die Goldwährung für unbe-
......beibehalten werden soll, so
......Sparbanken - Depositoren
......sein, ihre Einlagen heraus-
......um ihren Lebensunterhalt zu
......" Wirklich? Nun, es ist
......Thatsache, daß seit
......1873, den Jahren jenes
......Verbrechens", bis zum Jahre
......Zeit wir alle „die Ca-
......über uns ergehen lassen muß-
......die Gold-Währungszeit mit
......, die Depositen in Sparban-
......daß sie herausgenommen wur-
......die Einleger damit ihren
......halt bestreiten können, um
......000 gewachsen sind, — po-
......sind. Und sie würden
......angewachsen sein, hätten
......Depositoren ihre Einlagen
......, nicht um ihren Le-
......zu bestreiten, sondern um
......nach Europa in Sicherheit zu
......Herrn Bryan und anderen
......der „um ihr Leben säm-
......" aus dem Wege! Zwei-
......sie dieses Geld wieder zu-
......weshalb Herr Bryan geschla-

......ubiger und Schuldner.

......wir weiter. Fast ein Jeder,
......Geschäft betreibt, ist zugleich
......r und Schuldner: Schuldner

dem gegenüber, von dem es Nimmt, und Gläubiger gegenüber dem, an den es verliust. Sollte Bryan seine Bank herbeiführen, so werden Hunderte, wo nicht Tausende derselben, wenn sie für gewöhnlich auch noch so zahlungsfähig sind, zusammenbrechen, weil sie nicht eintreiben konnten, was ihnen zukam und deshalb auch nicht bezahlen können, was sie schuldig sind.

So ist auch eine jede Bank den Leuten, von denen sie Geld annahm, gegenüber Schuldnerin und den Leuten, denen sie Geld lieh, gegenüber Gläubigern. Dagegen erklärt Bryan in seiner Rede in New York Folgendes:

Es wird manchmal von unseren Gegnern behauptet, daß eine Bank zu den Schuldnern zu rechnen sei, was aber bei einer zahlungsfähigen Bank nicht der Fall ist. Bei einer jeden zahlungsfähigen Bank wird der Ausweis ergeben, daß die Activa die Passiva übersteigen. Bryan zufolge müßte man also bankerott sein, um Schuldner zu sein. Wir haben stets geglaubt, der sei Schuldner, welcher Schulden habe, ob er zahlungsfähig sei oder nicht; und der sei bankerott, welcher mehr schuldig sei, als er bezahlen könne. Die neue Bryan'sche Lehre aber macht das alles anders; wer Schulden hat, dieselben aber bezahlen kann, ist kein Schuldner, somit ist er auch nichts schuldig. Eine Menge Anhänger Bryan's werden sich freuen, das zu vernehmen.

Wiewohl es aber Bryan sehr darum zu thun ist, Banken von seiner Lieblingsklasse der Schuldner auszuscheiden, liegt ihm deren Wohl doch am Herzen. Es plagt ihn offenbar der Gedanke, der Golddollar würde bis in's Unendliche an Werth zunehmen, die Preise sich bis in's Unendliche vermehren und wir würden niemals den Grund erreichen. Er folgert, wenn die Goldwährung erhalten würde und die Preise fortfahren zu fallen, sei die Bank im Stande, an schlechten Guthaben mehr einzubüßen, als sie durch Zunahme der Kaufkraft ihres Capitals und des Ueberschusses ge-

Strohgespinst halten, will Bryan kurzen Proceß mit ihnen machen, indem er ein Verfahren einschlägt, das zur Einführung der Silberwährung führen und alle Guthaben von Banken mit einem 50 Cents-Dollar zahlbar macht. Hätte er vom Bankgeschäft und von der Geschichte des Bankgeschäfts auch nur eine Ahnung, so müßte er, daß Banken nicht durch Erhaltung der bestehenden Währung bedroht werden, sondern daß ihnen eine Gefahr aus der Verschlechterung dieser Währung aus dem einfachen Grunde droht, weil eine solche Gefahr bei den Depositoren das Gefühl der Unsicherheit erweckt, deren viele alsdann sich beeilen werden, ihr Geld der Bank zu entziehen, um dessen Verschlechterung nicht erst abzuwarten, wodurch sie das herbeiführen, was für eine Bank das Gefährlichste ist, den Ansturm der Gläubiger. Das ist es, was uns im Jahre 1893 gedroht hat, als man im Publikum stark darüber im Zweifel war, ob die Regierung im Stande sein werde, die Goldwährung aufrecht zu erhalten. Damals sind wir dem allgemeinen Bankkrach nur um Haaresbreite entgangen und nur durch die weiseste Verwaltung und durch die äußerste Anstrengung der Clearinghäuser ist derselbe vermieden worden. Nichts würde eine derartige Katastrophe sicherer herbeiführen, als eine Wahl Bryan's, der alsdann die Genugthuung haben würde, eine stattliche Anzahl zahlungsunfähiger Banken in dem Schafstall der Bankerotteure willkommen zu heißen, die seines Erachtens die einzigen Schuldner sind, die diesen Namen verdienen.

Die Farmer im Süden und Westen scheinen der Ansicht zu sein, daß ein Bankkrach sie wenig angehen würde. Ich möchte denselben rathen, wohl in Erwägung zu ziehen, wie sehr der Absatz ihrer Haupterzeugnisse von dem Vermögen der Banken abhängt, ihnen Geld zum Versandt ihrer Ernte vorzustrecken. Sie ren, den großen Getreidehändlern Vorschüsse zu machen und der Preis unaufhaltsam herunterging. Wenn sie das wieder und in noch hundertfachem Maße herbeiführen wollen, so brauchen sie nur die bestehende Währung zu bedrohen, d. h. Bryan zu wählen.

Man sagt uns aber, eine durch Bryan's Wahl herbeigeführte Panik könnte nicht ewig dauern. Schließlich würden sich die Geschäfte dieses Landes der Silberbasis anpassen und die Unruhe sich legen und Glück und Wohlstand zurückkehren. Die Unruhe würde sich nicht legen; denn mit Einführung der Silberbasis würde für diejenigen, welche dieselbe herbeigeführt, Enttäuschung sich einstellen.

Vom Silber zum Papier.

Wer einen Silberdollar will, wird etwas verkaufen oder Arbeit dafür geben, oder sich einen borgen müssen, wenn er ihn nicht stehlen will. Wer sich einen borgen will, wird genügende Sicherheit dafür hinterlegen müssen, gerade so wie es auch vordem mit dem Golddollar gewesen, und jeder wird mehr Silberdollars brauchen, als vorher Golddollars, wegen der verringerten Kaufkraft derselben. Die Silberbasis wird den Zinsfuß nicht verringern, sondern erhöhen, denn der Verleiher wird sich gegen die noch größere Entwerthung des Silbergeldes schützen wollen. Süden und Westen werden gerade so viel östliches oder europäisches Kapital brauchen, um ihre Hülfsquellen zu erschließen, wie vorher nöthig war, sie werden aber dort vergeblich anklopfen, denn ihr Kredit ist hin. Und was wird die Folge von dem allen sein? Die jetzt nach wohlfeilerem und reichlicherem Gelde schreien, weil es nicht genug Geld gebe, werden alsdann mit der Zeit nach noch wohlfeilerem und noch reichlicherem Gelde schreien, weil es nicht genug Silber gebe. Und man wird dann den Beweis zu führen suchen, daß man, gerade so wie vorhes den 50 Cents-Silberdollar

einen noch billigeren Doktor aus Papier herstellen könne und daß doch einmal das echte rechte Vollgeld das reine unverfälschte Zwangsgeld sei. Sie sagen, das wäre Wahnsinn, aber in diesem Wahnsinn liegt System. Zwischen dem werthlosen Papierdollar und dem halbwerthigen Silberdollar besteht der Unterschied nicht in der Art, sondern nur in dem Maße. Auf Bryan folgt Tillman.

Auf Rausch folgt Katzenjammer.

Doch das Endresultat ist klar vorauszusehen. Nach einer Periode unendlicher Verwirrung, des Krachs, der Erniedrigung, des Leidens und Elends wird das amerikanische Volk zur Vernunft zurückkehren und zu dem einfachen Schluß kommen: Wenn man ein „Peck" einen Bushel nennt, so hat man wohl mehr Bushel, aber nicht mehr Getreide; wenn man einen Fuß eine Elle nennt, so hat man mehr Ellen, aber nicht mehr Zeug; wenn man eine Quadratruthe einen Acre nennt, so hat man wohl mehr Acres, aber nicht mehr Land; und wenn man 50 Cents, oder 1 Cent, oder ein Stück Papier einen Dollar nennt, so hat man wohl mehr Dollars, aber nicht mehr Vermögen, ja sogar viel weniger Aussicht auf Vermögen, da man weit weniger Credit haben wird, weil man weniger ehrlich ist. Wir werden dann zur Einsicht gekommen sein, daß der Verstand des Menschen — trotz der Bemühungen einer Anzahl Verrückter — kein volkswirthschaftliches System erfinden kann, unter welchem Alles, was wir zu verkaufen haben, theuer, und Alles, was wir kaufen, billig ist. Und wenn das amerikanische Volk diese einfache Wahrheit erkannt hat, wird es in Sack und Asche Buße thun, und auf diesen verrückten Freiprägungsrausch wird der Katzenjammer folgen. Es wird dann einsehen, wie klug die großen civilisirten Nationen Europas waren, als sie das einzige Geld, das heutzutage das Geld des Welthandels zu sein im Stande ist,

...der Ehre Derjenigen, die Re=
... haben. Um den Preis der Achtung,
die die Welt unserer Intelligenz und
unserem praktischen Sinn entgegen=
bringt. Und schlimmer, viel schlimmer
kann dies Alles: Um den Preis dessen,
das niemals verscherzt worden ist, seit=
dem diese Republik in's Leben gerufen
wurde — um den Preis des edelsten
Gutes, dessen sich eine Nation rühmen
darf und für dessen Erhaltung sie käm=
pfen sollte bis zum letzten Blutstropfen
— um den Preis unserer nationalen
Ehre. Denn diese Nation, die so reich
und mächtig ist, würde als eine Schel=
min, als eine leichtsinnige Verächterin
guten Rathes, ja als betrügerische Ban=
krotteurin vor der Welt dastehen. Dies
werden die Kosten des Experimentes
sein. Sind Sie Willens diesen Preis
dafür zu zahlen?

Schuftige Hetzereien.

Ich bin nicht der Mann, der öffentlich
mit seiner Warmherzigkeit für die Ar=
men und Leidenden prahlt. Dennoch ist
mein Mitgefühl keineswegs geringer,
weil ich meine Liebe und Besorgtheit für
die weniger vom Glück Bevorzugten nicht
beständig auf der Zunge herumtrage. Zu
Denen, die mit Allem, was in der Welt
besteht, zufrieden sind, gehöre ich auch
nicht. Es giebt wohl wenige Menschen,
die so von Grund ihres Herzens die ge=
sellschaftliche Einrichtung, die man Plu=
tokratie nennt, verachten und die Arro=
ganz des Reichthums so zurückweisen, als
ich es thue. Ich weiß auch recht wohl,
daß der industrielle Aufschwung unseres
Landes in der jüngsten Zeit für manche
Bevölkerungsklassen Bedrückung und Un=
gemach gebracht hat, dem nur die kühn=
sten, thätigsten und energischsten unter
diesen so zu begegnen wuß=
ten, daß ihnen diese Zustände zum Segen
gereichten. Es giebt Gesetze und Prak=
tiken, die ich, — wenn ich die Macht da=
zu besäße — im Interesse des allgemeinen
Rechts und der allgemeinen Gleichheit
vollständig ändern würde. Gerade des=

lage, muß ich mich gegen eine ...
auflehnen, die nach meiner Ueberzeugung
die bestehenden Uebel noch in's Unermeß=
liche vermehren würde. Ich weiß fer=
ner recht wohl, daß eine große Menge
Derjenigen, die für Freiprägung sind, zu
den ehrenwerthen, gutmeinenden Bür=
gern gehören, welche von dem Wunsche be=
seelt sind, Recht zu thun. Gerade des=
wegen, weil ich das weiß, empört sich
mein Blut in Zorn und Unwillen, wenn
ich die unbedachten, gewissenlosen Versuche
sehe, die gemacht werden, um Jene dem
Verderben entgegenzuführen. Ich habe
bereits zehn Präsidentschafts = Wahl=
kämpfe miterlebt, aber noch keinen, in
welchem die Aufstachelung des Vorur=
theils, der Leidenschaft und der Begierde
so rücksichtslos und die Spekulation auf
die für möglich gehaltene öffentliche Un=
wissenheit und Schuftigkeit in so kühner
und verschlagener Weise stattgefunden
hätte. Einige der Silberredner lassen sich
wirklich so aus, als ob sie glaubten, das
amerikanische Volk bestehe aus geborenen
Narren oder Schuften oder aus Leuten,
die beides zugleich sein können.

Man richte nur sein Augenmerk auf
das Eine: Um den einfachen Mann mit
gräßlichen Einbildungen zu schrecken,
wird ihm ein fürchterliches Bild von
der „Geldmacht" der Wall= Street und
noch mehr der Geldmacht Englands
vorgeschwafelt, die fähig, begierig und
bereit sei, das Gold der ganzen Welt zu
„cornern" und dadurch das Volk zu be=
rauben und in ihre Gewalt zu bekom=
men.

Nun, wäre das der Fall und würde
die Geldmacht im Stande und auch Wil=
lens sein, das Gold der Welt zu control=
liren, würde der Freisilber = Währung
der Vereinigten Staaten im Stande
sein, die Ausführung eines solchen Vor=
habens zu vereiteln? Ich habe bewie=
sen, daß Freisilber = Währung dadurch,
daß sie unser Gold gerade in den Rachen
der Geldmacht treibt, nur dazu beiträgt,
daß diese das Gold aufhäuft. Nach
der Erklärung der Silber = Autokraten

sind in ▓▓▓▓ über viertausend Mil-
lionen ▓▓▓▓ und über viertausend
Millionen Gold-Dollars in Umlauf. Die
Silber-Dollars sind aber nur Fünfzig-
Cents-Dollars. Wenn nun die Geld-
macht mit Hülfe der Freisilber-Wäh-
rung alles Gold „gecornert", wird sie
da im Stande sein können, alles Silber
aufzukaufen und danach noch nahezu
zweitausend Millionen Dollars in Gold-
Ueberschuß zu haben, oder nicht?

Dagegen kann der Einwand erhoben
werden, daß die Geldmacht sich des Sil-
bers aus dem Grunde nicht bemächti-
gen könne, weil dasselbe, in Form von
Münzen oder Papierwerthen auf Grund
der Währung, als Geld allgemein in
Gebrauch sei. Aber ist unter der Gold-
währung das Gold, in Gestalt von
Münzen oder Papierwerthen nicht eben-
falls als Geld im allgemeinen Gebrau-
che? Und wenn aus diesem Grunde
das Silber nicht „gecornert" werden
kann, wird es aus demselben Grunde
nicht unmöglich sein, Gold zu „cor-
nern?" Dies klingt vielleicht wie ein
riesiger Scherz, aber es ist so! Zeigt
das aber nicht klar und deutlich, daß,
wenn diese schrecklichen Dinge überhaupt
geschaffen werden könnten, sie ebensogut
mit dem Silber wie mit dem Gold fer-
tig gebracht werden könnten? Und wenn
das mit Bimetallismus schwieriger wä-
re, habe ich nicht über allen Zweifel hin
dargelegt, daß Freisilber-Währung den
Bimetallismus, wenn der auch sonstwo
möglich wäre, in diesem Lande vollstän-
dig unmöglich machen würde?

Bryan's Phantasien.

Aber Herr Bryan hat für diese Gele-
genheit einen ganz eigenartigen Roman▓
▓▓▓▓▓. In seiner New Yorker
Rede — jener großen Bekundung seiner
▓▓▓▓▓▓▓▓schen Befähigung — sagte
er:

„Die Goldwährung begünstigt das
Aufhäufen des Kapitals, weil das Geld
im Werthe steigt; sie entmuthigt die Un-
ternehmungslust und legt die Industrie
lahm." Dies ist einzig. Nach Bryan's
Ansicht wird der „Goldsilber", wenn Gold-

schaftlichen Prinzipien und der bekanntesten Geschäftserfahrung geblieben ist, so müssen wir zugeben, daß er sowohl nichts weiß, als auch unfähig ist, noch zu lernen. Nun stelle man sich eine solche Unwissenheit im Verein mit solchen Zusicherungen und in einer mächtigen Stellung vor! Man denke sich, wie er als Präsident der Vereinigten Staaten, in seinen Botschaften solche kindische Absurditäten zur Schau trage. Wir würden zum Gespötte der ganzen Welt werden und jeder Amerikaner müßte sein Haupt vor Schande verhüllen.

Abgedroschene Demagogen-Kniffe.

Doch noch mehr. Indem die Silber-Apostel zu dem kleinsten aller abgedroschenen Demagogen-Kniffe, zur Aufwiegelung des amerikanischen Volksgemüthes gegen England im Besonderen und Europa im Allgemeinen ihre Zuflucht nehmen, erklären sie offenkundig, daß wir ein „unterjochtes Volk" den Fremden „Tribut" entrichten. Was hat Europa denn gethan, um uns „unterzukriegen"? Nichts, absolut nichts weiter, als daß es uns Geld borgte. Es hat uns sein Geld nicht aufgezwungen, aber es uns geliehen, als wir darum nachsuchten und froh waren, es zu bekommen. Es borgte uns Geld, als wir es brauchten, um die Union aufrecht zu erhalten, und wir in großer Noth waren. Es borgte uns Geld, als wir die Hilfsquellen des neuen Landes zu erschließen trachteten. Was fordert Europa jetzt dafür von uns? Nicht mehr und nicht weniger, als was wir zu zahlen versprachen zur Zeit, als wir das Lehen entgegennahmen. Wo bleibt da der „Tribut?" Man behauptet, Europa habe für seine Darlehen großen Profit eingestrichen. Für die Kriegs-Schuldscheine — ja —, doch da wir das als Hülfe in der Noth betrachteten, murrten wir nicht. Im Uebrigen aber, ist es nicht die Wahrheit, daß ungezählte Millionen europäischen Geldes auch in Unternehmungen untergegangen sind, die bankerott gingen? Schöner Tribut das! Die ... kann in dieser

Beziehung nur von dem Nichtsnutzigen in die Welt gesetzt werden, der dem Geldausleiher, als seinem Freund, Schmeicheleien über Schmeicheleien in's Gesicht sagt, so lange er dessen Geld haben will, und nachher, wenn er die Zinsen dafür begleichen soll, ihn als seinen Feind und als Verbrecher behandelt. Ist das der Geist des amerikanischen Volkes?

Diese Leute suchen ferner die Bevölkerung des Westens gegen die des Ostens aufzuhetzen, weil — wie Herr Bryan in der Chicagoer Convention erklärte — der Osten sich in verderblicher Weise in den Handel des Westens einmischt. Wohlan, der Osten mengt sich in den Handel des Westens — aber wie? Indem er dazu beiträgt, daß westliche Eisenbahnen gebaut, westliche Canäle gegraben, westliche Telegraphen-Verbindungen geschaffen, westliche Fabriken gebaut, westliche Ortschaften in's Leben gerufen, westliche Früchte in den Handel gebracht werden, daß Mangel im Westen, der durch Feuer, Wasser oder Mißernten verursacht wurde, aus der Welt geschafft wird. Haben diese Umstände dazu beigetragen, den Osten zu bereichern? Ja, aber sie haben auch den Westen bereichert. Beider Größe und Reichthum ist durch harmonische Cooperation ihrer Kraft, ihres Geistes und ihres Geldes gegenseitig aufgebaut worden, gerade wie das Blut des Ostens und des Westens gemeinsam geflossen ist auf den Schlachtfeldern unserer Republik. Und da kommt dieser junge Mann und spricht von einem „Feindesland", gerade als ob wir unter Entzweiung und dem Parteihader nicht schon genug zu leiden gehabt hätten!

Ferner wird der Versuch gemacht, „die Armen" — wie die Versucher sie nennen — gegen „die Reichen" aufzuhetzen, hier, in diesem Lande, in welchem sich wie nirgend sonst Jedem die Gelegenheit zum Emporkommen darbietet, in welchem, heutigen Tages ebenso wie früher, mancher Arme von gestern zu den Wohlhabenden von heute gehört und mancher Reiche von gestern

wohl wissen, daß sie durch eine unheil-
volle Störung des Geschäftsbetriebes,
die durch einen Sieg der Freisilberbewe-
gung sicher herbeigeführt werden würde,
weit mehr Verluste erleiden würden, als
sie möglicherweise durch eine Verbillige-
rung der Arbeitskräfte gewinnen könn-
ten. Und würden die Arbeiterklassen
durch eine solche Störung des Geschäfts-
lebens nicht am meisten leiden? Ein
Verräther an dem Arbeitsmann ist der-
jenige, der ihm sagt, er könne durch das
Zugrundegehen seines Arbeitgebers ge-
winnen.

Sie geben vor, Feinde der Geldherr-
schaft zu sein und befürworten eine Po-
litik, die ich, wenn ich ein gewissenloser,
selbstsüchtiger Geldwucherer wäre, als
eine seltene Gelegenheit zu meiner Be-
reicherung begrüßen würde. Fragt
man mich, ob ein Freisilbersieg Wasser
auf die Mühle der Geldherrschaft sein
würde und warum die Bankbesitzer und
Capitalisten allgemein Gegner eines sol-
chen sind? Die Antwort ist sehr ein-
fach. Unter den Reichen bie es Landes
giebt es zweifellos solche, welche vor kei-
nem Mittel zurückscheuen, um ihren
Reichthum zu vermehren, welche ihre
Concurrenten auf rohe und gesetzwidrige
Weise vernichten und aus den Geldver-
legenheiten der Unglücklichen Nutzen zie-
hen. Das sind die Leute, welche bei ei-
nem allgemeinen Geschäftsverfall am
üppigsten gedeihen. Doch die überwie-
gende Mehrzahl unserer Bankiers und
Handelsfürsten sind ehrbare Männer, die
auf ihren guten Ruf stolz sind, welche
Diejenigen, mit denen sie zu thun haben,
ehrlich und redlich behandeln, die ihr
Interesse nicht in dem Ruin ihrer Kun-
den suchen und ganz gut wissen, daß
ihr eigenes Gedeihen am sichersten aus
dem Gedeihen Aller hervorgeht. Da-
rum sind sie gegen Freiprägung; nicht
ihnen, sondern dem verwerflichsten Ele-
ment der „Geldherrschaft", würde Frei-
prägung dienstbar sein. Die wahren,
mitleidlosen Blutsauger im Westen und
Süden sind die dort ansässigen T

...m Banker oder reicher Capitalisten.

Die Volksaufwiegler verunglimpfen die Goldwährung als einen Behelf, eine Erfindung der Monarchen und Aristokraten, während doch die Weltgeschichte uns lehrt, daß seit undenklichen Zeiten es ein Lieblingskniff gewissenloser Despoten war, ihre Unterthanen durch Entwerthung der Landesmünze auszuplündern und daß diejenigen, welche aus der finanziellen Verwicklung einen festen Satz der Werthe und des Geldes entwickelten, welches ehrlich genannt werden konnte, stets zu den verdienstvollsten Wohlthätern der Menschheit, besonders der Armen und Schwachen, gezählt wurden.

Sie streben darnach, die Eitelkeit des amerikanischen Volkes dadurch zu entflammen, daß sie ihm sagen, wir seien mächtig und stark genug, um nach Belieben irgend ein Geldsystem und den Werth unseres Geldes ohne Rücksicht auf das gesammte Ausland aufrecht zu erhalten — während doch unsere eigene Landesgeschichte den Nachweis führt, daß das amerikanische Volk vor hundert Jahren stark genug war, das Joch Großbritanniens abzuschütteln, aber doch nicht so stark, um zu verhindern, daß sein Continental-Geld im Werthe auf Nichts zurückging; daß in jüngster Zeit das amerikanische Volk stark genug war, eine riesige Rebellion niederzuwerfen, aber zu schwach, eine unbeschränkte Ausgabe von „Greenbacks" auf Pari zu halten, und daß diese Republik im Stande sein mag, die Welt zu erobern, ohne indeß zu vermögen, aus zwei mal zwei fünf zu machen oder sich durch eine Verwässerung seines Courantgeldes zu bereichern.

Sie reden von den Silberdollars als dem Gelde unserer Verfassung, obschon sie wissen müssen, daß in der Verfassung nicht ein Wort geschrieben steht, welches ehrlich verdolmetscht, eine solche Behauptung rechtfertigen könnte. Sie rufen im Interesse ihrer Sache...

schichte kennt, weiß, daß Jefferson und Jackson einem solchen wilder Plane, geschickt einem falschen Werth zu schaffen, entsetzt gegenüber standen, und einen Jeden, der so etwas sich zu befürworten erdreistet hätte, aus ihrer Nähe fortgestoßen haben würden.

Mit solchen Dingen treten die Frei-Silber-Agitatoren vor das amerikanische Volk, in der Annahme, es sei ohne Vernunft; weil schlimmer aber noch sind die Aufrufe, mit denen sie sich an das Volk wenden, da diese die Voraussetzung in sich schließen, diesem mangele der moralische Sinn.

Sie haben das Volk belehrt, daß weil die Preise für Weizen und andere Sachen seit dem sogenannten Entwerthungsjahre 1873 etwa um die Hälfte gesunken sind — ich habe gezeigt, warum diese Preise zurückgegangen sind — es nicht billig sei, daß Schuldner angehalten sein sollten, mehr als die Hälfte ihrer Verbindlichkeiten in Gold abzutragen, daß sie im Verhältnisse zu dem Preisniedergange davon entbunden werden sollten, und daß es deshalb recht sei, durch Freisilberprägung den Werth des schuldenbezahlenden Geldes um die Hälfte zu vermindern.

Wirkung auf unser Schuldsystem.

Wenn das als allgemeiner Grundsatz recht wäre, wie würde das auf unsere Schulden Anwendung finden? Unter unseren Bundesschuldscheinen giebt es sehr wenige, die nicht lange nach 1873 datirt sind. Viele davon wurden zu dem ausgesprochenen Zwecke verkauft, um dem Schatze Gold zuzuführen. Unsere Corporationsbonds sind in der Regel ebenfalls ziemlich jung, aber alle diese Obligationen bedeuten nur eine Kleinigkeit den ungeheuren Summen von Schulden gegenüber, die im täglichen Geschäftsverkehr gemacht werden. Die durchschnittliche Dauer einer Grundeigenthumshypothek ist fünf

und Mann in ... von Wechseln, Lohnrechnungen und Buchcredit bestehen, deren Gesammtbetrag sich der Berechnung Wie alt sind nun diese? Sie haben ein Alter von einer Stunde bis zu sechs Monaten; wie würde ich obigen Grundsatz hierauf anwenden lassen? Würde da von Billigkeit oder auch nur einem Schatten oder Schein von Billigkeit d': Rede sein können, wenn der Werth dieser Verbindlichkeiten durch einen plötzlichen Uebergang von der Gold- zur Silberbasis um 50 Procent herabgesetzt werden würde?

Nun unterwerfe den Grundsatz selbst einer einfachen Prüfung. Wenn ich eine Schuld eingehe, so schulde ich, was ich nach gegenseitiger Vereinbarung zu zahlen habe. Unser ganzes Geschäftsleben und sociales Gewerbe, aller menschlicher Umgang beruht auf der bindenden Kraft solcher Vereinbarungen. Außer es ist besonders anders abgemacht, hat der Schuldner nicht das geringste Recht oder eine Ursache, zu verlangen, daß der Gläubiger deshalb, weil Weizen oder Baumwolle oder etwas Anderes mittlerweile im Preise gesunken ist, sich mit einer geringeren Abfindungssumme zufrieden geben solle. Wenn das anginge, würde der Gläubiger da nicht auch ein Recht haben, von seinem Schuldner, im Falle Weizen, Baumwolle oder sonst etwas mittlerweile im Preise in die Höhe gegangen ist, eine im Verhältniß größere Zahlung zu fordern? Wenn keiner von Beiden daran gedacht hat, einen solchen abenteuerlichen Vertrag vorzuschlagen oder anzunehmen, wie können solche Ansprüche, wenn sie nur auf einem geheimen Gedanken oder einer willkürlichen späteren Einsicht basirt sind, gerechtfertigt werden? Ist es nicht ungeheuerlich, daß solch eine Anmaßung als eine Gewähr für die durch eine Entwerthung des Geldes mit einem Schlage auszuführende Ermäßigung aller Schulden gelten soll? Kennen Sie einen sol-

mit der Erschütterung von Credit, mit Treue und Glauben im Geschäft auf Erde, die Zustände oder Gründe geln, welche den menschlichen Verkehr regieren, werden in den Staub getreten, eine Herrschaft von heuchlerischer Heuchelei und gewissenloser Habgier tritt an ihre Stelle, mit einem Wort, das geselltete Leben wird über den Haufen geworfen.

Und dennoch, wer die Freisilberagitation verfolgt hat, weiß, daß gerade dieser Appell an die Schuldner einer ihrer hauptsächlichsten Lockrufe ist. Lauscht ihren Reden, leßt ihre Schriften und Ihr begegnet, jetzt in sein geschmückter Weitschweifigkeit, dann wieder in schlauer Andeutung, oder in der Sprache des frechen Cynismus, immer und immer wieder dem Versprechen, daß Freiprägung den Schuldner in Stand setzen werde, sich seine Verbindlichkeiten durch die Abtragung nur eines Theils derselben vom Halse zu schaffen. Es ist das ein Projekt muthwilliger Nichtanerkennung privater sowohl als öffentlicher Schulden, nicht als ob wir nicht alles bis Heller und Pfennig bezahlen könnten, sondern weil wir es vorziehen, nicht in voll zu bezahlen — die Gewohnheit der trügerischer Bankerotteure; und das soll als ein Theil unserer nationalen Politik gesetzliche Zustimmung erhalten!

Schluß.

Mitbürger! Lebent dies wohl. Es ist eine ernste Sache, eine Lebensfrage für den Bestand dieser Nation. Der Vater, der seinen Kindern solche Moral lehrt, erzieht sie zum Betrug zur Unehrenhaftigkeit und für das Zuchthaus. Der öffentliche Redner, welcher dem Volke eine solche Moral verkündigt, erzieht das Volk, daß es der Verachtung und dem Abscheu der Menschheit anheim fällt. Eine Nation, die nach solcher Moral lebt, kann nicht bestehen. Sie wird langsam in dem Sumpfe der Corruption zu Tode faulen. Ist die

die unſerer Republik, dann verſetzt ſie dem Glauben an demokratiſche Inſtitutionen einen Schlag, von dem ſich die Sache der Volksfreiheit Jahrhunderte lang nicht erholen wird.

Aber, Gott ſei Dank, das amerikaniſche Volk wird eine ſolche Moral niemals zu der ſeinigen machen. Das amerikaniſche Volk wird, ehe der Wahltag anbricht, völlig verſtehen, was das bedeutet. Es wird mit Entrüſtung die niederträchtige Beleidigung jener Politiker zurückweiſen, die ihm zumuthen, an einen ſolchen Götzen anzubeten. Das Volk wird wiſſen, wie es die tiefe Schmach abzuwehren hat, in welche die Nation in den Augen der ganzen Welt von ſolchen Amerikanern verſetzt worden iſt, die nur ihre eigene Charakterloſigkeit bloſsſtellten, indem ſie dem amerikaniſchen Volke zumutheten, auf ſolche Leimruthen zu gehen.

Herr Bryan findet einen Geſchmack daran, Bibelſtellen zu citiren. Da wird einſt auf einen hohen Berg geführt wurde und daſs ihm alle Schätze der Welt verheiſſen worden ſind, wenn er ſich niederwerfe und den Satan anbete. Er wird ſich auch der Antwort erinnern, die Chriſtus gegeben hat. In gleicher Weiſe führt jetzt der Verſucher das amerikaniſche Volk auf den Gipfel des Berges und ſagt „Ich will Dir die Hälfte Deiner Schulden abnehmen, wenn Du mich anbeteſt." Der brave Uncle Sam aber richtet ſich in ſeiner ganzen Würde auf und ſpricht mit männlichem Stolze und in edelſter Entrüſtung mit donnernder Stimme: Hebe Dich hinweg von mir, Satan! Denn es ſteht geſchrieben, Du ſollſt nur einen Gott anbeten, den Gott der Wahrheit, der Ehre und der Rechtſchaffenheit und nur ihm allein ſollſt Du dienen!

So wird auch das amerikaniſche Volk am 3. November ſprechen. Und die Sterne und Streifen werden unbefleckt und in Ehren weiter wehen, hochgeehrt von allen Völkern des Erdkreiſes.

Can the University Teach Journalism?

Reprinted from National Printer-Journalist, August, 1909.

Address by Professor Merle Thorpe, of the Department of
Journalism, University of Washington, before the National
Editorial Association, July 21, 1909. At its conclusion
the Association Unanimously Endorsed the Work
of the Department. Similar Action was taken
by the Washington State Association
July 17, 1909.

Mr. President and Members of the Association:

I am deeply sensible of the courtesy extended me by your
body in the invitation to address you today, and I thank you.
It makes me feel that, despite the prevalent distrust of "tailor-
made newspaper men," that I have not departed from the blue
pencil and copy-pad long enough to be classed by you as a rank
outsider. Then your invitation emphasizes that prime charac-
teristic of the newspaper profession—the desire to hear both
sides of the question. And since I have the press of the country
with me today, and behind me, I am bold to confess what the
university is attempting to do in the way of training young men
and women for work in the newspaper field.

You have no doubt already noticed that I have carefully
avoided the use of the word "journalist." I see danger ahead

in the Honorable Tom McNeil's address on "Journalists and Common Newspaper Men." It is true that we are called a Department of Journalism. In the exigencies of the composing room since rubber type went out of fashion, we must have a title to fit the average column headline. Can you imagine us ever getting a top head, first page, seventh column if we had such a title as "Department of Newspaper Writing, Managing and Editing?" Or "Department Leading to Editorial and Reportorial Proficiency?" No, of course not. So we had to do what headwriters are always doing, sacrifice the sense to fit the space. But notwithstanding our title we are training just common newspaper men.

Seriously, I wonder how the good old English word, "journalism" acquired its present day stigma among editors. Mark Twain, I think it was, said that a journalist was a reporter out of a job, and no doubt this good-natured little flip has had its influence. The dictionary, however, and it might be said in passing that Webster, in spite of his woeful lack of unity of plot is our most valued text-book, states that journalism is the "periodical collection and publication of current news; the business of managing, editing and writing for journals or newspapers." So, I'm not so sure that it was necessary for me to apologize for calling our school for newspaper men a Department of Journalism.

Two years ago the University of Washington modestly announced a class in journalism and twenty-two students enrolled for the four hours a week. In the February following the demand for this specialized training was such that another class was organized and two months later the regents decided that the eagerness with which men and women applied for this branch of instruction warranted a department. Sixty-six students registered last year for the four-year course and one hundred and forty men and women took work in the department. Of these sixty-six, fifty-one intend to follow some phase of newspaper work as a career.

When the University of Washington installed this Department of Journalism, no other higher institution of learning, so far as I know had such a department. One or two universities had courses in "newspaper writing," but none offered system-

atic training for newspaper men. The past year, however, saw no less than half a dozen universities offering the four years' specialized work, with a full-fledged school at the University of Missouri, where a member of your Association holds forth as Dean. Next September six other universities, including Minnesota and Colorado, will inaugurate like departments. These institutions are not only heeding the call made on them by students, but have been forced to accede to the demand made on them by editors, educators and men of public affairs.

It is easy to understand why students are eager for the work. Some of them have had a taste of newspaper life, and those of us who have once been in the harness appreciate the fascination. Others choose journalism as the more technical courses are chosen, because it fits them for a profession. A deeper reason for the popularity of the work lies in the fact that the courses of journalism give the student a broader and more practical foundation than the regular arts course or a technical one. There are a great number of high school students, and I venture a number of us were in this class, who of necessity must choose a calling and specialize at once, yet whose inclination is for more studies of a general cultural nature. The boy or girl may have a liking for literature or philosophy or history, but his parents are obliged to send him to college with the injunction "to get into something that will pay your way when you get through." As a result he chooses some form of engineering or law or medicine, specializes, becomes strong in that particular line, but sacrifices breadth. The ideal way, I suppose, would be for him to spend the four years in the liberal arts, then the three or four years in the technical course, but the average young man of today cannot afford the eight years time.

This journalism training bridges over the English idea of culture as best exemplified in our own Harvard University, and the German idea of specialization at Yale, because it gives the student the greater part of a liberal arts course, allowing him to browse around in literature, political science and government, history and philosophy, and at the same time it gives him enough technical training to send him out at the end of four years with a profession. He has been laboring along the

lines of his inclination and has made it fit into his work as a writer and editor; he has the breadth of knowledge so essential in a newspaper man, and understands the game of gathering and editing news.

But I doubt if the great universities of the country would have regarded the wishes of the student in the matter if there had not been another agency urging them to provide training for the coming newspaper generation. That agency is public opinion. Editors themselves are admitting that a great majority of their brothers are not as well informed in law, politics, government and history as the editors of fifty years ago. There is a general feeling that the press is not making the best of its opportunities. In material and mechanical advancement its progress has been little short of miraculous. It is not too much to say that it has supplanted the pulpit and platform, the textbook and the market-place. But how about its influence. There was a time, it is said, that for a man to have a premature obituany notice published in a certain section of the New England press was to kill him to all intents and purposes of the credulous readers, but that doesn't hold today. It is almost necessary for the paper today to publish a coroner's certificate alongside the death notice.

Say what we will many of the large papers are losing their hold on their readers. "I saw it in the paper." "Ah, but that doesn't prove anything. Which paper?" is the usual reply. Readers have become skeptical. They are seeking motives behind policies. Some papers have abandoned their editorial pages altogether. Why? we ask their editors. Because persons no longer read the editorials, the expression of the paper on public affairs. Those who do read them do so only to assign motives and then attack the principles enunciated. With the editorials abolished the policy of the paper must be found in the way it handles the news. Whoever heard of more than a handful of men at a Republican rally in a Democratic paper? Whoever heard of a "rousing and ringing speech of Our Excellency the Governor" in an anti-administration organ. A public official answers charges of malfeasance in office "laughingly" in one paper, but in the other paper the same carbon answer is given out "angrily."

Since leaving the office I have had occasion to meet with

a large number of newspaper readers who, knowing me to be engaged in training newspaper men have spoken frankly of how they discredited most of the news appearing in the daily paper. One of your members said to me this morning, "Remarkable attendance you are having at the Exposition. I had seen stories of it in the papers, but was afraid it was only newspaper talk." Think of it and he an editor! And here is a significant fact: Nine out of ten freshmen who register with me have the idea that making a newspaper consists merely in filling it up with fake stories. There can be no doubt but that with the higher class of readers the daily press is becoming discredited and the feeling is spreading.

This state of affairs is brought about not because the newspaper profession has a lower standard of morals than other professions. There is not a more upright, generous and honest body of men anywhere than those chosen from the newspaper profession. The cause of this growing discredit lies in two directions: First, in the prevailing economic conditions which prevent the real editor from owning the paper. And the second is more reprehensible where the owner has political ambitions.

There are only three or four of the Greeley papers today in our large cities. The immense capital required to carry on a great daily today makes it impossible for the real editor to own his paper. The owner and the paper's policy is too often found in the business office, where the staggering bills for cable tolls, telegraph, special service, and the salary roll of five hundred men and enormous paper bills are to be met weekly. The owner is able to build up such a business by bending his energies in other channels and only too often he is associated with public service corporations. In such a case it is too much to expect of human nature, when public interests, whose guardian it is, and its own interests conflict, for it to deal fairly and squarely with its ward.

When the owner has political ambitions his paper ceases to be the servant of the people. It no longer fulfills its mission as an impartial observer of events and as advisor and counsellor on matters political. The whole office soon learns the politician who is the staunch statesman and sturdy patriot, because he is always in the headlines and quoted at length, and by the same

token it learns the demagogue and the rascal. The best journalism ánd politics that seek personal aggrandizement can never be co-operative, and because certain owners are attempting to serve all the people and themselves at the same time, the American press is being brought into disrepute.

It is this growing distrust that has caused thinking men and women to wonder if the press is living up to its responsible position as teacher and exponent of public opinion. The press will always remain the "regent of sovereigns, the tutor of nations"—we have no fear as to that—but we do feel that with these evils eliminated its capacity for regency and tutelage will be greatly increased. It is this feeling that caused the public to ask the university to assist in raising the tone of the press.

And how will it be done? By sending out young men and women, intelligent, broad-minded, fearless, and morally sound, to assist in making and editing the papers of the larger towns and smaller cities. Here they will be able to look forward to the ownership of their paper, preserve their individuality, and as editor and owner of conscience, character and conviction, who feels his responsibility to the whole people and is independent of all or any part he will soon have a following in his section that can successfully combat a large daily which has forgotten or neglected its duty to its readers. As independent editor of his own paper and respecting his profession will the young man or woman graduating from the department be able to pay back full tale to the state for his education. It may be that I am too idealistic, but I would like nothing better than to see at the top of every editorial column of every paper paper edited by the Department's students the following motto: "I have no political ambitions; I have no business affiliations; I have no axe to grind in any field."

I am not forgetting my young editor's relation to the advertiser. I should not be honest with him if I did not tell him how almost daily he will be called upon to decide between two radical courses of conduct. His biggest advertiser approaches him with the request to suppress the news that the advertiser's drunken son, while on a joy ride, has seriously injured an innocent passerby. Such a question has come more than once to me and to you, and I think you will bear me out that the only ad-

vice that can be given the young student is "to hew to the line and let the chips fall where they will;" that in spite of temporary financial and social loss in the end right and honesty must prevail.

I realize that what has been said so far is pretty idealistic stuff to come from a newspaper man and for the consumption of newspaper men. What you practical newspaper men want to know is: How does the university prepare men for such work as lies before him? The first thing the department tries to do is to teach the student to think clearly, to acquire what the lawyers call a "legal mind," to be able to see the many sides and quirks of a question, form a decision and form it quickly. Then the next thing is to teach him to express himself clearly and truthfully. "It is a long way from the eye to the arm and hand to the paper" said an old German philosopher. An exact quotation from a public man often misquotes him. Accuracy of impression rather than accuracy of statement is the ideal continually held before the student. In fact clearness of thought and lucidity of expression is the foundation of the four years' work.

The student is taught to grasp essentials. It is true that the news of today is the history of tomorrow, but not all the news is state and national history. It was the trained newspaper mind that saw history in a Fairbanks cocktail. Since the journalist is teacher, the teacher should be better educated than his pupil. He is called upon daily to place an estimate upon the scientific discovery; he must tell us the importance of a piece of literature or a play; he passes upon political, social, ethical, and economic topics, and to fit him for these tasks the Department is striving to have him grounded thoroughly in all that these fields represent. He will have a wider comprehensiveness of knowledge and will be able to apprehend more quickly the correct view-point of vital subjects. He should have all this; everyone.admits it; and where is he to look to for it if not to the university?

Training the student to look for the larger significance of passing events and to express himself truthfully and clearly, then are the two fundamental phases of the Department's work. He will also be taught to study human nature on every

hand and to individualize a character so that it can easily be distinguished from all others of its class. In the selection of feature stories the student will have his powers of observation whetted to a high degree. He soon learns that there is much of comedy and pathos in life all around him. To see things from another man's standpoint is no unimportant lesson in itself, and to draw a life-like picture of a tragedy or unusual happening, to recount a humorous incident, or give life to a man interviewed are valuable assets for the young writer.

Short prose fiction is having its inning today. The man or woman who can tell a short story is in demand. In the seventeenth century the great lessons of life found expression in the drama; in the eighteenth, the essay; the nineteenth, the novel, and today it seems that the twentieth will claim the short story. Poe's totality theory is at last justifying itself. So the student after developing his observation and expression and combining the technique and mechanics of the short story, may find his talent along this line. Last year, two short stories which were handed in by students for class work were accepted by magazines of national standing. This study is the legitimate work of the Department and while we do not expect to make all students short story writers they are certainly better equipped to approach a magazine editor than if they had not learned the fundamentals.

The young writer is taught early that he must be born creator and critic. He stands little chance of writing a masterpiece until he can recognize a masterpiece. When a Becky Sharp, caught in a trap, disgraced forever, is made to admire her husband for traits of manhood she did not know existed, our young writer must be able to throw down his pen and exclaim with Thackeray "That is a stroke of genius." The student must develop a critical consciousness which will guide his pen and make well-meant work a reality. To attain this dual personality he must write and study the masters, then write and write and study the masters. He describes a coyote and then compares his efforts with Mark Twain's celebrated "allegory of want;" he pictures a boarding house through sense of smell, then sees how Balzac shows us Madame Vauquer's boarding house by the same method.

He must be able to recognize a well-written news story

when he sees it. To this end a score of the best dailies in the United States are received by the Department and carefully studied. Editorial policies and methods are exemplified in the different papers in the manner in which the same news story is written, handled, or "played-up." Opportunity is given to study editorials on live subjects, and what is more important, to become familiar with the tools employed by the best editorial writers in the country. A New York World, anti-administration uses seven columns on the morning that Roosevelt leaves the White House; a New York Sun, anti-administration, uses one word and that spelled "thru."

News is gathered by the students and written for the university daily and state papers. Correspondents in the Department supply campus news regularly for eight daily papers. Last year these papers, excluding the three Seattle dailies, used eighty-six columns of news and feature stories from the department's students. The class wrote and edited the twelve-page magazine supplement of the Seattle Sunday Times and two of the stories were appropriated entoto by a national press association. The young journalists were the guests of the Seattle Post-Intelligencer staff on another occasion and went the rounds with the reporters, read copy at the desks and wrote heads. As further testimonial of the active support of the press of the state a half dozen prominent editors addressed the students during the year on various phases of the work.

This fall the department will have a complete modern composing-room, equipped with Mergenthaler Linotype and everything down to a quad-splitter that goes to make up an ideal printing plant. The daily will be increased to six columns, four-page, and will be supplied with a 12,000 word telegraphic service of the United Press. A staff will be organized with students acting in the various editorial positions and reporting. On Fridays a "Sunday" edition of eight pages will be published, containing interesting and instructive feature stories A weekly Alumnus journal and monthly literary magazine will also be published by the Department's students.

The Department is working toward a school of journalism when professors from the law school, science, economics, history and philosophy departments will give courses specially designed

for the young newspaper man. These respective subjects will be traced in bold outline and the student will learn the broad principles of each without spending the time necessary to specialize in the subjects. The first year has shown a demand on the part of young men and women for the work. A brighter and more eager group of students is not found in any other department of the university. The first year has shown that the university can give the students a broader comprehensiveness of knowledge and equip him with tools with which to express himself clearly and forcibly. The four years' training will install in the students a quick sense of the right and wrong of those problems which daily are met in the newspaper office and by precept we hope to guide him safely past snares that the rest of us found only by bitter experience. The university has shown that it can teach men the practical work of journalism, those ins and outs which go to make up the everyday life of any profession, and it proposes to place its graduate in a newspaper office so familiar with the work-a-day details that he will not become rusty in the other more important lines while working them out. To be sure there will be much left for him to learn in the office. The university does not pretend to turn out a full-fledged managing editor any more than a conservative school of law or medicine pretends to turn an experienced lawyer or surgeon. It believes, however, that training along certain lines in the university will do as much for the young journalist as it does for the doctor or lawyer, and with everything else equal the university trained newspaper man will be better able to benefit society and the state than the so-called self-made newspaper man who is obliged to get his training at hap-hazard.

Can the university teach journalism? We believe it can do all this for the man who intends to follow jouranlism. To deny it is to challenge the principles on which the university is founded, is to say that the institution is no longer fitting men and women for the larger problems of life.

Проект основныхъ положеній для рѣшенія польскаго вопроса.

Этот проектъ не является вовсе выраженіемъ мнѣній какой либо изъ сложившихся и существующихъ политическихъ партій. Но многими своими пунктами он сходится с программами прогрессивныхъ партій, какъ польскихъ, такъ и русскихъ.

Я полагаю, что на такихъ началахъ можно не только рѣшить польскій вопросъ, но кромѣ того вообще упрочить возможность мирнаго сожительства разныхъ народностей и другихъ общественныхъ групп в предѣлахъ Россіи и ея отдѣльныхъ частей.

Я буду весьма обязан за самую безпощадную критику моего проекта.

I. Общія замѣчанія.

1. Взаимныя отношенія между русскими и поляками, какъ и вообще между всѣми людьми и всѣми человѣческими группами, не должны никоимъ образомъ обусловливаться сантиментализмомъ, ссылками на «братство» и на взаимную любовь. Лозунг «kochajmy się» (будемте любить друг друга) годился для времен безшабашнаго шляхетскаго разгула, но теперь он совершенно не у мѣста. Полякамъ не за что любить русскихъ, а русскимъ не за что любить поляковъ. Евреямъ не за что любить христіанъ, а христіанамъ не за что любить евреевъ. Крестьянамъ не за что любить помѣщиковъ, а помѣщикамъ не за что любить крестьянъ. Рабочимъ не за что любить фабрикантовъ и заводчиковъ, а этимъ послѣднимъ не за что любить рабочихъ. Вообще человѣку не за что любить другого человѣка.

Но какъ жители одной квартиры или же одной общины, такъ же точно и жители извѣстной страны или же извѣстнаго государства, не смотря на всѣ различія во взглядахъ, вкусахъ и стремленіяхъ, не смотря на взаимную антипатію, должны всё таки, во избѣжаніе безпрестанныхъ ссоръ, драк и посяга-

тельств на жизнь, проявлять терпимость по отношенію друг к другу.

Преподносимая нам, в видѣ панацеи общественных недугов, «любовь ближняго» есть ничто иное, как ложь и лицемѣріе. Осуществленіе «любви ближняго» мы можем предоставлять, с одной стороны, разным «любвеобильным», в родѣ «любвеобильных» пастырей, приглашающих свою паству к погромам и к истребленію евреев, «студентов» и «интелигенціи», или же в родѣ „любвеобильнаго" духовнаго начальства, наказывающаго своих подчиненных за агитацію против смертной казни, с другой же стороны «христолюбивым» террористам, «мстителям» и «усмирителям», им же нѣсть числа.

Вѣроисповѣдная этика, гласящая эту «любовь ближняго», терпит постоянно полнѣйшее крушеніе и, перерождаясь в человѣконенавистничество, доводит в конце концов до взаимоистребленія.

Не любить нам друг друга слѣдует, а быть по отношенію друг к другу справедливыми и уважать друг в другѣ человѣческое достоинство в самом обширном смыслѣ этого слова.

2. В частности должны быть исключены и выброшены за борт слащавыя ссылки на «славянское братство» русских и поляков. Всякій панславизм, как боевой лозунг, объявляет войну остальному человѣчеству. Славянство, как идейное цѣлое, существует только в области славянской филологіи. Политическому же панславизму мѣсто в психіатрическом архивѣ.

Точно так же недопустимо обособленіе всѣх арійцев, всѣх семитов и т. д., в противоположность остальным человѣческим породам.

Что касается «славянства» Россіи, то дѣло находится под сомнѣніем. Довольно справиться со статистикою народонаселенія, чтобы убѣдиться, что Россія представляет из себя государство не только не великорусское, но даже не славянское.

Кромѣ того пора перестать лгать и притворяться «любвеобильными» «славянами». Как осуществлялось „славянское братство" и „общеславянская солидарность" в «славянских» частях Россіи, об этом вопіет исторія правительственных и общественных великорусских начинаній в Польшѣ, в сѣверозападном и югозападном краях. Да что говорить об этих

краях, населенных ненавидимыми «нехристями» и «инород-
цами»! Хроника послѣдних лѣт, в особенности же послѣдних
мѣсяцев, бросает краснорѣчивый свѣт на осуществленіе начал
«славянскаго братства» в самых коренных великорусских
областях.

Итак, мы отбрасываем, за негодностью, притворныя ссылки
на взаимную „любовь" и на „славянское братство".

3. Психическое основаніе для рѣшенія польскаго вопроса
и других ему подобных мы можем формулировать слѣдую-
щим образом:

Рядом с основанным на *логическом мышленіи чув-
ством справедливости* регулятором взаимных междуна-
родных, междуплеменных, междуклассовых и вообще между-
человѣческих отношеній должно признать пониманіе обоюд-
ных интересов. А для меня не подлежит сомнѣнію, что обоюд-
ный интерес русских и поляков требует разрѣшенія поль-
скаго вопроса в смыслѣ самоуправленія и автономіи, равно
как и в смыслѣ признанія равноправія всѣх національностей,
всѣх вѣроисповѣданій и всѣх прочих культурнообщественных
групп, до полной безвѣроисповѣдности и безнаціональности
включительно.

4. „Историческим правам" отдѣльных національностей мѣ-
сто в архивѣ исторіи. Туда должны быть направлены: консти-
туція 3-го мая, конституція Царства Польскаго 1815 года и т. д.

Ссылками на историческія права можно, если угодно, обо-
сновывать возстановленіе людоѣдства, рабства, крѣпостниче-
ства, самодержавія и т. д.

Нельзя, конечно, отрицать исторію, но источником для
практическаго рѣшенія политических вопросов может быть
один только современный историческій момент.

5. Замѣняя историческія права правами этографическими,
правами на самоопредѣленіе жителей данной территоріи и во-
обще правами даннаго историческаго момента, мы рѣшаем
вмѣстѣ с тѣм вопрос о сѣверо-западном и юго-западном краях.
Притязанія нѣкоторых, нынѣ чрезвычайно рѣдких, поляков
на какое-то преобладаніе в этих областях Россіи являются
пережитком минувшей исторической эпохи, когда націю со-
ставляли одни „благородные", bene nati et possessionati,

остальное же населеніе считалось живым инвентарем, живыми и мертвыми душами.

6. Политическая обособленность Царства Польскаго обусловливается не какими то архаическими воспоминаніями, но живыми фактическими условіями современности. Вѣдь же до сих пор это отдѣльный край, входящій, правда, в состав русскаго государства, но управляемый на особом положеніи. Раз имѣются мѣстные сатрапы (генерал-губернаторы, намѣстники и т. п.) со внушительными полномочіями, то для их ограниченія, в видѣ противоядія, требуется особое областное выборное учрежденіе, т. е. законодательный сейм Царства Польскаго. Наконец, — и это с точки зрѣнія общественной психологіи самое важное,—все сознательное населеніе нынѣ административно обособленной Польши требует автономіи и оно до тѣх пор не успокоится, пока это его вполнѣ справедливое требованіе не будет удовлетворено.

Если в других областях Россіи сложится такая же строго опредѣленная обособленность, то ео ipso и их придется удовлетворить предоставленіем им областной автономіи с особыми сеймами.

Децентрализаціи и областного самоуправленія нечего бояться. Напротив того, они послужат к сплоченію государственнаго единства и к развитію в населеніи чувства *общегосударственной солидарности.*

7. Требованіе „исправленія границ" между Царством Польским и остальною Россіей представляется мнѣ пока пустою и вздорною затѣей. Никакими усиліями нельзя достигнуть такого разграниченія, при которои административное или же государственное обособленіе совпадало бы с этнографическим однообразіем населенія. Мало того, подобное разграниченіе совершенно нежелательно. Надо показать на дѣлѣ, что мирное сожительство разных національностей п других общественных групп на одной и той же площади вполнѣ достижимо.

И без того накопилось в Россіи столько жгучих вопросов, что осложнять их, ради прихоти и какого-то доктринерства, вопросом об исправленіи границ и таким образом еще болѣе запутывать этот роковой гордіев узел русскаго общественнаго

переворота и перерожденія было бы по меньшей мѣрѣ легкомысленно.

Во всяком случаѣ при оставленіи границы между Царством Польским и остальной Россіей в ея теперешнем видѣ остальная Россія в этнографическом отношеніи ничего не теряет. Как раз на оборот. Правда, в Царствѣ Польском остается около 300.000 (трехсот тысяч) литовцев и извѣстное количество двуязычных (т. е. говорящих тоже по польски) русинов или малороссов, но эта «потеря» в нѣсколько раз вознаграждается находящимися в предѣлах остальной Россіи сплошным или же вкрапленным польским населеніем.

Не мѣшает тоже замѣтить, что начатый еще в «освободительную эпоху» Александра II и продолжавшійся вплоть до нынѣшняго «освободительнаго» года уніатскій погром заставил русское населеніе Царства Польскаго примкнуть еще крѣпче к польскому.

Со временем, если сплошное населеніе извѣстных пограничных частей как Царства Польскаго, так и остальной Россіи выразит желаніе присоединиться к другой области или административной единицѣ, можно будет путем всеобщаго голосованія или плебисцита заняться «исправленіем границ».

8. Долой лозунги: «Россія для русских», «Польша для поляков». Россія для всѣх тѣх, кто в ней живет; Польша для всѣх тѣх, кто в ней живет.

9. Стремленіе к отложенію Польши от Россіи являлось бы теперь тоже праздною затѣей. Созданіе особых государств с особыми правительствами и особыми представительствами обходится населенію слишком дорого; вмѣстѣ с тѣм оно представляет из себя столь ничтожную цѣль, что ради ея одной грѣшно жертвовать не только жизнями многих людей, но даже хотя бы жизнью одного человѣка.

Может быть со временем, при новых воззрѣніях на международныя отношенія, отдѣльныя части одного и того же государства сочтут за лучшее разойтись и достигнут этого мирным путем. Пример Швеціи и Норвегіи служит лучшим доказательством возможности подобнаго развода раньше соединенных государственных цѣлых. Однако стремленіе к насильственному расторженію, в сопровожденіи с кровопролитіем и

разореніемъ, слѣдуетъ считать просто или преступнымъ, или сумасбреднымъ.

10. Основныя формы правленія должны быть одинаковы и в Польшѣ и во всей Россіи. Пока,—если бы мы имѣли дѣло не только со стихійными силами, но тоже с людьми трезвыми и взвѣшивающими обоюдную пользу того и другого лагеря,— надлежало бы остановиться на конституціонной монархіи. При этомъ, конечно, мы руководствуемся не «беззавѣтною преданностью» кому бы то ни было, не «любовью», не «династическими чувствами», а только тѣмъ соображеніемъ, что, закусив удила и требуя республики во что бы ни стало, мы рискуем, при данных условіях, вызвать, с одной стороны, полную анархію, затѣмъ окончательную реакцію и военную диктатуру, с другой же стороны экономическую, культурную и политическую гибель как всего русскаго государства, так и его отдѣльных частей.

С замѣною монархіи республикою и с водвореніемъ республиканскаго «народовластія» можно бы подождать до появленія в Россіи достаточнаго количества настоящих, подлинных республиканцев, республиканцев не только по своим рѣчам и заявленіям, но тоже по складу ума и по привычкам,—а на это пока плохая надежда. Замѣтьте, что даже в Норвегіи не нашлось пока большинства голосов в пользу республики.

При республиканской формѣ правленія Польша, как автономная республика, сохранила бы,—надо полагать,—федеративную связь со всею Россіей, устроенной на тѣх же началах.

Конечно, при полной свободѣ слова и убѣжденій, каждому должно быть предоставлено право пропаганды как по направленію к отложенію Польши от Россіи, так и по направленію к устройству федеративной демократической республики в предѣлах всего государства. Пропаганда подобных политических идей, не сопровождаемая насиліемъ и террором, не должна подвергаться никаким взысканіям. Точно также должна быть каждому предоставлена свобода мирной,—смѣю думать, вполнѣ безнадежной,—пропаганды возврата к самодержавію.

11. Основные законы гражданскаго и экономическаго устройства должны быть тоже одинаковы во всем государствѣ,

как в Россіи вообще, так и в Польшѣ въ частности. Но ихъ осуществленіе и окончательное проведеніе въ жизнь должно сообразоваться съ мѣстными условіями.

Одни изъ этихъ законовъ касаются политической жизни вообще, независимо отъ международныхъ, междуплеменныхъ и междуклассовыхъ отношеній, другіе же имѣютъ ввиду урегулированіе именно этихъ международныхъ и междуклассовыхъ отношеній.

II. Общіе законы гражданскаго устройства.

12. Къ числу законовъ, обязательныхъ для всего государства и обезпечивающихъ возможность свободнаго развитія отдѣльныхъ личностей, т. е. къ числу законовъ, безъ которыхъ невозможна полная и всесторонняя политическая жизнь ни въ одномъ культурномъ государствѣ, принадлежатъ прежде всего:

а) Провозвѣщенныя въ манифестѣ отъ 17 октября 1905 г., но пока законнымъ путемъ не осуществленныя «свободы, съ ихъ дальнѣйшими послѣдствіями.

б) Отдѣленіе церквей отъ государства; низведеніе воинствующихъ церквей (ecclesiae militantes) на степень свободныхъ союзовъ людей, мнящихъ себя одинаково вѣрующими. Возможность для каждаго гражданина объявить себя безъисповѣднымъ (konfessionslos), что, конечно, влечетъ за собою, между прочимъ, учрежденіе гражданскаго брака, какъ внѣконфессіональнаго договора.

в) Полное упраздненіе понятія «господствующій» или же «привилегированный классъ населенія»; вообще отмѣна всякой сословности и ея замѣна полнымъ юридическимъ равенствомъ всѣхъ гражданъ.

г) Учрежденіе одинаковаго суда для всѣхъ безъ исключенія гражданъ. Отмѣна особыхъ военныхъ и вообще сословныхъ и профессіональныхъ судовъ.

д) Отмѣна смертной казни, съ которою никакъ не мирится современное этическое чувство.

е) Упраздненіе всякаго рода стѣсненій при передвиженіи съ мѣста на мѣсто, т. е. прежде всего упраздненіе обязательныхъ паспортовъ, какъ внутри края, такъ и заграничныхъ. Выдача замѣняющихъ паспорты и удостовѣряющихъ личность свидѣтельствъ только по требованію даннаго лица.

проступков, совершаемых путем печатнаго слова, одному только общеобязательному суду. Преследование подобнаго проступка вчиняется прокурорскою властью, или по собственному почину или же по заявлению частнаго лица.

Примечание. Сохраняется для всех печатных изданий обязательство доставлять известное число экземпляров в публичныя библиотеки. Контроль за исполнением этого обязательства и ведение всего этого дела возлагается на особое правительственное учреждение. Неисполнение упомянутаго обязательства штрафуется по суду.

з) Стремление к проведению в жизнь действительнаго общаго избирательнаго права. Постепенное привлечение к участию в законодательной деятельности и в управлении страною всего сознательнаго населения, конечно, без различия пола.

и) Обезпечение прав меньшинства по всем направлениям общественной и государственной жизни.

i) Предоставление всем жителям права публичных манифестаций, с какими угодно политическими эмблемами.

к) Стремление к такому устройству политической жизни страны, чтобы стали невозможны всякия поползновения со стороны правительства на беззаконие и насилие, до введения военнаго положения включительно.

III. Законы по вопросам экономическаго характера.

13. Удовлетворительное и успокоительное решение этих вопросов одинаково обязательно как для польскаго областного сейма, так и для всероссийской государственной думы.

Первенствующее место занимают здесь вопросы рабочий и аграрный.

14. Что касается рабочаго вопроса, то надо помнить два обстоятельства

Во-первых, в западной Европе из всех партий до сих пор одни социалисты, как сознательные представители пролетариата (за исключением только изменивших социалистическому принципу), решали удовлетворительно национальные вопросы, признавая полную равноправность всех национальностей и подчиняя в этой области не население чиновникам, но чиновников населению.

Во-вторых, без участія разноплеменнаго пролетаріата Россіи, т. е. без участія рабочихъ, безъ ихъ самоотверженныхъ дѣйствій, доходящихъ почти до экономическаго самоубійства, освободительное движеніе не достигло бы никакихъ результатовъ. Конечно, и одни только рабочіе, безъ содѣйствія другихъ классовъ населенія, не много бы сдѣлали, но все таки, взвѣсивъ всѣ обстоятельства, мы должны признать за сознательнымъ пролетаріатомъ великую заслугу в этомъ дѣлѣ.

Принимая это во вниманіе, необходимо первымъ долгомъ удовлетворить требованія рабочаго класса, клонящіяся к облегченію его участи и к созданію возможности с его стороны пріобщиться к умственной и культурной жизни страны.

15. Крестьяне, особенно в этнографически коренной Россіи, считаютъ себя обманутыми, обиженными и кромѣ того, частью вслѣдствіе малоземелья, частью же вслѣдствіе низкаго культурнаго уровня, почти безпрестанно страдаютъ отъ неурожая и голода. Какъ это обстоятельство, такъ и науськиванье со стороны разныхъ темныхъ силъ ведутъ крестьянъ к аграрнымъ возмущеніямъ и разнымъ насиліямъ, до сожиганія усадебъ и убійства помѣщиковъ включительно.

Рѣшеніе аграрнаго вопроса в удовлетворительномъ для крестьянъ и соотвѣтствующемъ ихъ психологіи смыслѣ является тоже одною изъ первыхъ обязанностей какъ польскаго сейма, такъ и всероссійскаго парламента.

16. Учреждается институтъ *юрисконсультовъ* для населенія. На обязанности этого института лежатъ: знакомленіе населенія с конституціоннымъ устройствомъ какъ всего государства, такъ и данной области, да кромѣ того юридическая помощь и предупрежденіе экономическихъ катастрофъ и несчастій вслѣдствіе незнанія правилъ и уставовъ. Безъ устройства подобнаго института оставлять в силѣ положеніе, что «никто не долженъ отговариваться незнаніемъ закона», с точки зрѣнія элементарной человѣческой справедливости просто нелѣпо.

IV. Вопросы общественной безопасности и поддержанія силою авторитета власти.

17. Полиція и вообще служба общественной безопасности должна перейти изъ вѣдѣнія государства в вѣдѣніе единицъ самоуправленія, т. е. городскихъ и сельскихъ общинъ. Но общее

руководство полицией должно объединяться в руках более крупных самоуправляющихся единиц: уездных земств, губернских земств и т. д.

18. Армія, на которую надо смотрѣть как на пока неизбѣжное зло, должна быть не областною, но общегосударственною. Ея задача состоит в защитѣ того государственнаго строя, который обезпечивает как за всѣми областями, так и за всѣми національностями и прочими общественными группами одинаковое свободное и безпрепятственное культурное развитіе. Но, как по экономическим соображеніям, т. е. для сбереженія издержек на передвиженіе, так и для облегченія гражданам этой тяжелой повинности, слѣдует сообщить арміи характер территоріальный: солдаты служат по возможности на своей родинѣ. Конечно, это непримѣнимо по отношенію к флоту.

Ввиду отмѣны всяких привилегій и сословных различій, гвардія, как привилегированная воинская часть, и казаки, как особое военное сословіе, упраздняются.

V. Законы, обезпечивающіе мирное сожительство національностей в Россіи вообще и в Польшѣ в частности.

19. Мѣрами, обезпечивающими полную равноправность всѣх національностей, народов и племен, являются между прочим:

а) Отмѣна понятія *господствующей* національности и признаніе всѣм національностям и племенам одинаковых прав в предѣлах их культурнаго развитія и національнаго самосознанія. Численное преобладаніе той или другой національности никак не дает ей права на господство и первенствующую роль.

б) Предоставленіе каждому гражданину права объявить себя принадлежащим к двум и даже болѣе національно-общественным группам, или же не принадлежащим ни к одной из них.

в) Ни один язык не считается государственным и обязательным для всѣх образованных граждан. Но, по соображеніям экономіи, т. е. по соображеніям наименьшей траты времени, языком центральных государственных учрежденій, языком общегосударственной думы, должен быть язык преобладающей численно національности, язык обоих государственных центров,

Петербурга и Москвы, *язык великорусскій*. Тѣм не менѣе в общегосударственной думѣ не может быть воспрещено употребленіе других языков, хотя оно явится вполнѣ безцѣльным с практической точки зрѣнія.

г) Каждому гражданину предоставляется право сноситься с центральными учрежденіями государства на своем родном языкѣ. Дѣло этих центральных учрежденій обзавестись переводчиками со всѣх языков и на всѣ языки, входящіе в состав государства.

д) Чиновники являются слугами населенія, и поэтому всѣ чиновники данной мѣстности или области должны владѣть всѣми свойственными ей языками. Это легче всего достигается, с одной стороны, предоставленіем населенію права выбора чиновников, с другой же, — в случаѣ невозможности провести этот принцип, — назначеніем чиновников из мѣстных уроженцев.

е) Так как в предѣлах Царства Польскаго этнографически польское населеніе составляет громадное большинство, то польскому языку приходится там играть такую же роль, какая во всем государствѣ выпала на долю великорусскаго.

Хотя в польском сеймѣ должен господствовать язык польскій, но тѣм не менѣе нельзя возбранять употребленіе в нем языков національнаго меньшинства.

Всѣ граждане Польши имѣют право сноситься с центральными учрежденіями края на своем природном языкѣ. Обязательно поэтому завести в этих учрежденіях переводчиков для мѣстных языков.

20. Признается за Царством Польским право на національно-областныя знамена и на особый областной герб.

На строго автономных учрежденіях этот герб является единственною государственною эмблемою. На развѣтвленіях же и филіях общегосударственных учрежденій рядом с ним помѣщается герб общегосударственный.

Надписи на строго автономных учрежденіях Царства Польскаго могут быть или только польскія, или же, по требованію хотя бы только меньшинства мѣстнаго населенія, тоже и на других языках. На отдѣленіях общегосударственных вѣдомств обязательны тоже надписи и на русском языкѣ.

21. Участіе в общеимперском дипломатическом вѣдомствѣ,

являющееся объединенным представительством перед заграницей, не должно быть исключительною привилегией одной самой остальной России, но должно быть открыто тоже для уроженцев Царства Польскаго.

22. Между Царством Польским и остальною Россией не должно быть никакой таможенной границы.

23. Получая особый законодательный сейм для нужд собственнаго края, жители Царства Польскаго наряду с этим принимают участіе в общем парламентѣ всей Россіи. Но по дѣлам, касающимся исключительно остальной Россіи, представители Польши пользуются только правом совѣщательнаго голо са.

24. Признаніе за Царством Польским автономнаго самоуправленія требует учрежденія автономных административных коллегій (комиссій, министерств) по части внутренних дѣл, юстиціи, финансов, промышленности и торговли, земледѣлія и народнаго просвѣщенія. Директоры или предсѣдатели этих коллегій, с намѣстником или же выборным президентом во главѣ и при участіи выборных представителей губерній, нѣкоторых учрежденій и союзов составляют областной государственный совѣт.

В центральных общеимперских вѣдомствах, военном, морском, путей сообщенія, почт и телеграфов, иностранных дѣл, обязательно участіе представителей Царства Польскаго.

25. По части финансоваго законодательства и хозяйства, по части почт и телеграфов и по части путей сообщенія польскій сейм и польскій областной государственный совѣт должны входить в соглашеніе с соотвѣтственными учрежденіями всей Россіи: с общегосударственным парламентом и с совѣтом министров.

26. Служащіе на желѣзных дорогах должны владѣть всѣми языками областей, через которыя проходит данный участок желѣзной дороги.

Согласно международным телеграфным правилам, телеграммы должны приниматься на всѣх без исключенія языках.

VI. Школьное дѣло в царствѣ польском.

27. Частным лицам предоставляется право открывать уче

ныя заведенія по какому угодно типу и с какимъ угодно преподавательскимъ языкомъ.

Программы преподаванія въ публичныхъ общественныхъ школахъ вырабатываются областными училищными совѣтами.

Преподавательскій языкъ во всѣхъ публичныхъ школахъ, низшихъ, среднихъ и высшихъ, опредѣляется по желанію большинства населенія данной самоуправляющейся единицы (общины, уѣзда, губерніи, цѣлой области ...), съ тѣмъ однакожъ, чтобы не страдали отъ этого интересы болѣе или менѣе значительнаго меньшинства. Такъ напримѣръ, въ Варшавѣ, согласно этому принципу, возникнутъ вѣроятно, рядомъ съ польскими низшими школами, тоже школы еврейскія и нѣмецкія. Мало того, если въ той же Варшавѣ евреи пожелаютъ имѣть свои особыя среднія школы, это ихъ желаніе должно быть удовлетворено.

Вообще же въ Царствѣ Польскомъ возможны не только низшія, но и среднія публичныя школы со слѣдующими, кромѣ польскаго, преподавательскими языками: еврейскимъ, литовскимъ, нѣмецкимъ и русскимъ (respective малорусскимъ или украинскимъ).

28. Кромѣ преподавательскаго языка данной школы изученіе другихъ языковъ необязательно. Но во всѣхъ школахъ, по крайней мѣрѣ въ среднихъ школахъ, должна быть дана возможность усваивать себѣ другіе языки. Такъ напримѣръ, ученики польскихъ среднихъ школъ Царства Польскаго должны имѣть возможность изучать слѣдующія категоріи языковъ:

а) языкъ русскій, какъ языкъ центральныхъ учрежденій государства и самый распространенный въ Россіи;

б) болѣе распространенные американско-европейскіе языки: нѣмецкій, французскій, англійскій, эсперанто ...;

в) языки иноязычныхъ согражданъ: смотря по мѣстности, еврейскій, литовскій, малорусскій или украинскій;

г) такъ называемые древніе языки: латинскій и греческій.

Само собою разумѣется, что за изученіемъ даннаго языка должно или можетъ слѣдовать изученіе соотвѣтственной словесности и литературы.

29. Языкомъ преподаванія въ высшихъ учебныхъ заведеніяхъ Царства Польскаго (въ Варшавѣ, въ Лодзи, въ Новой Александріи или Пулавахъ и со временемъ въ другихъ городахъ) будетъ языкъ польскій. Нѣкоторые предметы (напримѣръ, литературы другихъ

дается неограниченное право читать на каком угодно я

Кромѣ того, мыслимо со временем — для изъявивших
ніе в достаточном количествѣ и при наличности преподава
ских сил — открытіе высших учебных заведеній с другим
педавательским языком, прежде всего с еврейским, так
ваемым «жаргоном», с языком литовским и нѣмецким.

30. Предоставленіе полной свободы в выборѣ языка явл
лучшим средством для того, чтобы устранить междуплеме
и международную вражду и привязать всѣх жителей к
знающему принцип неограниченной терпимости государс
пому или же областному цѣлому.

И. Бодуэн-де-Куртенэ.

Октябрь—ноябрь 1905 г.

EDUCATIONAL ADVANTAGES FOR AMERICAN STUDENTS IN FRANCE

BY

JAMES GEDDES, JR., PH. D.

PROFESSOR OF ROMANCE LANGUAGES IN BOSTON UNIVERSITY

CAVALIERE DELLA CORONA D'ITALIA

Reprinted from
The WAVERLEY MAGAZINE
Fall of 1908

I. PAST AND PRESENT.

IT is becoming more generally recognized that, except in special cases, an American student has no need of going abroad to secure what was formerly unattainable at home. At the beginning of the twentieth century the situation of America as regards education is radically different from what it was at the beginning of the nineteenth century. With the rapidity with which changes take place as time goes on, the chances are that the changes that will have taken place at the opening of the twenty-first century will be even more remarkable to contemplate than those which have occurred during the century just closed.

At the beginning of the nineteenth century there existed a strong intellectual sympathy between France and America. Benjamin Franklin, during his ministry in France [1776—1785], had more to do with stimulating this friendly feeling than any other American in those early days. Thomas Jefferson, however, Franklin's successor as Minister to France [1785—1789], was no whit behind his illustrious predecessor in encouraging these relations between the two countries. It was while in Paris that he conceived the idea of founding an academy of arts and sciences at Richmond, Va., which should have branches in Baltimore, Philadelphia, and New York. But before his plans could be matured the French Revolution interrupted them. Nevertheless, upon his return to America the higher education continued actively to interest him. He corresponded with the French political economist, Dupont de Nemours, upon this subject. The result of this correspondence was that the French scholar published an essay embodying his own ideas in regard to education in the United States. French was then the language of international communication. France had, thru her distinguished writers, contributed powerfully to enlarge science. In Jefferson's opinion the only two modern nations whose career deserved to be closely studied were France and England.

The trend of ideas, as shown by Jefferson's attitude, turned gradually but persistently in another direction, towards Germany. The scholarly methods and work of the Germans became appreciated. Edward Everett was the first American to take the degree of doctor of philosophy, at Gottingen, in 1817. His example was followed by such well-known Americans as George Bancroft, Basil Gildersleeve, and William Goodwin. In this country, Yale University was among the first of the institutions

of learning to confer this degree, in 1861; Harvard followed in 1875, and Johns Hopkins in 1878. In all of these institutions the reasons for conferring this degree were practically those for which German universities gave it. That is, essentially, that in addition to college instruction the student must have had long training at a university in original investigation and proven his right to be recognized as a master workman by university examinations and the publication of some results or original research.

Thus it will be seen that if France and England hold places of importance in the world of science, they are not the only countries whose ways of investigating subjects and accomplishing results are considered worthy of attention. Particularly since 1870, Germany has developed remarkably, both materially and intellectually. During the nineteenth century the prestige of England, due largely to the admirable administration of her colonial possessions, has not failed to receive due recognition. Moreover, the ties of kinship, mutual interests, and common language are factors that must ever attract American students toward English university centers. It is, therefore, easy to understand why Americans go to the universities in Berlin, Leipsic, Bonn, and Heidelberg, as well as to Oxford and Cambridge. The influence of Americans who have received their training in German universities and are employed as teachers in many institutions of learning thruout the United States is now very sensibly felt. This is one of the reasons why hundreds of American students may be counted in German university centers. The inducements held out to foreign students in Germany are attractive. They are hospitably received, and upon presenting their credentials from an institution whose standing is known, are ordinarily duly matriculated. Two years of serious work along their chosen lines, together with a thesis showing some originality and hard work, and the passing of an examination upon the entire field covered, constitute a fair guarantee of receiving the degree of doctor of philosophy. The value of this degree to a young man intending to make teaching in his own country his life work nobody will be disposed to question.

II. The Effect of Centralization.

The advantages, particularly to Romance students, of a sojourn in France, and especially in Paris, are unsurpassed. Nevertheless, even for Romance studies our students flock in considerable numbers to Germany. There, as has just been shown, besides a hearty welcome and advantages of a high order, it is possible for them to secure a reward in the shape of something tangible, which upon their return home may prove of the

most valuable assistance in obtaining positions. These advantages are, generally speaking, very clearly understood by American students. Why is it, then, that our students, who during the past fifty years have known so well how to take advantage of the opportunities offered for study in England and Germany, have not been attracted towards a friendly country no less distinguished in letters, arts, and sciences than the other two foreign countries? In the first place, because the organization of the higher education in France has hardly been known. Almost everybody in the scholastic world has heard of the *Université de Paris*, of the *Sorbonne*, and of the *Collège de France;* also, perhaps, of the *Université nationale de France*, the *Ecole pratique des hautes études*, and sundry *académies or universités* in different parts of France, like Toulouse, Montpellier, Bordeaux, and Grenoble. But just what these institutions are, their relation to the state or to each other, whether they receive foreign students, or if so, whether degrees are granted, are questions not readily answered by those of us not making a specialty of educational topics. The vicissitudes, moreover, thru which educational institutions along with everything else in France passed during the French Revolution, have served to make the status of higher education seem more complex than it really is.

The *Université de Paris* still exists, bearing at least the name of the celebrated old seat of learning that came formally into existence about the middle of the twelfth century. A century later, Robert de Sorbon, the chaplain and confessor of St. Louis, founded in the University of Paris a school of theology. This school became one of the constituent parts, and the predominant one, giving its name to the entire theological faculty in the University; and today the University of Paris itself is everywhere familiarly known as the "Sorbonne," altho the latter school ceased to exist in 1790. The provincial universities in France arose to meet the wants of the districts where they were, at different epochs after the founding of the University of Paris. There were twenty-five of them, of which Toulouse, founded in the first part of the thirteenth century, and Montpellier, in the latter part, were the oldest. The *Collège de France* was founded by Francis I., in 1529. The king believed that the University of Paris was devoting too much attention to some subjects and not enough to others. It was designed to promote the more advanced tendencies of the time and to counteract the scholasticism taught in the University. The *Ecole pratique des hautes études* is a unique institution of comparatively recent origin, dating from the Second Empire (1852). These names, then, so often heard in connection with the subject of education in France, have indicated institutions whose status was clearly defined and easily understood. Why is it, then, that these establishments do not stand forth clearly cut like Oxford, Cambridge, Göttingen, and

Bonn? Both the names of the French universities, as well as the institutions of learning themselves, have a haze about them that is absent from similarly organized faculties of learning abroad. The principal reason for this vagueness is that at the time of the revolution the entire system of education was revolutionized. The University of Paris, as well as all the provincial universities, was supprest. The hand of Napoleon then made itself felt in the new organization. Centralization in education became the order of the day. The universities, originally independent, were consolidated into one great institution, the *Université nationale de France*, of which the *Université de Paris* and the faculties at Toulouse, Montpellier, and elsewhere in the provinces were sections known as *académies*. The whole system of education was directly under the minister of public instruction, entirely a government affair. Everything went on automatically and with such clockwork precision that it was said the minister could tell a visitor not only what subject was being taught thruout France at a particular time, but the verb itself that was being conjugated just then in all the schools.

III. RECENT SWEEPING CHANGES.

Since those times there have been a great many changes covering the entire educational field in France. Together with colonial expansion, and the reorganization of the army, the educational transformation is the most considerable undertaking the government has accomplisht. Characterized briefly, it is this. Public instruction has been developt in all directions and withdrawn as far as possible from the influence of the church. The laws relating to primary instruction have been improved and elementary education has been made free and obligatory. Moreover, France has awakened to a realization of the benefits to be derived by making her educational centers attractive to foreign students. Before the act of July 10, 1896, higher education was entirely under the control of the minister of public instruction. The act of July 10, 1896, did away with state control of the institutions for higher education, giving to them an independent existence of their own. Thus this act abolished Napoleon's consolidated organization, the *Université nationale de France*, and restored the academies to their former status of universities. These institutions are no longer under state control, for the regulations governing them are made by the University Council, a body consisting of the principal members of the various faculties. Moreover, the French universities now have a legal standing like that of individuals, and may receive bequests or gifts from any one desiring to aid them financially. Formerly they could not receive gifts of money.

The innovation that is of most interest to American students is one made especially to attract them, as well as foreign students in general, to the various French seats of learning, the fifteen universities in the different sections of the country. It pertains to degrees, and especially to the doctorate. Formerly the only possible way for a foreigner to secure a French *diplôme* or degree from any educational institution was by undergoing the same training and passing the same examinations prescribed for a French student. The French diploma confers rights upon the one holding it. For instance, the graduate who has received a degree from the medical school has the right to practise in France; the graduate, likewise, of the school of pharmacy has the right to open an apothecary shop; so, too, the law-graduate has a right to practise law and to aspire to judicial government positions; and the graduate of the different *écoles normales* has the right to give instruction in the institutions of the grade for which he has fitted himself. The French student begins at the age of sixteen a series of examinations, the first of which is the baccalaureate, a degree which represents, speaking broadly, attainments a little beyond those of our high-school graduates but considerably below those of our best colleges. He then goes on passing an examination yearly until he has reached the age of twenty-four or twenty-five years, when he should pass his final examination for the doctorate. These regulations still hold good for French or foreign students who desire to practise the learned professions in France.

Most foreign students, however, and particularly our own, have no intention of pursuing studies with a view of competing with natives or of profiting pecuniarily by their foreign acquisitions elsewhere than at home. As a rule, American students desire certain advantages procurable by a residence of about two years in the foreign country. They usually have had a college course at home and have no desire to spend nine years in France in order to become doctors in their specialties. Moreover, they can ill afford to spend two years of hard work in a foreign country without having an opportunity at the end of that time to possess a substantial guarantee vouching for the genuineness of their efforts. From the French standpoint, it was not possible for the French institutions to exempt foreign students from the regular course or to credit them with work done in foreign parts, without, in most cases, giving them an undue advantage over their own students. By any such method, the foreign student could secure a state degree in a relatively shorter time than the native. The problem was to adopt the curriculum to meet the wants of foreign students while preserving intact the rights of French students. This the act of 1896 accomplisht by authorizing the universities to create titles of a different character from the ones conferring state rights or privileges. In no case can the former degrees be considered a substitute for the latter.

IV. The French Ph.D., or Doctor de l'Université.

The different universities in France, in accordance with the act of July 10, 1896, have created doctorates. The regulations pertaining to acquiring this title are made by the university conferring it, but practically the principle governing the bestowal of the degree is the same in all of the fifteen French universities. The state degrees remain as before, open to all foreigners who care to submit to the same ordeal to obtain them as do the native students.

An American student who desires to obtain the *doctorat de l'université*, the title corresponding to the German doctor of philosophy, after his arrival at the university center, first secures a permit to reside in the place where he is to pursue his studies. This he does simply by dropping a line to the chief of police, if he is going to study in Paris, or to the mayor if he is at one of the universities in the provinces. This permit, besides giving the right to take up one's residence in the place for a long period, carries with it certain privileges accorded only to French citizens, and the protection of the law. If the student is pursuing one of the branches usually studied in a French college of liberal arts, for instance, philosophy, his next step is to register at the office of the secretary of the faculty of letters. At the same time he must present his American credentials or diplomas, with a French translation of them. He must then attend the courses during four semesters, or half-year terms. He need not, however, reside for two years in the same place. The tendency is rather to encourage migration. He can spend six months or more at another university, French or foreign, provided he registers there. Special cases are considered on their merits, and the regulation in regard to time requirement may be correspondingly shortened.

The examination for the doctorate of the university consists of two parts: (1) the thesis; (2) examination on the courses elected. The dean appoints a committee to examine the student's thesis. If satisfactory, the members of the committee affix their signature to the thesis and report favorably to the dean. The thesis is then submitted to the head of the university. This officer may or may not authorize the student to have the thesis printed. When, finally, the thesis is accepted, the student is called upon to support or defend before a committee of specialists what he has brought to light in the investigation of his subject. According as he displays more or less ability in handling the topic, he receives officially marks intended to testify correspondingly. The second part of the examination for the doctorate consists of questions by a picked committee upon the courses pursued by the candidate. If he passes successfully he becomes a doctor of the university where he presents himself, with the mention of his specialty: "philosophy," if that be the subject, upon the diploma.

The expense incurred by a student in order to receive the doctorate depends partly upon the time spent in obtaining it. The cost of registering for two semesters yearly is twenty-four dollars, making for two years' work forty-eight dollars. To this must be added examination and diploma fees, amounting for the two years to about sixty dollars. Finally, there is the expense of printing the thesis. The candidate is expected to give about one hundred and forty copies of it to the university. The cost of printing depends upon the number of pages, plates, type, etc. The Paris University ordinance of March 28, 1898, formulates the fees for the various faculties in that university that bestow the doctorate as follows for the two years: *Letters*, 2 matriculations at $4 each, $8; 2 library privileges at $2 each, $4; 1 examination, $28; total, $40. *Science*, total, $74 to $194. *Medicine*, total, $280. *Protestant Theology*, total, $48. Pharmacy, total, $146. The latest catalog, or *Livret de l'étudiant* (1907-1908), shows that these figures still remain unchanged. It should be said, however, that since the law of December 9, 1905, of absolute separation of the church and state, the *Ecole de théologie protestante* is no longer connected with the university.

Of the five faculties at the University at Paris, the law school faculty is the only one not yet giving the doctorate. The favor with which the new system of granting the degree of *docteur de l'université* is regarded can be in a measure appreciated by the fact that at the end of the year 1901, only five years after the establishment of the doctorate, there were sixty-six candidates who took the examination for this degree at the University of Paris. They were divided among the different faculties as follows: *Letters*: 3 American, 3 French, 1 Italian (a young woman), 1 Portuguese, 1 Servian, 1 Swiss; total, 10. *Sciences*: 3 American, 4 French, 1 Greek, 1 Hungarian, 2 Roumanian, 1 Russian; total, 12. *Medicine*: 1 English, 2 Canadian, 2 Italian, 1 Peruvian, 1 Swede, 1 Swiss; total, 8. *Pharmacy*: 1 Dane, 35 French; total, 36. In all, 42 of French nationality, 25 foreigners. These statistics are taken from *L'Informateur*, second semester, 1903, 15 *rue de Cluny*, Paris. This little publication, costing fifteen cents, and issued each semester, proved serviceable, but is no longer publisht. The sum total there given is 67, as there was at that time one candidate in theology, who for the reason just given above, is now not counted. It is a pleasure to note that the term "student" includes young women as well as young men. As regards impartiality in granting equal advantages to men and women, as well as liberality in offering educational opportunities that are mostly absolutely free of expense to all, France is unsurpast by any other nation. The function of offering examinations and giving degrees is kept rigidly distinct from that of offering instruction. The student pays for the former, but the latter is, save in rare instances, absolutely free.

V. Advantages of a French University.

It may now readily be seen that the higher education in France is practically upon the same basis as that in the universities of Germany or at the graduate schools of the well known universities in our own country. The system governing the reception of foreign students, the splendid advantages offered, and the bestowal of the doctorate by the universities in France are all along similar lines in Germany that have long proved attractive to Americans. The requirements enabling a student to pursue the courses in any one of the fifteen French universities—fitness shown by examination, or by the presentation of a diploma, or certificate or degree, from a college or school of high standing—are practically the same as those called for in order to pursue courses in any one of the twenty-six universities in Germany. The fifteen French universities, each with four or five faculties (Letters, Law, Science, Medicine, Pharmacy), now stand forth as clearly defined as the twenty-six sister universities in Germany. There is just the same practical advantage for a student of Romance subjects to pass his two years in France as there is for a student of Teutonic branches to pass them in Germany. There is nothing in either case that can entirely replace the atmosphere of the foreign country itself. It is therefore difficult to see why students who intend to become teachers of Romance languages in this country should go to Germany in order to get their training. The parallel case, which appears even more strange because Germany is considered the fountain-head of knowledge, is that of a student going to France to pursue Germanic subjects. He can do it quite well. Nevertheless, he misses the German atmosphere and much that only residence in the foreign country itself can give. As most of our teachers in the schools and colleges do not teach philology, but principally the essentials of a foreign language and some literature, it is not easy to overestimate for them the advantages to be secured by a long residence in the foreign country.

Of recent years in Paris, as well as at the seats of the provincial universities, a great deal has been done to render the life of the foreign student pleasant and profitable at a minimum expense. In the opinion of the writer, however, it is hardly prudent for a student to go abroad, counting on spending a year in a foreign country with less than five hundred dollars. It is often done, but is nevertheless a precarious thing to do. In America, generally speaking, it is not so very difficult for a student to find something to do or to work his way thru; but abroad the proposition is quite different, and is by no means safe to count on. Moreover, on the continent of Europe student life is quite different from the American variety. There are no Greek letter societies, no fraternities, no sororities. Yet both in the provinces and in Paris there are at the present time a number of most helpful organizations, membership

in which is likely to prove materially and socially of decided profit to the new comer.

The *Comite de patronage des étudiants étrangers* not only gives information, but is so organized as to be able to furnish material assistance to worthy students for the purpose of paying university fees. Moreover, special rates on ocean liners may sometimes thru this agency be obtained. Its quarters are in one of the halls of the Sorbonne. A secretary will there be found from half-past four to six o'clock every day except Friday, to attend to the wants of the new comer and oftentimes to furnish substantial aid and moral encouragement.

The *Association générale des étudiants de Paris*, 43 rue des Ecoles, is one of the largest of these mutual help organizations. Its aim is two-fold: (1) to facilitate the material life of the student; (2) to make him feel his responsibility to society as well as to himself. By offering him pleasant quarters to work in, like those of any well organized club, where a library of 25,000 volumes is at his reach, as well as more than 200 newspapers and periodicals, the first aim is to a certain extent secured. Moreover, rebates of many kinds for medical attendance, tutors' fees, books, theater tickets, etc., are obtained. There are sections composed of students of law, medicine, letters, science, and pharmacy, so that a new comer is naturally brought in contact with students whose training has been similar to his own. Thus the second aim, a kind of *noblesse oblige* spirit, is engendered and faithfulness of the individual to himself and to others is developt. The membership fee is $3.60 a year. There are nearly 10,000 active members. The club is on a most successful financial footing. The advantage of membership to the new comer who finds himself alone in the great city must be obvious.

By the side of this successful Association there has sprung up another, and indeed from the former. In the *Association générale des étudiants*, owing to the large number of members, certain rules have to be vigorously enforced. One is that discussion of religious or political topics is tabooed. But the many republican student members desire to give vent to their feelings, and so the *Union des étudiants républicains*, 161 boulevard de Montparnasse, has taken its rise. Lectures on literary and political subjects occur frequently, and in many ways the club promotes good fellowship.

University Hall or *Résidence universitaire*, 95 boulevard Saint-Michel, is a society after the manner of English establishments, where board and lodging and favorable surroundings for literary work are to be found. Of University Hall, M. Dupouey writes thus in his pamphlet mentioned in the present article, p. 16 (Americans in French Universities, p. 18): "The residents enjoy great freedom, inviting thither their friends and organizing their common life for the best comfort and pleasure of all. The excellent example ought certainly to be followed by many groups of students.

Young Americans in Paris, accustomed to their fraternities and clubs, would render a service to their French comrades should they take up this matter."

La Solidarité universitaire, 19 rue de Savoie, is a kind of co-operative mutual help society, more on the American plan of securing employment for its members. Such work as translation, compilation, summaries of books, bibliographical data, map-tracings, are among the tasks most usually called for. The American student who looks for such lucrative employment as reading gas-meters, taking tickets at the door, or checking coat and hat is apt to be bitterly disappointed. Nevertheless the Solidarité fulfils a useful mission. There are not lacking societies that are smaller than those above mentioned, and whose usefulness applies to special conditions. Such are the *Cercle catholique des étudiants de Paris*, 18 rue du Luxembourg; the *Cercle d'étudiants protestants de Paris*, 46 rue de Vaugirard, both excellent of the kind. Then there is the *Restaurant cooperatif du Quartier Latin*, 14 rue de la Sorbonne, where the average price of meals is about twenty-three cents. Besides the double aim of furnishing good food at very moderate rates, that of abstaining from alcohol and all kinds of liqueurs and brandy, except when prescribed by a physician, is carried out. The moderate use of wine, beer, and cider is permitted. Young men and young women students much appreciate the advantages of this hygienic and economical restaurant.

For young women, one of the most helpful of these associations will be found: *La Guilde internationale*, 6 rue de la Sorbonne. It has within itself organized elementary courses in the pronunciation and grammar of the French language, as well as in French history and literature, in order to pave the way of the new comer to take with profit the university courses. This society is in charge of Miss Williams, whose experience, knowledge, and familiarity with the surroundings are ever at the service of the new comers desirous of beginning work with a minimum loss of time. Besides the Guilde for young women, there is also the *Cercle Amicitia*, 12 rue du Parc Royal, in charge of Mlle Monod, where the same friendly spirit prevails, and where young women may count upon kindness and assistance in many ways.

Perhaps the latest and best home in Paris for young women is the Student Hostel at 93 boulevard Saint-Michel. The building was formerly a convent. Thru the efforts of Mrs. Grace Whitney Hoff, an American resident of Paris, it has been rebuilt, furnisht with baths, dispensary, and all manner of modern improvements. About forty or fifty girls are usually gathered together at meal time. The rooms accommodate about twenty-three students. Room and board may be had from four to seven dollars a week. The directress in charge of the Hostel is Miss Bushnell Smith.

Mention will be made later of the *Association américaine des arts à Paris* and of the *Alliance Française*, two most important auxiliaries for enabling students to become familiar with some of the best advantages obtainable. Sufficient here has been said to show that the French are keenly alive to the desirability and to the mutual advantage to be gained by doing what is possible to facilitate the progress of foreign students.

The act which has effected the great changes described in the organization of the French educational system, and particularly changed the attitude towards foreign students of all the institutions for the higher education in France, is so important that before going on to speak of the different universities it will be of interest to learn something of the prime movers who brought about modifications so beneficial and so far-reaching.

VI. Origin of the Recent Changes.

It seems a little odd than an American who, like many of his countrymen, after finishing his college course in America, had completed his studies in Germany by taking the degree Ph. D. at Halle, should have been the first to bring the matter of reorganization of the higher education in France to the attention of the French authorities. After having made, in 1895, quite a thoro examination of the principal schools in Paris, particularly the *Sorbonne, Collège de France, Ecole des hautes études*. Mr. Harry J. Furber, a graduate of the University of Chicago (1886), and for a number of years a student abroad and in foreign universities, came to the conclusion that the advantages which it might be possible for American students to procure in Paris were extraordinary. He then askt himself why it was that, notwithstanding, there were but thirty American students enrolled at the *Sorbonne*, while at the same time at the University of Berlin there were over two hundred. Moreover, if a count were made of all American students pursuing courses in the twenty-six German universities, the sum total of more than a thousand would offer a still more unfavorable and striking contrast for France to the total number of American students enrolled in the latter country's fifteen university centers. As regards the number of artists and sculptors studying in Paris, the sum total of Americans among them proved clearly the superior attractiveness of the French capital to them as an art center over all other places. Mr. Furber realized that if the figures showed in the domain of letters so marked a predilection on the part of American students for German university centers, the inducements offered there in science and letters must be far superior to those offered in France. He then found what has already been shown; namely, that the regulations in force, while doubtless well adapted to the needs of French students, were entirely unsuitable to the wants

of foreign students, and particularly Americans. Mr. Furber then drew up a memorial stating the case clearly to M. Poincaré, the minister of public instruction. These ideas, of which a summary has here been presented, were given to the general public in an article publisht in the *Journal des Débats,* of June 7, 1895, by M. Michel Bréal, a member of the Institute and a professor at the *Collège de France.* Moreover, M. Bréal made a strong plea for the advantages offered outside of Paris by the provincial universities. Nowhere, he said, could French life in all its intimacy and purity be so well studied as in the different French provinces. As examples of admirably equipt institutions, he cited those of Lyons and Lille; while others peculiarly endowed by nature with a rare climate and superb physical attractions are Dijon, Toulouse, Bordeaux, and Montpellier. Were he to begin life over again, he would be a student nowhere else than at Grenoble, the great natural beauties of which are so familiar to so many of our tourists. Paris, he concluded, may well be kept for the last semester and fittingly crown the foreign student's sojourn in France.

The result of this article from the pen of so distinguisht an educator as M. Bréal was the formation, about a fortnight later, of a committee composed of the best known and influential men in the educational world in and around Paris.

M. Brèal addrest the meeting, supporting by word what had already appeared in print. The discussion was participated in by M.M. Bonet-Maury, Gréard, Lavisse, Maspero, Paul Mellon, Paul Meyer, and Parrot. In the course of the discussion, the sympathy and encouragement of M. Hanotaux, the minister of foreign affairs, and of M. Poincaré, of public instruction, were clearly shown by their approval of the plan to form a Franco-American committee. On the other hand Mr. Furber voiced the equally hearty support of His Excellency, the ambassador of the United States, for this movement towards closer intellectual affiliation. A commission was then and there (June 26, 1895) appointed to study into the question of how to facilitate the entrance of American students into French schools, and what inducements might properly be held out. So important and far-reaching have been the results attained by this commission that it must be of interest to American students to know who the men are who have been instrumental in securing for them such magnificent opportunities for study as are now to be had at a mere nominal cost in France. The members of the French commission are MM. Bonet-Maury, Professor in the Theological School; Michel Bréal, of the Institute, Professor in the *Collège de France;* Bufnoir, Professor in the Law School; Darboux, of the Institute, Professor in the Scientific School; Giry, then Professor in the *Ecole des Chartes;* Lavisse, of the French Academy; Levasseur, Professor in the *Collège de France;* Maspéro, of the Institute; Paul Mellon, Secretary of the Commission; Paul Meyer, of the In-

stitute, Director of the *Ecole des chartes;* Gabriel Monod, Professor in the *Ecole pratique des hautes études;* Schefer, of the Institute, then Director of the *Ecole des langues orientales vivantes.* The name of the French ambassador to the United States, at that time, M. Jules Cambon, was afterwards added to the list.

To coöperate with this commission and aid the members in rendering their efforts as effective as possible, in accordance with Professor Furber's suggestion, the following committee, chosen from distinguisht American educators, was appointed: President Angell of the University of Michigan; President Dwight of Yale University; President Eliot of Harvard University; President Gilman of Johns Hopkins University; G. Brown Goode, Assistant Secretary in the United States National Museum; E. R. L. Gould, Secretary of the International Statistical Association; President G. Stanley Hall of Clark University; Wm. T. Harris, U. S. Commissioner of Education; S. P. Langley, Secretary of the Smithsonian Institute; President Seth Low of Columbia College; Simon Newcomb, U. S. N., Superintendent of the Nautical Almanac; President Schurman of Cornell University; Andrew D. White, ex-Minister to Germany; President B. L. Whitman of Columbian University; Carroll D. Wright, U. S. Commissioner of Labor. The commission and the committee together constitute the Franco-American Committee.

Immediately an active campaign to further the common cause was begun by both the members of the commission and those of the committee. In the way of propaganda, one of the best contributions appeared in the *Forum,* New York, May, 1897, from the pen of Simon Newcomb. This article is entitled "France as a Field for American Students." The advantages to be had by the American students at the *Sorbonne, Collège de France, and Ecole pratique des hautes études* are well set forth. The article appeared before the creation of the degree of doctor of the university; nevertheless, the comparison between the French system then in vogue and the German system is luminous and will repay reading any time. Another able article, most sympathetically written, and showing the friendly feeling between France and America during critical periods in the history of both, aimed to bring about closer intellectual relations in the immediate future. This article, by Professor Raphael George Lévy, of the *Ecole libre des sciences politiques,* was publisht in the *Revue internationale de l'enseignement* for February. 1897. In 1899, the Franco-American Committee, 87 boulevard Saint-Michel, publisht a pamphlet containing in one hundred and thirty-eight pages a clear account of the system of higher education in France, together with the changes recently effected. This publication has done much to do away with the lack of comprehension in regard to the status of the French universities. Also their requirements for the doctorate were made perfectly clear. The *Comité de patronage des étudiants étrangers,* office in the Sorbonne, has issued a luminous

pamphlet, entitled: "New Diplomas of the French Universities;
doctorate, license diplomas, certificates of studies; for the especial
use of foreign students." Finally, in 1907, there appeared in the
October number of the *Echo des deux mondes,* issued in
Chicago, perhaps the best French periodical publisht in the United
States, a concise summary of information upon the entire subject,
with practical hints to aid students going to France for study. This
summary is entitled *Conseil aux Américains,* and is written by M.
Robert Dupouey of the faculty of the University of California. The
substance of this useful article appeared in English in the University
of California Chronicle, vol. IX, no. 4, 1907, and was also separately
printed. By making application, most of the propaganda mentioned
in the present article can be readily obtained. There seems now to
be hardly any reason why a student intending to study abroad should
not have quite as clear an idea of the university system in France
and the opportunities it offers as of the German university system
and its advantages. To all of the above-mentioned articles, and
especially to the useful report of the Franco-American Committee,
the writer of the present article desires to acknowledge his indebted-
ness.

VII. The University of Paris.

Of the fifteen French universities, the University of Paris, or
the *Sorbonne,* is by far the most renowned. It possesses traditions,
like those of Salerno and Bologna, that only centuries of existence
can give. The most influential scholars have been and still are
connected with its teaching force. Of the original building con-
structed by Cardinal Richelieu in 1629 for the *Sorbonne,* then the
theological faculty of the University of Paris, the church is the only
portion that has been preserved. Since 1885 extensive build-
ing operations, only recently finisht, have been going on, and
now the University of Paris possesses one of the finest and costliest
structures for educational needs to be found in all Europe. The
front of the building is on the *rue des Ecoles,* just opposite the
Hôtel de Cluny, the site of the palace and baths of the Roman em-
perors. The beautiful new home of the University of Paris is
the seat of the French academy and of the faculties of letters,
science, and theology. The large amphitheater in the interior of the
building, where public functions take place, will hold three thousand
five hundred persons. This hall contains statues of Sorbon, Riche-
lieu, and Rollin, who so identified themselves with the university,
and of the eminent French scientists, Descartes, Pascal, and La-
voisier. At the end of the hall is the celebrated painting *The Sacred
Grove,* by Puvis de Chavannes. Other portions of the interior of
the *Sorbonne* are beautifully decorated by celebrated artists. Of
the five faculties constituting the University of Paris, law, letters,

science, medicine, and pharmacy, the faculty of law, as previously noted, is the only one not yet bestowing this new degree. The total number of students registered and in attendance at the courses offered by these various faculties during the year 1906-1907 was 15,789. The lectures are free to the public. In some cases in which the subject itself or the lecturer is popular, the halls are apt to be crowded, and to obtain a seat it is necessary to be on hand early. The courses in literature are much frequented by ladies. This fact has been made the subject of much good-humored pleasantry by French writers. In Edouard Pailleron's comedy, *le Monde où l'on s'ennuie*, which was very successful and now belongs to the répertoire of the *Comédie Française*, the author has amusingly set before the public the kind of fetich worship offered to a popular professor by his fair constituency. There are, besides the free lectures, courses called *cours fermés*, where the personnel is restricted to the competency of those desiring to pursue them. Considerable drill can be got in these courses.

Glancing over the prospectus of the faculty of letters of the University of Paris, the names of over fifty scholars, many of them distinguisht in their specialties, appear on the list of teachers. Some of these professors' names, widely known in connection with the literary work of their authors, will be readily recognized by students everywhere. Classed under one general heading, the different subjects or divisions of the subject are taught by the following professors: (1) *American institutions and literature*, the American exchange lecturer; (2) *Archeology*, Collignon; (3) *Art, musical, modern, ancient*, Lemonnier, Rolland; (4) *Auxiliary Sciences to History*, Langlois; (5) *Education*, Durkheim; (6) *English Language and Literature*, Baret, Legouis; (7) *European Literature*, Hauvette; (8) *French Language and Literature*, Brunot, Chamard, Gazier, Faguet, Lanson, Michaud, Reynier, Roques; (9) *Geography*, Bernard, Dubois, Gallois, Schirmer, Vidal de la Blache; (10) *German*, Andler, Lichtenberger; (11) *Greek*, Croiset, Faugère, Girard, Hauvette, Puech; (12) *History, Ancient*, Bloch, Bouché-Leclercq, Diehl, Grébault, Guiraud, Langlois, Pfister, Revon; (13) *History, Modern*, Aulard, Bourgeois, Denis, Lavisse, Seignobos; (14) *Italian Language and Literature*, Dejob; (15) *Latin*, Cartault, Courbaud, Durand, Goelzer, Havet, Lafaye, Martha, Plessis; (16) *Paleography, Classical*, Chatelain; (17) *Philology, Classical*, Goelzer, Havet; (18) *Philology, Romance*, Thomas; (19) *Philosophy*, Delbos, Egger, Lévy-Bruhl, Rauh, Seáilles; (20) *Psychology*, Dumas; (21) *Russian*, Haumant; (22) *Sanskrit and comparative grammar of the Indo-European languages*, Foucher, Vendryès; (23) *Sociology and Political Economy*, Espinas, Bouglé. This information is taken from *Le livret de l'étudiant*, the University of Paris yearly catalog, 1907-08, which the student in Paris will find indispensable,

the exact location of buildings, hours of courses, etc., being given.
It may be well to secure a copy long before going abroad. The
student in Paris is likely to have almost every question for informa-
tion answered at the *Bureau de renseignements*, in the Sorbonne.
The Bureau itself publishes a handy manual much resembling the
Livret de l'étudiant. The title is *L'Université de Paris et les
établissements parisiens d'enseignement supérieur. Programmes
sommaires. Renseignements divers*. In the 1907-8 edition, specific
information in English is given on pp. 161-165. Moreover, the
Office d'informations et d'études, 31 rue Gay Lussac, furnishes the
new comer with accurate information in regard to the various
schools, courses, instruction, etc. The *Comité Franco-Américain*.
formerly at 87 boulevard Saint-Michel, has been united to the In-
quiry Office of the Sorbonne.

Inasmuch as the department of science is strictly separated
from that of letters, the courses given by the above professors at
the faculty of letters will be found to be much along the lines laid
down in the catalogs of American universities and applicable to the
courses given in the college proper, omitting those devoted to the
sciences and mathematics. In brief, as seen above, they consist of
culture studies, and largely of those so highly esteemed of old, and
which, coming down thru the ages, still hold their own amid the
multitudinous subjects that are claiming recognition because of rapid
changes in civilization. These long-accepted and cherished studies
are philosophy, history, Greek, Latin, French, foreign language and
literature, political economy and sociology, all of them in their dif-
ferent phases, and relations to allied topics; in a word, the humani-
ties, using the word in the broadest possible sense. A subject not
usually put down in the curriculum of American colleges or univer-
sities is geography, to which much attention is given in the faculty
of letters of all the French universities. Like the other subjects
making up the courses, it is gone into very thoroly, and there appear
courses in modern, ancient, physical, colonial, and commercial geog-
raphy. Political economy and sociology figure on the prospectus of
the faculty of letters, of the University of Paris, yet not as promi-
nently as in the law-school course. It is in the latter faculty that
the subject is almost wholly pursued in all, or nearly all, the other
French universities. French literature, French history, and French
philosophy appear to be the centers to which attention is strongly
directed. It is undoubtedly due in a large measure to this fact that
France has in the past produced such brilliant philosophers, his-
torians, and littérateurs. This trend in the direction of studies cer-
tainly appears sensible from a practical standpoint, for it would seem
to be a duty to be well informed in regard to what directly con-
cerns one's native land and those who influence thought within its
borders.

Besides the ancient languages Greek and Latin, whose literature and philology receive a good share of attention, Sanskrit and comparative grammar of the Indo-European languages are studied under some of the foremost scholars in this department of linguistics. European literature, undoubtedly, embraces considerable of the best in the field in northern and southern Europe. The stress appears to be laid rather on the literary side of language than on the philological. This feature is in contrast with the curricula in some of the higher institutions of learning in the United States, where the emphasis is rather on the linguistic or philological side of language than on the literary. The two foreign languages to which most time and attention are given at the University of Paris are German and English, fully warranted by their importance. Paleography, generally speaking, is a subject that appears quite prominently in the courses offered by the faculties of letters in France, and for the study of which Paris has opportunities that are unsurpassed. It will be noticed that American Institutions and Literature have within recent years been given a place.

The faculty of sciences at the University of Paris embraces purely scientific subjects. They are treated widely in all their many phases, just as letters are in the faculty of letters. The subjects pursued are: astronomy, botany, chemistry, geology, mathematics in all the higher branches, mechanics, mineralogy, physical geography, physics, physiology, and zoölogy. No subjects, for instance, like language, letters, or political economy, such as are taught at the Massachusetts Institute of Technology, more or less in connection with work in science, are found on the program of studies of the faculty of sciences. The former subjects are considered as belonging to the department of letters, and to this latter faculty, consequently, they are relegated. The prominence given now in some of our scientific schools to engineering, architecture, and landscape architecture is due to the development of these subjects in recent years in this country. Altho these topics are not to be found on the program of the French faculties of science, the subjects themselves have long received the most careful attention in French technical schools.

The faculty of law of the University of Paris offers about forty courses given by as many different professors. Compared with the courses given in our law schools of good standing, the Paris courses are not so technical, and speaking broadly, have considerable more educational value. There are no less than fifteen courses on political and economical sciences, a number of which, like Comparative Social Economy, Public International Law, History of Economic Doctrines, are of much general interest and value. Judging by the program of courses recently made at the Boston University School of Law, that is the introduction of courses on international, colonial, and consular law, it would appear that in the future more such

courses as are offered abroad, and which are of educational value
to all, are likely to be given in our law schools here. The impetus
in this direction is in a large measure due to national expansion.

The courses offered by the faculty of medicine are similar to
those that appear on the programs of our best medical schools.
About sixty professors give as many courses either at the school
itself, in the *Place de l'École-de-Médecine,* or at various hospitals
in the city. As pointed out in comparing the announcement of the
law-school courses with similar ones in this country, the French
medical schools likewise may possibly offer a few more popular or
less technical courses than can be found in the American schools of
medicine. At least the subjects of some of the courses, Hygiene,
Physiology, Biological Physics, and Biological Chemistry, suggest
courses of educational value that may not be, and probably are not
intended exclusively for specialists.

The studies pursued at the *École supérieure de pharmacie* are
conducted by six professors. The subjects taught are Analytical
Chemistry, Galenic Pharmacy, Mineral Chemistry, Natural History
of Medicaments, Physics, Zoölogy. Over a year of study is required
at the school, and finally the presentation of a thesis containing per-
sonal research, which the candidate for a degree is called upon to
elucidate.

As already stated, there is no longer a sixth faculty, that of the
École de théologie protestante. The courses, however, at this school
continue to be given by ten professors, and are similar to those laid
down in the curricula of many Protestant theological schools in this
country. They include Ecclesiastical History, Evangelical Ethics,
German, History of Philosophy, Lutheran Dogma, New Testament,
Old Testament, Organization of the Reformed Churches in France,
Patristics, Practical Theology, Reformed Dogma, Revelation, and
Holy Scripture.

VIII. The Provincial Universities.

The fourteen universities outside of Paris and in the different
sections of France are Aix, Besançon, Bordeaux, Caen, Clermont-
Ferrand, Dijon, Grenoble, Lille, Lyon, Montpellier, Nancy, Poiters,
Rennes, Toulouse. As their curricula are modeled in a measure
upon that at the University of Paris, no detailed description of them
is necessary. None of them possesses, for obvious reasons, the un-
rivaled opportunities found at the University of Paris. Neverthe-
less, by this is not implied that they are lacking in attractiveness
either of natural or intellectual resources. Indeed, the natural at-
tractions of many of these institutions appeal to many more strongly
than the city advantages of Paris. With the exception of the uni-
versities of Besançon and Clermont-Ferrand, which have only the
three faculties, letters, science, and medicine, the remaining pro-

vincial universities have four faculties: law, letters, science, and medicine; or five, counting the schools of pharmacy, usually comprised in the medical schools. Toulouse had, like the University of Paris, before the law of December 9, 1905, of separation of church and state, a faculty of protestant theology. The universities of Bordeaux, Lille, Lyon, Montpellier, Nancy, and Toulouse are among the most important, by reason of their equipment and advantages, of the provincial universities. Some of the others, however, have in some respects advantages superior to any one of the six just named. It is possible, too, that each one of these university centers, by reason of its situation, or of particular circumstances, may possess, and probably does possess, superior advantages to any other for pursuing special branches.

Thus because of the fine laboratories, extensive collections, agricultural stations, botanical gardens and museums in Bordeaux, agriculture, natural sciences, and chemistry applied to industry are all especially studied. Among the courses at the faculty of letters serving to differentiate the curriculum from that offered by other institutions are found: History of Bordeaux and the Southwest of France, Language and Literature of the Southwest of France, Hispanic Studies. The University of Lille, in the ancient capital of Flanders, near the Belgian frontier, possesses very fine material as well as intellectual equipment. Among the courses at the faculty of letters, one will hardly fail to note, because not found elsewhere, Walloon and Picardy Language and Literature. The situation of the university in the heart of the Walloon district is in itself an advantage in pursuing this specialty such as no other university possesses. The University of Lyons, in one of the finest cities in France, not far from Switzerland, possesses exceptional advantages for the study of archeology. Industrial and agricultural chemistry holds an important place among the sciences. The influence of the silk industry, as well as of the metallurgic industry of the region, is traceable among the courses offered by the faculty of science. The study of psycho-physiology is one of the specialties of this university. In the department of letters a course on the History of Lyons is noticeable. The University of Montpellier is a most active intellectual center. The faculty of medicine to which Rabelais belonged, and added lustre by his efforts in its behalf, still retains its ancient prestige. The *Jardin des plantes* is one of the finest in Europe. It contains a great number of rare trees and plants. Botany and natural sciences are among the most popular studies at Montpellier. Moreover, the *Comité de patronage des étudiants étrangers* has recently issued a circular from the *Université de Montpellier*, announcing that during the winter semester of 1908-1909, courses adapted particularly to foreign students will be offered. The program, embracing subjects in French, Italian, Spanish, and Romance philology, appears very attractive. Among the courses in letters at

the University of Nancy, in the ancient capital of Lorraine, are to
be noted one on German Philology, another on History of the East
of France.

At the University of Toulouse, in the ancient capital of
Languedoc, more attention is given by the faculty of letters to the
study of the Spanish language and literature than elsewhere in
France. The annual competition in the subjects of poetry and elo-
quence still takes place in Toulouse, pleasantly commemorating the
famous *Jeux floraux*, instituted there in 1323. At the universities
of lesser importance than those just named, courses in certain sub-
jects will be found which do not appear at all elsewhere. Thus at
Aix, in Provence, not far from Marseilles, the faculty of letters of-
fers several fine courses on Provençal History, Language, and Lit-
erature. The University of Caen, situated in the very heart of Nor-
mandy, offers a course on Norman Art and Literature, which cannot
but be of considerable interest to students of art and architecture.
Grenoble, in the midst of the Alps, not far from Italy, is beautifully
situated, possessing the warmth of a southern sun tempered by the
coolness of the mountains. There is an Italian colony in the town,
and the faculty of letters offers a course in Italian Language and
Literature, a subject not found upon the curricula of the other fac-
ulties of letters, excepting Clermont-Ferrand, which is considerably
farther away from the immediate vicinity of Italy. The facilities for
pursuing science, especially geology and botany, at Grenoble are
very fine. The summer courses, together with the superb natural
attractions of Grenoble, are beginning to attract thither many for-
eign students. Thru the initiative of the *Alliance Française*, now
making a vigorous campaign at home and abroad in the interest of
French language and letters, holiday courses are now given in Bor-
deaux, Boulogne-sur-Mer (in connection with the University of
Lille), Saint-Malo-Saint-Servan (in connection with the University
of Rennes), and Villerville-sur-Mer. A number of universities
and schools in France and Switzerland have joined in the movement
either independently or in connection with the Alliance. Courses
are announced for the summer season of 1909 at Besàncon, Caen,
Dijon, Grenoble, Lyon, Nancy, all provincial university centers, at
Lisieux, Bayeux (both in Calvados, Normandy), at the Institut-
Moderne, Marseilles, and at the Lycée for girls in Versailles, un-
der the direction of Mme Kahn; also at the universities of Geneva,
and Lausanne, and at the Academy of Neuchâtel, in Switzerland.
The University of Clermont-Ferrand, in the capital of the old pro-
vince of Auvergne, in the center of Southern France, like Grenoble,
is in the midst of the mountains. Clermont is the center of a most
important volcanic region and possesses unique interest not only
for geologists and mineralogists, but for geographers as well. The
University of Dijon, in the town of that name, capital of the old
province of Bourgogne, offers a course on the History of Bur-

gundy; the University of Poitiers, in the old province of Poitou in Western France, where famous battles occurred in olden times, offers a course on the History of Poitou; the University of Rennes, in old Bretagne, offers a course in Celtic Language and Literature; the University of Besançon, in Franche-Comté, of which Besançon was the capital, a course in Russian; also one on the History and Geography of Antiquity and the Middle Ages, in which epoch Besançon played an interesting part.

It will now be clear that while the provincial universities offer courses in law, letters, science, and medicine quite similar to those described as given by the University of Paris, they make up in a measure for what they lack in variety by offering special courses, for which they have advantages superior to any that can be found elsewhere. The law-school courses are in many cases broadly educational as well as technical. The scientific courses are thoroly practical, as the names of some of them suggest: Industrial Electricity, Industrial Chemistry, Industrial Physics. The medical schools are the equal in excellence of the schools of law, letters, and science. The provincial universities, following the example of the University of Paris, are gradually introducing the doctor's degree for foreign students into their various faculties. An American student who desires to receive this degree as a recompense for successful work in France will have in the future only the perplexity of deciding where he can most advantageously spend his time.

IX. Special Schools for Higher Education.

It remains to speak of several institutions, some of which are not connected with the government, of no less interest to American students than those just described. Many of these are termed *écoles libres*, *libre* being used here in the sense of independent, and not, as sometimes supposed, of *free* in the sense of tuition free, altho such is often the case. First in importance is the *Collège de France*, rue des Ecoles, over the portals of which is seen the inscription *Omnia docet*. Here science and letters in their most advanced stage are taught by more than forty of the ablest specialists in France. The late lamented Gaston Paris was administrator of the institution, and his colleagues in their specialties are well known to scholars making researches in like fields everywhere. Some of the French professors whose visits to America or whose writings have made their names particularly well known to men of letters in this country are Joseph Bédier, Michel Bréal, Gaston Deschamps, Louis Havet, Pierre Janet, Leroy-Beaulieu, E. Levasseur, who succeeded Gaston Paris as administrator of the Collège de France, A. Longnon, G. Maspêro, Paul Meyer, Morel-Fatio, A. Réville, Georges Blondel. The school is as good a representative of the type that now exists in sev-

eral countries for special investigation as is to be found any-where. Very similar in its aims is the *Ecole pratique des hautes études*, Sorbonne. Over one hundred professors have charge of the instruction. The school is divided into five sections, each comprising broad divisions: 1° history, language, and philology; 2° mathematics and mathematical sciences; 3° physics, chemistry, mineralogy; 4° natural sciences; 5° religious sciences. The most complete liberty in regard to pursuing one's chosen subject exists. The professor meets his students when and where it is most con-venient, and continues his work with them for as long or short a time as may be deemed practicable. Each student may be pursuing some one particular part of a subject, in which case the student and professor come together by appointment, and carry on the special research in whatever manner they may consider most profit-able. No examinations are given nor are any degrees conferred. Probably no school in Europe stands higher in its field or is more widely and favorably known than the *Ecole pratique des hautes études*. The *Ecole des langues orientales vivantes*, 2 rue de Lille, is, perhaps, one of the best known of the kind. In it are taught the leading oriental living idioms. The professors are assisted by native teachers. The students pursuing the courses do so for po-litical, commercial, or philological reasons. Quite a number obtain positions as interpreters in eastern countries. The *Ecole nationale des chartes*, 19 rue de la Sorbonne, founded over eighty years ago, is frequented by specialists in archeology, philology, history, and diplomacy. They come from all parts of the world, attracted by the unrivaled resources of the school. The advantages, particularly for the study of paleography, because of the abundance of rare manu-scripts, are unsurpassed. The *Ecole libre des sciences politiques*, 27 rue Saint-Guillaume, fulfils a most useful mission. Here an ex-cellent preparation can be had for the various administrative careers in the government in conformity with the five sections composing the entire program: 1° interior administration; 2° finance; 3° politi-cal and social economy; 4° diplomacy; 5° law and history. There are no examinations to enter. A course can be taken for two or three years. A diploma is given when evidence is shown of good ability to investigate problems. There is an enrolment fee of $14.00 a year. Social doctrines may be profitably pursued at the *Collège libre des sciences sociales*, 28 rue Serpente. Of such institutions as the *Muséum d'histoire naturelle*, 57 rue Cuvier, where courses are given in zoölogy, anthropology, and kindred subjects, the *Ecole nationale supérieure des mines*, 60 boulevard Saint-Michel, for the training of mining engineers, the *Ecoles des ponts et chaussées*, 292 rue Saint-Martin, for bridge-builders and constructors, the *Con-servatoire des arts et métiers*, 292 rue Saint-Martin, for sciences and their industrial application, in all of which the instruction is ab-solutely free, nothing need be said other than that they represent

the best modern types of the kind. American students, however, are so amply provided with superb facilities for the pursuit of the sciences, natural history, mechanics, industrial arts, and agriculture, in all their varied ramifications, that the cases where these subjects might be pursued mainly abroad rather than at home are likely to be exceptional. Not so with the fine arts. Such schools as the *Ecole nationale et spéciale des beaux-arts,* 14 rue Bonaparte, for the study of painting, sculpture, architecture, and allied subjects, and the *Conservatoire nationale de musique et de déclamation,* 15 rue du Faubourg-Poissonnière, for vocal and instrumental music and the study of the voice, will long continue to attract, as in the past, foreigners from distant countries.

It is perhaps needless to say that the mere enumeration of special schools that offer the foreign student as well as the native a most attractive program of studies, either entirely free or at a nominal cost, would make a long list. It must here suffice to note two well-defined advantages that American students of art and language may profit by, if disposed to make use of them. The American Art Association has over two hundred members. Its function is that of a club. It gives opportunity for American students and artists to meet together informally and enjoy each other's society. The Association now possesses fine quarters at no. 2 *Impasse Conti.* A large art library, fine reading-rooms, recreation-halls, and a good but inexpensive restaurant contribute to the comfort of the members. The club is somewhat like the St. Botolph, in Boston, in that art exhibitions are held in the rooms quite frequently. It is well worth while for a student of art, intending to remain a year in Paris, to become a member immediately upon arriving. The fees are ten francs initiation and twenty francs membership annually.

The second advantage is that offered during the summer months by the *Alliance Française,* 186 boulevard Saint-Germain, to students of the French language. Two series of courses are given, the first, during the month of July, and the second during the month of August. Students are able to secure diplomas at the end of the course after an examination upon it. The fee for either course, which embraces, besides a large amount of instruction, lectures, etc., many desirable privileges, is twenty dollars. The *Alliance* has been wonderfully successful in Paris, and hundreds of students and teachers pursue these courses yearly. This success has encouraged the projectors of the movement, aided by the government, to start a similar movement in the nature of a propaganda outside of France. The object is to encourage the pursuit of the French language and literature and to attract favorable attention to France. Some idea of how successful the movement has been in this country may be got from the fact that at the present time there exist here and in Canada more than two hundred *Alliances Françaises,* or branches, groups, as they are called. of the central organization in Paris. Moreover,

some of these groups are very flourishing, the one in Boston, for instance, having annually for several years, more than four hundred members. This group in particular has been very ably managed by Professor de Sumichrast since taking charge of its interests in 1900. Lectures and entertainments in French, all of a high order, are given fortnightly. During the years 1901, 1902, and 1903, the Boston group, at its own expense, sent over to Paris, each summer, a teacher in the public schools to enjoy the advantages offered by the *Alliance* in Paris. It is well to be familiar with the work of the *Alliance Française* when preparing, whether here or abroad to make a study of French life, literature, and language. In this way it is quite possible to keep abreast of what is going on in a rather extensive circle of French interests. Both Frenchmen and Americans of distinction are connected with the organization, and directly or indirectly, may be of signal service to a student. Perhaps the simplest way to get posted quickly is to send for the *Bulletin officiel de la Fédération de l'Alliance Française aux Etats-Unis et au Canada*, 1402 Broadway, New York City.

X. L'Entente Cordiale.

It is beginning to be quite evident that the day is past when thoughts, ideas, and the possession of truth are national and the property of one particular people. The tendency of this generation is fast towards denationalization. Foreign methods when proven to be better than our own are no longer lookt upon askance because they are foreign, but are beginning to be adopted; just as abroad practical American ideas have found widely a favorable reception. The intrinsic value of ideas is an asset too precious to be long ignored by any wide-awake nation.

In 1897, Ferdinand Brunetière gave a course of lectures in French at Johns Hopkins University which were notable and besides attracted popular attention. He was invited to Harvard University, where he gave three lectures on Molière. The charm and magnetism of the man will not easily be forgotten by any one privileged to hear him. Since that time the French lectureship fund provided by Mr. James Hazen Hyde of the class of 1898 has made it possible for Americans to pass in review a long line of distinguisht French men of letters; for not only have these gentlemen lectured at Harvard University, but after finishing their course there, usually have also lectured in many places in the United States and Canada. The distinction of the lecturers and the variety of the topics treated has naturally called attention to France, a country for which American sympathy has been strong and lasting from old colonial days. The following are the names of the eminent lecturers who have visited our shores and their subjects:

1898. René Doumic: Histoire du romantisme français.
1899. Edouard Rod: La Poésie dramatique française.
1900. Henri de Regnier: Poésie française contemporaine.
1901. Gaston Deschamps: Le Théatre français contemporain.
1902. Hugues Le Roux: Le Roman français et la société française.
1903. L. Mabilleau: Idées fondamentales de la politique française.
1904. A Leroy-Beaulieu, *de l'Institut:* Christianisme et démocratie.
1905. René Millett, *ambassadeur:* La France et l'Islam dans la Méditerranée.
1906. Anatole Le Braz: La France celtique.
1907. Vicomte G. d'Avanel: Histoire économique de la France.
1908. André Tardieu: La France et les alliances.
1909. Abel Lefranc: Molière.

Nearly all of these men have, after visiting us, recorded their impressions of American life in books that students will have pleasure in familiarizing themselves with. This is likely to have a broadening effect upon their own point of view of a foreign country. Moreover, under the auspices of the Alliance Française, or possibly, at times, independently, Germain Martin, Jules Huret, André Michel, F. Funck-Bretano, Louis Madelin, Edmond Rossier, Bonet-Maury, Marcel Poète, and other Frenchmen of note have lectured in various parts of the United States and Canada. Distinguished Italians, Angelo de Gubernatis, Novelli, Guglielmo Ferrero have also addressed many groups of the Alliance.

So much activity on this side of the water has initiated a reciprocal movement in France. In 1904-1905, thru the generosity of Mr. Hyde, who has done so much to promote a good mutual understanding between France and America, Professor Barrett Wendell was invited to deliver a course of lectures on American literature at the Sorbonne and at the university towns in France. Students who intend studying in France will do well to profit from Professor Wendell's experience by reading his book, "The France of Today." He was followed by Professor A. C. Coolidge, and he in turn by Professor George Pierce Baker.

Of late years a number of French students have registered in our leading universities, and not only pursued courses, but given instruction and lectured in French at the university and outside. This idea of foreign students coming here to study in our institutions has been favorably received and encouragement is offered them to come. In 1896, for the first time, a fellow of the University of Paris, Charles Cestre, was sent to Harvard. An interesting contribution by him on the French Universities will be found in the Harvard Graduates' Magazine for December, 1897. About eight

years later, in 1903-1904, a fellowship of the *Cercle Français de l'Université Harvard* with a stipend of $600 was offered by Mr. Hyde and has been since then continued annually. The French fellow is selected by the minister of public instruction in France. According to the conditions of the fellowship, the young Frenchman is expected to give a certain amount of assistance to the department of French and other Romance languages. He is also to be admitted to any courses of instruction in the university he is qualified to pursue. These young men occasionally assist in the annual production of the Cercle Français play. The appointment of the American exchange fellow to Paris, to benefit by the fellowship offered in return by the French ministry of public instruction, is made on the recommendation of the president of Harvard University. The incumbents have been George Wallace Umphrey, 1903-4; Robert Bell Michel, 1904-5; Charles Marshall Underwood, 1905-6; Arthur Fisher Whittem, 1906-7; Warren Barton Blake, 1907-8; Samuel Montefiore Waxman, 1908-9. The same conditions govern the incumbent of this fellowship as those of the James Hazen Hyde fellowship offered by the Cercle Français. The *boursiers*, or fellows from France at Harvard, have been Robert Dupouey, 1903-4, to whose article, Americans in French Universities, reference has here twice been made; Henri Baulig, 1904-5, now an instructor in French in Harvard College; Médéric Tourneur, 1905-6; Edmond Jean Eggli, 1906-7; Jean Marie Giraudoux, 1907-8; Maurice Chelli, 1908-9.

So strong has been this influence for cordial inter-relation and so manifestly potent for good that other countries have taken up the idea. The announcement was made in 1905 that James Speyer of New York had given to the trustees of Columbia University $50,000 to endow the Theodore Roosevelt professorship of American history and institutions in the University of Berlin in accordance with a plan proposed by the German Emperor. The first incumbent of this professorship was the political economist, Professor John Williams Bnrgess, 1906-7. Dr. Hermann Schumacher, from the University of Bonn was the exchange lecturer at Columbia. The University of Chicago followed the good example and sent Professor J. Lawrence Laughlin of the department of political economy to Berlin, while Professor Oncken of the University of Berlin came from there to Chicago University to lecture on Germany history. Since 1905-6 there have been exchange professors between Harvard and Berlin universities, Professors Ostwald and Kühnemann having lectured in Cambridge and Professors Peabody, Richards and Schofield in Berlin. Other countries are desirous of pursuing the same friendly policy, and recently Professor Nicholas Murray Butler has been sent from Columbia University as exchange professor to the University of Copenhagen. Dr. Felix Adler of Columbia University and Professor William M. Davis of Harvard University are at

present (1908-9) lecturing in Berlin and were recently introduced by Ambassador Hill to Emperor William.

By a vote of the Corporation of Harvard University on June 15th, 1908, the president of the university was authorized to inform the Prussian minister of education that for a period of ten years Harvard University would remit the regular tuition fees in all its departments for any students, not exceeding five in any one year, who should be accredited by the Prussian ministry of education as students qualified to pursue advanced studies in Harvard University. The proposal has been accepted and thru this arrangement a further step in the direction of an intellectual exchange between America and Germany has been taken.

About fourteen years ago, Baron Pierre de Coubertin made four foundations for the study of French literature; one each at Princeton, Tulane, the University of California, and Leland Stanford. By way of reciprocity, there are now at the University of Paris: 1° The duc de Loubat's foundation at the Collège de France for the study of American antiquities. The late Léon Lejeal used to lecture in this course. 2° Mr. James Hazen Hyde's foundation at the Sorbonne for the study of America, American Ideas and Institutions; lectures in English by the American exchange lecturer. 3° The proposed foundation by some American bankers and financiers at the law-school of the university for the study of: The History and Outline of American Law; lectures in French, in 1904-5, by Charles F. Beach, Jr., a noted American lawyer and student of economic problems.

Perhaps one of the best known of all the foreign traveling fellowships is the *Bourse du Tour du Monde*, founded by Albert Kahn in 1898. This bequest provides for sending around the world "Cinq jeunes agrégés de l'université," each on a fellowship of $3,000. An account of experiences in foreign countries by thirteen of these young men during the years 1898, 1899, and 1900, will be found in *Autour du monde*, par les Boursiers de voyage de l'Université de Paris (Paris, Félix Alcan, 1904). The book is useful in giving the American student who studies abroad an excellent French point of view. Occasionally one of these educated Frenchmen remains in a foreign country some years, as in the case of M. Louis Allard, who taught and lectured a year or more in Laval University, Quebec, and for the past two years has been one of the regular instructors in French in Harvard College. This year (1908) a young woman, Mlle Elichabe, is one of the holders of the Around the World Fellowship. Her lectures in different parts of the country have been noteworthy.

Quite a number of the largest and best-endowed institutions of learning in this country, such as those already named, are quite well provided with traveling fellowships. The catalogs of a number of our colleges call particular attention to such special advantage. At

Boston University, for instance, the Ada Draper fund of $25,000, the income of which is to be applied "to enable the most meritorious and needy student among the young women to be sent to Europe after graduation to complete her studies." In this way students, sure of their future, are able to concentrate their whole time and thought on the main object of their foreign residence.

Thus, from what has been shown, the signs of the times seem to point not only to a mutual desire on the part of France and of this country to bind more cordially together the old intellectual ties of sympathy that were so strong in the days of Franklin and Jefferson, but to a common world understanding that shall ultimately do away with intellectual barriers between nations. That a movement so thoroly in accord with the best spirit of the times should be fraught with success is the earnest hope of all who desire the moral and intellectual advancement, not only of France and America, but of all civilized nations.

INTER-COLLEGIATE AND INTER-SCHOLASTIC

AMERICAN FOOTBALL

INTRODUCTORY NOTE.

The purpose of this compilation is to bring before patrons and Boards of Control of our universities, colleges, and secondary schools, the magnitude of the football interest and the serious injury it inflicts upon the character and work of the great student body. It is high time that men of influence in educational matters get together and put an end to the evils of public gladiatorial combats, corrupting gate receipts, professional coaches, and the frenzy for man-handling contests in which the combatants are under the spell of a stern necessity of winning at any cost.

My own paper, the first in the series given here, was called forth in connection with a resolution offered by Dr. William Taussig in the St. Louis Board of Education and duly adopted last November. The resolution asked the Superintendent of Instruction and his assistants to investigate, and at their convenience report to the Board their views as to the proper policy of the Board in regard to interscholastic football..

In response to my "Estimate," which I sent widely to educational friends, I received so much valuable material that I was unwilling to let it lie unpublished. Accordingly, I decided to supplement what I had written by extracts from Annual Reports, Committee Records, Magazines, etc., and to publish them to the world.

It is suggested that administrative officers and Boards of Control take resolute action. It is my deliberate opinion that it is vastly better to have no inter-institutional athletics than to retain and support a game which has so little to recommend it, and so much to condemn it.

It seems to have been abundantly proved that in a public contest, planned and directed by professionals whose

3

reputation is at stake, the standards of thought, speech,* and action, much too often, if not invariably, sink to the lowest level.

The views and opinions which follow are from men who know what they are writing about, and who have the courage of their convictions.

Though a member of the Faculty of Washington University and a member of the Board of Education of the City of St. Louis, I have no authority to represent, and I do not claim to represent, the views of either body on this important matter.

CALVIN M. WOODWARD.

St. Louis, March 1, 1910.

*P. S. I recently saw in print that Professor William James of Harvard had reported, that on one occasion the Harvard coach said to his team as they went on the field to meet Yale, "Now, fellers,—HELL!"

This reminds one of what General Sherman said of War, and yet it is several degrees less strong than the language used by one of the coaches in a Missouri-Kansas game last fall, as reported to me.

C. M. W.

THE HARMFUL INFLUENCE OF INTER-SCHOLASTIC AND INTERCOLLEGIATE FOOTBALL AS ORGANIZED AND PLAYED.

In answer to a request in December, 1909, I replied as follows:

I gladly give, with some detail, the conclusions I have reached as to the propriety of our continuing to approve and support football as now played. My long experience as teacher of boys and young men, and my service as a school and college officer have given me abundant opportunity to observe the evolution of what we have now on our hands, and to detect its character and influence. I therefore consider it my duty to respond fully and frankly.

GOOD POINTS IN THE GAME.

I am a firm believer in the value and necessity of physical training with indoor and outdoor games for boys and young men. I think every boy and young man is entitled to them, and school officers and parents should so co-operate as to secure to every growing lad an equal opportunity for all that is good in rational and wholesome games, and he should receive proper protection from all that is bad. I freely admit that there are some good points in the discipline and practice of football play. Alertness, agility, hardihood and the intelligent co-operation needed in team work are good things, and if there were not other things in the game which are not good, and if every boy could take his turn long enough to get the good things and under such conditions that he would miss the bad things, I should as heartily approve as I now condemn.

It is my firm conviction that interscholastic and inter-collegiate football as now conducted is neither just nor rational, nor is it morally wholesome either to the players or to the student body.

5

ITS INJUSTICE.

1. The coaching, practicing and playing of a picked team stands in the way of general athletics. Only a small minority of the student body participates in such games with sufficient regularity to reap the benefit which may come to the steady player. Not 10 per cent of the students play on a large school or college team long enough to get the good things I have named; on the contrary, a few picked boys or men dominate everything for three months every year.

Every regular member of the "team" represents from twenty to fifty boys who do not play at all, or only enough to be proved worthless for winning games and hence are rejected, though they may have the greatest need of rational training. The smuggling into the team of "ringers" and "ineligibles" is less frequent now than formerly, but I wish to call attention to the fact that every time an "ineligible" goes in an "eligible" goes out. I have known teams of so-called college players in which nearly every man was "ineligible," yet those ringers or favored drones got all the "fine physical, mental and moral benefits" named above, while the legitimate, *bona fide* students got little or none of them. No, it is a misnomer to call today's public football a feature of general physical culture.

MORAL EFFECT IS BAD UPON THE PLAYERS THEMSELVES.

2. The moral effect upon the players is bad, rather than good. I do not refer to intentional roughness and brutality in play; but I refer to the general moral atmosphere surrounding a team. Of course, there are good students and incorruptible men who play football, but it cannot be denied that they are exposed to bad influences. I am speaking of teams as they come and go, and I have seen scores of them, and I have noted the atmosphere that generally surrounds them.

Much too often the team is itself loud, rude, ill-mannered and disorderly. Of course, there are exceptions,

but as a rule a school or college team when on the street, in the cars, at the theater or in the corridors of a school or college building makes itself seen, heard and felt. Dr. Andrew Draper, ex-president of the University of Illinois, says:

"Five or six years ago I had occasion to leave my home early on the morning after Thanksgiving to meet an engagement at a teachers' association. On the way the football team from one of the central and conspicuous high schools of the country who had been out to play a Thanksgiving game, came into the car on their way home. They had been victorious, and their conduct was beyond description. Boys of the high school age, who manifestly lived in respectable homes, seemed to think it manly to indulge in profanity and obscenity with a familiarity which was shocking. They passed a bottle of liquor from one to another, and when the train stopped went out to have it refilled. The conditions were appalling and most suggestive."

The reasons for such exhibitions at home and elsewhere are not far to seek. They are, first, the companionship and example of professional sports and loafers, who crowd about a team when on the field and after a game; second, the habit of playing to a gallery and working for applause; third, the feeling that, by virtue of their winning fame and "big money," they are privileged to break the laws of decency and good order with impunity. Refined and well-bred members of a team are often made to feel ashamed of their associates.

THE DEMORALIZATION OF THE WHOLE STUDENT BODY.

3. The moral effect upon the student body is often very bad. The great bulk of the student body, whose only participation in football consists in giving the team moral and financial support, too often becomes indifferent to the rules for fair play and true refinement, and at times seems to lose all sense of propriety. The high schools ape the manners of the colleges, and, if we are to believe

what the daily papers tell us of the behavior of college
boys in New York City, at Urbana, Ill.; at Iowa City
and elsewhere, after a game, we must conclude that the
spectacle of the game and the lawless spirit of sporting
auxiliaries have been known to convert the body of stu-
dents into a mob of rioters. I have known bodies of
students who rose in rebellion because ineligible star
players were not allowed to play.

I recall an instance of demoralization which is very
significant. It is the case of a visiting college team
which brought to St. Louis a "ringer," who was not a
student at all, but who was a star player. The managers
presented the names of a team of eligible players, and
then deliberately presented the "ringer," who assumed
one of the names. The game was played, and the team
went home with the fraud undetected, yet every man on
the visiting team, and every representative of the college
from which they came must have known of the fraud, and
consented to it. I am told that such cases are not rare—
yet what moral degradation does such a case reveal!

As to betting, President Draper says "that he once
sat in a hotel lobby before a great game, and saw scores
of boys from two leading American universities daring
each other to put up money on their respective teams, and
when the dare was accepted and the terms settled, as fre-
quently happened, they placed their money in envelopes,
which they gave to the clerk of the house, to be delivered
to the winner after the game. The thing could hardly
have been worse."

RISK OF LIFE AND LIMB.

4. There can be no question as to the risk of life and
limb incurred in the game as now played. Parents of
strong, manly boys very generally disapprove of the
game, and, if they reluctantly consent to their sons' play-
ing, they cannot bear to see them play. There may be
occasionally a Roman or a Spartan mother who will say
to her son when she sends him into a typical game:
"Come home with a crown of victory on your head, or on
a stretcher with your neck broken." But such cases
are rare.

Often a strong and active boy who does not approve of rough games, and who does not need its training, is forced into a team by a strong public sentiment which declares it is his "duty" to play. He has no desire to cripple an opponent or to be crippled by one. For him the game is not worth what it may cost, but he has not the courage to say "No." To be called a "mollycoddle" or a "sissy-boy" often has more terrors for him than a tribe of Indians.

For a sacred principle, for one's country, or one's family, or for the supremacy of law, one may face danger with his life in his hand; but there is no adequate excuse for permitting our sons, or the sons of others, to risk life and limb in a brutal game.

EXHIBITION GAMES NOT NECESSARY.

There is no lack of interesting and wholesome field sports in which all students may join. The propriety of retaining and encouraging football, as now played, is not to be determined by a vote of those who are merely spectators of games. There is always a considerable number of people who "like to see a good game;" who see nothing objectionable in a good fight, and hence they approve of the game as they would approve of a Spanish bull fight, or a gladiatorial contest in a Roman arena. Such people have no idea of the total moral influence of such brutalizing sport.

I believe that the enthusiasm aroused by public football is altogether mischievous; it puts the emphasis in the wrong place; it overshadows vastly greater interests, and minimizes activities of far higher merit. Broken bones and shattered lives are not its greatest evil. The lowering of moral standards; the substitution of the rowdy and the sport for the gentleman and scholar, are stupendous evils far more widespread and infinitely more serious. If athletic contests of whatever sort between colleges and schools cannot be made morally and educationally harmless they should be abolished.

CALVIN MILTON WOODWARD.

St. Louis, January, 1910.

VIEWS FROM HARVARD.

The Editor of the "Harvard Advocate" (February 21, 1890) said:

"There is an element of the ridiculous, to speak as charitably as possible, in the fact that over thirty thousand dollars were spent by us in one year to maintain a few athletic teams with positive benefit to *only a few men.*"

Coach W. T. Reid, Jr., June, 1905, speaking of the "material on hand" for football, says:

"Much of the material has become ineligible through failure of various individuals comprising it to maintain satisfactory standards of *scholarship* and *morals.*"

Again, speaking of the "big men" who have been seen out practicing, he says: "Some of the men are too beefy to use—others have impossible (?) temperaments, while others still are very susceptible to injury. . . . The idea that beef alone makes a football player is all wrong. The beef must be active, teachable, and intelligent."

Mr. Reid advocates steady coaching by a steady coach for a "college generation," i. e., four years. And yet the Committee on Athletic Sports, September 30, 1903, reported: "It is unfortunate that the game should be regulated and directed so entirely by coaches whose point of view is strategy."

In February, 1906, the Faculty took the ground that football as played was thoroughly bad and ought to be stopped absolutely and finally.

The Committee of the Board of Overseers reported that "the game of football as at present played was essentially bad in every respect."

In his report for 1904-5, the Chairman of the Athletic Committee, Mr. A. C. Coolidge, said:

"The spirit of the best kind of amateur—that of sport for sport's sake—inevitably suffers under a system where each team is made up of the obedient tools of a highly paid professional. Under such a system, contests tend to degenerate into the triumph of this or that coach. The Committee are also convinced that the paying of great sums of money

to men who instruct our youths in what should be, not their work, but their play, tends to vitiate the opinion not only of the student body, but of the whole community, as to what is of real importance in a college training and in the education of a young man."

Then follows the remarkable confession:

"At the same time, neither Harvard nor any other institution is in a position as yet, to grapple boldly with the evil."

In a minority report of the Athletic Committee, in favor of the abolition of intercollegiate football at Harvard, Mr. Morefield Storey said (February 27, 1907):

"Of late years the successful athlete has eclipsed all other college heroes, and it is difficult for students in these conditions not to get a very distorted view of what life is really worth. The intellectual side of college life cannot fail to suffer when success in athletics is regarded of so much importance."

FROM DR. CHARLES W. ELIOT, EX-PRESIDENT OF HARVARD
UNIVERSITY.

Dr. Eliot's opinions on all matters connected with the education of young men have, and ought to have, great weight with parents and educational officers. He has always been a keen observer, a kind and friendly critic, a just judge, a noble and fearless man. I therefore quote him freely. Under date of February 9, 1910, he writes:

Ever since football became a popular sport in colleges and high schools I have been protesting against it. For your present purpose you might perhaps make a series of quotations from my published reports as President of Harvard University. I dealt with the subject in many of those reports, describing plainly its moral and physical evils. I still believe those descriptions to have been correct, and so far as my comments on the game had a prophetic character they have been fully justified by the actual result. I think a short collection of my remarks on football while I was President of Harvard University would serve your present purpose better than any letter from me now that I have retired.

FROM PRESIDENT ELIOT'S REPORT FOR 1903-04. AN ABSTRACT.

The game of football has become seriously injurious to rational academic life in American schools and colleges, and it is time that the public, especially the educated public, should understand and take into earnest consideration the objections to this game.

Some of the *lesser objections* to the game are:

1. Its extreme publicity;
2. The large proportion of injuries among the players;
3. The absorption of the undergraduate mind in the subject for two months;
4. The disproportionate exaltation of the football hero in the college world. The football hero is useful in a society of young men, if he illustrates generous strength and leads a clean life; *but his merits of body and mind are not of the most promising sort for future service* out in the world.
5. The state of mutual distrust and hostility between colleges which all too frequently football creates is another of these lesser evils.
6. The enfeebling theory that no team can do its best except in the presence of hosts of applauding friends is still another of the lesser evils of football. Worse preparation for the real struggles and contests of life can hardly be imagined.
7. None of these things, however, enter into the main objection to the game, for *the main objection lies against its moral quality.*

The common justification offered for these hateful conditions of the game is that football is a fight; and that its strategy and ethics are those of war. One may therefore resort in football to every ruse, stratagem, and deceit, which would be justifiable in actual fighting.

These rules of action are all justifiable, and even necessary, in the consummate savagery called war, in which the immediate object is to kill and disable as many of the enemy as possible. To surprise, ambuscade, and deceive the enemy, and invariably to overwhelm a smaller force by a greater one, are the expected methods of war. But there is no justification for such methods in a manly game or sport between friends. They are essentially ungenerous, and no sport is wholesome in which ungenerous and mean acts, which easily escape detection, contribute to victory, whether such acts be occasional and incidental, or habitual.

The essential thing for university youth to learn is the difference between practicing generously a liberal art, and driving a trade or winning a fight, no matter how. Civilization has been long in possession of much higher ethics than those of war, and experience has abundantly proved that the highest efficiency for service and the finest sort of courage in individual men may be accompanied by, and indeed spring from, unvarying generosity, gentleness, and good will.

FROM DR. ELIOT'S REPORT OF 1904-05 ON FOOTBALL, GIVEN ENTIRE.

The American game of football as now played is wholly unfit for colleges and schools.

(1) It causes an unreasonable number of serious injuries and deaths; not one in five of the men that play football several seasons escapes without injury properly called serious, and of the twenty to thirty picked players who play hard throughout a season hardly a man escapes serious injury. The public has been kept ignorant concerning the number and gravity of these injuries, the prevailing practice among coaches and players having been to conceal or make light of the injuries sustained. Many of the serious injuries are of such a nature—sprains, strains, wrenches, dislocations, ruptures of ligaments and muscles, and shocks to the brain—that in all probability they can never be perfectly repaired.

(2) Violations of the rules of the game by coaches, trainers, and players are highly profitable, and are constantly perpetrated by all parties.

(3) In any hard-fought game many of the actions of the players are invisible to the spectators, and even to the referee and umpire; hence much profitable foul play escapes notice.

(4) The game offers many opportunities for several players to combine in violently attacking one player.

(5) There is no such thing as generosity between combatants, any more than there is in war.

(6) Acts of brutality are constantly committed, partly as results of the passions naturally roused in fighting, but often on well-grounded calculations of profit towards victory.

(7) As a spectacle, for persons who know what the game really is, football is more brutalizing than prize-fighting, cock-fighting, or bull-fighting. Regarded as a combat between highly trained men, the prize-ring has great advantages over the football field; for the rules of the prize-ring are more humane than those of football, and they can be, and often are, strictly enforced. The fight in a prize-ring between two men facing each other is perfectly visible, so that there are no secret abominations as in football. Yet prize-fighting is illegal.

(8) The game sets up a wrong kind of hero—the man who uses his strength brutally, with a reckless disregard both of the injuries he may suffer and of the injuries he may inflict on others. That is not the best kind of courage or the best kind of hero. The courage which educated people ought to admire is not that reckless, unmotived courage, but the courage that risks life or limb to help or save others, or that risks popular condemnation in speaking the truth, or in espousing the cause of the weak or the maligned.

All these evils of football have now descended from the colleges into the secondary schools, where they are working great moral mischief. It is clearly the duty of the colleges, which have permitted these monstrous evils to grow up and to become intense, to purge themselves of such immoralities, and to do what they can to help the secondary schools to purge themselves also. Intercollegiate and interscholastic football ought to be prohibited until a reasonable game has been formulated and thoroughly exemplified in the practice of individual institutions. It is childish to suppose that the athletic authorities which have permitted football to become a brutal, cheating, demoralizing game can be trusted to reform it. CHARLES W. ELIOT, '53.

COLONEL J. S. MOSBY, A GRADUATE OF THE UNIVERSITY OF VIRGINIA, CONFEDERATE SOLDIER, NOW UNITED STATES LAND COMMISSIONER, SAID LAST NOVEMBER:

"I have read with indignation mingled with great sorrow the account of the murder of young Christian, a student of the University of Virginia, in a football game in Washington with Georgetown University. I use the word 'murder' advisedly. The killing was not an accident. The very fact that a university surgeon went with the team shows that they were going to war. They neglected, however, to provide an ambulance to carry off the wounded.

"I hope if this barbarous amusement is continued the board of visitors will require it to be conducted in accordance with the regulations of modern war. Some years ago I expressed to Dr. E. A. Alderman, president of the university, my objection to football because it was not a recreation for students; because many were making it a profession; because it developed the brutal instincts of our nature, and because it should be no part of the curriculum of the university, which it now is.

"Mr. Alderman says that there is great danger to life and limb in football, and that the danger must be eliminated before it is played any more. But if the danger is eliminated nothing will be left of the game. The danger is not only the chief but the only attraction to the mob that gathers to witness it. Without it there will be no rooters to cheer the combatants and no heroes with broken limbs and bloody noses.

"The shouts in the Coliseum over the dying gladiator, 'butchered to make a Roman holiday,' have for years echoed through the arcades of the university."

"The defenders of such sport say it develops the manhood of youth. I deny it, unless by manhood they mean physical strength. My idea of manhood is a sense of honor and courage; such qualities may exist in a weak body. The difference between our ideals is the distance between Stonewall Jackson and John L. Sullivan. Football simply develops the brute dormant in man's nature and puts the player on a level with an Eskimo or a polar bear.

FROM MR. J. W. GLEED, OF TOPEKA, REGENT OF THE UNIVER-
SITY OF KANSAS, UNDER DATE OF JANUARY 28, 1910.

This analysis of the football situation is so clear and
strong that I give it entire:

INTERCOLLEGIATE FOOTBALL.

"Inter-collegiate football means a series of fierce, ultra-strenuous,
physical contests, in various public arenas, for the amusement of large
miscellaneous audiences, who pay money to witness a highly exciting
spectacle.

"When a football man enters college in September, he sees before him
a series of such public exhibitions; the most important scheduled at
Kansas City before thirty thousand people on Thanksgiving day. He
hears in advance the plaudits of vast multitudes; he sees his name in
the paper day after day; he anticipates the sweets of final triumph, the
congratulations at home, and permanent distinction and admiration
among the student body. He is taught to think that upon him hangs
the good name and glory of his college.

LIFE AND LIMB DISREGARDED.

"Such publicity, such applause, such glory, constitute tremendous
prizes. It would be a strange 18-year-old boy who would not lay down
his life to win them. At any rate with such rewards before him—with
such responsibilities upon him—can anything during September, Octo-
ber and November seem important except football?"

"And when the great day comes, can anything seem important except
that his side win? Suppose there is danger that if he plays today that
injured ankle may be permanently ruined; can he stay out? Certainly
not. There is the glory of the college, the glory of his fellow players,
his own glory at stake.

"The actual play being on, what determination animates him? The
determination to do thus and so absolutely without regard to the life
and limb of his opponent; subject of course to the rules;—so that noth-
ing be lost by a foul. Subject to the rules, the will, the passion, which
must animate him, are the will and passion which animated the war-
rior of past centuries, when war was a hand to hand struggle.

BRUTE INSTINCTS AROUSED.

"If he, the young gladiator, is heavy enough, is strong enough, the
back of the desperate boy on the other side may be broken, may be
broken by him—the young gladiator; but if so, so it must be. The
ball must be advanced, thus and so, regardless of consequences.

"Your nice, good-natured son, my dear madame, of course does not
go into a game with murder in his heart. But suppose he loses a point
by reason of a foul on the other side, a palpable, contemptible foul, not

seen by the umpire—what is now the feeling in his heart? Is it possible for men to engage in fierce hand to hand physical struggle without arousing the smashing and destroying instinct which comes down to us from our animal ancestors?

"How is the game less brutal than prize-fighting? The percent of deaths or permanent injuries is less in prize fighting, and the game is the same in both cases—to accomplish certain physical results against physical opposition.

WHAT'S IN IT FOR THE PLAYER?

"And what does the player get out of it? Health and strength? He had health and strength to begin with, or he never would have been on the team. Health and strength? No physical trainer ever recommended football as the best preparation for a long life and permanent health and strength.

"Go to a great game and watch the defeated team stagger in after "all is lost"; watch them as they drop on the ground, every atom of muscular and nervous self-control gone, the whole man, physical and mental, absolutely gone—completely and utterly exhausted; watch the boy as he drops, a quivering, moaning heap; hear him cry and sob, and say, then; if you think he is promoting health and strength.

"His wretched ankle may get well; it may not. That blow on the head may never trouble him; it may lead to insanity. But such complete and overwhelming physical and nervous exhaustion must have permanently evil results.

"What good does the player get out of it? It is absurd to say that he does not neglect his studies. He may earn a passing grade, or he may get a passing grade without earning it; but the bulk of his time, determination, will and nerve power during three months goes to football and cannot go to his studies.

FOOTBALL'S FALSE IDEAL.

"Under the ordinary circumstances football cannot be to him either play, amusement or recreation; it is work and work only; and men can't do two days' work in one day.

"Colleges are institutions for the cultivation of mind and soul, and of bodies, so far as they serve mind and soul. A sound mind in a sound body; but the body for the sake of the mind. The aim of colleges is to turn out President Eliots, and not Jack Johnsons. It may be colleges are a mistake—that what we need is men of whom Johnsons and Jeffries are the supreme type—not men of whom Eliot is the type. If that is so, abolish the colleges. If that is not so, keep the college an intellectual institution.

"Inter-collegiate football puts the emphasis on the wrong thing; holds up a false ideal. It exalts force; God is with the big guns; force is the thing—power; who cares for scholarship, for truth, for wisdom, or for righteousness?

DO PARENTS WANT THE GAME?

"An industrious student has come to be looked upon with contempt by a large body of the students. Thirty years ago scholarship commanded respect and won honor; now apparently the prizes are all to the strong, the heavy, the swift of body.

"Athletics? Yes; particularly for those who need athletics; but football picks those who are already strong, and discourages, rather than encourages, the weak.

"Do the taxpayers of Kansas want their money spent to train gladiators for public exhibitions? My judgment is that they do not.

"Do the parents of Kansas want their sons trained as physical gladiators for public exhibitions? My judgment is that they do not.

"Do the parents or the taxpayers like these exciting public exhibitions with their attendant evils of betting and drunkenness? My judgment is that they do not."

PHYSICAL INJURIES AT HARVARD IN THE FALL OF 1905.

Of the Harvard "University Squad" not including Freshmen, the total number of "injuries of great or moderate severity (practically all of which were sufficient to keep men out of play) was *one hundred and forty-five.* This does not include the infinity of minor injuries which constantly came under observation of the two regular surgeons, Dr. E. H. Nichols and Dr. H. B. Smith, who had charge of the football squad from September 12 to November 25, 1905. In their report, the injuries are classified, for example:

"*Head injuries,* nineteen. Cases of concussion were frequent, both during practice and games. In fact, but two games were played during the entire season in which a case of concussion of the brain did not occur."

These gentlemen tell us that players generally minimize their injuries. After full discussion they reach conclusions as follows:

1. The number, severity, and permanence of the injuries received in playing football are very much greater than generally is credited or believed.

2. The percentage of injuries is incomparably greater in football than in any other of the major sports.

3. The game *does not develop the best type of men* physically, because too great prominence is given to weight without corresponding nervous energy.

4. The percentage of injury is much too great for any mere sport."

The Committee of the Board of Overseers reported that "The game of football as at present played was essentially bad in every respect."

FROM THE "NATION," OF NEW YORK.

In an address given at the Harvard Medical School last year and quoted in the "Nation," May 20, 1909, Dr. Nichols, himself an ex-Harvard athlete, distinctly took ground in opposition:

To "Coaches, professional and graduate;"

To "Gate-Receipts;"

To "Offensive Hippodrome features of Inter-University contests."

And the editor of the "Nation" adds:

"Public opinion is rapidly coming to the point where it will insist upon the use of the surgeon's knife upon these extraneous athletic growths. The sooner this is done, the better for education."

On December 10, 1908.—The editor of the "Nation" sums up the reported injuries of the season as *twelve dead* and *three hundred and fifty hurt in football contests,* largely in High schools and Normal schools. Nevertheless, "the strongest arguments against intercollegiate and interscholastic contests are not found in the casualty list, but in the demoralization and false emphasis."

FROM ROBERT E. SPEER, A PRINCETON GRADUATE.

The last weeks of every football season are critical weeks in the lives of many young men in the colleges and preparatory schools of this country. Seed is sown then which will yield a baleful harvest. Years hence some men would give thousands of dollars to undo what is done during these days. On the surface these days are distinguished from other seasons of the school and college year only by the fact that the great football games are played then and the question of supremacy decided. But beneath the surface they are marked

as the same weeks are marked every year by the sowing of acts from which men will reap habits and characters and destinies. Thousands of dollars are bet on the issue of these games. Men who never gambled before stake their own or their fathers' money on their favorite college.—[From "A Young Man's Questions."]

FROM MR. GEORGE F. FISKE, A BUSINESS MAN OF ST. LOUIS. WHO WANTS THE GAME ABOLISHED.

"I believe you have the right view of the matter. As a parent who has sons to send to college, I should be glad to see football as at present conducted abolished. As a business man, I believe the influence of such contests, physically, morally, and intellectually, is of decided disadvantage to the student and the community, and wrong notions of the *values* of life are encouraged.

"If this abuse of sport is allowed to prevail unchecked, I think many business men will begin to doubt the value of a college education as a preparation for business life, and will make their influence felt against it. As a college man, I deplore this."

FROM DR. SARGENT, DIRECTOR OF HEMENWAY GYMNASIUM, HARVARD UNIVERSITY.

"I fully agree with your statement in regard to the demoralizing effects of gladiatorial contests and large gate receipts."

VIEWS OF AN ADVOCATE OF RATIONAL PHYSICAL TRAINING, AND A TEACHER OF IT FOR EIGHTEEN YEARS.

Mr. A. E. Kindervater, Director of Physical Training in the St. Louis public schools, writes that he finds my

"arguments so true, to the point, and in accord with my knowledge of the game, that I can not help but thank you sincerely for the stand taken against this game, which in reality is not a game, but a brutal contest under the present rules."

FROM PRINCIPALS OF LARGE SECONDARY SCHOOLS.

FROM W. M. BUTLER, PRINCIPAL OF THE YEATMAN HIGH SCHOOL, ST. LOUIS.

"I think that all school men who have given the game serious thought must concur in the charges which you lay at the door of the game. Surely, *no one influence* in school and college life *has done as much injury* in recent years."

FROM GILBERT B. MORRISON, PRINCIPAL OF THE McKINLEY HIGH SCHOOL OF ST. LOUIS.

INTERSCHOLASTIC FOOTBALL.

The good points of the game of football have often been pointed out. It certainly requires physical courage, alertness, self-control, and a vigorous exercise of the will. Played on the home field 'between classes or clubs of the same school and under the sole control of one principal and one corps of teachers, I believe that the possibilities of the game for development might be realized. As a matter of fact it is being realized in several schools* that could be mentioned. Thus limited it can be held under control and adapted and conditioned to the school's ideals and be made to serve educational ends.

On the home field where the "honor of the school" is not at stake the game, while strenuous, is more in the nature of sport, and does not end with that fierce, uncontrolled exaltation of the victors, and that depressed lamentation of woe of the vanquished that is always conspicuous in an interscholastic battle. Matches between boys of nearly equal weight can be arranged in the same school, and the danger of injury minimized.

But it is in *interscholastic* contests that the evils of football may be pointed out:

(1) *In interscholastic games there is a prevailing fallacy that the honor of the school is at stake.* The idea that a school can be seriously affected one way or the other by the result of a game would be a confession that the school is a failure as an educational institution and has no standing in its own right. The sentiment that prevails among the boys and some teachers that the school is in need of a victory to improve its standing certainly borders on the ridiculous.

(2) *The contests between schools partake of the nature of war and not of the nature of sport.* The preparation for an important game on the practice field is a grim, joyless performance. The boys, with set, drawn faces, are urged and whipped into line by the coach, whose expression might be likened to that of a groom trying to drive horses from a burning stable. There is little fun or real sport about it, but a dogged and persistent preparation for war. That an interscholastic contest is not in the nature of sport was well evidenced in a recent conversation I had with a young friend of mine after he had finished a hard game in which he had received several hard bruises: "I suppose," I remarked, "that you boys get lots of fun out of these games whether you win or lose." "Don't you believe it," said he, "if it were

*Conspicuous among such schools are St. Paul Academy, of Concord, N. H., and the Manual Training High School of Kansas City, Mo., which have gained rather than lost in popularity by prohibiting interscholastic football. American football is forbidden between the high schools of New York City; they play Soccer ball instead.

not for the honor of the school, do you suppose I would volunteer to take such punishment? Not on your life." He had won for his school, and he felt paid for his hard work, but he would not confess to the fun.

(3) *The feeling engendered is often one of malevolence rather than one of benevolence.* With so much at stake and with the belief that the "honor" of the school must be won, this can not help but be the feeling. The signals are given in secret, and every visitor is looked upon suspiciously as a possible spy from the camp of the enemy. Sharp and unsportsmanlike practices are common, and each side regards the other as capable of anything to gain an advantage. "Anything to win," is generally the watchword.

(4) *The temptations to which the man who trains the team is subjected are too great for the average coach.* Say what we may to a coach about his work being for the development and sportsmanship of the boys and not for victory, the fact remains that under prevailing conditions his reputation really depends on victory, *and he knows it.* Nothing need be said about the professional coach *whose influence on the boys is always bad.* But the teacher-coach is not more than human, and, try as he may to hold to his ideals, it takes a very exceptional man who will sacrifice his reputation for a fine point in ethics. I believe there are such men, but they are few and far between.

(5) *The interest in interscholastic games, especially between the two schools playing for the championship, is too intense for wholesome educational purposes.* This interest often passes all reasonable bounds, and affects the whole school greatly to the detriment of the studies. The week preceding the final game is all excitement. It absorbs nearly the whole interest in the school, and little else is talked about, and even betting is not infrequent. The partizanship and "school spirit" displayed at the game by the pupils of the rival schools are extreme and unwholesome, and often break out in expressions of positive malevolence. Even the girls share in these exhibitions of hysterical enthusiasm. At a recent game between two leading high schools I overheard the following conversation about a boy who was being carried off the field unconscious from an injury:

Young Lady: "Oh, who is hurt? One of *our* boys?" "No," replied her escort, "it is one of the ——— boys," naming the other school.

Young Lady: "Oh, goody! goody!" as she clapped her hands for joy. The womanly, humanitarian instincts had for the moment become totally inhibited by a blind, brutal desire for the victory of her school. That the boy who had fallen in battling for his school might be dying or crippled for life, counted for nothing against a temporary advantage which his mishap gave to the rival team.

As to the players themselves after the game, we have seen in the dressing rooms the frantic demonstrations of joy and exaltation by the winners, even though the victory may have been decided on a single disputed point only; and at the same time in an adjoining room we have witnessed the weeping and wailing and lamentations of the losers resulting from the nervous reaction following an excessive strain and the crushing consciousness of defeat. The teams may be, and

often are, of equal merit and deserving of equal praise, but one leaves the field puffed up with fictitious exaltation, while the other slinks away with a degradation equally fictitious.

(6) *In the interscholastic league it is impossible for a school to carry out its own ideals respecting the aims and purposes of the game.* When the management of field athletics are taken out of the hands of the principal and faculty of a school and given up to an outside board or "judiciary committee" who know nothing about the merits of the boys, and who care for nothing except victory, it becomes impossible for a school to employ *football or any other game* for educational purposes. No care can be taken in matching boys of equal size and strength, no fixing of dates to suit individual necessities. No postponing of games. Boys must play the games on schedule, dead or alive, fit or unfit. They are a part of an unyielding machine that admits of no individual adjustment to rational ends. For one, I am free to say that I should like to see football and other athletics confind to the home field, where they could be employed as sport and relaxation instead of the present catering to all the methods and practices of professionalism.

EXTRACTS FROM AN ARTICLE ON FOOTBALL IN THE "REVIEW
OF REVIEWS," BY THE EDITOR, DR. ALBERT SHAW. DE-
CEMBER, 1909.

It is fast growing to be the opinion of thoughtful people outside of academic circles that the mania for sports and contests of physical prowess in our colleges and schools has gone so far that it constitutes an evil of great magnitude. . . .

A natural consequence of the intensity of this feeling is the undue responsibility placed upon the members of the representative teams. The football players are made to feel that upon them chiefly depends the glory or the disgrace of their college. So overwhelming is this feeling that it becomes a veritable obsession. Members of the faculty and of the board of trustees and all the old graduates become infected with the craze.

Women are especially susceptible to epidemic hysteria of this sort. Their influence is even worse than that of men in driving the players to that attitude of false heroism which would make any of them willing and glad, not merely to break his nose or his collarbone, but to lay down his life on the football field. They are doing it all for the glory of the college and the admiring applause of the score of thousands of well-dressed girls on the bleachers, who, all unaware to themselves, have become tainted with that wretched passion for dangerous gladiatorial combat that takes the fair women of Spain to the bull-fight every Sunday afternoon. . . .

Parents who have brought up their big, strong boy to the college age, and would like to have him become both a gentleman and a scholar, find that the exigencies of the college to which he is sent

require that he and all their plans for his life be sacrificed upon the altar of the institution's glory on the field of athletics. *Sometimes, though rarely,* the big football player who has been turned into a professional athlete, and victimized through his college course, escapes the permanent impairment of his health and gets out into the world *with as good a chance as the men who have not played football.* . . .

The college presidents are wont to tell us that very few football players are injured, and that the game upon the whole makes for the physical well-being of those who play it. But the old football coaches, who really know the facts far better than the college presidents, will tell you in confidence a very different tale. . . .

From the standpoint of the young fellow who struggles in the mass plays in the presence of 40,000 bellowing and screaming spectators, the great climax of human life has been reached. Here is the moment of supreme effort. All training, from the kindergarten up, has led to the brutal scramble in which men's lungs are crushed and spines are broken; and all future life must be lived in gray lights and obscurity when compared with the brilliancy and grandeur of this supreme moment.

It is a pathetic thing to take anybody's fine, strong boy and make a fool of him in this way. Parents should rise up with wrath and with sarcasm, and call for an end of unseemly gladiatorial contests in the pretended name of a friendly competition. The days of the great games in the vicinity of New York, as all policemen know, mean days and nights of disgraceful orgies. . . .

This blare of vulgar publicity is, in all its reflex influences, demoralizing to college life. It puts the emphasis upon wrong things and cheapens the right things. It involves all kinds of college athletics in a network of commercialism that thoroughly Tammanyizes what ought to be decorous and fine. . . .

The game as played is also a demoralizing game because it is often unsportsmanlike. In a game of tennis no one thinks of taking advantage of an opponent by any sort of cheating. But in the great contests at football the one object is to win by all possible means, and there is always an endeavor to beat the rules. If there is a star player on the opposing team, there is apt to be a definite intention to "put him out of the game" by one means or another.

A college president whose eyes are open to the evils of the game remarked the other day concerning certain recent fatalities, that these men had been killed intentionally. He hastened to explain that he did not mean that there was any deliberate intention to produce fatal results, but that there was probably a purpose to injure the opponent sufficiently to "put him out of the game." All of this has a very ugly sound, and it will be bitterly denied in some academic quarters. But let it stand as the expression of a very experienced and able observer. . . .

Among the incidental evils of the football mania in the big colleges may be mentioned the transmission of the craze to the preparatory

schools. Many of these schools are organized simply upon the football basis. They press football as a means of gaining place and standing among the competing institutions of their class. They become fanatical on the subject of football, make a sort of religion out of it, and at length reach the point where they isolate the boy whose parents think it best that he should confine himself to other sports. . . .

Let us repeat, then, that it is quite time for the parents and the general public to have their innings. The interscholastic games are carried to great excess, they interfere with school work, they injure health and morals, and they should at least be closely restricted. . . .

VIEWS OF PRESIDENT JAMES B. ANGELL.

This venerable head of Michigan University wrote in 1906:

I presume that all of you, like me, have looked with favor on the introdutcion of athletic games, including football, into our universities. In many respects they have been of great service. But I presume also that in the opinion of us all the present relation of our game of football is not what we desire.

The general complaint in the public press is of the roughness and dangerous character of the game. * * * I think that we who administer universities will agree that there are other objections to the present mode of carrying on the game quite as serious as the roughness in the play. Let us notice some of them.

1. Under the actual organization the absorbing interest and excitement of the students—not to speak of the public—in the preparation for the intercollegiate games make a damaging invasion into the proper work of the university for the first ten or twelve weeks of the academic year. This is true not of the players alone, but of the main body of students, who think and talk of little else but the game. * * *

2. The present conditions constantly hold before the students and before the world false ideals of college life. Not only in the college journals, but in the newspaper press of the whole country the students who by daily descriptions and by portraits are held up as the great men of the university are the men of brawn rather than the men of brains. Their slight ailments are chronicled with as much promptness as are those of a King in his Court Gazette. Their names are daily carried by the Associated Press from ocean to ocean. Not only undergraduates but school boys are filled with aspirations to follow in the footsteps, not of the best scholars, but of the best players.

3. The university is necessarily viewed in a wrong perspective. It is looked on as training men for a public spectacle, to which people come by thousands, instead of quietly training men for useful, intellectual, and moral service, while securing ample opportunity for reasonable athletic sports. Indeed the intellectual trainers are made to appear as of small consequence compared with the football coach. * * *

4. The expenditure of money in the preparation for the game is out of all proportion to what a rational provision for exercise and games for students ought to call for.

EXTRACTS FROM THE ANNUAL REPORT OF NICHOLAS MURRAY BUTLER, PRESIDENT OF COLUMBIA UNIVERSITY, NOVEMBER 5, 1906.

During the autumn of 1905 various occurrences took place which served to focus public attention upon the game of football as it had come to be played by American college students. . . .

While to many the game had become intensely uninteresting, to others it represented the most interesting and important thing in the world. Immense crowds were attracted to witness the contests, and sums equal to the annual income of many an American college were received in gate money in a single day. Football, indeed, threatened to overshadow, and in some institutions did already overshadow, every other academic interest. The example of the colleges had speedily been followed by the secondary schools, the game was increasingly popular there, and not a few schoolmasters were beginning to complain of the evils which afflicted the colleges. Appreciation of these facts had been growing in the public mind for some years past, and the events of the football season of 1905 brought matters to a crisis. Not only were participants in the contests often injured and sometimes killed, but the whole effect of the intense absorption in the game was antagonistic to the purposes and ideals of American colleges and universities. Because the game was obviously popular and because participation in it was supposed to advertise an institution of learning and attract students, it was either applauded, or excuses were made for it, by many persons who should have known better.

Not only did all the disadvantages above mentioned surround the game of football, but it had become a game in which the large majority of students could not participate. It required of most participants great weight and unusual physical strength; of others, swiftness of foot and highly trained powers of attack and defense. It was not a game that could be played in order to gain ordinary physical exercise. It required arduous training, almost complete absorption, and exceptional physical powers. As a result, it had come to be *at war with every sound principle of college sport or athletic exercise.*

*The italics are mine. C. M. W.

The moral qualities which it was supposed to foster were not strongly in evidence. The most important football games had become in fact purely professional contests, for professionalism is not so much a thing of money as it is a thing of spirit and point of view. At times when students should themselves be taking physical exercise for their own good, they stood grouped by hundreds watching a contest between trained representatives of their own institution and another. That these contests were gladiatorial in character, the history of the last few years of the game plainly proves. . . .

The most serious effects of intercollegiate football were *not* worked upon the participants, but upon the spectators and upon the general public. The participants were very often entirely unconscious of the criticism to which they exposed themselves, but there is not wanting evidence that the spectators, particularly the student spectators, were often swept into a vortex of hysteria and emotionalism which left its permanent mark upon their characters. . . .

Immediately upon the close of the autumn season of 1905, the Committee on Student Organizations, acting after consultation with the President and with his entire approval, announced that on December 31 the permission to maintain a football association at Columbia University would be revoked, and the existing association disbanded. The Committee on Student Organizations further expressed the opinion that the present game of football should be abolished, and they recommended to the University Council that the game be prohibited at Columbia University. The President at once addressed an open letter to the alumni and student members of the university, in explanation and support of the action that had been taken. . . .

Public testimony should be borne to the admirable spirit in which the alumni and students received the action of the university authorities abolishing football. While fully aware of the dangers and faults of the game, very many alumni and students felt that in view of the opportunity it afforded for gathering together large bodies of graduates and undergraduates and of calling forth demonstrations of college loyalty and college spirit, it would be nothing short of a misfortune to abandon football. The university authorities, however, deeply conscious of their responsibility for the maintenance of the university ideals, could not share this view, although they appreciated fully the hold which it had among both graduates and undergraduates. Great as was the disappointment of those alumni and students most interested in football, when the action of the authorities was fully and frankly explained, they accepted it loyally, even though some remained unconvinced as to its necessity or wisdom. This of itself is a triumph of true university spirit that should not pass unnoticed. . . .

It is hoped that it may soon be possible to make provision by which large numbers of students may be led to participate in outdoor sports, particularly in rowing, track athletics, cross-country running, baseball, tennis, lacrosse, and the so-called soccer form of football. The physical, mental and moral benefits resulting from such participation are well

known, and it is an unfortunate result of the system now usually followed in American institutions of learning that participation in sport is confined to the very few and the highly skilled.

FROM DAVID STARR JORDAN, PRESIDENT OF LELAND STANFORD JUNIOR UNIVERSITY.

There are good points in every game, but the game of football as now played has relatively no good points, while the drawbacks of every kind in a battle make this game *the heaviest burden higher education has ever been compelled to bear*. In the Rugby* game the moral effect is wholly good. It is not possible for a player to try to injure one of the other side without being put out of the game. No part of the game depends on wearing out the other side. It is not so much the risk of life and limb, which is very great, in the American game, but the fact that the game itself is one in which injury to the men on the other side is an essential character, and this injury is planned beforehand by the professional coach. There is no excuse for any university maintaining a professional coach who is not an alumnus.

The fight is on between university authorities and the mob spirit, led by clever men who make their living by leading it.

In 1904, at the height of the football obsession in California, the presidents and committees on athletics of the two universities notified the students that no form of football having mass play would be again permitted. The students then adopted the Rugby game. The Rugby game, for well or ill, draws larger crowds, because it is more interesting. It has been tested for five seasons, and it is wholly satisfactory to all concerned. The game demands a much higher grade of skill and alertness. It is far more interesting to watch. It is interesting to the players. It is a sport and not a battle. As with football, so with Rugby, each player must know the game. It is played, not in armor, but in cotton kneebreeches, and there have been in five years no injuries of any consequence. The game is now played in the universities and colleges of California and Nevada. It attracts (perhaps unfortunately) larger numbers of spectators than the old game ever did. It is now played in most of the leading high schools of California.

*By the "Rugby" game, he means "Soccer Ball." C. M. W.

EFFECTS OF FOOTBALL REFORM AT COLUMBIA.

By a "Close Observer."

It took a good deal more moral courage than is generally appreciated for the academic authorities of Columbia University to discontinue

the game of intercollegiate football as they did in 1905. In taking this step they knew perfectly well that they laid themselves open to bitter attack and criticism, as well as to serious misunderstanding of their motive and purpose on the part of students, alumni, and many outsiders of influence.

So completely was the academic world under the influence of the football mania, that the devotees of football believed that they could break the will of any individual or body which attempted to stand in their way. The public, eager for large spectacular contests, spiced with the element of physical danger, did not want the thing stopped. Highly paid coaches and managers and the manufacturers of football supplies, who have pushed their business from the big universities to the small colleges, from the small colleges to the high schools, and from the high schools almost to the kindergarten, were banded like a well-organized trust against anything which might interfere with their sales and profits.

The supporters of other academic sport defended football, often against their better judgment, because the enormous income from gate receipts, which it provided, saved them from the disagreeable necessity of paying themselves for the forms of sport which they preferred, but which, like rowing, could produce no gate receipts at all, or, like basketball and baseball, only moderate receipts as compared with those of football. It was against this whole body of opinion, vested interests, and unacademic practices that Columbia University set itself. That the step it took would be unpopular in high degree was certain; that it was right, was equally certain.

The cynical prediction was freely made that Columbia would have to back down from the position it took, because it could not stand the unpopularity and the criticism which the act called forth. The contrary happened. The Columbia authorities stood their ground like men and patiently answered the attacks leveled against them by appeals to reason which were, however, but little heard.

It is four years since football was abolished at Columbia, and there are now no undergraduates left there who have known or seen the demoralizing influence of intercollegiate football. It is the unanimous testimony of Columbia professors that the autumn weeks have now, for the first time, become quiet, orderly, and abundant in work. Previously serious academic work began after Thanksgiving. Football dominated everything until that day. The tone of the student-body has improved, and now on the university exercising ground, South Field, there may be seen every afternoon hundreds of young men actively engaged in sports, in games, and physical exercise, where, during the football period there were but twenty-two rushing and tearing at each other, while a few score or few hundred stood on the sidelines watching and cheering.

Football makes athletics impossible. Athletics cannot flourish until football is gotten out of the way. The rational and regular participation in outdoor sport by hundreds of students is an end devoutly to

be wished for. It cannot be obtained, however, so long as the body of the whole student interest is focused on the gladiatorial struggle between two trained bodies of combatants, leaving to the students as a whole nothing to do but to watch. The alternative is between the real and the vicarious. Football for the mass of American students is a vicarious participation in athletics.

It is deplorable that Columbia's example has not been followed by other large institutions. President Eliot talked and thundered against football, but Harvard did not uphold him. Other college presidents have gone to the length of defending football as a moral agent. One hardly knows how to deal with men who take such an attitude. Columbia has gained for itself a proud pre-eminence by an act of conspicuous moral courage, good sense, and high intelligence.—From the "Review of Reviews" of December, 1909, by permission.

WHAT THE FRIENDS OF THE GAME SAY OF IT.

In the light of the experience of Columbia, as shown above, the following pronouncement of the Athletic Committee of Harvard, made up of persons selected largely from their interest in athletics, is extremely interesting.*

"Intercollegiate athletics promote a general interest in athletic exercise; increase the number of men who take part in various forms of such exercise; furnish an active interest of a healthy sort to a number of men who but for them would be without any such interest; and are, on the whole, beneficial to the student body at large, as well as to the men who actually take part in them. Football, of which there has been more criticism than of any other branch of athletics, has been sufficiently improved, partly owing to the active efforts of the Athletic Committee, to justify its further continuance."

Mr. Morefield Storey refused to sign the majority report which contained the above.

From ANDREW S. DRAPER, Commissioner of Education for the State of New York, formerly President of the University of Illinois.

*Mr. R. B. Merriman says in "The Harvard Graduate Magazine" for June, 1907: "The faculty members of the Athletic Committee hitherto have been usually selected among that very small minority who, as undergraduates, either played on university teams or else took great interest in them."

I quoted from Dr. Draper twice in my "Estimate" on page one of this pamphlet. In a letter (February 5, 1910) he seems to have been convinced against his will. He says:

"I have always been extremely friendly to the game of football because of the belief that there was a great deal in it of much value, and that, while there were dangers, and some still more unfortunate factors in it, they could be eliminated and the game saved. I am beginning to believe that the evils in it will never be eliminated, because the men who are most interested in it do not seriously care about their elimination. I am now clearly of the feeling that the game should be radically reconstructed or prohibited."

In response to my request for views past and present, DR. R. S. WOODWARD, President of the Carnegie Institution, Washington, D. C., formerly Professor in Columbia University, New York, writes:

"I think you are not only entirely right in what you say, but that you have put the case very forcibly to people who are willing to take the trouble to think on the subject.

"My views on this perennial topic of controversy were expressed at length seven years ago in my address on 'Education and the World's Work of Today,' read at a commencement at Rose Polytechnic Institute, June 11, 1903, and published in Science, August 7, 1903.

"It seems to me that all sensible men ought to be substantially agreed with regard to this important matter. Athletics as practiced ten years ago were very sadly demoralizing, as I had occasion to learn by reason of the fact that I had then two sons in college and a third in preparation.

"The changes since that time seem to have justified my position, since football [at Columbia] has been abolished, and it is no longer possible for men to be retained on the teams who do not intend to meet some academic requirements."

I quote two paragraphs from the address referred to above:

"A noisy minority of college men have succeeded, apparently, in convincing the public and to a large extent the college authorities, that one of the principal functions of an educational institution is the cultivation of muscle and the conduct of athletic sports. Along with the growth of this minority there has sprung up, also, a class of less strenuous men, who, taking advantage of the elective system, are pursuing courses of aimless discontinuity involving a minimum of work

and a maximum of play. They toil not, except to avoid hard labor; neither do they spin, except yarns of small talk over their pipes and their bowls. I need not explain to you that these types of men are well known in natural history."

"It is not so well known, however, that these types of men—prospective bachelors of athletics and degree-hunting dudes—are now wielding an influence distinctly inimical to academic ideals and distinctly debasing to academic morals. Pray do not misunderstand me. I am not opposed to physical culture and athletic sports. My protest is against athletics as they are now generally carried on, and especially against intercollegiate contests. As now practiced, athletics seem to me to defeat the object they are intended to attain. They cultivate almost exclusively the men who are usually more in need of intellectual training, and they ignore almost completely the men who are physically defective."

AS OTHERS SEE US.

The following is taken from "The Bystander," a splendidly illustrated English publication of sport, pastimes and travel. This article is headed "Chartered Hooliganism":

"Of all the games played in the civilized world the most execrable is American football, nor is there anything more unintelligible than the fascination which this brutal and degrading pastime has for an intelligent nation like the Americans. An offshoot, presumably, of our own Rugby game in its earliest and crudest form, it still bears, outwardly at any rate, some resemblance to it. But whereas we have in process of time improved our game by eliminating its more brutal features, the tendency in America has been all the other way. That it is a scientific game nobody would be prepared to deny. To be proficient at it a team must practice assiduously with the aid of a professional coach, and one of its so-called beauties consists in the successful carrying out, after arduous training, of various concerted movements, the signal for which is given by code words, the significance of which is, of course, only known to the players on the side. This in itself is a form of mere trickery, which is repugnant to the ideas of the average sportsman, but apart from this, rough play, so far from being discouraged, is recognized as an essential feature of the game, and the costume of the players, with its pads and guards, may be likened to a suit of armor. Seldom does a match take place without some injuries of a more or less serious character taking place, and deliberate attempts on the part of the players to knock each other

out are part of the day's work. Things have come to such a pass this year that, although the season is comparatively young, a dozen or more "football deaths" have already been recorded. I am glad to hear that, as the result of the death of one of its cadets, football at West Point Academy has been stopped, and I hope that this may prove the beginning of the end of a game which is a disgrace to modern civilization. Our own game, which is manly without being brutal, has made tremendous headway in the Colonies. Why not in America, too?

"The Rugby (soccer ball) game is manly and interesting, without being brutal."

CONTENTS.

STUDIES IN PHILOLOGY

PUBLISHED UNDER THE DIRECTION OF
THE PHILOLOGICAL CLUB OF THE UNIVERSITY OF
NORTH CAROLINA

VOL. IV

Conjunction Plus Participle Group in English

BY

ORESTES PEARL RHYNE

The Dramatic Monologue: Its Origin and Development

BY

CLAUD HOWARD

CHAPEL HILL
THE UNIVERSITY PRESS
1910

CONJUNCTION + PARTICIPLE GROUP IN ENGLISH*

By

Orestes Pearl Rhyne

*A dissertation submitted to the Faculty of the University of North Carolina as a partial requirement for the degree of Master of Arts

THE UNIVERSITY PRESS
CHAPEL HILL

CONJUNCTION + PARTICIPLE GROUP IN ENGLISH

INTRODUCTION

Writers on English Syntax have as a general rule neglected the very common construction conjunction + participle phrase. The frequency of its occurrence and the variety of its functions merit at the hands of grammarians more than a mere mention as a present-day construction in good usage. All are agreed that it is good English, but only one or two give any historical treatment or venture any explanation of it.

In speaking of the appositive participle Einenkel says:[1] "Um andere Beziehungen zu verdeutlichen dienen Konjj, doch erst sehr spät; e.g. mod *experience, when dearly bought, is seldom thrown away*, Rogers; *if deceived, I have been my own dupe*, Bulwer." Einenkel's "Mod" does not mean modern in the usual signification of the word, but it denotes rather 19th century English. This one little sentence of eleven words is all that he devotes to the subject.

Sweet says:[2] "On the other hand, these participle-groups, through having the same function as dependent sentences, have come to adopt some of the grammatical peculiarities of the latter. Thus they can take conjunctions whenever clearness seems to make it desirable, as in *Mac Ian, while putting on his clothes and calling to his servants to bring some refreshment for his visitors, was shot through the head. I wrote a similar epitaph for my wife, though still living*, compared with *do good hoping for nothing*.

"A participle-group introduced by a conjunction no longer requires to be placed next to the word that it modifies, but

1. *Englishe Syntax*, par. 129. Strassburg. 1904.
2. *New English Grammar*, par. 2346-2348.

may be detached from it: *nor ever did I love thee less, though mourning for thy wickedness.*"

Jespersen says:[3] "Business-like shortness is also seen in such convenient abbreviations of sentences as abound in English, for instance, *while fighting in Germany he was taken prisoner. He would not answer when spoken to. To be left till called for*, etc. Such expressions remind one of the abbreviations used in telegrams; they are syntactical correspondences to the morphological shortenings that are of such frequent occurrence in English: photo for photograph, phone for telephone, etc."

Mätzner says:[4] " Diese [temporal, causal, concessive, etc.] und andere Verhältnisse, welche übrigens nicht scharf von einander gesondert werden können und zum Theil in einander übergehen, lassen sich leicht durch das logisch vieldeutige Particip andeuten. Desshalb haben sie auch in der jüngeren Sprache die das grammatische Verhältniss von Nebensätzen zu Hauptsätzen ausdrückenden Fügeworter zugelassen und erscheinen in Verbindung mit diesen als bestimmt ausgeprägte Satzverkürzungen; dieselben untersebeiden sich von anderen Satzverkürzungen, deren weiterhin zu gedenken ist, dadurch, dass bei ihnen in der That ohne den Zusatz einer Konjunktion zur grammatischen Vollständigkeit des Satzes nichts fehlt, welchem nur die völlige Klarheit des logischen Verhältnisses mangeln würde.

"*Mac Ian, while putting on his clothes and calling to his servants to bring some refreshment for his visitors, was shot through the head.* (Macaul. H. of E. VII. 241). *Whilst blessing your beloved name, I'd waive at once a poet's fame, To prove a prophet here.* (Byr. p. 309). *I met her, as returning, In solemn penance from the public cross.* (Rowe. J. Shore. 5, 1). *Our remaining horse was . . . unfit for the road, as wanting an eye.* (Goldsm. Vic. 14). *Talents angel-bright, If wanting worth, are shining instruments In false ambition's hand.* (Young N. Th. 6,273). *I wrote a similar epitaph for*

3. *Growth and Structure of the English Language*, ch. 1, par. 10.
4. *Englische Grammatik*, III, pp. 73-74.

my wife, tho' still living. (Goldsm. Vic. 2). *Nor ever did I love thee less, Though mourning o'er thy wickedness.* (Shelley, III. 79).

"Dabei kommen nur die nicht präpositionalen Konjunktionen in Betracht, da wir den Präpositionen, welche bei dieser Participialform vorkommen, eine andere Beziehung zu ihr als Gerundium anweisen. Allerdings berührt sich auch hier wiederum das Particip als solches mit der als Gerundium zu fassenden Form, deren Verfliessen in einander immerhin zugegeben werden muss, wenngleich der Versuch einer theoretischen Trennung beider dadurch nicht beeinträchtigt werden kann. Die Ausdehnung des Gebrauches jener Partikeln in Verbindung mit dem Particip gehört wesentlich dem Neuenglischen an, steht aber allerdings mit der Verwendung derselben in anderen Satzverkürzungen in Zusammenhang, welche in dem Abschnitte von der Verkürzung und Zusammenziehung des Nebensatzes mit dem Hauptsatze behandelt werden."

Koch in his *Historische Englische Grammatik* does not mention this construction. Krüger in his *Schwierigkeiten der Englischen Sprache* gives examples, but attempts no explanation. Franz (*Shakespeare—Grammatik*) does not mention it, although the construction was comparatively common in Shakespeare. Incidentally he gives one example, but in illustration of another point.

Earliest Uses

Einenkel in the passage quoted above states that the construction in question does not occur until very late. He traces it back no farther than the middle of the 18th century. Indeed, it seems to be the impression of all grammarians who have treated the subject that the construction first came into English about this time. But in reality it goes much farther back. I have been able to trace it as far back as 1552. I have sought the construction in the following list of books which are, I think, chronologically representative:

Chaucer's Troilus and Creseyde, 1379-1383.

Caxton's Aneid, (partly) 1490.

Heywood's Play of the Wether, 1533.

Heywood's Johan Johan, 1540.

Ralph Roister Doister, 1552.

Gammer Gurton's Needle, 1566.

Lyly's Euphues (partly), 1579.

Lyly's Alexander and Campaspe, 1584.

Peele's Old Wives' Tale, 1590.

Henry Porter's Two Angry Women, 1598.

Marlowe's Two Tamburlaines, Doctor Faustus, Jew of Malta, Edward II.

Bacon's Essays: Of Truth, Of Innovations, Of Nature in Men, Of Youth and Age, Of Negotiating, Of Studies.

All of Shakespeare.

All of Paradise Lost.

Milton's Freedom of the Press.

More has resulted from this reading in determining definitely when this idiom came into English than in its explanation.

The earliest cases that I have found are the following:

For that maketh me eche, where so highly favored.
Roister Doister (1552). 1, 2, 107.

Diogenes moves about with a lantern, as if seeking
someone. Lyly's Alexander and Campaspe (1584). 1,
3, 135.

As having greater sinne and lesser grace. Greene's
Friar Bacon. 9. 67.

And if these things, as being thine in right
Move not thy heavy grace. . . . Sydney's Astro-
phel and Stella, Sonnet 39.

It occurs several times in Lyly's Euphues.

The following are all the cases that occur in five plays
of Marlowe and in all of the plays of Shakespeare, includ-
ing his Sonnets. I give not only the cases of conjunc-
tion + participle, but conjunction + adjective, etc.

And though divorced from king Edward's eyes
Yet liveth Pierce of Gaveston unsurpassed. Marlowe's
Edward II. 2, 5.

Thus lives old Edward not relieved by any,
And so must die, though pitied by many. Marlowe's
Edward II. 2, 5.

These two are the only cases from Marlowe.

ILLUSTRATIONS FROM SHAKESPEARE

The following are all from Shakespeare.

WITH *though.*

For love's hours are long, though seeming short. **Venus and Adonis. 629.**

 . . . whom
Though bearing misery, I desire my life
Once more to look upon him. Winter's Tale. 5, 1, 134.

One port of Aquitane is bound to us,
Although not valued to the money's worth. **Love's Labor's Lost. 2, 1, 136.**

As you shall deem yourself lodged in my heart,
Though so denied fair harbour in my house. **Love's Labor's Lost. 2, 1, 175.**

Though to myself forsworn to thee I'll faithful prove.
Love's Labour's Lost. 4, 2, 111.

My Pericles, his queen and daughter seen,
Although assailed with fortune fierce and keen,
Virtue preserved from fell destruction's blast. **Pericles. 5, 3, 87.**

The gods for murder seemed so content
To punish them; although not done, but meant. **Pericles. 5, 3, 98.**

Sufficeth I am come to keep my word,
Though in some part forced to digress. **Taming of the Shrew. 3, 2, 108.**

That Slender, though well lauded, is an idiot. **Merry Wives. 4. 4, 86.**

I my brother know, yet living in my glass. Twelfth
Night. 3, 4, 415.

I know thee well, though never seen before. I Henry
VI. 1, 2, 67.

Hath he not twit our sovereign lady here
With ignominious words, though clerkly couched?
II Henry VI. 3, 1, 178.

 . . . And none of this,
Though strongly apprehended, could restrain
The stiff-borne action. II Henry VI. 1, 2, 180.

Her eyes, though sod in tears, looked red and raw.
Lucrece. 1529.

The organs, though defunct and dead before,
Brake up their drowsy grave and newly move. Henry
V. 4, 1, 21.

Then should I spur, though mounted on the wind.
Sonnet 51.

Some in their garments, though new-fangled ill. Son-
net 91.

Her audit, though delayed, must answered be. Son-
net 126.

Some in her threaden fillet still did bide,
Though slackly braided in loose negligence. A Lover's
Complaint. 35.

The record of what injuries you did use,
Though written in our flesh we shall remember. An-
tony and C. 2, 5, 117.

 . . . as they are,
Though in Rome littered. Coriolanus. 3, 1, 238.

Not sure, though hoping, of this good success,
I asked his blessing. King Lear. 5, 3, 194.

 . . . whom thou fought against,
Though daintily brought up. Antony and C. 1, 4, 60.

His brother warred upon him, although, I think not
moved by Antony. Antony and C. 2, 1, 41.

 . . . and indeed it takes
From our achievements, though performed at height.
Hamlet. 1, 4, 20.

So lust, though to a radiant angel linked,
Will sate itself in a celestial bed. Hamlet. 1, 5, 55.

Here Tamora, though grieved and killing grief. Titus
Andronicus. 2, 3, 260.

The other, though unfinished, yet so famous. Henry
VIII. 4, 2, 61.

Although unqueened, yet like a queen and daughter
And daughter to a king, inter me. Henry VIII. 4,2, 171.

And will maintain what thou hast said is false
In thy heart-blood, though being all too base
To stain the temper of my knightly sword. Richard
II. 4, 1, 27.

The cause I give I have, though given away. Richard
II. 4, 1, 199.

Wherein I wander, boast of this I can,
Though banished, yet a true-born Englishman. Rich-
ard II. 1, 3, 308.

Well could I curse away a winter's night,
Though standing naked on a mountain top. II Henry
VI. 3, 2, 336.

Come and get thee a sword, though made of a lath. II
Henry VI. 4, 2, 1.

 WITH *as.*

 . . . when my heart,
As wedged with a sigh would rive in twain. Troilus.
1, 1, 35.

Why then the thing of courage,
As roused with rage, with rage doth sympathyze. Troilus. 1, 3, 51.

Which when they fall, as being slippery standers,
The love that leans on them as slippery too. Troilus.
3, 3, 84.

I speak not "be thou true" as fearing thee. Troilus.
4, 4, 64.

Variable passions though her constant woe,
As striving who should best become her grief. Venus and Adonis. 976.

Which her cheek melts, as scorning it should pass . . .
Venus and Adonis 982.

Which seen, her eyes as murdered with the view,
Like stars ashamed of day themselves withdrew. Venus and Adonis 1031.

That o'er his wave-worn basis bowed,
As stooping to relieve him. Tempest. 2, 1, 118.

And though you took his life, as being our foe,
Yet bring him as a prince. Cymbeline. 4, 2, 249.

Bid him shed tears, as being overjoyed,
To see her noble lord restored to health. Taming of the Shrew. Ind. I, 121.

Hence comes it that your kindred shuns
Your house, as beaten hence by your strange lunacy.
Taming of the Shrew. Ind II. 30.

I say the business is not ended, as fearing to hear of it hereafter. All's Well. 4, 3, 110.

Yes truly speak, not as desiring more. Measure for M. 1, 4, 3.

You speak as having power to do wrong. II Henry
IV. 2, 1, 141.

. . . To that end
As matching to his youth and vanity,
I did present him with the Paris balls. Henry V. 2,
4, 129.

For pale they look with fear, as witnessing
The truth on our side. I Henry VI. 2, 4, 63.

Swift-winged with desire to get a grave,
As witting I no other comfort have. I Henry VI.
2, 5, 15.

As liking of the lady's virtuous gifts,
He doth intend she shall be England's queen. I Henry
VI. 5, 1, 43.

Why doth the great duke Humphrey knit his brows,
As frowning at the favours of the world. II Henry
VI. 1, 2, 3.

As being thought to contradict your liking. II Henry
VI. 3, 2, 252.

Each present lord began to promise aid,
As bound in knighthood to her impositions. Lucrece.
1696.

And ever since, as pitying Lucrece's woes. Lucrece.
1747.

Which I new pay, as if not paid before. Sonnet 30.

Thine eyes I love, and they, as pitying me. Son-
net 132.

And you bear it as answering to the weight. Antony
and C. 5, 2, 102.

Madam, as thereto sworn by your command,
I tell you this. Antony and C. 5, 2, 198.

Thou singest not in the day,
As shaming any eye should thee behold. Lucrece. 1142.

She thought he blushed, as knowing Tarquin's lust.
Lucrece. 1354.

 . . . thy angel
Becomes a fear, as being o'erpowered. Antony and
C. 2, 3, 22.

Traitors ensteeped to clay the guiltless keel.
As having sense of beauty do omit
Their mortal natures. Othello. 2, 1, 70.

Mark how the blood of Caesar followed it,
As rushing out of doors to be resolved. Julius Caesar.
3, 2, 182.

 . . . as by the same covenant
And carriage of the article designed,
His fell to Hamlet. Hamlet. 1, 1, 93.

But he, as loving his own pride and purposes,
Evades them with a bombast circumstance. Othello.
1, 1, 12.

Still blushing, as thinking their own kisses sin. Romeo
and Juliet. 3, 3, 39.

Thou seest, the heavens, as troubled with man's act,
Threaten his bloody stage. Macbeth. 2, 4, 5.

But if you faint, as fearing to do so,
Stay and be secret, and myself will go. Richard II. 2,
1, 297.

But for my hand, as unattempted yet,
Like a poor beggar, raileth on the rich. John. 2, 1,
591.

As hating thee, are risen in arms. II Henry VI. 4,
1, 93.

Why I challenge nothing but my dukedom,
As being well content with that alone. III Henry VI.
4, 7, 23.

I speak not this as doubting any here. III Henry VI.
5, 4, 43.

. I now repent I told the pursivant,
As too triumphing, how my enemies . . . Richard
III. 3, 4, 90.

. . . and is become as black
As if besmeared in hell. Henry VIII. 1, 2, 123.

If you suppose, as fearing you, it shook. I Henry IV.
3, 1, 23.

<p align="center">WITH *if*.</p>

Thus will I save my credit in the shoot;
Not wounding, pity would not let me do it;
If wounding, then it was to show my skill. Love's
Labor's Lost. 4, 1, 26.

Oh! never faith could hold, if not to beauty vowed.
Love's Labor's Lost. 4, 2, 110.

If broken, then it is no fault of mine. Love's Labor's
Lost. 4, 3, 71.

If by me broke, what fool is not so wise,
To lose an oath to win a paradise. Love's Labor's
Lost. 4, 3, 72.

If haply won, perhaps a hapless gain;
If lost, why then a grievous labor won. Two Gentle-
men. 1, 1, 32.

. . . If one jot beyond
The bound of honour, or in act or will
That may inclining, hardened be the hearts
Of all that hear me. Winter's Tale. 3, 2, 51.

If put upon you, make the judgment good. Pericles.
4, 6, 100.

If fair faced,
She would swear the gentleman should be her sister;
If black, why, Nature drawing of an antic,
Made a foul blot; if tall, a lance ill-headed;
If low, an agate very vilely cut;
If speaking, why a vane blown with all winds;

If silent, why, a block moved with none. Much Ado.
3, 1, 61-67.

As jewels lose their glory if neglected,
So princes their renowns, if not respected. Pericles.
2, 2, 12.

Choler, my lord, if rightly taken. I Henry IV. 2, 4,
356.

But best is best, if never intermixed. Sonnet 101.

If denounced against us, why should we not be there in
person? Antony and C. 3, 7, 5.

And, if possessed, as soon decayed and done. Lucrece.
23.

If partially affined, or leagued in office,
Thou dost deliver more or less than truth. Othello. 2,
3, 217.

For if of joy being altogether wanting,
It doth remember me the more of sorrow;
Or if of grief being altogether had,
It adds more sorrow to my wont of joy. Richard II.
3, 4, 13-17.

 . . . which, if granted,
As he made semblance of his duty. Henry VIII. 1, 2,
197.

The which, if wrongfully anointed,
Let heaven revenge. Richard II. 1, 2, 39.

If for thee lost, say ay, and to it, lords. III Henry VI.
2, 1, 165.

WITH *when*.

Love-thoughts lie rich when canopied with bowers.
Twelfth Night. 1, 1, 41.

He dies again to me when talked of. Winter's Tale.
5, 1, 19.

A true soul
When most impeached, stands least in thy control. Sonnet 125.

Fortune's blows,
When most struck home . . . craves a noble cunning.
Coriolanus. 4, 1, 8.

When most unseen, then most doth tyrannize. Lucrece.
676.

I wrote to you while rioting in Alexandria. Antony
and C. 2, 2, 71.

When being not at your lodging to be found,
The senate hath sent about three several guests
To search you out. Othello. 1, 2, 45.

WITH *until.*

As doubtful whether what I see be true,
Until confirmed, signed, ratified by you. Merchant of
V. 3, 2, 148.

Which I never use till urged. Henry V. 5, 2, 150.

Trouble him no more till further settling. King Lear.
4, 7, 81.

Knavery's plain face is never seen till used. Othello.
2, 1, 321.

WITH *where.*

Where having nothing, nothing can he lose. III Henry
VI. 3, 3, 152.

WITH *before.*

Why, let her except before excepted. Twelfth Night.
1, 3, 7.

WITH *adjectives.*

A giving hand, though foul, shall have fair praise.
Love's Labor's Lost. 4, 1, 23.

My beauty, though but mean,
Needs not the painted flourish of your praise. Love.
Labor's Lost. 2, 1, 14.

His face, though full of cares, yet showed content
Lucrece 1503.

Thy love, though much, is not so great. Sonnet 6.

For I must ever doubt, though ne'er so sure. Timon
of Athens. 4, 3, 514.

An aged interpreter, though young in years. Timon
of Athens. 5, 3, 8.

. . . Now our joy,
Although our last and least . . . what can you say?
Lear. 1, 1, 84.

Bid them farewell, Cordelia, though unkind. Lear 1,
1, 263.

Though not last, not least, in love, yours, good Tre-
bonius. Julius Caesar. 3, 1, 189.

Though nothing sure, yet much unhappily. Hamle
4, 5, 14.

. . . Though indirect,
Yet indirection thereby grows direct. John. 3, 1, 2'7

While then, though loth, yet must I be content. III
Henry VI. 4, 6, 48.

And though unskillful, why not Ned and I
For once allowed the skillful pilot's charge? III Henry
VI. 5, 4, 20.

. . . Old Escalus,
Though first in question, is the secondary. Measure
for M. 1, 1, 46.

. . . Thou churl, for this time,
Though full of displeasure, yet we free thee. Winter's
Tale. 4, 4, 442.

Though light, take pieces for the figure's sake. Cymbeline. 5, 4, 24.

Their encounters, though not personal,
Have been royally attorneyed. Winter's Tale, 1, 1, 28.

That they have seemed to be together, though absent.
Winter's Tale. 1, 1, 32.

Not black in my mind, though yellow in my legs.
Twelfth Night. 3, 4, 27.

　　　For the success,
Although particular, shall give a scantling,
Of good or bad into the general;
And in such indexes, although small pricks
To their subsequent volumes, etc. Troilus. 1, 3, 340.

Which are the moves of a languishing death,
But though slow, deadly. Cymbeline. 1, 5, 9.

And it gave present hunger,
To feed again, though full. Cymbeline. 2, 4, 137.

Beauty doth vanish age, as if new-born. Love's
Labor's Lost. 4, 3, 244.

Which he swore he would wear, if alive. Henry V. 4,
7, 135.

For I am nothing, if not critical. Othello. 2, 1, 120.

If good, thou shamest the music of good news. Romeo
and J. 2, 5, 23.

　　　　　　　　　　　If ill,
Why hath it given me earnest of success. Macbeth.
1, 3, 132.

If good, why do I yield to that suggestion? Macbeth.
1, 3, 134.

If not complete of, say he is not she. John. 2, 1, 434.

England is safe, if true within itself. I Henry VIII.
4, 1, 40.

If not true, none were enough.　　Measure for Measure. 4, 3, 177.

If not well, thou should'st come.　　Antony and C. 2, 5, 38.

If any, speak.　　Julius Caesar. 3, 2, 32.

The thorny brambles and embracing bushes,
As fearful of him, part, through whom he rushes.
Venus and A. 629.

　　　　　　And made
The water which they beat to follow faster,
As amorous of their strokes.　　Antony and C. 2, 2, 200.

His hand, as proud of such a dignity.　　Lucrece 437.

Is the more honor because more dangerous.　　III Henry VI. 4, 3, 15.

Sweet is the country, because full of riches.　　II Henry VI. 4, 7, 67.

WITH *phrases.*

Or if you cannot weep, yet give some groans, ·
Though not for me, yet for your aching bones.　　Troilus. 5, 10, 50.

But Margaret was in some fault for this,
Although against her will.　　Much Ado. 5, 4, 4.

Thou art no man, though of man's complexion.
Venus and A. 215.

Your lordship, though not clean past your youth,
Hath yet some smack of age in you.　　II Henry IV. 1, 2, 109.

Who am prepared against your territories,
Though not for Rome itself.　　Coriolanus. 4, 5, 140.

May stand in number, though in reckoning none.
Romeo and J. 1, 2, 33.

This cardinal, though from an humble

Stock, undoubtedly was fashioned to much
Honour from his cradle. Henry VIII. 4, 2, 48.

This royal infant, though in her cradle,
Yet now promises, etc. Henry VIII 5, 5, 18.

O spare mine eyes,
Though to no use but still to look on you. John. 4,
1, 103.

And many strokes, though with a little axe,
Hews down and fells the hardest-timbered oak. III
Henry VI. 2, 1, 54.

For now he lives in fame, though not in life. Richard
III. 3. 1, 88.

Though not by war, by surfeit die your king. Richard
III. 1, 3, 197.

Let me, if not by birth, have lands by wit. Lear. 1,
2, 199.

If not for any parts in him . . . yet more to move
you . . . Timon of Athens, 3, 5, 76.

If at home sir, he's all my exercise. Winter's Tale, 1,
2, 165.

And strike her home by force, if not by words. Titus
Andronicus. 2, 1, 118.

His master would be served before a subject, if not
before a king. Henry VIII, 2, 2, 8.

And banished I am, if but from me. II Henry VI. 3,
2, 351,

If not in heaven, you'll sup in hell. II Henry VI. 5, 1,
216.

As well we may, if not through your neglect. II Henry
VI. 5, 2, 80.

'Tis mine, if but by Warwick's gift. III Henry VI. 5,
1. 35

For shame if not for charity. Richard III. 1, 3, 272.

Be guilty of my death, since of my crime. Lucrece. 931.

For myself am best, when least in company. Twelfth Night. 1, 4, 37.

WITH *nouns.*

Shall I do that, which all the Parthian darts,
Though enemy, lost aim, and could not? Antony and C. 4, 14, 70.

Down from the waist they are centaurs,
Though women all above. Lear. 4, 6, 126.

The trees, though summer, yet forlorn and lean. Troilus. 2, 3, 94.

Thou art thyself, though not a Montague. Romeo and J. 2, 2, 39.

The iron of itself, though heat red-hot,
Approaching near these eyes would drink my tears. John. 4, 1, 61.

This we prescribe, though no physician. Richard II. 1, 1, 154.

Although the victor, we submit to Caesar. Cymbeline. 5, 5, 460.

Master Shallow, you yourself have been a great fighter, though now a man of peace. Merry Wives. 2, 3, 43.

If not Achilles, nothing. Troilus. 4, 5, 76.

And each, though enemies to either's reign. Sonnet 28.

WITH *infinitives.*

Hold Clifford! do not honour him so much,
To prick thy finger, though to wound his heart. III Henry VI. 1, 4, 54.

Though not to love, yet, love to tell me so. Sonnet 140.

The number of the above examples shows that the construction even in Shakespeare's day was becoming comparatively common. 120 clear cases of the conjunction+participle group are found in Shakespeare, or an average of about three to a play.

In *Paradise Lost*, which is equal in length to about three plays of Shakespeare, the construction occurs 91 times, or 10 times as often as in Shakespeare fifty years before. These figures in a general way indicate the increase in frequency of this idiom. No work later than *Paradise Lost* was examined, but this rate of increase, from all indications, has not since become less. In the middle of the 18th century it became frequent enough for recent grammarians casually to run upon it, and today it has become so common that its absence would almost make English prose seem slow and wordy.

Thus we see that the 18th century was not, as Einenkel seems to maintain, the date which saw the origin of this construction, but that it was the 16th and early 17th. One is surprised that a syntactician of Einenkel's ability should have overlooked this idiom of the 17th century.

Conclusion

After the time of the introduction of this construction has been determined, there remains the more difficult task of explaining the reason for and the manner of forming this idiom. The history of the idiom gives us no explanation. Its development has been merely a growth in frequency of occurrence. Its nature has not changed since the first time that it was used. It was exactly the same construction then as it is now. Its explanation, then, is to be sought, it seems to me, not in historical grounds, but from *a priori* considerations.

Is it to be considered from the standpoint of the participle, or from that of the subordinate clause? Is it a question solely of the crossing of two common constructions, or is it merely a question of ellipsis?

The larger number of those who have sought an explanation of the construction treat it from the standpoint of the participle. They begin with the participle and assume the addition of the conjunction. Some give as the reason for the addition of the conjunction one thing, and some another. Einenkel says that the conjunction is added to express other relations than those expressed by the simple participle. Now what relation can be expressed by a conjunction + participle phrase which was not already expressed by the participle? We already had the temporal, conditional, concessive, and causal participle. These, and usually only these relations are expressed by the conjunction + participle group. The *other relations* of Einenkel are certainly few in number.

Sweet, in the passage quoted above, makes the whole thing a question of clearness. If we assume that this hybrid construction originated from the simple participle, this view is at least plausible. The temporal, causal, conditional, and con-

cessive relation may be and actually is expressed by the participle alone. But this relation, though real, may be dim. To bring out and emphasize this subordinate relation, a conjunction was added. In theory this is plausible, but as a matter of fact it is not the case, as I hope to show later.

Jespersen mentions the construction among other elliptical expressions and seeks its explanation in the tendency in English towards "business-like shortness".[5] If considered from the standpoint of the participle alone, this participle-group is not elliptical, but quite the reverse. Only when considered from the standpoint of the subordinate clause, can it in any way be called ellipsis.

While this view may, and it seems to me, does give the ultimate reason why we have the construction, it does not explain its origin. It does not tell us whether it was formed from the simple appositive participle or from the subordinate clause or from both. It tells us *why* we made it, but not how we made it.

Mätzner[6] considers the question from both points of view. In his chapter on the participle, he says that a participle which is equivalent to a subordinate clause may permit a conjunction. In another place he considers this very same idiom as the result of a shortening-up of the subordinate clause. This is not consistent. If one view is correct, the other is surely incorrect, and vice versa.

Can this idiom be proved to be the remains of a subordinate clause after suffering ellipsis? In some cases it may seem to be so, as in *though hurt, he continued to play* from *though he was hurt, he continued to play.* Here the subject of the subordinate clause and the *be-* auxiliary may be assumed to have dropped out. This may always be the case when the verb is passive: the subject and auxiliary are dropped. But *though doing his best, he failed* cannot result from *though he did his best, he failed.* For this ellipsis to have taken place we must

5. *Growth and Structure of the English Language*, ch. 1 p. 10.
6. *Grammatik*, III. p. 440 and p. 73.

assume a resolution of the past definite into the corresponding past progressive and then to have had the subject and *be*-form drop out. This almost certainly was never the case. As a theory, the assumption of the addition of a conjunction to the participle is much simpler. The other hypothesis involves complications and has to resort to the overworked theory of ellipsis. The former assumes what the Germans call "Ergänzung," a procedure as objectionable as the other, were it not for the fact that it is not so frequently resorted to as is ellipsis.

The question cannot be settled historically. To start with, we had the participle equivalent to both a dependent clause and a subordinate clause. Later there developed the mixed construction under consideration. If we had had only one of the two to begin with and if there had resulted the construction as we now have it, the explanation would be simple and conclusive. But such is not the case.

The question cannot be considered exclusively from either standpoint, but from both. It is, it appears to me, not a question of deriving this idiom from the participle alone, or from the subordinate clause alone. When we look at the construction conjunction + participle we see that it is made up of an element from both. Hence is it not reasonable to assume that each has furnished one of the elements? Thus we have the conjunction from the subordinate clause, and the participle which, as we saw, is not necessarily the participle of the subordinate clause, but which in all probability is the original participle. Given the tendency to "brevity of expression," and the two original constructions,—one of which was brief but not clear, the other of which was clear but wordy,—is it not natural that we have evolved a new construction that harmonizes the demands of both clearness and brevity? This is just what the conjuction + participle group does. It is just as clear as the full subordinate clause and is only one word longer than the participle.

Thus the idiom is not the result of either of these two constructions alone, but the offspring of both. It is the child of

the pair. This crossing of construction is not uncommon in English,—quite the contrary. When two parallel constructions exist side by side and both are in constant use, it is nothing but natural for a word or a member of one to go over into the other.

The examples from Shakespeare show that the occurrence of the conjunction + adjective group is almost as common as the conjunction + participle group. In *Paradise Lost* about the same proportion holds. The figures are 55 of the former to 91 of the latter. This again is what Mätzner calls "elliptical subordinate clause". It seems to me that it is more reasonable to call this an elliptical subordinate clause than to designate the conjunction + participle group as such. The conjunction + adjective group, like the conjunction + passive participle group, could in every case be the result of ellipsis. But the active tenses, unless progressive, had to be resolved into the corresponding progressive tenses before ellipsis could be assumed. The adjective has the same form throughout and, in original subordinate clauses, was always used with some tense of the verb *be*. Hence nothing was in the way of ellipsis, and as Mätzner explains, the "elliptical subordinate clause" may have resulted. But may we not again call it a crossing, as in the case of the participle? Even an appositive adjective may express a causal, conditional, concessive, and temporal relation, as in *the man drunk and unruly, was put out*. Now this, crossed with *the man, because he was drunk and unruly, was put out*, could easily have given *the man, because drunk and unruly, was put out*. The only objection to this explanation is that the adjective alone was not used very often in the function of a subordinate clause.

In the last paragraph quoted from Mätzner, he cautions against construing the gerund as a participle after prepositions and conjunctions, as *before, after, till*, etc. But it is as reasonable to call them participles as gerunds and hence conjunctions as well as prepositions. The preposition necessarily becomes a conjunction before a passive participle, as in *keep*

it till called for; he stopped before hurt. Not for one moment would Mätzner try to construe *called* and *hurt* as gerunds. Wherein does the present active participle differ from the passive? Will the fact that it has the same form as the gerund prevent its being construed as a participle? It is reasonable to call it the gerund; it is just as reasonable to call it the participle and to consider what was a preposition a conjunction. This explanation is not inconsistent, since the word is either a participle or a gerund according to the aspect in which it is considered.

BIBLIOGRAPHY

The following books have been referred to in the preparation of this paper:

Mätzner, *Englische Grammatik.* 3d. ed. 3 vols. Berlin, 1885.

O. Jespersen, *Growth and Structure of the English Language.* Leipzig, 1905.

Henry Sweet, *New English Grammar.* Oxford, 1903.

C. Alphonso Smith, *Our Language: Grammar.* Richmond, 1903.

C. Alphonso Smith, *Studies in English Syntax.* Boston, 1906.

G. Krüger, *Schwierigkeiten des Englischen.* Dresden, 1904.

L. Kellner, *Historical Outlines of English Syntax.* London, 1892.

E. Einenkel, "Englische Syntax." *Grundriss der germanischen Philologie.* Band III. Strassburg, 1904.

C. F. Koch, *Historische Grammatik der englischen Sprache.* Cassell, 1878.

W. Franz, *Shakespeare-Grammatik.* Halle, 1900.

THE DRAMATIC MONOLOGUE: ITS ORIGIN AND DEVELOPMENT*

By

Claud Howard

*A thesis presented to the Faculty of the University of North Carolina as a partial requirement for the degree of Master of Arts.

THE DRAMATIC MONOLOGUE: ITS ORIGIN AND DEVELOPMENT[1]

INTRODUCTION

The present movement in literary study is especially characterized by intensive study of types. The old method of dividing the history of literature into chronological periods and studying each as a complete unit within itself is being superseded by a new method of treating each distinct form separately. The origin, development, and variations of each type are carefully studied. In this manner the literary species are disentangled from the mass of confused material which has obscured them for centuries, and, consequently, their independent histories are clearly understood. This method has a special advantage in that the essential continuity of literary development is emphasized.

Although this plan has been in use a comparatively short while, yet it has been successfully applied to several types of literature.[2] It has not been limited to the larger and more important forms, such as the drama, epic, and novel, but has been used in the treatment of many minor types, as the ballad, lyric, and short story. But one type which has failed to receive such comprehensive treatment is the dramatic monologue. The neglect of this form is due partly to its recent

1. A paper presented to the Faculty of the University of North Carolina as a partial requirement for the degree of Master of Arts.

2. Besides many independent treatments by individuals, "libraries" are being published in which each volume is devoted to one type and written by an acknowledged specialist. Some of the most important of these are "The Types of English Literature," edited by W. A. Neilson, and "The Wampum Library of English Literature," edited by Brander Matthews.

development and partly to a lack of a proper appreciation of its significance.

So far only one book³ and a few articles have been written on this type, but none has done more than explain the use of its developed form.⁴ Its origin and development still remain obscure. It is my purpose here to give some suggestions which will throw light upon these phases and to present what I consider to be the contributions of the more important writers of this form. And finally, I wish to show how these separate contributions or elements were combined into a distinct form of poetry.

3. S. S. Curry, *Browning and the Dramatic Monologue*.
4. Dr. Curry devotes one chapter to the history of the monologue to show that it "was no sudden invention of Browning's." Suggestive as it is, it makes no attempt to trace the stages of development.

A Conception of the Dramatic Monologue

In order to have, as a basis of treatment, a clear conception of this type, Browning's *The Patriot* is given below as a *typical* dramatic monologue. Like all monologues, this poem consists of three constitutent parts: the occasion, the speaker, and the hearer.

The first, the occasion, can be best understood by considering the purpose of the poem. Browning's plan was to present in the most impressive way the fickleness of popular opinion. To do this, he selected a patriot who had been borne upon the crest of popular applause, but who has fallen into the trough of public condemnation. The time most suited to the expression of this contrast is that when the patriot is going to his execution. While suffering the greatest tortue from unjust punishments, he recalls the incident one year ago,— when he was a worshiped hero. This state of lowest humiliation and degredation is given the boldest relief by being presented against the background of his memory of the most glorious moment he had ever experienced. Consequently, this occasion is the most suitable one for presenting the popular fickleness which had produced such a sudden and distressing change.

The second element of this dramatic monologue is the speaker. He was a patriot of the highest type. All his energies were devoted to the service of his people. He had left nothing undone that tended to their welfare. Although persecuted by his country, he remained true to his resolutions and ideals, and now "'Tis God shall repay". Thus the character of the speaker is clearly, though indirectly shown by his own words.

The third constitutional part, the audience, is of minor importance in this monologue. From the content of the

poem it appears that the hearers are doubtless the sheriff and the officers accompanying him to the execution. Although in the background, they are essential parts of the monologue. The patriot does not speak to them directly, since he is not the subject of individual caprice, but the victim of popular fickleness.

The three constitutent parts are thus combined to produce the following monologue, which is quoted here, not because it is the best dramatic monologue, but because it is typical and is so short that it may be quoted entire.

THE PATRIOT[5]
AN OLD STORY

It was roses, roses, all the way,
 With myrtle mixed in my path like mad:
The house roofs seemed to heave and sway,
 The church spires flamed, such flags they had,
A year ago on this very day.

The air broke into a mist with bells,
 The old walls rocked with the crowd and cries.
Had I said, "Good folk, mere noise repels—
 But give me your sun from yonder skies"
They had answered, "And afterward, what else?"

Alack, it was I who leaped at the sun
 To give it my loving friends to keep!
Naught man could do, have I left undone:
 And you see my harvest, what I reap
This very day, now a year is run.

There's nobody on the house-tops now—
 Just a palsied few at the windows set;
For the best of the sight is, all allow,
 At the Shambles' gate—or, better yet,
By the very scaffold's foot I trow.

5. Cambridge edition of Browning, p. 251. This edition is referred to throughout this paper

I go in the rain, and, more than needs,
 A rope cuts both my wrists behind;
And I think, by the feel, my forehead bleeds,
 For they fling, whoever has a mind,
Stones at me for my year's misdeeds.

Thus I entered, and thus I go!
 In triumphs, people have dropped down dead.
"Paid by the world, what dost thou owe
 Me?"—God might question; now instead,
'Tis God shall repay: I am safer so.

This poem is an example of a new and distinct type of poetry. It cannot be placed in either of the three orthodox categories, although it sustains a vital relation to them. It belongs to a separate and well-defined *genre* and deserves recognition as such by students of poetry.

There is perhaps no better method of thoroughly understanding the essential nature of this type than by comparing it to other well known forms of poetry. The monologue differs more widely from the epic than from any other type. It is not only a contrast to the epic as to length,—the epic being a prolonged narration of events, the dramatic monologue a short presentation of one occasion,—but it is, in addition to this, its very antithesis in spirit. The epic is an expression of a national consciousness at a crisis in its history as embodied in one individual, the hero of the race. Here the emphasis is not placed upon the individuality of the hero, but upon the national or universal significance of his experiences.[6] In contrast to this, the dramatic monologue is the most democratic form of poetry in existence. It is stictly individual. As Browning has done in the case of *The Patriot*, a poet may portray any characteristic of a state or individual, or he may even express his own opinions by selecting an appropriate character as a spokesman of his views. He is thus neither

6. See C. F. Johnson, *Forms of English Poetry*, p. 328 f.; also S. S. Curry, *Browning and the Dramatic Monologue*, p. 102 f.

interrupted by another person, nor limited by the conventionalities that he would meet in other types of poetry.

The dramatic monologue is much more closely related to
the lyric than to the epic.[7] They resemble each other in that
they are, for the most part, short emotional poems. Both are
organic units, every part of each contributing to a unified
impression. They are alike also in being personal expressions
of an individual. Naturally, however, the lyric is the more
subjective, since it is always the outcome of the emotions.
On the other hand, the dramatic monologue is often the
product of intense emotions, as, for example, in *Tennyson's
Clara Vere de Vere*, but not always so, for it may consist
altogether of expressions of the intellect, as Browning's *My
Last Duchess*. Another contrast is that in the lyric the poet
gives direct expression to his feelings and thoughts, while in
the dramatic monologue he expresses himself indirectly. In
the case of the latter he puts his ideas into the mouth of a
distinct individual who speaks on a significant occasion to a
definite audience. Consequently, the thoughts of the speaker
often bear the impress of the hearer, a characteristic altogether lacking in the lyric, where the thoughts proceed
directly from the isolated individual. This subtle result of
the contact of minds is not so marked in the lyric. So the
main difference between the lyric and the dramatic monologue
is that the former does not contain one of the essentials of
the latter,—a distinct and determining audience.

The close relation of the dramatic monologue to the drama
is denoted by the word *dramatic*. The word *monologue* denotes
one speaking, but the term *dramatic* prefixed to it indicates
one speaking in a dramatic situation. The dramatic elements
are seen in its portrayal of individuals on such occasions, or
rather by having them reveal their own motives and characters at a flash. The monologue differs from the drama,

7. For a discussion of the nature of the lyric, see Gummere, *The Beginnings of Poetry*, p. 420 f.; Johnson, *Forms of English Poetry*, p. 229 f.;
Curry, *Browning and the Dramatic Monologue*, p. 14 f.

however, not only in form, but also in treatment of materials. The drama requires a plot, divided into acts and scenes, which presents an action or a series of closely related actions as the outcome of the volitions of a group of individuals.[8] Through successive stages the rising action reaches a climax. Toward this, all preceding actions tend, and from it all subsequent actions flow, passing again into eqilibrium. The dramatic monologue, on the other hand, has no plot. The highest form of it dispenses with all preliminary action leading up to the climax and all falling action resulting from it. This new dramatic form catches up an individual at a critical moment, which corresponds to the climax of the drama, and reveals his character by a flashlight. There is no need for stage devices. The attitude or the state of the speaker's mind, whether in a struggle or in a mood of complacency, is laid bare without the assistance of complex movements of human beings. It is not, however, to displace the drama, but to supplement it. The dramatic monologue possesses its own distinctive dramatic elements and portrays them according to its individual method.

The monologue is not only related to the drama as a unit, but resembles also some minor forms used in the drama. It is similar to the dialogue form in that its style is that of a conversation, not that of a platform orator. But it differs from the dialogue in having only one speaker. The impression of abruptness which a dramatic monologue often produces on the reader is that received by a person who suddenly overhears a conversation in an adjoining room which has been monopolized by one person. Nothing can be learned except through the words of the speaker. Thus the dramatic monologue may be considered a monopolized conversation.

Another form used in the drama which is closely related to the dramatic monologue is the soliloquy. In both there is

8. Elizabeth Woodbridge, *The Drama, Its Law and Technique*, Introduction and p. 76 f.

only one speaker. The speaker in the soliloquy is merely
thinking aloud. His thoughts proceed freely and unmodified
from his own individuality. In contrast to this, the speaker
in the dramatic monologue is influenced more or less by the
personality of the hearer. The soliloquy, then, differs from
the monologue in that it does not imply an audience.

ORIGIN OF THE DRAMATIC MONOLOGUE AND ITS DEVELOPMENT IN THE ELIZABETHAN AGE

Ever since De Vries proposed the mutation theory as an explanation of the origin of species, our faith in accounting for the origin of all species as a result of a slow and a continual process of evolution has received a fatal shock. And this is especially true in the field of literature since Professor Manly has applied De Vries's theory to the origin of the drama.[9] We no longer consider it necessary that a type of literature must have existed ages and slowly unfolded its different possibilities one by one until it finally reached perfection, but, on the contrary, we assign more importance to exceptional circumstances and powerful individuals. Types of literature may suddenly come into existence and develop by leaps. Still no type has been perfect at its birth; all have grown with varied rapidity.

In the case of the dramatic monologue DeVries's theory is particularly applicable. Although in its period of growth its elements were differentiated somewhat sporadically and independently, yet the term "process of development" is legitimate when used with certain limitations and it is certainly indicative of the nature of its growth. This process of development extended over several centuries. During the time in which the dramatic monologue was progressing toward perfection, it drew much of its material from other types and received many contributions from different individuals.

It is not only my purpose to show that this process of development took place, but also to preface this with an

9. "Literary Forms and the New Theory of the Origin of Species", *Modern Philology*, IV. p. 577.

account of its origin. Of course, an exhaustive treatment of the origin of this form would require an explanation of the origin of poetry itself. I shall not attempt to account for the origin of the different elements themselves, but to give the sources of these elements as they had been developed in other forms of poetry and to show how they were selected and combined into a new and distinct type by a natural process of development.

All types of literature have had their origin in the natural instinct of man to give expression in language to his thoughts and emotions.[*] As experiences received their embodiment, they slowly and unconsciously crystalized into definite forms, varying according to their special fitness for conveying the spiritual content.[*] Thus the extended narration of events of national significance assumed the form termed epic. The expression of the poet's personal emotions naturally confined itself to the short lyric. So with all types of literature. They all arose to supply a demand for a certain form of expression.

As these types have developed they have passed through two stages.[*] The first was that of spontaneous expression in which the writer was completely absorbed in giving vent to his impulse. He was so lost in his material that he paid little or no attention to form. He was possessed with the impulse to write; his interest was in what he said, not in

10. Johnson, *Elements of Literary Criticism*, p. 2 f.

11. For the differentiation of the lyric, drama, and epic, see Gummere, *The Beginnings of Poetry*, p. 400 f.

12. See Gummere's chapter on "*The Two Elements of Poetry*, ibid. p. 116 f. Although his divisions of "communal" and "artistic" are more comprehensive than those indicated by conscious and unconscious art, yet they are based upon the same principle of development, namely, that "art,—thought and purpose, that is,—slowly took place of spontaneity" (p. 119). See also, Guyau, *L'Art au Point de Vue Sociologique*, p. 26. This is in harmony with Prof. Hoffding's position as to "the degree of express consciousness with which the imagination works", *Outlines of Psychology*, trans. by Mary E. Lowndes, V. B. 12 a. The first two forms correspond to the unconscious art of construction.

how he said it. His expression flowed freely, and only in so far as he was guided by his natural instinct for form did his productions fulfil the laws of structure. This was the period of unconscious art.

By constant use of the forms which he assumed instinctively, the writer becomes conscious of his vehicle of expression and its influence upon his content. Consequently, his attention is more and more directed to the structure of his composition. He develops a technique which is best adapted to the conveyance of his meaning and which is most capable of producing the desired artistic impression. He has learned the laws of construction and has entered upon a period of conscious art.

The short story, especially, illustrates these stages of development.[13] From the earliest times in which peasants and travelers beguiled the time away by telling tales until 1835, the short story was groping toward its destined form. When it passed into the hands of Poe, he immediately recognized its possibilities and constructed its technique, so that now no one attempts to write a good short story without conforming to its constitution as written by Poe.[14] He developed it into a conscious art with definite laws of construction.[15]

The development of the dramatic monologue may be divided into these two stages of unconscious and conscious construction. The first period of this development extends from its origin to its use by Browning; the second from its use by Browning to the present time.

A study of the first period of the dramatic monologue shows that it was not the invention of Browning,—not a mechani-

13. See S. C. Baldwin, *American Short Stories*, p. 2.

14. Poe's principle of "totality of effect" was first expressed in a review of Hawthorne, *Graham's Magazine*, May, 1842; Stedman and Woodberry's edition of Poe, vol. VII, p. 30.

15. See Brander Matthews, *The Short Story: Specimens Illustrating Its Development*, p. 25

cal device originated by a single individual,—but that it was a result of a process of development as natural, though not so clearly marked, as that of the drama. It arose in response to a need for a new form of literary expression which would reveal more directly and forcibly the new phases of modern culture and experience.

The most essential characteristic of the dramatic monologue is the attitude of mind of the speaker. He not only expresses his own ideas, but inevitably permits his thoughts to be colored by the personality of the hearer. Doubtless the earliest form of literature in which this dramatic monologue attitude of mind appears is the letter. Besides keeping his reader in mind while expressing his thonghts, the writer will unconsciously let his composition and style be modified by his relations and bear the imprint of the personality of his correspondent.

When this attitude was first carried into poetry, if, indeed, it did not exist there first, it received its earliest expression in the lyric. Consequently to speak in terms of poetry, it is not likely that the germs of the dramatic monologue manifest themselves earliest in the lyric. Moreover, as was pointed out above,[16] the lyric and the dramatic monologue are very closely related in that they are, for the most part, intense realizations of special occasions, implying deep emotions. In the lyric the emotion is of primary consideration, and this is wherein it differs from the monologue, for in it the emotion is of secondary importance. But the most significant consideration is that the emotional element or feeling was the motive force which made the transition from the lyric to the dramatic monologue.

In the pure lyric, which has no dramatic tendencies, the poet expresses his emotions without reference to others. The first step in the transition from this to the dramatic monologue is made when the emotions are directed toward an individual. When this is done, the poem is concerned with

16. See page 38.

two persons and their relations. As was natural, this transition was made in the love lyric. This is the form in which
the first tendencies toward the dramatic monologue are found.
It is here that the emotions become intense and personal.
The feelings of the lover are directed toward one individual,
and, in intensely realizing his intimate relations to his loved
one, it was perfectly natural that he should employ the most
direct and forcible form of expression, that is the form in
which time and space are eliminated, and in which he can
conceive himself in the presence of and speaking to his loved
one. The emotions and the imaginations have demanded an
external object for their vivid realization. As a result of
this tendency, the object is visualized and spoken to directly.

One of the earliest examples of the love lyric in English in
which this characteristic is discernible is Chaucer's *To Rosemounde.*[7] This poem implies two distinct individuals.

> Madame, ye ben of al beaute shryne
> As fer as cercled is the mappermounde;
> For as the crystal glorious ye shyne,
> And lyke ruby ben your chekes rounde.

The speaker is the lover and the hearer is the lover's lady
whom he is praising. In the first two parts of *Merciles
Beaute,*[8] Chaucer uses the same form. Both of these poems
represent a speaker and a hearer, or at any rate a correspondent. The relations of these two are clearly portrayed and
we may form a fairly clear impression of them. But this
rudimentary form is the only element of the dramatic monologue, for its spirit is essentially that of the lyric.

This embryonic form, which is to be gradually developed
until it becomes the framework of a new type of poetry, is
extensively used during the reigns of Henry VII and Queen
Elizabeth. This was the period in which the love lyric
reached its climax. The greater part of the works of the

17. Skeat, *The Works of Geoffrey Chaucer*, I. p. 389.
18. Ibid., p. 387

minor poets of this age consisted of lyrics and sonnets of lovers and their experiences. A few of these may be considered as illustrations of the embryonic form of the dramatic monologue.

Sir Thomas Wyatt's sonnet[19] beginning—

> Disdaine me not without desert:
> Nor leaue me not so sodenly:
> Sins well ye wot, that in my hert
> I meane ye not but honestly,

portrays a lover praying to his mistress to be just and true to him. The speaker and hearer are distinct persons. This, however, is its only dramatic element. The lyrical expression might be put into the mouth of any lover. It is not even concerned with character portrayal. Its form is the only element of the dramatic monologue.

This form is even more distinctly marked in a lyric written by Marlowe and in another which is a reply to Marlowe's. In the former, *The Passionate Shecpeard to his Love*,[20] a shepherd makes an ardent plea to a maiden:—

> Come liue with mee, and be my loue
> And we will all the pleasures pruue,
> That Vallies, groues, hills and fieldes,
> Woods, or steepie mountaine yeeldes.

In *The Nimphs Reply to the Sheepeard*,[21] attributed to Sir Walter Raleigh, the maid answers the shepherd—

> If all the world and loue were young,
> And truth in euery sheepheards tongue,
> These pretty pleasures might me moue,
> To live with thee, and be thy loue.

In both these poems, the individuals stand out distinctly.

19. Tottel's *Miscellany: Songes and Sonnetts*, Edited by Edward Arber, p. 58.

20. Francis Cunningham, *The Works of Christopher Marlowe*, p. 272.

21. Ibid., p. 272.

Each in turn assumes the role of speaker and, by this means, the characters of both are clearly portrayed. Although the lyrical qualities are predominant, the dramatic monologue form gives objective realization to the loved one in each case and thus lends increased intensity to subjective states.

In George Turberville's *A Poor Plowman to a Gentleman*, interest in character becomes more manifest. The plowman meets his landlord and tells him of the perfect condition of his farm and requests the "pleasure" of tending it again.

Besides having the dramatic monologue form, this poem makes an advance towards the real dramatic spirit. The plowman is characterized not only as a type, but also as a distinct individual. He unconsciously reveals himself by his own words.

A much nearer approach to the spirit of the dramatic monologue is made in Suckling's *A Barber*. Here characterization becomes predominant. The barber, while waiting on his customer, contrives to—

> So fall to praising his lordship's hair,
> Ne'er so deformed, I swear 'tis sans compare,

The speaker is vividly portrayed. His character is of principal interest. But this poem lacks one essential element of the dramatic monologue, a distinct hearer. However, it marks an unconscious and decisive advance in character portrayal.

One of the first examples in which the three constituent parts of the dramatic monologue are combined is the following sonnet of Michael Drayton:[22]

> Since there's no help, come let us kiss and part;—
> Nay, I have done, you get no more of me;
> And I am glad, yea, glad with all my heart,
> That thus so cleanly I myself can free;
> Shake hands forever, cancel, all our vows,
> And when we meet at any time again,

22. Quoted from F. I. Carpenter's *English Lyric Poetry*, p. 98.

Be it not seen in either of our brows
That we one jot of former love retain.
Now at the last gasp of Love's latest breath,
When, his pulse fallen, Passion speechless lies,
When Faith is kneeling by his bed of death,
And Innocence is closing up his eyes,—
Now, if thou would'st, when all have given him over,
From death to life thou might'st him yet recover.

Although this sonnet, on basis of chronology, should be placed before the example just quoted from Suckling, yet on basis of development it comes later. This fact within itself strengthens the applicability of DeVries's theory as to the development of the dramatic monologue. *A Poor Plowman* was first referred to to make complete the examples illustrating the independent development of each of the three constituent parts of the monologue.

In Drayton's sonnet, we not only find the addition of the third part,—the occasion, but the poem employs all the embryonic elements which are later developed into the dramatic monologue. The occasion or situation is one of dramatic intensity. At the parting of the lovers for the last time, the emotions cannot be inhibited, but well up and receive their most forcible expression in the form of the monologue. The speaker and hearer are distinct individuals, manifesting peculiar characteristics which are a part of their personalities. This is one of the first poems in which the three elements of the monologue are so skilfully combined.

Although it was the express purpose of this paper to give the beginnings and development of the dramatic monologue in English, yet the treatment of this form in the Elizabethan age would in no sense be adequate without giving some attention to foreign influences.

Evidently, the most popular form of literature in the Elizabethan age was the sonnet.[23] Through the influence of

23. See Sidney Lee, *A Life of William Shakespeare.* Section IX of the Appendix

Wyatt and Surrey, whose experiments were first published in 15L7 in Tottel's *Miscellany*, the sonnet was brought directly from Italy and introduced into England. Not only was the form transplanted, but its spirit[24] also was retained. The sonnet was the principal vehicle for the expression of the enlightened thoughts and emotions of the renaissance. "Thus the world of Italian sentiment comes before us in a series of pictures, clear, concise, and most effective in their brevity."[25]

Although the Italian was the ultimate source of the form and spirit of the sonnet, yet it was not the most influential of foreign literatures. Sidney Lee says,[26] "It was contemporary French, rather than older Italian, influence which first stirred in the Elizabethan mind a fruitful interest in the genuine sonnet." Since many of these sonnets were love sonnets, they correspond to the love lyrics in the development of the monologue. In the face of these facts, there is no doubt that French poetry exercised considerable influence over the dramatic monologue in its process of development.

At any rate, forms are found in the French poetry of the sixteenth century which possess all the undeveloped elements of the dramatic monologue. One example may be taken as an illustration. This poem, which fulfils the requirements of the dramatic monologue form and which is even a nearer approach to the real spirit of the monologue than any examples in English of the same period, is Charles Fontaine's *To His Son*.[27] The first stanza is quoted here to show its dramatic qualities.

24. For a discussion of the spirit of the Italian Sonnet, see Burckhardt, *The Renaissance in Italy*, p. 310 f.

25. Ibid., p. 311.

26. *The Cambridge History of English Literature*, ed. by A. W. Ward and A. R. Waller. III. 284. See ibid. ch. XII. for the French influence on the Elizabethan sonnet; also Lee's *A Life of William Shakespeare*, Section X. of the Appendix.

27. Given in H. Carrington's *Anthology of French Poetry*, p. 114.

My little son, who yet dost nothing know,
　This thy first day of life I celebrate.
Come, see the world which floods of wealth o'erflow,
　Honors, and goods of value, rare and great;
　　Come, see long-wished-for peace on France await;
Come, Francis, see your king and mine renowned,
　Who keeps our France in safe and noble state;
Come, see the world where all good things abound.

This poem contains all the essential characteristics of the dramatic monologue in an undeveloped form. But it is only one of the many productions in French which greatly influenced the English poetry of the Elizabethan era. Consequently, the dramatic monologue is indebted to French influence for giving it an additional impetus in its development.[28]

From this period in which the dramatic monologue has received its final, though undeveloped, form, we may pass to the following period and trace the monologue's fortune until it emerges completely developed in the Victorian age.

28. A more extensive consideration of the French and Italian influence in the development of the dramatic monologue is reserved for future treatment.

IV

The Dramatic Monologue from the Elizabethan to the Victorian Age.

The contribution of the Elizabethan age to the dramatic monologue was the independent development of the essential elements, and, finally, the combining of these into single productions which were the basis of future development. The characteristic mood of the Elizabethan lyric[28] which assumed the form of the dramatic monologue was one of enthusiasm, spontaneity, and elasticity. Expression was not confined to states of reflection and meditation, but, on the contrary, emotions were expressed with reference to persons and objects other than those of the writer. Interest was objective as well as subjective. Feelings were so spontaneous and altruistic that they naturally demanded outward direction. The individuals toward whom these emotions were directed were brought into close contact with the writer. No longer were the objects of these feelings considered apart from the production, but they were visualized, if not present and spoken to directly.

But in the century following, the attitude of the people and of the poets who expressed this attitude, was fundamentally changed.[29] After the intense enthusiasm, spontaneity, and activity of the Elizabethan period, a reaction set in. Dr. Carpenter, referring to this movement, says,[30] "The carnival of the Renaissance, the joyous bravado of the new awakening in England, was soon over. The Puritan undercurrent in the national character begins again to make itself felt. Life drunk

28. See F. I. Carpenter, *English Lyric Poetry (1500-1700)*, p. xliv. f.
29. See Barrett Wendell, *The Temper of the Seventeenth Century in English Literature*, p. 154 f.; also F. I. Carpenter, *English Lyric Poetry*, p. xlv. f.
30. *English Lyric Poetry*, p. xlviii.

to the lees casts us back into remorse and revulsion of feeling.
The lyric poetry of the new period reflects the entire process,
just as the drama does." The poetry no longer retains its
Elizabethan freshness and energy, but becomes intensely sub-
jective and deeply self-conscious. Consequently, the lighter
lyrics are superseded by the weightier ones, such as the ode
and the elegy.

This was the natural outcome of the current of English
history during this period. But this pendulum movement
was reinforced by foreign influence.[31] While the Elizabeth-
ans were stirred by French and Italian writers, the poets of
the seventeenth century were greatly influenced by Latin au-
thors. Especially was this the case with Jonson and his fol-
lowers. But the spirit of classicism is the very antithesis of
the spirit of the dramatic monologue. Classicism demands
conformity and restraint, while the monologue demands elas-
ticity and freedom. In so far as the classicists paid strict at-
tention to form, they might have developed the form of the
monologue, but since their attitude was not in harmony with
the spirit of the monologue, they never employed it.

With these facts before us, we may readily see that it is
unreasonable to expect to find much, if any, development of
the dramatic monologue in the century and a half following
the Elizabethan age.

Although the dramatic monologue received no marked de-
velopment during this period, still it was occasionally used.
Jonson's *Song To Celia*,[32] beginning—

> Drink to me only with thine eyes,
> And I will pledge with mine;
> Or leave a kiss but in the cup,
> And I'll not look for wine,

is characteristic of the poems of this age which assumed the
form of the monologue. Its sentiment is similar to that ex-

31. Ibid., p, 1. f.
32. Carpenter. *English Lyric Poetry*, p. 122.

pressed by Drayton in "Come, let us kiss and part", but the latter is a nearer approach to the dramatic monologue, since it has a dramatic occasion. Moreover, the latter demands a hearer, while Celia, in Jonson's lyric, may be a mere correspondent and not in the presence of the lover.

Another example which presupposes two distinct individuals, and which is similar to the preceding lyric, is Thomas Campion's *To Lesbia*.[33] The words are spoken by the lover to his beloved:

> My sweetest Lesbia, let us live and love,
>> And though the sager sort our deeds reprove
> Let us not weigh them.

Robert Herrick's *To Dianeme*[34] also belongs to this class. It is so short that it may be quoted entire:

> Sweet, be not proud of those two eyes,
> Which star-like sparkle in their skies;
> Nor be you proud that you can see
> All hearts your captives, yours yet free;
> Be you not proud of that rich hair,
> Which wantons with the love-sick air;
> Whenas that ruby which you wear,
> Sunk from the tip of your soft ear,
> Will last to be a precious stone,
> When all your world of beauty's gone.

Many other lyrics similar to these might be considered, but they all belong to the same class. These poems are typical and are illustrations of the stage of development of the dramatic monologue during this period. They make no advance over the Elizabethan love lyrics. They belong to the first stage of the development of the monologue,—the stage in which the altruistic emotions become so intense that the object of these emotions is no longer considered absent, but is visualized and spoken to directly.

33. Carpenter, *English Lyric Poetry*, p. 196.
34. Ibid., p. 212.

But directing our attention a little beyond the strict bounds
of English literature, we find a simple but vigorous poet who
used the dramatic monologue form and really made a contri-
bution to it. This writer was not limited by the require-
ments of classicism, but expressed his thoughts and emotions
freely and naturally. The style of this Scottish poet was so
elastic that he could assume the attitude of another person-
ality and express the ideas and feelings which were in per-
fect harmony with the character represented. Consequently,
in this most sterile period of poetry in the history of English
literature, it is refreshing to turn to the cherished poetry of
Robert Burns.[35]

None of his poems is a better illustration of his use of the
dramatic monologue form than *John Anderson My Jo.*[36]

> John Anderson my jo, John,
> When we were first acquent,
> Your locks were like the raven,
> Your bonnie brow was brent;
> But now your brow is beld, John,
> Your locks are like the snaw;
> But blessings on your frosty pow,
> John Anderson, my jo.
> John Anderson my jo, John,
> We clamb the hill thegither,
> And mony a cantie day, John, ·
> We've had wi' ane anither:
> Now we maun totter down, John,
> But hand in hand we'll go,
> And sleep thegither at the foot,
> John Anderson, my jo.

Here we find the sincere expression of conjugal love assum-
ing the monologue form. The center of interest is character
portrayal. And the characters are more than types. Espe-

35. See Edmund Gosse, *A History of Eighteenth Century Literature*, p. 310.
36. *Burn's Complete Poems*, Globe ed., p. 201.

cially is this true of the speaker. The love of this old Scottish house-wife is not that of any lover, but that of the aged woman devoted to her husband. The hearer here is not merely visualized, but is actually present. The dramatic style of Burns clearly portrays this intimate relation. Although the lyric element is predominant, the poem still makes a near approach to the true dramatic monologue. It might be properly termed a lyrical monologue.

Another poem of Burns, in which the hearer is not only present but is evidently acting, is *My Bonnie Mary.*" The two common elements of speaker and hearer are present in this poem, but in addition to this there is an occasion of some significance. Just as the speaker is ready to sail to a foreign land to take part in a war, he speaks to his lady:

> Go fetch to me a pint o' wine,
> And fill it in a silver tassie;
> That I may drink, before I go,
> A service to my bonny lassie.

In this poem, as in the preceding one, we may see the transition from the first to the second stage of the period of unconscious art. Of course, these two stages of development are based upon the speaker's attitude to the hearer. In the first the speaker merely visualizes his hearer,—or better, his correspondent,—but in the second the hearer is present and becomes a determining factor of the monologue.

Thus this valuable transition was not made by one connected with the national literary movement of England, but by one who was free from the current of classical influence, which was so powerful in England at this time.

Other poems in which Burns uses the dramatic monologue form are: *Whistle and I'll come to you, my Lad; Turn again, thou Fair Eliza; Come let me take Thee to my Breast*; and *Ane Fond Kiss.* Even *To Mary in Heaven* has the characteristic monologue attitude in that the speaker is addressing the departed spirit of his loved one.

37. *Burns's Poems*, London, n. d., p 211.

In the early part of the nineteenth century, before the opening of the Victorian era, we find a few examples of the dramatic monologue. The literature of this period is the outcome of a revolt against the standards of the immediately preceding age.* The new writers were freeing themselves from the classical influences and were finding a new field for their thoughts and imaginations. The productions are marked by a love of nature and a spirit of democracy.

Although this was the period that witnessed the beginnings of a new age, which was characterized by a new sympathy for nature and man and also by a new feeling of democracy, yet the time was not ripe for the highest development of these characteristics. The poetry of Wordsworth and Coleridge not only embodied these qualities, but directed them to a considerable extent. Granting that these poets were in thorough sympathy with the spirit of the age that greatly influenced or rather accelerated the development of the monologue, still this is far from saying that they themselves contributed to the monologue's development. Their method was opposed to that of the monologue, for they not only expressed their own emotions, but expressed them *as* their own. They gave forth their thoughts and emotions directly and simply. They lacked the elasticity of style that was required to assume the personality of another individual and express his characteristic feelings in his characteristic way. Consequently, although the time was becoming ripe, yet the poet had not appeared who was fitted for the work of perfecting the monologue.

Yet in this period of preparation for the final development of the dramatic monologue, there was one poet who employed this form. The movement and freedom of his verse and the vigor of his expression enabled Byron to use the dramatic monologue effectively.

38. See Gosse, *Modern English Literature*, p. 334.

The forcefulness of *Jephtha's Daughter* is certainly due to the monologue form. In this poem Byron employs the three constituent parts of the monologue. The occasion is a very dramatic one. The scene opens with the daughter upon the sacrificial altar. It is at the moment when the strong warrior hesitates before fulfilling his vow by sacrificing his daughter. She speaks words of consolation:

> Since our Country, our God—Oh, my Sire!
> Demand that thy Daughter expire;
> Since thy triumph was bought by the vow—
> Strike the bosom that's bared for thee now!

Her character is nobly expressed in these words while she attempts to console her father. Instead of lamenting her fate, she assuages his grief by saying,—

> I have won the great battle for thee.

The climax of her character revelation is reached in her closing words:

> Let my memory still be thy pride,
> And forget not I smiled as I died.

Another poem in which Byron uses all the essential elements of the dramatic monologue is the *Maid of Athens.* The occasion is the parting of the lovers.

> Maid of Athens, ere we part,
> Give, oh give me back my heart!

The first verses of the last stanza indicate directly that the hearer is considered present:

> Maid of Athens! I am gone:
> Think of me, sweet! when alone.

Other poems which illustrate Byron's different uses of the dramatic monologue are *When We Two Parted, Love and*

39. *The Works of Lord Byron*, ed. E. H. Coleridge, III. p. 387.
40. Ibid., III. p. 15.

Gold, and *On Parting*. In most of these poems Byron em-
ploys all of the three dramatic elements, but, in addition to
this, he makes the poems much more effective by using a dra-
matic style. In some cases he approaches the true dramatic
spirit. But Byron contributes no new element; he merely
combines harmoniously and forcibly the essential parts which
were often used before his time. Byron's use of this form
was not so much a result of a conscious device as it was a sat-
isfaction of an instinctive feeling for a more forcible type of
expression.

The foregoing treatment shows that the dramatic mono-
logue before the reign of Victoria was the result of an uncon-
scious art of construction. In this period of unconscious art,
it passed through two stages. In the first we found the be-
ginnings of the monologue in the most subjective type of
poetry, the lyric. But when the altruistic emotions of the lyric
poet became very intense and their objective tendency was
satisfied by imagining the object of these emotions to be pres-
ent, then we found the completion of the first stage of devel-
opment,—that in which the hearer is merely a visualized per-
son, but spoken to directly. Examples of this stage are
found in the Elizabethan love lyrics, as, for instance, Mar-
lowe's *The Passionate Sheepheard to his Love*. The second
stage[41] of the unconscious period is that in which the object is
not merely visualized, but is actually present, and becomes a
determining factor in the monologue. An example of this
stage of development is Byron's *Jephtha's Daughter*.[42] In ad-
dition to these two stages, there was a minor contribution
which received little attention before Browning. This was
the dramatic occasion, as illustrated in *Jephtha's Daughter*.
Thus the three elements of the dramatic monologue were de-
veloped independently and somewhat sporadically during the
fifteenth, sixteenth, and seventeenth centuries. In the eigh-

41. See p. 46.
42. See p. 57.

teenth century they were combined into single productions which constituted the final form of the monologue. This form, although crude and undeveloped, was the basis of its development during the Victorian age.

V

The Final Development of the Dramatic Monologue in the Victorian Age.

It was in the Victorian age that the dramatic monologue received the development which entitles it to the rank of a new type of poetry. This development was not, however, entirely due to the work of the poets who employed it, but, like all natural forms of literature, it was fundamentally influenced by the age in which it was written. Since the literature of this age was the expression of the life of the people, some attention must be given to forces which were of consequence in the development of the monologue, the characteristic form of this age.

Of the various characteristics of the Victorian age, there are four essential ones[42] which rendered the period especially congenial to the perfection of the dramatic monologue: (1) the central and "dominant influence of sociology", (2) "the preponderance of the subjective over the objective" in poetry, (3) restless rapidity and diversity of life, (4) the passion for democracy. All these characteristics were combined to make the Victorian age the most suited period for the final development of the monologue.

The interest in sociology gave a new impetus to the study of character portrayal and character development. This was reinforced by the subjective element in poetry. Subjective is used here in the sense that it pertains to the spiritual or psychical life, and does not have the meaning of being self-reflective and self-meditative. That writers' minds were occupied with attempts to discover and portray the sources and motives of human conduct is attested by the psychological novels of this

42. See Frederic Harrison's discussion of "The Characteristics of Victorian Literature", *Early Victorian Literature,* ch. I.

age. Moreover, the intense activity of the age demanded the most direct and effective method of portraying character. In connection with this, Mr. Arnold Smith says,[43] "One of the results of the complexity of life in the nineteenth century was a self-consciousness which, leading to minute introspection, produced a passion for mental analysis: the character of the individual became a subject of enthralling interest." As was pointed out above,[44] the dramatic monologue was especially adapted to the fourth characteristic,—the passion for democracy, since it is the most democratic form of poetry.

Consequently, to supply these demands, the dramatic monologue arose, with its ability to throw a flash-light upon the most intricate springs and motives of action and give a complete portrayal of a character without recourse to external means. From the characteristics which rendered this age especially congenial to the development of the monologue, we may pass to the consideration of the individual poets who directed this development.

As Stopford Brooke[45] remarks, there were two poets in the Victorian age who towered above all others. These two poets, Tennyson and Browning, were the writers of this age who emplyed the dramatic monologue extensively and made the final contribution to it. Of these two, Tennyson was the first to make use of the dramatic monologue. To anticipate conclusions, in many of his monologues Tennyson makes a distinct advance, especially in dramatic spirit, over the poets who preceded him. But, as is shown in the following treatment, he did not realize its full powers, and consequently he did not raise it to perfection. He was, however, the connecting link between what I have termed the unconscious and conscious art of constructing the dramatic monologue.

43. *The Main Tendencies of Victorian Poetry*, p. 3.
44. Page 37.
45. *The Poetry of Robert Browning*, p. 1.

The following poems of Tennyson are selected as
illustrations of his different uses of the monologue
and for the purpose of showing that even in his best mono-
logues he failed to utilize the high possibilities of this form.
One of his earliest monologues is *The Miller's Daughter.* The
old man, in a calm and retrospective mood, reviews, in the
presence of his aged wife who is the miller's daughter, his
life's experiences. The characters are clear and distinct.
They are of the type of devoted husband and wife whose
fortunes have always been happy and prosperous. No great
struggles or griefs have marred their calm and even flow of
life. Such a condition of life is presented in this poem.

The elements of this dramatic monologue are the speaker
and the hearer just described. But when these are named
the dramatic qualities are practically exhausted. The spirit
of the poem is in no sense dramatic. It is essentially that of
a reflective lyric. In its beauty, simplicity, and rythmic
movement, it is far superior to any preceding dramatic mono-
logue. The characters are much more clearly conceived and
elaborately portrayed than any so far discussed. But the
poem is lacking in one of the most important elements, the
dramatic occasion. The review of life is not expressed at
some critical moment, as in Browning's *Fra Lippo Lippi*, but
it is merely an evening reflection. It lacks the dramatic in-
tensity which can only be produced by a single dramatic occa-
sion.

In his *Northern Cobbler*, Tennyson makes an advance over
The Miller's Daughter in directness and intensity. The poem is
not a review of a whole life, but an explanation of a single
event. As the curtain rises, a naive cobbler is seen with his
brother-in-law, who has just returned from a voyage. The
cobbler is so interested in what he has to say that he requests
him to ''Waait till our Sally comes in, fur thou muna' sights to
tell''. We learn, through the repetition of his words by the
cobbler, that the sailor is ''sa' 'ot'', and that he wants ''sum-
mat to drink''. The cobbler replies, ''I 'a nowt but Adam's

[30]

wine". The sailor seeing a bottle on the mantle asks, "What's i' the bottle stanning theer?." The cobbler answers, "Gin," and proceeds to tell him why it is there. In his simple, unaffected style he tells how he had been a drunkard and had fallen into the depths of poverty and disgrace until he was brought to his senses by his cruel treatment of his wife. He is now reformed, and as to his bottle, "theer 'e stands an' theer 'e shall stan to my dying daay."

Little is learned of the character of the sailor or hearer, but the individuality of the cobbler is skilfully portrayed. He is more than merely a reformed drunkard; he possesses individual traits, for he alone would say of his bottle, "I'll have 'im a-buried wi'mma an' take 'im afoor the Throan." The dramatic force of this monologue is greater than that of *The Northern Farmer*, for here the interest is centered upon character portrayal and not upon a narration of incidents. By no other method could the character of the cobbler be more vividly and forcibly depicted than by the use of the dramatic monologue.

A poem of much greater dramatic intensity still is *Rizpah*. Here Tennyson has concentrated his attention upon one individual and one state of mind. The monologue opens with the wailing of an aged mother for her only son, who had been hanged for robbing the mail. In the midst of her unspeakable woe and grief, she hears "Willy's voice in the wind, 'O mother, come out to me!'" But she cannot while "the full moon stares at the snow", but must wait for the dark stormy nights when she can creep, unseen to the place where his bones were hanging and where, one by one as they fell, they were gathered up by the loving mother and buried in the churchyard.

This poem has all the essential parts of the dramatic monologue. The hearer is a missionary woman who has come to pray and read the Bible to this suffering mother. With all her good intentions, she does not have the least understand-

ing of the situation. We learn of the character of this missionary through the words of the speaker.

The speaker, of course, is the mother. The narration of her son's death and the passionate expression of her grief reveals her character with a clearness and effectivness which has caused her to be designated as the supreme type of suffering motherhood.

The dramatic occasion, though not at its greatest intensity, is one of the most effective of all of Tennyson's dramatic monologues. The main character is caught up at a point of greatest grief, and at this climax she pours forth her soul in her afflictions. Her character stands out in a strong contrast to that of the missionary.

Thus the three elements of the dramatic monologue are used in this poem. Two of them are very effective,—the speaker and the occasion. But the hearer, however, is merely a foil to the speaker.

A poem in which Tennyson gives a more proportional emphasis to the three constituent parts is *Clara Vere de Vere*. The speaker in this monologue is a young but intelligent countryman. He is indignantly rebuking Clara Vere de Vere, a proud coquette from the city, for having charmed and deceived his country friend. This deceit had resulted in the man's committing suicide. Accusing her of his friend's death, the young countryman says,

> But there was that across his throat
> Which you had hardly cared to see.

Then he speaks of the influence upon the young man's mother:

> Indeed, I heard one bitter word
> That scarce is fit for you to hear:
> Her manners had not that repose
> Which stamps the cast of Vere de Vere.

The characters of both speaker and hearer are equally portrayed. The interest of the poem is centered in character. The change of the attitude of the hearer is indicated by the

speaker's breaking away from the conventional method of repeating the formal name of his hearer and assuming a more intimate style of expression. This in itself denotes a lack of dramatic style. The greatest dramatic effect and the nearest approach to a conversational style would not tolerate this lyrical device.

Perhaps these examples will illustrate clearly enough Tennyson's different methods in his use of the dramatic monologue. He was the first to make an extended use of it. Preceding him the elements were developed somewhat sporadically. His contribution was the bringing of these together into single productions and the developing of these into a harmonious and unified production. Stopford Brooke says,[46] that he did not invent this type, but wrought his poems "into forms so especially his own, that they stand apart from work of a similar kind in other poets."

Tennyson's characteristic love of the simple, beautiful, and artistic limited his powers to produce dramatic monologues.[47] His style was not flexible enough to adjust itself to dramatic expression. His one long, six-accented line, continually resolving itself into a rhythmical harmony, was suited to the expression of a gradual rise and fall of lyrical emotions, but not to the rapid turns of thought and feelings demanded in the dramatic monologue. Not only was Tennyson limited in his style, but he was also handicapped by his narrow range of characterization. His characters are not taken from widely different ages and conditions of life, but are types that we meet in everyday life.

One of Tennyson's greatest defects, so far as the dramatic monologue is concerned, was his inability to appreciate the full value of the dramatic occasion. For the dramatic monologue to have the greatest effect, the character must be

46. *Tennyson: His Art and Relation to Modern Life*, p. 431.

47. Cf. E. C. Stedman's discussion of Tennyson's limitations, *Victorian Poets*, rev. ed., p. 188 f.

caught up at the supreme moment, and in such a state be permitted to pour forth his soul. In *The Miller's Daughter* there is no dramatic occasion,—only a quiet, peaceful evening when the aged husband and devoted wife review the incidents of their life. This is not an occasion for dramatic effectiveness, though an excellent situation for a lyric. Such occasions are never found in Browning. To have given it the greatest possible intensity, doubtless, Browning would have portrayed the old man as making his last review of life while on his death-bead,—an occasion similar to that of *Any Wife to Any Husband*. This would have given a convincing effectivness to the last words of the experienced character which could not otherwise be obtained. But, it may be said, this is not Tennyson's purpose; he wanted to express the happy, peaceful experience of the old man who in the evening of life reflets upon his past. Certainly, this is highly characteristic of Tennyson, but this is the reason he did not perfect the dramatic monologue. Even in *Clara Vere de Vere*, in which Tennyson made a marked advance in the selection of a dramatic occasion, the situation would have been more forcible had the mother hersef, instead of a friend of the young man, met Clara Vere de Vere and expressed her wrath while face to face with the coquette. Though this latter situation, which Browning would probably have selected, might have been foreign to Tennyson's purpose, yet the absence of it illustrates his inability to realize the vast importance of the dramatic occasion.

Besides having a significant occasion, *Clara Vere de Vere* is exceptional in another respect. In it a great part of the interest is directed to the hearer. Contrary to this, in the greater number of Tennyson's dramatic monologues, as in *Rizpah*, *The Flight*, *Locksley Hall Sixty Years After*, the hearer is of minor importance, being merely a foil or an occasion for the words of the speaker. Consequently, in Tennyson's typical monologues, there is not that close and intimate relation of characters, the subtle influence of the presence of

one mind upon another, that is most conducive to character portrayal.

Although Tennyson's style was essentially lyrical and although he was limited in his power of characterization and his selection of dramatic occasion, yet many of his dramatic monologues are far superior to any of his predecessors. He formed the connecting link between the unconscious and conscious art of construction. Doubtless he was conscious of his form and especially of his style, yet he was not conscious of the possibilities of this special form. He was too much of a lyric poet to make the contribution to the dramatic monologue which was to constitute its final development. We may pass from him to the poet who performed this work.

In passing from Tennyson to Browning, although they were contemporaries, we come for the first time to the second stage of the development of the dramatic monologue,—the period of conscious art. The poet no longer selects his material merely according to an artistic instinct, but he analyses the complete production and determines the relative value of each element. The rank of each of these is fixed according to the effect it gives to the whole. Form is no longer secondary, but vital. It is the polishing of the gem that reveals the beauty of the stone to the best advantage. The dramatic monologue is now an artistic production in whose construction there must be no extraneous elements. It has become an organism subject to definite laws of structure. The poet is now conscious of material, conscious of form, and conscious of their relations. To this plane of conscious art Browning raised the dramatic monologue.

So far in this treatment of the development of the dramatic monologue, not only has the germ of the origin of the monologue been found in the lyric, but all of the elements up to this time have been derived either directly or indirectly from the lyric. At first the speaker in the monologue was the lyric poet expressing his own personal emotions. Later on there were cases in which the poet found he could make his

ideas and feelings more forcible by presenting them not as
his own, but as those of another individual in whose mouth
they would be more natural and characteristic. The element
of hearer was also derived from the lyric. This constituent
part was the result of the objective tendency of the altruistic
emotions to visualize their object. The third constituent part,
the dramatic occasion, was very little used by the poets so
far considered. It was here that Browning made his greatest
contribution to the dramatic monologue. Coming to the
study of this poet, we meet an influence from another source.
The dramatic occasion was not derived from the lyric, as
were the speaker and hearer, but was taken directly from the
drama. Browning did not change the form of the monologue,
but he replaced its lyrical emotions with a dramatic spirit
which was infused into the old form of dramatic monologue.

The genuis of Browning was remarkably suited to this
work, for he was essentially a dramatic poet. In explaining
this Mr. Arnold Smith remarks,[48] "For however poor his
dramas, his dramatic monologues and lyrics as he called them,
are beyond comparison; and, indeed, the vast body of his work
is permeated with the dramatic principle and wrought in the
dramatic spirit." It was here that Browning and his age were
in perfect harmony, for the Victorian period demanded the
portrayal of the hidden sources of action, and it was for this
that Browning had a passion.

The period of conscious art of constructing a type of litera-
ture is marked by attempts to discover an underlying princi-
ple which can be made the basis of the structure of each indi-
vidual composition. When the short story reached this stage
its constitution was expressed by Poe in his review of Haw-
thorne.[49] Parellel to this, and practically at the same time,
Browning formulated the central principle of the dramatic
monologue in his "Advertisement" to *Paracelsus* (1835). As
he expressed it, his purpose was "to reverse the method usu-

48. *The Main Tendencies of Victorian Poetry*, p. 8.
49 See p. 43.

ally adopted by writers whose aim it is to set forth any phenomena of the mind or passion, by the operation of persons and events instead of having recourse to an external machinery of incidents to create and evolve the crisis I desire to produce, I have ventured to display somewhat minutely the mood itself in its rise and progress, and having suffered the agency by which it is influenced and determined, to be generally discernable in its effects alone, and subordinate throughout, if not excluded."

Browning's central object, then, is the revelation of the activities and conceptions of the soul of a character. Instead of doing this by a series of incidents, in which the individual is brought into contact with other characters, leading up to a catastrophe, he catches up his character at a pinnacle moment of his life and reveals his very nature by letting him express his own thoughts and emotions to another. In the drama we form a conception of a character inductively, putting together different characteristics displayed under different circumstances; but in Browning's dramatic monologues, character is revealed by turning a flash-light upon a soul in a great crisis, illuminating the subtle meshes of thought and emotion which are too elusive to be couched in action. As Mr. Symons expresses it," "He selects a character, no matter how uninteresting in itself, and places it in some situation where its vital essence may become apparent— in some crisis or conflict." Mr. Arnold Smith, in comparing Browning's method with the impressionistic movement in painting, says," "A scene is flashed upon us in glaring colors; we receive a vivid impression of one or two things only; we come into touch with life at its supreme moments; we receive the shock of a sudden sensation."

Thus it is seen that Browning did for the dramatic monologue what Shakespeare did for the drama. He took its old form and gave it a new spirit. He saw its dormant possibilities and

50. *Introduction to the Study of Browning,* p. 7.
51. *The Main Tendencies of Victorian Poetry,* p. 7.

brought every available influence to bear upon it which would develop it into a perfect art form and into a distinctive type of poetry adapted to modern needs.

A few of Browning's dramatic monologues may be selected to show his methods of combining the different elements of the monologue into compositions which may be termed sub-jective dramas. The poems selected illustrate his contribu-tions to the dramatic monologue and show how his dramatic genius raised this form to a distinctive type of poetry.

My Last Duchess, one of Browning's earliest dramatic monlogues (1842), is illustrative of his method of having the speaker reveal his character in his own words. The Duke is a wealthy gentleman with a "nine-hundred-year-old-name" who thinks only in terms of merchandise. He is now a widower and is preparing to mary the daughter of a Count. He takes the Count's deputy into his picture gallery to excite the Count's envy, and shows the deputy the picture of his last Duchess. In surprise and admiration, the companion turns as if to ask,—

How such a glance came there.
The carefully devised answer is,—

Sir, 'twas not
Her husband's presence only, called the spot
Of joy into the duchess' cheek.

She was too courteous and obliging to confine every kindness to his selfish sphere.

She had
A heart—how shall I say?—too soon made glad.
Too easily impressed.

He should receive all the profits on his investements. She smiled at him, but at others also.

This grew; I gave commands;
Then all smiles stopped together.

Into these few words Browning has compressed a life's tragedy. While passing down the stairs, the Duke calls attention to

the statue of Neptune taming a sea-horse,—a symbolism of the absolute submission which he demands. By this indirect method the speaker indicates that if he accepts the Count's daughter she will become his personal property, subject to his will, and must not share his dividends of smiles and thanks with others.

In this drama of the subjective, the curtain rises without any introduction, and we discover the Duke and the deputy. We are even held in suspense as to who the hearer is until the very last. The Duke's character becomes the center of interest at once. The workings of his soul, as of a watch whose faces are crystals, become perfectly clear. The main spring of his actions is selfish interest. A human soul to him is so much merchandise under the absolute control of the owner.

It is clearly seen that in this poem the lyric spirit of the earlier monologues is superseded by the dramatic. The words of the Duke have the directness of dramatic phrasing. They proceed from his real character and are in perfect accord with his attitude and disposition. As far as the dramatic monologue is concerned, this monologue makes a marked advance over the preceding dramatic monologues.

Moreover, the dramatic occasion is of considerable importance. This dealer in human souls has just disposed of his last Duchess and is selecting another to succeed her. The Count's deputy has just come to arrange for a suitable dowery. The occasion was one in which the Duke could be and was perfetly frank in the expression of his commercial spirit in selecting his future Duchess.

The hearer in this monologue is merely an occasion for the words of the speaker. On the other hand, the character of the Duke is the principal interest of the poem. Other poems in which character interest is centered in the speaker are *A Woman's Last Word*, *The Partiot*, and *Fra Lippo Lippi*.

Leaving *My Last Duchess* and considering *The Bishop Orders his Tomb at St. Praxed's Church*, we find that the latter differs from the former in that the audience consists of

several persons instead of one. The licentious art-for-art's-sake Bishop of the Renaissance lies dying, and instead of preparing for death he is giving instuctions to his natural sons about his tomb, which he desires them to erect. He has been deprived by old Gandolf of his favorite niche in the church, but hopes to make up for his loss by having a more artistic monument and a better classical inscription. He promises his sons to pray for horses and "brown Greek manuscripts" for them if they will pledge themselves to make his tomb of jasper.

John Ruskin said of this poem,[52] "I know no other piece of modern English prose or poetry in which there is so much told as in these lines of the Renaissance spirit—its worldliness, inconsistency, pride, hypocrisy, ignorance of itself, love of art, luxury, and of good Latin. It is nearly all I have said in thirty pages of the *Stones of Venice*, put into as many lines, Browning's also being the antecedent work." Such compression, effectiveness, and character interest give it a strong dramatic cast.

As in *My Last Duchess*, the main interest of this poem is in character. But in contrast to it, the occasion is very different. The Bishop is on his death bed. It is an occasion in which the vital essence of the individual reveals itself. His highest ambitions and his greatest hopes receive their final expression. Browning realized the dramatic importance of such an occasion and employed it in *The Patriot, Any Wife to Any Husband*, and *Pompilia*. Not only is this poem illustrative of Browning's genuis in selecting the most important occasion, but it is also an example of a dramatic monologue in which the audience is composed of more than one person.

In attempting to show how Browning reflected the spirit of his age, Mr. Arnold Smith writes,[53] "Another feature of the intellectual movement of the Victorian period was the critical

52. In *Modern Painters*, IV. p. 277-79.
53. *The Main Tendencies of Victorian Poetry*, p. 5.

spirit which, as applied to history, strove to re-establish the atmosphere of the past and realize imaginatively the conditions of a more remote period. The spirit is notably present in Browning's poetry." Not only may this spirit be seen in *Andrea del Sarto*, but it is an example in which both speaker and hearer are portayed equally well.

Although Browning doubtless meant the character of the speaker, Andrea del Sarto, to be the main interest of the poem, yet he has very clearly portrayed the character of Lucrezia, the hearer. From a few historical facts concerning the personages of Andrea del Sarto and his wife, Browning has constructed his greatest art poem. Speaking of the rank of this poem, Mr. Berdoe says,[54] "As *Abt Vogler* is his (Browning's) greatest music-poem, so this is his greatest art-poem."

The dramatic occasion of this poem is of unusual significance. The artist is seated in his studio at twilight, weary from his day's toil. His wife has entered and their quarrel has just ended when the curtain rises. The artist has been striving to his utmost capacity to put into execution his ideals. His prolonged concentration and pains-taking efforts have exhausted his strength. He now wished to relax himself and be strengthened by the encouragement and kind words of his loved one. It is at this period of his work that he assumes the most intimate relations, and it is the most suited occasion for complete self-revelation.

The opening line,[55]—

> But do not let us quarrel any more,—

strikes the keynote of the poem. The speaker is a "faultless painter" in the execution of his art, but he is immoral in character. He had loved Lucrezia while she was another man's wife and is now content that she should love other men. He demanded from this woman, who had neither heart nor

54. *The Browning Cyclopedia*, p. 17.
55. Cam. ed. p. 346.

intellect, only a portion of her affections. He was a genius
who could have coped with Rafael had he not dwarfed him-
self by a parasitic dependence upon a soulless woman. He
could execute with ease models which the greatest artists
could scarcely equal after years of toil.

The artist, sitting with wife on the window-seat, experi-
ences one of the pinnacle moments of his life. He expresses
himself thus to the woman:

> I often am much wearier than you think,
> This evening more than usual, and it seems
> As if—forgive me now—should you let me sit
> Here by the window with your hand in mine
> And look a half-hour forth on Fesiole,
> Both of one mind, as married people use,
> Quietly, quietly the evening through,
> I might get up to-morrow to my work
> Cheerful and fresh as ever.

When she smiles he sees the very picture he has been try-
ing to express in colors.

> You smile? why, there's my picture ready made,
> There's what we painters call harmony!
> A common grayness silvers everything.

Browning's purpose in this poem was to explain why Andrea
del Sarto was "faultless but soulless", as he was pronounced
by his critics. This is done, not by developing different
characteristics drawn out by different persons and situations,
but by letting us see him at a dramatic moment—at a mo-
ment when his weakness reveals itself most vividly. Andrea's
love for the immoral woman is not the explanation of his
being soulless, but is only an occasion of its manifestation.
He makes his fatal defect clear by saying that his achieve-
ments have reached his ideals.

> I can do with my pencil what I know,
> What I see, what at bottom of my heart
> I wish for, if I ever wish so deep—

| 42 |

Do easily, too—when I say, perfectly,
I do not boast, perhaps

.

No sketches first, no studies, that's long past:
I do what many dream of all their lives,
—Dream? strive to do, and agonize to do,
And fail in doing.

Speaking of his companion painters whom he so easily surpasses, he says,—

There burns a truer light of God in them,
In their vexed beating stuffed and stopped-up brain,
Heart, or whate'er else, than goes on to prompt
This low-pulsed, forthright craftsman's hand of mine.
Their works drop downward, but themselves, I know,
Reach many a time a heaven that's shut to me.

Then summing up his whole defect, he says,—

Ah, but a man's reach should exceed his grasp,
Or what's a heaven for?

In portraying the character of Andrea del Sarto, Browning has also depicted the character Lucrezia, the hearer, who is the occasion of Andrea's weakness. The supreme expression of her indifference and lack of appreciation of her husband's genuis is her characteristic interruption, "What he?", when Andrea speaks of the highest eulogy ever given him,—the pride of his life, Michel Angelo's praise of him. This one touch reveals her whole character.

For dramatic intensity, character interest, and a significant explanation of a life's failure, the poem is unsurpassed. All the elements of the dramatic monologue are harmoniously and most effectively combined. *Andrea del Sarto* is one of Browning's best dramatic monologues, and it was in this poem that the monologue's development received its perfection.

Not only did Browning use the dramatic monologue in his minor poems, but he also employed it in what is often considered his masterpiece, *The Ring and the Book*. This poem,

twice as long as *Paradise Lost*, is composed of the same story
told ten different times by as many different persons. Conse-
quently, interest in plot cannot possibly be sustained. Our
interest passes from the external to the internal. Plot devel-
opment is sacrificed for subjective interest. This book is a
social organism made up of various personalities, each looking
at the same thing from a different standpoint. Here Brown-
ing called the dramatic monologue to his aid, since it was
the most appropriate form of poetry for the presentation of
personal views.

Of the twelve books, ten are pure dramatic monologues.
Each of these monologues possesses the three constituent
parts,—speaker, audience, and occasion. By using this form
he gives the fullest play to individuality. Each speaker's
personality colors the common truth and gives it an altogether
different appearance. At the first glance it might seem that
such separate and distinct poems would deprive the book of
unity. But there is a broader and more fundamental unity
than form which underlies it and unites it into an organic
whole. *The Ring and the Book* is a masterpiece of poetry
which moulds the most diverse and individual views into an
artistic and unified whole by employing the dramatic mono-
logue. A democratic interpretation is the keynote of this book,
and without the most democratic form of poetry, the dramatic
monologue, the great success of the masterpiece would never
have been possible. Hitherto the dramatic monologue had
been confined to short poems, but Browning now proved its
adaptility to poems of great length.

Browning's contributions to the dramatic monologue were
fourfold. The first was the infusion of the dramatic spirit
into the old monologue form. This, as all his other
contributions, was principally due to his conception
of a "new drama". As Poe formulated the laws
of the short story according to one central and dom-
inating idea, — a "preconceived effect", — so Browning
derived his laws of the dramatic monologue from one central

principle,—that was, "to create and evolve the crisis" without "recourse to any external machinery of incidents". He transferred dramatic intensity from the drama to the dramatic monologue. This was, perhaps, his greatest contribution to the monologue, and from it were derived the other laws which he gave this new form of poetry.

As a natural result of his purpose to reveal vividly the intricate meshes of the thoughts and emotions of character, he placed his individual in the most revealing dramatic situation. He selects moments of such great intensity that the character will call to his aid all of his resources; and the essence of his soul is brought to light. Such is the occasion in Book VII of the *The Ring and the Book*. Pompilia is on her death bed telling to the nuns the tragic story of her life. She realizes that she is giving the final expression to the truths which she wishes to survive her. Without this occassion which demands unreserved revelation of character, no one would have thought that this girl of "just seventeen years and five months" was such a pure and noble woman, one who had passed through the greatest trials of life. On account of its natural dramatic significance, Browning often selected a death bed scene. Such is the dramatic occasion of *The Patriot*, *The Bishop Orders his Tomb at St. Praxed's Church*, and *Any Wife to Any Husband*.

But Browning did not confine his occasions to death bed scenes. His dramatic situations are practically as varied as they are in real life. He was very fond of ecstatic moments. This is illustrated by *Abt Vogler* and *The Last Ride Together*. In *Saul* he traces minutely the psychological state of Saul's soul as it was restored by David's music from a state of melancholia to its normal condition. Moreover, in *Fra Lippo Lippi* he gives a life's history of a monk. Thus his dramatic occasions are widely varied and are of unusual significance. In this respect he was far superior to Tennyson and all the writers of the monologue who preceded him.

Browning's second contribution, then, was the dramatic occasion.

His third contribution was his style. By no means is this saying that the styles of preceding poets were inferior in other respects, but that in the case of the dramatic monologue Browning's style, was much better adapted to this form than the styles of his predecessors. Tennyson's unvarying, six-accented line was admirably suited to lyrical expression, but was not flexible enough to adjust itself to the sudden changes of thoughts and feelings essential to dramatic phrasing. Browning's style, though at times abrupt and lacking in musical qualities, was always direct and forcible. He did not choose words for their melody, but for their fitness for expressing the exact state of the hearer's mind. His style is perfectly suited to the dramatic monologue. His metre variates from the short trochaic line in *A Woman's Last Word*, expressing abrupt outbursts of intense feeling, to the anapestic pentameters of *Saul*, expressing freedom and joy with slight reserve. Often in the same poem, as in *Hervc Ricl*, he changes the metre to suit the shifting of subjective states. Thus Browning's style was thoroughly adjusted to the direct and forcible expression of the dramatic monologue.

A fourth contribution made by Browning to the dramatic monologue was also dramatic. It was characterization. As in the cases of his other contributions, Browning did not originate the element of characterization, but accepted it as he found it and then began to appropriate it to his own use. In practically all of the dramatic monologues before Browning, character portrayal was of minor importance. Browning made it paramount. So great was his influence in this contribution that the idea of characterization is always associated with the dramatic monologue. The greater distinctness and life-likeness of Browning's characters when compared with those of his predecessors is due, for the most part, to the influence of the crisis in which he places them. In no other situations than those selected by Browning could his

characters have been more vividly portrayed. Such characters as the Duke in *My Last Duchess* and Rabbi Ben Ezra are so real that we often speak of them as we do of Hamlet. Moreover, Browning's's method was that of the flash-light, in contrast to the slow inductive method of the drama. As in *Andrea del Sarto*, we are allowed to see the workings of the character's mind directly.

Not only are Browning's characters life-like, but they are selected from a wider range than are those of Tennyson. Browning's array of characters includes individuals from all classes and from all ages. When he wishes to present a view or an ideal of an age, he selects the most typical person for expression. This he very forcibly does in *The Bishop Orders his Tomb at St. Fraxed's Church.* Browning's creations range from the brute nature of the sprawling, non-self-conscious Caliban in the "cool slush" to one of the noblest and purest characters in literature,—that of Pompilia. This ability to portray all types of characters gave a spontaneity and variety to his dramatic monologues that kept them from becoming monotonous. Instead of presenting truths abstractly he gave them artistic and vivid force by making the proper individuals their spokesmen.

These contrbutions of Browning to the dramatic monologue enabled this form to reach the climax of its development, as the drama did in the hands of Shakespeare. Browning was the Shakespeare of the dramatic monologue. He saw within it its potential powers and with his dramatic genius he developed it into a type of poetry peculiarly adapted to modern times. He raised it to the stage of conscious literary art and gave it its laws of construction.

THE DECLINE OF THE DRAMATIC MONOLOGUE IN THE PRESENT AGE

Although the dramatic monologue attained its highest point of perfection in the hands of Browning, yet it was by no means discarded afterwards; but, on the contrary, it has been used more extensively in the present age than ever before. This period following Browning may be appropriately called the decline of the dramatic monologue. But this decline is not an indication that the monologue is of less importance than it formely was, as the decline of the drama after Shakespeare was not an evidence of its lessened importance. Nor was this decline caused by less interest being taken in the form, but was brought about because there was no poet to hold it up to the former plane of excellence. A few of the monologues of this period, however, may be considered to show the importance of this form in our present age.

While Browning, in England, was coming into full possession of all his powers in the production of the dramatic monologue, Bret Harte, in America, was beginning to employ the same form. Although Bret Harte's greatest work as spokesman of the "forty-niners" was in the field of fiction, yet he found the dramatic monologue especially adapted to his needs. All of his monologues are written in dialect, and these constitute some of his best poems. Reference may be made to some of these poems, which are typical of his use of the dramatic monologue.

In *Dow's Flat*, Bret Harte gives expression to an experience common to hundreds who went to California to seek gold. The speaker in this poem is an experienced Westerner who is thoroughly acquainted with his locality. He is talking to a stranger, explaining how the place in which they were receiv-

ed the name of Dow's Flat. He says that it was named after a gold-seeker who had come there several years before when the place was noted for its gold. Instead of "striking a streak of good luck" as he expected, he soon fell into poverty. He was assisted a while by his campanions, but the work became unprofitable in a short time and he and his family were left there alone. His wife soon died, and he and his children were at the point of starvation. He decided, however, to make one more trial. Accidentally he struck gold. His fortune was won. Immediately the place became again the centre of activity. Then the speaker who was telling the experience says like a flash, "That's me." Thus he identifies himself with the person after whom the place was named.

Aside from its characterization, this dramatic monologue is interesting on acccount of its forcefulness. In no more effective way, perhaps, could the uncertainty of fortune be presented. It is the personal experience of a man who was at the point of starvation one moment and who became a man of wealth the next.

Another poem in which Bret Harte uses the dramatic monologue form very effectively is *Jim.* This monologue is a masterpiece of its kind. The dialect is that of a rough Westerner. Hunting for his chum whom he had known years ago, he approaches a crowd of men who are drinking and asks them if they know his friend.

> Say there! P'r'aps
> Some on you chaps
> Might know Jim Wild?
> Well,—no offence:
> Thar ain't no sense
> In gittin' riled!*

When he inquires of the barkeeper, in whom he sees some resemblance to his friend, he is told that Jim is dead. But the

56. Quoted from Warner's *Library of the World's Best Literature,* XII. p. 6988.

barkeeper's insinuation that Jim was not in his class is immediately resented by the inquirer. A wrangle between the two follows, and, after it is over, the barkeeper says that he himself is "Jim". His old companion immediately recognizes him and explains,—

> Derned old
> Long-legged Jim!

Both characters are clearly drawn and are distinct types of "forty-niners".

Jim and *In the Tunnel* are Bret Harte's greatest dramatic monologues. The dialect of these poems possesses a directness and force in depicting the Western characters which could never be equaled by the use of the lyrical style and method.

As interesting as these poems are, they illustrate the decline of the dramatic monologue. They do not possess the dramatic spirit, flexible style, and poetic qualities of Browning. Yet their directness is superior to that of Tennyson in most of his monologues. They are worthy of attention on account of their intrinsic value, as well as on account of being one of the means of bringing a new section of country into literature.

Another American poet who uses the dramatic monologue, in a more or less modified form, is James Whitcomb Riley. He is the poet leaureate of the plain, unlearned class of Western farmers. His sympathy may be seen in his own words:—

> The tanned face, garlanded with mirth,
> It has the kingliest smile on earth;
> The swart brow, diamonded with sweat,
> Hath never need of coronet.

Many of Riley's poems, as *Griggsby's Station* and *Knee-Deep in June*, have only one constituent part of the dramatic monologue, that is, the speaker. Although they are the supreme expression of the rustic's attitude toward life and although the characters of the speakers are reinforced by the

use of their native dialect, yet they are not true dramatic monologues and, consequently, deserve little attention.

Nothing to Say. however, contains all the constituent parts of the dramatic monologue. An old farmer is speaking to his daughter just before her marriage. He is opposed to it at first, but after reflecting that his wife married him against her parent's will, he says,[57]

> Nothing to say, my daughter! Nothing at all to say!
> Girls that's in love, I've noticed, giner'ly has their way!
> Yer mother did, afore you, when her folks objected to me—
> Yit here I am and here you air! and yer mother—where is she?

The close relation of hearer and speaker in this monologue is indicated by the answer to the father's question.

> And now yer—how old air you? W'y child, not "twenty"! When?

All of the elements of the dramatic monologue,—speaker, hearer, and occasion, are significant in this poem. These elements are also used in *Tradin' Joe, A Life's Lesson.* and many other poems written by Riley.

All of these dialect monologues are similar to Bret Harte's in construction, but are superior to them in pathos and sympathy. The poems that have been selected from both, however, may be considered as typical of the present use of the dramatic monologue in America.

Turning our attention to England again and for the last time, we find that the monologue is still extensively used. Rudyard Kipling employs a form which is a near approach to the dramatic monologue and is sometimes confused with it. This form, however, is the *monologue* in the strict sense of the word, and is not the *dramatic* monologue. The poems written in this form have only one element of the dramatic monologue,—the hearer. These monologues presuppose an audience, but the hearers are in no case distinct. We learn nothing of them through the words of the speakers. How-

57. *The Works of James Whitcomb Riley*, VII. p. 6.

ever, these monologues are well suited to Kipling's purpose. He simply gives voice to persons and inanimate objects and lets them speak for themselves, revealing their experiences and characteristics.

The Song of the Banjo is one of Kipling's poems in which he gives speech to inanimate objects. The banjo speaks from its own standpoint and gives a new revelation of its significance. It is "the war-drum of the White Man round the world!" *The Bell Buoy* is another monologue of this class. The buoy contrasts its mission of saving lives on the stormy sea, surrounded with "smoking scud", to that of its brother, sheltered in the church belfry. The poems make no contribution to the monologue, but employ a method far more effective than that of having the poet speak for the objects.

All of Kipling's ballads are written as dialect monologues. *Tommy*, one of the most noted of these, expresses from the soldier's standpoint the English disrespect for the private soldier when he appears as a citizen and their praise of him while he is protecting them. Other monologues of a similar nature are *Mulholland's Contract* and *M'Andrew's Hymn*.

In a few poems, as in *The Mary Gloster*, Kipling uses the regular dramatic monologue form. The speaker is an unlearned man who has risen from the class of laborers to a man of wealth. The hearer is his son who is careless of his father's advice. The occasion is the death bed scene of the old man. All of these elements may be seen from the first few verses.[*]

> I've paid for your sickest fancies: I've humored your
> crackedest whim—
> Dick it's your daddy, dying; you've got to listen to him!
> Good for a fortnight, am I? The doctor told you? He
> lied.
> I shall go by morning, and—Put that nurse outside.
> 'Never seen death yet, Dickie? Well, now is your time
> to learn.

58 *Collected Verse of Rudyard Kipling*, p. 45.

And you'll wish you held my record before it comes to
your turn.

Here both father and son are clearly drawn and the dramat-
ic tone of the poem is determined at once. But since this
poem is an exceptional one, Kipling can not be classed as a
writer of regular dramatic monologues. However, he uses a
form similar to the dramatic monologue which is well suited
to his purpose.

One other example of the English dramatic monologue
deserves brief attention. It is Mr. Alfred Noyes's *The
Lovers' Flight.*[59] Although the tone of this poem is lyrical, yet
the form is that of the dramatic monologue. The speaker is
the lover, while the hearer is the loved one. The first stanza
may be sufficient to illustrate these elements of the monologue.

> Come, the dusk is lit with flowers!
> Quietly take this guiding hand:
> Little breath to waste is ours
> On the road to lovers' land.
> Time is in his dungeon-keep!
> Ah! not thither, lest he hear,
> Starting from his old gray sleep,
> Rosy feet upon the stair.

It is interesting to note that practically all recent dramatic
monologues are written in dialect. This use of the individu-
al's own peculiar language is a great help to character por-
trayal, revealing the character's method of thought and ex-
pression. It is absolutely essential for the conveying of a cor-
rect conception of a speaker in this form of poetry. But this
may partly account for the inferior quality of poetry in the
more recent dramatic monologues, for dialect can hardly serve
as the vehicle for the highest reaches of poetry.

The preceding examples illustrate the origin, nature, and
use of the dramatic monologue and show that this form of
expression is the result of a slow and unconscious process of

59. Appeared in *Blackwood's Magazine*, Sept. 1909, p. 434

development. Its origin and contributions to its development of form up to the time of Browning were derived from the lyric. But in Browning we found a contribution from a different source, the drama. The work of Browning was the final perfection of the monologue, brought about by infusing the dramatic spirit into the old form of lyric origin; the dramatic monologue came to be a hybrid of two types of poetry, the lyric and the drama. The distinctive qualities of this form justify its classification as a new type—*genre*—of poetry.

That it is adapted to modern needs is seen not only from its nature, since it is the most democratic form of poetry, but also from its extensive use. This new type of literature, which has proved so adequate to present needs and which possesses so novel and so penetrating a method of revealing character, may be considered a permanent contribution to forms of poetical expression.

BIBLIOGRAPHY

W. W. Skeat, editor, *The Complete Works of Geoffrey Chaucer.* V. Oxford, 1899.

F. I. Carpenter, editor, *English Lyric Poetry* (*1500-1700*), Warwick Library, New York.

Edward Arber, editor, *Tottel's Miscellany.* Westminster, 1903.

Francis Cunningham, editor, *The Works of Christopher Marlowe.* London, 1902.

H. Carrington, *Anthology of French Poetry.* London, 1900.

Burn's Poems. Cambridge edition. Boston 1897.

E. H. Coleridge, editor, *The Works of Lord Byron.* III. London, 1900.

Tennyson's Complete Poetical and Dramatic Works. Cambridge edition. Boston, 1898.

Browning's Complete Poetical Works. Cambridge edition. Boston, 1895.

Poetical Works of Bret Harte. Boston, 1893.

The Works of James Whitcomb Riley. New York, 1906.

Collected Verse of Rudyard Kipling. New York, 1907.

Francis B. Gummere, *The Beginnings of Poetry.* New York, 1901.

J. W. Manly, *Literary Forms and the New Theory of the Origin of Species. Modern Philology.* IV. 577, April, 1907.

C. F. Johnson, *Forms of English Poetry.* New York, 1904.

C. F. Johnson, *Elements of Literary Criticism.* New York, 1898.

The Cambridge History of English Literature. III. London, 1909.

Sidney Lee, *A Life of William Shakespeare.* London, 1908.

Brunetiere, *Manuel de l'Histoire de la Litterature francaise.* Paris, 1899.

Tilly, *The Literature of the French Renaissance.* Cambridge, 1904.

Jacob Burckhardt, *The Renaissance in Italy,* trans. by Middlemore. London, 1898.

Edmund Gosse, *From Shakespeare to Pope.* New York, 1882.

Edmund Gosse, *A History of Eighteenth Century Literature.* London, 1889.

Edmund Gosse, *Modern English Literature.* New York.

Barrett Wendell, *The Temper of the Seventeenth Century in English Literature.* New York, 1904.

Mrs. Oliphant, *Literary History of England in the End of the Eighteenth and the Beginning of the Nineteenth Century.* New York, 1886.

Fredric Harrison, *Early Victorian Literature.* London, 1895.

Arnold Smith, *The Main Tendencies of Victorian Poetry.* Bournville, 1907.

E. C. Stedman, *Victorian Poets.* New York, 1887.

Hugh Walker, *The Great Victorian Poets.* London, 1895. 1898.

Brunetiere, *L'Evolution de la Poesie lyrique en France au XIXe Siecle.* Paris, 1894.

Stephen Gwynn, *Tennyson.* London, 1899.

Henry Van Dyke, *The Poetry of Tennyson.* New York, 1901.

Morton Luce, *A Handbook to the Works of Alfred Tennyson.* London, 1895.

Stopford A. Brooke, *Tennyson: His Art and Relation to Modern Life.* New York, 1898.

G. K. Chesterton, *Robert Browning.* London, 1891.

Arthur Symons, *An Introduction to the Study of Browning.* London, 1886.

Hiram Corson, *An Introduction to the Study of Browning.* Boston, 1888.

Mrs. Southerland Orr, *A Handbook to the Works of Robert Browning.* London, 1886.

Edward Berdoe, *The Browning Cyclopedia.* London, 1891.

S. S. Cury, *Browning and the Dramatic Monologue.* Boston, 1908.

L. Sherman, *Analytics of Literature* (Ch. XVI.). Boston, 1893.

R. H. Fletcher, *Browning's Dramatic Monologues. Modern Language Notes,* XXII. 4, pp. 108-111, April, 1907.

Boston Browning Society Papers. New York, 188 6-1897.

[*Whole Number* 165.

BUREAU OF EDUCATION
CIRCULAR OF INFORMATION NO. 2, 1890

ENGLISH-ESKIMO AND ESKIMO-ENGLISH VOCABULARIES

COMPILED BY

ENSIGN ROGER WELLS, Jr., U. S. N.

AND

INTERPRETER JOHN W. KELLY

PRECEDED BY ETHNOGRAPHICAL MEMORANDA CONCERNING THE ARCTIC
ESKIMOS IN ALASKA AND SIBERIA, BY JOHN W. KELLY

WASHINGTON
GOVERNMENT PRINTING OFFICE
1890

LETTER OF TRANSMITTAL.

DEPARTMENT OF THE INTERIOR,
BUREAU OF EDUCATION,
Washington, D. C., March 10, 1890.

SIR: I have the honor to transmit herewith an English-Eskimo vocabulary of 11,318 words, and to recommend the publication of 10,000 copies as a hand-book for the Alaskan teachers.

The introductory note by Lieut. Commander Charles H. Stockton, of the U. S. S. *Thetis*, to whose intelligent foresight the preparation of the work is due, and to whom this Office is indebted for the gift of the manuscript, explains the sources of the material and the circumstances of the compilation.

The Bureau of Education being charged with the supervision of education in Alaska, I have come to appreciate the value of all means or appliances that will in any way promote a better understanding of, and an easier communication with, the native races of that Territory, and I therefore deem the acquisition of this vocabulary as exceedingly fortunate. It will be of great service not only to the teachers for whom it is primarily intended, but to officers of the Navy and of the Revenue Marine service, all Government officials in Alaska, committees of Congress visiting that country, and many others who for various reasons are interested in the study of the Eskimo language. I may add, as evidence for this statement, that the Superintendent of the Census has earnestly requested the publication of the vocabulary as an aid to the Census Office.

The expense of this publication will not be great, and may properly be charged to the fund for the "education of children in Alaska, without distinction of race."

Very respectfully, your obedient servant,

W. T. HARRIS,
Commissioner.

The SECRETARY OF THE INTERIOR.

INTRODUCTORY NOTE.

The U. S. S. *Thetis* was detailed by the Navy Department to cruise, during the summer and autumn of 1889, in the Behring Sea and Arctic Ocean, for the purpose of looking out for the whaling and commercial interests of the United States in those waters, and also for the purpose of assisting in the establishment of a house of refuge at Point Barrow, the most northerly point of our territory.

During this cruise, in order to make it as broad and useful as possible, several of the officers on board of the *Thetis* were directed to prepare reports upon subjects connected with the waters and regions visited by the ship, from their observation and from other reliable sources. Two reports were submitted to me upon the subject of the Eskimos of north-western Alaska; one on the ethnography of the Eskimos, by John W. Kelly, and the other an Eskimo vocabulary, prepared by Ensign Roger Wells, jr., almost entirely from information and material furnished by Mr. John W. Kelly, the interpreter of the ship. Mr. Kelly spent three winters among the north-western Eskimos, and has been engaged for seven years at various times in acquiring a knowledge of the language. The vocabulary is the largest in number of words that I know of, treating of the language of the Eskimos upon our Arctic coast. It has a short vocabulary of the American Eskimos who are settled upon the Asiatic side of Behring Strait, which, I think, will be found particularly interesting and valuable.

The *Thetis* had the good fortune during this summer of reaching as far east as Mackenzie Bay and as far west as Herald Island and Wrangell Land, thus leaving an honorable name for service among Arctic cruisers. It is to be hoped that the reports, memoranda, and other contributions secured through the ready co-operation of the officers of the ship will serve also to make a permanent and useful record of the cruise creditable to the ship, interesting to the general reader, and of value as contributions to our knowledge of the Territory of Alaska.

<div style="text-align:right">

CHARLES H. STOCKTON,
Lieutenant-Commander, United States Navy,
Commanding U. S. S. Thetis.

</div>

FEBRUARY 17, 1890.

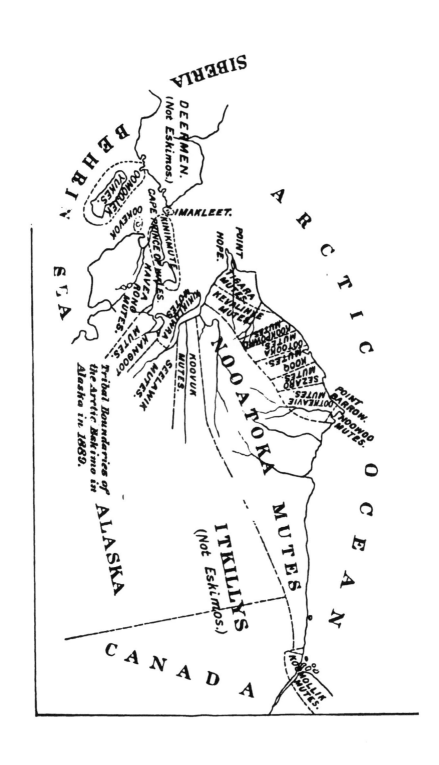

Tribal Boundaries of
the Arctic Eskimo in
Alaska in 1889.

MEMORANDA CONCERNING THE ARCTIC ESKIMOS IN ALASKA AND SIBERIA.

By JOHN W. KELLY.

[Revised and edited by Sheldon Jackson, D. D., United States General Agent of Education in Alaska.]

The Eskimos on the Arctic coast of Alaska claim to be indigenous to the country in which they live; that they inhabited the mountainous region on the north side of Kotzebue Sound before the surface of the Arctic land was changed and before the northern portion rose from the sea. Their traditions assert that in the beginning the people had heads like ravens, with eyes on the upper part of their breasts, and all the world was wrapped in gloom, with no change of day or night. At that time there lived a powerful chieftain on top of the highest peak. Suspended in the roof of his hut were two balls, which were considered very precious, and were carefully guarded. One day, the chief being absent and the guards asleep, some children, who had long admired the beautiful balls, knocked them down with a stick. They rolled across the floor of the hut, through the door, and down the mountain side. The noise awakened the guards, who hurried out after the escaped treasure. The extraordinary beauty of the bounding balls attracted the attention of the people, who rushed after them. A wild struggle for their possession ensued, which ended in breaking them.

Light sprang from one and darkness from the other. These were mighty spirits. Both claimed dominion and neither would yield. At length a compromise was made, and they agreed to an alternate rule. This was the beginning of day and night. Their violent struggles for the mastery had so disturbed the world that the anatomy of the people and the surface of the earth were changed. Light being upon the earth, men began to catch whales in the sea and to carry the flesh and bones to their mountain home.

One family wandering over the country recently arisen from the sea came down upon what is now called Point Hope. Finding vegetation springing up and whales plentiful, they built a hut, and made it their

7

permanent home. Years went on and the father and mother died. Some of the children had strayed away and others had returned to the home country, till only a brother and sister were left.

One day they quarreled, and he killed her. Ever after, when out hunting, her spirit would accost him from first one edible plant and then another. At each occurrence of the voice he would destroy the plant with a club. Following her from plant to plant he destroyed them all. She then took refuge in the sun, whose dazzling rays the murderer could not face. He then went to the moon, where with club in hand he could follow her up for all time.

The Eskimos were the only people in the world. Way back in the dim past some of them were carried away on the ice, and managed to live on seals and other animals they killed, until they reached an inhabited land a long distance north of Point Barrow. They remained there until winter, when they returned in safety to the main-land.

LOCATION.

Leaving the legendary and coming down to the present, we find the Eskimos occupying the whole Arctic coast of Alaska, together with a portion of the Siberian coast.

SIBERIAN ESKIMOS.

There are settlements of Eskimos at Cape Tchaplin (Indian Point), Plover Bay, and East Cape. How long they have been there and how much of the country they have occupied can only be conjectured. Those occupying St. Lawrence Island, Cape Tchaplin, and part of the shores of Plover Bay, on the main-land of Asia, opposite St. Lawrence Island, speak a dialect nearer like that of Point Barrow or the Mackenzie River than the dialects of the Diomedes or Kotzebue Sound. That the Eskimos of Asia have been there a great many years is a certainty. The Deermen people, whose principal support is domesticated reindeer, have gradually crowded out the Eskimos or Fishmen, and have almost absorbed them by assimilation. They wear no labrets, and in dress and tattooing are the same as the Deermen. That they have lived in underground houses is abundantly proved by the ruins at Cape Tchaplin of old huts which have been framed with whole jaws of whales. Now they live in huts above ground, covered with walrus hides. They are built in the same manner as those of the Deermen, who use a covering of reindeer robes. From the Deermen they have also learned to cremate their dead, instead of scattering the dead bodies over the plain, according to the custom of the American Eskimos. Like the American Eskimos, they deposit the personal property of the deceased at his grave. If he was a great hunter, they also erect a monument of reindeer antlers over his grave. Their songs and dances are to a certain extent the same as those of the Deermen, but their manner of living and their language

coincide more with that 'of the people 'on the north coast of Alaska. At East Cape, Siberia, there is a trace of the Arctic Eskimos, but differing from their nearest Eskimo neighbors, the Diomede people.

In the vicinity of East Cape there are a few ruins of underground houses, and a few Eskimo words are still used by the people. Twenty miles westward from Cape Tchaplin is Plover Bay, where both the Eskimo and Deermen language is spoken, but the Eskimo is on a rapid decline.

St. Marcos Bay, which lies between Plover Bay and Cape Tchaplin, is inhabited by Deermen; also the country between East Cape and Cape Tchaplin. In fact, the Deermen now have all the country from the Arctic to Cape Navarin and beyond, except the points named. Oomoojek, on Cape Tchaplin, is the Asiatic Eskimo metropolis. The principal industry is whaling, sealing, and walrusing.

The Oomoojek chief, Kohorra, is the wealthiest Eskimo in the northwest. In addition to large stores of guns, whisky, ammunition, and articles of trade, he possesses a large herd of tame reindeer.

ESKIMOS IN ARCTIC ALASKA.

KAVEA TRIBE.

The original home of the Kavea tribe was near the lakes east of Port Clarence. They love to boast of their former greatness. One old fellow, who is a philosopher, geographer, and seer among the Eskimos, made a map of his country of Kavea; although a little out of proportion it is an excellent one in its way. It contains all the mountains, streams, and settlements, with marks to indicate certain minerals. Some of these were afterwards located by personal observation. It includes East Cape and the Diomedes within the bounds of Kavea, which places, he says, were once peopled by the same natives. At the present day, however, the dialect of East Cape is different from both that of the Diomedes and Kavea. The Diomedes and Cape Prince of Wales people have a dialect which is more guttural and harder to understand than any other of the Eskimos.

The Kavea country is almost depopulated, owing to the scarcity of game, which has been killed off or driven away.

The country was once full of Arctic hare and marmots, both of which have been about exterminated. Reindeer have long since been driven away, but fish are still abundant in all the lakes and streams.

The remnants of the Kavea tribe are scattered over whole of Arctic Alaska. Wherever found they are impudent, energetic, and persevering. What few remain at home rival the Kinegans of Cape Prince of Wales in lawlessness. Nearly every year there is a report of from one to three being killed.

THE TIGARA MUTES.*

The Tigaras, who inhabit Point Hope and hunt over the hills imme-
liately back of that point, claim that they once exercised control over
ll the country from Kotzebue Sound north to Icy Cape, and eastward
s far as Deviation Peak, on the north side of the Kowak or Putnam
liver.

Point Hope, being favorably situated for whaling, sealing, and wal-
using, with an unfailing supply of food for winter, soon became the
entre of power. In the latter part of the eighteenth century, as near
s can be determined, the Tigara village on Point Hope had a popula-
ion of 2,000, with six council houses. At that time the growing tribe
f Nooatoks began pressing to the southward and westward, and it was
ot long before they were masters of the Tigara country westward to
he Kevalinye (Corwin Lagoon) between Cape Seppings and Cape
Krusenstern. One summer, about the year 1800, a great land and boat
ght took place between the Tigaras and the Nooatoks just below
Jape Seppings, in which the Tigaras were overthrown and compelled
ɔ withdraw from all that part of the country.

They were left in possession of the Kookpuk River, where reindeer
ass on occasional years. So badly crushed were the Tigaras that they
ɔst half of their population, which gradually led to the abandonment
f all their outstanding villages, the people taking refuge at the capi-
ıl place of Tigara (Point Hope). The sudden taking off of the lead-
ıg men, the great whalemen and skillful hunters, left the tribe badly
emoralized and comparatively helpless.

Before an equilibrium was established half of the remaining popu-
ıtion died of famine. Since then the population of the tribe has
teadily declined.

They have often attacked parties of whalemen who have been on
hore after casks of water or driftwood for fuel. Four instances are
ıentioned: once when the natives were driven off with clubs; another
me when they surrounded a boat's crew, pricked the men's throats
ith knives, stole their tobacco, and cut the buttons from their clothes;
gain, when they pursued the departing boats, caught hold of their
ainters, and tried to pull the boats ashore, which was frustrated by
utting the painter. Upon the last occasion, when they attacked a boat
ı force, the officer in charge stood them off with a whaleman's cutting-
pade, inflicting many wounds, but it is not known whether any were
illed.

In the summer of 1887 a whaling station was established at Point
lope by a San Francisco firm. The natives, under the leadership of
)wtonowrok, the Tigara chieftain, kept the station in a constant state
f alarm by menaces and threats for more than a year. In June, 1889,
he natives made friendly overtures of peace.

* Mutes, tribe or people.

Owtonowrok aspired to be a chief like Kohorra, of the Oomoojeks on Cape Tchaplin, Asia, of whom he had heard. In his efforts to become absolute master of his people he passed from tyranny to assassination. For trivial causes, such as losing something or failing to be prompt in paying tribute, he would sally forth on a shotgun expedition, and either hold the victim while one of his followers did the shooting, or shoot while some one else held the man; but usually he did the holding himself, as he was the most powerful man of his tribe. He became the head chief through defeating the old chief in a rough-and-tumble fight.

February 14, 1889, he was shot dead by two brothers, whom he had exiled, and who had returned for the purpose of killing him. During his life he killed five men and one woman. He inspired such terror that every year people left for distant hunting-grounds, till it seemed that a few more years of his reign would have seen Tigara depopulated.

Women take an active part in battle or assassinations by holding on to an enemy or otherwise impeding his movements. In executing an offensive movement the women have been noticed to get in the rear of an enemy to obstruct his retreat.

The Tigaras exchange arms and ammunition, obtained from whaleships, with the Nooatoks and Kevalinyes for furs. Whale-oil and sealskins are bartered for deer-skins and children. A child costs originally about one seal-skin bag of oil, or a suit of old clothes. If not resold they are brought up in the family purchasing them to do menial work as soon as able. As they grow up they are made to believe that their parents were bad people and that they would have died if they had not been taken in by their present owners. When grown they are free. Not knowing any other dialect or having any other home, they stay where they are and become recognized Tigaras. Owtonowrok, the chief, had a Nooatok boy, whose fidelity he afterwards rewarded by creating him chief, next in power to himself.

KINEGAN MUTES.

The nineteenth century has witnessed the rise and fall of the Kinegans of Cape Prince of Wales. A band of hypocrites and shylocks, possessing a large share of brazen effrontery, led on by what they believed to be invincible unutkoots (seers), they overran the country to the southward and eastward as far as the Selawik River. Taking the highlands for bearings, they sailed boldly across Kotzebue Sound from Cape Spanberg to Hotham Inlet and Cape Krusenstern, where they founded colonies, hunted reindeer, and plundered and scattered the habitations of other tribes.

They have a traditional story of having defeated and driven the Russians out of Kotzebue Sound. It is probable that they have reference to Beechy's English expedition, as there is a record that a surveying party

' that expedition was attacked and lost in an encounter with the
atives in 1827.

In 1868 a whale-boat's crew from a wrecked vessel was making its way
)uthward to civilized settlements, when it fell in with a band of Cape
rince of Wales natives on the north side of Kotzebue Sound. Some of
le natives held knives to the men's throats, while others robbed and
:ripped them of everything they had, even to their clothing. After
iffering many hardships the whalers reached Point Hope, where they
ere finally rescued.

Every December moon 150 or 200 Cape Prince of Wales natives
ould go over to Kavea, before they impoverished it. on a tax-collect.
ig expedition. Upon their arrival the whole population would be
rawn up in line just outside the village, when the old men would
:at drums, while two elegantly dressed women, springing into the open
.ace between the two tribes, danced in their most graceful style.
7hile the women were dancing two young men would dash into the
ena armed with bows and arrows, dance stiff-legged, draw their bows,
m east, west, north, and south. The whole ceremony being one of
ibmission and a declaration that they stood ready to defend themselves
id visitors from enemies from all directions. The performance being
·er, huts and council houses were thrown open, and dancing, games,
id theatricals were indulged in till the food became scarce, when the
sitors departed.

Beginning about the year 1860, vessels have been fitted out at Hono-
lu and San Francisco for the purpose of trading in Arctic waters.
lese are careful not to be surprised or captured by the natives of Cape
rince of Wales.

Soon after the acquisition of Alaska by the United States (1867) these
·ople captured and plundered a San Francisco trading vessel. En-
uraged by this success, and having as their leader an unutkoot,
hom the natives considered invulnerable, they seized and boarded a
awaiian brig, commanded by George Gilly, a Bouin Islander. The
itives drove the crew below, killing one man. The chief caught Gilly
· the throat and began pressing him back, when Gilly drew a revolver,
it was only jeered at by the chief; striking the chief over the head
:th it and loosening his hold he shot him dead. In the meantime the
ate had come on deck with a rifle, but was seized by the second chief,
id in the struggle for the gun both fell to the deck. Watching his
.portunity the helmsman brained the native with a spare tiller. Gilly
.d the mate then took up positions at the ports in the forward part of
e poop and opened fire on the natives, who swarmed on deck. Be-
ming panic-stricken, they fled into the rigging, and many sprang over
e sides of the vessel, capsizing their canoes, and were drowned. Those
at were left sought refuge under the top-gallant forecastle. When
awn out of their hiding places with long boat-hooks, they ran with
awn knives upon the crew and fought until knocked dead with cap-

stan bars. Fifteen natives lay dead on deck. The number drowned is not known. This incident broke the power of the Kinegans.

The unutkoots, who claimed to be invulnerable, were found to be but ordinary men. The conquered tribes, denouncing them as "liars," "frauds," and "ashooruk oklah" (very bad), asserted their independence. Shotgun parties for the purpose of collecting tribute became obsolete.

The Kinegan colonists north of Kotzebue Sound and elsewhere, finding their locations too dangerous, returned to their own region. The Kinegans still hold the little Diomede, and the coast-line between Cape Prince of Wales and Cape Spanberg, but the population has steadily declined, and within the last three years families have begun to migrate northward, and now they are to be found scattered along the coast as far north as Point Belcher.

COLONIES OF OUTLAWS.

On the south side of the headland just below St. Lawrence Bay, on the Siberian coast, is a colony of murderers gathered from different settlements on the Asiatic shores of the Behring Sea, where they dwell unmolested by surrounding tribes.

In Eskimo Alaska there is not only a settlement, but a considerable tribe of Arctic Ishmaelites who are called Kevalinyes, whose home lies between the Tigaras and the Nooatoks. They claim allegiance to the Nooatoks and ought to be classed under that head, but are spoken of here under a separate heading on account of their peculiarities. The larger number of these people are of Nooatok origin, re-enforced by desperadoes from Cape Prince of Wales, Kavea, and Point Hope.

They have been continually encroaching on the hunting-grounds of the Tigaras, who have repeatedly sent them word to pack up and move or be cleaned out. To these threats no attention has been paid.

Within the last three years they have even extended their ground to the shores of the Arctic, appropriating the northern portion of the Tigara hunting-ground, which lies south of the Kookpovoros at Point Lay. The Eskimos are given to boasting of their intentions. In most instances offensive movements are thus anticipated. Whenever the Tigaras have started out on a shot-gun adjustment expedition, the Kevalinyes have had time to call in a sufficent number of their people to prevent an attack. During the winter of 1889, the Kevalinyes advanced to the westward of Cape Seppings and killed a prominent Tigara native. As soon as the news reached Point Hope an armed party started out to avenge the murder, but did not dare advance beyond Cape Thompson. At no place are hostilities continuous. There are always seasons of civility, when they visit each other for the purpose of trade.

TRIBES DYING OUT.

The other coast tribes between Point Hope and Point Barrow have been cut down in population, so as to be almost obliterated. The Kook-

povoros of Point Lay have only three huts left; Ootookas of Icy Ca
one hut; Koogmute has three settlements of from one to four families
Sezaro has about eighty people.

POINT BARROW.

Ootkeavie, at Cape Smyth, 8 miles from Point Barrow, has a popu-
lation of about 360, and is the largest permanent settlement in Eskimo
Alaska. Its people are drawn from all portions of the territory north
of Behring Strait, being attracted there by the favorable situation o
the place for catching whales and killing deer.

Noowoo (Nuwŭk), on the extreme end of Point Barrow, has a popula-
tion of less than 100. Its people are native to the soil, and are un-
doubtedly the only true relics of the old stock of Eskimos within the
bounds of Alaska.

THE NOOATOKS.

The Nooatoks, originally called Napakato Mutes (timber people), be-
gan their tribal existence in the timbered country at the headwaters of
the Nooatok River. Like the herds of Genghis Khan they have moved
east and west, occupying as much of the territory as suits their pur-
pose.

The golden age of the Eskimos, as a whole, was probably two hundred
or more years ago, before they felt the pressure of southern savages.
Of individual tribes the Tigaras were at the height of their power about
1775, the Kaveas about 1800, Kinegans 1860, Ootkeavies about 1870.

The Nooatoks just now are in the ascendant and promise to overrun
the whole country. Around Point Barrow they have obtained a foot-
ing; at Point Hope they are gradually accomplishing the same end by
selling children to the Tigaras.

They are also gradually working in their dialect among the old Eskimo
stock.

The principal dialects of Arctic Alaska are:

Old Eskimo:

 (1) *Oomojek*, Cape Tchaplin and St. Lawrence Island.

 (2) *Kokmalect*, tribes between Icy Cape and Point Barrow.

 (3) *Kogmollik*, MacKenzie River.

Mixed Eskimo:

 (1) *Karea*, Lake region back of Port Clarence.

 (2) *Kinegan*, Cape Prince of Wales and Diomedes.

 (3) *Nooatok*, Kotzebue Sound inland to Arctic Ocean.

A few words will serve to show the variations of the language in dif-
ferent localities.

 SUN: *Shilinya*, St. Lawrence Islands and north coast of Alaska.

 Mersok, Diomedes and Kavea.

 MOON: *Abacloktuk*, St. Lawrence Sound.

 Amalituk, Diomedes.

 Amaloktuk, Nooatok.

 Amala, MacKenzie River.

The language is difficult to understand on account of there being so many synonymous terms. As many as six different names have been found for the same thing in a single tribe. What may be the traditional name of an object in one locality may be the common appellation in another.

PERSONAL APPEARANCE.

There are three types observable among the Arctic Eskimos of Alaska. The tall, cadaverous natives of Kangoot, Seelawik, Koovuk, and Kikiktowrnk, on Kotzebue Sound, who live on fish, ptarmigans, and marmots. They always have a hungry look, and habitually wear a grin of fiendish glee at having circumvented an adverse fate. There is a tendency among these people to migrate north.

Then there is the tall, strongly knit type of the Nooatoks, a gigantic race, of a splendid physique that would be remarkable in any part of the world.

Rugged as the mountains among which they live, vigorous and courageous, they stop at nothing but the impossible to accomplish a desired end. Their food supply is the reindeer, mountain sheep, ptarmigans, and fish. There are many of the coast natives of this type, but they lack the healthy glow and the indomitable will of the Nooatoks.

The third type is the short, stumpy one, probably that of the old Eskimo before the admixture with southern tribes, now found on the Arctic coast. Whale, seal, and deer meat are their food staples.

The Eskimos have coarse, black hair, some with a tinge of brown. Many of the coast people of both sexes are bald from scrofulous eruptions. Males have the crown of the head closely cropped, so that reindeer may not see the waving locks when the hunter creeps behind bunch grass. They have black eyes and high cheek-bones. The bones of the face are better protected from the severity of the climate by a thicker covering of flesh than southern races.

Among the coast people the nose is broad and flat, with very little or no ridge between the eyes. The adult males have short mustaches, and some of the elder ones (more noticeable in the interior) have rough, scraggy beards. Generally their beard is very scant, and most of them devote otherwise idle hours to pulling out the hairs. All have good teeth, but they are subjected to severe usage, being used for pinchers, vises, and fluting-machines. The teeth are employed in drawing bolts, untying knots, holding the mouth-piece of a drill, shaping boot-soles, stretching and tanning skins. When they become uneven from hard usage they are leveled off with a file or whetstone. A woman at the age of forty who has done her share of the house-work generally has her front teeth worn down so low that they are useless for mechanical purposes.

ORNAMENTATION.

At any time from sixteen to twenty-two years of age the male natives have their lower lips pierced under each corner of the mouth for labrets.

When the incision is first made, sharp-pointed pieces of ivory are put in. After the wound heals the hole is gradually stretched to half an inch in diameter. Some of the poorer natives wear labrets made from cannel coal, ivory, common gravel, and glass stoppers obtained from ships, which they shape for the purpose. All who can obtain them have agate ones. One labret is nearly always plain, and shaped like a plug hat, with the rim inside the mouth to hold it in; the other has a white washer an inch and a half in diameter just outside the lip, held in place by a nut of turquoise fastened to the end of the labret by petroleum pitch from Icy Reef or spruce gum from the Nooatok. It is not known where they have obtained the turquoise or the porcelain-like washer. The natives say they have always been in the country, and have been handed down by successive generations. Some of the old men who have made a good record as whalemen tattoo their cheeks ; some of the designs are triangular, an inch long, with one point intersecting the corner of the mouth. Another kind is a rectangular bar an inch and a half long, extending from the corners of the mouth toward the ears.

Some of the girls have their ears pierced just back of the lobe, where it is thinnest. They wear ivory ear-rings, some of which are carved with plain figures, while others have a setting of turquoise. Some of them have a string of beads extending from one ear-ring to the other, suspended under the throat. There are rare instances where the Cape Prince of Wales girls wear turquoise beads suspended to the cartilage of the nose between the nostrils. Tattooing the chin among the women is general, and it is kept up, so they say, because it has always been the custom. At the age of six one narrow perpendicular line is drawn down the centre of the chin, powdered charcoal being used in coloring. At about twelve years of age the line is broadened to a half of an inch, and a narrow line drawn parallel to it on each side. Sometimes the tattooing is delayed till the child has grown up and has the work done to suit herself, either with the narrow line, the broad line, or three lines. Some of the Kangoot women on the south side of Kotzebue Sound have been noticed with two narrow lines on each side of the broad one, and there are rare instances where the tattooing has been delayed till the birth of the first child or even longer. The women all have remembrance blotches tattooed on their wrists or back of the hands. The women wear their hair in braids, except when it is tied in two loose locks just below the ears. Mackenzie River women wear the hair in two rolls forward of the ears, hanging down, and a small pig-tail behind.

DRESS.

Clothing for men consists of knee-breeches, belted at the loins, a loose-fitting cloak trimmed around the bottom, and the hood with wolf or wolverine, or a blending of both, a pair of stockings and a short-legged pair of boots with seal-skin soles. In winter two suits are worn, the inner suit with the hair next to the body and the other with the hair

turned out. , In summer water-proof tanned seal-skin boots are substituted for reindeer ones. · Gloves are made of reindeer-skin with the hair turned in. Each tribe has some peculiarity of dress. Those south of Port Clarence (Cape Douglas) and those north of Point Hope wear shoulder-straps of different-colored furs trimmed with wolverine. Point Hope natives put little white tanned seal-skin tassels around the top of their summer boots, and others do not. The old Eskimos at Point Hope and Point Barrow fashion their boot-soles high, and cut out the upper in one piece, and sew their water-proof boots and mittens without a welt, while the Kavea and Diomedes make the sides of their boot-soles low, have the upper in two pieces, and sew with a welt. Old people often have portions of their clothes made of duck-skins, which are said to be tough and warm. All of them like to have civilized clothing for summer or indoor wear, which can be washed, so as to keep down vermin. The difference between the dress of men and women is that the latter have their boots, stockings, and pantaloons all in one garment. The cloaks of all females have at the back of the neck a fullness, for carrying infants. These cloaks come down below the knees and are gored out at the sides up to the hips, making the front look like an apron.

The chief employment of the women in winter is dressing skins and making clothes.

When the snow begins to melt in the spring, they cease manufacturing, and only repair or fit a garment when absolutely necessary.

CHARACTER.

They are intelligent beyond what might be expected of them, and have good natural abilities. They are quick in providing ways and means in cases of emergency. They are also anxious to adopt the methods of white people when they can do so to advantage to themselves. Some of them carve with a knife on pipe-stems, or drill bows made of mastadon or walrus ivory, pictures illustrating events in the life of the artist, tribal history, or festal occasions. There are instances where they have communicated with each other by means of pictures carved on wood or ivory. In their drawings they have no idea of the perspective, and instead of drawing from nature they are more apt to incline to the grotesque and hideous, just as the fancy may seize them. Our pictures are unintelligible to them, unless they are distinctly ludicrous.

They know no other motive than that of selfishness. Anything they part with is with the expectation of a double remuneration in the near future. Any promise of reward next year they deem idle talk and are unwilling to understand it. Everything is right if it coincides with their wishes, and everything wrong if it is contrary. Any man may have their friendship if he can pay for it; otherwise he must take the consequences, good or bad. The Eskimos have been proverbially honest and truthful in their dealings. Aside from forcible appropriations they

rarely steal anything, unless it is some small trinket of very little value. Any little article stolen may be easily traced, as it is not in their nature conceal a theft or keep a secret. Up to this time there has been no white man among them who can equal them in hunting, fishing, sealing, and shore-whaling. Judging from their stand-point they say the white man is "ilualok" (unfit for anything), nor have they any respect or veneration for anything pertaining to the whites.

CUSTOMS.

The Eskimos on going to bed strip off all their clothing and huddle together under reindeer-robes. The males scarcely ever wash their face and hands, and their bodies never. All births and deaths take place in out-houses.

Women carry their young astride their backs. The child is held in place by a strap passing under its thighs and around over the mother's breasts.

Children are given from two to six names, but none of them are those borne by the father or mother, but are those of ancestors or respected relatives. The literal meaning of the names are stone, foxes of different kinds, seals of all varieties and sizes, birds, animals, parts of animals, of birds, of fishes, or of the body, sections of the country, winds, tides, motion, fast or slow, decorative articles, and names compounded in an expressive way, as Amok Tigara, the she-wolf of the Tigaras.

Idiots and partially demented persons are permitted to live, contrary to what might be expected of these people; but the unfortunate wretches are only fed on refuse food, and if clothed at all are only given old worn-out garments. Fortunately only an occasional idiot is to be found.

COURTSHIP AND MARRIAGE.

Girls after they have reached puberty, at about thirteen years of age, have no one to protect them. Neither father, mother, or brother will raise a hand to ward off a ruffian who would outrage them. Eskimo girls are naturally modest, shy, and of a retiring disposition, and it is a severe shock to them to be pounced upon as a hawk would grab a dove. They often fight furiously until their clothes are cut or torn from them and they are beaten insensible. After a while they will not resist so heroically. Though tears fall like rain, the male Eskimo, youth or middle-aged, never relents. When a girl has finally taken a husband she is not often molested. An Eskimo begins his courtship by making the girl presents of food delicacies, such as deer breast, tongues, and seal liver. Then he has as fine a cloak made as his resources will permit, which is intended for the girl. Should she accept and put it on, he has won; but she often hesitates, sometimes rejecting all advances or preferring some one else. Should the latter be the case the man begins a cruel siege. She is waylaid and harassed upon every occasion. The

persecution is kept up for days and months before the man gives up, leaving the field for the next comer. When a couple does mate, the relation is scarcely ever permanent. Before they become settled they may have had a dozen or more matrimonial ventures. Women are inclined to be true to their husbands, and probably would be if the men did not insist on exchanging wives for a season, or prostituting them for a revenue to whalemen.

Women are kept in the huts a month after confinement, and are not allowed to enter any other house than their own till the season, summer or winter, is over. Maternal cares and drudgery make their lives such a burden that they often destroy their unborn offspring. Some of them do this secretly, and if it is found out by their husbands they are beaten till insensible, then thrown out of the house. Women who have been badly treated have hanged themselves. This last winter (1889) a Point Hope man, jealous of his wife, whom he had taken from the Nooatoks the summer before, hammered and cut her up with a knife. Despairing of life or liberty, in the night, during a raging blizzard, she fixed a noose around her neck, hitched some dogs to the hauling-cart, started them up, and was dragged to death.

Here are some of their love songs, in which I have preserved the meaning:

OKANITOO (LITTLE WOMAN).

Oh! Okanitoo! This I'll do
To win your noble heart;
In command of a magic wand
I'll cleave the mountains apart.

There, below the surface of snow,*
By the eternal hunting-ground,
A hut I'll build of rarest guild,
Where love may ever abound.

On wings I'll rise to the leaden skies
And drag the Aurora down,
Its trembling bars with glistening stars,
To make thee a wedding gown.

The rainbow, too, of varied hue,
For a bonny belt I'll bring,
The new moon trap, the ends I'll lap,
And weld thee a finger ring.

I'll hunt the hare, I'll fight the bear,
And banish the wolves for good;
Whales and deer, and seals I'll spear,
We'll never want for food.

When this is done, I'll moor the sun,
And turn the blizzard away;
The winter's blast forever past,
We'll live in endless day.

* The Eskimos' happy hunting-ground is below the ground, out of the cold.

KAVANA.

My little Kavana, my pretty Kavana,
Higher mounts the sun in its aerial ride,
And winter's darkness will soon be gone,
Will you be now my own bonny bride?
Not for a day, but forever and a day?
I know very well I have loved a host
(And who has not, I'd like to know)
Of beautiful girls up and down the coast.

My dearest one, my beloved one,
Very soon the snow birds will be here,
Perhaps with the next southerly gale,
To usher in our Arctic New Year.
Accept me do, for I love you true;
You "have hunted and mated with dozens before,
And plighted" you say "to another man;"
Then we are even, why hesitate more?

My darling girl, my own dear girl,
We'll soon leave our underground home.
To pitch our tent on some inland creek,
Once more my dear, will you, will you come?
What! mine at last, suspense is past,
Mine you are for woe or for weal,
Now, my wife, I'm hungry as a gull,
Off with your cloak, and skin that seal.

AHKETUCKY.

Ahketucky, tucky tah,
Ahketucky, tucky tah.
Ooninyah has a handsome face,
Lovely form, and winsome grace;
An arrant flirt, a coquette,
Easy to court, but hard to get.
Ahketucky, tucky tah.
Ahketucky, tucky tah,

Allungow is a slave to work,
Toil all day and never shirk;
But any girl that I wed
Works, or I break her head.
Ahketucky, etc.

Rechona, by angels given
From the fairest band in heaven,
Beautiful nymph, blessed ever,
Adore always marry never.
Ahketucky, etc.

Okpokto, of noble mind,
Honest, upright, and kind,
Exalted, incomparable virtues;
But goodness brings no revenues.
Ahketucky, etc.

Anakcho is a little ghoul,
For plunder yields her very soul,
And she shall be the wife
To share my lot in life.
Ahketucky, tucky tah,
Ahketucky, tucky tah.

POLYGAMY.

Polygamy is hereditary. If a father has a plurality of wives the sons also have an equal number, without regard to wealth or ability to support them. Many natives have two wives; there are rare instances of a man having three wives, and Owtonowrok of Tigara had five wives at the time of his death. He had previously killed one, and scarcely a day passed that he did not club or carve one or more of them. At his death the first wife took possession of all the property, to be held in trust for her eldest boy, twelve years of age, to the exclusion of all the other children or relations.

DISEASES.

The natural bodily ailments of the Eskimos are scrofula, diphtheria, bronchial, and pulmonary diseases. Many men are affected with sore eyes and partial blindness, brought on by the excessive refraction of the sun's rays on the white surface of snow during the months of April, May, and June. Left to themselves the Eskimos would have continued to battle successfully against these disorders; but the white people introduced syphilis among them. This has been a blight that has almost swept some of the coast tribes out of existence, and bids fair to depopulate the whole Eskimo country. The Nooatoks, being an inland tribe, have been comparatively free from it until lately, but the blight has now begun to affect them also. They might have had immunity much longer had they not forced their way to the sea-coast, where they could have communication with the whale-ships. They now come in boats to Point Hope, cross the mountains to Point Lay and vicinity, and go in large numbers every summer to Point Barrow.

According to an Eskimo's idea there is no wrong in adultery, especially among themselves, and it is correct with whalemen if there is a consideration; consequently, it does not take much time to scatter the germs of disease among a whole people.

The Diomede natives are not given to promiscuous intercourse with whalemen. The Oomoojeks, of Cape Tchaplin, Siberia, called a halt some years ago before it was too late.

The Kinegans, of Cape Prince of Wales, and the Kotzebue Sound tribes are not badly corrupted yet; but on the north coast there is the grossest abandon. The moral status of the Eskimos is very low, not above that of the brutes. The only thing they have been known to decry has been that of mating with blood relations. There are instances, however, of

brother and sister, parent and child, while that of uncle and niece i
quite common.

All their songs, stories, and traditions are of a ribald nature. In fac
obscenity is flagrant everywhere. The knowledge they have glean
from white people has been from a commercial stand-point. Mora
ideas have not yet reached them. Satisfaction of personal desires with
out regard to consequences has hardened them in their ways of iniquity

People when stricken with what is thought to be a fatal illness ar
carried out to the out-house, where, if they do not die according to thei
expectations, they request some one to kill them, and their wish is com
plied with by an unutkoot (seer), who stabs them with a knife eithe
in the breast or temple; the knife is then buried by the unutkoot
Pieces of graphite or other black stones are placed on the eyes of th
deceased, the body is wrapped up in reindeer-skins, and carried out fo
immediate burial, the head always being placed to the eastward. Th
body later on is usually placed in a crude box, and is generally left o
the ground, though it is sometimes placed on stilts or a frame. Four day
after a death the family remain in mournful idleness, and are not allowed
to enter another house until the expiration of one moon. Just after a
burial the natives walk around the body, then form a ring and drop
stones down through their cloaks, after which they file away homewards.
Just before the whaling season the Point Hope women are made to
carry a piece of whale blubber out to the cemetery and place it on the
grave of a deceased whaling relative. That the woman may not neglec
the duty through timidity, a man goes along after her carrying a club
Men not having a wife, sister, or mother. or other woman dependen
upon them carry the meat themselves. The bodies of people who di
during the whaling season are cut open, and any pieces of whale blubb
found in the stomach are thrown into the sea.

SHAMANS.

Unutkoots are the seers or medicine men, and are divided into seven
degrees. The vocation is hereditary, as far as a son or a daughter may
mentally or physically be able to acquire the knowledge. They are
graded according to their knowledge of spiritualism, ventriloquism,
feats of legerdemain, and general chicanery.

An unutkoot of the seventh degree claims to be immortal; that his
vision and knowledge extend beyond that of the world, to that of the
spirit life; that he can not be killed or even wounded. Those of this
grade are often heard of but never met with. Sixth grade unutkoots may
be wounded but not killed. Those of lesser grades are less pretentious;
they go into trances, during which the spirit leaves the body, roams
about the other world, communicating or treating with other spirits.

Sickness is supposed to be manifestations of evil spirits or devils,
which have taken possession of or located themselves in the body.

An unutkoot of the higher grades in treating a patient darkens the

room or waits until night; then in the presence of the assembled house-hold he begins operations; he takes his drum, made of walrus bladder stretched over a hoop, strikes it against a stick, making a doleful sound, during which time he alternately commands and exhorts, exciting loud and fervent ejaculations from the assembled people. At first the per-formance is mournful, but the unutkoot soon warms up and the per-formance becomes livelier. He winds up each peroration with a ques-tionable glance at the audience, as if to elicit approval; then the responses become more in keeping with a hilarious entertainment, such as " good boy," "go it Tommy," etc.

In the next act he removes the patient's clothing, breathes upon and sucks the parts affected; then bringing his powers of ventriloquism into play, he pretends to carry on a conversation with invisible spirits. Again the drumming and incantations are gone through with. Sud-denly all noise ceases; then he flips his right hand behind him, throw-ing little pebbles on the floor or ground, so as to imitate the sound of an animal scurrying away. The patient is then told that the devil is gone. If it is only a slight illness or mental depression, their faith is so great that the afflicted one gets well anyhow.

In treating rheumatism, swellings from fractures, or syphilis, in ad-dition to the incantations they fearlessly use a knife in lancing, always cutting into the part affected, where they insert a goose-quill to let out blood or pus. They cut deep, without regarding the state of the wound or whether it is ready to be lanced or not. Using no anæs-thetic and carving deliberately with a knife that is not remarkable for its sharpness, the patient endures the most intense agony, his screams being heard all over a village.

In dealing with children an unutkoot wears a mask and howls in a disguised voice to scare or divert their minds. The performance being over he takes his drum, goes around a house, chanting and beating an accompaniment, and describing a magic circle, to keep prowling devils away.

There are women unutkoots, but none of a high degree.

Eskimos who are not unutkoots use a stick 4 or 5 feet long, one end of which is held against the instep of a patient, while they chant in anx-ious efforts to banish or appease the tormenting devil.

Some of the tricks of legerdemain by which the unutkoots mystify their people are apparently driving a knife into their bowels without making a mark; taking a marked bead in their hand, showing it to the audience, toss it carelessly out into the snow, and later on remove what appears to be the same bead from some man's ear; they take a piece of twine, cut it into two pieces 2 inches long, open the mouth to show that it is empty, put in the bits of twine, a piece at a time, chew them up, then, after much heaving of the chest, draw forth from the throat the twine in its original length.

RELIGIOUS BELIEFS AND SUPERSTITIONS.

Eskimos are believers in ghosts. They also believe in the transmigration of souls, that spirits return in animals, winds, rocks, ice, and water, that they are evil, angry, or good, as the elements may be favorable or unfavorable, and that they can be appeased by hoodoo rites if the performer is sufficiently versed in occult sciences. Childless women, it is claimed, can not return to the surface of the earth after death. To change the wind, for instance, they chant, drum, and howl against it, build fires, shoot against it, and as a last resource fire the graves of the dead. Tribes put hoodoos on each other by ceremonial dances and howling. The hoodoo of total destruction upon neighbors is the building of a fire within sight of those coming under their displeasure. Tribal relations are severed by making a fire outside and burning all ornaments or disguises used in ceremonial dances, such as raven skins, eagle tails, deer horns, and masks. Tribes that are hoodooed answer by a return hoodoo, but with families and individuals it is different. Outlawed by their tribe or relations, they become discouraged, hopeless, and gloomy, and literally " go off and die." In whaling, a husband is hoodooed if his wife is confined within three months of the whaling season, or a death hoodoos the whole family till the boat in which they intended to work gets a whale ; then if the same boat gets another whale the women folks are released from the hoodoo and may go out on the ice.

Seals when brought home are offered a drink of water: a little of it is then poured on the seal's nose, and the rest thrown into or toward the sea. The same custom is observed toward the white grampus (beluga de mer) and whales when killed and brought alongside the ground ice. Eclipses of the moon create the greatest consternation and almost paralyze the people with fear. Arctic earthquakes having been coincident with eclipses of the moon, they say that an eclipse is the shadow of the earth being piled up and shaken. All the unutkoots in a village will howl and drum till it is passed, claiming that they have driven the thing away. Among the Nooatoks all hands rally around a pair of buckhorns, form a circle, and march around to the music of drums and wild chants till the eclipse is off. One old Eskimo described a calm as being a struggle between spirits of the wind from opposite directions.

FESTIVITIES.

Festal occasions are early in December, when they have a kind of harvest-home, entertainments being given every day by each hut in succession, with an evening dance in the assembly house. A day will be devoted to whales, another to reindeer, others to seal, their whaleboats, sleds, husbands, sweethearts, and wives. This festival is kept up until the whole program is completed or some one dies through exhaustion in dances of endurance.

The next is that of good-cheer, in June, when they quit whaling and exchange presents, give scraps to the poor, and toss each other up in blankets. Another season of gaiety is when the representatives of different tribes meet at the summer rendezvous for the purpose of exchanging commodities. Dancing, foot-races, and wrestling matches are indulged in. Both sexes join in games of polo, foot-ball, and tag. In summer girls toss sandstone balls with their hands, two balls with one hand, or three balls with both hands. In winter they toss an iceball with their feet, keeping it from touching the ground for hours at a time; sometimes they toss it from one to another. Sometimes the exercise makes their feet so sore that they tie a reindeer-skin pad across the top of the foot.

In December, 1888, a little Kevalinye girl, when every arrangement had been made for her taking a husband, begged one day more of freedom. Taking her ice-ball she tossed it throughout the short gloomy day till it was too dark to see, unmindful of the cutting wind and drifting snow.

HUNTING.

The primitive methods of taking game were:

(1) *Reindeer*, with bows and arrows ; rawhide snares secured among the dwarf willows that line the creeks; great brushwood corrals in the timbered country, where herds were driven to be slaughtered ; chasing them with kyaks and spearing them to death while crossing lakes or lagoons ; latterly, chasing herds of deer with dogs, after the fawns are dropped into the rivers and rushing torrents, where the fawns are drowned.

(2) *Seal.*—With nets suspended under blow-holes, or spearing them when they put their heads into the blow-holes.

(3) *Walrus.*—They are speared first and then lanced.

(4) *Whales.*—Striking them with spears to which 20 fathoms of walrus line is attached, with three seal-skin pokes or air-bags tied to it. These pokes keep the whale from sinking while the natives get around it with their boats, lance and worry it to death.

(5) *Birds.*—Ptarmigans are caught with little nooses set among dwarf willows and with nets staked down into the snow, into which they are driven. Lapland larkspur are caught with tiny nooses made of whalebone thread. Little auks, puffins, and crow-bills are caught with nets suspended over cliffs. Ducks, geese, and brants are brought to the ground by means of ivory or bone balls tied together with sinew thread, thrown into flocks, where they wind around the necks of the birds.

(6) *Foxes* are caught with dead-falls or automatic nooses set in holes in the snow. The fox in pulling at the bait draws the halter around his own neck, until, alarmed, he surges back and is strangled.

(7) *Lynx* they run down till close enough to shoot.

The primitive ways of taking reindeer have been abandoned, except under favorable circumstances among the Nooatoks. Since the intro-

duction of fire-arms the reindeer are too scary to be approached wi
bows and arrows.

The natives depend on reindeer for all their clothing and bedding
and particularly for tents and houses. The Alaskan Eskimos north o
Behring Strait kill about fifteen thousand annually. Many of the n
tives have adopted American methods of taking whales, in a modifi
way. From Cape Prince of Wales to Point Barrow they get abou
thirty whales annually of all sizes. The whalemen have almost elimi
nated the walrus from their food supply. Of seals they get abou
twenty thousand annually. Like the deer, they are killed with repeat-
ing-rifles, of which the natives have the latest and best patterns—Win-
chester 45–70, 45–60, and 44–50. Hotchkiss's, Marlin's, and Kennedy's
express and telescope rifles are also met with. There is scarcely a
male Eskimo over twelve years of age who does not own one or more
repeating-rifles. They receive annually from the ships $30,000 worth
of arms, ammunition, muslin, and flour, at San Francisco prices, in ex-
change for their furs and whalebones. As there is much rivalry be-
tween different traders, the natives receive full valuation for their pro-
ducts.

DRESSING SKINS.

When the snow has whitened the ground, and the streams are frozen
over, the women begin dressing skins.

First they dry and scrape the skin, removing the fat; then it is moist-
ened and put under pressure several hours, when it is taken out and
wet with warm water as it is scraped. This done, it is thrown over a
line to dry; then as it is scraped it is sprinkled with chalk or any kind
of white rock pulverized, which when done leaves the skin soft and
white. The best working-women can dress two reindeer-skins for ordi-
nary purposes within twelve hours, but a fine job requires three days
for one skin. Sometimes the skins before being made up are dyed a
dark brown with a decoction of alder bark, obtainable south of the
Chapomeakarook Mountains.

DWELLINGS.

The coast natives have fixed villages of underground houses where
they live in winter. In summer they scatter out in different parts o
their hunting-grounds or go to the different places where the natives
meet to exchange articles of trade. During these excursions they live
in muslin or deer-skin tents.

The Nooatoks have no fixed abode of underground houses, but live
in huts framed with spruce poles covered with reindeer skins. In winter
the hut is deeply covered with snow. In the latter part of May, when
the snow begins to thaw, they take out their effects and pitch a tent
on the surface of the snow. As soon as there is a bare spot of ground
the tent is removed to it. The Nooatoks, like the wolves, follow up the

Eskimo oomeaks (open boats) have a frame-work of spruce covered with split walrus hides, sea-lion skins, or white grampus skins; the latter is not used if sea-lion or walrus skins are obtainable, as it is rather thin. The Behring Strait and north coast boats are generally 24 feet long with 5 feet beam, and have a carrying capacity of 15 persons and 500 pounds of freight.

Those of Kotzebue Sound average about 35 feet in length and 6 feet in width. They have a carrying capacity of 20 persons and 1,000 pounds of freight, or 3,000 pounds of merchandise and a crew of six men. There are exceptional boats built on the Sound that are as much as 42 feet over all. In crossing Kotzebue Sound or Behring Strait the natives sew on bulwarks of sea-lion skins a foot high to keep the water from dashing in.

NOTE ON ESKIMO BIBLIOGRAPHY.

By SHELDON JACKSON,

United States General Agent of Education in Alaska.

A very complete "Bibliography of the Eskimo Language" has been compiled by Mr. James C. Pilling, and published by the Bureau of Ethnology, Washington, D. C. Whoever examines its pages must be impressed with the large number of persons who have unpublished manuscripts, containing from a score to a few hundred words; the large number of printed reports of Arctic explorations, which contain a partial list of words and phrases; and the fact that there is not a single comprehensive English-Eskimo vocabulary in print, and accessible to teachers and others, among the Alaskan Eskimos.

Among the most important in the past are—

Dr. Benjamin S. Barton's Vocabulary of the Greenlander's (from Cranz). 8vo; pages, 132. Pub. Philadelphia, 1798.

Eskimaux and English Vocabulary, compiled by Capt. John Washington, R. N., and published by order of the lords commissioners of the admiralty for the use of the Arctic Expedition in Search of Sir John Franklin. Oblong 12 mo. 160 pages. London. 1850.

English-Aleutian Dictionary prepared by Stephen N. Buynitzky, and published by the Alaska Commercial Company. San Francisco, 1871. 8 vo. 13 pp. .

The above are out of print.

The most recent vocabulary that is available is that of Lieut. P. H. Ray, in the Report of the International Polar Expedition to Point Barrow. 4°. Washington, D. C., 1885.

This volume gives 711 words and 307 phrases, as used by the Eskim
at Point Barrow.

Perhaps the most important contribution to the Eskimo language i
in process of preparation by L. M. Turner, in his observations made i
1882–1884, and will be published in connection with the Signal Servi
of the U. S. Army.

It will contain a vocabulary of the Koksoagmyut of over 7,000 words
the Unalit of Norton Sound, 3,000 words; the Malimyut, Norton Sound
250 words; and the Unalashka-Alyut Dictionary of 1,900 words.

ANGLO-ESKIMO VOCABULARY.

[Prepared by Ensign Roger Wells, jr., U. S. N., and John W. Kelly, interpreter.]

English	Eskimo	English	Eskimo
Abdomen	Nas'rak	Arrow	Kokarvot
Above	Kele'to	Ashamed	Kunnebook'to
Abscess	Own'yok	Ashamed	Egeebe'to
Ache	Ar'ah	Ashes	Ok'ave
Act	Keh	Ashes	Ok'erook
Additional	Shoo'lay	Aside	Kung'ea
Adhere	Nepe'to	Asleep	Stnikte'ka
Adopt	Tignong'a	Assembly house	Kon'geet
Adze	Oole'mah	Assembly house	Koaro'geet
Adze	Kehika'nok	Assist	Nulawhok'to
After	Attan'e	Astragal	Po a lo'ra
Again	Mawt'na	At	Nesha'na
Agate	Okkekwik'tuk	Aunt	Nis'cha
Agate	Ong'muk	Aurora	Kel go'ayo
Age	Ongashu'a	Aurora	Kel gak'aya
Ahead	Bonelek'to	Aurora	Ke li'look
Aim	Oomuk'shnk	Austere	Kollang a ta'a
Air	Ano'kla	Autumn	Ookaok'tuk
Alight	Ma'tnh	Autumn	Ookaok'to
Alive	Yoke	Awaken	Muk'etin
All	Iln'hun	Away	Ootik'too
All	Iluhut in	Awhile	Naa ak'amo
All of them	Tamut kwe	Awl	Kap ote'ok
Alone	Alootkoo'chena	Axe	An ow uk'leen
Also	Teo'wit	Axe	Kat'la pak
American	Mulle'keet	Baby	Il il'egah
Amputate	Taleake'pegah	Bachelor	Nuleot' gut chuk
Amulet	Tu pit'kwo	Back	Too loo a'ne
Amulet	Koo puk'tuk	Back and forth	Alep'eta
Anchor	Ke'shok	Back there	Tah run'e
Anchor, will	Ke shok'tak	Backbone	At tat'a
Anchored, is	Ke'shok-pola'rak	Bad	Ashoo'rnk
Ancient	Ah drah'ne	Bad, very	Ashoo'pi akto
Angry	Kunook'too	Bad person	Il u'alok
Angry	Kununaro'ak	Badger	Seek sreek'puk
Angry	Eohemal'o	Bag	Ok kuh'shuk
Ankle	Se nung'keet	Bag of oil	Ot kek'to
Anoint	Mahos'rait	Bald	Solin'yot
Another	Mant'na	Baleen	Sho'kok
Another time	Munt'neago	Ball	Nukpah
Answer	Chug'aren	Ball, foot	Ok'arok
Ant	Tap'che	Ball (to wind)	Klu ga tok'tuk
Anvil	Og'ewik	Band	Na pwe ba'ta
Apartment	Isg'in	Bank	Kah ve'a
Apartment	Sin ik' awik	Bare	Oo te mer'o
Appetite	Ok ke'oak	Bare	Oo ting'aroa
Appropriated	Koo le'ana	Bark of dog	Mug'aru
Apron	Pat che gee'kootegah	Bark of tree	Kua shel'look
Apron	Cham'erah	Bark of tree	Kot tel'loo
Are	Mar'rn	Barnacle	Na koo'nok
Arm	Kat'cha	Barrel	Kottow'rnk
Around	Ootkweawk'to	Bashful	Tal uk'aatuk
Arrive	Ta ket'py	Basket	Kol'lu
Arrived	Te kik'took	Bass	Sho'oak

Bathe	Im uk'tuk	Blizzard	E re luk'choak
Batter	Ah koo'to	Block and tackle	An o'ko luk
Battle	Oongaye'o whik	Block and tackle	Na luke'e gah
Battle	Top a rek to it	Blood	Owk
Bay	Im uk'a srook	Blow breath	Chu blu ok'to
Bayou	Toak'kook	Blow nose	Kok ik'cho
Beach	Kah ok tuk'too it	Blow nose	Kok uktanga
Bead	Shung ow'ro	Blue	Tawk rek'to ak
Beak	Kob'a roon	Blue bird	Oo ke uk tow'ruk
Bean	Ko mor'ra	Blush	Ka rek pul'uk to
Bear, white	Nan'ook	Boat, open	Oo me'ak
Bear, brown	Og'alok	Boat, closed	Ky'ak
Bear, black	E yar'ok	Boil	Kol lek'to
Bear, cub	Tol'lu	Boil over	Pe too whok'to
Beard	Mug'wa	Bolt	Ke ka ok'tit
Beard	Kog la oo'tin	Bolt	Ke lu'ta
Beat	Tig lu rok'toak	Bone	Chal'nok
Beautiful	Ah re'gay	Bone, remove	Chal nok'cho
Beaver	Pah look'ta	Bonfire	Ek woil'aro
Bed	Oo'leet	Book	Mop po'gah
Bee	Ma loo gi'a sok	Book	Kal le'ket
Beetle	In'yok	Boot	Kum'ma
Beetle, water	Nah che'nok	Boot, bottom of sole	Che bo'a
Beggar	Oo ma gib'o	Boot, deer	Pin u'kuh
Behind	Pe chu ru'ik	Boot, deer	Nal lo'it
Believe	E che mal'o	Boot, long	Kom'muk-ip pwo'shuk
Bell	Ah kook'a look	Boot, long	Akooptik'ten
Belt	Tap'che	Boot, short	Ni ho'yet
Bend	Perik'a	Boot-heel	Kim me'a
Bend	Na wing'a way	Boot instep	Al lo'a
Bend not	Na wing'i chuk	Boot laces	Se ne'a
Berries	As she'a	Boot soles	At tung'a
Berries	A se'ret	Boot tap	Un'ye
Berries, dark	So'whot	Boot upper	Kong'a
Betrothed	We a kok'to	Border	Ok koo'ra
Between	Woon a ye'ok	Border	Al e greet'ko tah
Beyond	Attan'e	Bother	Shu goon na ah gah'tin
Big	Ong a ru'rum	Bottle	Toak a la yonk'to
Big, very	Ong a ruit	Bottle	Tok a la you tow'ruk
Bind	Chim'o ra	Bottle	Mish o ak'to
Birch	Ush'uk	Bottle, small	Mish o oak'tow ro
Birch	Oo re ge'lik	Bottom	Nat'kah
Bird	Ting me'ak	Bottom	Nab tah'ga
Bird	Kah'wa	Bow, to shoot	Pe shik'she
Birds	Ting me'ret	Bow, of a ship	She'wa
Bird's nest	Chap poo'te	Box	A upe'kot
Bird-snare	Se uk'setik	Box, small	A upe'karook
Birth	On'e rook	Box, very small	Soo loo gow'rook
Bite	King mok'tit	Boy	Il il'e gah
Bitter	Ah'kok	Boys	Il il e yar guk
Black	Tawk to'ak	Boy, half grown	Nugat pe gi'lo
Black	Mun ok'to ak	Bracelet	Tah e chet'ka
Black lead	Oo rok'sa ken	Bracelet	Ta'yuk
Black one	Tawk ta loo'ret	Bracelet	Tah e ah'ret
Black skin, whale	Muk'tuk	Bracelet	Ta yak'ret
Black skin, whale	Kah'tuk	Bracelet, bead	Tah yat chate
Black skin, whale	Muk'tung	Bracelet wire	Tal e gow'ro
Bladder	Nat kot'chu	Brain	Kok'e chuk
Black tanned leather	Se lung'ok	Brain	Kah ek'tok
Blade of steel	Chow we'ruk	Brant	Neg'a leh
Blanket	Oo lig'a ra	Brant	Luk lu'ik
Bleed	Owk'e to	Brass	Cha wil'rok
Blind	Tap pe'ko	Bread	Chu blu'ta
Blindfold	Nat tu'ga	Bread	Poon'ik
Blister	Poo'we	Bread, hard	Kok'o
Blister	E ku kum'a	Bread, hard	Kok'e lah

Break	Na whik'to	Cap, gun	E tik' a rook
Breakers	Ki ink'tak	Cap, gun	E shew eati'look
Breast	Me'look	Capsize, boat	Oo me ret
Breast of bird	Kov'ka	Capsize, sled	Koot me ret
Breathe	An uk ter ra'luk	Capsize, kyak	Ki ab'rook
Bridge	Im u ep'kwo tah	Capsize, kyak	Koen su're
Bright	Kep luk'to	Captain	Oo ma'lik
Bring	Kok'to	Carbine	Nah chuh'uk
Bring	Pro	Coronas	Se'lu
Brittle	Cho gok a luk'to ak	Cards	Kar'tok
Broken	Na whik'to it	Cards to pass	Pah chok'to
Broken, not	Na whing'o oho	Cards, to play	Keh
Broom	Til a hut'oho	Cards, diamonds	Too'ne
Broth	Im'akok	Cards, hearts	Blig'aruk
Brother	Il yug'a	Cards, clubs	Ah re gay'luk
Brother, elder	Nugat che'a	Cards, clubs	Se'klokt
Brother, younger	Nook'a	Cards, spades	Kop'poon
Brow	Kowung'a	Cards, ace	Choo'cha
Brown	Ka wek'su ruk	Cards, king	Kililileruk
Bruise	Owng'a	Cards, queen	Okan'ok
Bruise	Ah zhe'ak	Cards, jack	Ulilegak
Brush	Shun neok'tuk	Cards, tens, etc	Same as numerals
Bucket	Ko lip'se	Careful	E zw'ge
Bucket	Kot tow ruk	Carry	Irrarup'kah
Bucket	Kot'ogah	Carry together	Taseoak'took
Bucket	Ko lip'setik	Cartridge	Kok' a rek
Buckle	Kog'a oot	Cask	Ma'chuh
Bud	Kot me yung'oit	Catarrh	Nu'whuh
Bug	In'yuk	Catch	Ko hy'at
Bullet	Kok ru'a	Catch fish	Now yo'ok
Bullet-mold	Koo'vin	Cave	E ren'ik
Bull-head fish	Kob row ote sok	Celery, wild	Sas re'gall
Bump	Pe cho kok'to	Chafe	Po wit'to
Bundle	She'lute	Chain	Ke liv'ora
Buoy	Pooktow'te	Chain	Ka lim'na ret
Burn	Oo tuk'too	Chalk	Ka'te
Burn	Oo tet tin ate	Changing	Tak semuruk
Burning earth	E ka ma ro'a	Charcoal	Ow'mah
Burrow	Nip ter'uk	Charm, talisman	Ong'mah
Burnt	E lik se mer'uk	Chastise	Oo powtook'too
Bush, edible	Nowayoi'hut	Cheek	Oo loo raken
Bushes	Ok'pook	Chew	Tam o kot'ohea
Butt	To wy' ya	Chew of tobacco	O ko me'a
Butts	Mit ho' a lo	Children	Kon neek'toik
Button	Mit ho a lo'ret	Chim'ney	E shuh' awik
Butterfly	Tok a luk'a sah	Chim'ney	E che'a
Butterfly	Chah ah lin' a tuk	Chin	Tab lo' a
Butterfly	Chuk a mik' atok	Chin tattoo	Tab lao'tit
Butterfly pupa	Ow zre'ok	Chin labrets	Too'toka
Button	Too atow'ruk	Chisel	Keya'ek
Button-hole	Nokto'ak-we'lt	Choke	Se lan'a
Buy	Ah ke'a	Cham	Ah win'mate
Cache	Chuk a lo'uk	Chute	Tal in yet
Cache	Chek a lo'ne	Circle	Tuk kowrume
Calf of leg	Nagot shung'nok	Clam	Kah ve'atok
Calico	Atig'aloo	Clam	E va'lo
Call	Ot'kuh	Clam	Um mung'me
Call a person	Ka o'te	Claw	Konk ke'a
Call a person	Kah ko rah' ah	Clay	O'rak-iman'ok
Calm	An o'wa-po'luk	Clean	Oo tum'o
Can	Poke'evy	Cliff	Imp'nl
Cancer	Ahyo'a	Climb	Mi uketu'lt
Canvas-back duck	Un at keo'ya	Cloak, spotted	Koo neag-ahtag'a
Cap	Nash ow'a tak	Cloak, outer	Ahtig'a
Cap, gun	Kob lu'it	Cloak, inner	D u'park
Cap, gun	Kob'looat	Cloak, open	Shahi'uke-ahtig'a

Cloak, long	Tool'wah	Crab	Kok'kook
Cloak, short	Ah koo ey'took	Crab	Nig a rok'puk
Cloak, heavy	Chum o rek'to	Crab	E la hoyhayet
Cloak, put on	Atil'ago	Crack	Eon'neh
Cloak. put on	Oo e yug'aya	Crane	Tah tiz'a rok
Clock	Toak tuk to'ak	Crane tripod	Nog'a ruk
Close	Mahtwo'ret	Cranky person	Kig look to ak
Close	Periktok'totin	Craw	Poo ye'ga
Closet	Anok'awik	Craw	Poo ey'ak
Cloth	Ookwil' auk	Crazy	Ke nung'a ro a
Cloud	Kal'luk	Crazy	Til ki'yok
Cloudless	Kai lo'a chuk	Creek	Koog ru'rok
Cloudless	Kii la'luck	Crisp	E lek'se mer uk
Coal	Alo'a	Crook	Pah ret'a
Codfish	Kaloog'a ra	Crooked	Al o'ra
Coffin	Soo'loon	Crooked, very	Nal lo'ret
Cohabit	Koo ya goo'tin	Cross, upright piece	Nuk per'uk
Coil	Og a la now'ra	Cross-bar	Oon na ahed'nor uk
Cold	Al a pah'	Cross-bow	Sat koo'lik
Cold, intense	Al a pak'took	Crossing	Nok toh leti'choa
Colic	Nok'a-e'lun	Crossing	Nok tok'to a
Collar bone	Ke too'ka	Crown	Kob ro'a
Comb	E la u'te	Crush	On wok'to
Come	Ky'le	Crush	Oo lu'ga
Come	Ki'wa	Cry	Ke a rook
Come not	Ki ne'tuk	Cub	Ab a ro tal'ik
Come in	E chuck a' tin	Cuff	Shuk a mit'ka
Come in, may I	E chuk a lum'a	Cup	Kale gow'ro
Coming	Ky'ro	Cup	Im u gow'ro
Coming, is not	An nun neak'to	Curlew	Shoo oop'toak
Coming, they are	Kyle ang'a	Curse	Tow'yok-sing oon'a
Coming after	Ki'ret-tum ah'rah	Curve	Mung o chuk
Coming home	Ki ne ak'to	Cut	In'yo
Companion	Ang'yow	Cut with woman's	
Compass, may	Oo'muh	knife	Oo loo ra'me
Compass, may	Tok to'ro	Cut with knife	Chow we'tuk
Compasses, dividers	Ko ka re'tik	Cut with scissors	Chal'e gah
Completed	Oo gin uk'tuk	Cut up, I	E rok se lung a
Comrade	Ong'yow	Cut you	E rok se lu'tin
Concert	Sow yok'to it	Daffodil	Ma lu kut'tow ro
Confirm	Kan uk'ra	Dam	Pal uk tit
Congratulate	Ko ya'rook	Damp	Mok'luk
Consumed	Nu woot'ka	Dance	Po al'a rah
Consumed	Nu mer'o	Dance	Po a'la ra
Continue	Og lan'i tuk	Dance of exhaustion	It kil e ah'ro
Cook	Egah ro'a	Dark	Tawk to ak
Cooking	Oot koo'che	Dark, very	Tawk to ak'puk
Cooked	Oot kah	Darken	Tawk too'tin
Copper	Ke noo'yok	Darken	Tal'nok
Cord	Ok lu'nok	Darling	Na koo she ak'to
Cormorant	Kong a yo'kok	Dart	Na le'gah
Corn, bunion	Unt'moke	Daughter	Pun'a
Corral	Kong'o vok	Daughter	Pun e'a
Correct	Ong ek'to	Day	Oo blu'puk
Correct	Nu e gal lo'a	Daylight	Oo bluke
Cotton grass	Pod la'rok	Dead	Toak'o ro
Cotton grass	Pola ra	Dead	Noon'a sin'ik
Cotton stalk	Na ka-a ro'it	Deaf	Tos luk'tuk
Cottonwood	Nin'ook	Deal	Ow'tin
Cough	Kee ik chu	Deep	E tik til ang'a
Cough	Noo wah	Deep	E shoo to
Count	Ki pert ke ge	Deer	Too too
Courageous	Kina a to a	Deer winter	Oo ke n'lik
Cousin	Unakutea	Deer, summer	Oo pun rah me
Cover	Met to'a	Deer, white	Koo ne'ag
Crab	Po ju ba ak	Deer, young	No'whok

Deer horns	Nog'ar uk	Drill mouth-piece	Nek'ara
Deer, back	Pung'nek	Drink	Im uk'to
Deer, running	Pan ei ik'to	Drink	E cho'ga
Deer fat	Kowa'ok	Dripping	Koo'chuk
Deer excrement	On'nite	Drop	Ir upe kah ah
Delicacy	Too ping'a	Dropped	Ir upe kwok'to
Departed	Ah wik to'ak	Drowsy	E yah ara rung'nah
Depopulated	Noon a re'a	Drum	Sow yung' a
Depth	E tip chung'a	Drum	Sow'yok
Desert	Okok cho re cho'a	Drum	Kil' yown
Doubt	At'a	Drum-stick	Moom wa' a
Devil	Toon rok	Drunk	Iman'a-aktung'a
Did	Tus'ra	Duck, widgeon	An a ve'a
Difficult	Shung'e rook	Duck, crowbill	Ot'pah
Dig	Kah ve ok'to a	Duck, eider	A mow'lik
Dig with pick	Se kiokt o'a	Duck, eider	Me'tik
Dipper	Kel'la	Duck, eider king	King' a lik
Dipper	Ky'uta	Duck, young	Ok peen'ik
Dipper	Im o'ga	Dull	E pik'tuk
Dipper	Kol'let	Dust	Cho plok'towah
Dirty	Wah'ak	Duster	Til a hut/cho
Dirty, not	Waa'e cho	Dwarf	Inu'vok-utting'ok
Disappeared	Pe yik'tin	Dye, red	E nung ne'ak
Dislike	Oo me shook'too	Eagle	Ting me ak'pak
Distant	Ah'pi	Ear	Se'tik
Distemper	Mul a kul'a ro	Ear of animal	Se ake'tat
Divide	Ah voo ga'wah	Ear-ring	Poo'too
Divorce	Chav o' a	Earth	Noon'a
Dizzy	E ring'ru rok	Earthquake	Noon'a-koo pe'ruk
Do	Po la'ruk	Earthquake	E boo re'a
Do it	Ke'a	East	Ki wunt'nuk
Down	Nat koh'a lik	East	Ke vnag' nuk
Down here	Ta kun' a	East	Pah mung'nah
Do you know?	Il u weet so'a	Eat	Ne ah'srook
Dock (vegetable)	Al lu'e kut	Eat	Now a yok'to
Dock (vegetable)	Ko ut'le rok	Eat	Nek a yok'to
Dock (vegetable)	Kaw'kut	Eat, wish to	E ying'ye ok
Dock, small	Eat'pik	Edge of a board	Ege le'kret
Dock, small	Su'rel	Edge of a blade	Ke eng ñ ung'a
Doctor	Un at'koot	Eel	Kob loy'ek
Doctor-house	Un at koo'a	Eight	Ping i'ahu-okving'i le
Doctor-house	Ungah u luk'it	Elastic	In u pe'a
Dog	King' mok	Elastic	Kush'ak
Dog pup	King mesh'rook	Elbow	E koo obe'ga
Dog pup	Ke moo'good	Empty	Noo woot'ka
Doll	In une'wok	Enclente	Nar a chok'to
Dome	Tus'ra vah	End	E'chook
Don't know	At'chu	End	E cho'a
Don't know	Kan o'me	Endway	Tal ing'nara
Door	Mopto'rok	Enemy	Tal oke'ne rak
Door-mat	Al o kle'on	Enemies	Tal loke'whate
Dorsal fin	Chung ho	Engine	Ow la'ta
Double	Ta pete'tok	Enough	Tus'ra
Down	Nat koh'alik	Enough	As in'o
Down here	Ta kun'a	Ensnare	Se uk sow'te tik
Down there	Kah vau'a	Enter	E chum'a
Down in	Shum mun'a	Entered	E chuh'in
Drag	Oo ne ah'ah	Entering	Ko he'wik
Draw or write	Og'a late	Entrails	Il gow'we
Drawers	Alik'sok	Erase	Oo le'rok
Dream	Senatoaktoo'na	Even	Ah le mes're geek
Dream	Oo ye go'a ya	Evening	A koo'puk
Dried	Panek'ta	Evening star	Num'nek
Drift	Teep'aret	Every one	Il u hut'in
Drill	Ne uk'toon	Exceedingly	Ok too' ret
Drill-handle	Pe ahik'ee rok	Excellent	Na koo pe yak'to

Excrement	On'ok	Fish-pole	A bah lu ha'ta
Excrement	Pook shak'tak	Fish-pole	Mun'ok
Exhort	Kat chug'a	Fish-net	Ko'bra
Extinguished	Kom mit'kon	Fissure	Oak sung'ok
Eye	E'rit	Five	Tal'e ma
Eyebrow	Kob lu'it	Five of them	Tal e man'ik
Eyelid	Kim me go it	Flag	Tok'o yo
Eye, open	E'rit oo' chuk	Flag	Ow let'ka
Eye-glasses	Ere'gak	Flag	E la'le
Eye of a needle	E'gra	Flag-pole	Na poy'oke
Face	Ke'nowk	Flame	E pir a ve'a
Fade	E chook'to a	Flapping	Se ek ru it'tu it
Fail	Pe uk'pah	Flat	E la'che
Failed	Pe uk'to ak	Flattened	E la tam'ne
Fall	Ki yaw'ro	Flaw	E ke che'tit
Fall over	O lo'rok	Flea	Puk la ya'ok
Family	Nal ma'at	Flesh	Nek'a
Fan	Pat koo tak'took	Flint	Kook'shook
Far	Oon a sik'took	Flint	Koo wuk'sruk
Fast	Shuk a sho'a rone	Flint-scraper	Ung'mah
Fasten	Nu o go ty'cho	Flint-dresser	Kig le
Fat	Ook'sruk	Flipper	Chit'kwo
Fat person	Ko in' u rook	Flirt	Ang a chuk a chuk'cho a
Father	Ah'pa	Floor	Nat'tah
Father-in-law	Ong a yo kong'ek	Floor	Nat cheet
Fathom	E chung'neh	Flour	Noo kah'ah
Fear	Hab'neta	Flour	Ky u cha'ok
Fear	E ta'rok	Flower	Me lu kut'a
Feared	E kche'ak	Flukes	Chok'puk
Feather	Mut koo'a	Flukes	Ah ki'chung
Feather	Mit koon'ik	Flute, with teeth	Ke'ret
Fool	Tap pa'choke	Flute, with needle	Mun ek'chuk
Feet	E te' gite	Fly	A nok'luk
Feldspar	Al le' gro	Fly	Na lu'ga ret
Female	Ok an'ok	Fly, blue-bottle	Oob a u'buk
Few	Ame ok'tua	Fly, blue-bottle	Nib a u'buk
Fight	Tig a lo'a	Fly, v.	Ting'a ro
File	Pin yah a go'ra	Foam	Kap oot'lok
File	Pe now'gan	Fog	Tap tik'to
File	Pin yow'a	Fog	Tap took'took
File	Ah yeh'ok	Fog-horn	Kook ti'took
File	Ag e ak'tua	Foggy, is	Tap shu'a why
Filing	Pin yowk'toong a	Following	Tum'e rah
Fin	Tal ik hu' it	Fool	Tit ki'ok
Find	Pah ket'kega	Foolish	Ke nung ok'to
Find not	Pat chu ang'a	Foot	Tig go'tit
Fine weather	Nip tok'took	For	Oon el'o
Finger 1	Tik'eh	Foreign	In u pe'a
Finger 2	Ka tek'a lik	Forget	Po woke'to
Finger 3	Mik'e lik	Fork	Na'crano
Finger 4	E tik'kook	Fork, table	Kok ez'rit
Finger, thumb	Koob'loo	Fork, table	Koo ke'it
Finger-nails	Ku kweet	Fork, creek	Kong'een
Finger-joints	Im u lu'ra	Four	So sam'at
Finished	Tuz ra'va	Four of them	Se saman'ik
Finished, not	Tul ven'e cho	Fox, blue	Ke en rok'tu ru
Fir	Na pak too'it	Fox, red	Ky uke'to
Fir	Ke ru'pe ak	Fox, white	Koosh'kok
Fir	Oo nok'set	Fox, white	Pe koosh'kok
Fir	Pin' yuk	Fox, white	Ko re'gah
Fire	Ik'nek	Fox, white	Te re in'do a
Fire-place	Ik nek'awik	Fox, cross	Ki en'rak
Fish	Ah kal'look	Fox, cross	E lav'ret
Fishes	Ah kal'lni	Fox, silver-black	Ker en uk'tuk
Fish-hook	Nik'shik	Fox, silver black	Tin'oop
Fish-line	E po tung'a	Freezing	Kok it ke gah'tin

English	Eskimo	English	Eskimo
Fresh	Ke la'gra	Good	Na koo'na
Friend	Hai gi'fa	Good, not	Ne kwe'ahuk
Fringes	Ke ok tow'ra	Goose, black	Lik lin now're
Fringes, skin	Kig er ah teet'ka	Goose, white	Kang'eet
Fringes of hood	E obeb'a wik	Gooseberry	Lak u o yak e reek
From	Ah wan'o	Gossip	Ne yut'e ro it
Front	Am o'kwol	Grampus, white	She to'ak
Frost	Ah'poon	Grampus, white	She aho'ak
Frost-bite	Ke ret'to gah	Grandfather	Toe ti le'a
Frost-bite	E sre ko'ak	Grandmother	At ti'leo
Frost fish	Kai koo'ret	Graphite	Tu ke re mo'tok
Frost fish	Kal-o'at	Graphite	O rok'aa kow
Frown	Kun u le'rok	Graphite	Min'tne
Frozen	Kwawk	Grass	Pe nik srait
Frozen	Se ka me'ruk	Grave	Kom'moke
Frozen mist	Tat'too	Grave	Kom'mook
Frozen limb	Ke ret'ta	Gravel	Kah oe'a
Fry	Pe shik che lok'to ak	Great bear (ursus majoris)	Too a tow'rak
Frying-pan	Pah shik'che tan	Green	Shung ok'to ak
Fugitive	Oit la'rok	Grindstone	Ah ge'ok
Full	Seel a wik'to	Grindstone	Me u'it
Fall of life	Ah kim nok'to ak	Grip	Ah sre gug'luk to ak
Fun	Koo'in	Gristle	Na tak ko'ak
Future	Oo blak'o	Groin	Na wik kung'a
Gale	An o wa'kah	Grooved	Ko'kut
Gale	An o wu'wah	Grow	Og lan a ok'to
Gall	Shung'wah	Grow	Now're
Gall	Sung'ah	Gull, black (jaeger)	E chang'mok
Gap	Chow'ne	Gull, black head	Kook'a ru
Gargle	Oo o al'ego	Gull (burgomaster)	Now'yak
Gasp	Nug a hok'to ak	Gull, black-tip wings	Nat chan a har'e
Genial	Ah nu na cho'ak	Gull, young	Cha ret'ke ga
Gesture	Wam it'in	Gums	E kit'ke
Get	Pol'e go	Gun	Shu'peon
Get out	Owk'ea lah	Gun, 44 Winchester	Cha wil'ik
Get out	Oo ma shook'toong a	Gun, 45 Winchester	Cha wil'ik pak
Get out	Chu ru ok'o ne	Gun, 45 Hotchkiss	A now ti'lek
Get out	Oo ma gib'o	Gun, rimfire, Henry	E ke me a'lik
Ghost	Ek che ro'a	Gun, Sharp's	Oo cheo rek'la
Ghost	Too noo ri'ok	Gun, carbine	Ni shu'rn
Giant	Kil'le	Gun, shot-gun	Kok a poy ok'toon
Giggle	Ig lat o'ro a	Gun, shot-gun	Mon ya la rek'toon
Gill	Mur'aho	Gun, shot-gun, Russian	Shoo poot a gew're
Girl	Nu ge uk'suk	Gun, firing pin	Oo shuk shug'a
Girl	Ok an ow'rok	Gun barrel	Shoop ru'a
Give	I'took	Gun barrel	Toob lee'a
Give me	I che'me	Gun cover	Shoo poo'te-po'gah
Give back	Kol u'na	Gun extractor	Nik she ag'a
Give, I	Ong e goo'tin	Gun guard	Kok a la go'ra
Gizzard	Nat moo'ta	Gun hammer	A now tung a
Glad	Pel let to ro'ak	Gun hammer	Ka roo'tuk
Glass	Mik o ok'to ak	Gun magazine	Alo rung'a
Glow-worm	Peo gwok so a hoy'ak	Gun mussle	Pung'a
Glove	Ah sre gite	Gun nipple	Chu plu'ru
Gluttony	Mup po wa'ga	Gun ramrod	Pow la'yo
Gnarled	Pow a wek'to	Gun sight	Lah low tig'a tow
Gnash	We la'ruk	Gun sight, hind	Muk tow go'tow
Gnaies	Ook a ru'rok	Gun spring	Pe shik she'rok
Gnaies	Ka'te	Gun stock	Ke ru'a
Go	Ah yok'to	Gun trigger	Pok e yung'a
Go back	I me ak'to	Gun wad	Me lig'a rok
Going, I am	Ah yung ne ak'to	Hair, of head	Nu'ya
Going inland	Pan uang ne ak'to	Hair, of animal	Mit'koon
Going, we are	Ah lang ne ak'to	Hair, of body	Ting'e
Going home	Ah nun ne ak'te go		
Gone	Ah lok'to		

Half	Ah wig a luk'puk	Hill	Fhet
Half	Attun'e a wig a luk'pak	Hill	Ye o'net
Half	Ko pin'na yak	Hip	Kat pug' a
Half	Ko'pah	Hip	Che ve ah'ga
Half of a thing	Iglupe'a	Hip	Ko'che
Hammer	Kow woo'te	His	E'lan
Hammer	Kowt	Hiss	Oo sing'a lo
Hammer	Kuz ru'tok	Hit	Tig a look'a
Hammer	Kuz'ruto	Hoisted	Pan'a
Hand	Ah re'gite	Hold	Tig u'ga
Hand in hand	Tasse oak'took	Hold	Te u'ga
Hand to me	Tam ut'che	Hole	Poo to'a
Handle, v.	Te kume ve'a	Hole, torn	A lik'tik
Handle of knife	U poo'zruk	Hole, torn	Al'eh
Handle of ax	U po'a	Hole in ground	Nip ter'uk
Handle of scraper	Ool ge'lik	Honest	Tig a ute'chah
Handsome	Se tang'e rook	Hood	Nash'oon
Hand	Ne win nok'took	Hoof	Mik'a
Hang up	Kok it' kah	Hook	Kok a zru'ok
Happy	Koo yel goo'chetin	Hop	Now ye rok'tuk
Hard	Te ck'to ak	Horizon	Al on'ok
Hard wood	Eek'kik	Hot	Oo nok'te
Hare	Oo kal'ik	House	Ig a lu
Harlot	Chung uk'too rooka	House traders	Ig a lu'puk
Harness	An' oot	House, summer	Too'pik
Harpoon	Ka el'ro	How	Kom'mo
Has	Ta kum'a-pe'gah	How much or many	Kap sin'ik
Has been	Ta kum'a-se mer'uk	Howl	Ma goo'ruk
Hasten	Ok a yok'e a yoo	Hug	Ye kik'a
Hat	Nash a to'cha	Hungry	Ne ar a chuk toong' a
Hatch	Pa'ya	Hungry	Na ka chuk'loon a
Hatchet	Oo le ma gow'rok	Hungry	Kah' cha
Hatchet	Kot la pow'ruk	Hungry	Kah'tu'a
Hate	Oo me chook'too	Hunter	Too we'ket
Hatred	Ton yo yok'tu tin	Hurry	Shuk kel'ly
Have	Kok'tit	Hurry	Shup kwer'uk
Hawk, grouse	Kiz ra gow'ik	Hurt	Ar'ah
Hawk, marmot	Kil'ruk	Hurt	Nin nok'to
Hawk, marmot	Kil'reh	Hut	Too puk'a rook
Hawk, bird	Kiz ra gowik'ok	Husband	Oo wing'a
Haze, tease	Nn ve ro'lt	Husband	Oo we'ga
Hazy	Nip ti'luk	I	Oo wung'a
He	E'lah	I have	Kok'it-ko'ne
Head	No a ko'ko	I am uncertain	Kan o'me
Headache	Ana nok'tu	Ice	Se'ku
Hear	Te shi'ro	Ice-cream	Al lupe'to ak
Heart	Oo'mun	Ice pike	Toag
Heart	Oo mut'a	Ice pressure	E boo ro'ak
Heart	Oo ma'ta	Ice scratcher	Az'e gown
Heart-burn	Kun nok'to ak	Ice flaw	E ke che'tet
Heaven	Kong'ook	Icicle	Koo choo'le gah
Heaven	Kong'o	Idle	Sava ak'choong toong a
Heavy	Oko mi'chuk	Ill-tempered	Kap zha'rook
Heel	King mik' a	Immovable	Sin'ik
Hell	To koad'rook	In	Kah mun'a
Help	Pn wat'ing	Indifferent	Shung'e cho
Help	Nu lu whok'to	Intercourse	Kooeg'alu pe'lu
Hen	Ok un a sel la	Intercourse	Koo va goo'ta
Her	E'la	Intercourse	Ko ke ko ag'a lo
Hers	eel'yat	Inside	Il yo'ne
Here	Ta man's	Inverted	Le'rek
Here now	Muz'ta	Iron or steel	Chow'wik
How	Oo loo ma ro'a	Is for	Oon'a
Hiccough	E choop'cha look to	It is there	Tuz'ra ok'pe
High	Muk a chan'a	Island	Ka kek'tah
High towering	King ik'took	It	E'lah

It	Ook'wah	Large	Ong a sru'rum
It is	Pe la'ruk	Larva	Ow ya'ruk
It is done	Tus ra'va	Lashings	No ming'a
It is snowing	Kosik'takah	Later	Mum ne'a go
It was	Musrugo'a	Laugh	Ig'a lok
Itch	Kil'ye	Laughing	Ig a lok'to
Jab	To sk'te	Lazy	E ka chook'toong a
Jade	Kek sook'to	Lead, v.	Tak sew'wa
Jar	Ke ho'wik	Lead, n.	Kok a ru'ruk
Jaw	Tam o whetik	Lead	O'whok
Jaw	Wan eto'ak	Leaf	Ma loo'ga tuk
Jealous	Chung nayek'to	Leaf fat	Kown'ah
Jelly-fish	Ippeah'ro	Leaf tobacco	Keo ver a'cho
Joint	Am na ga	Leaf tobacco, long	Shu rok a ro'me
Jump	Minutok'to	Leaf tobacco, Russian	To oak a po'a
Jump up and down	On u a wetok'to	Leak	Oo wim'a gow
Keep time	Ah moo tin	Lean person	Pun now'ro
Kettle	Oo koo che'te	Leaning	Ki ye'ro
Key	Ke loo chuk	Leap	Niah o gok'tuk
Kick	Ah rok'to	Leather	Ah koh'a le grok
Kidney	Dokto'a	Leave	An ning
Killed	To akto'me	Leer	E ret keet'ka
Killed	Sboak er'o	Left	Kun nes're se
Killed	Ta koot'ka	Leg	Nuke
Kiss	Ke ma ke'ta	Lend	Ah tuk'to a
Kitchen	E'jah	Let go	E pe'gown
Kite	Pa room'a	Let go	E pung'a
Knee	Muk'luk	Level	Mum ok'to
Knee	Nob a lute'ka	Lever	Ka pe'go an
Kneel	Chate kong'aroa	Lever	E pook'ta
Knee-pan	Chate ko'a	Lick	Al look to'a
Knife	Chow'wik	Lie	Chuk'loo
Knife, woman's	Oo loo'ra	Lie, I	Chuk lu ru'ne
Knife, pocket	Pinu'tok	Lie, you	Chuk lu'rutin
Knife, pocket	Pinyuktow'ro	Lie, not	Chuk loo'ne cho
Knife, pocket	Pin ek'ta	Lie down	In ok'to
Knife, pocket	Tob a ta'too	Lie down to sleep	Sin ik shok'to
Knife, pocket	Tapik topto'a	Lift	Ke wik'a
Knife, skinning	Kavingaro'a	Lift me	Ke win me gah'me
Knife-cut	Chow wik'tuk	Light	Ik ne a'to
Knock	Tik'loo	Light weight	O ka ohu'ruk
Knot	Kal luk'in	Light, very	Wolt tuk
Knot	Il ik'a	Light, very	Wolt tu row'nek
Knot in tree	Ah kweh'a	Light, very	Ka na ak se ruk
Knot in tree	Ek'aro	Lightning	Ik'nek
Know	Il eeeh o mug'egah	Limb	Ah a yate
Know not	Nel a ru'a	Limber	Tik sow'min e luk
Know not	Nel a we'ga	Limp	Shu shog ip pok'to
Knuckle	Ne gib'li boy	Line rope	Ok lu'nah
Labrets	Tov'toka	Living	Il u pah ung'a
Ladder	Meu how'te	Lip	Kok a lo'a
Ladle	Kok'aro	Listen	Ah tut'a
Ladle	Kog a ruru'ma	Little	Min ig srum'ik
Lagoon	Tash'uk	Little	Mik a sru'rum
Lake	Nasra'vok	Live	In yo'rok
Lake, large	Na'peck	Live	An uk'toot
Lame	Ship shi'lok	Live	Yoke'a lu
Lamenting	Ke a ro'a	Liver	Tin'ook
Lamp	Nan'uk	Lock	Ah yoke'kwoik
Lamp chimney	Kow look'in	Lofty	King ik'took
Lance	Ke la tak'too.	Loins	Pe'kwah
Land	Noon'a	Lonesome	Il o ah'rook
Land otter	Pum ma uk'tuk	Long	Tuk'a srook
Lap	Kok to kok'e	Loom, of an object	Oo'weet
Lard	Ook'a ruk	Loon	Kok an'it
Large	Ong a sro'ak	Loon	Kok a ro'it

Loon king	Too'lik	Mitten	Ite kot e ka
Lost	Tam uk to'a	Mitten	Ite'kun
Lost	Pat che ang'a	Mole, lemming	A win'yate
Lost, not	Pat kon e'cho	Mole, pimple	Oup'tuk
Loud	Nip'pe	Monkey-wrench	Ore'yowk
Louse	Koo'maik	Month } Moon }	Tat keh
Love, I	Na ko og'a ra		
Love, you	Na ko ag a gin	Moon, new	Nu boll'a ne
Lump	Ok lum'ok	Moon, first quarter	Now ak'tuk
Lung	Poo'walh	Moon, full	Ini ng e lik tik'toa
Lustful	Pal ig er ak tow'tin	Moon, last quarter	Ke mook'to
Lynx	Nu to'ya	Moon, old	Tat ke lang'ne ak cho
Mad	Kin nung'a ro a	Moon, 1st phase	Oo'me ang oo'te
Mad	Kun ook'too	Moon, 2d phase	Ab a tok'pa
Maggot	Koo maik	Moon, 3d phase	Oo leet'took
Magnifying glass	Kin u gah'ro	Moon, 4th phase	Oo me a-h lok'te
Maid	Nu le ak che'a	Moose	Too to'kwok
Make	Sa vak'to	More	Shu'lay
Male	Ong'oon	Morning	Ah koh'go
Male	A'yoon	Morning star	Og'a ro
Mammoth } Mastodon }	Ke lig'a buk	Morsel	Chu lu pe'to ak
		Mosquito	Kik to'ate
Mastodon ivory	Ke lig kom nok se go'a	Mosquito, long	Nu e yok'a rook
Man, native	In'uko	Moss, sea	Nuva ra ke
Man, white	Na lah'mute	Moss, fuel	Mon'eak
Man, white	Tan'ik	Moss, reindeer	Oo mee'hat
Man, white	Kob loo'na	Moss, reindeer	Ne'kaht
Man, negro	Tawk ta loo'rum	Moss, berry	So'whot
Man, old	Ong a yo kog'nek	Moth	Mal u'ge uk
Man, native, plural	In'weet	Mother	Ah'ka
Marline-spike	E zro'gown	Mother	Ah kah'ga
Marmot	Soek'sreek	Mother-in-law	Ong ung'uk
Marrow	Pot'ka	Motion	Ow la tin
Marrow of bone	Pot ka tel'nok	Mountain	E'het
Marry	Pig'a	Mountain	Oo'men
Marry	Nu le owk'kel owk to	Mountain sheep	Imp na'ok
Marten	Kap we to'ak	Mountain sheep	Too too imp'ni
Mask	Ke'nowk	Mouse, brown	Poo kook'tit
Mast	Napak'tit	Mouse, brindle	Ke lon mu'tik
Mat	Tep kal'nate	Mouse, gray	Oo gru'nok
Matches	E koo'tit	Mouth	Kal oo'kin
Match safe	E koo te'ra	Move	Ol la'ro
Mate	E ga'lu	Move off	Ow lum'e
Mate	Ni pung'a	Multitude	In u ba ook'took
Mattress	E kib'era	Mushroom	Ah yo'ok
Me, mine	Oo wung'a	Mushroom	Ah re gah'on yok
Measure	Oo rah'ah	Music	Yaw hoo'te
Meat	Nok'a	Music	Ah tut e gal uit
Melt	Ow'ka	Mus. instrument	Ah tuk'atong
Men	In'weet	Mus. instrument	Ah tuktoo'ra
Menses	Og lek to'ak	Musk-ox	Oo nung'mong
Menses, excessive	Ong eg a ro'a	Musk-rat	Kep gal'lupe
Menses, excessive	Oz re ke ru'vuk	Muslin	Naz ra'vok
Meteor	E ga'tah	Mussel	Ah ve'ok
Meteor	E ga'nek	Mussel	Ah'ayok
Mica	Al'e go	Mustache	Oo muktin'e
Mid-night sun	Ne pe leak'shek	Mustache	Oo ne'nek
Mineral, red	We'chok	Muzzle	Oo brow tit
Mink	Te te ak'puk	My place	Oo wapin'la
Mirage	Oo weet che'a	My xne	Ko pal'nk
Mirage	In ip koh ah	Nail	Ke ka ik
Mirage	Ne upe kok'to	Naked	Ting ung'a
Mirror	Tah oo to'a	Name	Ot'kuh
Mislaid	Sha nit'to	Name	In'a le
Miss	Ne la'to	Narrow	Oktoo'ret
Mitten	Ot kot'ek a	Naval	Kol'echo

Near	Kenik'to	Old woman	Ok a u og'a rook
Near	Kaz ntu'ra	On	We
Neck	Kong asho'nek	On	In im ne'a
Neck	Kong ik sho veeng'a gah	One	A tow'shek
Need	Pe shook kel awk'to	One of them	A tow'sho me
Needle	Mit'koon	Onion	New yate
Needle	Mitkoot'agana	Onion	Teo pis too'n ik
Needle-glovers	Pan el'uk	Only	Ke sho'me
Needle-glovers, fine	An mik cho'a	Open	Oo moo ey'kluk
Needle-glovers, large	Sho lik to'a	Open	Oo me uk'kuk
Needle, round, fine	Ko og'ralik	Open	E ta'ka
Needle, round, large	Ko og sreet'tou ik	Opera-glass	E rok'a ro
Needle-case	E ya me'ga	Opera-glass	Kia u ok'tak
Needle-case	Oo shum'ok	Opposite	Matte'roo
Needle-cushion	Too'loo	Orca (killer)	Ah'a lute
Negative	Ne gang'a	Orphan	Il e ah'a rook
Neglect	Much amok'to	Ostracise	Enmero'a
Nephrite	Echig'nok	Other	Ot'ia
Nerve	Oto'uke	Oars	Oo wung'a loo
Net	Ko'bra	Out	On'e ra
Nettle-rash	Pia u roo'a	Out of the light	Pe yik'ia
New	Nu'tok	Outside	Kong ing'a
Night	Oong nah'puk	Outside of house	Seal'a mon
Night	Oong'nah	Outside of house	Seal ya tan'a
Nights	Oo noo'nek	Over	Ko ling'a ok
Nine	Ko ling otali'a	Overcloak	Kup'e tok
Nipple	Ne loong'a	Owl, white	Ook'peek
Nit	Ik'kik	Owl, young	Ook pe'gi lo
No	Nah'ga	Owl, brown	Ik na se'ik
No, will not	Pe'chuk	Owl, brown	Ik na sa a hoy'ik
No more	Pi luk'tak	Owl, long ears	Too ta'u lat
Nod	Na yang'a	Owl, small brown	Ah'tok
Nodding	Na yang okto	Paddle	An oo'tit
Noise	Ah yo'mauy	Paddle	Ok'o
None	Pete pa la'ruk	Paddle	Ak'kson
None	Peto pi'ruk	Paddle	Ong a wok'to
None	Pa ne'latin	Pain	An nu'tok
North	Ne'ga	Paint	Na'neon
North	Ne'yak	Pair	Tak er o'a
Nose	King ok'a	Pale	Me cheet cho'uk
Nose, big	Moong a kok'te ro a	Palm	Oo too'muk
Nostril	Natut kwo'a	Pan	Pin'u loo
Not anything	Pete pe yak'to	Pantaloons	Kum'a
Not desired	Pa chung'e cho	Pantaloons	Nel a kow'ruk
Not enough	Ne kip eak'to	Pantaloons, short	Kok'le
Not enough	Mok lu'it	Pantaloons, woman's	She'ra loag
Not good	Po'lu	Paper	Mep'pe gite
Not here	Pe'ink	Paper	Og a la nok
Notch	Ke pil a gang'a	Parsnip, wild	Mush'o
Now	I'uk mum'my	Pass (in mountains)	Im ate'kon
Now	Puk'mah	Past ages	Hi pah'ne
New here	Mun'e	Pastime	Hi pah'go
Nozzle	Koo'vwa	Path	Too'mit
Nurse	Tig a mu ah'ga	Pearl	Im aik'to ak
Oar	E poo'ta	Pelvis	Hing'i
Ocean	Oo aa'ne	Pencil	Og la'nah
Ocean	Toy o'no	Pencil	Og'lown
Of	A'go	Peninsula, Alaskan	Im ah'ok
Off	Pah'ne	Pepper	Ken yak'roon
Off	Au	Perched	Me'tah
Oil	Ook a rook	Periwinkle	Ha goo'na
Oil	Ook'aruk	Phalarope	Ok vil a tum'ik
Oil stove	Ko lip cheh'a wik	Phalarope	Chav'ok
Old thing	Oo too'kok	Phalarope	Owg ro'a
Old man	Ong a yo kog'ara	Pick (tool)	Se kickt

Pick up	Tig a shu'rok	Present	Pig'a ren
Pickle	Kong'a look	Press	Nat kut'ka
Picture	Og'a late	Pretty	Ah re'ga
Piece	Ow e'ka	Prickly	Ip kol nok'to
Pieces	Ap woak'to	Primers	Ik na grum'ik
Pike (fish)	She	Ptarmigan	Kah'way
Pike (fish)	She'oak	Ptarmigan	O kos're gaik pe ah'rook
Piling up	E roo voo'ak	Ptarmigan, hooded	Ok os re gew'ik
Piling	E be'ruk	Puberty	Wing ik to'ak
Pill	Il u'oon	Puffin	Ke lung'ok
Pillow	Ah'kin	Pull	Nook a ta'ya
Pimple	Kig'lik	Pull	Che ung'a roo
Pincers	Kom'e gown	Punch (rivet)	Ke ka gown
Pinch	Pe u'ka	Punk	Ap pi'to
Pinch	Hoo moo ok'to ak	Pup	King me ah'rook
Pin feather	Maw'na	Pup	Ke moo'good
Pipe	Cha'nok	Purple	Tung uk'to ak
Pipe	Che na'ya	Pursuers	O nik'kik
Pipe, fancy	Ko in'yok	Push	Shoo poo loo'a
Pipe cleaner	Chu ba la'ta	Put	Shum'na
Pitch or toss	Nah lu'kate	Pyrite	Ik' nek
Plait	Pil gi'rok	Quack	Ka toak'kook
Plane	E'koon	Quick	Kel a man'ik
Plane	E luk too'ak	Quill	Te tak zro'gah
Planing-knife	Mik'lik	Quit	At'a
Planing-knife	Ky u'ta	Radish, wild	Kwik'nek
Platform	E keh'geet	Raft	Koo a whok'tit
Play	Al lay chook'toong a	Rain	She la'look
Plenty	Am a lok'tuk	Rainbow	Too loo'muk
Plenty	Am a li'tuk	Rainbow	Oov wan'uk
Plover	Nashat to ol'ik	Rainbow	Chaw'ne
Plover	E rez'go vraik	Raining	She la look'to
Plover, black belly	E lak tel'ik	Raise	Mi uke'to
Pocket	Ek'a we	Ramrod	Pow la'yo
Pocket	Eag a we'e kin	Rapid	Kel u ro'ak
Pocket	Kaw ma we'it	Rapids	Tap ka'nite
Point, n.	Tig a rah'ah	Raven	Too loo'a
Point, v.	Ong a na'nok	Raw	Ah ook'chook to a
Poise	Pe took kah'took	Razor	Pik cho'in
Poke (air bag)	Tog a ro'pok	Read	Chah ok'tuk
Poko (air bag)	Ab a tok'puk	Ready	Ah min'oft
Poke (air bag, whale)	Ah wuk tok'puk	Recently	Ikth'vok
Poke (air bag)	Pook'aruk	Receptacle	Poag'rn
Polo	Az u tok'to	Red	Ka rek cho'ak
Poor person	Il eak'puk	Reflection	Ta kung'a
Poor person	Il eak'chuk	Reflection	Tok'ba
Poor flesh	Pan uk too'tin	Reloading tools	Cha vow' te
Popgun	Shoo poo'wa	Reloading tools	Kok a retik
Porcupine	E lah'ka sook	Reloading tools	Too'tik
Porcupine	King ok'a look	Remaining	Ong a yang'ik pe
Porcupine	E lup kwo'tok	Remember	Lu'bet
Possession	Pe'gah	Remove (take off)	Pe a lo'go
Pot	Ko lip'se	Return	Oo tik'took
Pot	Oot koo'chik	Returned	Oo tektin'e
Pot	Lub lub'lah	Reverse	Le'rek
Potato	Oot'kwe	Revolver	Ik lo per'o
Potato	Put'kweet	Rib	Too loo'me
Potato	Sha'ro	Rice	Savakor'a
Pouch	Til om ni u'te	Rich	Oona'la
Pour	Koo ve'ga	Rifling	Ko og'arn
Pour	Koo'va	Right	Ah kun'alo
Pour down	Chuk choo'lu roa	Right side	Oo whil yig'a
Pour out	Koo vim	Rim	Ah me'chuke
Poverty-stricken	E kung a ro'a	Ring	Katuk alum'a
Powder	Ok a rum'ik	Ring	As ka me'tuk
Powder flask	Ok a ruk'chute	Ringworm	Ne goo'u

Rise up	Okah'yut	Scoop out	Ky n'to gan
River	Kook	Score (20)	Ko'je ak
Rivet	Ke ka ik'ok	Scrape	E kook'tookin
Rivulet	Koog ru'rok	Scraped	E kung'agoa
Road	Ap kwot'e	Scraper	E'koo
Road	Al'o	Scratch	Kitoho'a
Road	Ap'kon	Scratch	Cha uke chu ahoku'na
Rock	Oo yaw'ok	Screw	Na katow'gota
Rock	Oo yaw'hite	Scruff	Cbe a mo'ma
Rocks	Oo yaw'tak	Sculpin	Komeyo'ok
Rock tower	Oo kee'ok	Sea	Oo ma'ne
Roe	Cha'wa	Sea urchin	Ik pe ak'ru noy
Roof	Ki'luk	Sea quail	Ok pol'uk
Roll, n.	E moo'gwah	Sea quails	Ok pala'set
Roll, v.	Ok suk'to	Seal, banded	Eoho'wak
Rooster	Ayoon sel'a	Seal, banded	Ky roll'ik
Root	Nu'ma	Seal, common	Nat'chik
Root, substitute for		Seal, thick skin	Oog'a rook
food	Ah'vwa	Seal, leopard	Kat'ebo gai'k
Rope	Ok ln'nah	Seal, sinew	Na loo'a
Rope, pass me	Ok lunok'noot'mo	Seal, blow hole	Od ln'jt
Rope is off	Ok low'rok	Seal, baptism of dead	Nat chum'ek
Rotten	To'pe	Seam	Kelo'a
Round	Ke op'kok	Seasons past	Nipah'ne
Rub	Ahik'chu	Seated, be	Okavoo'tin
Rub	Telaif'rigin	See	Kin ya go
Rudder	Ah ko'ta	See	Tow'took
Rug	Ky o ko'tik	Sell	Ahko'chuk
Rule	Leet teh'uk	Send	Ah wukt eehah'tin
Run	Ok pok'to	Servant	Kape'gah
Run behind	Ma lik sok'tuk	Setting hen	Evaro'ok
Running water	Shokawok'tit	Seven	Tal'ema-makro'nik
Rust	Kal'ik	Seven stars	Shercop'satuk
Rusty	Kaliksemer'uk	Seven stars	Se kup'chaluk
Sack	Kal uk'tab	Sew	Kilayok'to
Sad	Echo mal'otoo	Sew	Kil louk'to
Saddle, venison	Oo kwet'a	Sew	Meg a ruk'toa
Said	Oo-kwok'ton	Sew, double seam	Mal'okillu'it
Sail	Ting a la'tok	Sew, palm and needle	Scat'mon
Salmon	Ah kal oo'rok	Sewed	Killa yung'aroa
Salmon	Oo kwad lu'okpuk	Sewing	Kle ya noktu'na
Salmon, humpback	Amok'tit	Shad	Seelook'took
Salmon-trout	Ah kal oo pik'pye	Shadow	Kok'etate
Salmon-berries	So'what	Shadow	Tah ah oak
Salt	Toy'oke	Shadow	Teh'na
Salt water	Toy'oke	Shake	Ow let'ka
Salt meat	Too to'a lo	Sharp	E op'ke lup
Same	Ty mun'a	Sharp knife	Chow wep'kelup
Same as that	Ty muwah'sing	Sharpen	Keñ uk shuk'tuk
Sand	Kahve'a	Sharpen	Ke pektol'ago
Sand-paper	Kal a'o	Sharpen	E pik chol'ago
Sand-bar	Tap'kok	Shave	Oo ma'ya
Sand-stone ball	Eluk'tuk	Shavings	E va goo'tit
Sat	Akoopukaloo'ra	She	Ok an'ok
Saw, n.	Oo loo'oktoon	Sheath	Ke na le'tok
Saw, v.	Oo loek'a	Shell	Oo wil'a
Scab	Ah me'a	Shell, flat	Ma lu gwituk
Scales (to weigh)	O ko ma etah'ga	Shell fish	Im an'e
Scallop (shell)	New yaki'ya	Shin	Kin ah'srook
Scalp	Oo toog'wa	Shin	Kin ah'ga
Scar	Ka la'ok	Ship	Oo meak'puk
Scar	Kil ya gow'a	Shipwreck	Oomeak'puk-shuk'assetuk
Scare	Hah ne'tah	Shiver	Ka ip'ka
Scissors	Chal'lokt	Shiver	Oo lik'to'a
Schooner	Mal o gow'rume	Shoot	Shoe pootil'ago
Schooner	Malo te gow'tuk	Shoot	Pe tik'te

Short	Ni'chuk	Smell	Ko ne ah'wa
Short	Ni shoo'ra	Smile	Ig low up chuk'cho ak
Shot, n.	Kok a roy'ah	Smoke	E'che
Shot	Kog ru'ek	Snail, sea	Scha look'a yok
Shoulder	Too'e gah	Snake	Nu mug'aik
Shoulder-blade	Ka ati'ga	Snare	Ne'yok
Shoulder-strap	Kuh yoo'ta	Snare	Toak a look'ahok
Shove	Pe kok'tin	Sneeze	Tog a yuk'puk
Shove in	Ko he'wik	Snipe	Noo'a luk
Shovel	Noo'ah	Snipe	I vuh'uk
Shovel	Piet'roon	Snipe	Tal ig'o wait
Shovel	Pig'ezoot	Snore	Ko moi'zuk
Show	Tow'took	Snow, fallen	A'poon
Shrimp	Ig le'a	Snow, fallen	Ah ne ah'poon
Shrimp	Ig ne'ek	Snow, falling	Kon eek'cho a
Shrimp	Now lan'ok	Snow house	An'e yok
Shroud	Poong'a	Snow house	An nu'yok
Shrubbery	Ok peek	Snow house	An a we'chuk
Shut	Oo mig'le ta	Snow house	Ap'e yok
Shut door	Oo mig'le pe	Snow-blind	E ga look'to
Shut up	E ek'tut	Snow-bird	A mond'luk
Sick	An'a nah	Snow-bird	A mow tok'puk
Side	Kat'cho	Snow-bird	Oo ke uk tow'ra
Side	Shan'o kok	Snow-bird	Ah what tal e gow'ro
Sideway	Ik a vuk'to	Snow-shoes	Tag'e look
Sigh	An ukta puk'to	Snow-storm	Kon ech puk'to
Silly	Ook wok to ro'a	Snow-drift	Kap'e gah
Silver	O'whok	Snowing	Kon eek'a rah
Sinew	Ewal'oo	So	Munt'na
Sinew	E ya'lu	Soap	Ye kok'koon
Sing	At toil'oo	Soap	Me al'o
Sink	Ke veru'n	Soft	Owek'to
Sister	Ni'ya	Soft soil	Ook a ru'a
Sister	Ni'yung	Soften	Ke roop to'ak
Sister	Nook'a	Sole	At tung'a
Sit	In eek'te nek	Some	Oo'va
Sit	Ok o we'tin	Song	At to'a lu
Six	Ok vin'i le	Sons	Ek a yang'a
Six	Ah cheg'a ret	Soot	Pow'la
Six of them	Ok vin le'ne	Sore	Kil'ye
Skates	Ky ya yar'til leet	Sorrel, wild	Kong'a look
Skeleton	Too noo'ok	Sorry	Kot tung'a go ra
Skin, human	Oo win'ok	Sound, or gulf	E'lu
Skin, animal	Ah'me	Sound (noise)	Ah tuk'kwoi
Sky	Kob lu'it	Soup	Im'a kok
Sky	Ke'luk	Soup	Al loo'ra
Slap	Ek'a rok	South	Oong'a luh
Slate	Ou'nok	South	Oo mud'luk
Slate	Tan nal'ook	Span	At lik'a chan
Sled	Oo ne'et	Speak	Kan'uk
Sled, low	Kom mo'te	Speak	Ah'a hah
Sled, one man	Oon a zrook'tuk	Spear, bird	Moo e yat'ing
Sled-track	Tu mon'eat	Spear, seal	Muk set'uk
Sleep	Sin'ik	Spear, seal	Too'ka
Sleeping	Sin ik'to	Spear, seal	Toak'pe
Sleet	Me shu'look	Spear, whale	Now'a luk
Sleeve	I sha'a	Speckled	Ke kood'look
Slice	Tir'a lu	Speckled	Og lek to'ak
Slide	Ki ya to'ak	Spectacles	E rek'a rah
Slide	Che che'ru	Spectacles	E zre'gak
Sling	E'hlook	Spilt	Koo ve'ro
Slippers	Pin n'ra	Split	Oo lek'shuk
Slop-bucket	Koo va'yo	Spoilt	Te'pe-ke'zrook
Slough	Tash'nk	Spoon	Al lo'tok
Slung-shot	Ow'ya	Spoon	Al lu'tok
Small	Mik'ero	Spots on moon	In une op kwo'tah

Spotted	Ket-ok to a tik	Sunrise	Shu'a rok
Spout of whale	Oo aung'na rah	Sun dog	Nu'ga uh'tuk
Spread	Min o cha'nok	Suspenders	E ka ru'chok
Spring (season)	Pun soog'a rook	Suspenders	Ne ak a la o'ta
Spring (season)	Oo pun ruk shuk	Swallow, or similar	
Spring of water	Kal en'ok	bird	Toy u'nok
Spy-glass	Toak'a lo	Swallow	Hel'a we
Square (tool)	Ook'toon	Swallowed	Eel a ok'pe
Squat	Ok vil'a to	Swan	Koog ru'it
Stab	Men'ah	Swan	Koog'rook
Stain	Im u'na	Sweat	Oo nok'ja ka me
Staircase	Ke le'a ink	Sweat	Kis ze oak'tuk
Stake	O yah'i	Sweat dance	Kis re guk'tak
Stale	Ow rel'a	Sweep	Til a com'a
Stamp	Keet'me tuk	Swelling	Po wit'to a
Stand	Nuk koo'vuk	Swelling	Il geke chik'cho ah
Star	Oo blu'a ok	Swim	Peo grav'to it
Star-fish	Ah re ga'luk	Swing	Ow la'rok
Star-fish	Og ra o'it	Table	Nek'a wik
Start	Ma lik'pa le	Table	Ne koo'wik
Stay	Kia na nok'to	Tag (a game)	On oo ke'ga
Steal	Tig'a lik	Tag (a game)	Oo lap kit/ke a
Steam	Poo'yuk	Tail, bird	Pup'ke
Steam launch	Ik nel a gow'ruk	Tail, animal	Pum my co'ga
Stern (vessel)	Ah ko'a	Tainted	Tiy'late
Stick, v.	Ne pe'to	Take	Tig'goo
Stiff	Oo ma'rok	Take	Tig a ak tu'a
Stiff	Tik a ya'rok	Take	Tik a we'a
Stiff	Tik sew'mer uk	Take down	E nok ov'tu a
Stiff	Nok'e ru	Take from	Aht e'ga
Stiff	Ke took'a cho ak	Take up	Te u me uk'tuk
Stink	Ko ne ok'to	Take away	Ah vung'a
Stir	Ow la'yo	Talk	Oo kwok'to
Stir	Ah kup'ka	Tallow	Peod naa'uk
Stocking	At toad'lok	Tan	Eet kil ak'a rook
Stocking	Al tik a lo'ne	Tassel	Nig er'ah
Stocking	Pin u kun'ik	Tattoo	Tab le o'tit
Stocking	Al lik'ee	Tea	Ne uk'kwak
Stocking	Pin'a hok	Tea	Chy
Stomach	Nar'a kwok	Teapot	Neuk ko'me
Stomach-ache	Nok'a-e'lun	Toar (rend)	A lik'tah
Stoop	Pol uk'tuk	Tears	Te'ya
Stop	Ah'kun	Tease	Kil ye'ro
Stopped up	Ong ne'a	Teeth	Ke ru'te
Stove	Ik nek'a wik	Teeth	Te kru'tit
Stove pipe	Poo ey yek'a wik	Telescopic glass	Tob ro a
Strait	Mal o tik'lona	Telescopic glass	Tob lo'a
Strap	Nat mow tung'a	Temple	E go we'ro
Strap	Nan ma'tah	Ten	Ke'leet
Straw	Kok'rate	Ten of them	Ko lin'ik
Strike	Shuk a mit'ka	Tent	Too'pik
String, twine	Min ok'took	Tent	Balap'kar
String, leather	E'chook	Tent flap	E tik to'a
Strip	Koo pe go ke'ga	Termigant	Ah gung'a ro a
Stripe	Che vol'geet	Tern	To ret ko'yak
Strung	Shung'e rook	Tern	Mit ko ti'luk
Stubborn	Ah gung a ro'a	Tetter	Ne koo'yah
Succession	Am ne ah'ru tit	Thank	Ko yaa'o
Suck	Kok to me ok'to gah	Thank you	Ko yan ot tu'a
Sugar	Kap so'tak	That	Tam'na
Summer	Oo pun'rok	That	Oo'kwah
Summer	Oo pun yug'a ra	That is it	Ta mun'ra
Summer	Oo pun'rah	That one	Tab room'a
Summer fur	Shag'ok	Than	Owk se mer'uk
Sun	Shi kin'ya	Tho	Im no'a
Sun	Mer'uak	Them	Tag'kwo

There	Oo woo'na	Towel	Ek'nune
These	Tap'kwo	Tower	Oo kee'ok
They	Oo'kwah	Town	Too pukern'lt
Thick	Muk too'ruk	Track	Too'may
Thick	Ib bru'ra	Tracks	Too'mon
Thick weather	Mun ok'to	Trade	Tawk'se
Thief	Tig a lik to's	Trade	Ah ke'chuk
Thigh	In u o'muk	Transparent	Kit ko ate'kon
Thigh	Ki n'e	Trap	Nan na'reok
Thimble	Tig's	Travail	Nib la a ro'ak
Thimble	Tig'aga	Travail, difficult	Im nachokto's
Thin	Shat tu'ruk	Tree	Na pak'took
Thin	Shat'tu	Tree climbing	An a nok toak
Thin	Muk too'ka chuk	Tree creeper	Ty'u
Things	Ot lum'ok	Trout	Oo kwad lu'puk
This	Oo'va	Truly	Chuk loo ne'che
This side of	Ne sha'ne	Truth	Chuk lu le'luk
Thong	Ah'lik	Truth	Chuk lu'rok
Those	Tap'kwo	Tub	Oo vok'to
Those	Oo'kwah	Tumble	Oo ling'le lok
Thread	Oo wal'oo	Tumor	Ob'a rah
Thread	E ya'lu	Turbot	Natak'took
Thread, intestine	Yogowtik'sok	Turbot	Natang'nok
Three	Ping'ishute	Turbot	Ik kah'nalook
Throat	Toopt u'ra ken	Turf	Mun'o it
Throbbing	Toak tuk to'ak	Turn	Toom'ago
Through	Pah wun'e	Turn around	Puwa'neruk
Throw	Pe yuk'suk	Turn back	Toom'atin
Throw	Oo te'ka	Turn forward	Ki neshah'tin
Thumb	Koob'loo	Turn over	Ok chelok'to
Thunder	Ke lo ok'ru it	Turn from	Mow ne show tin
Thus	Munt'na	Turn from	Mu me ok'to
Tickle	Ko in uk tu'ma	Turn my	Tu'room
Tide water	Toak'kook	Turn upward	Ki ya'ta
Tired	Cheh a ak'eluk	Turn your	Tu ra'tin
Tired	Minook'took	Twine	Kwip'shok
Titulate	Ah kal ook chok to ak	Twist	Kle pik'chin'la
Tobacco	Topam's	Two	Hi'pah
Tobacco, plug	Kowk'ta	Two	Mal'ho
Tobacco, Russian	To pam ik pe'a	Ugly	Nok e week'shu
Tobacco, Russian	Kot'loet-topam'a	Ulcer	Ko he'wik
Tobacco, chew	Oo'elah	Unbalanced	Nn ok'sha rook
Tobacco, chew	O ko may'a	Uncertain	Kan o me'ke
Tobacco leaf	Shn roka ro'me	Uncle	Kang a yang'me a
Tobacco sack	Til om ni u'te	Under	Ko wek'to ak
Toboggan	Che cho ok to's	Undo	An uk'cho
Toboggan	She to whok'tif	Unfit	Il n'a lok
To-day	Oo blu'puk	Unroll	Oo shoo gwit'ka
Toes, big	Pootoo'go	Unseen	Tow toong'ik pe
Toes, little	Koob'loo	Untie	Ung a wil'kin
Toggle	In im'une	Untie	Un ob'ro gi
Tomcod	Ana le ok'puk	Unwell	An'a nah
To-morrow	Oo blak'o	Unwind	Ne lep'toon
Tongue	Oo'kok	Up	Mi yo'lo
Tongue	Oowa	Upright	Nuk puk'too
Tools	Cha vowte	Upright	Nuk per'o
Top	Nato'a	Upside down	Le'rek
Top-sail	Ko le'ra	Up to there	Me chok'to tin
Torn	Al ik'to	Urine	Kwi'ro
Torn	Te let'ko	Us	Oo wug'oot
Tossing balls (hands)	E ga'lu-a sha'ga	Valley	Kut ko nel'e ot
Tossing balls (hands)	E ga'lu-ke cho'na	Vanish	At a sheet'she
Tossing balls (feet)	Nuk pung'a	Vapor	Poo e yowk'to
To there	E sho'ne	Vein	Tah'ok
Tough	Te upe'tuk	Venereal	Nok'e rook
Towel	Im a'yo	Venereal sores	Ke lik'she

Vestibule	Pah	Whale fin	Ak lik'o ma
View	Ihe	Whale fin	Tal lir'ha it
Village	Ig'e lute	Whale head	Che og'un
Violin	Kit'ow	Whale jaw	Moy'le gok
Violin	A le'ta	Whale meat	Mak'tuk
Vise	King'mah	Whale spout	Ah sung'ne rah
Vise	Kik kaig'gow ro	Whale spout-hole	King'ah
Vise	Ow'a rok	Whale tail	Chok'peek
Vise	Kig'e tik	Whale tail	O war'rek
Visit	An uk'ta	Whale vent	Oo zhug'ok
Volcano	Ik ne shek'a rook	Whalebone	Sho'kek
Volcano	Ik neahoog'a rook	What	Chu
Vomit	Mak ik'cho	What	Shu'ma
Waist	Ka te'rah	Wheel	Ok shuk'to
Wait	Nan ak'o	Wheel	Og a ra lu'it
Wait a little	Un ak'kun	When	Sha'pen
Wake up	E tug'a shaw	Where	Nah
Walk	Pe shu'ra	Where	Nah'me
Walked	Pe chu nok'to ak	Where	Nan'ne
Walking	Pe shu ok'to	Whetstone	Moo ho'ya
Walrus	I'wek	Whetstone	Sest'lee
Walrus tusk	Too'wa	Whetstone	Seed'le
Walrus tusk	Too war'uk	Whetstone	Ah yeh'ok
Wand	Ke liz'rook	Which	She
Want	Pe shook'took	Which one	Ke'tuk
Wanted	Pe gow'tin	Which one	Ke'sho
Warbler	E'rit kan'e suk	Which way	Nut'mon
Warbler	Oo pin row'lik	Whip	Paw hah'ta
Warm	Oo nok'to	Whip	Ko ke ah'hi ta
Warrior	Ong a ya'kite	Whisky	Tong'ong
Wart	Oot'mok	Whisky	Im'uk shred'na
Was	In el'o	Whisper	Ish u ba suk'tuk
Wash	Ir a vik'to	Whistle	Oo in yo ok'to
Wash basin	Moo se an'a	Whistle (tin)	Kal loak'ta
Water	Im'uk	White	Ka tek'to ak
Waterfall	Ere'to-im'uk	White fish	Too'poop
Waterfall, slight	Shok a wok'to	Whittle	Chow wel'a roy
Waterfall, medium	Man ik'to	Who	Kin 'ya
Waterfall, grand	Shok a wah ik'took	Wick	E pir'ak
Water, none	Im a'cho	Wide	Nu le'eat
Wave	Ow lit'ga	Widgeon	Kru'kuk
Waves	Im uk tok'took	Widgeon	U'wok
Way	Al'e	Widgeon	To'yok
We	Oo wung'a loo	Wife	Nu le'a
Weak	Te ya'cho	Wife	Koo ne'a
Weak	Te cha'cho	Wife, my	Ok a ru'ra
Weather	Seel'ya	Wife, my	Kawk
We are going	Ah yung ne ok'to	Willow	Chu'ret
Weave	Loo loo'luk	Will	Ko'ko
Wedge	Kah koo'na	Win	Tok she'ro
Well	An e'vah	Win	Geo re lok'tu il
Well	Ne rah ak'puk	Wind (to ball)	Im n'ga
Went	Ah uke'to	Wind	An o'wa
Were	Shum'na	Wind, east	Ke lung'a
West	Ka'tek	Wind, north	Ne ge'a
West	Nik'ik	Wind, north	Ne'yak
Wet	I lok'to	Wind, south	Oong'a luh
Wet soil	Mok'luk-nooa'n	Wind, south	Oo med'lnk
Whale	Ok'a wuk	Wind, west	Kik'ok
Whale, large	Oo ching no'ak	Wind, west	Kong nag'nung
Whale, small	In a'to	Window	E go lah'to
Whale, small of	Pub'o greet	Windpipe	Toopt'u
Whale back	Tim ung'a	Wing	E Shok ku'a
Whale belly	Shag'a	Wing	E chu'ka
Whale ear	Oo gung'a	Winter	Oo ko'pak
Whale eye	E ring'a	Winter	Oo ke'ek

Winter darkness	Kop lo'tok	Wrist	Ty a no'ka
Winter darkness	Shi kin'ye luk	Writing	Og lak'to
Wipe	Pe'yok	Writing	Min u ok tok'to
Wire	Cha'wik-al o'ra	Yawn	Ow chow'to
Wish-bone	Mit ko'a	Year	Oo ke'ok
Wish-bone	Pot'u mak	Year (next)	I pah'go
Wolf	A moh'oak	Yellow	E chook'to ak
Wolf	A mow'o	Yes	Ong ek'to
Wolk, dark	E goh'a lik	Yesterday	Oo noo'mon
Wolverine	Kap'we	Yesterday	Ik pug rah'puk
Woman	Ok an'ok	You	Il'we
Women	Ok an'ite	You (familiar)	Oo'ma
Wood	Ke ru'it	You are	E lip'cho
Wood	Ke'rook	You have	Il im'ne
Wood (limbs)	Ke ru'mik	You will	E lip'tin
Wood, drift	Tak ig er'ie-ke'rook	Young boys	Nu gat pe gi lo
Work	Sa vak'to	Young girl	Nu ge uk'suk
Worm	Too let'chuk	Young girls	Nu ge uk sow'ro
Wound	E ke'na	Young man	Nu gat pe'a
Wreath	Ke pit ching'a ru a	Young men	Nu gat pe ah'ro
Wring	Kit'look	Yours	E lip'che
Wrinkle	E mon ik'ten		

b'a bab	Talk	Ah'lik	Thong
b a lanha'ta	Fish-pole	Ah lok'egy	Are they gone
b'a rok	Summer festival	Ah lok she na'luk	Will not go
b a rotal'ik	Cub bear	Ah lok'to	Gone
b'avok	Mussel	Ah'me	Skin
g a ak'tua	File	Ah me'a	Scab
'go	Of	Ah me'chuke	Rim
'gu-e'tite	Of them	Ah mik cho'a	Fine glover's needle
h'a lute	Whale killer	Ah min cok'te geet	Put on canoe-cover
h'a rouk	Loon	Ah min o'it	Ready
h'a yate	Limb	Ah moo'tin	Keep time
h'che	Get	Ah ne ah'poon	Snow on ground
bcbe'a	Berries	Ah nu na che'ak	Genial
h cheat'chy	A plant	Ah nung ne ak'te go	Going home
h chok'to	Lend	Ah on'yok	Old squaw duck
h chok'tun	Lend	Ah cok chook'to ak	Raw
i drah'ne	Ancient	Ah'pah	Father
h geh'ok	Grindstone, whetstone	Ah pah'lu	Don't
h gung'a ro a	Stubborn	Ah'pi	Distant
h bol'ik	Old squaw duck	Ah re'gay	Beautiful
h ik'cha	Rub	Ah re gay'luk	Starfish, clubs in cards
h'ka	Mother	Ah re'gy	Glove, hand
h kah'ga	Mother	Ah rek'to	Kick
h kal'look	Fish	Aht'e ga	Take from
h kal'lui	Fishes	Ah te mes're gook	Even
h kalook'pe	Little brother	Ah tik'a lo ne	Stocking
h kaloo'rok	Salmon	Ah'tok	Small owl
h ke'a	Buy	Ah tak'kwol	Sound
h kecho'na	Relative	Ah tak tow'ra	Musical instrument
h ke'chuk	Buy, trade, sell	Ah tat's	Listen
i ki'chung	Whale's tail	Ah uks'to	Went
i kim nok'toak	Full of life	Ah upe'kot	Box
	Pillow	Ah vu ga'wah	Divide
h ko'a	Stern of a boat	Ah vun a pun'a	From now
h koh'a le' grok	Black tanned leather	Ah vung'a	Take from
h koh'go	In the morning	Ah wan'e	From
h koh'puk	This morning	Ah wik to'ak	Departed
h'kok	Bitter	Ah wuk tok'puk	A poke
h kecsy'tak	Short cloak	Ah wun'mute	Chum
h kook'a kook	Sleigh bell	Ah'ya	Staff
h kook a lung'a	Dinner bell	Ah yeh'ek	File
h kook a la'ok	Ship's bell	Ah yo'a	Cancer
'koon	Paddle	Ah yok'te	Go
h koo'ta	Batter	Ah yo'ok	Mushroom
h ko'ta	Rudder	Ah yung'ne ak to	We are going
h'kun	Stop	Ah shu'ak	Bruise
h kun'ale	To the right	Ah sre'ga	Let
h kup'ta	Stir	Ah sre'vuk	Worm
	A plant	Ah ka'ruk	Medium box
h kua'rais	Canvas-back duck	Ah ke le'ga	Decoy
h kwuh'a	Knot in a tree	A kee pe'ta	Chair
h kung ncak'te	We are going	A koop te tet'in	Long boots

A koop tik'ta	Long deer boots
A koo'puk	Evening
A koo puk a loo'ra	Sat
Al'a pah	Cold
Al a pak'took	Very cold
Al a pah yak'took	Intense cold
Al e ga'ret	Small oogarook seal
Al e geet'ke ta	Border
Al'ego	Mica
Al'eh	Ripped
Al ep'e ta	Back and forth
Al geet'cho	Could not
Al gong'a	Birth
A lek'tah	Tear, tattered
A lik'to	Full of holes
Al lay chook'toonga	Play
Al le'gro	Feldspar
Al lo'ke gy	Have they gone
Al look'to a	Lick
Al loo'ra	Soup
Al lu'e kut	Dock weed
Al lupe'to ak	Ice-cream
Al lu renk chum'na	Put on coal
Al lu'tok	Spoon
Alo	Crooked
Alo'a	Coal
Al ok'egah	Wet
Al o kle'on	Door-mat
Al on'yok	Horizon
A loot'koo che ne	Alone
Al o'ra	Bent
Al o'tok	Spoon
A lo'ta	Violin
A maga rok'to	Sew
Am a li'tuk	Plenty
Am a lok'tuk	Much, plenty
Am e ok'tu a	Few
Am fi ga	Joint
Am ne a ru'tit	In succession
A moh'ook	Wolf
A mok'tit	Humpback salmon
Am o'kwoi	Front
A moo rok'to ak	Doctor frothing
A moud'luk	Snow-bird
A mowl'geet	Eider-duck
A mow'lek	Eider-duck
A mow'o	Wolf
An	Off
An'a nah	Sick
An a nok'tu	Headache
An a ve'a	Brown duck
An a yang'ik pe	Remaining
An e'vah	Well
Angachukachuk'choa	Flirt
Ang'yow	Companion
An'ing	Leave
An ing a ak'pe	We are leaving
An in'wile	Old marmot
An in'yok	Old marmot
An nun ne ak'to	Not coming
An nu'tok	Pain
An nu'yok	Snow house
An o hok'to ak	Climbing
An ok a chook'toon ga	Wish to go to a closet
An ok'a wik	Closet
An ok'kuk	House fly

An ok'la	House fly
An o'kla	Air
An o ko'luke	Ship's block
An o lo rok'to	Kill
An'oot	Dog harness
An oo'tit	Paddle
An o'wa	Wind
An o'wa kah	Gale
An ow ok'loon	Axe
An ow ti'luk	Hotchkiss rifle
An ow tok'puk	Kind of bird
An ow to la too'tek	Hotchkiss bullet moulds
An uk'cho	Undo
An uk'ta	Visit
An uk ta puk'too	Sigh
An uk ter va'luk	Breathe
An uk tok'to	I will go, too
A nung'ne rah	Whale's spout
Ap'kon	Road
Ap kwot'e	Road
A'poon	Frost, or snow
Ap wouk'to	Piece
Ar'rah	Ache, hurt
A se'ret	Berries
A shu'na	What
A shu'rok	Bad
A shu pi ak'to	Very bad
As ke mo'tuk	Finger ring
At'a	Desist, quit
At'a go	Notice
At ak'en e	Weak
At a sheet'she	Get out
At cha kin'ga	Who is he
At'chu	Don't know
A tig'a	Cloak, coat, shirt
At il'a go	Put on cloak
At lik'a chaw	Span
A tow'shek	One
A tow she'mo	One of them
At tan'e	Beyond, after
At tik'a lone-ig'aloo	Pair of stockings
At ti'loo	Grandmother
At toad'lok	Stocking
At to'a lu	Song
At toil'oo	Sing
At took'to a	Lend
At tun'e-wit'o	Out of reach
At tung'a	Solo
At tut'a	Backbone
A tuk a tong'mer uk	Musical instrument
Aus le ok'puk	Tomcod
A ve'ok	Mussel
A vwo	Root, substitute for tobacco
A wad'luk	Father-in-law
A what tal e gow'ro	Snow-bird
A win'yate	Lemming
A wuk te chah'tin	You will send
A yo'many	Noise
A yoon	Male
A'yoon-sell'a	Rooster
Az'e gown	Ice scratcher
Az re gow'a	Let it be
Az n tok'to	Pole
Balapkar	Tent

Benelek'to	Leader
Chah ah lin'a tek	Butterfly
Chah ok'tuk	Read
Chah'a ena	Breast of deer
Chai a o'tet	Wolf and wolverine trimmings blended
Chak'e gah	Scissor cut
Chai ick'che	Scissors
Chal'nok	Bone
Chal nek'che	Take out bone
Che inpe'took	Morsel
Cham'e rah	Apron
Chan'ik	Deer hair
Cha nek	Pipe
Chsep pew'te	Bird's nest
Chate ke'a	Knee
Chate keng'a ren	Kneel
Chave'a	Divorced
Chav'ek	Divorced
Cha vew'te	Tools
Cha wik'a lo ra	Wire
Cha wik'a re me	Whittle
Cha wil'ik	44 Winchester rifle
Cha wilik'puk	45 Winchester rifle
Cha wil'rek	Brass
Cha wing'mon	Iron
Chaw'ne	Rainbow
Che be a	Bottom of sole
Che cha'ru	Slide
Che gek a look'to ak	Brittle
Cheh a ak'chuk	Tired
Chah'a lo ne	Cache
Che ne'ya	Pipe
Che og'u a	Whale's head
Che'ra	What now
Che te ek'toa	Toboggan
Che uag'a ra	Pull
Che ve ah'ga	Hip
Che vel'geet	Large white stripe
Che srel'geet	Small white stripe
Chik'a ro	Wink
Chim o'ra	Bind
Chiv'kwe	Flipper
Che a me'ma	Scarf
Chek'peek	Whale's tail
Cheo loo me'a	Bowstring
Cheep lee'ro	Gun nipple
Che plek'te wah	Dust
Chewrie	Gap
Chew wep'ke lup	Sharp
Chew we'rak	Steel blade
Chew we tuk	Knife cut
Chew'wik	Iron, steel, knife
Chew wik'tuk	Cut with knife
Chu be'la ta	Pipe cleaner
Chu bla'ek te	Blow breath
Chu'che	Ace
Ching'a tea	Answer
Chuk a mik'a tok	Butterfly
Chuk'lee	A lie
Chuk lee'le rok	Not a lie
Chuk lee'ne chin	You don't lie
Chuk lee'ne che	Not lying
Chuk lee'ne huk	I don't lie
Chuk lee ru'ne	I lie
Chuk lee ru'ten	You lie
Chuk lee'ok	Cache
Chum e rek'to	Heavy cloak
Chung'he	Dorsal fin
Chung ne ug'gah	Chest
Chung na yek'te	Jealous
Chung mug'gah	Breast
Chun uk too ree'ok	Harlot
Chu'rot	Willow
Cha'u	Tea
Chu uke chu ah'chu a	Scratch
Chu'wa	Roe
Chy	Tea
Chy'elke	Cache
Chy yooag'a ro a	Empty-headed fool
Dak to'a	Kidney
Do'bra	Sufficient
Eag a we'e kin	Pocket
Eag ru'ga	Testicles
Eat'pik	Small dock weed
E boo ro'ak	Earthquake
E boo roo'ak	Ice pressure
E'che	Smoke
E che'a	Chimney
E cheh'a wik	Hood fringe
E cheh'in	Enter
E che mal'o	Think, believe
E che mal'o too	Sad
E chig'a nek	Adze or nephrite stone
E'che	End
E che'hin	Wing
E'chook	End
E chook'to a	Fade
E chook'to ak	Yellow
E choop cha'look to	Hiccough
E chow'ta	Adam's apple
E chu'ga	Drink
E chug'e ra	Seven
E chu'ka	Wing
E chuk'a leun a	May I enter
E chuk' alik a go	Come in
E chuk'a rook	Go out
E chuk'a tin	Come in
E chuk la'ago	I go in
E chum'a	Enter
E chung'mek	Parasite gall
E chung ok'olek	Parasite gall
E chu'roa	Stagnation of blood
E ek'tut	Shut up
Eek'kik	Hard, pliable wood
Eel a ok'pe	To swallow
Eel'yat	Here
Eet kil ak'a rook	Tanned
E'gah	Kitchen
E gah ta gow'ro	The cook
E gah ta ro'a	The cook
E ga lah'to	Window
E ga la moak'tuk	Moonshine
E ga'look	Enough
E ga look'to	Snowblind
E ga'in	Mate, or one of a pair
E ga lu a aba'ga	Tossing balls with both hands
E ga luk'oho	Can not see out
E ga lu'ke cho'na	Tossing balls with feet
E ga me'ga	Needle-case
E ga'nek	Meteor

E ga ro'a	Cooked done
E ga'tah	Meteor
E ge le'kret	Edge
E goh'alik	Black wolf
E go she'to	Ashamed
E gow'e re	Temple
E'het	Mountain
Eh'look	Sling
Eh'uh	Yes
E kachook toong'a	Lazy
E ka lu'ga	Mute
E ka ma ro'a	Smouldering
Ek an yang'a	Sons
E ka re'chek	Suspenders
Ek a ro'a	Knot in a tree
Ek'a rok	Slap
E ka ru'la	Deer pen
Ek'a we	Pocket
Ek che'ak	Feared
Ekchero'a	Afraid
Ek che'ro a	Ghost
E ke che'tet	Edge of shore ice
E keh'gut	Elevated cache
E ke mealik	Rim-fire Winchester rifle
E ke'na	Wound
E kib'era	Mattress
E kit'ka	Guns
Ek'nune	Towel
E'koo	Scraper
E koo che'a	Elbow
E koo che gah	Elbow
E kook'too tin	You scrape
E'koon	Plane
E koo'ta	Matches
E koo'tet	Matches
E koo'te ra	Match box
E ku kn'kuma	Blister
E kung'a ro a	Poverty-stricken
E kung'ne	West
E kuth luk'suk	Black-tanned leather
Ek woil'a ro	Bonfire
E la'chu	Flat
E la'go	Him
E'lah	He, she, it
E lah in ik'to	When did he
E lah ka'sook	Porcupine
E la hoy'ha yet	Crab
E lak'tel ik	Snipe
E la'le	Flag
E'lan	They are
E las'ret	Cross fox
E'late	That, it
E la tum'ne	Flattened
E la u'tet	Comb
E le'tok	You do it
E lik se mer'uk	Burned black
E lim'ne	You have (singular)
E lip'che	Yours
E lip'cho	You have (plural)
E lip'tin	You will
E lip'tik	You
E lite	He is
E'lu	Sound or gulf
E luk'a luk	Back of hand
E lup'kwo tuk	Porcupine
E luk'tuk	Sandstone ball
E lung'a	Enough
E mon ik'ten	Wrinkle
E moo'gah	Roll
E moo'gwah	Coil, or roll up
E mun'e ak	Sea-shell
En me ro'a	Ostracise
E numg'ne ak	Alder dye
E op'ke lup	Sharp
E pe'a	Cup handle
E pe'goun	Let go
E pe tung'a	Fish-line
E pik chowl'a go	Sharpen
E pik'choun	Sharpener
E pik'tah	Dull
E pir'ak	Wick
E pir ak'a ve a	Flame
E poo cho'a	Put a handle on
E poo'ta	Oar
E pung'a	Let go
E ra'ge	Exclamation of fear
E re gak	Eye-glasses
E re ge'me	I saw
E re'gik	Saw
E reh'aro	Opera-glass
E rek'che ro a	Screen over the dead
E re lukcho'uk	Blizzard
E ren'ik	Cave
E ro tek'pe go	Worn out
E re'to lim'nk	Waterfall
E rez'go vrauk	Plover
E rik'a gah	Goggles
E ling'ru rok	Dizzy
E rit	Eye
E rit'kane zuk	Warbler
E rit keet'ke	Leer
E rit shuk'a moo nek	Eyes shut
E ro kok'hm	Take down
E rok'se lung a	I cut up
E rok'se lu tin	You cut up
E too voo ok	Piling up
E se voo wuk	Gun-spring
E sha'no	To them
E shaw os'til ook	Gun-caps
E shok'kn a	Wing
E sho'wuk	Banded seal
E shuh'a wik	Chimney
E'shuk	Leather string
E tako'	Open
E te'gite	Feet
E tig'a rok	Hearts, of cards
E tik to'a	Tent-door
E tip chung a	Depth
E tip til ang'a	Deep
E tit'kook	Little finger
E'to	On
E to ok to	Snap off
E tug'a shaw	Wake up
E tuk'too ak	Plane
E u ti let	Gone out
E va goo tit	Shavings
E va lo	Clam
E va'roak	Setting hen
E'vu	Blister
E vuk'che roa	Medicine rites
E wal'o	Thread or sinew
E yah'zra rung na	Drowsy

Eskimo	English
E ve'west	Kind of grass
E yas'ok	Black bear
E ying'ye ok	Wish to eat
E are gek'to a	Chased
E are gewn	Marline spike
E are ke'ak	Frost bitten
Fesh i yung'or	Baby dear
Goo re lok'too it	Win
Hah	Yes
Hah ne'ta	Scared
Hi	What (exclamation)
Hing'i	Pelvis
Hi'pah	Two
Hi pah'gu	Recent past
Hi pah'ne	In the past
Hi pung'a	Mate, or second person
Hi upe'kaw tak	Small box
Hi upe'kot	Large box
Ib'low	Unborn seal
I brn'ra	Thick
I chel'o e guy	Skull I give
I che'me	Give me
Ig'a lek	Laugh
Ig a lok'to	Laughing
Ig'a-lu	House
Ig a la'puk	Trader's house
Ig'a lute	Town
Ig la te ro'a	Giggle
Ig le'n	Shrimp
Ig lo per'o	Revolver
Ig low up chak'choak	Smile
Ig la'pea	One side
Ig ne'ak	Shrimp
Ik a rak'to	Sideway.
Ik kate'ebu ru a	Lazy
Ik'bik	Nit
Ik sa se'ik	Brown owl
Ik sa sa ahey'ik	Brown owl
Ik se'a	Fire
Ik se a'to	Alight
Ik se grem'ik	Primers
Ik'nek	Lightning or pyrite
Ik nek a tik'sek	Primers
Ik nek'a wik	Stove or fireplace
Ik nek o ti luk	Not a steam-ship
Ik sel a gow'ruk	Steam launch
Ik ne chek'a rook	Volcano
Ik ne shoog'a rook	Volcano
Ik pa krak	Near future
Ik pe ak'ru ney	Sea urchin
Ik pe er'o	Sewing bag
Ik pe krah'puk	Near past
Ik pag rah'pak	Yesterday
Ik pag'rak	Recently
Il each e mug'e gah	Know
Il e ah'pah	Destitute person
Il e ak'chuk	Destitute person
Il e ah'reek	Orphaned, lonesome
Il gake'chik cho ak	Swelling
Il gwe'e	Entrails
Il ik'e	Knot
Il ge gah	Child
Il e yang'uk	Boys
Il im'ho	You have
Il klk'ro	Wet
Im' a lok	Unfit
Il'u ben	All
Il u hes'in	All, everything
Il a pah ung'a	Living
Il'a park	Undershirt
Il up nah'tak	All
Il'u von	Pill
Il'a west	You
Ilu west se'a	Do you understand
Il yo'ne	Inside
Im'a cho	No water, empty
Im ah'ok	Peninsula
Im a ik to ak	Pearl
Im a kok	Soup
Im an'e	Shell-fish
Im ate'kon	Pass
Im a'yo	towel
Im aa chok'to a	Travail
Im ne'a	Will you
Im o'ga	Dipper
Im o'ro	Pipe of tobacco
Imp na'ak	Mountain sheep
Imp'ni	Cliff
Imp'not	Cliff
Im n'ga	To wind or ball
Im u ga lik'tik to ak	Full moon
Im u gow're	Cap
Im u'greh	Cup
Im'ak	Water
Im ak a'srook	Bay or harbor
Im uk arel'na	Whisky
Im uk tok'to ak	Waves
Im uk'too	Drink
Im uk'tak	Bathe
Im u lu'ra	Joints
Im u'na	Stain
Im u'na	Is mine
Im un'auk'tang'a	I am drunk
Im u op'kwo tah	Bridge
In a'le	It
I ne ak'to	Go back
In eek'ta neoh	Sit down
In eb'a wik	Guillemot (winter plumage)
Ing'in	Apartment
In ik'tin	Are you through
Iu im'une	Toggle
In ip koh'ok	Mirage
In ok'to	Lie down
In u ba ook'took	A crowd
Ia'uke	Man
In une op'kwo tah	Spots on moon
In une'wrok	Doll
Ia upo'a	Strangers
In u'took	Little
In u vok'ut ting a	Dwarf
In'west	Native met
In'yo	Cut
In'yok	Beetle
In yo'roke	Live
In'yuk	Bug
I pah'go	Next year
Ip kuh na'luk	Turbot
Ip kel nok'to	Turbot
Ip koon'ik cho	Scrape
Ip pe ah'ro	Jelly-fish
Ir a wik a-a til'a go	Wash clothes

Kob row ote'nok	Bull-head fish
Kog'a oot	Buckle
Kog a rah'yah	Shot
Kog a rah yok'toon	Shot-gun
Kog a ru'ik	Shot (large)
Kog a ru'ma	Ladle
Kog la oo'tin	Beard
Kog ok'to	Leaking
Kok'e chok	Brain
Ko he'wik	Running sore
Ko hy'at	Catch
Ko in uk'too ma	Tickle
Ko in'a rook	Fat
Kok a la luk'a	Old pantaloons
Kok a lek'a	New pantaloons
Kok a lo'a	Lip
Kok'a re	Ladle
Kok'a rotik	Dividers
Kok'a rook	Cartridge
Kok'a root	Arrow
Kok a ru'rok	Lead
Kok a sru'uk	Hook
Ko ke a hi'ta	Whip
Kok'e lah	Hard bread
Kek'e tate	Shadow
Kok'e srit	Fork
Kok ik'cho	Blow nose
Kok'ik kak	Hang up
Kok ik ko'ne	I have
Ko kit ke gah'tin	Freezing
Ko kit kok'sea	Have not
Kok kook	Crab
Kok'lee	Knee-breeches
Kok me la'ya	North-east Alaska
Kok mol'let	North-east Alaska
Kok'o	Hard bread
Ko kood'look	Speckled
Ko ko voo'ro	When will
Kok'rate	Straw
Kok're tik	Bullet moulds
Kok'ru a	Bullet
Kok so'it	Loon
Kok sook'to	Jade (stone)
Kok'tit	Have
Kok'to	Person's lap
Kok to me ok'to gah	Suck
Kek uk'tung a	Blow nose
Ko'kut	Grooved
Ko'kweet	Finger nails
Ko la'to	Above
Kol e'cho	Naval
Ko'leet	Ten
Ko le'pe at	Ten
Ko le'ro	Top-sail
Ko ling a ok	Over
Ko ling o tal'i a	Nine
Ko lip cheh'aw ik	Oil stove
Ko lip se	Pot, kettle
Ko liv a ta	Chain
Kol le	Dipper
Kol lek'to	Boil
Kol let	Dipper
Kol lu	Basket
Kol lung'a ro a	Austere
Kol nk chu'uke	Fish hawk
Kol u'na	Give back

Kom'e gown	Pincers
Kom'e ro	Make dark
Kom main'mik	Mixture of snow, ries, and deer fat.
Kom mi cho'a	Little dark
Kom mit'kon	Darkened
Kom'mo ke	Grave
Kom mo'te	Low sled
Kom'muk-ip pwo'shek	Long boots
Kom oi'zuk	Snore
Ko mo le'gy	A plant
Ko mor'ra	Bean
Kom un'e	In here; in there
Ko ne ah'wa	Stink
Kon eeh'a tah	Snowing fast
Kon eeh'cho	Snowing
Kon eeh puk'to	Snow-storm
Ko ne ok'to	Smell
Kon'e zruk	Outside
Kong'a look	Wild sorrel
Kong a yo'kok	Cormorant
Kong'een	Fork of a creek
Kong ik'she veeng'a gah	Neck
Kong lug'a	Outside
Kong'o	Happy hunting-
Kong'o	Game
Kong'ok	Heaven
Kong'o vok	Rounding up deer
Kong'ung nung	West wind
Kon in ik'ke gah	Not extinguished
Kon me gah'ro	Cup
Kon'nah	A root
Kon ne'ag	Tame reindeer
Kon'ne ah	Crack
Kon neek'to ak	Children
Kon oo'yok	Gold, or copper
Kon o yo'ok	Sculpin
Kon yik'a ro	Mad
Koo a whok'tit	Raft
Koob a rok'puk	Fish-net float
Koob'lu	Little toe; thumb
Koob'ra	Net
Koo choo le gah	Icycle
Koo'chuk	Dripping
Koog'am	Rifling
Koo gar o	Big stream
Ko og a ru'la	Round needle
Koog ru'it	Swan
Koog ru'lik	Glover's needle
Koog ru'rok	Creek
Ko og sree't'to on ik	Glover's needle
Koo ik chu	Cough
Koo in'yok	Fancy pipe
Kook	River
Kook'a ru	Blackhead gull
Kook'e	Claw
Kook puk	Big river
Kook shook	Flint
Ko ok te tuk	Fog-horn
Koo le an'a	Appropriated
Koo le ok'a ru ne	Appropriated
Koo lun'ok	Puffin
Koon'muk	A grave
Koo'muk	Louse, or maggot
Koo ne'a	Wife
Koo ne'o ag	Winter, white deer

Koo pe ge'ke ga	Dirty	Kuah'uk	Elastic
Koo pe ge'en	Undress	Kuz ke nel'e ote	Valley
Koop gel'upe	Musk-rat	Kuz'rute	Hammer
Koo pak'tuk	A charm	Kuz ru'tek	Hammer
Koo re'guet	Hills	Kwawk	French
Koo ree'eh	Land duck	Kwik'mek	Edible grass root
Koo row'nek	Small, speckled fish	Kwip'stok	Twine
Kooah'kok	White fox	Kwl're	Urinate
Keet'chook	Pellet	Ky	Come
Koo ve'ga	Pour	Ky'ak	Closed boat
Kee ve're	Spill	Ky'le	Come
Koo'vim	Empty	Ky o kot'ik	Rug
Koo vin	Bullet mould	Ky roll'ik	Banded seal
Koo'vu a	Nozzle	Ky u ka'ok	Flour
Koe'vuk	Big river	Ky u'look	Black skin fish
Koo wuk'sruk	Flint	Ky u'ta	Small dipper
Koo ya goo'ta	Intercourse	Ky u'te gan	Scoop out
Koo ya ro'ak	Congratulate	Ky ya yar'til leet	Scates
Koo yel goo'ohe tin	Glad	Ky yo'ro	Leaning
Koe yook'to	Intercourse	Lah low tig'a ton	Gun sight
Ko'pah	Half	La lu gik'puk	Flower
Ko pal'uk	Myxine	Leet teh'nk	A rule
Ko pel'o ohe	Crab	Le'rek	Reverse
Kep'peou	Spades (cards)	Lik lin now'ru	Black goose
Kop sha'rook	Ill-tempered	Loo'loot	Web
Ko re'gah	White fox	Loo loo'tuk	Making web
Kot'ka	Bird's breast	Lu'bet	Remember
Kot' la pak	Axe	Luk lu'ik	Brant
Kot'la pow'ruk	Hatchet, boy's axe	Luk u ey ak a'rook	Goose
Kot me yung'oit	Bud	Ma goo'ruk	Howl
Kot tel'leo	Bark of tree	Mah'cha	A plant
Kot tow'ro	Bucket	Mah mung'in ya	Gum on whalebone
Kot tung'a go	Sorry	Ma hos'ru it	Anointing
Koo'vu	Pour	Ma ik'cho	Vomit
Koo va'yo	Slop-bucket	Ma lik'pa lo	Start
Ko va'yok	Red sunset	Ma lik ank'to uk	Start to run
Ko wek'to ak	Under	Mal'o	Two
Kewkt	Hammer	Mal o gow'rum o	Schooner
Kowk'ta	Plug tobacco	Mal o kit'lu it	Double seam
Kew loo'kon	Lamp chimney	Ma loo'gatuk	Leaf
Kew mowk'took	Burning out	Mal o te gow'ruk	Schooner
Kew mun'e	Broken up	Mal o tok'klona	Straight
Kown'ah	Leaf fat	Mal ro'nik	Two of them
Kew ung'a	Brow	Ma lu'ge uk	Moth
Kew woo'te	Hammer	Ma lu gi'a sok	Bee
Ko yan'o	Thank you	Ma lu gwi'tuk	Flat shell
Ko yan et'tna	Thank you	Man	Here
Kas're geet	Council house	Man'a	Here
Kah kee'ra tuk	Wedge	Man'ik	Egg
Kuh yee'tah	Shoulder-strap	Man ik'to	Shallow
Kuk kung'a a lu tin	To lie down	Man'neh	Here
Kul lee'kee ut	Bunch of fish	Mant'na	Another
	Boots	Mant'nea go	Another time
Kun'a roa	Courageous	Ma too'ret	Close
Kum'neh	Boots and pantaloons combined	Mat tn'gah	Blindfold
		Maw'na	Pin-feather
Kung'en	Aside	Meal'o	Soap
Kun nee're ve	To the left	Me cheet'ohe rek	Pale
	What will you do	Me chok'to tin	Up to then
Kun nek'to ak	Heartburn	Me'chu	Sack
Kun ook'too	Mad	Me'chuh	Cask
Kun u cho ek'too	Ashamed	Mede'lik	Planing-knife
Kun a le'rok	Frown	Me lig'a rok	Gun-wad
Kun u naro'a	Angry	Me'look	Breast
Knah el'eek	Bark of a tree	Me lu kut'a	Flower
Ku ahng'na	Outer shirt	Men'kh	Stab

Mer'ank	Sun	Mum ok'to a	Level
Me ahu'lak	Sleet	Mun'e	Nowhere
Me'tik	Eider-duck	Munek'chuk	Flute with a needle
Met te'a	Cover	Mung e chuk'to	To carve
Me'tuh	Alight	Mung ok'to	Thick weather
Me u'it	Grindstone	Mun'eit	Turf
Mik'a	Hoof	Munt'na	Thus, so, this
Mik a zru'rum	Little	Munt ne a'go	Later
Mik e look	Third finger	Mun'uk	Fish-pole
Mik e lu'e	Third toe	Mun uk'to a	Black
Mik'e ro	Little	Muppo wa'ga	Gluttony
Mik'lik	Planing-knife	Mur'she	Fish-gill
Mik o ok'to a	Glass	Mush'o	Wild parsnip
Min ig zrum'ik	Little	Mutkoo'a	Feather
Min ok'took	String	Mutteroo'	Other side
Min ook'to	Tired	Mu y tinging	Ice-bailer
Min'une	Graphite	Mur'ra	There is, here is
Min u ok'tukto	Writing	Muz ra go'a	It was
Min u tok'to	Jump	Muz'rake	Here now
Miah a vak'to	Bottle	Muz rel'ago	Is more
Mite'pah	Old bread	Na ak'a mo	Tea-pot
Mit ko'a	Wish-bone	Na goo'na	Periwinkle
Mit ko'a lo ret	Butte	Na got shung'not	Calf of leg
Mit'koon	Animal hair, needle	Nah'	When
Mit koon'ik	Feather	Nah che'nok	Beggar
Mit koot'a chana	Needle	Nah'erane	Wooden fork
Mit ko ti'lak	Tern	Nah'ga	No
Mit te'roo	Turn inside out	Nah kot'ehn	Bladder
Mi u how'te	Ladder	Nah lu'kate	Pitch or toss
Mi u la'cho	Not up	Nah'ma	When
Mi ute' veit	Come up	Nah'me	No
Mi yo'lo	Upon	Nak a ro'it	Cotton grass
Mi yuk'to	Raise	Nak a tow go'ta	Screw
Mi yuk'to ik	Climb	Na ko og'a gin	You love
Mok'lego	Put here	Na ko og'a ra	I love
Mok lu'it	Not enough	Na koo'nok	Snail
Mok'luk	Damp	Na koo pe yak'to	Excellent
Mok'luk noon'a	Damp ground	Na koo'ra	Good
Mo'kwah	That	Na le'gah	A dart
Mon'eak	Fuel moss	Na le goo'buk	A root
Mon oche'nek	Spread	Nal lo'it	Crooked
Mon'o rook	Fuel moss	Na long'naute	White men
Mon ya la rek'toon	Shot-gun	Nal oo'ah	Seal sinew
Moo ey yatting	Bird-spear	Na lu ge ret	Small fly
Mooho'ya	Whetstone	Na luke'e gah	Block and tackle
Moom wa'a	Drum-stick	Nan ak'a mo	Awhile
Moo se an'a	Wash-basin	Nan ak'o	Wait, by and by
Mop'lo gok	Whale-jaw	Nan'a pah	Where
Moppo'gah	Book	Nan a're ok	Trap
Moppo'gite	Papers	Nan'e	When
Mowneshow'tin	Turn from	Nan muk'to a	Carry by a strap
Much a muk'to	Neglect, don't understand	Nun'ook	White bear
Mug'a roo	Bark of a dog	Na noon	Paint, liniment
Mug'wa	Beard	Nan'uk	Lamp
Muk'e la	Get up	Na pak'tet	Mast, tree
Muk'e tin	Stand up	Na pak'too it	Fir
Muk'look	Knee	Na pov'oke	Flag-staff
Muk o cha'na	High	Na pwe'ha ta	A band
Muk set'uk	Seal-spear	Nar a chok'to	Enciente
Muk too'ka chuk	Not thick	Nar a chook too'ma	I want to eat
Muk too'ruk	Thick	Nar'a kwok	Stomach
Muk tow'go ton	Hind sight	Nar a yok'to	You eat
Muk tuk	Whale-skin	Na rook a	Contents of a stomach
Mul e kul'e to	Distemper		
Mul'le keet	American	Nash a ok'to	Hooded
Mu meek'to	Turn over	Nash a to'cha	Hat

Eskimo	English
Na chnette dwk	Plover
Naah i'chuk	Barehaded
Naah'con	Hood
Naah oy'a tak	Cap
Na tak'ge	Bottom
Na tak'ho ok	Gristle
Na tak'tnak	Turbot
Na taag'nok	Turbot
Nat chan'a bur o	A gull
Nat'cheet	Floor
Nat'chik	Common seal
Nat chum'ok	Ceremony of offering water to a dead seal
Nat'kah	Bottom
Nat kat'ka	Press
Nat koh'a lek	Down
Nat me'at	Family
Nat mee'ta	Gizzard
Nat mow'tung a	Strap
Na te'a	Top
Na tuk'kwo	Nostril
Na whik'ka	Break
Na whik tn'it	Broken
Na wik'kung a	Groin
Na wing'a wy	Bench
Na wing'i chuk	Not bend
Na yung'a	Nod
Na yung ok'to	Nodding
Nas'rn vek	Lake, sheet, muslin
Nas'rak	Abdomen
Ne ah'sreek	Eat
Ne ak'a me	Tea-pot
Ne ak ko'ko	Head
Ne ak'kwuk	Tea; broth
Ne ar a chook too ma	I am hungry
Neg'a lek	Brant
Nu ge'a	North
Ne geb'll boy	Knuckle
Ne ge uk'tuk	Sun-dog
Ne goo'u	Ringworm
Ne gung'a	Negative
Ne'kaht	Reindeer moss
Neh'a we	Leg of meat
Nek'a wik	Dining-table
Nek a yek'to	You eat
Nek'ah	Meat, flesh
'ek ch ak che'ro ak	Plenty of meat
'e kip e ak'to	Not enough
'e hee'wik	Table
'e kee'yan	Tetter
'e kwe'chuk	Not good
'ek'a kek	Thigh
'ek a kow'ruk	Pantaloons
'ek'a ru	Don't know
'ek a ru'it	I don't know
'e la'to	Miss
'el a we'ga	Unknown
'e kap'teen	Unwind
'e ling'ne	Leg sinew
'e keeng'a	Nipple
'e ming'a	Lashings
'e pe le ak'shok	Midnight sun
'e pa'te	Stick together
'e pai'e re it	Gossip
'e suh ak'yuk	Well
'e chu'ue	This side of
Note chak'to ne	Seal liver
No u ge uk chu guh chu ok	Big girl
No u ge uk po ah che ak	Little girl
No u ge uk'euk	Young girl
No u ge nk'sow ro	Young girls
Ne uke	Leg
Ne nk'toon	Drill
Ne upe kek'to	Mirage
Nev'a ya	Scaly-skin disease
Ne wing nok'to	Hang
Ne'yak	North
Ne'yek	Snare
Nib au buk	Bine-bottle fly
Nib la ro'ak	In labor
Ni chuw'el o	Strike me again
Ni chuh' nk	Carbine
Ni' chuk	Short
Nig a rok' puk	Crab
Nig a ru' too	Small tassels
Nig er'ah	Tassel
Nig er ah teet'ka	Fringes
Nik'ik	West
Nik'ahik	Fish-hook
Nin'cha	Aunt
Ning'e rook	Pull down
Niu'vok	Cottonwood
Nip'ko	Dried
Nip'pe	Loud
Nip ter'ak	Barrow
Nip ti'luk	Thick weather
Nip tok'took	Good weather
Nish egok'tuk	Leaping
Ni shoo'ra	Short
Ni tu'ruk	Short one
Ni'ya	Sister
No ak ala o'ta	Suspenders
Nob a lute'ka	Knee
Nog'a rook	Horn
Nok'a e'lun	Colic
Nok a week'ahn	Ugly
Nok'e rook	Venereal disease
Nok'e ru	Stiff
No koo'nok	Barnacle
Nok'sru	Drill brace
Nok tere'a	Hang up
Nek to ak'we it	Button hole
Nok tok to'a	Crossing
Nok to' ret	Long horns
Non a yol'hut	Edible bush
Nong neh'sret	A pool of water
Non ma'ta	Strap
Noo'ah	Shovel
Noo'a luk	Snipe
Nook'a	Brother, or sister
Noo kah'ah	Flour
Nook a ta'ya	Pull
Noun'a	World, earth, land
Noon'a keep er'uk	Earthquake
Noonare'a	Abandoned
Noon'a sin'ik	Dead; sleeping on ground
Noong a kok'to ro a	Big nose
Noo soo ok'to ak	Pinch
Noo woo'jek	Snow clouds
Noo weet'ka	End; consumed
Noo'ya	Hair of head

Eskimo	English
Now a ak'tuk	Moon, first quarter
Now'a luk	Whale spear
Now a yak'to	Eat
Now'cheet	Wild onion
No'whok	Young deer
No why yo'ok	Embryo deer
Now lau'nk	Shrimp
Now'ro	Grow
Now'yak	Large, gray gull
Now yak'a ya	Scalloped shell
Now yang a ok'to pe	Don't want to eat it
Now'yate	Onion
Now ye'ok	Fishing
Now ye rok'tuk	Hopping
Now yok'to	Eat
Nu boil'a ru	New moon
Nu'chat	Hair of the head
Nu e gi'lu	Friend
Nu e yok'a rook	Long mosquito
Nug a hok'to ak	Gasp
Nu gal lo'a	All right
Nu gat che'a	Brother
Nu gat che'a	Sister
Nu gat pe'a	Young man
Nu gat pe ah'ro	Young men
Nu gat pe gi'lo	Boys
Nu kah'in-tapt che ro'a	Married to two sisters
Nuk koo'vuk	Stand
Nuk'pah	Ball
Nuk pah'ah	Fastened upright
Nuk per'uk	Upright piece of a cross
Nuk pung'a	Tossing up a ball with feet
Nuk to'o lik	Avocet, or plover
Nu le'a	Wife
Nu le ak'che a	Maid
Nu le a ko'la cho	Can't keep a wife
Nu le e'ah	Wife
Nu leet gut'chuk	Bachelor
Nu le owk'kel owk to ak	Many
Nu le whok'klo	Help
Nu'ma	Root
Nu mer'o	Consumed
Num'nek	Evening star
Nu mung'aik	Snake
Nu o go ty'che	Sick
Nu ok'sha rook	Unbalanced
Nut'mon	Which one; what one
Nu'tok	New
Nu to'ya	Lynx
Nu uk'kwuk	Tea, or beverage
Nu ve ro it	To haze
Nu'whuk	Cold; coughing
Nu'ya	Hair of head
Nu'ya rote	Sea moss
Oak peen'ik	Young duck
Oak sung'ok	Fissure
O ak'to to	Spit
Ob'a rah	Tumor
Od lu'it	Seal hole
Og a la now'ra	Coil
Og a la'rok	Papers
Og'a late	Write, or draw
Og a la'to	Writing
Og a la tu'tin	Are you writing
Og'a lok	Brown bear
Og a ra lu'it	Wheel
Og'a ro	Morning star
Og'e wik	Anvil
Og la'nah	Pencil
Og lana ok'to	Gun
Og lan l'tuk	Continue
Og lek'to ak	Menses
Og'lo un	Pencil
Og luk'to	Writing
Og na zrek'to ak	Evil-minded
Og ra o'it	Star-fish
Ok ah-put	Rise up
Ok a le'ga mah	Grow
Ok an a sel'a	Hen
Ok an a shu'rok	Bitch
Ok an'ito	Women
Ok an'ok	Woman; female
Ok an'ot	Women
Ok an ow'rok	Girl
Ok a og'a rok	Old woman
Ok'a ruk	Football
Ok a ruk'chute	Gun-nipple
Ok a ru luk chuk'to ak	Fat of a stag
Ok a rum'ik	Powder
Ok a ru'ro	My wife
Ok a ve'	Ashes
Okavu'tin	Be seated
Ok a yoke'ya	Hasten
Ok chel okto	Turn over
Ok'e ruk	Ashes
Ok'a wuk	Bow-head whale
Okke kwik'tuk	Agate
Okke'oak	Appetite
Okke oak ke'chook	No appetite
Okke oak'ke ro a	Big appetite
Ok'ko	Paddle
Okkoo'ra	Lower border of
Okkuk'kah	Cease
Oklum'ok	Emit
Oklu'na	Rope
Ok lu nok	Rope
Okok che ra ko'a	Deserted
Oko ma e tah'ga	Scales, to weigh
Oko mi chuk	Heavy
Oko we'chin	Sit down
Ok oz re gaik pe ah'rook	Ptarmigan
Ok oz re gew'ik	Hooded ptarmigan
Ok pa la'ret	Sea-quail
Ok'peek	Bushes
Ok'peek al lu it	Currants
Ok pok'to a	Run
Ok pok zroak tuk	Run fast
Ok pol'uk	Sea-quai
Ok shuk'to uk	Wheel
Ok'arak	Sweet-ol.
Okuuk'to	Roll
Ok suk'tuk	Rolling
Ok to'it	Half
Ok too mer uk	Blizzard
Oktoo'ret	Long
Oktow'rok	Rope is off
Ok vil ato	Squat
Ok vil'a tumik	Phalarope
Ok vin'i le	Six

Ok vin-j la'oo	Six of them
Ok wonk'nak	Old woman
Ole ma gow'rak	Hatchet
Oo'mah	Adze
Ol la'ru	Move
Olo'rok	Fall over
On'e rook	Birth
On e'ru	Out
On e srook	Out
Ong a na'yok	To point
Ong'a ru	Big
Ong a yak'to	Enemy
Ong'a yo	Elder brother
Ong a yo kog'ara	Old animal
Ong a yo kog'nek	Old man
Ong a yo kong'ek	Father-in-law
Ong a shu'a	Age
Ong a sra'it	Very large
Ong a sra'rum	Very large
Ong eg a ro'a	Excessive
Ong e goo'tin	You consent
Ong ek'to	I consent
Ong'e sroak	Big
Ong'mok	Agate
Ong ne'a	Stopped up
Ong'nek	Elder sister
Ong'nuk	Darkness of night
Ong'oon	Male
Ong o wok'to	To paddle
Ong ung'ek	Mother-in-law
Ongna'rito	Currant
Oug'yoa	Comrade
On na'ruk	Currants
Ong ik'kik	Pursuers
Ong alto	Deer excrescence
Ong'wah	Talisman
Oo'nok	Slate
On co ho'ga	Game of tag
On u a we tok'to	Jump up and down
Ooban'bak	Blue-bottle fly
Ooblak'o	To-morrow, future
Ooblow'ret	Cottonweed
Oob'lnke	Daylight
Oo bluke tok'eto	February moon
Oo ble'pak	Day (from morn to eve)
Oobsow'tit	Dog-muzzle
Oo ching'no ak	Large whale
Oo'chsk	Spruce gum
Oo e al'ego	Gargle
Oo's lah	Chew of tobacco
Oogal'ik	Have
Oog'a rook	Sea-lion
Oo gin ak'tak	Completed
Oogra'nok	Gray mouse
Oogung'o	Whale's ear
Oo in yo ok'to	Whistle
Oakal'ik	Hare
Oak'arook	Oil
Ook a ru'a	Soft
Ooko'e ok	Rock tower
Ooko'ak	Year, winter
Ooko ok'to	Autumn
Ooko ok'tak	Autumn
Ooko u a srook'took	December moon
Ooko ahtow'ruk	Snow-bird
Ooko o'tik	Winter game
Oo'bok	Tongue
Ooko ne'a	Chew of tobacco
Ookpe gi'lo	Young owl
Oak'peek	Snowy owl
Ook put'ik	Lower part of back
Ook'sruk	Oil, fat, or lard
Ook'toon	Square (a tool)
Oo kwad lnok'pak	Salmon
Oo kwad lu'pak	Trout
Oo'kwah	Those
Oo kwcawk'eo	Around here
Oo kweet'a	Saddle of venison
Oo kwil'awk	Calico, cloth
Oo kwok'to	Talk
Ook wok'ton	Said
Ook wok to ro'a	Silly
Oolapkit'ke	A game of tag
Oo'loh	Bed
Oolek'shuk	Split
Oole'kret	Erase
Oo le la'go	Open out, turn inside out
Oole'ma	Axe
On le'to	Back sinew
Ool ge'lik	Blanket
Oo lig'rua	Blanket
Oo lik'to a	Shiver
Ooling'lo luk	Tumble
Oolook'ah	Saw-dust
Oo'loon	A saw, or woman's knife
Ooloo-ok'toon	A saw
Oo loo'ra	Woman's knife
Ooloo'raken	Cheek
Ooloora'me	Cut with woman's knife
Oolu'gah	Crush
Oomagib'o	Get out
Oo'mah	My husband
Ooma'la	Rich man
Ooma'lik	Chief or head man
Ooma'rok	Stiff
Ooma'ya	Shave
Ooma'ya	Chief or head man
Oo'me ak	An open boat
Oomeak'puk	Ship
Oomeak'tuk	Ship
Oome'chat	Reindeer moss
Oomechook'ton	Hate
Oo me lok'to	Making faces
Oo'men	Mountain
Oo me'rat	Capsize boat
Oo meabuk'tuk	Dislike
Oo me ug auk'to ak	Boat festival
Oomeuk'kuk	Open it
Oomig a rok'toak	Close
Oomig'lapo	Shut
Oomik'tin'e	Mustache
Oomoit gum'e	Heavy
Oomnd'luk	South wind
Oo'muh	Mag. compass
Oo'muh	Oh, yon!
Oomuk'shuk	Aim
Oomuk'tin'e	Mustache
Oo muk'tuk	Aim
Oo'man	Heart
Oomung'moag	Musk-ox
Oomutah	Heart
Oou'a	It

Oo'nah	Whale and walrus spear	Oo wil'a	Shell
Oon'aloo	For	Oo wing'a	Husband
Oona'ne	Sea	Oo win'ik	Human skin
Oonashed'neruk	Cross	Oo wok'to	Crumble
Oon a zrok'tuk	One-man sled	Oo woon'a	Over there
Oo neah'ah	Drag	Oo wng'oot	We, us
Oo ne'et	Sled	Oo wal'uk	Warbler
Oon el'o	It is from	Oo wung'a	I, me, mine
Oone'nek	Mustache	Oo wung a loo	Ours
Oong'a luh	South, south wind	Oo yaw hite	Rock
Oong'a ye owhik	Battle	Oo yaw'ok	Rock
Oong nah'puk	Night	Oo ye ge'a ya	To dress
Oong ne'ak	Night	Oo yow'tuk	Rocks
Oon moo'lik	Muzzle-loading gun	Oo zhug'ok	Vent
Oonok'ja ka ma	Sweat	Oo zhum'a ga	Needle case
Oonok'set	Fir	Oo'zrok	Smooth-tanned seal
Oo nok'to	Hot	Op kwa a nok	This side
Oo nok tu it	Hot	Op'kwo	Trump
Oo noo'mon	Yesterday	Op pol loil'luk	A species of small bi
Oo noo noh'e ret	Four deerskins	Orak-im'uk	Fire-clay
Oo piu'ok	Summer	Oro'yowk	Monkey-wrench
Oo pin row'lik	Warbler	O rok'sa kon	Black lead
Oo pin yug'a ra	Summer	Ot kok'to	Bag of oil.
Oo pow took'too	Chastise	Ot kot'e ka	Mittens
Oo puh n'rook	Post	Ot'kuh	Name of a thing
Oo pun'rah	Summer	Ot'la	Other
Oo puu-rok	In summer	Ot'pah	Crow-bill duck
Oo pun ruk'shak	Spring	Oup'tuk	Pimple
Oo rah'ah	Measure	Ow'a rok	Vise
Oo re ge'lik	Birch	Ow chow'to	Yawn
Oo'ahook	Male gender organ	Ow e'ka	Pieces
Oo shug wit'ka	Uaroli	Ow ek'to	Soft
Oat'chook	Female organ	Owg ro'a	Phalarope
Oot choo'rel a	Sharp's rifle	O'whok	Lead, silver
Oo te'kah	Throw	O wim'a gow	Leaking
Oo tek'tine	Return	Owk	Blood
Oo te mer'o	Bare spot	Ow'ka	Melt
Oo tet tin'a te	Burn	Owk chel'a go	Melt it
Oo tik'too	Away	Owk e'to	Blood
Oo tik'touk	Return	Owk se'lah	Get out
Oo ting'a roa	Bare	Owk se mer'uk	Thaw
Oot'kah	Cooked done	Ow la'rok	Swing
Oot koo che	To cook	Ow la'ta	Engine
Oot koo'chik	Pot	Ow la'tin	Motion
Oot koo je'tin	You cooked	Ow la'yo	Stir
Oot'kwe	Potato	Ow ler'o	Hash mixer, head
Oot'mok	Wart	Ow let'ka	Stake
Oo toog'wa	Scalp	Ow lit'ga	Wave
Oo too'kok	Old, abandoned	Ow lum'e	Move off
Oo too'muk	Palm	Ow'mah	Charcoal
Oo to'uke	Nerve	Owng'a	Bruise, clotted blood
Oo tuk'too	Burn	Own'e cho	Not bloody
Oo tuk'toone	Burn person	Own'yok	Abscess
Oo'va	This, now	O wok'che ga	Damp
Oo va'kee	See this	Ow rel'a	Summer game
Oo va'lo	This one	Ow'tin	Deal
Oo ving'a lo	Hist	Ow'tong	A ball
Oo vok'to	Tub	Ow'ya	Slung-shot
Oo van'e	Down there (distant)	Ow ya ok'to ak	String puzzle
Oo'vwah	This	Ow ya pal op in	Stir
Oo vwan'uk	Rainbow	Ow zre'uk	Pupae
Oo wap ting le	My country	O yah'l	Stake
Oo'weet	Perspective	Oz re ke ru'vuk	Excessive menses
Oo weet'chea	Mirage	Pah	Vestibule
Oo we ga	Husband	Pah chik'che tan	Frying-pan
Oo whil'yig a	Right side up	Pah chok'e kwo	A game of cards

Pah chek'te-	To pass (cards)	Po too whah'to	Boil over
Pah haw'ta	Whip	Po u'ra	Pinch
Pah'hine	Come (to a child)	Po ah'pah	Faded
Pah ket'ka gah	Find	Po uk to ak	Full
Pah kow'e cho	Not found	Po yek'in	Get away
Pah look'te	Beaver	Po yak'pun	Is gone
Pah muk'too	Crawl	Po yek'tin	Begone
Pah maung'nah	East	Po'yok	Clean out
Pah'ne	Off	Po yowk tin	You are wanted
Pah rot'a	Creek	Po yuk'sak	Throw
Pah wun'e	Through	Pig'a	Many
Pal ig or ak'tow tik	Lustful	Pig'a ron	Present
Pal lo tak	Kind of moss	Pig'e soot	Shovel
Pal uk'tel	Dam	Pik a rot'ka	Present me
Pan'e	Hoisted	Pik a rum aik	Give me food
Pan ak'ta	Dried	Pik obo'in	Razor
Pan mang'ne ak to	Back island	Pil gi'rok	Plait
Pan'niag	Daughter	Pi'lot-a shu'ra	Too slow
Pa room'a	Kite	Pi luk'tak	No more
Pat chu ang'a	Not find	Pin ek'toa	Pocket-knife
Pat keo lak'took	Fan	Ping'i shute	Three
Paw wun'e	Through	Ping'i shu'nek	Three of them
Pu'ya	Hatch	Ping'i shu-okvin lie	Eight
Po ah'a rook	Killed	Pin'uhok	Stocking
Po a'le-go	Take off	Pin'ukuk	Short deer-boots
Po che kek'tung	Strike against	Pin u kun'ik	Stocking
Po che kuk'tak too	Bump	Pin n'leo	Bread-pan
Po chik cho lok'to ak	Fry	Pin u'ra	Slippers
Po'chuk	Will not	Pin u roo'a	Nettle-rash
Po chung'e cho	Not wanted	Pin u'tok	Pocket-knife
Po chu nok'rok to ak	Walked	Pin ya ago'ra	File
Po chu ru'ik	Walk	Pin'yok	Grass to put in boots
Po e ga lu'tin	Intercourse	Pin yow'a	File
Peg'a	Take off	Pin yowk'toonga	Filing
Po'gah	Has	Pin yuk'ta	Pocket-knife
Po'gown	They want	Pin yuk'howr'a	Pocket-knife
Po gow tin	You are wanted	Poa'la ra	Dance
Po ke te ov'ak	Kick	Pegatow'ro	Dish, plate, pan
Po hak'tin	Shove	Pok chagah'yah	Will meet
Po kee'le gah	Loin; back	Poke'ary	Receptacle
Po kun'e	On there	Pok nor'a ok	Ice window
Po'kwah	Loins	Polahro'a	Eclipse
Pel'ego	Bring	Pola'ruk	Doing
Po lak'ta	Cut out	Pol uk'tuk	Stoop
Po'lu	Intercourse	Pood nan'uk	Tallow
Po'luk	Not here	Poo ey'tuk	Blister
Po ne la'tin	None	Pon e'yak	Craw
Po nik'srait	Grass	Poo ey yowk tuk	Vapor
Po nik ers'ne	On the grass.	Poog'ra	Receptacle
Po now'gan	File	Poo grat'to it	Swim
Po rik'a	Bent	Pook'ke	White hair on deer's belly
Po rik tok'to tin	Around the bend		
Po ahik'she rok	Drill handle	Pook chak'tuk	Excrement
Po ahik'she	A bow	Pook'shook	A seal bag
Po ahik'she rok	A gun spring	Pook tow'te	Bony
Po shook'a'wah	What do you wish	Poong'a	Shroud
Po shook kel awk'to	Need	Poon'ik	Bread
Po shook'kok	White fox	Poo'to	Ear-ring
Po shook'teek	Wish	Poo to'a	Hole
Po shu ok'toa	Walking	Poo to gwok'so ah o yik	Glow-worm
Po chu'ru-	Walk	Poo too'go	Big toe
Pote po la'ruk	None	Poo took'e to	Stumble
Pote'po ruk	None	Poo'waih	Lung
Pote pi yak'to	Not anything	Poo'we	Blister
Po tiir'te	Shoot	Poo ye'ga	Craw
Po teek luk'took	Poise	Poo yok'a wik	Stove pipe

Eskimo	English	Eskimo	English
Poo'yuk	Steam	Se lung'ok	Black-tanned leather
Pot'ka	Marrow	Se na toak'too na	Dream
Pot ka tol'nok	Marrow bone	Se ne'a	Bootlace
Pot tow'rah a lo	Clapping of hands	Se nung'koot	Ankle
Po tu'mak	Wish-bone	Se rook'ta at a	Take it
Pow a lik'to	Gnarled	Se sam an'ik	Four of them
Po wit'to a	Swollen	Se sam'at	Four
Pow kas'a	Wide awake	Se tang'e rook	Handsome
Pow'lah	Soot	Se ta yo'ruk	Herring
Pow la'yo	Ramrod	Se'tik	Ear
Po woke'to	Forget	Se ti'luk	No ear
Pow'ake	Cup	Se uke'tat	Ear of an animal
Po'yoke-po la'ret	Forgot about it	Se uk'se tik	Bird snare
Po yrok'tet	Forgot	Se uk sow'se tek	Ensnare
Pub'o greet	Whale's small	Shag'a	Whale's stomach
Pnk la ya'ok	Flea	Sha hi'uke-a tig'a	Open cloak
Puk'ma	At present	Shab tu'ruk	Very thin
Puk mnm'my	Now	Sha nit'to	Mislaid
Puk to'ak	Meet	Shan'o kok	Side
Pum mung'na	East	Sha to ak'a yuk	Periwinkle
Pum my oo'ga	Animal's tail	Shal'tu	Thin
Pum my uk'tuk	Land otter	She	Pike (fish)
Pum my ung'a	Animal's tail	She'la look	Rain
Pun'a	Daughter	She la look'tu	Raining
Pun ol'ik to	Deer, running	She lik'to a	Large glover's needle
Pung'a	Gun muzzle	She'lute	Bundle up
Pung'nek	Stag	She'oak	Pike (fish)
Pau ne'a	Daughter	She og'a ruk	Rising water
Pun'ne	A staff	She ra'le ag	Woman's pantaloons
Pun noo'ga rook	Spring (season)	She roop'sa tuk	Seven stars
Pun now'rea	Lean person	She sho'ak	White grampus
Pun uk'she ruk	Dried up	She to a'kak	White grampus
Pun uk'she yek	To dry	She'wa	Bow of a vessel
Pun uk'to mik	To dry	Shi kin'ya	Sun
Pun uk'tu tin	Withered	Shi kin'yekt	Short days
Pup'ke	Bird's tail	Shi kin'ye lnk	No sun
Pnt kweet	Potato	Ship shi'lok	Lame
Pu wa'ne rok	Turn around	Sho	Which
Pu wat'ing	Help	Sho ak'e ro	Killed
Sat koo'lik	Cross-bow	Shog'ok	Summer skin
Sava ak chung toong a	Wont work	Shog ok'to	Summer fur
Sav a ko'ra	Rice	Shok a wah ik'tok	Torrent, water-fall
Sa vak'to	Work, make	Shok a wok'to	Current, tide
Sa vak'to cho	Working	Shok a wok'tit	Running water
Sa vak'ton	Made	Sho'kok	Baleen, or whalebone
Saz're gait	Wild celery	Shoo'loo	Arrow-guides
Seat'mon	Sew with palm and needle	Shoong ah	Gall
Se ek ru it'tu it	Flapping	Shoo poo til a go	Shoot
Seek'sreek	Marmot	Shoop ru'a	Gun barrel
Seek sruk'puk	Badger	Shu'a	What
Seel'a mon	Outside	Shuk a mit'ka	Strike, or cuff
Seel a wik'to	Full	Shuk i sho'a rone	Fast
Seel gav'a ok	Work outside	Shu ki shape'ru ne	Slow
Seel ook'took	Shad	Shu'la	More, additional
Seel'ya	Weather	Shu'ma	What
Seet'lee	Whet-stone	Shu ma'go	What is it
Se'klokt	A pack, clubs (cards)	Shuun'na	Put
Se'klokt	A constellation of stars	Shu'mon	What is it
Se klokt'oa	Dig with pick	Shu mon no a	What do you wish
Se'ku	Ice	Shum un'e	Down in
Se ku e'ber uk	Ice pressure	Shu na ok'pe	What are your intentions
Se ku i luk	No ice	Shung e cho	Indifferent
Se ku no r'ak	Frozen	Shung e ruk	Strong, difficult
Se kup chek lup	Seven stars	Snung ok'to ak	Green
Se lan'a	Choke	Shung ow'ro	Beads
Se'lu	Carcass	Shun nek'took	Ridge

Shun se ok'tuk	Brush	Tam ok ot'ohe a	Chew
Shu oop'to ak	Curlew	Tam uk to'a	Lost
Shu'pen	When	Ta man'e	At this place
Shup kar'uk	Water-wheel	Tam ut'che	Hand me
Shup kwer'uk	Hurry	Tam ut'kwo	All of that kind
Shu poo'loo	Shave	Ta mus'ra	Is here
Shu poo'wa	Pop-gun	Tan al'look	Slate
Shu rok'a ro me	Leaf tobacco	Tang'ong	Intoxicating liquor
Shu shog ip pok'to	Limp	Tan'ik	White man
Shu'to kwe	Why did you come	Tap'che	Belt
Sid'le	Whetstone	Tap ete tuk	Double
tik'ek	Deer boot-bottom	Tap ik top'to a	Pocket-knife
Sing'a re-poo'wik	Fur border on boots	Tap ka'nite	Rapids
Sin'ik	Sleep, immovable	Tap'kok	Sand bar
Sin ik'a wik	Bedroom	Tap'kwo	These
Sin ik lek'to ak	Dreamed	Tap pe'choke	Feel
Sin ik'ahok'to	Lie down to sleep	Tap pe'ko	Blind
Sin ik'to	Sleeping	Tap pe look'to ak	Near-sighted
Sin ik'to ka	Asleep	Tap au'a why	It is foggy
Sin ik'u tin	You will sleep	Tap su ra'tin	You lost
So lin'yat	Bald	Tap tik'too	Fog
See'loon	Coffin	Tap took'tuk	Fog
See'loon	Box	Tash'uk	Lagoon
See'klo mit	Fourth toe	Tau seoak'took	Together
Se'whet	Moss-berry	Tat'ka	Moon
Sow'yok	Drum	Tat ka ne'cho	No moon
Sow yek'to it	Concert	Tat kom'e	Above here
Sew yung'a	Drum	Tat pat wun'e	In; back there
Sung'wah	Gall	Tat pi'na	Up there
Se'ret	Deckweed	Tat'too	Frozen mist
Tab la o'tit	Tattoo on woman's chin	Ta vun'a	Back there
Te ble'a	Chin	Tawk rek'toak	Blue
Tab room'a	That one	Tawk'se	Trade
Tag a yuk'puk	Sneeze	Tawk ta lu'rum	Negro
Tag'e look	Snow-shoes	Tawk ta lu'ret	Black one
Tah ah'ook	Shadow	Tawk to'ak	Black, dark
Tah e ah'ret	Bracelet	Tawk to ak'puk	Very dark
Tah ik hu'it	Whale's fin	Tawk too'tin	Darkened
Tah mus'ra	That's it	Ta ya'cho	Weak
Tah'ek	Vein	Ta yah'chato	Bead bracelet
Tah ok'te a	Mirror	Ta yah'ret	Bracelets
Tah tis'a rok	Crane	Ta'yuk	Bracelets
Tah vun'e	In there	Ta yung now'te ka	Wrist
Tak a luk'a sah	Butterfly	Te ek'to ak	Hard
Tak er o'a	A pair (cards)	Teep'seret	Drift
Tak ig'e rie-ke'rook	Drift wood	Te gov'te	Teeth
Ta keot'ka	Kill	Te ke luk chuk'too	Not here yet
Tak ee mer'uk	Changing	Te kik'took	Arrived
Tak ee u'wah	Lead, or guide	Te kol'let	Out
Tak ti'rok	Loose	Te kru'tet	Teeth
Ta kun'a	Down here	Te ku me ve'a	Handle
Takung'a	Reflection in water	Te la if'rig in	Rub
Tal ee ke'po gah	Amputate	Te lek'to ak	Scrub
Tal e gow'rak	Wire bracelet	Te let'ko	Tattered
Tale ma	Five	Te'po	Rotten
Tal e maa'ik	Five of them	Te pe ke'zrook	Spoilt
Tal ig'o wait	Snipe	Tep kal'nait	Meat
Tal ing'na rah	Endway	Te're ak	Ermine
Tal la'is e	Shake hands	Te re ak'puk	Mink
Tal loke'ne nek	Enemy	Te re ak puk e sru'it	Small can of powder
Tal la'yeh	Chute	Te re in'de a	White fox
Tal'nek	Darken	Ter'e va	Finished
Tal uk'un tuk	Bashful	Te shi'ro	Hear, understand
Ta man'a	Here, at this place	Te tak'zro gah	Quill
Tan'na	That	Te upo'tuk	Tough
Tan men'e	That one there	Te'ya	Tears

Eskimo	English	Eskimo	English
Tig'a	Thimble	Toog a ling'a	Braid of hair
Tig a ak'tu a	Take	Too im ne'a	Last
Tig'a ga	Thimble	Took'a	Seal spear
Tig'a lik	Steal	Too koad'rook	Hell
Tig a lek'to a	Thief	Too let'chuk	Worm
Tig a lo'a	Fight	Too'lik	King loon
Tig a look'a	Hit	Too'lik	Golden plover
Tig a mu sh'ga	Nurse	Too loo	Needle-case
Tig a rah'ah	Point of land	Too loo'a	Raven
Tig a shu'ruk	Pick up	Too loo'ane	Back
Tig go'et	Foot	Too loo'muk	Rainbow
Tig lu rok'to ak	Beat	Too lu'me	Rib
Tig'oo	Take	Tool'wah	Long cloak
Tig u'ga	Hold	Too'ma	Track
Tig u ong'a	Adopt	Toom'a go	Go ahead; lead off
Tik a we'a	Take	Toom'a tin	Turn back
Tik a ya'rok	Stiff	Too'mit	Path
Tik'ek	First finger	Too'mon	Tracks
Tik lo'a	Knock	Too mon'eat	Sled tracks
Tik sow'me ruk	Stiff	Too mook'took	Pale
Til a hut'che	Broom, brush, duster	Too'ne	Diamonds (cards)
Til a oon'a	Sweep up	Too noo'ok	Skeleton
Til om'ni ute	A pouch	Too noo'riok	Ghost
Tim ung'a	Whale's back	Toon'rok	Devil
Ting'a cha too	Fly away	Too pal nik'toot in	Desire to sleep
Ting a lo'tok	Nail	Too'pik	Tent, summer house
Ting'a ro	To fly	Too ping'a	Delicacy
Ting'e	Hair on body	Too pit too'uit	Onion
Ting me'a	Bird	Too'poop	White fish
Ting me ak'puk	Golden eagle	Toopt'u	Windpipe
Ting me'ret	Birds	Toop tu'ra ken	Throat
Ting'ook	Liver	Too puk'e rook	Two houses
Tin'oop	Black or silver fox	Too puk er u'it	Many houses
Tir'a lu	Slice	Too puk'zrook	One house
Tit ki'ok	Crazy	Too tau'let	Eared owl
Tit ki'yo	Foolish	Too tl lu'a	Grandfather
Toag	Ice pike	Too to'alo	Salt meat
Toak'a lo	Spy-glass	Too'tok	Chin labrets
Toak'a lo mat-au'na	Foster-mother	Too to'kwok	Moose
Toak a look'shok	Snare	Too tong'ik pi	No deer
Toak'kook	Tidewater	Too'too	Reindeer
Toak'o ro	Dead	Too'too-imp'ni	Mountain sheep
Toak'pe	Seal spear	Too'wa	Walrus tusk
Toak'tome	Killed	Too war'uk	Walrus tusk
Toak'too	Job	Too we'ke	Hunters
Toak tuk'to ak	Throbbing, clock	Too'wit	Also
To a vwek	Small bat-like bird	To par tok'tit	Battle
Tob a la'ta too	Small penknife	To ret ko'yak	Term
Tog'o ro kok	Seal bag	Tos luk'tuk	Deaf
Toh'ha	Shadow	Tow'took	Show it; see
Toh hi'tin	Bottle	Tow toong ik pe	Not see
Tok a la u tow'ruk	Bottle	Tow'yok-sing oo na	Malediction
Tok'ha	Shadow	To wy'ya	Butt
Tok'o yo	Flag	To'yok	Old squaw duck
Tok o ro mo'tok	Graphite	Toy'oke	Salt
Tok o ro now'tuk	Graphite	Toy o'ne	Seaward, ocean
Tok she'ro	Win	Toy u'rok	Sea swallow
Tok shu ru tin	You win	Tu'bweet	My turn
Tol'lu	Cub, brown bear	Tuk e'zrook	Long
Tom o whot ik	Jaw	Tuk kow rum'e	Circle
Tong o yok'tu tin	Hatred	Tum'e ra	Following
Too'a recht	Constellation of stars	Tung uk'to ak	Purple
Too a tow'ruk	Button	Tu'pen	When
Toob'room'a	Follow	Tu pit'kwe	Amulet
Too'e	Shoulder	Tu ra tin	Your turn
Too o'gah	Shoulder	Tu rek'toong	Your turn

Tu'room	Year turn	U poo'nrak	Knife handle
Tav're	That will do, did	Uah'ak	Birch
Tus'ra fk'pe	Not done	U'wok	Widgeon
Tus'rava	Finished	Wah'ok	Dirty
Ty' nam'a	Same	Wam it'in	To dress
Ty nam'ah sing	Same as that	Wam it'in	To gesticulate
Ty'a	Tree creeper	Wau ro ho'ak	Not dirty
Ty u se'ka	Wrist	We at ok'to	Betrothed
Ty sng'ok	A small sea bird	We'chok	Red lead
Ty yaw'kut	Hoop	We'it	Sent
U ki shook'tna	Lasy	We la'ruk	Gnash
Um mung'me	Clam	Wing ar ok'to ak	Dance in honor of fiance
Un'a kun	Wait little while	Wing ik'to ak	Puberty
Un a kut'e a	Cousin	Wol'tik	Light weight
Ung'a lung	South wind	Wol'tuk	Light weight
Ung a hu luk'tet	Doctor's house	Wol in row'nek	Very light
Ung a wit'kin	Untie	Wo ne to'ak	Jaw
Ung'mah	Flint scraper	Yaw hoo'tet	Music
Un gob'rogi	Untie	Ye kik'a	Hug
Ung at'koo a	Doctor's house	Ye o' het	Hill
Uat'moke	Acorn	Ye ak'al n	Live
Un at koo'ya	Small, canvass-back duck	Yoke	Live
Un at'kout	Doctor, magician	Yer'a yek	A kind of fish
U pu'a	Ax handle		

NUMERALS.

1 A tow'ahek		15 E ke'me ak	
2 Hi'pah, or mal'ho		16 E ke'me ak a tow'ahek	
3 Ping i ahato		19 E nu'e nok o tal'in (20—1)	
4 Su sam'at		20 E nu'e nok	
5 Tal'e ma		30 E nu'e nok ko lin'ik (20+10)	
6 E chug'e ret, or ok vin'ile		40 Mal'ho ke'pe ak (2×20)	
7 Tal'e ma-mal ro'nik (5+2)		50 Mah'ho ke'pe ak-kol'mik che pah ak te (2×2 +10)	
8 Tale ma-ping i ahu'nik (5+3)		60 Ping'i ahu-ke'pe ak (3×20)	
9 Ko ling'o tal in (10—1)		100 Tal'e ma-ke'pe ak (5×20)	
10 Ko'leet		400 E nu'e nok ke pe ak (20×20)	
11 Ko leet a tow'ahek (10+1)			

GEOGRAPHICAL.

Herschel Island	Imp'na rok	Cape Thompson	Imp nah'puk
Return Reef	Oo lik'te me	Cape Seppings	Ke che nud'luk
Barter Island	Noo boo'a	Cape Blossom	Kik ik tow ruk
Colville River	Nag'a leh	Kotzebue Sound	E'lu
Meade River	Kol u gru'a	Cape Spanberg	To gu'tet
St. Clair River	Koo gar'o	Cape Lowenstern	Ke pod'luk
River west of Colville	Ik pek'pung	Schismareff Inlet	Oo pe shuk'a ru it
Point Barrow	Noo'wooh	Cape Prince of Wales	Kin o'gan
Cape Smyth	Oot ko ar'io	Fairway Rock	Oo ke'e ok
Coast Point Barrow to		Krusenstern Island	Im ok'leet
Pearl Bay	Im'nowk	Ratmanoff Islands	In ek'leet
Pearl Bay	Ping i ahn'gu mute	East Cape	No'whok
Franklin Point	At ten ok'mute	Coast northwest of	
Point Belcher	Se zar'o	East Cape	Kot leet
Point Collie	Koog mute	Coast southwest of	
Wainwright Inlet		East Cape	As re go's
River	Kook	Kings Island	Ov ke'roh
Village south of Wain-		Sledge Island	Ah ya'ak
wright's	Ke la man tow'ruk	Cape Douglas	Ong ne'ah
Icy Cape	Oo too'kok	Port Clarence	Nook
Point Lay Village and		Great Lake east of Port	
River	Kook pow rook	Clarence	Im ak'a srook
River 30 miles east of		Point Spencer	Pa rol'l it
Cape Lisburne	Pet mag e'a	Water Place Port Clar-	
Cape Lisburne	We'vok	ence	Oka veen ok
Point Hope	Fig a rok	St. Michaels	Tash'ak
Point Hope River	Kook'puk		

In the above vocabulary the words are spelled phonetically, letters being ꞁ
their natural English sounds; k is substituted for c, except in ch, and k take
place of q. Where g occurs it has the hard sound, as in "gas." —. (N) is for ꞁ
Hope and North Coast; —... (B), Point Barrow; .. — (D), Diomedes and Cape P
of Wales; —. — (K), Lake region back of Port Clarence; —. — —(Kev), ꞁ
between Novatok and Point Hope; —. — ′′′′′ (KP), Point Lay.

The vocabulary is the result of four years' study and practice, one year with na
alone, when no English word was heard. It has been re-written and corrected ꞁ
four months.

<div align="right">John W. Kelly, 1885–18</div>

ESKIMOS IN SIBERIA, FROM CAPE BEHRING TO EAST CAPE.

ANGLO-ESKIMO VOCABULARY.

In this vocabulary y is always hard.

Symbols—

East Cape	(e. c.)
St. Lawrence Bay	... —...	(a. b.)
Inland Deermen	—.. ——	(d. m.)
Plover Bay	(p.)
Cape Tchaplin	.. —	(o. t.)
St. Lawrence Island	... —	(c. t.)
Cape Behring	—... .	(b. e.)

Anchor	Oo u're
Arm	Tas'luk
Aurora	Ka yo a yok
Ax	Ka ka le'ma
Baby	Tal no'whok
Bad	Suk'a luk
Bad man	Suk a lu'uko
Badger	Hae'to
Badger	Nne'to
Badger	Ke n'ye
Badger	Ne tong'ook
Band	Ok now'oot
Bay	Snuh'ok
Bead	Shung ow'ro
Bead	Ow ga'be
Bear, white	Room'ka
Bear, white	Naw o'a
Bear, white	Naw'ook
Bear, brown	Pub kin'ok
Bear, black	Ka ing'a
Bed, go to	Mun ra'mok
Bell	Wun'ye
Belt	Tap'che
Big	Ne main'kin
Big	Ong'a re
Bird	Kah wag'a nin
Black	Tak nil'er gie
Black skin	Mnn'tuk
Blood	Owk
Boat, open	Ung'yet
Boat, closed	Ky'ak
Boots	Pe lek'it
Boots, fancy	Ko lip'se kan
Boots, water	Ko ve'n ke
Boots, deer	Bo'ne ye kok
Box	Se u'suk
Boy	Muk gil'ge
Bracelet	Tol yo'a
Brant	Luk'luk
Brants	Mum mu'ha
Brants	Mam'ma
Browse	Kow o'a ruk
Brother	Yo'ope
Button	Nuk tu'wha
Button	Too to'kwok
By-and-by	Ki'wa
alm	Kap'se nok
artridge	Ya pia'ka
ertainly	Whing yu'o
	Poo'noon

Clear	Ah vak'lak
Cliff	Imp'set
Cloudy	Kü la'luk
Coat	E rin
Coat	At'kook
Codfish	Toongoo'u
Cold	Ho tang'a
Comb	Soo'nek
Come	Tug'a
Consumed	A bang'ota
Cord	Im'who
Cotton	Koo we'a
Crab	Kang ko'le
Crab	Kang'kok
Crab	Ne ot'ke
Crane	Sho'kwa
Crazy	Okt nek'to
Crazy	Na sho'kwok
Curlew	Na to'chet
Curlew	Do'chet
Dance	Kan ka'ro
Day	Ka vok'tuk
Dead	Tu'kok
Deaf	Tus luk'tuk
Deer	Toom too
Deer	Toon'ta
Deer	Ko rong'a
Deer	Il wil'loo
Devil	To'nok
Dog	Kig'mok
Dog	At'ki ne
Dog	Kig meen'rook
Door	Kot'pok
Drawers	Ne'pa
Dream	Ka va nok'too ma
Drum	Sow woo'guk
Duck, elder	Kwal'la
Duck, elder	Kwad'la
Duck, elder	Too'nuh
Duck, elder	Tu'brok
Duck (loon)	U wy'u wa
Duck (diver)	Ka ing'ik
Duck, widgeon	Koug'wuk
Duck, crow-bill	Ot'pah
Duck, old squaw	Sang sek'a hoy ik
Duck (puffin)	Chu kwil'puk
Eagle	Ka wag'puk
Eagle	Wed'le
Ear	Se'guh
Ear-ring	Kwo paw'yet
Eat	Nin gum'e ta
Eat	Neg'a
Egg	Man'eak
Enough	Aa in'o
Ermine	Ah me ta'too
Ermine	To wy'ka
Ermine	Ah me'klu ke
Eye	E'ye
Face	Ke noak'a
Father	Ah tok'a
Fathom	Yok'tah
Feet	E'te yet

Fight	Kwu'to	Kiss	Sing nah'a look
File	E tam'nok	Knife	Wot le'a
Finger, first	Tig'eh	Knife	Chow'wik
Finger, second	Ah kle'nko	Knife, pocket	Om kwot'wa
Finger, third	Ah lunk'to	Know	Ne she'muk
Finger, fourth	E tel'ko	Lake	Na'peek
Finger, thumb	Koom'luk	Lamp	O'rak
Finger nail	Stoke	Lance	Kal loo yok
Finished	Too pht'ko	Land ot er	Nan'net
Fire	Ook took	Leg	It'ag o
Fly	Ma ning'la	Line, whale	Pa rekt
Fly	Kok'wa	Line, large	Tap'kwok
Fog	Ka go'took	Lip	Kun'yuk
Foreigners	Tan'u tan	Louse	Koo muk
Fox, red	Il'wah	Lynx	Ta pah'let
Fox, red	Kah vin'ok	Man, native	Yoke
Fox, white	Tre'gu	Man, native	Kol'loun
Fox, white	Doo'too	Man, negro	Tow'il ery-yoke
Fox, white	Kot le'a	Man, white	Kot'il ery-yoke
Fox, white	Tah'o wok	Man, white	La lute'wa len
Glove	E'het	Marmot	Seek'eek
Go	Ow e tok'to	Marmot	An uk'keo
Good	U pin uk'took	Marmot	E'li
Goose, black	Luk luk'puk	Mast	Na poah'yak
Grass	Wook	Matches	Nak'set
Grindstone	Te chin'na	Me	Oo wung'a
Gull	U a'ya	Medicine	At ha'ga
Gull, tern	Koh'u ma	Mine	Pung'a
Gum (of whale)	Soh'o ro	Mine	Hum'neen
Gun	Too'wuk	Mittens	La'leet
Hair, human	Noo'yok	Mittens	Ah ya poich chuug'
Hair, human	Noo'ya	Moon	Ten'kuh
Hair, human	Kit awe'a	Moose	Oap'ka
Hair, animal	Neea'kwok	Mother	Nag'a
Hammer	Yup'pa	Mother, my	Oo wung'a nag
Hand	E'net	Mountain	Ni'rek
Hare	Oo kwa'jek	Mountain sheep	Ken'nek
Hare	Oo kaw'che	Mountain sheep	Te pal'et
Hare	Oo kaw'chuk	Mouth	Kan'ka
Hare	Na lufa tot	Mustache	A mow'ah
Harpoon	A'yo ukt	Nail	To ko'a
Hatchet	Ki'i	Naked	Me tom'elkook
Hawk	Tok'luk	Near	Kun a too'rok
Hawk	Che a kaw'ret	Needle	Se'kuh
Heart	Ka sha'hok	Needle	Se'koon
Hermaphrodite	On ah'shuk	New	Nu tow'ok
Herring	Koh loo'ra	No	A bang'e to
Hill	Ni'ret	No	Wing'a
Hit	Ti gu'ok	No; will not	Wing a wing
Hole	Oot ke me'kluk	Nose	Ke'nowk
House	Mung to'ha	Now	E'nte
House, underground	Mung lah	Oar	Ya bo'kwa
How many	Kap seen'a	Oil	Me se'nk
Hungry	Nin gum'e ta	Oil skin	Kal'luk
Husband	Oo wing a	Oil skin	Ke tig'a
Ice	Se ku	Old	Oo too'kwo
Iron	Pil win'tin	Open water, big	Mok'look
Ivory (walrus)	Too ko'ra	Owl, snowy	Tok'a lo
Ivory (walrus)	Too'wang	Owl, snowy	Ha ne'pa
Ivory balls	Up klut'e tit	Paddle	An ox'ok
Jaw	Ow'e look	Paint	Ung a oo'shok
Jelly-fish	To ret'kok	Pantaloons	Ke he'nk
Jelly-fish	To ret kot'ka	Pantaloons	Ka now'tin
Jelly-fish	King'oo	Pantaloons, deer	Ip pe ha'ha wa
Killer (orca)	Ne gan'e	Pick, or mattock	Seet'look
Killer	Shung'sho	Plenty	Nim ka keen

English	Eskimo	English	Eskimo
Plenty	Ab a e lob'tak	Snow on ground	An se yak'a peon
Poke, seal bag	A wo'kah wuk	Snowing	Kong'ok
Pot	Kay ka'ne	Snow-shoe	Wool wuh'yak
Pot	Moo'ha	Spear, whale	Oo's nok
Ptarmigan	Tal'et	Spear, seal	Too'kwa
Puffin	Koob ro'a	Stand up	Muk koo'vuh
Puffin	Po ni'a	Star	E la lu'ke tah
Quick	Shu kwil'uuk	Star-fish	Tas'ki ville
Quick, very	Shu ki loog'tin	Star-fish	As'ka vo obe
Rain	Nip'chook	Stocking	Pum'ya
Raven	Kwil'wit	Stone tool	Wil um'ok
Raven	Mut tuk'look	Stoop	Goak'tah
Ring, finger	Loag ko'hoit	Summer	Keek
River	Ni'wuk	Sun	Shi kin'ya
Rum, drink of	A kwim'yeak	Teeth	Koo'tit
Sable	E la'yot	Thimble	Tig'ch
Sack	Cho klo'wuk	Thread	Klo'puk
Sail	Ting a lan uk ok	Tobacco	Cha lu'pa
Salmon	Kwad lu'pe	To-morrow	Oo gut'tek
Salmon	Too in'a	Tongue	Oo'loh
Salmon-trout	Ah'cho	Turbot	Col su gu am
Sand	Kun'ak	Turbot	Al sor g a'nek
Saw	Til be gew'na	Vise	Pum chu'wuk
Scissors	Poo jook'tat	Walrus	I'wok
Screw	Tap'pe tok	Walrus	Chit'chu
Sculpin	Ki sa'ga	Walrus skin	Mun goo'na
Sculpin	Oo'rok	Water	Im'ak
Seal, common	Al mu'chuke	Water, drink of	Ne kwe'sheak
Seal, common	Nat'chok	We	Oo mung'ham
Seal, common	Mam'lek	Whale, bow-head	Ok'kuh wuk
Seal, common	Nat'suk	Whale, bow-head	Bo sruk
Seal rope	Tap'kwa	Whale, gray	Uag to'hok
Sexual	O yo kwot'e ka	Whale, fin-back	Te po'hok
Sexual	Oo a look'in	Whale, hump-back	Tsag wo'hok
Ship	Uag ye ok'puk	Whale, narwal	Poo'jak
Shirt	Loo'luk	Whalebone	Gok lung'a
Shovel	Poo'goodt	Whalebone	Sho'kok
Shrimp	Kung'a sa	Whale flukes	Kom'in tok
Shrimp	King'yak	What do you wish	Cha lu'ga la
Shrimp	Oh shah'se ruk	What do you wish	Pe ra kot'ka
Shut (door)	Ted li pat'ka	Wife	A lik'ha
Shut (door)	Ma kot'u	Wind	An o'ka
Sing	La lug'era	Winter	Sho'ka
Sink	Ki lu geo'ta	Wish	A lu'ga nu
Sister	Ni yig	Wolf	Kun la'ga
Sit down	Ko a ko'a	Wolf	Oo koo'a
Sit down	Ok'o noke	Wolverine	Kap'se
Skin	Ah me we jek	Woman	Ok'an ok
Sled	Kom mi'a	Woman	Now'akat
Sled	Kom me ke	Woodcock (golden	
Sled	O'ro go'ro	plover)	Too'lik
Sleep	Ka'vok	Wrestle	Too'a walk
Small	Pi lo'kin	You	Shu'pa
Smell	Nah'bah	You	Han
Smoke	Poo'yok	Yours	Han'yun

ESKIMO-ENGLISH VOCABULARY.

Eskimo	English	Eskimo	English
A bang'e ta	Consumed	Ah me'ta	Ermine
Ab e lok'tak	Plenty	Ab me we'we jek	Skin
Ab'e look	Arctic Ocean	Ah toh'a	Father
A bang'e to	No	Ah vak'leok	Clear
A gah'tik	To-morrow	Ah ya poich'chung na	Mittens
Ah'cho	Salmon-trout	A kwin'yeak	Drink of rum
Ah ha'ga	Medicine	Al mu'chuke	Seal
Ah klo'ake	Second finger	Al scrag a nek	Turbot
Ah me klu ke	Ermine	A lu'ga me	Want

A lunk'to	Third finger	Ke noak'a	Face
A mow'at	Mustache	Ke tig'a	Oil Skin
A ne'yok-a'poon	Snow on ground	Keu'ye	Badger
An o'ka	Wind	Kig meen'rook	Pot
A now'ok	Paddle	Kig'mok	Dog
An uk'e a	Marmot	Kil la'luk	Cloudy
As in'o	Enough	Ki lu goo'too	Sink
As'ka voche	Starfish	Kiu'a ga	Sculpin
At'kine	Dog	King'ik	Diver
At'kook	Coat	King'oo	Jelly-fish
Awot'kuh wuk	Seal poke	King'yuk	Shrimp
Ayouwkt	Harpoon	Kit swea	Human hair
Bo ne ye'kok	Deer boots	Ki'u	Hatchet
Bo'zruk	Bow-head whale	Kle'puk	Thread
Cha lu'ga la	What do you wish	Ko a ko'a	Sit down
Cha lu'pa	Tobacco	Kob loo'ra	Herring
Chit'chu	Walrus	Kob ro'a	Puffin
Cho klo'wok	Sack	Kohu ma	Tern
Choro'nok	Deer horns	Kol ip'se kan	Fancy boots
Chow'wik	Knife	Kol'loun	Woman
Do'chet	Curlew	Kol su'gwam	Turbot
Doo'loo	White fox	Kom'is tok	Whale flukes
E'het	Hand; glove	Kom'me a	Sled
E la lu ke ta	Star	Kom'me ke	Sled
E la'yet	Sable	Kong'wok	Widgeon
E'li	Marmot	Kon'ik	Snowing
E'ren	Coat	Koo ka'ne	Pot
E tam'nok	File	Koom'luk	Thumb
E'te get	Feet	Koo'muk	Louse
E tel'ko	Fourth finger	Koo'tit	Teeth
E'ye	Eye	Koo we'a	Cotton
E'yute	Now	Ko roug'a	Deer
Goak'ta	Stoop	Kot'il e ry yoke	White man
Ha ne'pa	White owl	Kot'lea	White fox
Ho tang'a	Cold	Kot pok'u	Door
Hue'to	Badger	Kow'o a rok	Breeze
Hun	You	Ko ve'uke	Water boots
Hun yun	Yours	Kuh'ya	Lip
Il'wah	Red fox	Kun at oo'rok	Near
Il wil'loo	Reindeer	Kung'ara	Shrimp
Imp'net	Cliff	Kun la'ga	Wolf
Im'uk	Water	Kun uk	Sand
Im'who	Cord	Kwal'lu	Elder duck
Ip pe ha'ha wa	Pantaloons	Kwil'wit	Raven
Ir'ago	Leg	Kwute	Fight
I'wok	Walrus	Ky'ak	Covered canoe
Ka go'ay ok	Aurora	La'leet	Mittens
Kah vin'ok	Red fox	La lug'a ra	Sing
Kah wag'a nin	Bird	La lnte'walen	White man
Kaing'a	Black bear	Long ko ho'it	Finger ring
Ka kale'ma	Ax	Loo'luk	Over-shirt
Kal loo'yok	Lance	Luk'luk	Brant
Kang'kok	Crab	Lukluk'puk	Goose
Kang ko'le	Crab	Ma kot'u	Shut door
Kan'ka	Mouth	Mam'lek	Seal
Kan'ka re	Dance	Mam'ma	Breasts
Ka now'tin	Pantaloons	Man'eak	Egg
Kap'se	Wolverine	Ma ra ning'ta	Fly
Kap seen'a	How much	Me mlek	Seal
Kap se'nok	Calm	Mes'kwok	Animal hair
Ka sha'hok	Heart	Me tom'el kook	Naked
Ka va nok'too ma	Dream	Mok luk	Big, open water
Ka'vok	Sleep	Moo ha	Pot
Ka wag'puk	Eagle	Muk gil'ge	Boy
Ke he'ik	Pantaloons	Mum ma'ha	Beasts
Ken'nek	Mountain sheep	Mun goon'a	Walrus skin

Eskimo	English	Eskimo	English
Mungt o'ha	House	Ow e tak'a	Go
Mun ra'mok	Go to bed	Owk	Blood
Mun'tuk	Whale meat	O yok wot'eka	Intercourse
Mut tuk'look	Raven	Pah kin ok	Brown bear
Nag'e	Mother	Pa'recht	Whale line
Nab'huh	Smell	Pe lek'it	Boots
Nak'set	Matches	Pe lo'kin	Small
Na lu'e tat	Hare	Pe ni'a	Puffin
Nau'net	Land otter	Pe rak ot'ku	What do you want
Nan o'a	White bear	Pil' wint in	Iron
Nam'ook	White bear	Poo'goodt	Shovel
Na'peek	Lake	Poo'jak	Narwal
Na peah'yak	Mast	Poo jook' tat	Scissors
Na aho'kwok	Crazy	Poo'noon	Clam
Nat'ohek	Seal	Poo'yok	Smoke
Na to'ohet	Curlew	Pam chu'wuk	Vise
Nav'euk	Seal	Pum'ye	Stocking
Neg'a	Eat	Pung'a	Mine
Ne gua'ne	Whale killer	Rok'ua	Fly
Ne kwe'ohe ok	Drink of water	Room'ka	White bear
Ne mam kin	Big	Sang sek'a hoy ik	Duck
Ne ot'ka	Crab	Seek'eek	Marmot
Ne'pa	Drawers	Seet'look	Mattock
Ne ahe'mok	Know	Se'guh	Ear
Ne toeng'ook	Badger	Se'koon	Needle
Nim ka'koen	Plenty	Se'ku	Ice
Nin gum'e ta	Hungry	Se'kuh	Needle
Nip'ohok	Rain	Se a'suk	Box
Ni rek	Mountain	Sha lig a not	What do you wish
Ni'ret	Hill	Shi kin'ya	Sun
Ni'wuk	River	Sho'ka	Winter
Ni'yig	Sister	Sho'kok	Whalebone
Noo'ya	Human hair	Sho'kwa	Crane
Noo'yok	Human hair	Shn ki loog'tin	Very quick
Now'ekat	Woman	Shu kwil'aut	Quick
Nue'tu	Badger	Shnng ow'ro	Bead
Nug a luk'pe	Go to bed	Shung sho	Whale killer
Nuk koo vuk	Stand	Sha'pa	You
Nuk to'wha	Button	Sing noh'a luk	Kiss
Nung'luh	Under-ground house	Saub'uk	Boy
Nu tow'ok	New	So ko'ra	Whale gum
Ok an'uk	Woman	Soo'nek	Comb
Ok'aw ak	Bow-head whale	Sow woo'yuk	Drum
Ok mine'ok	Big duck	Stoke	Finger nail
Oknek'to	Crazy	Suk ala'yuke	Bad man
Ok'o noke	Sit down	Suk'a luk	Bad
Ok'pah	Crow-bill duck	Tah'o wok	White fox
On ah'ehuk	Hermaphrodite	Tak nil'or ge	Black
Oug'arn	Big	Tal'let	Ptarmigan
Or'an ok	Whale spear	Tal no'whoh	Baby
Ou kaw'ohe	Hare	Ta pal'let	Lynx
Oo ke'mek luk	Hole	Tap'che	Belt
Oo klung'a	Whalebone	Tap'kwok	Cable
Ou kue'a	Wolf	Tap pe'tok	Screw
Oak'took	Fire	Tas'luk	Arm
Ook wad in'pe	Salmon	Ta chim'na	Grindstone
Ook wa'yek	Hare	Ted li pat'ka	Shut door
Oo'lah	Tongue	Ten keh	Moon
Oo loo'kwo	Old	Te pal'et	Mountain sheep
Oo mung'hum	We	Te po'hok	Fin-back whale
Oop'ka	Moose	Tig'vh	forefinger; thimble
Oo a look'in	Intercourse	'Tig n'ok	Hit
Oo u'rn	Anchor	Til he gew'na	A saw
Oo wing'a	Husband	Ting a lan uk'ok	Sail
O'rak	Lamp	Tis ke ville	Star-fish
O'ro-go'ro	Sled	To a walk	Wrestle

To'brok	Eider duck	Tung yo'a	Bracelet
Tok'a lo	Small owl	Tus luk'tuk	Deaf
Tok'a uke	Sick	U'a yeh	Gull
Tok look	Hawk	Uk shuk'se ruk	Shrimp
To ko'a	Nail	U lik'a	Wife
To'kok	Dead	Ung a oo'shok	Paint
To'nok	Devil	Ung to'hok	Gray whale
Too'in a	Salmon	Ung ye ok'puk	Ship
Too kah'a	Walrus tusk	Ung'yet	Boat
Too'kwa	Seal-spear	U piu uk'tuk	Good
Toolik	Golden plover	Up kut'e tet	Ball; missile
Toom'ta	Deer	U wy'u wa	Loon
Too'muh	Eider duck	Wed'le	Eagle
Toon goo'u	Codfish	Whing yo	Certainly
Toon'too	Deer	Wil um'ok	Stone tool
Too plit'ko	Finished	Wing'a	No
Too to'kwok	Button	Wing'a wing	Will not
Too'wang	Walrus tusk	Wool wuk yuk	Snow-shoe
Too'wuk	Gun	Wot le'a	Knife
To ret'kok	Jelly-fish	Ya ho'kwa	Our
To ret kot'ka	Jelly-fish	Yapis'ka	Cartridge
Tow il'er y uke	Negro	Yoke	Man
Tu'ga	White fox	Yok'tuh	Fathom
Tug'a	Crane	Yo'o po	Brother
Tung wo'hok	Hump-back whale	Yup pa	Summer

TOASTS PROPOSED AT ::
THE BANQUET GIVEN BY
THE CITY OF MUNICH IN
:: HONOUR OF THE ::
BRITISH COMMITTEE
FOR THE STUDY OF
FOREIGN MUNICIPAL
·· INSTITUTIONS. ::

I.

HEALTH OF THE KING OF GREAT BRITAIN AND IRELAND PROPOSED BY :: HIS EXCELLENCY :: BARON DE PODEWILS.

It is with esspecial pleasure that I rise in order to give expression to the satisfaction His Majesty's Government feel in seeing here as guests of our city to many distinguished representatives of the English people.

I look backward to ancient times, when a noble descendant of British blood came to our Bavarian provinces to preach Christianity and to lay the foundation-stone of civilisation: Winfried it was, a messenger of peace. And if today, after more than one thousand years, again messengers of peace have come from the mother-country of Bonifatius to this land, you will see that the seed sown by your great compatriot has born rich fruit. Where of yore holy monks guarded the treasures of learning and litterature, now stands the capital of Bavaria, our busy city, where arts and science thrive and, under the aegis of a noble family of royal patrons gain new strength and grow to fuller life from year to year. And where art and science bloom, those noblest fruits of years of peace, where genial feelings and true heartedness belong to the character of the people, there you will find a perfect appreciation of the common bonds which unite all civilised nations. There has always been, every where in our German fatherland, a strong feeling of esteem and admiration for the glorious British race; and this feeling, you may be sure, has been here, with us, as strong as anywhere.

5

Mylords and Gentlemen! If today our countrymen throughout Germany, from the coast lands of the north to the snowclad mountains of the south proffer friendly hands to their British guests, you may be sure this is meant sincerely. „We came in the world like brother and brother." This quotation of your great poet holds good, I venture to say, also as far as German and Englishmen are concerned. Mindful of such a word we surely ought not any estrangement allow to arise between us. How should it be possible that the gigantic political and commercial development, which has taken place in both nations during the lapse of a century, should sow the seeds of discord between us? He, indeed, must hold both nations in low esteem, who thinks them capable of jealousy and envy such as this. Two peoples, who have based their educational principles upon truth, justice and free development of character are historically called upon to struggle side by side for the moral and material progress of mankind. Keeping this aim before our eyes there will be only friendly rivalry between us whereever the German and English spirit of enterprise enter into competition throughout the world. And the mighty work performed by the powerful energies of the British and German people, in the domains of intelligence and political economy, will become a source of blessing to both nations and the whole world.

> „Ah, if our souls but poise and swing
> Like the compass in its brazen ring,
> Ever level and ever true
> To the toil and the task we have to do,
> We shall sail securely, and safely reach
> The Fortunate Isles, on whose shining beach
> The sights we see, and the sounds we hear,
> Will be those of joy and not of fear."

6

Mylords and Gentlemen! I beg your to accept our sincerest thanks for having come here, personally to study the institutions of the German cities, wich, I hope, will give you a true idea of what has been done, by a quiet aud industrions people, for civilisation and social progress. You will meet with a highly developed interest in all public concerns which has its root in self government. Getting a personal insight into our German life you will win a true opinion of our German character, our feelings and our mode of thought. There is no better way for a good mutual understanding than to become personally acquainted. There is no doubt, it is the only way to swell the great number of those who are working for friendly relations between the two nations to an overwhelming majority, whose voice — stronger than all sounds of discord — will at length be paramount.

Take then, Mylords and Gentlemen, together with my thanks for your noble efforts on behalf of hearty relations between Germany and England the assurance that your call will find a full cebo in the German heart. — I call upon you then when, an expression of our sincerest admiration for the great British nation, we drink to the health of the august and powerful king of Great Britain and Ireland, who is equally connected with Germany by ties of blood and those of tradition.

II.

PROSPERITY to the BRITISH
COMMITTEE PROPOSED BY
D^{R.} VON BORSCHT, CHIEF
BURGOMASTER OF MUNICH.

The citizens of Munich have always felt a great satisfaction when they have met with a lively interest in their institutions and especially when they have had an opportunity of making foreign delegates acquainted with these institutions.

But it is with the greatest pleasure that we bid welcome, in this noble old hall, our visitors to day, not only on account of their great number and the high position they take in life but still more because of the intentions which have brought them to the German Empire, and the rich blessing which I am sure, will come from their procedure. The organisation of the British Committee for the study of foreign municipal institutions marks an epoch in the history of civilisation for, quite apart from the secret and antangled ways of high policy, it opens a wide field of work for all friends of peace between nations, of whatever nationality they may be, for all those who are willing to keep and augment the highest possessions of mankind.

For the members of this committee the question is not to much to get information about the condition of such and such an institution but to become acquainted with the spirit which led to the creation of these institutions to gain an intimate knowledge of German manners, German charakter and of the organisation of German labour, and to get this knowledge from those circles which are mostly interested in the promotion of public good and welfare: the German citizens.

11

In this sense Your visit has been interpreted by all German cities, which have received You as honoured guests. And Munich is proud of being able not only to impress you favourably with all it has done and created, but, above all, to give evidence of being at one with you in the ardent desire that the two greatest cultured States of Germanic origin should come nearer to each other by a mutual understanding of their national character, their peculiar way of thinking and feeling and that, moreover, the many ties uniting the two countries may become stronger and stronger by a liberal exchange of all the blessings of civilisation.

If we join You, my honoured guest, in working for such a high aim, we stick to the tradition which, for many centuries, has controlled the relations of both countries. There is — in the most important questions of civilisation — a solidarity between England and Germany which, I dare say, has become stronger from year to year.

Wherever we look in the history of the world, we never see Germany and England waging war against each other. It is an actual fact that England never laid hand upon German territory, whereas other states, in times gone by, tried to profit by the weakness and disunion of the old German empire.

On the contrary, Germany and England have fought bravely side by side, wherever there was to be maintained the balance of power in Europe and wherever liberty and justice were at stake. Could there be anything more absurd than the idea of the two nations becoming enemies, that there should be any other rivalry than the cordial competition in fulfilling, to the best of their power, the noble duties of humanity?

It is true, the position of Germany in the European concert has undergone a great change. The German

„Michael", once langhed at so much, has become a German „Siegfried", who, with his self-wrought sword will never destroy the hoard of the Niflungs, the greatest treasures of mankind, but will keep down the dragon of envy and discord, and will protect an honest blissful peace between the nations. And if we, at the same time, succeeded in making up for what was neglecled trough centuries of disunion and misery, in the fields of political economy, this, I hope, will be no danger to the welfare of other countries especially to England, but a source of her prosperity as well as of ours.

It is not for the first time that thoughts of this kind have been uttered in this hall. At the beginning of last year, more than one thousand men from all social ranks came together here in order to declare that they would reject the idea of an estrangement between the two nations, emphasizing, at the same time, the need of a kindly intercourse in feeling and action between Germany and England on the natural basis of political equality. Today, enjoying the great distinction of seing so highly estcemed Englishmen amongst us, I consider it as a duty of honour, to declare in my own name and that of my fellow-citizens, with all energy, that we in our relations with your country, wish to leave out of sight every thing by which we may be separated in order to consider only what we have in common, and that we sincerely hope to remain connected with you in true friendship.

That is the welcome with which, my honoured guests, we shake hands with you, fully aware of the ethical and national importance of Your visit, and as a token of our warm admiration and esteem offer the toast: the health of our British guests, the sincere friends of our German Fatherland!

13

Gladly and heartily did I obey the call to bring a health to that great and famous nation — England, dear old England, many of whose foremost sons are gathered here at our banquet to day.

England, bonny Scotland, Ereie, I like the ring of these good old names. Pleasant are the memories they awaken, when I think of all the help and encouragement You afforded me a stranger, come to study Your English tongue, of the true and trusty friends I won there, and those glorious times we spent together. And of the many cosy chats over crackling fires, when winter stormed outside; and lovely landscapes I saw on my roams — proud Oxford with its scented meadows bathed in the evening light, and Dover's cliffs towering up over the migthy sea. Feelings of gratitude arise in me; rich memories are these of days when I was free, and kindly hearts endeared each thing.

But now to other topics and the nearer subject of my theme!

To night, having the honour of treating as guests so many distinguished Englishmen, I think it is not out of place if I point out, how much all of us owe to their mother country, how much German intellectual life has been fructified by English civilisation.

England gave us Shakespeare to whom all classical authors and all poets ever since have looked as to the perfect model of dramatic art. England bore a Bacon,

17

the Father of English empiricism, who showed us the ways by which, above all else our German sciences attained such unforseen results. Great, indeed, was also the influence which the romantic movement in English litterature, beginning in the second half of the XVIII. Century, has exerted upon Germany. J think of the poetry of Ossian which inspired our Herder and Gœthe, of the immortal songs of Robert Burns, opening new paths for the best of our German popular singers: Claus Groth, Leitholdl and many others. Let me also mention Byron, whose fascinating personality struck continental people perhaps more than his countrymen, Shelley whose ideal works have brought comfort and joy to thousands of minds in Germany.

Later times again, have produced in England men who, in the best sense of the word, were apostles of culture and from whom we Germans have derived much benefit. Thus Carlyle, the preacher of sincerity in thought, act and feeling, who wrote the biography of Schiller and the history of our immortal Frederick the Great. Also Ruskin who revealed the Gospel of Beauty to the world thereby giving an impulse to social reform, which we then also recognised as expedient and necessary.

As a matter of fact in England first the feeling of responsibility and the need of providing for the desinherited and helpless began to stir among the educated and higher classes. There, the necessily of life's joys for all was first emphasized, of the pleasure of intellectual enjoyment, and the blessing of beauty and art, and of enabling the lowest classes (all too much despised) to partake of these blessings. In England Art was first made popular under the aegis and by the strength of will, born of the victorions belief in humanity, of William Morris. The present remarkable and dominant need for aesthetic intellectual pursuits is of

18

English origin. In England, more than a hundred years ago woman's claim to freedom and work began to be discussed to the general advantage, since the days when Mary Wollstonecraft wrote her „Vindication of the Rights of Woman".

The life of to-day teaches us in the same way as it did in the past, how much Germany and England can import te each other in the realm of culture.

Any one who has visited England with the honest intention of learning, will come back to his home the richer in experience and convictions. It is indeed no small advantage that the impartial and yet critical observer can derive from English life: the unshakeable faith in the necessity and blessing of individual and political freedom; the respect for individuality and its expression, even when opinions clash the upholding, of the maxim of „fair dealing" and fighting fair in public life; the efficacy of private initiative, which does not wait for higher orders but marches on confident in its own strength; the self discipline and self government of all classes of the people; the cultivation of home life and pure relations. As to these advantages England can be, at least to a certain degree, an example to us and to other nations.

We are not however, only recipients in regard to England. The British Nation, too, owes much to Germany in the realms of culture. At the banquet, which was given, about one year ago, in honour of the German Burgomasters by the British Committee for the Study of foreign municipal institutions, Mr. Haldane in an excellent speech pointed out of what enormous importance German litterature and philosophy have been in the history of English civilisation. The tribute the English minister of war paid to our German poets and thinkers was one of the most marked attentions we received in those never to be forgotten days. It was

Mr. Haldane, too, who personally informed me of the great authority our philosopher Hegel exercises in modern England. Nearly $\frac{4}{5}$th of the English university lecturers are under the influence of this ideal German thinker.

Having treated of past and present let me now pass on to the future. And here, not less, have England and Germany much to learn from each other; nay they will be mutually dependent, the one on the other, in a very high degree. Both nations at this moment, or appearances must greatly deceive me, are abont to enter on a new phase of development. Each has thus far grandly deployed her peculiar forces, with relatively high results. The one owes her greatness to that methodical and sientific spirit whith wich we approach the solution of every task to centralisation and organized public-control. E n g l a n d ' s place among the nations has been won for her by the sound practical common-sense of her people, their matter of fact turn of mind and the untrammelled development of their individual powers; and further, I would say, by their aptitude to organize more on inductive lines proceeding from particulars to generals.

It is the very intensity of these so divergent forms of development which must needs engender a certain narrowness, and of this we are both now becoming conscions. In England one is beginning to see that in technics and industry John Bull will be left behind in the race, if he will not hear of system and scientific proceedings, that in education there must be no loose handling of intellectual forces, that, to carry the day, the troops must be held in hand and uniformly directed at the point at issue, that the social problem can not be solved by private initiative alone without the aid and intervention of the state.

In Germany, too, it is more and more beginning to dawn on us that theories and abstract dogmas must not

blind our eyes to the importance of facts, that centralization must not degenerate into a mere routine, only there to stifle at its birth every free development of individual talent, that, especially in sozial questions, legislation alone is not allsufficient, but needs to be supplemented by the charity and labour of each unit of the population. One nation's eyes are bent, on the other's, on the friend that brings what the other wants, whose virtues and gifts she would fain make her own.

Thus, and not till then, shall England and Germany, mutually giving of their best, arrive at their full strength and fulfil their glorions mission in the world. High is the ideal, and easy of attainment on one condition: We must live in friendship, and „keek peace and ensue it". And here at our sumptuons banquet good feeling reigns, of that I am assured, in the hearts of all. From my mouth then be spoken the general wish: May there always be a good understanding between us, may peace and friendship be ours, now and for ever!

It is true, there are, fire eating editors as Mr. Winston Churchill styles them, who tell us that both countries hate each other. Why should there be such an hatred? a reasonable man naturally asks. They point to the growing competition in trade and commerce between us. Even peaceful enlightened people will say: Your efforts for a good understanding between Germany and England will be fruitless as long as there is such great industrial and commercial rivalry. But, I should like to ask, do you really believe commercial rivalry could be done away with by brute force. No resort to arms could either uphold or further a country's progress. There have been commercial wars in centuries gone by, but they have led to nothing. Was there ever a commercial war which paid a dividend of a farthing in the pound? such was the satirical question

of Mr. Winston Churchill at the Eighty Club Dinner in honour of the German burgomasters'visit. The very first step in such a war, nay even the first diplomatie measures would involve losses for the commercial world, which could not be reimbursed by any success. Commercial circles are fully aware of this fact. Their work, like that of all productive classes, can only thrive in time of peace. When, a year ago, we arranged the meeting in this hall, which our burgomaster has alluded to, the representatives of commercial interests were the first and readiest to answer to our appeal.

Does this same feeling prevail in the commercial world of England? In my hand is a letter which, I think, has quite the value of a document. It coutains the answer of the Lord Mayor of London, W. Vaughan Morgan to a declaration which was sent to him by our burgomaster after our above mentioned manifestation. I think the Lord Mayor as the representative of the City of London must be fairly well informed about what is felt and thought in the commercial world of England. In this letter we read:

„The reports of any estrangement between our two nations are, if they exist at all, greatly exaggerated and of no possible moment. My fellow countrymen are sincerely desirous of continuing the friendly relations with which they have so long regarded their German neighbours and associates. The only rivalry permitted to us is that cordial competition in trade and commerce in which we are mutually interested.

I beg you to accept yourself and to convey to the distinguished personages, by whom your Declaration was signed, my warmest acknowiedgements with the renewed assurance that all their statements are earnestly and entirely reciprocated in the City of London".

22

Mylords and Gentlemen! Such is the hostile feeling entertained in English commercial and industrial centres. Clever men, and I reckon successful members of the commercial world amongst them know very well that: Only intelligence, industry and energy can win prosperity. If one people sees itself outstripped in the hard struggle of competition, it ougtth to be spurred on to greater zeal and emulation on the forward march of economic, technical, social and moral progress.

But there is a certain amount of feeling on both sides of the channel. Whence does it originate? The principal cause this touth must out — is the press, not the whole press, I am glad to say, but a certain class of papers whose ignorance, whose love of sensation and scandal is, I am afraid, greater than the zeal for trouth. The dangerous activity of these papers is furtherd by the attitude of certain people, superpatriots I should like to call them, who impressed with thew own national superiority and integrity have a painful conscientionsness of the baseness of others. Without doubt, patriotism is a glorious adornment of mankind, bat if it serves as a mere mask for arrogance and pretension and mean derogation of others, the greatest vertue becomes the most disgusting thing in the world.

Of course, the influence of the press and superpatriots would have been less dangerous, if both nations were better informed about each other. The ignorance of large classes of people in Germany with regard to England and vice versa is, indeed, sometimes astonishingly great, and this ignorance is dangerons. Bucktle in his History of Civilisation points out that Ignorance is the principal cause of hatred between nations, but if traffic spreads und brings nations together, such ignorance will disappear. The task of spreading enlightenment devolves in the first place on our tchools and, above all, on those educationalists who have

28

to teach the languages and the litterature of modern nations.

The more signal will this englightenment be if it goes hand in hand with more intimate personal intercourse between the inhabitants of Germany and England.

Repentedly has the idea been expressed to have an exchange of professors not only with America but also between Germany and England. Even in regard to Grammar Schools — nay even students — such an exchange might take place. This idea has already taken shape in the Cecil Rhodes Scholarships. But nothing seems to me to be more promising than those, systematically arranged excursions which the British Committee has abready practically organized. Thereby leading men of both nations come in personal contact, and we all know how a hearty shake of the hand, friendly looks from honest eyes, draw sóul to soul, and strengthen those bond ofs friendship which find their expression in our good comradeship today. Such meetings are rich in opportunities forical exchange of feelings and thoughts. I think we are alle agreed that everything works to unite us, and our little differences are not worth the mention. And this community of noble interests, and our united efforts to further the morch of the world's progress, will prove a blessing, a force outweighing all the evil, the ignorance and the malice of the times.

I conclude with the words of Baron de Wurtzburg which he spoke at our meeting here on the sixth of January last year: „Political values rise and fall and are for ever subject to change. Immutable tough, and enduring beyond all political constellations is the value of culture and ethies, science and art, religion and morals, public spirit, manhood and justice".

————

IV.

WELFARE ADDRESS
OF DR. VON BORSCHT.

The task we had undertaken, namely, to afford you an insight into those conditions which exercise a beneficial influence on the development of the community of our city, would have been but imperfectly fulfilled, had we not given you, by this excursion, an opportunity to become acquainted with a particular advantage possessed by the City of Munich, an advantage which none other of the greater municipalities of the German Empire can offer, a gift of inestimable worth, pleced by Providence in the cradle of the infant „Münchner Kindl"; I refer to Munich's matchless situation at the foot of the Bavarian Mountains, of the German Alps.

In this most lovely spot, above which, on the loftiest pinnacle of the German Empire, stands a Munich House, as a token that we people of Munich feel at home in this magnificent world of mountains, here then, before we part, let me again turn to you and express my sincerest and warmest thanks for the great pleasure that your visit has afforded us, and let me also thank you for the hearty goodwill you have shown, for the lively interest you have taken in the government and management of our community.

It was, in truth, a daring deed to invite the representatives of Great Britain to investigate our activity in the extensive domain of the administration of the public welfare. For where in the world is there a nation more deserving of the gratitude of the human race for its propagation of the

27

benefits of civilisation. or possessing a greater fund
experience in all questions relating to social and cultu
activity than the English nation. than the people of yo
country. of that happy land. whose pastures, during m
than a century and a half, no enemy has trodden dow
A land, predestinated from the very beginning through l
insular position both for a remarkable concentration a
wonderful expansion of her home power and an extens
of her might to all parts of the earth.

And yet, although we knew that in the great cit
of your country and more especially in London c
ditions exist, beside which our institutions appear but
significant. we have looked forward to your judgment w
the consciousness that by what we have here created
development of our community has been furthered in
highest degree, and that Munich possesses the warm
sympathy of foreigners, and especially of your countrym

I will resist the temptation of speaking at grea
length on this subject, but I feel compelled in this co
pany to affirm that the municipal boards and committ
in the execution of measures for the furtherance of
public welfare have, during the past thirty years, regar
your activity in this province as a shining example a
model, and that they and also all other German munici
corporations owe you their warmest gratitude for
stimulating influence derived from the work of your count

And if the days in which we are permitted to welco
our eminent guests from the British Empire in the Bavar
Metropolis will, in a few hours, be things of the past,
our memory they will always be present. May you al
my Lords and Gentlemen, take back with you a favoura
impression of what we have shown you, and of the man
in which we have shown it to you, and above all,
assured that we Germans, in the North and South, in

28

East and West, are imbued with a true love of peace, and that we all entertain the sincere wish that Great Britain, your glorious native land, may ever remain closely and loyally united to our country, that she may for ever flower and thrive as the mightiest support of the welfare of the nations, as the invincible warder of universal peace.

Take then, as a farewell greeting, this pledge with you to your country and permit us to once more condense our feelings in the words: „Long live Great Britain and her people and especially our most esteemed English guests!"

———

WHITMAN AND GERMAN CRITICS.

A few months before Ferdinand Freiligrath left his London exile, he read W. M. Rossetti's *Selections from Whitman's Poems.* Impressionable as he was and ever eager to contribute toward the realization of Goethe's ideal of "Welt-Literatur," he published at once a tentative account of his discovery in the *Augsburger Allgemeine Zeitung*, April 24th, 1868.[1] Admitting that his judgment of the American author is by no means settled and that he writes under the spell of a first infatuation, he urges his fellow-countrymen to note in Whitman the advent of a new and singular power.

Whitman, he says, is the poet of the Ego as a part of America, of the earth, of mankind, of the universe. With all its individualism and Americanism Whitman's philosophy is transcendental and cosmic. Whatever he hears or sees, whatever he comes in contact with, even the lowly and commonplace, seems a symbol to him of something higher, something spiritual. Or rather, the ideal and the real, spirit and matter, are to him one and the same. So, asserting himself a proud, free man, and neither more nor less than a man, he opens world-wide social and political vistas.

The metrical structure of *Leaves of Grass* reminds Freiligrath of the "Northern Magus," Hamann, of Carlyle's oracular wisdom, of the *Paroles d'un Croyant,* and first of all, of the Bible. Whitman's rhapsodic rhythms, which sound like the sonorous roar and surge of ocean waves, make our traditional prosody, our scanning, our sonnet-writing appear almost childish. Is this, Freiligrath asks, to be the poetry of the future as there has been a music of the future announced to us for years? Is Walt Whitman more than Richard Wagner?

This article did not create a sensation, nor were the German versions that followed characteristic illustrations. All of the

[1] Cf. vol. IV of Freiligrath's Collected Works.

ten pieces which Freiligrath translated refer to the Civil War;
nine being taken from the original edition of *Drum-Taps*, the
tenth from *Ashes of Soldiers*. The poems are: Arm'd year!
year of the struggle!=Jahr in Waffen! Jahr du des Kampfs!
. . . Rise, O days, from your fathomless deeps, = Auf aus
euren grundlosen Tiefen, o Tage, steigt, . . . I see before
me now, a traveling army halting, = Halt machen seh' ich vor
mir nun ein Heer, das auf dem Marsche. . . . As toilsome
I wandered Virginia's woods, = Als müh'voll ich schritt durch
Virginia's Wälder . . . Bathed in war's perfume—delicate
flag! = Gebadet im Dufte des Kriegs,—weichzarte Flagge du.
. . . A march in the ranks hard prest, and the road un-
known = Ein Marsch in den Reihn hart bedrängt, und der Weg
uns fremd. . . . A sight in camp in the day-break grey and
dim=Eine Lagerschau, eine Schau im düstern Taggrau'n.
. . . Over the carnage rose prophetic a voice = Über das
Blutbad prophetisch hub eine Stimme sich. . . . Far hence,
amid an isle of wondrous beauty = Weit von hier, auf einer
Insel (wunderschön sie!). . . . In clouds descending, in
midnight's sleep = Aus Wolken nieder, im Mitternachtsschlaf.

It is surprising that the same man who gave the Germans
the classical translation of *Hiawatha*, was unable to master the
Whitmanian verse. There is almost nothing left of the sway of
pathos, of the mighty roar of waves Freiligrath himself had
found in the original. Those translations are a stale mixture of
prose and rhymeless doggerel, as may be seen even by the begin-
ning lines quoted above. Since the selection was indifferent, the
version poor, it is but natural that the eulogy remained abstract
and unheeded.

In 1870 Adolf Strodtmann, who had spent the years between
1852 and 1856 in the United States, published an *Amerikanische
Anthologie* with more selections and with the same negative re-
sult as Freiligrath.

An equally unsuccessful attempt was made in 1877, by the
German-American poet Ernst Otto Hopp, who included a version

of "O Captain! My Captain!" in a volume of prose-sketches, poems, and translations *Unter dem Sternenbanner.*

Freiligrath had ended his essay with the warning that Whitman, if any writer, must be judged by the sum total of his work. Dr. Eduard Bertz was the first, and has remained up to the present time, the only German to come up to that critical standard. He, too, like Strodtmann and Hopp, had lived in America for some time (as a member of the ill-fated Rugby colony in Tennessee, 1881-1883); he had thoroughly absorbed Whitman, and, after settling in London, had served George Gissing as a model for the Whitmanite in the novel *Thyrza.* But it was not until after his return to Germany in 1889, that he felt called upon to take part in the international Whitman-propaganda. In the *Deutsche Presse*, II, No. 23, he published an article: *Walt Whitman zu seinem siebzigsten Geburtstag.* It begins with the sweeping confession: "As the greatest benefit which I derived from my sojourn in America, nay as one of the happiest events of my life, I regard the acquaintance with the writings of the most original and deepest of all American poets." He praises the sound vitality, the spiritualized naturalness, the universal sympathy of "that most humane of all philanthropists." Under the disguise of Gissing's hero he quotes himself as saying that Whitman will help him grow to be a perfect and mature man. For Whitman is a man, a great, healthy, plain, strong, fully-developed man. What to many critics seems sheer materialism is in reality purest spiritualism, the body being a revelation of the soul. The poet's own soul is so full of unlimited love that it may well be considered identical with mankind at large. Whitman makes his readers realize their unity with the universe. In him for the first time nature has found a true expression in words. It is through him that forests and seas sing to us, that the healthy average man speaks out at last what he had so far been unable to articulate, i. e., his secret yearning, his silent love and admiration. Bertz goes on to defend the poet's sensuality as the religious view of the sanctity of all life.— Whitman is an optimist in the real sense. He does not deny

the existence of evil but assigns it [?] Mother Nature with
the fervent reverence of a loyal son. Being in harmony with the
will of the universe, he points forward to the ultimate salvation
from all earthly woes. An all-embracing sympathy, then, is the
source of Whitman's poems; they are sure to live through cen-
turies and will be a consolation to future generations. Judged
merely from an esthetic point of view, Whitman is inferior to
a number of other poets; however, his form must be acknowl-
edged as a thoroughly adequate vehicle of his thought.

Whitman was delighted with the homage of his German ad-
mirer. He entered into a correspondence with him, and, hoping
to make him a permanent advocate of his cause, he liberally
provided him with material—photographs, laudatory newspaper-
clippings, and the like. The effect upon Dr. Bertz was quite
contrary to Whitman's expectations. The German disagreed with
what he considered a typical American self-advertizing scheme,
became critical, and soon stopped responding to Whitman's ad-
vances. Nevertheless, he kept up his interest and wrote a favor-
able, though somewhat reserved, account of Whitman's work and
life for *Spemann's Goldenes Buch der Weltliteratur*, 1900. In
view of Bertz's later attitude one statement in that article de-
serves special mention: "The most modern of all poets, Whit-
man has assimilated the scientific investigations of the century
and connected their results into a grand harmony, thus becoming
the poetical interpreter of monistic philosophy."

In the meantime T. W. Rolleston, assisted by Karl Knortz,
had made another attempt to introduce Whitman in Germany.
With the sanction of the author himself they published, in 1889,
a selection from *Leaves of Grass—Grashalme*—which was headed
by a comparatively well-balanced preface. The book was an
improvement upon Freiligrath. It contained the entire *Song
of myself* and a goodly number of other characteristic *Leaves*,
e. g., *Out of the Cradle, The mystic Trumpeter*. The version
is rather crude, at times even faulty, neither German nor Eng-
lish. It suggests the interlinear method of medieval scribes and

would probably have met with the same fate as Freiligrath's, if it had not been for Whitman's German pendant.

Even Whitman's death in 1892 did not cause more than a shallow ripple in the sea of letters. There was an insignificant article by Johannes Schlaf in *Freie Bühne* (now *Neue Rundschau*), which simply reproduced the views of Rolleston-Knortz, Freiligrath, and Bertz. Nor did any of the other professional journalists and magazine writers find it worth while to read Whitman's original text. What they said about him was a sort of second- or third-hand literary gossip, such as Whitman himself had indulged in—"Kant having studied Fichte, Schelling and Hegel." Toward the middle of the decade, however, the Nietzsche-cult reached its high-water mark. "Jüngst-deutschland" turned largely away from the rigid tenets of naturalism, reveling instead in the rhetorical symbolism of *Zarathustra*. Whitman was illuminated by Nietzsche: democratism versus aristocratism in their political, social and religious aspects respectively. *Grashalme* and *Zarathustra*: each seemingly destroying the old, traditional institutions and proclaiming new ethical standards; the form of each resembling the oracular tone of oriental prophets. Nietzschemania was the beginning of Whitmania in Germany. The latter has to the present time fortunately been limited to a small group of adepts, while Nietzsche's influence, directly or indirectly, exerted itself as a fertilizing power upon the thought of the masses.

An Austrian, Karl Federn, a student of Emerson and Nietzsche, was attracted to Whitman by his transcendentalism. In 1897 he published an essay on Whitman (*Die Zeit*), which two years later was reprinted, with papers on Emerson and Thoreau under the title *Essays zur Amerikanischen Literatur*. In contrast to Schlaf he had not rested satisfied with the knowledge of selections only. Federn had read all of Whitman's writings, poetry as well as prose. But he also knew Bucke's biography and O'Connor's eulogy, *The good gray poet,* and completely identified himself with their views. Accordingly Whitman is represented by him as the most perfect, the most

original and the grandest of all American poets—as *the* poet of America. Whitman is also the greatest of thinkers, not only in his own country, but in all countries, for his ideas are the ultimate fruit of the Nineteenth Century. His Ego is the physically and spiritually perfect man in whom there is contained the essence of civilization and nature alike. His sensuality is as pure as nature herself. He is the most healthy, powerful, loving, life-asserting personality since Goethe. He is possessed of a magic magnetism such as is ascribed to Moses, Buddha and other founders of religions—a parallel to Christ is indirectly drawn, cf. O'Connor. Whitman is a Cosmos, a symbol and type of universal life. His gospel of love and comradeship reconciles democracy with aristocracy, the equality of all being the soil out of which great aristocratic individuals—Ibsen's Adelsmenschen—grow. As in Whitman the two principles of individualism and collectivism are combined into a higher synthesis, so Heaven and Earth, spirit and matter are forever united.

Whitman's, the wound-dresser's, superhuman qualities are enlarged upon in another article of the same volume: *Aus Amerikanischen Kriegszeiten.* It is, here as before, Bucke's and O'Connor's phantastic exaggerations that guide Federn's pen. The author did not think it necessary to change his opinion when, in 1904, he published a *Selection* from the *Leaves,* using for an introduction what he had written five and seven years before.

Curiously enough, reprinting from stored-up material with slight or no alterations seems to have been a tenacious habit with the German Whitmanites. In 1899 Karl Knortz republished an essay *Walt Whitman als Dichter der Demokratie,* which previously had appeared in the *New Yorker Staats-Zeitung,* December 1882, again in 1886, and once again, translated into English by Alfred Forman and R. M. Bucke, in *In Re Walt Whitman,* 1893. Knortz's article, in itself, was worth reading. It was based upon independent study and good common sense— a very exceptional quality with Whitman-admirers—; it was enthusiastic and yet free from ecstatic madness. Knortz did not

worship Whitman as a modern Christ, but he respected him as a
great poet and fearless thinker. Admitting that there is some
rubbish among the *Leaves,* he declares *Out of the cradle* and
When lilacs last in the door-yard bloom'd [2] to be masterpieces
that equal any of the world's greatest achievements in literature.
Whitman's philosophy is interpreted as monistic optimism, his
eroticism as a wholesome antidote against puritanic prudery,
his gospel of fellowship as the democratic principle of sympathy
for all mankind. A brief biography, an enlightening analysis of
Democratic Vistas and an appendix of good translations, e. g.,
The Song of the Broad-Axe and *Night Poem (The Sleepers),*—
all that makes Knortz's pamphlet the most valuable contribution
to Whitman-literature in Germany, before Dr. Bertz entered
the field once more.

Johannes Schlaf repeated his article of 1892 in the magazine
Neuland of 1896, and two years later again in book-form. In
1900 he prefaced a superfluous German translation of Whitman's
Novellen by Thea Ettlinger. In 1904 he established himself as
the authorized Whitman-apostle by a monograph *Walt Whitman*
which appeared as volume 18 of *Die Dichtung.* This little book
is an unparalleled example of high-handed arrogance, cowardly
imposition and utter ignorance. As Dr. Bertz, in *Whitman-
Mysterien,* 1907, has clearly shown, Schlaf had even then, 12
years after his first contribution, no knowledge of Whitman's own
language. He discussed an author of whose writings he had not
read more than perhaps 15%, and for his judgment he relied
solely on the few German articles that have been mentioned.
What, then, could he do but pilfer his sources and conceal his
plagiarism behind nebulously mystic exaggerations? Whitman
is not only Buddha plus Jesus re-incarnated but at the same
time an anticipation of Nietzsche's superman. Whitman at last
has brought to an end the long struggle between religion and
science. His is the scientific religion of monism.[3]

[2] First translated into German by the present writer and published
in *Aus fremden Zungen,* Berlin, 1906.

[3] Fritz Lienhard in *Wege nach Weimar* is uncritical enough to make
Whitman a successor of Goethe; cf. *Erwinia,* Strassburg, Sept. 1909.

Absurd and blasphemous as such hero-worship was, Schlaf's non-chalant charlatanism duped publishers as well as reviewers. In 1907 the reputable firm of H. Haessel, Leipzig, published Henry B. Binns's Life of Whitman translated by Johannes Schlaf. The book was another proof of Schlaf's literary irresponsibility. With the exception of certain portions which were taken care of by an anonymous helper,[4] the translation is absolutely worthless, as has been shown elsewhere.[5] And yet this remarkable translator boldly advertizes himself in the preface: "I have rendered the English text without any alterations whatever!" But that was not all. Schlaf surpassed himself by publishing *Grashalme* of his own selection where the Whitman student will be able to make many sensational discoveries, such poems as had previously been translated by others excepted.[6]

In 1904 and 1906 other translations had appeared: *Grashalme* by Wilhelm Schölermann and *Prosa-Schriften* by the present writer. Schölermann's introduction did not essentially differ in point of view from Federn-Bucke. I myself confess to the guilt of a serious attack of Whitmania, although I tried to be moderate in my statements and made Whitman *only* a superman instead of a God as my predecessors had done.[7] Both Schölermann and myself defended Whitman against what we believed possible misinterpretations of his gospel of friendship.

Dr. Bertz had the courage to face the truth and he had the scholarly equipment to prove the truth, i. e., the fact that Whitman's conception of friendship is based upon an abnormal sexual instinct. This being the case, Whitman can no longer be considered the perfect, typical man, the model, the leader of others. On the contrary: the world must be enlightened and warned as to the real meaning of Whitman's principal message. Bertz's article: *Walt Whitman, Ein Charakterbild*, appeared in Vol.

[4] So Mr. Binns informed me.

[5] *Englische Studien*, 1907, p. 117.

[6] Appeared in the Reclam-Library.

[7] Cf. *Deutsche Arbeit*, Prag, 1905-06, V. pp. 392-403.

VII of the *Jahrbuch für sexuelle Zwischenstufen,* 1905.[8] It systematized, strengthened and brought to a conclusion the evidence gathered by Havelock Ellis, J. A. Symonds, Raffalovich, Edward Carpenter, Max Nordau, and others. It was not without reluctance that Bertz destroyed with his own hands the idealizing picture of Whitman which he had painted before. During many years of careful study he had found the solution of the secret lurking behind Whitman's seemingly unfathomable personality; and once recognized, truth must be revealed to others. Bertz, in this matter, is far from British cant. He does not condemn Whitman; for how can anything be condemned, the cause of which lies beyond the control of personal will power? Nor does he join Edward Carpenter in extolling Whitman and all Uranians, as if they represented a higher type of humanity than the normally built. As a man of science Bertz knows that nature tends to differentiation and that the most purely differentiated species, not the hybrid, is typical.

In addition to Bertz's arguments we may call attention to the curious onesidedness of Whitman's gospel. If it ever had meant an ideal love of mankind, as the adepts—even the women among them—claim, Whitman would have declared the love of woman to woman a means of redemption as solemnly and emphatically as he did the love of man to man. But there is no allusion in his writings to that essential part of the conception of friendship. And as to the love of man to woman, did he ever sing of anything higher than brutally physical relations, did he ever find an expression for the sweet charm of soulful womanly love? No, among the lyrists of the world Whitman stands almost alone in not having given us one true love song, nor ever having dreamed of that most beautiful of all forms of friendship, the friendship between husband and wife, between man and woman. Whitman's "universal love" may refer to rocks and trees, to mountains and oceans, to clouds and planets, but it excludes the basic love of mankind and contaminates the conception of manly friendship with morbid passion.

[8] This article contains some excellent translations from *Calamus.*

Whitman shaped his covenant to suit his own individuality, not to make it acceptable by humanity at large. And if, toward the end of his life, after his fatal passion had died out, he encouraged a symbolical interpretation of *Calamus*, he deceived, more or less consciously, himself and the world.

The sound scholarship, the matter-of-fact tone and discretion of Bertz's article, stand in glaring contrast to the vicious attack it called forth. Johannes Schlaf again assumed the rôle of the Whitman-apostle. Without investigating the sources, without even entering into a serious discussion of the arguments advanced, Schlaf hurls a pasquil at Dr. Bertz so mean in contents and form that Bertz, in sheer self-defence, was forced to expose to the public Schlaf's astounding ignorance and thievish methods. That was done in the booklet *Whitman-Mysterien*, 1907, referred to above. At the same time Dr. Bertz published another volume on Whitman: *Der Yankee-Heiland*, in which he proved himself definitely the superior of any Whitman student on the continent.

The book is a final refutation of Whitman's claim to have found the synthesis of science and religion. It shows how extensively and how indiscriminately Whitman borrowed his ideas from others. It shows that he contradicts himself, not in the Emersonian sense of a progressive development and self-revelation, but in the sense of a disharmonious chaos.[9] Side by side with Emerson's (or Rousseau's) individualism, pantheistic transcendentalism, and dogmatic metaphysics, we have a crude theism and a materialistic doctrine of personal immortality which seem Whitman's own mental possession. For does he not announce his religion as entirely new? In reality Whitman's theism does not differ from the creed of the Old Testament, and his conception of personal immortality—identity as he is pleased to call it—is nothing else than the doctrine of St. Paul.

[9] Similarly Leopold Weber in *Kunstwart*, October 1905, and Hermann Esswein in *Der Deutsche*, November 1905, point out the barbarous chaos of Whitman's thought. *Der Yankee-Heiland* bears the significant sub-title: "Ein Beitrag zur Modernen Religions geschichte."

After drawing a parallel with Carlyle and Berkeley, Bertz points out Whitman's indebtedness to Novalis, whose principal ideas were transmitted to him by Carlyle. Here we have a striking illustration of Whitman's method of second hand philosophizing: Carlyle gives extracts from Novalis; Whitman in his turn gives extracts from Carlyle's. For Novalis as well as for Whitman religion is the center of gravitation, the purpose of creation. Both dream of a uniform, universal religion. Both see manifestations of God in every natural phenomenon (cf. the Psalms, too, etc.). Both value faith more highly than knowledge, mystic intuition more highly than science. It goes without saying that here again Whitman is inconsistent, inasmuch as he never ceases to pose as a radical rationalist. To both love seems the basis of all metaphysics—only, Whitman's theory of love has that peculiar tinge alluded to above. Both fall a prey to that romantic ecstasy, where religion and sensual passion intermingle. Even in thinking of death they experience the sensation of voluptuousness. Both are typical romanticists in their quest of the blue flower, in their longing for an illusory ideal in a world of dreams. Again Whitman is inconsistent. According to the materialistic element in his philosophy, the pleasures of this life mean as much to him as the pleasures of the beyond, and the joys of Heaven are no less physical than the joys of the world.

It was stated above that Whitman shared with St. Paul the conception of immortality. With the author of the first epistle to the Corinthians he believes in the transcendental reality of space and time as the abode of the eternal soul. He also believes that the soul is born with the body. It is the predestined purpose and end of all material evolution to bring forth the immortal soul. The human body itself is the ultimate stage in the preparation of the soul for an everlasting individual existence.

The same biblical teleology Whitman applies to his conception of God. And yet Whitman is not a Christian. He does not believe in the salvation through Christ nor in the remission of sins. Redemption and condemnation are allotted to man ac-

cording to his deeds in this life. If Christ were acknowledged as our Saviour, there would be nothing left for Whitman to do. So Whitman expects of his disciples a mystical faith in his own mission. If there is any intercessor at all—it is Walt Whitman.

Christians conceive of God as a Trinity. Whitman invents —following the example of Spinoza et al.—a Quaternity including Satan. Evil is not a punishment for sins committed, but a benevolent part of God's original program of human education Consequently Evil is the same as Good, sin as perfect as virtue; and if Whitman were capable of thinking out one thought logically, he would have come to the conclusion that the world should be left alone, no salvation of any kind being needed. His only mission would then have been to interpret somewhat liberally Pope's and Hegel's famous sayings: All that is, is right; or: all that is, is reasonable.

This seems absolute and unshakable optimism. Indeed, if any one, Whitman has the reputation of being the optimist par excellence. It is his emphatic and thousandfold affirmation of life and death, bliss and misery, good and evil, body and soul that attracts to him those who are discontented with established church-religions. But how can an optimist declare life a fraud of the most tragic kind, if there should be no immortality? That is what our optimist actually did: literally in conversation with Horace Traubel; practically in his well known debate with Robert Ingersoll. Socrates, Lucretius, Marcus Aurelius welcomed eternal sleep as the greatest of blessings. They did not take refuge to the theory of personal immortality for a justification of this life. Nor did Nietzsche. They accept life unconditionally as it really is. That is the standpoint of science. Whitman's affirmation, however, depends upon a hypothesis, which may be believed, which can never be scientifically proved. Where, then, is the Whitmanian synthesis of religion and science? Dr. Bertz drily remarks: Whitman's intellect disapproves, his faith approves the world. Apparently he is an optimist, secretly a pessimist.

Certainly Dr. Bertz deserves credit for having laid bare this irreconcilable discrepancy in Whitman's philosophy and, besides, its principal cause: Whitman's abnormal sexuality. As an Uranian the poet was at variance with the ethical standard of society. Therefore his spells of moral anarchism, as well as the undertone of despondency, misery, and negation in his gospel of affirmation. Whitman was anything but the type of manly perfection. While his instincts were largely feminine, his constitution degenerate, he tried to persuade himself and others of the contrary—just as Nietzsche did.

Bertz devotes a brilliant chapter to a detailed comparison of the two poet-prophets. In spite of certain points of similarity in their life and thought—the latter being due chiefly to a common source: Emerson—they are direct counterparts as regards the ultimate meaning of their message. Nietzsche's superman is a lofty, if utopian, ideal to be reached in a faraway future, as the result of gradual evolution. The superman is really Godlike. Whitman sees his ideal of manhood, the divine average, fulfilled now among the common people. An ordinary hack-driver with the spiritual aspirations of a savage meets his requirements completely, if only he is a "good fellow." But since both Whitman and Nietzsche place instinct above reason, and since both have never attained to logical consistency in their philosophy, they may not be counted among the leaders of mankind. They have not given new cultural values to the world as have Goethe and Emerson.

As artists they have fallen below many a less famous poet. Neither *Zarathustra* nor *Leaves of Grass* are, strictly speaking, poetical compositions. They contain a wealth of esthetic material. But the passages where form and content reach the permanency of concrete images are few. Nietzsche and Whitman are poetizing orators, not artists with the formative power of visualization. As to Whitman we have said that he shaped his gospel to suit his own individuality. The same is true of his theory of art. Accepting Sainte-Beuve's view [10] that a work of

[10] Cf. Diary of 1882 and *Democratic Vistas.*

art should rather suggest emotions than give definite form to an esthetic experience, Whitman, in true romantic fashion, meets the critics' objection to the hazy vagueness of the majority of his poems.[11]

But his own theory offers no excuse for the monotony of his verse. If it reminds the poet and some of his readers of the roll of ocean waves, we have to ask the question: What does that mean? Are we to take for comparison the indefinable roar of the agitated sea with its general effect upon the ear of monotony? Or are we to think of the equally indefinable, innumerable, ever changing curves the sea in its calm moods inscribes upon the sand of the beach? Or what? The fact remains that Whitman applies the same technique of rhetorical pathos to any and all subjects: *Cavalry crossing a ford* in its rhythmical structure does not differ from *Passage to India*. And that is uncreative impressionism. Nor does Whitman's theory do away with the greatest objection to his poetry, viz., that its final effect is enervating rather than invigorating. In this Whitman resembles a vastly superior artist: Richard Wagner, whom Nietzsche justly called the great sorcerer.

Both Whitman and Wagner were possessed of an indomitable sensuality, the magnetism of which, vibrating through all their compositions, causes an ecstatic intoxication invariably followed by utter exhaustion. This may not be an esthetic consideration, but it is a fact worth recording. The more openly we face the truth, the sooner we get over that dangerous malady which Swinburne diagnosed as Whitmania. Nations that have produced a Goethe and an Emerson need not and should not worship a Whitman as one of their heroes.

 O. E. LESSING.

[11] Cf. Knut Hamsun, *Die Gesellschaft*, XVI, pp. 24-35. It is interesting to note that Jakobowsky, the editor, published Hamsun's severe criticism of Whitman with the footnote "We who love Whitman prefer to have Johannes Schlaf instruct us." For criticism of Whitman's rhetorical style, cf. Arno Holz, *Revolution der Lyrik*, Berlin 1899.

TOLSTOY AS A LITERARY ARTIST

CHAUNCEY WETMORE WELLS

[Reprint from the UNIVERSITY OF CALIFORNIA CHRONICLE, Vol. XI, No. 4]

TOLSTOY AS A LITERARY ARTIST.*

CHAUNCEY WETMORE WELLS.

Great literary men are of two kinds. There are, first, the epitomists, the strictly representative men of their times. They are the "voices" of the multitude, and their success is to utter with adequate compass and tone what would spring to the lips of every man if he could only speak. Such a man was Dante, such a man was Tennyson, and such in great part was Goethe. Of these we have a right to expect a coherent philosophy, and a rounded perfection of form, because their function is to give order and proportion to the great body of current ideas, rather than to add new ideas to the common stock.

The other kind may fitly be called liberators. These break through the enclosing walls of life, whether imposed by social convention and literary habit, or by unregenerate nature,—

> —this muddy vesture of decay
> Doth grossly close it in.

They free the minds of men by endowing them with new outlooks and visions by the power of which men feel imprisoned energies to be released, and so come to realize and to possess themselves. The type of this kind of literary man

* Address in commemoration of the eightieth anniversary of the birth of Count Leo Tolstoy. Delivered in California Hall on the evening of September 10, 1908 (corresponding to August 28 of the Russian calendar.)

is Browning, or Walt Whitman. We shall be disappointed if we expect of such writers either a coherent philosophy or a perfect form. They are more than likely to waste half their effort; their paths are strewn with such titanic wreckage as *The Prelude, Sordello,* and—must one say it?— *War and Peace;* even their best work will be covered with blemishes. Vitality, not totality, is their immediate jewel and their bequest to mankind.

Of this latter sort is Tolstoy. He is a fire-bringer. But not because he more than any predecessor or contemporary has brought Russia to Europe and to the world. It is very well, so far as the saying is true, to speak of Tolstoy as the "voice" of Russia. But the literary "find" is surely the most perishable of literary assets. Tolstoy's Russia no more than Kipling's India will of itself give title to enduring fame. But when the still comparatively fresh interest in Russia has vanished with its novelty, it will be seen that Tolstoy has given us a new vision, at once local,.of the soil, and universal, of mankind—that he has sounded a new note in literature and has compelled all the world to listen. It will also be seen that using the most modern of literary instruments, the novel, he has not only increased its gamut and the depth and power of its tone, but by the very means of these new capabilities he has made it voice the new message. I am not now concerned with Tolstoy's large contributions to the technique of novel writing; I speak merely of the way in which he brings home to the untechnical but intelligent reader his vision of the world and of truth. I must treat first of the means, of the adequacy of the instrument, and then of the end, of the message itself.

It will be agreed that Tolstoy has given his message to the world—in the field of creative art, at least—in the two novels, *War and Peace* and *Anna Karenina.* For vital and personal as are their predecessors, *Childhood and Youth, The Cossacks, The Sevastopol Sketches,* they are but studies and without body enough to bear the full import of what the author has to say. Nor does he write them in a manner

entirely free. It is as if Turgenieff were standing at his elbow, restraining, if not guiding, the hand that will escape into bold, original strokes; it is still the 'prentice hand. The latest novel, *Resurrection*, the larger part of it written after the religious books, makes disclosure of no new artistic scope or resource, but rather, in the latter part at least, of a dimmed vision and a cramped hand. It is fair, then, to judge him as an artist by his two representative books.

Two things are observable in them: (1) an utter disregard of, if it be not positive rebellion against, the mere conventions of literary form; (2) an unexampled intimacy in the recording of human experience. As for the former, it is highly honorable in the artist and a mark of his authenticity that he will not put new wine into old wine-skins. For the liberator in art must at all risks create new forms or recreate old ones. Though our concern with him is about substance rather than about form, yet in judging the worth of his substance we rightly ask whether it takes on a recognizable form, a firm and clear, though it may be a rugged, outline, and whether the outline conforms to the nature of the substance, there being no such thing as a formless art. Now the worth of Tolstoy's rebellion against the conventions of the French school, in particular against the overstrained economy of Turgenieff who out-Frenches the French, must be judged by its success in substituting a worthier formative principle, at least a principle by which the structures once erected will stand up.

War and Peace Professor James has called "assuredly the greatest of human novels." Let us see. The great novels are *Don Quixote*, *Père Goriot*, *Vanity Fair*, *Adam Bede*, to mention no others. Grant that there is a more abundant talent displayed in *War and Peace* than in any of the four—and that, when one considers *Don Quixote* and *Vanity Fair*, is a large concession—it yet does not succeed in expressing itself as they do; with, perhaps, larger things to say, it does not attain to their large and clear utterance. The reason is plain.

It is the business of the novelist to give us the significance of life told in the terms of life itself. Unlike the essayist he cannot abstract this significance as a formula. Conduct itself is what he must represent to us; but conduct *motivirt*, as the Germans say. In this respect his task is like that of the dramatist, and that is why the French school had succeeded in imposing dramatic conventions upon the novel, to the exclusion of much that is vital and real. Now in attaining freedom from these conventions and in restoring to the novel its old-time breadth and range, Tolstoy in *War and Peace* seems to have forgotten the necessary formative principle common to drama and novel—the significance of life told in the terms of life itself.

War and Peace is an attempt to portray Russian society, high and low, under the stress of the Napoleonic wars, from the Austerlitz campaign to the retreat from Moscow—a representative cross-section of Russian life under extraordinary national and social excitement. The novel is an attempt, that is, at a more sweeping and universal *motivirung* than any since *Don Quixote;* in inclusiveness it surpasses even *Don Quixote;* in breadth it is fairly to be compared with the scriptural *Kings* or *Samuel;* it is an attempt, not to make fiction out of history but to merge history and fiction; it is an attempt at the artistically impossible. The book lacks a central significance; that is to say, there is no single principle of causality. Hence the several stories in it do not work towards one tremendous conclusion; often their strands cross without becoming interwoven, so that no pattern is traced; even the reaction of character upon character is quite as often casual as causal. And, most astonishing of all, the interest in *War and Peace* as fiction is supplanted, or almost supplanted, in the last third of the book, by an historical interest in the campaigns of Borodino and Moscow, so that we are almost surprised to see the characters of the novel appear upon the battlefield. Here is a blunder in structure comparable only to Victor Hugo's obtruding an account of Waterloo into *Les Miserables,*

but the result in Tolstoy's case is far more disastrous. Grant the author an encompassing idea and a single viewpoint—the futility of leadership, the ultimate value of the common lives of men sincerely lived—this principle is not definite enough to supply that larger harmony in which the warring discords can be resolved. We have only to turn to the Waterloo chapters in *Vanity Fair* to see that Thackeray has been strong where Tolstoy is weak.

It is not surprising, therefore, that we have dreary page after page, unmagnetized, *unmotivirt*, a sheer waste of energy, mere beating the air, exasperating to the critic, but also, I am sure, to the untechnical intelligent reader, to all in fact but to ardent Tolstoyans, wearying and baffling. Nor is the objection met by Arnold's warning (*Essays In Criticism, 2d Series*) that we are "not to take these novels as art but as pieces of life." We are to abandon art, then, abandon interpretation in the light of significance, and resort to the photographic and phonographic? Mr. Howells' dictum (*Criticism and Fiction*) that "a big book is necessarily a group of episodes more or less loosely connected by a thread of narrative," and that "the final effect will be from the truth of each episode, not from the size of the group," may be urged on behalf of a *Comedie Humaine*, where each episode is clearly evolved along the line of its causality, not in defense of *War and Peace* where episode overlays episode and character blurs character. "But *War and Peace* isn't a novel, exactly," Tolstoy's worshippers will say. What, then, "exactly," is it?

These strictures would not be worth making had not our author amply atoned for the confusion and at least partial self-defeat of *War and Peace* by the masterful success of *Anna Kareñina*. Here as in *Don Quixote, Père Goriot, Vanity Fair, Adam Bede*, we have a central, animating idea that vitalizes, if not every page, at least every chapter-group: social purity, marital fidelity, the sacredness of family life—

—the true pathos and sublime
Of human life.

This truth Tolstoy brings home by two stories: that of Anna and Vronsky and that of Levine and Kitty; the one ending in spiritual defeat because the law is broken, the other in spiritual victory because the law is kept. *Anna Kareñina*, like *Vanity Fair*, comes by a double road to a single end—but it arrives. The central significance is maintained, and that without loss of a full reality: there is ample circumstance, the cast of the play is full, traits and tendencies are closely studied, the scope of incident for displaying them is large; the illusion of life is quite as rich and deep as that of *War and Peace*. And the irresistible logic in the working out of the central theme through the parallel stories brightens not dims this illusion. For Tolstoy without permitting the logic of his theme to predestine his characters, as Balzac too often does, yet releases each stream of tendency to flow its own way, to seek its own end, to map itself, as it were—one to a moral degeneration, the other to a moral awakening. The difference between Anna's decline and that of Tito in *Romola* is the difference between a course of nature and an argued case. Nor is it a loss in verisimilitude that there is flow and counterflow between these two currents. When Kitty near the opening of the book rejects Levine because of a deep though girlish passion for Vronsky, and yet must witness the beginnings of the fatal *liaison* between Vronsky and her friend Anna, a married woman, is there gain or loss in reality? Or, later in the book, when Levine, drawn into the social circle of the Vronskys, strains at the ties of his married life with Kitty, does Tolstoy violate the truth in letting the birth of Levine's child recall him from those dangerous ways.

Not that *Anna* is free from blemishes. There are, *e. g.*, far too many unused characters, scenes, and incidents: the author does not always make the strands of his story cross at the most significant moments; his preoccupation with life leads him astray upon unimportant things, for Tolstoy, no more than Wordsworth, has a sure sense of the distinction between fact and truth. Nevertheless, *Anna* is a beautiful

constructive success, fit to stand with the four great novels
I have mentioned; in my judgment it is not the least in that
company. We do not say of it, as we must say of *War and
Peace*, that its bigness obscures its greatness, that the
general failure is partly redeemed by the great moments.

I must speak now of the revealing moments in both
novels—the moments in which the author utters himself
with the utmost individuality and success. Great moments
in a novel are not sufficient to themselves. We come upon
them in the journey, often after long series of incidents, the
steady evolution of characters, the slow adjustment of per-
sonal and social relations. Though they emerge as arresting
and brilliant figures in the pattern, they abide in the whole
texture of the book; no reverent and judicious editor can
excerpt them, as Arnold did for Wordsworth's best pieces,
so as to let them speak for themselves. Nevertheless is
Tolstoy as distinctly the liberator in these as in the main
progress and intent of the novels; these are his heights of
vision.

I have alluded to the quality of intimacy in *Anna* and in
War and Peace. Intimacy is, perhaps, the most modern
quality in art, the most distinctive mark of the emergence
of the individual from the mass. But there are degrees and
kinds of intimacy. There is, for instance, the familiar and
somewhat garrulous intimacy of Montaigne. There is the
sublimated intimacy of Wordsworth, at once self-revealing
and unfamiliar.

> ". . . . when like a roe
> I bounded o'er the mountains, by the sides
> Of the deep rivers, and the lonely streams,
> Wherever nature led; . . .
> . . . The sounding cataract
> Haunted me like a passion. . . .
> . . . That time is past,
> And all its aching joys are now no more,
> And all its dizzy raptures."

Among writers of our own time there is the statistical,
some would say the pathological intimacy, of Zola and his

school; there is the filtered and subtilised intimacy of
Meredith and James, and there is the poignant intimacy
of Browning and Tolstoy.

I have said so much in dispraise of *War and Peace* that
I must beg leave to quote a delightful passage or two:

Natasha, just flowering into young-womanhood, is all
a-flutter because Boris, the sweetheart of former days, now
a grown stripling, has returned from the war and has begun
to cast eyes in her direction:

"One evening, when the old countess, in nightcap and
dressing-sack, with her false curls removed, and with one
thin strand of white hair escaping from under her white
calico cap, was performing the low obeisances of her evening
devotions on a rug, sighing and groaning, the door of her
room creaked on its hinges, and Natasha came running in,
with her bare feet in slippers, and also in dressing jacket
and curl papers.

"The countess glanced around, and a frown passed over
her face. She went on repeating her last prayer. 'If this
couch become my tomb.' . . . This couch was a lofty
feather bed, with five pillows, each smaller than the other.
Natasha jumped into the middle, sinking deep into the
feather mattress, rolled over next the wall, and began
to creep under the bedclothes, snuggling down, tucking
her knees up to her chin, then giving animated little kicks,
and laughing almost aloud, now and again uncovering her
head and looking at her mother. . . .

" 'Come, Mamma, stop laughing at me!' cried Natasha.
'You make the whole bed shake. You are awfully like me.
You laugh just as easily as I do. Do stop!'

"She seized the countess's two hands, kissed the joint of
the little finger of one of them for June, and went on kissing
July and August on the other hand. 'Mamma, but he's
very, he's so very much in love—you think so, do you? Was
anyone ever as much in love with you? And he's very nice,
very, very nice, isn't he? Only he's not quite to my taste—
he's so narrow, just like the dining-room clock. You know

what I mean, don't you? Narrow, you know,—grayish and serene.'

"'What nonsense you talk!' exclaimed the countess."

Still more poignantly intimate is the death of the little Princess, Andrei's wife, in childbirth:

"The door opened. The doctor with his shirt sleeves rolled up, without his coat, pale and with trembling jaw, came from the room. Prince Andrei went to him, but the doctor looked at him with a strange expression of confusion, and without saying a word passed by him. A woman came running out, but when she saw Prince Andrei, stopped short on the threshold. He went into his wife's room.

"She was dead, lying in the same position in which he had seen her five minutes before, and notwithstanding the fixity of her eyes, and the pallor of her cheeks, that charming little childish face, with the lip shaded with dark hairs wore the same expression as before—

"'I love you all, and I have done no one any harm, and what have you done to me?' said her lovely face, pitifully pale in death. In the corner of the room, a small red object was yelping and wailing in the trembling white hands of Marya Bogdanova."

Two passages are, so far as I know, without example: one is the travail of Kitty in *Anna;* the other is the temptation in *Resurrection,* where the hero stands at the dead of night outside the chamber-door of the girl he is to ruin:

"She tore herself away from him and returned into the maid's room. He heard the latch click, and then all was quiet. The red light disappeared, only the mist remained and the bustle on the river went on. Nekhludoff went up to the window, nobody was to be seen; he knocked, but got no answer. He went back into the house by the front door, but could not sleep. He got up and went with bare feet along the passage to her door, next Matróna Pávlovna's room. He heard Matróna Pávlovna snoring quietly, and was about to go on when she coughed and turned on her creaking bed, and his heart fell, and he stood immovable for about five

minutes. When all was quiet and she began to snore peacefully again, he went on, trying to step on the boards that did not creak, and came to Katúsha's door. There was no sound to be heard. She was probably awake, or else he would have heard her breathing. But as soon as he had whispered 'Katúsha' she jumped up and began to persuade him, as if angrily, to go away.''

Like Browning Tolstoy has said with poignant intimacy the thing that could not be said, but unlike Browning he has said it in what Stevenson calls "the dialect of life," not in an intricate phrase-pattern, whimsical and perverse. This shadowing the common experiences of common men and women in the plain prose of their every-day conversation, yet in such wise as to impart the utmost significance, is one of Tolstoy's greatest achievements. It is possible to him because life itself sincerely lived seems so good that even its sins, squalid as they are, have a kind of dignity. Never does he say of any experience that

> ''—all its aching joys are now no more,
> And all its dizzy raptures.''

because with Tolstoy the desire of experience is just beneath the surface, and quick. This I call liberating in the highest degree.

For he does not see through a microscope darkly, as Zola does. With at least equal sincerity—the courage of his perceptions, in Henry James' phrase—he too sees ruin and squalor, but he sees also the compensating things, the regenerative forces abundant in the life of every man. And he convinces us that we may safely rest upon our common dignity, as men. This is his liberation. This is why he seems to me the most significant literary artist of our time —if indeed he be not the very greatest man.

PHYSICS AND POLITICS:

AN APPLICATION OF THE PRINCIPLES OF NATURAL SELECTION AND HEREDITY TO POLITICAL SOCIETY.

BY

WALTER BAGEHOT,

AUTHOR OF "THE ENGLISH CONSTITUTION."

1. THE PRELIMINARY AGE.

ONE peculiarity of this age is the sudden acquisition of much physical knowledge. There is scarcely a department of science or art which is the same, or at all the same, as it was fifty years ago. A new world of inventions—of railways and of telegraphs—has grown up around us which we cannot help seeing, a new world of ideas is in the air and affects us, though we do not see it. A full estimate of these effects would require a great book, and I am sure I could not write it; but I think I may usefully, in a few papers, show how upon one or two great points the new ideas are modifying two old sciences—politics and political economy. Even upon these points my ideas must be incomplete, for the subject is novel; but, at any rate, I may suggest some conclusions, and so show what is requisite even if I do not supply it.

If we wanted to describe one of the most [...] results, perhaps the most marked [...] of late thought, we should say that by it everything is made "an antiquity." When, in former times, our ancestors thought of an antiquarian, they described him as occupied with coins and medals and Druids' stones; these were then the characteristic records of the decipherable past, and it was with these that decipherers busied themselves. But now there are other relics; indeed, all matter is become such. Science tries to find in each bit of earth the record of the causes which made it precisely what it is; those forces have left their trace, she knows, as much as the tact and hand of the artist left their mark on a classical gem. It would be tedious (and it is not in my way) to reckon up the ingenious questionings by which geology has made part of the earth, at least, tell part of its tale; and the answers would have been meaningless if physiology and conchology and a hundred similar sciences had not brought their aid. Such subsidiary sciences are to the decipherer of the present day what old languages were to the antiquary of other days; they construe for him the words which he discovers, they

s a richness and a truth-like complexity
he picture which he paints, even in cases
re the particular detail they tell is not
ch. But what here concerns me is that
h himself has, to the eye of science, be-
ie "an antiquity." She tries to read, is
inning to read, knows she ought to read,
the frame of each man the result of a
le history of all his life, of what he is
what makes him so—of all his fore-
ers, of what they were and of what made
m so. Each nerve has a sort of memory
s past life, is trained or not trained, dulled
quickened as the case may be ; each feat-
is shaped and characterized, or left loose
meaningless, as may happen : each hand
arked with its trade and life, subdued to
at it works in—*if we could but see it.*

t may be answered that in this there is
hing new : that we always knew how
ch a man's past modified a man's future ;
t we all knew how much a man is apt to
like his ancestors ; that the existence of
ional character is the greatest common-
, in the world ; that when a philosopher
not account for anything in any other
ner, he boldly ascribes it to an occult
lity in some race. But what physical
nce does is, not to discover the hereditary
ient, but to render it distinct—to give us
accurate conception of what we may ex-
t, and a good account of the evidence by
ich we are led to expect it. Let us see
at that science teaches on the subject ;

as far as may be I will give it in the
ls of those who have made it a profes-
al study, both that I may be more sure
tate it rightly and vividly, and because—
I am about to apply these principles to
jects which are my own pursuit—I would
er have it quite clear that I have not
le my premises to suit my own conclu-
s.

'irst, then, as respects the individual, we
n as follows :

Even while the cerebral hemispheres are
ire and in full possession of their powers,
brain gives rise to actions which are as
npletely reflex as those of the spinal cord.
When the eyelids wink at a flash of
it or a threatened blow, a reflex action
es place, in which the afferent nerves are
optic, the efferent the facial. When a
smell causes a grimace, there is a reflex
on through the same motor nerve, while
olfactory nerves constitute the afferent
nuels. In these cases, therefore, reflex
on must be effected through the brain, all
nerves involved being cerebral.

When the whole body starts at a loud
e, the afferent auditory nerve gives rise
n impulse which passes to the medulla
ngata, and thence affects the great ma-
ty of the motor nerves of the body.
It may be said that these are mere me-
nical actions, and have nothing to do with
acts which we associate with intelligence.
let us consider what takes place in such
act as reading aloud. In this case, the
le attention of the mind is or ought to

be bent upon the subject-matter of the book,
while a multitude of most delicate muscular
actions are going on, of which the reader is
not in the slightest degree aware. Thus the
book is held in the hand, at the right distance
from the eyes ; the eyes are moved, from
side to side, over the lines, and up and down
the pages. Further, the most delicately ad-
justed and rapid movements of the muscles
of the lips, tongue, and throat, of laryngeal
and respiratory muscles, are involved in the
production of speech. Perhaps the reader
is standing up and accompanying the lecture
with appropriate gestures. And yet every
one of these muscular acts may be performed
with utter unconsciousness, on his part, of
anything but the sense of the words in the
book. In other words, they are reflex acts.

" The reflex actions proper to the spinal
cord itself are *natural*, and are involved in
the structure of the cord and the properties
of its constituents. By the help of the brain
we may acquire an affinity of *artificial* reflex
actions. That is to say, an action may re-
quire all our attention and all our volition for
its first or second or third performance, but by
frequent repetition it becomes, in a manner,
part of our organization, and is performed
without volition or even consciousness.

" As every one knows, it takes a soldier a
very long time to learn his drill—to put him
self, for instance, into the attitude of ' at
tention ' at the instant the word of command
is heard. But after a time the sound of the
word gives rise to the act, whether the sol-
dier be thinking of it or not. There is a
story, which is credible enough, though it
may not be true, of a practical joker, who,
seeing a discharged veteran carrying home
his dinner, suddenly called out ' Attention !'
whereupon the man instantly brought his
hands down, and lost his mutton and potatoes
in the gutter. The drill had been gone
through, and its effects had become embodied
in the man's nervous structure.

" The possibility of all education (of which
military drill is only one particular form) is
based upon the existence of this power which
the nervous system possesses of organizing
conscious actions into more or less uncon-
scious or reflex operations. It may be laid
down as a rule that if any two mental states
be called up together or in succession, with
due frequency and vividness, the subsequent
production of the one of them will suffice to
call up the other, and that whether we desire
it or not."[*]

The body of the accomplished man has
thus become by training different from what
it once was, and different from that of the
rude man ; it is charged with stored virtue
and acquired faculty which come away from
it unconsciously.

Again, as to race, another authority
teaches : " Man's life truly represents a
progressive development of the nervous sys-
tem, none the less so because it takes place

* Huxley's " Elementary Physiology," pp. 284-286.
† Maudsley on the " Physiology and Pathology of
the Mind," p. 73.

ary transmutati̇ of o o mcu are a first voluntary into secondary automatic motions, as Hartley calls them, is due to a gradually effected organization; and we may rest assured of this, that co-ordinate activity always testifies to stored-up power, either innate or acquired.

"The way in which an acquired faculty of the parent animal is sometimes distinctly transmitted to the progeny as a heritage, instinct, or innate endowment, furnishes a striking confirmation of the foregoing observations. Power that has been laboriously acquired and stored up as statical in one generation manifestly in such case becomes the inborn faculty of the next; and the development takes place in accordance with that law of increasing specialty and complexity of adaptation to external nature which is traceable through the animal kingdom; or, in other words, that law of progress from the general to the special in development which the appearance of nerve force among natural forces and the complexity of the nervous system of man both illustrate. As the vital force gathers up, as it were into itself inferior forces, and might be said to be a development of them, or, as in the appearance of nerve force, simpler and more general forces are gathered up and concentrated in a more special and complex mode of energy, so again a further specialization takes place in the development of the nervous system, whether watched through generations or through individual life. It is not by limiting our observations to the life of the individual, however, who is but a link in the chain of organic beings connecting the past with the future, that we shall come at the full truth; the present individual is the inevitable consequence of his antecedents in the past, and in the examination of these alone do we arrive at the adequate explanation of him. It behoves us, then, having found any faculty to be innate, not to rest content there, but steadily to follow backward the line of causation, and thus to display, if possible, its manner of origin. This is the more necessary with the lower animals,* where so much is innate."†

The special laws of inheritance are indeed as yet unknown. All which is clear, and all which is to my purpose is, that there is a tendency, a probability, greater or less according to circumstances, but always considerable, that the descendants of cultivated parents will have, by born nervous organization, a greater aptitude for cultivation than the descendants of such as are not cultivated, and that this tendency augments, in some enhanced ratio, for many generations.

I do not think any who do not acquire—and it takes a hard effort to acquire—this notion of a transmitted nerve element will ever understand "the connective tissue" of civilization. We have here the continuous force which binds age to age, which enables each to begin with some improvement on the last, if the last did itself improve; which

dous, no a m o co or, surely enhance shade by shade. There is, by this doctri a physical cause of improvement from g eration to generation; and no imaginal which has apprehended it can forget it; unless you appreciate that cause in its sul materialism, unless you see it, as it w playing upon the nerves of men, and, after age, making nicer music from fi chords, you cannot comprehend the princi of inheritance either in its mystery or power.

These principles are quite independent any theory as to the nature of matter or nature of mind. They are as true upon theory that mind acts on matter—though e arate and altogether different from it upon the theory of Bishop Berkeley tl there is no matter, but only mind; or up the contrary theory, that there is no mi but only matter; or upon the yet sub theory now often held, that both mind matter are different modifications of some *tertium quid*, some hidden thing or for All these theories admit—indeed they but various theories to account for—the f that what we call matter has consequen in what we call mind, and that what we mind produces results in what we call m ter; and the doctrines I quote assume of that. Our mind in some strange way a on our nerves, and our nerves in some equa strange way store up the consequences, a somehow the result, as a rule, and commo enough, goes down to our descendant these primitive facts all theories admit, all of them labor to explain.

Nor have these plain principles any tion to the old difficulties of necessity free-will. Every Free-willist holds that special force of free volition is applied to pre-existing forces of our corporeal structu he does not consider it as an agency acting *vacuo*, but as an agency acting upon oti agencies. Every Free-willist holds that, up the whole, if you strengthen the motive i given direction, mankind tend more to act that direction. Better motives—better i pulses rather—come from a good bod worse motives or worse impulses come fr a bad body. A Free-willist may admit much as a Necessarian that such improv conditions tend to improve human actio and that deteriorated conditions tend to prave human action. No Free-willist ei expects as much from St. Giles's as he expe from Belgravia; he admits an hereditary n vous system as a *datum* for the will, thou he holds the will to be an extraordinary coming "something." No doubt the mode doctrine of the "Conservation of Force," applied to decision, is inconsistent with fr will; if you hold that force "is never lost gained," you cannot hold that there is a n gain—a sort of new creation of it in free vo tion. But I have nothing to do here w the universal "Conservation of Force." T conception of the nervous organs as stores will-made power does not raise or need

t a discussion.

till less are these principles to be con- uded with Mr. Buckle's idea that material :es have been the main-springs of prog- , and moral causes secondary, and, in iparison, not to be thought of. On the trary, moral causes are the first here. It ie action of the will that causes the un- scious habit ; it is the continual effort of beginning that creates the hoarded energy he end ; it is the silent toil of the first eration that becomes the transmitted apti- ; of the next. Here physical causes do create the moral, but moral create the sical ; here the beginning is by the higher rgy, the conservation and propagation / by the lower. But we thus perceive / a science of history is possible, as Mr. :kle said—a science to teach the laws or iencies—created by the mind, and trans- ted by the body—which act upon and in- e the will of man from age to age.

II.

ut how do these principles change the losophy of our politics ? I think in many 's ; and, first, in one particularly. Politi- ecouomy is the most systematized and it accurate part of political philosophy ; yet, by the help of what has been laid m, I think we may travel back to a sort ' pre-economic age," when the very as- iptions of political economy did not exist, n its precepts would have been ruinous, when the very contrary precepts were iiste and wise.

or this purpose I do not need to deal with dim ages which ethnology just reveals to -with the stone age, and the flint imple- its, and the refuse-heaps. The time to ch I would go back is only that just before dawn of history—coeval with the dawn, iaps, it would be right to say—for the . historians saw such a state of society, igh they saw other and more advanced es too : a period of which we have dis- t descriptions from eye witnesses, and of ch the traces and consequences abound he oldest law. " The effect," says Sir iry Maine, the greatest of our living jurists ie only one, perhaps, whose writings are ceeping with our best philosophy—" of evidence derived from comparative juris- lence is to establish that view of the neval condition of the human race which nown as the Patriarchal Theory. There o doubt, of course, that this theory was inally based on the scriptural history of Hebrew patriarchs in Lower Asia ; but, as been explained already, its connection i Scripture rather militated than other- ; against its reception as a complete theory. e the majority of the inquirers who till ntly addressed themselves with most ear- ness to the colligation of social phenom- were either influenced by the strongest udice against Hebrew antiquities or by strongest desire to construct their system iout the assistance of religious records n now there is perhaps a disposition to

undervalue these accounts, or rather to de- cline generalizing from them, as forming part of the traditions of a Semitic people. It is to be noted, however, that the legal testi- mony comes nearly exclusively from the in- stitutions of societies belonging to the Indo- European stock, the Romans, Hindoos, and Sclavonians supplying the greater part of it ; and indeed the difficulty, at the present stage of the inquiry, is to know where to stop, to say of what races of men it is not allowable to lay down that the society in which they are united was originally organized on the patriarchal model. The chief lineaments of such a society, as collected from the early chapters in Genesis, I need not attempt to depict with any minuteness, both because they are familiar to most of us from our ear- liest childhood, and because, from the inter- est once attaching to the controversy which takes its name from the debate between Locke and Filmer, they fill a whole chapter, though not a very profitable one, in English litera- ture. The points which lie on the surface of the history are these : The eldest male par- ent—the eldest ascendant—is absolutely su- preme in his household. His dominion ex- tends to life and death, and is as unqualified over his children and their houses as over his slaves ; indeed the relations of sonship and serfdom appear to differ in little beyond the higher capacity which the child in blood pos- sesses of becoming one day the head of a family himself. The flocks and herds of the children are the flocks and herds of the father, and the possessions of the parent, which he holds in a representative rather than in a proprietary character, are equally divided at his death among his descendants in the first degree, the eldest son sometimes receiv- ing a double share under the name of birth- right, but more generally endowed with no hereditary advantage beyond an honorary precedence. A less obvious inference from the scriptural accounts is that they seem to plant us on the traces of the breach which is first effected in the empire of the parent. The families of Jacob and Esau separate and form two nations ; but the families of Jacob's children hold together and become a people. This looks like the immature germ of a state or commonwealth, and of an order of rights superior to the claims of family re- lation.

" If I were attempting, for the more special purposes of the jurist, to express compendi- ously the characteristics of the situation in which mankind disclose themselves at the dawn of their history, I should be satisfied to quote a few verses from the ' Odyssey ' of Homer :

" ' τοῖσιν δ' οὔτ' ἀγοραὶ βουληφόροι οὔτε θέμιστες.
θεμιστεύει δὲ ἕκαστος
παίδων ἠδ' ἀλόχων, οὐδ' ἀλλήλων ἀλέγουσιν.' "

' They have neither assemblies for consulta- tion nor themistes, but every one exercises jurisdiction over his wives and his children, and they pay no regard to one another.' "

And this description of the beginnings of

history is confirmed by what may be called the last lesson of prehistoric ethnology. Perhaps it is the most valuable, as it is clearly the most sure result of that science, that it has dispelled the dreams of other days as to a primitive high civilization. History catches man as he emerges from the patriarchal state; ethnology shows how he lived, grew, and improved in that state. The conclusive arguments against the imagined original civilization are indeed plain to every one. Nothing is more intelligible than a moral deterioration of mankind—nothing than an æsthetic degradation—nothing than a political degradation. But you cannot imagine mankind giving up the plain utensils of personal comfort, if they once knew them; still less can you imagine them giving up good weapons—say bows and arrows—if they once knew them. Yet if there were a primitive civilization these things must have been forgotten, for tribes can be found in every degree of ignorance and every grade of knowledge as to pottery, as to the metals, as to the means of comfort, as to the instruments of war. And, what is more, these savages have not failed from stupidity; they are, in various degrees of originality, inventive about these matters. You cannot trace the roots of an old perfect system variously maimed and variously dying; you cannot find it as you find the trace of the Latin language in the mediæval dialects. On the contrary, you find it beginning—as new scientific discoveries and inventions now begin—here a little and there a little, the same thing half done in various half ways, and so as no one who knew the best way would ever have begun. An idea used to prevail that bows and arrows were the "primitive weapons"—the weapons of universal savages; but modern science has made a table, and some savages have them and some have not, and some have substitutes of one sort and some have substitutes of another—several of these substitutes being like the "boomerang," so much more difficult to hit on or to use than the bow, as well as so much less effectual. And not only may the miscellaneous races of the world be justly described as being upon various edges of industrial civilization, approaching it by various sides, and falling short of it in various particulars, but the moment they see the real thing they know how to use it as well, or better, than civilized man. The South American uses the horse which the European brought better than the European. Many races use the rifle—the especial and very complicated weapon of civilized man—better, upon an average, than he can use it. The savage with simple tools —tools he appreciates—is like a child, quick to learn, not like an old man, who has once forgotten and who cannot acquire again. Again, if there had been an excellent aboriginal civilization in Australia and America, where, botanists and zoologists ask, are its vestiges? If these savages did care to cultivate wheat, where is the wild wheat gone which their abandoned culture must have

left? If they did give up using good domestic animals, what has become of the wild 'ones which would, according to all natural laws, have sprung up out of them? This much is certain, that the domestic animals of Europe have, since what may be called the discovery of the world during the last hundred years, run up and down it. The English rat—not the pleasantest of our domestic creatures—has gone everywhere: to Australia, to New Zealand, to America: nothing but a complicated rat-miracle could ever root him out. Nor could a common force expel the horse from South America since the Spaniards took him thither; if we did not know the contrary, we should suppose him a principal aboriginal animal. Where then, so to say, are the rats and horses of the primitive civilization? Not only can we not find them, but zoological science tells us that they never existed, for the "feebly pronounced," the ineffectual, marsupials of Australia and New Zealand could never have survived a competition with better creatures, such as that by which they are now perishing.

We catch then a first glimpse of patriarchal man, not with any industrial relics of a primitive civilization, but with some gradually learned knowledge of the simpler arts, with some tamed animals and some little knowledge of the course of nature as far as it tells upon the seasons and affects the condition of simple tribes. This is what, according to ethnology, we should expect the first historic man to be, and this is what we in fact find him. But what was his mind; how are we to describe that?

I believe the general description in which Sir John Lubbock sums up his estimate of the savage minds suits the patriarchal mind. "Savages," he says, "unite the character of childhood with the passions and strength of men." And if we open the first record of the pagan world—the poems of Homer—how much do we find that suits this description better than any other. Civilization has indeed already gone forward ages beyond the time at which any such description is complete. Man, in Homer, is as good at oratory, Mr. Gladstone seems to say, as he has ever been, and, much as that means, other and better things might be added to it. But after all, how much of the "splendid savage" there is in Achilles, and how much of the "spoiled child sulking in his tent." Impressibility and excitability are the main characteristics of the oldest Greek history, and if we turn to the East, the "simple and violent" world, as Mr. Kinglake calls it, of the first times meets us every moment.

And this is precisely what we should expect. An "inherited drill," science says, "makes modern nations what they are; their born structure bears the trace of the laws of their father;" but the ancient nations came into no such inheritance; they were the descendants of people who did what was right in their own eyes; they were born to no tutored habits, no preservative bonds, and therefore they were at the mercy

very impulse and blown by every passion.

The condition of the primitive man, if we conceive of him rightly, is, in several respects, different from any we know. We nonsciously assume around us the existence of a great miscellaneous social machine working to our hands, and not only supplying our wants, but even telling and deciding when those wants shall come. No one can now without difficulty conceive how people got on before there were clocks and watches; as Sir G. Lewis said "it takes a vigorous effort of the imagination" to realize a period when it was a serious difficulty to know the hour of day. And much more is it difficult to fancy the unstable minds of such men a neither knew nature, which is the clockwork of material civilization, nor possessed polity, which is a kind of clock-work to moral civilization. They never could have known what to expect; the whole habit of steady but varied anticipation, which makes our minds what they are, must have been wholly foreign to theirs.

Again, I at least cannot call up to myself the loose conceptions (as they must have been) of morals which then existed. If we set aside all the element derived from law and polity which runs through our current moral notions, I hardly know what we shall have left. The residuum was somehow and in some vague way intelligible to the ante-political man, but it must have been uncertain, wavering, and unfit to be depended upon. In the best cases it existed much as the vague feeling of beauty now exists in minds sensitive but untaught: a still small voice of uncertain meaning—an unknown something modifying everything else, and higher than anything else, yet in form so indistinct that when you looked for it, it was gone; or if this be thought the delicate fiction of a later fancy, then morality was at least to be found in the wild spasms of "wild justice," half punishment, half outrage; but anyhow, being unfixed by steady law, it was intermittent, vague, and hard for us to imagine. Everybody who has studied mathematics knows how many shadowy difficulties he seemed to have before he understood the problem, and how impossible it was, when once the demonstration had flashed upon him, ever to comprehend those indistinct difficulties again, or to call up the mental confusion that admitted them. So in these days, when we cannot by any effort drive out of our minds the notion of law, we cannot imagine the mind of one who had never known it, and who could not by any effort have conceived it.

Again, the primitive man could not have imagined what we mean by a nation. We, on the other hand, cannot imagine those to whom it is a difficulty; "we know what it is when you do not ask us," but we cannot very quickly explain or define it. But so much as this is plain, a nation means a *like* body of men, because of that likeness capable of acting together, and because of that like-

ness inclined to obey similar rules; and even this Homer's Cyclops—used only to sparse human beings—could not have conceived.

To sum up: *law*—rigid, definite, concise law—is the primary want of early mankind; that which they need above anything else, that which is requisite before they can gain anything else. But it is their greatest difficulty, as well as their first requisite; the thing most out of their reach, as well as that most beneficial to them if they reach it. In later ages many races have gained much of this discipline quickly, though painfully; a loose set of scattered clans has been often and often forced to substantial settlement by a rigid conqueror; the Romans did half the work for above half Europe. But where could the first ages find Romans or a conqueror? Men conquer by the power of government, and it was exactly government which then was not. The first ascent of civilization was at a steep gradient, though when now we look down upon it, it seems almost nothing.

III.

How the step from polity to no polity was made distinct, history does not record; on this point Sir Henry Maine has drawn a most interesting conclusion from his peculiar studies:

"It would be," he tells us, "a very simple explanation of the origin of society if we could base a general conclusion on the hint furnished us by the scriptural example already adverted to, and could suppose that communities began to exist wherever a family held together instead of separating at the death of its patriarchal chieftain. In most of the Greek states and in Rome there long remained the vestiges of an ascending series of groups out of which the state was at first constituted. The family, house, and tribe of the Romans may be taken as a type of them, and they are so described to us that we can scarcely help conceiving them as a system of concentric circles which have gradually expanded from the same point. The elementary group is the family, connected by common subjection to the highest male ascendant. The aggregation of families forms the *gens*, or house. The aggregation of houses makes the tribe. The aggregation of tribes constitutes the commonwealth. Are we at liberty to follow these indications, and to lay down that the commonwealth is a collection of persons united by common descent from the progenitor of an original family? Of this we may at least be certain, that all ancient societies regarded themselves as having proceeded from one original stock, and even labored under an incapacity for comprehending any reason except this for their holding together in political union. The history of political ideas begins, in fact, with the assumption that kinship in blood is the sole possible ground of community in political functions; nor is there any of those subversions of feeling, which we term emphatically revolutions, so startling and so com-

plete as the change which is accomplished when some other principle—such as that, for instance, of *local contiguity*—establishes itself for the first time as the basis of common political action."

If this theory were true, the origin of politics would not seem a great change, or, in early days, be really a great change. The primacy of the elder brother, in tribes casually cohesive, would be slight; it would be the beginning of much, but it would be nothing in itself; it would be—to take an illustration from the opposite end of the political series—it would be like the headship of a weak parliamentary leader over adherents who may divide from him in a moment; it was the germ of sovereignty—it was hardly yet sovereignty itself.

I do not myself believe that the suggestion of Sir Henry Maine—for he does not, it will be seen, offer it as a confident theory—is an adequate account of the true origin of politics. I shall in a subsequent essay show that there are, as it seems to me, abundant evidences of a time still older than that which he speaks of. But the theory of Sir Henry Maine serves my present purpose well. It describes, and truly describes, a kind of life antecedent to our present politics, and the conclusion I have drawn from it will be strengthened, not weakened, when we come to examine and deal with an age yet older and a social bond far more rudimentary.

But when once politics were begun, there is no difficulty in explaining why they lasted. Whatever may be said against the principle of "natural selection" in other departments, there is no doubt of its predominance in early human history. The strongest killed out the weakest, as they could. And I need not pause to prove that any form of polity is more efficient than none; that an aggregate of families owning even a slippery allegiance to a single head would be sure to have the better of a set of families acknowledging no obedience to any one, but scattering loose about the world and fighting where they stood. Homer's Cyclops would be powerless against the feeblest band; so far from its being singular that we find no other record of that state of man, so unstable and sure to perish was it that we should rather wonder at even a single vestige lasting down to the age when for picturesqueness it became valuable in poetry.

But though the origin of polity is dubious, we are upon the *terra firma* of actual records when we speak of the preservation of politics. Perhaps every young Englishman who comes nowadays to Aristotle or Plato is struck with their conservatism: fresh from the liberal doctrines of the present age, he wonders at finding in those recognised teachers so much contrary teaching. They both—unlike as they are—hold with Xenophon—so unlike both—that man is the "hardest of all animals to govern." Of Plato it might indeed be plausibly said that the adherents of an intuitive philosophy, being "the tories of speculation," have com-

monly been prone to conservatism in government: but Aristotle, the founder of the experience philosophy, ought, according to that doctrine, to have been a liberal, if any one ever was a liberal. In fact, both of these men lived when men had not "had time to forget" the difficulties of government. We have forgotten them altogether. We reckon, as the basis of our culture, upon an amount of order, of tacit obedience, of prescriptive governability, which these philosophers hoped to get as a principal result of their culture. We take without thought as a *datum* what they hunted as a *quaesitum*.

In early times the quantity of government is much more important than its quality. What you want is a comprehensive rule binding men together, making them do much the same things, telling them what to expect of each other—fashioning them alike, and keeping them so. What this rule is does not matter so much. A good rule is better than a bad one, but any rule is better than none; while, for reasons which a jurist will appreciate, none can be very good. But to gain that rule, what may be called the impressive elements of a polity are incomparably more important than its useful elements. How to get the obedience of men is the hard problem; what you do with that obedience is less critical.

To gain that obedience, the primary condition is the identity—not the union, but the sameness—of what we now call Church and State. Dr. Arnold, fresh from the study of Greek thought and Roman history, used to preach that this identity was the great care for the misguided modern world. But he spoke to ears filled with other sounds and minds filled with other thoughts, and they hardly knew his meaning, much less heeded it. But though the teaching was wrong for the modern age to which it was applied, it was excellent for the old world from which it was learned. What is there requisite is a single government—call it Church or State, as you like—regulating the whole of human life. No division of power is then endurable without danger—probably without destruction; the priest must not teach one thing and the king another; king must be priest, and prophet king: the two must say the same, because they are the same. The idea of difference between spiritual penalties and legal penalties must never be awakened. Indeed, early Greek thought or early Roman thought would never have comprehended it. There was a kind of rough public opinion and there were rough, very rough, hands which acted on it. We now talk of political penalties and ecclesiastical prohibition, and the social censure, but they were all one then. Nothing is very like those old communities now, but perhaps a "trades-union" is as near as most things; to work cheap is thought to be a "wicked" thing, and so some Broadhead puts it down.

The object of such organizations is to create what may be called a *cake* of custom. All the actions of like are to be submitted

single rule for a single object ; that gradually created the "hereditary drill" which science teaches to be essential, and which the early instinct of men saw to be essential too. That this *régime* forbids free thought is not an evil ; or rather, though an evil, it is the necessary basis for the greatest good ; it is necessary for making the mould of civilisation, and hardening the soft fibre of early man.

The first recorded history of the Aryan race shows everywhere a king, a council, and, as the necessity of early conflicts required, the king in much prominence and with much power. That there could be in such ages anything like an oriental despotism or a Cæsarean despotism was impossible ; the outside extra-political army which maintains them could not exist when the tribe was the nation, and when all the men in the tribe were warriors. Hence, in the time of Homer, in the first times of Rome, in the first times of ancient Germany, the king is the most visible part of the polity, because for momentary welfare he is the most useful. The close oligarchy, the patriciate, which alone could know the fixed law, alone could apply the fixed law, which was recognized as the authorized custodian of the fixed law, had then sole command over the primary social want. It alone knew the code of drill ; it alone was obeyed ; it alone could drill. Mr. Grote has admirably described the rise of the primitive oligarchies upon the face of the first monarchy ; but perhaps because he so much loves historic Athens, he has not sympathized with pre-historic Athens. He has not shown us the need of a fixed life when all else was unfixed life.

It would be schoolboyish to explain at length how well the two great republics, the two winning republics of the ancient world, embody these conclusions. Rome and Sparta were drilling aristocracies, and succeeded because they were such. Athens was indeed of another and higher order ; at least to us instructed moderns who know her and have been taught by her. But to the "Philistines" of those days Athens was of a lower order. She was beaten ; she lost the great visible game which is all that short-sighted contemporaries know. She was the great "free failure" of the ancient world. She began, she announced the good things that were to come, but she was too weak to display and enjoy them ; she was trodden down by those of coarser make and better trained frame.

How much these principles are confirmed by Jewish history is obvious. There was doubtless much else in Jewish history—whose elements with which I am not here concerned. But so much is plain The Jews were in the beginning the most untable of nations ; they were submitted to their law, and they came out the most stable of nations. Their polity was indeed defective in unity. After they asked for a king the spiritual and the secular powers (as we should speak) were never at peace, and never

their law melted away into the neighboring nations. Jeroboam has been called the "first Liberal ;" and, religion apart, there is a meaning in the phrase. He began to break up the binding polity which was what men wanted in that age, though eager and inventive minds always dislike it. But the Jews who adhered to their law became the Jews of the day, a nation of a firm set if ever there was one.

It is connected with this fixity that jurists tell us that the title "contract" is hardly to be discovered in the oldest law. In modern days, in civilized days, men's choice determines nearly all they do. But in early times that choice determined scarcely anything. The guiding rule was the law of *status*. Everybody was born to a place in the community ; in that place he had to stay ; in that place he found certain duties which he had to fulfil, and which were all he needed to think of. The net of custom caught men in distinct spots, and kept each where he stood.

What are called in European politics the principles of 1789 are therefore inconsistent with the early world ; they are fitted only to the new world in which society has gone through its early task ; when the inherited organization is already confirmed and fixed ; when the soft minds and strong passions of youthful nations are fixed and guided by hard transmitted instincts. Till then not equality before the law is necessary, but inequality, for what is most wanted is an elevated *élite* who know the law ; not a good government seeking the happiness of its subjects, but a dignified and overawing government getting its subjects to obey ; not a good law, but a comprehensive law binding all life to one routine. Later are the ages of freedom ; first are the ages of servitude. In 1789, when the great men of the Constituent Assembly looked on the long past, they hardly saw anything in it which could be praised, or admired, or imitated : all seemed a blunder—a complex error to be got rid of as soon as might be. But that error had made themselves. On their very physical organization the hereditary mark of old times was fixed ; their brains were hardened and their nerves were steadied by the transmitted results of tedious usages. The ages of monotony had their use, for they trained men for ages when they need not be monotonous.

IV

But even yet we have not realized the full benefit of those early polities and those early laws. They not only "bound up" men in groups, not only impressed on men a certain set of common usages, but often, at least in an indirect way, suggested, if I may use the expression, national character.

We cannot yet explain—I am sure, at least, I cannot attempt to explain—all the singular phenomena of national character ; how completely and perfectly they seem to be at first framed ; how slowly, how gradually

tered at all. But there is one analogous fact which may help us to see, at least dimly, how such phenomena are caused. There is a character of *ages* as well as of nations; and as we have full histories of many such periods, we can examine exactly when and how the mental peculiarity of each began, and also exactly when and how that mental peculiarity passed away. We have an idea of Queen Anne's time, for example, or of Queen Elizabeth's time, or George II.'s time; or, again, of the age of Louis XIV., or Louis XV., or the French Revolution—an idea more or less accurate in proportion as we study, but probably even in the minds who know these ages best and most minutely, more special, more simple, more unique than the truth was. We throw aside too much, in making up our images of eras, that which is common to all eras. The English character was much the same in many great respects in Chaucer's time as it was in Elizabeth's time or Anne's time, or as it is now. But some qualities were added to this common element in one era and some in another; some qualities seemed to overshadow and eclipse it in one era, and others in another. We overlook and half forget the constant while we see and watch the variable. But for that is the present point—*why* is there this variable? Every one must, I think, have been puzzled about it. Suddenly, in a quiet time—say, in Queen Anne's time—arises a special literature, a marked variety of human expression, pervading what is then written and peculiar to it: surely this is singular.

The true explanation is, I think, something like this. One considerable writer gets a sort of start because what he writes is somewhat more—only a little more very often, as I believe—congenial to the minds around him than any other sort. This writer is very often not the one whom posterity remembers—not the one who carries the style of the age farthest toward its ideal type, and gives it its charm and its perfection. It was not Addison who began the essay-writing of Queen Anne's time, but Steele; it was the vigorous forward man who struck out the rough notion, though it was the wise and meditative man who improved upon it and elaborated it, and whom posterity reads. Some strong writer or group of writers thus seize on the public mind, and a curious process soon assimilates other writers in appearance to them. To some extent, no doubt, this assimilation is effected by a process most intelligible, and not at all curious —the process of conscious imitation: A sees that B's style of writing answers, and he imitates it. But definitely aimed mimicry like this is always rare; original men who like their own thoughts do not willingly clothe them in words they feel they borrow. No man, indeed, can think to much purpose when he is studying to write a style not his own. After all, very few men are at all equal to the steady labor, the stupid and mistaken labor mostly, of *making* a style. Most

men catch the words that are in the air, and the rhythm which comes to them they do not know from whence; an unconscious imitation determines their words, and makes them say what of themselves they would never have thought of saying. Every one who has written in more than one newspaper knows how invariably his style catches the tone of each paper while he is writing for it, and changes to the tone of another when in turn he begins to write for that. He probably would rather write the traditional style to which the readers of the journal are used, but he does not set himself to copy it; he would have to force himself in order *not* to write it if that was what he wanted. Exactly in this way, just as a writer for a journal without a distinctly framed purpose gives the readers of the journal the sort of words and the sort of thoughts they are used to, so, on a larger scale, the writers of an age, without thinking of it, give to the readers of the age the sort of words and the sort of thoughts— the special literature, in fact—which those readers like and prize. And not only does the writer, without thinking, choose the sort of style and meaning which are most in vogue, but the writer is himself chosen. A writer does not begin to write in the traditional rhythm of an age unless he feels or fancies he feels a sort of aptitude for writing it, any more than a writer tries to write in a journal in which the style is uncongenial or impossible to him. Indeed if he mistakes he is soon weeded out; the editor rejects, the age will not read his compositions. How painfully this traditional style cramps great writers whom it happens not to suit is curiously seen in Wordsworth, who was bold enough to break through it, and, at the risk of contemporary neglect, to frame a style of his own. But he did so knowingly, and he did so with an effort. "It is supposed," he says, "that by the act of writing in verse an author makes a formal engagement that he will gratify certain known habits of association; that he not only then apprises the reader that certain classes of ideas and expressions will be found in his book, but that others will be carefully eschewed. The exponent or symbol held forth by metrical language must, in different ages of literature, have excited very different expectations; for example, in the age of Catullus, Terence, or Lucretius, and that of Statius or Claudian; and in our own country, in the age of Shakespeare and Beaumont and Fletcher, and that of Donne and Cowley, or Pope." And then, in a kind of vexed way, Wordsworth goes on to explain that he himself can't and won't do what is expected from him, but that he will write his own words, and only his own words. A strict, I was going to say a Puritan, genius will act thus, but most men of genius are susceptible and versatile, and fall into the style of their age. One very unapt at the assimilating process, but on that account the more curious about it, says:

How we
Track a livelong day, great Heaven, and watch our

shadows !

aat our shadows seem. forsooth, we will ourselves
be.

I look like that ? You think me that : then I *am*
that.

What writers are expected to write they
ite, or else they do not write at all ; but,
e the writer of these lines, stop discour-
ed, live disheartened, and die leaving frag-
nts which their friends treasure, but which
ushing world never heeds. The Noncon-
mist writers are neglected, the Conformist
iters are encouraged, until perhaps on a
lden the fashion shifts. And as with the
iters, so in a less degree with readers.
any men—most men—get to like or think
y like that which is ever before them, and
iich those around them like, and which re-
ved opinion says they ought to like ; or if
ir minds are too marked and oddly made
get into the mould, they give up read-
; altogether, or read old books and foreign
oks, formed under another code and ap-
aling to a different taste. The principle
" elimination," the " use and disuse " of
gans which naturalists speak of, works
re. What is used strengthens ; what is
used weakens : " to those who have, more
given ;" and so a sort of style settles upon
age, and imprinting itself more than any-
ng else in men's memories becomes all
it is thought of about it.

[believe that what we call national char-
er arose in very much the same way. At
it a sort of " chance predominance" made
nodel, and then invincible attraction, the
cessity which rules all but the strongest
n to imitate what is before their eyes, and
be what they are expected to be, moulded
n by that model. This is, I think, the
y process by which new national charac-
s are being made in our own time. In
nerica and in Australia a new modification
what we call Anglo-Saxonism is growing.
sort of type of character arose from the
iiculties of colonial life—the difficulty of
uggling with the wilderness , and this type
given its shape to the mass of characters
ause the mass of characters have uncon-
ously imitated it. Many of the American
aracteristics are plainly useful in such a
', and consequent on such a life. The
ger restlessness, the highly-strung nervous
anization are useful in continual struggle,
l also are promoted by it. These traits
m to be arising in Australia too, and
erever else the English race is placed in
e circumstances. But even in these useful
ticulars the innate tendency of the human
ad to become like what is around it has
ected much, a sluggish Englishman will
en catch the eager American look in a few
irs ; an Irishman or even a German will
ch it too, even in all English particulars.
d as to a hundred minor points—in so
ny that go to mark the typical Yankee—
fulness has had no share either in their
gin or their propagation. The accident
some predominant person possessing them
the fashion, and it has been imitated to this

day. Anybody who inquires will find even
in England, and even in these days of assim-
ilation, parish peculiarities which arose, no
doubt, from some old accident, and have
been heedfully preserved by customary copy-
ing. A national character is but the suc-
cessful parish character ; just as the national
speech is but the successful parish dialect—the
dialect, that is, of the district which came to
be more—in many cases but a little more—
influential than other districts, and so set its
yoke on books and on society.

I could enlarge much on this, for I believe
this unconscious imitation to be the principal
force in the making of national characters ;
but I have already said more about it than I
need. Everybody who weighs even half these
arguments will admit that it is a great force
in the matter, a principal agency to be
acknowledged and watched ; and for my
present purpose I want no more. I have
only to show the efficacy of the tight early
polity (so to speak) and the strict early law
on the creation of corporate characters.
These settled the predominant type, set up a
sort of model, made a sort of *idol* ; this was
worshipped, copied, and observed, from all
manner of mingled feelings, but most of all
because it was the " thing to do." the then
accepted form of human action. When
once the predominant type was determined,
the copying propensity of man did the rest.
The tradition ascribing Spartan legislation to
Lycurgus was literally untrue, but its spirit
was quite true. In the origin of states strong
and eager individuals get hold of small knots
of men, and made for them a fashion which
they were attached to and kept.

It is only after duly apprehending the si-
lent manner in which national characters thus
form themselves, that we can rightly appre-
ciate the dislike which old governments had
to trade. There must have been something
peculiar about it, for the best philosophers,
Plato and Aristotle, shared it. They re-
garded commerce as the source of corruption
as naturally as a modern economist considers
it the spring of industry, and all the old gov-
ernments acted in this respect upon the phi-
losophers' maxims. ' Well," said Dr. Ar-
nold, speaking ironically and in the spirit of
modern times—" well, indeed, might the
policy of the old priest-nobles of Egypt and
India endeavor to divert their people from
becoming familiar with the sea, and represent
the occupation of a seaman as incompatible
with the purity of the highest castes. The
sea deserved to be hated by the old aristo-
racies, inasmuch as it has been the mightiest
instrument in the civilization of mankind."
But the old oligarchies had their own work,
as we now know. They were imposing a
fashioning yoke ; they were making the hu-
man nature which after times employ. They
were at their labors, we have entered into
these labors. And to the unconscious imita-
tion which was their principal tool, no im-
pediment was so formidable as foreign inter
course. Men imitate what is before their
e es, as it is before their eyes alone, but they

do not imitate it if it is only one among many present things—one competitor among others, all of which are equal and some of which seem better. "Whoever speaks two languages is a rascal," says the saying, and it rightly represents the feeling of primitive communities when the sudden impact of new thoughts and new examples breaks down the compact despotism of the single consecrated code, and leaves pliant and impressible man —such as he then is—to follow his unpleasant will without distinct guidance by hereditary morality and hereditary religion. The old oligarchies wanted to keep their type perfect, and for that end they were right not to allow foreigners to touch it.

"Distinctions of race," says Arnold himself elsewhere in a remarkable essay—for it was his last on Greek history, his farewell words on a long favorite subject—" were not of that odious and fantastic character which they have been in modern times; they implied real differences of the most important kind, religious and moral." And after exemplifying this at length, he goes on, "It is not then to be wondered at that Thucydides, when speaking of a city founded jointly by Ionians and Dorians, should have thought it right to add "that the prevailing institutions of the two were Ionian," for according as they were derived from one or the other the prevailing type would be different. And therefore the mixture of persons of different race in the same commonwealth, unless one race had a complete ascendency, tended to confuse all the relations of human life, and all men's notions of right and wrong ; or by compelling men to tolerate in so near a relation as that of fellow-citizens differences upon the main points of human life, led to a general carelessness and scepticism, and encouraged the notion that right and wrong had no real existence, but were mere creatures of human opinion." But if this be so, the oligarchies were right. Commerce brings this mingling of ideas, this breaking down of old creeds, and brings it inevitably. It is nowadays its greatest good that it does so ; the change is what we call " enlargement of mind." But in early times Providence " set apart the nations ;" and it is not till the frame of their morals is set by long ages of transmitted discipline that such enlargement can be borne. The ages of isolation had their use, for they trained men for ages when they were not to be isolated.

II. THE USE OF CONFLICT.

"The difference between progression and stationary inaction," says one of our greatest living writers, "is one of the great secrets which science has yet to penetrate." I am sure I do not pretend that I can completely penetrate it ; but it undoubtedly seems to me that the problem is on the verge of solution, and that scientific successes in kindred fields by analogy suggest some principles which wholly remove many of its difficulties, and indicate the sort of way in which those which remain may hereafter be removed too

But what is the problem ? Common En lish, I might perhaps say common civilis thought ignores it. Our habitual instructo our ordinary conversation, our inevitable a ineradicable prejudices tend to make think that " Progress" is the normal fact human society, the fact which we should pect to see, the fact which we should be s prised if we did not see. But history refu this. The ancients had no conception progress ; they did not so much as reject idea ; they did not even entertain the id Oriental nations are just the same no Since history began they have always be what they are. Savages, again, do not i prove ; they hardly seem to have the ba on which to build, much less the material put up anything worth having. Only a f nations, and those of European origin, vance ; and yet these think—seem irresi bly compelled to think—such advance to inevitable, natural, and eternal. Why, the is this great contrast ?

Before we can answer, we must inve gate more accurately. No doubt histo shows that most nations are stationary no but it affords reason to think that all nati once advanced. Their progress was arres at various points ; but nowhere, probal not even in the hill tribes of India, not ev in the Andaman Islanders, not even in savages of Terra del Fuego, do we find m who have not got some way. They ha made their little progress in a hundred diff ent ways ; they have framed with infin assiduity a hundred curious habits ; th have, so to say, screwed themselves into t uncomfortable corners of a complex li which is odd and dreary, but yet is possib And the corners are never the same in a two parts of the world. Our record beg with a thousand unchanging edifices, but shows traces of previous building. In h toric times there has been little progress ; prehistoric times there must have been mu

In solving or trying to solve the questio we must take notice of this remarkal difference, and explain it too, or else we m be sure our principles are utterly incomple and perhaps altogether unsound. But wl then is that solution, or what are the prin ples which tend toward it ? Three lav or approximate laws, may, I think, be l down, with only one of which I can deal this paper, but all three of which it will bost to state, that it may be seen what I aiming at.

First. In every particular state of world, those nations which are strong tend to prevail over the others ; and in c tain marked peculiarities the strongest to to be the best.

Secondly. Within every particular nati the type or types of character then and th most attractive tend to prevail ; and most attractive, though with exceptions, what we call the best character.

Thirdly. Neither of these competitions is most historic conditions intensified by exte nal forces, but in some conditions, whi

se nowng in the most influential
t of the world, both are so intensified.
These are the sort of doctrines with which,
der the name of " natural selection" in
ysical science, we have become familiar ;
I as every great scientific conception tends
advance its boundaries and to be of use in
ving problems not thought of when it was
rted, so here what was put forward for
re animal history may, with a change of
m, but an identical essence, be applied to
man history.
t first some objection was raised to the
nciple of "natural selection" in physical
nce upon religious grounds ; it was to be
ected that so active an idea and so large
lifting of thought would seem to imperil
ch which men valued. But in this as in
er cases, the objection is, I think, passing
y ; the new principle is more and more
u to be fatal to mere outworks of religion,
to religion itself. At all events, to the
of application here made of it, which
y amounts to searching out and following
an analogy suggested by it, there is
inly no objection. Every one now admits
t human history is guided by certain
s, and all that is here aimed at is to indi-
, in a more or less distinct way, an infin-
ally small portion of such laws.
he discussion of these three principles
not be kept quite apart except by pedan-
; but it is almost exclusively with the
t—that of the competition between nation
nation, or tribe and tribe (for I must use
e words in their largest sense, and so as
nclude every cohering aggregate of human
gs)—that I can deal now ; and even as to
I can but set down a few principal con-
rations.
he progress of the military art is the most
spicuous, I was about to say the most
y, fact in human history. Ancient civ-
tion may be compared with modern in
y respects, and plausible arguments con-
cted to show that it is better ; but you
not compare the two in military power.
leon could indisputably have conquered
xander ; our Indian army would not
k much of the Retreat of the Ten Thou-
And I suppose the improvement has
a continuous : I have not the slightest
ence to special knowledge ; but, looking
he mere surface of the facts, it seems
ly that the aggregate battle array, so to
of mankind, the fighting force of the
man race, has constantly and invariably
wn. It is true that the ancient civiliza-
long resisted the "barbarians," and was
a destroyed by the barbarians But the
barians had improved. "By degrees,"
a most accomplished writer, "barbarian
cenaries came to form the largest, or at
t the most effective, part of the Roman
ies. The body-guard of Augustus had
a so composed ; the prætorians were gen-
ly selected from the bravest frontier
ps, most of them Germans." "Thus,"
ontinues, "in many ways was the old
gonism broken down, Romans admitting

barbarians to rank and office , barbarians
catching something of the manners and cul-
ture of their neighbors. And thus, when
the final movement came, the Teutonic tribes
slowly established themselves through the
provinces, knowing something of the system
to which they came, and not unwilling to be
considered its members." Taking friend
and foe together, it may be doubted whether
the fighting capacity of the two armies was
not as great at last, when the empire fell, as
ever it was in the long period while the em-
pire prevailed. During the Middle Ages the
combining power of men often failed ; in a
divided time you cannot collect as many sol-
diers as in a concentrated time. But this
difficulty is political, not military. If you
added up the many little hosts of any cen-
tury of separation, they would perhaps be
found equal or greater than the single host,
or the fewer hosts, of previous centuries
which were more united. Taken as a whole,
and allowing for possible exceptions, the ag-
gregate fighting power of mankind has grown
immensely, and has been growing continu-
ously since we knew anything about it.
Again, this force has tended to concentrate
itself more and more in certain groups which
we call "civilized nations." The literati of
the last century were forever in fear of a new
conquest of the barbarians, but only because
their imagination was overshadowed and
frightened by the old conquests. A very
little consideration would have shown them
that, since the monopoly of military inven-
tions by cultivated states, real and effective
military power tends to confine itself to those
states. The barbarians are no longer so
much as vanquished competitors ; they have
ceased to compete at all.
The military vices, too, of civilization
seem to decline just as its military strength
augments. Somehow or other civilization
does not make men effeminate or unwarlike
now as it once did. There is an improve-
ment in our fibre—moral, if not physical. In
ancient times city people could not be got to
fight—seemingly could not fight ; they lost
their mental courage, perhaps their bodily
nerve. But nowadays in all countries the great
cities could pour out multitudes wanting noth-
ing but practice to make good soldiers, and
abounding in bravery and vigor. This was
so in America ; it was so in Prussia ; and it
would be so in England too. The breed of
ancient times was impaired for war by trade
and luxury, but the modern breed is not so
impaired.
A curious fact indicates the same thing
probably, if not certainly. Savages waste
away before modern civilization ; they seem
to have held their ground before the ancient.
There is no lament in any classical writer for
the barbarians. The New Zealanders say
that the land will depart from their children ;
the Australians are vanishing, the Tasma-
nians have vanished. If anything like this
had happened in antiquity, the classical
moralists would have been sure to muse over
it : for it is just the large solemn kind of fact

that suited them. On the contrary, in Gaul, in Spain, in Sicily—everywhere that we know of—the barbarian endured the contact of the Roman, and the Roman allied himself to the barbarian. Modern science explains the wasting away of savage men; it says that we have diseases which we can bear, though they cannot, and that they die away before them as our fatted and protected cattle died out before the rinderpest, which is innocuous, in comparison, to the hardy cattle of the Steppes. Savages in the first year of the Christian era were pretty much what they were in the 1800th; and if they stood the contact of ancient civilized men, and cannot stand ours, it follows that our race is presumably tougher than the ancient; for we have to bear, and do bear, the seeds of greater diseases than those the ancients carried with them. We may use, perhaps, the unvarying savage as a metre to gauge the vigor of the constitutions to whose contact he is exposed.

Particular consequences may be dubious, but as to the main fact there is no doubt; the military strength of man has been growing from the earliest time known to our history, straight on till now. And we must not look at times known by written records only; we must travel back to older ages, known to us only by what lawyers call *real* evidence—the evidence of things. Before history began there was at least as much progress in the military art as there has been since. The Roman legionaries or Homeric Greeks were about as superior to the men of the shell mounds and the flint implements as we are superior to them. There has been a constant acquisition of military strength by man since we know anything of him, either by the documents he has composed or the indications he has left.

The cause of this military growth is very plain. The strongest nation has always been conquering the weaker; sometimes even subduing it, but always prevailing over it. Every intellectual gain, so to speak, that a nation possessed was in the earliest times made use of—was *invested* and taken out—in war; all else perished. Each nation tried constantly to be the stronger, and so made or copied the best weapons; by conscious and unconscious imitation each nation formed a type of character suitable to war and conquest. Conquest improved mankind by the intermixture of strengths; the armed truce, which was then called peace, improved them by the competition of training and the consequent creation of new power. Since the long-headed men first drove the short-headed men out of the best land in Europe, all European history has been the history of the superposition of the more military races over the less military—of the efforts, sometimes successful, sometimes unsuccessful, of each race to get more military; and so the art of war has constantly improved.

But why is one nation stronger than another? In the answer to that, I believe, lies the key to the principal progress of early civ-

ilization, and to some of the progress o civilization. The answer is that there very many advantages—some small and a great—every one of which tends to make nation which has it superior to the na which has it not; that many of these ad tages can be imparted to subjugated ra or imitated by competing races; and t though some of these advantages may perishable or inimitable, yet, on the wh the energy of civilization grows by the lescence of strengths and by the competi of strengths.

II.

By far the greatest advantage is tha which I observed before—that to whi drew all the attention I was able by ma the first of these essays an essay on the liminary Age. The first thing to acquir if I may so express it, the *legal fibre* polity first—what sort of polity is immater a law first—what kind of law is seconda a person or set of persons to pay deferenc —though who he is or they are by com ison scarcely signifies.

"There is," it has been said, "hardly exaggerating the difference between civil and uncivilized men; it is greater than difference between a tame and a wild mal," because man can improve more. the difference at first was gained in much same way. The taming of animals as it goes on among savage nations, and as t ellers who have seen it describe it, is a of selection. The most wild are killed w food is wanted, and the most tame and to manage kept, because they are agreeable to human indolence, and so keeper likes them best. Captain Gal who has often seen strange scenes of sav and of animal life, had better describe process: "The irreclaimably wild mem of every flock would escape and be utt lost; the wilder of those that remained w assuredly be selected for slaughter whene it was necessary that one of the flock sho be killed. The tamest cattle—those wh seldom ran away, that kept the flocks gether, and those which led them homew —would be preserved alive longer than of the others. It is, therefore, these chiefly become the parents of stock and queath their domestic aptitudes to the fu herd. I have constantly witnessed this cess of selection among the pastoral sav of South Africa. I believe it to be a v important one on account of its rigor and regularity. It must have existed from earliest times, and have been in continu operation, generation after generation, do to the present day."[a]

Man, being the strongest of all anim differs from the rest; he was obliged to his own domesticator; he had to tame h self. And the way in which it happe was, that the most obedient, the tamest tri are, at the first stage in the real struggle life, the strongest and the conquerors. are very wild then; the animal vigor

age virtue of the race has died out in
ie, and all have enough of it. But what
kes one tribe—one incipient tribe, one bit
a tribe—to differ from another is their rel
re faculty of coherence. The slightest
aptom of legal development, the least in-
ation of a military bond, is then enough
arn the scale. The compact tribes win,
l the compact tribes are the tamest. Civ-
ation begins, because the beginning of civ-
ation is a military advantage.
'robably if we had historic records of the
e-historic ages—if some superhuman
ver had set down the thoughts and actions
nen ages before they could set them down
themselves—we should know that this
t step in civilization was the hardest step.
t when we come to history as it is, we are
re struck with the difficulty of the next
). All the absolutely incoherent men—
the "Cyclopes"—have been cleared away
g before there was an authentic account
them. And the least coherent only re-
in in the "protected" parts of the world,
we may call them. Ordinary civilization
ins near the Mediterranean Sea ; the best,
abtless, of the ante-historic civilizations
re not far off. From this centre the coun-
ering swarm—for such it is—has grown
l grown ; has widened its subject terri
ies steadily, though not equably, age by
. But geography long defied it. An
antic Ocean, a Pacific Ocean, an Austra-
a Ocean, an unapproachable interior
ica, an inaccessible and undesirable hill
lia, were beyond its range. In such re
te places there was no real competition.
l on them inferior half-combined men con-
aed to exist. But in the regions of rivalry
he regions where the better man pressed
on the worse man—such half made asso-
tions could not last. They died out, and
tory did not begin till after they were
te. The great difficulty which history re-
ds is not that of the first step, but that of
second step. What is most evident is not
difficulty of getting a fixed law, but get-
r out of a fixed law ; not of cementing (as
on a former occasion I phrased it) a cake
custom, but of breaking the cake of cus-
a ; not of making the first preservative
it, but of breaking through it, and reach-
something better.
his is the precise case with the whole
aily of arrested civilizations. A large
t, a very large part, of the world seems to
ready to advance to something good—to
re prepared all the means to advance to
nething good—and then to have stopped,
l not advanced. India, Japan, China,
aost every sort of Oriental civilization,
agh differing in nearly all other things,
in this alike. They look as if they had
ased when there was no reason for paus-
—when a mere observer from without
ald say they were likely not to pause.
he reason is, that only those nations can
gress which preserve and use the funda-
ntal peculiarity which was given by na-
e to man's organism as to all other organ-

isms. By a law of which we know no rea
son, but which is among the first by which
Providence guides and governs the world,
there is a tendency in descendants to be like
their progenitors, and yet a tendency also in
descendants to *differ* from their progenitors.
The work of nature in making generations is
a patchwork—part resemblance, part con-
trast. In certain respects each born genera-
tion is not like the last born ; and in certain
other respects it is like the last. But the pe-
culiarity of arrested civilization is to kill out
varieties at birth almost ; that is, in early
childhood, and before they can develop.
The fixed custom which public opinion alone
tolerates is imposed on all minds, whether it
suits them or not. In that case the commu-
nity feel that this custom is the only shelter
from bare tyranny, and the only security for
what they value. Most Oriental communi-
ties live on land which in theory is the prop-
erty of a despotic sovereign, and neither
they nor their families could have the ele-
ments of decent existence unless they held
the land upon some sort of fixed terms.
Land in that state of society is (for all but a
petty-skilled minority) a necessary of life, and
all the unincreasable land being occupied, a
man who is turned out of his holding is
turned out of this world, and must die. And
our notion of written leases is as out of place
in a world without writing and without
reading as a House of Commons among An-
daman Islanders. Only one check, one sole
shield for life and good, is then possible—
usage. And it is but too plain how in such
places and periods men cling to customs be-
cause customs alone stand between them
and starvation.

A still more powerful cause co-operated,
if a cause more powerful can be imagined.
Dryden had a dream of an early age, "when
wild in woods the noble savage ran ;" but
"when lone in woods the cringing savage
crept" would have been more like all we
know of that early, bare, painful period.
Not only had they no comfort, no conven-
ience, not the very beginnings of an epicu-
rean life, but their mind within was as pain-
ful to them as the world without. It was
full of fear. So far as the vestiges inform
us, they were afraid of everything ; they
were afraid of animals, of certain attacks by
near tribes, and of possible inroads from far
tribes. But, above all things, they were
frightened of "the world ;" the spectacle of
nature filled them with awe and dread.
They fancied there were powers behind it
which must be pleased, soothed, flattered,
and this very often in a number of hideous
ways. We have too many such religions,
even among races of great cultivation. Men
change their religions more slowly than they
change anything else ; and accordingly we
have religions "of the ages"—(it is Mr.
Jowett who so calls them)—of the "ages be-
fore morality ;" of ages of which the civil
life, the common maxims, and all the secular
thoughts have long been dead. "Every
reader of the classics," said Dr. Johnson,

"finds their mythology tedious." In that old world, which is so like our modern world is so many things, so much more like than many far more recent, or some that live beside us, there is a part in which we seem to have no kindred, which we stare at, of which we cannot think how it could be credible, or how it came to be thought of. This is the archaic part of that very world which we look at as so ancient; an "antiquity" which descended to them, hardly altered, perhaps, from times long antecedent, which were as unintelligible to them as to us, or more so. How this terrible religion—for such it was in all living detail, though we make, and the ancients then made, an artistic use of the more attractive bits of it—weighed on man, the great poem of Lucretius, the most of a nineteenth-century poem of any in antiquity, brings before us with a feeling so vivid as to be almost a feeling of our own Yet the classical religion is a mild and tender specimen of the preserved religions. To get at the worst, you should look where the destroying competition has been least—at America, where sectional civilization was rare, and a pervading coercive civilization did not exist; at such religions as those of the Aztecs.

At first sight it seems impossible to imagine what conceivable function such awful religions can perform in the economy of the world. And no one can fully explain them. But one use they assuredly had: they fixed the yoke of custom thoroughly on mankind. They were the prime agents of the era. They put upon a fixed law a sanction so fearful that no one could dream of not conforming to it.

No one will ever comprehend the arrested civilizations unless he sees the strict dilemma of early society. Either men had no law at all, and lived in confused tribes, hardly hanging together, or they had to obtain a fixed law by processes of incredible difficulty. Those who surmounted that difficulty soon destroyed all those that lay in their way who did not. And then they themselves were caught in their own yoke. The customary discipline, which could only be imposed on any early men by terrible sanctions, continued with those sanctions, and killed out of the whole society the propensities to variation which are the principle of progress.

Experience shows how incredibly difficult it is to get men really to encourage the principle of originality. They will admit it in theory, but in practice the old error—the error which arrested a hundred civilizations—returns again. Men are too fond of their own life, too credulous of the completeness of their own ideas, too angry at the pain of new thoughts, to be able to bear easily with a changing existence; or else, having new ideas, they want to enforce them on mankind—to make them heard, and admitted, and obeyed before, in simple competition with other ideas, they would ever be so naturally. At this very moment there are the

most rigid Comtists teaching that we ou to be governed by a hierarchy—a comb tion of sacans orthodox in science. Yet can doubt that Comte would have b hanged by his own hierarchy; that his materiel, which was in fact troubled by "theologians and metaphysicians" of Polytechnic School, would have been in impeded by the government he wanted make? And then the secular Comtists, Harrison and Mr. Beesly, who want "Frenchify the English institutions"—t is, to introduce here an imitation of Napoleonic system, a dictatorship foun on the proletariat—who can doubt that both these clever writers had been Frenchmen they would have been irasc anti-Bonapartists, and have been sent Cayenne long ere now? The wish of th writers is very natural. They want to " ganize society," to erect a despot who do what they like, and work out their ide but any despot will do what he himself lif and will root out new ideas ninety-nine th for once that he introduces them.

Again, side by side with these Comti and warring with them—at least with on them—is Mr. Arnold, whose poems we kn by heart, and who has, as much as any ing Englishman, the genuine literary pulse; and yet even he wants to put a y upon us—and, worse than a political yo an academic yoke, a yoke upon our mi and our styles. He, too, asks us to imit France; and what else can we say tl what the two most thorough Frenchme the last age did say?—" Dans les corp talent, nulle distinction ne fait ombrage ce n'est pas celle du talent. Un duc et p honore l'Académie Française, qui ne v point de Boileau, refuse la Bruyère, fait tendre Voltaire, mais reçoit tout d'ab Chapelain et Conrart. De même nous v ons à l'Académie Grecque le vicomte inv Corâl repoussé, lorsque Jormard y en comme dans un moulin." Thus spe Paul-Louis Courier in his own brief ini table prose. And a still greater writer real Frenchman, if ever there was one, (what many critics would have denied to possible) a great poet by reason of his n French characteristics—Béranger, tells u verse:

Je croyais voir le président
Faire bâiller—en répondant
Que l'on vient de perdre un grand homme ;
Que moi je le vaux, Dieu sait comme.
Mais ce président sans façon
Ne pérore ici qu'en chanson :
Toujours trop tôt sa harangue est finie.
Non, non, ce n'est point comme à l'Académie;
Ce n'est point comme à l'Académie.

Admis enfin, aurai-je alors,
Pour tout esprit, l'esprit de corps ?
Il rend le bon sens, quoi qu'on dise,
Solidaire de la sottise ;
Mais, dans votre société,
L'esprit de corps, c'est la gaîté.
Cet esprit là règne sans tyrannie,
Non, non, ce n'est point comme à l'Académie
Ce n'est point comme à l'Académie.

Asylums of commonplace, he hints, ac mice must ever be. But that sentence

; the true one is—the academies are
ms of the ideas and the tastes of the
age. "By the time," I have heard a
eminent man of science observe, "by
me a man of science attains eminence
y subject he becomes a nuisance upon
cause he is sure to retain errors which
in vogue when he was young, but
h the new race have refuted." These
re sort of ideas which find their home
ademies, and out of their dignified win-
pooh-pooh new things.

nay seem to have wandered far from
society, but I have not wandered. The
scientific method is to explain the past
e present—what we see by what we do
se. We can only comprehend why so
nations have not varied, when we see
hateful variation is; how everybody
against it; how not only the conserva-
of speculation try to root it out, but the
innovators invent most rigid machines
rushing the "monstrosities and anoma-
—the new forms, out of which, by com-
on and trial, the best is to be selected
he future. The point I am bringing
a simple: one most important pre-re-
te of a prevailing nation is that it should
passed out of the first stage of civiliza-
into the second stage—out of the stage
e permanence is most wanted into that
e variability is most wanted; and you
ot comprehend why progress is so slow
ou see how hard the most obstinate ten-
ies of human nature make that step to
tind.

course the nation we are supposing
keep the virtues of its first stage as it
s into the after stage, else it will be
len out; it will have lost the savage
es in getting the beginning of the civil.
virtues; and the savage virtues which
to war are the daily bread of human
re. Carlyle said, in his graphic way,
e ultimate question between every two
an beings is, 'Can I kill thee, or canst
kill me?'" History is strewn with the
ks of nations which have gained a little
ressiveness at the cost of a great deal of
manliness, and have thus prepared
selves for destruction as soon as the
ements of the world gave a chance for
But these nations have come out of the
-economic stage" too soon; they have
put to learn while yet only too apt to
arn. Such cases do not vitiate, they
rm, the principle—that a nation which
just gained variability without losing
ity has a singular likelihood to be a prev-
nation.

nation admits of an abstract definition;
ations are beings of many qualities and
sides; no historical event exactly illus-
s any one principle; every cause is in-
ined and surrounded with a hundred
s. The best history is but like the art
mbrandt; it casts a vivid light on cer-
selected causes, on those which were
and greatest; it leaves all the rest in
ow and unseen. To make a single

nation illustrate a principle, you must exag-
gerate much and you must omit much. But,
not forgetting this caution, did not Rome—
the prevalent nation in the ancient world—
gain her predominance by the principle on
which I have dwelt? In the thick crust of
her legality there was hidden a little seed of
adaptiveness. Even in her law itself no one
can fail to see that, binding as was the habit
of obedience, coercive as use and wont at
first seem, a hidden impulse of extrication
did manage, in some queer way, to change
the substance while conforming to the acci-
dents—to do what was wanted for the new
time while seeming to do only what was
directed by the old time. And the moral of
their whole history is the same: each Roman
generation, so far as we know, differs a little
—and in the best times often but a very little
—from its predecessors. And therefore the
history is so continuous as it goes, though
its two ends are so unlike. The history of
many nations is like the stage of the English
drama: one scene is succeeded on a sudden
by a scene quite different—a cottage by a
palace, and a windmill by a fortress. But
the history of Rome changes as a good
diorama changes; while you look, you hard-
ly see it alter; each moment is hardly differ-
ent from the last moment; yet at the close
the metamorphosis is complete, and scarcely
anything is as it began. Just so in the his-
tory of the great prevailing city; you begin
with a town and you end with an empire,
and this by unmarked stages. So shrouded,
so shielded, in the coarse fibre of other qual-
ities was the delicate principle of progress,
that it never failed, and it was never broken.

One standing instance, no doubt, shows
that the union of progressiveness and legality
does not secure supremacy in war. The
Jewish nation has its type of progress in the
prophets, side by side with its type of per-
manence in the law and Levites, more dis-
tinct than any other ancient people. No-
where in common history do we see the two
forces—both so necessary and both so dan-
gerous—so apart and so intense: Judæa
changed in inward thought, just as Rome
changed in exterior power. Each change
was continuous, gradual, and good. In early
times every sort of advantage tends to be-
come a military advantage; such is the best
way, then, to keep it alive. But the Jewish
advantage never did so, beginning in re-
ligion, contrary to a thousand analogies, it
remained religious. For that we care for
them; from that have issued endless conse-
quences. But I cannot deal with such mat-
ters here, nor are they to my purpose. As
respects this essay, Judæa is an example of
combined variability and legality not invec-
ing itself in warlike power, and so perishing
at last, but bequeathing nevertheless a legacy
of the combination in imperishable mental
effects.

It may be objected that this principle is
like saying that men walk when they do
walk, and sit when they do sit. The prob
lem is, why do men progress? And the

answer suggested seems to be, that they progress when they have a certain sufficient amount of variability in their nature. This seems to be the old style of explanation by occult qualities. It seems like saying that opium sends men to sleep because it has a soporific virtue, and bread feeds because it has an alimentary quality. But the explanation is not so absurd. It says: "The beginning of civilization is marked by an intense legality; that legality is the very condition of its existence, the bond which ties it together: but that legality—that tendency to impose a settled customary yoke upon all men and all actions—if it goes on, kills out the variability implanted by nature, and makes different men and different ages facsimiles of other men and other ages, as we see them so often. Progress is only possible in those happy cases where the force of legality has gone far enough to bind the nation together, but not far enough to kill out all varieties and destroy nature's perpetual tendency to change." The point of the solution is not the invention of an imaginary agency, but an assignment of comparative magnitude to two known agencies.

III.

This advantage is one of the greatest in early civilization—one of the facts which give a decisive turn to the battle of nations; but there are many others. A little perfection in *political institutions* may do it. Travellers have noticed that among savage tribes those seemed to answer best in which the monarchical power was most predominant, and those worst in which the "rule of many" was in its vigor. So long as war is the main business of nations, temporary despotism—despotism during the campaign—is indispensable. Macaulay justly said that many an army has prospered under a bad commander, but no army has ever prospered under a "debating society;" that many-headed monster is then fatal. Despotism grows in the first societies, just as democracy grows in more modern societies; it is the government answering the primary need, and congenial to the whole spirit of the time. But despotism is unfavorable to the principle of variability, as all history shows. It tends to keep men in the customary stage of civilization: its very fitness for that age unfits it for the next. It prevents men from passing into the first age of progress—the very slow and very gradually improving age. Some "standing system" of semi-free discussion is as necessary to break the thick crust of custom and begin progress as it is in later ages to carry on progress when begun; probably it is even more necessary. And in the most progressive races we find it. I have spoken already of the Jewish prophets, the life of that nation, and the principle of all its growth. But a still more progressive race—that by which secular civilization was once created, by which it is now mainly administered—had a still better instrument of progression. "In the very earliest glimp-

ses, says Mr. Freeman, "of Teutonic political life, we find the monarchic, the aristocratic, and the democratic elements already clearly marked. There are leaders with or without the royal title; there are men of noble birth, whose noble birth (in whatever the original nobility may have consisted) entitles them to a pre-eminence in every way; but beyond these there is a free and armed people, in whom it is clear that the ultimate sovereignty resides. Small matters are decided by the chiefs alone; great matters are submitted by the chiefs to the assembled nation. Such a system is far more than Teutonic; it is a common Aryan possession; it is the constitution of the Homeric Achaians on earth and of the Homeric gods on Olympus." Perhaps, and indeed probably, this constitution may be that of the primitive tribe which Romans left to go one way, and Greeks to go another, and Teutons to go a third. The tribe took it with them, as the English take the common law with them, because it was the one kind of polity which they could conceive and act upon; or it may be that the emigrants from the primitive Aryan stock only took with them a good aptitude—an excellent political nature, which similar circumstances in distant countries were afterward to develop into like forms. But anyhow it is impossible not to trace the supremacy of Teutons, Greeks, and Romans in part to their common form of government. The contests of the assembly cherished the principle of change; the influence of the elders insured sedateness and preserved the mould of thought; and, in the best cases, military discipline was not impaired by freedom, though military intelligence was enhanced with the general intelligence. A Roman army was a free body, at its own choice governed by a peremptory despotism.

The *mixture of races* was often an advantage, too. Much as the old world believed in pure blood, it had very little of it. Most historic nations conquered pre-historic nations, and though they massacred many, they did not massacre all. They enslaved the subject men, and they married the subject women. No doubt the whole bond of early society was the bond of descent; no doubt it was essential to the notions of a new nation that it should have had common ancestors; the modern idea that vicinity of habitation is the natural cement of civil union would have been repelled as an impiety if it could have been conceived as an idea. But by one of those legal fictions which Sir Henry Maine describes so well, primitive nations contrived to do what they found convenient, as well as to adhere to what they fancied to be right. When they did not beget they *adopted*; they solemnly made believe that new persons were descended from the old stock, though everybody knew that in flesh and blood they were not. They made an artificial unity in default of a real unity; and what it is not easy to understand now, the sacred sentiment requiring unity of race was somehow satisfied; whe

made did as well as what was born.
ions with these sort of maxims are not
ly to have unity of race in the modern
se, and as a physiologist understands it.
at sorts of unions improve the breed, and
ch are worse than both the father-race
the mother, it is not very easy to say
subject was reviewed by M. Quatrefages
n elaborate report upon the occasion of
French Exhibition, of all things in the
ld. M. Quatrefages quotes from another
ter the phrase that South America is a
t laboratory of experiments in the mix-
of races, and reviews the different re-
s which different cases have shown. In
th Carolina the Mulatto race is not very
lific, whereas in Louisiana and Florida
ecidedly is so. In Jamaica and in Java
Mulatto cannot reproduce itself after the
d generation; but on the continent of
erica, as everybody knows, the mixed race
ow most numerous, and spreads genera-
after generation without impediment.
ially various likewise in various cases
been the fate of the mixed race between
white man and the native American;
etimes it prospers, sometimes it fails.
d M. Quatrefages concludes his descrip-
thus: 'En acceptant comme vraies
tes les observations qui tendent à faire
nettre qu'il en sera autrement dans les
lités dont j'ai parlé plus haut, quelle est
onclusion à tirer de faits aussi peu sem-
bles? Evidemment, on est obligé de re-
naitre que le développement de la race
lâtre est favorisé, retardé, ou empêché
des circonstances locales; en d'autres
nes, qu'il dépend des influences exercées
l'ensemble des conditions d'existence,
le *milieu*.' By which I understand him
nean that the mixture of race sometimes
ags out a form of character better suited
n either parent form to the place and
e; that in such cases, by a kind of nat-
l selection, it dominates over both parents
l perhaps supplants both, whereas in
er cases the mixed race is not as good
n and there as other parent forms, and
n it passes away soon and of itself.
Early in history the continual mixtures by
quest were just so many experiments in
king races as are going on in South
erica now. New races wandered into
e districts, and half killed, half mixed
h the old races. And the result was
btless as various and as difficult to ac-
nt for then as now; sometimes the cross
answered, sometimes it failed. But
en the mixture was at its best, it must
e excelled both parents in that of which
much has been said—that is, variability,
l consequently progressiveness. There is
re life in mixed races. France for in-
ce, is justly said to be the mean between
en the Latin and the German races. A
rman, as you may see by looking at him,
f the north; a Provençal is of the south,
ll that there is most southern. You have
France Latin, Celtic, German, compound-
in an infinite number of proportions one

as she is in feeling, she is various not only in
the past history of her various provinces, but
in their present temperaments. Like the
Irish element and the Scotch element in the
English House of Commons, the variety of
French races contributes to the play of the
polity; it gives a chance for fitting new
things which otherwise there would not be.
And early races must have wanted mixing
more than modern races. It is said, in
answer to the Jewish boast that "their race
still prospers, though it is scattered and
breeds in-and-in," "You prosper *because*
you are so scattered; by acclimatization in
various regions your nation has acquired sin-
gular elements of variety; it contains within
itself the principle of variability which other
nations must seek by intermarriage." In
the beginning of things there was certainly
no cosmopolitan race like the Jews; each
race was a sort of "parish race," narrow in
thought and bounded in range, and it want-
ed mixing accordingly.
But the mixture of races has a singular
danger as well as a singular advantage in the
early world. We know now the Anglo-Indian
suspicion or contempt for "half-castes."
The union of the Englishman and the Hin-
doo produces something not only between
races, but *between moralities*. They have no
inherited creed or plain place in the world;
they have none of the fixed traditional senti-
ments which are the stays of human nature.
In the early world many mixtures must have
wrought many ruins; they must have de-
stroyed what they could not replace—an in-
bred principle of discipline and of order.
But if these unions of races did not work
thus; if, for example, the two races were so
near akin that their morals united as well as
their breeds, if one race by its great numbers
and prepotent organization so presided over
the other as to take it up and assimilate it,
and leave no separate remains of it, *then* the
admixture was invaluable. It added to the
probability of variability, and therefore of
improvement; and if that improvement even
in part took the military line, it might give
the mixed and ameliorated state a steady ad-
vantage in the battle of nations, and a greater
chance of lasting in the world.
Another mode in which one state acquires
a superiority over competing states is by
provisional institutions, if I may so call them.
The most important of these—slavery—arises
out of the same early conquest as the mixture
of races. A slave is an unassimilated, an
undigested atom; something which is in the
body politic, but yet is hardly part of it.
Slavery, too, has a bad name in the later
world, and very justly. We connect it
with gangs in chains, with laws which keep
men ignorant, with laws that hinder families.
But the evils which we have endured from
slavery in recent ages must not blind us to,
or make us forget, the great services that
slavery rendered in early ages. There is a
wonderful presumption in its favor; it is one
of the institutions which, at a certain stage
of growth, all nations in all countries choose

and cleave to. "Slavery," says Aristotle, "exists by the law of nature," meaning that it was everywhere to be found—was a rudimentary universal point of polity. "There are very many English colonies," said Edward Gibbon Wakefield, as late as 1848, "who would keep slaves at once if we would let them," and he was speaking not only of old colonies trained in slavery, and raised upon the products of it, but likewise of new colonies started by freemen, and which ought, one would think, to wish to contain freemen only. But Wakefield knew what he was saying ; he was a careful observer of rough societies, and he had watched the minds of men in them. He had seen that *leisure* is the great need of early societies, and slaves only can give men leisure. All freemen in new countries must be pretty equal ; every one has labor, and every one has land ; capital, at least in agricultural countries (for pastoral countries are very different), is of little use ; it cannot hire labor ; the laborers go and work for themselves. There is a story often told of a great English capitalist who went out to Australia with a shipload of laborers and a carriage ; his plan was that the laborers should build a house for him, and that he would keep his carriage, just as in England. But (so the story goes) he had to try to live in his carriage, for his laborers left him, and went away to work for themselves.

In such countries there can be few gentlemen and no ladies. Refinement is only possible when leisure is possible ; and slavery first makes it possible. It creates a set of persons born to work that others may not work, and not to think in order that others may think. The sort of originality which slavery gives is of the first practical advantage in early communities ; and the repose it gives is a great artistic advantage when they come to be described in history. The patriarchs Abraham, Isaac, and Jacob could not have had the steady calm which marks them if they had themselves been teased and hurried about their flocks and herds. Refinement of feeling and repose of appearance have indeed no market value in the early bidding of nations ; they do not tend to secure themselves a long future or any future. But originality in war does, and slave-owning nations, having time to think, are likely to be more shrewd in policy and more crafty in strategy.

No doubt this momentary gain is bought at a ruinous after-cost. When other sources of leisure become possible, the one use of slavery is past. But all its evils remain, and even grow worse. "Retail" slavery—the slavery in which a master owns a few slaves, whom he well knows and daily sees—is not at all an intolerable state ; the slaves of Abraham had no doubt a fair life, as things went in that day. But wholesale slavery, where men are but one of the investments of large capital, and where a great owner, so far from knowing each slave, can hardly tell how many gangs of them he works, is an abominable state. This is the slavery whi has made the name revolting to the be minds, and has nearly rooted the thing o of the best of the world. There is no o of-the-way marvel in this. The whole h tory of civilization is strewn with creeds a institutions which were invaluable at fir and deadly afterward. Progress would n have been the rarity it is if the early fo had not been the late poison. A full exa ination of these provisional institutions wou need half a volume, and would be out place and useless here. Venerable o garchy, august monarchy, are two th would alone need large chapters. But t sole point here necessary is to say that su preliminary forms and feelings at first oft bring many graces and many refinement and often tend to secure them by the preser ative military virtue.

There are cases in which some step in i *tellectual* progress gives an early society son gain in war ; more obvious cases are wh some kind of *moral* quality gives some su gain. War both needs and generates certa virtues ; not the highest, but what may called the preliminary virtues, as valor, v racity, the spirit of obedience, the habit discipline. Any of these, and of others li them, when possessed by a nation, and matter how generated, will give them a mi tary advantage, and make them more like to *stay* in the race of nations. The Roma probably had as much of these efficacio virtues as any race of the ancient world perhaps as much as any race in the mode world too. And the success of the natio which possess these martial virtues has be the great means by which their continuan has been secured in the world, and the d struction of the opposite vices insured als Conquest is the missionary of valor, and tl hard impact of military virtues beats mea ness out of the world.

In the last century it would have sounde strange to speak, as I am going to speak, the military advantage of *religion*. Such idea would have been opposed to rulin prejudices, and would hardly have escape philosophical ridicule. But the notion is b a commonplace in our day, for a man genius has made it his own. Mr. Carlyle books are deformed by phrases like "infin ties" and "verities," and altogether are fu of faults, which attract the very young, an deter all that are older. In spite of his gre genius, after a long life of writing, it is question still whether even a single work his can take a lasting place in high liter ture. There is a want of sanity in the manner which throws a suspicion on the substance (though it is often profound) ; an he brandishes one or two fallacies, of whic he has himself a high notion, but whic plain people will always detect and derid But whatever may be the fate of his fam Mr. Carlyle has taught the present gener tion many lessons, and one of these is th "God-fearing" armies are the best armi Before his time people laughed at Cromwe

ing. "Trust in God, and keep your pow-
dry." But we now know that the trust
 of as much use as the powder, if not of
re. That high concentration of steady
ing makes men dare everything and do
thing.

his subject would run to an infinite ex-
t if any one were competent to handle it.
se kinds of morals and that kind of re-
on which tend to make the firmest and
st effectual character are sure to prevail,
else being the same ; and creeds or sys-
s that conduce to a soft limp mind tend
erish, except some hard extrinsic force
p them alive. Thus Epicureanism never
spered at Rome, but Stoicism did ; the
t, serious character of the great prevailing
ion was attracted by what seemed a con-
ning creed, and deterred by what looked
 a relaxing creed. The inspiriting doc-
es fell upon the ardent character, and so
firmed its energy. Strong beliefs win
ng men, and then make them stronger.
h is no doubt one cause why Monotheism
ds to prevail over Polytheism ; it produces
higher, steadier character, calmed and
centrated by a great single object ; it is
confused by competing rites, or distract-
by miscellaneous deities. Polytheism is
gion *in commission*, and it is weak accord-
ly. But it will be said the Jews, who
re monotheist, were conquered by the
mans, who were polytheist. Yes, it must
answered, because the Romans had other
s ; they had a capacity for politics, a
it of discipline, and of these the Jews
l not the least. The religious advantage
 an advantage, but it was counter-
ghed.

o one should be surprised at the promi-
ice given to war. We are dealing with
ly ages ; nation-*making* is the occupation
man in these ages, and it is war that
kes nations. Nation-*changing* comes
rward, and is mostly effected by peace-
revolution, though even then war, too,
ys its part. The idea of an indestructible
ion is a modern idea ; in early ages all
ions were destructible, and the farther we
back the more incessant was the work of
truction. The internal decoration of na-
s is a sort of secondary process, which
ceeds when the main forces that create
ions have principally done their work.
have here been concerned with the poli-
l scaffolding ; it will be the task of other
ers to trace the process of political fin-
ng and building. The nicer play of finer
es may then require more pleasing
ughts than the fierce fights of early ages
ever suggest. It belongs to the idea of
gress that beginnings can never seem at-
tive to those who live far on ; the price
mprovement is, that the unimproved will
ays look degraded.

ut how far are the strongest nations
ly the best nations ? how far is excellence
war a criterion of other excellence ? I
not answer this now fully, but three or
 considerations are very plain. War, as

I have said, nourishes the "preliminary
virtues, and this is almost as much as to sa
that there are virtues which it does n
nourish. All which may be called " grace
as well as virtue it does not nourish ; h
lty, charity, a nice sense of the rights
others, it certainly does not foster. The
sensibility to human suffering, which is
striking a fact in the world as it stood wh
history first reveals it, is doubtless due
the warlike origin of the old civilizatio
Bred in war and nursed in war, it could n
revolt from the things of war, and one of tl
principal of these is human pain. Since w
has ceased to be the moving force in tl
world, men have become more tender one
another, and shrink from what they used
inflict without caring ; and this not so mu
because men are improved (which may
may not be in various cases), but becau
they have no longer the daily habit of war
have no longer formed their notions u
war, and therefore are guided by thoug
and feelings which soldiers as such—sold
educated simply by their trade—are too
to understand.

Very like this is the contempt for physic
weakness and for women which marks ea l
society too. The non-combatant populatio
is sure to fare ill during the ages of comba
But these defects, too, are cured or lessened
women have now marvellous means of wir
ning their way in the world ; and min
without muscle has far greater force tha
muscle without mind. These are some
the after-changes in the interior of nation
of which the causes must be scrutinized, an
I now mention them only to bring out ho
many softer growths have now half-hidde
the old and harsh civilization which w
made.

But it is very dubious whether the spiri
of war does not still color our morality fa
too much. Metaphors from law and meta-
phors from war make most of our current
moral phrases, and a nice examination would
easily explain that both rather vitiate what
both often illustrate. The military habit
makes man think far too much of definite
action, and far too little of brooding medita-
tion. Life is not a set campaign, but an ir-
regular work, and the main forces in it are
not overt resolutions, but latent and half-
involuntary promptings. The mistake of
military ethics is to exaggerate the concep-
tion of discipline, and so to present the
moral force of the will in a barer form than
it ever ought to take. Military morals can
direct the axe to cut down the tree, but it
knows nothing of the quiet force by which
the forest grows.

What has been said is enough, I hope, to
bring out that there are many qualities and
many institutions of the most various sort
which give nations an advantage in military
competition ; that most of these and most
warlike qualities tend principally to good
that the constant winning of these favored
competitors is the particular mode by which
the best qualities wanted in elementary civ-

lliation are propagated and preserved.

III. NATION-MAKING.

In the last essay I endeavored to show that in the early age of man—the "fighting age" I called it—there was a considerable, though not certain, tendency toward progress. The best nations conquered the worst, by the possession of one advantage or another, the best competitor overcame the inferior competitor. So long as there was continual fighting there was a likelihood of improvement in martial virtues, and in early times many virtues are really "martial"—that is, tend to success in war—which in later times we do not think of so calling, because the original usefulness is hid by their later usefulness. We judge of them by the present effects, not by their first. The love of law, for example, is a virtue which no one now would call martial, yet in early times it disciplined nations, and the disciplined nations won. The gift of "conservative innovation"—the gift of *matching* new institutions to old—is not nowadays a warlike virtue, yet the Romans owed much of their success to it. Alone among ancient nations they had the deference to usage which combines nations, and the partial permission of selected change which improves nations; and therefore they succeeded. Just so in most cases, all through the earliest times, martial merit is a token of real merit: the nation that wins is the nation that ought to win. The simple virtues of such ages mostly make a man a soldier if they make him anything. No doubt the brute force of number may be too potent even then (as so often it is afterward): civilization may be thrown back by the conquest of many very rude men over a few less rude men. But the first elements of civilization are great military advantages, and, roughly, it is a rule of the first times that you can infer merit from conquest, and that progress is promoted by the competitive examination of constant war.

This principle explains at once why the "protected" regions of the world—the interior of continents like Africa, outlying islands like Australia or New Zealand—are of necessity backward. They are still in the preparatory school; they have not been taken on class by class, as No. II., being a little better, routed and effaced No. I.; and as No. III., being a little better still, routed and effaced No. II. And it explains why Western Europe was early in advance of other countries, because there the contest of races was exceedingly severe. Unlike most regions it was a tempting part of the world, and yet not a corrupting part; those who did not possess it wanted it, and those who had it, not being enervated, could struggle hard to keep it. The conflict of nations is at first a main force in the improvement of nations.

But what are nations? What are these groups which are so familiar to us, and yet, if we stop to think, so strange; which are as old as history; which Herodotus found in almost as great numbers and with quite marked distinctions as we see them now? What breaks the human race up into fragments so unlike one another, and yet each its interior so monotonous? The question most puzzling, though the fact is so familiar and I would not venture to say that I can answer it completely, though I can advance some considerations which, as it seems to me, go a certain way toward answering it. Perhaps these same considerations throw some light, too, on the further and still more interesting question why some few nations progress, and why the greater part do not.

Of course at first all such distinctions of nation and nation were explained by original diversity of race. They are dissimilar, it was said, because they were created dissimilar. But in most cases this easy supposition will not do its work. You cannot (consistently with plain facts) imagine enough original races to make it tenable. Some half dozen or more great families of men may or may not have been descended from separate first stocks, but sub-varieties have certainly not so descended. You may argue, rightly or wrongly, that all Aryan nations are of a single or peculiar origin, just as it was long believed that all Greek-speaking nations were of one such stock. But you will not be listened to if you say that there were one Adam and Eve for Sparta, and another Adam and Eve for Athens. All Greeks are evidently of one origin, but within the limits of the Greek family, as of all other families, there is some contrast-making force which causes city to be unlike city, and tribe unlike tribe.

Certainly, too, nations did not originate by simple natural selection, as wild varieties of animals (I do not speak now of species) no doubt arise in nature. Natural selection means the preservation of those individuals which struggle best with the forces that oppose their race. But you could not show that the natural obstacles opposing human life much differed between Sparta and Athens, or indeed between Rome and Athens; and yet Spartans, Athenians, and Romans differ essentially. Old writers fancied (and it was a very natural idea) that the direct effect of climate, or rather of land, sea, and air, and the sum total of physical conditions varied man from man, and changed race to race. But experience refutes this. The English immigrant lives in the same climate as the Australian or Tasmanian, but he has not become like the races; nor will a thousand years, in most respects, make him like them. The Papuan and the Malay, as Mr Wallace finds, live now, and have lived for ages, side by side in the same tropical regions, with every sort of diversity. Even in animals his researches show, as by an object-lesson, that the direct efficacy of physical conditions is overrated. "Borneo," he says, "closely resembles New Guinea, not only in its vast size and freedom from volcanoes, but in its varied geological structure, its uniformity of c

e, and the general aspect of the forest
etation that clothes its surface. The
uccas are the counterpart of the Philip-
es in their volcanic structure, their ex-
ne fertility, their luxuriant forests, and
r frequent earthquakes ; and Bali, with
east end of Java, has a climate almost as
. as that of Timor. Yet between these
esponding groups of islands, construct-
as it were, after the same pattern, sub-
ed to the same climate, and bathed by
same oceans, there exists the greatest
ible contrast, when we compare their
nal productions. Nowhere does the an-
t doctrine—that differences or similari-
in the various forms of life that inhabit
erent countries are due to corresponding
sical differences or similarities in the
ntries themselves—meet with so direct
palpable a contradiction. Borneo and
v Guinea, as alike physically as two dis-
t countries can be, are zoologically as
e as the poles asunder ; while Australia,
a its dry winds, its open plains, 'ts stony
rts, and its temperate climate, yet pro-
es birds and quadrupeds which are close-
elated to those inhabiting the hot, damp,
ariant forests which everywhere clothe
plains and mountains of New Guinea."
t is, we have like living things in the
t dissimilar situations, and unlike living
gs in the most similar ones. And though
e of Mr. Wallace's speculations on eth-
gy may be doubtful, no one doubts that
he archipelago he has studied so well, as
n elsewhere in the world, though rarely
a such marked emphasis, we find like
t in contrasted places, and unlike men in
mbling places. Climate is clearly not
force which makes nations, for it does
always make them, and they are often
le without it

he problem of " nation-making"—that
he explanation of the origin of nations
h as we now see them, and such as in
orical times they have always been—can-
as it seems to me, be solved without
arating it into two : one, the making of
adly-marked races, such as the negro, or
red man, or the European ; and the
nd, that of making the minor distinc
s, such as the distinction between Spar-
and Athenian. or between Scotchman
Englishman. Nations, as we see them,
(if my arguments prove true) the produce
wo great forces : one the race-making
e which, whatever it was, acted in antiq-
, and has now wo dly, or almost, given
r acting ; and the other the nation-mak-
force, properly so called, which is acting
r as much as it ever acted, and creating
auch as it ever created.

he strongest light on the great causes
ch have formed and are forming nations
hrown by the smaller causes which are
ring nations. The way in which nations
nge, generation after generation, is ex-
lingly curious, and the change occasion-
happens when it is very hard to account
Something seems to steal over society,

say of the Regency time as compared with
that of the present queen. If we read of
life at Windsor (at the cottage now pulled
down), or of Bond Street as it was in the
days of the Loungers (an extinct race), or of
St. James's Streetas it was when Mr. Fox and
his party tried to make " political capital "
out of the dissipation of an heir-apparent,
we seem to be reading not of the places we
know so well, but of very distant and unlike
localities. Or let any one think how little is
the external change in England between the
age of Elizabeth and the age of Anne com-
pared with the national change. How few
were the alterations in physical condition,
how few (if any) the scientific inventions
affecting human life which the later period
possessed, but the earlier did not ! How
hard it is to say what has caused the change
in the people ! And yet how total is the
contrast, at least at first sight ! In passing
from Bacon to Addison, from Shakespeare
to Pope, we seem to pass into a new world.

In the first of these essays I spoke of the
mode in which the literary change happens,
and I recur to it because, literature being
narrower and more definite than life, a
change in the less serves as a model and il-
lustration of the change in the greater.
Some writer, as was explained, not neces-
sarily a very excellent writer or a remem-
bered one, hit on something which suited the
public taste : he went on writing, and others
imitated him, and they so accustomed their
readers to that style that they would bear
nothing else. Those readers who did not
like it were driven to the works of other
ages and other countries—had to despise the
" trash of the day," as they would call it.
The age of Anne patronized Steele, the be-
ginner of the essay, and Addison its perfect-
er, and it neglected writings in a wholly
discordant key. I have heard that the found-
er of the Times was asked how all the arti-
cles in the Times came to seem to be written
by one man, and that he replied, " Oh,
there is always some one best contributor,
and all the rest copy." And this is doubt-
less the true account of the manner in which
a certain trade mark, a curious and indefina-
ble unity, settles on every newspaper. Per-
haps it would be possible to name the men
who a few years since created the Saturday
Review style, now imitated by another and a
younger race. But when the style of a
periodical is once formed, the continuance of
it is preserved by a much more despotic im-
pulse than the tendency to imitation—by
the self-interest of the editor, who acts as
trustee, if I may say so, for the subscribers.
The regular buyers of a periodical want to
read what they have been used to read—the
same sort of thought, the same sort of
words. The editor sees that they get that
sort. He selects the suitable, the conform-
ing articles, and he rejects the non-conform-
ing. What the editor does in the case of a
periodical, the readers do in the case of liter-
ature in general. They patronize one thing
and reject the rest.

Of course there was always some reason (if we only could find it) which gave the prominence in each age to some particular winning literature. There always is some reason why the fashion of female dress is what it is. But just as in the case of dress we know that nowadays the determining cause is very much of an accident, so in the case of literary fashion the origin is a good deal of an accident. What the milliners of Paris, or the *demi-monde* of Paris, enjoin our English ladies, is (I suppose) a good deal chance; but as soon as it is decreed, those whom it suits and those whom it does not all wear it. The imitative propensity at once insures uniformity; and "that horrid thing we wore last year" (as the phrase may go) is soon nowhere to be seen. Just so a literary fashion spreads, though I am far from saying with equal primitive unreasonableness —a literary taste always begins on some decent reason, but once started it is propagated as a fashion in dress is propagated; even those who do not like it read it because it is there, and because nothing else is easily to be found.

The same patronage of favored forms and persecution of disliked forms are the main causes too, I believe, which change national character. Some one attractive type catches the eye, so to speak, of the nation, or a part of the nation, as servants catch the gait of their masters, or as mobile girls come home speaking the special words and acting the little gestures of each family whom they may have been visiting. I do not know if many of my readers happen to have read Father Newman's celebrated sermon, "Personal Influence the Means of Propagating the Truth;" if not, I strongly recommend them to do so. They will there see the opinion of a great practical leader of men, of one who has led very many where they little thought of going, as to the mode in which they are to be led; and what he says, put shortly and simply, and taken out of his delicate language, is but this—that men are guided by *type*, not by argument; that some winning instance must be set up before them, or the sermon will be vain, and the doctrine will not spread. I do not want to illustrate this matter from religious history, for I should be led far from my purpose, and after all I can but teach the commonplace that it is the life of teachers which is *catching*, not their tenets. And again, in political matters, how quickly a leading statesman can change the tone of the community! We are most of us earnest with Mr. Gladstone; we were most of us *not* so earnest in the time of Lord Palmerston. The change is what every one feels, though no one can define it. Each predominant mind calls out a corresponding sentiment in the country: most feel it a little. Those who feel it much express it much; those who feel it excessively express it excessively; those who dissent are silent, or unheard.

After such great matters as religion and politics, it may seem trifling to illustrate the subject from little boys. But it is not trifling. The bane of philosophy is pomposity: people will not see that small things are the miniatures of greater, and it seems a loss of abstract dignity to freshen their minds by object-lessons from what they know. But every boarding-school changes as a nation changes. Most of us may remember thinking, "How odd it is that this 'half' should be so unlike last 'half:'" now we never go out of bounds, last half we were always going: now we play rounders, then we played prisoner's base;" and so through all the easy life of that time. In fact, some ruling spirits, some one or two ascendant boys, had left, one or two others had come; and so all was changed. The models were changed, and the copies changed; a different thing was praised, and a different thing bullied. A curious case of the same tendency was noticed to me only lately. A friend of mine—a Liberal Conservative—addressed a meeting of working-men at Leeds, and was much pleased at finding his characteristic, and perhaps refined points both apprehended and applauded. "But then," as he narrated, "up rose a blatant Radical who said the very opposite things, and the working-men cheered him too, and quite equally." He was puzzled to account for so rapid a change. But the mass of the meeting was no doubt nearly neutral, and, if set going, quite ready to applaud any good words without much thinking. The ringleaders changed. The radical tailor started the radical cheer; the more moderate shoemaker started the moderate cheer; and the great bulk followed suit. Only a few in each case were silent, and an absolute contrast was in ten minutes presented by the same elements.

The truth is that the propensity of man to imitate what is before him is one of the strongest parts of his nature. And one sign of it is the great pain which we feel when our imitation has been unsuccessful. There is a cynical doctrine that most men would rather be accused of wickedness than of *gaucherie*. And this is but another way of saying that the bad copying of predominant manners is felt to be more of a disgrace than common consideration would account for its being, since *gaucherie* in all but extravagant cases is not an offence against religion or morals, but is simply bad imitation.

We must not think that this imitation is voluntary, or even conscious. On the contrary, it has its seat mainly in very obscure parts of the mind, whose notions, so far from having been consciously produced, are hardly felt to exist; so far from being conceived beforehand, are not even felt at the time. The main seat of the imitative part of our nature is our belief, and the causes predisposing us to believe this, or disinclining us to believe that, are among the obscurest parts of our nature. But as to the imitative nature of credulity there can be no doubt. In "Eothen" there is a capital description of how every sort of European resident

: East, even the shrewd merchant and he post captain," with his bright, wake- eyes of commerce, comes soon to believe witchcraft, and to assure you, in confi- ice, that there " really is something in ' He has never seen anything convinc- 'himself, but he has seen those who have n those who have seen those who have n. In fact, he has lived in an atmosphere infectious belief, and he has inhaled it, ircely any one can help yielding to the rent infatuations of his sect or party. r a short time—say some fortnight—he is olute ; he argues and objects ; but, day day, the poison thrives and reason nes. What he hears from his friends, at he reads in the party organ, produces effect. The plain, palpable conclusion ich every one around him believes has an uence yet greater and more subtle ; that iclusion seems so solid and unmistakable ; own good arguments get daily more and re like a dream. Soon the gravest sage res the folly of the party with which he s and the sect with which he worships.

n true metaphysics I believe that, con- ry to common opinion, unbelief far ener needs a reason and requires an effort n belief. Naturally, and if man were de according to the pattern of the logi- ns, he would say, " When I see a valid ument I will believe, and till I see such ument I will not believe." But, in fact, ry idea vividly before us soon appears to to be true, unless we keep up our percep- is of the arguments which prove it un- e, and voluntarily enforce our minds to re- mber its falsehood. " All clear ideas are e," was for ages a philosophical maxim, l though no maxim can be more unsound, ie can be more exactly conformable to or- ary human nature. The child resolutely epts every idea which passes through its in as true ; it has no distinct conception in idea which is strong, bright, and per- nent, but which is false too. The mere sentation of an idea, unless we are care- about it, or unless there is within some isual resistance, makes us believe it , and i is why the belief of others adds to our ef so quickly, for no ideas seem so very ir as those inculcated on us from every .

he grave part of mankind are quite as le to these imitated beliefs as the frivo- s part. The belief of the money-market, ich is mainly composed of grave people s imitative as any belief. You will find day every one enterprising, enthusiastic, prous, eager to buy, and eager to order ; i week or s o you will find almost the whole iety depressed, anxious, and wanting to . If you examine the reasons for the ivity, or for the inactivity, or for the nge, you will hardly be able to trace them ull, and as far as you can trace them they of little force. In fact, these opinions re not formed by reason, but by mimicry. nothing happened that looked a little d, on which eager sanguine men talked

loudly, and common people caught their tone. A little while afterward, and when people were tired of talking this, something also happened looking a little bad, on which the dismal, anxious people began, and all the rest followed their words. And in both cases an avowed dissentient is set down as "crotchety." "If you want," said Swift, "to gain the reputation of a sensible man you should be of the opinion of the person with whom for the time being you are con- versing." There is much quiet intellectual persecution among "reasonable" men ; a cautious person hesitates before he tells them anything new, for if he gets a name for such things he will be called "flighty," and in times of decision he will not be attended to.

In this way the infection of imitation catches men in their most inward and intel- lectual part—their creed. But it also in- vades men—by the most bodily part of the mind—so to speak—the link between soul and body—the manner. No one needs to have this explained ; we all know how a kind of subtle influence makes us imitate or try to imitate the manner of those around us. To conform to the fashion of Rome—whatever the fashion may be, and whatever Rome we may for the time be at—is among the most obvious needs of human nature. But what is not so obvious, though as certain, is that the influence of the imitation goes deep as well as extends wide. "The matter," as Wordsworth says, "of style very much comes out of the manner." If you will en- deavor to write an imitation of the thoughts of Swift in a copy of the style of Addison, you will find that not only is it hard to write Addison's style, from its intrinsic excellence, but also that the more you approach to it the more you lose the thought of Swift. The eager passion of the meaning beats upon the mild drapery of the words. So you could not express the plain thoughts of an Eng- lishman in the grand manner of a Spaniard. Insensibly, and as by a sort of magic, the kind of manner which a man catches eats into him, and makes him in the end what at first he only seems.

This is the principal mode in which the greatest minds of an age produce their effect. They set the tone which others take, and the fashion which others use. There is an odd idea that those who take what is called a "scientific view" of history need rate light ly the influence of individual character. It would be as reasonable to say that those who take a scientific view of nature need think little of the influence of the sun. On the scientific view a great man is a great new cause (compounded or not out of other causes), for I do not here, or elsewhere in these papers, raise the question of free-will), but, anyhow, new in all its effects and all its results. Great models for good and evil sometimes appear among men, who follow them either to improvement or degradation. I am, I know, very long and tedious in setting out this ; but I want to bring home to others what every new observation of society

brings more and more freshly to myself—that this unconscious imitation and encouragement of appreciated character, and this equally unconscious shrinking from and persecution of disliked character, is the main force which moulds and fashions men in society as we now see it. Soon I shall try to show that the more acknowledged causes, such as change of climate, alteration of political institutions, progress of science, act principally through this cause; that they change the object of imitation and the object of avoidance, and so work their effect. But first I must speak of the origin of nations—of nation-making as one may call it—the proper subject of this paper.

The process of nation-making is one of which we have obvious examples in the most recent times, and which is going on now. The most simple example is the foundation of the first State of America, say New England, which has such a marked and such a deep national character. A great number of persons agreeing in fundamental disposition, agreeing in religion, agreeing in politics, form a separate settlement; they exaggerate their own disposition, teach their own creed, set up their favorite government; they discourage all other dispositions, persecute other beliefs, forbid other forms or habits of government. Of course a nation so made will have a separate stamp and mark. The original settlers began of one .ype; they sedulously imitated it; and (though other causes have intervened and disturbed it) the necessary operation of the principles of inheritance has transmitted many original traits still unaltered, and has left an entire New England character—in no respect unaffected by its first character.

This case is well known, but it is not so that the same process, in a weaker shape, is going on in America now. Congeniality of sentiment is a reason of selection, and a bond of cohesion in the "West" at present. Competent observers say that townships grow up there by each place taking its own religion, its own manners, and its own ways. Those who have these morals and that religion go to that place, and stay there; and those who have not these morals and that religion either settle elsewhere at first, or soon pass on. The days of colonization by sudden "swarms" of like creed is almost over, but a less visible process of attraction by similar faith over similar is still in vigor, and very likely to continue.

And in cases where this principle does not operate, all new settlements, being formed of "emigrants," are sure to be composed of rather restless people mainly. The stay-at-home people are not to be found there, and these are the quiet, easy people. A new settlement voluntarily formed (for of old times, when people were expelled by terror, I am not speaking) is sure to have in it much more than the ordinary proportion of active men, and much less than the ordinary proportion of inactive; and this accounts for a large part, though not perhaps all, of the difference be-

tween the English in England and the E[ng]lish in Australia.

The causes which formed New Engl[and] in recent times cannot be conceived as act[ing] much upon mankind in their infancy. [So]ciety is not then formed upon a "volunt[ary] system," but upon an involuntary. A [man] in early ages is born to a certain obedien[ce] and cannot extricate himself from an inherited government. Society then is ma[de] up, not of individuals, but of families; cre[eds] then descend by inheritance in those fa[mi]lies. Lord Melbourne once incurred the ri[di]cule of philosophers by saying he should [ad]here to the English Church because it was the religion of his fathers. The philosophers, course, said that a man's fathers' believ[ing] anything was no reason for his believing unless it was true. But Lord Melbou[rne] was only uttering out of season, and i[n] modern time, one of the most firm and [ac]cepted maxims of old times. A secess[ion] on religious grounds of isolated Romans sail beyond sea would have seemed to ancient Romans an impossibility. In [a] ruder ages the religion of savages is a th[ing] too feeble to create a schism or to foun[d a] community. We are dealing with peo[ple] capable of history when we speak of g[reat] ideas, not with pre-historic flint-men or present savages. But though under v[ery] different forms, the same essential cause the imitation of preferred characters and elimination of detested characters—were [at] work in the oldest times, and are at wo[rk] among rude men now. Strong as the propensity to imitation is among civilized m[en] we must conceive it as an impulse of wh[ich] their minds have been partially denud[ed.] Like the far-seeing sight, the infallible he[ar]ing, the magical scent of the savage, it [is a] half-lost power. It was strongest in anci[ent] times, and is strongest in uncivilized regio[ns.]

This extreme propensity to imitation [is] one great reason of the amazing samen[ess] which every observer notices in savage [na]tions. When you have seen one Fuegi[an] you have seen all Fuegians—one Tasman[ian] all Tasmanians. The higher savages, as New Zealanders, are less uniform; they h[ave] more of the varied and compact structure [of] civilized nations, because in other respe[cts] they are more civilized. They have grea[ter] mental capacity—larger stores of inw[ard] thought. But much of the same monoton[ous] nature clings to them too. A savage t[ribe] resembles a herd of gregarious beasts; wh[ere] the leader goes they go too; they c[opy] blindly his habits, and thus soon becom[e] that which he already is. For not only [the] tendency, but also the power to imitat[e is] stronger in savages than civilized m[en.] Savages copy quicker, and they copy bet[ter.] Children, in the same way, are born mimi[cs;] they cannot help imitating what comes [be]fore them. There is nothing in their mi[nds] to resist the propensity to copy. Every [ed]ucated man has a large inward supply [of] ideas to which he can retire, and in wh[ich] he can escape from or alleviate unple[asant]

ard objects. But a savage or a child
to resource. The external movements
e it are its very life ; it lives by what it
and hears. Uneducated people in civil-
isations have vestiges of the same condi-

If you send a housemaid and a phi-
ser to a foreign country of which
er knows the language, the chances are
the housemaid will catch it before the
sopher. He has something else to do ;
n live in his own thoughts. But unless
an imitate the utterances, she is lost ;
as no life till she can join in the chatter
a kitchen. The propensity to mimicry
the power of mimicry are mostly
gest in those who have least abstract
s. The most wonderful examples of
tion in the world are perhaps the imita-
of civilized men by savages in the use
artial weapons. They learn the *knack*,
ortsmen call it, with inconceivable ra-
. A North American Indian—an Aus-
n even—can shoot as well as any white
Here the motive is at its maximum,
ill as the innate power. Every savage
more for the power of killing than for
other power.

e persecuting tendency of *all* savages,
indeed, of all ignorant people, is even
striking than their imitative tendency.
arbarian can bear to see one of his nation
te from the old barbarous customs and
s of their tribe. Very commonly all
ribe would expect a punishment from
ods if any one of them refrained from
was old, or began what was new. In
rn times and in cultivated countries we
d each person as responsible only for his
actions, and do not believe, or think of
ing, that the misconduct of others can
guilt on them. Guilt to us is an indi-
l taint consequent on choice and cleav-
the chooser. But in early ages the act
a member of the tribe is conceived to
all the tribe impious, to offend its pe-
god, to expose all the tribe to penalties
heaven. There is no "limited lia-
" in the political notions of that time.
arly tribe or nation is a religious part-
ip, on which a rash member by a sud-
npiety may bring utter ruin. If the state
ceived thus, toleration becomes wicked.
mitted deviation from the transmitted
inces becomes simple folly. It is a
ce of the happiness of the greatest
er. It is allowing one individual, for
nent's pleasure or a stupid whim, to
terrible and irretrievable calamity upon
No one will ever understand even Athe-
history who forgets this idea of the old
, though Athens was, in comparison
others, a rational and sceptical place,
for new views and free from old prej-
. When the street statues of Hermes
mutilated, all the Athenians were
ened and furious ; they thought that
hould *all* be ruined because some *one*
mutilated a god's image, and so offended
Almost every detail of life in the classi-
es—the times when real history opens

—was invested with a religious **sanction** ; a
sacred ritual regulated human **action** ;
whether it was called "law" or not, much
of it was older than the word "law ;" it was
part of an ancient usage conceived as ema-
nating from a superhuman authority, and not
to be transgressed without risk of punish-
ment by more than mortal power. There
was such a *solidarité* then between citizens
that each might be led to persecute the other
for fear of harm to himself.

It may be said that these two tendencies
of the early world—that to persecution and
that to imitation—must conflict ; that the im-
itative impulse would lead men to copy what
is new, and that persecution by traditional
habit would prevent their copying it. But
in practice the two tendencies co-operate.
There is a strong tendency to copy the most
common thing, and that common thing is the
old habit. Daily imitation is far oftenest a
conservative force, for the most frequent
models are ancient. Of course, however,
something new is necessary for every man
and for every nation. We may wish, if we
please, that to-morrow shall be like to-day,
but it will not be like it. New forces will
impinge upon us ; new wind, new rain, and
the light of another sun ; and we must alter
to meet them. But the persecuting habit
and the imitative combine to insure that the
new thing shall be in the old fashion ; it
must be an alteration, but it shall contain as
little of variety as possible. The imitative
impulse tends to this, because men most
easily imitate what their minds are best pre-
pared for—what is like the old, yet with the
inevitable minimum of alteration ; what
throws them least out of the old path, and
puzzles least their minds. The doctrine of
development means this—that in unavoidable
changes men like the new doctrine which is
most of a "preservative addition" to their
old doctrines. The imitative and the perse-
cuting tendencies make all change in early
nations a kind of selective conservatism, for
the most part keeping what is old, but an-
nexing some new but like practice—an addi-
tional turret in the old style.

It is this process of adding suitable things
and rejecting discordant things which has
raised those scenes of strange manners
which in every part of the world puzzle the
civilized men who come upon them first.
Like the old head-dress of mountain villages,
they make the traveller think not so much
whether they are good or whether they are
bad, as wonder how any one could have
come to think of them ; to regard them as
"monstrosities," which only some wild ab-
normal intellect could have hit upon. And
wild and abnormal indeed would be that in-
tellect if it were a single one at all. But in
fact such manners are the growth of ages,
like Roman law or the British constitution.
No one man—no one generation—could have
thought of them—only a series of genera-
tions trained in the habits of the last and
wanting something akin to such habits,
could have devised them. Savages *pet* their

favorite habits, so to say, and preserve them as they do their favorite animals ; ages are required, but at last a national character is formed by the confluence of congenial attractions and accordant detestations.

Another cause helps. In early states of civilization there is a great mortality of infant life, and this is a kind of selection in itself—the child most fit to be a good Spartan is most likely to survive a Spartan childhood. The habits of the tribe are enforced on the child ; if he is able to catch and copy them he lives ; if he cannot he dies. The imitation which assimilates early nations continues through life, but it begins with suitable forms and acts on picked specimens. I suppose, too, that there is a kind of parental selection operating in the same way and probably tending to keep alive the same individuals. Those children which gratified their fathers and mothers most would be most tenderly treated by them, and have the best chance to live, and as a rough rule their favorites would be the children of most " promise"—that is to say, those who seemed most likely to be a credit to the tribe according to the leading tribal manners and the existing tribal tastes. The most gratifying child would be the best looked after, and the most gratifying would be the best specimen of the standard then and there raised up.

Even so, I think there will be a disinclination to attribute so marked, fixed, almost physical a thing as national character to causes so evanescent as the imitation of appreciated habit and the persecution of detested habit. But, after all, national character is but a name for a collection of habits more or less universal. And this imitation and this persecution in long generations have vast physical effects. The mind of the parent (as we speak) passes somehow to the body of the child. The transmitted "something" is more affected by habits than it is by anything else. In time an ingrained type is sure to be formed, and sure to be passed on if only the causes I have specified be fully in action and without impediment.

As I have said, I am not explaining the origin of races, but of nations, or, if you like, of tribes. I fully admit that no imitation of predominant manner, or prohibitions of detested manners, will of themselves account for the broadest contrasts of human nature. Such means would no more make a Negro out of a Brahmin, or a Red-man out of an Englishman, than washing would change the spots of a leopard or the color of an Ethiopian. Some more potent causes must co-operate, or we should not have these enormous diversities. The minor causes I deal with made Greek to differ from Greek, but they did not make the Greek race. We cannot precisely mark the limit, but a limit there clearly is.

If we look at the earliest monuments of the human race, we find these race-characters as decided as the race-characters now. The earliest paintings or sculptures we anywhere have give us the present contrasts of dissim-

ilar types as strongly as present observati[on]. Within historical memory no such diff[er]ences have been created as those betwe[en] Negro and Greek, between Papuan and F[?] Indian, between Esquimaux and Goth. [We] start with cardinal diversities ; we trace o[nly] minor modifications, and we only see mi[nor] modifications. And it is very hard to [see] how any number of such modifications co[uld] change man as he is in one race-type to m[an] as he is in some other. Of this there a[re] but two explanations : one, that these gr[eat] types were originally separate creations. [as] they stand—that the Negro was made so, a[nd] the Greek made so. But this easy hypoth[e]sis of special creation has been tried so ofte[n] and has broken down so very often, that [in] no case, probably, do any great number [of] careful inquirers very firmly believe it. Th[ey] may accept it provisionally, as the best h[y]pothesis at present, but they feel about it [as] they cannot help feeling as to an army whi[ch] has always been beaten ; however strong [it] seems, they think it will be beaten aga[in]. What the other explanation is exactly I ca[n]not pretend to say. Possibly as yet the da[ta] for a confident opinion are not before u[s]. But by far the most plausible suggestion [is] that of Mr. Wallace, that these race-mar[ks] are living records of a time when the inte[l]lect of man was not as able as it is now [to] adapt his life and habits to change of regio[n] that consequently early mortality in the fir[st] wanderers was beyond conception grea[t] that only those (so to say) haphazard ind[i]viduals throve who were born with a pr[o]tected nature—that is, a nature suited to t[he] climate and the country, fitted to use its a[d]vantages, shielded from its natural disease[s] According to Mr. Wallace, the Negro is t[he] remnant of the one variety of man who wit[h] out more adaptiveness than then existe[d] could live in Interior Africa. Immigran[ts] died off till they produced him or somethin[g] like him, and so of the Esquimaux or t[he] American.

Any protective habit also struck out [in] such a time would have a far greater effe[ct] than it could afterward. A gregarious trib[e] whose leader was in some imitable respec[t] adapted to the struggle for life, and whic[h] copied its leader, would have an enormo[us] advantage in the struggle for life. It woul[d] be sure to win and live, for it would be c[o]herent and adapted, whereas, in compariso[n] competing tribes would be incoherent an[d] unadapted. And I suppose that in earl[y] times, when those bodies did not alread[y] contain the records and the traces of endle[ss] generations, any new habit would more easi[ly] fix its mark on the heritable element, an[d] would be transmitted more easily and mo[re] certainly. In such an age, man being soft[er] and more pliable, deeper race-marks wou[ld] be more easily inscribed and would be mo[re] likely to continue legible.

But I have no pretence to speak on su[ch] matters ; this paper, as I have so often e[x]plained, deals with nation-making and [?] with race-making. I assume a worl[d]

d varieties of man, and only want to how less marked contrasts would bly and naturally arise in each. Given homogeneous populations, some , some Mongolian, some Aryan, I have o prove how small contrasting groups l certainly spring up within each—to last and some to perish. These are dies in each race-stream which vary its e, and are sure to last till some new changes the current. These minor ies, too, would be infinitely compounded, nly with those of the same race, but :hose of others. Since the beginning n, stream has been a thousand times d into stream—quick into sluggish, dark ale—and eddies and waters have taken hapes and new colors, affected by what before, but not resembling it. And ou the fresh mass, the old forces of comon and elimination again begin to act, reate over the new surface another . "Motley was the wear" of the world Herodotus first looked on it and ded it to us, and thus, as it seems to me, ts varying colors produced.

, be thought that I have made out that forces of imitation and elimination be ain ones, or even at all powerful ones, formation of national character, it will that the effect of ordinary agencies :hat character will be more easy to unnd than it often seems and is put down ks. We get a notion that a change of iment or a change of climate acts y on the mass of a nation, and so are zzled—at least I have been puzzled—to ve how it acts. But such changes do first act equally on all people in the . On many, for a very long time, they act at all. But they bring out new es, and advertise the effects of new

A change of climate, say from a sing to an invigorating one, so acts. ody feels it a little, but the most acel it exceedingly. They labor and r and their prosperity invites imita-Just so with the contrary change, n animating to a relaxing place—the lly lazy look so happy as they do g, that the naturally active are cor-. The effect of any considerable on a nation is thus an intensifying cumulating effect. With its maxipower it acts on some prepared and dal individuals; in them it is seen to e attractive results, and then the creating those results are copied far ide. And, as I believe, it is in this but not quite obvious way, that the s of progress and of degradation may lly be seen to run.

IV. NATION-MAKING.

theories as to the primitive man must e uncertain. Granting the doctrine of on to be true, man must be held to common ancestor with the rest of the e. But then we do not know what ommon ancestor was like. If ever we

are to have a distinct conception of him, it can only be after long years of future researches and the laborious accumulation of materials, scarcely the beginning of which now exists. But science has already done something for us. It cannot yet tell us our first ancestor, but it can tell us much of an ancestor very high up in the line of descent. We cannot get the least idea (even upon the full assumption of the theory of evolution) of the first man; but we can get a very tolerable idea of the Paulo-prehistoric man, if I may so say—of man as he existed some short time (as we now reckon shortness), some ten thousand years, before history began. Investigators whose acuteness and diligence can hardly be surpassed—Sir John Lubbock and Mr. Tylor are the chiefs among them—have collected so much and explained so much that they have left a fairly vivid result.

That result is, or seems to me to be, if I may sum it up in my own words, that the modern pre-historic men—those of whom we have collected so many remains, and to whom are due the ancient, strange customs of historical nations (the fossil customs, we might call them, for very often they are stuck by themselves in real civilization, and have no more part in it than the fossils in the surrounding strata)—pre-historic men in this sense were "savages without the fixed habits of savages;" that is, that, like savages, they had strong passions and weak reason; that, like savages, they preferred short spasms of greedy pleasure to mild and equable enjoyment: that, like savages, they could not postpone the present to the future; that, like savages, their ingrained sense of morality was, to say the best of it, rudimentary and defective. But that, unlike present savages, they had not complex customs and singular customs, odd and seemingly inexplicable rules guiding all human life. And the reasons for these conclusions as to a race too ancient to leave a history, but not too ancient to have left memorials, are briefly these: First, that we cannot imagine a strong reason without attainments; and, plainly, pre-historic men had not attainments. They would never have lost them if they had. It is utterly incredible that whole races of men in the most distant parts of the world (capable of counting, for they quickly learn to count) should have lost the art of counting, if they had ever possessed it. It is incredible that whole races could lose the elements of common-sense, the elementary knowledge as to things material and things mental—the Benjamin Franklin philosophy—if they had ever known it. Without some data the reasoning faculties of man cannot work. As Lord Bacon said, the mind of man must "work upon stuff." And in the absence of the common knowledge which trains us in the elements of reason as far as we are trained, they had no "stuff." Even, therefore, if their passions were not absolutely stronger than ours, relatively they were stronger, for their reason was weaker than our reason. Again, it is certain that races of men capable

of postponing the present to the future (even if such races were conceivable without an educated reason) would have had so huge an advantage in the struggles of nations, that no others would have survived them. A single Australian tribe (really capable of such a habit, and really practising it) would have conquered all Australia almost as the English have conquered it. Suppose a race of long-headed Scotchmen, even as ignorant as the Australians, and they would have get from Torres to Bass's Straits, no matter how fierce was the resistance of the other Australians. The whole territory would have been theirs, and theirs only. We cannot imagine innumerable races to have lost, if they had once had it, the most useful of all habits of mind—the habit which would most insure their victory in the incessant contests which, ever since they began, men have carried on with one another and with nature, the habit which in historical times has above any other received for its possession the victory in those contests. Thirdly, we may be sure that the morality of pre-historic man was as imperfect and as rudimentary as his reason. The same sort of arguments apply to a self-restraining morality of a high type as apply to a settled postponement of the present to the future upon grounds recommended by argument. Both are so involved in difficult intellectual ideas (and a high morality the most of the two) that it is all but impossible to conceive their existence among people who could not count more than five—who had only the grossest and simplest forms of language—who had no kind of writing or reading—who, as it has been roughly said, had " no pots and no pans"—who could indeed make a fire, but who could hardly do anything else—who could hardly command nature any further. Exactly also like a shrewd far-sightedness, a sound morality on elementary transactions is far too useful a gift to the human race ever to have been thoroughly lost when they had once attained it. But innumerable savages have lost all but completely many of the moral rules most conducive to tribal welfare. There are many savages who can hardly be said to care for human life—who have scarcely the family feelings—who are eager to kill all old people (their own parents included) as soon as they get old and become a burden—who have scarcely the sense of truth—who, probably from a constant tradition of terror, wish to conceal everything, and would (as observers say) " rather lie than not"—whose ideas of marriage are so vague and slight that the idea, " communal marriage" (in which all the women of the tribe are common to all the men, and them only), has been invented to denote it. Now if we consider how cohesive and how fortifying to human societies are the love of truth, and the love of parents, and a stable marriage tie, how sure such feelings would be to make a tribe which possessed them wholly and soon victorious over tribes which were destitute of them, we shall begin to comprehend how unlikely it is that vast

masses of tribes throughout ... the world sho[uld] have lost all these moral helps to conqu[er] not to speak of others. If any reasoning safe as to pre-historic man, the reason which imputes to him a deficient sense morals is safe, for all the arguments s[ug]gested by all our late researches conve[rge] upon it, and concur in teaching it.

Nor on this point does the case rest who[lly] on recent investigations. Many years [ago] Mr. Jowett said that the classical religio[n] bore relics of the " ages before morality And this is only one of several cases which that great thinker has proved b[y] chance expression that he had exhausted [in] pending controversies years before they [ar]rived, and had perceived more or less [the] conclusion at which the disputants wo[uld] arrive long before the public issue w[as] joined. There is no other explanation such religions than this. We have but [to] open Mr. Gladstone's " Homer" in order [to] see with how intense an antipathy a re[al] moral age would regard the gods and g[od]desses of Homer; how inconceivable it is t[hat] a really moral age should first have inven[ted] and then bowed down before them; h[ow] plain it is (when once explained) that t[hey] are antiquities, like an English court-suit, a *stone* sacrificial knife, for no one would [use] such things as implements of ceremony [ex]cept those who had inherited them fro[m] past age, when there was nothing better.

Nor is there anything inconsistent with [our] present moral theories of whatever kind in thinking about our ancestors. The intuit[ive] theory of morality, which would be that n[at]urally most opposed to it, has lately take[n] new development. It is not now maintai[ned] that all men have the same amount of c[on]science. Indeed, only a most shallow dis[pu]tant who did not understand even the pla[in]est facts of human nature could ever h[ave] maintained it; if men differ in anything th[ey] differ in the fineness and the delicacy of th[e] moral intuitions, however we may supp[ose] those feelings to have been acquired. [We] need not go as far as savages to learn t[his] lesson; we need only talk to the English p[eople] or to our own servants, and we shall [be] taught it very completely. The low[er] classes in civilized countries, like all clas[ses] in uncivilized countries, are clearly wanti[ng] in the nicer part of those feelings whi[ch] taken together, we call the *sense* of morali[ty] All this an intuitionist who knows his c[ause] will now admit, but he will add that, thou[gh] the amount of the moral sense may and d[oes] differ in different persons, yet that as far [as] it goes it is alike in all. He likens it to [the] intuition of number, in which some sava[ges] are so defective that they cannot really n[?] easily count more than three. Yet as far [as] three his intuitions are the same as those [of] civilized people. Unquestionably if th[ese] are intuitions at all, the primary truths [of] number are such. There is a felt necess[ity] in them if in anything, and it would be p[al]try to say that any proposition of n[?] was more certain than that five and five

The truths of arithmetic, intuitive or ertainly cannot be acquired independ-of experience nor can those of morals either. Unquestionably they were d in life and by experience, though hat comes the difficult and ancient conry whether anything peculiar to them it to be found in the other facts of life radded to them, independently of exce out of the vigor of the mind itself. uitionist, therefore, fears to speak of uscience of his pre-historic ancestor as 'eet, rudimentary, or hardly to be dis, for he has to admit much the same to square his theory to plain modern and that theory in the modern form onsistently be held along with them. irse if an intuitionist can accept this sion as to pre-historic men, so asy may Mr. Spencer, who traces all ty back to our inherited experience of , or Mr. Darwin, who ascribes it to an ed sympathy, or Mr. Mill, who with teristic courage undertakes to build : whole moral nature of man with no rhatever either from ethical intuition m physiological instinct. Indeed of erlasting questions, such as the reality :-will, or the nature of conscience, it . have before explained, altogether intent with the design of these papers to

They have been discussed ever since story of discussion begins ; human n is still divided, and most people still nany difficulties in every suggested , and doubt if they have heard the last of argument or the whole solution of oblem in any of them. In the interest nd knowledge it is essential to narrow utmost the debatable territory : to see nany ascertained facts there are which usistent with all theories, how many is foreign lawyers would phrase it, be y hel'l in *condominium* by them.

though in these great characteristics is reason to imagine that the pre-hisman—at least the sort of pre-historic : am treating of, the man some few nd years before history began, and all, at least not necessarily, the primian—was identical with a modern savu another respect there is equal or r re·son to suppose that he was most a modern savage. A modern savage thing but the simple being which phiers of the eighteenth century imagined) be ; on the contrary, his life is twisted thousand curious habits ; his reason is ied by a thousand strange prejudices ; elings are frightened by a thousand superstitions. The whole min l of a n savage is, so to say, *tattooed* over monstrous images · there is not a h place anywhere about it. But there reason to suppose the minds of pre-hisnen to be so cut and marked ; on the ry, the creation of these habits, these ditions, these prejudices, must have ages. In his nature, it may be said, storic man was the same as a modern

savage ; it is only in his acquisition that he was different.

It may be objected that if man was developed out of any kind of animal (and this is the doctrine of evolution which, if it be not proved conclusively, has great probability and great scientific analogy in its favor) he would necessarily at first possess animal instincts ; that these would only gradually be lost ; that in the mean time they would serve as a protection and an aid, and that pre-historic men, therefore, would have important helps and feelings which existing savages have not. And probably of the first men, the first beings worthy to be so called, this was true : they had, or may have had, certain remnants of instincts which aided them in the struggle of existence, and as reason gradually came these instincts may have waned away. Some instincts certainly do wane when the intellect is applied steadily to their subject-matter. The curious "counting boys," the arithmetical prodigies, who can work by a strange innate faculty the most wonderful sums, lose that faculty, always partially, sometimes completely, if they are taught to reckon by rule like the rest of mankind. In like manner I have heard it said that a man could soon reason himself out of the instinct of decency if he would only take pains and work hard enough. And perhaps other primitive instincts may have in like manner passed away. But this does not affect my argument. I am only saying that these instincts, if they ever existed, *did* pass away—that there was a period, probably an immense period as we reckon time in human history, when pre-historic men lived much as savages live now, without any important aids and helps.

The proofs of this are to be found in the great works of Sir John Lubbock and Mr. Tylor, of which I just now spoke. I can only bring out two of them here. First, it is plain that the first pre-historic men had the flint tools which the lowest savages use, and we can trace a regular improvement in the finish and in the efficiency of their simple instruments corresponding to that which we see at this day in the upward transition from the lowest savages to the highest. Now it is not conceivable that a race of beings with valuable instincts supporting their existence and supplying their wants would need these simple tools. They are exactly those needed by very poor people who have no instincts, and those were used by such, for savages are the poorest of the poor. It would be very strange if these same utensils, no more no less, were used by beings whose discerning instincts made them in comparison altogether rich. Such a being would know how to manage without such things, or if it wanted any, would know how to make better.

And, secondly, on the moral side we know that the pre-historic age was one of much license, and the proof is that in that age descent was reckoned through the female only, just as it is among the lowest savages. "Maternity," it has been said, "is a matter

of fact, paternity is a matter of opinion;"
and this not very refined expression exactly
conveys the connection of the lower human
societies. In all slave-owning communities
—in Rome formerly, and in Virginia yester-
day—such was the accepted rule of law; the
child kept the condition of the mother, what-
ever that condition was; nobody inquired as
to the father; the law, once for all, assumed
that he could not be ascertained. Of course
no remains exist which prove this or any-
thing else about the morality of pre-historic
man; and morality can only be described by
remains amounting to a history. But one of
the axioms of pre-historic investigation binds
us to accept this as the morality of the pre-
historic races if we receive that axiom. It
is plain that the widespread absence of a
characteristic which greatly aids the pos-
sessor in the conflicts between race and race
probably indicates that the primary race did
not possess that quality. If one-armed peo-
ple existed almost everywhere in every con-
tinent; if people were found in every inter-
mediate stage, some with the mere germ of
the second arm, some with the second arm
half grown, some with it nearly complete;
we should then argue—" the first race can-
not have had two arms, because men have
always been fighting, and as two arms are a
great advantage in fighting, one-armed and
half-armed people would immediately have
been killed off the earth; they never could
have attained any numbers. A diffused de-
ficiency in a warlike power is the best at-
tainable evidence that the pre-historic men
did not possess that power." If this axiom
be received it is palpably applicable to the
marriage-bond of primitive races. A cohe-
sive "family" is the best germ for a cam-
paigning nation. In a Roman family the
boys, from the time of their birth, were bred
to a domestic despotism, which well prepared
them for a subjection in after life to a mili-
tary discipline, a military drill, and a mili-
tary despotism. They were ready to obey
their generals because they were compelled
to obey their fathers; they conquered the
world in manhood because as children they
were bred in homes where the tradition of
passionate valor was steadied by the habit of
implacable order. And nothing of this is
possible in loosely-bound family groups (if
they can be called families at all) where the
father is more or less uncertain, where de-
scent is not traced through him, where, that
is, property does not come from him, where
such property as he has passes to his sure re-
lations—to his sister's children. An ill-knit
nation which does not recognize paternity as
a legal relation, would be conquered like a
mob by any other nation which had a vestige
or a beginning of the *patria potestas*. If,
therefore, all the first men had the strict mo-
rality of families, they would no more have
permitted the rise of *semi*-moral nations any-
where in the world than the Romans would
have permitted them to arise in Italy. They
would have conquered, killed, and plundered
them before they became nations; and yet

semi-moral nations exist all over the world
It will be said that this argument pro
too much. For it proves that not only t
somewhat-before-history men, but the ab
lutely first men, could not have had cl
family instincts, and yet if they were li
most though not all of the animals neares
man they had such instincts. There i
great story of some African chief who c
pressed his disgust at adhering to one wi
by saying it was "like the monkeys." T
semi-brutal ancestors of man, if they existe
had very likely an instinct of constan
which the African chief, and others like hi
had lost. How, then, if it was so benefici
could they ever lose it? The answer is plai
they could lose it if they had it as an in
tional propensity and habit, and not as
moral and rational feeling. When reas
came, it would weaken that habit like
other irrational habits. And reason is a for
of such infinite vigor—a victory-maki
agent of such incomparable efficiency—th
its continually diminishing valuable instinc
will not matter if it grows itself steadily
the while. The strongest competitor wins
both the cases we are imagining; in the fir
a race with intelligent reason, but witho
blind instinct, beats a race with that instin
but without that reason; in the second,
race with reason and high moral feeling be
a race with reason but without high mor
feeling. And the two are palpably consisten
There is every reason, therefore, to su
pose pre-historic man to be deficient in mu
of sexual morality, as we regard that mor
ity. As to the detail of "primitive marriag
or "no marriage," for that is pretty mu
what it comes to, there is of course muc
room for discussion. Both Mr. M'Clenn
and Sir John Lubbock are too accomplishe
reasoners and too careful investigators
wish conclusions so complex and refined
theirs to be accepted all in a mass, besid
that on some critical points the two diffe
But the main issue is not dependent on ni
arguments. Upon broad grounds we ma
believe that in pre-historic times men foug
both to gain and to keep their wives; th
the strongest man took the best wife aw
from the weaker man; and that if the wi
was restive, did not like the change, her ne
husband beat her; that (as in Australia no
a pretty woman was sure to undergo mar
such changes, and her back to bear tl
marks of many such chastisements; that
the principal department of human condu
(which is the most tangible and easily trace
and therefore the most obtainable specime
of the rest) the minds of pre-historic me
were not so much immoral as unmoral: the
did not violate a rule of conscience, but the
were somehow not sufficiently developed f
them to feel on this point any conscience,
for it to prescribe to them any rule.
The same argument applies to religio
There are, indeed, many points of the grea
est obscurity, both in the present savage
ligions and in the scanty vestiges of pre-h
toric religion. But one point is clear.

ge religions are full of superstitions ded on luck. Savages believe that al omens are a sign of coming events ; some trees are lucky, that some animals lucky, that some places are lucky, that e indifferent actions—indifferent appar- y and indifferent really—are lucky, and f others in each class, that they are un ty. Nor can a savage well distinguish be- en a sign of "luck" or ill-luck, as we ld say, and a deity which causes the d or the ill ; the indicating precedent and causing being are to the savage mind h the same ; a steadiness of head far be- d savages is required consistently to di - uish them. And it is extremely natural they should believe so. They are play- a game—the game of life—with no wledge of its rules. They have not an of the laws of nature ; if they want to a man, they have no conception at all ue scientific remedies. If they try any- g they must try it upon bare chance. most useful modern remedies were often overed in this bare, empirical way. t could be more improbable—at least, what could a pre-historic man have les n a good reason—than that some mineral ngs should stop rheumatic pains, or min- springs make wounds heal quickly ? yet the chance knowledge of the mar- ous effect of gifted springs is probably as ent as any sound knowledge as to medi- whatever. No doubt it was mere casual at first that tried these springs and id them answer. Somebody by accident l them and by that accident was instant ured. The chance which happily di- d men in this one case misdirected them thousand cases. Some expedition had vered when the resolution to undertake as resolved on under an ancient tree, and rdingly that tree became lucky and sa- . Another expedition failed when a pie crossed its path and a magpie was to be unlucky. A serpent crossed the of another expedition, and it had a mar- ous victory, and accordingly the serpent ame a sign of great luck (and what a sav- cannot distinguish from it—a potent y which makes luck). Ancient medicine ually unreasonable : as late down as the dle Ages it was full of superstitions ded on mere luck. The collection of criptions published under the direction e Master of the Rolls abounds in such ies as we should call them. According ne of them, unless I forget, so e disease fever, I think—is suppose to be cured lacing the patient between two halves of re and a pigeon recently killed. Noth- can be plainer than that there is no nd for this kind of treatment, and that idea of it arose out of a chance hit, which e right and succeeded There was noth- so absurd or so contrary to common-sense re are apt to imagine about it. The lying reon two halves of a hare or a pigeon d priori, and to the inexperienced mind. e as likely to cure disease as the drinking

certain draughts of nasty mineral water. Both, somehow, were tried ; both answered —that is, both were at the first time, or at some memorable time, followed by a remark- able recovery ; and the only difference is, that the curative power of the mineral is persistent, and happens constantly ; whereas, on an average of trials, the proximity of a hare or pigeon is found to have no effect, and cures take place as often in cases where it is not tried as in cases where it is. The nature of minds which are deeply engaged in watch- ing events of which they do not know the reason, is to single out some fabulous ac- companiment or some wonderful series of good luck or bad luck, and to dread eve after that accompaniment if it brings evil, and to love it and long for it if it brings good. All savages are in this position, and the fascinating effect of striking accompani- ments (in some single case) of singular good fortune and singular calamity, is one great source of savage religions.

Gamblers to this day are, with respect to the chance part of their game, in much the same plight as savages with respect to the main events of their whole lives. And we well know how superstitious they all are. To this day very sensible whist-players have a certain belief—not, of course, a fixed con- viction, but still a certain impression—that there is "luck under a black deuce," and will half mutter some not very gentle male- dictions if they turn up as a trump the four of clubs, because it brings ill-luck, and is "the devil's bed-post." Of course grown- up gamblers have too much general knowl- edge, too much organized common sense, to prolong or cherish such ideas ; they are ashamed of entertaining them, though, nev- ertheless, they cannot entirely drive them out of their minds. But child-gamblers—a number of little boys set to play loo—are just in the position of savages, for their fancy is still impressible, and they have not as yet been thoroughly subjected to the confuting experience of the real world ; and child- gamblers have idolatries—at least I know that years ago a set of boy loo-players, of whom I was one, had considerable faith in a certain "pretty fish," which was larger and more nicely made than the other fish we had. We gave the best evidence of our belief in its power to "bring luck ;" we fought for it (if our elders were out of the way) ; we offered to buy it with many other fish from the en- vied holder, and I am sure I have often cried bitterly if the chance of the game took it away from me. Persons who stand up for the dignity of philosophy, if any such there still are, will say that I ought not to mention this, because it seems trivial ; but the more modest spirit of modern thought plainly teaches, if it teaches anything, the cardinal value of occasional little facts. I do not hes- itate to say that many learned and elaborate explanations of the totem—the "clan" deity —the beast or bird who in some supernatu- ral way attends to the clan and watches over it—do not seem to me to be nearly as

akin to the reality as it works and lives among the lower races, as the "pretty fish" of my early boyhood. And very naturally so, for a grave philosopher is separated from primitive thought by the whole length of human culture ; but an impressible child is as near to, and its thoughts are as much like, that thought as anything can now be.

The worst of these superstitions is that they are easy to make and hard to destroy. A single run of luck has made the fortune of many a charm and many idols. I doubt if even a single run of luck be necessary. I am sure that if an elder boy said that "the pretty fish was lucky—of course it was," all the lesser boys would believe it, and in a week it would be an accepted idol. And I suspect the Nestor of a savage tribe—the aged repository of guiding experience—would have an equal power of creating superstitions. But if once created they are most difficult to eradicate. If any one said that the amulet was of certain efficacy—that it always acted whenever it was applied—it would of course be very easy to disprove ; but no one ever said that the "pretty fish" always brought luck ; it was only said that it did so on the whole, and that if you had it you were more likely to be lucky than if you were without it. But it requires a long table of statistics of the results of games to disprove this thoroughly ; and by the time people can make tables they are already above such beliefs, and do not need to have them disproved. Nor in many cases where omens or amulets are used would such tables be easy to make, for the data could not be found ; and a rash attempt to subdue the superstition by a striking instance may easily end in confirming it. Francis Newman, in the remarkable narrative of his experience as a missionary in Asia, gives a curious example of this. As he was setting out on a distant and somewhat hazardous expedition, his native servants tied round the neck of the mule a small bag supposed to be of preventive and mystic virtue. As the place was crowded and a whole townspeople looking on, Mr. Newman thought that he would take an opportunity of disproving the superstition. So he made a long speech of explanation in his best Arabic, and cut off the bag, to the horror of all about him. But as ill-fortune would have it, the mule had not got thirty yards up the street before she put her foot into a hole and broke her leg ; upon which all the natives were confirmed in their former faith in the power of the bag, and said, "You see now what happens to unbelievers."

Now the present point as to these superstitions is their military inexpediency. A nation which was moved by these superstitions as to luck would be at the mercy of a nation, in other respects equal, which was not subject to them. In historical times, as we know, the panic terror at eclipses has been the ruin of the armies which have felt it ; or has made them delay to do something necessary, or rush to do something destructive. The necessity of consulting the au-

spices, while it was sincerely practised and before it became a trick for disguising foresight, was in classical history very dangerous. And much worse is it with savages, whose life is one of omens, who must always consult their sorcerers, who may be turned this way or that by some chance accident, who, if they were intellectually able to frame a consistent military policy—and some savages in war see farther than in anything else —are yet liable to be put out, distracted, confused, and turned aside in the carrying out of it, because some event, really innocuous but to their minds foreboding, arrests and frightens them. A religion full of omens is a military misfortune, and will bring a nation to destruction if set to fight with a nation at all equal otherwise, who had a religion without omens. Clearly, then, if all early men unanimously, or even much the greater number of early men, had a religion *without* omens, no religion, or scarcely a religion, anywhere in the world could have come into existence *with* omens ; the immense majority possessing the superior military advantage, the small minority destitute of it would have been crushed out and destroyed. But, on the contrary, all over the world religions with omens once existed, in most they still exist ; all savages have them, and deep in the most ancient civilizations we find the plainest traces of them. Unquestionably therefore the pre-historic religion was like that of savages—viz., in this that it largely consisted in the watching of omens and in the worship of lucky beasts and things, which are a sort of embodied and permanent omens.

It may indeed be objected—an analogous objection was taken as to the ascertained moral deficiencies of pre-historic mankind— that if this religion of omens was so pernicious and so likely to ruin a race, no race would ever have acquired it. But it is only likely to ruin a race contending with another race otherwise equal. The fancied discovery of these omens—not an extravagant thing in an early age, as I have tried to show, not a whit then to be distinguished as improbable from the discovery of healing herbs or springs which pre-historic men also did discover— the discovery of omens was an act of reason as far as it went. And if in reason the omen-finding race were superior to the races in conflict with them, the omen-finding race would win, and we may conjecture that omen-finding races were thus superior since they won and prevailed in every latitude and in every zone.

In all particulars therefore we would keep to our formula, and say that pre-historic man was substantially a savage like present savages, in morals, intellectual attainments, and in religion : but that he differed in this from our present savages, that he had not had time to ingrain his nature so deeply with bad habits, and to impress bad beliefs so unalterably on his mind as they have. They have had ages to fix the stain on themselves, but primitive man was younger and had no such

time.

I have elaborated the evidence for this conclusion at what may seem needless and tedious length, but I have done so on account of its importance. If we accept it, and if we are sure of it, it will help us to many most important conclusions. Some of these I have dwelt upon in previous papers, but I will set them down again.

First, it will in part explain to us what the world was about, so to speak, before history. It was making, so to say, the intellectual *society*—the connected and coherent habits, the preference of equable to violent enjoyment, the abiding capacity to prefer, if required, the future to the present, the mental prerequisites without which civilization could not begin to exist, and without which it would soon cease to exist even had it begun. The primitive man, like the present savage, had not these prerequisites, but, unlike the present savage, he was capable of acquiring them and of being trained in them, or his nature was still soft and still impressible, and possibly, strange as it may seem to say, his outward circumstances were more favorable to an attainment of civilization than those of our present savages. At any rate, the pre-historic times were spent in making men capable of writing a history, and leaving something to put in it when it is written, and we can see how it was done.

Two preliminary processes indeed there are which seem inscrutable. There was some strange preliminary process by which the main races of men were formed; they began to exist very early, and except by intermixture no new ones have been formed since. It was a process singularly active in early ages, and singularly quiescent in later ages. Such differences as exist between the Aryan, the Turanian, the Negro, the Roman, and the Australian, are differences greater altogether than any causes now active are capable of creating in present men, at least in any way explicable by us. And here is, therefore, a strong presumption that as great authorities now hold those differences were created before the nature of men, specially before the mind and the adaptive nature of men had taken thier existing constitution. And a second condition precedent of civilization seems, at least to me, to have been equally inherited, if the doctrine of evolution be true, from some previous state or condition. I at least find it difficult to conceive of men, at all like the present men, unless existing in something like families—that is, in groups avowedly connected, at least on the mother's side, and probably always with a vestige of connection, more or less, on the father's side, and unless these groups were like many animals, gregarious, under a leader more or less fixed. It is almost beyond imagination how man, as we now man, could by any sort of process have attained this step in civilization. And it is a real advantage, to say the least of it, in the evolution theory that it enables us to remit this difficulty to a pre-existing period in na-

ture, where other instincts and powers th our present ones may perhaps have co into play, and where our imagination c hardly travel. At any rate, for the present may assume these two steps in human pro ress made, and these two conditions realis

The rest of the way, if we grant these tw conditions, is plainer. The first thing is t erection of what we may call a custom-ma ing power—that is, of an authority which e enforce a fixed rule of life, which, by mea of that fixed rule, can in some degree crea a calculable future, which can make it r tional to postpone present violent but m mentary pleasure for future continual ple ure, because it insures, what else is n sure, that if the sacrifice of what is in ha be made, enjoyment of the contingent e pected recompense will be received. C course I am not saying that we shall find i early society any authority of which the shall be the motives. We must have trav elled ages unless all our evidence be wron from the first men before there was a co prehension of such motives. I only mea that the first thing in early society was a authority of whose action this shall be th result, little as it knew what it was doing little as it would have cared if it had know

The conscious end of early societies wa not at all, or scarcely at all, the protection o life and property, as it was assumed to be b the eighteenth-century theory of govern ment. Even in early historical ages—in th youth of the human race, not its childhood— such is not the nature of early states. Si Henry Maine has taught us that the earlies subject of jurisprudence is not the separat property of the individual, but the commo property of the family group; what w should call private property hardly then ex isted; or if it did, was so small as to be of no importance; it was like the things little children are now allowed to *call* their own which they feel it very hard to have taken from them, but which they have no real right to hold and keep. Such is our earlies property-law, and our earliest life-law is that the lives of all members of the family group were at the mercy of the head of the group. As far as the individual goes, neither his goods nor his existence were protected at all. And this may teach us that something else was lacked in early societies besides what in our societies we now think of.

I do not think I put this too high when I say that a most important if not the most important object of early legislation was the enforcement of *lucky* rites. I do not like to say religious rites, because that would in volve me in a great controversy as to the power, or even the existence, of early relig ions. But there is no savage tribe without a notion of luck; and perhaps there is hardly any which has not a conception of luck for the tribe as a tribe, of which each member has not some such a belief that his own ac tion or the action of any other member of it —that he or the others doing anything which was unlucky or would bring a "curse"—

might cause evil not only to himself, but to all the tribe as well. I have said so much about "luck" and about its naturalness before, that I ought to say nothing again. But I must add that the contagiousness of the idea of "luck" is remarkable. It does not at all, like the notion of desert, cleave to the doer. There are people to this day who would not permit in their house people to sit down thirteen to dinner. They do not expect any evil to themselves particularly for permitting it or sharing in it, but they cannot get out of their heads the idea that some one or more of the number will come to harm if the thing is done. This is what Mr. Tylor calls survival in culture. The faint belief in the corporate liability of these thirteen is the feeble relic and last dying representative of that great principle of corporate liability to good and ill fortune which has filled such an immense place in the world.

The traces of it are endless. You can hardly take up a book of travels in rude regions without finding "I wanted to do so and so. But I was not permitted, for the natives feared it might bring ill-luck on the 'party,' or perhaps the tribe." Mr. Galton, for instance, could hardly feed his people. The Damaras, he says, have numberless superstitions about meat which are very troublesome. In the first place, each tribe, or rather family, is prohibited from eating cattle of certain colors, say "who come from the sun" eschewing sheep spotted in a particular way, which those "who come from the rain" have no objection to. "As," he says, "there are five or six canons or descents, and I had men from most of them with me, I could hardly kill a sheep that everybody would eat;" and he could not keep his meat, for it had to be given away because it was commanded by one superstition, nor buy milk, the staple food of those parts, because it was prohibited by another. And so on without end. Doing anything unlucky is in their idea what putting on something that attracts the electric fluid is in fact. You cannot be sure that harm will not be done, not only to the person in fault, but to those about him too. As in the scriptural phrase, doing what is of evil omen is "like one that letteth out water." He cannot tell what are the consequences of his act, who will share them, or how they can be prevented.

In the earliest historical nations I need not say that the corporate liabilities of states is to a modern student their most curious feature. The belief is indeed raised far above the notion of mere "luck," because there is a distinct belief in gods or a god whom the act offends. But the indiscriminate character of the punishment still survives; not only the mutilator of the Hermæ, but all the Athenians—not only the violator of the rites of the Bona dea, but all the Romans—are liable to the curse engendered; and so all through ancient history. The strength of the corporate anxiety so created is known to every one. Not only was it greater than any

anxiety about personal property, but it was immeasurably greater. Naturally, even reasonably we may say, it was greater. The dread of the powers of nature, or of the beings who rule those powers, is properly, upon grounds of reason, as much greater than any other dread as the might of the powers of nature is superior to that of any other powers. If a tribe or a nation have, by a contagious fancy, come to believe that the doing of any one thing by any number will be "unlucky"—that is, will bring an intense and vast liability on them all—then that tribe and that nation will prevent the doing of that thing more than anything else. They will deal with the most cherished chief who even by chance should do it as in a similar case the sailors dealt with Jonah.

I do not of course mean that this strange condition of mind as it seems to us was the sole source of early customs. On the contrary, man might be described as a custom-making animal with more justice than by many of the short descriptions. In whatever way a man has done anything once, he has a tendency to do it again: if he has done it several times he has a great tendency so to do it, and, what is more, he has a great tendency to make others do it also. He transmits his formed customs to his children by example and by teaching. This is true now of human nature, and will always be true, no doubt. But what is peculiar in early societies is that over most of these customs there grows sooner or later a semi-supernatural sanction. The whole community is possessed with the idea that if the primal usages of the tribe be broken, harm unspeakable will happen in ways you cannot think of, and from sources you cannot imagine. As people nowadays believe that "murder will out," and that great crime will bring even an earthly punishment, so in early times people believed that for any breach of sacred custom certain retribution would happen. To this day many semi-civilized races have great difficulty in regarding any arrangement as binding and conclusive unless they can also manage to look at it as an inherited usage. Sir H. Maine, in his last work, gives a most curious case. The English Government in India has in many cases made new and great works of irrigation, of which no ancient Indian Government ever thought; and it has generally left it to the native village community to say what share each man of the village should have in the water; and the village authorities have accordingly laid down a series of most minute rules about it. But the peculiarity is that in no case do these rules "purport to emanate from the personal authority of their author or authors, which rests on grounds of reason not on grounds of innocence and sanctity; nor do they assume to be dictated by a sense of equity; there is always, I am assured, a sort of fiction under which some customs as to the distribution of water are supposed to have emanated from a remote antiquity, although, in fact, no such artificial supply had ever been so much

hought of." So difficult does this ancient ace—like, probably, in this respect so much of the ancient world—fin l it to imagine a ule which is obligatory, but not traditional.

The rea ly formation of custom-making groups in early society must have been greatly helped by the easy divisions of that society. Much of the world—ail Europe, for example—was then covered by the primeval orest ; man had only conquered, and as yet could only conquer, a few plots and corners from it. These narrow spaces were s ion exausted, and if numbers grew some of the new people must move. Accordingly, migrations were constant, and were necessary. And these migrations were not like those of modern times. There was no such feeling s binds even Americans who hate, or speak s if they hated, the present political England—nevertheless to "the old home." There was then no organized means of communication—no practical communication, we may say, between parted members of the same group ; those who once went out from hs parent society went out forever ; they oft no abiding remembrance, and they kept to abiding regard. Even the language of the parent tribe and of the descended tribe would differ in a generation or two. There being no written literature and no spoken intercourse, the speech of both would vary (the speech o such communities is always varying), and would vary in different directions. One set of causes, events, and associations would act on one, and another set on another ; sectional differences would soon arise, nd, for speaking purposes, what philologists all a dialectical difference often amounts to eal and total difference : no connected interhange of thought is possible any longer keparate groups soon " set up house ;" the early societies begin a new set of customs, cquire and keep a distinct and special 'luck."

If it were not for this facility of new formations, one good or bad custom would long ince have " corrupted " the world ; but even his would not have been enough but for hose continual wars, of which I have spoken t such length in the essay on " The Use of Conflict," that I need say nothing now. These are by their incessant fractures of old nages, and by their constant infusion of ew elements, the real regenerators of society. And whatever be the truth or falseood of the general dislike to mixed and alf-bred rac s, no such suspicion was robably applicable to the early mixtures of rimitive society. Supposing, as is likely, ach great aboriginal race to have had its wn quarter of the world (a quarter, as it could seem, corresponding to the special uarters in which plants and animals are divided), then the immense majority of the mixtures would be between men of different ribes but of the same stock, and this no one could object to, but every one would praise.

In general, too, the conquerors would be etter than the conquered (most merits in irly society are more or less military merits), but they would not be very much better, f the lowest steps in the ladder of civilizatic are very steep, and the effort to mount the is slow and tedious. And this is probabl the better if they are to produce a good an quick effect in civilizing those they hav conquered. The experience of the Engli in India shows—if it shows anything—that highly civilized race may fail in producing rapidly excellent effect on a less civiliza race, because it is too good and too differen The two are not en rapport together ; th merits of the one are not the merits prized h the other ; the manner-language of the one not the manner-language of the other. Th higher being is not and cannot be a model fo the lower ; he could not mould himself on it h would, and would not if he could. Con sequently, the two races have long lived to gether " hear and yet far off," daily seeing on another and daily interchanging superficia thoughts, but in the depths of their min separated by a whole era of civilization, an so affecting one another only a little in com parison with what might have been hoped But in early societies there were no such great differences, and the rather superio conqueror must have easily improved th rather inferior conquered.

It is in the interior ot these customar groups that national characters are formed As I wrote a whole essay on the manner o this before, I cannot speak of it now. By proscribing nonconformist members for gen erations, and cherishing and rewarding con formist members, nonconformists become fewer and fewer, and conformists more and more. Most men mostly imitate what they see, and catch the tone of what they hear, and so a settled type—a persistent character —is formed. Nor is the process wholly mental. I cannot agree, though the greatest authorities say it, that no " unconscious se lection" has been at work at the breed of man. If neither that nor conscious selection has been at work, how did there come to be these breeds, and such there are in the greatest numbers, though we call them na tions? In societies tyrannically customary, uncongenial minds become first cowed, then melancholy, then out of health, and at last die. A Shelley in New England could hardly have lived, and a race of Shelleys would have been impossible. Mr. Galton wishes that breeds of men should be created by matching men with marked characteris tics with women of like characteristics. But surely this is what nature has been doing time out of mind, and most in the rudest na tions and hardest times. Nature disheart ened in each generation the ill-fitted mem bers of each customary group, so deprived them of their full vigor, or, if they were weakly, killed them. The Spartan character was formed because none but people with a Spartan make of mind could endure a Spar tan existence. The early Roman character was so formed too. Perhaps all very marked national characters can be t.aced back to a time of rigid and pervading discipline. In

modern times, when society is more tolerant, new national characters are neither so strong, so featurely, nor so uniform.

In this manner society was occupied in pre-historic times—it is consistent with and explicable by our general principle as to savages, that society should for ages have been so occupied, strange as that conclusion is, and incredible as it would be, if we had not been taught by experience to believe strange things.

Secondly, this principle and this conception of pre-historic times explain to us the meaning and the origin of the oldest and strangest of social anomalies—an anomaly which is among the first things history tells us—the existence of *caste* nations. Nothing is at first sight stranger than the aspect of those communities where several nations seem to be bound up together—where each is governed by its own rule of law, where no one pays any deference to the rule of law of any of the others. But if our principles be true, these are just the nations most likely to last, which would have a special advantage in early times, and would probably not only maintain themselves, but conquer and kill out others also. The characteristic necessity of early society as we have seen is strict usage and binding coercive custom. But the obvious result and inevitable evil of that is monotony in society ; no one can be much different from his fellows, or can cultivate his difference.

Such societies are necessarily weak from the want of variety in their elements. But a *caste* nation is various and composite ; and has in a mode suited to early societies the constant co-operation of contrasted persons, which in a later age is one of the greatest triumphs of civilization. In a primitive age the division between the warrior caste and the priestly caste is especially advantageous. Little popular and little deserving to be popular nowadays as are priestly hierarchies, most probably the beginnings of science were made in such, and were for ages transmitted in such. An intellectual class was in that age only possible when it was protected by a notion that whoever hurt them would certainly be punished by heaven. In this class apart discoveries were slowly made and some beginning of mental discipline was slowly matured. But such a community is necessarily unwarlike, and the superstition which protects priests from home murder will not aid them in conflict with the foreigner. Few nations mind killing their enemies' priests, and many priestly civilizations have perished without record before they well began. But such a civilization will not perish if a warrior *caste* is tacked on to it and is bound to defend it. On the contrary, such a civilization will be singularly likely to live. The head of the sage will help the arm of the soldier.

That a nation divided into *castes* must be a most difficult thing to found is plain. Probably it could only begin in a country several times conquered, and where the boundaries of each caste rudely coincided with the

boundaries of certain sets of victors and vanquished. But, as we now see, when founded it is a likely nation to last. A party-colored community of many tribes and many usages is more likely to get on and help itself than a nation of a single lineage and one monotonous rule. I say " at first," because I apprehend that in this case, as in so many others in the puzzling history of progress, the very institutions which most aid at step number one are precisely those which most impede at step number two. The whole of a caste nation is more various than the whole of a non-caste nation, but each caste itself is more monotonous than anything is, or can be, in a non-caste nation. Gradually a habit of action and type of mind forces itself on each caste, and it is little likely to be rid of it, for all who enter it are taught in one way and trained to the same employment. Several non-caste nations have still continued to progress. But all caste nations have stopped early, though some have lasted long. Each color in the singular composite of these tesselated societies has an indelible and invariable shade.

Thirdly, we see why so few nations have made rapid advance, and how many have become stationary. It is in the process of becoming a nation, and in order to become such, that they subjected themselves to the influence which has made them stationary. They could not become a real nation without binding themselves by a fixed law and usage, and it is the fixity of that law and usage which has kept them as they were ever since. I wrote a whole essay on this before, so I need say nothing now ; and I only name it because it is one of the most important consequences of this view of society, if not indeed the most important.

Again, we can thus explain one of the most curious facts of the present world. " Manner," says a shrewd observer, who has seen much of existing life, " manner gets regularly worse as you go from the East to the West ; it is best in Asia, not so good in Europe, and altogether bad in the Western States of America." And the reason is this —an imposing manner is a dignified usage, which tends to preserve itself and also all other existing usages along with itself. It tends to induce the obedience of mankind. One of the cleverest novelists of the present day has a curious dissertation to settle why on the hunting-field, and in all collections of men, some men " snub and some men get snubbed ;" and why society recognizes in each case the ascendancy or the subordination as if it was right. " It is not at all," Mr. Trollope fully explains, " rare ability which gains the supremacy ; very often the ill-treated man is quite as clever as the man who ill-treats him. Nor does it absolutely depend on wealth ; for, though great wealth is almost always a protection from social ignominy, and will always insure a passive respect, it will not in a miscellaneous group of men of itself gain an active power to snub others. School-boys, in the same way," the

im... savage nature. They could not look steadily to a given end for an hour in their pre-historic state; and even now, when excited or when suddenly and wholly thrown out of their old grooves, they can scarcely do so. Even some very high races, as the French and the Irish, seem in troubled times hardly to be stable at all, but to be carried everywhere as the passions of the moment and the ideas generated at the hour may determine. But thoroughly to deal with such phenomena as these, we must examine the mode in which national characters can be emancipated from the rule of custom, and can be prepared for the use of choice.

V. THE AGE OF DISCUSSION.

THE greatest living contrast is between the old Eastern and customary civilizations and the new Western and changeable civilizations. A year or two ago an inquiry was made of our most intelligent officers in the East, not as to whether the English Government were really doing good in the East, but as to whether the natives of India themselves thought we were doing good; to which, in a majority of cases, the officers, who were the best authority, answered thus: "No doubt you are giving the Indians many great benefits: you give them continued peace, free trade, the right to live as they like, subject to the laws; in these points and others they are far better off than they ever were; but still they cannot make you out. What puzzles them is your constant disposition to change, or, as you call it, improvement. Their own life in every detail being regulated by ancient usage, they cannot comprehend a policy which is always bringing something new; they do not a bit believe that the desire to make them comfortable and happy is the root of it; they believe, on the contrary, that you are aiming at something which they do not understand—that you mean to 'take away their religion;' in a word, that the end and object of all these continual changes is to make Indians not what they are and what they like to be, but something new and different from what they are, and what they would not like to be." In the East, in a word, we are attempting to put new wine into old bottles—to pour what we can of a civilization whose spirit is progress into the form of a civilization whose spirit is fixity, and whether we shall succeed or not is perhaps the most interesting question in an age abounding almost beyond example in questions of political interest.

Historical inquiries show that the feeling of the Hindoos is the old feeling, and that the feeling of the Englishman is a modern feeling. "Old law rests," as Sir Henry Maine puts it, "not on contract but on status." The life of ancient civilization, so far as legal records go, runs back to a time when every important particular of life was settled by a usage which was social, political, and religious, as we should now say, all in one—which those who obeyed it could not have

been able to analyze, for those distinctions had no place in their mind and language, but which they felt to be a usage of imperishable import, and above all things to be kept unchanged. In former papers I have shown, or at least tried to show, why these customary civilizations were the only ones which suited an early society; why, so to say, they alone could have been first; in what manner they had in their very structure a decisive advantage over all competitors. But now comes the further question: If fixity is an invariable ingredient in early civilizations, how then did any civilization become unfixed? No doubt most civilizations stuck where they first were; no doubt we see now why stagnation is the rule of the world, and why progress is the very rare exception; but we do not learn what it is which has caused progress in these few cases, or the absence of what it is which has denied it in all others.

To this question history gives a very clear and very remarkable answer. It is that the change from the age of status to the age of choice was first made in states where the government was to a great and a growing extent a government by discussion, and where the subjects of that discussion were in some degree abstract, or, as we should say, matters of principle. It was in the small republics of Greece and Italy that the chain of custom was first broken. "Liberty said, Let there be light, and, like a sunrise on the sea, Athens arose," says Shelley, and his historical philosophy is in this case far more correct than is usual with him. A free state—a state with liberty—means a state, call it republic or call it monarchy, in which the sovereign power is divided between many persons, and in which there is a discussion among those persons. Of these the Greek republics were the first in history, if not in time, and Athens was the greatest of those republics.

After the event it is easy to see why the teaching of history should be this and nothing else. It is easy to see why the common discussion of common actions or common interests should become the root of change and progress. In early society, originality in life was forbidden and repressed by the fixed rule of life. It may not have been quite so much so in Ancient Greece as in some other parts of the world. But it was very much so even there. As a recent writer has well said, "Law then presented itself to men's minds as something venerable and unchangeable, as old as the city; it had been delivered by the founder himself, when he laid the walls of the city and kindled its sacred fire." An ordinary man who wished to strike out a new path, to begin a new and important practice by himself, would have been peremptorily required to abandon his novelties on pain of death; he was deviating, he would be told, from the ordinances imposed by the gods on his nation, and he must not do so to please himself. On the contrary others were deeply interested in his action. If he disobeyed, the gods might inflict

ns harm on all the people as well as him.
Each partner in the most ancient kind of
partnerships was supposed to have the power
of attracting the wrath of the divinities on
he entire firm, upon the other partners quite
s much as upon himself. The quaking by-
tanders in a superstitious age would soon
have slain an isolated bold man in the begin-
ning of his innovations. What Macaulay so
relied on as the incessant source of progress
—the desire of man to better his condition—
was not then permitted to work ; man was
required to live as his ancestors had lived.

Still further away from those times were
the "free thought" and the "advancing
sciences" of which we now hear so much.
The first and most natural subject upon
which human thought concerns itself is re-
ligion ; the first wish of the half-emancipated
thinker is to use his reason on the great
problems of human destiny—to find out
whence he came and whither he goes, to
form for himself the most reasonable idea of
God which he can form. But, as Mr. Grote
happily said—" This is usually what ancient
times would not let a man do. His *gens* or
his *φρατρια* required him to believe as they
believed." Toleration is of all ideas the
most modern, because the notion that the
sad religion of A cannot impair, here or
hereafter, the welfare of B, is, strange to
say, a modern idea. And the help of "sci-
ence," at that stage of thought, is still more
nugatory. Physical science, as we conceive
t—that is, the systematic investigation of
external nature in detail—did not then exist.
A few isolated observations on surface things
—a half-correct calendar, secrets mainly of
priestly invention, and in priestly custody—
were all that was then imagined ; the idea
of using a settled study of nature as a basis
for the discovery of new instruments and
new things did not then exist. It is indeed
modern idea, and is peculiar to a few Eu-
opean countries even yet. In the most in-
ellectual city of the ancient world, in its
most intellectual age, Socrates, its most in-
tellectual inhabitant, discouraged the study
of physics because they engendered uncer-
tainty and did not augment human happi-
ness. The kind of knowledge which is most
connected with human progress now was
that least connected with it then.

But a government by discussion, if it can
be borne, at once breaks down the yoke of
fixed custom. The idea of the two is incon-
sistent. As far as it goes, the mere putting
up of a subject to discussion, with the object
of being guided by that discussion, is a clear
admission that that subject is in no degree set-
led by established rule, and that men are
free to choose in it. It is an admission too
hat there is no sacred authority— no one
transcendent and divinely appointed man
whom in that matter the community is
bound to obey. And if a single subject or
group of subjects be once admitted to discus-
sion, erelong the habit of discussion comes
to be established, the sacred charm of use
and wont to be dissolved. "Democracy," it

has been said in modern times, " is like the
grave ; it takes, but it does not give." The
same is true of "discussion." Once you ac-
tually submit a subject to that ordeal,
you can never withdraw it again ; you
never again clothe it with mystery, or fe
it by consecration ; it remains forever o
to free choice, and exposed to profane d
eration.

The only subjects which can be first ad-
mitted, or which till a very late age of ci
zation can be submitted to discussion in
community, are the questions involving
visible and pressing interests of the
munity ; they are political questions of l
and urgent import. If a nation has in
considerable degree gained the habit and
hibited the capacity to discuss these q
tions with freedom, and to decide them w
discretion, to argue much on politics and
to argue ruinously, an enormous advance
other kinds of civilization may confide
be predicted for it. And the reason
plain deduction from the principles wh
we have found to guide early civilizat
The first pre-historic men were passio
savages, with the greatest difficulty coer
into order and compressed into a state.
ages were spent in beginning that order
rounding that state ; the only sufficient
effectual agent in so doing was consecra
custom ; but then that custom gathered o
everything, arrested all onward progress,
stayed the originality of mankind. If, th
fore, a nation is able to gain the benefit
custom without the evil—if after ages
waiting it can have order and choice toget
—at once the fatal clog is removed, and
ordinary springs of progress, as in a mod
community we conceive them, begin t
elastic action.

Discussion, too, has incentives to prog
peculiar to itself. It gives a premium to
telligence. To set out the arguments
quired to determine political action
such force and effect that they really sho
determine it, is a high and great exertio
intellect. Of course, all such arguments
produced under conditions : the argun
abstractedly best is not necessarily the w
ning argument. Political discussion
move those who have to act ; it mus
framed in the ideas and be consonant
the precedent of its time, just as it m
speak its language. But within these mar
conditions good discussion is better t
bad ; no people can bear a governmen
discussion for a day, which does not, wit
the boundaries of its prejudices and its id
prefer good reasoning to bad reasoning, so
argument to unsound. A prize for argu
tative mind is given in free states, to wh
no other states have anything to compare

Tolerance, too, is learned in discussi
and, as history shows, is only so learned.
all customary societies bigotry is the rul
principle. In rude places to this day
one who says anything new is looked on w
suspicion, and is persecuted by opinio
not injured by penalty. One of the grea

pains to human nature is the pain of a new idea. It is, as common people say, so "upsetting;" it makes you think that, after all, your favorite notions may be wrong, your firmest beliefs ill-founded; it is certain that till now there was no place allotted in your mind to the new and startling inhabitant, and now that it has conquered an entrance you do not at once see which of your old ideas it will or will not turn out, with which of them it can be reconciled, and with which it is at essential enmity. Naturally, therefore, common men hate a new idea, and are disposed more or less to ill-treat the original man who brings it. Even nations with long habits of discussion are intolerant enough. In England, where there is on the whole probably a freer discussion of a greater number of subjects than ever was before in the world, we know how much power bigotry retains. But discussion, to be successful, requires tolerance. It fails wherever, as in a French political assembly, any one who hears anything which he dislikes tries to howl it down. If we know that a nation is capable of enduring continuous discussion, we know that it is capable of practising with equanimity continuous tolerance.

The power of a government by discussion as an instrument of elevation plainly depends—other things being equal—on the greatness or littleness of the things to be discussed. There are periods when great ideas are "in the air," and when, from some cause or other, even common persons seem to partake of an unusual elevation. The age of Elizabeth in England was conspicuously such a time. The new idea of the Reformation in religion, and the enlargement of the *mœnia mundi* by the discovery of new and singular lands, taken together, gave an impulse to thought which few, if any, ages can equal. The discussion, though not wholly free, was yet far freer than in the average of ages and countries. Accordingly, every pursuit seemed to start forward. Poetry, science, and architecture, different as they are, and removed as they all are at first sight from such an influence as discussion, were suddenly started onward. Macaulay would have said you might rightly read the power of discussion "in the poetry of Shakespeare, in the prose of Bacon, in the oriels of Longleat, and the stately pinnacles of Burleigh." This is, in truth, but another case of the principle of which I have had occasion to say so much as to the character of ages and countries. If any particular power is much prized in an age, those possessed of that power will be imitated; those deficient in that power will be despised. In consequence an unusual quantity of that power will be developed, and be conspicuous. Within certain limits vigorous and elevated thought was respected in Elizabeth's time, and, therefore, vigorous and elevated thinkers were many; and the effect went far beyond the cause. It penetrated into physical science, for which very few men cared; and it began a reform in *philosophy* to which almost all

were then opposed. In a word, the tem of the age encouraged originality, and consequence original men started into pro nence, went hither and thither where t liked, arrived at goals which the age ne expected, and so made it ever memorable

In this manner all the great movement of thought in ancient and modern times h been nearly connected in time with gove ment by discussion. Athens, Rome, Italian republics of the Middle Ages, the *communes* and states-general of feudal Euro have all had a special and peculiar quick ing influence, which they owed to their fr dom, and which states without that freed have never communicated. And it has b at the time of great epochs of thought—the Peloponnesian war, at the fall of the man Republic, at the Reformation, at French Revolution—that such liberty speaking and thinking have produced t full effect.

It is on this account that the discussion savage tribes have produced so little effec emancipating those tribes from their desp customs. The oratory of the North Am can Indian—the first savage whose peculi ties fixed themselves in the public imaginat —has become celebrated, and yet the No American Indians were scarcely, if at better orators than many other savages. most all of the savages who have mel away before the Englishman were be speakers than he is. But the oratory of savages has led to nothing, and was likely lead to nothing. It is a discussion not principles, but of undertakings; its top are whether expedition A will answer, should be undertaken; whether expedit B will not answer, and should not be dertaken; whether village A is the best lage to plunder, or whether village B i better. Such discussions augment the v of language, encourage a debating facil and develop those gifts of demeanor and gesture which excite the confidence of hearers. But they do not excite the spe lative intellect, do not lead men to ur speculative doctrines, or to question anci principles. They, in some material respe improve the sheep within the fold; but t do not help them or incline them to leap of the fold.

The next question, therefore, is, Why discussions in some cases relate to prol ideas, and why did discussions in other ci relate only to isolated transactions? The ply which history suggests is very clear very remarkable. Some races of men at earliest knowledge of them have already quired the basis of a free constitution; t have already the rudiments of a comp polity—a monarch, a senate, and a gene meeting of citizens The Greeks were of those races, and it happened, as was n ural, that there was in process of time struggle, the earliest that we know of, tween the aristocratical party, origi represented by the senate, and the p party, represented by the "general me

als is plainly a question of principle, and being so has led to its history being written more than two thousand years afterward a very remarkable manner. Some seven-years ago an English country gentleman med Mitford, who, like so many of his e, had been terrified into aristocratic opinns by the first French Revolution, suddenly und that the history of the Peloponnesian ar was the reflex of his own time. He ok up his Thucydides, and there he saw, in a mirror, the progress and the struggles his age. It required some freshness of nd to see this; at least it had been hidden many centuries. All the modern histos of Greece before Mitford had but the guest idea of it; and not being a man of preme originality, he would doubtless have d very little idea of it either, except that analogy of what he saw helped him by a ling object-lesson to the understanding of at he read. Just as in every country of rope in 1793 there were two factions, one the old-world aristocracy, and the other the incoming democracy, just so there s in every city of ancient Greece, in the ar 400 B.C., one party of the many and an er of the few. This Mr. Mitford perved, and being a strong aristocrat, he ote a "history," which is little except a ty pamphlet, and which, it must be said, even now readable on that very account. e vigor of passion with which it was writ puts life into the words, and retains the ention of the reader. And that is not all. Grote, the great scholar whom we have lately to mourn, also recognizing the ntity between the struggles of Athens and arts and the struggles of our modern rld, and taking violently the contrary side that of Mitford, being as great a democrat Mitford was an aristocrat, wrote a reply.

above Mitford's history in power and rning, but being in its main characteristic ost identical, being above all things a book vigorous political passion, written for perls who care for politics, and not, as almost histories of antiquity are and must be, the ok of a man who cares for scholarship re than for anything else, written mainly not exclusively for scholars. And the ct of fundamental political discussion was same in ancient as in modern times. The ole customary ways of thought were at e shaken by it and shaken not only in closets of philosophers, but in the comn thought and daily business of ordinary n. The "liberation of humanity," as ethe used to call it—the deliverance of n from the yoke of inherited usage, and igid, unquestionable law—was begun in eece, and had many of its greatest effects, ld and evil, on Greece. It is just because he analogy between the controversies of t time and those of our times that some has said, "Classical history is a part of dern history; it is mediæval history only ich is ancient."

f there had been no discussion of princiin Greece, probably she would still have produced works of art. Homer contains no such discussion. The speeches in the "Iliad," which Mr. Gladstone, the most competent of living judges, maintains to be the finest ever composed by man, are not discussions of principle. There is no more tendency in them to critical disquisition than there is to political economy. In Herodotus you have the beginning of the age of discussion. He belongs in his essence to the age which is going out. He refers with reverence to established ordinance and fixed religion. Still, in his travels through Greece, he must have heard endless political arguments; and accordingly you can find in his book many incipient traces of abstract political disquisition. The discourses on democracy, aristocracy, and monarchy, which he puts into the mouth of the Persian conspirators when the monarchy was vacant, have justly been called absurd, as speeches supposed to have been spoken by those persons. No Asiatic ever thought of such things. You might as well imagine Saul or David speaking them as those to whom Herodotus attributes them. They are Greek speeches, full of free Greek discussion, and suggested by the experience, already considerable, of the Greeks in the results of discussion. The age of debate is beginning, and even Herodotus, the least of a wrangler of any man, and the most of a sweet and simple narrator, felt the effect. When we come to Thucydides, the results of discussion are as full as they have ever been; his light is pure, "dry light," free from the "humors" of habit, and purged from consecrated usage. As Grote's history often reads like a report to Parliament, so half Thucydides reads like a speech, or materials for a speech, in the Athenian Assembly. Of later times it is unnecessary to speak. Every page of Aristotle and Plato bears ample and indelible trace of the age of discussion in which they lived; and thought cannot possibly be freer. The deliverance of the speculative intellect from traditional and customary authority was altogether complete.

No doubt the "detachment" from prejudice, and the subjection to reason, which I ascribe to ancient Athens, only went down a very little way among the population of it. Two great classes of the people, the slaves and women, were almost excluded from such qualities; even the free population doubtless contained a far greater proportion of very ignorant and very superstitious persons than we are in the habit of imagining. We fix our attention on the best specimens of Athenian culture—on the books which have descended to us, and we forget that the corporate action of the Athenian people at various critical junctures exhibited the most gross superstition. Still, as far as the intellectual and cultivated part of society is concerned, the triumph of reason was complete; the minds of the highest philosophers were then as ready to obey evidence and reason as they have ever been since; probably they were more ready. The rule of custom over them at least had been wholly broken, and the

rimary conditions of intellectual progress
ere in that respect satisfied.

It may be said that I am giving too much
weight to the classical idea of human devel-
opment ; that history contains the record of
nother progress as well ; that in a certain
sense there was progress in Judæa as well as
Athens. And unquestionably there was
progress, but it was only progress upon a
ngle subject. If we except religious and
nit also all that the Jews had learned from
reigners, it may be doubted if there be
uch else new between the time of Samuel
id that of Malachi. In religion there was
rogress, but without it there was not any.
his was due to the cause of that progress.
ll over antiquity, all over the East, and over
her parts of the world which preserve more
less nearly their ancient condition, there
e two classes of religious teachers—one,
e priests, the inheritors of past accredited
spiration ; the other, the prophet, the
essesor of a like present inspiration. Cur-
us describes the distinction well in relation
the condition of Greece with which history
rst presents us :

" The mantic art is an institution totally
fferent from the priesthood. It is based
the belief that the gods are in constant
oximity to men, and in their government
the world, which comprehends everything
th great and small, will not disdain to
anifest their will ; nay, it seems necessary
at, whenever any hitch has arisen in the
ore! system of the human world, this
ould also manifest itself by some sign in
e world of nature, if only mortals are able
understand and avail themselves of these
vine hints.

" For this a special capacity is requisite ;
t a capacity which can be learned like a hu-
an art or science, but rather a peculiar state
grace 'n the case of single individuals and
ngle 1. milies whose ears and eyes are
ened to the divine revelations, and who
rticipate more largely than the rest of man-
nd in the divine spirit. Accordingly it is
eir office and calling to assert themselves
organs of the divine will ; they are justi-
d in opposing their authority to every
wer of the world. On this head conflicts
ere unavoidable, and the reminiscences liv-
g in the Greek people, of the agency of a
iresias and Calchas, prove how the Heroic
nge experienced not only support and aid,
it also opposition and violent protests, from
e mouths of the men of prophecy."

In Judæa there was exactly the same op-
sition as elsewhere. All that is new comes
om the prophets ; all which is old is re-
ined by the priests. But the peculiarity of
dæa—a peculiarity which I do not for a
oment pretend that I can explain—is that
e prophetic revelations are, taken as a
hole, indisputably improvements ; that
ey contain, as time goes on, at each suc-
eeding epoch, higher and better views of
ligion. But the peculiarity is not to my
esent purpose. My point is that there is
such spreading impetus in progress thus

caused as there is in progress caused by dis-
cussion. To receive a particular conclusion
upon the *ipse dixit*, upon the accepted author-
ity of an admired instructor, is obviously
not so vivifying to the argumentative and
questioning intellect as to argue out conclu-
sions for yourself. Accordingly the relig-
ious progress caused by the prophets did not
break down that ancient code of authoritative
usage. On the contrary, the two combined.
In each generation the conservative influence
" built the sepulchres," and accepted the
teaching of past prophets, even while it was
slaying and persecuting those who were liv-
ing. But discussion and custom cannot be
thus combined ; their " method," as modern
philosophers would say, is antagonistic.
Accordingly, the progress of the classical
states gradually awakened the whole intel-
lect ; that of Judæa was partial and improved
religion only. And, therefore, in a history
of intellectual progress, the classical fills the
superior and the Jewish the inferior place ;
just as in a special history of theology only,
the places of the two might be interchanged.

A second experiment has been tried on the
same subject-matter. The characteristic of
the Middle Ages may be approximately—
though only approximately—described as a
return to the period of authoritative usage and
as an abandonment of the classical habit of
independent and self-choosing thought. I do
not for an instant mean that this is an exact
description of the main mediæval character-
istic ; nor can I discuss how far that charac-
teristic was an advance upon those of previ-
ous times ; its friends say it is far better than
the peculiarities of the classical period ; its
enemies that it is far worse. But both
friends and enemies will admit that the most
marked feature of the Middle Ages may
roughly be described as I have described it.
And my point is that just as this mediæval
characteristic was that of a return to the es-
sence of the customary epoch which had
marked the pre-Athenian times, so it was
dissolved much in the same manner as the
influence of Athens, and other influences like
it, claim to have dissolved that customary
epoch.

The principal agent in breaking up the
persistent mediæval customs, which were so
fixed that they seemed likely to last forever,
or till some historical catastrophe over-
whelmed them, was the popular element in
the ancient polity which was everywhere
diffused in the Middle Ages. The Germanic
tribes brought with them from their ancient
dwelling-place a polity containing, like the
classical, a king, a council, and a popular
assembly ; and wherever they went, they
carried these elements and varied them, as
force compelled or circumstances required.
As far as England is concerned, the excellent
dissertations of Mr. Freeman and Mr. Stubbs
have proved this in the amplest manner, and
brought it home to persons who cannot claim
to possess much antiquarian learning. The
history of the English Constitution, as far
the world cares for it, is, in fact, the co

ex history of the popular element in this icient polity, which was sometimes weaker id sometimes stronger, but which has never ed out, has commonly possessed great ough varying power, and is now entirely edominant. The history of this growth is e history of the English people; and the scussions about this constitution and the scussions within it, the controversies as to structure and the controversies as to true effects, have mainly trained the Engih political intellect, in so far as it is ained. But in much of Europe, and in ngland particularly the influence of relign has been very different from what it as in antiquity. It has been an influence discussion. Since Luther's time there has en a conviction, more or less rooted, that a an may by an intellectual process think it a religion for himself, and that, as the ghest of all duties, he ought to do so. The fluence of the political discussion and the fluence of the religious discussion have en so long and so firmly combined, and ave so effectually enforced one another, iat the old notions of loyalty, and fealty, id authority, as they existed in the Middle ges, have now over the best minds almost effect.

It is true that the influence of discussion is t the only force which has produced this ast effect. Both in ancient and in modern mes other forces co-operated with it. rade, for example, is obviously a force hich has done much to bring men of different customs and different beliefs into close ontiguity, and has thus aided to change the istoms and the beliefs of them all. Coloniition is another such influence: it settles en among aborigines of alien race and sages, and it commonly compels the colosts not to be over-strict in the choice of ieir own elements, they are obliged to alesce with and "adopt" useful bands and ieful men, though their ancestral customs ay not be identical, nay, though they may , in fact, opposite to their own. In modn Europe, the existence of a cosmopolite burch claiming to be above nations, and ally extending through nations, and the attered remains of Roman law and Roman vilization co-operated with the liberating fluence of political discussion And so d other causes also. But perhaps in no se have these subsidiary causes alone been ile to generate intellectual freedom; cerinly in all the most remarkable cases the fluence of discussion has presided at the eation of that freedom, and has been acve and dominant in it.

No doubt apparent cases of exception may isily be found It may be said that in the ourt of Augustus there was much general itellectual freedom, an almost entire detach ient from ancient prejudice, but that there as no free political discussion at all But, ien, the ornaments of that time were deved from a time of great freedom: it was ie republic which trained the men whom ie empire ruled. The close congregation

of most miscellaneous elements under the empire was, no doubt, of itself unfavorable to inherited prejudice and favorable to intellectual exertion. Yet, except in the instance of the Church, which is a peculiar subject that requires a separate discussion, how little was added to what the republic left! The power of free interchange of ideas being wanting, the ideas themselves were barren. Also, no doubt, much intellectual freedom may emanate from countries of free political discussion, and penetrate to countries where that discussion is limited. Thus the intellectual freedom of France in the eighteenth century was in great part owing to the proximity of and incessant intercourse with England and Holland. Voltaire resided among us; and every page of the "Esprit des Lois" proves how much Montesquieu learned from living here. But, of course, it was only part of the French culture which was so derived: the germ might be foreign, but the tissue was native. And very naturally, for it would be absurd to call the ancien régime a government without discussion: discussion abounded there, only, by reason of the bad form of the government, it was never sure with ease and certainty to affect political action. The despotism "tempered by epigram," was a government which permitted argument of licentious freedom within changing limits, and which was ruled by that argument spasmodically and practically, though not in name or consistently.

But though in the earliest and in the latest time government by discussion has been a principal organ for improving mankind, yet, from its origin, it is a plant of singular delicacy. At first the chances are much against its living. In the beginning, the members of a free state are of necessity few. The essence of it requires that discussion shall be brought home to those members. But in early time, when writing is difficult, reading rare, and representation undiscovered, those who are to be guided by the discussion must hear it with their own ears, must be brought face to face with the orator, and must feel his influence for themselves. The first free states were little towns, smaller than any political division which we now have, except the Republic of Andorre, which is a sort of vestige of them. It is in the market-place of the country town, as we should now speak, and in petty matters concerning the markettown, that discussion began, and thither all the long train of its consequences may be traced back Some historical inquirers, like myself, can hardly look at such a place without some sentimental musing, poor and trivial as the thing seems. But such small towns are very feeble. Numbers in the earliest wars, as in the latest, are a main source of victory. And in early times one kind of state is very common and is exceedingly numerous. In every quarter of the globe we find great populations compacted by traditional custom and consecrated sentiment, which are ruled by some soldier—

generally some soldier of a foreign tribe, who has conquered them, and, as it has been said, "vaulted on the back" of them, or whose ancestors have done so. These great populations, ruled by a single will, have, doubtless, trodden down and destroyed innumerable little cities who were just beginning their freedom.

In this way the Greek cities in Asia were subjected to the Persian Power, and so *ought* the cities in Greece proper to have been subjected also. Every school-boy must have felt that nothing but amazing folly and unmatched mismanagement saved Greece from conquest both in the time of Xerxes and in that of Darius. The fortunes of intellectual civilization were then at the mercy of what seems an insignificant probability. If the Persian leaders had only shown that decent skill and ordinary military prudence which it was likely they would show, Grecian freedom would have been at an end. Athens, like so many Ionian cities on the other side of the Ægean, would have been absorbed into a great despotism ; all we now remember her for we should not remember, for it would never have occurred. Her citizens migh have been ingenious, and imitative, and clever ; they could not certainly have been free and original. Rome was preserved from subjection to a great empire by her fortunate distance from one. The early wars of Rome are with cities like Rome—about equal in size, though inferior in valor. It was only when she had conquered Italy that she began to measure herself against Asiatic despotisms. She became great enough to beat them before she advanced far enough to contend with them. But such great good fortune was and must be rare. Unnumbered little cities which might have rivalled Rome or Athens doubtless perished without a sign long before history was imagined. The small size and slight strength of early free states made them always liable to easy destruction.

And their internal frailty is even greater. As soon as discussion begins the savage propensities of men break forth ; even in modern communities, where those propensities, too, have been weakened by ages of culture, and repressed by ages of obedience, as soon as a vital topic for discussion is well started the keenest and most violent passions break forth. Easily destroyed as are early free states by forces from without, they are even more liable to destruction by forces from within. On this account such states are very rare in history. Upon the first view of the facts a speculation might even be set up that they were peculiar to a particular race. By far the most important free institutions, and the only ones which have left living representatives in the world, are the offspring either of the first constitutions of the classical nations or of the first constitutions of the Germanic nations. All living freedom runs back to them, and those truths which at first sight would seem the whole of historical freedom can be traced to them. And both the Germanic and the classical nations belong to

what ethnologists call the Aryan race. Plausibly it might be argued that the power of forming free states was superior in and peculiar to that family of mankind. But unfortunately for this easy theory the facts are inconsistent with it. In the first place, all the so-called Aryan race certainly is not free. The eastern Aryans—those, for example, who speak languages derived from the Sanscrit—are among the most slavish divisions of mankind. To offer the Bengalese a free constitution, and to expect them to work one, would be the maximum of human folly. There then must be something else besides Aryan descent which is necessary to fit men for discussion and train them for liberty ; and, what is worse for the argument we are opposing, some non-Aryan races have been capable of freedom. Carthage, for example, was a Semitic republic. We do not know all the details of its constitution, but we know enough for our present purpose. We know that it was a government in which many proposers took part, and under which discussion was constant, active, and conclusive. No doubt Tyre, the parent city of Carthage, the other colonies of Tyre besides Carthage, and the colonies of Carthage, were all as free as Carthage. We have thus a whole group of ancient republics of non-Aryan race, and one which, being more ancient than the classical republics, could not have borrowed from or imitated them. So that the theory which would make government by discussion the exclusive patrimony of a single race of mankind is on the face of it untenable.

I am not prepared with any simple counter theory. I cannot profess to explain completely why a very small minimum of mankind were, as long as we know of them, possessed of a polity which as time went on suggested discussions of principle, and why the great majority of mankind had nothing like it. This is almost as hopeless as asking why Milton was a genius and why Bacon was a philosopher. Indeed it is the same, because the causes which give birth to the startling varieties of individual character, and those which give birth to similar varieties of national character, are, in fact, the same. I have, indeed, endeavored to show that a marked type of individual character once originating in a nation and once strongly preferred by it, is likely to be fixed on it and to be permanent in it, from causes which were stated. Granted the beginning of the type, we may, I think, explain its development and aggravation ; but we cannot in the least explain why the incipient type of curious characters broke out, if I may so say, in one place rather than in another. Climate and "physical" surroundings, in the largest sense, have unquestionably much influence ; they are one factor in the cause, but they are not only factor : for we find most dissimilar races of men living in the same climate and affected by the same surroundings, and we have every reason to believe that those very races have so lived as neighbors for a

he cause of types must be something out-
de the tribe acting on something within—
)mething inherited by the tribe. But what
1at something is I do not know that any one
1n in the least explain.

The following conditions may, I think, be
1storically traced to the nation capable of a
olity, which suggests principles for discus-
on, and so leads to progress. First, the
ation must possess the *patria potestas* in
)ne form so marked as to give family life
1stinctness and precision, and to make a
) one education and a home discipline prob-
)le and possible. While descent is traced
)ly through the mother, and while the fam-
y is therefore a vague entity, no progress to a
gh polity is possible. Secondly, that polity
ould seem to have been created very grad-
ally; by the aggregation of families into
ans or *gentes*, and of clans into nations, and
1en again by the widening of nations, so as
) include circumjacent outsiders, as well as
1e first compact and sacred group—the
umber of parties to a discussion was at first
1gmented very slowly. Thirdly, the num-
er of "open" subjects—as we should say
owadays—that is, of subjects on which
ublic opinion was optional, and on which
scussion was admitted, was at first very
nall. Custom ruled everything originally,
1d the area of free argument was enlarged
ut very slowly. If I am at all right, that
rea could only be enlarged thus slowly, for
1stom was in early days the cement of so-
ety, and if you suddenly questioned such
1stom you would destroy society. But
1ough the existence of these conditions may
e traced historically, and though the reason
f them may be explained philosophically,
1ey do not completely solve the question
"by some nations have the polity and some
ot; on the contrary, they plainly leave a
1rge "residual phenomenon" unexplained
1d unknown.

Ii.

In this manner politics or discussion broke
p the old bonds of custom which were now
1rangling mankind, though they had once
ded and helped it. But this is only one of
1e many gifts which those polities have
onferred, are conferring, and will confer on
1ankind. I am not going to write an eulo-
ium on liberty, but I wish to set down three
oints which have not been sufficiently no-
ced.

Civilized ages inherit the human nature
hich was victorious in barbarous ages, and
1at nature is, in many respects, not at all
1ited to civilized circumstances. A main
1d principal excellence in the early times of
1e human race is the impulse to action.
he problems before men are then plain and
mple. The man who works hardest, the
1an who kills the most deer, the man who
1tches the most fish—even later on, the man
ho tends the largest herds, or the man who
lls the largest field—is the man who suc
2eds; the nation which is quickest to kill
s enemies, or which kills most of its ene-

mies, is the nation which succeeds. All the
inducements of early society tend to foster
immediate action; all its penalties fall on the
man who pauses; the traditional wisdom of
those times was never weary of inculcating
that "delays are dangerous," and that the
sluggish man—the man "who roasteth not
that which he took in hunting"—will not
prosper on the earth, and indeed will very
soon perish out of it. And in consequence
an inability to stay quiet, an irritable desire
to act directly, is one of the most conspic-
uous failings of mankind.

Pascal said that most of the evils of life
arose from "man's being unable to sit still
in a room;" and though I do not go that
length, it is certain that we should have been
a far wiser race than we are if we had been
readier to sit quiet—we should have known
much better the way in which it was best to
act when we came to act. The rise of phys
ical science, the first great body of practical
truth provable to al' men, exemplifies this in
the plainest way. If it had not been for
quiet people, who sat still and studied the
sections of the cone, if other quiet people
had not sat still and studied the theory of in-
finitesimals, or other quiet people had not
sat still and worked out the doctrine, of
chances, the most "dreamy moonshine," as
the purely practical mind would consider, of
all human pursuits: if "idle star-gazers"
had not watched long and carefully the mo-
tions of the heavenly bodies—our modern
astronomy would have been impossible, and
without our astronomy "our ships, our
colonies, our seamen," all which makes
modern life modern life could not have ex-
isted. Ages of sedentary, quiet, thinking
people were required before that noisy exist-
ence began, and without those pale prelim-
inary students it never could have been
brought into being. And nine tenths of
modern science is in this respect the same:
it is the produce of men whom their contem-
poraries thought dreamers—who were
laughed at for caring for what did not con-
cern them—who, as the proverb went,
"walked into a well from looking at the
stars"—who were believed to be useless, if
any one could be such. And the conclusion
is plain that if there had been more such peo-
ple, if the world had not laughed at those
there were, if rather it had encouraged them,
there would have been a great accumulation
of proved science ages before there was. It
was the irritable activity, the "wish to be
doing something," that prevented it. Most
men inherited a nature too eager and too
restless to be quiet and find out things;
and even worse—with their idle clamor they
"disturbed the brooding hen," they would
not let those be quiet who wished to be so,
and out of whose calm thought much good
might have come forth.

If we consider how much science has done
and how much it is doing for mankind, and
if the over-activity of men is proved to be
the cause why science came so late into the
world, and is so small and scanty still, that

will convince most people that our over-ac-
tivity is a very great evil. But this is only
part, and perhaps not the greatest part of the
harm that over-activity does. As I have
said, it is inherited from times when life was
simple, objects were plain, and quick action
generally led to desirable ends. If A kills B
before B kills A, then A survives, and the
human race is a race of A's. But the issues
of life are plain no longer. To act rightly in
modern society requires a great deal of pre-
vious study, a great deal of assimilated infor-
mation, a great deal of sharpened imagina-
tion ; and these prerequisites of sound ac-
tion require much time, and, I was going to
say, much "lying in the sun," a long period
of "mere passiveness." Even the art of
killing one another, which at first particular-
ly trained men to be quick, now requires
them to be slow. A hasty general is the
worst of generals nowadays ; the best is a
sort of Von Moltke, who is passive if any man
ever was passive ; who is "silent in seven
languages ;" who possesses more and better
accumulated information as to the best way
of killing people than any one who ever lived.
This man plays a restrained and considerate
game of chess with his enemy. I wish the
art of benefiting men had kept pace with
the art of destroying men ; for though war
has become slow, philanthropy has remained
hasty. The most melancholy of human re-
flections, perhaps, is that, on the whole, it is
a question whether the benevolence of man-
kind does most good or harm. Great good,
no doubt, philanthropy does, but then it also
does great evil. It augments so much vice,
it multiplies so much suffering, it brings to
life such great populations to suffer and to
be vicious, that it is open to argument
whether it be or be not an evil to the world,
and this is entirely because excellent people
fancy that they can do much by rapid action
—that they will most benefit the world when
they most relieve their own feelings ; that as
soon as an evil is seen "something" ought to
be done to stay and prevent it. One may in-
cline to hope that the balance of good over
evil is in favor of benevolence ; one can
hardly bear to think that it is not so ; but
anyhow it is certain that there is a most heavy
debit of evil, and that this burden might al-
most all have been spared us if philanthro-
pists as well as others had not inherited from
their barbarous forefathers a wild passion
for instant action.

Even in commerce, which is now the
main occupation of mankind, and one in
which there is a ready test of success and
failure wanting in many higher pursuits, the
same disposition to excessive action is very
apparent to careful observers. Part of every
mania is caused by the impossibility to get
people to confine themselves to the amount
of business for which their capital is suffi-
cient, and in which they can engage safely.
In some degree, of course, this is caused by
the wish to get rich ; but in a considerable
degree, too, by the mere love of activity.
There is a greater propensity to action in

such men than they have the means of grat
fying. Operations with their own capit
will only occupy four hours of the day, a
they wish to be active and to be industrio
for eight hours, and so they are ruined.
they could only have sat idle the other fo
hours, they would have been rich men. Tl
amusements of mankind, at least of the En
lish part of mankind, teach the same lesso
Our shooting, our hunting, our travellin
our climbing have become laborious pursuit
It is a common saying abroad that "an En
lishman's notion of a holiday is a fatiguin
journey ;" and this is only another way
saying that the immense energy and activi
which have given us our place in the wor
have in many cases descended to those w
do not find in modern life any mode of usu
that activity, and of venting that energy.

Even the abstract speculations of mankin
bear conspicuous traces of the same excessiv
impulse. Every sort of philosophy has be
systematized, and yet as these philosophi
utterly contradict one another, most of the
cannot be true. Unproved abstract principl
without number have been eagerly caught u
by sanguine men, and then carefully spu
out into books and theories, which were
explain the whole world. But the wor
goes clear against these abstractions, and
must do so, as they require it to go in anta
onistic directions. The mass of a system a
tracts the young and impresses the unwar
but cultivated people are very dubious abo
it. They are ready to receive hints and su
gestions, and the smallest real truth is ev
welcome. But a large book of deducti
philosophy is much to be suspected. N
doubt the deductions may be right ; in mo
writers they are so ; but where did the pr
mises come from ? Who is sure that th
are the whole truth, and nothing but t
truth, of the matter in hand ? Who is n
almost sure beforehand that they will co
tain a strange mixture of truth and err
and therefore that it will not be worth whi
to spend life in reasoning over their cons
quences. In a word, the superfluous energ
of mankind has flowed over into philosoph
and has worked into big systems what shou
have been left as little suggestions.

And if the old systems of thought are n
true as systems, neither is the new rev
from them to be trusted in its whole vig
There is the same original vice in that al
There is an excessive energy in revolutio
if there is such energy anywhere. The pe
sion for action is quite as ready to pull do
as to build up ; probably it is more read
for the task is easier.

"Old things need not be therefore true,
 O brother men, nor yet the new ;
 Ah, still awhile the old thought retain,
 And yet consider it again."

But this is exactly what the human mi
will not do. It will act somehow at on
It will not "consider it again."

But it will be said, What has govern
by discussion to do with these things?
it prevent them, or even mitigate the

can and do... do both in the very plainest way. If you want to stop instant and immediate action, always make it a condition that the action shall not begin till a considerable number of persons have talked over it, and have agreed on it. If those persons be people of different temperaments, different ideas, and different educations, you have an almost infallible security that nothing, or almost nothing, will be done with excessive rapidity. Each kind of persons will have their spokesman; each spokesman will have his characteristic objection, and each his characteristic counter-proposition, and so in the end nothing will probably be done, or at least only the minimum which is plainly urgent. In many cases this delay may be dangerous; in many cases quick action will be preferable. A campaign, as Macaulay well says, cannot be directed by a "debating society;" and many other kinds of action also require a single and absolute general. But for the purpose now in hand—that of preventing hasty action, and insuring elaborate consideration—there is no device like a polity of discussion.

The enemies of this object—the people who want to act quickly—see this very distinctly. They are forever explaining that the present is "an age of committees," that the committees do nothing, that all evaporates in talk. Their great enemy is parliamentary government; they call it, after Mr. Carlyle, the "national palaver;" they add up the hours that are consumed in it, and the speeches which are made in it, and they sigh for a time when England might again be ruled, as it once was, by a Cromwell—that is, when an eager, absolute man might do exactly what other eager men wished, and do it immediately. All these invectives are perpetual and many-sided; they come from philosophers, each of whom wants some new scheme tried; from philanthropists, who want some evil abated; from revolutionists, who want some old institution destroyed; from new æmists, who want their new æra started forthwith. And they all are distinct admissions that a polity of discussion is the greatest hindrance to the inherited mistake of human nature, to the desire to act promptly, which in a simple age is so excellent, but which in a later and complex time leads to so much evil.

The same accusation against our age sometimes takes a more general form. It is alleged that our energies are diminishing; that ordinary and average men have not the quick determination nowadays which they used to have when the world was younger; that not only do not committees and parliaments act with rapid decisiveness, but that no one now so acts. And I hope that in fact this is true, for, according to me, it proves that the hereditary barbaric impulse is decaying and dying out. So far from thinking the quality attributed to us a defect, I wish that those who complain of it were far more right than I much fear they are. Still, certainly, eager and violent action is somewhat diminished,

though only by a small faction of what ought to be. And I believe that this great part due, in England at least, to government by discussion, which has fost a general intellectual tone, a diffused sition to weigh evidence, a conviction much may be said on every side of eve thing which the elder and more fanatic of the world wanted. This is the real son why our energies seem so much less those of our fathers. When we have a nite end in view, which we know we w and which we think we know how to ob we can act well enough. The campaig our soldiers are as energetic as any paigns ever were; the speculations o merchants have greater promptitude, gr audacity, greater vigor than any such s lations ever had before. In old times a ideas got possession of men and communi but this is happily now possible no lon We see how incomplete these old ideas we how almost by chance one seized on one tion, and another on another; how often set of men have persecuted another set opinions on subjects of which neither, we n perceive, knew anything. It might be if a greater number of effectual demons tions existed among mankind; but whil such demonstrations exist, and while the dence which completely convinces one seems to another trifling and insufficient us recognize the plain position of inevita doubt. Let us not be bigots with a do and persecutors without a creed. We beginning to see this, and we are railed for so beginning. But it is a great bene and it is to the incessant prevalence of de tive discussion that our doubts are due; much of that discussion is due to the l existence of a government requiring cons debates, written and oral.

This is one of the unrecognized benefits free government, one of the modes in wh it counteracts the excessive inherited pulses of humanity. There is another for which it does the same, but which I only touch delicately, and which at first si will seem ridiculous The most success races, other things being equal, are th which multiply the fastest. In the confli of mankind numbers have ever been a g power. The most numerous group has ways had an advantage over the less num ous, and the fastest breeding group has ways tended to be the most numerous. consequence, human nature has descen into a comparatively uncontentious civili tion, with a desire far in excess of what needed; with a "felt want," as politi economists would say, altogether greater th the "real want." A walk in London is which is necessary to establish this. "T great sin of great cities" is one vast evil c sequent upon it. And who is to reckon how much these words mean? How ma spoiled lives, how many broken hearts, h many wasted bodies, how many ruined min how much misery pretending to be gay, h much gayety feeling itself to be miserat

how much after mental pain, how much eating and transmitted disease. And in the moral part of the world, how many minds are racked by incessant anxiety, how many thoughtful imaginations which might have left something to mankind are debased to mean cares, how much every successive generation sacrifices to the next, how little does any of them make of itself in comparison with what might be. And how many Irelands have there been in the world where men would have been contented and happy if they had only been fewer; how many more Irelands would there have been if the intrusive numbers had not been kept down by infanticide and vice and misery. How painful is the conclusion that it is dubious whether all the machines and inventions of mankind "have yet lightened the day's labor of a human being." They have enabled more people to exist, but these people work just as hard and are just as mean and miserable as the elder and the fewer.

But it will be said of this passion just as it was said of the passion of activity. Granted that it is in excess, how can you say, how on earth can any one say, that government by discussion can in any way cure or diminish it? ·Cure this evil that government certainly will not; but tend to diminish it—I think it does and may. To show that I am not making premises to support a conclusion so abnormal, I will quote a passage from Mr. Spencer, the philosopher who has done most to illustrate this subject:

"That future progress of civilization which the never-ceasing pressure of population must produce, will be accompanied by an enhanced cost of Individuation, both in structure and function; and more especially in nervous structure and function. The peaceful struggle for existence in societies ever growing more crowded and more complicated, must have for its concomitant an increase of the great nervous centres in mass, in complexity, in activity. The larger body of emotion needed as a fountain of energy for men who have to hold their places and rear their families under the intensifying competition of social life, is, other things equal, the correlative of larger brain. Those higher feelings presupposed by the better self-regulation which, in a better society, can alone enable the individual to leave a persistent posterity, are, other things equal, the correlatives of a more complex brain; as are also those more numerous, more varied, more general, and more abstract ideas, which must also become increasingly requisite for successful life as society advances. And the genesis of this larger quantity of feeling and thought in a brain thus augmented in size and developed in structure, is, other things equal, the correlative of a greater wear of nervous tissue and greater consumption of materials to repair it. So that both in original cost of construction and in subsequent cost of working, the nervous system must become a heavier tax on the organism. Already the brain of the civilized man is larger by nearly thirty per cent than the brain of the savage. Already, too, it presents an increased heterogeneity—especially in the distribution of its convolutions. And further changes like these which have taken place under the discipline of civilized life, we infer will continue to take place. . . . But everywhere and always, evolution is antagonistic to procreative dissolution. Whether it be in greater growth of the organs which subserve self-maintenance, whether it be in their added complexity of structure, or whether it be in their higher activity, the abstraction of the required materials implies a diminished reserve of materials for race-maintenance. And we have seen reason to believe that this antagonism between Individuation and Genesis becomes unusually marked where the nervous system is concerned, because of the costliness of nervous structure and function. In § 346 was pointed out the apparent connection between high cerebral development and prolonged delay of sexual maturity; and in §§ 366, 367, the evidence went to show that where exceptional fertility exists there is sluggishness of mind, and that where there has been during education excessive expenditure in mental action, there frequently follows a complete or partial infertility. Hence the particular kind of further evolution which Man is hereafter to undergo, is one which, more than any other, may be expected to cause a decline in his power of reproduction."

This means that men who have to live an intellectual life, or who can be induced to lead one, will be likely not to have so many children as they would otherwise have had. In particular cases this may not be true; such men may even have many children—they may be men in all ways of unusual power and vigor. But they will not have their maximum of posterity—will not have so many as they would have had if they had been careless or thoughtless men; and so, upon an average, the issue of such intellectualized men will be less numerous than those of the unintellectual.

Now, supposing this philosophical doctrine to be true—and the best philosophers, I think, believe it—its application to the case in hand is plain. Nothing promotes intellect like intellectual discussion, and nothing promotes intellectual discussion so much as government by discussion. The perpetual atmosphere of intellectual inquiry acts powerfully, as every one may see by looking about him in London, upon the constitution both of men and women. There is only a certain *quantum* of power in each of our race; if it goes in one way it is spent, and cannot go in another. The intellectual atmosphere abstracts strength to intellectual matters; it tends to divert that strength which the circumstances of early society directed to the multiplication of numbers; and as a polity of discussion tends, above all things, to produce an intellectual atmosphere, the two things which seemed so far off have been shown to be near, and free government

) a second case, been shown to tend to cure
n inherited excess of human nature.

Lastly, a polity of discussion not only
ends to diminish our inherited defects, but
lso, in one case at least, to augment a herit-
ble excellence. It tends to strengthen and
ncrease a subtle quality or combination of
ualities singularly useful in practical life—
quality which it is not easy to describe ex-
ctly, and the issues of which it would re-
uire not a remnant of an essay, but a whole
ssay to elucidate completely. This quality
call *animated moderation.*

If any one were asked to describe what it
s which distinguishes the writings of a man
f genius who is also a great man of the
rorld from all other writings, I think he
rould use these same words, "animated
noderation." He would say that such writ-
ngs are never slow, are never excessive, are
ever exaggerated ; that they are always in-
tinct with judgment, and yet that judgment
s never a dull judgment : that they have as
nuch spirit in them as would go to make a
vild writer, and yet that every line of them
s the product of a sane and sound writer.
The best and almost perfect instance of this
n English is Scott. Homer was perfect in
t, as far as we can judge ; Shakespeare is
ften perfect in it for long together, though
hen, from the defects of a bad education
nd a vicious age, all at once he loses him-
elf in excesses. Still, Homer and Shake-
peare at his best, and Scott, though in other
espects so unequal to them, have this remark-
ble quality in common—this union of life
vith measure, of spirit with reasonableness.

In action it is equally this quality in which
he English—at least so I claim it for them
—excel all other nations. There is an in-
inite deal to be laid against us, and as we are
mpopular with most others, and as we are
ilways grumbling at ourselves, there is no
want of people to say it. But, after all, in a
certain sense, England is a success in the
world ; her career has had many faults, but
still it has been a fine and winning career
upon the whole. And this on account of the
exact possession of this particular quality.
What is the making of a successful mer-
chant ? That he has plenty of energy and
yet that he does not go too far. And if you
ask for a description of a great practical
Englishman, you will be sure to have this,
or something like it : " Oh, he has plenty of
go in him ; but he knows when to pull up."
He may have all other defects in him ; he
may be coarse, he may be illiterate, he may
be stupid to talk to ; still this great union of
spur and bridle, of energy and moderation,
will remain to him. Probably he will hardly
be able to explain why he stops when he
does stop, or why he continued to move as
long as he, in fact, moved ; but still, as by a
rough instinct, he pulls up pretty much
where he should, though he was going at
such a pace before.

There is no better example of this quality
in English statesmen than Lord Palmerston.
There are of course many most serious ac-

cusations to be made against him. The sort
homage with which he was regarded in
last years of his life has passed away ;
spell is broken, and the magic cannot
again revived. We may think that his
formation was meagre, that his imaginat
was narrow, that his aims were short-sigh
and faulty. But though we may often
ject to his objects, we rarely find much
criticise in his means. " He went," it
been said, " with a great swing :" but
never tumbled over ; he always managed
pull up " before there was any danger."
was an odd man to have inherited Ha
den's motto ; still, in fact, there was a g
trace in him of *mediocria firma*—as muc
probably, as there could be in any one
such great vivacity and buoyancy.

It is plain that this is a quality which,
much as, if not more than, any other mul
plies good results in practical life. It
ables men to see what is good ; it gives th
intellect enough for sufficient percepti
but it does not make men all intellect
does not " sickly them o'er with the
cast of thought ;" it enables them to do
good things they see to be good, as well
to see that they are good. And it is plain
a government by popular discussion te
to produce this quality. A strongly idios
cratic mind violently disposed to extre
of opinion is soon weeded out of politi
life, and a bodiless thinker, an ineffect
scholar, cannot even live there for a day.
vigorous moderateness in mind and body
the rule of a polity which works by disc
sion ; and, upon the whole, it is the kind
temper most suited to the active life of 'su
a being as man in such a world as the p
ent one.

These three great benefits of free gove
ment, though great are entirely seconda
to its continued usefulness in the mode
which it originally was useful. The fi
great benefit was the deliverance of
kind from the superannuated yoke of cu
tomary law, by the gradual development
an inquisitive originality. And it continu
to produce that effect upon persons a
parently far remote from its influence, a
on subjects with which it has nothing to c
Thus, Mr. Mundella, a most experienced a
capable judge, tells us that the English ar
san, though so much less sober, less instru
ed and less refined than the artisans of son
other countries, is yet more inventive th
any other artisan. The master will get m
good suggestions from him than from a
other.

Again, upon plausible grounds—lookir
for example, to the position of Locke a
Newton in the science of the last centu
and to that of Darwin in our own—it m
be argued that there is some quality in En
lish thought which makes them strike out
many, if not more, first-rate and original s
gestions than nations of greater scientific c
ture and of a more diffused scientific interest.
both cases I believe the reason of the E
lish originality to be that government by

cassion quickens and enlivens thought all through society; that it makes people think no harm may come of thinking; that in England this force has long been operating, and so it has developed more of all kinds of people ready to use their mental energy in their own way, and not ready to use it in any other way than a despotic government. And so rare is great originality among mankind, and so great are its fruits, that this one benefit of free government probably outweighs what are in many cases its accessory evils. Of itself it justifies, or goes far to justify, our saying with Montesquieu. "Whatever be the cost of this glorious liberty, we must be content to pay it to heaven."

VI. VERIFIABLE PROGRESS POLITICALLY CONSIDERED.

The original publication of these essays was interrupted by serious illness and by long consequent ill-health, and now that I am putting them together, I wish to add another which shall shortly explain the main thread of the argument which they contain. In doing so there is a risk of tedious repetition, but on a subject both obscure and important, any defect is better than an appearance of vagueness.

In a former essay I attempted to show that slighter causes than is commonly thought may change a nation from the stationary to the progressive state of civilization, and from the stationary to the degrading. Commonly the effect of the agent is looked on in the wrong way. It is considered as operating on every individual in the nation, and it is assumed, or half assumed, that it is only the effect which the agent directly produces on every one that need be considered. But besides this diffused effect of the first impact of the cause, there is a second effect, always considerable, and commonly more potent—a new model in character is created for the nation; those characters which resemble it are encouraged and multiplied; those contrasted with it are persecuted and made fewer. In a generation or two, the look of the nation becomes quite different; the characteristic men who stand out are different, the men imitated are different · the result of the imitation is different. A lazy nation may be changed into an industrious, a rich into a poor, a religious into a profane, as if by magic, if any single cause, though slight, or any combination of causes, however subtle, is strong enough to change the favorite and detested types of character.

This principle will, I think, help us in trying to solve the question why so few nations have progressed, though to us progress seems so natural—what is the cause or set of causes which have prevented that progress in the vast majority of cases, and produced it in the feeble minority. But there is a preliminary difficulty: What is progress, and what is decline? Even in the animal world there is no applicable rule accepted by physiologists, which settles what animals are higher or lower than others; there are controversies about it. Still more then in the more complex combinations and politics of human beings it is likely to be hard to find an agreed criterion for saying which nation is before another, or what age of a nation was marching forward and which was falling back. Archbishop Manning would have one rule of progress and decline; Professor Huxley, in most important points, quite an opposite rule; what one would set down as an advance, the other would set down as retreat. Each has a distinct end which wishes and a distinct calamity which he fears, but the desire of the one is pretty nearly the fear of the other; books would not hold the controversy between them. Again, in art, who is to settle what is advance and what decline? Would Mr. Ruskin agree with any one else on this subject, would he even agree with himself, or could any common inquirer venture to say whether he was right or wrong?

I am afraid that I must, as Sir William Hamilton used to say, "truncate a problem which I cannot solve." I must decline to sit in judgment on disputed points of art morals, or religion. But without so doing I think there is such a thing as "verifiable progress," if we may say so—that is, progress which ninety-nine hundredths or more of mankind will admit to be such, against which there is no established or organized opposition creed, and the objectors to which essentially varying in opinion themselves and believing one one thing and another the reverse, may be safely and altogether rejected.

Let us consider in what a village of English colonists is superior to a tribe of Australian natives who roam about them. Indisputably in one, and that a main sense they are superior. They can beat the Australians in war when they like; they can take from them anything they like, and kill any of them they choose. As a rule, in all the outlying and uncontested districts of the world, the aboriginal native lies at the mercy of the intruding European. Nor is this all. Indisputably in the English village there are more means of happiness, a greater accumulation of the instruments of enjoyment than in the Australian tribe. The English have all manner of books, utensils, and machines which the others do not use, value, or understand. And in addition, and beyond particular inventions, there is a general strength which is capable of being used in conquering a thousand difficulties, and is a abiding source of happiness, because those who possess it always feel that they can use it.

If we omit the higher but disputed topic of morals and religion, we shall find, I think, that the plainer and agreed on superiorities of the Englishmen are these: first that they have a greater command over the powers of nature upon the whole. Though they may fall short of individual Australia in certain feats of petty skill, though they may not throw the boomerang as well, light a fire with earth-sticks as well. You

the whole twenty Englishmen with their im-
plements and skill can change the material
world immeasurably more than twenty Aus-
tralians and their machines. Secondly, that
this power is not external only ; it is also in-
ternal. The English not only possess better
machines for moving nature but are them-
selves better machines. Mr. Babbage taught
us years ago that one great use of machinery
was not to augment the force of man, but
to register and regulate the power of man ;
and this in a thousand ways civilized man
can do, and is ready to do, better and more
precisely than the barbarian. Thirdly, civil-
ized man not only has greater powers over
nature, but knows better how to use them,
and by better I here mean better for the health
and comfort of his present body and mind.
He can lay up for old age, which a savage,
having no durable means of sustenance, can-
not ; he is ready to lay up because he can dis
tinctly foresee the future, which the vague,
minded savage cannot : he is mainly desirous
of gentle, continuous pleasure, whereas the
barbarian likes wild excitement and longs
for stupefying repletion. Much, if not all, of
these three ways may be summed up in Mr.
Spencer's phrase, that progress is an in-
crease of adaptation of man to his environ-
ment—that is, of his internal powers and
wishes to his external lot and life. Some-
thing of it too is expressed in the old pagan
idea, " Mens sana in corpore sano." And I
think this sort of progress may be fairly in-
vestigated quite separately, as it is progress
in a sort of good every one worth reckoning
with admits and agrees in. No doubt there
will remain people like the aged savage,
who in his old age went back to his savage
tribe and said that he had " tried civilization
for forty years, and it was not worth the
trouble." But we need not take account of
the mistaken ideas of unfit men and beaten
races. On the whole the plainer sort of civ-
ilization, the simpler moral training, and the
more elementary education are plain benefits.
And though there may be doubt as to the
edges of the conception, yet there certainly
is a broad road of " verifiable progress"
which not only discoverers and admirers will
like, but which all those who come upon it
will use and value.

Unless some kind of abstraction like this
is made in the subject, the great problem
" What causes progress?" will, I am confi-
dent, long remain unsolved. Unless we are
content to solve simple problems first, the
whole history of philosophy teaches that we
shall never solve hard problems. This is
the maxim of scientific humility so often
insisted on by the highest inquirers that, in
investigations, as in life, those " who exalt
themselves shall be abased, and those who
humble themselves shall be exalted ;" and
though we may seem mean only to look for
the laws of plain comfort and simple present
happiness, yet we must work out that simple
case first, before we encounter the incredibly
harder additional difficulties of the higher
art, morals and religion.

The difficulty of solving the problem
thus limited is exceedingly great. The
palpable facts are exactly the cont
what we should expect. Lord M
tells us that " in every experimental
there is a tendency toward perfection.
every human being there is a tenden
ameliorate his condition ;" and these
principles operating everywhere and alv
might well have been expected to "
mankind rapidly forward." Indeed,
verifiable progress in the sense which
just been given to it, we may say that
ture gives a prize to every single step
Every one that makes an invention that
efits himself or those around him, is l
to be more comfortable himself and t
more respected by those around him.
produce new things, " serviceable to
life and conducive to man's estate," it
should say, likely to bring increased h
ness to the producer. It often bring
mense reward certainly now ; a new
of good steel pen, a way of making
kind of clothes a little better or a l
cheaper, have brought men great fortu
And there is the same kind of prize for
dustrial improvement in the earliest time
in the latest ; though the benefits so obtain
in early society are poor indeed in com
son with those of advanced society. No
is like a schoolmaster, at least in this,
gives her finest prizes to her high and
instructed classes. Still, even in the earl
society, nature helps those who can
themselves, and helps them very much.

All this should have made the progre
mankind—progress at least in this lin
sense—exceedingly common ; but, in
any progress is extremely rare. As a rule
as has been insisted on before) a statio
state is by far the most frequent conditic
man, as far as history describes that c
tion ; the progressive state is only a rar
an occasional exception.

Before history began there must have
in the nation which writes it much prog
else there could have been no history.
a great advance in civilization to be ab
describe the common facts of life, and
haps, if we were to examine it, we sh
find that it was at least an equal advan
wish to describe them. But very few r
have made this step of progress ; very
have been capable even of the meanest
of history ; and as for writing such a his
as that of Thucydides, most nations coul
soon have constructed a planet. When
tory begins to record, she finds most of
races incapable of history, arrested, un
gressive, and pretty much where they
now.

Why, then, have not the obvious and
ural causes of progress (as we should
them) produced those obvious and nat
effects? Why have the real fortunes of n
kind been so different from the fort
which we should expect? This is the p
lem which in various forms I have taken
in these papers, and this is the outline of

solution which I have attempted to propose.

The progress of *man* requires the co-operation of *men* for its development. That which any one man or any one family could invent for themselves is obviously exceedingly limited. And even if this were not true, isolated progress could never be traced. The rudest sort of co-operative society, the lowest tribe and the feeblest government, is so much stronger than isolated man that isolated man (if he ever existed in any shape which could be called man) might very easily have ceased to exist. The first principle of the subject is that man can only make progress in "co-operative groups;" I might say tribes and nations, but I use the less common word because few people would at once see that tribes and nations *are* co-operative groups, and that it is their being so which makes their value; that unless you can make a strong co-operative bond your society will be conquered and killed out by some other society which has such a bond; and the second principle is that the members of such a group should be similar enough to one another to co-operate easily and readily together. The co-operation in all such cases depends on a *felt union* of heart and spirit; and this is only felt when there is a great degree of real likeness in mind and feeling, however that likeness may have been attained.

This needful co-operation and this requisite likeness I believe to have been produced by one of the strongest yokes (as we should think if it were to be reimposed now) and the most terrible tyrannies ever known among men—the authority of "customary law." In its earlier stage this is no pleasant power—no "rose-water" authority, as Carlyle would have called it—but a stern, incessant, implacable rule. And the rule is often of most childish origin, beginning in a casual superstition or local accident. "These people," says Captain Palmer of the Fiji, "are very conservative. A chief was one day going over a mountain-path followed by a long string of his people, when he happened to stumble and fall; all the rest of the people immediately did the same except one man, who was set upon by the rest to know whether he considered himself better than the chief." What can be worse than a life regulated by that sort of obedience and that sort of imitation? This is, of course, a bad specimen, but the nature of customary law as we everywhere find it in its earliest stages is that of coarse casual comprehensive usage, beginning, we cannot tell how, deciding, we cannot tell why, but ruling every one in almost every action with an inflexible grasp.

The necessity of thus forming co-operative groups by fixed customs explains the necessity of isolation in early society. As a matter of fact, all great nations have been prepared in privacy and in secret. They have been composed far away from all distraction. Greece, Rome, Judæa, were framed each by itself, and the antipathy of each to

men of different race and different speech is one of their most marked peculiarities, and quite their strongest common property. And the instinct of early ages is a right guide for the needs of early ages. Intercourse with foreigners then broke down in states the fixed rules which were forming their characters, so as to be a cause of weak fibre of mind, of desultory and unsettled action; the living spectacle of an admitted unbelief destroys the binding authority of religious custom and snaps the social cord.

Thus we see the use of a sort of "preliminary" age in societies, when trade is bad because it prevents the separation of nations, because it infuses distracting ideas among occupied communities, because it "brings alien minds to alien shores." And as the trade which we now think of as an incalculable good is in that age a formidable evil and destructive calamity, so war and conquest, which we commonly and justly see to be now evils, are in that age often singular benefits and great advantages. It is only by the competition of customs that bad customs can be eliminated and good customs multiplied. Conquest is the premium given by nature to those national characters which their national customs have made most fit to win in war, and in many most material respects those winning characters are really the best characters. The characters which do win in war are the characters which we should wish to win in war.

Similarly, the best institutions have a natural military advantage over bad institutions. The first great victory of civilization was the conquest of nations with ill-defined families, having legal descent through the mother only by nations of definite families tracing descent through the father as well as the mother, or through the father only. Such compact families are a much better basis for military discipline than the ill-bound families which indeed seem hardly to be families at all, where "paternity" is, for tribal purposes, an unrecognized idea, and where only the physical fact of "maternity" is thought to be certain enough to be the foundation of law or custom. The nations with a thoroughly compacted family system have "possessed the earth"—that is, they have taken all the finest districts in the most competed-for parts; and the nations with loose systems have been merely left to mountain ranges and lonely islands. The family system and that in its highest form has been so exclusively the system of civilization, that literature hardly recognizes any other, and that, if it were not for the living testimony of a great multitude of scattered communities which are "fashioned after the structure of the elder world," we should hardly admit the possibility of something so contrary to all which we have lived among, and which we have been used to think of. After such an example of the fragmentary nature of the evidence, it is in comparison easy to believe that hundreds of strange institutions have passed away and have left behind

not only no memorial, but not even a trace or a vestige to help the imagination to figure what they were.

I cannot expand the subject, but in the same way the better religions have had a great physical advantage, if I may say so, over the worse. They have given what I may call a *confidence in the universe*. The savage subjected to a mean superstition is afraid to walk simply about the world—he cannot do *this* because it is ominous, or he must do *that* because it is lucky, or he cannot do anything at all till the gods have spoken and given him leave to begin. But under the higher religions there is no similar slavery and no similar terror. The belief of the Greek

ὅ, αἰωνος ἄριστος ἀμύνεσθαι περὶ πάτρης ;

the belief of the Roman that he was to trust to the gods of Rome, for those gods are stronger than all others ; the belief of Cromwell's soldiery that they were "to trust in God and keep their powder dry," are great steps in upward progress, using progress in its narrowest sense. They all enabled those who believed them "to take the world as it comes," to be guided by no unreal reason, and to be limited by no mystic scruple ; whenever they found anything to do, to do it with their might. And more directly what I may call the *fortifying* religions—that is to say, those which lay the plainest stress on the manly parts of morality—upon valor, on truth and industry—have had plainly the most obvious effect in strengthening the races which believed them, and in making those races the winning races.

No doubt many sorts of primitive improvement are pernicious to war ; an exquisite sense of beauty, a love of meditation, a tendency to cultivate the force of the mind at the expense of the force of the body, for example, help in their respective degrees to make men less warlike than they would otherwise be. But these are the virtues of other ages. The first work of the first ages is to bind men together in the strong bound of a rough, coarse, harsh custom ; and the incessant conflict of nations effects this in the best way. Every nation is an "hereditary co-operative group," bound by a fixed custom ; and out of those groups those conquer which have the most binding and most invigorating customs, and these are, as a rough rule, the best customs The majority of the "groups" which win and conquer are better than the majority of those which fail and perish, and thus the first world grew better and was improved.

This early customary world no doubt continued for ages. The first history delineates great monarchies, each composed of a hundred customary groups, all of which believed themselves to be of enormous antiquity, and all of which must have existed for very many generations. The first historical world is not a new-looking thing but a very ancient, and according to principle it is necessary that it should exist for ages. If human na-

ture was to be gradually improved, each generation must be born better tamed, more calm, more capable of civilization—in a word, more *legal* than the one before it, and such inherited improvements are always slow and dubious. Though a few gifted people may advance much, the mass of each generation can improve but very little on the generation which preceded it ; and even the slight improvement so gained is liable to be destroyed by some mysterious atavism—some strange recurrence to a primitive past. Long ages of dreary monotony are the first fact in the history of human communities, but those ages were not lost to mankind, for it was then that was formed the comparatively gentle and guidable thing which we now call human nature.

And indeed the greatest difficulty is not in preserving such a world, but in ending it. We have brought in the yoke of custom to improve the world, and in the world the custom sticks. In a thousand cases—in the great majority of cases—the progress of mankind has been arrested in this its earliest shape ; it has been closely embalmed in a mummy-like imitation of its primitive existence. I have endeavored to show in what manner, and how slowly, and in how few cases the yoke of custom was removed. It was "government by discussion" which broke the bonds of ages and set free the originality of mankind. Then, and then only, the motive which Lord Macaulay counted on to secure the progress of mankind, in fact, begin to work ; then "the tendency in every man to ameliorate his condition" begins to be important, because then man can alter his condition while before he is pegged down by ancient usage ; then the tendency in each mechanical art toward perfection begins to have force, because then the artist is at last allowed to seek perfection, after having been forced for ages to move in the straight furrow of the old fixed way.

As soon as this great step upward is once made, all or almost all the higher gifts and graces of humanity have a rapid and a definite effect on "veritable progress"—on progress in the narrowest, because in the most universally admitted sense of the term Success in life, then, depends, as we have seen, more than anything else on "animated moderation," on a certain combination of energy of mind and balance of mind, hard to attain and harder to keep. And this subtle excellence is aided by all the finer graces of humanity. It is a matter of common observation that, though each separate, a taste and fine judgment go very much together, and especially that a man with gross want of taste, though he may act sensibly and correctly for a while, is yet apt to break out, sooner or later, into gross practical error. In metaphysics, probably both taste and judgment involve what is termed "poise of mind"—that is, the power of true passiveness—the faculty of "waiting" till the stream of impressions, whether those of life or those of art, have done all that they have

to do, and cut their full type plainly upon the mind. The ill-judging and the untasteful are both over-eager; both move too quick and blur the image. In this way the union between a subtle sense of beauty and a subtle discretion in conduct is a natural one, because it rests on the common possession of a fine power, though, in matter of fact, that union may be often disturbed. A complex sea of forces and passions troubles men in life and action, which in the calmer region of art are hardly to be felt at all. And, therefore the cultivation of a fine taste tends to promote the function of a fine judgment, which is a main help in the complex world of civilized existence. Just so too the manner in which the more delicate parts of religion daily work in producing that "moderation" which, upon the whole, and as a rule, is essential to long success, defining success even in its most narrow and mundane way, might be worked out in a hundred cases, though it would not suit these pages. Many of the finer intellectual tastes have a similar restraining effect; they prevent, or tend to prevent, a greedy voracity after the good things of life, which makes both men and nations in excessive haste to be rich and famous, often makes them do too much and do it ill, and so often leaves them at last without money and without respect.

But there is no need to expand this further. The principle is plain that, though these better and higher graces of humanity are impediments and incumbrances in the early fighting period, yet that in the later era they are among the greatest helps and benefits, and that as soon as governments by discussion have become strong enough to secure a stable existence, and as soon as they have broken the fixed rule of old custom, and have awakened the dormant inventiveness of men, then, for the first time, almost every part of human nature begins to spring forward, and begins to contribute its quota even to the narrowest, even to "verifiable" progress. And this is the true reason of all those panegyrics on liberty which are often so measured in expression but are in essence so true to life and nature. Liberty is the strengthening and developing power—the light and heat of political nature; and when some "Cæsarism" exhibits, as it sometimes will, an originality of mind, it is only because it has managed to make its own the products of past free times or neighboring free countries; and even that originality is only brief and frail, and after a little while when test-

ed by a generation or two, in time of need it falls away.

In a complete investigation of all the conditions of "verifiable progress," much else would have to be set out: for example science has secrets of her own. Nature does not wear her most useful lessons on her sleeve; she only yields her most productive secrets, those which yield the most wealth and the most "fruit," to those who have gone through a long process of preliminary abstraction. To make a person really understand the "laws of motion" is not easy, and to solve even simple problems in abstract dynamics is to most people exceedingly hard. And yet it is on these out-of-the-way investigations, so to speak, that the art of navigation, all physical astronomy, and all the theory of physical movements at least depend. But no nation would beforehand have thought that in so curious a manner such great secrets were to be discovered. And many nations, therefore, which get on the wrong track may be distanced—supposing there to be no communication—by some nation not better than any of them which happens to stumble on the right track. If there were no 'Bradshaw" and no one knew the time at which trains started, a man who caught the express would not be a wiser or a more business-like man than he who missed it, and yet he would arrive whole hours sooner at the capital both are going to. And unless I misread the matter, such was often the case with early knowledge. At any rate before a complete theory of "verifiable progress" could be made, it would have to be settled whether this is so or not, and the conditions of the development of physical science would have to be fully stated; obviously you cannot explain the development of human comfort unless you know the way in which men learn and discover comfortable things. Then again, for a complete discussion, whether of progress or degradation, a whole course of analysis is necessary as to the effect of natural agencies on man, and of change in those agencies. But upon these I cannot touch; the only way to solve these great problems is to take them separately. I only profess to explain what seem to me the political prerequisites of progress, and especially of early progress. I do this the rather because the subject is insufficiently examined, so that even if my views are found to be faulty, the discussion upon them may bring out others which are truer and better.

CONTENTS.

2

Reprinted from the Report of the
Librarian, 1906-07.

Publications by Members of the Faculty
OF THE
University of Michigan
FROM
JANUARY 1, 1906 to JUNE 30, 1907

The following is a continuation of the list published in
the *University of Michigan News-Letter* of May 21, 1906,
which comprised the publications of the members of the
Faculty from January 1, 1904, to December 31, 1905. By
vote of the Board of Regents the list will hereafter be a
feature of the Annual Report of the Librarian, and members
of the Faculty are asked to co-operate by responding
promptly to requests for information in regard to their
publications. Presentation copies of all publications issued
separately will be much appreciated for the "Memorial
collection" as well as for the regular shelves of the
University Library. THEODORE W. KOCH.

Allen, John Robins. Notes of heating and ventilation. 2d
ed. Chicago, Domestic engineering, July, 1906. 269 p.
illus. 17cm.

Angell, James Burrill. Honesty; a baccalaureate dis-
course delivered June 17, 1906. [Ann Arbor, 1906]
cover-title. 10 p. 23½ cm. (University bulletin.
New series. vol. 7. no. 16)

Bailey, Benjamin Franklin. The advantages of alter-
nating current dynamos in engine testing. (*In*
Horseless age. Jan. 10, 1906. v. 17. p. 54-55).

——The efficiency of the touch spark coil. (*In* Horse-
less age. Nov. 7, 1906. v. 18. p. 649-652)

——Maximum efficiency of a storage battery. (*In* Elec-
trical world. Apr. 21, 1906. v. 47. p. 809-810)

——A new variable speed motor. (*In* Electrical world. May 11, 1907. v. 49, p. 947-948)

——A way to economize in gasoline engine testing. (*In* Horseless age. May 2, 1906. v. 17, p. 619-621)

Bartlett, George Miller. Numerical problems in descriptive geometry, for class and drawing room practice. Rev. ed. Ann Arbor. Mich., The author, Feb. 1907. 83 p. diagrs. 20 cm.

Bean, Robert Bennett. The negro brain. (*In* Century. Sept., 1906. v. 50, p. 778-784)

——A preliminary report on the measurements of about 1000 students at Ann Arbor, Mich. (*In* American journal of anatomy. 1907. v. 6. Proceedings of the Association of American anatomists. Apr. 1, 1907. p. 67-68)

 An abstract.

——A racial peculiarity in the temporal lobe of the negro brain. (*In* American journal of anatomy. 1907. v. 6. Proceedings of the Association of American anatomists. Apr. 1. 1907. p. 57)

 An abstract.

——Some racial peculiarities of the negro brain. (*In* American journal of anatomy. Sept. 1906. v. 5, p. 353-432)

——The training of the negro. (*In* Century. Oct. 1906. v. 60, p. 947-953)

Bigelow, Melville Madison. Law of torts. 8th ed. Boston, Little, Brown & co., 1907. 2 p. l. iii, xxxv, 502 p. 23 cm.

Bigelow, Samuel Lawrence. Are the elements transmutable, the atoms divisible and forms of matter but modes of motion? (*In* Popular science monthly. July, 1906. v. 69, p. 38-51)

 Also in Michigan schoolmasters' club. Proceedings, March, 1906. no. 41, p. 81-94.

——Denatured alcohol. (*In* Popular science monthly. March, 1907. v. 70, p. 243-264)

——[Review of] General inorganic chemistry, by Alexander Smith. (*In* American chemical society journal. Aug. 1906. v. 28, p. 1081-1084)

——[Review of] Zur erkenntniss der kolloide, by Richard Zsigmondy. (*In* Science. Sept. 1906. v. 24, p. 372-374)

Bohn, William Edward. The development of John Dryden's literary criticism. (*In* Modern language association of America. Publications. March, 1907. v. 22, no. 1)

Thesis (Ph.D.)—Univ. of Michigan.

Bragg, Edward Milton. An investigation of the pressures upon the main bearings and crank pins of marine engines. (*In* American society of naval engineers. Feb. 1906. v. 18, p. 22-42)

Breakey, William Fleming. Phagedenic and serpiginous ulcers and infective granulomata. (*In* Journal of cutaneous diseases. March, 1907. v. 25, p. 108-113)

——The unsuspected parasitic origin of many dermatoses. (*In* Physician and surgeon. Sept. 1906. v. 28, p. 385-388)

——Treatment of syphilis in primary stage. (*In* American journal of dermatology and genito-urinary diseases. 1906)

Also various abstracts and reviews in Physician and surgeon. 1906 and 1907.

Breitenbach, Harold Prell. The value of English to the practicing engineer. Ann Arbor, Mich., Library printing plant, May, 1906. 2 p. l. 9 p. 23½ cm. (Contributions to rhetorical theory, ed. by F. N. Scott, 7)

Also descriptive articles, news and editorial notes in Engineering news, July-Sept. 1906.

Bunting, Russell Welford. The pulp and its pathology. (*In* Dental digest. June, 1907. v. 13, p. 599-604)

Burns, George Plumer. Bog studies. (*In* Michigan. University. Botanical dept. Field studies in botany. June 1, 1906)

University bulletin. n. s., v. 7, no. 14; Botanical series, no. 4.

——Preparation for field work. (*In* Michigan. University. Botanical dept. Field studies in botany. Feb. 6, 1906. p. 1-5)

University bulletin. n. s., v. 7, no. 5; Botanical series no. 1.

——River studies. (*In* Michigan. University. Botanical dept. Field studies in botany. March 30, 1906)

University bulletin. n. s., v. 7, no. 9; Botanical series, no. 2.

——*ed.* Field studies in botany. (*In* Michigan. University. Bulletin. n. s., v. 7, no. 5, 9-10, 14-15; Botanical series, no. 1-5)

Burrett, Claude Adelbert. The clinical laboratory **course.** (*In* University homœopathic observer. **Apr. 1906.** v. 4, p. 68-69)

——The detection of the bacillus tuberculosis. (*In* University homœopathic observer. July, 1906. v. 4, p. 209-214)

——General analysis of copaiba and euonymons. (*In* University homœopathic observer. Oct. 1906. v. 4, p. 268-273)

——Practical work in pathogenetic laboratory. (*In* University homœopathic observer. Jan. 1906. v. 4, p. 36-41)

——Report of the department of drug pathogenecy of the University of Michigan Homœopathic college. Further provings of copaiba officinalis. (*In* Medical century. Apr. 1907. v. 15, p. 100-115)

——Value of laboratory methods in diagnosis to the general practitioner. (*In* Medical century. Oct. 1906. v. 14, p. 295-300)

Campbell, Earl H. Biennial report of the Upper Peninsula hospital for the insane. Lansing, Mich. State printers, June 30, 1907.

> E. H. Campbell, Medical superintendent.

Campbell, Edward De Mille. A convenient air-bath and hot plate. (*In* American chemical society. Journal. March, 1907. v. 29, p. 283-286)

——Some conditions influencing constancy of volume in Portland cements. (*In* American chemical society. Journal. Oct. 1906. v. 28, p. 1273-1303)

> Jointly with A. H. White

Carhart, Henry Smith. Formula for the Helmholtz concentration cell. (*In* American electro-chemical society. 1906. v. 10, p. 31-34)

——A new electrolyte for the silver coulometer. (*In* American electro-chemical society. Transactions. 1906. v. 9, p. 375-380)

> Jointly with H. H Willard and W D Henderson

· · · Physics for high school students. New ed., thoroughly rev. and furnished with new problems. Boston, Allyn and Bacon, June, 1907. vii, 435 p. illus., diagrs. 19½ cm.

> Jointly with H. N. Chute.

——Physics for university students. Pt. I. New ed.—
thoroughly rev. Boston, Allyn and Bacon, 1906.
Pt. I. illus., diagrs. 19 cm.

Cone, Lee Holt, *joint author.* Monohalogen derivatives of
triphenylcarbinol-chloride. (*In* American chemical
society. Journal. Apr. 1906. v. 28, p. 518-524)

Jointly with C. P. Long.

——*joint author.* Ueber triphenylmethyl. 13.-15. mittheil-
ung. (*In* Deutsche chemische gesellschaft. Berichte.
1906-07. v. 39, p. 1461-1470, 2957-2970, 3274-3297)

Jointly with M. Gomberg.

Cooley, Charles Horton. The need of social structure in
religion. (*In* Unity. March 7, 1907. v. 59, p. 8-10)
——Social consciousness. (*In* American journal of sociol-
ogy. March, 1907. v. 12, p. 675-687)

Cooley, Mortimer Elwyn. Detailed exhibits of the tan-
gible property of the Chicago City railway company as of
June 30, A. D. 1906, accompanying the Valuation report,
submitted to the committee on local transportation of
the Chicago City council. Chicago, 1906. 451 p. incl.
diagrs. fold. tables. 24 cm.
——Detailed exhibits of the tangible property of the street
railway system in the possession of and operated by the
receivers of the Union traction company as of June 30,
A. D. 1906, accompanying the Valuation report submit-
ted to the Committee on local transportation of the
Chicago City council. Chicago, 1906. 967 p. incl.
diagrs. fold. tables. 24 cm. •

Jointly with Bion J. Arnold and A. B. du Pont.

——Report on the values of the tangible and intangible
properties of the Chicago City railway company and the
Chicago Union traction company, submitted to the Com-
mittee on local transportation of the Chicago City coun-
cil. Chicago, Dec. 1906. 1 p. l., 79 p. 23 cm.

Jointly with Bion J. Arnold and A. B. du Pont.

Copeland, Royal Samuel. Affections of the drainage sys-
tem. (*In* New York homœopathic medical society.
Transactions. 1906. v. 41, p. 263-266)
——The Dean in Bulgaria. (*In* University homœopathic
observer. Apr. 1906. v. 4, p. 87-95)

——Epiphora and blennorrhœa of the lachrymal sac. (*In* University homœopathic observer. Oct. 1906. v. 4. p. 253-258)

——Has homœopathy a scientific foundation? (*In* Medical century. May, 1907. v. 15, p. 129-136)

——Homœopathy and posology. (*In* New England medical gazette. Oct. 1906. v. 41, p. 553-556)

– ·—Infinitesimal dose. (*In* New York homœopathic society. Transactions. 1906. v. 41, p. 46-56)

——Institutional treatment of tuberculosis in the United States. (*In* University homœopathic observer. July, 1906. v. 4, p. 163-173)

Cowie, David Murray. A comparative study of the occult blood tests; a new modification of the Guiac reaction; its value in legal medicine. (*In* American journal of the medical sciences. March, 1907. v. 133, p. 408-423)

——Rural city milk supplies and their relation to infant feeding. Home modification *versus* laboratory modification. (*In* Physician and surgeon. July, 1906. v. 28, p. 289-302)

Jointly with Anna Marion Cook.

——Urine segregation by means of kidney massage. Report of a case of tuberculosis of the kidney with special reference to the importance of cytologic examination of urine sediment. (*In* American medicine. July, 1907. v. 13 (n.s., v. 2) p. 36-39)

Cross, Arthur Lyon. Report on recent publications in English history. (*In* Michigan schoolmasters' club. Journal. May, 1907. v. 42, p. 88-90)

Cutler, James Elbert. Capital punishment and lynching. (*In* American academy of political and social science. Annals. May, 1907. v. 29, p. 622-625)

—·—The practice of lynching in the United States. (*In* South Atlantic quarterly. Apr. 1907. v. 6, p. 125-134)

——Race riots and lynch law: a northern professor's view. (*In* Outlook. Feb. 2, 1907. v. 85, p. 263-268)

Davis, Charles Albert. Field work in towns and cities. (*In* Michigan. University. Botanical dept. Field studies in botany. June 15, 1906)

University bulletin. n. s. v. 7, no. 15: Botanical series, no. 4 [i e 5]

——[The wells and water supplies of] Oxford. . . Ortonville district. . . Groveland township. . . Big meadows district. . . Imlay City. . . Lapeer. . . Elsie and vicinity. (*In* U. S. Geological survey. Water supply and irrigation paper. Feb. 1907. no. 182, p. 178-180, 184-188, 214-216, 230-233)

——[The wells and water supplies of] the Saginaw Bay drainage basin, south of Bay and Isabella counties. (*In same.* Feb. 1907. no. 183, p. 121-246)

——Woodlot studies. (*In* Michigan University. Botanical dept. Field studies in botany. Apr. 15, 1906)
University bulletin, n. s., v. 7. no. 10; Botanical series, no. 3.

Demmon, Isaac Newton, *ed.* History of the University of Michigan, by the late Burke A. Hinsdale, with biographical sketches of the regents and members of the university Senate from 1837 to 1906, ed. by Isaac N. Demmon. Ann Arbor, Mich. Published by the University, Sept. 1906. xiii, 376 p. illus. (incl. ports.) 30½ cm.

——*ed.* [Shakespeare's] As you like it. New York, Cincinnati, [etc.] American book co., June, 1907. 169 p. front. (port.) 16½ cm. (The gateway series of English texts)

Dennison, Walter. An emendation of Caesar Bellum gallicum. VI. 30. 4. (*In* Classical philology, 1906. v. 1, p. 290-291)

——The Oberlin "Scipio" head. (*In* Oberlin alumni magazine. Apr. 1906. v. 2, p. 221-222)

——Recent Caesar literature. (*In* Classical journal. Apr. 1906. v. 1, p. 131-145)

——[Review of] Cour d' épigraphie latine, par René Cagnat. Supplement à la 3me. éd. (*In* Classical philology. 1906. v. 1, p. 192)

——[Review of] Signacula medicorum oculariorum, recensuit Aemilius Espirandieu. (*In* Modern philology. Apr. 1907. v. 2, p. 240)

——[Review of] The classics and modern training, by Sidney G. Ashmore. (*In* Bibliotheca sacra. Jan. 1906. v. 63, p. 197-198)

——[Review of] The Greek painters' art, by Irene Weir. (*In* Bibliotheca sacra. Jan. 1906. v. 63, p. 199-200)

——[Review of] Thesaurus linguæ latinæ epigraphicæ: a dictionary of the Latin inscriptions, by George N. Olcott. (*In* Classical philology. 1906. v. 1, p. 420-421)

——[Review of] Virgil's Aeneid, books I-VI, with introduction, notes, and vocabulary, by Charles E. Bennet. (*In* Classical journal. 1906. v. 1, p. 206-207)

——Syllabification in Latin inscriptions. (*In* Classical philology. 1906. v. 1, p. 47-68)

D'Ooge, Martin Luther. [Review of] The Agamemnon of Aeschylus. A revised text and translation by W. W. Goodwin. (*In* Classical journal. May, 1907. v. 2, p. 319)

——[Review of] Euripides, Iphigenia in Tauris; ed. by William Nickerson Bates. (*In* Classical journal. Feb. 1906. v. 1, p. 87-88)

Dow, Earle Wilbur. Notes and news. (*In* American historical review. Jan. 1907. v. 12, passim p. 443-461)
Unsigned.

——[Review of] Codex diplomaticus moenofrancofurtanus. Urkundenbuch der Reichstadt Frankfurt, hrsg. von Johann Friedrich Boehmer. (*In* American historical review. Jan. 1907. v. 12, p. 354-356)

——[Review of] A history of mediæval and modern Europe, by Henry E. Bourne, [and of] Essentials in mediæval and modern history, by S. B. Harding. (*In* American historical review. Apr. 1906. v. 11, p. 718-721)

——*ed.* Emancipation of the mediæval towns, by A. Giry & A. Réville, tr. and ed. by Frank Greene Bates and Paul Emerson Titsworth. New York, H. Holt & co., 1907. iii p., 1l. 69 p. 24½ cm. (Historical miscellany, ed. by E. W. Dow. No. 3)

Eckler, Charles Ralph, *joint author.* The development and structure of the seed of *Argemone Mexicana.* (*In* American pharmaceutical association. Proceedings. 1906. v. 54, p. 466-469)
Jointly with J. O. Schlotterbeck.

Edmunds, Charles Wallis. The influence of digitalis, strophanthus and adrenalin upon the velocity of the blood current. (*In* American journal of physiology. March 1, 1907. v. 18, p. 129-148)

——Paroxysmal irregularity of the heart and auricular fibrillation. (*In* American journal of the medical sciences. Jan. 1907. v. 133, p. 66-67)

Jointly with A. R. Cushny.

——The standardization of cardiac remedies. (*In* American medical association. Journal. May 25. 1907. v. 48, p. 1744-1747)

Also reviews of pharmacological and therapeutic literature in the Michigan state medical journal.

Eggert, Carl Edgar, *ed.* Heine's poems, selected and edited with introduction and notes. Boston, New York, [etc.] Ginn & co., [May, 1906.] lxxix, 233 p. incl. front. (port.) 17½ cm. (International modern language series)

——*ed.* Der heilige; novelle von Conrad Ferdinand Meyer; ed. with introduction and notes. New York, H. Holt & co. May, 1907. 1 p. 1, xlvii, 215 p. front. (port.) 17½ cm.

Escott, Edward Brind. The converse of Fermat's theorem. (*In* Messenger of mathematics. March, 1907. v. 36, p. 175-176)

——Miscellaneous notes and solutions. (*In* L'Intermédiaire des mathématiciens. 1906-7. v. 13, p. 25, 61, 62, 65, 99, 100, 103, 113, 114, 115, 126, 141, 151, 158, 198, 207; v. 14, p. 194, 195, 218, 220, 223, 225)

——Solution of a problem in the theory of numbers. (*In* American mathematical monthly. Aug. 1906. v. 13, p. 155-156)

Fairbanks, Arthur. The message of Greek religion to Christianity to-day. (*In* Biblical world. Feb. 1907. v. 29, p. 111-120)

——Mythology of Greece and Rome, presented with special reference to its influence on literature. New York, D. Appleton & co., Feb. 1907. xvii, 408 [1] p. illus., 2 fold. maps (incl. front), geneal. tables (fold.) 20 cm. (Twentieth century text-books. Classical section)

Fairlie, John Archibald. Local government in counties, towns, and villages. New York, The Century co., 1906. 4 p. 1, v-xii, 3-289 p. 20 cm. (The American state series)

——Municipal codes in the middle west. (*In* Political science quarterly. Sept. 1906. v. 21. p. 434-446)

——Municipal functions. (*In* New York. State library.
Bulletin. Legislation. Oct. 1906. no. 29, p. 208-214)
——Municipal note. (*In* American political science re-
view. Nov. 1906. v. 1, p. 114-122)
——The problems of city government from the adminis-
trative point of view. (*In* American academy of
political and social science. Annals. Jan. 1906. v.
27, p. 132-154)
——Some suggested changes in the constitution of Mich-
igan. (*In* Michigan law review. Apr. 1907. v. 5,
p. 439-449) ·
——The street railway question in Chicago. (*In* Quar-
terly journal of economics. May, 1907. v. 21, p. 371-
404)

Field, Peter. Note on certain groups of transformations
of the plane into itself. (*In* American mathematical
society. Bulletin. Feb. 1906. v. 12, p. 234-236)
——On the form of a plane quintic curve with five cusps.
(*In* American mathematical society. Transactions.
Jan. 1906. v. 7, p. 26-32)
——[Review of] Mélanges de géométrie à quatre dimen-
sions, par E. Jouffret. (*In* American mathematical
society. Bulletin. March, 1907. v. 13, p. 301-302)

Finney, Byron Alfred. Co-operation with colleges. (*In*
Michigan pioneer and historical society. Collections
and researches. 1907. v. 35, p. 526-630)

> Read before the society at its meeting at Lansing, June 7,
> 1906, in "Conference showing how co-operation with different
> educational departments would aid Michigan's historical in-
> terests."

Florer, Warren Washburn. Material and suggestions for
the use of German in the classroom. Ann Arbor,
Mich., G. Wahr. [1906]. v. 1. 19½ cm.
——The possibilities and purpose of interpretative read-
ing. (*In* Schoolmaster. Jan. 1907. v. 1, p. 299-305)
——Schiller's conception of liberty and the spirit of '76.
(*In* German-American annals. Apr. 1906. n. s., v. 4
(o. s., v. 8), p. 99-115)

Ford, Walter Burton. On the analytic extension of func-
tions defined by double power series. (*In* American
mathematical society. Transactions. Apr. 1906,
v. 7, p. 260-274)

——Sur les équations linéaires aux différences finies. (*In* Annali di matematica. March, 1907. ser. 3, v. 13, p. 263-328)

French, James Leslie, *ed.* The correspondence of Caspar Schwenckfeld of Ossig and the Landgrave Philip of Hesse, 1535-1561. Edited from the sources with historical & biographical notes. Leipzig, Breitkouf & Härtel, 1907. vi, 107 p. 28 cm.

Georg, Conrad, *jr.* A few results of Roentgen ray therapy with report of cases. (*In* Michigan state medical society. Journal. Jan. 1906. v. 5, p. 13-16)

Glaser, Otto Charles. Correlation in the development of fasciolaria. (*In* Biological bulletin. March, 1906. v. 10, p. 139-164)
——Movement and problem-solving in *Ophiura brevispina.* (*In* Journal of experimental zoology. June, 1907. v. 4, p. 203-220)
> Abstract published in Science. (May 10. 1907. n. s., v. 25, p. 726.)

——The nematocysts of eolis. (*In* Science. Apr. 6, 1906. n. s., v. 23, p. 525-526)
> An abstract.

——Pathological amitosis in the food-ova of fasciolaria. (*In* Biological bulletin. June, 1907. v. 13, p. 1-4)

Goddard, Edwin Charles. [Review of] The law of innkeepers and hotels, by Joseph Henry Beale, jr. (*In* Michigan law review. Dec. 1906. v. 5, p. 150-152)
——[Review of] The law of railroad rate regulation . . . by Joseph Henry Beale, jr., and Bruce Wyman. (*In* Michigan law review. Dec. 1906. v. 5, p. 152-153)
——[Review of] A treatise on the law of agency, by William Lawrence Clark and Henry H. Skyles. (*In* Michigan law review. Jan. 1906. v. 4, p. 254-255)
——[Review of] A treatise on the law of carriers, by Dewitt C. Moore. (*In* Michigan law review. Dec. 1906. v. 5, p. 153-154))

Gomberg, Moses. Ueber triphenylmethyl. 13-16. mittheilung. (*In* Deutsche chemische gesellschaft. Berichte. 1906-07. v. 39, p. 1461-1470, 2957-2970, 3274-3297; v. 40, p. 1847-1888)
> Mittheilung 13-15 jointly with L. H. Cone.

Hale, William Jay. Grignard syntheses in the furfuran group. (*In* American chemical journal. Jan. 1906. v. 35, p. 68-78)

 Jointly with W. D. McNally & C. J. Pater.

—— *joint author.* A laboratory outline of general chemistry. by Alexander Smith. 3d ed., rev. in collaboration with William J. Hale. New York, The Century co., June, 1907. ix, 136 p. illus. 19 cm.

—— *joint author.* Supplementary pamphlet to the Laboratory outline of general chemistry. New York, Century co., June, 1907.

 Jointly with Alexander Smith.

Hamilton, George Livingstone. [Review of] Johannis Scottis [by] E. K. Rand. (*In* American journal of philology. Apr.-June, 1907. v. 28, p. 241)

—— [Review of] Waltharii Poesis [ed. by] Hermann Althof. (*In* American journal of philology. Oct.-Dec. 1906. v. 27, p. 459-460)

— —Ventaille. (*In* Modern philology. Apr. 1906. v. 3, p. 541-546)

Henderson, William D., *joint author.* A new electrolyte for the silver coulometer. (*In* American electrochemical society. Transactions. 1906. v. 9, p. 375-380)

 Jointly with H. S. Carhart & H. H. Willard.

Hinsdale, Wilbert B. Albuminaria of pregnancy. (*In* Hahnemann monthly. March, 1906. v. 41, p. 171-176)

——Broncho pneumonia. (*In* Homœopathic medical society of Ohio. Proceedings. 1907. v. 43, p. 207-215)

——Medical lessons from life. (*In* University homœopathic observer. Oct. 1906. v. 4, p. 258-268)

——The stomach, a few remedies. (*In* Medical century. March. 1907. v. 15, p. 81-84)

——Tuberculosis and its victims. (*In* University homœopathic observer. July, 1906. v. 4, p. 131-153)

——Two or three things about pneumonia. (*In* Medical century. Jan. 1907. v. 15, p. 19-20)

—— -The value of humanistic studies as a preparation for the study of medicine. (*In* School review. Oct. 1906. v. 14, p. 394-404)

 [Also *in* Michigan alumnus. Oct. 1906. v. 13. p 20-23]

Hobbs, William Herbert. America and seismological research. (*In* Popular science monthly. 1906. v. 69, p. 226-228)

—Calabrian earthquake of September 8, 1905. (*In* Geological society of America. Bulletin. 1906. v. 17, p. 720-721)

Abstract.

—The Charleston earthquake of 1886 in a new light. (*In* Geological magazine. May, 1907. n. s., decade 5, v. 4, p. 197-202)

—Correspondence relating to the study of an area of crystalline rocks in southwestern New England. (*In* Science. Nov. 23. 1906. n. s., v. 24, p. 655-668)

—The geotectonic and geodynamic aspects of Calabria and northwestern Sicily ; a study in orientation. (*In* Beiträge zur geophysik. 1907. v. 8, p. 293-362)

—The Goldschmidt law of complication applied to the solar system. (*In* Popular astronomy. 1907. v. 15, p. 345-356)

—The grand eruption of Vesuvius in 1906. (*In* Journal of geology. 1906. v. 14. p. 636-655)

—Guadix formation of Granada, Spain. (*In* Geological society of America. Bulletin. 1906. v. 17, p. 285-294)

—The iron ores of the Salisbury district of Connecticut, New York, and Massachusetts. (*In* Economic geology. March-Apr. 1907. v. 2, p. 153-181)

—Israel Cook Russell. (*In* Michigan technic. Feb. 1907. v. 20, no. 1, p. 1-3. Portrait)

—Mining in Spain. (*In* Mining world. Jan. 27. 1906. v. 24, p. 109-110)

—Minutes of the first meeting of the Committee on seismology. (*In* Science. May 24, 1907. n. s., v. 25, p. 838-839)

—On some principles of seismic geology. (*In* Beiträge zur geophysik. 1907. v. 8, p. 219-292)

—On two new occurrences of the "Cortlandt series" of rocks within the state of Connecticut. Sonderabdruck aus der Festschrift zum siebzigsten geburtstage von Harry Rosenbusch gewidm. von seinen schülern. Stuttgart, E. Schweitzerbart, 1906. 24-28 p. illus., fold. diagr. 26 cm.

—Origin of ocean basins in the light of the new seismology. (*In* Geological society of America. Bulletin. 1907. v. 18, p. 233-250)

——The pre-Cambrian volcanic and intrusive rocks of the Fox River valley, Wisconsin. (*In* Wisconsin. University. Bulletin. Science series. May, 1907. v. 3, p. 247-277)
 Jointly with Charles Kenneth Leith.

——Producing fertilizer from the atmosphere. (*In* Mining world. 1906. v. 24, p. 666)

——Seismology in America. [Editorial] (*In* Journal of geology. Feb.-March. 1907. v. 15, p. 182-184)

——The significance of some recent naval developments. (*In* Navy league journal. Apr. 1906. v. 4, p. 59-60)

——Some topographic features formed at the time of earthquakes and the origin of mounds in the Gulf plain. (*In* American journal of science. Apr. 1907. v. 173 (4th ser., v. 23), p. 245-256)

——Studies for students: The recent advance in seismology. (*In* Journal of geology. Apr.-June, 1907. v. 15, p. 288-297. 396-409)

——Vesuvius in eruption. (*In* Madison democrat. Aug. 26, 1906)

Houghton, Elijah Mark. A comparison of the pharmacologic activity of the fluid extract of squill prepared according to the United States pharmacopeia 1890 and 1900. (*In* American medical association journal. May 12, 1906. v. 46, p. 1417-1420)

——Extracts from an address on antitoxins, and their uses in public health work. (*In* Public health. Michigan. Apr.-June, 1906. v. 1, p. 45-52)

——A review of the opsonins and bacterial vaccines. (*In* Therapeutic gazette. Jan. 15, 1907. v. 31 (3d ser., v. 23), p. 24-28)

——A simplified method of diagnosing glanders by agglutination. (*In* American veterinary review. May, 1907)

——A study of para-aeth-oxy-phenyl-camphoryl-imid (camphenal) as an antipyretic. (*In* American journal of physiology. Apr. 2, 1906. v. 15, p. 433-443)

Huber, G. Carl. The arteriolæ rectæ of the mammalian kidney. (*In* American journal of anatomy. May, 1907. v. 6, p. 391-406)

——The ductless glands. Originally written by Sir Frederick Treves. . .Arthur Hensman. . .and Arthur Robinson. . .Revised by G. Carl Huber. (*In* Morris, Henry, ed. Human anatomy, ed. by J. Playfair McMurrich. 1907. p. 1233-1243)

——On the veins of the kidneys of certain mammals. (*In* American journal of anatomy. 1907, v. 6. Proceedings of the Association of American anatomists. May 1, 1907. p. 75-76)

——The organs of digestion, by Arthur Hensman. . . and Sir Frederick Treves. . . Revised by G. Carl Huber. (*In* Morris, Henry, *ed.* Human anatomy, ed. by J. Playfair McMurrich. 1907. p. 1075-1128)

——The physiology and development of the ovum. (*In* Peterson, Reuben, *ed.* Practice of obstetrics. 1907. p. 17-81)

Hunt, Walter Fred, *joint author.* The occurrence of sulphur and celestite at Maybee, Mich. (*In* American journal of science. March, 1906. v. 171 (4th ser., v. 21) p. 237-244)

> Jointly with E. H. Kraus.
> *Also in* Zeitschrift. für krystallographie. 1906. v. 42, p. 1-7.

Hussey, William Joseph. The Lick observatory—Crocker eclipse expedition to Egypt. (*In* Astronomical society of the Pacific. Publications. Feb. 1906. v. 18, p. 37-46)

——Observations of one hundred and twenty-seven new double stars. Twelfth catalog. (*In* Lick observatory. Bulletin, 1907. No. 117, p. 124-128)

——[Review of] An introduction to astronomy, by F. R. Moulton. (*In* Science. Sept. 28, 1906. n. s., v. 24. p. 397-398)

——Southern double stars. (*In* Lick observatory. Bulletin. 1907. no. 117, p. 129)

Hutchins, Harry Burns. The compensation of medical witnesses. (*In* Michigan law review. April, 1906. v. 4, p. 413-432)

——The Cy-pres doctrine. (*In* Michigan law review. Feb. 1906. v. 4, p. 287-292)

——Disbarment or suspension of attorney. (*In* Michigan law review. March, 1907. v. 5, p. 354-357)

——Liability of charitable corporations for the torts of their servants. (*In* Michigan law review. June, 1907. v. 15, p. 662-665)

——Liability of hospitals for the negligence of their physicians and nurses. (*In* Michigan law review. May. 1907. v. 5, p. 552-559)

——[Review of] Centralization and the law, by Melville M. Bigelow. (*In* Michigan law review. May, 1906. v. 4, p. 566-570)

——[Review of] Pomeroy's Equity jurisprudence, and Equitable remedies. (*In* Michigan law review. Jan. 1906. v. 4. p. 248-250)

———Should men bearing the same title in any institution receive the same pay? (*In* Association of American universities. Journal of proceedings. Nov. 1906. v. 8, p. 92-99)

——Surgical operation on minor without consent of parent. (*In* Michigan law review. Nov. 1906. v. 5. p. 40-41)

——Thomas McIntyre Cooley. (*In* Michigan alumnus. Oct. 1906. v. 13. p. 23-29)

 Also in Law student's helper. Jan. 1907. v. 15, p. 8-12.

———What is the practice of medicine? (*In* Michigan law review. Mar. 1906. v. 4. p. 373-379: Jan. 1907. v. 5, p. 181-183)

———Waiver of the statutory protection to the confidential relation of physician and patient. (*In* Michigan law review. Feb. 1907. v. 5, p. 266-269)

Johnson, Otis Coe. Analytical equations. 4th ed. Ann Arbor, 1906. 38 p. 23½ cm.

Jones, Edward David. Are we approaching an economic crisis? (*In* Journal of commerce. Jan. 2, 1907)

Kauffman, Calvin Henry. Cortinarius as a mycorhiza-producing fungus. (*In* Botanical gazette. Oct. 1906. v. 42., p. 208-214)

———The genus cortinarius, with key to the species. (*In* Journal of mycology. Jan. 1907. v. 13. p. 32-39)

———Unreported Michigan fungi from Petoskey, Detroit and Ann Arbor for 1905. (*In* Michigan academy of science. Reports. 1906. v. 8, p. 26-37)

Kelsey, Francis Willey. Archaeological bills passed by Congress. (*In* The nation. Sept. 27. 1906. v. 83, p. 258-259)

———The eues of Caesar. (*In* Classical journal. Dec. 1906. v. 2. p. 49-58)

———George Horton's latest book. [Review of The Monk's treasure.] (*In* Michigan alumnus. Feb. 1906. v. 12, p. 247-248)

———Hirtius' letter to Balbus and the Commentaries of Caesar. (*In* Classical philology. Jan. 1907. v. 2. p. 92-93)

——The position of Latin and Greek in American education. (*In* Educational review. Dec. 1906-Feb. 1907. v. 32, p. 461-472; v. 33, p. 59-76, 162-176)

Contents:—I. The present position of Latin and Greek. II. The value of Latin and Greek as educational instruments. III. Latin and Greek in our courses of study.

——The present position of Latin and Greek. (*In* The nation. Nov. 1, 1906. v. 83, p. 369)

——Recent archaeological legislation. (*In* Records of the past. Nov. 1906. v. 5, p. 338-342)

——The State universities and the churches. (*In* Proceedings of the Conference on religious education held at the University of Illinois. Oct. 19, 1905. Published by the University, 1906)

——A symposium on the value of humanistic, particularly classical, studies as a preparation for the study of medicine and engineering. I. Statement of the problem. (*In* Michigan alumnus. Oct. 1906. v. 13, p. 13-17)

——The twelfth Michigan classical conference. (*In* School review. Oct. 1906. v. 14, p. 560-562)

——The villas of Boscoreale. (*In* Chautauquan. May, 1906. v. 43, p. 234-242)

——*ed.* C. Juli Caesaris De bello Gallico, libri VII. With an introduction, notes and vocabulary. 17th ed. Boston, Allyn & Bacon, 1906. viii, 576 p. illus., plates (partly col.), map, plans (partly col.)

——*ed.* T. Lucreti Cari De rerum natura libri VI. With an introduction and notes to books I, III, and V. 6th ed. Boston, Allyn & Bacon, 1906. lxiv, 385 p. 18½ cm.

——*ed.* P. Ovidi Nasonis Carmina selecta. With an introduction, notes and vocabulary. 8th ed. Boston, Allyn & Bacon, 1906. vii, 444 p. illus., plates, plan.

King, Irving. Educational value of classical languages. (*In* Educational review. May 1907. v. 33, p. 467-485)

——Problem of the subconscious. (*In* Psychological review. 1906. v. 13, p. 35-49)

Many short reviews in School review, Psychological bulletin, etc.

Kinyon, Claudius Bligh. Differential diagnosis and treatment of placenta prævia. (*In* Homeopathic journal of obstetrics and gynecology. Jan. 1907. Reprints)

——Early diagnosis in cases of pelvic tumors and diseases. (*In* Journal of surgery, gynecology and obstetrics. Oct. 1906. v. 28, p. 399-404)

——Five valuable remedies in gynecology. (*In* University homeopathic observer. Jan. 1906. v. 4, p. 15)
——Homeopathy in the practice of the specialties: the gynæcologist. (*In* American institute of homeopathy. Transactions. 1907. v. 63, p. 381-396)
——Organizations and agencies for the development and maintenance of homœopathy. (*In* University homœopathic observer. Jan. 1907. v. 5, p. 9-15)
——Toxemia of pregnancy. [Prophylaxis.] (*In* American institute of homeopathy. Transactions. 1907. v. 63. p. 730-733)

Kirk, Richard Ray. How to learn to spell. (*In* The nation. May 2. 1907. v. 84, p. 408)
——Verses. Ann Arbor, Mich., G. Wahr, Dec. 1906. 3 p. l. [ii] 43 p. 18½ cm.

Knowlton, Jerome Cyril. [Review of] Principles of the English law of contract, by Sir William R. Anson. 2d American edition with American notes by Ernest W. Huffcut. (*In* Michigan law review. Jan. 1907. v. 5, p. 225)
——Thomas McIntyre Cooley. (*In* Michigan law review. March, 1907. v. 5. p. 309-325)

Koch, Theodore Wesley. Carnegie libraries. (*In* The Chautauquan. June, 1906. v. 43. p. 345-351)

Address before the Cleveland meeting of the American Civic Association.

——New Shakespeareana and periodical agents. (*In* Library journal. July, 1906. vol. 31. p. 348)

With supplementary notes on the Shakespeare Press of Westfield, N. J., in the Library Journal, Jan. 1907 (p. 48) and March, 1907 (p 144)

——On the extension to students of the privilege of borrowing books from the General Library of the University of Michigan. [Ann Arbor, 1906] 11 p. 19 cm.

Memorial presented to the Board of Regents, Jan. 19, 1906. Reprinted as a circular letter to the Faculty, Feb. 12, 1906.

——A portfolio of Carnegie libraries; being a separate issue of the illustrations from "A book of Carnegie libraries." Ann Arbor, George Wahr, 1907. viii p., 120 p. of illus. (incl. ports, plans) front. (port.) 25 cm.

——Preliminary report of the Committee on college and university library statistics. [Ann Arbor] May, 1907. 15 p. 24 cm.

Submitted to the Asheville meeting of the American Library Association and reprinted in its Papers and Proceedings, p. 261-267.

——[Review of] Harper's "Book of facts," 1906. (*In* Library journal. April, 1906. v. 31, p. 200)

——Student circulation in a university library. (*In* Library journal. Nov. 1906. v. 31, p. 758-761)

Kraus, Edward Henry. Datolite from Westfield, Mass. (*In* American journal of science. July, 1906. v. 172 v. 171 (4th ser. v. 21) p. 237-244)

Jointly with C. W. Cook.

Also in Zeitschrift für krystallographie. 1906. v. 42, p. 327-333.

——Essentials of crystallography. Ann Arbor, Mich., G. Wahr, Oct. 1906. x, 162 p. illus., diagrs. 23½ cm.

——The occurrence of sulphur and celestite at Maybee, Mich. (*In* American journal of science, March, 1906. v. 171 (4th ser. v. 21 p. 237-244)

Jointly with W. F. Hunt.

Also in Zeitschrift für krystallographie, 1906. v. 42, p. 1-7.

——[Review of] Einleitung in die chemische krystallographie, by P. Groth. English translation by Hugh Marshall; [also of] Chemische krystallographie, by Groth. (*In* Science. Jan. 1907. n. s., v. 25, p. 142-143)

——The teaching of crystallography. (*In* Science. Dec. 28, 1906. n. s., v. 24, p. 855-856)

Laguna, Theodore de Leo de. The beautiful in music. (*In* Music teachers' national association. Proceedings. 1906. v. 28, p. 150-166)

——Evolution and moral education. (*In* Michigan schoolmasters' club. Proceedings. March 1906. 41st annual meeting. p. 18-30)

——[Review of] The relation of the principles of logic to the foundations of geometry, [by] J. Royce. (*In* Journal of philosophy, psychology and scientific methods. June 21, 1906. v. 3, p. 357-361)

——[Review of] Science and hypothesis, by H. Poincaré. (*In* Philosophical review. Nov. 1906. v. 15. p. 634-641)

——-Should our high school course in Latin be extended downward into the seventh and eighth grades. II. The view-point of a department of education. (*In* Michigan schoolmasters' club. Proceedings. May, 1907. v. 42, p. 118-123)

-----Vocational studies for college entrance requirements. (*In* Society for the scientific study of education. Yearbook. 1907. v. 6, p. 36-49)

Levi, Moritz. Mon habit, [by] Béranger, [and] Der alte reiter und sein mantel, [by] Carl von Holtei. (*In* Modern language notes. Dec. 1906. v. 21, p. 250-251)

-----*ed.* La grammaire, by Eugène Labiche; ed., with notes & vocabulary. Boston, D. C. Heath & co., Jan. 1906. v. 70 p. 17 cm. (Heath's modern language series)

Lichty, David Martin. The chemical kinetics of the decomposition of oxalic acid in concentrated sulphuric acid. (*In* Journal of physical chemistry. March 1907. v. 11, p. 225-272)

Lind, Samuel Colville. Alkalimetric method for the determination of tungsten in steel. (*In* American chemical society. Journal. April 1907. v. 29, p. 477-481)

Jointly with B. C. Trueblood.

-----Geschwindigkeit der bildung der bromwasserstoffs aus seiner elementen. (*In* Zeitschrift für physikalische chemie. 1906. v. 57, p. 168-192)

Jointly with Max Bodenstein.

Lloyd, Alfred Henry. The poetry of Anaxagoras's Metaphysics. (*In* Journal of philosophy, psychology and scientific methods. Feb. 14, 1907. v. 4. p. 85-94)

-----Some important situations and their attitudes. (*In* Psychological review. Jan. 1907. v. 14, p. 37-53)

Loeffler, Egbert Theodore. In the administration of anæsthetics can accidents and failures be avoided? (*In* Dentist's magazine. June, 1906)

-----Modern dental remedies. (*In* Dentist's magazine. Sept. 1906)

Lombard, Warren Plimpton. A method of recording changes in body weight which occur within short intervals of time. (*In* American medical association. Journal. Dec. 1906. v. 47, p. 1790-1793)

McMurrich, James Playfair. Leonardo da Vinci: a review. (*In* Medical library and historical journal. 1906. v. 4, p. 338-350)

——The phylogeny of the plantar musculature. (*In* American journal of anatomy. 1907. v. 6, p. 407-437)

——Present-day conditions and the responsibilities of the university. (*In* Science. Apr. 26, 1907. n. s., v. 25, p. 641-647)

——The valves of the iliac vein. (*In* British medical journal. Dec. 15, 1906. v. 2, p. 1701-1702)

Preliminary note.

——*ed.* Atlas and text-book of human anatomy, by Johannes Sobotta, ed. with additions. Philadelphia & London, W. B. Saunders co., 1906. 2 v. illus., plates (partly col.) 25 cm.

McNeal, Ward J., *joint author.* Mosquito trypanosomes. (*In* Science. Feb. 9, 1906. n. s., v. 23, p. 207-208)

Jointly with F. G. Novy and H. N. Torrey.

Also in Journal of hygiene. Apr. 1906. v. 6, p. 110-111.

——Trypanosomes of mosquitoes and other insects. (*In* Journal of infectious diseases. Apr. 10, 1907. v. 4, p. 223-276)

Jointly with F. G. Novy and H. N. Torrey.

Meader, Clarence Linton. German *selb.* (*In* Modern language notes. Apr. 1907. v. 22, p. 109-110)

——[Review of] The elements of Latin, by Clifford H. Moore and John T. Schlicher. (*In* School review. 1907. v. 15, p. 475-476)

——[Review of] Latin grammar, by William Gardner Hale and Carl Darling Buck. (*In* School review. 1907. v. 15, p. 311-312)

——[Review of] Preparatory Latin writer, by Charles E. Bennett. (*In* Classical journal. Jan. 1906. v. 1, p. 61-62)

Munson, James Decker. Report of the Board of trustees of the Northern Michigan asylum at Traverse City, June 30, 1906. Lansing, 1906.

J. D. Munson, Medical superintendent.

Nancrede, Charles Beylard Guerard de. Life and character of Moses Gunn. (*In* Physician and surgeon. Feb. 1906. v. 28, p. 49-62)

Newman, Horatio Hackett. The habits of certain tortoises. (*In* Journal of comparative neurology and psychology. Apr. 1906. v. 16, p. 126-152)

——On the respiration of the heart (with special reference to the heart of limulus). (*In* American journal of physiology. March 1, 1906. v. 15, p. 371-386)

——The significance of the scute and plate "abnormalities" in chelonia. (*In* Biological bulletin. Jan.-Feb. 1906. v. 11, p. 68-114)

——Spawning, behavior and sexual dimorphism in Fundulus heteroclitus and allied fish. (*In* Biological bulletin. Apr. 1907. v. 12. p. 314)

Novy, Frederick George. The cultivation of spirillum Obermeieri. Preliminary note. (*In* American medical association. Journal. Dec. 29, 1906. v. 47. p. 2152-2154)

> Jointly with R. E. Knapp.

——Food poisons. (*In* Osler, William, *ed.* Modern medicine. Philadelphia, Lea bros. & co., 1907. v. 1, p. 223-246)

——Immunity against trypanosomes. (*In* Science. May 3, 1907. n. s., v. 25, p. 699-700)

> *Also in* Society for experimental biology and medicine. Proceedings. 1907. p. 42-44.

——Mosquito trypanosomes. (*In* Science. Feb. 9, 1906. n. s., v. 23, p. 307-308)

> Jointly with W. J. MacNeal and H. N. Torrey.
> *Also in* Journal of hygiene. Apr. 1906. v. 6, p. 110-111.

——Isolation of trypanosomes. (*In* Science. Feb. 9, 1906. n. s., v. 23, p. 208-209)

> Jointly with R. E. Knapp.
> *Also in* Journal of hygiene. Apr. 1906. v. 6, p. 111.

——On trypanosomes. (*In* Harvey society lectures. 1906. v. 1, p. 33-72)

——Relapsing fever and spirochetes. (*In* Association of American physicians. Transactions. 1906. v. 21, p. 456-464)

> Jointly with R. E. Knapp.
> *Also in* British medical journal. Dec. 1, 1906. v. 2. p. 1573-1575)

——Spirochaete Obermeieri. (*In* American medical association. Journal. Jan. 13, 1906. v. 46, p. 116)

> Jointly with R. E. Knapp.
> *Also in* Science. Feb. 9, 1906. n. s., v. 23. p. 206-207.

——Studies in Spirillum Obermeieri and related organisms. (*In* Journal of infectious diseases. May 1906. v. 3, p. 291-393)

Jointly with R. E. Knapp.

——Trypanosomes. (*In* American medical association. Journal. Jan. 5, 12, 1907. v. 48, p. 1-10, 124-127)
——Trypanosomes of mosquitoes and other insects. (*In* Journal of infectious diseases. Apr. 10. 1907. v. 4. p. 223-276)

Jointly with W. J. MacNeal and H. N. Torrey.

——The trypanosomes of tsetse-flies. (*In* Journal of infectious diseases. May, 1906. v. 3, p. 394-411)

Parker, Walter Robert. [Abstract of] A clinical lecture on optic neuritis and its relationship to intercranial tumors [by] R. L. Flemming. (*In* Annals of ophthalmology. Jan. 1907. v. 16, p. 123-126)
——[Abstract of] Obstruction of the central retinal vein [by] F. H. Verhoeff. (*In* Annals of ophthalmology. Jan. 1907. v. 16, p. 122-123)
——[Abstract of] The pathology and treatment of the ocular complications of gonorrheal infection [by] W. J. McCettles. (*In* Annals of ophthalmology. Jan. 1907. v. 16, p. 129-130)
——[Abstract of] Some unusual ocular manifestations of gonorrhea [by] William Campbell Posey. (*In* Physician and surgeon. Apr. 1907. v. 29, p. 162-163)
——[Review of] Chorioidal hemorrhage following cataract extraction [by] H. Horsman McNabb. (*In* Annals of ophthalmology. Oct. 1906. v. 15, p. 568)
——[Review of] Metastatic affections of the eye [by] W. T. Holmes Spicer. (*In* Annals of ophthalmology. Oct. 1906. v. 15, p. 569-570)
——[Review of] The old and the new in ocular therapeutics [by] A. Maitland Ramsay. (*In* Annals of ophthalmology. Oct. 1906. v. 15, p. 569)
——[Review of] Specific hyalitis [by] Stephens. (*In* Annals of ophthalmology. Oct. 1906. v. 15. p. 568-569)
——Tubercular affections of the eye. (*In* Ophthalmic record. July, 1906. v. 15, p. 301-309)

Patterson, George Washington. Magnetic lines of force. (*In* Michigan technic. June, 1907. v. 20, p. 35-38)

Paxson, Frederick Logan. The county boundaries of Colorado. (*In* Colorado. University. Studies. 1906. v. 3. p. 197-215)

——International morality. (*In* Friends' intelligencer. Oct. 28, 1906. Suppl. p. 91-95)

——A preliminary bibliography of Colorado history. (*In* Colorado. University. Studies. 1906. v. 3, p. 101-114)

———— The territory of Colorado. (*In* American historical review. Oct. 1906. v. 12, p. 53-65)

Also book reviews in The Independent, etc.

Peterson, Reuben. The passing of a beloved physician [Gilbert Lester Rose]. (*In* Physician and surgeon. Feb. 1907. v. 29, p. 90-94)

———Shortening of the round ligaments within the inguinal canals through a single suprapubic transverse or median longitudinal incision. (*In* Surgery, gynecology & obstetrics. July. 1906. v. 3. p. 85-95)

——Urinary incontinence. The treatment of certain forms by the formation of a vesico-vagino-rectal fistula, combined with closure of the introitus vaginæ. (*In* American medical association. Journal. Nov. 3. 1906. v. 47. p. 1447-1449)

———— *ed.* The practice of obstetrics in original contributions by American authors. Philadelphia & New York, Lea brothers & co., 1907. XV, 17-1087 p. illus., XXX pl. 25 cm. (The practitioner's library)

Pillsbury, Walter Bowers. L'attention. . .Traduit. . .par Miss Monica A. Molloy et Raymond Meunier. Paris, O. Doin. 1906. 304 p. 19½ cm. (Bibliothèque internationale de psychologie expérimentale, normale, et pathologique)

——Present day teaching of hygiene in its psychologcial aspects. (*In* Schoolmaster. Dec. 1906-Jan. 1907. v. 1, p. 290-296)

———[Review of] Le mécanisme des émotions, par Paul Sollier. (*In* Philosophical review. May, 1906. v. 15, p. 342-343)

———— [Review of] Psychologie des deux messies positivistes. Saint Simon et Auguste Comte, par Georges Dumas. (*In* Philosophical review. May, 1906. v. 15, p. 342)

———[Review of] Über die willenstätigkeit und das denken von Narziss Aach. (*In* Philosophical review. Jan. 1907. v. 16, p. 98-99)

——I rial and error as a factor in evolution. (*In* Popular science monthly. 1906. v. 68, p. 276-282)

——*ed.* Memory for lifted weights, by E. A. Hayden. (*In* American journal of psychology. Oct. 1906. v. 17, p. 497-521)

——*ed.* Some effects of incentives on work and fatigue, by William R. Wright. (*In* Psychological review. Jan. 1906. v. 13, p. 23-34)

——*ed.* The telephone and attention waves, by George I. Jackson. (*In* Journal of philosophy, psychology and scientific methods. Sept. 1906. v. 3, p. 602-604)

Also reviews of English philosophical and psychological works in Index philosophique, 1906.

Pollock, James Barkley. Some physiological variations of plants and their general significance. (*In* Michigan academy of science. Report. March 1907. v. 9, p. 35-42)

Also in Science. June 7, 1907. n. s., v. 25, p. 881-889.

——Variations in the pollen grain of *Picea excelsa.* (*In* American naturalist. Apr. 1906. v. 40, p. 253-286)

Rankin, Thomas Ernest. The modern short story; its nature and origin. (*In* Poet lore. March, 1906. v. 17, no. 1, p. 100-111)

Rood, John Romaine. A digest of important cases on the law of crimes. Ann Arbor, Mich., G. Wahr, 1906. xiii, 623 p. 24 cm.

Rous, Francis Peyton. The clinical examination of the cerebrospinal fluid. (*In* International clinics. June. 1907. 17th ser., v. 2, p. 79-88)

——Clinical studies of the cerebrospinal fluid. (*In* American journal of the medical sciences. Apr. 1907. v. 133, p. 567-582)

——Effects of struggle on the content in white cells of the lymph. (*In* Society for experimental biology and medicine. Proceedings. May 1907. v. 4, p. 129-130)

——A method for the simultaneous passage of many paraffin sections through the more difficult stains. (*In* Journal of infectious diseases. June 15, 1907. v. 4, p. 382-384)

——Specific somatogenic cytotoxins. (*In* Physician and surgeon. Jan. 1907. v. 29, p. 40-41)

Ruthven, Alexander Grant. Annotated list of the molluscs of the Porcupine Mountains and Isle Royale, Michigan. (*In* Michigan. Geological survey. Annual report for 1905 (Pub. 1906), p. 93-99)
Jointly with Bryant Walker.

——Another specimen of Cory's bittern. (*In* The auk. July, 1907. v. 24, p. 338)

——The cold-blooded vertebrates of the Porcupine Mountains and Isle Royale, Michigan. (*In* Michigan. Geological survey. Annual report for 1905 (Pub. 1906), p. 107-112)

——An ecological survey in the Porcupine Mountains and Isle Royale, Michigan. (*In* same. p. 17-55)

——Notes on the plants of the Porcupine Mountains and Isle Royale, Michigan. (*In* same, p. 75-93)

——A preliminary note on the variation of scutellation in the garter snakes. (*In* American naturalist. June. 1907. v. 41. p. 400)

——Spiders and insects from the Porcupine Mountains and Isle Royale, Michigan. (*In* Michigan. Geological survey. Annual report for 1905 (Pub. 1906). p. 100-106)

Sadler, Herbert Charles. The experimental tank at the University of Michigan. (*In* Society of naval architects and marine engineers. Transactions. 1906. v. 14, p. 51-63)

——Propellers. (*In* Fore and aft. Apr., May. June, 1907)

Sanders, Henry Arthur. The chronology of Livy. (*In* Classical journal. 1906. v. 1, p. 155-156; v. 2, p. 82-83)

———The Oxyrhynchus epitome of Livy and Reinhold's lost chronicon. (*In* American philological association. Transactions. 1906. v. 36. p. 5-31)

———[Review of] Ancient legends of Roman history, by Ettore Pais, tr. by Mario E. Cosenza. (*In* Classical journal. 1907. v. 2, p. 186-188, 338-339)

———[Review of] M. Tulli Ciceronis Tusculanae disputationes, by Thomas W. Dougan. (*In* Classical journal. 1906. v. 1, p. 126-127)

Schlotterbeck, Julius Otto. The development and structure of the seed of *Argemone Mexicana*. (*In* American pharmaceutical association. Proceedings. 1906. v. 54. p. 466-469)
Jointly with C. R. Eckler

Scholl, John William. Friedrich Schlegel and Goethe, 1790-1802; a study in early German romanticism. (*In* Modern language association of America. Publications. March, 1906. v. 21, no. 1)
Thesis (Ph.D.)—Univ. of Michigan.

——Ode to the Russian people. Boston, The Poet lore co., March, 1907. 41 p. 20 cm.

Scott, Fred Newton. A primitive short story. (*In* Modern language notes. Nov., 1906. v. 21, p. 208-211)

——*ed.* Contributions to rhetorical theory. v. 6-7. Ann Arbor, 1906.

CONTENTS.—v. 6. On the limits of descriptive writing apropos of Lessing's Laocoon, by Frank Egbert Bryant.—v. 7. The value of English to the practicing engineer, by Harold P. Breitenbach.

Shepard, John Frederick. Organic changes and feeling. (*In* American journal of psychology. Oct. 1906. v. 17, p. 522-584)

——[Review of] Abhängigkeit der atem-und pulsveränderung vom reiz und vom gefühl [by] M. Kechner. (*In* Psychological bulletin. Feb. 1907. v. 4, p. 49-50)

——Some organic changes in sleep. (*In* Physician and surgeon. May, 1907. v. 29, p. 201-202)

Sellars, Roy Wood. The nature of experience. (*In* Journal of philosophy, psychology and scientific methods. Jan. 3, 1907. v. 4, p. 14-18)

Slocum, George. The visual fields as an aid to diagnosis. (*In* Physician and surgeon. Aug. 1906. v. 28, p. 337-343)

Smalley, Harrison Standish. Railroad rate control in its legal aspects; a study of the effect of judicial decisions upon public regulation of railroad rates. [New York, The Century co., etc., etc.] 1906. v, 147 p. 24½ cm. (*In* American economic association. Publications. 3d ser. v. 7, no. 2)

——Rate control under the amended interstate commerce act. (*In* American academy of political & social science. Annals. March, 1907. v. 29, p. 292-309)

——[Review of] Supplement to Snyder's Interstate commerce act and Federal anti-trust laws, by William L. Snyder. (*In* Michigan law review. March, 1907. v. 5, p. 403-404)

——What will rate regulation mean? (*In* Chicago Sunday tribune. Apr. 29, 1906)
——Why railroads oppose rate regulation. (*In* Chicago Sunday tribune. Apr. 1, 1906)

Smeaton, William Gabb. An improved colorimeter. (*In* American chemical society. Journal. Oct. 1906. v. 28. p. 1433-1435)
——*tr.* The principles of qualitative analysis from the standpoint of the theory of electrolytic dissociation and the law of mass action, by Wilhelm Böttger. Tr. & rev. . . Philadelphia, P. Blakiston's son & co., June, 1906. xvi, 300 p. fold. col. front., illus. 24½ cm.

Smith, Arthur Whitmore. Heat of evaporation of water. (*In* Physical review. Sept. 1907. v. 25. p. 145-170)

Smith, Dean Tyler. Before and after surgical operations. . .Philadelphia, Boericke & Tafel, 1906. viii, [17]-200 p. 20½ cm.
——Drainage after operations. (*In* Medical century. Sept. 1906. v. 14. p. 276-279)
——Hernia. (*In* University homœopathic observer. Jan. 1906. v. 4. p. 11-12)
——Hydrocele of the round ligament. (*In* University homœopathic observer. Jan. 1907. v. 5. p. 16-17)
——Traumatic aneurysis. (*In* University homœopathic observer. Jan. 1906. v. 4. p. 23-28)
——Treatment of inoperable cancer. (*In* Medical counselor. May, 1907. v. 26. p. 93-97)
——Tuberculosis from the standpoint of the surgeon. (*In* University homœopathic observer. July, 1906. v. 4. p. 174-193)
——Varicocele operation. (*In* University homœopathic observer. Jan. 1907. v. 5. p. 17-18)

Smithies, Frank William. Aneurysm of the aorta. (*In* Physician and surgeon. Oct. 1906. v. 28. p. 467-469)
——A case of arthritis deformans treated by Bier's passive hyperemia. (*In* Physician and surgeon. May, 1907. v. 29. p. 209-213)
——A new graphic urine chart, for urine findings in diabetes mellitus. (*In* American medical association. Journal. May 18, 1907. v. 48. p. 1677)
——Progress in internal medicine. (*In* Detroit medical journal. June, 1907. v. 7. p. 209-216)

——[Review of] A treatise on the principles and practice of medicine, by Arthur R. Edwards. (*In* Physician and surgeon. May, 1907. v. 29, p. 239-240)

Stevens, Alviso Burdett. Biographical sketch of Prof. A. Tschirch. (*In* American journal of pharmacy. Jan. 1906. v. 78, p. 38-40)
——Poisonous species of rhus. (*In* Pharmaceutical era. Dec. 1906. v. 36, p. 527-529)

Stevens, Rollin Howard. The barber and skin diseases. (*In* Medical counselor. June, 1907. v. 26, p. 132-135)
——A preliminary report of my experience with the opsonic therapy in certain skin diseases. (*In* Medical century. March, 1907. v. 15, p. 69-75)
——The Roentgen ray and Finsen light in the treatment of malignant diseases of the skin. (*In* Progress (Denver) Feb. 1906. v. 5, p. 55-63)
——Some skin manifestations of syphilis. (*In* Medical counselor. Dec. 1906. v. 25, p. 12-14)
——The treatment of eczema in children. (*In* Medical counselor. Aug. 1906. v. 25, p. 16-20)

Sunderland, Edson Read. Law as a culture study. (*In* Michigan law review. Jan. 1906. v. 4, p. 179-188)

Tatlock, John Strong Perry. Chaucer and Dante. (*In* Modern philology. 1906. v. 3, p. 367-372)
——Chaucer's Vitremyte. (*In* Modern language notes. 1906. v. 21, p. 62)
——The development and chronology of Chaucer's works. London, K. Paul, Trench, Trübner & co., 1907. xiv, 233 [1] p. 23 cm. (*In* Chaucer society. Publications. 2d series, 37)
——The duration of the Canterbury pilgrimage. (*In* Modern language association of America. Publications. 1906. v. 21 (n. s., v. 14) p. 478-485)
——Milton's Sin and Death. (*In* Modern language notes. 1906. v. 21, p. 239-240)
——[Review of] English literature from the Norman conquest to Chaucer, by William Henry Schofield. (*In* Modern language notes. June, 1907. v. 22, p. 186-189)
——[Review of] John C. French: The problem of two prologues to Chaucer's Legend of good women. (*In* Modern language notes. 1906. v. 21, p. 58-62)

——[Review of] Lodowick Carhill: his life, a discussion of his plays, and 'The deserving favorite,' by Charles P. Gray. (*In* Michigan alumnus. March, 1906. v. 12, p. 292)

Taylor, Fred Manville. Some chapters on money; printed for the use of students in the University of Michigan. Ann Arbor, Mich., G. Wahr, 1906. 316 p. 20½ cm.

Thieme, Hugo Paul. Some recent works on French versification. (*In* Modern language notes. Feb. 1906. v. 21, p. 55-57)

Tilden, Charles Joseph. Graphical determination of centroids. (*In* Harvard engineering journal. Nov. 1906. v. 5, p. 111-116)
——Tests of reinforced concrete beams. (*In* American society for testing materials. Proceedings. 1906. v. 6, p. 425-432)
————Uniform loads for test beams. (*In* Michigan technic. Feb. 1906. v. 19, p. 14-18)

Trueblood, Thomas Clarkson. Forensic training in colleges. (*In* Education, March, 1907. v. 27, p. 381-392)
————Qualities of a good oration. (*In* National speech arts association. Proceedings. 1906. v. 15, p. 40-46)
——*joint author.* Standard selections; a collection and adaptation of superior productions from best authors for use in class room and on the platform, arranged and ed. by Robert I. Fulton. . .Thomas C. Trueblood. . .and Edwin P. Trueblood. Boston, New York. [etc.] Ginn & co., 1907. x, 510 p. 19 cm.

Van Tyne, Claude Halstead. Sovereignty in the American revolution. (*In* American historical review. Apr. 1907. v. 12, p. 529-545)

Vaughan, Victor Clarence. A contribution to the chemistry of the bacterial cell and a study of the effects of some of the split products on animals. (*In* Boston medical and surgical journal. Aug.-Sept. 1906. v. 155. p. 215-222, 243-247, 271-276)
————The dangers in impure foods. (*In* St. Paul medical journal. Apr. 1907 v. 9, p. 203-225)

——The effects of egg-white and its split products on animals. A study of susceptibility and immunity. (*In* Association of American physicians. Transactions. June, 1907. v. 22, p. 268-303)

 Also in Journal of infectious diseases. June 15, 1907. v. 4, p. 476-508.
 Jointly with Sybil May Wheeler.

——Experimental immunity to colon and typhoid bacilli. (*In* New York medical journal. June 22, 1907. v. 85, p. 1170-1176)

 Jointly with Sybil May Wheeler.

——Michigan water supplies. (*In* Michigan academy of science. Annual report. 1906. v. 8, p. 111-118)

——The split products of the tubercle bacillus and their effects on animals. (*In* National association for the study and prevention of tuberculosis. Transactions. May, 1907. v. 3, p. 237-243)

 Jointly with Sybil May Wheeler.

Wagner, Charles Philip. Material for Spanish conversation. Ann Arbor, Ann Arbor press, [1907] 48p.

Wait, William Henry. German science reader, with notes and a vocabulary. New York, London, The Macmillan co., 1907. IX, 321 p., incl. tables. 19½ cm.

——2d ed. 1907.

——*ed.* Orations of Lysias. 3d ed. New York, Cincinnati, [etc.] American book co., 1906.

——4th ed. Boston, American book co., 1907.

Ward, Marcus Llewellyn. Some reasons for instituting a public means of protecting the profession against the use of poor alloys. (*In* Dental review. Apr. 1907. v. 21, p. 406-423)

Warthin, Aldred Scott. A case of lymphatic leukæmia with histological picture resembling that of Hodgkin's disease. (*In* Association of American physicians. Transactions. 1906. v. 21, p. 465-474)

——The changes produced in the kidneys by Röntgen irradiation. (*In* American journal of the medical sciences. May, 1907. v. 133, p. 736-746)

——The clinical diagnosis of enlargement of the thymus. (*In* International clinics. Jan. 1907. 17th ser., v. 1, p. 48-65)

——Experimental ligation of splenic and portal veins, with
the aim of producing a form of splenic anemia. (*In*
Society for experimental biology and medicine. Pro-
ceedings. May. 1907. v. 4. p. 127-128)

——An experimental study of the effects of Röntgen rays
upon the blood-forming organs, with special reference
to the treatment of leukemia. (*In* International clinics.
Jan. 1906. 15th ser., v. 4. p. 243-277)

.*Also in* Physician and surgeon. Jan., Feb., March. 1907.
v. 29, p. 1-12, 69-87, 105-119.

——Inflammation. (*In* Bryant, Joseph D., *ed.* American
practice of surgery. New York, W. Wood & co., 1906.
v. 1. p. 71-145)

——Leukemia of the common fowl. (*In* Journal of infec-
tious diseases. June 15, 1907. v. 4. p. 369-381)

——The pathology of the placenta...decidua...chor-
ion...amnion and umbilical cord...fœtus (*In* Pe-
terson, Reuben, *ed.* Practice of obstetrics. Philadel-
phia, Lea bros. & co., 1906. p. 404-535)

——Primary basal-celled carcinoma of appendix; report of
a new case with some observations bearing upon its
histogenesis. (*In* Physician and surgeon. Dec. 1906.
v. 28. p. 544-551)

——Tuberculosis of the placenta. (*In* Journal of infec-
tious diseases. June 15. 1907. v. 4. p. 347-368)

——Two cases of sudden death associated with hypertrophy
of the thymus. (*In* Association of American physi-
cians. Transactions. 1906. v. 21, p. 475-490)

Wenley, Robert Mark. [Review of] The syllogistic
philosophy or Prolegomena to science, by Francis
Ellingwood Abbot. (*In* Science. May 31, 1907.
v. 25. p. 854-856)

——The Rhodes experiment. (*In* Michigan alumnus.
Feb. 1907. v. 13. p. 197-201)

——Sociology as an academic subject. (*In* University
review. Nov. 1906. p. 281-299)

——Transition or what? (*In* Educational review. May,
1907 v. 33. p. 433-451)

——The university in the United States. (*In* University
review. May, 1907. p. 81-100)

Wheeler, Sybil May, *joint author.* The effects of egg-white and its split products on animals. A study of susceptibility and immunity. (*In* Association of American physicians. Transactions. June, 1907. v. 22, p. 268-303)

> *Also in* Journal of infectious diseases. June 15, 1907. v. 4, p. 476-508.
>
> Jointly with Dr. V. C. Vaughan.

——*joint author.* Experimental immunity to colon and typhoid bacilli. (*In* New York medical journal. June 22, 1907. v. 85, p. 1170-1176)

> Jointly with Dr. V. C. Vaughan.

——*joint author.* The split products of the tubercle bacillus and their effects on animals. (*In* National association for the study and prevention of tuberculosis. Transactions. May, 1907. v. 3, p. 237-243) .

> Jointly with Dr. V. C. Vaughan.

White, Alfred Holmes. The nitrides of zinc, aluminium and iron. (*In* American chemical society. Journal. Oct. 1906. v. 28, p. 1343-1350)

> Jointly with L. Kirschbraun.

——The removal of napthalene from coal gas. 3d paper. (*In* Michigan gas association. Proceedings. Sept. 1906)

> Jointly with J. L. Barnes.

——*joint author.* Some conditions influencing constancy of volume in Portland cements. (*In* American chemical society. Journal. Oct. 1906. v. 28, p. 1273-1303)

> Jointly with E. D. Campbell.

Willard, Hobart Hurd, *joint author.* A new electrolyte for the silver coulometer. (*In* American electro-chemical society. Transactions. 1906. v. 9. p. 375-380)

> Jointly with H. S. Carhart & W. D. Henderson.

Willey, Vernon Justin. The teaching of Roentgenology in medical colleges. (*In* Archives of physiological therapy. Dec. 1906)

> *Also in* American quarterly of Roentgenology. Oct. 1906. v. 4. p. 170-173.

Williams, Gardner Stewart. Discussion on engineering education. (*In* American society of civil engineers. Transactions. Dec. 1906. v. 57. p. 156-157)

——[Review of] A textbook on hydraulics. . . by L. M. Hoskins. (*In* Engineering news. March 14, 1907. v. 57, p. 304)

Wood, Norman Asa. Annotated list of the birds of the Porcupine Mountains and Isle Royale, Michigan. (*In* Michigan. Geological survey. Annual report for 1905 (Pub. 1906) p. 113-127)

Jointly with Max M. Peet and O. McCreary.

——Twenty-five years of bird migration at Ann Arbor. Mich. (*In* Michigan academy of science. Annual report. 1906. no. 8, p. 151-156)

Woodson, Myrta. Dietetics. (*In* Smith. Dean Tyler. Before and after surgical operations. Philadelphia, Boericke & Tafel, 1906. p. 90-101)

Wrentmore, Clarence George. Batter tables, for 192 batters from one-sixteenth in., one-eighth in., three-sixteenth in., to 12 inches per foot. New York. Engineering news publishing co., 1906. [107] p. of tables. diagr. 25 x 21½ cm.

Yutzy, Simon Menno. Manual and atlas of dissection. Philadelphia, P. Blakiston's son & co., 1906. 1 p. l. v-xvi, 256 p. illus. (partly col.) 27 cm.

Zimmerschied, Karl Wilhelmj. A new apparatus for polishing metal sections. (*In* American chemical society. Journal. June, 1907. v. 29, p. 855-858)

flüſſe kommen hie und da zum Vorſchein, nicht nur in „My little grey Landlord". Z. B.: „accompanied by millions of curses" (E. 27); „For my part, my road was not difficult to find" (E. 26); „I felt myself suddenly arrested by a man" (E. 408); „They would have less in their caskets if their earnings depended upon themselves" (E. 402). Solche Beiſpiele franʒöſiſchen Einfluſſes, deren noch mehr angeführt werden könnten und die übrigens auch in den deutſchen Werken vereinʒelt vorkommen, haben nichts auffallendes: hatte ſich ja Sealsfield wenige Wochen vorher in Paris aufgehalten, hatte er doch in New-Orleans gelebt und in New-York für eine franʒöſiſche Zeitung gearbeitet.

Es bliebe endlich ʒu ʒeigen, daß auch der Stil in allen fünf Novellen ſchon faſt alle Sealsfieldſchen Eigentümlichkeiten aufweiſt: häufiges Auslaſſen der Pronominal-Subjekte, elliptiſche Säʒe, verhältnismäßige Seltenheit der Relativſäʒe uſw. Bei dem unabgeſchloſſenen Stande der Forſchung aber und mit Rückſicht auf die ſchwere Zugänglichkeit der Zeitſchrift „The Englishman's Magazine" möge uns hier erlaubt ſein, dieſe Mitteilungen mit einer Probe anſtatt eines methodiſchen Beweiſes abʒuſchließen. Die folgende Stelle hat ein beſonderes Intereſſe, indem ſie ſtark an Sealsfields leʒtes Werk „Süden und Norden" erinnert. Sie iſt aus „Scenes in Poland II[1] entnommen und enthält eine Beſchreibung des Zigeunerlagers:

„The whole preserve is enveloped in a dense cloud of sulphur smoke. These are their tents. We approach the largest. It is a coarse goat-hair texture, with numberless holes, the top open, volumes of smoke issuing from it; nothing to be distinguished. Now the forms become a little perceptible. An agreeable sight it is! In the midst of the tent, before a kettle which hangs from three poles, joined on the top, there stands a frightful old woman, in an absolute state of nature, throwing pigs, chickens, cats, mice, and all kinds of bipeds and quadrupeds, into an enormous kettle. Round the fire women are sitting in the same frightful state, suckling their babes. One of them puts down the child, and the next moment it is taken up by her neighbour for the same purpose. The most terrible equality of rights and conditions prevails. No demarcative line of races human or brutal. My stomach is strong and can bear something, but this — what's that again? A dog raises its voice and the whole tent is in motion. Three or four run towards the doorhole, and leaping round demand in a barbarous medley of Polish, Russian and Gipsey, what we want. As many hideous brats accompany them, holding firebrands in their hands.

As the glare of the brands, and the lanterns of my people fall upon us, they become less abrupt. Stanislas pronounces the mandate of withdrawal, and they moan with extreme humility; women, children and beasts joining in the concert.

„And the lords of the soil will turn out the wandering children of the desert and misery, and they will not allow them even this cold spot

[1] Englishman, S. 186.

of ground, to rest their weary limbs upon. Twenty yards is all they beg,
and this they cannot have for one single night. Wo for the children of
the wood! Wo to the Christian tongue that bids them go!" There is in
these lamentations something so object, and at the same time so sinister;
their little piercing eyes, their bony, hideously emaciated bodies assume
so formidable an attitude, their countenances so demoniac an expression,
as to stifle every feeling of pity. „Stanislas, tell them to depart." — „The
children of the forest are tired, the very next step will be their burying
ground. — The wolf, the fox have a resting place, and shall we be denied
one?" is the reply. Stanislas raises his cane. Men and children dart away,
and a hollow laugh is heard. Jaromir impatiently tears up one of the four
pegs by which the cords of the tent are fastened to the ground. There is
a brief pause, as the tent wavers; but the next moment a dozen of women,
twice as many children with dogs, cats, and all sorts of animals, emerge
from their cover. These female furies, with their long, greasy hair hanging
round their brown emaciated shoulders, their eyes burning like ignes
fatui, rush upon us, threatening us with their inch-long nails, venting at
the same time the most horrible imprecations of which the most barbarous
language is capable. When their throats refuse them words, each of them
seizes in one hand one of their brood by the foot, and with the other a
firebrand, and dart again forwards, brandishing them over our heads. My
people no sooner behold me turning than they take to their heels; the
whole tribe follows, yelling like fiends.

Heine im Dienste der „Idee".
Von Ewald A. Boucke (Ann Arbor, Michigan).

Bei dem Ausdruck „Weltanschauung" denkt man entweder an eine
systematische, weit ausblickende und tief eingreifende Behandlung der
Grundprobleme des Daseins, oder an die in Wort, Bild und Tat
sich spiegelnde Arbeit einer schöpferischen Persönlichkeit, den Abglanz
eines reichen Lebens und Strebens. Weder in dem einen philoso-
phischen noch in dem anderen praktischen Sinne scheint es statthaft,
von einer Weltanschauung Heines zu reden. System und Theorie
wird allerdings niemand von dem Dichter erwarten; aber auch seiner
Lebensführung und praktischen Weisheit fehlt es sowohl an Einheit
und Konsequenz wie an Tiefe und Fruchtbarkeit, um Anspruch auf
jene Bezeichnung erheben zu können.

Überhaupt besteht Heines Denkverfahren weniger in einem ruhigen
Anschauen und planvollen Ordnen der Dinge durch den zielbewußt
wählenden Geist, als in einem Projizieren des problematischen,
veränderlichen Selbst in die bunte Mannigfaltigkeit der Erscheinungen.
Die Welt wird zum Tropus des Ichs, und die Vorgänge der
Außenwelt erscheinen als Ausstrahlungen dieses Ichs, die mit seinen
Leiden und Freuden in geheimer Sympathie mitschwingen.

2

Der objektive Naturbetrachter will das Seelenleben zwar auch in Wechselwirkung mit der Außenwelt setzen, aber er ist bereit, seine Abhängigkeit von den ewigen Tatsachen des Seins und Prozessen des Werdens freudig anzuerkennen. Der subjektive Naturträumer sieht alle Linien auf sein Ich als Mittelpunkt konvergieren und ist von der Intensität des inneren Erlebnisses so ergriffen, daß ihm die nah und fern vernehmbaren Stimmen der Außenwelt als begleitende Harmonien, gleichsam als Obertöne des seelischen Grundakkordes entgegenklingen. Dieses intensive Ausleben des Moments befähigt ihn, für jede Phase des Gemütslebens einen ungemein farbenreichen und volltönenden Gesamtausdruck zu finden, für seine Schöpfung die erforderliche Stimmung und Atmosphäre zu erzeugen. Und wenige Dichter haben in dem Hervorbringen von Stimmung, in dem Verweben von Vorstellung, Farbe und Klang eine solche Meisterschaft bewiesen wie Heine. Wenn ihm eine einheitliche Lebensanschauung versagt ist, so steht ihm ein um so größerer Reichtum von fein abgetönten Lebensstimmungen zu Gebote.

Bei einem Dichter von dem Typus Heine tritt also an Stelle einer objektiven Anschauung ein außerordentlich intensives Empfinden und Auskosten des Moments. Anderseits aber erklärt es sich aus den eigentümlichen Verhältnissen und Aufgaben ihres Zeitalters, warum weder die Schriften Heines noch seiner Mitstrebenden den Eindruck eines harmonischen Weltbildes zu erwecken vermögen. Diese streitbaren Ritter vom Geiste hatten keinen Blick für das Bleibende, Ewige, wie es sich in den Grundtatsachen des Naturlebens offenbart, sondern waren durch den unwiderstehlichen Drang der Ereignisse und das gebieterische Heischen der Gegenwart getrieben, über die Probleme der menschlichen Gesellschaft und das geschichtliche Werden nachzudenken. Sie lebten und wirkten in einer Epoche, die Goethe eine „fordernde" genannt hätte.[1]) Ihr Ziel war, „das Leben mit der Wissenschaft zu verbinden" und die gewaltige Geistesarbeit der Vergangenheit nunmehr einem praktischen Zwecke dienstbar zu machen. Das Schauen tritt zurück hinter dem Fordern und Wollen.

Eine solche ausgesprochene Tendenz pflegt die Organisation der gesamten geistigen Arbeit wesentlich zu beeinflussen und geradezu den Mittelpunkt des Denkens und Wirkens zu bilden, um den sich alle übrigen Interessen und Tätigkeiten gruppieren. Dies läßt sich auch

¹) Er verwendet den Ausdruck gern zur Charakteristik der Sturm- und Drangzeit und verwandter Tendenzen. Man vergleiche auch den Ausspruch: „Vor der Revolution war alles Bestreben, nachher verwandelte sich alles in Forderung" (Hempel 19, 125). — Was die oben berührten geistigen und sozialen Probleme des „jungen Deutschland" betrifft, so sei auf die bekannten Darstellungen von Ziegler, Prutz, Lublinski und anderen verwiesen.

im vorliegenden Fall beobachten, und es ist der Zweck des folgenden
Aufsatzes, den theoretischen Mittelpunkt in dem Komplex Heinescher
Lebensstimmungen genauer zu bestimmen. Die Aufgabe wird dadurch
erleichtert, daß sich der Begriff der „Forderung" oder des taten-
zeugenden Gedankens bei Heine gern zu einem Schlagwort verdichtet,
dessen Prägnanz auch dem flüchtigen Leser nicht entgehen kann: zu
dem Wort „Idee". Heine bedient sich dieses Ausdruckes nicht selten,
wenn er ein Höheres im Sinne hat und weiß ihm dann eine eigen-
tümliche Resonanz zu verleihen. Die „Idee" wird somit bei Heine
zu einem bedeutsamen Symbol, und dürfte man von einer Weltan-
schauung Heines reden, so ließe sich ihr Verständnis am ersten durch
eine Analyse jenes Begriffs erschließen. Zunächst ist über die Vorge-
schichte des Wortes und über den scheinbaren Gegensatz zwischen der
natur- und geschichtsphilosophischen Bedeutung desselben einiges vor-
auszuschicken.

1. Die Idee in Natur und Geschichte.

Der Begriff „Idee" hat seine eigene Vergangenheit, die neuer-
dings vom geschichtsphilosophischen Standpunkt ausführlicher darge-
stellt ist.[1]) In der Geschichte offenbart sich die Idee als treibende
Kraft, als das vom Genie klar, von der Menge unklar verfolgte Ziel,
als das scheinbar willkürliche und singuläre Element. Der Natur-
philosoph dagegen verbindet mit dem Wort „Idee" zunächst eine
andere Vorstellung, und es verlohnt sich zur Vermeidung von Miß-
verständnissen auf diesen Unterschied etwas näher einzugehen. Die
naturphilosophische Färbung des Wortes läßt sich an Goethes Ver-
wendung desselben trefflich erläutern.

Bei Goethe ist die Idee die mit geistigem Auge geschaute Einheit
in der Mannigfaltigkeit der Erscheinungen, das Beharrende, der
Gattungsbegriff oder Typus. Somit würde sich also die geschichtliche
Idee auf das Singuläre und Veränderliche, die naturphilosophische
Idee auf das Typische und Bleibende beziehen. Dieser Widerspruch
löst sich aber, wenn man in Betracht zieht, daß im Grunde bei „Idee"
in beiden Fällen an das Wesentliche, Bedeutende gedacht ist. Nun
lenkt sich beim Studium der Naturgebilde die Aufmerksamkeit zunächst
auf die Einheit, das Bleibende, die Konstanz, — beim Studium
geschichtlicher Vorgänge dagegen auf das Successive, den Fortschritt.
In beiden Fällen deckt sich Idee etwa mit „Bildungsprinzip", und
dieses kann entweder kollektiv und normal, oder individuell und ab-
norm wirken. Tatsache ist, daß auch in der Natur die umbildende
Individualidee den Entwicklungsprozeß bewirkt, aber wir können

[1]) J. Goldfriedrich, Die historische Ideenlehre in Deutschland. Berlin 1902.

kaum beurteilen, wie sich der „Fortschritt" im kosmischen Sinne äußert; wir können nicht so ungeheure Perioden überblicken und haben zu wenig sichere Daten.

Man hat ferner zu bedenken, daß der Gebrauch des Wortes „Idee" von den Zeitströmungen und Denkrichtungen abhängig ist, die den Gang der letzten Jahrhunderte bestimmen. Die ältere Naturphilosophie richtete ihr Augenmerk vorwiegend — bei Goethe wohl ausschließlich — auf das erhaltende Prinzip, auf das Sein; die Geschichtsphilosophie anderseits, wenigstens die vorherrschende Richtung derselben, betonte das treibende, singuläre Prinzip, das Werden. So läßt sich der scheinbare Widerspruch auf verschiedene Weise erklären und auflösen.[1]

In der geschichtlichen Ideenlehre, mit der wir uns von hier ab beschäftigen, bezieht sich der Ausdruck also auf das fortschrittliche evolutionistische Element. Diese Auffassung, die zuerst Vico in seiner „Nuova Scienza" zur Grundlage seiner entwicklungsgeschichtlichen Theorien machte, bestimmt die Kulturphilosophie der Neuzeit, obwohl in mannigfachen Schattierungen. Iselin, Herder, Kant, Schelling, Fichte, Humboldt, Hegel, — jeder von diesen Denkern verwendet das Wort in seiner eigenen Weise und prägt ihm einen besonderen Sinn auf. Am vielseitigsten und kräftigsten von allen hat Hegel den Begriff zur Geltung gebracht und damit einem ganzen Zeitalter den Stempel seines Geistes aufgedrückt. Man kann eine dreifache Anwendung des Ideenbegriffes unterscheiden. Im logischen Sinne ist die Idee bei Hegel der absolute Geist an sich, das Prinzip der notwendigen Bewegung und Tätigkeit, während die Kulturgeschichte die Auswirkung der Idee auf den verschiedenen Stufen und Gebieten darstellt. Vom rein aktuellen Standpunkt aus wäre unter „Idee" demnach soviel zu verstehen als: Bedürfnis, Losung des Zeitalters, — und diese Schlußfolgerung zogen auch die jüngeren Anhänger der Hegelschen Schule. Es ist bekannt, daß der Meister selbst von dieser Folgerung keinen Gebrauch machte, sondern den Blick von den umgestaltenden Ideen der Gegenwart zurückwandte auf die Verwirklichung einer einzigen Idee, nämlich des preußischen Staatsbegriffs, und daß ihm gerade diese Idee immer mehr als Verwirklichung des von der Vernunft zu Postulierenden erschien.

[1] Die heutige Biologie, die vorwiegend an den Gesetzen der fortschreitenden Entwicklung und Umbildung interessiert ist, also an dem zeitlichen Prozeß, würde sich in diesem Punkte mit der geschichtlichen Ideenlehre ohne weiteres verständigen, denn als das Wesentliche, die Idee, gilt ihr die Variabilität, das Singuläre. Sie zieht es aber vor, mit derartigen allgemeinen und spekulativen Hilfsbegriffen möglichst wenig zu operieren. — Hinsichtlich der Begriffe „Idee" und „Typus" bei Goethe vgl. mein Buch: „Goethes Weltanschauung auf historischer Grundlage". Stuttgart 1907, S. 212 f., 252 ff.

Von den drei Anwendungen der Idee, der logischen, kulturge-
schichtlichen und realistisch-aktuellen vernachlässigt Hegel also die dritte.
Anders die jüngere Generation, der auch Heine angehörte. Sie be-
nutzte die logischen und geschichtlichen Tatsachen geradezu als Stütze
und Hebel für ihre revolutionären Pläne und Forderungen an die
Zukunft. Denn warum sollte der Entwicklungsprozeß plötzlich zum
Abschluß kommen und keinen neuen Gestaltungen zustreben? Es ist
anderseits begreiflich, daß die rein logische Seite, die von dem Ab-
soluten ausgehende Deduktion, bei den Männern der Tat und des
Fortschritts weniger Beachtung fand. Das gleiche gilt naturgemäß
auch von Heine, zu dessen Auslegung des Ideenbegriffs wir nunmehr
unter Beibehaltung der obigen drei Gesichtspunkte übergehen.

2. Die logische Idee.

In den „Geständnissen" (6, 47 ff.) berichtet Heine von seinem
Studium der Hegelschen Schriften und von seinem Plan, „eine allge-
gemein verständliche Darstellung der ganzen Hegelschen Philosophie
zu verfassen ... Doch als das Werk endlich fertig war, erfaßte mich
bei seinem Anblick ein unheimliches Grauen, und es kam mir vor,
als ob das Manuskript mich mit fremden, ironischen, ja boshaften
Augen ansähe ... Ich empfand überhaupt nie eine allzu große Be-
geisterung für diese Philosophie, und von Überzeugung konnte in
bezug auf dieselbe gar nicht die Rede sein ... an einem stillen
Winterabend, als eben in meinem Kamin ein starkes Feuer brannte,
benutzte ich die schöne Gelegenheit, und ich warf mein Manuskript
über die Hegelsche Philosophie in die lodernde Glut; die brennenden
Blätter flogen hinauf in den Schlot mit einem sonderbaren kichern-
den Geknister."

Über dieses Bekenntnis braucht man sich kaum zu wundern,
denn tatsächlich lag Heine die Fichtesche Doktrin von der Selbst-
herrlichkeit des Ichs weit näher, als Hegels Objektivität und Ver-
nunftlehre.[1] An dem „gekochten grauen Spinnweb der Hegelschen
Dialektik" konnte der Impressionist und Dichter, dem sich die ganze
Welt in ein kaleidoskopisches Spiel von Tropen und Analogien auf-
löste, kaum Geschmack finden. Im allgemeinen zeigt Heine daher
schon früh eine unverhehlte Abneigung gegen das abstrakte Hegeltum.
Von Lüneburg schreibt Heine an Moser über einen seiner Träume:
„Ich sah eine Menge Menschen, die mich auslachten, ... und ich
lief schäumend vor Ärger zu dir, und du ... sprachest mir Trost
ein, und sagtest mir, ich solle mir nichts zu Gemüte führen, denn

[1] Siehe Näheres unten. ! Kif

ich sei ja nur eine Idee, und um mir zu beweisen, daß ich nur eine Idee sei, griffest du hastig nach Hegels Logik und zeigtest mir eine konfuse Stelle darin, und Gans klopfte ans Fenster, — ich aber sprang wütend im Zimmer herum und schrie: ,Ich bin keine Idee, und weiß nichts von einer Idee, und hab' mein Lebtag keine Idee gehabt'" (Br. 1, 102). — In einem der nächsten Briefe beschwört Heine abermals seinen Freund: „Um des Himmels willen, sag nicht noch einmal, daß ich bloß eine Idee sei! Ich ärgere mich toll darüber. Meinethalben könnt ihr alle zu Ideen werden: nur laßt mich un- geschoren. Weil du und der alte Friedländer und Gans zu Ideen geworden seid, wollt ihr mich jetzt auch verführen und zu einer Idee machen" (Br. 1, 127).

Heines dichterische Phantasie, die er selbst als ein Verschlingen und Zusammenrinnen der Erscheinungswelt mit der Gemütswelt beschreibt, sträubt sich natürlich gegen das abstrakte Kategorisieren, wodurch „wir unsere Köpfe apothekenartig mit tausend Schubladen versehen, wo in der einen Vernunft, in der andern Verstand, in der dritten Witz, in der vierten schlechter Witz und in der fünften gar nichts, nämlich die Idee, enthalten ist" (3, 78). — Als Verspottung von Hegels Schematismus sind auch die bekannten Auslassungen in Kapitel 14 und 15 des Buches Le Grand zu erklären, besonders die Einteilung der Ideen in vernünftige und unvernünftige, ge- wöhnliche und solche, die mit grünem Leder überzogen sind, usw. Man braucht nur diesen Scherz und die lächerlichen Definitionen des Ideenbegriffs in Kapitel 14 des gleichen Werkes mit den oben zitierten Briefstellen zusammenzuhalten, um die ironische Neben- bedeutung zu würdigen, die in dem Obertitel („Ideen") liegt. — Die gleiche Geringschätzung der abstrakten Idee äußert sich in den bekannten Spöttereien über das ewige Theoretisieren der Deutschen, des Volkes, „das im Wissen seine Lust befriedigt, nicht im Leben". „Die Engländer sind brutal wie eine Tatsache und widerstehen materiell. Ein Deutscher mit seinen Gedanken, seinen Ideen, die weich wie das Gehirn, woraus sie hervorgegangen, ist gleichsam selbst nur eine Idee, und wenn diese der Regierung mißfällt, so schickt man sie auf die Festung" (5, 127).

Auch in seinen Ansichten über die Kunst lehnt sich Heine nirgends an Hegel an, und wenn auch manche seiner Sätze, in denen von der Idee die Rede ist, an Hegel anklingen, so darf man sich doch nicht darüber täuschen, daß Heine das Wort im populären, nicht im meta- physischen Sinne braucht. Statt des dialektischen Prozesses, der bei Hegel die drei Stufen des Symbolischen, Klassischen und Romanti- schen durchläuft, erscheint bei Heine die Gegenüberstellung von Klassisch und Romantisch, wie sie seit Schiller und Schlegel geläufig ist. Die

Ausdrücke haben bei ihm also eine ästhetisch-prinzipielle und nicht metaphysisch-konstruktive Bedeutung. Seine Definition lautet folgendermaßen: „Die Behandlung ist klassisch, wenn die Form des Dargestellten ganz identisch ist mit der Idee des Darzustellenden, wie dieses der Fall ist bei den Kunstwerken der Griechen, wo daher in dieser Identität auch die größte Harmonie zwischen Form und Idee zu finden. Die Behandlung ist romantisch, wenn die Form nicht durch Identität die Idee offenbart, sondern parabolisch diese Idee erraten läßt[1] ... In diesem parabolischen Geist wurden nun auch alle Künste im Mittelalter behandelt, und diese Behandlung ist romantisch. Daher in der Poesie des Mittelalters jene mystische Allgemeinheit; ... die Idee ist in der Form nur wie ein Rätsel angedeutet, und wir sehen hier eine vage Form, wie sie eben zu einer spiritualistischen Literatur geeignet war. Da ist nicht wie bei den Griechen eine sonnenklare Harmonie zwischen Form und Idee; sondern manchmal überragt die Idee die gegebene Form, und diese strebt verzweiflungsvoll jene zu erreichen, und wir sehen dann bizarre, abenteuerliche Erhabenheit: manchmal ist die Form ganz der Idee über den Kopf gewachsen, ein läppisch winziger Gedanke schleppt sich einher in einer kolossalen Form, und wir sehen groteske Farce; fast immer sahen wir Unförmlichkeit" (4, 202 f.).

Diese Stellen beweisen, daß Heine von Hegels metaphysischer Ausdeutung des Romantischen als einer Stufe des historischen Prozesses keinen Gebrauch macht. Er hält an der Schiller-Schlegelschen Lehre fest, wonach die Formel Klassisch-Romantisch zwei ästhetische Prinzipien und nicht wie bei Hegel zwei metaphysische Welten bezeichnet[2]. Es muß ferner zugestanden werden, daß der Ausdruck

[1] Ähnlich heißt es in der „Romantischen Schule": „Die romantische Kunst hatte das Unendliche ... darzustellen oder vielmehr anzudeuten, und sie nahm ihre Zuflucht zu einem System traditioneller Symbole oder vielmehr zum Parabolischen ..." (5, 224). Beide Stellen weisen auf die Schlegelsche Definition zurück, wonach das Romantisch-Schöne als symbolische Darstellung des Unendlichen gilt. — Der Ausdruck „parabolisch", den Heine hier und an anderen Stellen substituiert, paßt ohne Zweifel besser auf die mittelalterliche Kunst, insofern diese eine bewußte Auslegung und Kommentierung von überlieferten Stoffen ist und ohne die Idee unverständlich bleibt. Man braucht nur an Dante zu erinnern. An sich aber kann das Romantische ebensowohl aus symbolischer Behandlung hervorgehen, wenn nämlich die spontan schaffende Phantasie den konkreten Einzelfall so anzuschauen und darzustellen vermag, daß sich ein Allgemeines, Typisches darin spiegelt. Ein Beispiel bietet Wolframs Parzival.

[2] Vgl. die Abhandlung von Bruno Bauch, „Klassisch und Romantisch — Naiv und Sentimental" im Archiv für Geschichte der Philosophie 16, 488 ff. — Allerdings ist bezüglich Heines noch zu bemerken, daß die Schlegelsche Konstruktion bei ihm allmählich zurücktritt zu Gunsten seiner eigenen geschichtsphilosophischen Grundformel, des Gegensatzes zwischen Sensualismus und Spiri-

„Idee" hier kaum einen metaphysischen Nebensinn hat, sondern soviel
wie Inhalt oder Grundgedanke bedeutet. Es bleibt also nichts als
die besondere Art der Formulierung, die auf Hegel und Solger
hinweist.

Auch Heines Ansichten über den künstlerischen Schaffensprozeß
enthalten keine spezifisch Hegelschen Elemente. Folgende Sätze geben
den Kern seiner Anschauungen: „Der große Irrtum besteht immer
darin, daß der Kritiker die Frage aufwirft: was soll der Künstler?
Viel richtiger wäre die Frage: was will der Künstler, oder gar, was
muß der Künstler? ... Jeder Genius muß studiert und nur nach
dem beurteilt werden, was er selbst will. Hier gilt nur die Beant-
wortung der Fragen: hat er die Mittel seine Idee auszuführen? hat
er die richtigen Mittel angewendet? Hier ist fester Boden. Wir modeln
nicht mehr an der fremden Erscheinung nach unsern subjektiven
Wünschen, sondern wir verständigen uns über die gottgegebenen Mittel,
die dem Künstler zu Gebote stehen bei der Veranschaulichung seiner
Idee. In den rezitierenden Künsten bestehen diese Mittel in Tönen
und Worten. In den darstellenden Künsten bestehen sie in Farben
und Formen. Töne und Worte, Farben und Formen, das Erscheinende
überhaupt, sind jedoch nur Symbole der Idee, Symbole, die in dem
Gemüt des Künstlers aufsteigen, wenn es der heilige Weltgeist bewegt,
seine Kunstwerke sind nur Symbole, wodurch er andern Gemütern
seine eigenen Ideen mitteilt" (4, 42 f.).

Es ist klar, daß sich auch in diesen Sätzen die „Idee" des
Kunstwerks nur auf den treibenden Grundgedanken bezieht, während
das Wort „Symbol" hier in ziemlich willkürlicher Weise für „sinn-
liches Ausdrucksmittel" eingesetzt ist. Auch sonst ist in diesen Sätzen
nichts von Hegel zu spüren, denn Heine befürwortet eine individuell-
genetische Beurteilung des Kunstwerks statt der dogmatischen und
nimmt darin eine ziemlich unabhängige Stellung ein. Tatsächlich
hätten weder die älteren noch die jüngeren philosophischen Schulen,
nach der Beschaffenheit ihrer Methoden und Ziele, so rein nachempfin-
dend verfahren können, wie Heine es verlangt. Der impressionistische
Künstler erscheint hier als Vorkämpfer der impressionistischen
Kritik, wie sie heute von Bourget, Brandes und anderen ver-
treten wird.

Aus der bisherigen Untersuchung geht hervor, daß Heines Ideen-
begriff von der Logik und Ästhetik Hegels kaum berührt wird. Die
Prägnanz des Wortes liegt vielmehr auf dem geschichtsphilosophischen
Gebiete.

tualismus. Diese Verschiebung ist bezeichnend für den Wandel des Zeitgeistes.
Die ältere Generation entnahm ihre Kriterien der Ästhetik und Logik, die jüngere
pochte auf das Recht, zu leben, zu handeln und zu genießen.

8. Die geſchichtlichen Ideen.

Wie vollſtändig Heines Geſchichtsauffaſſung im Banne der Iden-
titätsphiloſophie ſteht, läßt ſich ohne weiteres aus der folgenden
längeren Betrachtung erkennen, die ſeiner bedeutendſten geſchichts-
philoſophiſchen Abhandlung entnommen iſt: „Gott iſt identiſch mit
der Welt. Er manifeſtiert ſich in den Pflanzen, die ohne Bewußtſein
ein kosmiſch-magnetiſches Leben führen. Er manifeſtiert ſich in den
Tieren, die in ihrem ſinnlichen Traumleben eine mehr oder minder
dumpfe Exiſtenz empfinden. Aber am herrlichſten manifeſtiert er ſich
in dem Menſchen, der zugleich fühlt und denkt, der ſich ſelbſt indi-
viduell zu unterſcheiden weiß von der objektiven Natur und ſchon in
ſeiner Vernunft die Ideen trägt, die ſich ihm in der Erſcheinungswelt
kundgeben. Im Menſchen kommt die Gottheit zum Selbſtbewußtſein,
und ſolches Selbſtbewußtſein offenbart ſie wieder durch den Menſchen.
Aber dieſes geſchieht nicht in dem einzelnen und durch den einzelnen
Menſchen, ſondern in und durch die Geſamtheit der Menſchen: ſo
daß jeder Menſch nur einen Teil des Gottweltalls auffaßt und dar-
ſtellt, alle Menſchen zuſammen aber das ganze Gottweltall in der
Idee und in der Realität auffaſſen und darſtellen werden. Jedes Volk
vielleicht hat die Sendung, einen beſtimmten Teil jenes Gottweltalls
zu erkennen und kundzugeben, eine Reihe von Erſcheinungen zu be-
greifen und eine Reihe von Ideen zur Erſcheinung zu bringen, und
das Reſultat den nachfolgenden Völkern, denen eine ähnliche Sendung
obliegt, zu überliefern. Gott iſt daher der eigentliche Held der Welt-
geſchichte, dieſe iſt ſein beſtändiges Denken, ſein beſtändiges Handeln,
ſein Wort, ſeine Tat; und von der ganzen Menſchheit kann man
mit Recht ſagen, ſie iſt eine Inkarnation Gottes" (4, 222).

Welcher von den beiden Hauptvertretern der Identitäts-Philoſo-
phie dieſe Sätze inſpiriert hat, iſt nicht leicht zu entſcheiden und auch
wenig von Belang. Soweit die naturphiloſophiſchen Ingredienzien in
Betracht kommen, könnte man eher an Schelling denken. Zwar in
ſeiner Darſtellung der Schellingſchen Philoſophie ſpricht ſich Heine
etwas geringſchätzig und ſpöttiſch über dieſen Denker aus, aber ſeiner
naturphiloſophiſchen Richtung nach zeigt er mehr Verwandtſchaft mit
Schelling als mit den anderen beiden ſpekulativen Syſtemen, denn
was iſt Heines Naturbeſeelung, ſein Schwelgen im „duftigen, ſonnigen
Realen" und in den „Blumentälern der Symbolik" anders als
die zur freien dichteriſchen Tat geſteigerte romantiſche Naturphilo-
ſophie?

Andererſeits iſt kein Zweifel, daß das geſchichtsphiloſophiſche Element
auf Hegel zurückgeht, da Heine in Berlin zu den Füßen des Meiſters
geſeſſen und mit ihm im perſönlichen Gedankenaustauſch geſtanden

hatte.[1] Einen weiteren Beweis, wenn es eines solchen bedürfte, bietet folgende Stelle aus der Schrift „Über Polen": „Kein Volk, als ein Ganzes gedacht, verschuldet etwas; sein Treiben entspringt aus einer inneren Notwendigkeit, und seine Schicksale sind stets Resultate derselben. Dem Forscher offenbart sich der erhabenere Gedanke: daß die Geschichte (Natur, Gott, Vorsehung usw.) wie mit einzelnen Menschen, auch mit ganzen Völkern eigene große Zwecke beabsichtigt, und daß manche Völker leiden müssen, damit das Ganze erhalten werde und blühender fortschreite" (7, 204). Hier findet sich also der gleiche Gedanke, wie in dem viele Jahre später entstandenen philosophischen Werk, und da die Schrift über Polen in das Jahr 1822, also in die Berliner Studienzeit fällt, so ist die direkte Einwirkung von Hegels Lehren unverkennbar.

Auch der Ideenbegriff, mit dem wir uns hier vor allem beschäftigen, trägt die Hegelsche Prägung, wie die angeführten Stellen beweisen. Während also Heine auf dem Gebiet der Ästhetik seine eigenen Wege geht, steht seine Geschichtsphilosophie ganz unter dem Einfluß der herrschenden Richtung. Über das Wesen und die Funktion der historischen Idee finden sich bei Heine zahlreiche Betrachtungen der verschiedensten Art, und eine Prüfung dieses Materials gibt uns einen Einblick in die buntschillernde Gedankenwelt dieser Proteusnatur, die gleichwohl einen Mittelpunkt in sich trug, und wenn sie nicht einem festen Ziele zustrebte, doch an einer allgemeinen Grundrichtung festhielt.

Eine Formulierung seiner geschichtsphilosophischen Anschauungen versucht Heine in folgendem Aphorismus: „Ich glaube, die Philosophen müssen noch tausend Jahr warten, ehe sie den Organismus der Geschichte nachweisen können; bis dahin, glaube ich, nur folgendes ist anzunehmen. Für Hauptsache halte ich: die menschliche Natur und die Verhältnisse (Boden, Klima, überlieferte Gesetzgebung, Krieg, unvorhergesehene und unberechenbare Bedürfnisse), beide in ihrem Konflikt oder in ihrer Allianz geben den Fond der Geschichte, sie finden aber immer ihre Signatur im Geiste, und die Idee, von welcher sie sich repräsentieren lassen, wirkt wieder als Drittes auf sie ein; das ist hauptsächlich in unseren Tagen der Fall, auch im Mittelalter. Shakespeare zeigt uns in der Geschichte nur die Wechselwirkung von der menschlichen Natur und den äußern Verhältnissen — die Idee, das Dritte, tritt nie auf in seinen Tragödien; daher eine viel klarere Gestaltung und etwas Ewiges, Unwandelbares in seinen Entwicklungen, da das Menschliche immer dasselbe bleibt zu allen Zeiten. Das ist auch der Fall bei Homer. Beider Dichter Werke sind unvergänglich"

[1] Vgl. A. Strodtmann, H. Heines Leben und Werke. 3. Auflage, 1, 181 ff.

(7, 411). Dieſe Aufzeichnung iſt merkwürdig, weil ſie genau die Theorie wiedergibt, die zuerſt Taine im größeren Stil verwertete: daß alle geiſtigen Erzeugniſſe als Produkt von Raſſe, Milieu und Idee („Moment") anzuſehen ſeien. Taine entlehnte die Beſtandteile dieſer Formel teils aus Hegel (vgl. das Kapitel über die „Geographiſche Grundlage der Weltgeſchichte" in deſſen Philoſophie der Geſchichte), teils aus Comte, Montesquieu u. a.[1]). Daß die Unabhängigkeit von beſtimmten zeitlichen Ideen und ſtofflichen Tendenzen Shakeſpeare zu dem Dichter des Menſchlich-Typiſchen macht und ihn in eine Reihe mit Homer und der Bibel ſtellt, hebt Heine auch an anderen Stellen hervor (vgl. 5, 378; 7, 52).

Unter den eben erwähnten drei Elementen iſt es das geiſtige, die Idee, deren zeugende Kraft den Dichter zur Bewunderung hinreißt. Ihre Bedeutung liegt darin, daß ſie eine Potenz iſt, die unaufhaltſam zur Entladung drängt, daß ſie die unmittelbare Vorſtufe der Tat bildet. Dieſe Vorſtellung kehrt in vielen Variationen bei Heine wieder. „Der Gedanke geht der Tat voraus wie der Blitz dem Donner" (4, 294). So ungeſtüm iſt das Drängen des Gedankens, daß er keine Ruhe findet, bis er zur Tat geworden, „bis wir ihm ſeinen Leib gegeben, bis wir ihn zur ſinnlichen Erſcheinung gefördert. Der Gedanke will Tat, das Wort will Fleiſch werden . . . Die Welt iſt die Signatur des Wortes. Dieſes merkt euch, ihr ſtolzen Männer der Tat. Ihr ſeid nichts als unbewußte Handlanger der Gedankenmänner, die oft in demütigſter Stille euch all eu'r Tun aufs beſtimmteſte vorgezeichnet haben" (4, 248). Am großartigſten iſt dieſe Anſchauung verewigt in dem Bild vom Liktor, der dem Dichter, wie Kapitel 6 des Wintermärchens „Deutſchland" erzählt, in den Straßen von Köln mit einem Richtbeil unter dem Mantel beſtändig folgt. Er legitimiert ſich mit den Worten:

> Ich bin von praktiſcher Natur,
> Und immer ſchweigſam und ruhig,
> Doch wiſſe: was du erſonnen im Geiſt,
> Das führ' ich aus, das thu' ich.
>
> Und gehn auch Jahre drüber hin,
> Ich raſte nicht, bis ich verwandle
> In Wirklichkeit, was da gedacht;
> Du denkſt, und ich, ich handle.

[1]) Vgl. V. Giraud, Essai sur Taine. Paris 1901, S. 87 ff. — Daß die Vorausſetzungen zu ſolchen Konſtruktionen ſeit Hegel gegeben waren, zeigt Gutzkows Schrift: „Philoſophie der Tat und e Ereigniſſes". Gutzkow erörtert hier die Möglichkeit einer Geſchichtsphiloſophie auf Grundlage ähnlicher Theorien, wie ſie Taine ſpäter benutzte; er ſelbſt bekämpft bekanntlich den Hegelianismus und befürwortet eine pragmatiſch-realiſtiſche Auffaſſung (vgl. R. Feſter, Eine vergeſſene Geſchichtsphiloſophie. Hamburg 1890).

Dem Konsul trug man ein Beil voran
Zu Rom, in alten Tagen.
Auch du hast deinen Liktor, doch wird
Das Beil dir nachgetragen.

Ich bin dein Liktor, und ich geh'
Beständig mit dem blanken
Richtbeile hinter dir — ich bin
Die Tat von deinem Gedanken.

Die Generation, der Heine angehört, begnügt sich nicht mit Ideen als Mitteln der Kontemplation und inneren Befreiung: sie verlangt nach Umsetzung in die Tat, nach einer Neuordnung der wirklichen Welt. Sie fühlt sich zwar äußerlich geknebelt, aber sie ist sich der furchtbaren Gewalt ihrer Waffen bewußt, denn die Idee ist unzerstörbar und muß früher oder später zur Tat werden. Solche Betrachtungen waren für den Dichter und seine Gesinnungsgenossen ein gewisser Trost in der politischen Misere der Zeit. Sie nahmen zuweilen sogar solch paradoxe Form an wie in dem folgenden Bekenntnis: „Ich preise nie die Tat, sondern nur den menschlichen Geist, die Tat ist nur dessen Gewand, und die Geschichte ist nichts anders als die alte Garderobe des menschlichen Geistes" (3, 274). Man wird Heine dieses Ausspruchs halber gleichwohl nicht als Ideologen ansehen; sagt er doch mit Recht von sich an anderer Stelle: „Ich bin nicht dazu geeignet, ein Kerkermeister der Gedanken zu sein" (4, 248). Nicht das Leben in Ideen wird auf Kosten der Tat gepriesen, sondern die tatenzeugende Kraft der Idee, ja die Identität von Tat und Gedanke.

Das geschichtliche Werden ist also nur die äußere Erscheinungswelt, die von der Dynamik der Idee getrieben wird. Warum aber gewisse Ideen zu gewissen Zeiten einen so hypnotisierenden Einfluß ausüben, bleibt ein Rätsel. „Die Fakta sind nur die Resultate der Ideen; ... aber wie kommt es, daß zu gewissen Zeiten sich gewisse Ideen so gewaltig geltend machen, daß sie das ganze Leben der Menschen, ihr Dichten und Trachten, ihr Denken und Schreiben, aufs wunderbarste umgestalten? Es ist vielleicht an der Zeit, eine literarische Astrologie zu schreiben und die Erscheinung gewisser Ideen oder gewisser Bücher, worin diese sich offenbaren, aus der Konstellation der Gestirne zu erklären. Oder entspricht das Aufkommen gewisser Ideen nur den momentanen Bedürfnissen der Menschen? Suchen sie immer die Ideen, womit sie ihre jedesmaligen Wünsche legitimieren können? In der Tat, die Menschen sind ihrem innersten Wesen nach lauter Doktrinäre; sie wissen immer eine Doktrin zu finden, die alle ihre Entsagungen oder Begehrnisse justifiziert" (5, 826).

Auf die hier aufgeworfene Frage nach dem Ursprung der Ideen
gibt Heine bei anderer Gelegenheit unbedenklich Antwort, und zwar
im Sinne einer streng individualistischen Geschichtsauffassung.
Träger der Idee sind die großen Männer, die singulären Persönlich-
keiten, die Ritter vom Geiste — die große Masse ist, „ohne es zu
wissen, nichts anderes als ein kolossaler Sancho Pansa ... getrieben
von der mystischen Gewalt, die der Enthusiasmus immer ausübt auf
den großen Haufen" (3, 422). Nichts erbittert Heine mehr als der
eifersüchtige Gleichheitssinn, der in Republiken „alle ausgezeichneten
Individualitäten immer zurückstoßen, ja unmöglich machen wird"
(7, 558; vgl. 5, 140; 7, 811). Und doch kann sich Heine nicht der
Einsicht verschließen, daß die Herrschaft der Demokratie auch hierin
eine Umwälzung herbeiführen muß, und daß vielleicht eine Zeit
kollektivistischen Heldentums bevorsteht. „Überhaupt scheint die Welt-
periode vorbei zu sein, wo die Taten der Einzelnen hervorragen; die
Völker, die Parteien, die Massen selber sind die Helden der neuern
Zeit" (5, 146). Gerade in dieser Erkenntnis liegt die Tragik von
Heines Zwitterstellung zwischen dem ästhetischen Individualismus
des scheidenden und den sozialethischen Idealen des kommenden Zeit-
alters.[1]

Die treffendste Erläuterung zu Heines individualistischer Ideen-
lehre bietet sein Napoleonkult. Es ist nur zu natürlich, daß er in
der dämonischen Persönlichkeit, die auch über seine Jugend ihre Schatten
warf, „den Mann der Idee, den ideegewordenen Menschen" erblickte
(Br. 20, 18). Und zwar ist hier „Idee" nicht nur im allgemein-
geschichtsphilosophischen, sondern aktuellen Sinne zu nehmen: galt ihm
doch Napoleon zu jener Zeit als „der Repräsentat der Revolution,
das Sinnbild der siegenden Volksgewalt". In welcher Weise Heine
später sein Urteil über Napoleon modifizierte, ist bekannt; aber selbst
dann möchte er sich das Bild des Heros möglichst rein erhalten, und
er rettet sich aus dem Dilemma auf eine köstliche Weise. „Der tote
Napoleon," heißt es in einem seiner ersten Berichte über französische
Zustände, „wird von den Franzosen noch mehr geliebt als der lebende
Lafayette. Vielleicht eben weil er tot ist, was wenigstens mir das
Liebste an Napoleon ist; denn lebte er noch, so müßte ich ihn ja
bekämpfen helfen" (5, 40). — Noch ehe Heine seine große Napoleon-
Apotheose dichtete, hatte übrigens schon Goethe ganz dieselbe Defi-
nition des Korsen gegeben und ihn als einen Mann bezeichnet, „der
ganz in der Idee lebte.[2] Beide Dichter stimmen auch darin überein,
daß sie ihm jede Einsicht in die Macht der geschichtlichen Ideen ab-

[1] Siehe Weiteres unten.
[2] Werke, Ausgabe Hempel 19, 77.

sprechen. Goethe fährt an jener Stelle fort: „Er leugnet alles Ideelle durchaus und spricht ihm jede Wirklichkeit ab, indessen er es eifrig zu verwirklichen trachtet." Heine erklärt sich Napoleons Untergang geradezu daraus, daß er die alte und neue Zeit nicht zu versöhnen und ihre entgegengesetzten Prinzipien nicht zu einem dritten zu verschmelzen wußte. „Nur die Personen und die Interessen wußte er zu vermitteln, nicht die Ideen, und das war sein großer Fehler und auch der Grund seines Sturzes" (6, 148).

Von größter Wichtigkeit ist die praktische Verwendung des Ideenbegriffes zu geschichtsphilosophischen Konstruktionen. Ein Beispiel universalgeschichtlicher Betrachtung bietet folgende Stelle, die sich ziemlich mit Hegels Schema deckt: „Wie der Grieche groß ist durch die Idee der Kunst, der Hebräer durch die Idee eines heiligsten Gottes, so sind die Römer groß durch die Idee ihrer ewigen Roma, groß überall, wo sie in der Begeisterung dieser Idee gefochten, geschrieben und gebaut haben" (8, 262). Die „Idee der ewigen Roma", das heißt der Weltherrschaft ist Heinesches Pathos: Hegel führt das innerste Wesen der römischen Welt auf die Idee des „Abstrakt-Allgemeinen" zurück.

Von den großen weltbewegenden Ideen sind es zwei, die Heine andauernd beschäftigen: das Christentum und die französische Revolution. In dem Prinzip des Christentums, den Spiritualismus, erblickt er die allbeherrschende Idee des Mittelalters, das geistige Ferment, das die gesamte Kultur des Abendlandes zu durchdringen strebt, dessen Wirkungen aber von Zeit zu Zeit durch andere Ideen eingeschränkt oder neutralisiert werden. Unter diesen ist die Bewegung, die in der französischen Revolution ihren kräftigsten Ausdruck fand, die wichtigste, und indem Heine den Gegensatz zwischen Christentum und Revolution mit einer Verschiebung des Gesichtspunktes als Kampf zwischen Weltverneinung und Weltbejahung interpretiert, gelangt er zu seiner bekannten kulturphilosophischen Formel, wonach sich die Geschichte des menschlichen Geistes als ein Hin- und Herwogen zwischen den feindlichen Richtungen des Spiritualismus und Sensualismus darstellt.[1]

Die Epochen lösen sich etwa in folgender Weise ab. Die Idee des Christentums ist die Tötung des Fleisches und die Weltflucht. Auf die einseitige Despotie dieser spiritualistischen Richtung reagiert die Renaissance mit einem ungestümen Hervorbrechen der Sinnlichkeit und der materiellen Bedürfnisse. Zugleich aber gelangt in dieser Epoche die Idee der Denkfreiheit, die Autonomie der Vernunft auf religiösem und später philosophischem Gebiete zur Herrschaft. Endlich steigert

[1] Weiteres über diese Formel siehe unten. A 44 5.

sich das Bedürfnis nach geistiger Unabhängigkeit im 19. Jahrhundert zu dem heftigen Verlangen nach politischer und sozialer Freiheit. Seit der französischen Revolution hat die Idee der Menschengleichheit und Emanzipation ihren Siegeszug angetreten. Indem Heine nun die Revolution als herrschende Idee seines Zeitalters ansieht, wird sie für ihn zur Idee par excellence. Wie alle Ideen entwickelt sie sich zu ihrer Vorgängerin im Reiche des Geistes durch den Gegensatz, und das abzulösende Prinzip ist in diesem Falle das Bildungsideal der ästhetischen Kultur, die „Idee der Kunst", die noch von den Schlegeln vertreten wird, und die „ihren eigentlichen Mittelpunkt in Goethe selbst" findet. Dieses „Prinzip der Goetheschen Zeit, die Kunstidee, entweicht, eine neue Zeit mit einem neuen Prinzip steigt auf" (7, 225).

Die Bedeutung dieser Sätze für die damalige Zeitperiode ist klar. Die Generation, die seit der französischen Revolution herangewachsen war, gelangte allmählich zur Erkenntnis, daß alle Debatten und Kämpfe sich bisher nur auf theoretischem Gebiete abgespielt hatten. Mochte die Harmonie des Sittlichen und Sinnlichen oder der Idee und Erscheinung auch für den Einzelnen erobert und eine Ästhetik der Lebensführung auf der Basis innerer Freiheit gewonnen sein — dieses ästhetische Bildungsideal war zu einseitig, zu abstrakt gegenüber den Forderungen der neuen Zeit nach politischem Zusammenschluß, nach Teilnahme am öffentlichen Leben und nach äußerer Freiheit. Man begreift so einigermaßen die Geringschätzung, mit der Heine auf die literarischen Fehden des 18. Jahrhunderts herabsieht. „Der Schiller-Goethische Xenienkampf war doch nur ein Kartoffelkrieg, es war die Kunstperiode, es galt den Schein des Lebens, die Kunst, nicht das Leben selbst — jetzt gilt es die höchsten Interessen des Lebens selbst, die Revolution tritt in die Literatur, und der Krieg wird ernster" (Br. 20, 149).

Das Goethesche Kunstprinzip — dies fühlten die Männer von 1830 — hatte zur Gleichgiltigkeit gegen soziale Fragen geführt, denn die ruhige Entfaltung und Vervollkommnung des Individuums, die Virtuosität des Lebenskünstlers war nur dadurch erreichbar, daß alle Energie auf Selbstentfaltung, auf Verinnerlichung gerichtet und die störenden Einflüsse der Außenwelt möglichst ferngehalten wurden. Diese Kunst „muß zugrunde gehen, weil ihr Prinzip noch im abgelebten alten Regime, in der heiligen römischen Reichsvergangenheit wurzelt. Deshalb, wie alle welken Überreste dieser Vergangenheit, steht sie im unerquicklichsten Widerspruch mit der Gegenwart ... die neue Zeit wird auch eine neue Kunst gebären, die mit ihr selbst in begeistertem Einklang sein wird, die nicht aus der verblichenen Vergangenheit ihre Symbolik zu borgen braucht, und die

sogar eine neue Technik, die von der seitherigen verschieden, hervorbringen muß" (4, 72).

Neue Ideale verlangt die neue Zeit: an Stelle der Philosophie der Lebenskunst muß die „Ästhetik der schönen Tat" treten. Wenn Wienbarg in seinen „Ästhetischen Feldzügen" diese Forderungen im Zusammenhang entwickelte, so lassen sie sich bei Heine, der so wenig wie Goethe diskursiv verfuhr, nur aphoristisch und in Spiegelungen wahrnehmen. Auch ist sich Heine wohl seiner Schwäche bewußt, denn er war nicht zum Mann der Tat geboren. Ihn, den Dichter, fesselte vielmehr die Dynamik der Idee, die Gewalt der Rede. Er wollte diese Mittel zwar um keinen Preis lediglich im Dienst des schönen Scheins sehen, sondern er verlangte den Zusammenhang von Kunst und Nationalleben. Aber gleichwohl hält er sich selbst von der opferheischenden Wahlstatt fern. Er berauscht sich im Geiste an der feurigen Schlachtmusik, an dem Klirren der Schwerter und an dem Triumph des freien Wortes über die Knute der Unterdrücker und den Stumpfsinn der trägen Masse. Gerade deshalb haben die Ausdrücke „Idee" und „Gedanke" bei Heine einen so tiefen, bedeutenden und oft geheimnisvollen Klang. „Die Idee" im abstrakten Sinne wird gleichbedeutend mit „Lebensaufgabe, Ideal", denn Heine betrachtete es als seine Mission, der Idee der politischen und sozialen Emanzipation mit allen seinen geistigen Kräften zum Siege zu verhelfen.

<div align="right">(Schluß folgt.)</div>

Zum Kampf der preußischen Regierung gegen die „Deutsch-Französischen Jahrbücher" und Heinrich Börnsteins „Vorwärts".

Von Manfred Laubert in Breslau.

Während sich um 1840 zwischen den meisten Anhängern des „Jungen Deutschland" und der preußischen Regierung allgemach ein Friedensschluß anbahnte, blieb einer unter den Wortführern der literarischen Opposition vervehmt bis an sein Lebensende, Heinrich Heine. Der durch das Wintermärchen wieder zu hellen Flammen entfachte Zorn der Berliner Ministerien gegen den ungezogenen Liebling der Grazien war schon vorher geschürt worden durch Heines Mitarbeit an den von Arnold Ruge und Karl Marx in Paris im März 1844 herausgegebenen Deutsch-Französischen Jahrbüchern, denn ihr Inhalt war „sowohl der ganzen Tendenz dieser Zeitschrift nach als in vielfachen Stellen verbrecherisch" und ins-

<div align="right">9*</div>

besondere lag darin „der Thatbestand des versuchten Hochverraths und des Majestätsverbrechens".[1]) Deshalb ersuchte das Ministerium des Innern die Oberpräsidenten, sie möchten, „ohne Aufsehen dadurch zu erregen", die Polizeibehörden ihres Verwaltungsbezirkes mit der Anweisung versehen, daß Ruge, Marx, Heine und Ferdinand Cölestin Bernoys (!) beim Betreten des preußischen Staatsgebietes zu verhaften und etwa bei ihnen vorgefundene Papiere ungesäumt nach Berlin einzusenden seien, von wo aus wegen des weiteren Verfahrens Bescheid erfolgen werde.

Die der preußischen Monarchie von den Deutsch-Französischen Jahrbüchern her drohende Gefahr zog freilich rasch vorüber, da das Blatt nach dem Erscheinen der ersten Doppellieferung bei der Mittellosigkeit seines Verlegers, Fröbel, und den auseinandergehenden Anschauungen seiner Redakteure wieder einschlief (vgl. Mehring a. a. O. Band I und Strodtmann: Heinrich Heine's Leben und Werke. 3. Auflage. Hamburg 1884. Band II. 318).

Indessen hatte schon im Januar 1844 Heinrich Börnstein in Paris ein anderes kleines deutsches Wochenblatt: „Der Vorwärts" begründet — die Mittel hierzu erhielt er in wunderbarer Ironie des Schicksals durch ein ihm von Meyerbeer vor dessen Übersiedelung nach Berlin gespendetes Neujahrsgeschenk von 3000 Franks —, wobei ihn zunächst die Absicht leitete, für seine Übersetzungsfabrik französischer Theaterstücke Reklame zu machen und das Mißtrauen der jungen deutschen Autoren gegen diese Ware zu bekämpfen.[2]) Da das Organ jedoch trotz seiner anfänglichen Mäßigung in Österreich und Preußen verboten wurde, also kein Grund mehr zur Schonung der deutschen Regierungen vorlag, versuchte Börnstein nach dem Ver-

[1]) Der Minister des Innern Graf Arnim an den Posener Oberpräsidenten v. Beurmann 16. April 1844; von diesem wie auch die folgenden Ministerialerlasse mitgeteilt an den Posener Polizeipräsidenten v. Minutoli und den Bromberger Regierungspräsidenten Freiherrn v. Schleinitz. Staatsarchiv Posen. Oberpräsidialakten Nr. 73 (Polizeiliche Vorsichtsmaßregeln in Bezug auf die Pläne der Umsturzpartei 1830/45). — Über den Inhalt der Jahrbücher vgl. Groß: Karl Marx. Allgemeine deutsche Biographie XX. 542 und: Aus dem literarischen Nachlaß von Karl Marx, Friedrich Engels und Ferdinand Lassalle, herausgegeben von Franz Mehring. Band I/II. Stuttgart 1902, woselbst die fünf wichtigsten Aufsätze des 236 Seiten starken Heftes aus der Feder von Marx und Engels wieder abgedruckt sind; ferner enthielt es Heines Lobgesänge auf König Ludwig von Bayern, das Urteil des Oberappellationssenats in der Sache Jacobys 2c.

[2]) Vgl. Börnstein: Fünfundsiebzig Jahre in der Alten und Neuen Welt. Memoiren eines Unbedeutenden. Band I. Leipzig 1881. Nach diesen — freilich unzuverlässigen — Aufzeichnungen erschien der Vorwärts zweimal wöchentlich, kostete jährlich 24 Franks und zählte sofort 1000 Abonnenten, deren Zahl stetig wuchs. Er war geplant als konstitutionelles Oppositionsblatt, als Journal „des gemäßigten Fortschritts", mehr einer unterhaltenden als politischen Tendenz huldigend.

schwinden der Jahrbücher deren Getreue als Stützen für sein eigenes Journal anzuwerben und übertrug sogar dessen Leitung, da Ruge sie ablehnte, auf Carl Ludwig Bernays.[1]

Nun änderte der Vorwärts seine Tonart. Unter den Mitarbeitern, Heine, Ruge, Herwegh, Bakunin, Engels, Marx, Bernays gewannen bald die radikaleren Elemente die Oberhand und überschütteten die Misère des damaligen deutschen Absolutismus und Scheinkonstitutionalismus „mit beißendem Spott".[2] Dem Drängen der durch die schrankenlosesten Angriffe auf gekrönte Häupter gereizten fremden Diplomaten nachgebend, verhängte Guizot endlich über Bernays eine mehrmonatliche Gefängnishaft und 300 Franks Geldstrafe, weil er die für politische Blätter vorgeschriebene Kaution nicht hinterlegt hatte. Da die deutschen Machthaber auch hierdurch noch nicht zufriedengestellt waren, unterzeichnete der willfährige französische Minister auf Grund eines Gesetzes von 1795 am 11. Januar 1845 eine Ordre, wonach die wirklich oder mutmaßlich an der Herausgabe des Vorwärts beteiligten Literaten Paris binnen 24 Stunden, Frankreich binnen kürzester Frist verlassen sollten. Obwohl unter dem Druck der entrüsteten öffentlichen Meinung in Paris und bei dem in Presse und Parlament erhobenen Lärm dieser Befehl nicht streng durchgeführt und, da Börnstein als Eigentümer des Blattes dieses preisgab, nach acht Tagen sogar teilweise zurückgenommen ward, war die kleine Schar der Betroffenen doch völlig auseinandergesprengt.[3] Marx ging nach Brüssel, Ruge nach Sachsen zurück; Börnstein und Bernays blieben zunächst, zogen es aber bald vor, sich in Amerika eine neue Existenz zu gründen. Herwegh als Schweizer Bürger und Heine[4] wurden mit dem Ausweisungsbefehl verschont.

Arnim hatte indessen, sobald er von der Existenz des Vorwärts erfuhr, auch die Polizei des eigenen Staates auf diese junge Gift-

[1] Ursprünglich Rechtsanwalt, dann als Nachfolger von Karl Grün Redakteur der „Mannheimer Abendzeitung"; vgl. Mehring a. a. O. Band II und Salomon: Geschichte des deutschen Zeitungswesens. Oldenburg und Leipzig 1900/6. Band III. 424.

[2] Vgl. Engels: Karl Marx im Handwörterbuch der Staatswissenschaften; Börnstein a. a. O. Mehring (a. a. O. Band II, 41—60) veröffentlicht aus dem Inhalt den einzigen Beitrag von Marx: „Randglossen zu dem Artikel: Der König von Preußen und die Sozialreform", eine scharfe Abrechnung mit Ruge.

[3] Vgl. über diese Vorgänge die herausgeputzte, stark auf das Persönliche zugeschnittene Darstellung von Börnstein und die vielfach korrigierende, wesentlich das Verhalten von Marx verteidigende Schilderung Mehrings.

[4] Die unter anderem auch von Treitschke (Deutsche Geschichte im 19. Jahrhundert. 4. Auflage. Band V. Leipzig 1899. 379) aufgestellte Behauptung, daß Heine seiner ausdrücklichen Erklärung zuwider sich in Frankreich habe naturalisieren lassen und deshalb nicht ausgewiesen werden konnte, ist durch die Untersuchungen Elsters endgiltig widerlegt.

pflanze im deutschen Zeitungswald aufmerksam gemacht. Am 11. Juli 1844 teilte er dem Oberpräsidenten mit, daß einige Aufsätze in den neuesten Nummern des Blattes die Einleitung der Kriminaluntersuchung und persönliche Haft gegen den Verfasser und Herausgeber unzweifelhaft rechtfertigen würden. Während jener noch unbekannt war, hätte man als Redakteur Börnstein entdeckt und vermutete, daß er als namhafter Übersetzer französischer Stücke mit deutschen Bühnen in Verbindung stehe. Von seiner Persönlichkeit wußte man zunächst nur, daß er jüdischer Abstammung war. Im Betretungsfall sollte mit ihm nach der am 16. April vorgeschriebenen Weise verfahren und die Polizei, wieder „ohne dadurch Aufsehen zu erregen", entsprechend instruiert werden.

Am 21. Dezember bestimmte der Minister, daß wenn einer der inzwischen als Mitarbeiter benunzierten Männer: Heine, Ruge, Marx, Bernays, Börnstein ergriffen würde, er unter sicherer Bedeckung nach Berlin zu bringen und dem dortigen Polizeipräsidium auszuliefern sei. Außerdem war Arnim jetzt in der Lage, das ihm von Paris aus mitgeteilte Signalement „dieses p. Börnstein und p. Heyne" an die Unterbehörden zu senden; es lautet bei Börnstein:

„homme de lettres, rédacteur en chef du journal allemand „„le Vorwaerts"", demeurant rue des moulins 32; de 30 à 35 ans, cheveux et barbe châtains, taille moyenne"

und bei Heine:

„homme de lettres, 50 ans (!) taille moyenne, nez et menton pointus, type israëlite marqué; c'est un débauché dont le corps affaissé dénote l'épuisement."

Am 18. Februar 1845 stellte der Minister den Chefs der Provinzialverwaltung zur schleunigen Mitteilung an die Polizeibehörden die Personalbeschreibung von Ruge und Marx, sowie eine genauere von Börnstein zu. Wir lesen hierin:

Dr. A. Ruge: Gestalt: gedrungen, 5 Fuß, 5 Zoll.
 Alter: ca. 50 Jahre [geb. 13. Sept. 1802].
 Haare: blond und dünn.
 Augen: lebendig, blau oder blaugrau.
 Stirn: etwas hoch und rund.
 Nase: stumpf.
 Mund: klein, etwas starke Lippen.
 Gesicht: rund, etwas bleich, doch nicht kümmerlich.
 Sprache: fließend, deklamatorisch, mit einiger Schärfe im
 Ton, doch ohne eigentlichen Nasenlaut.
In neuerer Zeit soll er sein Barthaar haben wachsen lassen.

Charles Marx: Né à Trèves.
 Agé de 27 ans.
 Taille: 5 pieds 5 pouces.
 Cheveux: } noirs.
 Sourcils: }

Front: droit.
Yeux: bruns.
Nez: gros.
Bouche: moyenne.
Barbe: —
Menton: rond.
Visage: ovale.
Teint: clair.
Profession: Docteur en philosophie.

Dr. Henri Börnstein: Né en Autriche.
Agé de 37 ans[1])
Taille: 1 m 68 c.
Cheveux: }
Sourcils: } noirs.
Front: dégagé.
Yeux: bruns.
Nez: ordinaire.
Bouche: moyenne.
Barbe: noire.
Menton: rond.
Visage: plein.
Teint: coloré.
Profession: Directeur du Théâtre de Trieste.

Am 14. März wurde endlich auch noch das bisher fehlende Signalement von Bernays beigebracht:

Prénoms: Charles Louis.
Né à Mayence.
Agé de 29 ans.
Cheveux: bruns.
Sourcils: id.
Front: haut.
Yeux: bleu foncé.
Nez: court.
Bouche: moyenne.
Barbe: brune et collier.
Menton: —
Visage: —
Teint: ordinaire.
Portant habituellement des lunettes.
Marques particuliers: —

Es ist bereits erwähnt, daß die Flüchtlinge nach ihrer Ausweisung jeden Zusammenhang aufgaben und getrennte Wege gingen, ohne den preußischen Boden zu berühren, so daß den dortigen Behörden keine Gelegenheit geboten wurde, Stichproben auf die Zuverlässigkeit der ihnen übermittelten Signalements anzustellen.

―――――――

[1]) Geboren 1806 in Hamburg, aber 1818 mit seinen Eltern nach Österreich gezogen.

Ein Beitrag zu Adalbert Stifters Stil.

Von Franz Hüller in Prag.

Der Stil Adalbert Stifters ist sein ureigenstes Gut, bei weitem mehr als seine Motive und seine Kompositionstechnik. Er hätte schon längst eine eingehende Untersuchung verdient. Alle Untersuchungen, die bisher sich mit Stifters Stil beschäftigten, beschränken sich nur auf ganz spezielle Fragen. Der Teil in Bertrams Buch[1]) über Stifters sprachliche Technik befriedigt nicht alle wissenschaftlichen Ansprüche einer stilistischen Arbeitsart. — Stifter war mehr Formtalent als schöpferisches Genie. Dies sprach schon Lambel in seiner bekannten Charakteristik aus: „Seine Erzählungen fesseln nicht durch reiche, überraschend geführte Handlung, ihr Werth liegt in der bis ins Kleinste musterhaft sorgfältigen, künstlerischen Ausführung.“[2]) Das hat auch neuerdings die Untersuchung seiner Novellenstoffe bei der Herausgabe der weiteren Bände der „Studien“ bewiesen.[3]) Vom Anfang bis zum Ende zieht sich ein Grundstrich seines Wesens durch; nur daß er im Anfang mehr zersprengt und getrübt, am Ende mehr gehäuft und in breiterer Lage zu sehen ist. Wenn man romantische Elemente in seinem Stil sucht und findet, so ist zu sagen, daß sie sich erstens nur konzentrieren und verkörpern in Jean Paul, der ihn wirklich eine Zeitlang förmlich hypnotisch gefangen hielt; nur ganz wenig ist von Tiecks Sprache angeflogen. Zweitens war diesen romantischen Elementen im Stil nur eine ganz kurze Lebensfrist gegönnt. Nur in der Zeit des „Condor“ und der „Feldblumen“ allein treiben sie ihr loses Spiel. Von da an müssen sie immer schneller flüchten vor seinem tiefen, ernsten, epischen Wesen.

Es ist also der Einfluß Jean Pauls auf den Stil Stifters durchaus nicht zu überschätzen. Stifter übernimmt vor allem von Jean Paul nur Gleichnisse und Bilder. Lediglich seine Phantasie

[1]) Studien zu Adalbert Stifters Novellentechnik von Ernst Bertram. Schriften der literarhistorischen Gesellschaft, herausgegeben von Berthold Litzmann. III. Dortmund 1907.

[2]) Die österreichisch-ungarische Monarchie in Wort und Bild. Wien 1889. J. 216 f.

[3]) Zitiert nach: Adalbert Stifters sämtliche Werke, erster Band, herausgegeben von August Sauer. Prag 1904. Zweiter Band, herausgegeben von Rudolf Frieß, Hans Hartmann, Josef Taubmann. Prag 1906. Fünfter Band, herausgegeben von Franz Egerer und Rudolf Raschner. Prag 1908. Die übrigen Bände und die Briefe als Band XVII und XVIII, Vermischte Schriften als Band XV (enthaltend auch „Wien und die Wiener“) im Erscheinen begriffen. — „Der Nachsommer“, zweite Auflage. Pest 1865.

ist infiziert. Das Epitheton, die Darstellung der Natur, der Satz-
bau sind sein Eigenes. Diese Gleichnisse sind gleichsam nur glänzende
Flitterblättchen, die er seinem im Grunde mäßigen und einfachen Stil
aufheftet. Stifter hat seine Gleichniskunst überhaupt sehr früh durch-
genossen; in den „Feldblumen" hat er bereits die letzten Blüten ab-
gepflückt; von da an findet er nur ganz sparsam eine. So war das
Schwärmen in Jean Pauls Gleichnissen mehr wie ein Fieber, das
Stifters absolut nicht verwandtes Wesen bald überwinden mußte.
Es entstand in jenem Sommer, wo der Student auf dem Sopha
liegend und Tabak schmauchend mit seinem Lieblingsdichter „Feste der
süßen Brote" feierte (wie Jean Paul sagen würde). Er verschlang ihn
im wirren Phantasierausch, nicht nüchtern reflektierend; und nachdem
er den Rausch ausgeträumt, schwirrten immer noch in seiner Phan-
tasie jene Jean Paulschen Bilder herum und mußten sich unwill-
kürlich im „Condor" und in den „Feldblumen" niederlassen. Nachdem
sich aber seine Phantasie wieder beruhigt und sich selbst wieder ge-
funden hatte, drang sein eigenes klares, stilles Wesen durch, und
schon im „Hochwald" finden wir kaum eine Jean Paulsche Schnörkel
mehr. Die Sprache ist ruhiger, zusammenhängender und objektiver,
und zum ersten Male wird er sich hier seiner dichterischen Eigenart
bewußt. Es ist auch hier stilistisch zu verbinden, wie all die Anklänge
an Jean Paul in den Sprachton unseres Dichters herüberdrangen.
Es ist jedenfalls ein ganz unbewußter Niederschlag aus den Höhen
Jean Pauls. Stifter dachte wohl selbst am wenigsten an sein
Vorbild, als die entlehnten Bilder aus seiner Phantasie flossen.
Merkwürdigerweise hat Stifter keine einzige Stelle Jean Pauls direkt
wohlbehalten herübergenommen, sondern sie ist bei ihm ganz neu,
originell erlebt. So hat er all die Jean Paulschen Eindrücke in
seiner Vorstellungswelt ganz schöpferisch wiedergeboren, ja manchmal
viel reiner und stimmender, als sie bei Jean Paul entstanden.
Einige Beispiele mögen illustrieren, wie Stifter Jean Pauls Stil in
sich aufnahm.

Jean Paul, „Hesperus", 7. 61. Franz Kochs doppelte Mundharmonika hat
ausgeklungen: „Viktor blickte in die stille schwarze Luft vor ihm, die vor wenig
Minuten mit hängenden Gärten von Tönen, mit zerfließenden Luftschlössern e
menschlichen Ohrs, mit verkleinerten Himmeln erfüllt gewesen und die nun da
blieb als nacktes, schwarzes Feuerwerks-Gerüst." Vgl. Stifters „Feld-
blumen", 75₁₀: Nachdem die Tanzmusik aufgehört: „Ich trat daher, wie ge-
wöhnlich, Reisen durch alle Zimmer und durch die Gruppen darin an, und als
ich im Bedienstenzimmer die Pulte und Reste der Symphonie, wie ein kahles
Feuerwerksgerüste, antraf, hatte ich eine Art Schmerzempfindung, wie bei
dem Anblicke eines abgebrannten Hauses." Das Bild ist bei Stifter bei weitem
einfacher, anschaulicher und plastischer, da das Bauwerk und die Form der Noten-
pulte dem Stangenwerk eines Feuerwerksgerüstes tatsächlich in vielen Punkten
gleicht. Diese Brücke zu der Vorstellung der verrauschten Symphonie als abge-

branntes Feuerwerk ist bedeutend zugänglicher und natürlicher als bei Jean Paul
die gestaltlose, finstere Luft; auch das „kahl" ist wirklicher als das „nacht". —
Jean Paul, „Titan", II. 315, Liane spielt die Harmonika: „— nur tönende
Bienchen flogen aus der lauten fernen Welt durch die schwelgende Musik
wieder ins Getöse — ... In diesem Zauber ließ sie die Töne wie Nachti=
gallen aus ihren Händen fliegen —"[1]; vgl. Stifters „Feldblumen",
109[17]: Angela am Klavier: „und wenn hierbei ihre Finger über die Tasten
gehen, ... und die guten frommen Töne, wie goldene Bienen aus den
vier Händen fliegen und draußen die Nachtigall darein schmettert, ...

„Feldblumen", 67[16]: „In dem reichsten, wie ärmsten Menschen geht eine
Bibliothek von Dichtungen zu Grabe, die nie erschienen sind — nur aus
den drei Stanzen, die er herausgab, machen wir ein Urtheil zusammen und
sagen, seht, das ist der Dichter." — Jean Paul, „Hesperus", 5. 143: „... und
es ist Schade, daß man an gute Köpfe keinen Barometergraphen oder kein Kla=
vier anbringen kann, das außen alles nachschreibt, was innen gedacht wird.
Ich wollte wetten, jeder große Kopf geht mit einer ganzen Bibliothek un=
gedruckter Gedanken in die Erde, und bloß einige wenige Bücherbretter
voll gedruckter lasset er in die Welt auslaufen."

„Feldblumen", 120[16]: „Wir reden oft stundenlang miteinander, und sachte
geht dann ein Thor nach dem andern von den innern Bildersälen auf;
sie werden gegenseitig mit Freude durchwandelt; ganze Wände voll quellen roth
und schwärmen, und wenn dann plötzlich manche Götterform vorspringt,
längst gehegt, geträumt und geliebt im eignen Innern —" — Jean Paul,
„Titan", I. 112: „dann ging sein inneres Kolosseum voll stiller Götter=
formen der geistigen Antike auf," dazu vgl. „Feldblumen", 109[10]: „wenn ..
dieß unbegreiflich überschwengliche Tonherz, Beethoven, sich begeistert, die Thore
aufreißt von seinem innern tobenden Universum und einen Sturmwind über
die Schöpfung gehen läßt," — ebda, 102[20]: „Titus, eine Tempelhalle, weit
und ungeheuer, hat sich in meinem Herzen aufgebaut, und ich trage einen
neuen seligen Gott darinnen." vgl. auch Briefe XVIII. 73[10] u. 128[21] — „Halde=
dorf", 183[29]: „allein er schloß alle Thore seiner Seele weit auf und ließ
den phantastischen Zug eingehen" — vgl. Jean Paul, „Hesperus", 5. 90: „er

[1] Vgl. noch „Hesperus", 5. 68: „wenn die Seufzer in Gesänge verhüllet
aus diesen Lippen .. wie Bienen aus Rosen ziehen" — „Flegeljahre", 20.
47: „Worte, wie süße Bienen, flogen dann von seinen Blumenlippen." —
„Siebenkäs", 12. 108: „und da jetzo aus einem nahen Garten Ruths Melodie
des Liedes: ‚Nicht für diese Unterwelt schlingt sich der Freundschaft Band etc.'
wie eine schlagende Nachtigall aufflog." — „Flegeljahre", 20. 82: „so ..
spielten die Töne wieder drüben auf den rothen Höhen und zuckten in den
vergoldeten Vögeln." — „Titan", IV. 374: „die Flötentöne schlüpften wie
Schmetterlinge, wie schuldlose Kinder unter dem großen Flügel weg." —
„Hesperus", 5. 112: „... worin Klotildens Töne wie verirrte Engel sinkend und
steigend umherflogen," — „Flegeljahre", 20. 188: „Cherube von Tönen, die
auf Flammen flogen," — „Titan", IV. 376: „Aus dem Prinzengarten flat=
terten Töne durch die Abendstrahlen," — „Hesperus", 7. 50: „als die Töne
leiser flatterten," — „Siebenkäs", 11. 85: „Die entfernten Neujahrstöne flat=
terten noch immer um mich;" — „Hesperus", 8. 151: „Flatterndes Gefieder
der Aolsharfen" — vgl. Stifter „Feldblumen", 74[16]: „Auf unbefleckten, weißen
Taubenschwingen zieht (diese Musik) siegreich in die Seele." Dies ist natürlich
nur eine einzige Variation von der bei Jean Pauls phantastisch ausgenützten
Qualitätenmischung. — Jean Paul zitiert nach: „Jean Pauls Werke, Berlin 1840,
Verlag von Georg Reimer" — Der „Titan" ausnahmsweise aus: Deutsche
Nationalliteratur, Band 132 und 133. Berlin-Stuttgart.

genieße sanft und still und im Tempel seines Herzens spiele die Lust nur wie ein ungehört irrender Schmetterling in einer Kirche —" — ebda, S. 187: „denn Klotilde wich täglich in ein dunkleres Heiligthum seiner Seele zurück;" — „Titan", I. 48: „als wenn die Gottheit der Liebe ein Erdbeben in seinen innern Tempel schickte,"

„Feldblumen", 44₂₂: Das Schamroth auf den Wangen der Mädchen, gleichsam rothseidene Vorhänge zieht die junge Seele plötzlich vor dem fremden Auge über," vgl. Jean Paul, „Hesperus", S. 142: Viktor findet Klotilden am Hofe blasser als früher: „.. so waren sonst ihre Wangen mehr dunkle Rosenknospen, als aufgegangene abgebleichte Rosenblätter .. sie hatte irgend einen Kummer, .. statt Blutes schien die stillere, zartere Seele durch den weißen Florvorhang zu blicken." — ebda, S. 24: „und erhöhe ganz im Stillen — hinter der herabgelassenen Gardine der Gesichtshaut — Komisches der Natur zu Komischem der Kunst."

„Feldblumen", 47₁₂: „jene Wunder, die in Wüsten prangen, über Oceanen schweben und den Gottesdienst der Alpen feiern helfen." — vgl. Jean Paul, „Hesperus", 7. 143: „Der Frühgottesdienst der Natur, der in Stille besteht,"

„Feldblumen", 55₃₇: „als schon das Abendroth .. im jungen Buchengrün von Laub zu Laub neben uns hüpfte," — Jean Paul, „Vorschule", 649: „denn ich sehe wohl, wie jetzt die holde Abendsonne von Goldzweig zu Goldzweig niederhüpft." — „Hochwald", 242₂₂: „Die Nachmittagssonne .. spann schon manchen rothen Faden zwischen den dunklen Tannenzweigen herein, von Ast zu Ast springend,"

„Condor", 30₁₁: „und die Lippen schmolzen heiß zusammen," — vgl. Jean Paul, „Titan", IV. 278: „und wie Morgenröten zweier Welten schmolzen ihre Lippen zusammen."

„Feldblumen", 176₂₂: „... die Goldammer, das Rothkehlchen, die Haidelerche, daß von ihr oft der ganze Himmel voll Kirchenmusik hing;" — vgl. Jean Paul, „Siebenkäs", 12. 181: „Natalie stand außen auf dem Balkon wie eine überglänzte Seele .. und hing mit ihren großen Augen an der leuchtenden, erschütternden Welt — Rotunde voll Kirchengesang," — ebda, 12. 82: „Baum, dessen Blätter und Zweige ein Chorpult singender Wesen waren."

„Condor", 16₃₀: „.. fernabliegend von der friedlichen Insel seiner Kindheit." — vgl. Jean Paul, „Hesperus", 8. 47: „Genius der Träume! der du durch den nebligen Schlaf der Sterblichen trittst und vor der einsamen in einen Leichnam gesperrten Seele die glücklichen Inseln der Kindheit heraufziehest," — „Mappe", 139₁₉: „.. das fernabliegende Land der Kindheit."

„Hochwald", 301₁₃: Der Nebel .. „silberne Inseln und Waldesstücke durcheinander wälzend," — vgl. „Mappe", 146₃₆: „da die Wolken sich zerrissen hatten .. und in dichten, weißen Ballen über den Wald hinauszogen, die blassen, goldenen Inseln des heitern Himmels," — vgl. Jean Paul, „Titan", II. 321: „Majestätisch schwammen durch das Blau die silbernen Inseln, die Wolken,"

„Feldblumen", 101₁₄: „Freilich steht neben dem Tintenfasse eine Flasche Rußberger;" — vgl. Jean Paul, „Hesperus", 7. 174: „Ich habe daher gar eine Flasche Burgunder aufgestegelt und neben die Dintenflasche gestellt,"

„Feldblumen", 51₃₀: „Da kamen mir allerlei Spintisirungen über sie: ich möchte sie einmal beten sehen; aber nicht in der Kirche, wo sie die Augen mit den Wimpern kalt verhüllt, sondern wenn sie in ihrem Zimmer einsam Gott dankt oder um Abwendung eines entsetzlichen Wehes bittet; — oder ich möchte sie in Liebesfreude schwärmen sehen oder im Schmerze das Auge aufschlagen — oder tanzen — oder eine Gebirgspartie machen — lachen — ihren Vogel kosen — eine kleine Schwester belehren; oder wenn sie Thee bietet;

wenn ihr etwas sehr komisch erscheint — und so weiter — und so weiter." —
vgl. Jean Paul, „Hesperus", 5. 73: „Er dachte immer, wie soll' ihr wol das
Sitzen lassen — oder das Darreichen eines Fruchttellers — oder e
Essen einer Kirsche — oder e Niedersehen in ein Briefchen." — „Flegeljahre",
20. 47: „O der Liebliche! Ich fühlt es ordentlich, wie er Gott liebt und jedes
Kind. Ach ich möcht ihn wol heimlich sehen, wenn er betete, und auch wenn
er selber weinen müßte in einem großen Glück."

Wie verwickelt der Prozeß der Herübernahme manchmal gewesen sein mag,
zeige folgendes Beispiel. „Abdias", 19₍₂₁₎: „Aber es waren nur flatternde Ge-
danken, wie Einem, der auf dem Atlas wandert eine Schneeflocke vor dem Ge-
sichte sinkt, die er nicht haschen kann." — In der ersten Fassung lautet die Stelle,
wie folgt: „Aber es waren nur vorüberziehende Gedanken, die er nicht
haschen konnte, wie etwa eine Schneeflocke, die zerfließend und vor dem
Auge dessen vorübersinkt, der auf dem Atlas wandert." — Der Ausdruck
„vorüberziehende Gedanken, die er nicht haschen konnte", ist wahrscheinlich
Stifters Eigentum; denn vgl. in den zeitlich früheren „Feldblumen", 103₍₁₄₎:
„da kommen mir dann Träume von glänzenden Lüften .. und von tausend
andern Dingen, die sich nicht erhaschen lassen, schattenhaft und träumerisch
durch die Seele ziehend." Das Bild von der Schneeflocke ist zweifellos von
Jean Paul angeregt: „Hesperus", 7. 45: Viktor besteigt den Wartturm und
schaut in die schneiende Winterlandschaft, „in die weite von Schnee durchbrochne
Nacht — und alle Thränen seines Herzens fielen und alle Gedanken seiner
Seele riefen: „so sieht die Zukunft aus! So schimmernd sinken die Freuden
des Menschen vom Himmel und zerfließen schon unter dem Sinken!" Mit
Individualisierungskunst verlegt er die Szene auf den Atlas. Bertram (a. a. O.
S. 132) erklärt die Stelle für homerisch (oder biblisch); er bringt keinen andern
Beweis dafür als sein Gefühl.

So ist das Verhältnis von Stifters Stil zu dem der Romantiker
dahin zu formulieren, daß es sich lediglich auf Jean Paul beschränkt
und nur ganz kurz auf dem Gebiete des Gleichnisses bis zum „Hoch-
wald" sich verfolgen läßt. Es wurde auch einmal die Ansicht aus-
gesprochen, daß die Romantik nur mittelbar auf dem Wege der zeit-
genössischen Literatur Stifter zukam. Diese Meinung ist wohl durch
die oben angeführten Beispiele gründlich widerlegt. Sie zeigen viel-
mehr, wie direkt Stifters Phantasie im Jean Paulschen Geiste auf-
ging, solange natürlich eine Beeinflussung überhaupt festzustellen ist.

Die Betrachtung lenke hier vor allem jenem Stilmittel zu, das
uns im Kleinen die ganze Physiognomie eines Stils Zug um Zug
enthält und am zweifellosesten wiedererkennen läßt: dem Epitheton.
Es ist der Probierstein einer jeden Persönlichkeit, ja sogar ganzer
Dichtergenerationen. R. M. Meyer nennt das Epitheton in seiner
Stilistik den licht- und lebensprühenden Begriff. In der Tat spricht
auch aus dem Epitheton in Stifters Prosa seine ganze Individua-
lität. Sein durchaus episches, behäbiges, mit der Zeit pedantisches
Wesen ist in den zusammengesetzten Bau seiner Eigenschaftswörter hinein-
gewachsen, um so mehr, als sie in seiner Sprache zur reichsten,
üppigsten Blüte gediehen sind; meist zwei, sehr oft drei, ja auch vier
und mehr, teils asyndetisch, teils durch „und" verkoppelt, — je

nachdem es der Rhythmus des Satzes heischt — sind dem Beziehungs-
worte vorgespannt. Es erscheint darum so reichlich und oft zu Haufen,
weil es die ganze schildernde, beschreibende Charakteristik des Erzählers
schleppen muß. In ihm ruht nicht selten der Schwerpunkt der An-
schaulichkeit des dargestellten Gegenstandes. Daher kommt es, daß
diese Epitheta nicht aus dem momentanen Zusammenhang heraus
entsprossen sind; sie beleuchten auch nicht ein persönliches Verhältnis
des Dichters „im Lichte seines Temperaments": ihr Grundzug ist
vielmehr stark und rein episch, typisch charakterisierend. Sie
sind also beschreibende Schmuckwörter, wie die Homerischen. Man
möchte fast sagen, Stifter ist in seinem Epitheton stets Naturhistoriker
im weitesten Sinne des Wortes. Sie haben keine plötzliche, auf-
leuchtende, zeitlich schillernde Farbe; sie sind rein typisierend. Der
äußeren Struktur nach ist sein Epitheton fast durchwegs zusammen-
gesetzt. Er versteht es nicht, wie die Jungdeutschen durch einfache
Beiwörter packend zu zeichnen. Die Composita sind oft recht schwer-
fällig, künstlich zusammengedrängt und bringen eben in Stifters Stil
jenen ruhig-würdigen Erzählerton hinein.

Nichts weniger als romantische, Jean Paulsche Elemente lassen
sich nun in Stifters Epitheton entdecken, wie es etwa Bertram ver-
sucht. Vielmehr kann man Quellen aus dem alten, ehrwürdigen
Strome der Homerischen Epen herüberleiten. Homer mag schon den
Dichter während der Schulzeit ins Kremsmünster stark gefesselt und
begeistert haben. „Habe ich in der lateinischen Schule in der Benedik-
tiner-Abtei nicht den ersten Preis erhalten? Muß ich daher nicht
tüchtig Lateinisch gelernt haben? und auch Griechisch?" sagt er in
den „Nachkommenschaften". Ja er mag es selbst versucht haben,
sich darin zu üben, „bis der Vers leicht und schön floß und tiefe
Gestaltung hatte wie bei Homeros", wie er selbst in eben dieser Er-
zählung (189) berichtet. Jener räsonierende Herzenserguß aber in
dem letzten Aufsatze in „Wien und die Wiener" (erschienen 1844),
eines der frühen Dokumente in der Zeit der dichterischen Produk-
tion, weiht uns überraschend klar in sein begeistertes, inniges Ver-
hältnis zur Antike ein; er zieht über die damals zeitgemäßen litera-
rischen Salons her und beklagt es aus tiefster Seele, daß man in
keinem einzigen mit tiefem, ernstem Kunststreben zu den alten Klassikern
greife: „Wien und die Wiener", 246$_{19}$: „Aber meines Wissens existiert
kein einziger solcher Salon, und nur der eine oder der andere ein-
same Mann trägt sich mit seinem Sophokles, Äschylus und Homer.
Es ist eine Sünde, die zum Himmel schreit, ich will nicht sagen, daß
nicht sogenannte Gebildete, sondern daß nicht einmal Schriftsteller, ja
Dichter im Stande sind, eine Zeile im alten Griechischen zu lesen —
die einzige Sprache, in der die einzigsten Produkte geschrieben sind,

die so weit über Alles hinausgehen, was unsere Zeit produciert, welchen Producten alle späteren Jahrhunderte nacheiferten"; besonders die weichere Odyssee schien seinem Herzen näher zu liegen: Briefe, XVIII. 41, f.: „hätte ich nur mehr Kräfte — mehr Kräfte — was bin ich gegen Homer, dessen Odysseus ich eben gelesen habe — ja das heißt dichten." Natürlich zum „Witiko" stärkt er sich mit der „unglaublichen Kraft und Gewalt Homers". „Lesen Sie doch," rät er seinem Freunde Heckenast, „Vossens Übersetzung des Odysseus, obwohl holperig und dem Originale weit nachstehend, ist das Werk auch in dieser Gestalt so groß, daß alle neueren Dichter nicht davor bestehen können. Die Alten hießen ihn auch darum den göttlichen Homer." Wenn auch diese letzteren Äußerungen erst in die späteren, reiferen Jahre (1853) fallen, so sind sie doch undenkbar, wenn sie einer erst in dem nahenden Alter plötzlich aufbrechenden Begeisterung für Homer entströmt sein sollten. Der Umgang mit den alten Griechen war stets vorhanden; August Sauer meint, er sei vielleicht um das Jahr 1843 herum am stärksten gewesen. Dazu kommt noch das äußere Moment, daß er als Hofmeister und Instruktor wohl auch aus dem Homer dem Schüler vortragen und erklären mußte. Später wurde dieses Verhältnis zu den alten Griechen veredelt und vertieft. Übrigens gesteht er selbst mit einer apodiktischen Bestimmtheit den Einfluß der alten Griechen auf sich zu: Er berichtet 1856 an Heckenast von einem Briefe eines Fremden, der der künstlerischen Form seiner späteren Arbeiten „den entschiedensten Vorzug" gab und sagte, daß die „Bunten Steine" antik seien; „namentlich seien sie mit Xenophontischer Klarheit und Einfachheit geschrieben. Da es nun in der That so ist, daß meine Kunstbildung auf der griechischen Kunst hauptsächlich ruht, so war mir dieses Urteil ebenso auffallend als es mich freute. Seit Jahren war es mir nicht so gegönnt, über meinen Liebling Homer und Äschylos so zu plaudern, wie in diesen 2 Tagen." XVIII. 174₈. Als ihm endlich ein kindlich ersehnter Wunsch erfüllt wurde und er in Triest das Meer sehen durfte, schreibt er an einen Amtsgenossen: „Ich bin plötzlich reich geworden, und ich habe eine unverlierbare Sehnsucht erhalten, das „ewige Meer" (wie Homer sagt) nie mehr ganz aus den Augen zu verlieren." XVIII. 227₂₁, 286₂₂. — Die Folge dieser Reise war die geistige Anregung, daß er allen Ernstes ein Trauerspiel „Nausikaa" schreiben wollte. „In Homers Odysseus," schreibt er an seine Freundin Louise von Eichendorff, „können Sie gleich zu Anfang den Stoff lesen." [1] Ähnlich fühlte sich ja auch Goethe, als

[1] Wie gut er in Homer versiert war und ihn zu analysieren verstand, zeigt: Briefe (Aprent), II. 345. — Vgl. auch die Beschreibung der Marmorstatue im „Nachsommer", II. 105: „Edle Schatten wie schöne Hauche hoben den sanften

er in dem „Wundergarten" zu Palermo unter Orangen= und Citronen=
lauben wandelte, im dichterischen Traume nach der Insel der Phäaken
versetzt, so daß er sich einen Homer kaufte und sich ihm der Nausikaa=
Stoff als liebliche Tragödie aufdrängte.[1]

Die Stiftersche Kunst ruht also auf breiter, hellenischer, ja
spezifisch Homerischer Basis. Der Hintergrund seines Wesens über=
haupt ist rein episch, und Wilhelm Kosch kann in seinem sonst
grundlegenden Buche über Stifter das Urteil unmöglich auf den
allgemeinen Umfang beziehen, wenn er sagt, Stifter sei im Grunde
seines Wesens lyrisch gestimmt (was er in seinem Buche über Martin
Greif wiederholt). Wenn eben in der frühesten Zeit der hohe, epische
Ton nicht so breit hervordringt, so darf man das Bekenntnis des
Helden im „Nachsommer" sprechen lassen: „Die Alten, die ich einst
zu verstehen geglaubt, kamen mir doch jetzt anders vor als früher."
„Nachsommer", II. 40 f.[2]): Stifter machte absolut keinen Wandel vom
romantischen Stil zum klassisch=epischen durch, sondern das epische
Gut, das sich von Natur aus vorfand, wurde verfeinert, geläutert
und gedieh dann aus vollster Kunstüberzeugung zu einer bewußten
Reife. — Einige formelhafte Ausdrücke zeigen ganz intensiv Homerische
Farbe:

„Narrenburg", 64₅: „ein edles Geschlecht weißer, schlanker Säulen." —
„Narrenburg", 23₃: „Vorerst kam das leichtfüßige und leichtfertige Ge=
schlecht der Ziegen und Böcke von allen Flecken und Farben," — „Brigitta",
249₁₇: „und das Geschlecht jener schönen zottigen Hunde war neben ihnen,"
vgl. Homer, Ilias, 19. 30: „Jenem (Patroklos) versuch' ich selber hinweg=
zuscheuchen die Fliegen, deren Geschlecht raubgierig erschlagene Männer ver=
zehrt." — Wien und die Wiener, 173₃₇: „Das verschiedenartigste Geschmeide
vom Diamantbiademe an .. bis zu dem Geschlechte der Ringe," — ebda 283:
„daneben das Geschlecht der Öfen" — „Witiko", 1. 2: „höher hinauf das Reich
der Tannen und des ganzen Geschlechtes der Nadelhölzer" — „Hochwald",
306₂₃: „Die Fichtengeschlechter" — „Steine", 44₁₁: „und das Volk der
Gebüsche" — Wien und die Wiener, 138₃₁: „Schilderung der Trödelkammer:
all das kleinere Volk der Lichtputzen, Scheeren, Beschläge .." vgl. Homer,
Ilias, 2. 460: „und das Volk langhalsiger Schwäne" — „Tännling", 272₁₁:
„dann steht die einsame, verlassene Bevölkerung von Strünken dahin," —
„Narrenburg", 62₃₀: „Auch war jene wimmelnde Bevölkerung von Kreuzen

Glanz der Brust, und dann waren Gewänder bis an die Knöchel hinunter. Ich
dachte an Nausikaa, wie sie an der Pforte des goldenen Saales stand, und zu
Odysseus die Worte sagte: ‚Fremdling, wenn du in dein Land kömmst, so ge=
denke meiner.'"

[1]) Goethes Werke, 31. Band. Weimar 1904. S. 106 und 201.

[2]) Hier heißt es weiter: „Ich trug Homeros Aeschylos Sophokles Thuki=
dides fast auf allen Wanderungen mit mir. Um sie zu verstehen, nahm ich alle
griechischen Sprachwerke, die mir empfohlen waren, vor, und lernte mit ihnen." —
Erwähnt sei noch, daß Stifter in dem mit Aprent fertiggestellten, aber nicht ge=
nehmigten Lesebuch „die aus dem Griechischen und Lateinischen genommenen Be=
standtheile besorgen und größtentheils selbst übersezen" mußte. Briefe XVIII. 10₁₁.

und Zeichen nicht da," — „Schwestern", 127₂₃: „eine Pistole loszudrücken, um
die Wirkung unter dieser Steinbevölkerung zu beobachten;" — „Mappe",
327₈: „wo .. die unzähligen Gesellschaften der Laubbaumgruppen stehen." —
ebda, 302₇: „wie ich .. wieder in die finstere Gesellschaft der Tannen ein-
bog." — „Erzählungen", 179: „wo eine Gesellschaft von Felsen steht," —
„Mappe", 327₂₄: „aber auf dem Gipfel trägt er eine große Versammlung
von Fichten, Föhren, Birken und anderen Bäumen." — „Wien und die Wiener",
28₂₃: „eine Versammlung glänzender Paläste tritt um ihn herum und nimmt
ihn in die Mitte," — „Hochwald", 303₁₀: „eine ganze Versammlung jener
schönen, großen Tagesfaltern,"

Auch Vergleiche dehnen sich zur Erhabenheit Homerischer Bilder aus:
„Narrenburg", 76₁₁: „denn der alte Mann neben ihnen war von einer so
furchtbaren Erregung gefaßt, daß er bei seinen letzten Worten in ein krampf-
haftes Weinen ausbrach, die Hände vor das Gesicht schlug und die überreich-
lichen Tropfen zwischen den dürren, saltigen Fingern hervorquellen ließ, so daß
sein ganzer Riesenbau vor Schmerz zitterte, wie der See schwankt, wenn
ein ferner Sturm tobt." — „Mappe", 235₃₁: „das Brechen (des in Eis
erstarrten Waldes) wurde auch immer deutlicher, als ob ein starkes Heer,
oder eine geschreilose Schlacht im Anzug wäre." — Vielleicht auch
condensiert: „Hochwald", 241₁₆: „Der alte Mann reichte die seine (Hand) fast
verschämt zögernd hin, und es war eine seltsame Vermählung, ein lieblicher
Gegensatz, als sich ihre weiche, kleine Hand, wie eine Taube, in die Felsen
seiner Finger duckte,". Vgl. Ilias, 21. 492:

> Weinend floh die Göttin nunmehr, wie die schüchterne Taube,
> Welche, vom Habicht verfolgt, in den höhligen Felsen hineinfliegt.
> Tief in die Kluft;"

Für unsere Zwecke kommt meistenteils die Vossische Homerüber-
setzung[1] in Betracht, die er, wie die oben angeführte Briefstelle
zeigt, gut kannte. Jedenfalls aber hat Stifter auch den griechischen
Urtext Homers gelesen, aber so, daß ihm die Übertragung Vossens
dabei immer im Ohre klang.

Zuerst möge die bei Stifter am häufigsten auftretende Bildung
angeführt werden, die auf den ersten Blick die Homerische Bauart
nicht verleugnen kann: Ein attributives Adjektiv vereinigt sich mit
einem Beziehungsworte zu einem natürlich typisierenden Epitheton.
Es hat eine rein epische, typisch beschreibende Rolle, gilt für das
Beziehungsobjekt ständig, auch wenn es aus dem individuellen Zu-
sammenhang der Stelle herausgerissen wäre. Stets kann es den
Gegenstand begleiten und es trägt auch nicht einen Hauch einer
momentanen Stimmung oder eines besonderen Verhältnisses des Er-
zählers zum Objekte an sich. Bei den nebeneinander gestellten Formen
soll natürlich nicht gesagt sein, daß sie Stifter direkt aus Homer
herübergenommen habe. Die Epitheta sind gewiß Stifters eigenes
Produkt; nur klingen gleichsam als Ober- und Untertöne die Home-
rischen Stilweisen mit.

[1] Leipzig, bei Philipp Reclam.

hat in einem Berichte an das k. k. Ministerium für Kultus
und Unterricht einer der hervorragendsten Literaturgeschichten den

Deutschen Literatur-Atl
von
Dr. Siegfried Robert Nagel
k. k. Professor in Steyr

genannt, der geeignet sei, die Literaturwissenschaft auf eine
neue Grundlage zu stellen, nämlich auf die geographische.
Kartographisch und praktisch wird zum ersten Male der fruchtbare
Gedanke herausgearbeitet, daß Land und Stadt, Ebene und
Gebirg und die Besonderheiten gewisser Landschaften den aller-
größten Einfluß auf den Gang der Literatur haben.

= Preis eleg. kart. M. 6.— = K 7.20 =

Die Ausführung der 47 dreifarbig lithographierten Karten ist überaus instrukt
ein einziger Blick genügt, um eine ganze Literaturperiode vollkommen gekennz
zu finden. Auf der Karte I: ,,Althochdeutsche Zeit'' ist sogleich zu sehen, d
Klöster Süddeutschlands die Literatur beherrschen, der Höhepunkt der mitte
deutschen Literatur ist ebenso rasch zu überblicken, wie ihr Verfall. Mi
16. Jahrhundert springt die Literatur wie mit einem Schlage nach dem N
wie die drei Reformationskarten (,,Luther, Hans Sachs, Fischart'') z
Mystik und Kanzelpredigt sind getrennt behandelt, ebenso die Deut-
und Humanisten. Das Versiegen der geistigen Kräfte der Deutschen zu
Gegenreform und 30jähr. Krieg zeigt deutlich die Opitz-Karte, das allm
Ansteigen der Literatur, namentlich in Schlesien, veranschaulichen die folg
Karten. Mit 1730 beginnt die Vorherrschaft Sachsens unter Gottsched; 1748 zei
die Verteilung der dichterischen Kräfte im Messiasjahr, worauf als Ruhe
das ,,Götzjahr'' 1773, das Xenienjahr 1794, Schillers Tod 1805, Wiener Ko
1815, Goethes Tod 1832 und endlich das Revolutionsjahr 1848 folgen; sie b
die entschiedene Anziehungskraft der großen Städte gegenüber dem
Den Stürmern und Drängern, den Göttingern, den Romantikern sind
Karten gewidmet, aus denen zu ersehen ist, welche Länder an ge
geistigen Richtungen Anteil nehmen. Eigene Karten sind den Lebens
Wanderungen und Reisen der bedeutendsten Dichter gewidmet, und
Walther, Hans Sachs, Luther, Opitz, Klopstock, Wieland, Lessing, H
Goethe, Schiller, Grillparzer, Kleist, Hebbel.

l'an 1813 et 14, le glorieux dévouement de la Prusse a excité toutes les passions haineuses, et la mauvaise conscience de plusieurs Souverains les fait croire qu'il n'y a de salut pour eux qu'autant qu'ils réussissent à intriguer contre la Prusse. Ach mit dem Fall Napoleons sind seine Grundsätze leider nicht mit der Wurzel ausgerissen, reichlich haben sie gewuchert und wer weiß, ob mit diesem Kriege alles gereinigt wird. Mit Freuden können Ew. Durchlaucht wohl denken habe ich die Détails dieses letzten großen Sieges erfahren, und preise die glücklich die dafür siegreich gefallen sind, allein man kann sich keiner Freude ohne die Ahndung schwer lastender Zukunft jetzt hingeben — und diese Ahndung kann ich auch jetzt nicht aus der Brust verbannen, und finde einzig Trost in dem Gedanken, daß Alles Alles Irdische ja nur Erziehung und Uebergang zu dem Ewigen und Bleibenden ist. Ich wünschte sehr, ich hätte das Glück haben können Sie, Gnädigste Theuerste Fürstin, diesen Sommer zu sehen. Auch über den Magnetismus wäre es mir unendlich wichtig gewesen mit Ihnen sprechen und Ihnen die bedeutenden Erscheinungen mittheilen zu dürfen, die ich hier gesehen habe. Es ist in dem sogenannten Mesmerismus vieles als Anwendung auf die Staats Einrichtung wohl unausführbar, allein es ist ein großer Gedanke das eigentlich einzige große Heilmittel als die göttliche Kraft zu denken die von Gott ausströmend durch das Universum geht. Die Erläuterungen im 2 ten Band scheinen mir außerordentlich schön und tief[1]). Ich habe Gelegenheit gehabt eine Hell Schlafende beinahe täglich und auf das vertraulichste zu sehen und ich kann Ihnen, Gnädigste Fürstin, betheuern daß sich nie geahndete Wunder in diesem — ich muß ihn so nennen — heiligen Zustand vor mir offenbart haben. Ich möchte ihn mit keinem als mit dem eines seelig in Gott sterbenden Menschen vergleichen."

Berlin, 25. März 1820: „Mon mari ne va nulle part le soir, sinon chez Madame la Princesse Louise, de sorte qu'il est le plus souvent des notres. Les évenemens[2]) n'ont alteré en rien son humeur. Votre Altesse qui le connait sait qu'il a peutêtre moins que qui que ce soit la soif d'une influence générale, il veut le bien pour le bien et est content pourvu qu'il se fasse. Son véritable gout et son naturel le portent infiniment plus à une vie contemplative et à des études particulières. Il a repris toutes les sciences et ce fut une des premieres choses qu'il dit après l'événement du 31 Decembre: Nun wird man doch wieder etwas für sich thun können."

Unter den Briefen finden sich noch zwei Gedichte Karolinens von Humboldt, „Erinnerung an Sorrento 1827", abgedruckt bei Pertz, Leben Steins 6, 697, und das folgende, noch unbekannte auf Francias Madonna im Rosenhag (vgl. ihre Briefe an Rennenkampff, S. 152):

[1]) Gemeint ist das zweibändige, Berlin 1815 erschienene Werk „Mesmerismus oder System der Wechselwirkung, Theorie und Anwendung des tierischen Magnetismus als die allgemeine Heilkunde zur Erhaltung des Menschen" von Mesmer mit Erläuterungen von Wolfart. Über Karolinens Auffassung von Wolfarts magnetischen Kuren und ihre Erfahrungen auf diesem Gebiete orientieren eingehend ungedruckte Briefe von ihr an Welcker aus den Monaten Juni, Juli und September 1815; vgl. auch Varnhagen, Denkwürdigkeiten des eigenen Lebens[3] 4, 294.

[2]) Seine zu Neujahr erfolgte Entlassung aus dem Staatsdienst; vgl. darüber auch Karolinens Brief an Welcker vom 22. Januar in den Neuen Briefen von Karoline von Humboldt S. 77 und Gabriele von Bülow S. 172. 174.

Sonett.

Bei Betrachtung des Bildes von Fr. Francia, in der k. Gallerie zu
München, die Anbetung der Mutter Gottes vor dem Jesus Kinde darstellend
2. 8. 27.

Der Friede Gottes ist herabgeflossen,
Es athmet die Natur in hoher Feier,
Zerrissen ist der Zukunft dunkler Schleier,
Ein Rosengarten rings der Erd' entsprossen.

Freut Euch, o Heiles seelige Genossen,
Vertilgt ist nun der Sünde nagend Feuer,
Gebohren uns der göttliche Befreier,
Der Gnade Quell in Ewigkeit erschlossen.

So spricht, nachdem Jahrhunderte entrollten,
Dein Innres mich, Du frommer Künstler, an!
So fühltest Du's, und Kunst und Leben zollten

Dir Kraft mit der Du schrittest himmelan.
O laß auch mich, Maria! niederfinken,
Am Born des ew'gen Lebens mit Dir trinken!

Heine im Dienste der „Idee".
Von Ewald A. Boucke (Ann Arbor, Michigan).[1]
(Schluß.)

4. Die Idee als Lebensaufgabe und Forderung der Zeit.

Mit der eben angeführten Definition erreichen wir die letzte
und wichtigste Phase in der Abwandlung des Ideenbegriffes: die
Beziehung auf die aktuellen Fragen und Probleme des Tages. Ob-
wohl auch diese Funktion der Idee in Hegels Schema berücksichtigt
war, so trat sie doch, wie schon oben bemerkt, bei dem Meister selbst
ganz in den Hintergrund. Wenn Heine also solchen Nachdruck auf die
revolutionäre, vorwärtstreibende Macht der Idee legt und auf die Hin-
gabe an die großen Aufgaben der Gegenwart, so genügt der Hinweis
auf Hegel nicht zur Erklärung dieser Tendenz. Vielmehr scheint hier
ein Fichtesches Element nachzuwirken, und es ist notwendig, auf
diesen Punkt zunächst etwas näher einzugehen.

In seinen Vorlesungen über die „Grundzüge des gegenwärtigen
Zeitalters" lehrt Fichte, daß die reine Tätigkeit als Selbstzweck den
eigentlichen Kern des Daseins bilde. Das Ideal als Triebkraft und
Willensmotiv erzeugt die Wirklichkeit. Nun läßt sich aber eine solche

[1] Vgl. oben S. 116 ff.

intereſſeloſe Tätigkeit nur durch Entäußerung des empiriſchen Jchs
erreichen; eine würdige Aufgabe kann nur aus der Beſtimmung des
Menſchengeſchlechts, aus den Bedürfniſſen der Gattung entſpringen,
und es iſt die Pflicht jedes einzelnen, ſeine Tätigkeit in den Dienſt
der Gattung und ihrer Aufgaben zu ſtellen. Dieſe Aufgaben und
Ziele nun nennt Fichte auch „Ideen", während „die Idee" bei
ihm die ſittliche Weltordnung oder die Gattungsvernunft bedeutet.
Die Unterordnung unter dieſe Idee, das Leben und Handeln im
Dienſte der Idee iſt der Kardinalpunkt in Fichtes Ethik. — Zweierlei
iſt alſo charakteriſtiſch für dieſe Lehre: einerſeits die Vorſtellung der
Tätigkeit als Selbſtzweck, anderſeits die Begeiſterung für das Ganze,
für die große Aufgabe, die Idee. Beide Begriffe führen zu der gleichen
praktiſchen Folgerung: der träge Egoiſt lebt nur ſeiner Selbſt-
kultur, der Sinnlichkeit, während der Held ſich für die Idee opfert;
in der eminenten Perſönlichkeit wird die Idee zur lebendigen Flamme,
welche ihr individuelles Leben beſtimmt und aufzehrt.

Die Übereinſtimmung dieſer Lehren mit Heines Anſchauungen —
innerhalb beſtimmter Grenzen — iſt augenfällig. Freilich mangelt
Heine vollſtändig der ſittliche Ernſt und geiſtige Adel jenes Philo-
ſophen; was bei Fichte ſtrenge Denkarbeit und ſeeliſches Bedürfnis,
iſt bei Heine das Werk der frei ſpielenden Phantaſie, ein Moment
feurigſter Empfindung, der zufolge der Souveränität des romantiſchen
Jchs ſofort in ſein Gegenteil umſchlagen kann. Aber wenn ſich der
ſchöpferiſche Augenblick einſtellt und den Dichter die Begeiſterung er-
faßt, der „eroico furore", der nur in der ſelbſtloſen Hingabe an
eine erhabene Pflicht ſeine Befriedigung findet, dann glauben wir einen
Nachhall jener gewaltigen Reden zu vernehmen, mit denen der große
Ideologe einſt die Nation zum Handeln entflammt hatte.

Heines perſönliches Verhältnis zu Fichte iſt etwa ähnlich zu
beurteilen, wie ſeine Abhängigkeit von Hegel. Theoretiſch fühlte das
Kind der Welt keine Neigung zu dem rigoroſeſten aller Sittenlehrer
und er bezeichnet den tranſzendentalen Idealismus Fichtes geradezu
als einen „der koloſſalſten Irrtümer, die jemals der menſchliche Geiſt
ausgeheckt" (4, 276). Dagegen zollt er gewiſſen Eigenſchaften dieſes
Mannes, ſeiner ſtählernen Willenskraft und dem kühnen Fluge ſeiner
Gedanken unbedingte Anerkennung und Bewunderung. „Die Geiſter
ſind noch aufgeregt von den Gedanken, die durch Fichte laut geworden,
und unberechenbar iſt die Nachwirkung ſeines Wortes. Wenn auch
der ganze Tranſzendentalidealismus ein Irrtum war, ſo lebte doch in
den Fichteſchen Schriften eine ſtolze Unabhängigkeit, eine Freiheitsliebe,
eine Manneswürde, die beſonders auf die Jugend einen heilſamen
Einfluß übte" (4, 265). Fichte wird mit einer glücklichen Wendung
„der Napoleon der Philoſophie" genannt, denn beide „repräſentieren

das große, unerbittliche Ich, bei welchem Gedanke und Tat eins
sind, und die koloffalen Gebäude, welche beide zu konstruieren wissen,
zeugen von einem koloffalen Willen" (4, 264)[1]). Einen Hauch Fichte-
schen Geistes verspürte Heine, als er den Predigten Schleiermachers
zuhörte; er schreibt in den „Briefen aus Berlin": „Ich finde mich
im bessern Sinne dadurch erbaut, erkräftigt, und wie durch Stachel-
worte aufgegeißelt vom weichen Pflaumenbette des schlaffen Indiffe-
rentismus. Dieser Mann braucht nur das schwarze Kirchengewand
abzuwerfen, und er steht da als Priester der Wahrheit" (7, 578).

Dieses Fichtesche Pathos, im Bunde mit der Überzeugung von
der Macht geschichtlicher Ideen, macht es begreiflich, warum der
Ausdruck „Idee" bei Heine einen besonderen Vollklang gewinnt,
wenn aktuelle Fragen im Spiele sind. „Idee" heißt dann soviel wie
„Zeit- und Lebensaufgabe". Was sich Heine selbst unter der Idee
seines Lebens vorstellt und wie er dieselbe zu verwirklichen suchte,
darüber lassen seine Schriften keinen Zweifel. Schon nach seinem
Weggang von Berlin glaubt er den Leitstern seines Lebens im Nebel
der Zukunft zu erkennen. Er verweist in einem Briefe an Ludwig
Robert auf seine einst zu schreibenden Bekenntnisse, in denen zu lesen
sein wird, „wie mein ganzes trübes, drangvolles Leben in das Un-
eigennützigste, in die Idee übergeht" (Br. 19, 178). Auch die Schriften
der nächsten Jahre enthalten manche Anspielungen auf diese Frage
(vor allem das Buch Le Grand), aber erst seit 1827 entwickelt sich
eine Art Programm, in welchem der Dichter seiner eigenen Zukunft
Richtung und Ziel vorschreibt. Die englischen Fragmente, von denen
einzelne Abschnitte seit 1827 in den Politischen Annalen erschienen,
beginnen und schließen mit einem Hymnus auf die Freiheit, „eine
neue Religion, die Religion unserer Zeit". Von der „Idee der neuen
Zeit" ist in den Aufsätzen des Jahres wiederholt die Rede, und es
ist bezeichnend, daß Heine, der Repräsentant der revolutionären Epoche,
die historische Bedeutung von Goethes Werther viel weniger in
der psychologischen Darstellung der Liebestragödie und seelischen Zer-
rüttung des Helden erblicken möchte, als in dem sozialen Motiv.
Gemeint ist „die Erzählung, wie der junge Werther aus der hoch-
adeligen Gesellschaft höflichst hinausgewiesen wird. Wäre der ‚Werther'

[1] Noch weiter ist diese Parallele ausgeführt in der „Einleitung zu Kahl-
dorf über den Adel", wo Heine von dem Gedanken ausgeht, daß die deutsche
Philosophie nichts anderes sei „als der Traum der französischen Revolution . . .
um die Kritik der reinen Vernunft sammelten sich unsere philosophischen Jakobiner,
die nichts gelten ließen, als was jener Kritik standhielt. Kant war unser Robes-
pierre. — Nachher kam Fichte mit seinem Ich, der Napoleon der Philosophie . . .
unter Schelling erhielt die Vergangenheit mit ihren traditionellen Interessen
wieder Anerkenntnis, sogar Entschädigung . . . bis Hegel, der Orleans der
Philosophie, ein neues Regiment begründete oder vielmehr ordnete . . ." (7, 281).

in unſeren Tagen erſchienen, ſo hätte dieſe Partie des Buches weit bedeutſamer die Gemüter aufgeregt als der ganze Piſtolenknalleffekt" (7, 226). Heine geht ſogar ſoweit, Goethes Werther als eines der erſten Werke zu bezeichnen, in denen die „Idee der Menſchengleichheit" hervortritt — eine etwas gewaltſame Verrückung der geſchichtlichen Perſpektive[1]).

Als der eigentliche locus classicus der Formulierung von Heines Lebensprogramm laſſen ſich die Kapitel 29—31 der „Reiſe von München nach Genua" anſehen. Wir heben nur einige Stellen heraus. „Jede Zeit hat ihre Aufgabe, und durch die Löſung derſelben rückt die Menſchheit weiter ... Was iſt aber dieſe große Aufgabe unſerer Zeit? Es iſt die Emanzipation. Nicht bloß die der Irländer, Griechen, Frankfurter Juden, weſtindiſchen Schwarzen und dergleichen gedrückten Volkes, ſondern es iſt die Emanzipation der ganzen Welt, abſonderlich Europas, das mündig geworden iſt und ſich jetzt losreißt von dem eiſernen Gängelbande der Bevorrechteten, der Ariſtokratie ... Jede Zeit glaubt, ihr Kampf ſei vor allen der wichtigſte, dieſes iſt der eigentliche Glaube der Zeit, in dieſem lebt ſie und ſtirbt ſie, und auch wir wollen leben und ſterben in dieſer Freiheitsreligion, die vielleicht mehr den Namen Religion verdient als das hohle, aus- geſtorbene Seelengeſpenſt, das wir noch ſo zu benennen pflegen — unſer heiliger Kampf dünkt uns der wichtigſte, wofür jemals auf dieſer Erde gekämpft worden ..." (3, 275 f.).

Dieſer Hauptſtelle reihen ſich andere Äußerungen aus der Vor- pariſer Zeit an, in denen unter der herrſchenden Idee die gleiche Bewegung verſtanden wird: der Kampf gegen die privilegierten Klaſſen, gegen Adel und Prieſter, die Erweckung des Volkes aus dem Zuſtand der Unmündigkeit und die Gründung einer Religion der Vernunft und Freiheit. Erſt ſeit 1831 erfährt dieſe Formel eine Erweiterung;

[1]) An die von Heine angezogene Stelle im Werther knüpft ſich die be- rühmte Diskuſſion zwiſchen Goethe und Napoleon über die Frage, ob der Dichter weiſe daran tat, zur Motivierung von Werthers Gemütszuſtand außer der Liebestragödie auch verletztes Ehrgefühl ins Spiel zu bringen. Napoleon tadelte bekanntlich dieſe Vermiſchung der Motive, während Goethe ſein Ver- fahren mit Recht verteidigte. Es liegt eine merkwürdige Ironie darin, daß Heine hier weit radikaler denkt, als Napoleon ſelbſt, „das Sinnbild der ſiegenden Volksgewalt", der Mann der Idee, der aber gleichwohl Kunſt und Politik ge- trennt wiſſen wollte. — Was Heines Interpretation betrifft, ſo wirft ſie ein grelles Licht auf den geiſtigen Abſtand zwiſchen den Generationen von 1770 und 1830. Es iſt der gleiche Abſtand, den Heine an der oben (S. 180) ange- führten Stelle als Gegenſatz zwiſchen der Kunſtidee des 18. und der Revolutions- idee des 19. Jahrhunderts charakteriſiert. — Der große Zeitroman, in dem der Haß gegen die privilegierte Klaſſe wenigſtens teilweiſe den Hebel des tragiſchen Konflikts bildet und einer politiſchen Werthernatur viel zu ſchaffen macht, entſtand erſt ein Menſchenalter ſpäter: Friedrich Spielhagens „Problematiſche Naturen".

— ehe wir jedoch hierauf eingehen, iſt es nötig, den Zuſammenhang zwiſchen Heines Überſiedlung nach Frankreich und ſeinen politiſchen Theorien ins Auge zu faſſen. Denn es beſteht kein Zweifel, daß ihn vor allem das Bewußtſein einer wichtigen Miſſion über den Rhein trieb, und daß die Ideen der Zeit ſomit beſtimmend für ſein ganzes Lebensſchickſal wurden. Deutſchland war allerdings das Land der Ideen, ja jeder Deutſche war gleichſam eine fleiſchgewordene Idee, aber wo blieb die Tat? Und wie war es möglich, auch nur die Idee ſelbſt zu verfechten, außer in der zahmſten Schreibart und in der ſorgfältigſten Verhüllung? Frankreich war das Land der verwirklichten Ideen und Paris der Ort, an dem ſich der Dichter ſeiner Miſſion am ungeſtörteſten und erfolgreichſten widmen konnte.

Noch ehe ſich Heine über ſeine Lebensaufgabe im klaren war, fühlte er den geheimnisvollen Zug zu dem geographiſchen Mittelpunkt der neuen Freiheitsreligion. „Dieſen Herbſt," ſchreibt er im Mai 1823, „hoffe ich in Paris zu ſein. Ich gedenke viele Jahre dort zu bleiben, ... und für Verbreitung der deutſchen Literatur, die jetzt in Frankreich Wurzel faßt, tätig zu ſein" (Br. 19, 100). Nachdem ſich in den nächſten Jahren die literariſchen Ziele zu politiſchen und ſozialen erweitert haben, richtet ſich ſein Blick immer ſehnender nach dem „Mutterboden der modernen Geſellſchaft". Die „Engliſchen Fragmente" ſchließen mit dem Satz: „Die Franzoſen ſind ... das auserleſene Volk der neuen Religion, in ihrer Sprache ſind die erſten Evangelien und Dogmen verzeichnet, Paris iſt das neue Jeruſalem, und der Rhein iſt der Jordan, der das geweihte Land der Freiheit trennt von dem Lande der Philiſter" (3, 501). Die Julitage des Jahres 1830 bringen die Entſcheidung. „Ich träume jede Nacht, ich packe meinen Koffer und reiſe nach Paris, um friſche Luft zu ſchöpfen, ganz den heiligen Gefühlen meiner neuen Religion mich hinzugeben und vielleicht als Prieſter derſelben die letzten Weihen zu empfangen" (Br. 20, 225). Auch in ſpäteren Jahren, als ſein freudiger Optimismus allmählich einer Entnüchterung und reſignierten Stimmung weicht, kann er ſich nicht von ſeinem Glauben an die Miſſion Frankreichs trennen und fühlt ſich ergriffen von dem „furor francese".

Heines Sehnſucht nach Paris hatte alſo einen tiefen Grund: er fühlte ſich in Sympathie mit den Franzoſen, ſoweit es ſich um politiſche und ſoziale Probleme und um Verſtandesdinge handelte. Die franzöſiſche Ideologie war nicht ſo abſtrakt und phlegmatiſch wie die deutſche; der Künſtler und Stimmungsvirtuoſe fand hier die geeignete Atmoſphäre für ſeine Ideen und Pläne. Aber Paris war für Heine mehr als die Hauptſtadt Frankreichs — es war der Mittelpunkt der europäiſchen Kultur und die Hochburg des Kosmopolitismus.

Von hier aus konnten am ersten europäische Weltinteressen ver-
fochten werden. Deshalb erschien ihm Paris als das natürliche
Zentrum seiner Tätigkeit, nicht weil er sich als Franzose fühlte oder
gebärden wollte. Nach Paris möchte er 1826 reisen, um dort „ein
europäisches Buch zu schreiben ... die Aufgabe ist, nur solche Inter-
essen zu berühren, die allgemein europäisch sind" (Br. 19, 427).
Wir treffen damit auf eine weitere Eigenschaft seines Ideenbe-
griffs: die internationale Färbung desselben. Daraus erklärt sich, daß
Heines Forderungen einerseits etwas Unbestimmtes und Vages an-
haftet, anderseits daß sie sich auf die verschiedensten Verhältnisse an-
wenden lassen und noch heute ihre Berechtigung nicht eingebüßt haben.
Dieser ausgesprochene Kosmopolitismus ist bei der Beurteilung von
Heines Methoden und Handlungen stets in Rechnung zu ziehen und
macht es begreiflich, daß er eine ausschließliche Parteinahme für
nationaldeutsche Bestrebungen von vornherein ablehnte. Seine deutsch-
französische Zwitterstellung und vor allem sein Judentum ließen ein
ausgeprägtes Nationalgefühl bei ihm gar nicht aufkommen.

Was das Rassenproblem anlangt, so ist neuerdings darauf
hingewiesen worden, daß auch die alten Hebräer keinen Sinn für
politische Organisation besaßen, daß sie dagegen leidenschaftlich für
Gerechtigkeit und individuelle Freiheit eintraten und übrigens stark
subjektiv veranlagt waren[1]). Folgende Betrachtungen Heines, die er
gelegentlich der Charakteristik der Jessika in „Shakespeares Mädchen
und Frauen" einschaltet, verdienen in diesem Zusammenhange Be-
achtung: „Die Juden trugen schon im Beginne das moderne Prinzip
in sich, welches sich heute erst bei den europäischen Völkern sichtbar
entfaltet. Griechen und Römer hingen begeistert an dem Boden, an
dem Vaterlande. Die spätern nordischen Einwanderer in die Römer-
und Griechenwelt hingen an der Person ihrer Häuptlinge, und an
die Stelle des antiken Patriotismus trat im Mittelalter die Vasallen-
treue, die Anhänglichkeit an die Fürsten. Die Juden aber von jeher
hingen nur an dem Gesetz, an dem abstrakten Gedanken, wie unsere
neueren kosmopolitischen Republikaner, die weder das Geburtsland
noch die Person der Fürsten, sondern die Gesetze als das Höchste
achten. Ja, der Kosmopolitismus ist ganz eigentlich dem Boden
Judäas entsprossen, und Christus ... hat ganz eigentlich eine Pro-
paganda des Weltbürgertums gestiftet" (5, 455; ähnlich 7, 47).

Dieser kleine Beitrag zur Rassenpsychologie enthält viel Wahres
und stellt mit Recht zwischen dem jüdischen Kosmopolitismus und

[1]) Vgl. Maurice Muret, L'Esprit Juif. Paris 1901; ferner die Abhandlung
von A. Leroy-Beaulieu, „Les Juifs et l'Antisémitisme." Revue des Deux Mondes,
vol. 114, S. 773 ff.; 779.

der universalistischen Tendenz des Christentums einen engeren Zu-
sammenhang her. Vor allem wirft er Licht auf Heines eigene Stellung
zu der Nationalitätsfrage. Wer sich so ausgesprochen als euro-
päischer Kosmopolit fühlt, kann unmöglich ein sicheres Stammes-
bewußtsein besitzen; er wird die Schwächen und Vorzüge der ver-
schiedenen Nationen gegeneinander abwägen und je nach Gelegenheit
und Stimmung sein Urteil fällen. Dies ist auch bei Heine zutreffend.
Auf der einen Seite stehen Aussprüche wie der folgende, der einem
neuerdings publizierten Briefe entnommen ist: „Ich weiß, daß ich eine
der deutschesten Bestien bin, ich weiß nur zu gut, daß mir das Deutsche
das ist, was dem Fische das Wasser ist, daß ich aus diesem Lebens-
element nicht herauskann, und daß ich . . . zum Stockfisch vertrocknen
muß, wenn ich . . . aus dem Wasser des Deutschtümlichen heraus-
springe. Ich liebe sogar im Grunde das Deutsche mehr als alles auf
der Welt, ich habe meine Lust und Freude dran, und meine Brust
ist ein Archiv deutschen Gefühls, wie meine zwei Bücher ein Archiv
deutschen Gesanges sind"[1]). Solche enthusiastischen Äußerungen werden
reichlich aufgewogen durch entgegengesetzte Bekenntnisse, an denen es
nicht fehlt. Im Jahre 1822 schreibt Heine: „Ich liebe Deutschland
und die Deutschen; aber ich liebe nicht minder die Bewohner des
übrigen Teils der Erde, deren Zahl vierzigmal größer ist als
die der Deutschen. Die Liebe gibt dem Menschen seinen Wert.
Gottlob! ich bin also vierzigmal mehr wert als jene, die sich nicht
aus dem Sumpfe der Nationalselbstsucht hervorwinden können, und
die nur Deutschland und Deutsche lieben" (7, 183). Noch kräftiger
lauten folgende Sätze aus dem Jahre 1838: „Ich bin der inkarnierte
Kosmopolitismus, ich weiß, daß dieses am Ende die allgemeine Ge-
sinnung wird in Europa, und ich bin daher überzeugt, daß ich mehr
Zukunft habe, als unsere deutschen Volkstümler, diese sterblichen
Menschen, die nur der Vergangenheit angehören"[2]).
 Will man Heines Nationalität genauer bestimmen, so hat man
von seiner komplexen Natur und den verschiedenen Seiten seiner
Tätigkeit auszugehen: als Dichter wurzelt er im deutschen Gefühls-
leben, seine politischen Sympathien gehören Frankreich, nach Rasse
und Temperament ist er Weltbürger. Alle drei Elemente wirken mit
bei der Gestaltung seiner Lebensaufgabe. Als deutscher Romantiker,
der deutsche Innigkeit mit gallischem Esprit vereint, träumt er in
Frankreich, dem Lande revolutionärer Bewegungen, von einer kosmo-
politischen Freiheits- und Schönheitsreligion. Daher macht er sich
ausdrücklich in jener klassischen Formulierung seines Programms zum

[1]) Deutsche Rundschau, Bd. 107, S. 282; vgl. auch Elsters Kommentar S. 286.
[2]) Zitiert bei Lichtenberger, Heine als Denker, S. 188.

Herold der Emanzipation der ganzen Welt und ist überzeugt, daß die Zeitidee auf eine internationale Kultur und Verbrüderung der Nationen gerichtet ist. „Der Haupthebel, den ehrgeizige und habsüchtige Fürsten zu ihren Privatzwecken sonst so wirksam in Bewegung zu setzen wußten, nämlich die Nationalität mit ihrer Eitelkeit und ihrem Haß, ist jetzt morsch und abgenutzt; täglich verschwinden mehr und mehr die törichten Nationalvorurteile, alle schroffen Besonderheiten gehen unter in der Allgemeinheit der europäischen Zivilisation, es gibt jetzt in Europa keine Nationen mehr, sondern nur Parteien" (3, 274). — In dieser Annahme irrte sich Heine mit anderen seiner Zeitgenossen allerdings gewaltig, denn das 19. Jahrhundert zeitigte die intensivste Förderung und Kräftigung des Nationalbewußtseins in allen Ländern. Gleichwohl ist nicht zu verkennen, daß sich seit dem Aufkommen des Sozialismus eine starke kosmopolitische Unterströmung durch das ganze Jahrhundert fortgesetzt hat und auch heute in gewissen kommunistischen Lehren andauert.

Es wäre übertrieben zu behaupten, daß mit Heines Übersiedlung nach Paris auch ein neuer Abschnitt in seinem geistigen Leben und in seinen Theorien über die Aufgabe der Zeit beginne. Wohl aber gewinnt eine bis dahin nur vereinzelt auftretende Anschauung immer mehr an Bedeutung und verschmilzt mit dem revolutionspolitischen Programm zu einer weitausblickenden sozialen Utopie. Obwohl die Lehren des Saint-Simonismus Heine in seiner Sozialphilosophie wesentlich bestärkten, so waren doch die Voraussetzungen zu dieser Programmerweiterung längst vorhanden und in verschiedenen Umständen begründet.

Schon früh war sich Heine bewußt geworden, daß das Zeitalter, dem er angehörte, sich vor allem in einer Hinsicht zu dem vorhergehenden in Gegensatz stellte: in dem Verlangen, mit den realen Mächten der Gegenwart und mit der Sinnenwelt in lebendigere Beziehung zu treten. Die Romantik war schließlich bei einem hektischen Spiritualismus angelangt und hatte über dem völligen Versenken in die Tiefen des Innenlebens die reale Außenwelt und die Ansprüche des derben Erdelebens vergessen. Die Generation von 1830 stellte daher die Forderung einer kräftigen Weltbejahung an die Spitze ihres Programms. Bei Heine fand die Forderung besonders ungestümen Ausdruck, weil sie seinem sanguinischen und sinnlichen Temperament entsprach. Eine unersättliche Lebenslust und ungewöhnliche Empfänglichkeit für sinnliche Eindrücke — diese Haupteigenschaften seines Gefühlslebens bestimmen auch sein Denken, und so ist es erklärlich, daß die schwächere oder stärkere Ausbildung des sinnlichen

Trieblebens für ihn zum Kriterium geistiger Richtungen und Bewegungen wurde. In der ganzen Menschheit glaubte er ein durchgehendes Gesetz wahrzunehmen, wonach sich Völker wie Individuen entweder dem Sensualismus oder Spiritualismus zuneigten. Im größten Maßstab wandte er dieses Kriterium auf die Geschichte an und konstruierte sich einen fundamentalen Gegensatz zwischen der antiken oder sensualistischen und christlichen oder spiritualistischen Kultur. Im Banne der letzteren hat die Menschheit nun lange genug geschmachtet, und es gilt ein neues Zeitalter vorzubereiten, das die Versöhnung jener beiden Hauptrichtungen zu einer höheren Synthese herbeiführen wird.

Es wurde Heine immer klarer, daß die französische Revolution im Grunde nichts anderes sei, als eine Phase dieser großen Freiheitsbewegung, daß die allgemeine Sehnsucht der Menschheit nach einem volleren Ausleben der ganzen Persönlichkeit darin stürmischen Ausbruch fand. Eine Emanzipation des Geistes wie des Fleisches muß angestrebt werden, denn der Spiritualismus und die einseitige Pflege des Innenlebens sind schuld an der Vernachlässigung der äußeren weltlichen Güter, an der politischen und sozialen Knechtschaft. Im Tempel der Freiheitsreligion wird auch der Sensualist seinen Gottesdienst halten. So trägt das Lebensprogramm Heines in seiner erweiterten Gestalt auch den ästhetischen Bedürfnissen Rechnung und gewinnt gleichzeitig eine Art geschichtlicher Perspektive. „Ein zweites ‘nachwachsendes Geschlecht'", schreibt Heine bereits 1833, „hat eingesehen, daß all mein Wort und Lied aus einer großen, gottfreudigen Frühlingsidee emporblühte, die wo nicht besser, doch wenigstens ebenso respektabel ist, wie jene triste, modrige Aschermittwochsidee, die unser schönes Europa trübselig entblumt und mit Gespenstern und Tartüffen bevölkert hat" (4, 13).

Es ist bekannt, daß sich Heine bei der weiteren Ausgestaltung seiner Kulturphilosophie an den St. Simonismus anlehnte, weil er hier unter anderen Lehren auch das Verlangen nach einer Versöhnung von Geist und Materie und nach einer neuen Religion vorfand[1]). In seinen beiden geschichtsphilosophischen Hauptwerken legte er seine Theorien am ausführlichsten dar und gliederte seinen Stoff in der Schrift über die deutsche Philosophie ausschließlich nach jener Formel. Gleichwohl darf nicht übersehen werden, daß Heine in der St. Simonistischen Doktrin im Grunde nur die Bestätigung seiner selbständig gefundenen Anschauungen fand, auf die ihn sein Temperament und der Zeitgeist hindrängten. Schon in dem 1820 geschriebenen Aufsatz

[1]) Vgl. neuerdings die ausführliche Behandlung dieses Gegenstandes bei Henri Lichtenberger, Heine als Denker, S. 125 ff.

„Die Romantik", in welchem Heine die Schlegelsche Gegenüberstellung von Plastik und Romantik erläutert, legt er besonderen Nachdruck auf den Gegensatz zwischen der Sinnesfreudigkeit der Antike und der unendlichen Wehmut, die in der Idee des Christentums zum Ausdruck komme. Auch lehnt sich Heine hier gegen die einseitige Auffassung des Romantischen als einer nebelhaft verschwommenen Gefühlsschwelgerei auf und behauptet, daß die Romantik so plastische Gebilde erzeugen könne, wie die Antike. Obwohl sich Heine in diesem Aufsatz auf sein engeres Thema beschränkt, so deutet seine Opposition gegen die nazarenische Romantik und sein Ideal einer zukünftigen Poesie schon auf die spätere Utopie einer lebens- und farbenfreudigen Zukunft unverkennbar hin. Der Aufsatz schließt nämlich mit folgendem Ausruf: „Deutschland ist jetzt frei; kein Pfaffe vermag mehr die deutschen Geister einzukerkern; kein adeliger Herrscherling vermag mehr die deutschen Leiber zur Fron zu peitschen, und deshalb soll auch die deutsche Muse wieder ein freies, blühendes, unaffektiertes, ehrlich deutsches Mädchen sein und kein schmachtendes Nönnchen und kein ahnenstolzes Ritterfräulein" (7, 151).

Seine Geschichtsphilosophie gründete Heine später bekanntlich auf den Gegensatz zwischen Hellenismus und Nazarenismus, und auch diese Anschauung ist schon vor 1831 vorhanden. Bei seinem Aufenthalt in Italien wurde Heine, wie auch seinerzeit Goethe, seltsam berührt von dem schroffen Gegensatz zwischen einem zu heiterem Sinnengenuß einladenden Himmel und einer Religion, die sich an Symbolen des Leidens und Martyriums erbaut. Er glaubte auf so vielen Gesichtern die Spuren einer unheilbaren Krankheit zu erkennen. Diese Eindrücke kleidet er in eine wunderbar plastische Vision, die das sechste Kapitel jener Schrift eröffnet und das plötzliche Erscheinen des judäischen Kreuzesträgers im Kreise der heiter schmausenden Götter schildert. „Da plötzlich keuchte heran ein bleicher, bluttriefender Jude, mit einer Dornenkrone auf dem Haupte und mit einem großen Holzkreuz auf der Schulter; und er warf das Kreuz auf den hohen Göttertisch, daß die goldnen Pokale zitterten und die Götter verstummten und erblichen und immer bleicher wurden, bis sie endlich ganz in Nebel zerrannen. — Nun gab's eine traurige Zeit, und die Welt wurde grau und dunkel. Es gab keine glücklichen Götter mehr, der Olymp wurde ein Lazarett, wo geschundene, gebratene und gespießte Götter langweilig umherschlichen und ihre Wunden verbanden und triste Lieder sangen. Die Religion gewährte keine Freude mehr, sondern Trost; es war eine trübselige, blutdünstige Delinquentenreligion" (3, 394 f.). Hier liegt also der gleiche Gedanke zugrunde, den Heine so vielfach, bald abstrakt, bald in bildlicher Einkleidung ausgeführt hat, und der das ganze zweite Buch der Denkschrift über

Börne in Form eines Leitmotives durchzieht: „Pan ist tot" — ein neues Reich bricht an.

Es ist hier nicht der Ort, die vielseitige Anwendung, die Heine von seiner geschichtsphilosophischen Formel macht, weiter zu verfolgen; aus den angeführten Beispielen geht aber hervor, daß diese Anschauungen nicht erst durch den St. Simonismus geweckt wurden, sondern nur ihre Bestätigung und festere Gestaltung erhielten. Was Heine aus den Lehren Pater Enfantins entlehnte, waren vor allem Schlagwörter. Mit kräftigerem Bewußtsein als früher wird neben der Emanzipation des Geistes auch die Rehabilitation der Materie verkündigt und gefordert. Das politisch-revolutionäre Programm wird zu einer sozialen Utopie auf kulturphilosophischer Grundlage. Was Heine besonders zu der St. Simonistischen Religion hinzieht, ist ihre ästhetische Färbung, der Glaube an die vergeistigende Funktion der Schönheit in dem diesweltlichen Reiche sinnlich-geistiger Harmonie. Der eine persönliche Gott, der Gott der Leiden und Schmerzen, wird seines Thrones entsetzt — „Hört ihr das Glöckchen klingen? Kniet nieder — Man bringt die Sakramente einem sterbenden Gotte" (4, 246). Das neue Reich wird dem Pantheismus huldigen, es wird „die Gottesrechte des Menschen" anerkennen, „eine Demokratie gleichherrlicher, gleichheiliger, gleichbeseligter Götter" (4, 223).

Man gewahrt die Erweiterung und Klärung von Heines Lebensprogramm, wenn man das Zukunftsbild, das er 1828 von der Menschheit entwirft, mit einem ähnlichen Bilde aus dem Jahre 1834 vergleicht. In der „Reise von München nach Genua" heißt es: „Emporblühen wird ein neues Geschlecht, das erzeugt worden in freier Wahlumarmung, nicht im Zwangsbette und unter der Kontrolle geistlicher Zöllner; mit der freien Geburt werden auch in den Menschen freie Gedanken und Gefühle zur Welt kommen, wovon wir geborenen Knechte keine Ahnung haben — O! sie werden ebensowenig ahnen, wie entsetzlich die Nacht war, in deren Dunkel wir leben mußten, und wie grauenhaft wir zu kämpfen hatten mit häßlichen Gespenstern, dumpfen Eulen und scheinheiligen Sündern!" (3, 281). In dem Werke über die deutsche Religion und Philosophie kehrt das gleiche Bild wieder, aber die Religion der Freiheit hat sich inzwischen zu einer Religion der Schönheit und Freude erweitert. „Einst, wenn die Menschheit ihre völlige Gesundheit wiedererlangt, wenn der Friede zwischen Leib und Seele wiederhergestellt und sie wieder in ursprünglicher Harmonie sich durchdringen: dann wird man den künstlichen Hader, den das Christentum zwischen beiden gestiftet, kaum begreifen können. Die glücklichern und schönern Generationen, die, gezeugt durch freie Wahlumarmung, in einer Religion der Freude emporblühen, werden wehmütig lächeln über ihre armen Vorfahren, die

ſich aller Genüſſe dieſer ſchönen Erde enthielten und durch Abtötung
der warmen farbigen Sinnlichkeit faſt zu kalten Geſpenſtern ver-
blichen ſind!" (4, 170).

Beide Faſſungen von Heines Lebensidee, die engere politiſche
und die weitere kulturphiloſophiſche, laufen eine Zeitlang neben-
einander her und werden bald einzeln, bald verbunden ins Treffen
geführt. Aber ſehr bald machen ſich Widerſprüche und Antinomien
bemerkbar, die im Keime von jeher vorhanden geweſen waren, und
die unter dem Einfluß gewiſſer Bedingungen ihre zerſetzende Kraft
immer intenſiver entfalteten, um endlich zu einem vollſtändigen Zu-
ſammenbruch des Gedankengebäudes zu führen.

5. Die Zerſetzung der Jdee.

Es bleibt nach Heines eigenartiger Veranlagung zweifelhaft, ob
ſich der Dichter auch unter den günſtigſten Verhältniſſen zu einer
klaren Vorſtellung über die Verwirklichung und Ausführbarkeit ſeiner
Jdeen erhoben hätte. Vollends aber erklären ſeine durch Probleme
aller Art komplizierten Lebensumſtände und vor allem ſeine phyſiſche
Zerrüttung zur Genüge, warum er ſich mit ſeinen Theorien in un-
auflösbare Widerſprüche verwickelte, und warum am Ende auf den
Rauſch der Begeiſterung eine höchſt aſchermittwochliche Stimmung
folgte. Am ſchwerſten hatte die Religion der Schönheit zu leiden.
Es kam die Zeit, wo der „fette Helene" ſich in einen ſchwergeprüften
Lazarus wandelte, und die körperlichen und ſeeliſchen Qualen konnten
nicht ohne Einfluß bleiben auf die religiöſen Vorſtellungen eines
Mannes, der ſo ganz von ſeinem Gefühlsleben und ſeinen Stim-
mungen beherrſcht war. Vom Pantheismus kehrte er zum Deismus
zurück, nicht weil eine tiefe geiſtige Wandlung oder gar Entwicklung
in ihm vorgegangen war, ſondern weil die entſetzliche Heimſuchung
ihm den Glauben an die Gottähnlichkeit und Selbſtherrlichkeit des
Menſchen benommen hatte. Nebukadnezar war von ſeiner Höhe herab-
geſtürzt und kroch grasfreſſend am Boden: aus dieſem Erlebnis er-
wuchs das Gefühl des Beſiegtſeins und des Reſpekts vor der Macht
des zürnenden Jehovah. Mit ſolch peſſimiſtiſcher und reſignierter
Stimmung war der äſthetiſche Pantheismus und der Glaube an ein
Reich der Weltſchönheit ſchwer zu vereinen. So verblaßt die kultur-
philoſophiſche Faſſung der Jdee, während die ältere politiſch-revolu-
tionäre ſich länger behauptet. Dieſem Teil ſeines Programms blieb
Heine wenigſtens inſofern treu, als es ſich um die Jdee der Eman-
zipation handelt. Im Nachwort zum Romanzero geſteht der Dichter
ein, daß er in der Theologie einen Rückſchritt gemacht habe; in der
Politik aber „verharrte ich bei denſelben demokratiſchen Prinzipien,

denen meine früheste Jugend huldigte und für die ich seitdem im
flammender erglühte" (1, 487).

Und doch bleibt auch der politische Teil seines Lebensprogram
von dem allgemeinen Prozeß der Zersetzung nicht verschont.
betätigt sich an Heine das Wort eines englischen Kritikers, daß
bloßem Protest nichts Positives hervorgehen könne, daß eine P
der Revolte gegen sittliche Ideen zugleich eine Poesie der Rev
gegen das Leben selbst bedeute. Heine ist gleich Byron die Verkörper
der revolutionären Stimmung des angehenden 19. Jahrhunde
Sein Lebensprogramm und seine Kampfesmethoden sind von vo
herein nicht konstruktiv veranlagt, sondern atmen den Geist
Protestes und der Abwehr. Diese Abwehr richtete sich gegen E
seitigkeit, Überhebung und Pedanterie, und zwar gleichmäßig nach a
Seiten, auch wenn sie im Bunde mit der heiligen Sache auft
Bei seiner Religion der Freiheit dachte Heine viel weniger an ei
Zukunftsstaat oder an bestimmte politische und soziale Einrichtun
als an eine geistige Tendenz, an das freie Spiel des souveränen S
und die Überwindung des Philistertums. So erklärt sich seine Gle
giltigkeit gegen Regierungsformen, die er in einem Briefe an La
ganz offen zugesteht. „In den politischen Fragen können Sie so
Konzessionen machen, als Sie nur immer wollen, denn die politi
Staatsformen und Regierungen sind nur Mittel; Monarchie u
Republik, demokratische oder aristokratische Institutionen sind gle
giltige Dinge, so lange der Kampf um erste Lebensprinzipien, um
Idee des Lebens selbst, noch nicht entschieden ist. Erst später kor
die Frage, durch welche Mittel diese Idee im Leben realisiert wer
kann, ob durch Monarchie oder Republik, oder durch Aristokr
oder gar durch Absolutismus, ... für welchen letzteren ich gar k
große Abneigung habe" (Br. 20, 307). Ein solch allgemeines I
war aber überhaupt nicht im konkreten Sinne zu verwirklichen, sonr
konnte nur als richtunggebendes Prinzip dienen. Gegenüber
Schwungkraft und dem Glanz der reinen Idee erscheint die W
lichkeit immer träge und bleiern; die Idee hat fortwährend Komp
misse einzugehen und muß sich oft die merkwürdigsten Verschwi
rungen gefallen lassen, um überhaupt noch als geistige Potenz
Hintergrund eine bescheidene Wirksamkeit zu entfalten.

Dieser große Abstand zwischen der realen Welt und der Idee erk
Heines wachsende Unzufriedenheit und Skepsis, die ihn sogar hinder
den tatsächlichen Fortschritten gerecht zu werden und daraus n
Hoffnung für die Zukunft zu schöpfen. Ferner aber drängte sich ihm
wachsender Bekanntschaft mit dem vielverschlungenen Gewebe des sozia
Lebens immer mehr die Erkenntnis auf, daß jede Idee ihr pol
Element in sich trägt. Da traf es sich nun als eine merkwürdige Iro

daß der zweite Teil von Heines Programm, der Kultus der Schönheit auf Grund der Rehabilitation der Materie, mit der politischen Emanzipation der Völker fast unvereinbar schien. Schon auf seinem Ausfluge nach England hatte Heine Gelegenheit, über diese Antinomie nachzudenken; er konnte nicht umhin, den Freiheitssinn des Volkes, ihr Parlament und öffentliches Leben zu bewundern (5, 129; 7, 242), während ihn doch das Maschinenmäßige, Automatenhafte, sowie der Mangel an Geist und Schönheitssinn im höchsten Grade zurück-stießen (4, 851; 6, 827; 5, 58). Diese eigentümliche Mischung seines Temperaments, in welchem sich die Begeisterung für demokratische Prinzipien mit aristokratischem Individualismus und Künstlertum stritten, erklärt die zahlreichen Widersprüche in seinen Schriften und entging Heine selbst keineswegs. Er schreibt z. B. 1820 an Varn-hagen: „Am gefährlichsten ist mir noch jener brutale aristokratische Stolz, der in meinem Herzen wurzelt und den ich noch nicht aus-reuten konnte, und der mir so viel Verachtung gegen den Industria-lismus einflüstert und zu den vornehmsten Schlechtigkeiten verleiten könnte" (Br. 20, 210).

Mit den Jahren steigerte sich das Bewußtsein dieser Antinomie und weitete sich der Spalt, der eine Versöhnung der beiden Lebens-ideen Heines unmöglich machte: zwischen Emanzipation und Indivi-dualismus, Demokratie und Kunst schien eine Gemeinschaft un-denkbar. Gerade das Leben in der Großstadt mit ihren grellen Kon-trasten von Glanz und Armut, von Überkultur und Verrohung erfüllte den empfänglichen Geist des Dichters mit den widersprechendsten Bildern und ließ ihm seine eigene Doktrin in recht fragwürdigem Lichte erscheinen. Wie übel stimmte der heisere Gesang der hungernden Weber zu den zarten Kantilenen oder dem bacchantischen Jubel der Florentinischen Nächte! Wie war es möglich, die entfesselten Volks-instinkte je durch die Zauber der Schönheit zu binden? Die Demokratie war freilich im Anzuge, aber nicht eine solche von Göttern, sondern von öden Werkeltagsmenschen und Nützlichkeitskrämern. „Sowie die Demokratie wirklich zur Herrschaft gelangt, hat alle Poesie ein Ende" (7, 418). „Es wird vielleicht alsdann nur Einen Hirten und Eine Herde geben, ein freier Hirt mit einem eisernen Hirtenstabe und eine gleichgeschorene, gleichblökende Menschenherde!" (6, 316). Die Berichte über das Pariserleben seit 1840 sind reich an solchen pessimistischen Betrachtungen über das schier unlösbare Dilemma, in das sich der rationalistische Romantiker verstrickt sieht, und je näher das Schreck-gespenst des nackten „feigenblattlosen, kommunen" Kommunismus heran-rückte, desto mehr begann Heine für die Sache der ästhetischen Kultur zu fürchten, desto skeptischer und resignierter wurde seine Stimmung. „Nur mit Schreck und Grausen denke ich an die Epoche, wo diese

finſteren Bilderſtürmer zur Herrſchaft gelangen werden; mit ihren ſchwieligen Händen werden ſie erbarmungslos alle Marmorſtatuen der Schönheit zerbrechen, die meinem Herzen ſo teuer ſind; ſie werden all jenes phantaſtiſche Spielzeug und Flitterwerk der Kunſt zertrümmern, das der Poet ſo ſehr geliebt; ſie werden meine Lorbeerhaine fällen und dort Kartoffeln pflanzen . . ." (6, 572; franzöſiſche Vorrede zur Lutezia, überſetzt von Strodtmann, Heine 2, 292).

Mit trübem Sinn ſchaut der Dichter in die Zukunft und entwirft ein aſchgraues Bild von dem modernen Gleichheitsſtaate. Einer Medizin bedarf die leidende Menſchheit allerdings, aber wie würde ſie nach der Geneſung ausſehen? „Gelänge es auch, die leidende Menſchheit auf eine kurze Zeit von ihren wildeſten Qualen zu befreien, ſo geſchähe es doch nur auf Koſten der letzten Spuren von Schönheit, die dem Patienten bis jetzt geblieben ſind; häßlich wie ein geheilter Philiſter wird er aufſtehen von ſeinem Krankenlager und in der häßlichen Spitaltracht, in dem aſchgrauen Gleichheitskoſtüm, wird er ſich all ſein Lebtag herumſchleppen müſſen. Alle überlieferte Heiterkeit, alle Süße, aller Blumenduft, alle Poeſie wird aus dem Leben herausgepumpt werden, und es wird davon nichts übrigbleiben als die Rumfordſche Suppe der Nützlichkeit. — Für die Schönheit und das Genie wird ſich kein Platz finden in dem Gemeinweſen unſerer neuen Puritaner, und beide werden ſketriert und unterdrückt werden noch weit betrübſamer als unter dem älteren Regimente. Denn Schönheit und Genie ſind ja auch eine Art Königtum, und ſie paſſen nicht in eine Geſellſchaft, wo jeder im Mißgefühl der eigenen Mittelmäßigkeit alle höhere Begabnis herabzuwürdigen ſucht bis aufs banale Niveau" (7, 143 f.) [1].

Trotz dieſer fortſchreitenden ſkeptiſchen Reſignation und inneren Zerriſſenheit bleibt Heines Kampfſtimmung und ſein Intereſſe an allen Vorgängen des Tages unvermindert, aber ſie äußern ſich vorwiegend negativ oder paſſiv: einesteils als Proteſt gegen Beſchränktheit und blöden Fanatismus, andernteils als Mitleid mit den Enterbten und Beſiegten. Die beiden großen Tendenzgedichte aus dem Anfang der Vierzigerjahre eröffnen dieſe Epoche, und beſonders „Atta Troll", der „Schwanengeſang der untergehenden Periode" gibt das getreueſte Bild von dem paradoxenreichen Geiſte des Dichters. Er fühlte ſich als ein zweiter Kunz von der Roſen, als der tiefſinnige

[1] So wenig wie Heine gelang es Ibſen, die Löſung der Antinomie klar zu faſſen. Auch der ſkandinaviſche Dichter träumt in ſeinem Drama „Kaiſer und Galiläer" von einem dritten Reich, in welchem ſowohl dem Fleiſch wie dem Geiſt Genüge geſchehen ſoll; freilich kommt es Ibſen vor allem auf die innere Freiheit und höhere Sittlichkeit des „Adelsmenſchen" an, während bei Heine das äſthetiſche Bedürfnis die Triebfeder bildet.

Schalk, der seinem Publikum allerlei Kurzweil bereitete, und hinter dessen abenteuerlichen Sprüngen sich doch ein tragischer Ernst verbarg. Daher nahm er in der Vorrede Gelegenheit, sich gegen falsche Auslegungen oder Verdächtigungen von vornherein ausdrücklich zu verwahren und seine unverbrüchliche Treue gegen die Idee selbst zu beteuern. „Du lügst, Brutus, du lügst, Cassius, und auch du lügst, Asinius, wenn ihr behauptet, mein Spott träfe jene Ideen, die eine kostbare Errungenschaft der Menschheit sind und für die ich selber so viel gestritten und gelitten habe. Nein, eben weil dem Dichter jene Ideen in herrlichster Klarheit und Größe beständig vorschweben, ergreift ihn desto unwiderstehlicher die Lachlust, wenn er sieht, wie roh, plump und täppisch von der beschränkten Zeitgenossenschaft jene Ideen aufgefaßt werden können. Er scherzt dann gleichsam über ihre temporelle Bärenhaut. Es gibt Spiegel, welche so verschoben geschliffen sind, daß selbst ein Apollo sich darin als eine Karikatur abspiegeln muß und uns zum Lachen reizt. Wir lachen aber alsdann nur über das Zerrbild, nicht über den Gott“ (2, 363).

Es ist von Interesse, mit dieser Stelle eine Äußerung des jungen Heine aus dem Jahre 1822 zu vergleichen; schon damals ist er genötigt, sich wegen des bitteren, spottenden Tones zu rechtfertigen, womit er zuweilen von Dingen spreche, „die andern Leuten teuer sind und teuer sein sollen. Ich kann aber nicht anders. Meine Seele glüht zu sehr für die wahre Freiheit, als daß mich nicht der Unmut ergreifen sollte, wenn ich unsere winzigen, breitschwatzenden Freiheitshelden in ihrer aschgrauen Armseligkeit betrachte; in meiner Seele lebt zu sehr Liebe für Deutschland und Verehrung deutscher Herrlichkeit, als daß ich einstimmen könnte in das unsinnige Gewäsche jener Pfennigsmenschen, die mit dem Deutschtume kokettieren; und zu mancher Zeit regt sich in mir fast krampfhaft das Gelüste, mit kühner Hand der alten Lüge den Heiligenschein vom Kopfe zu reißen, und den Löwen selbst an der Haut zu zerren, — weil ich einen Esel darunter vermute“ (7, 587). — So hatte Heine sein ganzes Leben darunter zu leiden, daß er nur allgemeine Ideen verfocht, ohne sich je zu bestimmten, positiven Zielen zu bekennen.

Mit Heines Teilnahme an sozialen Fragen verhält es sich ähnlich. Seine Sympathie mit dem „glückenterbten“ Volke tritt schon früh zutage, besonders wo es sich um die Vergewaltigung und Tyrannisierung des Volkes durch den Adel handelt. Bezeichnend ist z. B. der Ingrimm, mit dem Heine daran zurückdenkt, wie er einst zu Göttingen einige hannövrische Junker hinter einem keuchenden Schnellläufer galoppieren sah, der um ein paar Taler seine letzte Kraft zu einem Dauerlauf daransetzen mußte (8, 103). In London ist er tief erschüttert von dem Gegensatz zwischen den vornehmen Vierteln des

Westends und den abgelegenen Gäßchen und dunklen, feuchten Gängen, in denen die Armut wohnt mit ihren Lumpen und ihren Tränen. Er knüpft an eine kurze Schilderung der Armen und Bettler folgenden pathetischen Ausruf: „Arme Armut! wie peinigend muß dein Hunger sein dort, wo andre im höhnenden Überflusse schwelgen! Und hat man dir auch mit gleichgiltiger Hand eine Brotkruste in den Schoß geworfen, wie bitter müssen die Tränen sein, womit du sie erweichst! Du vergiftest dich mit deinen eignen Tränen. Wohl hast du Recht, wenn du dich zu dem Laster und dem Verbrechen gesellst. Ausgestoßene Verbrecher tragen oft mehr Menschlichkeit im Herzen als jene kühlen, untadelhaften Staatsbürger der Tugend, in deren bleichen Herzen die Kraft des Bösen erloschen ist, aber auch die Kraft des Guten" (3, 442).

Über dieses, ohne Zweifel echte Mitgefühl und Mitleid mit den unteren Klassen kommt Heine jedoch nicht hinaus. Auf die national-ökonomischen Lehren des St. Simonismus geht er überhaupt nicht ein, und auch die sozialethischen Neuerungen dieser Religion haben für ihn nur ein allgemeines Interesse. Tatsächlich entspringt seine Teilnahme an dem Los der Armen und Unglücklichen jener allgemeinen pessimistischen Stimmung, die seine Lebensphilosophie gegen Ende fast ausschließlich beherrscht. Hatte er doch am eigenen Leibe die grausame Ironie des großen Welthumoristen erfahren und allen Grund, sich selbst in die Kategorie der Enterbten und Besiegten einzureihen, deren Leiden und Entsagung er im Romanzero verewigt. Es klingt wie eine Sehnsucht nach einem Nirvana der Erlösung durch Heines letzte Poesien; die Idee hatte sich als Illusion herausgestellt, und er, der das Leben so leidenschaftlich geliebt hatte, mußte aus der Philosophie des Leidens seine letzte Inspiration schöpfen. Die Religion der Freiheit und Schönheit löste sich in ein Fragezeichen; der Ritter vom heiligen Geist, der einst so siegesgewiß auf die Entdeckung der Insel Bimini ausgefahren war, kam endlich in das Land,

> In das stille Land, wo schaurig
> Unter schattigen Cypressen
> Fließt ein Flüßlein, dessen Wasser
> Gleichfalls wundertätig heilsam —
>
> Lethe heißt das gute Wasser!
> Trink daraus, und du vergißt
> All dein Leiden — ja, vergessen
> Wirst du, was du je gelitten —
>
> Gutes Wasser! gutes Land!
> Wer dort angelangt, verläßt es
> Nimmermehr — denn dieses Land
> Ist das wahre Bimini.

6. Das Pathos der Idee.

Nachdem wir die unauflöslichen Antinomien in Heines Lebensprogramm und die Zersetzung der Ideensubstanz aufgezeigt haben,
erhebt sich die Frage: Was ist an Heines Streben wahrhaft produktiv?
Warum vermögen seine Freiheitsreden trotz des Mangels an positivem
Gehalt noch heute zu wärmen und zu zünden? Die Antwort ergibt
sich, wenn man Heines Wirken alles Zufälligen und Zeitlichen entkleidet und aus dem widerspruchsvollen Inhalt seines Programms
den Kern herausschält: was sich dann ergibt, ist die Forderung der
Bewegungsfreiheit, das Verlangen nach dem vollen Ausleben der
Persönlichkeit, nach ungehemmter Entfaltung der sinnlichen und geistigen
Anlagen. Es ist das dynamische Element in Heines Wirken, das
ihm die Fortdauer sichert, die Intensität seines Freiheitsdranges, das
Pathos, das seinen Vortrag durchzittert. Freilich ist es ein „Streben
ins Unbedingte", wie Goethe das Gebaren des Enkelgeschlechts nannte,
aber es bleibt ein Streben nach idealen Zielen, ein Kämpfen, das aus
der Erhabenheit der Aufgabe immer neue Begeisterung schöpft. Eine
Kämpfernatur, ein „Fordernder" war Heine seinem innersten Wesen
nach; stilles, stetiges Schaffen im selbstgezogenen beschränkten Kreise war
nicht seine Sache. „Der Kampf war seine Natur und die Negation
sein Wesen" — so charakterisiert ihn mit Recht sein Freund Meißner.

Das dynamische Element in der Idee ist es auch, das Heine
vor allem verehrt, denn die Idee, wie an anderer Stelle (oben S. 126)
ausgeführt, gilt ihm als geistige Potenz, als tatenzeugender Gedanke.
Geist sehnt sich nach Geist: wo immer Heine eine geistige Kraft
fühlt, wo ein schöpferisches Genie sich in Taten entladet, da senkt er
die Waffen der Kritik und zollt uneingeschränkte Bewunderung. „Das
ist ja eben die Kraft der Kraft, daß sie uns unmittelbar zur Bewunderung hinreißt, ohne daß wir erst rechten über ihre Anwendung.
So geschieht es, daß in unseren Tagen Napoleon Bonaparte von
einem Demokraten ... gepriesen wird" (3, 652). Sein Napoleonkultus, auf den Heine an dieser Stelle anspielt, erklärt sich zur
Genüge aus dem ehrfürchtigen Staunen, mit dem ihn jedes Walten
einer dämonischen Kraft erfüllt, sei es ein erhabenes Naturschauspiel
oder die Kraftentfaltung eines Titanen des Geistes. In diesem Punkte
begegnet sich Heine mit Goethe, dessen Bewunderung des großen
Welteroberers gleichfalls mit seiner dynamischen Grundanschauung
zusammenhängt. „Was ist Genie anders als jene produktive Kraft,
wodurch Taten entstehen, die vor Gott und der Natur sich zeigen
können, und die eben deswegen Folge haben und von Dauer sind?"[1]

[1] Gespräche, siehe Biedermann 6, 274. Vgl. ferner die vortreffliche Arbeit
von A. Fischer, Goethe und Napoleon. Frauenfeld 1900, S. 12 ff., 160 ff.

Und wie sich Heine als Zuschauer von der siegenden Gewalt
der Idee hingerissen fühlt, so umgibt er sich selbst mit dem Glorien-
schein der eminenten Persönlichkeit und sogar des Märtyrers, wo er
als Repräsentant der Idee auftritt. Dort schwelgt er in der
Dynamik, hier im Pathos der Idee. Nicht als Führer einer bestimmten
Partei wollte Heine gelten, sondern als Herold der Idee, und wenn
er zum Kampfe aufruft, so geschieht es durch rauschende Fanfaren
und Siegeslieder. Diese pathetische Geberde, die Pose des heroischen
Affekts, die auch Byron und Musset gern annehmen, erscheint bei
Heine verkörpert in der Gestalt des „Ritters vom heiligen Geist".
Der Ausdruck springt scheinbar ganz spontan in der „Bergidylle"
hervor, als treibe der Dichter, wie auch sonst gelegentlich (vgl. 7, 58),
mit jenem Symbol der christlichen Religion sein loses Spiel. Auf
die Gretchenfrage der Bergmannstochter versichert ihr der Dichter
eifrig, daß er sowohl an den Vater, wie den Sohn, und ganz von
Herzen an den heiligen Geist glaube.

> Dieser tat die größten Wunder,
> Und viel größre tut er noch;
> Er zerbrach die Zwingherrnburgen,
> Und zerbrach des Knechtes Joch.

> Alle Todeswunden heilt er,
> Und erneut das alte Recht:
> Alle Menschen, gleichgeboren,
> Sind ein adliges Geschlecht.

Tausend Ritter hat der heilige Geist erwählt, seinen Willen zu er-
füllen, und zu ihrer Schar gehört der Dichter selbst:

> Nun, so schau mich an, mein Kindchen,
> Küsse mich, und schaue dreist;
> Denn ich selber bin ein solcher
> Ritter von dem heil'gen Geist.

Worauf Heine mit dieser kühnen Umdeutung des christlichen
Dogmenbegriffs zielt, erhellt aus dem Gang der bisherigen Unter-
suchungen: der heilige Geist ist nichts anderes als die heilige Sache
der neuen Freiheitsreligion, die „Idee", in deren Dienst sich der
Ritter stellt[1]. Diese Definition bedarf jedoch einer genaueren Be-

[1] Über die nicht allzuhäufige Verwendung dieses Ausdrucks im nicht-
kirchlichen Sinne belehrt Hildebrands unausschöpfbare Abhandlung: „Geist" im
Deutschen Wörterbuch. Auch Goethe ist hier vertreten, und zwar denkt er bei
den Ausdrücken „heiliger Geist", „der Gesalbte Gottes", „Geist und Salbung",
„heilige Geisteskraft" zunächst an das schöpferische Prinzip, das Göttliche, das
sich in der Natur, wie im Wirken des Genies offenbart. Wenn er Frau von
Stein einmal anredet: „die du manchmal wähnst, der heilige Geist des Lebens
habe dich verlassen" — so ergibt sich die Bedeutung „Lebensfreude, Harmonie

stimmung, um die Prägnanz des Ausdruckes in schärferes Licht zu
rücken. Das Wort „Geist" hat bei Heine und seinen Anhängern
nicht selten eine ganz individuelle Färbung, die aus dem Glauben
an die treibende Kraft der geistigen Potenzen oder Ideen hervorgeht;
„Geist" bedeutet also so viel wie „Geist des Fortschritts". Für
diese kulturphilosophische Umdeutung ist zunächst Hegel verantwortlich,
der das Geschehen als Entwicklung des Selbstbewußtseins des Geistes
und die Freiheit als das wahrhafte Wesen des Geistes ansah. Wie
vollständig sich Heine in diese Vorstellung eingelebt hatte, zeigt eine
längere Betrachtung in der Schrift „Die Nordsee", in der Heine die
Gebundenheit primitiver Zeiten und Völker mit der „höheren Geistes-
würde" der neuen Zeit vergleicht. „Der Geist hat seine ewigen Rechte,
er läßt sich nicht eindämmen durch Satzungen und nicht einlullen
durch Glockengeläute; er zerbrach seinen Kerker und zerriß das eiserne
Gängelband, woran ihn die Mutterkirche leitete, und er jagte im
Befreiungstaumel über die ganze Erde, erstieg die höchsten Gipfel
der Berge, jauchzte vor Übermut, gedachte wieder uralter Zweifel,
grübelte über die Wunder des Tages und zählte die Sterne der
Nacht" (8, 92)[1].

Von großer Bedeutung ist ferner der Gedanke des Zusammen-
schlusses aller Gleichgesinnten, eine dem deutschen Humanismus sehr
geläufige Vorstellung. Man braucht nur an Goethes „Weltbund"
und die „Gemeinschaft der Heiligen" oder an Herders „Zerstreute,
unsichtbare Kirche" zu denken. Am großartigsten führte später Gutzkow
diese Idee in seinem Roman „Die Ritter vom Geist" aus, indem er
alle freien Geister zu einem Bündnis aufrief zum Zwecke der sozialen
Wiedergeburt der Nation. Bei Heine fehlt es auch in diesem Falle
bezeichnenderweise an positiven oder klar ausgearbeiteten Theorien:
um so intensiver wirkt das Pathos, mit dem die neue „Geister-

der Seele" aus einem der nächsten Briefe, in welchem Goethe schreibt: „Wenn
ich nur den tiefen Unglauben Ihrer Seele an sich selbst begreifen könnte, Ihrer
Seele, an die Tausende glauben sollten, um selig zu werden" (Briefe, siehe
Fielitz 1, 28 f.). — Bei Heine gewinnt der Ausdruck eine politisch-soziale
Färbung, und so spiegelt sich auch in diesem Bedeutungswandel der Unterschied
der beiden Zeitalter.

[1]) Die prägnante Bedeutung des Wortes „Geist" läßt sich besonders in
Wienbargs „Ästhetischen Feldzügen" verfolgen — einer Schrift, die mit schwerem
wissenschaftlichen Geschütz die gleichen Ideen verficht, für die Heine im lustigen
Turnier seine Lanzen bricht. Bei Wienbarg begegnet auch der Ausdruck „Heiliger
Geist" in der Heineschen Bedeutung; es heißt S. 30: „Alles was jung ist in
Deutschland, steht auf unserer Seite und lebt der frohen Hoffnung, daß auch
ohne Verjüngung mittelaltriger Formen eine Wiedergebärung der Nation, eine
poetische Umgestaltung e Lebens, eine Ergießung des heiligen Geistes, eine
freie, natürliche, zwanglose Entfaltung alles Göttlichen und Menschlichen in uns
möglich sei."

politik" auf den Schild erhoben wird: „Nicht mehr die gekrönten Häuptlinge, sondern die Völker selbst sind die Helden der neuern Zeit, auch diese Helden haben eine heilige Allianz geschlossen, sie halten zusammen, wo es gilt, für das gemeinsame Recht, für das Völkerrecht der religiösen und politischen Freiheit; sie sind verbunden durch die Idee, sie haben sie beschworen und dafür geblutet, ja sie sind selbst zur Idee geworden — und deshalb zuckt es gleich schmerzhaft durch alle Völkerherzen, wenn irgendwo, sei es auch im äußersten Winkel der Erde, die Idee beleidigt wird" (3, 490). — So kollektivistisch denkt Heine allerdings nicht immer; er bleibt im Herzen Aristokrat, und sein Bund der „Ritter vom heiligen Geiste" vereinigt die eminenten Persönlichkeiten, die über die Schranken von Zeit und Raum hinweg sich die Hand reichen, „und solchermaßen, in einer mystischen Gemeinschaft, leben die großen Männer aller Zeiten: über die Jahrtausende hinweg nicken sie einander zu und sehen sich an bedeutungsvoll, und ihre Blicke begegnen sich auf den Gräbern untergegangener Geschlechter, die sich zwischen sie gedrängt hatten, und sie verstehen sich und haben sich lieb" (3, 113).

Daß endlich die Sache der Geistesfreiheit als eine „heilige" bezeichnet wird, ist mit der umfassenderen Bedeutung dieses Wortes ohne weiteres vereinbar. Tatsächlich aber handelt es sich bei Heine nicht selten um eine gleichnisartige Verwendung des Wortes im engeren kirchlichen Sinne, indem ihm die große Sache der Völkerbefreiung zu einer wahrhaften Religion wird. Man kann diese Identifizierung in dem Kapitel „Die Befreiung" aus den Englischen Fragmenten deutlich verfolgen; es heißt daselbst: „Nicht bloß die Helden der Revolution und die Revolution selbst, sondern sogar unser ganzes Zeitalter hat man verleumdet, die ganze Liturgie unserer heiligsten Ideen hat man parodiert mit unerhörtem Frevel ... Heuchlerische Duckmäuser wagen es, ein Zeitalter zu lästern, das vielleicht das heiligste ist von allen seinen Vorgängern und Nachfolgern, ein Messias unter den Jahrhunderten." Gleichviel, wie man die Helden der Revolution lächerlich zu machen und zu schwärzen versucht hat, sie werden einst „um so enthusiastischer verehrt werden in der heiligen Genovevakirche der Freiheit" (3, 499 f.). — Solche und ähnliche Stellen beweisen, daß es sich bei der heiligen Geisterschaft Heines um eine jener Identitäts-Metaphern handelt, die für seine dichterische Konzeption so charakteristisch sind. Durch den St. Simonismus wurde Heine natürlich in dieser Auffassung der religiösen Gemeinschaft aller freien Geister noch bestärkt.

So laufen in der Wendung: „Ritter vom heiligen Geiste", wie in dem Knotenpunkte eines vielverschlungenen Gedankengewebes, zahlreiche Fäden zusammen. Der Ausdruck selbst scheint nur ein einziges

Mal in seiner vollständigen Gestalt wiederzukehren, in einem 1827 geschriebenen Briefe, in welchem Heine die Zumutung, ein schlechtes, lukratives Buch zu schreiben, mit den Worten zurückweist: „Ich bin der Ritter vom heiligen Geist" (Br. 20, 27). Nahe kommt es, wenn die großen Männer als „Repräsentanten des heiligen Geistes" bezeichnet werden, die uns „heilige Schauer" einflößen (Br. 21, 118). Häufiger hören wir von dem „Heiligen Geist" selbst und seinem Wirken, in der gleichen mannigfachen Bedeutungsschattierung, die das Wort „Idee" aufweist[1]). Wie eine Paraphrase der oben zitierten Verse von der Macht des Heiligen Geistes klingt die folgende Stelle aus den „Englischen Fragmenten", in der die kollektiv-soziale Färbung vorherrscht: „Erst zur Zeit der Reformation wurde ... die Freiheit verlangt nicht als ein hergebrachtes, sondern als ein ursprüngliches, nicht als ein erworbenes, sondern als ein angeborenes Recht ... Noch heutigen Tags, in Franken und Schwaben, schauen wir die Spuren dieser Gleichheitslehre, und eine grauenhafte Ehrfurcht vor dem Heiligen Geiste überschleicht den Wanderer, wenn er im Mondschein die dunkeln Burgtrümmer sieht aus der Zeit des Bauernkriegs" (3, 496). Aus der gleichen Grundstimmung erwächst Heines Zorn gegen den Abfall Laubes von der Sache der Freiheitsreligion; er schreibt am 12. Oktober 1850: „Du hast ein Verbrechen an dem heiligen Geist begangen ..."

Mit der Erweiterung des Lebensprogrammes in der ersten Pariser Zeit nimmt auch der Ausdruck „Heiliger Geist" eine philosophisch-ästhetische Färbung an. Das Glaubensbekenntnis des Pantheisten lautet: „Gott ist sowohl Materie wie Geist, beides ist gleich göttlich, und wer die heilige Materie beleidigt, ist ebenso sündhaft wie der, welcher sündigt gegen den Heiligen Geist" (4, 219). Die Religion der Freude erkennt Heine in dem kräftigen Realismus der niederländischen Kunst, besonders in den Werken Jan Steens. „Keine Nachtigall wird je so heiter und jubelnd singen, wie Jan Steen gemalt hat. Keiner hat so tief wie er begriffen, daß auf dieser Erde ewig Kirmes sein sollte; er begriff, daß unser Leben nur ein farbiger Kuß Gottes sei, und er wußte, daß der Heilige Geist sich am herrlichsten offenbart im Licht und Lachen" (4, 128).

Die Heinesche Pose des Ritters vom heiligen Geist, in der sich die ganze Gefühlsintensität des Dichters ausspricht, hat noch ein weiteres sehr charakteristisches Merkmal: das Pathos des Marty-

[1]) Ganz vereinzelt steht der Fall, daß Heine die Idee des weltfeindlichen Spiritualismus als „heilige Geistpflanze" bezeichnet (7, 47). Hier wäre also die rein theologische Bedeutung des Wortes beibehalten.

riums, der Aufopferung für die Sache der neuen Religion: „Überall, wo ein großer Geist seinen Gedanken ausspricht, ist Golgatha" (4, 215). „Die Geschichte der großen Männer ist immer eine Märtyrerlegende; wenn sie auch nicht litten für die große Menschheit, so litten sie doch für ihre eigene Größe, für die große Art ihres Seins, das Unphilisterliche, für ihr Mißbehagen an der prunkenden Gemeinheit, der lächelnden Schlechtigkeit ihrer Umgebung" (4, 242). Diese Sätze drücken allgemein aus, was Heine mit Bezug auf die freiheitlichen Tendenzen des 19. Jahrhunderts besonders lebhaft empfand: das tragische Geschick, das alle Neuerer und Vorkämpfer der Idee erwartet, das die Apostel der neuen Religion zu Märtyrern stempelt. Und dieses Martyrium wird heutzutage nicht einmal von der Glorie der unerschütterlichen Siegesgewißheit umstrahlt, wie in so vielen anderen religiösen Bewegungen; an ihre Stelle tritt das Gefühl der Resignation, das Heine später fast ausschließlich beherrschte und sich gelegentlich schon früh geltend macht. Er schreibt 1828: „Das Wesen des Martyrtums, alles Irdische aufzuopfern für den himmlischen Spaß, ist noch immer dasselbe; aber es hat viel verloren von seiner innern Glaubensfreudigkeit, es wurde mehr ein resignierendes Ausdauern, ein beharrliches Überdulden, ein lebenslängliches Sterben, und da geschieht es sogar, daß in grauen kalten Stunden auch die heiligsten Märtyrer vom Zweifel beschlichen werden" (3, 421). Den einzigen Trost bei diesem Anblick einer wahrhaften „Schädelstätte des Geistes" gewährt die Zuversicht, „daß wenn auch im Befreiungskampfe der Menschheit der einzelne Kämpfer zugrunde geht, dennoch die große Sache am Ende siege" (7, 55) [1].

Heines Begriff des Martyriums erinnert an das Fichtesche Pathos der opferheischenden Idee, das den Vorträgen über „die Grundzüge des gegenwärtigen Zeitalters" solch nachhaltige Wirkung verlieh. Aber während jene Forderung bei Fichte einem tiefernsten Bedürfnis nach sittlicher Vertiefung entsprang, erscheint Heine eher als Künstler und Rhapsode. Er genießt als Ästhet das erhabene Schauspiel des Martyriums und berauscht sich in dem Pathos eines opferfreudigen Heldentums. Er ist so hingerissen von der Gewalt dieser Empfindungen, daß er sich wie Robespierre als Sklave der Freiheit fühlt. „Wir ergreifen keine Idee, sondern die

[1] Diese Resignation, die in der Aufopferung für die Idee einen Ersatz sucht für den Mangel an einem gesunden politischen Leben, kennzeichnet das ganze Zeitalter der Reaktion. Man vergleiche mit dem obigen Ausspruch Heines z. B. die Erklärung des Journalisten Bolz in Freytags Lustspiel: „Wenn Konrad Bolz, das Weizenkorn, in der großen Mühle zermahlen ist, so fallen andere Körner auf die Steine, bis das Mehl fertig ist, aus welchem vielleicht die Zukunft ein gutes Brot bäckt zum Besten vieler."

Idee ergreift uns und knechtet uns und peitscht uns in die Arena hinein, daß wir, wie gezwungene Gladiatoren, für sie kämpfen. So ist es mit jedem echten Tribunat oder Apostolat" (4, 14). Heine mag wohl an sich selbst gedacht haben, wenn er A. Weill, den Verfasser einiger radikaler Flugschriften, mit einem Reiter vergleicht, „der die Unbehagnisse und Ekeltümer unserer heutigen Weltordnung nicht mehr zu ertragen weiß und hinausgaloppiert in die Zukunft, auf dem Rücken einer Idee ... Ja, solche Menschen sind nicht allein die Träger einer Idee, sondern sie werden selbst davon getragen, und zwar als gezwungene Reiter ohne Sattel und Zügel: sie sind gleichsam mit ihrem nackten Leibe festgebunden an die Idee, wie Mazeppa an seinem wilden Rosse auf den bekannten Bildern des Horaz Vernet — sie werden davon fortgeschleift durch alle fürchterliche Konsequenzen, durch alle Steppen und Einöden, über Stock und Stein ..." (7, 375). Gern legt sich Heine auch die Gestalt des Don Quichotte, die seine Phantasie so vielfach beschäftigte, als Repräsentanten aller Menschen aus, „die für irgend eine Idee kämpfen und leiden" (7, 291; vgl. 3, 422).

Besonders charakteristisch für den Ideenkultus des jungen Heine ist die kühle Souveränität, mit der er nach seinem denkwürdigen Besuch bei Goethe über den größten seiner Zeitgenossen urteilt. „Im Grunde sind ich und Goethe zwei Naturen, die sich in ihrer Heterogenität abstoßen müssen. Er ist von Haus aus ein leichter Lebemensch, dem der Lebensgenuß das Höchste, und der das Leben für und in der Idee wohl zuweilen fühlt und ahnt, ... aber nie tief begriffen und noch weniger gelebt hat. Ich hingegen bin von Haus aus ein Schwärmer, das heißt bis zur Aufopferung begeistert für die Idee, und immer gedrängt, in dieselbe mich zu versenken; dagegen aber habe ich den Lebensgenuß begriffen und Gefallen daran gefunden, und nun ist in mir der große Kampf zwischen meiner klaren Vernünftigkeit, die den Lebensgenuß billigt und alle aufopfernde Begeisterung als etwas Törichtes ablehnt, und zwischen meiner schwärmerischen Neigung, die oft unversehens aufschießt und mich gewaltsam ergreift, und mich vielleicht einst wieder in ihr uraltes Reich hinabzieht, — wenn es nicht besser ist zu sagen: hinaufzieht; denn es ist noch die große Frage, ob der Schwärmer, der selbst sein Leben für die Idee hingibt, nicht in einem Momente mehr und glücklicher lebt, als Herr von Goethe während seines ganzen sechsundsiebzigjährigen egoistisch behaglichen Lebens" (Br. 19, 290) [1]. —

[1] Ähnlich drückt sich Heine in einem Brief an R. Christiani aus, den Elster vor einigen Jahren in der Deutschen Rundschau (Band 107, 447) veröffentlicht und trefflich kommentiert hat. — Erwähnung verdient in diesem Zusammenhang ein gleich einseitiges Urteil Fr. Joh. Frommanns über Goethe

Daß dieses Verdikt sich nicht gegen den Dichter und die Persönlich-
keit richtet, erhellt sogleich, wenn man anderweitige Äußerungen Heines
über Goethe heranzieht, in denen die alles überragende Bedeutung
des Mannes als etwas Selbstverständliches vorausgesetzt wird. Als
Herold der Emanzipation dagegen kann Heine nicht umhin, in Goethe
einen Hauptvertreter jener „Kunstidee" des 18. Jahrhunderts zu
erblicken, die das 19. Jahrhundert, wenn nicht zu überwinden doch
zu berichtigen hatte. Der hierdurch aufgerollte Gegensatz ist freilich
viel unversöhnlicher, als Heine ahnt, der wie alle seine Kampfes-
genossen Goethe gegenüber zum Doktrinär wird und die geschichtliche
Perspektive ganz aus den Augen verliert. Er hätte sich sonst damit
begnügt, den Weimaraner als Typus einer ganz anders fundierten
Weltanschauung und Denkrichtung verstehen zu lernen, und hätte von
einem, der an stetige Entwicklung und organische Umbildung glaubte,
nicht Enthusiasmus für revolutionäre Ideen verlangt.

Besonders erheiternd aber wirkt es, Goethe eines „behaglichen
Egoismus" angeschuldigt zu sehen, wenn man sich das Leben beider
Männer vergegenwärtigt, das fürwahr einen sprechenden Kommentar
zu ihren Lehren bietet. Auf der einen Seite gänzlicher Mangel an
Begeisterung für soziale und politische Ideale, vereinigt mit prakti-
schem Eingreifen und aufopferndem Wirken im Dienste eines kleinen
Staates. Auf der anderen Seite ein edler Enthusiasmus für die
großen, treibenden Ideen der Zeit bei vollständigem Mangel an
praktischer Erfahrung und Tätigkeit. Beide bekennen sich zum Helle-
nismus, aber Goethe zum apollinischen, Heine zum dionysischen.
Dort ein prometheischer Drang, der sich selbst Schranken setzt, der
vom Genießen zum Handeln fortschreitet und sich für den Mangel
an nationalen Aufgaben durch Kulturideale, durch innere Freiheit
entschädigt, — hier ein schrankenloses Begehren, ein intensives Sich-
ausleben und ein Verlangen nach absoluter Freiheit[1]). Auch für
Goethe ist das Leben eine Entfaltung des organischen Bildungs-
triebes, aber zugleich eine Lösung selbstgestellter Aufgaben. — Heines

aus dem Jahre 1818; es deckt sich genau mit Heines Äußerung und zeigt, wie
die meisten seiner Zeitgenossen damals über Goethe dachten. Frommann schreibt:
„Er kennt die Menschen nur, wie er die Pflanze kennt. Er kann alles beschreiben,
nur nicht die Begeisterung für eine Idee, den Willen, der Hölle und Teufel
trotzt, die Heldengeduld, die für das Wahre und Rechte alles leidet mit Freude
und Liebe" (Goethe-Jahrbuch 8, 249).

[1]) Bedenklich ist es daher, Heine direkt als Nachfolger und Fortsetzer
Goethes hinzustellen, wie es Matthew Arnold in seinem Essai über Heine
mit großem Nachdruck getan hat. Heine äußert allerdings einmal als Göttinger
Student den Wunsch: „Wie gerne möcht ich den Goetheschen Befreiungskrieg
mitmachen als freiwilliger Jäger," — und der Olympier hätte an manchen
Attacken Heines gegen Philistertum und geistige Beschränktheit sicher seine Freude

Philosophie lautet: „Das Leben ist weder Zweck noch Mittel; das Leben ist ein Recht. Das Leben will dieses Recht geltend machen gegen den erstarrenden Tod, gegen die Vergangenheit, und dieses Geltendmachen ist die Revolution" (7, 296). So stehen sich die beiden Männer als Repräsentanten zweier Zeitalter und Temperamente gegenüber, und es bewahrheitet sich an ihnen wenigstens teilweise der ebenso bündige wie tiefe Ausspruch des Weisen von Weimar: „Vor der Revolution war alles Bestreben, nachher verwandelte sich alles in Forderung."

————

Die übermütig sprudelnde Bergidylle ist ein treuer Spiegel Heineschen Heldentums, dieser Mischung von begeistertem Opfermut und eitler Selbstvergötterung. Und Heine war nicht so naiv, daß er den Widerspruch zwischen seinen Worten und Taten nicht selbst empfunden hätte. Wenn er sich als Märtyrer der Idee fühlte, so schmauste er gleichwohl von reichbesetzten Tafeln, und das Lächerliche dieser Situation entging ihm keineswegs. Aber er hatte früh bemerkt, daß Welt und Leben voll solcher Widersprüche seien, und daß echte Begeisterung, auch wenn prosaische Naturen gern persönliche Eitelkeit und vorübergehende Gefühlsaufwallung darin erblickten, dennoch einen erhabenen Zweck zu erfüllen habe. „Die kühlen und klugen Philosophen! Wie mitleidig lächeln sie herab auf die Selbstquälereien und Wahnsinnigkeiten eines armen Don Quichotte, und in all ihrer Schulweisheit merken sie nicht, daß jene Donquichotterie dennoch das Preisenswerteste des Lebens, ja das Leben selbst ist, und daß diese Donquichotterie die ganze Welt mit allem, was darauf philosophiert, musiziert, ackert und gähnt, zu kühnerem Schwunge beflügelt! Denn die große Volksmasse mitsamt den Philosophen ist ... nichts anders als ein kolossaler Sancho Pansa, der ... dem wahnsinnigen Ritter in allen seinen gefährlichen Abenteuern folgt, gelockt von der versprochenen Belohnung, ... mehr aber noch getrieben von der mystischen Gewalt, die der Enthusiasmus immer ausübt auf den großen Haufen ..." (3, 422).

In der Tat hat das ästhetische Gefallen an der flammenden Rede und pathetischen Gebärde oft größeren Anteil an der Verwirklichung großer Ideen, als der Rationalist zugeben möchte. So ist auch das Lebenswerk Heines, des „Fordernden", zu beurteilen. Es war seinem Temperament unmöglich, den Lebensgenuß der Idee

gehabt. Aber ihre Kampfesmethoden und Ziele gingen doch weit auseinander, und vor allem ist der wichtige Unterschied nicht zu übersehen, daß es sich bei Goethe um innere Freiheit, das heißt Selbstbeschränkung, bei Heine um äußere Freiheit und unbedingtes Streben handelt. Arnolds geistreicher Aufsatz leidet beträchtlich unter jener falschen Parallele.

zu opfern, aber sein Wort hat doch in Tausenden das ästhetische Gefallen an der „schönen Tat" erweckt und sich dadurch sein Fortleben gesichert. „Und was verlangt ihr mehr von einem Dichter? Wir sind alle Menschen, wir steigen ins Grab und lassen zurück unser Wort, und wenn dieses seine Mission erfüllt hat, dann kehrt es zurück in die Brust Gottes, den Sammelplatz der Dichterworte, die Heimat aller Harmonie."

Ein Beitrag zu Adalbert Stifters Stil[1]).
Von Franz Hüller in Prag.
(Schluß.)

Eine dritte und vierte Gruppe von Epitheta stellt wenigstens ihrer allgemeinen Bewertung nach die Ähnlichkeit mit homerischer Ausdrucksweise dar: die Zusammensetzungen mit -reich und -voll. Auch sie nehmen jene steife, unbiegsame Haltung typischer Charakteristik an.

„Haidedorf", 198₇: „Es kam der blüthenreiche Frühling" — „Mappe", 298₂₀: „mein Vogelkirschbaum, der liebe, große, kronenreiche Baum," — „Nachsommer", II. 314: „den blätterreichen Bäumen" — ebda, III. 117: „die dornenreichen Brombeerreben" — „Abbias", 67₃₇: „ein dunkler, waldreicher Streifen der afrikanischen Küste" — „Erzählungen", 45: „eine sanftgeschwungene, grasreiche Wiese" — ebda, 14: „darauf das Korn so klein und mehlreich wurde" — „Nachsommer", III. 112: „in dem schwülen und gewitterreichen Dunstkreise der Monate Juni oder Juli" — „Nachsommer", III. 145: „das fensterreiche Wirtshaus" — ebda, II. 4: „die Bretter (der Zither) .. könnten von keiner singreicheren Tanne sein." — „Abbias", zu „Abbias" : „dem bücherreichen Europa" — Textkrit. Anmert. 72₁₂₋₁₃ der „Narrenburg": „von der marmorreichen Fichtau" — „Erzählungen", 86: „weil (die Luft) .. noch anmuthiger und balsamreicher" — „Steine", 319₃₀: „die faltenreichen Wangen der Großmutter" — „Feldblumen", 152₁: „das klangreiche Lallen und Jauchzen der Sennerinnen" — ebda, 71₃: „ein phantasiereicher Greis" — „Haidedorf", 194₃₀: „... noch freudenreicher" — „Nachsommer", II. 85: „manche freudige und empfindungsreiche Stunde" — „Haidedorf", 182₃₃: „Ihre gemüthreiche Tochter" — „Schwestern", 231₂₀: „noch zarter und gemüthsreicher als sonst" — „Waldsteig", 7₄: „wenn die Sonne ganz besonders heiß und strahlenreich schien" — „Feldblumen", 150₅: „der Mittag sank blendend und stumm und strahlenreich in die brennenden Steine" — ebda, 112₃₀: „eine strahlenreiche Jungfrau" — „anmuthsreich", „Hochwald", 229₂₁ — „ahnungsreich", „Hochwald", 306₇ — „Feldblumen", 103₄, — „Narrenburg", 33₁₆ —

Auch hierfür bietet Vossens Homer recht seltsame, auffällige Formen:

[1]) Vgl. oben S. 186 ff.

OLD ENGLISH Ċ, ĊĠ, &c. [1]

It was formerly [2]) supposed that OE. pala
palatal *g* in *ċġ* and *nġ* were still true palatal st
and *g* of *kill* and *give* as distinguished from the
of *cool* and *good*, and this pronunciation is allow
to-day even in some good institutions of learning.
(in his Anglo-Saxon Primer &c.) taught that these
were equivalent to *kj* and *gj* as in the dialectic pr
sky and *garden*. In the sixth edition of his Rea
of them as a *k* or *t* and a *g* or *d* formed in the
(that is, *y* in *ye*) and adds that they closely r
ch and *dg* respectively. Sweet's position is thus
on the one hand, he appears to hold on to th
and stop *ġ* are simple palatal stops, but by re

[1]) This paper was written in the spring of 1898 and
ready for the printer, when (in October) I came across Bülb
articles in the July-August number of the Beiblatt. I
references to a few of the points where we touch one an
added a reference or two to Sievers [a], which I had not re
article was written.

[2]) Bright still occupies practically this position. He
his Introduction to his Reader, 1894): "*c* has always the
This *k*-sound has a guttural or a palatal quality (somewh
cold, and *kind*), according to its pronunciation with gu
vowels". [Cf. the same in Baskervill & Harrison's rece
Reader, p. 4.] Bright is unfortunate in the choice of *kind*
of the palatal consonant, for in normal English *kind* is ph
and the *k* is velar. Possibly Bright was thinking
Moreover, he inconsistendly accepts (though evidently with
the affricate pronunciation for *ċġ*: "The combination *c*
geminated *g*) may be pronounced as *dg* in English *ridge*".

similarity to modern *ch* and *dg*, he implies some sort of affricate pronunciation.

Sievers early assumed an advanced position on this subject. In the second edition of his grammar (§ 206 A 3) he said: "Dass das echt palatale *c*, *cc* bereits im ags. eine dem heutigen engl. *ch* ähnliche aussprache hatte, lehren die formen *orceard* [< *ort-geard*], *feccean* [< *fet-jan*], etc. § 196, 3"; and (§ 216 A 3): "Aus *dg* ist entstanden das *cg* des erst ziemlich spät belegten *micgern* fett, für **midgern*, ahd. *mittigarni*. Dieser übergang setzt für seine zeit eine aussprache des *cg* als *dž* voraus, vgl. § 210, [4]." This position he defended in Anglia XIII, 311 &c. by a line of reasoning that it would be difficult to break.

There is no question in my mind that the development[1]) was along a line in which the chief stages may be marked as: —

velar	stop	*c*	*g*
palatal	„	*ċ*	*ġ*
„	affricate	*čh*	*ǧj*
dental[2])	„	*tš*	*dž*

[1]) This full development applies only to cases in which the consonant was preceded by an originally palatal vowel or one palatalized by *i*-mutation, or by no other sound at all, — and followed by a palatal vowel or no other sound (Kluge, Paul's *Grundriss* I 836). (a) When preceded by a palatal vowel but followed by a velar vowel, the consonant was only partly palatalized & so did not pass on to a front affricate at all. In this case, in all probability, the closure for the stop consonant was palatal and the opening velar; similarly as in such a word as *act*, most speakers make the closure for *k* and, rolling the upper surface of the tongue to the position for *t*, make the opening there. (b) In cases of syncope like *þync(e)ð*, *sæc(e)ð*, the *ċ* had not become affricated when the following *e* fell out, or, if it had, the fricative disappeared with the vowel; this is shown by ME. *þinkþ*, *sekþ*, &c. In Modern English the 2d and 3d sing. with *k* has generally prevailed (just as in *I say | he says*) : thus, *I think* and *seek | he thinks* and *seeks*; in *beseech* the *ch* of the first person sing. has prevailed because that form of the verb was most frequently used. [Bülbring has now shown (Anglia, Beiblatt, July 1898, p. 102) that this is also true in cases like *eó(e)nes*, *eknesse*.]

[2]) In the third edition of his grammar (§ 216, 3, &c.) Sievers speaks of the "palatalen affricata (*dž*)"; of course, there are many stages in the development *ġ > dž*, *ċ > tš*, but when we recognize *d*, we can no longer speak of a "palatal". Cf. Sievers' *Phonetik* § 154: "Es ist besonders darauf zu achten, dass wir unter dem Namen Palatalen nicht auch die zusammengesetzten *tsch*-Laute begreifen, die man vielfach mit diesem Namen bezeichnet."

The *ħ* = *ch* in German *ich*. The *c* and *ċ* would probably be more correctly written *ch* and *ċh*, that is, as aspirated stops.

Now, the question is: When were these various stages reached? We know that the palatalization of *c* > *ċ* and *g* > *ġ* took place early, in fact, on the continent, cf. Kluge, Paul's *Grundriss* ² I, p. 992. The palatal-affricate stage is clearly shown by the spelling of the Epinal Gloss, which is assigned to the seventh century. For original *gg* the Epinal Gloss has *gg* : *mygg* 916, *segg* 463, *ilugsegg* 781. This could represent (1) the geminated palatal stop, that is, *ġġ*, or (2) the palatal affricate, that is, *ġġ*, *g* being the usual spelling for *j*. That we have to do with the palatal affricate is, however, made certain by the spelling of the fronted *ng*. If this were still *n* + the palatal stop *ġ*, we should have only the spelling *ng*; we find, however, both *ng* and *ngi* : for example, *gimængdæ* 543, *mengio* 659, (*gimængiungiæ* 203, a mistake for) *gimængiungæ* as shown by the corresponding *gemengiungæ* of the Erfurt Gloss and the *gemengiunge* of the Corpus. This *ngi* undoubtedly spells *nġj*. As we shall see directly that the ~~dent~~ affricate stage was attained in the latter half of the seventh century, it is clear that the Epinal Gloss represents a late point in the palatal-affricate stage, which must then have begun in the sixth century, if not earlier.

That the dental-affricate stage was reached in Old-English times, is shown by the ninth-century forms *gefeccan* = *gefetjan*, *orceard* = *ort-geard*, and the later *wicca* = *wit-ga* = *witega*, *cræfca* = *cræft-ga* = *cræftega*, *Muncgiu* = *Muntgiof* = *Montem Jovis*, and by *micgern* = **mid-gern*. It is my purpose to show that there is good reason to believe that these spellings are not the first evidence of dental affricates and that the dental-affricate stage was reached before 700 A. D. My argument is based on the use of *c* for *g* or in connection with *g*. This use of *c* has usually been explained as a sign of the palatal quality of the *gg*. I shall show that this is a mistake and that the occurrence of the *c* is, instead, an indication of the presence of the affricate. [1])

¹) In the new edition of his grammar Sievers indicates that he suspects this: "Für altes *ngi* und *ngj* schreiben manche jüngere texte, die altes *ng*

If *c* was employed as a sign of the palatal quality of *g*,
it is strange that we do not find it so used until several
hundred years after the palatalization took place, but observe
it coming into use at a time when we may look for the
affricate.

Secondly, if *c* was a sign of palatal quality, we are
justified in wondering why it was used to show this only in
the case of those palatal *g*'s that became affricates. There
was far more need of a palatal sign in the case of the palatal
fricative *g* (= *j*) as distinguished from the velar fricative *g*
(= *γ*). If it be urged that *c*, being itself a stop, could in-
dicate the palatal quality of a stop only, it must have been
to distinguish the palatal stop from the velar stop. But this
latter sound is, except in the combination *ng*) of so very rare
occurrence, that it would be unreasonable to suppose that the
use of *cg* &c. was due to a desire to avoid the danger of
confusion with it.

Thirdly, *c* was itself a symbol not only for the palatal *c*
but also for the velar *c*, or *k*, and so had no special call to
be regarded as preëminently fitted to stand as a sign for
palatal quality. Had it been so regarded, we should expect
that when *k* came to displace *c* before secondary palatal
vowels as a sign for the velar [1]) stop (for example, *cyning* >
kyning), it would have displaced it before back vowels as
well. We have a similar state of things in Modern English.
The letter *c* is often used for the dental sound *s* before front
vowels (*city, ounce*, &c.), and for the velar sound *k* before

im inlaut sonst regelmässig durch *ng* wiedergeben, öfter *ncg*. **Hier**
soll das *cg* vermutlich die palatale aussprache, und zwar eventuell schon
die aussprache als affricata (*dž*) ausdrücken", § 215 A 2.

[1]) Bülbring (Anglia, Beiblatt, Feb. 1899, p. 289) assigns to the *c* of
cyning &c. the value of a true palatal stop *č*. As the *k* in *king* &c. is
to-day only in the transition stage *č* > *čh*, I think it very unlikely that
it was already *č* in Old English. Or has Bülbring evidence that the velar
had become palatal before a vowel fronted by *i*-mutation? No such evidence
is furnished by the rune that consists of a *gar*-rune with a vertical shaft.
I am convinced that this rare character is no special rune at all: the
stone-cutter by mistake cut the voiced velar stop in place of the voiceless
one and then corrected it by inserting the vertical shaft of the *calc*-rune.
Vietor can vouch for but two cases of this peculiar character on the
Ruthwell cross and a possible one on the neighboring Bewcastle cross.

back vowel (*cook* &c.), and *k* is used for the *k*-sound heard before front vowels (*kill, keep,* &c.); but who would say that when *c* displaced *s* in *once* (older *ones*) it was because *c* was a sign of dental quality? It was used simply because of the likeness of the sounds represented by *s* and *c*.

Moreover, *g* was fully as often a palatal as *c* was, and so at least as good a symbol for the palatal quality, and in fact a better one for representing a v o i c e d palatal. If the language had been at the simple palatal stage, it would be ridiculous to suppose that a scribe who did not hesitate to use *g* as a symbol for both the palatal and the velar fricatives *j* and *γ*, as well as for the velar stop *g*, should feel it an imperfect symbol for the palatal stop.

But the whole idea that *c* was a diacritic of *g* is to be discarded. Its absurdity appears when we consider that *c* was also used (Sievers § 215) with or in place of *g* to represent the more or less unvoiced final velar stop, for example in *gecranc* Beowulf 1209, Byrht. 250 &c., and so rarely, also medially, *cruncon* Byrht. 302, whence there has been erroneously deduced a verb *crincan* as distinguished from *cringan*. In neither case was *c* a diacritic. We must be cautious in ascribing to writers the deliberate use of a letter as a diacritical sign. The closer we study the history of writing, the rarer do we find this. A scribe uses a letter because he hears a sound that is more or less like one that he is accustomed to spell with that letter. That is all there is to it. Thus *gg* had come to sound very much like one of the sounds for which *c* was the symbol, namely, the affricate *tš* and so *c* was used to represent it. In just the same way, when final velar *ng* gradually became more and more like *nc*, it was written *ngc, ncg,* or *nc.* Thus

$$ \left. \begin{array}{c} \text{the spelling} \\ cranc \text{ or } crancg \\ \text{for } crang \end{array} \right\} : \left\{ \begin{array}{c} \text{the spellings} \\ sencan \text{ or } sencgan \\ \text{for } sen\breve{g}an \\ \text{and } lencg \text{ for } len\breve{g} \end{array} \right\} : : boc : ic. $$

There was no design on the part of anyone and there was no diacritic system devised: each scribe simply strove as best he could to represent the sounds he heard by the letters he had learned.

When the language had, besides the velar fricative γ and the palatal fricative j, the stop consonants —

<div align="center">

velar c and palatal \dot{c}

„ g „ „ \dot{g}

</div>

corresponding to Modern-English

<div align="center">

coop and *kill*

good and *give*,

</div>

\dot{g} was much more like g than it was like \dot{c}, and that, too, whether the palatal sounds were pure, aspirated, or affricated. One needs but try it to be convinced. It would, therefore, be very strange if at that stage of the language, anyone had chosen c as a symbol (or part symbol) for \dot{g}. When, however, the language had, besides the velar fricative γ and the palatal fricative j,

<div align="center">

the velar stop c and the dental affricate $t\check{s}$,

„ „ „ g „ „ „ „ $d\check{z}$,

</div>

the voiced dental affricate $d\check{z}$ was much more like the voiceless dental affricate $t\check{s}$ than it was like any of the other sounds spelled with g. As the voiceless affricate arose out of all single palatal c's as well as out of $\dot{c}\dot{c}$, it was a much more common sign for an affricate than was g, which stood for an affricate only when palatal after n and when doubled. c was, therefore, the usual sign for a dental affricate, and it is not strange that it slipped from the pen when the writer heard the corresponding voiced affricate. The spelling c, cc, for the affricate \breve{g}, $\breve{g}\breve{g}$, was defective only in ignoring voice, a matter regularly ignored in Old-English writing in the case of all simple and geminated fricatives. But even this defect was usually avoided by the retention of one or both of the g's.

In brief, we must regard the rise of the spellings c, cg, cgg, gc, &c. as an indication that the language was at the time at the dental-affricate stage.

Let us now consider *when* these spellings for what had been $\dot{g}\dot{g}$ arose. As has been stated above, the seventh-century Epinal Gloss consistently uses gg. A charter of 692 or 693 has *egcbaldus*. [1]) As early as 737 (List of Kings, Ms. 1. of

[1]) The alleged Runic *Ecgfripu* (OET. p. 124) is shown by Vietor (*Die Northumbrischen Runensteine*, p. 16) to be untrustworthy.

Bede's History, the Corpus Gloss) [1]), *cg* was the usual spelling.
Variants are rare: Ms. 3 of Bede's History (? 750) has seven
c's and three *cg*'s (Ms. 2. has five *g*'s and two *cg*'s, but it is
in a continental hand), Charter 3/13 (778) has *egcbaldus*, 19/7
(798) *uuicggan*, 12/6 (799) *wigga*, 49/11 (805) *uuigga*, Genea-
logies 13 *sicgga* but eight *cg*'s, Charter 25/8 (843) *cadacahrygc*,
29/20 (862) *egcberht*, *hryg*. Of the early West-Saxon MSS.
those of the Cura Pastoralis alone show a considerable number
of variants: Hat. nineteen *cgg*'s, one *gcg*, six *gg*'s; Cot. eight
cgg's; Orosius three *cgg*'s. Considering, however, the greater
number of *cg*'s in these MSS., I cannot regard the variants as
necessarily intentional.

There are but few early records of words with *nǧ*. We
have seen (page 377) that the Epinal Gloss has *ng* and *ngi*.
Similar spellings occur in certain texts later: thus usually *ng*
in the Hatton Ms. of the Cura Pastoralis, and *nge* in the
Cotton Ms., and once *ngi* in the Hatton 85,23 *strengio*. But,
as in the case of the affricate that arose out of *gg*, the
spellings *ngc*, *ncg*, &c. early [2]) make their appearance. The
Parker Ms. of the Chronicle (755) has *þincgferþ* and *þincg-
ferþing*. The former appears as *ðingcferð* in a charter (33/9)
of 803. A charter of 825 has *gedincgo* 58/23. A charter of
832 has *þincg-gewrit* 40/25. The Codex Aureus inscription of
about 870 has *lencg* 7. The Hatton Ms. of the Cura Pasto-
ralis has *behrincgde* 163/16, and *gemencgde* 79/9. (In *gedyncðo*
411/25, *gedyncðum* 75/7, 81/23, the affricate has been unvoiced
by the *þ*, cf. *ofermetto* < *ofermedþo*; and the same is true of
the *nc* in *ðincfrið*, *ðincfri[ð]ing*, in the Genealogies 100, written
about 814.) Later texts need not be mentioned, observe

[1]) Corpus retains two of the *gg*'s of Epinal, changes three to *cg*, and
introduces three *cg*'s and one *cgg*.

[2]) I see that in the new edition of his Grammar Sievers recognizes this
spelling for *nǧ* ("Für altes *ngi* und *ngj* schreiben manche jüngere texte,
die altes *ng* im inlaut sonst regelmässig durch *ng* wiedergeben, öfter
ncg", &c. § 215 A 2). He is, however, in error in restricting the statement
to later texts, as will be seen from the citations above. The reason why
we find more of these spellings in later texts lies simply in the fact that
the literature is more abundant and the words in question occur more
frequently. This use of *ncg* &c. for *nǧ* must not be confused with the use
of *ncg* &c. to represent the more or less unvoiced velar *ng*, cf. page 379
above.

however *sencan* = *senǧan* Genesis 2906 (The Academy, London, April 21, 1894, p. 2706).

It is evident that there is a distinct change in spelling between the Epinal with its *gg*, *nǧi*, &c., and the subsequent literature with its *cg*, *ncg*, &c. Before usage settled down to *cg* as the symbol for *dǐ*, various similar spellings (*cgg*, *gc*, *c*, &c.) were employed in the effort to express the voiced dental affricate. We cannot be sure just how much earlier than 692 the spelling with *c* began, and hence the dental-affricate arose, but it is safe to say that it was in the latter half of the seventh century. In connection with this it is interesting to observe the conclusion at which Bülbring arrives.

The fact that even in comparatively late Old-English times the two *c*'s alliterated does not throw doubt on the argument that one was *k* and the other *tǐ*. The ancient poetry that was composed before the dental-affricate period, had rimes of this kind, but in reciting this poetry the bard, ignorant of the pronunciation of his ancestors, of course articulated the words with the pronunciation of his own day [Bülbring's cautious suggestion to the contrary (p. 103) does seem to me very "bedenklich"]. He was therefore familiar with such rimes as *k* : *tǐ* and did not hesitate to employ them in his own compositions. Similarly, but with even less justification — for the committing of older poetry to memory is rare to-day — our poets use, under the name of "rimes to the eye", what are now no rimes at all, for example, *war* : *car*, *none* : *bone*; *foot* : *boot*; &c., simply because they find these words associated in older English poetry and, ignorant of the pronunciation of the past, pronounce them, when reading this older poetry, just as they would in speaking. Nay, even such poets as Matthew Arnold rime other words that are spelled alike, for example, *home* : *come*, on the supposition that they are parallel to Pope's *none* : *bone* &c.

I cannot close this article without expressing my deep regret that Sievers did not find time to distinguish in the new edition of his Grammar (cf. § 206, 5) the various sounds represented by *c* and *g*, for example, *cuman* 'come', *ćin* 'chin', *finger* 'finger', *besęnǧan* 'singe', *ǧōd* 'good', *ǧiestrundæǧ* 'yesterday'. Sweet and Kluge (in his *Deutsches etymologisches*

Wörterbuch and in Kluge and Lutz's *English Etymology*) have
made a good start in this matter. I know that it is no easy
task, but it is far more difficult for each one of the thousands
of users of Sievers' Grammar than it would be for its author.
The inaccuracy and inconsistency now prevailing in Old-
English classes will never be removed until teacher and
learner have in their hands a reliable guide in this matter.
It is as important as the marking of the long vowels.
Compared with it, the use of the letters ę and ǫ is of little
consequence and the retention of the Old-English manuscript
forms of *w* and *g* is immaterial. Perhaps in the next edition
this task could, like the making of indexes, be assigned to
an able student.

UNIVERSITY OF MICHIGAN, ANN ARBOR, March 1899.

GEORGE HEMPL.

ZUR TEXTKRITIK DER SPIELE VON YORK.

1. Zu 1/3.

Im ersten der Yorker Spiele, welches die schöpfung und den fall der engel behandelt, beginnt der herr seine rede mit den worten:

> I am gracyus and grete, god withoutyn begynnyng,
> I am maker vnmade, all mighte es in me,
> I am lyfe and way vnto welth wynnyng,
> I am formaste and fyrste, als I byd sall it be.

Zum dritten vers bemerkt Holthausen Angl. XXI 443: 'Der rhythmus erfordert die einsetzung von *þe* vor *way* und von *þat is* nach *welth*'. Er will also lesen:

> I am lyfe and [þe] way vnto welth [þat is] wynnyng,

d. h. er hält es für notwendig, streng anapästischen rhythmus herzustellen. Seine besserung trifft besonders den zweiten halbvers, wo er an dem fehlen der senkung zwischen den hebungen anstoss genommen hat. Aber wenn auch die meisten verse dieses spiels in dem tonfall verlaufen, den Holthausen herstellen will, so ist er durchaus nicht alleinherrschend. Speziell fehlen der senkung findet sich auch sonst; so im zweiten halbvers:

> Ay with stedefaste steuen lat vs stánde still 75
> Lorde! to be fede with þe fode of thi fáyre fáce 76
> A! lorde, louid be thi name þat vs þis lighte lénte 121
> The nighte euen fro þe day, so þat thai méte néuer 154;

im ersten:

> And in þe fýrste fáythely, my thoghts to full-fyll 19
> Euen to myne áwne fýgure þis blys to fulfyl 140
> Aude in my fýrste mákyng to mustyr my mighte 145.

[Reprinted from the *Publications of the Modern Language Association of America*, Vol. XIV, No. 4.]

PEPPER, PICKLE, AND KIPPER.

When we find an English word beginning with *p*, we quite properly suspect it of being an adopted word—if not evidently imitative or of nursery origin. For early English words beginning with *p* there are two chief sources: Latin (including indirectly Greek) and Celtic. If the word appears only in England, it may *a priore* have come from either of these languages. If it is found both in England and on the continent, it is almost sure to have come from the Latin. *Pickle* appears both in England and in North Germany, Holland, etc., and we are therefore justified in suspecting a Latin origin for it. It also belongs to the category of words that we know to have been largely drawn from Italy. In the earliest days the Italian traders introduced *piper* 'pepper,' *vinum* 'wine,' *acetum* 'essig,' etc. Later the Germanic peoples owed much of the development of the culinary art among them to the Christian priests and monks from Italy. They were fond of good living, of spices and of sauces. They brought with them from the South seeds and plants, and they raised vegetables and herbs for the table and for the cure of the sick. It is, therefore, but natural that we should suppose that so artificial a product as pickles should have had a

449

similar source. These considerations and a knowledge of the
South-German use of *pfeffer* in senses similar to those of
pickle led me to associate *pickle* with *pepper*. One kind
of pickling suggested that *kipper* was only another form of
the same word.

The following are the important forms :—

OHG. *pfeffar.*

MHG. *pfeffer.*

NHG. *pfeffer, pfefferfisch, pfeffergurke,* etc., and, from Low
German, *pökel, pökelfleisch, pickelhering.*

MLG. *peper, pekel, pickel.*

MnLG. *peper, pekel, pickel, pekelhering,* etc.

MDu. *peper, pekel.*

MnDu. *peper, pekel, pekelharing,* etc.

OFrz. *piper.*

MnFrz. *peper, päper, pekel, päkel, pekelherink,* etc.

OE. *pipor, piper.*

ME. *piper, peper, pikil.*

MnE. *pepper, pickle, pickleherring,* etc., *kepper, kipper,
kippel.*

Icelandic *piparr, pœkill, saltpœkill* ' saltpetre.'

Sw. *peppar.*

Dan. *peber.*

The Latin word offered a temptation to dissimilate. We
find that this happened in the two chief ways that would be
most natural : (1) *pip- > pik-* ; (2) *pip- > kip-.* Cf. Skt.
pipīlá- > Pali *kipilla-,* Lat. *papilio >* Du. *pepel* and *kapel*
(in *capellenvogel*). Lat. *papȳrum >* OE. *tapor,* Eng. *taper,*
OF. *poupe* ' nipple,' ' breast ' *> pouque* ' bag,' Ger. *pumpe >*
Rhinefrankish *kumpe (gumbe),* Lat. *plēbānus >* Lith. *klebōnas,*
etc. Lat. *hippopotamus* became *ypotamus* in Middle English,
with loss of whole syllable (Brugmann², I, § 988); and children
now usually call it *hitapotamus.* Eng. *hickock* became *hicket*
and the proper names *Babcock* and *Bartlett* are often called,
even by the members of the families, *Babcot* and *Barklett.*
Cf. also Brugmann², I, p. 853. The dissimilated forms of the

word we have under consideration appear only in the North—in Low German, Dutch, Frizian, English, and Scandinavian.

In the Germanic forms the Latin suffix -er is sometimes exchanged with -el. Compare the same phenomenon in OHG. *amar* > MHG. *amer* and *amel*, OHG. *hadara* > MHG. *hader* and *hadel*, OHG. *zinseri* > MHG. *zinsel*, OHG. *panthera* > MHG. *panter* and *pantel*, and see Wilmanns[2], I, § 114. The *i* also interchanges with *e*, for which see Wilmanns[2], I, § 181, middle p. 235, and Morsbach's *Mittelenglische Grammatik*, §§ 113–115. For the ō of German *pökel*, see Wilmanns[2], I, § 230.[1]

The chief meanings of the words are as follows:[2]—

I. *pepper, pfeffer*, etc.

(1) (*a*) The fruit of the pepper plant, whether powdered or in the berry.

(*b*) The latter is also called *pepper-corn*, which word then assumes the general meaning of anything small or of small value, also the technical meaning 'a rent or other consideration that is only nominal.' The verb 'to *pepper*' also has acquired a general meaning: 'to pelt with kernels of any grain or with other small bodies.' (*English and German*.)

(2) (*a*) A spiced sauce containing vinegar, stewed elderberries, etc. (*Tyrol*). A similar pearsauce, plumsauce, etc. (*Nassau*).

(*b*) A sauce or gravy of which the brine forms a small or a large part and to which vinegar is usually added. This is

[1] It is strange that Wilmanns attributes the change of *e* to ō to a neighboring *l* or *sch*, and admits the influence of a neighboring labial only in the dialects. There are but four words in his list that do not contain a labial, and more than that number that contain a labial but do not contain an *l* or *sch*. The truth appears to be that labials and *sch* and *l* tend to labialize an *e*, and that they are particularly successful if a labial and an *l* or *sch* occur near the same *e*, just as English u is generally retained only between a labial and an *l* or *sh* (*full, pull, bull, wolf*, etc.; *push, bush*, etc.), while it sinks and becomes unrounded elsewhere (*but, cup, us*, etc.; *rush, gush*, etc.).

[2] The meanings of the three words are classified and arranged alike, so that the corresponding uses may easily be found.

poured over the pickled meat (cf. 3 below) after it has been boiled (in the brine, in *Bavaria*) or roasted (in *Hesse*, etc.), and is about to be served. Also distinguished as 'ein schwarzer pfeffer' or 'ein gelber pfeffer,' also 'pfefferbrühe' or 'pfeffersauce.' Cf. English 'peppersauce.'

(c) ———.

(3) A brine containing spices for pickling fish, game, and very fat meat, especially hare, mutton, goose, and pork; for example, 'einen hasen in pfeffer einmachen.' The period of pickling varies: in Silesia over night, in Hesse one or two days, in Bavaria four to eight days. (*Silesia, Austria, Bavaria, Würtemberg, Switzerland, Hesse.*)

(4) The process: to *pepper, pfeffern, einpfeffern.*

(a) To strew or season with pepper.

(b) To strew or rub with pepper, etc., as a means of preserving: *gepfefferte würste, gepfefferte häringe, eingepfefferte melonen.*

(5) (a) The thing pickled according to 4: *hasenpfeffer, gänsepfeffer; pfeffergurke,* etc. Also the thing otherwise made with pepper = *pfefferwurst* etc.

(b) ———.

(6) Figuratively :—

(a) = 'pungent' in *pepperroot* etc., cf. *kippernut.*

(b) = uncomfortable situation : *in den pfeffer geraten; er liegt* (or *sitzt*) *im pfeffer; aus dem pfeffer laufen; einen aus dem pfeffer helfen.*

All these meanings the word *pepper, pfeffer,* still has in High-German territory. In the North and in England the byforms *pekel, pökel, pickle* and *kepper, kipper, kippel* have relieved it of some of its burden. It was natural that the original thing, the pepper itself, should retain the more original form of the word. The dealers were familiar with it in bills and orders and they and, in many cases, their customers could see the word daily in distinct letters on the front of the pepper drawer or can. The corrupted forms, therefore, attached themselves to the home preparations and

thus the differentiated forms accommodated themselves to the differentiated meanings.

II. The form *pekel, pökel, pickle* has the following meanings—using the same numbers as above.

(1) (*a*) ———.

(*b*) 'A kernel of any kind of grain;' then, more generally, 'anything of small size or value,' so 'a small amount' or 'a small number' of anything, 'a few.' (*Scotland.*) Where *mickle* becomes *muckle*; for example, in Aberdeenshire, *pickle* becomes *puckle.*

(2) (*a*) A spiced liquid containing a large amount of vinegar and used for preserving cucumbers, peaches, pears, blackberries, etc. (*England, Scotland, and America.*) Before being pickled in this way, the cucumbers are immersed in a brine for about a day.

(*b*) ———.

(*c*) A liquid consisting of brine and vinegar for pickling tongue, etc. (*England, Scotland, and America.*)

(3) A brine (sometimes spiced) for pickling fish and meat, especially herring, pork, and beef. (*North Germany, Holland, Frisia, England,* etc.)

(4) The process: to *pickle, pökeln, einpökeln,* to put up meat, fish, vegetables, and fruit in vinegar or brine (or both), to which various spices and leaves have been added.

(5) (*a*) The thing pickled, especially pickled vegetables. Thus pickled cucumbers are called *cucumber pickles,* cf. also *tomato pickles,. mixed pickles,* and *pickles* in general. Fish and meats are usually distinguished as *pickled herrings, pickled pork,* etc.

(*b*) The thing that is most commonly pickled is often spoken of as a *pickle* even before the process. Thus we speak of 'putting up pickles' and of 'buying pickles (= cucumbers) to put up.' Last fall a farmer came to the door and, when my wife asked him whether he had any cucumbers, he answered: "Not this morning, but I have some very nice cucumber pickles," meaning cucumbers too small to slice up

but just right for pickling. Children and, in some parts, even grown people call cucumbers on the vine 'pickles.' Hence, too, *pickleworm* 'a worm that infests cucumber vines.'

(6) Figuratively :—

(*a*) ———.

(*b*) = uncomfortable situation : *He left us in a pretty pickle* (England, etc.), *in de pekel zitten* (Holland), *er liegt im pökel* (North Germany).

III. The form *kepper, kipper, kippel* is, so far as I know, restricted to English. *kipper* is now the usual form.

(1) ———.

(2) ———.

(3) ———.

(4) The process: to *kipper*.

(*a*) ———.

(*b*) 'To prepare or cure, as salmon, herring, etc., by cleaning them well, giving them several dry rubbings of pepper and salt, and then drying them, either in the open air or artificially by means of smoke or peat or juniper berries.'— *Century Dictionary*.

(5) (*a*) The salmon, herring, or trout kippered according to 4.

(*b*) The salmon, herring, or trout not yet kippered, especially one in the stage when they are (or formerly were) most commonly kippered, rather than eaten fresh, that is, in the spawning season, and particularly the spent male salmon. "He [Scott], and Skene of Rubislaw, and I were out one night about midnight, leistering [spearing] kippels in Tweed," Hogg, quoted in the *Century Dictionary*. "That no person take and kyl any Salmons or Trowtes, not beyng in season, being kepper Salmons, or kepper Trowtes, shedder Salmons, or shedder Trowtes," Acts Hen. VII., c. 21. Rastell's Statutes, Fol. 182, a, quoted by Jamieson. Hence the spawning season is called *kipper-time*: "That no salmon be taken between Gravesend and Henly upon Thames in kipper-time, viz., between the Invention of the Cross (3 May) and the

Epiphany." Rot. Parl. 50, Edw. III., Cowel, Quoted by Jamieson.

(6) Figuratively :—

(a) = ' pungent ' in *kippernut,* cf. *pepperroot,* etc.

(b) ———.

The development and the branching of the meaning of *pepper,* etc., are very natural. From the fruit of the plant itself it spread to various preparations containing pepper and other spices; cf. the use of *honig* in *honigkuchen* and of *ginger* in *gingerbread, gingerpears,* etc. That in the form *pickle* it was in time applied to processes in which little or no pepper was used is not at all strange. We find the same where the form *pepper* itself is used, namely, in *pfefferkuchen,* which is usually made without any pepper at all. But, of course, this extension was more likely to take place in *pickle* than in *pepper,* because the latter word constantly reminds one of its original meaning, while *pickle* does not. The development of the word was not the same in all parts. A chief point of difference is whether vinegar or brine is used. In most of North Germany brine alone is understood by *pökel,* while, on the contrary, in many parts of England the word *pickle* necessarily implies the use of vinegar. In those parts of England and America, in which this is the case, we hear of *salt herring, salt pork,* and *corned beef,* of *salting down* and of the *brine* not the *pickle.* So in parts of Germany, especially Middle Germany, where neither *pökel* nor *pfeffer* is employed, we hear of *salzfleisch, salzgurke* or *sauere gurke* (dill pickle), of *einsalzen* or *in salz legen,* and of *salzlake* or *salzbrühe.* In some parts *pökeln* is restricted to pork ; herrings, for example, being called *salzheringe* or *gesalzene heringe.* In some cases, for example, in pickling ordinary cucumbers (*pfeffergurken* or *essiggurken*), the things to be pickled are first placed in a brine and afterwards in vinegar; in others, for example, in pickling tongue, the pickle consists of both brine and vinegar. Hence the confusion of the two processes of preserving was almost inevitable.

It will be well to consider briefly the etymologies heretofore given for *pickle* and *kipper*.

No one has ever offered a satisfactory explanation of the word *pickle pōkel*. The German books repeat, with more or less disapproval, an old story according to which the word is due to the name of a man who first invented the process, Wilhelm Böckel or Bökel. But it has long ago been shown that this is impossible. The change of *b* to *p* is irregular, and such a German form could never explain the English form; moreover the English word and the process long antedate Wilhelm Böckel. Koolmann, in his *Wörterbuch der Ostfriesischen Sprache*, derives the word from Du. *beek*, Eng. *beck*, Ger. *bach*, assuming 'fluid' as the original meaning; but the *p* of *pickle*, etc., makes this too impossible. The original character of the *p* is thoroughly established and in no way invalidated by the rare spelling *bökel* (for *pökel*), which is probably due to *böcking* and *böckling* 'smoked herring,' or to the erroneous association of the word with the name *Böckel*, just as Mahn contrariwise changes the name *Böckel* to *Pökel* to agree with *pökeln*. Others suggest that the word may be derived from Eng. *pick*—thus Wedgwood calls attention to the meaning 'cleanse' that *pick* is said to have locally, and Kluge, refers to the meaning 'prick' that *pick* sometimes shows, evidently having in mind the sharp, pungent taste of pickles. But the authors of these suggestions make them in a half-hearted way, evidently because at a loss for something better.

Two plausible but erroneous etymologies of *kipper* have been brought forward. The first derives it from *kip* 'point,' with reference to the 'beak' that the male salmon is said to have when he has spent milt. A similar idea appears to have been in Walton's mind when he wrote: "Those [i. e., salmon] left behind by degrees grow sick and lean, and unseasonable, and kipper—that is to say, have bony gristles grow out of their lower chaps," *Complete Angler*, p. 122, quoted in *Century Dictionary*. The idea, at first sight, seems a natural

one; it is, however, a case of popular etymology. If the fish
were named for the sort of hook that it appears to have when
spent, we should expect it to be called at best a '*kipped
salmon*,' or perhaps a '*kip*' or '*kippie*.' To call it a *kipper*
would be like calling a beaked bird a '*beaker*,' the horned
owl a '*horner*,' the tufted titmouse a '*tufter*,' the spotted bass
a '*spotter*,' or the speckled trout a '*specker*' or '*speckler*.'
Nouns in -*er* are, for the most part, derived from verbs and
denote an agent or actor (*fighter, giver, speaker*, etc.). When
derived from other nouns, they denote a functionary (*jailor,
bencher, executioner, larderer*), or one following a line of
business (*fruiter, palmer, lawyer*); they never, to my knowl-
edge, denote the possessor of a peculiarity, except in the
comparatively recent slang of English universities. Further-
more, the beaklike lower jaw of the spent salmon bends
down ["the male salmon, often especially during the spawn-
ing season, having his nose beaked down like a bird's bill,"
cf. Jamieson under *kipper nose*], but a *kip* is an upturned
point, a peak (especially of a mountain), and 'to *kip*' is to
turn up or to be turned up, as the horns of cattle, etc. So
'*kip-nosed*' means 'having the nose turned up at the point'—
our 'pug-nosed.' A '*kipper nose*,' on the contrary, is a long
beaked nose: "This scene went on—the friar standing before
the flame, and Tum and Giffie, with their long kipper noses,
peeping over his shoulder," *Perils of Man*, II, 50, quoted by
Jamieson.—The usual etymology of the word traces it to Du.
kippen 'to hatch,' from which the step to 'to spawn' is easy,
and thus Skeat says a *kipper* is a 'spawner.' If this were
true, we should expect the word to be applied particularly to
the female fish; but, when any distinction of sex is made, the
term is applied specifically to the male, the female being called
a 'shedder' or 'roan' (cf. Jamieson). The derivation of the
word from the Dutch would be natural if this process of
preserving fish and, with the process, the name for it had
come from Holland. We know, however, that the Dutch
have no word corresponding to *kipper*, and, so far as I can

learn, even *kippen* is not used of fish in Holland. In Dutch
and Low German the word means primarily to 'peck' or
'pick,' then specifically of a young bird or chick in the egg,
that picks the shell open; also of the old bird or hen that
aids it with her bill. It might be urged that *kipper* was not
derived directly from the continental *kippen* but from a cog-
nate English verb that is lost, but whose meaning may have
been extended from birds to fish, from hatching chicks to
spawning. Now, it happens that there not only was such an
English verb but that it still exists; its meaning is, however,
as restricted as that of the continental *kippen*, and its form, as
was to be expected, is *chip* not *kip*. As *kipper* is not restricted
to those parts of England that retain original *k* before *i*, we
should expect the word, if derived from original *k*, to have
in most of England the form *chipper*, which to my knowledge
it never has.

Both of these attempts to explain the word have made it
necessary to ignore the natural and usual meaning of *kipper*
and to seek its explanation in one of its rarer meanings. Cf.
Skeat: "Kipper, to cure or preserve salmon. (Du.). This
meaning is quite an accidental one, arising from a practice
of curing *kipper-salmon*, i. e., salmon during the spawning
season." The association of *kipper* with *pepper* shows that
the most usual meaning of the word (namely, the fish pre-
served by being subjected to "dry rubbings of pepper and
salt," not the living fish) is the more original, as we observe
also in the case of *pickle* as applied to the preserved cucumber
and to the green cucumber.

This etymology clearly illustrates the fact, so often for-
gotten, that the solution of a problem in English word-lore
frequently lies in one of the other Germanic languages.
Without an acquaintance with the South-German usage as to
the word *pfeffer* no one would have thought of associating
English *pepper*, *pickle*, and *kipper*.

GEORGE HEMPL.

On the Teaching of Written Composition*

Reprinted from EDUCATION, March, 1910

LANE COOPER, CORNELL UNIVERSITY, ITHACA, NEW YORK

THE teaching of English composition is a large subject for consideration in a paper of necessity so brief as this. Properly amplified, the subject would involve some treatment of various other topics, among them the gradual decline of interest in the disciplines of Greek and Latin, which have been essential to the development of English style in the past; and the concomitant popular demand for a kind of education in the vernacular which shall directly liberate the utterance of the masses, rather than raise up leaders in scholarship whose paramount influence might elevate and sustain the standards of taste and good usage.

My purpose, however, is necessarily restricted, and very simple. It is my hope to direct the attention of teachers of English, particularly those who are concerned with classes in written composition, to certain underlying principles which ought to govern the practice of requiring themes or essays from the immature. Fundamental principles are seldom free from the danger of neglect. With reference to composition in the vernacular, the present seems to be a suitable occasion for reverting to such principles, since within the last two years or so a great and exemplary educational power in the East has been rediscovering one of them, and has at length concluded that the children of America should not be forced to make bricks without straw. In the academic year of 1907–1908 at Harvard University the number of undergraduates in courses primarily devoted to the writing of English was considerably larger than the number in courses primarily devoted to the study of English literature, the proportion being almost three to two. Since then, owing, as I understand, to measures designed by the Department of English, this disproportion has

*A paper read before the Modern Language Association of America, December 28, 1909.

undergone a change, so that now there would appear to be a leaning toward courses whose first aim is the acquisition of knowledge, and the development of insight rather than expression. It is not my intention to make use of statistics, and I cite the preceding case, and the following, only in order to define a general impression, namely, that the tide has begun to drift away from courses in the daily theme and its like at the place from which many other institutions have ultimately borrowed such devices, though this drift may not as yet be perceptible everywhere else. For the present semester at a representative university in the Middle West, the number of students in courses mainly devoted to English composition, as against those in courses mainly devoted to the study of English literature, exclusive of graduate students, bears a proportion of about ten to seven. I have no desire to draw especial notice to the university in question, and have given the instance as presumably typical of a good many institutions.

To one who from the beginning could have watched the daily theme advance from its home in New England to a gradual conquest of the South and West—while Greek kept sailing ever farther into the north of Dame Democracy's opinion—the sight must have been attended with some misgivings. In the case of many teachers who, after years of experiment, persist—to use the words of Milton—in "forcing the empty wits of children to compose themes, verses, and orations, which are the acts of ripest judgment," a process which he compares to the wringing of blood from the nose, and "the plucking of untimely fruit," * it may be that the only words to apply are those from Burns :—

> One point must still be greatly dark,
> The moving *why* they do it.

To do a thing mainly because one hundred or one thousand others are engaged in the same pursuit, may be reasonable in a polity like that of Mr. Kipling's Bandar-log; it is not the sort of motive that ought to dominate the republic of American colleges and universities. Yet one may pertinently inquire

* Tractate on Education. Throughout the following remarks I have kept in mind certain passages from Milton's Tractate, Wordsworth's sonnets entitled Personal Talk, and Bacon's Advancement of Learning.

whether some such external imitation of one institution by another in this country has not been the chief cause in forcing the jaded wits of partly trained instructors in English, sometimes known as "English slaves," to correct endless themes, essays, and orations, and allowing them to do little else, during what ought to be a most critical period of their growth, that is, during the period when the *docent* in a German university pursues the liberal investigations that shall shortly make him, within his field, a master of those who know. In a land like ours, which prides itself upon the development of efficiency, no harsher accusation could be brought against the daily theme than that it squanders the energy of the teacher. It causes him to spend an immoderate share of his time upon a mass of writing that has no intrinsic value, and easily leads him into the habit of regarding the details of outer form, rather than the substance of what he reads. "Here, therefore, is the first distemper of learning, when men study words and not matter." Is it true that if you take care of the teacher of English, his pupil will be taken care of? Whatever value may attach to this notion, daily themes and their like, once established in the curriculum, constitute a barrier to its acceptance. But let us turn to the pupil.

What, then, are the laws that should govern the kind and amount of writing which we may require from our undergraduates? In asking this question, we are to have in mind the needs of students of the first and second year, but the answer is applicable to a much larger circle of learners. By way of preliminary, one might inquire whether it is necessary that the art of written composition should be taught at all. The common belief that it is necessary may be too readily accepted. The wisest of all teachers, though He constantly referred to written tradition as a standard, and expected his hearers to be familiar with it, is not reported to have written more than once —and then in the sand. The wisest of the Greeks in the time of Pericles is represented by Plato at the end of the Phædrus as arguing to the uttermost against the art of written composition, except as a pastime for the old. Aside from his main contention, this argument of Socrates in favor of the spoken

word offers no little support to the increasing, number of those who maintain that our present courses in English composition should turn more and more upon the exercise of distinct utterance, that clear and well-formed speech is more intimately connected than writing itself with that precision of thought and feeling which is the basis of all good style. Yet it may be urged that Plato, the consummate artist in Greek prose, is himself an example with which to combat the argument against writing that he chooses to put into the mouth of a dramatic character. Even so, shall we, then, immediately rush away to the inference that it is desirable both for the individual and for the state that all persons, or all the persons in any group, should obtain an equal opportunity for self-expression, whether in writing or otherwise?

So far as concerns the individual, it is clear that the teacher, whether of English or any other subject, should prefer to make his pupil well-informed and happy, rather than enable him to advertise his wisdom and contentment. Even in a democracy it may now and then be true that silence is golden, and long, barren silence better than personal talk. As for the state, it is obvious that the commonwealth is benefited when the few who have a comprehension of its needs are allowed a hearing, and the many possess themselves in quiet; on some such basic thought rests Herbert Spencer's Philosophy of Composition. Nevertheless, among the platitudes that have escaped challenge is the current notion that every one should be taught to express himself when on his feet, since there is no telling how often, in the way of civic duty, the average man may need to address an audience. One may venture to think that an inordinate amount of precious time has been lavished in debate upon airy generalities by students who have never made a speech, or needed to make one, after turning their backs upon the academic rostrum; and the fact remains that the average man, either in civic or in private relations, always needs to know his business before he talks about it. A similar observation holds with reference to the excessive practice of written composition for its own sake. It sounds like a truism to say that to acquire, and to meditate upon what is acquired, are

more essential than to express the result in writing. Yet this essential priority of insight over expression is not reflected in the large number of undergraduates throughout our country who engage in the writing of themes with little or no restriction of subjects, as compared with the number engaged in the systematic study of English literature under teachers who are supposed to have made this field, or part of it, their own.

It may be objected that such a disproportion exists only on the surface, and that the student's whole experience, including his activity at the time in other branches of the curriculum, should furnish him with material about which he can write the truth. But the experience of the under-classman is easily exhausted; and in the other subjects which he may be studying, his teachers are better fitted to gauge the precision of his statements than is the teacher of English. In any case, we can hardly avoid the admission that everywhere, and at all times, the truth is of more importance than any language into which it may happen to be translated.

May we not put the argument into a form like this? The main function of the vernacular, Talleyrand to the contrary notwithstanding, is the communication of truth. In a given case the importance of the function is measured by the importance of the truth to be conveyed. Since we may seldom take for granted that the immature student is in possession of a valuable truth, and since the first inquiry of the teacher should, therefore, be concerning the truth and accuracy of the pupil's communication, it follows that the teaching of expression can never safely be made the primary aim of any course. If a sense of values is, in the nature of things, primary, it will remain so in spite of a thousand courses that may be built upon some other hypothesis. If expression is a medium for imparting one's sense of values, if it is essentially a means to an end, we fall into the gravest possible error when we treat it as an end in itself.

Our main question, therefore, resolves itself precisely into this one of means and end; hence we must lay the emphasis where it is due, and no longer ask, "Can we teach such and such persons the art of composition?" Instead, we are bound

to ask, "Can we use the practice of written composition as a means of imparting insight?" Obviously we can use it as a test for determining whether the pupil has gained an appreciation of any particular subject, and by successive tests can determine whether he continues to advance in his appreciation. We may perhaps use it with some frequency in order to note the increasing faithfulness of his observation within a definite province, more rarely in order to measure his ability to compare his observations and to draw inferences from them. Employed by a teacher who has such ends in view, the writing of English becomes an instrument of value for promoting a general education, which may be taken to mean a study of particular disciplines in the order of their importance and possibility. Employed for less serious, or mistaken, ends, written composition may be regarded as a pastime for the young, or as an injurious waste of time.

From these considerations we may pass to a few others, some of which may be implicit in what has gone before. The insight which it is the function of the teacher of English to impart is an insight, not into present-day theories of geology, or economics, or agriculture, or, in short, into much of the heterogeneous material that so often serves as a basis for studying the formal structure of exposition and the like; it is an insight into the best traditions of English literature and such other literatures as are inseparably connected with an understanding of the English. This, presumably, is the material into which the vision of the teacher himself has most deeply penetrated. If not, he ought to be teaching something else, or nothing. Let the teacher of writers, as well as the writer, observe the caution of Horace, and choose well his proper field. Some portion, or phase, of this subject which he loves is the thing about which he may ask his students to write; and not in helter-skelter fashion, as if it made no difference where one began, what one observed next, and so on, save as a question of formal order; but progressively, on the supposition that in the advance toward knowledge and understanding certain things, not formal, but substantial, necessarily precede others.

Further, the amount of writing demanded of the immature

student should be relatively small. In the space of a term, how many teachers of English composition produce as much manuscript of an academic nature as they expect from individuals of the freshman or sophomore class? Are our courses in daily themes to any extent founded upon the educational theories of antiquity? We may imagine that by one channel or another they eventually go back to Quintilian. But what is their real connection with the familiar advice of Quintilian, so vigorously rendered by Ben Jonson, "No matter how slow the style be at first, so it be labored and accurate;" or with this, "So that the sum of all is, ready writing makes not good writing, but good writing brings on ready writing"? Or what relation have they to the Horatian counsel, not merely of filling the mind from the page Socratic before one commences writing, but, after one has written, of correcting, even to a tenth review? And the page Socratic itself in one case is said to have been seven times rewritten. Accordingly, from Plato, who remodeled the opening of the Republic these seven times, to Bacon, who revised the Instauratio Magna at least twelve times, and Manzoni, who would often recast a sentence a score of times, and then perhaps not print a word of it, and John Richard Green, who rewrote the first chapter of The Making of England ten times, there is a host of witnesses* crying out against the facile penmanship of five themes a week on five different subjects, or approximately one hundred and seventy-five in an academic year, from the empty wits of sophomores. To this number must be added six or eight "long themes." Could any course of reading be designed which at the end of the year

* On rewriting and other forms of painstaking in composition, see Horace, Ars Poetica, 289-294; Ben Jonson, Discoveries, ed. Castelain, pp. 34, 35, 84–86; Boswell's Life of Johnson, Oxford Edition, 2: 562; Rousseau, Confessions, Book 3 (in the translation published by Glaisher, pp. 86, 87); Gillman's Life of Coleridge, p. 63; Christabel, ed. E. H. Coleridge, p. 40; Journals of Dorothy Wordsworth, ed. Knight, 1: 83 ff.; Letters of the Wordsworth Family, ed. Knight, 2: 312, 313, 470; Cooper, The Prose Poetry of Thomas De Quincey, p. 32; Letters of J. H. Newman, ed. Mozley, 2: 476, 477; Lucas, Life of Charles Lamb, 1: 335, 336; Nation, Nov. 9, 1905 (on Manzoni); Revue Politique et Littéraire, Feb. 22, 1890, p. 239; Faguet, Flaubert, pp. 145 ff.; William Allingham, A Diary, p. 334; W. P. Chalmers, R. L. Stevensons Stil, pp. 1–4; Life and Letters of Lafcadio Hearn, Elizabeth Bisland, pp. 132–135; Jowett, College Sermons, Preface.

preceding should make of the freshman a full man to th
extent which such an exercise as this in the sophomore yea
demands?

In fact, the more one compares the current practice of them
writing with traditional theory and the actual experience
good writers in the past, the less this practice seems to harmo
nize with either. Nor does it meet with the approval, so fa
as I can discover, of representative literary men in the presen
Speaking at Oxford University some eleven years ago, M
Frederic Harrison delivered himself as follows :—

"I look with sorrow on the habit which has grown up in th
university since my day (in the far-off fifties)—the habit
making a considerable part of the education of the place t
turn on the art of serving up gobbets of prepared informatio
in essays more or less smooth and correct—more or less suc
cessful imitations of the viands that are cooked for us daily i
the press. I have heard that a student has been asked t
write as many as seven essays in a week, a task which woul
exhaust the fertility of a Swift. The bare art of writing readabl
paragraphs in passable English is easy enough to master ; on
that steady practice and good coaching can teach the averag
man. But it is a poor art, which readily lends itself to harm
It leads the shallow ones to suppose themselves to be deep, th
raw ones to fancy they are cultured, and it burdens the worl
with a deluge of facile commonplace. It is the business of
university to train the mind to think, and to impart solid knowl
edge, not to turn out nimble penmen who may earn a living a
the clerks and salesmen of literature." *

And to much the same effect Lord Morley, speaking
decade earlier than Mr. Harrison :—

"I will even venture, with all respect to those who ar
teachers of literature, to doubt the excellence and utility of th
practice of over-much essay-writing and composition. I hav
very little faith in rules of style, though I have an unbounde
faith in the virtue of cultivating direct and precise expression
But you must carry on the operation inside the mind, and no
merely by practising literary deportment on paper. It is no

* On English Prose, in Tennyson, Ruskin, Mill, and other Literary Estimate

everybody who can command the mighty rhythm of the greatest masters of human speech. But every one can make reasonably sure that he knows what he means, and whether he has found the right word. These are internal operations, and are not forwarded by writing for writing's sake. Everybody must be urgent for attention to expression, if that attention be exercised in the right way. It has been said a million times that the foundation of right expression in speech or writing is sincerity. That is as true now as it has ever been. Right expression is a part of character. As somebody has said, by learning to speak with precision, you learn to think with correctness; and the way to firm and vigorous speech lies through the cultivation of high and noble sentiments. So far as my observation has gone, men will do better if they seek precision by studying carefully and with an open mind and a vigilant eye the great models of writing, than by excessive practice of writing on their own account." *

Could one wish for a better defense than Lord Morley has given of the notion that the cultivation of the vernacular must go hand in hand with a systematic study of English literature, and of no models short of the best?

Now I am far from wishing to suggest that the battle which has been waged against the illiteracy of our freshmen and sophomores, and which has centered in the daily theme, has been totally without avail, though all of us must remember instances where a compulsory exercise in fluent writing has chiefly served to encourage shallowpates in shallow thinking and heedless expression. But where the battle has availed, this has resulted from the more or less random observance of the principle which has been enunciated, namely the priority of insight; for even where the teacher of composition at the outset announces his belief that the disease which shows itself in bad writing is bad thinking, he nevertheless is prone to spend the term, or the year, in warring against the symptoms. He lacks the courage of his convictions, and needs to restore his

* Studies in Literature, pp. 222, 223.

spirit with the passage in which Milton says: "True eloquence I find to be none but the serious and hearty love of truth." *

The whole question does, indeed, finally reduce itself to one of pedagogical faith, to a belief that the ideal will work—that it is the only thing that will work effectively. If we never ask the student to write for us save on the basis of something which we ourselves may properly be supposed to know; if the material is one concerning which his knowledge is made to grow throughout a considerable length of time; if we expect of every essay, paragraph, sentence, phrase, and word which he writes that it shall tell the exact, if not the whole truth; if the subject-matter of his study be itself the truest and most inspiring that we can employ to fire his imagination and clarify his vision; if we observe all these conditions, will he altogether fail in acquiring the outward badge of education which is popularly demanded of the college graduate? Will he fail to express himself better as his personality becomes better worth expressing? If, for example, we took our cue from the Greeks, and restricted our training in the vernacular to the patient absorption of one or two supreme masterpieces, would not our students escape what Ruskin says such a practice enabled him to escape, " even in the foolishest times of youth," the writing of " entirely superficial or formal English"?† Nay, might they not thus appropriate a matter wherein, on occasion, they might with justice become right voluble? No teacher can deny it unless he is willing to pretend that insight and expression are separable, or that insight is subordinate. Yet the belief that they are inseparable, and that expression is subordinate, is not merely a matter of present-day common sense; it has received frequent enough vindication in the history of culture. But in closing we may content ourselves with one quotation, and that

*" True eloquence I find to be none but the serious and hearty love of truth; and that whose mind soever is fully possessed with a fervent desire to know good things, and with the dearest charity to infuse the knowledge of them into others, when such a man would speak, his words (by what I can express), like so many nimble and airy servitors, trip about him at command, and, in well-ordered files, as he would wish, fall aptly into their own places."—*From the Apology for Smectymnuus.*

†Ruskin, Præterita, Chap. I; cf. also Chap. II.

from the very practical man to whom, more than to any other one person in the history of Europe, the existence of modern culture is owing, that is, Charles the Great. In a plea for the study of letters, lest the knowledge of the art of writing vanish away, and hence the knowledge of how to interpret the Scriptures, he says to the abbots and bishops in the year 787 :—

"While errors of speech are harmful, we all know that errors of thought are more harmful still. Therefore, we exhort you not merely not to neglect the study of letters, but to pursue it with diligence."*

*Comparetti, Vergil in the Middle Ages, pp. 96, 97.

Professor Scott.

𝔄merican 𝔖chool
of ℭlassical 𝔖tudies
in 𝔕ome

SYMMETRY IN EARLY CHRISTIAN RELIEF SCULPTURE

WHAT considerations determined the choice and arrangement of the subjects selected by the early Christians for representation in relief sculpture? The present paper aims to throw some light upon this much-discussed question by calling attention to the important influence exercised over the sculptors by a desire to secure a merely external symmetry and balance of the component elements of groups or of single figures, and by a desire to select themes appropriate to the shape and size of the field at their disposal.

The discussion will be confined almost entirely to the sarcophagi, since these form by far the largest part of the extant monuments of early Christian relief sculpture.

The attempt to secure symmetry and balance is evident (I) in the disposition of the relief fields; (II) in the composition of the special groups and single figures; (III) in the distribution of the figures and groups upon the relief field.

I

The simplest ornamentation of the sarcophagi — one often employed by both Christians and pagans — is the so-called strigilation, a series of S-shaped flutings vertically crossing the face of the sarcophagus. True to the taste for symmetry, the sculptor so disposes the ornamentation that the direction of the S-curves in the right and left halves of the field is reversed. By causing the upper curves to open toward the centre, he secures a rather broad lenticular field just above the

American Journal of Archaeology, Second Series. Journal of the
Archaeological Institute of America, Vol. IV (1900), No. 1.

126

central point of the sarcophagus face. The first step[1] toward a more complex system of ornamentation consists in the introduction of a relief into this lenticular field. This relief usually represents the Good Shepherd or an *orans* — a figure *en face* with arms outstretched in attitude of prayer (see Garrucci, *Storia dell' Arte Cristiana*, vol. V, pl. 375, fig. 2[2]). In other cases a regular,[3] rectangular field of varying size and bordered by a simple moulding,[4] is substituted for this lenticular field. The remainder of the face of the sarcophagus is then symmetrically decorated. The central panel, though sometimes reserved for the epitaph, usually bears an unpretentious relief, such as the Good Shepherd,[5] an *orans*,[6] a biblical scene, *e.g.* the Nativity,[7] Christ alone or attended by disciples,[8] the denial of Peter,[9] a liturgical scene (a husband and wife alone or in the presence of Juno Pronuba[10]). In other cases the upper half of this panel is occupied by an *imago clypeata*, and the lower half by a plate for the epitaph,[11] by a conventional design[12] or by a pastoral[13] or biblical[14] scene. Of the terminal decorations the simplest forms are plain mouldings,[15] columns, or pilasters;[16] the last two suggest the original house-form of the sarcophagus. A variant form consists in a tall and narrow rectangular field bearing a relief-representation of a genius with an inverted torch, the figures at both ends being the same, but with attitudes reversed.[17] This field is not infrequently still further enlarged and adorned with

[1] *i.e.* in complexity, not in chronological development.

[2] Hereafter citations from vol. V of Garrucci's work will be given thus: G. 375, 2.

[3] An exception is G. 295, 2.

[4] Sometimes separated from the strigilation by fluted pilasters or columns (G. 295, 1; 325, 4; 362, 3).

[5] G. 295, 1, 2; 300, 1; 301, 1; 303.

[6] G. 373, 4, 5; 374, 1, 2; 375, 1, 2, 4; 403, 2; 377, 4; 378, 1; 380, 1. In the last three instances the *orans* forms one of a symmetrical group of three figures.

[7] G. 310, 4. [8] G. 329, 3; 330, 1, 2; 342, 2. [9] G. 316, 4.

[10] G. 325, 4; 327, 1; 361, 1; 362, 3; 368, 3. [11] G. 358, 2.

[12] G. 357, 3; 360, 2. [13] G. 359, 2; 363, 1-3; 366, 1. [14] G. 357, 1, 2, 4.

[15] G. 298, 2; 342, 2. [16] G. 295, 1; 300, 2-4; 301, 1, 3-5; 306, 1-4; 380, 1.

[17] G. 297, 1, 2; 403, 1.

other single figures or groups, such as a lion attacking a deer,[1] Cupid and Psyche,[2] a human figure,[3] an *orans* or Good Shepherd,[4] or a sheep near a tree.[5] In all these instances there is a close correspondence between the figures at the right and left, either in external form or in content, or in both. When we pass from this range of scenes to the biblical scenes, the correspondence becomes less conspicuous, although instances are not wanting which show an effort on the part of the sculptor to break with tradition and alter the composition of the established subjects, so as to render them more appropriate in form to the new conditions. Desire to secure symmetry seems to have played some part also in the choice of subjects. Thus the most frequently recurring scenes are those from the life of Moses,[6] representations of resurrections,[7] the sacrifice of Isaac,[8] all of which are especially easy to adjust to the requirements of a terminal position.[9]

A more complex system of decoration arises when each terminal panel is divided by horizontal mouldings into two equal fields.[10] A still more complex system is seen when the strigilated field is subdivided vertically as well as horizontally, so as to exhibit two pairs of superposed panels. In such cases the central and terminal figured reliefs are sometimes also subdivided into superposed compositions,[11] and sometimes more satisfactorily left undivided.[12] These subdivided terminal panels exhibit biblical subjects only. Occasionally, between terminal reliefs the strigilation is omitted and a figured composition substituted.[13]

[1] G. 357, 3; 383, 2. [2] G. 357, 1. [3] G. 307, 4; 363, 3.

[4] G. 358, 2; 360, 2; 370, 4. [5] G. 300, 1.

[6] The striking of the rock (G. 357, 2; 359, 2; 361, 1; 366, 1; 374, 2; 375, 1), the receiving of the tablets of the Law (357, 2; 366, 1).

[7] G. 361, 1; 364, 1. [8] G. 310, 4.

[9] The representations of Lazarus and of Moses striking the rock may thus be adjusted by shifting the tomb of Lazarus or the rock to the left or to the right side of the composition, thus causing the figures of Christ and of Moses to face in a different direction.

[10] G. 364, 1. [11] G. 361, 1; 399, 1, 2, 7.

[12] G. 324, 4. [13] G. 308, (from Trèves).

An important type of Christian sarcophagus[1] is that which has the form of a peripteral temple. There is usually an odd number of intercolumniations along the front, one in the centre and two to four at each side, with alternating round and pointed arches. Each intercolumniation is occupied by a figure or a group; the correspondence in form between these being often not less striking than that between the architecturally formed fields they adorn[2] (see Fig. 1).

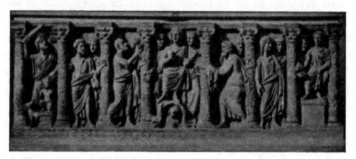

FIGURE 1.—CHRISTIAN SARCOPHAGUS IN THE LATERAN MUSEUM, ROME.

There is no Christian sarcophagus bearing on its face more than one field of reliefs that does not show a symmetrical disposition of the fields, and few that show a neglect of symmetry in the composition of the groups that fill them.

II

Passing to the consideration of the special groups and single figures, we have first to note a striking contrast between Christian and pagan relief sculpture. While the pagan artist usually filled his field with one scene, the Christian sculptor almost invariably placed upon the sarcophagus face a series of from four to fifteen different scenes.[3] In this method of pro-

[1] One often used by the pagans also. [2] G. 321, 1-4 ; 322, 2 ; 361, 2.
[3] The only important exceptions are (1) the Children of Israel crossing the Red Sea, represented on several Gallic and on one Roman sarcophagus, and (2) Christ attended by his disciples.

cedure, however, he was not an innovator. The pagan sarcophagi also show a tendency to break up a group into a number of elements, as in the representations of Endymion [1] and of Venus and Adonis.[2] We find also in pagan reliefs separate scenes standing side by side. The well-known sarcophagus of the ' Mourners' from Sidon affords a close parallel to the Christian representations of Christ sitting with his disciples. In these instances there is generally some inner connection between the scenes, these being usually scenes from the life of some individual.[3] The Christian sarcophagi, however, so far as has yet been demonstrated, aside from a few examples,[4] show no such bond of union.[5]

Furthermore the early Christians confined themselves to a rather limited range of subjects,[6] and thus repeated again and again the same scene. This tendency to repetition is not peculiar to Christian sculpture. To mention only a few conspicuous examples from pagan art: Robert in *Die antiken Sarkophag-Reliefs*, vol. III, cites over fifty existing sarcophagi bearing representations of Endymion and Selene, which, though divided by him into three classes, show in reality only slight variations from each other. The same volume contains plates illustrating forty-six sarcophagi bearing representations of the labors of Hercules. Of these thirty-one represent the twelve labors and show the same lack of variety and the same tenacity in clinging to traditional types as do the Christian sarcophagi.

[1] See Robert, *Die antiken Sarcophag-Reliefs*, III, pls. 12–25.

[2] Robert, *op. cit.* III, pls. 2–5.

[3] Examples are the scenes from the lives of Iphigenia and Orestes (Robert, *op. cit.* II, pls. 57–59), and from the life of Hercules (Robert, *op. cit.* III, pls. 27–43).

[4] *E.g.* scenes from the life of Susannah on a Gallic sarcophagus (G. 377, 3).

[5] Schultze, *Archaeologische Studien, passim*, urges the importance of the idea of the resurrection in this connection. Other attempts to find a unifying idea are mentioned below (p. 144 f.).

[6] The number and variety of subjects is really larger than is usually realized. Over seventy-five scenes from the Old and New Testaments occur, several of them in two or three different forms. If we add to these the symbolical and liturgical scenes, and the scenes borrowed from pagan art, the number rises above 150 (cf. Kraus, *Geschichte der christlichen Kunst*, I, pp. 91–222).

Examining these subjects in detail, we note that the symmetrical arrangement of parts is strikingly prominent in the following single figures and groups:

(1) *The orans.* The symmetry of the figure is complete.

(2) *The Good Shepherd.* The most frequent type is that in which the Shepherd appears in the attitude of the classical *kriophoros*, that is, carrying a sheep across his shoulders. At his feet stand two other sheep, one at each side. They usually face him and stand in perfectly symmetrical attitudes and positions; or, if not facing him, their heads are turned toward him. If four, six, or eight sheep surround him, they are divided into equal groups at his right and left. A tree at the right and one at the left often close the scene.

(3) *Daniel in the lions' den.* This theme is subject to fewer variations than almost any other. Daniel is represented nude,[1] standing with arms outstretched in the attitude of an *orans*. At each side stands a lion facing[2] him. On the sarcophagi he is sometimes alone, sometimes attended by Habakkuk and other persons. In the frescoes he is always represented alone. The lions[3] occupy symmetrical positions except in extremely rare instances. They sometimes stand or lie, but most frequently sit on their haunches, thus imparting to the composition a distinctly pyramidal form. When two persons attend the prophet, they stand at the right and left, one behind each lion. In a few instances only is a third attendant added.

(4) *Christ attended by disciples.* In these scenes, which ordinarily occupy the entire face of the sarcophagus, either in a single field or in a succession of intercolumniations, Christ uniformly occupies the centre, either seated or standing upon a rock from which flow the four streams of Paradise. The dis-

[1] He is rarely clothed (see Kraus, *Real-Encyclopädie der christlichen Alterthümer, s.v.* Daniel; Hennecke, *Altchristliche Malerei und altchristliche Literatur*, p. 57).

[2] In a few instances turned from him (see Hennecke, *l.c.*).

[3] Two in number. A single exception (G. 301, 3) has only one lion; yet even here a symmetrical effect is secured.

ciples (two, four, six, ten, or twelve in number — in one instance there are twenty-four persons represented) sit or stand, an equal number at each side of the central figure. In the attitudes and the grouping of these figures the tendency is to balance group with group or figure with figure, to the right and left of the centre. Particularly noticeable in this respect is a Gallic sarcophagus.[1] In the accessories also, *e.g.* a palm tree at each side of Christ, a man and a woman kneeling at the right and left below Him, or two deer drinking from the streams, a strict symmetry of position and attitude is preserved.[2]

(5) *Representations of the temptation and transgression of Adam and Eve.* Like most of the other groups composed by the early Christians it contains but few elements. The two parents, nude, stand *en face* on each side of the Tree of Life, about which a serpent is sometimes coiled. The strict symmetry of the group is broken only by the position of the arms and (though less frequently) by the sheaf of grain and the sheep which accompany them as symbols of the fields of labor to which they are respectively condemned. In many instances the arms also are symmetrically placed; both being held before them or one being extended toward the tree. In the frescoes the tree also is treated with a symmetry almost geometrical, sending out, for example, in one case, two branches from one side, which correspond exactly in form, size, and position to two others on the opposite side.[3] The fuller treatment of the tree in the frescoes is due not only to the greater ease with which they were produced, but also to the larger field at the disposal of the painter, as is shown by the fact that the group receives a similar fuller treatment in the sarcophagi, when it is sculptured upon the cover or one of the small sides, positions which are favorable to the lateral expansion of the scene.[4]

[1] Le Blant, *Étude sur les sarcophages chrétiens antiques de la ville d'Arles*, pl. iv.

[2] Cf. Schnaase, *Geschichte der bildenden Künste*, III[2], p. 91.

[3] Garrucci, vol. II, pl. 63. [4] Cf. below, pp. 144 f.

When the sheep and the sheaf are present, they are employed to fill in the spaces at each side of the foot of the tree.[1]

(6) *The condemnation of Adam and Eve.* Christ, the Λόγος, stands *en face* between the two. Eve is generally at his left, as usually in the preceding group. Christ holds in his right hand a sheaf of grain, in his left he holds a lamb by the fore feet. The group is composed with almost exact symmetry, extending frequently even to the positions of the hands of Adam and Eve.[2]

(7) On one sarcophagus is a representation of the offerings of Cain and Abel modelled closely upon the preceding group.[3]

(8) *The multiplication of the loaves and fishes.* In the treatment of this miracle the frescoes and the sarcophagi present marked divergencies. In the frescoes Christ is unattended by other figures.[4] Near him stand seven baskets of loaves, one of which he touches with a wand. On the sarcophagi Christ is represented standing between two men, each of whom holds a plate with both hands. On the plate at the right are two fishes, on the other are loaves of bread. Christ extends his hands and touches the loaves and fishes. Deviations from this symmetrical type[5] are usually explainable on technical grounds.

(9) A scene composed strictly on the model of the preceding and explained as Isaac blessing Jacob and Esau.

(10) *The labarum*, at the base of which sit two soldiers in full armor. The *labarum* is often made the centre of groups similar to (4). The arrangement is in all cases strictly symmetrical.

The following groups betray less clearly the influence of a desire to secure symmetry :

(11) *The arrest of Moses, Peter, or Christ.* Each shoulder of the person arrested is seized by an officer. The energy of action — quite unusual in early Christian sculpture — that char-

[1] Illustrations of this group in G. *passim*, in particular 333, 3 ; 372, 3 ; 377, 1.
[2] G. *passim*, in particular 367, 2, 3. [3] G. 310, 2.
[4] The only exception is G. vol. II, pl. 18, 3 ; yet here the scene is symmetrical.
[5] G. 320, 1.

acterizes this scene, serves to break somewhat the **formal** monotony which it would otherwise have and which **would** give it much the same form as that assumed by the **miracle of** the loaves and fishes.

(12) The denial of Peter.[1]

(13) Christ and the woman of Samaria.[2]

These subjects, except Nos. 7, 9, 12, 13, are among those of most frequent occurrence in the early Christian art, there being but few sculptured sarcophagi that do not contain one or more of them. Those which show the most striking symmetry — Adam and Eve, Daniel, the Good Shepherd, and the *orantes* — are among the earliest themes chosen for representation by the Christians, and are found with great frequency in frescoes. The multiplication of the loaves, on the other hand, first finds a symmetrical representation in the relief sculpture. The arrest of Moses was developed out of the representation of the striking of the rock,[3] and the arrest of Peter and of Christ are formed upon its model.

III

As stated above, the Christian sculptor usually filled the field with reliefs representing, not a single scene, but a series of from four to fifteen different scenes. In the distribution of these scenes over the surfaces of sarcophagi, we find not less striking evidence of a tendency to symmetrical arrangement and balance combined with an effort to adjust the given group to the form or the division of the field in which it finds its place.

As in the examination of the sarcophagi bearing simple ornamentation we found the centre to be the chief point of interest, so on the more elaborately decorated sarcophagi the centre receives in all but a few instances a strong emphasis. This is particularly true of the representations of Christ surrounded by his disciples. Although the scene often fills the

[1] G. 316, 4 ; 323, 5 ; 334, 1, 3. [2] G. 319, 1 ; 333, 1 ; 334, 1.

[3] Schultze, *op. cit.* p. 167.

entire face and both small sides of the sarcophagus, yet, on the other hand, it is often reduced until only one or two attendants are left at each side. In this case the group loses much of its independent value, and becomes a mere central group on a par with those surrounding it. It is then still further simplified by a substitution of the *labarum* for the figure of Christ, and in this form frequently occupies the middle one of a series of intercolumniations.[1]

Next to this type that which occurs most frequently as a central figure is the *orans*. Its independence as a central element is often formally indicated by its separation from the adjacent groups, either by a field left free from reliefs,[2] by two columns,[3] or by two trees.[4] The same effect is secured by setting the figure before a *parapetasma*.[5] Not infrequently two men stand at the right and left in corresponding attitudes. In a few instances — reliefs of very poor execution — the figure is somewhat confused with the adjacent groups.[6]

The Good Shepherd when employed as a central figure is not often associated with biblical scenes. An instance of such a grouping is afforded by a Gallic sarcophagus.[7] The subject is more frequently found filling a central panel,[8] and once has a place within the central intercolumniation of a series of five, the other four being filled by the four Horae.

Of the New Testament miracles, the multiplication of the loaves and fishes, which received the most symmetrical treatment, has, in several instances, been employed as a central group.[9]

The Samaritan woman at the well occurs as the central group on a sarcophagus found in Rome.[10]

Daniel between the lions was used more frequently as a central element than any other Old Testament theme. Thus

[1] G. 335, 2–4 ; 350, 1, 2. 　[2] G. 377, 1. 　[3] G. 369, 1, 3.
[4] G. 378, 4. 　[5] G. 360, 2; 376, 1; 380, 3. 　[6] G. 382, 2.
[7] Le Blant, *l.c.* 　[8] Cf. p. 127.
[9] G. 312, 1, 3; 313, 1, 2; and in a slightly varied form, 312, 2.
[10] G. 313, 3.

placed it occurs four times below the *imago clypeata*,[1] and three times on covers.[2]

Adam and Eve form the central group on one relief,[3] and on another,[4] Cain and Abel bringing their offerings.

It is noticeable that the subjects which from preference are given a central position on the sarcophagi are precisely those which in the above examination of the special scenes have been found to be symmetrical in composition.

Although the number of different subjects employed as central elements is small, yet these find such frequent application that a very large proportion of the extant sarcophagi show them.[5] The prominence of the central element is in fact so marked that Garrucci determined the succession of the illustrations in his *Storia dell' Arte Cristiana* almost exclusively on this basis.

In the selection of the subjects for representation at each end of the sarcophagus face, the desire to secure symmetry, together with a fitting termination, is not less evident than in the case of the central group. This is the more surprising because the great majority of the subjects employed by the early Christians contain or consist of standing figures, any of which might have been used as terminal elements without seriously detracting from the artistic finish of the composition as a whole. The monotony, however, produced by a long line of standing figures has led the sculptors to vary the series at the ends.

The following scenes[6] are used in preference to others as terminal[7] groups. The number of occurrences of each subject is here given.

[1] G. 364, 3; 365, 2; 367, 1, 2.　　[2] G. 384, 2, 5; 308, 4.

[3] G. 310, 1.　　[4] G. 310, 2.

[5] The exceptions are: G. 313, 4; 314, 5. 6; 316, 3; 318, 1 (?), 4 (?); 361, 2; 71, 1; 372, 2 (?); 377, 3.

[6] Several have already been cited by Le Blant, *op. cit.* p. xiii.

[7] Counting also as terminal positions those on each side of the *imago clypeata*. Sarcophagi with arcades are also included contrary to the precedent set by Le Blant, *l.c.*, since these show even more clearly than the ordinary type an effort to balance the corresponding scenes right and left of the centre.

(1)	Resurrection of Lazarus	25
(2)	Resurrections of other persons	9
(3)	Vision of Ezekiel	1
(4)	Sacrifice of Isaac	29
(5)	Moses striking the rock	25
(6)	Moses receiving the law	19
(7)	Adoration of the Magi[1]	10
(8)	Handwashing of Pilate[1]	9
(9)	Job and his friends[1]	5
(10)	Offerings of Cain and Abel[1]	4
(11)	Washing of Peter's feet[1]	8
(12, 13)	Man reading, A person seated (2 each)[1]	4
(14)	Slaughter of the innocents[1]	1
(15, 16)	Saul, Stoning of Stephen (1 each)	2
(17)	Creation of Adam and Eve	1
(18)	A royal personage seated	1
		148

The following subjects, though not especially suited for use as terminal elements, occur as such:

Three Babylonians before Nebuchadnezzar	6
Miracle of the loaves and fishes	6
The Haemoroessa, Paralytic, Blind, Daniel destroying the serpent (5 each)	20
Adam and Eve, Peter receiving the keys (4 each)	8
Story of Jonah, Denial of Peter (3 each)	6
Moses and the burning bush, Daniel between the lions (2 each)	4
Miracle of Cana, an *orans*, Baptism of Christ (2 each)	6
Miscellaneous scenes (1 each)	14
	70

The most common instance of the balancing of similar terminal groups is that of Moses striking the rock and the resurrection of Lazarus. The subjects Moses receiving the law and the Sacrifice of Isaac are frequently found at each side of the *imago clypeata*. In these scenes the hand of God appearing in the clouds is made to fill the triangular space between the upper moulding of the sarcophagus face and the rim of the '*clypeus*.'[2] The frequent recurrence of the first two scenes

[1] Each of these scenes has a seated figure at the end of it.

[2] Le Blant, *op. cit.*

n connection with each other is used by Kraus[1] as evidence
or substantiating the theory that the sculptor desired to
ymbolize in them the Old Testament type and its fulfilment
n the New ('Typus und Erfüllung des Typus'). Le Blant,
owever, in the passage cited above seems to come nearer the
ruth, when he says that the desire mentioned above to provide
. suitable terminal element for the series of reliefs guided the
rtist in the choice of these subjects.[2] Schultze[3] calls atten-
ion to the 'unmittelbare Verbindung' or 'Inbeziehungsetzen'
f these two groups, in commenting on the frescoes of *cubicu-
um* B in the catacombs of St. Callixtus. When scenes repre-
enting resurrections other than that of Lazarus[4] occur as
erminal elements, they are probably so used because of con-
usion with it. The position of the scenes of Moses receiving
he law and the Sacrifice of Isaac at the close of a series of
eliefs on each side of the *imago clypeata* led to their employ-
nent as terminal elements at the ends of the sarcophagus
ace as well. The subjects 7–14 in the above list are ren-
lered suitable by the fact that the seated figure in each may
asily be made to occupy a position at the end of the sar-
ophagus face and turned toward the centre. The eighteen
ubjects in the first list occur in the great majority of cases
n final positions; the twenty-nine[5] in the second list occupy
hese positions a relatively small number of times. For exam-
le, the miracles of Christ, although they belong to the most
ommon themes of early Christian art,[6] occur only two to six
imes each as terminal elements.

Besides using biblical scenes for this purpose the Christians

[1] *Real-Encyclopädie der christlichen Alterthümer*, II. p. 431.

[2] That which renders these two scenes suitable for the position is that the
omb of Lazarus in the one, and the rock with the stream of water in the other,
re solid vertical masses having the effect of a pilaster or column.

[3] *Op. cit.* p. 39.

[4] Regarding as resurrections of Lazarus only those scenes having an
edicula-like tomb.

[5] Except the first and sixth.

[6] I have noted over four hundred instances on the sarcophagi alone.

sometimes followed the practice of the pagans and chose an architectural form [1] or rocks and vegetation.[2]

In the disposition of the reliefs lying between the centre and end groups we do not note so marked an effort to secure a balance of lines and forms; yet instances in which this consideration has had its weight are far from uncommon, as the following cases will show: a scene of arrest is balanced with the miracle of the loaves and fishes [3] in ten instances.[4] The Adam and Eve group is balanced with the miracle of the loaves and fishes,[5] and with Daniel between the lions,[6] an arrest with an arrest,[7] the stoning of Paul (?) with Christ led before Pilate,[8] Peter led to punishment with Christ led before Pilate.[9] Balancing of double or triple pairs of New or Old Testament scenes which are made to correspond in general also occur; [10] likewise New Testament miracles are balanced with each other.[11] An excellent example of symmetrical compositions on a Christian sarcophagus is furnished by a sarcophagus found at Arles.[12]

The covers of the sarcophagi offer a peculiar and somewhat difficult problem to the sculptor. He is called upon to fill a field which is very low in proportion to its length; too low to admit well a standing human figure, and too long for any but a rather extended scene. The pagan sarcophagi show a number of more or less successful attempts to solve the problem. The field is often reduced to less than one-half its former length by inserting the plate for the epitaph in the centre, thus producing two fields for reliefs. Whether thus diminished in length or not, the space is usually filled with scenes that naturally demand but little height, and may be extended indefi-

[1] G. 298, 1 (an arched doorway); 299, 1–3; 300, 2–4; 301, 1, 3–5 (columns or pilasters). [2] G. 298, 1; 304, 4.

[3] The close resemblance between these groups in external form was mentioned above (p. 133).

[4] G. 314, 2, 6; 318, 4; 364, 3; 366, 3; 372, 2; 376, 1; 378, 2; 380, 4; 382, 2.

[5] G. 365, 2. [6] G. 301, 3; 322, 2. [7] G. 340, 5; 322, 2 (?).

[8] G. 346, 1. [9] G. 335, 2. [10] G. 321, 3; 366, 2; 370, 1; 379, 1.

[11] G. 319, 2; 375, 3 (paralytic and the blind); 320, 1 (the·blind and the haemoroessa); 353, 1; 403, 4 (the haemoroessa and the centurion); 353, 1 (the blind and the denial of Peter). [12] G. 361, 2.

nitely in length. Such are: (1) a train of sea animals or dolphins,[1] the former often bearing sea nymphs on their backs; (2) a train of captive women in sitting posture;[2] (3) two sphinxes facing, with vertically compressed bodies;[3] (4) a chase;[4] (5) cupids holding garlands.[5] Less frequently the required length is secured by representing a series of moments in a myth, as that of Medea in Corinth,[6] Iphigenia among the Taurians,[7] or the labors of Hercules.[8]

The Christian sculptors showed themselves no less skilful in dealing with the problem. They had the choice of several methods. They might adopt pagan subjects, reorganize and adjust the distinctively Christian subjects (in case they were inappropriate) to the new conditions, or adopt suitable Christian subjects. As a matter of fact, they resorted to all of these methods. Of the pagan subjects the dolphin was the one most frequently adopted, perhaps because of its association with the fish, the symbol of Christ. Christian compositions were altered by expanding them laterally.[9] The representations of Adam and Eve and of Daniel between the lions are somewhat capable of lateral expansion and occur several times on covers. The following scenes,[10] all rather long in proportion to their height, find frequent representation on covers: the story of Jonah (19 occurrences), the Nativity (3), the adoration of the Magi (18), the three men in the fiery furnace (6), the same before Nebu-

[1] Robert, *Die antiken Sarkophag-Reliefs*, III, pl. 12, no. 40.

[2] Robert, *op. cit.* II, pl. 32, nos. 77, 78.

[3] Robert, *op. cit.* II, pl. 18, no. 27.

[4] Robert, *op. cit.* III, pls. 38, 40, nos. 127, 132.

[5] Robert, *op. cit.* III, pl. 13, no. 48.

[6] Jason and Creusa, the children bearing the gifts to Creusa, the death of Creusa and Creon, the murder of the children, the flight of Medea (Robert, *op. cit.* II, pl. 62, no. 191).

[7] The recognition of Iphigenia and Orestes, the carrying of the image of Artemis to the shore, the battle on the shore, the flight of Iphigenia and Orestes (Robert, *op. cit.* II, pl. 54, no. 155).

[8] Robert, *op. cit.* III, pl. 33, no. 120.

[9] Good examples are found in Garrucci's work, pl. 383, 5 ; 384, 2, 4 ; *et al.*

[10] The list is not complete. The number of omissions, however, does not have any appreciable effect upon the relative proportion of occurrences.

chadnezzar (2), the crossing of the Red Sea and the fall of manna (1), the slaughter of the innocents (1), the twelve apostles (1), the striking of the rock and the arrest of Moses [1] (5). Other groups which do not possess these proportions occur only rarely on covers. Fully seventy per cent of the representations found on covers are of the third kind, subjects adopted as specially appropriate for such a field. These subjects may be divided into two classes. The first class comprises those which are composed of an extended series of seated or standing figures, while the second shows a predominance of horizontal lines.

That it was chiefly a regard for the form of the field that led the sculptors to choose these subjects for cover decorations, is proved by their occurrence in the narrow field below the *imago clypeata* on many sarcophagi,[2] and in the narrow fields resulting from the distribution of the reliefs on the sarcophagus face into two horizontal bands instead of one.[3] Noticeable is also the fact, that many biblical scenes occur rarely on covers, although they frequently appear in other positions on the sarcophagi. Such are the miracles of the Lord and several Old Testament subjects (the sacrifice of Isaac, Adam and Eve).

A similar set of conditions presents itself in the short sides of the sarcophagi. Here the field is usually scarcely long enough to admit the representation of more than one ordinary group of two or three figures without overcrowding.[4] The sculptors, therefore, in most instances selected single scenes that are either somewhat longer than the ordinary groups or are capable of lateral expansion. The groups most frequently occurring there are: the three men in the fiery furnace (4 times), Adam and Eve (8), the three men before Nebuchadnezzar (4),

[1] The two scenes are so intimately associated that the sculptors seem to have regarded them usually as a single group.

[2] The adoration: G. 358, 1; 365, 1; Jonah: G. 359, 1; 366, 3; 367, 3; Daniel between the lions: G. 310, 1.

[3] Jonah: G. 377, 1; Adoration: G. 365, 2; 377, 1; the three men before Nebuchadnezzar: G. 365, 1.

[4] The difficulty does not exist in the case of very deep sarcophagi.

Daniel between the lions (4), Adoration of the Magi (2). Others are of less frequent occurrence : Jonah, Job and his friends, Christ's entry into Jerusalem, Tabitha. A remarkable example of the departure of a sculptor from a traditional type is found in the treatment of two subjects (Moses striking the rock, and the baptism of Christ) on the ends of a Gallic sarcophagus,[1] where the composition is entirely changed. Another not less striking instance of an effort to adjust a group to the field is afforded by the treatment of the miracle of the loaves and fishes on another Gallic sarcophagus.[2] This scene[3] does not readily admit of lateral expansion, since Christ must

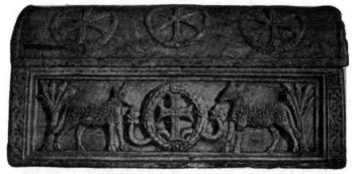

FIGURE 2. — CHRISTIAN SARCOPHAGUS IN S. APOLLINARE IN CLASSE,
RAVENNA.

stand quite close to the attendants that he may touch the loaves and fishes. The sculptor of the present sarcophagus, however, in order to fill his field, separated the figures so widely that the Christ is forced to stretch out his arms in a painful manner. A similar unsuccessful attempt to represent a subject inappropriate to a field of a certain shape is observable on the well-known sarcophagus in the Lateran Museum representing the history of Jonah.

In this discussion no account has been taken of a class of sarcophagi, which show exact geometrical symmetry and which are chiefly, though not exclusively, to be found in Ravenna.

[1] G. 398, 9. [2] G. 361, 3. [3] Cf. p. 133.

The reliefs are either modifications of the scenes representing Christ with his disciples or symbolic designs composed upon its general plan. In the former case the subordinate figures are reduced to six, four, or two. By placing the figures some distance from each other, and inserting a palm at the right and left, the scene is made to occupy the entire field. In the latter case the place of Christ is occupied by a lamb standing upon the Hill of Paradise, by a cross, or by the monogram of Christ within a circle (Fig. 2). Instead of the apostles, a lamb or a peacock stands at each side. In a few instances the centre is occupied by a vase from which the two peacocks drink. The field is not infrequently filled with a network of vines; these show an exact correspondence in form at the right and left of the centre.

IV

The preceding discussion has shown that the Christian sculptors, besides following in many cases the traditions of the pagan ateliers, were influenced (1) by a desire to secure a formal symmetry in the composition of the special scenes, (2) by a desire to secure a symmetrical arrangement of these groups on the relief field (*a*) by strongly emphasizing the centre, (*b*) by providing mutually corresponding terminal elements, (*c*) by disposing the intermediate subjects in mutually corresponding groups, and (3) by a desire to choose (or render) subjects appropriate to the shape and size of the field at their disposal.

These tendencies are not confined to or characteristic of any one geographical district. They are found in Gaul, Italy, Spain, and Numidia, although, as stated above, sarcophagi of a certain type occur most numerously in Ravenna. Neither can the chronological development of the tendencies be clearly made out, owing to the small number of monuments that can be accurately dated.

The principles here established are of great importance for the interpretation of the monuments of early Christian art.

Although they have occasionally been referred to by various writers,[1] and somewhat superficially and briefly discussed by Schnaase,[2] their influence has been overlooked by a class of archaeologists who lay great stress on the symbolic or allegorical interpretation of the remains of early Christian art. Several passages of recent scholars demand reconsideration on the basis of these principles. Garrucci,[3] whose deductions often bear a strongly subjective character, makes the following statement regarding the bond of relationship connecting the various groups represented on a given sarcophagus: "Gli antichi artisti cristiani aver dovevano una ragione che regolava la scelta dei soggetti, da loro scolpiti sulla faccia di un sarcofago, o sopra alcuna volta cimiteriale, o intorno ad una nicchia di arcosolio; questo concetto dominante, questa idea superiore, che non era il semplice fatto, vestir doveva il carattere medesimo, che le particolari representanze, le quale se non sono figurate in istorico senso, un altro certamente ne hanno, che profetico, dommatico ovvero morale si appella; e come le riunioni di soggetti in senso storico si seguono l' una l' altra, senz' altra ragione che la successione dei fatti, così le unioni in senso figurato star debbono insieme per quel concetto superiore che ha preseduto nella mente dell' artista alla loro scelta, e che è dovere del interprete andar cercando." De Waal further carries out the idea as follows:[4] "In der That haben denn de Rossi, Garrucci u. A. für einzelne Sarcophagen die tiefere einheitliche Idee, welche der Wahl und Anordnung der Bilder zu Grunde liegt, nachgewiesen; wir glauben, dass sie sich durchgängig wenigstens bei den bessern Arbeiten nachweisen lasse, . . ." The judgments passed by Garrucci and De·Waal are based mainly on the examination of the well-known sarcophagus from S. Paolo fuori le Mura, which now stands in the Lateran Museum. The correctness of their interpretation of this

[1] Cf. Schultze, *Archaeologische Studien*, p. 42, who in this connection cites Costadoni, *Il pesce simbolico*.

[2] *Geschichte der bildenden Künste*, 2d ed. One passage is cited below.

[3] *Op. cit.* vol. I, pp. 45 ff.

[4] In Kraus, *Real-Encyclopädie der christlichen Alterthümer*, II, p. 725.

monument is, to say the least, rendered very uncertain by Schultze,[1] who proposes quite a different explanation.

It is much more than doubtful that, as Garrucci and De Waal claim, the disposition of the subjects upon the sarcophagi was determined by the content ('concette dominante,' 'idea superiore,' 'tiefere einheitliche Idee '), and that they are to be read off like a homily ('omilia '). Garrucci begins with the assumption that the Christians followed pagan tradition in the disposition of the scenes. There is nothing improbable in this statement. That the pagans, however, always or even usually followed the historical order of events is by no means true; an examination of the sarcophagi published in volumes II and III of Robert's work shows that they were frequently uninfluenced by the historical order of events. An instance is the sarcophagus cover bearing reliefs illustrating the life of Oedipus.[2] It is not impossible, perhaps not improbable, that in some instances the Christians were more influenced by the idea than by the form,[3] but that the considerations discussed above played an important, if not the chief part, is shown by the fact that sixty per cent of the reliefs[4] occurring on Christian sarcophagi have had their choice, composition, or arrangement determined by such motives. This large percentage further shows that Schultze[5] has gone too far toward the opposite extreme. 'Künstlerische Motive' which have affected nearly

[1] *Op. cit.* pp. 146 ff. [2] Vol. II, pl. 60, no. 183.

[3] Professor Marucchi stated to the writer that the sarcophagus from S. Paolo was probably the only one which gave evidence of a consideration of the content in the arrangement.

[4] Leaving out of account the large class described on p. 143.

[5] *Op. cit.* pp. 173 ff.: "Der Komplex von Sarcophag-Reliefs, über den wir verfügen, lehrt übereinstimmend, dass die Künstler sich fast ausnahmslos darauf beschränkten, aus den vorhandenen Besitzstücken eine bestimmte Zahl auszuwählen und diese gegebenen Sujets, ohne Rücksicht auf eine bestimmte einheitliche Idee oder einen fortlaufenden Gedanken, einfach mechanisch aneinander zu ordnen. Sogar künstlerische Motive scheinen nur selten massgebend geworden zu sein; der Vergleich der einzelnen Gruppen mit einander erregt vielmehr die Vermuthung, dass allein das Streben nach Variation diese oder jene Bilderfolge geschaffen habe, deren Gedankenreihe die Ausleger beharrlich und in bester Überzeugung zu erkennen sich abmühen."

two-thirds of the entire number of our extant monuments can scarcely be described as being 'of infrequent occurrence' ('nur selten'). The passage from Schnaase mentioned above reads as follows:[1] "Sie (*i.e.* the subjects represented on sarcophagi) sind immer in ungerader Zahl, das mittlere Bildwerk gewöhnlich etwas breiter und voller, so dass es sich als die mitte auszeichnet, während die beiden nächsten und dann wieder die beiden entfernteren mit einander correspondieren, und zwar nicht durch ihren Inhalt, der vielmehr dabei gar nicht berücksichtigt zu sein scheint, sondern durch ihre Form." The words 'immer' and 'gewöhnlich' do not correctly describe the facts. The clause 'während . . . correspondieren' should be essentially modified in the light of the facts stated on p. 139. It has not been proved that *no* consideration was had for content in choosing the subjects. On the contrary, instances can be cited where it has entered into the question.[2]

Although, in the treatment of the sarcophagi, the sculptors often followed certain traditional modes of procedure in regard to the principles discussed in this paper, yet the application or non-application of these principles in special cases seems to have depended largely upon the choice of the artist, since some sarcophagi show no effort to apply them, besides offering in other respects noticeable exceptions to the usual mode of procedure. The arrest of Moses, for example, is regularly placed next to the striking of the rock, yet in two instances it is separated from it.[3] Once the striking of the rock is not placed at the end.[4] The composition of the scene is entirely changed in two cases.[5] The *orans* is occasionally placed out of the centre.[6] On two sarcophagi[7] the composition is in striking contrast with the usual forms.

It remains only to draw a brief comparison between classical and Christian sculpture. Symmetrical balancing of forms and

[1] *Op. cit.* III. p. 90. [2] G. 335, 2, 3. 4 ; 341, 4 ; 377, 3.
[3] G. 378, 2 ; 377, 1. [4] G. 314, 6.
[5] G. 351, 6 ; 367, 2. [6] G. 312, 3 ; 370, 2 ; 371, 2 ; 377, 3 ; cf. 371, 1.
[7] G. 374, 4 ; and the well-known one in the Lateran bearing scenes from the life of Jonah.

masses has been noted by many writers [1] as a prominent characteristic of the Greek and Graeco-Roman art in all periods of its development. An important change, however, takes place in its nature in the course of centuries. The Greeks of the fifth and fourth centuries before the Christian era display a very delicate refinement in this respect. With them it is always subordinate to the idea. As the creative imagination grew weaker, and form gained in importance, the symmetry in the composition of works of art either became more and more formal or was entirely neglected. In many instances being made an end in itself, it becomes painfully conspicuous. The Christian sculptors, who belong to the last period in the development of ancient art, following the general tendencies of their times, show only mediocre skill or in many instances total lack of it, and their efforts often result in an almost mathematical exactness or in great crudeness. This fact renders more conspicuous the presence of the influence of symmetry in Christian art, and so not only gives greater weight to the evidence cited in this paper, but incidentally exemplifies a truth often lost sight of or neglected by specialists in Christian archaeology: namely, that in the interpretation of the monuments we must in all instances take into consideration the intimate dependence of Christian upon pagan art.

<div align="right">C. L. MEADER.</div>

[1] *e.g.* De Cou, *Am. J. Arch.*, First series, vol. VIII, pls. ii, iii.

CHILDREN'S INTEREST IN THE BIBLE.

By GEORGE E. DAWSON,
Sometime Fellow in Psychology, Clark University.

CHAPTER I.

INTRODUCTION.

The following study is an attempt to apply to religious education a principle and a method generally accepted in secular education. The *principle* may be thus stated : The spontaneous interests of a child are expressions of a stage of life. They indicate, therefore, fundamental needs and aptitudes. They afford a starting point for all education, formative and reformative. If they are healthy interests, they suggest the material and method to be employed in developing character through the use of good tendencies. If they are unhealthy interests, they suggest the material and method to be employed in developing character through the disuse or transformation of bad tendencies.

The scientific study of man is opening up to us many avenues of approach to this problem of interest. First of all, we may approach it through the child's relations to the race it springs from. Embryology, comparative anatomy, and comparative psychology supply evidence that the child, in the main lines of its development, repeats racial history. Its physical and psychical life begins with a summary of what humanity before it has lived through. In bone, muscle, nerve-cell, instinct and intelligence, we find traces of ancestral struggle, and progress or retrogression. Baldwin[1] says: "What is present in the mind now, in the way of function, is due somehow to the past. Nervous inheritance provides for the apparatus, and mental inheritance sums up the experience." The implication of this view is, that a child's spontaneous interests at different stages of its development reflect more or less clearly the tendencies built up in the experience of the race. Says Dewey:[2] "There is a sort of natural recurrence of the child mind to the typical activities of primitive peoples; witness the hut which the boy likes to build in the yard, playing hunt, with bows, arrows, spears, and

[1] *Mental Development in the Child and the Race*, p. 27.
[2] *School and Society*, p. 62.

so on." These interests are transitional, as are the stages of development of which they are an expression, but they have an important relation to the child's life. They indicate, in a broad way, what the child needs, or does not need, at that particular period.

Again, we may consider a child's interests from the view-point of its individual development. Neurology is showing us that there is a definite order of growth in the brain and nervous system. First to mature is the reflex mechanism; then, the mechanism of special sensation and movement; and finally, the mechanism underlying association of ideas and other more complex psychic processes. This suggests that the child's life is first reflex and instinctive; next, sensori-motor; and, last of all, associative and rational. Here genetic psychology makes its contribution to the problem, and tells us that the suggestions of neurology are true. The child is found to be first a creature of psychic reflexes or instincts, such as hunger, fear, anger, and sympathy; then, of sensations, such as tactile, gustatory, auditory and visual; then, of the more complex psychic processes, such as memory, imagination, will and conscience. The study of children's interests discloses to us the fact that these stages of neuro-psychical development are closely paralleled by just the spontaneous interests that we should expect to crop out. In general, the first interests of the child are those centering in its instinctive life. The next are those centering in its sensations and activities. The next are those centering in its intellectual life and its more complex feelings. According as the various stages of development throw into prominence one or the other group of neuro-psychical tendencies, we may expect to find certain interests distinctive of that group and pointing the direction and progress of the child's growth.

As a result of such conclusions regarding the fundamental character of children's spontaneous interests, most of the branches ordinarily taught in the public schools are being scrutinized in a new light, and the entire question as to choice and gradation of lesson material is being reopened. Both educational experts and teachers practically engaged in school-room work are testing in various ways the educational values of the subjects taught and their adaptation to the different levels of feeling and intelligence. The elementary interests of children in the qualities of objects, such as *use*, *action*, *color*, *form*, and the like, have been studied by Binet,[1] Barnes,[2] and Shaw.[3] The distribution of interests among the subjects of the public school

[1] *Revue Philosophique*, December, 1890.
[2] *The Pacific Educational Journal*, February, 1896.
[3] *Child Study Monthly*, Vol. II, pp. 152-167.

curriculum has been studied by Taylor.[1] Children's interests in the reading matter of the school curriculum, as well as their general literary interests, have been studied by Wissler,[2] Miss Chase,[3] and Kirkpatrick.[4] Miss Ward[5] has studied the geographical interests of children; Mrs. Barnes,[6] the historical interests; and Miss Gates,[7] the musical interests. Play-interests have been studied by President Hall,[8] Ellis and Hall,[9] Gulick,[10] and Mrs. Burk.[11] The puzzle interests, as showing the more complex intellectual aptitudes of children, have been studied by Lindley.[12] O'Shea,[13] has studied children's interests in pictures, myth and nature literature, etc. While their interests as revealed in ideals, ambitions, and choice of occupations, have been studied by Barnes,[14] Miss Darrah,[15] Monroe,[16] and Jegi.[17]

It is evident, therefore, that the principle of interest has the sanction of scientific research, and that it is rapidly becoming a standard for estimating the material of instruction. I see no reason why the same principle should not be recognized in shaping the curriculum of religious education. And I see no reason why those who are concerned with the education of children in the Sunday School, or in the church at large, should not abandon the standards of adult *opinion* and adopt a standard of *facts*, derived experimentally from the consciousness of the child. As it seems to me, the evidence is conclusive that until this is done, the programme of religious instruction will lack a secure basis. We live in an age when the principles of inductive science are being applied to every form of human culture. In secular education at least, Bacon's prophetic dictum is at last coming to be recognized. ''Man, as the minister and interpreter of nature, does and understands as much as his observations on the order of nature, either with regard to things

[1] *Pedagogical Seminary*, Vol. V, pp. 497-511.
[2] *Pedagogical Seminary*, Vol. V, pp. 523-540.
[3] *Proceedings N. E. A.*, 1898, pp. 1011-1015.
[4] *North Western Monthly*, Vol. VIII, pp. 651-654; Vol. IX, pp. 188-191, and pp. 338-342.
[5] *Education*, Vol. XVIII, pp. 235-240.
[6] Barnes's *Studies in Education*, pp. 83-93.
[7] *Journal of Pedagogy*, Vol. II, pp. 265-284.
[8] *Scribner's Magazine*, Vol. III, pp. 690-696.
[9] *Pedagogical Seminary*, Vol. IV, pp. 129-175.
[10] *Pedagogical Seminary*, Vol. VI, pp. 135-151.
[11] *North Western Monthly*, Vol. IX, pp. 349-355.
[12] *American Journal of Psychology*, Vol. VIII, pp. 431-493.
[13] *Child Study Monthly*, Vol. II, pp. 266-278.
[14] *North Western Monthly*, Vol. IX, pp. 91-93.
[15] *Popular Science Monthly*, Vol. LIII, pp. 88-98.
[16] *Education*, Vol. XVIII, pp. 259-264.
[17] *Transaction of the Illinois Soc. of Child Study*, Vol. III, pp. 131-144.

or the mind, permit him, and neither knows nor is capable of more " (*Novum Organum*). In such an age, the *a priori* conclusions of adults, or guesses, more or less accurate, as to what a child needs, cannot much longer meet the requirements.

Such considerations as the foregoing have suggested the *method* employed in this study. Starting from the conclusions of current scientific inquiry as to the meaning of children's spontaneous interests, and following the same general lines that have been followed in the studies of children's interests referred to above, I have attempted to investigate the interest of children in the Bible. The questions I have kept before me are the following :

1. How do children feel towards the Old and the New Testament, respectively, at different ages?
2. How do they feel towards the various books of the Bible at different ages?
3. How do they feel towards the different scenes, stories, and characters of the Bible at different ages?
4. What is the development of interest in the scenic, narrative, and personal elements of the Bible as age advances?
5. What is the development of interest in the person and works of Jesus as age advances?

A syllabus of questions was prepared in such a way as to bring out directly and indirectly the information sought under each of these heads. Over 12,000 copies of this syllabus were given out to parents, Bible-school teachers, and public school teachers. Instructions were usually given to extend the observations over as long a period as possible, and to use such exact tests as they could in getting at the preferences of children. From the children thus studied by others, and those studied by myself, 1,000 have been selected as the basis of this paper. Most of these children live in the larger cities and towns of New England. They are mainly of American parentage, though there are included a few Italians and French Canadians. They are distributed among all the evangelical denominations, the Congregationlists predominating. There are, besides, a few Catholics. The children range in age from 8 to 20, and are about equally distributed as to age and sex. Returns were received from some adults above 20, but these are not included in the results as summarized. In general, it is believed that the children studied are typical, and that the returns afford a reasonably accurate illustration of children's Bible-interests within the ages and classes represented.

CHAPTER II.

ANALYSIS OF DATA.

§ I.

Choice between the Old and the New Testament.

I have based my estimate of children's choice between the main divisions of the Bible upon three classes of facts: (1) Their own direct statements as to their preference; (2) indirect evidence secured through their choice of Bible scenes, stories and characters; and (3) the judgment of teachers. At first thought, a child's statement that he likes one part of the Bible better than another might seem to have little value. And yet, when we look at the matter from the standpoint of every-day experience, is there not every reason for thinking that the average child, in the Christian home or Sunday School, knows what he likes, or does not like, in the Bible as in other things? When the schoolboy says he likes United States history better than arithmetic, or *vice versa*, there is no reason for doubting the genuineness of his preference. When the boy says he likes to read the life of Daniel Boone, or the story of Robinson Crusoe, better than a treatise on physics, we do not hesitate to accept his statement as significant. We adults often forget that children's likes and dislikes are more spontaneous than our own, and that they are apt to be much less disguised. There has nothing impressed me more in looking over the returns received from children than the perfect candor of their answers. This was not always the case in the returns received from adults. The latter often hesitated to express a preference, giving reasons that indicated clearly a feeling that it was not just the proper thing to like one part of the Bible better than another. Every part of the Bible is holy; therefore, the properly constituted man or woman should like one as well as another. The typical child is not troubled with any such feeling towards the Bible. If he doesn't like some portion of it, he says so; or if he doesn't like any of it, he says so. This may be additional evidence of his innate depravity. I merely state the fact. A child's statement that he likes the Old Testament better than the New, or *vice versa*, seems to me therefore to be worthy of acceptance as an index of his interest. When such a statement is, in general, confirmed by the indirect evidence of other preferences and by the testimony of teachers, one's conclusions ought to rest upon a fairly substantial basis.

At eight years old, the majority of children of both sexes prefer the New Testament; that is to say, 60% of the boys and 72% of the girls. The interest in the New Testament declines, however, during the next few years, reaching its

minimum at 14, in the case of boys, and at 12, in the case of
the girls. At this point, 32% of the boys and 40% of the
girls prefer the New Testament. At 15, the interest of the
boys remains about the same as at 14, but thereafter it rises
rapidly and steadily until at 20 years 88% prefer the New
Testament. The girls' interest rises slowly from 12 to 14, and
thereafter rises even more rapidly than the boys', until at 20
years 97% prefer the New Testament. At eight years, 40%
of the boys and 28% of the girls prefer the Old Testament.
From eight years on, the interest in the Old Testament steadily
rises, reaching its maximum at 13, in the case of the boys, and
at 12 in the case of the girls. At this point, 63% of the boys
and 46% of the girls prefer the Old Testament. Thereafter,
in the case of both sexes, the interest steadily declines, until
at the age of 20, 12% of the boys and 3% of the girls express
a preference for the Old Testament. From 13 to 19 years,
some of the boys say they have no choice, the maximum of
such being reached at 15 and 16. In the case of the girls,
this period of uncertainty reaches from 10 to 17, the maximum
being reached at 11 and 12. A graphic presentation of these
results is given in diagrams 1 and 2.

What interpretation may we place upon these results? To
begin with, the interest of the youngest children in the New
Testament is probably not a general interest in that division

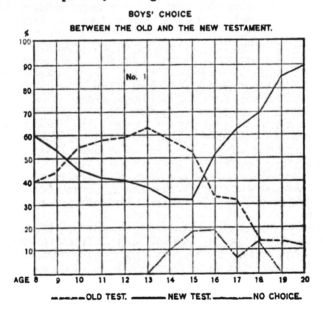

BOYS' CHOICE
BETWEEN THE OLD AND THE NEW TESTAMENT.

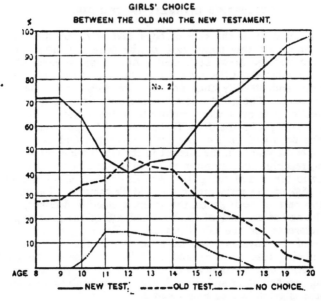

GIRLS' CHOICE
BETWEEN THE OLD AND THE NEW TESTAMENT.

No. 2

AGE 8 9 10 11 12 13 14 15 16 17 18 19 20

———— NEW TEST. ————OLD TEST.———.——— NO CHOICE.

of the Bible. It centers rather in the Infant Jesus. A child is always of interest to other children, whether in life or story. The scenes and incidents of the Bible relating to childhood are prime favorites with most of the younger children that have been studied. Thus, the birth of Jesus, the finding of Moses by Pharoah's daughter, Jesus blessing little children, and the flight into Egypt are among the most commonly mentioned. To this natural interest in the childhood of the Bible must be added the special interest derived through Christian art and literature, dealing with such events as the Annunciation, the Nativity, and the Flight into Egypt, much of which the average child has some acquaintance with. Besides these aids to interest, we must also take into account the associations of Christmas time, which give the birth and childhood of Jesus a unique place in children's affections. It is not surprising, therefore, that the New Testament, which contains the stories and scenes relating to a child naturally interesting, and rendered more so by the art, literature, and customs of Christian civilization, should be preferred by so many of the younger children.

This element of attractiveness aside, however, it is probable that the New Testament does not naturally appeal so strongly to children as does the Old. So early as eight years, 40% of the boys and 28% of the girls prefer the Old Testament,

ard these percentages steadily rise for some years. This indicates that even in the youngest children, to whom the Infant Jesus is especially attractive, there are other forces at work in determining their interest. These forces assert themselves more and more, and during the years from nine or ten, on to thirteen or fourteen, they shift the center of interest to the Old Testament. How strong these forces must be, is suggested by another important fact, that should be taken into account in this connection. In general, religious teachers lay much more stress upon the facts and teachings of the New Testament than upon those of the Old. As shown by this study, the interest of adults is overwhelmingly in favor of the New Testament. Estimating the child from the adult standpoint, these adults impose their interests upon the children they instruct. Very naturally, there is thus given to the children an interest in facts, doctrines, etc., that is not spontaneous, but derived from the teachers. This derived interest undoubtedly enters into the choice of children. And yet, as we have seen, the forces at work in these children's natures are sufficiently strong to offset the bias induced by adult example and to turn the balance in favor of the Old Testament. *Everything considered, it is probable that the typical boy or girl from nine years to fourteen, is more attracted to the Old Testament than to the New.*

There is some light shed upon this matter by the scientific studies already referred to. If it be true that the various levels of instinct and intelligence in racial life have their outcroppings in the development of the individual child, and if we may regard the development of the Hebrew people as typical of the life of the race as a whole, ought we not to expect that the main centers of children's interest in the Bible will shift from the Old to the New Testament as manhood and womanhood approaches? To illustrate: The fundamental human instincts may be classified as *egoistic*, or selfish, and *altruistic*, or unselfish. Psychologists are agreed that racial development, as well as individual development, is away from the predominantly selfish instincts towards the predominantly unselfish instincts. Now the Old Testament scriptures appeal more especially to the former class of instincts; while the New Testament scriptures appeal rather to the latter. Fear, anger, jealously, hatred, revenge, etc., are conspicuous attributes of God and men, in the Old Testament; while sympathy, compassion, trustfulness, and love are the most prominent attributes of God and men, in the New. In short, the Bible moves from an egoistic point of view regarding God and mankind, to an increasingly altruistic point of view. The parallelism between the development of the child and the devel-

opment of the Bible is therefore clearly suggested, so far as concerns these great central instincts of the human soul.

Again, psychologists are agreed that the human race has developed from a predominantly sensori-motor type towards a predominantly associative and rational type. Primitive man lives in his senses and activities. The world is essentially a sensuous world to him. He delights in everything that appeals strongly to sight, hearing, touch, taste, and smell. This explains his fondness for bright colors, massive sounds, pungent tastes, strong odors, and the like. His motor nature is also dominant in his enjoyments, as is shown especially in his fondness for dancing, wrestling, and other feats of strength and prowess. The individual child likewise develops from the sensori-motor to the rational in its nature and interests. In vividness of sense-impressions and in constancy and variety of spontaneous movements, children surpass adults. Gilbert[1] found by testing school children that the great period of sense-development is from early childhood up to 10 or 12. The play-activities of children during the same period are very marked, as many investigations have shown. Out of this sensuous and intensely active life of children spring those interests that reveal themselves in a fondness for spectacular scenes, feats of skill and daring, and the general flesh-and-blood heroism so attractive to boys and girls. Studies made of children's reading interests bring to light the fact that in the period just preceding adolescence there is a marked fondness for the heroic in literature. Thus, Principal Atkinson,[2] of the Springfield, (Mass.) High School, found that the books read the preceding summer by an entering freshman class were largely biographical, including a range of heroes from Charlemange and Cromwell to Daniel Boone and Buffalo Bill. In general, an ideal or heroic character placed in a historic situation seemed to appeal to the largest number.

Now the Bible illustrates a similar development from the sensori-motor type of life towards the associative and rational type of life. The Old Testament abounds with spectacular scenes, such as the fight between David and Goliath, and Daniel in the lion's den; thrilling stories, such as those associated with the lives of Moses and Joseph; and heroic characters, such as Abraham and David. There is throughout a combination of scenic splendor, striking episodes, and unique personalties that impresses the senses most vividly and appeals to the love of dramatic action. It is true, of course, that the motive

[1] *Studies from the Yale Psychological Laboratory*, Vol. I, p. 80, and Vol. II, p. 90.
[2] *Proceedings of the N. E. A.*, for 1898.

of the Old Testament is religious. There was no design on the part of its writers to present a pageant of striking characters and incidents. But the method is, nevertheless, that of the primitive mind, which seizes upon the sensuous and the dramatic, rather than the rational and reflective, elements of life and religion. Here again, therefore, we find a parallelism between the development of the child and the development of the Bible.

This parallelism between the unfolding of racial consciousness as revealed in the Bible and the unfolding of the child's consciousness, has further illustration when we direct our attention to the older children included in this study. Here we find that as life ripens into adolescence, the centers of interest shift to the New Testament. From 15 years on, in the case of the boys, and from 14 years on, in the case of the girls, the preference for the latter becomes more and more marked. Now, all the studies of adolescence tend to show that this period marks a psychical, as well as a physical rebirth. The child is born out of an individualistic type of feeling into a social type of feeling ; out of a sensori-motor type of intelligence into a reflective type of intelligence ; out of an *egocentric* and *sensuous* life, in short, into a life *altrocentric* and *rational*. Hancock [1] has found by experimental tests that children's ability to reason increases rapidly with the approach of adolescence. Lancaster [2] shows that during this period altruistic feeling is extremely active in both sexes, revealing itself in philanthropic work of all kinds. Starbuck [3] and Gulick,[4] by statistical studies of conversion, find that the great majority of accessions to the church take place between 12 and 20 years of age. We may conclude, therefore, that just as Jesus and the Christian type of consciousness represented a new birth for the race, so does the flowering out of the altruistic and reflectively religious consciousness of adolescence represent a new birth for the individual. In other words, just as the personality of Jesus and his regimen of life sum up the ideals towards which the race is struggling, so do they sum up the ideals towards which the individual soul is struggling.

As regards the children who express no preference between the Old and the New Testament, it will be observed that they fall within those ages when the interests of the majority of the children are shifting from the Old to the New Testament. From what has already been said, it is evident that the trans-

[1] *Educational Review*, Oct., 1896.
[2] *Pedagogical Seminary*, Vol. V, pp. 61-128.
[3] *American Journal of Psychology*, Jan., 1897, and Oct., 1897.
[4] *Association Outlook*, Springfield, Mass., Vol. VIII, pp. 33-48.

formation from the egoistic, sensuous life of childhood, to the altruistic, reflective life of adolescence, must occasion a severe conflict of interests. This general conflict of interests is doubtless reflected in the inability, or disinclination, of some to choose between the Old and the New Testament. Teachers and parents often remark upon the indifference of some children during these beginning years of adolescence. As is well known in Sunday-School work, this is a period when children are kept in their classes with difficulty. The study of children reveals the fact that early adolescence is the birth-time of doubts and vacillations in conduct. Now probably these phenomena are due in part to the physical and psychical strain of the period, more intense in some children than in others. But I venture to suggest that all such indifference, doubt, or whatever it may be, is largely due to the conflict of interests incident to the transition from one type of life to another.

To conclude this discussion regarding the choice of children between the Old and the New Testament: Have we not in the development of children's interest in the main divisions of the Bible a verification of an age-long belief? The Christian world has long been familiar with the thought that the Old Testament is preparatory to the New. The historical events recorded in the former have their culmination in the latter. The prophecies springing from the life of ancient Israel anticipate the life and utterances of Him who came out of Nazareth. The laws given at Sinai have their fulfillment in the Sermon on the Mount. In short, in the words of Paul:[1] "The law was our schoolmaster to bring us unto Christ." This popular view of the relation between the Old and the New Testament is being confirmed by the conclusions of modern biblical scholarship. The Hebrew Scriptures illustrate the general laws of development in the life of a people. Each step in the unfolding of Hebrew institutions, customs, laws, and moral and religious ideals, is related to all that precedes and all that follows. The new dispensation could not come till the old had prepared at least a few choice souls for its reception. The words of Paul,[2] "When the fullness of time was come, God sent forth his Son," have thus their modern reading in the theory of human development.

§ II.

Choice among the Books of the Bible.

The data summarized under this head contribute to the same general results as those reached in the preceding section. In addition, however, they bring to light the interests of children

[1] *Epistle to the Galatians*, Chap. 3, Verse 24.
[2] *Ibid*, Chap. 4, Verse 4.

from a more distinctively educational point of view. The material of the Bible, as commonly given to children, may be classified under the following heads: (1) Historical (including the geographical), (2) prophetic, (3) gospel, and (4) doctrinal. To these may be added the literary, including the poetic and wisdom books. Following the lines of this classification, I have grouped the various books of the Bible for which the children indicated a preference, under six heads: *Historical, prophetic, poetic, wisdom, gospel,* and *doctrinal.*

At eight years of age, the choice of the boys is equally divided between the historical and the gospel books. During the next three years, the interest in the historical books increases, reaching in the eleventh year 60%. Thereafter, the historical interest declines, falling to 22% in the fourteenth year and to 8% in the twentieth year. The interest in the gospel books falls off rapidly from the eighth to the thirteenth year, reaching at that time 22%. Then it rises steadily and rapidly to the twentieth year, when it reaches 78%. Interest in the poetic books begins at 9 years, rises steadily to the fourteenth year, when it reaches 33%, and then falls off more or less irregularly to the twentieth year, when it stands at 14%. From 12 to 15, there is some interest shown in the prophetic books, the maximum being 18% in the fourteenth year. There is also a slight interest shown in the wisdom books from 16 to 18, the maximum being reached at 17, when the percentage is seven. Not a single boy between the ages of 8 and 20 expressed a preference for a book that could be classed as doctrinal.

The girls also distribute their preferences equally between the historical and gospel books to start with. The historical interest then declines to 37% at 10 years, rises steadily to 46% in the 13th year, and thereafter falls to zero in the 19th year. The interest in the gospel books falls to 30% in the 12th year, and thereafter rises steadily and rapidly to 90% in the 20th year. The poetic interest appears first in the 9th year, rises to 20% in the 11th and 12th years, and then slowly declines to zero in the 17th year. Interest in the prophetic books has a somewhat uneven run from 12 to 20, reaching its maximum at 12 and again at 17. Interest in the wisdom books begins at 14, being at its maximum from that age to 15, and then declining to zero at 20. A slight interest is shown in the doctrinal books from 19 to 20, the maximum being 10%, at the latter age.

In general, therefore, we have a somewhat wide distribution of interests up to the beginning of adolescence, with some advantage in favor of the historical books, especially on the part of the boys. Literary, prophetic, and wisdom books come more into favor in the years just preceding adolescence

and maintain a somewhat prominent place throughout the
early years of that period; while the gospel interest stands
out conspicuously as the pre-eminent adolescent interest.
These results are brought out more graphically in diagrams 3
and 4.

In interpreting the foregoing results, we have first to note
that, in general, the preferences coincide with those considered
in the preceding section. Thus, the preference for the his-
torical books, which are mainly in the Old Testament, run
more or less parallel with the preference for the first division
of the Bible. The preference for the gospel books, which are
in the New Testament, run more or less parallel with the
second division of the Bible. This is not so much the case
with the younger children. Here the choice of gospel books
is not so general as is the choice of the New Testament as a
whole, while the choice of historical books is more general
than is that of the Old Testament as a whole. This dis-
parity of choice is due, in part at least, to some children's
choosing the Acts of the Apostles, which was classed among
the historical books. In general, therefore, the choice among
the books of the Bible at different ages has the same explana-
tion that has already been given to account for the choice
between the Old and the New Testament. The preference

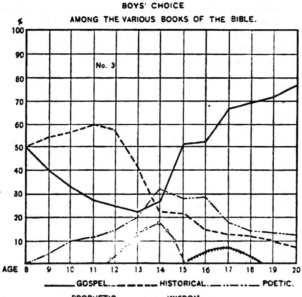

BOYS' CHOICE
AMONG THE VARIOUS BOOKS OF THE BIBLE.

No. 3

_____ GOSPEL._ _ _ _ _ _ HISTORICAL._ .._ .. ._ POETIC.

•—•—•— PROPHETIC. ʜʜʜʜʜʜʜʜ WISDOM,

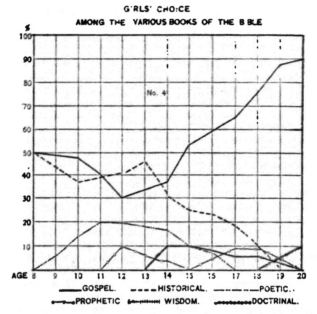

GIRLS' CHOICE
AMONG THE VARIOUS BOOKS OF THE BIBLE

of the younger children for the gospel books is due to the fact that these books contain the scenes and incidents associated with the infancy of Jesus. The preference of the older children for the historical books is due to the fact that these books contain the elements most attractive to the egoistic and sensuous natures of such children, while the choice of gospel books by adolescents is explained by reference to the general ripening of the altruistic and reflective life at that period.

However, we may look at children's choice among the books of the Bible from a somewhat different point of view and in greater detail. First, as to the choice of historical books. It has been found that the interest of public school children in history and geography is marked during the period from 9 or 10, on to 13 or 14. Mrs. Barnes[1] found that the historic sense has a rapid development during these years. Her curves are very similar to those shown in the above diagrams. She concludes that from seven years on, history becomes an increasingly attractive subject for children, though the larger historical interest does not develop, perhaps, before 11 or 12. Miss Ward,[2] who studied the geographical interests

[1] Barnes's *Studies in Education*, pp. 43-52, and 83-93.
[2] *Education*, Vol. XVIII.

of several thousand children, finds that there is a marked interest in places, especially in places that have human associations. I have studied the general school-interests of over 1,000 children in the public schools of Springfield, Mass., and find that both the historical and the geographical interests begin to be prominent at 10 years. These facts make it probable that children from 9 or 10 years, on to 13 or 14, will be naturally interested in the historical and geographical elements of the Bible. There is also another fact to be taken into account in this connection. There is evidence for believing that children during this period have especial aptitude for memorizing. All those studies that involve a constant exercise of memory, such as language, arithmetic, geography and history, are more easily taught to children at this time. Street[1] concludes from his study of language-training that children acquire languages most readily from 8 to 12 years. Bolton[2] found that the memory of children for numbers practically reaches its maximum in the grades below the high school. Shaw[3] found that the memory of children for the essential elements of a story culminated just before the high school period is reached. Scripture[4] found that the time-memory in children reaches its greatest accuracy at about 13 or 14 years. These investigations indicate that the period of life in question is peculiarly adapted for *fact-studies*, which make great demands upon the memory. And this again renders it probable that children's preference for the historical books of the Bible is based, in part, upon certain special intellectual aptitudes.

Next, as to the choice of prophetic and literary books. "Prophecy" consists of two things as applied to the Bible: (1) The revelation of coming events; and (2) The speaking forth of the deeper truths of life. Perhaps, in the last analysis, these two things are one, but we ordinarily consider them distinct. Now, adolesence is the "Golden Age" of prophecy. It is then that the individual consciousness is reborn into the consciousness of the race. The deeper truths of existence are yearned for and glimpsed. There is a moral and religious ferment, and the loftiest and the most sordid ideals struggle for mastery. Moreover, it is then that the human soul looks most anxiously into the future. Perhaps it looks farthest into the future. Certainly it tries then, as at no other time, to learn its horoscope. Witness the idealizing, the day-dreaming, the fortune-telling devices of young peo-

[1] *Pedagogical Seminary*, Vol. IV, pp. 269-293.
[2] *American Journal of Psychology*, Vol. IV.
[3] *Pedagogical Seminary*, Vol. IV, pp. 61-78.
[4] *Thinking, Feeling, Doing*, p. 251.

ple. Lancaster[1] in his study of the psychology and pedagogy of adolescence, has collected data illustrating both these aspects of the prophetic spirit. The longing for the more vital truths of life, and the far-looking into the future. recur again and again in the returns received from the youth of both sexes. Adolescence is also the period when literary feeling and aspirations ripen. These are offshoots of the æsthetic nature, and studies of adolescent life bring to light the fact that all the forms of æsthetic feeling and activity begin to crop out early in this period. In the study of children's school-interests already referred to, I have found that the interest in painting. drawing and music increases rapidly from 12 years on. Lancaster found that of 100 actors, 50 poets, 100 musicians, 50 artists, and 100 writers, the majority had achieved success in their art before the age of 20. showing that the life of æsthetic feeling and idealism is well developed in early adolesence. The preference of children for the prophetic and literary books of the Bible, in the early adolescent years, is, therefore, doubtless an expression of more general moral and æsthetic interests.

Finally, as to the choice of gospel books: This is pre-eminently the choice of the adolescent. From what has already been said, it is evident that adolescence needs, and seeks, above everything else, some kind of a philosophy and regimen of life. Life has become a thing fraught with a new but vague meaning; the struggle is to make its meaning clear. Life has become a larger, richer thing; the struggle is to learn the method by which its largeness and richness may be personally realized. The quickening of moral feeling leads to self-scrutiny and an apprehension of more or less friction between the self and the best environments. The quickening of the religious feelings begets a desire to get adjusted to the largest and best ideals. The quickening of the sense of life, as lived through others and for others, awakens the impulse to become a part of the great cosmic struggle for more complete existence. In the gospels is found the Christian philosophy of life; and in the gospels is found the Christian regimen of life, in its broad outlines. For the gospels reveal the personality of One who "came that they might have life and that they might have it more abundantly," and Christian philosophy sums itself up in personal character. And the gospels reveal broadly the Christian regimen of life, for this is simply to follow where He leads. It is not surprising, therefore, that, when the meaning and method of life are sought with such earnest zest as during

[1] *Pedagogical Seminary*, Vol. V, pp. 61-128.

the adolescent years, the Christian explanation of what life is, and how it may be lived, should be of interest.

§ III.

Choice of Bible Scenes, Stories and Characters.

The data collected under this head bear upon three points: (1) The scenes, stories, and characters that are most liked; (2) The development of interest in the scenic, narrative, and personal elements; and (3) The comparative interest in the three classes of elements at different ages. Preferences were shown for 57 different Bible scenes, 26 from the Old Testament and 31 from the new. Of these, the fifteen most popular scenes are the following:

		BOYS.	GIRLS.	TOTAL.
1.	Daniel in the Lion's Den,	53	52	105
2.	The Crucifixion,	45	33	78
3.	The Birth of Jesus,	27	38	65
4.	Jesus Blessing Little Children,	13	42	55
5.	The Lord's Supper,	30	23	53
6.	Feeding the Five Thousand,	25	24	49
7.	Jesus Walking on the Sea,	10	27	37
8.	The Resurrection,	18	18	36
9.	The finding of Moses,	13	21	34
10.	The Raising of Lazarus,	8	24	32
11.	The Transfiguration,	10	21	31
12.	Jesus before the Wise Men,	5	20	25
13.	Jesus' Triumphal Entry,	12	13	25
14.	The Woman at the Well,	15	10	25
15.	The Stilling of the Tempest,	12	12	24

It will be observed that all but two of these fifteen scenes are from the New Testament. Probably this is to be accounted for, in part, by the influence of pictures. Many of the scenes mentioned are the commonest subjects of the masterpieces of Christian art, reproductions of which appear in pictorial Bibles, Sunday-School literature, and the like. It is also due, undoubtedly, to the intrinsic attractiveness of the personality and works of Jesus. All of the scenes from the New Testament have him as their central figure, three presenting him as a child or in connection with children. The most popular scene of all, however, is Daniel in the Lions' Den. This is unquestionably one of the most graphic scenes in the Bible when given pictorial representation, as it often is, in religious literature. This fact is sufficient to account for its popularity. The popularity of the crucifixion is doubtless due, in part, to Christian art and to the emphasis placed in

religious teaching upon the death of Jesus. It is also, probably, due to a lurking fondness in some children for cruel and tragic scenes. One boy, in describing his preferences, said, "I like anything that has murder and such things in it." It is to be hoped that not many children share this feeling. But there is here suggested a possibility that should inspire caution in those who are disposed to dwell upon such scenes in religious teaching.

The choice of Bible stories has a total range of 38, twenty-three of these being drawn from the Old Testament and 15 from the New. The most popular of these are the following:

		BOYS.	GIRLS.	TOTAL.
1.	The Selling of Joseph,	48	99	147
2.	David and Goliath,	50	50	100
3.	Daniel and the Assyrian Kings,	43	41	84
4.	Moses and Pharoah's Daughter,	25	44	69
5.	The Story of Ruth,	10	41	51
6.	Story of Jesus' Birth,	20	29	49
7.	The Prodigal Son,	15	23	38
8.	Story of Noah's Ark,	20	18	38
9.	The Calling of Samuel,	16	16	32
10.	Samson and the Philistines,	20	7	27
11.	The Flight into Egypt,	3	15	18
12.	Jonah and the Whale,	10	7	17
13.	Story of Esther,	7	10	17
14.	Changing Water into Wine,	5	12	17
15.	The Good Samaritan,	5	11	16

It appears from this that Old Testament stories are more popular than are New Testament stories, the five standing highest in the list being drawn from the Old Testament. These five stories have all the essential elements that make such productions attractive to the young,—heroic characters, heroic situations, heroic actions. The same is true, in a somewhat less degree, of the remaining five stories drawn from the Old Testament. From all that has been said about the egoistic sensuous life of children in the earlier years, we are prepared to understand why the story-interest should center in that division of the Bible. The most popular story in the New Testament is that of Jesus' birth, many of the youngest children choosing this, as we might expect from what has preceded. But one story in this group of fifteen is based upon a miracle, and this probably owed its interest for children to the human elements involved. In general, few children expressed a liking for miracles.

A total of 45 Bible characters were chosen—25 Old Testament

characters and 20 New Testament characters. The fifteen most popular are the following:

		BOYS.	GIRLS.	TOTAL.
1.	John the Disciple,	48	104	152
2.	Peter,	48	77	125
3.	Jesus,	48	66	114
4.	David,	49	65	114
5.	Moses,	44	59	103
6.	Paul,	31	63	94
7.	Joseph,	32	43	75
8.	Daniel,	19	36	55
9.	Samuel,	13	17	30
10.	Ruth,	7	17	24
11.	Elijah,	16	8	24
12.	Abraham,	10	11	21
13.	Solomon,	11	9	20
14.	John the Baptist,	8	7	15
15.	Mary, the Mother of Jesus,	4	11	15

From the foregoing, it appears the three characters most often chosen, are New Testament characters. The boys distribute their preferences equally among these. A much larger percentage of the girls, however, choose John the Disciple, while more of the girls choose Peter than Jesus. The qualities found in John are sufficient to account for his popularity. He is a gentle, loving, yet manly character. He is doubtless also loved for the sake of his Master, whom he so fittingly portrayed in the fourth gospel. The prominence of Peter is not so easily understood. Aside from his rugged, virile manhood, we have probably to take into account his unique place in Jesus' regard and the distinction he has enjoyed in church-history. It may seem strange that Jesus should rank lowest in the total preferences shown for these three New Testament characters. I am inclined to believe that this is not accidental, however. It is doubtful if the younger children at least were influenced by the theological estimate of Jesus. They probably see only the human Jesus, and if they think of Jesus as a man, when they are asked to express a choice between him and another man, they do so with the same candor that they show in other matters. I doubt not that Jesus is naturally the most attractive character in the Bible for children of all ages. This study shows that, as a child, he is more often chosen by the younger children than is any other character. It seems to me probable that this preference would continue among older children if the latter were allowed spontaneously to grow into an appreciation of the adult Jesus. But religious teachers are usually so anxious to present Jesus to children as a divine per-

son, and children's minds are so unable to grasp the mystical implications of this dogma, that the human Jesus is taken away from them and the divine Jesus is made an intellectual abstraction. The result is, that the child can love neither the one nor the other. This religious forcing will inevitably shift the interest of a child to a character whose simple humanity it can understand and love. I believe this will account for the preference which so large a percentage of the girls show for John.

Among the Old Testament characters chosen, the most prominent are David, Moses, Joseph and Daniel. This is what we would expect from what we have already learned of children's preference for the heroic and dramatic elements of the Old Testament.

As regards the development of interest in the scenic, narrative, and personal elements of the Bible, we find: (1) That, in general, the interest in scenes and stories is somewhat more marked in the younger children than in the older; and (2) that the interest in characters increases with advancing age. Reference to diagrams 5 and 6 makes this sufficiently clear. From these diagrams, it will also be observed that the comparative interest in the three classes of elements at different ages is overwhelmingly in favor of the characters. *The larger percentage of children of all ages are attracted more strongly to the personal elements of the Bible than to any other.* This is shown not alone by the preference expressed for characters, but also by the choice of scenes and narratives themselves. Thus, of the 57 scenes mentioned, all but four have their center of interest in persons; while of the 38 Bible stories selected, all but three owe their interest to the characters that take part in them.

Sufficient has already been said in this and preceding sections to explain most of the above results. The overwhelming interest of children of all ages in the personal elements of the Bible deserves further discussion, however. The human interest of children has been generally observed by those who have studied the psychology of childhood. To adapt the sentiment of the Latin poet, nothing of human concern is foreign to the child. The first efforts of the little boy to realize his artistic ideals are usually pictures of men. The principal play-activities are reproductions of the lives of adult men and women. The reading interests of older children run mainly along the line of biography, or fiction in which the character element is prominent. Atkinson,[1] in commenting

[1] *A Year's Study of the Entering Pupils of the Springfield, (Mass.) High School, (Proc. N. E. A., 1898).*

COMPARATIVE CHOICE, AMONG BOYS, OF BIBLE-
CHARACTERS, STORIES, AND SCENES.

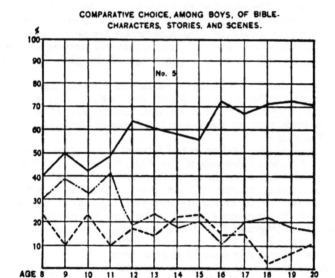

————CHARACTERS. - - - - -STORIES. . —. . —. .——SCENES.

COMPARATIVE CHOICE, AMONG GIRLS, OF
BIBLE - CHARACTERS, STORIES, AND SCENES

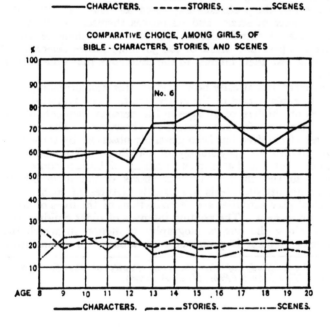

————CHARACTERS. - - - - -STORIES. . —. . —. .——SCENES.

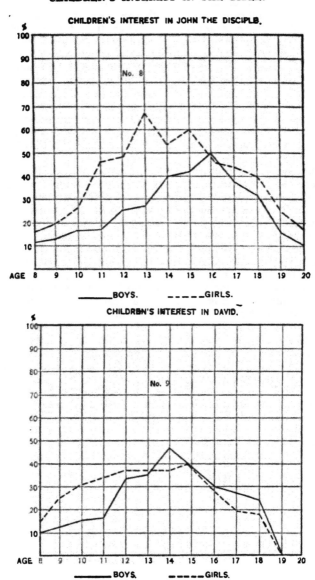

CHILDREN'S INTEREST IN JOHN THE DISCIPLE.

No. 8

AGE 8 9 10 11 12 13 14 15 16 17 18 19 20

———————BOYS. _ _ _ _ _GIRLS.

CHILDREN'S INTEREST IN DAVID.

No. 9

AGE 8 9 10 11 12 13 14 15 16 17 18 19 20

———————BOYS. _ _ _ _ _GIRLS.

We have, therefore, the outstanding fact that children's interest in Jesus, as an adult, is an adolescent interest. This what we should expect from the numerous tendencies of

this period of life, elsewhere referred to. In considering the general interest of adolescents in the New Testament, we found that this runs parallel with the ripening of the altruistic and reflective consciousness. Thus, it is the opinion of those who have studied the religious aspects of adolescence that the character and teaching of Jesus appeal strongly to the adolescent mind. Lancaster[1] says: "Adolescents will sacrifice and perform duty for the Master as at no other time of life. Instruction should take the form of an appeal to free, spontaneous loyalty to the King, and Jesus should be presented as the ideal, heroic God-man. His self-sacrifice and self-denial, his suffering and passion may be taught with the assurance that they will appeal most strongly to the soul-life of the adolescents."

This intrinsic attractiveness of the personality of Jesus for young people, appears in what is called conversion. The meaning attached to the latter by evangelical Christianity is essentially the acceptance of Jesus as a personal Saviour. As has already been pointed out, statistical studies of conversion show that this is an adolescent phenomenon. Starbuck[2] found that the curve of conversion reached its maximum at 16, for both sexes, though a considerable percentage of conversions among the girls took place in the 13th year. Gulick[3] found that the maximum for boys was reached in the 18th year, with a large number falling in the 16th year also. In general, these investigations show that most young people who enter the church, do so in the first half of adolescent life. This virtually coincides with the period of maximum interest in Jesus, as shown in diagram 7. The attractiveness of Jesus for adolescents is therefore but one of a large class of phenomena, which the investigation of adolescent life is bringing to light. It would seem to afford another and weighty reason for concluding that this period of life is the time when the human soul spontaneously opens to the ideals of character and conduct which Jesus represents.

[1] *The Psychology and Pedagogy of Adolescence, Pedagogical Seminary,* Vol. V, p. 128.
[2] *Psychology of Religion.*
[3] *Association Outlook,* Vol. VIII, pp. 33-48.

CHAPTER III.

CONCLUSION.

The most general conclusion growing out of this study of children's Bible interests, is that it confirms the results obtained from similar studies along other lines, and is, in turn, confirmed by them. This fact goes far towards offsetting any suspicion as to method or completeness of data. It cannot be accidental that children's interest in the Old Testament falls mainly in a period of life which experimental studies of children's mental aptitudes, as well as their historical, geographical, reading, play and other interests, have shown to be characterized by just the instinctive tendencies and intellectual qualities that the material of the Old Testament most powerfully appeals to. Nor can it be accidental that adolescent interest in the Gospels, and in Jesus, runs parallel with the general altruistic and religious interests brought to light by the various studies of adolescence. It seems to me, therefore, that this concurrence of results does two things: (1) It vindicates the point of view and method of the present study; and (2) it serves to strengthen the conclusions which the study suggests. These conclusions are as follows:

1. Children up to 8 or 9 years are more interested in the portions of the New Testament which give accounts of the birth and childhood of Jesus. They are interested, however, in Old Testament stories relating to the childhood or youth of characters like Moses, Samuel, Joseph and David. This suggests that children of this age should be given instruction in the Bible from the view-point of the childhood of the Bible, beginning with Jesus and using the others for purposes of comparative study. Of course, such material would serve only as the nucleus of the primary curriculum. Around this could be grouped a great diversity of material derived from studies in nature, art, industries, and other departments of human life, so selected and presented as to give the children a religious outlook upon their environments. A great deal of the material of the corresponding grades of the public schools could be appropriated, and given an ethical and religious interpretation. This could be done most effectively, as it seems to me, through the medium of this great world-soul, who summed up in his character and life all the most fundamental human interests, who came into the world through the gateway of childhood, and who said: "Suffer little children, and forbid them not, to come unto me, for of such is the kingdom of heaven."

2. From 9 years, on to 13 or 14, children are more interested in the Old Testament. This interest shows itself more especially in a fondness for the historical books, the literary and prophetic books, and the heroic and dramatic elements gen-

erally. This suggests that the religious curriculum for this period should occupy itself with the history, geography, literature, prophecy, and general moral and religious contents of the first division of the Bible. It would coincide with the grades of public school work above the primary and below the high school, in that it would deal essentially with *fact-studies*. It would really mark the beginning of formal biblical instruction, the instruction of the earlier period being more general and unsystematic. The order of material would be: (1) history and geography, (2) literature, and (3) prophecy. The moral and religious elements would be involved throughout. Incidentally, the history of other ancient peoples, and, at least the elements of comparative religion could be taught. Much might profitably be made of the manners and customs, and the social life, especially as reflected in the industries, religious and political ceremonials, and feats of arms. Sacred art might be brought into requisition to aid in the study of characters and customs. This is the period for memorizing selected passages of scripture, such as Psalms, Proverbs, etc.

3. Children in the adolescent period show a decided interest in the New Testament, especially in the four Gospels and the Acts of the Apostles. They also show a very special interest in Jesus and the principal Disciples. The interest in John the Disciple, is an early adolescent interest, while the interest in Jesus culminates somewhat later, and is sustained throughout. This suggests that the material of instruction for adolescence should be derived largely from the New Testament. It would center in Jesus and his teachings, the principal Disciples being studied incidentally. The study of types of Christian character and the development of Christian thought and institutions might very profitably be extended to the later history of Christianity. Every possible side-light of history, literature, art and science could be utilized in revealing the ideals of Christian manhood and Christian society. The religious instruction of this period should, it seems to me, aim to establish a correct personal relationship with the Divine Father and with society. Altruistic and religious feelings should be made use of to stimulate and guide a spirit of co-operation with God and men.

4. At all ages, children feel more interest in persons than in any other elements of the Bible. Even Bible scenes and stories appeal to them mainly through the man, woman, or child that is the center of the scene or the principal actor in the story. This suggests that the Bible should be given to children, of all ages, through its personal element. Thus, the Bible should be given to young children through the child Jesus. Everything in either the Old or the New Testament that could be properly used to make this human child Jesus intelligible and lovable should be employed. No theological

explanation of his birth, nature, or mission need be attempted.
The spontaneous love of one child for another may be trusted
to give Jesus a secure place in the affections of children, if he
is presented simply and attractively. And it is better that
the affections should be enlisted in this matter than the intel-
lect. God, whom the little child should have already come to
know through its sense of causality as instructed by older
people, may be given anew to it as the Father of this Child of
Bethlehem, whom so large a portion of mankind love and
serve. But, whatever the theological belief of parents or
teachers, there can be no economy, at this early period, in
making God and Jesus the persons of a mystical trinity.
They should be kept separate in the child's thought, as Father
and Child, each standing for what such terms connote. Any
attempt to invest Jesus with the mysteries of divine incarna-
tion and sacrificial function must, it seems to me, detract from
his simplicity and lovableness in the estimation of little
children.

Again, the Bible should be given to children from eight or
nine years, on to thirteen or fourteen, through the heroes of
the Old Testament. These heroes may be selected with es-
pecial reference to their importance to history or prophecy, or
with reference to their moral and religious example. The
number is sufficiently large to give ample choice in these direc-
tions. When such a selection of heroes has been made, their
characters, deeds, and sayings may become the media through
which the children shall be taught Hebrew history and geog-
raphy, moral and religious principles, and anything else that
the Old Testament can supply for purposes of religious instruc-
tion. Finally, the Bible should be given to adolescents through
Jesus as an adult, and, incidentally, through the disciples and
apostles who have interpreted his character and teachings.
Here, again, all historical or geographical material, all doc-
trines and exhortations, all individual and social elements of
ethics or religion that the New Testament presents, should be
taught through the personal medium most closely identified
with them. In Trinitarian circles, this would be the time to
give the theological interpretation of Jesus' character and
function. Having established the human Jesus in the affections
of childhood, and having guided the child throughout the in-
tervening years along the lines of a healthy, normal life which
finds the fulfillment of its ideals in this same Jesus, any doc-
trines of the Godhead or the atonement that may seem neces-
sary to a religious philosophy, may be added. In any case,
the spontaneous interest in Jesus should be seized upon to
bring the adolescent lives into harmony with him, and to make
his teachings effective in establishing a correct regimen of con-
duct as it affects the self and others.

AGE AND ANCIENT HOME OF THE BIBLICAL MANUSCRIPTS IN THE FREER COLLECTION

[PLATES I–III]

THE brevity and haste of my first report on these Mss. have brought some misunderstandings, a few of which I shall try to remove.

The Deuteronomy Ms. has one late marginal note on p. 35: ϝ εἰς την μνημην τῶ αγιω πτρῶ εἰς το λυχνηκō (to the memory of the holy fathers for the evening time). This is a designation of a regular reading with αρχ and τε showing the beginning and end of the passage (Deut. x. 14–22). Professor Grenfell and Dr. Kenyon agree in dating this cursive note at the end of the sixth or early in the seventh century. Its black ink contrasts strongly with the brown of the text. It seems probable that the note was inserted by a visiting churchman, who marked beforehand the appropriate passage for the day to avoid delay at the time of the services.

An interesting parallel to the hand of the whole Deuteronomy Ms. was found in an unpublished fragment of the Aegyptisches Museum in Berlin (PLATE I). It is numbered P. 6794 and is a double leaf of a parchment book containing Homer, *Il.* 22, 390 ff. The fragment was bought of an Egyptian dealer and has been dated in the fourth or fifth century. The writing is slightly larger than that of the Deuteronomy Ms. (facsimile *A.J.A.* XII, Pl. II). Its cross strokes are slightly heavier, and the M and Ω are sometimes a little broader. The ornamental dots of Є, C, T, Γ. etc., are a little larger. Υ and Ρ have longer tails, Κ a sharper angle, and Φ is slightly enlarged. The accents and a few breathings are perhaps second hand. It seemed that only every other line was ruled, but as the Ms. was under glass, I could not be certain.

American Journal of Archaeology, Second Series. Journal of the Archaeological Institute of America, Vol. XIII (1909), No. 2.

130

P. 6794. HOMER. ILIAD, XXII, 403 FF.

III (1909) PLATE II

GOSPELS MANUSCRIPT. JOHN 1. Vss. 1-15

GOSPELS MANUSCRIPT. MARK XVI, Vss. 17-20.

To this hand in turn a near parallel is found in the Codex Ephraemi (facsimile in Omont, *Mss. grecs de la Bib. Nat.* Pl. III), though it must be considered a rather more advanced stage of the writing. Among other slight differences, we may note the size of the Φ, increase in ornamental dots to T, Γ, Є, longer tail to P, etc.

Professor Goodspeed (*Bibl. World*, XXXI, 3, 218) has compared with the Deuteronomy Ms. Add. Ms. 17210 of the British Museum (facsimile in *Cat. Anc. Mss. Brit. Mus.*, Greek, Pl. 9), a Homer palimpsest from the Nitrian Desert, not only finding the writing identical, but also that the two agree in ruling only every other line, except at the top of the page. This peculiarity occurs in parts of the Alexandrinus and of a Coptic Ms. in the Freer Collection, as well as in the Frag. Fabianum and some other old Latin Mss. As regards the similarity of writing it is clear that the Homer palimpsest stands closer to Codex Ephraemi and P. 6794 than to the Deuteronomy Ms. It has the same peculiarities in a somewhat higher degree. Also B has the top loop smaller and the bottom flattened, and Δ has the right hand line extended at the top, a heavy dot on the prolongation of the bottom line to the left, but no extension of that line to the right. On the other hand, it shows two forms of the T as in the Deuteronomy Ms. Most of the variations incline toward the hand found in the fragment of Paul's Epistles of the Freer Collection (facsimile *A.J.A.* XII, p. 54, fig. 2). Noteworthy is the tendency to join the top of the T and the bottoms of P and Φ into other letters in both these Mss.

The great similarity of all the above Mss., combined with the distinct development in type of hand from the Deuteronomy Ms. through P. 6794, Codex Ephraemi, and Add. Ms. 17210 to the fragment of Paul's Epistles, makes the conclusion almost unavoidable, that they are products of the same school and century. This conclusion is opposed to the view held by some French and German scholars, that the Codex Ephraemi belongs early in the fifth century and is older than the Alexandrinus. I prefer to place it, as well as its two younger relatives, late in the fifth century, at any rate after the Alexandrinus, the Deuteronomy of the Freer Collection, and the slightly younger

Homer fragment, P. 6794; and I further feel confident that all these represent stages in the development of the same school of writing and are probably from the same region, Lower Egypt.

Add. Ms. 17211 of the Brit. Mus. (facsimile in *Fac. of Bib. Mss. Brit. Mus.*, Pl. III) has also been compared to the Deuteronomy Ms. by Professor Goodspeed. In forms of letters it really stands closer than Add. Ms. 17210, but the hand is larger, irregular, and imitative. It belongs to a period a generation or two later.

In the Gospels Ms. the most interesting discovery is a single quire at the beginning of John, which is in a quite different hand. All of the rest of the Ms. is of the style previously described (cf. PLATE III), and was written by one writer, probably in the fifth century. The writing in the first quire of John looks younger, while the parchment appears much older and more worn (cf. PLATE II).

There are four possible ways of explaining the presence of this strange quire: (1) it was written later to fill out a lost or damaged part; (2) it was taken from an old Ms. for the same purpose; (3) a quire from the parent Ms. was retained and bound in again, because of its good state of preservation; (4) it was written by another copyist at the same time. We may safely dismiss the fourth explanation on the basis of difference in parchment, ruling, etc., and the second because of the likeness and continuity of text with the following quires. For a comparison of our Ms. for eighteen verses in each of the Gospels shows, in opposition to the composite text of Matthew containing a considerable Syrian element, that both parts of John as well as Luke have almost no Syrian and few Western readings, while individual variants are fairly common.

The text of Mark is likewise composite, showing many readings usually designated as Syrian, but even more Western and Pre-syrian in general, as well as many individual variants. On this evidence we must accept the belief that the strange quire in John is a portion of the same Ms. tradition as the rest of that Gospel.

The dirty, greasy, worn condition of the first page of John, quire 1, shows that it was once the outside leaf. This may have been at some time when the volume was out of its bind-

ing, yet no other part of the Ms. has suffered in proportion. The aged appearance alone is not enough to prove that this quire was from the parent Ms. nor does the slight stretching of the text on its last page prove that it was later copied to fill a gap. In ancient Mss. we find not infrequent instances of stretching or crowding at the quire ends so as to agree with the copy. In this Ms. we find more instances of crowding at quire ends. As we dare not base our decision entirely on this unknown but apparently late style of writing, it is necessary to look for other hints.

Compared with the Matthew portion of the Ms. this quire shows these regular differences:

(1) Much more frequent punctuation, usually a single dot in middle position, but sometimes a colon; punctuation by blank spaces is more common in Matthew;

(2) Less frequent paragraphs, but these project more than one or sometimes than two letters; capitals are larger and rather more frequent;

(3) Frequent curved marks (not breathings) over vowels beginning words or even over two successive vowels; twenty-six cases of correctly placed rough breathings occur in Matthew;

(4) Initial v has two dots over it instead of one; ξ is much better made, with one, two, or three strokes, but always having a good curve in the middle; one example of a finely made Egyptian μ occurs as a numeral;

(5) Paragraph marks are sometimes the κορωνίς, instead of the dash;

(6) Numerals are always given by the letters except once, though the letters had been used but once in Matthew, viz. in the first chapter;

(7) Abbreviations not found in Matthew are \overline{vc}, \overline{ovpoc}, βλεια, while $\overline{ιηλ}$ is used for $\overline{ιερλ}$, which occurs in Matthew; on the other hand, και, -θαι, and -ται are not abbreviated though sixteen cases of such abbreviation occur in Matthew;

(9) Bad spelling and especially itacisms are much more common than in Matthew.

It seems certain that this so different Ms., if it were the parent Ms., must have exerted some influence on even the most careful copyist. I have accordingly searched the remaining

portion of the Gospels Ms. for hints of that influence with the following results:

(1) There is no variation in punctuation from Matthew;

(2) Paragraphs are less frequent, especially in the remainder of John and in Mark, but projections and capitals are as in Matthew;

(3) A rough breathing occurs only once in the remainder of John, forty-seven times in Luke, and three times in Mark; there are no cases of incorrect use;

(4) The writer breaks his custom and puts two dots over υ once at the end of ten pages; he regularly tries to improve the shape of ξ after a model similar to that of John, quire 1; the one case of Egyptian μ is from a third hand and late;

(4) The κορωνίς paragraph mark occurs once early in Luke and in the same form as in John, quire 1;

(6) Letters appear as numerals once in the remainder of John, 6 times in Luke, and 19 times in Mark;

(7) \overline{vc} occurs once in John and 6 times in Mark; $\overline{ιηλ}$ occurs once early in the remainder of John; και, -θαι, and -ται are abbreviated only once in the rest of John, but 16 times in Luke, and 13 in Mark;

(8) In Matthew the custom of ruling across the two pages from outer bounding line of text to outer bounding line seems to have been broken but once by ruling to the edge of the parchment, and then for but five lines at the top of a page. In John, quire 1, the ruling seems to have been consistently across the entire parchment. Correspondingly we find that this manner of ruling occurs 7 times in the remainder of John (probably four double sheets), 8 times in Luke, and 6 times distinguishable in Mark;

(9) The characteristic misspellings of John, quire 1, are ι for ει and ε for αι, while the opposite mistakes are far fewer. In Matthew all four misspellings occur somewhat frequently; ι for ει and αι for ε are the more common, though much less frequent than in John, quire 1. On the other hand, in the remainder of John, Luke, and Mark ει occurs for ι much more often. This looks as if the copyist, discovering the besetting sin of his parent Ms., had changed every possible case to the opposite spelling. In accord with this we note that ε for αι

almost vanishes, while $\alpha\iota$ for ϵ increases decidedly in the remainder of John. In Luke and Mark the spelling of this sound improves.

To sum up, on points 1 and 2 there was no noteworthy variation. Peculiarities 4, 5, 6, 7, and 8 all creep in sporadically later. The extremes involved in 9 were objectionable to the writer, who reached the opposites in his attempt to avoid them entirely. No. 3 is impossible to classify, yet it is noteworthy that the rough breathing is practically non-existent for John.

These items hardly furnish valid proof that the latter part of John with Luke and Mark were copied from the Ms. of which the first quire of John is the surviving remnant, but the concurrence of such indications, combined with the similarity of text and the extremely ancient appearance of the parchment for these 16 pages, furnishes a presumption for this interpretation.

It must of course be admitted that some of the above-mentioned peculiarities can be explained on the basis of the unquestionable difference in archetype of Matthew and John, if we suppose that a later copyist of John, quire 1, exaggerated or modified those points in which the Ms. of John chanced to differ from that of Matthew.

Yet this explanation can hardly account for all the above variations. Moreover, we have yet to consider the most striking peculiarity. The titles of the Gospels, Matthew, Luke, and Mark, show marked differences from the hand of the text and subscriptions. Perhaps most striking is the fact that the word $\epsilon\nu\alpha\gamma\gamma\epsilon\lambda\iota o\nu$ measures just one inch in length each time in the title, though it measures $1\frac{1}{4}$ inches in both text and subscriptions. Likewise a comparison of the forms of the letters shows that the titles, as well as some 40 instances of second hand in the text and margins, have the following differences from the first hand : κ more, but τ and γ less regularly have dotted points on the ends of the top line ; ν and ρ seem to have shorter tails ; o is smaller ; ω is the same, except for a tendency to curve in at the top ; ϵ does not often have the middle line so prolonged as in the text ; μ seems narrower and the outer lines are almost perfectly parallel, the last one being generally shorter.

These differences, though decided, are yet so unimportant, that I believe the second hand was contemporary, hence the διορθωτής.

The fact that the title of John is also by a second hand suggests that the same person added all four titles; yet this cannot be proved, since the writer who added the title of John tried, though with ill-success, to imitate the hand of the text (cf. PLATE II). Note the following : · α is different every time, and never exactly like any α of the text; ε omits the heavy dot on the middle line; γ has too light a dot on end of the top stroke; λ is too narrow and the second stroke extends above the first; κ has a light dot on the upper side, not a heavy one on the under side of the top slanting stroke; τ has only one light dot; ω has the middle lines rising nearly to the top of the letter and the outer lines curve in only slightly at the top; ν seems made with three strokes, the slanting stroke touching the first upright a little below the top, though these two strokes seem to be made in one, forming a perfect angle, by the regular hand of the text. Most striking of all is the lack of a consistent slant. The first ε, υ, and ο have too much and show the natural tendency of the hand. The second γ, first ν, and τ have no slant. Those mistakes which betray the natural character of the hand seem to point toward the second hand of the Ms. as a whole, at any rate toward a sloping hand of the general type of the whole Ms. except these sixteen pages. This seems to prove the first quire of John older than the rest of the Ms., unless we can succeed in showing that the second hand was considerably later. Yet such a conclusion presents very decided difficulties, for it forces us to date the early part of John in the fourth century, a date which passes well with the bad spelling (cf. Westcott and Hort, II, 307), but is decidedly questionable on account of the style of writing.

The natural distrust of a strange hand will lead others, as it has me, to seek a later date for this portion, even though we must confess that nothing exactly like it has thus far been published. It seems to have some general resemblance to the Slavonic sloping uncial hand of the seventh and eighth centuries. Note especially heavy dots or ornamental strokes on τ, γ, υ, κ, and the enlarged φ. Against this the forms of ω, ξ, ρ, ψ, and

especially μ, with middle strokes not reaching to the bottom line, look rather strange. Yet it does not seem an early, but rather a well-developed stage of some such hand. Therefore, if we connect it with the late Slavonic sloping uncial, we must presumably date it not earlier than the eighth century, a very questionable date, since the Ms. shows such plain signs of long use. If we attempt to connect it with the earlier type of sloping hand, which arose on papyrus in the third and fourth centuries, we are met by the difficulty that the remainder of the Ms. is itself a late development of that hand, probably of the fifth century, and it is extremely questionable to suppose that style of writing to have lived on much longer. Furthermore, this hand is clearly a development independent of the hand found in the rest of the Ms., for while the slant is less, the pen was cut with a broader point, and the writing makes more the impression of a papyrus style. Also dots and shadings are more pronounced. Furthermore, individual characteristics, such as capitals, awkwardly projecting paragraphs, and punctuation point toward a later time, though such characteristics are found infrequently even on papyrus fragments of the second century A.D. or earlier.

On the whole I prefer, though with a good deal of hesitation, to call these sixteen pages a part of the parent Ms. and date them in the fourth century.

The other alternative is to call this an early replacing of a torn but still legible quire. Those who take this view will doubtless be inclined thereby to refer the rest of the Ms. to the fourth century, a date which I am not yet ready to accept.

This parent Ms. did not contain Matthew and was perhaps otherwise defective. On the other hand, the Ms. from which Matthew was copied possibly contained the four Gospels, so it will be necessary to watch for its influence in other places. The differences in character of text of the different Gospels point plainly back to a time when the text transmission of each was independent.

Another question, which has been much considered, concerns the place of origin of the Mss. To trace out and interpret all of the stories of Arab dealers is such a hopeless task that in despair I turned to the Mss. themselves.

Of the original subscription to the Gospels, which was written in lighter ink than the Mss. and in a fifth century hand, there remains ϝ χριστὲ ἅγιε σὺ μετὰ τοῦ δούλο[υ] (cf. PLATE III). Though the first hand has disappeared at the end of the line, the name of some early owner, not necessarily a private person, appeared there. Then the subscription was changed as to name and enlarged by adding a second line ϝ καὶ πάντων τῶν αυτοῦ ϝ. This was written in the same shade of light brown ink, but in a smaller, somewhat more cursive hand; the retention of approximately the same color of ink would suggest that any change of ownership accompanying this erasure and addition took place within the original church or monastery. Slightly later the name was again erased and also the letter under σ of σου and that part of the Ms., covering υ also of δουλου, was probably washed. Then a hand very similar to No. 2 rewrote υ σοῦ Τιμοθέου ϝ in black ink of the tint used in the cursive note on p. 35 of the Deuteronomy Ms., discussed above, and in certain curved reading marks of the same Ms. This third hand cannot be dated much later than the second, hence the early sixth century. Both the original name and the form of it going with the second version have absolutely perished. Yet from the length of the erasure, extending under ϝ, we may infer that at least one was longer than the present name. Also a letter reaching well below the line occurred near the beginning of the name, in one of the earlier versions. σοῦ cannot have stood in either first or second hand, but perhaps [τ]οῦ in the second hand, and, if so, τῆς in the first, the latter with the name of a monastery, the former of a prior or bishop.

The final or third form of the subscription is translated: "O holy Christ, be thou with thy servant Timothy and all of his." In spite of the interpretations of Professors Goodspeed and Gregory (*Das Freer Logion*, p. 22), I can see no reference to a private owner here, but rather to a church and its congregation. "Timothy" is St. Timothy and "all his" are the worshippers in his church or the inmates of his monastery.

In Abu Salih's *Churches and Monasteries of Egypt* (trans. by Evetts and Butler, p. 190) we read: "Near this place there is a monastery known as the Monastery of the Vine-dresser (Dair al-Karrám), but called by the heretics the Mon-

astery of the Dogs (Dair al-Kilâb). The Monastery is near the Pyramids on the western side and its church is called the Church of Timothy, the monk, a native of Memphis, whose body is buried in it." This Timothy was a soldier in the Roman army and suffered martyrdom in the persecution of Diocletian, 304 A.D. Though Abu Salih, who wrote soon after 1208 A.D., names 707 churches and 181 monasteries, he mentions no other dedicated to Timothy.

Al Makrizi († 1441), while naming 125 churches and 86 monasteries, presumably a complete list for his time, does not mention the monastery of the Vinedresser ; it had probably perished before his time.

The Ms. of Abu Salih is defective at the beginning, so that none of the monasteries of the Nitrian Desert are described. This is the more to be regretted as Butler (*Anc. Cop. Churches of Egypt*, I, p. 287) quotes Vansleb (*Voyage fait en Egypte* [1664 and 1672–3], p. 227), that "there were formerly seven monasteries there ; viz. Macarius, John the Little, Anba Bishôi, Timothy, Anba Musa, Anba Kaima, and Sûriânî, of which only Bishôi and Sûriâni survive," an obvious error, for besides Macarius, there is left one other, Al Baramus. Al Makrizi (App. to Abu Salih, pp. 320 ff.) names eleven, as known to him, viz. all of the above except Timothy, and besides, Elias, the Virgin of St. John the Dwarf, St. Anub, and the Armenians. The Monastery of Timothy may be another name for the Monastery of the Armenians, or the name may be an error of Vansleb or his informers. I incline to the second alternative, for Al Makrizi also singles out just seven monasteries as existing in his time, viz. the four now remaining and St. John the Dwarf, the Virgin of St. John the Dwarf, and Abu Musa the Black. The second of these was inhabited by the Abyssinians after their two monasteries of John Kama and of Elias were destroyed by worms. So Anba Kaima of Vansleb's list means the Abyssinian monastery, and the two lists agree, except that the Monastery of Timothy is substituted for Al Baramus. This looks like an error of memory or pure invention to complete the desired number seven.[1]

[1] The error is partly in Butler's quotation. Professor Goodspeed kindly looked up the original for me and writes as follows : "The fourth monastery in

If we omit this rather doubtful case, the church of Timothy in the Monastery of the Vinedresser was the only one of the name in Egypt. This was a Jacobite, *i.e.*, a Coptic, monastery, and was once burned by the Melkites (Abu Salih, p. 186), probably in the fifth century or the early sixth, for the Melkites were too weak later. This monastery seems to have finally perished in the persecutions of the fourteenth century, but of the fate of its most ancient Bible we hear no word. Yet it seems hardly likely that it was abandoned, especially if any of the monks escaped. They may well have taken it to some more secure monastery.

In this connection the statement of Professor Schmidt (*Theolog. Literaturz.* 1908, p. 359) is of interest, for he says that all four of the Biblical Mss. of the Freer Collection came from the White Monastery, near Sohag, opposite Akhmim.[1] From the same source came three Mss., which he himself bought in Akhmim in 1905: (1) The first epistle of Clemens in Coptic (Akhmimic dialect), of the fourth or fifth century ; (2) Proverbs in the same dialect and of about the same date ; (3) An Easter letter in Greek, of the early eighth century. These three were bought at the same time and were later proved to have come from the White Monastery. The following year a fragmentary Ms. of Genesis in cursive Greek of the late third or fourth century was obtained of the same dealer. It is supposed to have come from the same source, though proofs fail. These Mss. are all on papyrus and show absolutely no relationship to the Freer Mss. either in content or style of writing.

It seems clear that the White Monastery had a library hidden in the upper part of the massive church (first seen by Amélineau in January, 1885), which had escaped fire and thieves, except those of the monastery itself, during its long history.

Vansleb's list is '*celui de Saint Massime et Timothée.*' Al Baramous was known to Vansleb, therefore, under the name *Maximus and Timotheus*, which doubtless means *Maximus et Domitius*, as the dedication of that convent is more precisely described by recent writers. Vansleb's error was due to the similarity of sound."

[1] Cf. Goodspeed, *Bibl. World*, 1909, p. 201, who ably supports this view, but seems misinformed as to some essential facts.

Yet the rest of the monastery was plundered and burned several times.[1]

At the last plundering (1812), 100 Mss. are said to have perished. Under these circumstances it seems that Mss. could have survived only in this hidden library. Yet the decayed condition of all the Freer Mss. except the Gospels, which were protected by thick board covers, is hardly compatible with preservation in so secure a place.

I further learned from Professor Schmidt, that the Freer Mss. were first heard of in the hands of a dealer of Eshmunên, who showed them at the Mission School in Assiut, and then sold them to Ali Arabi. On inquiry, however, I learned from Dr. Grant of the School, and from the Rev. Dr. Kyle of the United Presbyterians' Missions, that the Mss. were never shown at the school. Professor Schmidt has probably been deceived by one of the numerous Arab stories; all are of equal value with the first one told, viz. that the Mss. came from Akhmim. To accept the White Monastery as the last home of the Mss. would imply that this first story was near the truth. Yet any one acquainted with Arab stories would advise us to look in every other direction first, as toward the Nitrian Desert, or the Fayoum, or the region toward Sinai, if we wish to find the last resting place of this ancient Bible.

HENRY A. SANDERS.

ANN ARBOR.

[1] Cf. Denon, *Voyages dans la Basse et la Haute Egypte* (1798), London, 1807, I, 157 f. ; Curzon, *Ancient Monasteries* (1833), p. 113.

THE STAGING OF THE COURT DRAMA
TO 1595.

It has usually been assumed by historians of the drama that amusements of a dramatic kind at court kept pace with those of the country in general. The entries of 1348 in the Record Books of the Great Wardrobe, which belong to the reign of Edward III, and which concern tunics and visors used in a Christmas celebration, have been interpreted as referring to dramatic entertainments (Collier, i, 15, 22; Warton, ii, 72; Brotanek; Ward, i, 148). This view, however, has recently been called into question in the researches of Professor Arthur Beatty, of the University of Wisconsin, who has pointed out that tunics and visors were also necessities of the tournament, that "It is antecedently improbable that Edward III should have had dramatic entertainments on important occasions," and that therefore these important entries do not prove the existence of dramatic entertainments at this early date.[1]

[1] Beatty, Professor Arthur: *On the Supposed Dramatic Character of the Ludi in the Great Wardrobe Accounts of Edward III*, 1345–1349. A paper read by title at the meeting of the Modern Language Association, 1908. See program for abstract of the paper.

Subsequent notices of Royal entertainments, so far as court records have been edited, belong to the year 1389, to 1402, to 1416 when the Emperor Sigismund was in London; and to the reign of Henry VI. From this time on such notices become much more frequent. In the records of Henry VI's reign, though no players are named, it is stated that the minstrels belonging to the Household of the king were twelve in number and that they were permanently engaged for the entertainment of the court (Collier, I, 25). These paid servants, often assisted by various members of the court, were undoubtedly the survivors or successors of the minstrels, and are often still so named. The minstrels, in the reign of Edward IV, had been increased to fourteen, and along with them are mentioned besides, eight "Children of the Chappell, founded by the King's Jewell Howse for all things that belong to their apparell by the oversight of the Deane or the Master of the songe, assynde to teach them . . ." (Collier, I, 31 ff.). The records of the reign of Henry VII provide many more notices of court revels and also set down the interesting fact that the king kept three sets of players in his Household to whom he paid a fixed sum besides "rewards," and that the court was further entertained at times by players of the various lords.

But Henry VII was parsimonious in the matter of court amusements as compared with the lavish Henry VIII (Collier, I, 60). In the first year of his reign Henry VIII spent nearly £600 for this purpose alone. Not satisfied with the three sets of players of his predecessor, he added a fourth in 1514. A description of the Revels for the 13th of February of the first year of his reign gives brief but interesting knowledge of one of his entertainments. "After supper his grace with the Quene, Lordes and Ladies came into the White Hall within the said Pallays, which was hanged rychely, the Hall was scaffolded and rayled on al

partes. There was an Interlude of the Gentelmen of his chapell before his grace, and divers fresh songes : that done, his grace called to him a great man or a Lord of Ireland called Odonell, whom in the presence of the Ambassadours he made knyght : then mynstrells beganne to play, the Lordes and Ladyes began to daunce " (Collier, 1, 62).

In connection with the various items of payment and record, the name, Master of the Revels, is not used, although it seems more than likely that such was the title given to the officer appointed to organize a' Christmas or Easter Entertainment. The evidence for this is found in an *Order for Sitting in the King's Great Chamber*, dated December 31, 1494 (Chambers, *Tudor Revels*, 4). The order provides that "if the master of revells be there, he may sitt with the chapleyns or with the esquires or gentlemen ushers." Under the pleasure-loving Henry VIII, when expenses for court amusement were multiplied many times, the office of Master of the Revels became much more important, as is shown by the fact that courtiers of position and dignity are mentioned as superintending the revels (Chambers, 5). Although the fee of the office was 10s for every day of attendance, it is not probable that the Courtier-Master attended to all of the many details of organization inseparable from the duties of providing the court with amusement. From the beginning of Henry VIII's reign, all such details, as obtaining goods from the merchants, ornaments from the Jewel House and the Mint, engaging architects, carpenters, painters, tailors, embroiderers—actually overlooking the presentation of the play—taking charge of the various properties, making inventories of them, keeping minute accounts, and obtaining funds from the Exchequer, were in the hands of an officer who belonged at first to the Great Wardrobe. In 1534 by a patent granted to an official under the name of the Yeoman of the Revels, with the duties briefly outlined above, the

Revels office technically became a separate department (Chambers, 7).

In the early records, there are many references to an official called the Abbot or Lord of Misrule. Chambers agrees with Collier in the opinion that this functionary was quite distinct from the Master of the Revels. The former was originally appointed for the Christmas season. His duties seemed to have been rather ceremonial than administrative (Chambers, 4).

Among the Lansdowne MSS., No. 83, Art. 59, is an interesting document, dated by competent scholars about the year 1573, which furnishes valuable information concerning the office of the Revels, its functionaries and their various duties. The document is described by Chambers in his *Tudor Revels* and is given in full in Albert Feuillerat's Edition of *Documents Relating to the Office of the Revels in the Time of Queen Elizabeth* in volume 21 of Bang's *Materialien* (1908). Only a few of the points can be noticed here. The document opens with the interesting words: "The Office of the Revelles as it should seeme to reporte hath in tymes past bene in that order that the Prince beinge disposed to pastyme would at one tyme appoynte one persone, at sometyme an other, suche as for credite pleasaunte witte and habilitye in learnynge he thought meete to be the Master of the Revelles for that tyme, to sett fourthe suche devises as might be most agreable to the Princes expectacion . . ." (Feuillerat, 5). And in another document these words are found: "The office of the Revells comprisinge all Maskes, triumphes, Plaies, and other shows of dispourte with Banquettinge howses and like devises to be used for the Anornemente of the Queenes Maiesties most roiall courte and her highness recreacioun pleasure and pastyme" (Feuillerat, Table 1). Before each show the master and his officers were to meet together and to take an inventory of the

properties. "The chiefe busynes of the office resteth speciallye in three poyntes In makinge of garmentes, In makinge of hedpeces and in payntinge. The Connynge of the office resteth in skill of devise, in understandinge of historyes, in iudgement of comedies, tragedyes and shewes, in sight of perspective and architecture some smacke of geometrye and other thinges wherefore the best helpe is for thofficers to make good choyce of cunynge artificers severally accordinge to their best qualitie, and for one man to allowe of an other mans invencion as it is worthie especiallye to understande the Princes vayne . . ." (Feuillerat, 11–12). The officers were further to agree on the number of workmen and the hours of work for the day and night. It was provided also that three books of account were to be kept, most carefully itemising the results of the frequent inventories, the new goods bought, the amounts paid to various workmen in wages ; in fact, all payments made or due.

The holder of the first patent for the Mastership of the Revels was Sir Thomas Cawarden. He received an annual fee of £10 besides the revenue from the sale of old properties, especially costumes no longer of use in the production of Court entertainments. With him were soon associated a Clerk Comptroller whose duty it was to make an inventory of all properties, to issue orders for goods, and a clerk who supervised the cutting of garments and otherwise attended expressly to bookkeeping duties. In addition to these three, the office continued, of course, to include the Yeoman. Up to 1559, when Cawarden's Mastership ceased, the office of the Revels was closely related to that of the Tents, but this relation it is not necessary to explain here.

The properties of the Revels' Office were at first housed in the great Wardrobe. Later, in 1539 or 1540, they were, together with the Tents, at Warwick Inn. While the Tents

were being moved first to one place, then to another, the
Revels remained at Warwick Inn until the accession of
Edward VI when they were moved to Blackfriars where the
Tents already were. On the death of Sir Thomas Cawarden
both Offices were removed to the Hospital of St. John's
where they remained until the beginning of James I's reign
(Feuillerat, 430–1).

After Cawarden's death in 1559, Sir Thomas Benger
succeeded to the office of the Master of the Revels. Benger
appears not to have been a very effective master, although
he made a good beginning in words at least. His activity
as Master ceased in 1572, but his duties were performed in
his name by the clerk until 1579 when Edward Tilney
received the patent of the office. He held the position until
1610.

The average amount spent by the Revels office for court
amusement amounted to between £400 or £500 annually.
In spite of Benger's protestation of economy, as shown in a
note appended to his first Revels' account—in which note he
naively says, " that the Chargies for making of maskes cam
never to so little a somme as they do this yere for the same
did ever amount aswell in the Quenes highnes tyme that
nowe is, as at all other tymes heretofore, to the somme of
ccccli alwaies when it was Leaste "—he seems not to have
been a careful manager (Feuillerat, 111 ; Chambers, 19).
In 1560 the accounts show a debt of £700, and the expenses
of 1561, which included a progress, amount to £3,209, 10s,
8d, a princely sum considering the value of money at that
time. But this was very unusual even taking into con-
sideration the extravagance of Benger as a master. Im-
mediately after Tilney's accession to the Office the accounts
show an increased expenditure over the regular average, but
no such extravagance as during Benger's tenure of office is
visible on the books at least.

The Revels Records also give much information as to the various duties of the office. At the head of each set of accounts stands an item for " Translatinge newe makinge garnysshinge furnysshinge and fynysshinge of dyuers and sundrye garmentes Apparrell vestures and propertyes aswell of Maskes as for playes and other pastymes sett forthe and shewen in her Maiesties presence with the chaunge and Alteration of the same to serve her Highnes pleasure and determynacion as occasion required from tyme to tyme upon comaundement to be in Areddines when it was called ffor " (Feuillerat, 79). For the year 1571 and 1572 the account books contain a list of six plays produced, on what nights they were given and by what actors, " All whiche.vj. playes being Chosen owte of many and ffownde to be the best that then were to be had, the same also being often pervsed, & necessarely corrected & amended (by all thafforeseide officers) Then, they being so orderly addressed : were lykewise Throwghly Apparelled, & ffurnished with sundry kindes, and sutes, of Apparrell, & ffurniture, ffitted and garnished necessarely : & answerable to the matter, person and parte to be played : Having also apt howses : made of Canvasse, fframed, ffashioned & paynted accordingly : as mighte best serve theier severall purposes. Together with sundry properties incident : ffashioned, paynted, garnished, and bestowed as the partyes them selves required and needed . . ." (Feuillerat, 145).

This interesting entry shows that one of the duties of the office was to choose, after having heard several plays, such as would please the court, and if necessary, remodel them to whatever extent it seemed expedient. Other notices refer to the rehearsing of plays. Sometimes the Lord Chamberlain wished to see the rehearsal ; on such occasions the players were obliged to appear before him, but most often the rehearsals were held at the Revels Office.

The usual time of the court entertainments, which not only consisted of plays, but of masks, tumbling feats, and other amusements of like kind, was in the evening at Hallowtide, Christmas, Candlemas, Shrovetide, Easter, Whitsuntide, at Progresses, or whenever a royal personage or an ambassador from abroad was present at the court of England. The place of these entertainments varied with the situation of the court. The Revels' Accounts mention Hampton Court Palace, Greenwich, Whitehall, Westminster, Windsor and Richmond. No doubt entertainments were given in other palaces also.

In Law's *History of Hampton Court Palace* it is stated that Hampton Court Palace was most often favored by the Queen's presence at Christmas, especially in the earlier years of her reign, and that this season was always celebrated with great joviality and rejoicing when the Queen was there. Hampton Court Palace had one of the largest "Great Halls"; it was at least one hundred and eighteen feet long and ninety feet high.[1] Plays were usually given in the Great Hall, although there were other large rooms available. Law states—and it can be proved by the records—that entertainments were presented at this palace with great magnificence. The stage, it is supposed, was customarily erected across the lower end of the hall in front of the screens and minstrels' gallery. It was composed of strong scaffolding, posts, rafters, "having also apt houses : made of Canvasse, fframed, ffashioned & paynted accordingly : as mighte best serve theier severall purposes." In the Great Halls things were most conveniently arranged for the players. The pantry behind the screens at the lower end of the Hall could be used for a tiring room (E. Law, I, 166 ;

[1] Search has failed to reveal the width of this Hall. Travelers through England, however, estimate its width at about fifty feet.

313 ff.). The lighting of the immense Halls was accomplished by drawing wires across the open roof from beam to beam, and hanging lights from them. Sums by no means small were spent on the proper lighting of the improvised theaters. Every account shows careful and artistic attention to the illumination.

Thus far, no account of a court stage, such as has been recently printed in volume xx of the *Publications of the Modern Language Association* from the Latin of John Bereblock concerning the staging of plays at Oxford,· has come to light. In the absence of such a document it may be of interest, besides being illuminating because of the comparison which may be drawn, to give in substance what John Bereblock has reported. He is writing of the production of *Palamon and Arcyte* before the Queen. He says that the stage was built in the upper part of the Hall, and that on each side of the stage magnificent palaces and well equipped houses were provided for the actors and for the masked persons. The Hall was brilliantly lighted, and seats and balconies for the Lords and ladies built tier upon tier on the three sides of the Hall. On high—but Bereblock leaves the exact location a matter of dispute—was arranged, suitably adorned and canopied, the seat for the Queen. Whether the stage was built the full width of the Hall is still an open question, but it seems likely that it would be so built, because many of these halls, while very long and high, were nevertheless very narrow, in most cases really necessitating the use of their whole width for the stage.

The actors in the dramas played at court were the Monarch's own company of players, the Children of the Chapel, of Windsor, of Paul's, of Westminster, of Eton, or of some grammar school, the players or children of the various noblemen, and rarely, the Gentlemen of Gray's Inn.

For a long term of years the court players received an
annual sum of £3, 6s, 8d each. The children received a
gratuity of £6, 3s, 4d which passed in the hands of their
masters. The costumes of the players and all the stage
properties were furnished by the Revels' Office.

Since documents giving adequate information on the
performance of plays before Elizabeth's reign are still in the
process of being edited, and since therefore at most, any
attempt to picture the staging of the early interludes must be
necessarily incomplete, I pass immediately to the reign of
Elizabeth, omitting thereby the very interesting Interludes of
John Heywood produced at court, only pausing to say that
some of the early interludes require scenic apparatus of the
simplest; that is, a scaffold upon which to act, although
when they were performed at court it may be said with
certainty, judging from the scanty accounts now available,
that every attempt was made to give them all the magnifi-
cence in costume, and all the properties which were called
for within the lines and very meagre stage directions. The
costumes for the interludes staged in 1516, to cite an item or
two, amounted to nearly £250. For 1527 is recorded,
"and after all this was the most goodliest disguising, or
interlude, made in Latin, the plaiers being so rich and of so
strange devices that it passeth my capacity to expound."
(Collier, I, 107).

In the Revels' Accounts for the year 1567–8 there is some
interesting material as to the scenery and other mechanical
contrivances employed in court production. Several plays
are noted as having been performed, "The sevoenthe of
Orestes and a Tragedie of the kinge of Scottes, to yᵉ whiche
belonged diuers howses, for the settinge forthe of the same
as Stratoes howse, Gobbyns howse, Oresties howse Rome,
the Pallace of prosperitie Scotlande and a gret Castell on

thothere side Likwise . . ." (Feuillerat, 119). A play
entitled *Orestes* has recently been printed by Alois Brandl
in his *Quellen* (460 ff.), but Feuillerat (449) agrees with
Collier (II, 412) that a production of such low description as
Orestes could never have been presented at court. However
that may be, it is nevertheless a play illustrating a certain
stage of development in the construction of the drama with
reference to stage machinery. It demands practically a
balcony stage or what later became a balcony stage ; in this
play it is a scaffold or an upper stage upon which two of the
characters walk and it is high enough to be scaled by a
ladder. During the progress of the action a man is hanged
upon the ladder and left suspended there for some little
time. The entry in the Revels' Accounts shows also that
stage illusion was sought for in the preparing of a painted
castle for one side of the stage and another set for the other
side, demonstrating that while illusion was sought for, it
was rather symbolic than completely realistic as far as
indicating place was concerned.

The Revels' Accounts abound in painters' items for houses
and castles, but only two such items are mentioned for the
reign of Elizabeth before the Orestes entry in 1567–8. In
succeeding years, however, they become more and more
numerous and the amount spent upon painting scenery
greater and greater.

But if complete realism in stage illusion, as far as scenery
was concerned, cannot with absolute certainty be declared to
have been practised in the production of a play, it can be
said with assurance that realism the most realistic was
sought after in the matter of properties. It needs but a
glance through the various Revels' Accounts to convince one
of this. In a record for the year 1571–2 the following
illuminating entry occurs under the heading,

"Implementes for propertyes such as sundry playes required provided & employed
by .

Iohn Carow for sundry percells of stuf by him bowghte and provyded for the use of this office & for the plaies maskes & showes sett foorth thereof by the seide Masters commaundement, videlicet. Sparres, Rafters, boordes, punchyns, Nayles, vices, Hookes, Hinges, Horstayles, hobby horses, pitchers, paper, Braunches of sylke & other garniture for pageantes, fethers, flagbroches, Tow, Trenchers, gloves black, septers, wheate sheaves, Bodyes of men in tymber, Dishes for develles eyes, devices for hell, & hell mowthe staves for banners &c., Bowes, bills, daggs, Targettes, swordes, daggers, fawchins fierworkes, Bosses for bittes, speares, past, glew, pacthrede, whipcorde, Holly, Ivy & other greene bowes, bayes & strewing erbes & such like Implementes by him employed at the coorte & in thoffice to acceptable purposes with cariages & Rewardes by him paid in all. Summa—xiiijli ijs ijd (Feuillerat, 140).

hunters	Iohn Tryce for mony to him due for Leashes, & Doghookes, with staves, & other necessaries: by him provyded for the hunters that made the crye after the fox (let loose in the Coorte) with theier howndes, hornes, and hallowing, in the playe of narcisses, which crye was made, of purpose even as the woordes then in vtterance, & the parte then played, did Requier, for the whiche the same sir Thomas Benger also appointed him to geve certeyne Rewardes the whole amounting to Summa—xxjs. viijd. (Feuillerat, 141).
Thunder & Lightning	Iohn Izarde for mony to him due for his device in coun- terfeting Thunder & Lightning in the playe of Narscisses being requested therunto by the seide Master of this office And for sundry necessaries by him spent therin in all xxijs.
Armour	Morris Pickering and William Iening for mony by them disbursed for the hier of certeine Armour for the playe of parris & vienna to furnish the triumphe therin and for Rewardes by them geven to the armorers that attended by thappoyntment of the seide Master 51s vjd.

Bryan Dodmer for mony by him disbursed for A Cristall sheelde & certaine Bumbaste by him delyvered into thoffice & for his expences travell & dilligence in thaffares of this office by the speciall appoyntment of the seide Sir Thomas Benger lxs (Feuillerat, 142).

Bumbast to make snoballs—vs 6d (Feuillerat, 174).

Iohn Carow[1] for sparres to make frames for the players
howses ; ix⁵ 6ᵈ.

Canvas for A monster; vij ells
ij spears for the play of Cariclia
A tree of holly for the Duttons playe
other Holly for the forest
A palmers staf
A desk for farrantes playe
An Awlter for theagines . . . (Feuillerat, 175).

The Lynnen
draper

Mistris Dane for Canvas to paynte for howses for the
players & for other properties as Monsters, greate hollow
trees & suche other x̄ij ells at xijᵈ the ell xijˡⁱ.
(Feuillerat, 107).

Propertymaker.

To Iohn Rosse for vj branches of flowers made of ffethers—
vjˢ ; fflowers for Garlandes iiij dosen—viijˢ. Long boordes
for the Stere of a clowde—vjˢ. Pulleyes for the Clowdes
and curteynes—iiijˢ Bote hier to & fro the Coorte—viijˢ
Lynkes to receive the stuf—viijᵈ. Dubble gyrtes to hange
the soon in the Clowde—xijᵈ for sowing the curtyns &
setting on the frenge for the same—iijˢ. Wyer to hang
the Curtyns—vjᵈ. vyces for the pulleys &c.—iiijˢ. xljˢ. ijᵈ.
(Feuillerat, 240).

The
Propertymaker

To Iohn Carow in his lyfe tyme not long before his
death—vjˡⁱ. And to his wyfe after his deathe in full
satisfacion for all the wares by him delyvered this yeare
into the said office or is to be by him the saide Carow his
executors or admynistrators demawnded for any dett due
before the third of ffebruary 1574 or not entred in this
booke—vjˡⁱ xiiijˢ. iiijᵈ. as which grew by propertyes
videlicet Monsters, Mountaynes, fforrestes, Beastes, Ser-
pentes, Weapons for warr as Gvnnes, dagges, bowes,
Arowes, Bills, holberdes, borespeares, fawchions daggers,
Targetts, pollaxes, clubbes, headdes & headpeeces Armor
counterfet Mosse, holly, Ivye, Bayes, flowers quarters,
glew, past, paper, and suche lyke with Nayles hoopes
horstailes dishes for devells eyes, heaven, hell, & the
devell & all the devell I should saie but not all—xijˡⁱ.
xiiijˢ. iiijᵈ " (Feuillerat, 241).

[1] Record for 1573 and other years.

Although the Revels' Accounts contain many very interest-
ing items under the heading of Mercers' parcels, an idea of
the beautiful and expensive materials used for costuming the
court plays can best be given from one of the numerous
Warrants for Delivery of Stuff from the Wardrobe of the
Queen :

"Item to Sir Thomas Benger knighte Master of our
maskes Revells and tryumphes for the better furnyture and
setting forth of the same these parcells followinge That is
to saie Of clothe of golde yellowe plaine thirtie Fyve yardes
and a half Of cloth of golde yellowe with workes ffoure score
foure yardes & three quarters / Of cloth of gold crimsin
plaine thirtie two yardes three quarters / Of cloth of Siluer
plaine ffyvetie yardes half and half quarter / Of vel-
uet purple Twentie yardes. ... Of veluet Carnacion twentie
fyve yardes and three quarters / Of veluet Blewe
Bard with gold Seaventeen yardes / Of sateen crimsin
fouretie foure yardes and a half. ... Of satten chaungeable
striped fouretie and seaven yardes," (Feuillerat, 187), etc.,
and so the fascinating warrant runs on and on, and as one
reads one is quite sure that modern extravagant costume
plays could not excel the magnificence and splendor exhibited
in the court drama.

There are one hundred and twenty four plays referred to
in the Revels Documents for the reign of Elizabeth, some
by title, others as being given by some company and still
others simply designated "a play," besides fifty-seven
masques and three shows. It is probable that there were
many more because many of the accounts record items with-
out reference to any particular play. Unfortunately, only a
very small percentage of plays given at court are extant.
But among those which have survived are the dramas of
John Lyly. The Revels' Accounts, it is true, do not mention
Lyly's name, but there is no doubt about the production of

Lyly's plays at court. The actors in all his dramas except the *Woman in the Moone*, which does not specify the company, were the St. Paul's boys and the Children of the Chapel. Lyly's plays illustrate admirably in their demand for a more elastic stage the advance which had been gradually made in staging. In all of Lyly's plays a rear stage which can be concealed by a curtain is demanded. It is needed for Alexander's Castle and Apelles' studio, for Vulcan's Forge, for Sapho's chamber, for Sybilla's cave, for the Lunary bank and Corsites' castle, for Apollo's shrine, and for several other sets as well. An upper or balcony stage is demanded, for example, as the station of the several planets in the *Woman in the Moone*. This play also requires a trap to represent the hollow vault from which Stesias is to surprise his false wife and her lover. Some of the interesting properties needed for Lyly's plays are the tub for Diogenes, a large tree for Love's Metamorphoses, out of which a nymph emerges during the progress of the action, an aspen tree into which Bagoa is transformed, and a hawthorne into which Gunophilus is turned in the *Woman in the Moone*. Considerable ingenuity must have been possessed by the Elizabethan mechanicians of the stage to change people into trees and back to nymphs again. " A thick mist which Proserpine shall send " or " a showre " sent by Venus, are in two instances the friendly cover of restoration or transformation.

It is certain that a curtain was used to divide the rear stage from the front stage, just as in the public theaters ; it is not so certain, however, that a front curtain was employed, although it seems more than probable that such was the case. The managing of a front curtain in a Great Hall of a palace would not be such an impossible matter as in the public theater with its three open sides. The stage carpenters had merely to stretch a large wire across the Hall and the thing

was done, just as they did for the curtain before the rear
stage. There are many items for wires stretched across the
Hall in the Revels' Accounts; many items for hundreds of
ells of material for curtains, and dozens upon dozens of
curtain rings mentioned. The curtains are often provided
with costly gold fringe and tassels. In no instance, how-
ever, do the Revels' Accounts give any hint as to what
specific purpose the curtains were put, whether they were
used to conceal the rear stage, the balcony stage, or the front,
or all three. The fact that so many of the scenes of Lyly's
plays need curtains, suggests the question of whether the
rear stage always used for the scenes would not have caused
some of them to be lost both to sight and hearing. And in
the plays produced at court, where the Halls were loftier
than any we now know, this would be more of a real prob-
lem than at first appears.

The sort of stage needed for the production of a court
drama of a well developed type can perhaps be best illustra-
ted by considering in detail one of Lyly's plays. I choose
the *Woman in the Moone*, one of Lyly's later plays, for the
reason that it has many times more stage directions than any
other play he has left. The reason suggested as to why
there is such a goodly number of these much desired direc-
tions is that since it is not explicitly stated to have been
acted by the Chapel Children or by Paul's, Lyly was not the
stage manager, and that he therefore wrote out instructions
he was not in position to give orally (Bond, *The Works of
Lyly*, III, 236).

The scene of the play is laid in Utopia (Bond III, 280).
The characters are Nature and her hand maids, the seven
Planets, Utopian shepherds, four in number, Cupid and
Joculus, and Pandora, the Woman. Nature, petitioned by
the shepherds, creates for them a woman. The treachery of
Pandora and jealousy of Stesias, who is her chosen husband,

are the cause of all the complication in the play. The first stage direction of interest to us is that in which Nature bids her maidens, Discord and Concord, to disclose her work. The instruction reads: " they draw the curtains from before Nature's shop, where stands an Image clad, and some unclad, they bring forth the clothed image" (Bond, III, 243). This image turns out to be Pandora.

Then the seven Planets enter and speak jealously about this new creation of Nature. Saturn is the first among them to have his turn to influence her. The stage direction reads " He ascends." Later, when under his influence, Pandora has done all sorts of ungracious things, the direction runs, " Saturne descendeth on the stage " (Bond, III, 248).

In the next act, Jupiter occupies the high place, which is without doubt a balcony stage. When Jupiter who has been holding converse with Pandora below, disappears quickly,— he dare not stay longer because Juno has discovered his whereabouts—Pandora asks, " And art thou clouded up ?" suggesting that some device was used for making a mist in the balcony to cover the exit of Jupiter, or perhaps curtains were merely drawn before the balcony and the audience were left to imagine the mist.

The real complication of the plot begins when Venus is in the ascendant, both metaphorically and literally. Gunophilus, the servant of Pandora, plots to betray her to her husband. Stesias asks where he may hide himself in order to witness the banquet which Pandora has provided for her numerous lovers. Gunophilus answers, " O, in this cave, for over this they'll sit." Gunophilus promises to make a sign to him if anything interesting occurs at the banquet. Stesias descends, threatening that if he hears the sign

> "And as a strange winde bursting from the earth,
> So will I rise out of this hollow vault,
> Making the woods shake with my furious wordes."

2

As the banquet progresses, Stesias gives much evidence that he is extremely uneasy in his cave, for the trap rises slightly more than once. Meanwhile the banquet goes on. Gunophilus brings the dishes and food from the back, showing that in this instance, the trap is in front. The second act ends with the dramatic appearance of Stesias from the trap, but Gunophilus helps to exonerate Pandora.

In the fourth act, the shepherds discover that they all have been duped by Pandora. They straightway tell Stesias, but when he confronts his perfidious wife she manages to clear herself again, and at the same time plans a dexterous revenge on all three of her lovers. She makes appointments with each one in turn to meet her in the evening at different places. Night falls. Stesias enters in woman's apparel and the three swains immediately take Stesias to be Pandora herself. There is a transfer of scene which must be imagined in this play, for the moment after the scene is in the grove, Stesias comes in saying: "This is Enipeus bank, here should she be."

The only point of interest in Act V for the subject under consideration, is that Nature turns Gunophilus into a hawthorne because he has not been a model servant. Nature says:

> " Vanish into a Haythorne as thou standest,
> Neare shalt thou wait upon Pandora more."

Stesias is commanded to follow Pandora who is set in the moon. He cannot revenge himself upon Pandora, but he can upon the hawthorne. He says:

> "Then to revenge me of Gunophilus
> Ile rend this hawthorne with my furious hands,
> And beare this bush ; if eare she looks but back,
> Ile scratch her face that was so false to me."

How the transformation of Gunophilus into the tree was

managed is a question of interest. In the Revels' Accounts
several items of hollow trees are recorded among the proper-
ties. Perhaps one of the convenient mists hid the exit into
the tree, or simpler still, the tree might have had an open
back, invisible to the audience.

There are some interesting questions which immediately
occur to the student of the court drama and they are
questions which unfortunately, from the present state of our
knowledge can be answered in most cases only by conjecture.
Was there a front curtain used to discover scenes in the
staging of the court drama? If so, were there then three
sets of curtains? Was the scenery used movable; in other
words, did the production of the play involve sets which
could be removed between acts or scenes? There is no
manner of doubt about the use of scenery in itself. The
Revels' Accounts contain numberless painters' items and
references to castles, towns, cities, battlements, pictures, etc.
And further, I think there is good evidence to prove that
this scenery was painted in perspective. In a document
quoted above, concerning the duties of the Revels' Office
occur these words, " The Connynge of the office resteth in
skill of device, in understandinge of historyes, in iudgement
of comedies, tragedyes and shewes, in sight of perspective
and architecture, some smack of geometrye and other things
wherefore the best helpe is to make good choyce of connynge
artificers severally according to their best qualitie, and for
one man to allowe of an other mans invencion as it is
worthie . . ." (Feuillerat, 11, 12).

Two views may be taken of the situation, but first let us
look at the facts. The Revels' Accounts give the clearest
evidence that curtains were used, as do also some of the
plays; that scenes were painted, most likely in perspective;
that elaborate and realistic properties of almost every con-
ceivable description were provided; that rich costuming was

the practice from the earliest times; that very often extrav-
agant sums were expended in the production of court
entertainments; and that Elizabeth thought so much of, this
department of her Household that she from time to time
granted special commissions to her Masters of the Revels
which would enable them effectively to carry on their office.
It may with no little color of truth be contended that a
people who could write such plays as were staged in Eliza-
bethan times, who had such vast sums to draw upon as the
court coffers provided, who were, it must be believed, very
clever workmen, who understood the art of building, deco-
rating and painting, who knew very well how to make a
room artistic, would know how to produce perfect stage
illusion, and would use their ingenious wits to this purpose,
not only by the aid of a front curtain disclosing the scenes,
but by movable, perspective scenery as well. They could
hang a sun in a cloud by means of pulleys; could they then
not move a castle and quickly put a country house in its
place?

The other view which may be taken is this: the Revels'
Accounts afford, it is true, the clearest evidence that scenery
was used in conjunction with curtains, but evidence is quite
lacking to show to what use the latter were put, or that the
stage could be set in the modern way by movable scenery.
Creizenach (3, 571 ff.), is of the opinion that the " howses
aptly paynted" mentioned in the Records were immovable
when once set. A palace supposed to be miles away was
placed on one side of the stage, while a country dwelling or
city was placed on the other; the spectator was left to
imagine the distance between them. And since he could
imagine one or the other of these sets away, he could also
imagine away if necessary both sets, if the location suddenly
demanded a woodland spot which was perhaps indicated by
a tree standing on the stage the whole time. This state

of things did not strike the spectator as incongruous. The
stage pictured to him was not real, but symbolic. Such
realistic illusion as was obtained resulted from the use of
very realistic properties. The spectator of plays was accus-
tomed to this sort of imperfect illusion and incongruous
setting from very early times ; therefore he was not dis-
turbed by it. That illusion was not perfectly observed can
be proved by the use of Diogenes' tub in *Alexander and
Campaspe* alone, not to mention others of Lyly's plays
which afford evidences of the same kind. Bond supposes
the tub thrust on and off as needed, its presence on the stage
pointing to a transfer to the market place or street. If the
old stage traditions are adhered to,—and history shows that
stage customs have a way of living on and on and that
people are very conservative about customs,—the tub most
probably stayed on the stage all the time ; when the action
did not demand its use the good people who looked at the
production of the court play simply did not see it; their
imaginations were equal to this task. Of course, some of
the stage property were no doubt moved ; there would be no
reason why they should not be. The rear stage with its
curtains, and the balcony perhaps, always provided a
friendly cover for changing the scenes and the properties.
But the point is that the Elizabethan spectator would not
be in the least disturbed by having a bed chamber scene on
the rear stage, while the front stage might be set with a
castle on one side, a country house supposed to be a long
distance away on the other, and a tree in the center or off at
one side, pending the moment when a scene was to be located
in a grove, the tree being symbolic of the grove.

What we have to base our idea of the staging of the court
drama upon is simply this : evidence, and plenty of it, that
curtains were used somewhere on the stage ; evidence of a
front, back, and balcony stage, with the additional elasticity

afforded by a trap; evidence in the Revels' Accounts of an
abundant use of realistic properties and rich costumes; in
short, a stage conforming in its broad outlines to that of the
public theaters, but richer in its furnishings and costumes
and more realistic in its more numerous properties, because
the king's treasury stood behind its business manager. But
until, in some manuscript not yet given to the world, is
found a detailed description or a careful picture, absolutely
authentic of the stage as erected in great Halls of Palaces,
and until evidence is really adduced that curtains hung in
front and that scenes could be and were shifted for every
scene and act, the weight of the evidence will be with those
who hold to the theory of incongruous staging, inharmonious
as that may seem to modern pampered eyes and imagination.
Such a theory, besides, accords with historical custom and
development.

ANNA AUGUSTA HELMHOLTZ-PHELAN.

STUDIES

FROM THE

Yale Psychological Laboratory

EDITED BY

EDWARD W. SCRIPTURE, Ph.D.

Director of the Psychological Laboratory

1899

VOL. VII.

YALE UNIVERSITY
NEW HAVEN, CONN.

PRESS OF
THE NEW ERA PRINTING COMPANY
LANCASTER, PA

CONTENTS

RESEARCHES IN EXPERIMENTAL PHONETICS

(*First Series*)

BY

E. W. SCRIPTURE.

The science of speech is at the present moment passing into the phase of experiment. For many years experiments have been made on the vowel sounds and on similar topics from a physical point of view, but it is only recently that the attempt has been made to arrange systematic work exclusively for the purposes of a science of speech itself. The present study, begun in October, 1897, gives the account of some of the results already obtained (to the end of 1899) in the system of researches now in progress in the Psychological Laboratory of Yale University. The scope of these researches is far wider than the topics considered in this first report. "Experimental phonetics" would include the material of the present study but such a term would need to be extended beyond its present significance to include all the work now in progress here. I believe, however, that there will be no objection to using the name "experimental phonetics" for a science of speech in all its forms as a matter of expression. This would include not only speech sounds as material for language, but also their changes resulting from different mental conditions such as fatigue, emotion and the like ; it would also include the study of rhythm in speech with its application in poetry and music.

The present investigation owes its immediate origin to suggestions from and discussions with Prof. T. D. GOODELL (Greek) and Prof. HANNS OERTEL (Comparative Philology). The question was raised concerning the possibility of using laboratory methods to settle the controversy in regard to the quantitative character of English verse. It was finally decided to study some records of English poetry made for one of the talking machines. After various trials it was found possible to obtain speech records in such a way that they could be measured.

It quickly became apparent that work on this problem required preliminary work on the elementary sounds of language. This work led to so many novelties and showed so clearly the need of revising many of our concepts of the nature of speech that the original problem was postponed

until the most valuable facts in regard to spoken sounds could be collected. These facts lay before me immediately in the records ; it was only necessary to measure the sound curves and interpret them. This measuring was a most laborious and fatiguing process but after a month or two of practice in interpreting the curves the work proved to be incredibly profitable ; it was rare to spend an hour at work on them without discovering some new fact. The field is, indeed, so rich and so unexplored that there is unlimited gain for any one wishing to enter it. To any one wishing to use the same methods every possible facility will be afforded by the Yale laboratory.

I. APPARATUS FOR STUDYING SPEECH RECORDS.

The choice of a method for obtaining measurable records seemed to lie between :

1. Causing the sound to trace a record that might be directly studied, without the possibility of reproducing the sound.

2. Causing the sound to trace a record which could be used to reproduce the sound and which could also be studied.

Both of these principles involved most serious difficulties; a long series of investigators and inventors had, however, rendered them possible.

The *former principle* appears to have been first applied by SCOTT in his phonautograph.[1]

In SCOTT's phonautograph a large parabolic receiving trumpet carries at its end a thin membrane whose movements cause a small recording lever to write upon the smoked surface of a cylindrical drum. The sounds of the voice passing down the receiver agitate the membrane and cause the lever to draw the speech curve on the drum. A vibrating fork serves to write the time line beside the speech line. SCOTT was a typographer and afterwards a dealer in photographs; the instrument was made by RUDOLPH KOENIG, the well-known maker of acoustical apparatus in Paris.

The instrument as improved by KOENIG was used by DONDERS and others.[2]

The logograph of BARLOW consisted of a trumpet or mouthpiece end-

[1] SCOTT, Inscription automatique des sons de l'air au moyen d'une oreille artificielle, 1861.

SCOTT, *Phonautographe*, Annales du Conservatoire des Arts et Metiers, Oct., 1864.

SCOTT, *Phonautographe et fixation graphique de la voix*, Cosmos, 1839 XIV 314.

LIPPICH, *Studien über d. Phonautographen von Scott*, Sitzb. d. Wien. Akad., Math.-naturw. Kl., 1864 L. (II. Abth) 397.

[2] DONDERS, *Ueber d. Natur aer Vokale*, Arch. f. d. holländ. Beiträge z. Natur.. u. Heilk., 1858 I 157.

ing in a thin membrane of rubber. A thin lever of aluminum carrying a point dipped in color wrote the speech curves on a band of paper.[1]

A still further improved phonautograph was used by SCHNEEBELI,[2] which carried two points, one fixed to aid in comparison and the other moving with the membrane. The inscription was made on a light strip of glass covered with a light coating of smoke and drawn on a carriage rapidly in front of the recording points. The tracings were measured with the aid of micrometric screws. SCHNEEBELI gives a number of the characteristic curves of the vowels.

Various similar methods have been employed with constantly better results. The ear drum has been used for the membrane by C. BLAKE.[3] The hindrance due to the inertia of material levers was avoided by E. W. BLAKE, who attached a mirror to a telephone plate in such a way that a beam of light was deflected by each movement. A ray of light from a heliostat was reflected through lenses upon a photographic plate moving with a constant velocity. The sound wave thus recorded a line on the plate.[4]

PREECE AND STROH used a thin membrane of rubber stretched by a cone of paper. The cone was made to move a fine glass tube supplied with an aniline ink, the record being taken on a band of paper.[5]

RIGOLLOT ET CHAVANON covered the wider end of a paraboloid with a very thin membrane of collodion, to the center of which was fixed a small mirror working on an axis of fine thread. The deflections of the ray of light were recorded on a sensitive paper.[6]

DONDERS, *Zur Klangfarbe der Vokale,* Arch. f. d. holländ. Beiträge z. Natur. u. Heilk., 1861 III 446.

DONDERS, *Zur Klangfarbe der Vokale,* Ann. d. Phys. u. Chem., 1864 CXXIII 527.

DONDERS, De physiologie der spraakklanken, Utrecht 1870.

SCHWAN UND PRINGSHEIM, *Der französische Accent,* Arch. f. d. Studium d. neueren Sprachen, 1890 LXXXV 203.

[1] BARLOW, *On the pneumatic action which accompanies the articulation of sounds by the human voice, as exhibited by a recording instrument,* Proc. Roy. Soc. London, 1874 XXII 277.

BARLOW, *On the articulation of the human voice, as illustrated by the logograph,* Proc. Roy. Dublin Soc., 1880 N. S. II 153.

[2] SCHNEEBELI, *Expériences avec le phonautographe,* Arch. des Sciences phys. et nat. de Genève, 1878 (Nouvelle période) LXIV.

SCHNEEBELI, *Sur la théorie du timbre et particulièrement des voyelles,* Arch. des Sciences phys. et nat. de Genève, 1879 (III. période) I 149.

[3] BLAKE, *The use of the membrana tympani as a phonautograph and logograph,* Archives of Ophthal. and Otol., 1876 V No. 1.

[4] BLAKE, *A method of recording articulate vibrations by means of photography,* Amer. Jour. Sci., 1878 XVI 55 ; also in Nature, 1878 XVIII 338.

[5] PREECE AND STROH, *Studies in acoustics,* Proc. Roy. Soc. London, 1879 XXVIII 358.

[6] RIGOLLOT ET CHAVANON, Journal de physique, 1883 553.

E. W. Scripture,

The most highly developed instrument of the lever recording type seems to be that of HENSEN.[1] It consists of a membrane of goldbeater's skin in a conical form produced by molding it over a shape while moist and allowing it to dry before removal. A single light lever attached to the center of the membrane carries a fine glass thread as a recording point. It writes the curve on a thinly smoked strip of glass. The curves are studied with a microscope. This instrument has been used in several investigations.[2]

An important improvement was made in HENSEN'S recorder by PIPPING who replaced the glass thread by a small diamond which scratched the curve directly on the glass strip. With this instrument PIPPING has made a series of investigations, chiefly on the vowels.[3]

RAPPS also avoids the difficulties of a diaphragm or membrane by an ingenious optical method.[4]

The MAREY tambours in various modifications have been frequently used.[5] Other devices have been employed at different times.[6]

[1] HENSEN, *Ueber die Schrift von Schallbewegungen*, Zt. Biol., 1887 XXIII 291 ; first described by GRUETZNER, Physiologie d. Stimme u. Sprache, 187, in HERMANN's Handb. d. Physiol., I. Bd., II. Theil, Leipzig 1879.

[2] WENDELER, *Ein Versuch, d. Schallbewegung einiger Consonanten u. anderer Geräusche mit d. Hensen'schen Sprachzeichner graphisch darzustellen*, Diss. Kiel, 1886 ; also in Zt. f. Biol., 1887 XXIII 303.

MARTENS, *Ueber das Verhalten von Vokalen und Diphthongen in gesprochenen Worten*, Diss. Kiel, 1888 ; also in Zt. f. Biol., 1889 XXV 289.

[3] PIPPING, *Om Klangfärgen hos sjunga vokaler*, Diss. Helsingfors, 1890 ; also as *Zur Klangfarbe d. gesungenen Vokale; Untersuchung mit Hensens Sprachzeichner* (Diss. in Swedish, Helsingfors 1890), Zt. f. Biol., 1890 XXVII 1.

PIPPING, *Nachtrag zur Klangfarbe der gesungenen Vokale*, Zt. f. Biol., 1890 XXVII 433.

PIPPING, *Zur Lehre v. d. Vocalklängen*. Zt. f. Biol., 1895 XXXI 525.

PIPPING, *Phonautographische Studien über d. Quantität schwedischer Worte u. d. musikalischen Accent*, Finländska Bidrag. till Svensk Språk och Folklifsforskning, Helsingfors 1894.

PIPPING, *Ueber d. Theorie d. Vokale*, Acta Societatis Scientiarum Fennicæ, 1894 XX No. II.

[4] RAPPS, *Ueber Luftschwingungen*, Diss., Berlin 1892 ; also in Ann. d. Phys. u. Chem., 1893 L 193.

[5] ROUSSELOT, Les modifications phonétiques du langage, Paris 1892.

BOURDON, *L'Application de la méthode graphique à l'étude de l'intensité de la voix*, Année psychol., 1897 IV 369.

WAGNER, *Französische Quantität (unter Vorführung des Albrecht'schen Apparats)*, Phonet. Studien, 1893 VI 1.

[6] FICK, *Zur Phonographik*, Beiträge zur Physiologie LUDWIG gewidment, 23, Leipzig 1887.

KOSCHLAKOFF, *Die künstliche Reproduction u. graphische Darstellung d. Stimme*, Arch. f. d. ges. Physiol. (Pflüger), 1881 XXXIV 38.

The manometric flame method was devised by KOENIG.[1] The vowel is sung or spoken into the trumpet leading to the small box known as the manometric capsule. This box is divided in two parts by a thin rubber membrane. The part opposite the trumpet is a tight chamber through which illuminating gas is flowing; the gas is lighted at the end of the small tube. As the sound waves descend they strike the rubber membrane, set it in vibration and thus produce movements of the gas analogous to those of the air in the sound waves. By means of a revolving mirror the vibrations of the flame can be seen. These flames can be photographed[2] by selecting the right composition of the illuminating gas; cyanogen gas has been used; a mixture of hydrogen and acetylene gas burning in a chamber of oxygen seems to be successful.

The foregoing methods have been employed for the solution of the most diverse problems.[3]

The *second principle* is that of the sound-reproducing machines, or talking machines.

The original talking machine seems to have been the phonograph of EDISON. The tin-foil phonograph was afterwards superseded by the wax-cylinder form.

A sheet of thin glass receives the sound waves and engraves them in a surface of hard wax by means of a sapphire knife attached to it. By replacing the sapphire knife with a round sapphire point the glass diaphragm is made to reproduce the sound.

The great advantage of this method lies in the fact that the record can be made audible at any time; the accuracy of the result can thus be always tested.

[1] KOENIG, *Die manometrischen Flammen*, Ann. d. Phys. u. Chem., 1872 CXLVI 161.
KOENIG, Quelques expériences d'acoustique, 46, Paris, 1882.
AUERBACH, *Untersuchungen ü. d. Natur. des Vokalklangs*, Diss. Berlin, 1876; also in Ann. d. Phys. u. Chem., 1876 Ergänzungsbd. VIII.
[2] STEIN, in MAREY, La methode graphique, p. 647.
DOUMER, *Mesure de la hauteur des sons par les flammes manométriques*, C. r. Acad. Sci. Paris, 1886 CIV 340.
DOUMER, *Études du timbre des sons, par la méthode des flammes manométriques*, C. r. Acad. Sci. Paris, 1887 CV 222.
DOUMER, *Des voyelles dont le caractère est très aigu*, C. r. Acad. Sci. Paris, 1887 CV 1247.
MARAGE, *Études des voyelles par la photographie des flammes manometriques*, Bull. de l'Acad. de Med., 1897 XXXVIII 476.
NICHOLLS AND MERRITT, *Photography of manometric flames*, Physical Review, 1898 VII 93.
[3] AUERBACH, *Die physikalischen Grundlagen der Phonetik*, Zt. f. franz. Sprache u. Lit., 1894 XVI 117.
ROUSSELOT, Principes de Phonétique Expérimentale, Paris 1897.

6 *E. W. Scripture,*

The phonograph has been used to receive records which have after-
wards been studied.

The methods of studying phonograph records are of two kinds.
Direct enlargement and measurement by means of the microscope is the
method followed by BOEKE.[1] Enlargement by means of amplifying
levers, recording directly on a smoked cylinder is the method used by
a series of observers.[2] Phonograph records have been studied to a con-
siderable extent.[3]

Enlargement by means of levers recording on photographic paper by
means of a beam of light is the method developed by HERMANN.[4] The
Yale laboratory is equipped for this method also.

[1] BOEKE, *Mededeeling omtrent onderzoekingen van klinkerindruksels op de watrollen
van Edison's verbeterden fonograaf,* De natuur, 1890, July.

BOEKE, *Mikroskopische Phonogrammstudien,* Arch. f. d. ges. Physiol. (Pflüger),
1891 L 297.

MEYER, *Zur Tonbewegung des Vokals im gesproch. u. im gesung. Einzelwort,* Phonet.
Studien, 1897 X 1 (Neuere Sprachen, IV).

[2] MAYER, *Edison's talking machine,* Nature, 1878 XVII 469.

FICK, *Zur Phonographik,* Beiträge zur Physiologie LUDWIG gewidmet, 23, Leipzig
1887.

JENKIN AND EWING, *The phonograph and vowel theories,* Nature, 1878 XVIII 167,
340, 394.

JENKIN AND EWING, *On the harmonic analysis of certain vowel sounds,* Trans. Roy.
Soc. Edinb., 1878 XXVIII 745.

KLUENDER, *Ueber d. Genauigkeit der Stimme,* Arch. f. d. ges. Physiol. (Pflüger),
1879 I 119.

LAHR, *Die Grassmann'sche Vokaltheorie im Lichte des Experiments,* Diss., Jena
1885 ; also in Ann. d. Phys. u. Chem., 1886 XXVII 94.

M'KENDRICK, *On the tone and curves of the phonograph,* Jour. Anat. and Physiol.,
1896 XXIX 583.

M'KENDRICK, MURRAY AND WINGATE, *Committee report on the physiol. application of
the phonograph and on the form of the voice curves by the instrument,* Rept. Brit. Ass.
Adv. Sci., 1896 669.

WAGNER, *Ueber d. Verwendung d. Gruetzner-Marey'schen Apparats u. d. Phono-
graphen zur phonetischen Untersuchungen,* Phonet. Studien, 1890 IV 68.

[3] MARICHELLE, La parole d'après le tracé du phonographe, Paris 1897.

GELLE, L'audition, Paris 1897.

MARAGE, *Les phonographes et l'étude des voyelles,* Anneé psychol., 1898 V 226.

[4] HERMANN, *Phonophotographische Untersuchungen,* I., Arch. f. d. ges. Physiol.
(Pflüger), 1889 XLV 582.

HERMANN, *Ueber d. Verhalten d. Vokale am neuen Edison'schen Phonographen,*
Arch. f. d. ges. Physiol. (Pflüger), 1890 XLVII 42.

HERMANN, *Phonophotographische Untersuchungen,* II., Arch. f. d. ges. Physiol.
(Pflüger), 1890 XLVII 44.

HERMANN, *Phonophotographische Untersuchungen,* III., Arch. f. d. ges. Physiol.
(Pflüger), 1890 XLVII 347.

Another of the talking machines is the gramophone. This is a development of the recording idea contained in SCOTT's phonautograph in combination with the idea of reproducing the sound in a special manner. The inventor of the method is Mr. EMIL BERLINER, of Washington, D. C. The United States patents covering the apparatus and processes are as follows : Gramophone, No. 372,786, Nov. 8, 1887 ; Process of producing records of sound, No. 382,790, May 15, 1888 ; Gramophone, No. 534,543, Feb. 19, 1895 ; Sound-record and method of making same, No. 548,623, Oct. 29, 1895 ; Gramophone, No. 564,586, July 28, 1896. These patents can be readily found in the annual reports published by the United States Patent Office.

The researches to be now reported have been made with the aid of the gramophone ; an acquaintance with the principles involved in the production of the gramophone records is necessary to the proper understanding of the results obtained.

1. Making gramophone plates.

For convenience the apparatus may be divided into two sections, the recorder and the impression disc.

The recorder with which I am acquainted is that described in the Letters Patent No. 564,586 ; it is shown in Fig. 1. The recorder comprises a thin glass diaphragm held in a frame, Fig. 2. This frame opens on one side into a speaking tube. It is cut away on the other side to afford connection with the recording stylus. From the center of the diaphragm a metal post rises, whose free end has an axial slot into which a piece of soft rubber tube is forced and flattened. The free end of the tube receives the metal stylus, which extends outward radially and ends in a flat, sharp, flexible point. Near the middle of the stylus a hole is bored and a pin formed at one end of a metal block passes through the hole and into the central bore of a similar block. Between each block and the stylus there is a soft rubber washer. The blocks are made to clamp the stylus by means of the pointed screws passing through the support and serving as pivots.

HERMANN, *Bemerkungen zur Vokalfrage*, Arch. f. d. ges. Physiol. (Pflüger), 1890 XLVIII 181, 543.

HERMANN, *Phonophotographische Untersuchungen*, IV., *Untersuchungen mittels des neuen Edison'schen Phonographen*, Arch. f. d. ges. Physiol. (Pflüger), 1893 LIII 1.

HERMANN UND MATTHIAS, *Phonophotographische Mittheilungen*, V., *Die Curven d. Consonanten*, Arch. f. d. ges. Physiol. (Pflüger), 1894 LVIII 255.

HERMANN, *Phonophotographische Untersuchungen*, VI., *Nachtrag zur Untersuchung der Vocalcurven*, Arch. f. d. ges. Physiol. (Pflüger), 1894 LVIII 264.

HERMANN, *Weitere Untersuchungen ü. d. Wesen d. Vocale*, Arch. f. d. ges. Physiol. (Pflüger), 1895 LXI 169.

These pivots form the fulcrum of the stylus. The stylus is dampened by a piece of soft rubber inserted between it and the metal cover of the sound box.

Fig. 1.

The sound waves coming down the speaking tube set the diaphragm in motion ; this diaphragm moves one arm of the stylus and the point at the end of the other arm repeats this movement.

Fig. 2.

The impression disc is prepared by two methods. I shall describe first the method with which I am acquainted and then a later method which seems of special interest.

In the former method (Patent No. 382,790) a highly burnished zinc disc 18ᵐ in diameter is flowed with a saturated solution of wax in benzine; the film of wax thus deposited is so thin that the touch of a camel's hair brush marks it perceptibly.

The prepared disc is placed on a revolving plate so that its surface is touched by the point of the recording stylus (Patent No. 534,543). As the plate revolves the recorder is made to travel toward the center; thus its point cuts a spiral groove through the wax. The vibrations of the point make deflections in this groove. These deflections are in the plane of the surface of the plate and not dug into it as in the case of the phonograph.

The record disc is then placed in an etching bath similar to that used by photo-engravers (Patent No. 548,623). The part of the zinc from which the wax has been removed by the stylus is attacked by the acid and a permanent groove is made. A copper matrix is then made from this by electrolysis. The matrix contains the sound-line in relief. After the matrix has been protected by a layer of nickel, unvulcanized rubber is pressed into it. The rubber is then vulcanized in place. When removed from the matrix the rubber plate is a true copy of the original disc.

Fig. 3.

The later method of making record discs I know only from a study of the Letters Patent, No. 564,586. I judge, however, that it is a better method and I believe that it may be of easy application in the direct study of records by the microscope.

In this method a glass plate is clamped on an axis by which it can be rotated. The under-surface of the disc is carefully polished and dried

and is then covered with a thin film of linseed oil by means of a camel's hair brush. A smoky flame then held under the plate deposits a fine layer of lamp-black, thus forming an amorphous ink which covers the glass in an even, exceedingly thin layer. This coating of ink does not flow spontaneously and requires only a minute force to trace a line in it. The sound line is drawn by the point of the recording stylus in a manner similar to that just described. Copies of the disc are made by placing it over a sensitized photographic plate and proceeding by photo-engraving.

To reproduce the sound the rubber disc is placed on a plate which can be rotated by some motor power. A reproducing sound box is so arranged that the point of its stylus travels in the sound-groove. The deviations in the sound groove move the point of the stylus whereby a glass diaphragm is made to reproduce the sound waves. The reproducing sound box differs from the recording sound box chiefly in having a stiff round steel point at the end of the stylus instead of a cutting point, as shown in Fig. 3.

2. *Transcribing gramophone records.*

The speed at which the plate travels in the record-making machine is about 70 revolutions a minute. This stretches out the curves for the speech sounds so that the variations in amplitude are visible through the microscope only in the case of musical sounds and vowels. The method of direct reading by the microscope is therefore not available. · The record must be transcribed in such a way that the relation between length and height, that is between time and amplitude, shall be changed. In the method about to be used the height was enlarged while the length was decreased.

In the transcribing apparatus (Fig. 4) the gramophone plate was put on a metal disc *E* similar to that of the original record-making machine. This disc was rotated at a speed of 0.1 revolution a minute by a system of spur and bevel gears. The particular system used was adopted after long experimenting ; as it may be of use to others it may be profitable to briefly describe it.

A small 110-volt Edison motor *A* was connected with the electric mains through an appropriate resistance. A convenient and cheap form of resistance *L* was found in the so-called reduction sockets for 16 c. p. lamps. These contain fine resistance wire wound on asbestos, which can be placed in circuit with the lamp to any desired extent, thereby reducing the current passing through it. An appropriate plug carrying the motor wires was placed in one of these sockets ; this socket was connected to another plug which was placed in another reduction socket ; this finally was con-

nected to a plug placed in a socket on the main line. By moving the
knobs on the reduction sockets the speed of the motor could be reduced
as desired. Finally the current was passed through a 4 c. p. lamp as a
permanent resistance of 800 ohms. In making the present records the
motor was adjusted to about 800 revolutions a minute.

FIG. 4.

A miter gear *a* on the axle of the motor fitted into another miter gear on
the first axle of the reducing machine *B*. The first axle of the reducing
machine thus revolved at 800 revolutions per minute. (For still finer
work it has been found convenient to use a worm on the motor axle and
a worm gear on the first reducing axle ; for a worm gear of *n* teeth the
speed of the first axle is $1/n$ that of the motor.) The second axle carried
a large spur gear with 160 teeth which fitted into small spur gear with 16
teeth on the first axle; thus the second axle made 80 revolutions per
minute. In a similar way gear-transmission to a third axle reduced the

speed to 8 revolutions, and transmission to a fourth axle reduced it to o.8 of a revolution. This fourth axle carried a spur gear of 20 teeth which fitted into the 160 teeth of the final driving machine of the disc whose axle thus made o. 1 revolution a minute.

The axle of the final driving mechanism carried on its further end a tube C with a longitudinal slit in it. Within this tube was a rod 1ᵐ in diameter with a thread of 96 turns to the inch on its surface; it was held by a nut correspondingly threaded. A projection from the rod fitted into the slit in the tube; thus the rod was forced to turn with the tube. At the same time the thread on its surface forced it to move lengthwise $\frac{1}{96}$ of an inch for each revolution. The rod bore on its end a carefully centered point and just back of this point a miter gear. The point pressed against the disc-carriage. This carriage consisted of a bar of brass running on a pair of rails and carrying the metal wheel *E*. The metal wheel rested on the carriage and its axle projected through it. As the rod traveled forward it pushed the carriage ahead of it. At the bottom of the axle there was a second miter gear *D* bearing against the first one on the rod; this turned the metal wheel in unison with the rod. When a gramophone plate was clamped on the wheel with proper centering, it was turned once in 10 minutes and was driven forward radially $\frac{1}{96}$ of an inch per revolution. Thus the speech curve on a plate would travel steadily under a fixed point from beginning to end.

Just above the disc the amplifying lever *F* was adjusted so that the soft steel point rested in the sound groove. The distance from the fulcrum to the point was 22ᵐᵐ. The lever possessed side movement in order to transcribe the curve, and vertical movement in order to follow the changes in the thickness of the plate. The long arm of the lever reached 595ᵐᵐ beyond the fulcrum. The extreme part of it consisted of a recording point of pendulum ribbon *M* 152ᵐᵐ long. This point traced the side movement on the smoked paper and also yielded to the up and down fluctuations without any noticeable effect on the records. The amplification was approximately 27 times.

It was afterwards found desirable to replace the simple supporting adjustments of the steel point by an adjusting standard such as is used in ordinary laboratory work. The point could be raised or lowered by a rack and pinion and adjusted sidewise by a small screw. The vertical movement was convenient for regulating the pressure of the recording points on the drum; the rubber gramophone plates varied in thickness and would consequently raise the point more at one side than the other. This variation has been avoided in the most recently made plates.

The centering of the gramophone plate was not an easy matter. The

speech curve was made in the form of a spiral around the center of rotation in the original machine; neither the edge of the rubber disc with the record nor the hole in its center coincided with this center. To center the spiral accurately on the metal plate two methods could be used. The microscope method proved somewhat the more convenient. The metal disc was moved away from the point of the rod. A microscope or a large magnifying glass was fixed so that it was focussed on the spiral groove. As the disc was turned the groove passed through the field of vision. If the plate was not centered, it would move to one side or the other during one half a revolution; it was adjusted by the fingers until the groove did not appear to move back and forth with every turn, but to maintain a steady side movement amounting to once the width between lines for one revolution. The other method consisted in turning the disc with the recording point adjusted and noting the deviation to one side for one half a revolution. The disc was then moved radially until the point marked one half the deviation. If this was properly done, the point would show no deviation as the disc is turned.

The steel point was pressed into the groove of the plate by means of the rubber band on the thread *b*; the verticality of the pressure was assured by the plumb line *C*.

The record was made on smoked paper moved by the BALTZAR kymograph *K* in the usual way with side movement of the drum by the driving mechanism *G*.

There were such minor adjustments of recording points, levers, etc., as were requisite for accuracy and convenience. To avoid jarring through the floor the table was at a later date suspended from the ceiling by wires. The jarring of the motor was avoided by placing it on sand. The slight variations in the potential of the city current did not appreciably affect the record.

In the laborious work of transcribing these records I was greatly aided by Mr. Minosuke Yamaguchi.

The records were measured with a scale graduated in 10ths of a millimeter under a watchmaker's eye-glass or under a magnifying glass. Thus 0.1ᵐᵐ was the unit of measurement. This represented an interval of time of 0.003¼ˢ, or 0.3¼ˢ. In the case of regularly repeated vibrations the determination could be made still finer by measuring a long series of vibrations. In the calculations only the tenth of a millimeter was used. The tenths of a sigma in the results may be out by one or two units; thus a series of vibrations recorded as 2.1ˢ, 2.1ˢ, 1.9ˢ, 1.9ˢ, etc., would be possibly more correctly given as 2.1ˢ, 2.0ˢ, 1.9ˢ, 1.9ˢ, etc. These steps disappear in the plotted curves of results which were drawn smoothly by aid of rubber curves.

The calculation was aided by ZIMMERMANN's Rechentafeln and a table of reciprocals. Thus millimeter measurements were turned into periods of vibration by using the table for 35, and frequencies were found by taking the reciprocal of the period.

The reproductions of speech curves in this study were obtained by having the originals photographed, with an enlargement of four times, directly on a wooden block; the engraver then cut the line with his tool. As some of the finer details were necessarily lost in this way, the attempt was made to get larger amplification in the records. Six months of unsuccessful work with compound levers were followed by an attempt (Dec., 1899) with a single very long lever of straw having the fulcrum close to one end and the recording point of glass. This method gives most beautiful curves of the greatest delicacy; they are as large as the curves shown in the figures for *ai*, etc. below and can be reproduced directly by zinc etching. This method is being used for further researches. Many other improvements have also been lately introduced.

In addition to the illustrations produced by photography and cutting by the engraver, others have been made by drawing with the free hand on a very large scale the curve as seen through the magnifying glass; in this way the finer details could be brought out with great accuracy.

II. THE DIPHTHONG *ai* FOUND IN THE WORDS *I, eye, die, fly, thy.*

The words first studied in the present case are those of WILLIAM F. HOOLY, a trained speaker, reciting the nursery-rhyme entitled "The Sad Story of the Death and the Burial of Poor Cock Robin." The record is contained on the plate numbered 6015 made by the National Gramophone Company of New York. As it is impossible to get any definite idea of how the words actually sound except by putting the plate in the gramophone, I will try to indicate some of the characteristics of the words heard.

MR. HOOLY speaks in what appears to be the normal American accent in the neighborhood of New York except in two respects: 1. he makes an unusual effort at distinctness; 2. he recites in the manner frequently adopted by adults in speaking to children—a manner that I am able to characterize only as having an excess of expressiveness and melodiousness.

The record on the gramophone plate, as far as it has been traced off, reads as follows:

Now, children, draw your little chairs nearer so that you can see the pretty pictures and Uncle Will will read to you the sad story of the death and the burial of poor Cock Robin.

Who killed Cock Robin?
I, said the sparrow,
With my bow and arrow.
I killed Cock Robin.

Who saw him die?
I, said the fly,
With my little eye
I saw him die.

Who caught his blood?
I, said the fish,
With my little dish
I caught his blood.

Who'll make his shroud?
I, said the beetle,
With my thread and needle
I'll make his shroud.

Who'll be the parson?
I, said the rook,
With my little book
I'll be the parson.

Who'll dig his grave?
I, said the owl,
With my spade and trowel
I'll dig his grave.

Who'll carry the link?
I, said the linnet,
I'll fetch it in a minute.
I'll carry the link.

To extend the treatment to prose some cases of *I* were studied in another record by Mr. WILLIAM F. HOOLEY, entitled "Gladstone's Advice on Self-Help and Thrift," being record number 6014 of the gramophone series. The speech runs as follows :

"Ladies and gentlemen, the purpose of the meeting on the 14th instant may, I can say, be summed up in a very few words : self-help and thrift."

Two examples of this diphthong were also studied in the word *thy*, as it appears in record number 668 Z (name of speaker not given), which runs as follows :

Our Father, which art in Heaven ; hallowed be Thy name, Thy kingdom come . . .

In order to get some idea of the relation between the character of the vibrations and the mental character of the word I have recorded judgments

as to how the words appear to the ear. The statements are given with appended initials. in the accounts of the various words ; the persons observing were : (O), Hanns Oertel ; (E. M. C.), Miss E. M. Comstock; (E. W. S.), E. W. Scripture.

ai in the word *I* (first example).

The first occurrence of *ai* is in the verse *I, said the sparrow.*

A reproduction of the curve for this word is given in Fig. 5. As explained on p. 14, some of the details are lost in making the figure and others are not quite correctly given ; the original curve is much sharper and clearer.

Fig. 5.

This word *I* occupies an interval of 452e (e = 0.001s). It is preceded by a silent interval of 770e, or about ¾ of a second ; this is the full stop in the stanza after the question is asked and before the answer is given, indicated by ? in print. It is followed by a silent interval of 210e, indicated in print by a comma.

Beginning.—The beginning of the *a* is apparently clear, that is, it is not preceded by any breathing. The vocal cords are apparently adjusted for voice production before the expiration begins ; the vowel starts with a light vibration of the cords. There is no explosive sound, or glottal catch, before the vowel.

Pitch.—Beginning with a period of 18e, the cord tone changes slowly through 11, 10, 9, 8, 7e, reaching 6e at the 11th vibration, 5e at the 15th, 4e at the 30th ; the period of 4e is maintained to about the 100th vibration, after which it falls slightly to 4.2e during the last 7 vibrations. In other words, the pitch glides slowly upward from a tone of 56 complete vibrations per second to one of 200 per second, then more slowly to one

of 250 per second, at which pitch it remains constant except for a slight drop as the diphthong ends. Fig. 6 shows the course of the pitch-changes

FIG. 6.

during this word. The horizontal axis in this figure, as well as in all similar ones, represents time. The point $x = 0$ is taken at the moment of the first vibration and the sound curve is supposed to be laid along the *X*-axis. At each point on this axis at which the curve shows a cord vibration to begin an ordinate is erected, inversely proportional to the time from this moment to the beginning of the previous vibration, that is, to the frequency of the cord vibration at that point. By an oversight the figures 300 and 400 have been interchanged.

Formation.—A drawing of the first three vibrations is given in Fig. 7 ; the dots indicate intervals of 1˚.

FIG. 7.

The vowel *a* begins with a movement of the vocal cords by which an extremely weak puff of air is emitted. This puff of air passing through the resonance-chamber of the mouth arouses 3 or 4 vibratory oscillations of air contained in the chamber. There is first a half oscillation of weak amplitude, then a comparatively strong oscillation, followed by very weak ones. Even the strongest is, however, very weak ; the following oscillations are so weak as to be hardly perceptible. The resonance vibrations disappear and there is an interval of silence before the second puff appears. Then the cords emit another puff of air a trifle stronger than the first, the time from puff to puff being 18˚. The 6 resonance vibrations are slightly stronger than before. The period of silence is shorter than before. The third puff occurs 11˚ after the second one. The

resonance vibrations are a trifle stronger still ; there are 7 of them with a brief interval of silence. The fourth puff begins at 10ᵛ after the beginning of the third one. The fourth puff contains 8 resonance vibrations, all slightly stronger than before ; there is no interval of silence because the fifth puff begins just as the last resonance vibration of the fourth puff ends. The interval occupied by the fourth puff is 9ᵛ. The end of the fourth puff, the whole of the fifth puff and the beginning of the sixth are shown greatly enlarged in the drawing, Fig. 8.

FIG. 8.

It is a characteristic trait of this particular *a* that the vibration is strongest at the start ; this indicates a sudden and complete opening of the cords. The quickest opening requires, however, a little time and there must be a measureable change from no passage of air to full passage ; this is shown by the weak half of the first resonance vibration preceding the large half. The form of vibration may possibly be held to indicate a complete closure of the cords whereby they actually touch each other. This is supposed to be a characteristic of spoken vowels as distinguished from sung vowels. The *a* sung by HERMANN[1] shows a gradual rise and fall of intensity such as would arise from a free vibration of the cords without touching of their edges. Spoken vowels, however, may be also produced by free vibrations of the cords as in the case of the *I* analyzed below (p. 25).

In this *I* there appears a trace of the strong secondary resonance vibration discussed below (p. 23) ; the phenomenon is here so faint that a discussion of it is best postponed to the study of the 2d example of *I*. The resonance tone indicated by it has a period of 3½ᵛ, or a frequency of 286 ; this is approximately the note shown in Fig. 9.

FIG. 9.

The resonance vibration in the first part of the word has a period of 1ᵛ or a frequency of 1000. Its pitch is approximately as indicated in Fig. 10.

FIG. 10.

─────────────────────
[1] HERMANN, *Phonophotographische Untersuchungen*, IV., *Untersuchungen mittels des neuen Edison'schen Phonographen*, Arch. f. d. ges. Physiol. (Pflüger), 1893 LIII Tafel II.

HERMANN, *Weitere Untersuchungen ü. d. Wesen d. Vocale*, Arch. f. d. ges. Physiol. (Pflüger), 1895 LXI Tafel V.

As the period of the cord tone becomes shorter, the number of reso-
nance vibrations to each period becomes smaller. Beyond the 30th period
of the cord tone the resonance vibrations show a lengthening of period.
In the 39th cord vibration the resonance tone reaches a period of 2.2ʳ or
a frequency of about 450 ; it thus falls more than an octave in the time
of 9 cord vibrations, or, in this case, in 33ʳ. Here the resonance tone
is nearly but not quite of the same period as the octave, 2ʳ, of the cord
tone, 4ʳ. This change is shown in the hand-drawing, Fig. 11, which be-

FIG. 11.

gins with the 31st vibration. This relation between resonance tone and
cord tone is maintained to the end of the word ; it produces the peculiar
alternation of waves seen in the last two vibrations in Fig. 11.

The vibrations up to the 31st unquestionably belong to the *a*. In
the vibrations beyond the 39th both the cord tone and the resonance
tone are constant, except for a slight fall at the end. They unquestion-
ably belong to the *i*. The vibrations from the 31st to the 39th show a
constant cord tone and a falling resonance tone. They are presumably
to be considered as belonging to the " glide." During the *a* the cords
have been stretched more and more until at the 31st vibration they
reach the tension required for the *i* ; the only further change necessary
is the lowering of the resonance tone.

Beyond the portion shown in Fig. 11 the curve shows strong vibrations
so nearly alike that one is naturally induced to consider each one a cord
vibration, as shown in Fig. 13. This would not be the proper way be-
cause close inspection shows that succeeding vibrations differ slightly,
while alternate ones are alike. This likeness of all the resonance vibra-
tions in the *i* as contrasted with the *a* is probably also due to a difference
in the action of the cords ; this difference appears more clearly in the
word *eye* analyzed below, and the discussion is postponed to that point.

With the understanding that no definite limit can properly be made
between one sound and the neighboring one in this case, we may, on ac-
count of the foregoing consideration, consider the *a* to have occupied the
time 203ʳ ending with the 30th vibration, the glide to have occupied
33ʳ ending with the 38th vibration and the *i* to have occupied the remain-
ing 216ʳ.

The resonance tone of the *i* is one of about 450 vibrations per second, or about that in Fig. 12.

FIG. 12.

This resonance tone is much lower than the very high tone assigned to *i* by HERMANN and others but is not so low as those assigned by some other observers. There is, however, the possibility of different tones in the vowels from different speakers and also that of several resonances in the same vowel. In careful examination of the curves I find them often marked by small additional vibrations. These are frequently quite prominent

FIG. 13.

in the *i* of *ai*. Their fineness rendered it impossible to settle on any definite facts regarding them. In the drawing, Fig. 13, I have tried to give some idea of how the curve of the *i* might appear if freed from the defects of tracing. It is impossible to assign any period to these small vibrations ; the regularity in the drawing was adopted for purely mechanical reasons.

The changes of the cord tone and the resonance tones are indicated in a general way in Fig. 14.

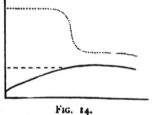

FIG. 14.

·········· Upper resonance tone.
- - - - Lower resonance tone.
———— Cord tone.

Amplitude.—The amplitude of a vibration is the distance from the position of equilibrium to the extreme position on either side ; it is thus one-half the difference in altitude between the crest and the trough of a wave. The course of change in amplitude is given in Fig. 15. The horizontal axis represents time as explained for Fig. 6. The vertical axis represents amplitude.

The initial resonance vibration of the first puff of this *a* has an amplitude of less than 0.1mm. This slowly increases to 0.3mm at the 20th vibration after which it remains practically constant to the 38th. Beyond

the 38th, that is, from the beginning of the *i*, the amplitude rapidly increases from 0.3mm to 0.7mm at the 50th vibration ; thereafter it slowly sinks, becoming 0.3mm at the 60th vibration and 0.2mm at the 80th, 0.1mm

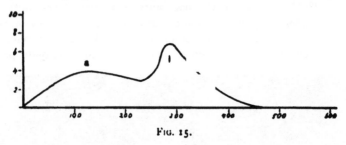

Fig. 15.

at the 88th and 0 at the 96th. The vibrations of the *i* just beyond the 50th, or the maximum of the *i*, are shown in Fig. 13 ; in this figure two of the large vibrations belong to one cord vibration.

The maximum for the *i* is 2½ times that for the *a*.

Ending.—The word *ai* ends by a gradual cessation of the expiratory impulse with hardly a noticeable change in the tension of the vocal cords ; this is the clear ending usual in English. The slight fall in pitch of the *i* toward the end indicates a change that may be apparent in the auditory effect of the word, although it cannot be distinguished separately. It is probably due to a relaxation of the cords.

Relation between curve and color.— To the ear the sound of this word *I* appears from the record " colorless, without emotion, without inflectional rise or fall within the word, a monotone " (Θ.) ; " a mild statement " (E. W. S.).

The mildness of this word seems related to its length and its gradual changes in pitch and intensity.

ai in the word *I* (second example).

The second case of the word *I* occurs in the sentence *I killed Cock Robin.*

The complete reproduction of the curve is given in Fig. 16. The first five puffs are shown enlarged in the drawing, Fig. 17.

This word occupies an interval of 334$^{\sigma}$. It is preceded by a silent interval of 420$^{\sigma}$, or nearly half a second ; this considerable interval would indicate a full stop. The words *With my bow and arrow* seem therefore in the thought of the speaker to belong to the previous *I*. The thought seems best indicated by a period after *arrow* ; thus, I, said the sparrow, with my bow and arrow. *I killed,* etc. This second *I* is followed by

an interval of about 125″ before any trace of the following sound can
be found.

FIG. 16.

FIG. 17.

Beginning.—Similar to that of the 1st *l*, p. 16. The first five vibra-
tions are shown in the drawing, Fig. 17.

Pitch.—Beginning with a period of 12″, the cord tone changes steadily
through 9, 8, 8, 7, 7, 6, 6, 6, 6, 5, 5, 5, 5, 5, 5, 5, 4, 4, 4, 4, 4, 4, 4,
etc., to the 48th vibration after which it slowly falls to 4.4″ at the 70th.
The course of the pitch-change is shown in Fig. 18 ; the plotting is done
in the manner described for Fig. 6.

FIG. 18.

Formation.—The formation of the *a* is apparently the same as in the
preceding case ; the secondaries indicate a resonance tone of 1000, as in
Fig. 10. At the distance of 3½″ beyond the beginning of the vibration

there is another large oscillation markedly greater than the other second-aries, as shown in the drawing Fig. 18. This large secondary keeps at the same time behind the primary. As the pitch of the cord tone rises, the primary resonance vibrations come closer together ; the large secondary, being at a constant interval behind the preceding primary, thus comes steadily closer to the following primary until it disappears in it. A drawing of two such vibrations is given in Fig. 19.

FIG. 19.

I do not believe that this larger secondary is due to an overtone-vibra-tion of the cords. A stretched string or a reed may vibrate primarily as a whole, secondarily in halves, thirds, and so forth, producing the funda-mental tone and its overtones. As the tension of the string or reed is in-creased, the fundamental tone rises in pitch and its overtones must do so likewise. For example, a string or a reed that vibrates in halves in ad-dition to its fundamental vibration, will continue to vibrate in halves as the tension is changed. The curves for this vowel do not represent such a vibration. The strong secondary keeps at the same distance after the preceding primary while the distance to the following primary steadily decreases.

Two explanations of this phenomenon may be proposed.

It might be suggested that the primary and the strong secondary may represent two waves of a lower resonance while the primary and the other secondaries represent the waves of a higher resonance ; this resonance would have a period of 3½ or a frequency of about 286. The note corresponding to this tone is shown in Fig. 9. It would require a rather large cavity to resonate to such a low tone. Such a cavity may perhaps arise from the pharynx and mouth acting as a single resonator of great length. There would then be at least three tones present in the *a* : the rising cord tone, the lower resonance tone of 286, which finally coincides with the cord tone, and the higher resonance tone of 1000.

Another explanation that may at least be considered is that the strong secondary arises from a flap-like action of the cords. The closure of the glottis across the air-current brings about a vibration of the edges, pro-ducing a tone whose pitch depends upon the tension of the edges. The edges can be assumed to vibrate as wholes in the manner of stretched

strings. As the tension is increased, the pitch rises. In addition to this the tissue stretching from the edges to the walls may also vibrate in unison with the edges, but just as in the case of a piece of cloth attached to a string, it may be assumed to execute an additional flap owing to the first impulse being reflected from the further walls to which the membrane is attached. If we assume that the tension of this tissue (Musculus thyreo-arytenoideus) remains constant during the vowel, this membranous flap would be independent of the tension of the cords and would follow it at a constant interval. This flap would impress itself with the air current and thus produce a stronger resonance vibration at a constant interval after the primary resonance vibration. On the assumption that the regular repetition of a sound produces a tone, the large secondary would combine with the preceding primary to produce a tone with a period of 3.5^σ or a frequency of about 286. Likewise it would combine with the following primary to produce a tone of changing pitch ; this tone would start with a period of 5.6^σ or a frequency of about 178 and rise steadily in pitch till it disappeared.

The lowering of the resonance tone can be clearly seen at the 12th vibration just as at the 31st in the preceding case, although it may possibly begin earlier ; it is finished at the 28th. Thus, 80^σ can be assigned as the time occupied by the *a*, 70^σ by the glide and 184^σ by the *i*.

The resonance tone of the *i* has a period of 1.8^σ or a frequency of about 555 ; this is approximately the note shown in Fig. 20.

FIG. 20. The smaller vibrations are also present as mentioned on p. 20.

The changes of the three tones in this vowel are indicated in Fig. 21.

Amplitude.—The maximum amplitude in the first vibration is less than 0.1^{mm} ; it increases steadily to 0.4^{mm} at the end of the *a*.

Beyond the 25th vibration the amplitude begins to increase ; it reaches a maximum of 0.6^{mm} at the 31st vibration. Thereafter it decreases rather rapidly, becoming 0.2^{mm} at the 45th vibration and fading away gradually to 0 after the 75th. If the vibrations from the 12th to the 30th are to be considered as the glide, the maximum occurs just after the beginning of the *i*.

The *i* is thus weaker throughout than in the previous case ; its maximum amplitude is also slightly less. Owing to the loudness of the

FIG. 21.

......... Upper resonance tone.
– – – – Lower resonance tone.
———— Cord tone.

a, the maximum amplitude of the *i* in this case is only 1½ times that of the *a*.

The course of change in amplitude is shown in Fig. 22 ; the plotting is done in the manner described for Fig. 15.

FIG. 22.

Ending.—Similar to that of the 1st *I*, p. 21.

Relation between curve and color.—To the ear this *I* is "shorter than the 1st *I*; more emphatic" (O.); "the word is spoken emphatically and boldly " (E. W. S.).

The emphatic character of the word may arise from its shortness, the loudness of the *a*, the quick fall of the *i*, or from other causes not determined.

<center>*ai* in the word *I* (third example).</center>

The third example of *I* occurs in the words *I, said the fly.*

This word occupies an interval of 598ᵟ. It is preceded by a long silent interval of 560ᵟ, or over ½ of a second, indicating the full stop after the question has been asked. It is followed by a silent interval of 200ᵟ, or ⅕ of a second, indicated in print by a comma.

Beginning.—The first strong resonance vibration is preceded by 4 very small secondaries, Fig. 23. This would indicate that the expiration be-

FIG. 23.

gan before the cords had closed for their first explosion but that the mouth was already in position for the vowel. Such a brief passage of air through the mouth before the cords began to vibrate would cause the resonance tone to be heard for a brief instant before the cord tone began. In this case the resonance tone began 4 thousandths of a second before the cord tone. This can hardly be considered as an extremely brief

aspirate, or *h;* the time is too short, 5ʳ, for any perception of the sound distinct from the rest of the vowel.

It is quite possible that this manner of beginning a vowel may be that called by Ellis and Sweet a "gradual glottid" and by Sievers a "lightly breathed beginning." " In this the cord opening passes through the positions for toneless breath and whispering before the cord tone begins, whereas the really strong impulse of expiration begins only at the moment when the voice itself sounds."[1]

Pitch.—Beginning with a period of 7.7ʳ(131 vibrations per second) it rises to 7ʳ at the 8th vibration to 6ʳ at the 13th, to 5ʳ (200 vibrations)

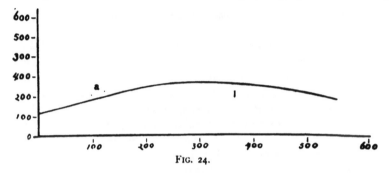

FIG. 24.

at the 20th, slowly to 3.8ʳ (250 vibrations) at the 40th after which it remains constant to the 70th. Thereafter it falls slowly to 4.2ʳ at the end. The course of change in pitch is shown in Fig. 24, which is plotted in the manner described for Fig. 6.

Formation.—The primary and secondary resonance vibrations are present in the *a* as in the previous cases but the secondary vibrations are relatively stronger in this case. This would indicate a more gradual opening of the cords ; not so much of the energy of the puff is expended at the start, and some of it is reserved to carry the resonance longer. There is no silent interval within the puff.

In the greater part of the curve the secondary vibrations in the *a* differ in form from those of the previous cases. They take a form that would indicate a series of partial tones differing from each other in phase by ¾ as shown in the drawing, Fig. 25.

Some of the curves for the other cases of *I* appear of the simple pendular harmonic form, but many of them show tendencies toward forms with the overtones differing in phase by ¼. Those that resemble the cases of difference by 0 and ½ cannot be distinguished from simple curves

[1] Sievers, *Grundzüge der Phonetik*, 4. Aufl., 140, Leipzig 1893.

on the small scale of the records. According to HERMANN the differences in phase produce no differences in the tone heard.[1] I note this particular vowel, however, as its curve differs from the others. The different forms

<center>FIG. 25.</center>

for different cases of *I* presumably indicate differences in the shape of the mouth.

The curve in this *a* presents great irregularities ; they are all explainable, however, from the gradually rising pitch of the puffs whereby the number of resonance vibrations is gradually reduced as in the previous cases.

Just as in the previous cases the resonance tone begins to change while the cord tone is constant. The change begins somewhere around the 40th vibration and proceeds rather rapidly to the 50th. Thus 217″ can be assigned to the *a*, 46 to the glide and 335″ to the *i*.

The resonance tone for the *a* has, as before (p. 18), a period of 1 or a frequency of 1000 (Fig. 10). The resonance tone beyond the 50th vibration—which we may consider as the beginning of the *i*—has a period of 2.0″, or a frequency of 500, or approximately as indicated in Fig. 26.

<center>FIG. 26.</center>

The resonance tone remains constant for about 20 vibrations of the *i* and then slowly falls with the cord tone to about 2.2″ at the end. The resonance tone of·the *i* is very closely the octave of the cord tone.

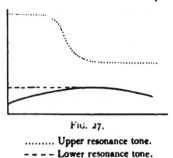

<center>FIG. 27.</center>

.......... Upper resonance tone.
- - - - Lower resonance tone.
———— Cord tone.

The resonance vibrations of the *a* show a fairly strong secondary (p. 23) at 3.5″ after the beginning. This would indicate a tone with a frequency of 286.

On the first hypothesis (p. 23) this would be the lower resonance tone, Fig. 9. On the second hypothesis it would be the constant flap tone ; the changing flap tone would begin also with period of about 3.5″, and rise in pitch rapidly.

[1] HERMANN, *Beiträge zur Lehre v. d. Klangwahrnehmung*, Arch. f. d. ges. Physiol. (Pflüger), *1894 LXV* 467.

The changes in the tones of this vowel are indicated in **Fig. 27**.

Amplitude.—The amplitude of the maximum resonance vibration in the *a* is less than o.1mm in the first vibration; it gradually increases to o.4mm and remains constant to the end of the *a* and through the glide.

After the glide the amplitude rises with moderate rapidity to o.6mm at the 62d vibration. Thereafter the amplitude falls more evenly and slowly to o than in the second example.

The course of change in amplitude is indicated in **Fig. 28**; the plotting is done in the manner described for Fig. 15.

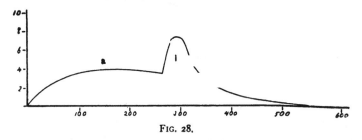

FIG. 28.

The amplitude of the *a* in this example closely resembles that in the 2d example; the *i* is also similar but its rise is more gradual and its fall more sudden. The amplitude throughout this example is a trifle less than in the first one. The maximum for the *i* is 1½ times that for the *a*.

Ending.—As on p. 21.

Relation between curve and color.—To the ear this *I* is "like the 2d but longer; a little more self-assertive" (O.); "spoken rather emphatically; like the 2d example rather than the first" (E. W. S.).

The maintenance of the pitch of the *i* may have something to do with this assertiveness.

ai in the word *I* (fourth example).

The fourth occurrence of *I* is in the line *I saw him die*. It occupies an interval of 350$^{\sigma}$; the word is thus shorter than any of the previous examples.

It is preceded by a silent interval of 165$^{\sigma}$, which is shorter than the similar interval before *I killed*. The speaker evidently feels that the words *With my little eye* belong to the following words *I saw* in making a sentence; thus no mark of punctuation should be placed after the word *eye*. This view is supported by the existence of a pause of 385$^{\sigma}$ before the word *With*. In the previous stanza there was a pause of 770$^{\sigma}$ after the words *With my bow and arrow* and of o (zero!) before them, that is, between *sparrow* and *with*. In that stanza the

speaker evidently felt the phrase beginning with *With* to belong to the preceding *I* and not to the following one. Both stanzas have been punctuated on p. 15 in accordance with these views.

The tracing of the *I* is followed by a straight line for 200ᵛ ; this time includes the pause after the *I* and the time of the *s* of *saw*.

Beginning.—The first primary resonance vibration of the *a* is preceded by several secondaries (see Fig. 30); the beginning thus resembles that of the 3d example, p. 25

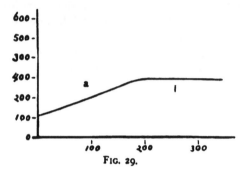

FIG. 29.

Pitch.—Beginning with a period of 9ᵛ it rises steadily through 8, 8, 7, 7, 7, 6, 6, 6, 6, 6, 6, 6, 5, 5, 4, 4, 4, ⋯ 4 (at the 28th), to 3½ at the 35th ; this pitch is maintained practically unchanged to the end. In regard to pitch also this *a* closely resembles that of the 2d example but it is throughout a little higher. Starting with a frequency of about 111 it rises to about 286 and maintains this. The course of change in pitch is shown in Fig. 29, which is plotted in the manner described for Fig. 6.

Formation.—The first three vibrations are shown in the drawing Fig. 30. The motion of the cords is seen to be free and gradual as in the

FIG. 30.

third example, p. 26 and Fig. 23. The resonance vibrations in the *a* resemble those in the 2d example in having one of the secondaries stronger than the others. This secondary maintains its place in respect to the preceding primary resonance vibration with about 3.5ᵛ between them. As the puffs come more rapidly, the primaries come more closely in succession, cutting off the secondaries at the end in the usual way (p. 17). Thus the larger secondary comes steadily nearer to the following primary while maintaining its constant distance from the preceding primary.

If the primary resonance vibration and the strong secondary following it indicate a tone, the period of the tone will be about 3.5$^\sigma$ and the frequency about 286. If a tone is to be considered as being formed by the interval from the strong secondary to the following primary, it would begin at about 4.5$^\sigma$, or a frequency of 220, and would rise in pitch till it is extinguished. In this respect this *a* closely resembles that in the 2d example of *I* (p. 23).

It is peculiar to this *I* that the cord tone rises during the *a* to the pitch of the lower resonance tone 286 and that the *i* keeps this pitch for the cord tone.

The upper resonance tone of the *a* has at the start a period of a little over 1$^\sigma$ or a frequency a little less than 1000. The lowering of the resonance tone may begin at the start but it cannot be detected until about the 30th vibration, owing possibly to the unusual complexity of the curve in this case. Shortly before the 40th vibration it reaches 1.5$^\sigma$, and at about the 48th 1.8$^\sigma$. Around the 50th it reaches 2.1$^\sigma$, at the 65th about 2.5$^\sigma$; after this there is scarcely any fall to the end.

FIG. 31.

......... Upper resonance tone.
– – – – Lower resonance tone.
———— Cord tone.

The changes in the tones of this vowel are indicated in Fig. 31.

Amplitude.—The maximum amplitude in the first vibration is less than 0.1mm; it increases rapidly to 0.3 in the 6th vibration, reaches 0.4½ at the 17th, decreases to 0.2½ at the 28th and remains with no noticeable variation from this till the 35th. In all previous cases the *a* has steadily increased in intensity; here we have a rise and a fall.

In the *i* the amplitude rises quickly from 0.3 to 0.7 at the 42d vibration of the word (7th of the *i*) after which it sinks quickly to 0.3 at the 45th and thereafter more slowly to the end. Such a

FIG. 32.

quick fall of intensity is not found in any of the preceding cases of *i*. The loud part of the *i* is shorter than in the previous cases. The maximum amplitude is reached at its 13th vibration, where it is 1½ times that of the *a*.

The course of the change in amplitude is given in Fig. 32, which is plotted in the manner described for Fig. 15.

Ending.—The *i* ends with a steady fall in intensity without noticeable change in pitch.

Relation between curve and color.—To the ear the word seems to be spoken " like the 3d *I* " (O.) ; " triumphantly " (E. W. S.). The emphatic or triumphant character of the word may be due to its shortness. The high pitch of the word and the relation of tones arising from the strong secondary may also be elements tending to make the word emphatic.

ai in the word *I* (further examples).

Nine further cases of *I* were studied, making thirteen in all. In general the fundamental characteristics of the four cases already considered were found in all the rest. Some peculiarities, however, are to be noted.

Sometimes the first vibration of the *a* is shorter than the following one. This occurs, for example, in *I'll make his shroud*, and *I'll be the parson*. In the former case the periods are 9.8ᵉ, 11.6ᵉ, 10.9ᵉ, 9.8ᵉ, etc., and in the latter 8.1ᵉ, 10.5ᵉ, 9.8ᵉ, 8.8ᵉ, 8.8ᵉ, 8.1ᵉ, etc. The cords seem to receive an excess of tension before the breath begins and to be then relaxed to the tension desired. This suggests the possibility that in all cases of *I* the tension of the cords may be made greater than desired and that it is adjusted by relaxation before the breathing begins. There are two ways of reaching an adjustment of any muscular force, one by increasing the force upward until it reaches the proper point and the other by making an excessive increase and then relaxing. This latter method is familiar in many activities. I merely suggest its possibility in speech ; I see no reason for supposing it to be the method employed in the cases of *I* that do not show it in the records.

Another peculiarity lies in the ending. Most cases of *i* in *I* fade slowly away in intensity while a slight fall in pitch takes place. In the case of *I* in *I caught his blood*, the vibrations reach a maximum in the early part of the *i* as usual and thereafter decrease in amplitude ; but instead of steadily decreasing to zero they are rather suddenly cut off at a point 56ᵉ beyond the maximum, at which point the amplitude is about ¼ that of the maximum. Beyond this point there are still some faint vibrations in the tracing during a time of about 10ᵉ, after which the tracing is straight. The straight tracing represents the *k*-sound in the word *caught;* the faint vibrations correspond to the glide during which the cords are still vibrating but the mouth is changing from the *i*-position to the *k*-position. The condition seems to correspond to what may be called a " sharp cut off " to the vowel (KUDELKA : " stark geschnittener Accent '") in contrast with the " fading end" to the cases of *I* above.

[1] SIEVERS, *Grundzüge der Phonetik,* 4. Aufl., 204, Leipzig 1893.

In the case of *I* in *I'll make his shroud* there is also no **fading away**; *i*
passes into '*ll* and '*ll* into *m* without any break, although a fluctuation in
amplitude takes place.

In one case the fall of the upper resonance tone appears to take place
from the very beginning of the word; the resonance tone is thus steadily
falling while the cord tone is steadily rising. This occurs in the *a* of *I* in
I, said the fish. The period of the resonance tone begins with 1.4ᵞ, reaches
1.5ᵞ at about the 10th vibration, 1.8ᵞ at the 40th vibration and then re-
mains constant to the end of the word. The typical *a* form is lost in the
curve at this point, namely the 40th vibration, or 228ᵞ after the begin-
ning; the typical *i* form appears clearly after the 45th vibration, justify-
ing us presumably in assigning 19ᵞ to the glide and 240ᵞ to the *i*.

<center>*ai* in the word *I* (prose example).</center>

This occurs in the words *may, I can say, be summed up in a very few
words* of the prose speech given on p. 15.

It occupies an interval of 354ᵞ. It is preceded by a silent interval of
not over 16ᵞ; the preceding sound is *ay* of *may* which fades away slowly
and may occupy in extreme faintness some of this interval. It is fol-
lowed by a line showing no vibrations through an interval of 70ᵞ; this
represents undoubtedly the gutteral *k* in the word *can* which seems to fol-
low the *I* without pause as in the case mentioned on p. 31, yet the *k* does
not cut off the *i* suddenly in this case as is shown by a study of the am-
plitude (p. 34 and Fig. 40).

Beginning.—Very faint but apparently clear, as on p. 16.

Pitch.—The successive periods are 9.8, 8.4, 7.0, 6.7, 6.0, 6.0, 6.3,
6.0, 6.0, 6.0, 6.0, 6.3, 6.7, 6.7, 6.7, 6.7, 6.3, 6.3, 6.3, 5.6 at the 20th

<center>FIG. 33.</center>

vibration; after this the period remains constant at 5.6ᵞ to the 68th vi-
bration at the end of the word. This is indicated in Fig. 33, which is
plotted in the manner described for Fig. 6.

Formation.—In general the curve resembles those with the strong secondary but with the difference that this secondary occurs at a smaller interval, 2.8", after the primary. As the primary has a period of 1.0", this produces the peculiar curve of which one vibration, is shown in the drawing, Fig. 34. This secondary is almost as strong as the primary in the early part of the *a*, but is lost sight of at a later point in the curve, possibly by coming into some relation to the upper resonance tone.

FIG. 34.

This difference from the previous cases would indicate some difference in the resonance adjustment of the mouth or in the action of the cords; it may possibly have something to do with the parenthetical character of the phrase.

The tone represented by the interval between the strong secondary and the preceding primary is constant at 2.8" or about 360, or approximately the note shown in Fig. 35. The resonance tone of the *a* starts at 1.0" or 1000, as in the first example, p. 18, being indicated approximately in Fig. 10.

FIG. 35.

At about the 17th cord vibration the resonance tone begins to fall in pitch. As its period becomes longer, it more nearly coincides with the period between the strong secondary and the preceding primary; the curve becomes smoother and loses the little notch after the primary. The 20th vibration is shown in the drawing, Fig. 36. The resonance tone continues to fall slowly but steadily to the end of the *i*, reaching 2.8" or about 360 at the end; this is, curiously enough, the pitch of the lower resonance tone of the *a* (Fig. 35). The curve at the point where the *i* has fallen greatly in amplitude and the period of the resonance vibration is

FIG. 36.

somewhat less than half that of the cord vibration is shown in the drawing, Fig. 37.

FIG. 37.

We are perhaps justified in placing the end of the *a* at the point where the resonance tone begins to fall, that is, at the 17th cord vibration; this would give *a* a length of 116".

The vowel *i* thus continues the constant pitch of the *a* and also the

drop of the resonance tone in the glide. It is thus quite **impossible to** assign any limit between the glide and the *i*. Even the **peculiar increase** in amplitude that characterizes all the previous cases of *i* in *I* is **here so** gradual that it cannot be used to mark the limit (see Fig. 40).

FIG. 38.

The remarkable fall of the resonance **tone from** 1.0°, or 1000, in the *a* throughout the *i* **to its end** at 2.8°, or 360, at the end, extends over **about the** musical interval of a duodecime, or approximately as indicated in Fig. 38.

The changes in the three tones of the *I* are indicated in Fig. 39.

Amplitude.—The amplitude incréases rather steadily at first, then rapidly in the early part of the *i* and falls rather more rapidly than usual to the end. This is indicated in Fig. 40, which is plotted in the manner described for Fig. 15. The maximum amplitude for the *i* is about 1½ times that for the *a*.

Ending.—A fall of amplitude to o without any fall in pitch of the cord tone, as in the 4th example, p. 31.

FIG. 39.

......... Upper resonance tone.
_ _ _ _ Lower resonance tone.
———— Cord tone.

Relation between curve and color.—To the ear this word is " colorless, unemphatic" (O.); "short, high, colorless, firm, a statement of no particular importance " (E. W. S.). It seems impossible to find any relation

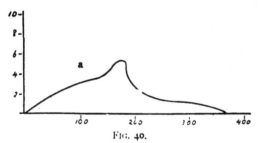

FIG. 40.

between these judgments and the recorded curve. Shortness was noted above (p. 31) as connected with emphasis; the unemphatic *I* (first example) was long and had a different curve of pitch. The very peculiar change in the resonance tone may by future collation with similar cases be found to be connected with the color of the word.

αi in the word *eye.*

The word occurs in the line *With my little eye.* A reproduction of the

curve is given in Fig. 41 ; the first few vibrations of the *a* are not very satisfactorily shown in the cut.

FIG. 41.

It occupies an interval 556″. It follows immediately on the last vibration of the *l* in the word *little*. The three words *my little eye* are here spoken with no separation. It is interesting, in passing, to consider the possibility that this fusion of the three words go parallel to a fusion of thought. It is evident from the very tone of the speaker that he is thinking of one thing, a certain *eye*, and that the facts of *mine* and *smallness* are not of any particular account to him.

The word *eye* is followed by a pause of 165″ before the word *I* (see p. 28) which does not seem sufficient to justify a comma.

Beginning.—The faint vibrations of *I* in *little* die away just before the first primary resonance vibration of *eye* appears. The *a* begins as in *I*, 1st example, p. 16.

Pitch.—The vibrations of the preceding *l* decrease in amplitude until the line shows only a faint wavering. The first indication of *a* is a single resonance vibration on the line ; this is repeated after 2.5″, and again after 3.9″. From this point the *a* curve clearly appears. It slowly falls in pitch to a period of 4.2″ at the 20th vibration, 4.6″ at the 40th, 4.9″ at the 50th, 5.3″ at the 54th, 5.6″ at the 60th, 6.3″ at the 66th, 6.7″ at the 70th and 7.0″ at the 73d. From this point onward the pitch continues to fall slowly, reaching 8.4″ at the 80th vibration and ending with about 11″.

In pitch this *ai* differs radically from all the other **examples**; it **starts** with a moderately high pitch and falls continuously. **The course of the** change in pitch is indicated in Fig. 42, plotted in the **manner described** for Fig. 6.

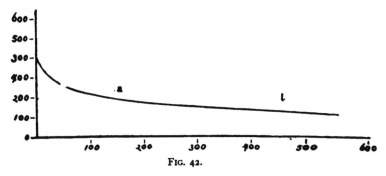

<center>FIG. 42.</center>

There is the possibility that the fall in pitch in this word **may have** something to do with its position at the end of a phrase. **If the word** had been followed by a long pause, it would naturally have **fallen on ac-** count of its position at the end of a sentence; the pause, **however, was** extremely short and we cannot very well assume a short pause **as the** equivalent of a period unless we give up the accepted theory **of relation** between punctuation and time. It is, nevertheless, possible **that this** theory may have to be modified as later researches have shown **that comma** pauses may be long and semi-colon and colon pauses may be **very short.** I am inclined to think, however, that the true explanation is **to be found** by supposing the *ai* in *eye* to be a phonetically different sound **from the** *ai* in *I*, although the ear may not clearly distinguish between **them.** This point will be spoken of below in the section on general **observations** on *ai*.

Formation.—In the portion from the beginning to the 43d cord **vibra-** tion the formation resembles that of the 2d and the prose examples of *I* in having a large secondary resonance vibration at a constant distance after the beginning of the primary one; this constant distance represents a period of 2.3^σ or a frequency of 435 (indicated in Fig. 43) as contrasted

<center>FIG. 43.</center>

with the period of 3.5^σ (frequency of 286, Fig. 9) for the former and 2.8^σ (frequency of 360, Fig. 35) for the latter. After the 43d vibration there is a change in the curve indicating a change in this large second- ary; apparently it decreases and disappears but I have not been able to decide with any confidence just what happens. After the 43d vibration the curve resembles that shown in Fig. 25.

The resonance tone of the *a* has a period of about 1ᵉ or a frequency of about 1000 (Fig. 10). At about the 40th cord vibration the period begins to lengthen, becoming 1.8ᵉ at the 63d, 2.1ᵉ at about the 77th, after which it continues to fall slowly to 2.5ᵉ at the end. The resonance tone of the *i* is thus on an average about the same as the lower resonance tone of the *a* (Fig. 43).

In spite of the fact that the fall in resonance begins at about the 40th vibration, the curve maintains its typical *a* form till after the 70th vibration. Beyond this point there is a decided difference, which is fairly well apparent in Fig. 41. The primary resonance vibration is of about the same amplitude as that of the *a* but the secondaries are all nearly as large as the primary. Such a difference might possibly be explained by a difference in the action of the vocal cords. The following theory is proposed. In the *a* they vibrate so that the air current is entirely cut off at one point in each vibration; the pressure of the air forces them outward suddenly, producing a strong puff after which there is an interval before the cords again strike and cut off the air. This puff sets the air in the resonance chamber into vibrations that decrease in amplitude. As long as this complete closure occurs, any increase in the force of expiration will increase the force of the puff and of the primary and secondary resonance vibrations in approximately the same ratios. Increased force will change the amplitudes without essentially modifying the original form of the curve.

During the *i* there is no such great predominance of one resonance vibration over the others; the secondary resonance vibrations are nearly as strong as the primary. This is the case also in all the examples of *ai* studied above, but here it is very striking on account of the fact that the cord period for the *i* is longer and not shorter than that for the *a*; there can thus be no attempt at explanation of the strength of the secondaries by the assumption of force gained by the shortening of the cord period. The explanation rather seems to lie in a different action of the cords. The following theory is suggested. In the formation of this *i* the cords do not strike or entirely close the air passage and thus the emission of air at the beginning is strong and steady rather than explosive; the first resonance vibration would thus be somewhat stronger than the following ones but all would be nearly alike. The increased force in the *i* would make all of them nearly as strong as the primary of the *a* as in this word, or even far stronger than in the cases of *I* studied above.

The changes within this word are so gradual that any assignment of definite limits for the *a* and the *i* would be apparently capricious. The distinct *a* character appears to my eye to be lost somewhere after the 66th

vibration and the distinct *i* character to begin somewhere about the 72d. If these points are selected as limits—an action that is hardly justifiable —the *a* would occupy an interval of 315ᵉ, the glide 35ᵉ and the *i* 206ᵉ.

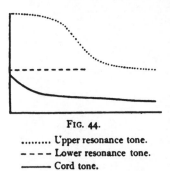

The *a* is at any rate longer than the *i*, in quite a marked opposition to the cases analyzed above.

The changes of the three tones in the *I* are indicated in Fig. 44.

Amplitude.—The *a* rises from zero as usual to an amplitude of o.5ᵐᵐ at the 17th vibration and remains practically constant to about the 66th vibration, after which there is a slow decrease to zero at the end. There is not the rapid increase to a maximum in the *i* found in the cases

FIG. 44.
......... Upper resonance tone.
- - - - Lower resonance tone.
———— Cord tone.

of *I* studied above. The maximum for the *i* is somewhat less than that for the *a*. The course of the change is indicated in Fig. 45, which is plotted in the manner described for Fig. 15.

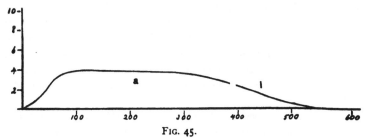

FIG. 45.

Ending.—This occurs by a fall of the amplitude to zero.

Relation between curve and color.—The ear notices that this word appears "weaker than the preceding *I*'s and also than the cases of *die;* lower in pitch" (O.); "somewhat higher in pitch than most of the *I*'s but not so high as the immediately following *I;* a somewhat colorless and unimportant word, differing quite from the modulated, flexible *fly* just preceding" (E. W. S.). The weakness of the word seems related to the falling pitch and the weakness of the *i*. The words *die* and *fly* are considered below. To the ear there is no essential difference between the *ai* in *I* and that in *eye,* yet the speaker makes a difference as indicated by the curves of results for pitch and amplitude.

ai in the word *die* (first example).

This occurs in the phrase *Who saw him die?* The word occupies an

interval of 510ᵛ of which 47ᵛ belong to *d* and 463ᵛ to *ai*. The curve of
the entire word is reproduced in Fig. 46.

FIG. 46.

Beginning.—The word begins with 20 vibrations belonging to the *d*.
These vibrations have a period of 2.0ᵛ or a frequency of 500. At the
present moment it is impossible to say whether these are resonance vibra-
tions imposed on a cord vibration or separate cord vibrations ; it is quite
probable that they are cord vibrations as they have no appearance of
being grouped as is the case in resonance vibrations imposed on cord
vibrations.

The amplitude increases rapidly from zero to o.3ᵐᵐ at the end of the *d*.

Immediately after the strongest vibration of the *d* there follows a set of
strong vibrations showing the *a* form.

In speaking the word *die* a decided movement of the larynx can be felt
with the fingers ; this would indicate a considerable difference between
the tension of the cords for *d* and that for *a*. The period of this first
vibration is 3.2ᵛ ; its amplitude is o.3ᵐᵐ. The *a* thus begins promptly
and loudly, as might be expected from the fact that the expiration is
already in progress and the cords are already in vibration. The pitch of
the *a* in the first vibration is higher than in the subsequent vibrations as
might be expected on the assumption that the cords are already stretched
to give a period of 2.0ᵛ for the *d*, and must be relaxed to produce the
lower tone of the *a*. While this relaxation is going on, the cords must pass
through all intermediate positions between that for a period of 2.0ᵛ and
that for one of 3.2ᵛ. This occurs to a large extent apparently within

the time required for the vibrations of the *d.* At the same time the
mouth is changing from the *d* position to the *a* position. These facts
seem sufficient to explain the curve of change in the drawing, Fig. 47;

FIG. 47.

the three vibrations on the left are the last of the *d,* the strong one on the
right is the primary resonance vibration of the first puff of the *a* and
the connecting line shows the curve during the glide.

Pitch.—The successive periods of the cord vibrations are 2.8, 3.2,
4.9, 5.6, 5.3, 4.6, 4.4, 4.2, 4.2, 4.2, 4.2, 4.2, 4.2, 4.1, 4.1, 4.0, 4.0, 4.0,
3.9, 3.9, 3.9, 3.9, 3.9, 3.9, 3.9, 3.9, 3.9, 3.9, 3.9, 4.1, 4.1, 4.2, 4.2,
4.2, 4.3, 4.3, 4.3, 4.4, 4.4, 4.5, 4.5, 4.6, 4.6, 4.6, 4.6, 4.6, 4.7, 4.7,
4.7, 4.7, 4.8, 4.9, 5.0, 5.1, 5.3, 5.3, 5.3, 5.3, 5.3, 5.3, 5.5, 5.7, 5.9,
6.0, 6.1, 6.3, 6.5, 6.7, 7.0, 7.2, 7.4, 7.4, 7.5, 7.6, 7.7, 8.1, 8.4, 8.8,
8.9, 9.1, 9.5, 9.8, 10.5, 10.9, 11.2, 12.3, 13.0. These figures may be
0.1ᵐ either side of the correct values as, owing to instrumental difficul-
ties, the curves could not be read to a smaller unit than 0.1ᵐᵐ.

The pitch thus quickly descends from the tone of 500 vibrations for the
d to one of 179, then ascends to one of 257 and then again descends
slowly to the very low one of 77. These changes are shown in Fig. 48,
which is plotted like Fig. 6.

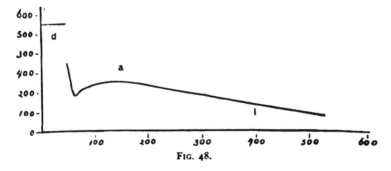

FIG. 48.

Formation.—The *a* portion of the curve resembles that of *l,* 1st ex-
ample, p. 17. The resonance vibration in the first part has a period of

1" or a frequency of 1000, as in the first *I*, p. 18, Fig. 10. At about the 40th cord vibration it is lengthened to 1.4", at the 55th to 1.6", at the 58th to 1.8"; after this it changes slowly reaching 2.1" at the 75th and increasing but little more to the end at the 86th.

At about the 52d vibration the curve, while still retaining the *a* form, appears to begin to take on the *i* character as described on p. 19; the *i* character appears fairly complete at about the 57th vibration. Although no definite limits are to be made, we can assign very roughly 240" to the *a* and 220" to the *i*, or about half of the time to each.

No trace of a strong secondary resonance vibration in the *a* portion can be detected. The *a* starts at a pitch too high for the lower resonance tone found in the previous cases, but even after the pitch has fallen this tone seems to be absent.

A rather peculiar distribution of amplitude among the resonance vibrations can be seen in the *a* portion in Fig. 46. Although the puff for the cords is strong and sudden, as indicated by the large abrupt primary resonance, yet the force of the puff is not so quickly exhausted as in previous cases, as indicated by the greater size of the following resonance vibrations. The second case of *die* (below) resembles this one in this respect.

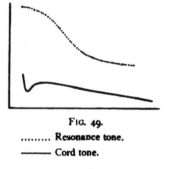

FIG. 49.

......... Resonance tone.

———— Cord tone.

The changes in pitch of the two tones of this *ai* are indicated in Fig. 49.

Amplitude.—The vibration begins with an amplitude of 0.3ᵐᵐ for the primary resonance vibration which becomes 0.4ᵐᵐ at about the 35th vibration; it sinks thereafter very slowly to zero at the end. The maximum amplitude is thus found in the *a* and there is no such sudden rise as is found in all the cases of *I* above. The course of change is indicated in Fig. 50 plotted like Fig. 15.

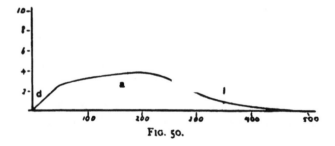

FIG. 50.

Ending.—The *i* ends with a fall in both pitch and amplitude, indicating simultaneous relaxation of the cords and the respiratory pressure.

Relation between curve and color.—The effect on the ear is that of "more emphasis at the beginning with decrease toward the end " (O. and E. W S.). The high pitch of the *d* and the *a* at the start seem to correspond to the word-color.

ai in the word *die* (2d example).

This occurs in the phrase *I saw him die.* The entire word occupies an interval of 504ᵉ, of which 28ᵉ can be assigned to the *d* and 476ᵉ to the *ai.* The entire curve is reproduced in Fig. 51.

FIG. 51.

Beginning.—The word begins with 11 vibrations rapidly increasing in amplitude from o to 0.4ᵐ and having a constant period of 2.5ᵉ, or frequency of 400. These are the vibrations for the *d;* they resemble those of *die,* 1st example, p. 39.

The sudden fall in pitch after the *d* is quite marked. The *d* curve is lost at once. The following interval of 7ᵉ can hardly be said to be the first vibration of *a* as its secondaries are very irregular in form ; during this interval the mouth is changing from the *d* shape to the *a* shape. The peculiar form of the vibration is well shown in Fig. 51 ; the secondaries of the first few *a* vibrations are, however, slightly more prominent than in the original curve.

Pitch.—The successive vibrations of *ai* occupy periods measuring 8.4, 7.7, 4.6, 4.2, 4.2, 4.6, 4.6, 4.6, 4.6; 4.6, 4.6, 4.6, 4.9, 5.3, 5.3, 5.3, 4.9, 4.9, 5.3, 5.3, 5.3, 5.3, 5.3, 5.3, 5.3, 5.3, 5.6, 5.6, 5.6, 6.0, 6.0, 6.3, 6.7, 6.3, 6.0, 6.3, 6.3, 6.7, 7.0, 7.0, 7.0, 7.0, 7.4, 7.7, 7.7, 7.7,

8.4, 8.4, 8.4, 9.0, 9.5, 10.5, 10.5, 10.5, 11.2, 11.6, 12.3, 12.3, 12.3, 13.0, 14.0, 14.0, 14.7, 15.8, 15.8, 15.8, ?. As previously explained p. 13, these figures may be in error by one or two tenths of a sigma, or in ten-thousandths of a second. The pitch of the cord tone thus descends as low as a frequency of 63. The general course of pitch is shown in Fig. 52 plotted like Fig. 6.

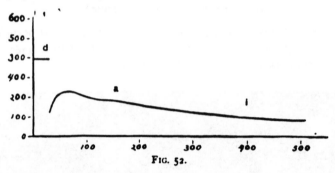

FIG. 52.

Formation.—The *a* curve differs from that of most cases of *ai* in hav-
ing less difference between the first resonance vibration and the rest;
the first and second are, in fact, of almost equal intensity. This would
indicate a more gradual opening of the cords with less explosive effect.
The *a* thus does not differ so much from the *i* as in most cases. Another
case of *i* like this is found in the first ex-
ample of *die* (above) and in *thy* (below).

The resonance vibration in the *a* has a
period of 1ᵛ or a frequency of 1000 at
the start (Fig. 10). It falls steadily,
reaching a period of 1.4ᵛ around the
20th vibration, 1.8ᵛ around the 40th,
and 2.1ᵛ around the 60th, which is
maintained to the end. There is no
indication of a lower resonance tone.

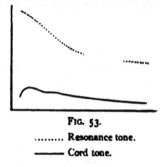

FIG. 53.

......... Resonance tone.

———— Cord tone.

The curve changes from the *a* form so
gradually to the *i* form that it is quite
impossible to place any dividing lines; each element of the diphthong
may be said roughly to occupy half the total time.

The changes of the two tones are indicated in Fig. 53.

Amplitude.—The amplitude of the strongest resonance vibration be-
gins at 0.3 and is maintained with fair consistency for about half the *ai*;
after this it slowly falls to zero. This curve is given in Fig. 54 plotted
like Fig. 15.

Ending.—The *i* ends with a fall in both pitch and amplitude, indi-
cating a simultaneous relaxation of the cords and the respiratory pressure.

Relation between curve and color.—To the ear " it does not rise to a
high pitch but starts with it and maintains it better than the other word

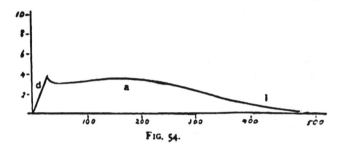

FIG. 54.

die " (O.); " it starts high and steadily falls " (E. W. S.). The
apparent high start is probably due to the pitch of the *d*.

ai in the word *fly.*

This occurs in the phrase *I, said the fly.* The curve for *ly* occupies an

FIG. 55.

interval of 489e of which 25e belong presumably to the *I* and 464e to
the *ai*. The curve is given in Fig. 55. It is followed by a silent inter-
val of 371e which is longer than the comma pauses mentioned above
(p. 16) and shorter than the full stop (pages 22, 25).

Beginning.—No specific details concerning the *f* can be derived from the curve. The strong vibrations just preceding those of the *a* are presumably from the *l* sound. They rise rapidly in intensity and greatly resemble those of the *d* in the two cases of *die* above; their period is 1.9″ and their frequency 526.

Immediately after the last vibration of the *l* there follows a short *a* vibration with primary resonance vibrations not so strong as in the following ones. The cord adjustment seems not to be perfected for the *a* till the second characteristic *a* vibration occurs; this is well shown in Fig. 55. The *a* begins promptly and loudly after the *l*.

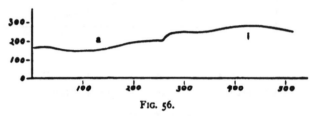

FIG. 56.

Pitch.—The successive periods of the cord vibrations are 6.0, 6.3, 6.3, 6.3, 6.3, 6.3, 6.7, 6.7, 6.7, 6.7, 6.7, 6.7, 6.7, 6.7, 6.7, 6.7, 6.3, 6.3, 6.3, 6.0, 6.0, 6.0, 6.0, 6.0, 5.8, 5.8, 5.8, 5.8, 5.6, 5.6, 5.6, 5.4, 5.3, 5.3, 5.3, 5.3, 4.9, 4.9, 4.9, 4.9, 4.9, 4.9, 4.9, 4.9, 4.2, 4.2, 4.2, 4.2, 4.2, 4.2, 4.2, 4.2, 4.2, 4.2, 4.2, 4.2, 4.2, 4.2, 3.9, 3.9, 3.9, 3.9, 3.9, 3.9, 3.9, 3.5, . . . (retaining this period for 27 vibrations) . . ., 3.9, 4.2, 4.2, 4.6, 4.6, 4.6, 4.6, 4.6. There is a rather sudden, though small, change in period from 4.9 to 4.2; this occurs at the irregular place a little to the left of the middle of the fourth line of the curve in Fig. 55. This is due presumably to a rather sudden tightening of the cords for the *i*. The course of change in pitch is shown in Fig. 56, which is plotted like Fig. 6.

FIG. 57.

Formation.—The *a* portion of the curve resembles that of the 2d example of *I* (p. 22), with a specially strong secondary resonance vibration at 3.9″ after the primary, representing a tone with a frequency of 256. This is lower than in any of the previous cases (Fig. 57).

FIG. 58.

The resonance tone begins with a period of 1.6″ or a frequency of about 625 (approximately as in Fig. 58). This falls slowly reaching 1.8″ at about the 35th vibration, 2.0 at about the 40th, 2.2 at about the 50th, and 2.5 at the end. This indicates a resonance tone about the same as that of *i* in *eye* (p. 36, Fig. 43).

The change from *a* to *i* proceeds in general as in all the other case
but the change in curve-form seems a little more marked. It may be
said to occur at the 43d vibration, or 301ᵛ after the beginning and 163ᵛ
before the end.

The changes in the three tones are indicated in Fig. 59.

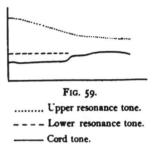

FIG. 59.

......... Upper resonance tone.

– – – – Lower resonance tone.

——— Cord tone.

Amplitude.—The *a* begins with an am-
plitude of 0.2ᵐᵐ for the strong resonance
vibration in the first puff from the cords,
0.3ᵐᵐ for that in the second puff and rises
quickly to 0.3½ᵐᵐ. After remaining fairly
constant for a while, it becomes 0.3ᵐᵐ toward
the end of the *a*. In the first part of the *i*
it rises to 0.4ᵐᵐ, after which it gradually falls
to zero at the end. The change of amplitude
shown is in Fig. 60, which is plotted like
Fig. 15.

Ending.—The *i* ends, like most of the cases examined, in a combined
fall in pitch and intensity.

Relation between curve and color.—To the ear this word has a full-and
rise of intonation like that of *well* and *yes* in such dubitative as *Well, you
may do so if you wish, but I would prefer not. Yes, it may very well be so*
although we have no evidence for it (O. and E. W. S.).

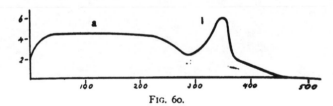

FIG. 60.

The word *fly* appears to sink and then rise in intonation to a greater
degree than the corresponding words *sparrow*, *fish*, etc. This fall.
and-rise is due to the fall from a tone of the frequency 526 of the *I* to
one of 160 at the beginning of the *a* and then the rise in the *a* and *i* as
shown in Fig. 56. Probably the reason for the rise in the *i* is to be
found the rising intonation usual in English at the end of a parenthetical
clause :[1] that the clause *said the fly* is such a one inserted in the statement
I, with my little eye, I saw him die seems indicated also by the fact that
the silent interval after *fly* is less than that usual for a period. If *said
the fly* were not parenthetical, there would probably be a longer pause

[1] SWEET, New English Grammar, § 1946, Oxford 1898.

after *fly* and it would have a falling instead of a rising intonation. In this case the lines would read : *Who saw him die ? I, said the fly'. With my little eye I saw him die.* If special weight is to be given to the falling intonation of *eye* (p. 36) as opposed to the brevity of the pause after it, then *eye* would be considered as ending a phrase. The reading required by the intonations of *fly* and *eye* would thus be : *Who saw him die ? I, said the fly', with my little eye'. I saw him die.*

 ai in the word *thy* (first example).

 The word occurs in the phrase *Hallowed be thy name* on the gramophone record plate described on p. 15. Much of the work on this word has been done by Miss E. M. COMSTOCK. The entire curve is reproduced in Fig. 61.

 The time occupied by the word is 505.8ʳ. It is preceded by a silent interval of 73.5ʳ. It is followed by an interval of 145.3ʳ before any trace of the *n* of the following word appears.

<div align="center">Fɪɢ. 61.</div>

 Beginning.—The word begins with 7 vibrations belonging to the *th*. These vibrations have a period of 2.5ʳ or a frequency of 400. These are probably cord vibrations for the same reasons as given in the case of *d* in *die*, p. 39. The amplitude increases rapidly from zero to 0.2ᵐᵐ at the end.

 Immediately after the last vibration of *th* there follows the first strong vibration of the set showing the *a* form. The beginning of the *a* is thus prompt and loud.

 Pitch.—The successive periods of the cord vibrations in the *ai* are 7.0, 7.0, 7.4, 7.0, 6.7, 6.7 which is maintained with slight fluctuations to the end of the word. The sudden lengthening of the cord period

(that is, the lowering of pitch) at the start is peculiar ; it is made specially so because it is accompanied by a sudden rise in the pitch of the resonance tone (see below).

Formation.—The vowel portion of the curve shows throughout its whole length a common character. This character is that of a group of resonance vibrations imposed on each of a series of cord vibrations. In the earlier portion these resonance vibrations are not of equal amplitude while in the later portion they are very nearly so. In the earlier portion there is a strong primary resonance vibration followed by three secondary resonance vibrations (making a total of four resonance vibrations) except in the first two cord periods where there are only two secondaries after the primary (making a total of three). This first portion of the curve resembles that of an *a* but differs in having less difference between the primary and the secondary resonance vibrations ; in this fact it resembles the typical *i*.

At the 40th vibration the number of resonance vibrations has changed from four to three, showing a strong initial vibration followed by decreasing ones with a pause before the initial vibration of the next puff. The typical *a* of the preceding examples appears here strongly.

The *i* vibrations may be said to begin in the 44th with three resonance vibrations of almost equal strength, the initial vibration being slightly the stronger.

In the latter portion there are 3 resonance vibrations to every cord vibration ; the curve is that of a weak *i* of the kind seen in *eye*, p. 37.

If these vibrations just mentioned, namely the 40th and the 44th, may be considered as limits, the *a* may be said to occupy an interval of 258.3$^\sigma$, the glide an interval of 19.6 and the *i* an interval of 210.0$^\sigma$. This subdivision, however, is rather a questionable procedure.

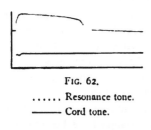

FIG. 62.

...... Resonance tone.

——— Cord tone.

The resonance tone in the first portion begins with a period of 2.1$^\sigma$ or a frequency of 476 which immediately rises to 1.7$^\sigma$ or a frequency of about 588 in the third vibration. The period then changes steadily to 1.9$^\sigma$ at the 40th vibration ; it becomes 2.4$^\sigma$ at about the 44th and remains constant to the end. The sudden rise of the resonance tone at the start is accompanied by an equally sudden fall of the cord tone (see above). It seems tnaural to infer that the resonance cavity of the mouth for the *d* must have been lower than that required for the *a*.

There is no trace of a lower resonance tone as described on p. 23.

FIG. 63.

FIG. 64.

The changes in the tones of *thy* are sketched in Fig. 62. In general the resonance tone of the *a* can be said to be one of 588 vibrations or approximately as indicated in Fig. 63, and that of the *i* to be of 416 vibrations or as in Fig. 64.

Amplitude.—The primary resonance vibration on the first cord vibration of the *ai* has an amplitude of 0.1½ᵐᵐ. Up to about the 50th cord vibration the amplitude fluctuates between 0.1ᵐᵐ and 0.2ᵐᵐ; after that it gradually falls to zero. The fluctuations may be due to interference of the resonance vibrations. The course of amplitude is indicated in Fig. 65 which is a sketch and not a careful plot like Fig. 15.

FIG. 65.

Ending.—The word ends by a fall of intensity with maintenance of the cord tension (p. 31).

Relation between curve and color.—The sound of this word *thy* as taken from the record appears to the ear "higher and shorter than the second example; varying more in pitch, rising rapidly at first and then falling" (E. M. C.); "high and short when compared with the second one" (E. W. S.).

The measured results show a shorter word of higher pitch than the second example. There is a slight rise at the start but no fall. The following word *name* is much lower in pitch.

<div align="center">

ai in the word *thy* (second example).

</div>

The second example of *thy* occurs in the phrase *Thy kingdom come.* A reproduction of the curve is given in Fig. 66. Most of the work on this word has been done by Miss E. M. COMSTOCK.

The curve for this word shows 6 faint vibrations at the beginning. These belong presumably to the *th* and correspond to the strong vibrations of *th* in the first *thy*, and of *d* in *die*. In contrast with the cases just mentioned these vibrations are so weak that little can be said about them definitely except that their period is 2.4ᵉ. It is just possible that they may belong to the first cord vibration of the *a*; this is suggested by the fact that the period is the same as that of the resonance tone of the *a*. Although the matter is doubtful, we have assigned the beginning of the *a* to the end of these vibrations.

The *ai* in this word occupies an interval of 1085ᵉ. It is preceded by a silent interval of 2100ᵉ, represented by a period and including possibly a short time for the *th*. It is followed by a silent interval of 324ᵉ which undoubtedly represents the guttural *k*.

Pitch.—Begining with a period of 11.9ᵉ the cord tone changes slowly, reaching 8.4 at the 10th vibration, 7.7 at the 20th, 7.4 at the 30th, and 7.0 at the 60th, which it maintains to the end.

Formation.—The curve of the *a* differs from most of the cases of the *ai* studied above in regard to the resonance vibrations. The first resonance vibration for each cord vibration is followed by a second one nearly as strong and this by a third one somewhat weaker, whereas in the previous cases there was one resonance vibration greatly exceeding the rest in amplitude. The curve suggests a more gradual opening

FIG. 66.

of the cords and a less explosive effect; the cord action in this *a* may be supposed to somewhat resemble that in the *i* as explained on p. 37.

There is no strong secondary of the kind described on p. 23. The *a* thus resembles the *a* in *die* and *thy* (above) rather than that in *I* in showing no evidence of a strong lower resonance tone.

The resonance vibration in the first part of the word shows a period of 2.4ᵉ. It rises to 1.6 at the 20th cord vibration falls to 1.9 at the 50th, 2.2 at the 70th, 2.5 at the 90th, and 3.5 at the end. This curious

rise of the resonance vibration during the *a* has not been observed in any of the previous cases. The rise and fall are so gradual that it is impossible to decide on any place as the turning point between them. For the same reason it is impossible to divide the word into *a*, glide and *i*. In the earlier portion the typical *a* form is distinctly seen in the curve and in the latter portion the typical *i* form, but the main portion shows a gradual passage from the former to the latter. There is no sudden increase in amplitude as in nearly all the *i*'s studied.

The changes in the two tones of *ai* are indicated in Fig. 67. It will be noticed that the resonance tone of the *a* begins on the same pitch as the tone of the *d*.

FIG. 67.
...... Resonance tone.
——— Cord tone.

Amplitude.—The amplitude runs from 0.1^{mm} in the first part of the word to 0.2^{mm} at the 30th vibration, falls to 0.1^{mm} at the 50th, increases to 2.5^{mm} at the 70th, maintains this figure to the 80th and gradually falls to zero. The change in amplitude is indicated in Fig. 68.

Ending.—The sound *ai* ends by a fall of amplitude, the respiratory pressure gradually ceasing while the cords are still tense.

Relation between curve and color.—To the ear this word " is longer and more mellow than the first example " (E.M.C.) ; " begins low and rises with considerable inflection as compared with the first example "(E.W.S.).

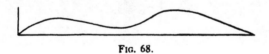

FIG. 68.

The measured results show a very long word, beginning very low and rising in pitch.

General observations on *ai*.

The *ai* in the cases studied above is to be considered as a union of two speech sounds, that is, as a diphthong.

The family of sounds represented by *ai* contains many members that differ greatly in their characters. This is true of the same speaker on a

single occasion; the changes for different speakers and for the same speaker on different occasions may be left out of consideration at present. The first sound in *ai* in words like *fly, my, thy,* etc., is generally stated to be an *a* (as in *ah*) which inclines toward the mixed *œ*, that is, the vowel sound heard in *burn* and *about;*[1] it may even shade into the palatal *æ* (as in *man, fat*)[2] while in some cases it has a tendency to broadening, even to *o* (*not*) as in the Irish.[3] These statements all refer to British forms of pronunciation.

The second sound in *ai* as in *fly* is said to be a very open *i*, something between the *i* in *kin* and the *e* in *ken.*[4]

The diphthong *ai* cannot contain the vowel *i* as in *keen* or *i* as in *kin.* By holding down the tongue and lower jaw with a pencil it is not possible to pronounce either *keen* or *kin,* whereas there is no difficulty in saying *I.* It seems rather to be the vowel sound heard in the last syllable of *foxes.*

The sounds given above as the British pronunciation of *ai* do not, to my ear, correctly represent the North Atlantic form as heard in the region around New York. In this speech the first sound of *ai* seems to be a somewhat short *a* (as in *father*). Both pronunciation and curve indicate it to be like the *a* in *parson,* below. A similar judgment by the ear has been given by GRANDGENT.[5]

In its first half the North Atlantic *ai* (as in *I, eye*) seems to resemble the average German *ai* with a distinct *a* (*father*) sound. The second half seems to be different in the two cases. For the sake of comparison several cases of *ai* were examined in some records which were traced off with the machine described on p. 10 but with a shorter recording lever. Various words like *ein, weisser, Eis, Zeiten, Schein,* etc., were closely studied in the tracings from Record No. 1500, *Die Lorelei and Der Fichtenbaum,* by W. L. ELTERICH. When examined under the magnifying glass, the *a* portion of the record showed in most cases curves analogous to those in the cases of *I,* whereas the *i* portion was extremely weak. This peculiarity of the weak *i* in the German *ai* and the very strong *i* in

[1] VIETOR, Elemente d. Phonetik, 3. Aufl., 95, 101, Leipzig 1894.
SWEET, Handbook of Phonetics, 9, Oxford 1877.
STORM, Englische Philologie, 2 Aufl., 358, Leipzig 1892.
[2] STORM, Englische Philologie, 2. Aufl., 142, Leipzig 1892.
LLOYD, *Speech sounds ; their nature and causation,* Phonet. Studien, 1892 V 263;
also a review on p. 87 of the same volume.
[3] SWEET, History of English Sounds, 21, Oxford 1888.
[4] VIETOR, Elemente der Phonetik, 3. Aufl , 95, Leipzig 1894.
STORM, Englische Philologie, 2. Aufl., 103, 358, Leipzig 1892.
LLOYD, Review in Phonet. Studien, 1892 V 87.
[5] GRANDGENT, *English in America,* D. neueren Sprachen, 1895 II 446.

most cases of the American *ai* gives the former the effect of containing a longer *a*. It must be noted, however, that many sounds usually treated as the same are really different. Thus the vowel in *weiss* in *Ich weiss nicht was soll es bedeuten* gives a curve differing greatly in character from that of *weisser* and the other words mentioned above. Again, some of the cases of the American *ai* reported above show a weakening of the *i* that indicates a tendency toward the German form. The details of the work now being done on the German *ai* will appear on a future occasion.

It has been pointed out that the quality of *ai* is different in a strongly accented syllable from what it is in a less accented one, as can be readily heard by comparing the two *ai*'s in *likewise*.[1] This difference is perhaps analogous to that found to exist between *I* and the words *eye, die, fly,* and *thy*.

The two chief sounds of *ai* are generally said to be joined by a rapid glide, which is not acoustically of much effect except to produce the impression of continuity.[2] Yet it has been asserted that such a diphthong consists in an even and gradual change of the vowel from beginning to end.[3] The above analyses show that the *ai* is not the sum of the two vowels *a* and *i* but an organic union into a new sound *ai*. Thus, there is no necessary pause or sudden change of intensity or change in pitch or even change in character. The later sound shows its influence in the earlier one, and the earlier one keeps its influence far into the later one. This is what would be expected on psychological grounds. The speaker does not think and speak of two sounds separately but of only one ; the execution of this one idea by two distinct processes would be unusual. The various degrees of perfection of the synthesis of the two elements would correspond to various expressive characters of the resulting sound.

The degree of synthesis of the two elements would be lessened by any great or sudden change in intensity, pitch or character of the cord tone or the resonance tone. In some of the cases of *ai* there are greater changes than in others.

In so far as they can be considered to be constant, the resonance tones in these cases of the *a* and the *i* were found to be as in Table I. These results may be compared with those of other observers ; this is done in Table II.

[1] BELL, Visible Speech, 113, London 1867.
SWEET, Primer of Phonetics, 76, §204, Oxford 1890.
STORM, Englische Philologie, 2. Aufl., 358, 405, 424, Leipzig 1892.
[2] LLOYD, Review in Phonet. Studien, 1892 V 83.
STORM, Englische Philologie, 2. Aufl., 204, Leipzig 1892.
[3] SOAMES, Introduction to Phonetics, 53, London 1891.

	a	
	Lower resonance tone.	Upper resonance tone.
I, 1st example	286	1000
I, 2d "	286	1000
I, 3d "	286	1000
I, 4th "	286	1000
I (*I caught his blood*)	385	1000
I, prose example	360	1000
Eye,	435	1000
Die, 1st example		1000
Die, 2d "		1000
Fly,	256	625
Thy, 1st example	588	
Thy, 2d "	416	

	ɩ
I, 1st example	450
I, 2d "	555
I, 3d "	500
I, 4th "	400
I, prose "	360
Eye	400
Die, 1st example	473
Die, 2d "	473
Fly	400
Thy, 1st example	416
Thy, 2d "	288

When allowance for the individualities of different speakers is made, the two resonance tones that I have found for the *a* agree quite well with the tones found by other observers. The serious differences among these observers can be partially explained on the supposition that some have found the lower tone and some the upper one.

Although the *i* in *ai* is not the ordinary long *i*, its resonance tone shows some agreement with those of a few observers. The higher resonance tone noted by other observers was also probably present in the *i* but it was impossible to measure it in the examples studied above (p. 20).

Particular emphasis must be laid on the fact that the tones in a vowel are not constant factors and that the changes they undergo from instant to instant are presumably highly important in producing its peculiar character. Only two previous investigators have observed the change in the cord tone and no one seems to have suspected a possible change in the resonance tone.

TABLE II.

a

a in	Lower resonance tone.		Upper resonance tone.
I (E. W. S.)	d^1		b^2
I (E. W. S.)	f^1#, g^1		b^2
Eye (E. W. S.)	a^1		b^2
Die (E. W. S.)			b^2
Fly (E. W. S.)	c^1		e^2♭
Thy (E. W. S.)		d^2	
Thy (E. W. S.)		g^1#	
a (WILLIS)		d^3♭, f^3	
a (DONDERS)		b^1	
a (HELMHOLTZ)		d^3	
a (KOENIG)		b^2	
a (AUERBACH)		a^2, f^2, b^2	
a (TRAUTMANN)		f^3, g^3	
a (PIPPING)		c^3#–d^3	
a (HERMANN)		f^2, g^2	
a (STORM)		c^1#, d^1, f^1#, a^1	
a (BOEKE)		f^2#, c^3	
ai (BOEKE)		b^3	
a (BEVIER)	d^2–g^2#		b^2–c^3

i in			
I (E. W. S.)		f^1# to d^2♭	
Eye (E. W. S.)		g^1#	
Die (E. W. S.)		b^1♭	
Fly (E. W. S.)		g^1#	
Thy (E. W. S.)		a^1♭, ?	
i (DONDERS)		f^3	
i (HELMHOLTZ)		$f + d^4$	
i (KOENIG)		b^4	
i (AUERBACH)		c^3, f^1	
i (TRAUTMANN)		f^4, g^4	
i (PIPPING)		{ c^1–d^1 c^4–d^4	
i (HERMANN)		c^4#–g^4	
i (STORM)		d^2	
i (LLOYD)		{ $b^{-1} + a^4$ $b^{-1} + d^5$	

The rise of pitch in the cord tone of the vowel *a* has been observed by
BOEKE[1] to have extended over more than half a tone in words like *Vader*

[1] BOEKE, *Mikroskopische Phonogrammstudien*, Arch. f. d. ges. Physiol. (Pflüger),
1891 L 301.

(Dutch). MARICHELLE makes the following observations on his phono-graph records of the vowel *a* sung on different notes. "The periods corresponding to low tones are divided into two distinct parts; the intensity is feebler in the second half of the period. The gradual modification of the character [timbre] under the influence of variations of pitch operates almost entirely at the expense of the less intense portion of the period; this second half even disappears little by little."[1]

I have observed similar changes in the *a* of the German *ei* and in the vowels *u* and *a* described below.

It seems hardly possible at the present moment to specify the positions of the mouth corresponding to the resonance tones and their changes. Some idea of them may perhaps be obtained in the following way. GRANDGENT'S sections [2] of the mouth for the vowels *a* and *i* are shown in Figs. 69 and 70.

FIG. 69. FIG. 70.

The following view of the physiological action of the vocal cavities in producing *ai* in the case studied above is proposed tentatively. The depressed position of the tongue for the *a* leaves open a large cavity reaching from the teeth to the vocal cords; the uvula offers no great interruption. The lower resonance tone of the *a* may be considered to arise from the vibration in this cavity. The upper resonance tone of the *a* may be supposed to arise from the rear resonance cavity, that is of the throat cavity from the cords to the slight elevation of the tongue at the uvula. As the *a* changes to *i* this elevation of the tongue moves forward enlarging the rear cavity by including continually more of the mouth; this continuously lowers the upper resonance tone until the tongue comes to rest in the typical *i* position. The variety of changes in the course of the upper resonance tone corresponds to individualities of action of the tongue in the various cases. In some cases the change from *a* to *i* is more sudden and definite (Figs. 14, 21, 27, 44, 62) and in others it is less definite (Figs. 31, 39, 49, 53); in other cases there is even laxity and fluctuation in the typical terminal positions (Fig. 66). The supposition that the upper resonance tone arises from the cavity

[1] MARICHELLE, La parole d'après le tracé du phonographe, 47, Paris 1897.

[2] GRANDGENT, *Vowel measurements*, Publ. Mod. Lang. Ass., 1890 V 148.

behind the elevation of the tongue rather than from the one in front of it, although opposed to the usual view, does not exclude the presence of tones from the front cavity also. In fact these other tones are presumably also present though not distinguishable in my records.

The greater importance of the rear cavity seems to be indicated by the following facts. The laying of the finger on the tongue does not appreciably modify the enunciation of *a*. When the finger is introduced into the mouth and kept in front of the elevation for the *i*, it produces no appreciable effect; but when it is pushed beyond the elevation into the rear cavity it changes the sound completely.

It may be noted that curious relations exist between the tones of two succeeding sonants (speech sounds with tones); in general it is true that the tones of a sonant form approximately musical intervals with a tone or tones of the preceding sonant.

In all cases of *ai* there is no sudden jump of the cord tone; the *i* continues the cord tone of the *a*, forming with it the easiest musical interval, a unison. This tone is, however, different in different cases; the cord tone of the *a* rises to a certain point selected for that of the *i*. The selection of the pitch of the cord tone for the *i* is influenced by the preceding resonance tones of the *a*, as may be seen in the following table.

	Tone of d, th, l.	Tones of the a. Cord, start.	Cord, end.	Lower resonance.	Upper resonance.	Tones of the i. Cord.	Resonance.
I, 1st example		56	250	286	1000	250	450
I, 2d "		83	250	286	1000	250	555
I, 3d "		131	250	286	1000	250	500
I, 4th "		111	286	286	1000	286	400
I, prose "		102	180	360	1000	180	360
Eye,		400	160	435	1000	160	476
Die, 1st example	500	179	200		1000	200	473
Die, 2d "	400	217	133		1000	133	473
Fly,	526	160	204	256	625	256	500
Thy, 1st example	400	143	149	588		149	416
Thy, 2d "	417	84	143	416		143	288

In the 1st *I* the cord tone of *i* is practically identical with the lower resonance tone of the *a*; the fixed lower resonance tone of the *a* apparently furnishes a standard toward which the cord tone of the *a* rises to begin the *i*. The cord tone is also just two octaves below the upper resonance tone of the *a*. There is no very simple relation between the resonance tone of the *i* and any of the tones of the *a*.

In the 2d *I* the relations are similar to those in the 1st *I*.

In the 3d *I* the cord tone of the *i* is also practically
lower resonance tone of the *a* and also at two octaves
resonance tone. The resonance tone of the *i* is just an
upper one of the *a*.

In the 4th *I* the relations are practically as in the pr
for the fact that the resonance tone of the *i* is two and
low the upper resonance tone of the *a*.

In the prose *I* the cord tone of the *i* is an octave
resonance tone of the *a* while the resonance tone of th
continuation of the lower resonance tone of the *a* with
to its upper resonance tone.

In *eye* the cord tone of the *i* is one and a-half octave
resonance of the *a* and the resonance tone is practically
that tone, with no relation to the upper resonance of th

In *die* (1st example) the cord tone is five octaves be
sonance tone of the *a*, which has no lower resonance ton
and a-half octaves below the tone of the *d*. The resor
i shows no relation to any tones of the *a*, although it
tone of the *d*.

In *die* (2d example) the cord tone of the *a* starts
octave below that of the *d*. No other relations between
are apparent.

In *fly* the lower resonance tone of the *a* is an octave
the *l*. The cord tone of the *i* in its main portion co
resonance tone.

In *thy* (1st example) the cord tone of the *i* is appro
taves below the resonance tone of the *a* and its resonanc
mately in unison with the tone of *th*.

In *thy* (2d example) the resonance tone of the *a* is i
tone of *th*. The cord tone of the *i* is three octaves
The resonance tone of the *i* is an octave above its co
octaves below the resonance tone of the *a*.

Such a relation between successive tones in speech is m
be expected in a melodious voice. An illustration of
will be found below in the account of the sound *ll* of

STUDY OF THE WORDS " *Who'll be the par*

In the following phonetic analysis of a complete ph
much assisted by Miss E. M. COMSTOCK.

The complete curve is given in Fig. 71. It begins

indicated by the letters *wh ;* this is not the sound of *wh* in *wh* breathing *h.*

The aspirate *h.*

The first of the series of sounds is heard as an aspirate fo the vowel *u.* The curve (Fig. 71, line 1) shows that it time of 35". Its tone has a constant period of 2.8", or about 380 vibrations per second. Its amplitude rises fro a maximum of 0.2". It is thus a "crescendo sustained in particular, a crescendo sustained light breath. The to *h,* as shown by the vibrations in the curve, is a resonance ing from the passage of the air through the mouth; it is n tone. The reasons for considering the vibrations to have al a resonance tone and not from a cord tone are the follow such high cord tones are not found in the other sounds produc speaker; (2) the vibrations of 2.5" are followed by two vibratio and 2.1" respectively and then by the vibrations of the *u* begin a cord tone of 6.3" and a resonance tone of 1.9"; the tone of leads rather to the resonance tone of the *u* and could with h possibility be considered as a cord tone with an instantaneou three octaves.

These results do not agree with the view that the first sound is a voiceless form of *u.* The sound *h* is usually said to arise breath passing through the mouth already adjusted to the followi the cords being open and the resonance tone alone being hea the opinion of some authorities, *h* has the same position as the l of the following vowel."[1] Most later observers have adopted view.[2] According to this view we cannot speak of a single *h* suppose for each vowel a corresponding *h: h*", *h'*, *h*", *h'*, *h*", etc. which has an adjustment of the mouth like that of the corre vowel and differs from that vowel only in having a noise from instead of a tone.[3] "Our *h* combines a noise from the cords (sidiarly a noise in the mouth-cavity) with the mouth position of The common element in *h*", *h'*, *h*", etc., does not lie in the voc tion of the mouth-cavity, which is really different, but in the the vocal cords, whose position is here a peculiar one, differ

[1] Tâittirîya Prâtiçâkhya, ii 47, ed. by WHITNEY, Journ. Amer. Oriental IX 77.

[2] MICHAELIS, *Ueber das H und die verwandten Laute,* Arch. f. d. Studiu ren Sprachen (Herrig), 1887 LXXIX 49, 283.

[3] See quotations in MICHAELIS, as before, 79.

that for the loud voice (*vox*) and from that for the whisper voice (*vox clandestina*)."[1]

A special adjustment of the mouth for *h* seems to have been first asserted by VALENTIN who remarks: "The palate, apparently narrowed as a whole, is somewhat drawn upward whereas the root of the tongue is moderately arched."[2] MERKEL asserts: "The whole cavity from larynx to mouth-opening opens or narrows itself at once to the degree required by the following vowel. The tongue however in forming the *h* does not yet assume the position required for the vowel in question. Thus when *i* is to follow it lies lower than the position for this vowel."[3] Both these and a series of later observers apparently supposed the configuration of the mouth to aid in the rough noise of the *h*. This view is undoubtedly partially true as in many cases of *h* the friction of the air can be felt in the mouth. I venture to suggest, however, that the assumption of a particular position for the *h* is for the purpose of giving it a resonance tone instead of making more noise by friction; the curve for *wh* in the case under consideration shows a resonance period of 2.5" as contrasted with that of 1.9" for the following *u*.

Indications of a tendency to give *h* an independent resonance cavity are apparent in remarks by LLOYD. "*h* and *o* in *hold* are successive, but they slightly overlap. When such a combination is to be produced, the cords instantly leap into a position sufficiently close to cause a slight friction. They then close more slowly, until they are planted close together, and voice ensues. The vowel *position* has already been assumed, but there is no vowel so long as the glottal orifice is still comparatively wide. But there is a moment, just before the cords begin to sound, when the glottis is narrowed to a whispering position; and, for that moment, the sound is both *h* and whispered vowel. If *ho* is whispered, the *h* is still prior, for it begins with a glottal orifice so large as quite to mar the adjusted resonance of the *o* vowel-configuration; and there is no vowel until the close position of whisper is reached. When that is reached, it is held; and the whispered vowel itself may be viewed as the mere promulgation of the final element of the *h*. *h* is therefore really a glide from simple *Mund und Kehlresonans* (such as is heard in a *sigh*) to a whispered *Anlaut* of the following vowel, *i. e.*, from a nearly uniform beginning to a far from uniform end."[4]

[1] MICHAELIS, as before, 79.

[2] VALENTIN, Lehrbuch der Physiologie des Menschen, II 291, 1844, quoted by MICHAELIS, as before, 61.

[3] MERKEL, Laletik, 72, 1866, quoted by MICHAELIS, as before, 72.

[4] VIETOR, Elemente der Phonetik, 3. Aufl., 22, Leipzig 1894.

There seems to be some conflict between LLOYD's statement that in the *h* the vowel position has been already assumed and that it starts from a nearly uniform beginning. I would suggest the view that the *h* in this case of *wh* possesses a definite resonance cavity of its own which may be related to but is yet different from that of the following *u*.

The most plausible view of the nature of this *wh* seems to include the following points.

In the first place it is either the glottal fricative produced by a narrowing of the glottal opening sufficient to produce a rough sound without a tone, or a sonant fricative produced by a narrowing of the proper cord glottis while the cartilage glottis remains open.[1] Both views are consistent with the fact that a distinct movement of the larynx can be felt with the fingers when *wh* is pronounced. The former view is consistent with the curve under consideration, but the latter view is favored by some of the other cases of *wh* in the record studied, which show some slight but not quite certain indications of a grouping of the resonance vibrations and therefore of the presence of a cord tone.

The *h* is considered as a sonant in all Sanskirt treatises.[2] Traces of a sonant *h* have been found in speech curves of the Finnish language.[3] The consideration of the vexed question of sonant *h* must be postponed to a future occasion.

In the second place the *h* contains at least one tone arising from the resonance cavity in front of the cords. This tone I believe to be one of a pitch peculiar to *h*, just as certain tones are peculiar to certain vowels. The frequency of the *h* tone in this *h* is 400. I do not believe that for this tone the mouth is adjusted to the position of the following *u* with a resonance tone of 526, and that the pitch of the cavity is modified by the difference in the greater enlargement of the glottal orifice so that the tone 400 is produced. My reasons for this last statement are: 1st, *h* can be sounded alone without giving information concerning the following vowel; 2d, the difference between the opening of the cords for the *h* position and that for the vowel position is too small to produce such a great difference in the pitch of the resonance cavity; 3d, the assumption that the *h* cavity is the same as that of the following vowel is not supported by any positive proof and in the absence of such proof it is unwise to accept an

[1] CZERMAK, *Ueber d. Spiritus asper und lenis, etc.*, Sitz.-Ber. d. Wiener Akad., math.-naturw. Cl., 1866 LII (2) 630, Anmerk. 1 (also in Schriften, I 756).

[2] Tâittirîya Pràtiçàkhya, i 13.

[3] PIPPING, *Zur Phonetik d. finnischen Sprache: Untersuchungen mit Hensen's Sprachzeichner*, Mém. de la Société finno-ougrienne, XIV, Helsingfors 1899. (Review in Deutsche Litteraturzeitung, 1900, April 28.)

arrangement involving an anticipatory adjustment of the vocal organs whereby the vowel is prepared for before the *h* is produced.

The *hu* glide.

The aspirate *h* is followed by two vibrations with periods of 2.3" and 2.1" respectively (Fig. 71, line 2). They are resonance vibrations produced by the passage of the air through the mouth cavity. They might with propriety be considered as belonging to the *h*, from which they differ only in period. Yet the change from the *h* period of 2.5" denotes the rise of an impulse toward another sound and, if the concept of a glide is to be admitted at all, they are to be treated as a glide. The intention shown in the glide is to change the mouth tone from 2.5" for the *h* to 1.9" for the *u*. The second of these glide vibrations ends suddenly with the puff of air from the first vibration of the cords in making the *u*.

The vowel *u*.

The word is so short that the ear is not able to attribute any particular quality to the vowel.

The curve for the *u* (Fig. 71, lines 2 and 3) closely resembles that for *ai* in its general character. The first part shows a rising cord tone and a nearly constant but afterwards falling resonance tone. In the latter portion the cord tone is approximately constant while the resonance tone falls. The change in the character of the action of the cords appears clearly also as in *ai* (p. 37). It is, in fact, very evident that this sound is really a diphthong with possibly less difference between the two elements than in the case of *ai*. This diphthongal character of the English *u* is well known to phoneticians; the sound is generally indicated by *uw*. A separation of the sound into its two parts will not be attempted here.

The curve at the beginning of the *u* shows a vibration of 6.3" from the vocal cords acting on a cavity whose period 1.9" is not a sub-multiple of the cord period. As the cord period is gradually shortened, the resonance period (remaining the same) steadily modifies the form of the resultant vibration, and the curve is seen to change its form gradually. The relation between cord tone and resonance tone is closely analogous to that in the *a* of *ai* (p. 19).

The successive vibrations of the *u* occupy the periods of 6.3, 6.1, 6.1, 5.6, 5.4, 5.4, 4.9, 4.9, 4.9, 4.9, 4.9, 4.6, 4.6, 4.6, 4.2, 4.2, 4.2, 4.2, 4.2, 4.2, 4.2, 4.6, 4.6, 4.6, 4.6, 4.6, 4.6, 4.6, 4.6, 4.6, 4.6, 4.6, 4.6, 4.6, 4.6". The total time occupied by the *u* is 167".

The *u* thus shows a sudden tightening of the cords to a tension necessary for a tone with a period of 6.3" and thereafter a gradual increase of

tension to a maximum represented by 4.2$^\sigma$, after which there is a fall to 4.6$^\sigma$ at which the tone remains constant.

The resonance tone begins with period of 1.9$^\sigma$ or a frequency of 526. For the vowel *u* the following resonance tones have been assigned: DONDERS, *f*1; HELMHOLTZ, *f*; KOENIG, *b*; AUERBACH, *g–b*, *f*1; TRAUT-MANN, *f*2, *g*2; PIPPING, *f♯–f*$^{♯1}$, *g*2–*b*2; HERMANN, *c*2–*e*2; STORM, *a*; BOEKE, *d*4. My measurements indicate a resonance tone of 526 vibrations a second, or approximately *c*2. I have not yet been able to settle the question of a lower resonance tone.

This resonance tone is, however, not constant. This is especially evident during the last part of the *u* where the cord tone is constant. In this region of constancy the curve steadily changes its form from the earlier *u* form toward the *l* form ; during the last 8 or 10 cord vibrations it is difficult to say whether the curve belongs to the *u* or the *l*. The cord vibrations of the *u* period persist in their own constant period, however, to a point which can be detected. We are thus justified in reckoning these vibrations to the *u* although the mouth cavity has been presumably steadily shaping itself for another sound.

Repeatedly observed facts of this kind have forced upon me the belief that the view of a word as composed of a set of fixed sounds with glides between them is a somewhat inadequate one. It is derived from the attempt to get away from the artificial character of spelling but it still largely retains that character. The usual view of the word *who'll* would represent it as composed of *h*—glide—*u*—glide—*l*. The vocal organs are supposed to occupy three distinct positions, the glides representing the intermediate positions during the moments of change.

A somewhat different view seems better fitted to the actual curves. The unit of speech is sometimes a phrase, sometimes a word, and never a vowel or a consonant unless it is at the same time a word. In speaking a word the vocal organs pass through a series of positions of a special character without stopping in any one position. Thus the word *who'll* represents a continuous change in the force of expiration following a definite plan, also a continuous change in the tension of the vocal cords, likewise continuous movements of the parts of the mouth. The force of expiration rises from 0 to a maximum in 35$^\sigma$ at the end of the *h*, continues with slight fluctuation during 171$^\sigma$ in the glide and *u*, and finally dies away at 277 with the end of the *l*. Before the breath begins the mouth has adjusted itself to a tone of a period of 2.8$^\sigma$; this position changes very slightly during the 35$^\sigma$ of *h* : then it makes a rapid change through 2.3, 2.1 to 1.9$^\sigma$ in the *u*, remains constant during 167$^\sigma$ and rises suddenly to the mouth tone of the *l* (not determinable here).

On speaking the word *who' ll* I perceive apparently *continuous* movements of the lips and tongue ; they do not assume fixed positions at any moment. This would agree with the changes just described.

The cord tone has a somewhat similar history. It begins with a period of 6.3ᵛ in the *u* at 39ᵛ after the beginning of the word ; it rises steadily to 4.2ᵛ and then falls to a constant pitch of 4.6ᵛ for the latter part of the *u* ; suddenly it rises to 2.1ᵛ for the *l* and remains practically constant for 71ᵛ.

There are thus at least three distinct but coöperating continuous processes following different courses throughout the word, namely, the force of expiration, the resonance tone and the cord tone.

It seems thus somewhat artificial to divide the word *who'll* into 3 or 5 sounds ; we may preferably say that for the sake of discussion 5 stages in the changing sound may be picked out as typical of the whole process. To illustrate by an analogy, we might take single pictures out of a series of views of a runner made for the kinetoscope and treat the whole movement as made up of a series of positions in which the runner remains at rest. This treatment has its advantages for certain cases but we should never lose sight of the fact that the true movement occurs otherwise.

This view is not inconsistent with the fact that some of the elements of a vocal sound may remain approximately constant for a short time. Thus, the pitch of the *h* is nearly constant—as far as our methods can discover—though the intensity is changing, and the pitch of the *u* is fairly constant for a while.

The liquid *ll*.

The sound *ll* apparently does not begin suddenly but arises from a modification of the *u*. The *u* itself has been steadily changing its character from the very beginning ; during its last five or more cord vibrations it gradually approaches the form of curve that characterizes the *ll*. After this point the curve takes the *ll* form which differs completely from that of the *u* at the start (Fig. 71, line 4). As stated above, the explanation is presumably (1) that the cord tone remains on the *u* pitch until a certain moment at which it suddenly rises to the *l* pitch, whereas (2) the mouth cavity begins to modify itself from the *u* form to the *l* form before the cord tone changes. This is quite in agreement with the view that in the English *l* the back part of the tongue is elevated whereby it receives a guttural character [1] and is in this respect related to *u*.

The *l* shows 34 vibrations with a constant period of 2.1ᵛ. It occupies a total time of 71ᵛ.

[1] Literature in STORM, Engl. Philologie, 2. Aufl., 139, Leipzig, 1892.

The form of the vibration steadily changes as shown in the figt
The changes in pitch in this word *who'll* confirm the law d
for *ai* (p. 57) to the effect that in a succession of sonants (speech el
with tones) the cord tone of a sonant tends to be a multiple or
multiple of the cord tone or the mouth tone of the preceding sona
The relations are not exact but only approximate. The moul
2.5$^\sigma$ of the *h* is followed by a cord tone for the *u* having a gener:
rage of 5.0$^\sigma$ or an octave below the former. The mouth tone ol
1.9$^\sigma$ is followed by a cord tone for the *l* of pretty nearly the same
2.1$^\sigma$.

Such a law is what would be expected in a voice—at any rate
that was not unpleasant—for the human ear finds pleasure in a suc
of tones whose periods stand in certain relations. Possibly some
explanation of disagreeable voices may be found in the violation
law.

In general the curve of this *l* may be said to resemble the form:
by WENDELER[1] and HERMANN and MATTHIAS.[2]

The *l* given by WENDELER is a spoken sound; the figure shows
must have had a falling cord tone and a decreasing intensity.

The examples of *l* studied by HERMANN and MATTHIAS were s(
notes of different pitch. Their analysis showed that these examị
contained a tone between *f*[2] and *g*[2]. They also found for the
notes also a tone that was the octave of the cord tone and change(
it, and for the higher notes a reinforcement of the cord tone itself.
reinforcement of a partial tone of the cord tone is not found i
vowels studied by HERMANN or in the cases of *ai* considered above (
in two cases, namely, in the *i* in the 3d example of *I* and in *ạ*
list on p. 57). There is apparently some difference in the acti
the mouth in forming the *l*. This difference may be felt by si
the *l* on a note of rapidly rising or falling pitch; there is appa
a movement of the tongue whereby it is pressed more strongly a
the palate as the pitch rises. The consequent change in the size (
resonance cavity might, by the appropriate connection between t(
and cord, go parallel with the change in the cord tone and thus a
reinforce one of its partials.

Our curve does not enable us to make any measurements of the
nance tones, but its steady change in form while the cord ton

[1] WENDELER, *Ein Versuch, die Schallbewegung einiger Consonanten und a.
Geräusche mit dem Hensen'schen Sprachzeichner graphisch darzustellen,* Zt. f. Biol.
XXIII 314, Tafel III, Fig. 21 B.

[2] HERMANN UND MATTHIAS, Phonophotographische Mittheilungen, V. Die C
der Consonanten, Arch. f. d. ges. Physiol. (Pflüger), 1894 LVIII 315, Tafel II.

mains constant shows that the resonance tone or tones change independently. The tongue probably moves while the cords remain at a constant tension. This example of *l* thus differs from those of HERMANN and MATTHIAS.

The labial *b*.

In the spoken words on the gramophone plate the sound *b* follows immediately upon the *ll* without pause. The speech curve at this point (Fig. 71, line 5) shows no measurable vibrations, the enlargement not being great enough to reveal the details of the weak tone of the *b*. The interval occupied is 96ᵉ.

The vowel *i*.

The vibrations (Fig. 71, lines 6 and 7) have constant period of 2.8ᵉ. They start with an amplitude of o and rises steadily to an amplitude of 0.2ᵐᵐ. At the end they fall to o suddenly in four vibrations (Fig. 71, line 8). The pitch of the mouth tone could not be determined. This *i* seems a rather weak vowel when compared with the *i* in *ai*. The sudden ending indicates a quick cut by the following *th* (see above p. 31). The last four vibrations (Fig. 71, line 8) differ somewhat in character from the others and seem to indicate a diphthongal ending to the *i*.

The sonant post-dental *dh*.

As can be heard from the gramophone plate, the *i* sound in *be* is cut short by the *dh* of *the*. This sound appears in the tracing (Fig. 71, line 8) as a space with faint waves following immediately on the sudden fall of the *i* vibrations; the scale of enlargement is not sufficient to give definite information concerning the waves of the *dh*. This sound occupies a time of 56ᵉ.

The indefinite vowel *ʌ*.

This vowel follows *dh* in *the*. It rises somewhat rapidly to its maximum, remains at an even amplitude (Fig. 71, line 9), and drops suddenly to o in the last 4 vibrations. It has a pitch of 6.7ᵉ on an average and a maximum amplitude of 0.4ᵐᵐ. The entire vowel contains 12 cord vibrations and occupies a total time of 84ᵉ.

The *ʌp* glide.

The vowel *ʌ* of *the* is cut short by the closing of the lips for *p*. This suddenly reduces the amplitude of the vibrations till they are very faint (Fig. 71, line 9), yet the cords continue to vibrate after the closure as may be seen from the faint vibrations (Fig. 71, lines 9 and 10). The

sound can no longer be considered to be the vowel *a* and cannot in the usual sense be called a *p*. It may be treated as a glide although it occupies fully two thirds of the interval of 112*σ* between the *a* in *the* and the *a* in *parson*.

The labial *p*.

If the period of sonancy after *the* is to be considered as a glide, the remaining third of the 112*σ* may be assigned to the *p* (Fig. 71, line 10).

The vowel *a*.

The word *parson* appears to the ear (E.W.S.) to have an inflectional force of the form indicated in Fig. 72, as often appears at the end of questions ; the circumflexion appears to lie in the *a* and the deep fall to be in the *n* ; this word seems to contain a trace of an *r*. This word differs

FIG. 72. FIG. 73.

from the same word four lines later (p. 15) which appears to the ear to have a deep inflectional tone, at first level and then falling as in deciding a matter ; this is indicated in Fig. 73. This latter word seems to contain no *r*. The word *parson* is in both cases apparently continuous with the word *the* and would be acoustically written *theparson*.

The vowel *a* in this case occupies a period of 180*σ*. It is preceded by the interval of 112*σ* belonging to the *p* and is followed by a glide of 12.3*σ*.

It shows 36 cord vibrations. The pitch rises gradually as shown by the following measurements of the successive periods : 6.7, 7.0, 6.7, 6.0, 6.0, 6.3, 5.3, 5.3, 5.3, 5.3, 5.3, 5.3, 4.9, 4.9, 4.6, 4.6, 4.6, 4.6, 4.6, 4.2, 4.2, 4.2, 3.9, 3.9, 3.9, 3.9, 3.9, 3.9, 3.9, 3.9, 3.9, 3.9, 3.9, 3.9, 3.9, 3.9, 4.0, 4.2.

It contains a constant lower resonance tone with a period of 2.8*σ* or a frequency of 357 (Fig. 35).

The upper resonance tone is one of about 714 vibrations per second.

The amplitude rises through the first four vibrations from zero to 0.3*ᵐᵐ* and is maintained at this to the end.

The vowel *a* in *parson* has undoubtedly a diphthongal character. The first portion resembles the *a* sound discussed above (p. 16) in the rising cord tone but differs radically in the falling resonance tone, in which respect it is somewhat like the *a* in *die* (Figs. 49 and 53). The latter

portion (Fig. 71, line 13) is related to the earlier portion much as the *i* is related to the *a* in *ai* in respect to amplitude, the lowering of the resonance tone and the continuance of the cord tone. Although this latter portion is not so long as in most cases of *ai*, the resemblance is sufficient to justify the statement with which this paragraph begins. The sound might be written *a*✕ where the sign ✕ indicates a brief vowel not yet determined. It may be suggested that this brief vowel may arise from the weakening of the *r*, whereby a vowel sound partially or completely replaces the full *r*. It seems, however, to be a general rule, that in English long vowels have a diphthongal character.

The *ar* glide.

The sudden fall in amplitude and the change in pitch of the vowel ✕ in *a*✕ is continued through an ·interval of 8.8ᵛ in which 3 vibrations with a period of 2.4ᵛ appear (Fig. 71, line 13, middle). During this time the tongue is presumably passing to the *r* position.

The liquid *r*.

The very brief *r* is distinctly heard in the word *parson;* it occupies a time of 63ᵛ (Fig. 71, line 13 middle to line 14 beginning).

The *r* shows clearly 3 " pseudo-beats "[1] with a period of 19ᵛ or a frequency of 53. The vibrations within the beats are grouped in pairs indicating a cord tone acting upon a resonance cavity. The period of the cord tone is at first constant at 3.5ᵛ (frequency 286) but falls slightly in the third beat. The resonance tone has a period apparently constant at 1.4ᵛ (frequency 714). Still higher resonance tones are probably present. The following explanation of this curve is proposed tentatively. The *r* consists of a cord tone with a frequency of 286 acting upon a resonating cavity adjusted to a frequency of 714. The tongue is adjusted to vibrate with a frequency of 53 ; this vibration of the tongue closes and opens the air passage so that the intensity of the sound escaping from the mouth is regularly varied from zero to a maximum and again to zero at the rate of 53 times a second.

The pseudo-beats with the cord and resonance vibrations are shown in the curves by WENDELER[2] and in those by NICHOLS and MERRITT. The German rolled *r* of WENDELER has a much longer beat period, in general over 250ᵛ or ¼ sec. ; the Finnish *r* of PIPPING has a beat of ⅓

[1] WENDELER, as before, p. 304.

[2] WENDELER, as before, Tafel II.

[3] NICHOLS AND MERRITT, *The photography of manometric flames*, Physical Review 1898 VII 93, Plates I and II.

to $\frac{1}{2}$ sec.[1] The American rolled *r* of NICHOLS and MERRITT has also apparently a long beat-period as far as can be judged from the picture. The brief *r* in three examples given by these last observers has apparently a shorter beat-period than that of *parson*. The cord period in WENDELER's examples varies apparently from 2.3r to 3.3r (WENDELER's own computation of a frequency of 200 or a period of 5r can hardly be correct); the resonance period lies in the neighborhood of 1.7r, according to my calculation from his records.

The sibilant *s*.

This follows directly upon the *r*. The vibrations in the curve are hardly distinguishable and no very definite limit can be set to them.

The liquid *n*.

This follows immediately on *s* (Fig. 71, line 14 to end). It occupies an interval of 197r. The successive vibrations occupy periods of 4.2, 3.5, 5.1, 3.7, 5.3, 4.1, 4.1, 5.3, 4.2, 4.9, 4.9, 5.3, 5.3, 5.3, 5.3, 5.3, 5.6, 5.3, 5.3, 5.6, 5.6, 5.3, 6.7, 6.3, 6.7, 6.7, 7.0, 7.0, 7.0, 7.0, 7.0, 8.4, 8.8, 8.8, 9.1, 8.8. The maximum amplitude is 0.1mm.

IV. THE NATURE OF VOWELS.

To the question, "What is a vowel?" several kinds of answers may be given.

A vowel may be defined as the sound produced by a certain action of the vocal organs. Some specially peculiar position of one or more of the organs is usually selected as characteristic. Nearly every writer on phonetics gives a definition whose elements are the positions of the vocal organs. Such a definition may be called a "physiological definition of a vowel."

Another method of defining a vowel consists in giving the physical character of the sound of which it consists. This method was proposed by WILLIS who justifies it by the following considerations:

"The mouth and its apparatus were constructed for other purposes besides the production of vowels, which appear to be merely an incidental use of it, every part of its structure being adapted to further the first great want of the creature, his nourishment. Besides, the vowels are mere affections of sound, which are not at all beyond the reach of human imitation in many ways, and not inseparably connected with the human organs, although they are most perfectly produced by them ; just so,

[1] PIPPING, *Zür Phonetik d. finnischen Sprache,* Mém. de la Soc. finno-ougrienne, XIV, Helsingfors 1899.

musical notes are formed in the larynx in the highest possible purity and perfection, and our best musical instruments offer mere humble imitations of them ; but who ever dreamed of seeking from the larynx an explanation of the laws by which musical notes are governed ? These considerations induced me, upon entering on this investigation, to lay down a different plan of operation ; namely, neglecting entirely the organs of speech, to determine, if possible, by experiments upon the usual accoustical instruments, what forms of cavities or other conditions, are essential to the production of these sounds, after which, by comparing these with the various positions of the human organs, it might be possible, not only to deduce the explanation and reason of their various positions, but to separate those parts and motions which are destined for the performance of their other functions, from those which are immediately peculiar to speech (if such exist)."[1]

WILLIS's idea of studying the physical characteristics of a vowel has been developed by a series of later observers, finding its full expression in the study of curves of speech by the investigators referred to in Section I (p. 2). In its perfection the "physical definition of a vowel" will consist of a mathematical expression for the course of the molecular vibration of the air which it involves.

A third method of defining a vowel might be proposed, namely, a summarization of its mental characters as perceived by the person hearing it. This might be called a "psychological definition." It would consist in a statement of the pitch of the vowel as heard, whereby reference might be made to some standard musical instrument in determining the pitch ; also in a statement concerning its apparent intensity ; also one concerning its apparent length ; and finally one concerning its expressive character. Such definitions have not before been given ; they have been crudely attempted in some cases of the vowels I have studied in the preceding pages.

WILLIS's *theory.*

Probably the earliest well-founded statement in regard to the nature of vowels was that of WILLIS. His line of thought was as follows :

"It is agreed on all hands, that the construction of the organs of speech so far resembles a reed organ-pipe, that the sound is generated by a vibratory apparatus in the larynx, answering to the reed, by which the pitch or the number of vibrations in a given time is determined; and that this sound is afterwards modified and altered in its quality, by the

[1] WILLIS, *On vowel sounds, and on reed-organ-pipes,* Trans. Camb. Phil. Soc., 1830 III 231.

cavities of the mouth and nose, which answer to the pipe that organ builders attach to the reed for a similar purpose."

WILLIS fitted a reed to the bottom of a funnel-shaped cavity and obtained sounds resembling vowels by modifying the opening of the cavity. He then tried closed cylindrical tubes of different lengths and found that different vowel-like sounds were produced by different lengths of the tube. His experiments led him to the conclusion that the vowel-like sounds are produced by the repetition of one musical note in such rapid succession as to produce another. "It has been long established, however, that any noise whatever, repeated in such rapid succession at equidistant intervals as to make its individual impulses insensible, will produce a musical note. For instance, let the musical note of the pipe be g'', and that of the reed c', which is 512 beats a second, then their combined effect is $g'' \cdots g'' \cdots g'' \cdots g'' \cdots$ (512 in a second) in such rapid equidistant succession as to produce c', g'' in this case producing the same effect as any other noise, so that we might expect *à priori*, that one idea suggested by this compound sound would be the musical note c'.

"Experiment shows us that the series of effects produced are characterized and distinguished from each other by that quality we call the vowel, and it shows us more, it shows us not only that the pitch of the sound produced is always that of the reed or the primary impulse, but that the vowel produced is always identical for the same value of s [the length of the pipe]. Thus in the example just adduced, g'' is peculiar to the vowel A° [*à* as in all]: when this is repeated 512 times in a second the pitch of the sound is c', and the vowel is A°: if by means of another reed applied to the same pipe it were repeated 340 times in a second, the pitch would be f, but the vowel still A°. Hence it would appear that the ear in losing consciousness of the pitch of s [the length of the pipe] is yet able to identify it by this vowel quality. But this vowel quality may be detected to a certain degree in simple musical sounds; the high squeaking notes of the organ or violin speak plainly I, the deep bass notes U, and in running rapidly backwards and forwards through the intermediate notes, we seem to hear the series U, O, A, E, I, I, E, A, O, U, etc., so that it would appear as if in simple sounds, that each vowel was inseparable from a peculiar pitch, and that in the compound system of pulses, although its pitch be lost, its vowel quality is strengthened." . . . "Having shown the probability that a given vowel is merely the rapid repetition of its peculiar note, it should follow that if we can produce this rapid repetition in any other way, we may expect to hear vowels. ROBINSON and others had shown that a quill held against a

toothed wheel, would produce a musical note by the rapid equidistant repetition of the snaps of the quill upon the teeth. For the quill I substituted a piece of watch-spring pressed lightly against the teeth of the wheel, so that each snap became the musical note of the spring. The spring being at the same time grasped in a pair of pincers, so as to admit of any alteration in length of the vibrating portion. This system evidently produces a compound sound similar to that of the pipe and the reed, and an alteration in the length of the spring ought therefore to produce the same effect as that of the pipe. In effect the sound produced retains the same pitch as long as the wheel revolves uniformly, but puts on in succession all the vowel qualities, as the effective length of the spring is altered, and that with considerable distinctness, when due allowance is made for the harsh and disagreeable quality of the sound itself."

Thus WILLIS maintains two theses : 1. that a vowel consists of [at least] two tones, a cord tone and a mouth tone ; 2. that the mouth tone is independent of the cord tone in regard to pitch.

The first of these theses led to attempts to determine the pitch of the mouth cavity ; the results will be considered in Section V below.

The second thesis was for a long time entirely neglected in favor of another one, although, as I hope to show, it is the one that correctly represents the facts.

HELMHOLTZ'S *theory.*

According to HELMHOLTZ the vowels arise from the vibrations of the vocal cords through the strengthening of certain overtones by the resonance of the mouth.

" We may well suppose, that in tones of the human larynx, as in those of other reed instruments, the overtones would continuously diminish in intensity with rising pitch, if we could observe them without the resonance of the mouth. In fact they correspond to this assumption fairly well in those vowels that are spoken with widely opened, funnel-like mouth-cavities, as in sharp *A* or *Ä*. ₁This relation is however very materially changed by the resonance in the mouth. The more the mouth-cavity is narrowed by the lips, teeth or tongue, the more prominently its resonance appears for tones of very definite pitch, and by just so much more it thus strengthens those overtones in the tone of the vocal cords which approximate the favored degrees of pitch ; and by just so much more the others are weakened."[1]

The pitch of the tones for which the mouth resonates best was studied

[1] HELMHOLTZ, Die Lehre v. d. Tonempfindungen, 4. Aufl., 170, Braunschweig 1877.

by HELMHOLTZ by means of tuning forks held before the mout[
resonance differed for different vowels.

"The pitch of the strongest resonance of the mouth depends
the vowel for whose production it has been arranged, and chang
tially even for small changes in the character of the vowel as for
in various dialects of the same language. On the other hand
onances of the mouth are almost independent of age and sex.
found in general the same resonances for men, women and c
What is lacking to the childish and female mouth in capacity
easily replaced by narrower closure of the opening, so that the re
can still be as deep as in the larger male mouth."

According to HELMHOLTZ "the vowel sounds are different [
sounds of most musical instruments essentially in the fact that the
of their overtones depends not only on the number of the over[
above all on its actual pitch. For example, when I sing the vo
the note E#, the reinforced tone is $b_{,,}$ or the 12th one, and whe
the same vowel on the note $b_{,}$ it is the second one."[1]

This view of HELMHOLTZ necessitates the assumption of an acco[
tion of the resonance tone to the voice tone within quite a rang
as the voice tone rises or falls the mouth must also change its to[
able to extend its resonance to a considerable degree. This ass[
was made by HELMHOLTZ, the range of accommodation being s[
to extend over as much as an interval of a fifth in music each w
the tone of best resonance. This view has been called the "
modation theory." According to this theory the mouth must ac[
date itself to one overtone of the voice tone and when this rises or
a considerable degree it must readjust itself to some other one in
keep the resonance tone within a limited range.

The difference between the theories of WILLIS and HELMHO
chiefly in the relation between the mouth tone and the voice tone;
former there was no relation, for the latter the resonance tone wa[
the overtones of the cord tone.

"WILLIS's description of the acoustic movement in the vowel[
less coincides closely with the truth; but it gives only the ma
which the motion occurs in the air, and not the corresponding
of the ear to this motion. That even such a motion is analyzed
ear according to the laws of resonance into a series of overtones i[
by the agreement in the analysis of the vocal sound when it is e
and by the resonators."[2]

[1] HELMHOLTZ, as before, 191.
[2] HELMHOLTZ, as before, 191.

HELMHOLTZ also devised an apparatus of electric tuning forks and produced vowel-*like* sounds by combining a fundamental tone with different sets of overtones.

HELMHOLTZ was greatly influenced in his theory by his views of the action of the ear. The hypothesis that all regular vibratory movements reaching the ear are analyzed by it into a series of harmonics of the fundamental period is an assumption that seems to lead necessarily to the HELMHOLTZ theory. This assumption, however, we must disregard at the present time; the problem concerns the nature of the vibratory movement characterizing a vowel and the solution must be found in an unbiased analysis of the vowel curve; the question of how the ear acts is a later one.

PIPPING'S [1] work with HENSEN's instrument (see above, p. 4) led him to the following conclusions.

" In agreement with HELMHOLTZ I have found that each vowel is distinguished by one or more regions of reinforcement of constant pitch. The intensity of its partial tone is, *cæteris paribus*, greater as it coincides more accurately with the range of reinforcement.

" In regard to the range of the reinforcement I cannot agree with HELMHOLTZ. HELMHOLTZ indeed states that the range can be different according to the opening of the mouth, the firmness of walls of the oral cavity, etc. But he lays so little weight on this difference that he does not attempt to use it in the characterization of the different vowels. To judge from page 183 of the Lehre von den Tonempfindungen HELMHOLTZ thinks that the range of reinforcement must extend in general at least a musical fifth above and below, and this is certainly not the case.

" Sung vowels contain only harmonic partial tones." That is, a vowel produced by singing consists of a series of tones whose vibrations stand in the relations of $1 : 2 : 3 : 4 : \cdots$.

" The intensities of the various partial tones do not depend to any essential degree on their ordinal numbers." That is, in distinction to most musical instruments it is not the fact that the first partial is much the stronger and that the higher partials are in general weaker.

" The various vowels differ from each other in ranges of reinforcement which are of different numbers, width and position in the scale of pitch." That is, one vowel may have two ranges of reinforcement, another three, etc., and these ranges may differ.

On a later occasion [2] PIPPING believes that the range of accommodation may exceed even the limits allowed by HELMHOLTZ.

[1] PIPPING, *Zur Klangfarbe der gesungenen Vocale*, Zt. f. Biologie, 1890 XXVII 77.

[2] PIPPING, *Zur Lehre von den Vokalklängen*, Zt. f. Biologie, 1895 XXXI 573, 583.

Comparison of the two theories.

The two conflicting theories require a decision concerning
validity.

Among the results that support the view of WILLIS we may notic
obtained by DONDERS with the SCOTT phonautograph.[1]

" Each of the fourteen vowels when sung on a constant tone pr
a constant curve. . . . " For each vowel the form of the curve c
with the pitch. This result is connected with the peculiarity
vowels, that their timbre is determined not by overtones of a
order to the fundamental, but rather by overtones of a nearly cc
pitch.' '

This last statement implies the fact that if the resonance tones
mouth were overtones of the voice tone bearing a definite relatioı
such as 1st, 2d, the curve would remain the same in form no
what the pitch, just as the curve of vibration for a violin string
typical form which persists in spite of changes in the pitch of the
On the other hand if the tone of the mouth is a constant one, as 1
assumes, the combined vibration produced by the voice tone aı
mouth tone would change for any change in pitch of the voice ton

HERMANN's investigations were carried out by transcribing the
of song from the phonograph. He finds that the essential fact in a
is the intermittent or oscillatory blowing of the mouth tone by the
Under such circumstances it makes no difference whether the res
tone coincides with any fraction of the voice tone period or not.[2]

MANN thus supports the theory of WILLIS in asserting that the mout
is completely independent of the voice tone. To this statement
MANN adds that of the intermittence of the voice tone which seems
to have been suspected by previous observers. This new fact of
mittence appears much more clearly in my curves of the spoken
Figs. 7, 17, 30) than it does in HERMANN's curves of the sung v
HERMANN believes that this intermittence is essential to the prod
of a vowel and that merely adding a constant tone to a complex of
does not give a vowel.[3] This intermittence, however, occurs oı
some vowels of low pitch, as in the first portions of the cases of
mentioned ; it does not occur in the *i.* Even in the latter portion

[1] DONDERS, *Zur Klangfarbe der Vocale*, Annalen de Physik u. Chemie, 1864 C
528.

[2] HERMANN, *Phonophotographische Untersuchungen*, Archiv f. d. ges. P
(Pflüger), 1890 LXXIV 380, 381.

[3] HERMANN, *Weitere Untersuchungen ū. d. Wesen der Vocale*, Archiv f.
Physiol. (Pflüger), 1895 LXI 192.

cases of *a* it is hardly proper to speak of intermittence ; the pressure in the wave from the voice tone is not evenly distributed throughout the period, but there is nothing resembling intermittence. Even in HER-MANN'S own curves for *i* as shown, for example, in one of his latest publications,[1] there is no such intermittence.

According to HERMANN each vowel has one or two fixed mouth tones whose pitch varies within narrow limits if at all ; these tones he calls "Formants." Thus, the vowel *u* when sung by a certain person contains not only the voice tone but also one or two mouth tones ; these mouth tones are the same when the same vowel is sung at different pitches.

HERMANN has objected to the overtone theory of the mouth tone that in many voices the formant is so high above the voice tone that it cannot be supposed that an overtone of that pitch could possibly be present. Thus as the voice-tone *G* the vowel *i* has a strong mouth tone that would correspond to the 28th or 29th partial of the voice tone, whereas such a high partial, if present at all, would be too weak to be heard.[2]

A final decision in the case of the vowel *a* can, I believe, be established on the basis of the curves described above in Section I. The independent tone theory is certainly the only one that will account for this vowel. In the first place the vowels studied were spoken vowels and were open to none of the objections that may be made against sung vowels. In the second place the resonance vibrations can be seen starting at regular intervals and dying away completely in some instances and less completely in others within a single period of a voice tone. Again, the resonance vibration can be seen to remain of constant period while the voice tone rises through a distance of several octaves *within one single vowel.*

In the face of such conclusive evidence it is hard to see any point in which the decision in favor of the theory proposed by WILLIS and developed by HERMANN can possibly be attacked. It is natural to assume that a theory found to be valid for one vowel will be valid for all ; it is, of course, possible that other laws may hold good in other vowels, but until this possibility is proven we can treat all vowels on the independent-tone theory.

The noise theory.

Another view of the way in which the resonance tone is aroused resembles an older view of the action of organ pipes. "The concomitant resonances [mouth tones] which create or constitute vowel quality are

[1] HERMANN, *Weitere Untersuchungen über d. Wesen der Vocale*, Archiv f. d. ges. Physiol. (Pflüger), 1895 LXI Tafel V.

[2] HERMANN, *Phonophotographische Untersuchungen*, Arch. f. d. ges. Physiol. (Pflüger), 1894 LVIII 274.

animated, primarily and essentially, by the irregular noises which is *together* with the vocal tone from a speaking or singing glottis, but **x** *out* it from a whispering one. Some of these are always found caps of affording just the appropriate impulse, and of kindling the resonan of the configuration [mouth cavity]." [1]　This view is undoubtedly rect as far as whispered vowels are concerned, but it can hardly be s ported for spoken vowels.　In one respect the case is analogous to t of an ordinary resonator ; by blowing against the opening or by tapp the walls the tone of the resonator can be faintly heard.　Thus, in w pering, the vowels can be produced with faint tones.　These faint to are, however, quite different affairs from the strong mouth tones spoken vowels although they may be of the same pitch.　In speak there must be a stronger force to set the mouth cavity in vibration tl the faint noises that accompany the cord tone ; otherwise the mouth t would be quite overpowered by the cord tone and there would be no ticeable difference between vowels spoken on the same note.　Moreo noises seem to have no power to arouse strong resonances ; thus the n of *s*, though loud and produced directly on the edge of the resona cavity, does not produce any marked resonance vibrations (p. 70).　1 force that sets the mouth cavity in vibration can only come from the tone and the "noise theory" of vowels may be definitely laid aside.

Observations on the nature of spoken vowels.

Previous investigators have had in mind almost exclusively the v els sung on musical notes.　It has been universally assumed that spoken vowels do not differ essentially from the sung ones.　Thus H MANN says, "The difference between sung and spoken articulation I exclusively in the fact that the pitch, intensity and duration of the s lables—or more accurately, of the vowels—are governed in song melody and rhythm and in speech by the laws of emphasis according meaning and arrangement.　In a single vowel there can thus be absolute no difference between song and speech." [2]

My investigations show, I believe, that this view is erroneous.

In the first place the voice tones of spoken vowels are seldom of co stant pitch.　Some are nearly constant in pitch, some fluctuate, some ri and fall in various simple or complicated ways.　I have looked over hu dreds of vowels in the records and find that there is a typical tone for tl whole discourse which occurs in a majority of the vowels, while the othe

[1] LLOYD, *Speech sounds : their nature and causation*, Phonet Stud., 1890 III 277.
[2] HERMANN UND MATTHIAS, *Phonophotographische Untersuchungen*, Archiv f. ges. Physiol. (Pflüger), 1894 LVIII 258.

have quite different tones. Many of the vowels are fairly constant, but many others vary. Indeed, it is just such changes and fluctuations in pitch and also in intensity that enable the voice to express the character of the thought. Without these changes the speech would be a monotonous sing-song resembling the speech of the deaf who have been taught by the oral method. When words are sung, they lose most of their character; speech is capable of expressing by its modulations the various emotions and conditions of the individual, whereas the singer has few resources at his command.

In the second place vowels have certain characteristic laws of pitch and intensity in certain positions. Thus the *a* of *ai* in my curves begins practically at zero in both pitch and intensity. The *i* has a nearly constant pitch with a slight fall, and a peculiar rise and fall of intensity. Presumably we shall at some time be able to determine the analytical expressions for the vowels and shall find that their properties follow definite laws.

It is interesting to note that this change in pitch in the spoken vowels has so generally escaped notice. I know of only one recorded observation that might refer to the subject.

ARISTOXENUS,[1] in discussing κίνησις φωνῆς opposes κίνησις συνεχής to κίνησις διαστηματική. The first term may be translated as "change in pitch of the voice," the second as "continuous change," and the last as "change by steps." The continuous change he considers to be characteristic of speech as opposed to song. "Now the continuous movement is, we assert, the movement of conversational speech, for when we converse the voice moves through a space in such a manner as to seem to rest nowhere."[2] It is not quite clear to me what he means by "continuous change." If he had definitely in mind the change in pitch of a vowel within itself, he certainly furnishes an example of most precise hearing and careful observation whereby he anticipates a result arrived at later only by careful experimental methods. I am somewhat inclined to doubt that he had in mind anything more than the general observation that in speech the voice rises and falls irregularly, yet the special statement that the changes are *continuous* necessarily involves the changes within single vowels.

One of the most curious facts observed in the vowels studied in the previous section is the change of the resonance tone. The pitch of the

[1] ARISTOXENUS, Harmonica, I § 25, p. 8, Meib. The passages are collected in JOHNSON, *Musical pitch and the measurement of intervals*, Thesis, Baltimore 1896.

[2] ARISTOXENUS, Harmonica, I § 28, p. 8, Meib., quoted in JOHNSON, *The motion of the voice in the theory of ancient music*, Trans. Amer. Philol. Assoc., 1899 XXX 47.

resonance tone is frequently not a fixed one but one altered accordi: some law. In most of the cases of the *a* it begins to change in the portion ; in the *i* it is frequently constant but often falling.

To the foregoing account of vowels it is necessary to make some tions. The most important one is the statement that a vowel is fixed thing, but a changing phenomenon. There is no such thing vowel *a* with a definite character under all circumstances. Even fo same speaker there are continual changes and variations in this w For different speakers, for different dialects and for different lang the changes become so great that the *a* finally has little resemblan the one chosen as a standard. We may say that a large number of speech sounds may be classed together by a more or less close resembl and may be designated by the term *a*. A similar statement would good of any speech sound.

The changes from *a* take place in all directions, in voice to: mouth tone, in length, etc. By selecting examples properly a contir series can be made of forms whose members differing but little from neighbors, reaching from *a* to any of the other vowels. For exar between a typical *a* and a typical *o* all the intermediate vowels m: found corresponding to the position of the mouth between the *a* pos and the *o* position. "In no language or dialect are the sounds w pass current for one and the same vowel absolutely identical. They perceptibly in individual use : and hence . . . a vowel is not one si definite sound, but a group of more or less closely resembling so which in a given speaking commuity pass current as one vowel. T seems to be no practical limit to the range of this wandering so lor the sounds employed do not actually *overlap* those of any other v which happens to be used in the same language."[1]

Mechanical action in producing vowels.

Although it may be regarded as settled that a vowel consists of a tone with its overtones and one or more resonance tones from the m and possibly from the pharynx,[2] there still remains the physical prob of the method in which the cord tone arouses the resonance tone.

The mouth cavity with the pharynx and vocal cords may be consid as a pipe with membranous reeds. The theory of its action will similar to that of an ordinary reed organ pipe.

Each vibration of the reed sent a wave of condensation and rarefac along the pipe. When the pipe is of such a length that this wave is

[1] LLOYD, *Speech sounds : Their nature and causation,* Phonet. Stud., 189 III.
[2] LLOYD, brief note in Proc. Brit. Assoc. Adv. Sci., 1891 796.

flected back in such a way as to reinforce the vibration of the reed, the resonance tone is a loud one. Thus, when a properly adjusted resonator is placed behind a vibrating fork the tone of the fork is strongly reinforced. The reinforcement is also strong when the resonator coincides in pitch with an overtone of the reed.

Such a coincidence between the periods of the pipe tone and the reed tone is not necessary. Each impulse from the reed may be considered as striking the pipe with something of the nature of a blow, whereby the proper tone of the pipe itself may be aroused for an instant. The pipe may thus have its own pitch and be heard, no matter what relation there may be between it and the pitch of the reed. When the blow from the reed is rapidly repeated, both the reed tone and the pipe tone will be heard.

Such a method of producing resonance tones has been declared to be impossible hy HENSEN,[1] who remarks that air from a reed pipe cannot arouse a resonance tone. The experiment on which he bases this statement consisted in placing a resonator at the end of a reed pipe. At a certain pressure of air the pipe sounded its own tone, at a different·pressure it was silent. The resonator sounded only when the pipe was silent. Nevertheless there were occasions when both the pipe tone and the resonance tone appeared together ; these were called by HENSEN unsuccessful experiments. We ought perhaps to call them rather the successful ones.

To these experiments and deductions HERMANN replied that a labial pipe can be used to sound·a reed pipe, and some experiments were made to demonstrate the fact.[2] I have attempted in another way to show that a series of puffs of air of any periodicity may be used to sound a labial pipe of any pitch.

A disc with its edge cut into waves forming approximately a sine-curve was rotated by an electric motor at any desired speed. Its edges passed between the ends of two pieces of rubber tubing so arranged that the air blown into one of them passed directly into the other one if the waves of the disc permitted ; the position was so chosen that the waves of the · disc regularly interrupted the air current completely. The end of the rubber tubing was flattened and placed so as to blow against the edge of a piece of brass pipe stopped at the other end. The experiment began with the disc at rest. A current of air was blown through the tubing ; the pipe gave forth a tone. The disc was then set in rotation ; the tone

[1] HENSEN, *Die Harmonie in den Vocalen*, Zt. f. Biol., 1891 XXVIII 39.

[2] HERMANN, *Weitere Untersuchungen ü. d. Wesen d. Vocale*, Arch. f. d. ges. Physiol. (Pflüger), 1895 LXI 195.

of the pipe was regularly intermitted. As the disc moved faster, this in
termittence became more rapid. Finally, the intermittence itself wa
heard as a tone in addition to the pipe tone. Thus an intermittent ai
current, such as is employed for producing tones directly, can be use
to produce a pipe tone in addition.

I have even succeeded in arousing the resonance of a closed tube b
blowing through an artificial larynx. The artificial larynx was made b
binding a piece of thin soft rubbe
around the end of a glass tube. Tw
opposite points of the thin-walled rub
ber tube thus made were each caugh
between the thumb and finger ; the
tube was then stretched till the side
come together. A blast of air through
the tube set these edges in vibration
and produced a tone. By placing the
edges at the right spot over the mouth
of a bottle or a test-tube or a key
(Fig. 74) the resonance tone of the
latter could be distinctly heard.

When the edges of the artificial
larynx are properly placed against the
opening of a small tube such as the
hole of a door-key, the tone of the key
is heard loudly in addition to that of
the artificial larynx. The pitch of
the larynx-tone may be altered at will.

FIG. 74.

This experiment illustrates with great vividness the method in which
vowels are actually produced in the vocal organs.

It is not so easy to arouse a tube of low pitch such as a bottle in this
way, because the volume of air passing through the artificial larynx is not
large.

It can thus be regarded as definitely settled that the current of air from
a reed can be used to arouse a resonance tone in a cavity properly ad-
justed to receive the air. The WILLIS theory of vowel production is
therefore at least a physical possibility.

To this statement we may add that the reed tone and the resonance
tone may vary independently of each other, but that the resonance tone
is loudest when its pitch is higher than that of the reed tone.

WILLIS's view of the way in which the resonance tone was superimposed
on the reed tone is very explicit. " According to ᴇʀᴀꜱᴍ, if a single

pulsation be excited at the bottom of a tube closed at one end, it will travel to the mouth of this tube with the velocity of sound. Here an echo of the pulsation will be formed which will run back again, be reflected from the bottom of the tube, and again present itself at the mouth where a new echo will be produced, and so on in succession till the motion is destroyed by friction and imperfect reflection. . . . The effect therefore will be a propagation from the mouth of the tube of a succession of equidistant pulsations alternately condensed and rarefied, at intervals corresponding to the time required for the pulse to travel down the tube and back again ; that is to say, a short burst of the musical note corresponding to a stopped pipe of the length in question, will be produced."[1]

The true view of the action of the mouth in producing a resonance tone seems to be the following one. The sudden puff of air from an explosive opening of the cords may be considered to act as a piston compressing the air before it in the mouth cavity. The air acts as a spring by its resistance to compression and drives the piston back beyond its position of equilibrium ; the resistance to dilatation draws it back, and so a vibratory movement is set up. Under these circumstances the air acts merely as a spring ; the form of the cavity is immaterial and the period of vibration remains the same, provided the capacity be not varied. The single impulse of the piston thus makes the resonator a source of vibration, whose period remains practically constant but whose amplitude steadily diminishes from loss of energy mainly by communication to the external air. Such vibrations are seen in the curves for *a* in Section II above. This statement is an adaptation of that given by RAYLEIGH for resonators in general.

The question arises as to the period of the tone thus produced by the resonator.

There are cases in which the HELMHOLTZ view of the action of the mouth cavity might seem to have a possibility of correctness. If we assume (1) that a uniform condition has been attained, (2) that the natural period of the resonator does not differ greatly from that of the cord period, and (3) that the cord vibrations are of not too explosive a nature, it follows that the effect of the resonator can only be to modify the intensity and phase of the partials of the cord note. The partial or partials nearest to the natural periods of the mouth cavity will be reinforced and they can be found from the cord by the FOURIER analysis.

Under the assumptions made above the vibration of the resonance cavity is a *forced* one, and the conclusion concerning the section of the

[1] WILLIS, as before, 243.

mouth cavity is necessarily correct.[1] The first and second assumptions
made above have been explicitly stated by RAYLEIGH, who concludes
that both the WILLIS and the HELMHOLTZ ways of treating the action of
the mouth cavity are legitimate and not inconsistent. "When the
relative pitch of the mouth tone is low, so that, for example, the partial
of the larynx note most reinforced is the second or the third, the analysis
by FOURIER's series is the proper treatment. But when the pitch of the
mouth tone is high, and each succession of vibrations occupies only a
small fraction of the complete period, we may agree with HERMANN that
the resolution by FOURIER's series is unnatural, and that we may do bet-
ter to concentrate our attention upon the actual form of the curve by
which the complete vibration is expressed."[2] The two forms of treatment
imply that the resonance tone is to be considered in the one case as a
free vibration of the air in the cavity, and in the other case as a forced
vibration. Some cases of the *i* (Figs. 44 and 53) may be reconciled
with the HELMHOLTZ view, the resonance tone being an overtone of the
cord tone and changing with it. The cases of *a* and most of those of *i*
are decidedly inconsistent with the overtone theory. Possibly the vari-
ation from the overtone theory arises from the explosive manner in
which the cords open. The general description of their action for *a*
probably holds good even when the resonance tone is only about an
octave above the cord tone ; each puff of air is stronger at the start and
fades away, setting the air in the resonance chamber into free instead of
forced vibration. This general characteristic can be traced in each *a*
even to the point where the resonance tone is slightly less than the
octave of the cord tone, as in Fig. 11. We are probably justified in con-
cluding that the WILLIS theory of the production of vowels holds good
universally.

V. THE MOUTH TONE IN VOWELS.

DONDERS sought to determine these tones by noting the pitch of the
mouth cavity when the various vowels were whispered.[3]

HELMHOLTZ[4] and AUERBACH[5] by holding tuning forks before the
mouth when it had been fixed for a certain vowel have found those whose
tones are most strongly reinforced. The mouth acts as a resonator and the
tone most strongly reinforced is that to which the mouth is tuned. The

[1] RAYLEIGH, Theory of Sound, § 48, 66, 322k, 397, London ; 1894, 1896.
[2] RAYLEIGH, as before, § 397.
[3] DONDERS, *Ueber d. Natur. d. Vokale*, Archiv f. d. holländ. Beiträge z. Natur. u.
Heilkunde, 1858 I 157.
[4] HELMHOLTZ, Lehre v. d. Tonempfindungen, 4. Aufl., 171, Braunschweig 1877.
[5] AUERBACH, *Untersuchungen ü. d. Natur. des Vokalklanges*, Diss., Berlin 1876.

objections arise : that there is no certainty that the mouth is really in the vowel position desired ; and that the mouth may resonate to several tones. The adjustment of the mouth may be quite different when no expiration is occurring from what it is during whispering or speaking or singing.[1] At any rate we have no assurance that it is the same. I quite agree with HERMANN that the only trustworthy determinations of the mouth tone are those obtained by actual whispering, singing or speaking. Whispered vowels were examined by DONDERS, HELMHOLTZ and HERMANN.

The pitch of the mouth tone has been studied in a different way by LLOYD. The mouth, as an excentric cavity, would naturally have two resonance tones : the tone of the " porch " or narrow front part, and the tone of the " chamber " or rear part.[2] A combination of a tube and a cylinder can be made to give a vowel-like sound when the sizes are properly selected. LLOYD produced various vowel-like sounds and determined the tones of the tube and the cylinder. The vowel-character of a sound is, according to LLOYD, essentially determined by the relations of pitch between these two tones, or among several tones when there are more than two.

LLOYD[3] has also mapped out the forms of the mouth cavity involved in different vowels and has calculated the tones to which they would resonate. Thus for the vowels in the following words he has calculated the resonance tones as indicated : *piece* 2816, *pit* 2500, *rein* 2112, *there* 1508, *man* 1431, *half* 1082, *law* 834, *note* 623-444, *put* 528, *blue* 314.

Another method used in seeking the mouth-tone consists in analyzing the curve of vibration representing the vowel into a series of curves representing simple tones and determining which of these tones above the voice tone is apparently the loudest.

A simple tone is defined as one for which the deviation of the material particle from its position of rest is given by an expression of the form

$$y = a \sin \frac{2\pi t}{T}$$

where y is the deviation at the moment t, a the amplitude or maximum value of y, and T the time of one complete vibration of the particle through its positive and negative phases. A curve of this kind is called a " sinu-

[1] HERMANN, *Phonophotographische Untersuchungen*, Arch. f. d. ges. Physiol. (Pflüger), 1890 XLVII 374.

[2] LLOYD, *Speech sounds ; their nature and causation*, Phonetische Studien, 1890 III 275, 278; 1890 IV 39; 1891 V 125.

[3] LLOYD, Proc. Roy. Soc. Edin., March 1898.

soid" or a "harmonic" and such a vibration is said to be sinusoidal or
harmonic. The exact expression for such a vibration must give the phase
from which the values of t are measured; this is done in

$$y = a \sin \left(\frac{2\pi t}{T} - \epsilon \right)$$

where ϵ indicates the time between $t = 0$ and the next preceding moment
when $y = 0$.

A number r of sinusoids superimposed give a vibratory movement in
which

$$y = \sum_{n=1}^{n=r} A_n \sin \left(\frac{2\pi n t}{T} - \epsilon_n \right) .$$

It can be proven that any single-valued finite periodic function with
the period T can be expressed by a series of sinusoids whose periods are
T, $T/2$, $T/3$ \cdots . This is generally known as FOURIER's theorem.[1] The
analysis of such a function into a series of sinusoids is known as the
FOURIER analysis.

Likewise a number of sinusoids may be added to produce a vibration
resembling some given curve. Such a synthesis can be performed by
machines constructed for the purpose, for example, the machine of
PREECE and STROH[2] or that of MICHELSON.[3] The curves produced by
PREECE and STROH somewhat *resemble* the curves of vowels, but so dis-
tantly that they indicate the impropriety of considering a vowel curve as
a sum of a series of harmonics.

A vowel curve gives by the FOURIER analysis a series of sinusoids of
various amplitudes.[4] Those of greatest amplitude are assumed to be the
most prominent tones in the complex tone of the vowel. It is also as-
sumed that the one or more stronger tones after the fundamental are the
tones of the mouth.

As an objection to this method we are entitled to say, that the FOURIER
analysis is in this case a means of representing a vibratory movement by
a formula. We may add that it is nothing more than an interpolation
formula by which the value of y can be found for any desired instant of

[1] FOURIER, Theorie analytique de la chaleur, Ch. III, Paris 1822.

[2] PREECE AND STROH, *Studies in acoustics. I. On the synthetic examination of vowel
sounds*, Proc. Roy. Soc. London, 1879 XXVIII 358.

[3] MICHELSON, *A new harmonic analyzer*, Amer. Jour. Sci., 1898 (4) V 1.

[4] The scheme for the computation and various essential practical devices are given by
HERMANN, *Phonophotographische Untersuchungen*, Arch. f. d. ges. Physiol. (Pflüger),
1890 XLVII 47.

time. It is merely one case of a more general method[1] of interpolation by a periodic series; it is thus considered in works on the adjustment of measurements.[2]

Such an interpolation formula remains simply a mathematical tool unless it is found to express the actual nature of the phenomenon measured. It has been assumed by practically all writers, that all musical sounds are really combinations of a series of sinusoidal partial tones: for example, it can be readily demonstrated that a violin string vibrates not only as a whole, but also in halves, thirds, quarters, etc. It is also presumably true that each of these parts produces a sinusoidal vibration of the air. Thus, the peculiar tone of the violin is presumably really the sum of a series of approximately sinusoidal tones. The FOURIER analysis in such a case undoubtedly expresses the nature of the tone.

In the case of sung vowels the assumption that the vocal cords vibrate like reeds, and the further assumption that the mouth acts as a resonator reinforcing one or more of the partial tones of the cord would justify the use of the FOURIER analysis for finding the partial tones of the voice-tone and also the tones reinforced by the mouth, provided these assumptions were proved to be correct.

The vocal cords are certainly to be treated as membranous reeds. In the main their vibrations can be supposed to follow the usual laws.

The other assumption, that the mouth acts also as a resonator to reinforce some of the partial tones of the cord vibration, is certainly not justified (p. 73). The main effect of the mouth is to impose a vibration of its own upon the vibration coming from the cord. The reinforcement of partial tones may possibly be present, but it is certainly not prominent. The FOURIER analysis would be applicable only if the mouth tone were coincident with one of the partial tones of the voice tone; this is, at least generally, not the case in song, as has been indicated by WILLIS, DONDERS and HERMANN, and is certainly not the case in speech as is proven by my curves for *a*. With a mouth tone not coincident with a partial tone the FOURIER analysis may, in a vowel of constant pitch, indicate a reinforcement of the nearest partial vibration, or it may show reinforcement of the two nearest partials above or below. The analysis can thus be used to indicate the approximate pitch of the mouth tone in such a case, although it may not coincide with a partial of the voice tone.[3]

[1] GAUSS, *Theoria interpolationis methodo nova tractata*, Werke III 265, 1876.

[2] WEINSTEIN, Physikalische Maassbestimmungen, I 486, Berlin 1886.

[3] HERMANN, *Phonophotographische Untersuchungen*, Archiv f. d. ges. Physiol. (Pflüger), 1894 LVIII 276.

With vowels of changing pitch, as in my examples of *a*, any attempt to apply the FOURIER analysis would be an absurdity. In this vowel the pitch of the voice tone changes from vibration to vibration. The analysis would be thus utterly different for each vibration and would indicate a different mouth tone every time, whereas the reonance vibrations can be seen in the curves to remain constant.

It is an imaginable hypothesis that, since the period of the voice tone in a rising or a falling vowel is not the constant T but some value $f(t)$ which steadily changes, we might make an analysis into a series of sinu-soids whose periods change likewise. We would thus have

$$y = \sum_{n=1}^{n=\infty} A_n \sin\left(\frac{2\pi n t}{f(t)} - \epsilon_n \right).$$

The expression for $f(t)$ would differ for different vowels. Such an analysis might accurately represent the case when a musical sound com-posed of a fundamental with overtones is reproduced on a phonograph whose speed is constantly accelerated. It might also be applicable to the analysis of a glide produced on a musical instrument like a violin. The curve, however, would be of the same form in each period, which—as DONDERS first pointed out and I have abundantly shown—is not the case in the vowels.

Other methods of finding the pitch of the mouth tone may be used. The method that suggests itself at once is simply that of measuring the length of a wave of the mouth tone. This could best be done in my curves by measuring the length of a set of waves and dividing by the number; though the measurement could not be made to a finer unit than 0.1^{mm} this reduces the error for a set of 5 waves to $\frac{1}{5}$ of 0.1^{mm}, or 0.02^{mm}. This method is applicable only when the vowel curve shows regular vi-brations within a single period of the voice tone. When the curve shows irregular or complicated vibrations, some other method would be used.

HERMANN has used three other methods: (1) the centroid method, (2) the method of proportional measurement, and (3) the counting of the vibrations when they exactly fill one period of the voice tone.[1] The last method amounts to the same thing as mine for a particular case. The proportional method is also practically the same for other cases. The centroid method seems to give only approximate results.[2] The term "centroid" seems to me preferable to "center of gravity" used by HERMANN.

[1] HERMANN, *Phonophotographische Untersuchungen*, Arch. f. d. ges. Physiol. (Pflü-ger), 1890 XLVII 359.

[2] HERMANN, *Phonophotographische Untersuchungen*, Arch. f. d. ges. Physiol. (Pflü-ger), 1893 LIII 51 ; 1894 LVIII 276.

Of all the methods and investigations employed for determining the mouth tone those of HERMANN[1] are entitled to by far the weightiest consideration. He finds for *u* (*oo*) two tones, one in the first part of the first octave and one in the second octave, for *o* (*au*), and *a* a tone in the second octave which rises in pitch as *o* changes to *a*, for *ä* and *ě* a tone in the second octave and one in the third octave, for *ö*, *ü* and *i* a very high tone which is in the middle of the third octave for *ö*, at the end of that octave for *ü* and in the fourth octave for *i*. The octaves are numbered in the German fashion, middle *c* being in the first octave. The resonance tones for my examples of *a* and *i* are given on pages 55 and 56, and those of some other vowels in Section III.

These data give only the approximate regions in which we may expect to find the mouth tone. It is unquestionably true that within these regions the mouth tone will vary for different dialects and different conditions of speech.

The mouth tone need not bé a fixed one though it is generally so. A rise and fall of the mouth tone might readily be used as a factor of expression in speech. Several examples of such changes have been given in Section II.

It seems fairly well established that in addition to the cord tone there may be several resonance tones from the mouth cavity. LLOYD distinguishes at least two: that of the front part of the mouth (the porch resonance) and that of the whole mouth (the fundamental resonance).[2] There may be also a resonance tone from the pharynx.[3] The various vowels arise from different "radical ratios" between the porch tone and the fundamental mouth tone,[4] while it is possible to change the pitch of both to some extent. Various other tones may arise from the configuration of the mouth and the coexistence of the tones already mentioned.[5]

Although LLOYD's supposition of the possible presence of a number of resonances in the mouth cavity[6] may be partly justified, yet one of these resonances must far exceed all others in prominence in order to produce the constancy in form and period of the resonance vibrations seen in the

[1] HERMANN, *Phonophotographische Untersuchungen*, Arch. f. d. ges. Physiol. (Pflüger), 1894 LVIII 270.

[2] LLOYD, *Speech sounds; their nature and causation*, Phonet. Stud, 1890 III 261.

[3] LLOYD, *Speech sounds; their nature and causation*, Phonet. Studien, 1891 IV 294; also a note in Proc. Brit. Assoc., 1891 p. 796.

[4] LLOYD, *Speech sounds; their nature and causation*, Phonet. Stud., 1891 IV 52.

[5] Same, 207.

[6] LLOYD, *Speech sounds; their nature and causation*, Phonet. Stud., 1890 III 261; 1891 IV 52, 206.

curves examined in Section II. It is doubtful if there are more than two resonances of the mouth that are of any noticeable strength ; as ex- plained above (p. 83) the air in a resonance cavity acts as a spring whose period depends on the size while the form of the cavity is imma- terial for the chief resonance tone. We must add that, although the additional resonance tones and the overtones of the cord tone may not appear in any record, they undoubtedly give characteristic colors to the final result.

The importance of the pharyngeal resonance has been strongly empha- sized by MARICHELLE.[1]

This author maintains the following theses: *A.* The capacity of the buccal resonator does not exercise a characteristic influence on the pitch of the vowels. The statement that the mouth cavity in front of the elevation of the tongue has no influence is based on an experiment in filling the cav- ity of the palate with wax and finding that the vowels *O* and *OU* can still be pronounced. Compensation for the size of the resonating cavity by change in the lip opening is avoided by forming the opening in a card placed before the mouth. These experiments seem to me too inaccurate and so contrary to our knowledge of the action of resonating cavities that we cannot accept them. Moreover, a vowel like *O* is—to my ear at least —distinctly modified in expression by any change of the mouth cavity although it still remains an *O* until the change is a great one. This can be conveniently tested by inserting two fingers in the mouth ; the *O* changes in expression and can be readily made into an *OU* by the proper manipulation. *B.* The dimension of the lip opening constitutes only a general vague and unstable indication of the vowel. *C.* The separation of the jaws does not sufficiently characterize the vocal sounds. *D.* The displacement of the tongue forward or backward furnishes no precise and essential information on the character [timbre] of the vowels. It is possible to produce all the vowels with practically any position of the tongue. "Here again the physiological description, as comprehended generally, gives only accessory facts and no characteristic ones." These three statements are true in a vague way but they do not prove that the vowel character is independent of these factors ; the vowels undoubtedly depend essentially and directly on them. MARICHELLE'S point, however, seems to be that the essential factor is the size of the resonance cavity and not its exact form ; and in this he is presumably correct.

According to MARICHELLE three distinct regions of the mouth are used in forming vowels: 1. the anterior tongue-palate cavity ; 2. the pos-

[1] MARICHELLE, La parole d' après le tracé du phonographe, 27, Paris 1897.

terior tongue-plate cavity ; 3. the lip opening. The characteristic tones are modified by *a.* the nature of the walls, whether soft or hard ; *b.* the capacity of the posterior resonator ; *c.* the degree of opening of the tongue-palate orifice ; *d.* the lip opening.

MARICHELLE seems to be quite correct in insisting on the importance of the posterior cavity ; it is the one into which the vibrations of the cords pass immediately and it undoubtedly acts as a strong resonator. It would be somewhat rash, however, to say that the most prominent resonance vibration comes from this cavity. It may be suggested that the vowel is a complex of resonance tones of which the pharyngeal tone would be one, the anterior mouth tone another, and so on.

The assumption of PIPPING [1] that the chief resonance tone of the vowels may be derived from the resonance of the chest seems to have little justification. The tone of the chest is a low one—my own has a frequency of about 100 complete vibrations a second—as can readily be determined by singing the scale ; the chest resonance occurs only on very low notes. Its low pitch can also be heard by tapping the chest as in auscultation. The chest possibly resonates when very low tones are sung or spoken, but the pitch of ordinary speech is generally quite above it.

I believe we shall not go very far wrong if we assume that the entire mouth cavity may give rise to one resonance tone, the rear portion (pharyngeal) to another and the anterior portion to a third. Such an assumption has been made the basis of my attempt on p. 56 to explain the formation of *ai.*

VI. THE CORD TONE IN VOWELS.

Simple tones have three fundamental properties: pitch, intensity and duration. The so-called "timber" is not a property of simple tones, but the resulting effect of combinations of tones. In the present section it is proposed to discuss the cord tone in various vowels in regard to pitch and intensity. For this purpose only the fundamental tone of the vowel will be considered and no regard will be paid to the particular form of the curve resulting from the overtones of the cord tone and the superposition of the resonance tones. We will also assume that the vibration of the cords involves the usual supposition that the force of attraction to the position of equilibrium varies as the distance from that position. In such a case we can represent the fundamental tone by the equation

$$y = F(t) \sin \frac{2\pi t}{f(t)}$$

[1] PIPPING, *Zur Phonetik d. finnischen Sprache*, Mém. de la Société finno-ougrienne, XIV, Helsingfors 1899.

In a circumflex vowel we may assume the amplitude to be of sinusoid form whereby

$$F(t) = E \sin \frac{2\pi t}{s}$$

and

$$y = E \sin \frac{2\pi t}{s} \sin \frac{2\pi t}{f(t)}$$

where E would be the maximum amplitude and s the length of the vowel. When the pitch is constant the curve will have the form

$$y = E \sin \frac{2\pi t}{s} \sin \frac{2\pi t}{T} \cdot$$

I have found one vowel, *a* in *said* in the line *I, said the sparrow*, that can be with close approximation considered as a circumflex vowel of constant pitch. Its equation is (in seconds and millimeters)

$$y = 0.5 \sin \frac{2\pi t}{0.108} \sin \frac{2\pi t}{0.0053} \cdot$$

It does not fill a complete period of circumflexion as it is suddenly cut short by the *s* of *sparrow*.

Among the hundred or so English vowels that I have inspected, I have been unable to find one that can with any close approximation be considered as steady in intensity and constant in pitch. Thus a vowel of the form $y = a \sin \frac{2\pi t}{T}$ must be a rare one. Some vowels during part of their course are of this form, but a change of some kind seems characteristic at some moment. Even such approximations have been found only in the interior of words, that is, with boundaries of consonants or of vowels with the vocal organs already in action. It seems to be the rule in English that a vowel following a pause shall be a rising or crescendo one, and one preceding a pause shall be a falling or diminuendo one.

Sequence of cord tones.

There seems to be for a particular voice on a particular occasion certain tones around which the cord tones group themselves. BOEKE found that in ordinary speech his cord tone ranged from 181 to 256 complete vibrations.[1]

In the first stanza of *Cock Robin* the general tone seems to be one with a period of 5.3^σ (about 190 vibrations).

[1] BOEKE, *Mikroskopische Phonogrammstudien*, Arch. f. d. ges. Physiol. (Pflüger), 1891 L 297.

In addition to this a tone with a period of 7.0ᵛ (about 143 vibrations, making a musical interval of a fourth below the general tone) has a tendency to appear for the sonants of lower pitch and another tone with a period of 1.8ᵛ (about 560 vibrations, making a musical interval of a duodecime above the general tone) for the sonants of higher pitch.

The periods of the various sonants, as far as I have been able to determine them in this stanza, are given in thousandths of a second by the figures below them in the following quotation :

Wh o k i lled C o ck R o b i n
3.3 1.8 4.2 1.8 5.3 5.6 8.4

I, s ai d th e sp a rr ow,
18 to 4 5.3 5.3 5.3 2.8 5.2

W i th m y b ow a nd a rr ow
5.3 2.1 5.3 5.6–3.6 7.0 5.3 4.2 2.5 7.0

I k i lled C o ck R o b i n.
12 to 4 5.6 7.0 to 5.3 3.9 3.9 4.2 5.6 8.8

It may be suggested that the melodiousness of speech must depend to a great degree on the musical sequence of the cord and resonance tones.

VII. Verse-analysis of the 1st stanza of Cock Robin.

As stated on p. 1 these researches were begun in order to settle the controversy in regard to the quantitative character of English verse. A nursery rhyme was selected as being verse in the judgment of all classes of people for many ages. When compared with some of what many of us now consider to be the best verse, it shows various defects, but these defects are typical of the usual deviations from our present standards and are, moreover, not defects according to other standards. It is also a fact that our notions of verse are largely derived from the rhymes heard in childhood.

An analysis of the sounds of the first stanza is given in the four tables on the adjacent pages.

The first column gives the sounds in the phonetic transcription used by Vietor.[1] The second column gives the duration of each sound as determined by measurements of the curves in the records as described on p. 13. The third column gives the period of the cord tone, and the fourth gives the amplitude of the vibration in the tracing (p. 20), not the amplitude of the vibration on the gramophone plate or of the move-

[1]Vietor, Elemente der Phonetik, 3. Aufl., Leipzig 1894.

E. W. Scripture,

Line 1: *Who killed Cock Robin?*

Sound.	Duration in thousandths of a second.	Pitch (period in thousandths of a second).	Intensity (maximum amplitude in mm.).	Syllable effect.	REMARKS.
h	>10				Very short sound, not distinguishable in the record, not over 10ᵃ in length. Compare with *h* on p. 60.
ū	189	3.3	0.4	strong	Forcible vowel, large amplitude in earlier portion, rises somewhat in pitch, average period 3.3. Compare with *ū* on p. 63.
k	119				Appears in the record as a straight line.
i	154	1.8	0.6	strong	Long vowel, large amplitude throughout, double circumflex in amplitude (p. 93). The high pitch of this *i* is in contrast with that of *killed* in the 4th line (below)
l	74	1.8	0.1		Compare p. 65.
d	0				No sound of *d* can be heard in this record; the record plate speaks "Who kill Cock Robin?"
	53				Appears in the record as a straight line.
å	126	4.2	0.5	weak	Rises somewhat in pitch to 4.2 in the main portion, weak on account of lowness in pitch.
	70				The vibrations of the *å* are suddenly cut short by a few vibrations of a different form that rapidly decrease in amplitude. In listening to the record plate the ear hears no glide between *å* and *h*: the word seems to be simply and distinctly *kåk* and not *kåᵊk*. This glide seems to be, to the ear, an essential part of the *k*. The cords are still vibrating while the mouth is changing from the *å* position to the *k* position.
	31				Straight line measured from *∗* to *r*; there is no pause between *k* and *r*.
r	74	1.8	0.3		Very distinctly and heavily rolled *r*; pseudo-beats are apparent. Compare p. 69.
å	140	5.3	0.5	strong	Of very low but constant pitch; steady rise in intensity till the vowel is cut short by *b*; forcible on account of length and amplitude.
b	49				Straight line from *å* to *i*. Compare p. 67.
i	56	5.6	0.3	weak	Short but distinctly heard; weak on account of shortness, lowness and faintness.
n	74	8.4	0.2		Falls in pitch and amplitude.
ʔ	770				

Line 2 : *I, said the sparrow.*

Sound.	Duration in thousandths of a second.	Pitch (period in thousandths of a second).	Intensity (maximum amplitude in mm.).	Syllable effect.	REMARKS.
ai	452	18 to 4	0.7	strong	Full analysis on p. 16 ; strong by length, pitch of *i* and amplitude.
ꞇ	210				
s	?				Very brief sound, no trace in record.
e	105	5.3	0.5	weak	Rather long and loud, but low in pitch.
d	81	5.3	0.1		Pitch falls from 5.3.
dh	32	?	>0.1		Very weak vibrations.
a	84	5.3	0.2	weak	
sp	273				Impossible to distinguish between the two sounds in the tracing ; the *s* is heard as a brief sound.
*	18	1.9	0.4		Distinct sound different from the following *æ*.
x	170	5.3	0.5	strong	Constant very low pitch but steadily increasing amplitude ; falls suddenly in intensity during 5*σ* to *r* ; no sound of *a* as stated in VIETOR, p. 115 ; strong on account of length and amplitude.
r	11	2.8	0.2		Clearly marked vibrations ; the rolling of the *r* can be distinctly heard. Compare p. 69.
o	294	5.2	0.6	strong	Very long vowel of constant pitch, but of rising and then falling intensity (p. 93) ; strong by length and amplitude ; followed without pause by *ñ* of next line.

ment of the cords. The fifth column gives what I consider to be the character of each syllable, whether strong or weak; the judgment is based on the sound of the gramophone record, aided by a study of the tables.

The elements in speech whose rhythmical arrangement is the essential of verse as contrasted with prose are : 1, quality ; 2, duration or length ; 3, pitch ; and 4, intensity. The element of quality consists in the nature of the sound as a complex of tones and noises producing a definite effect as a speech-sound. Length, pitch and intensity are properties of the speech-sound that can be varied without destroying its specific nature, that is, without changing the quality. These four elements can be varied independently.

It seems to be sufficiently well settled that, in addition to variations of quality, that is, of the speech-sounds, the essential change in Greek verse was one of pitch. I have observed a similar characteristic in Japanese

Line 3 : *With my bow and arrow.*

Sound.	Duration in thousandths of a second.	Pitch (period in thousandths of a second).	Intensity (maximum amplitude in mm.).	Syllable effect.	REMARKS.
ü	108	5.3	0.2		Amplitude rises from 0.
i	60	2.1	0.4	strong	Circumflex sustained vowel ; compare p. 94;
dh	56	?	0.1		strong by pitch and amplitude.
m	74	5.3	0.1		
a	179	5.6	0.4 ⎞		Both parts of this diphthong are nearly constant
			⎬ strong		in pitch and amplitude ; compare p. 92 ; strong
i	112	3.6	0.5 ⎠		by length and amplitude.
ᵕ ⎫					*My* is followed by a brief rest in order to bring
b ⎬	140				out the *b* distinctly. The *b* makes no curves in
					the record.
ð	490	7.0	0.4	strong	Extremely long vowel of very low pitch with
					two maxima of intensity ; it might be considered
					as a close succession of two *o*'s ; compare p. 93;
ᵕ	11				strong by length and amplitude.
æ ⎱	⎧	7.7–5.3	0.2	weak	The *æ* begins at a very low pitch 7.7 and rises
n ⎰	382 ⎨	5.3	0.1		steadily to 5.3, which is maintained throughout
	⎩				the *n*. The form of the curve for *æ* differs from
					that for *n*, yet the change is so gradual that it is
					impossible to assign any dividing line.
d	18				Straight line in the record.
*	102	5.3	0.4		This extra vowel arises from the attempt at extra distinctness in speaking.
æ	189	4.2	0 3	strong	Strong by length and pitch.
r	39	2.5 (?)	0.1		Rolled *r*, brief.
o	331	7.0	0.6	strong	A single vowel of circumflex intensity ; compare p. 93 ; strong by length and amplitude.
ᵕ	420				

verse. Probably no better way of getting an idea of the nature of Greek verse could be found than that of listening to typical Japanese verse. I have also found another form of pitch-verse in a kind of poetical dictionary used by the Turks for learning Persian.

Latin verse was essentially a time-verse, the chief distinction among the syllables being that of length in addition to the change in speech-sounds.

English verse is usually considered to be an intensity-verse, or a verse of loud and soft syllables. The four tables show quite evidently that English verse is also a pitch-verse and a time-verse.

It may be said that in all probability changes of length and intensity

Line 4 : *I killed Cock Robin.*

Sound.	Duration in thousandths of a second.	Pitch (period in thousandths of a second).	Intensity (maximum amplitude in mm.).	Syllable effect.	REMARKS.
ai	334	12–4	0.6	strong	Full analysis on p. 22; strong by length, pitch of *i* and amplitude.
k	125				Straight line in the record.
i } l }	324	5.6	0.2	weak	It is impossible to assign any definite point as the limit between these two sounds; weak, low *i* in contrast to the *i* in the first line above.
d	33				This *d* is distinctly heard; compare *d* in first line above.
⁕	81	4.9	0 2		Additional vowel due to the extra distinctness in speaking the *d*; it arises from the explosive opening of the mouth; the pronunciation of the word *killed* is different from that in the first line chiefly in the great difference in pitch and in the greater distinctness of the *d*.
k	133				Straight line in the record
d	147	7 0–5.3	0.3	weak	Pitch rises from beginning to end.
⁕	76				See the same word in the first line above.
k	46				Straight line in the record.
r	60	3.9	0.6		The *r* is more vowel-like than the corresponding *r* in the first line; the strong roll is not heard; the curve of *ro* very much resembles in period and amplitude the curve of an *ai* in *thy* (Fig. 61) turned backward; the period of the cord tone is practically constant; the resonance tone of the mouth undergoes a continuous change; any assignment of a limit between the two sounds must be somewhat arbitrary; the sound *ro* is strong by
				strong	
d	103	3 9	0.5		length, pitch and amplitude.
b	53	4.2	0.1		The *b* cuts off suddenly the sound of *o*.
i	82	5.6	0.4	weak	The *i* is heard, but not so distinctly as in the first line above.
n	74	8.8	0.1		Weak, low, diminuendo.
⁊	955				

went along with the changes of pitch in Greek verse but that they were of minor importance. Perhaps, also, changes of pitch and intensity likewise accompanied the long and short syllables in Latin verse. But I do not think that for English verse we can fully accept the analogous statement that, although the changes in pitch and length may be present,

they are quite subordinate to the changes in intensity. It would, I believe, be more nearly correct to say that English verse is composed of strong and weak, or emphatic and unemphatic syllables and that strength can be produced by length, pitch or intensity.

The usual scansion of this stanza in strong and weak syllables would give

The three elements: length, pitch and intensity, are all used to produce strength. Thus the forcible vowel \bar{u} in Line 1 is long and moderately high and loud.

The strength of a syllable may be kept the same by increasing one of the factors as another one decreases. The vowel *o* of *Robin* in Line 1 is strong on account of its length and intensity, although its pitch is low. A syllable necessarily short may be made as strong as a longer one by making it louder or higher; or a syllable necessarily of small intensity may be strengthened by lengthening it or raising its pitch. Thus, the short *i* of *With* in Line 3 is strong on account of its high pitch and large amplitude; and the weak *æ* of *arrow* in Line 3 is strong on account of its high pitch and its length. This might be called the *principle of substitution.*

An increase in the loudness, length or pitch of a syllable renders it stronger—other things being equal. Using the symbol f to indicate dependence we may put $m = f(x, y, z)$, where m is the measure of strength and x, y and z are the measures of intensity, length and pitch respectively. This might be called the fundamental *principle of strength.*

The study of this and other specimens of verse has made it quite clear that the usual concept of the nature of a poetical foot is erroneous in at least one respect. *Lines* in verse are generally distinct units, separated by pauses and having definite limits. A single line, however, is not made up of smaller units that can be marked off from each other. It would be quite erroneous to divide the first stanza of Cock Robin into feet as follow.

> Who killed|Cock Rob|in?
> I, said the|sparrow.
> With my bow|and ar|row
> I killed|Cock Rob|in.

No such divisions occur in the actually spoken sounds and no dividing points can be assigned in the tracing.

The correct concept of the English poetical line seems to be that of a certain quantity of speech-sound distributed so as to produce an effect equivalent to that of a certain number of points of emphasis at definite intervals. The proper scansion of the above stanza would be :

> Who killed Cock Robin ?
>
> I, said the sparrow,
>
> With my bow and arrow
>
> I killed Cock Robin. ·

The location of a point of emphasis is determined by the strength of the neighboring sounds. It is like the centroid of a system of forces or the center of gravity of a body in being the point at which we can consider all the forces to be concentrated and yet have the same effect. The point of emphasis may lie even in some weak sound or in a mute consonant if the distribution of the neighboring sounds produces an effect equivalent to a strong sound occurring at that point. Thus the first point of emphasis in the third line lies somewhere in the group of sounds *mybow*, probably between *y* and *o*.

With this view of the nature of English verse all the stanzas of Cock Robin can be readily and naturally scanned as composed of two-beat or two-point lines.

It is not denied that much English verse shows the influence of quantitative classical models, but such an influence is evidently not present in Cock Robin.

Thanks are due to Prof. HANNS OERTEL who has very kindly read most of the proof of this article ; he has enriched it by various suggestions particularly in regard to the *h* discussed on p. 60.

OBSERVATIONS ON RHYTHMIC ACTION[1]

BY

E. W. Scripture.

Two entirely different forms of regularly repeated action are to be distinguished. In one form the subject is left free to repeat the movement at any interval he may choose. This includes such activities as walking, running, rowing, beating time, and so on. A typical experiment is performed by taking the lever of a Marey tambour between thumb and index finger and moving the arm repeatedly up and down; the recording tambour writes on the drum the curve of movement. Another experiment consists in having the subject tap on a telegraph key or on a noiseless key and recording the time on the drum by sparks or markers. Other experiments may be made with an orchestra leader's baton having a contact at the extreme end, with a heel contact on a shoe, with dumb-bells in an electric circuit, and so on. For this form of action I have been able to devise no better name than "free rhythmic action."

In contrast with this there is what may be called "regulated rhythmic action." This is found in such activities as marching in time to drum-beats, dancing to music, playing in time to a metronome, and so on. A typical experiment is that of tapping on a key in time to a sounder-click, the movement of the finger being registered on a drum.

Regulated rhythmic action differs from free rhythmic action mainly in a judgment on the part of the subject concerning the coincidence of his movements with the sound heard (or light seen, etc.). This statement, if true, at once brushes aside all physiological theories of regulated rhythmic action. One of these theories is based on the assumption (Ewald) that the labyrinth of the ear contains the tonus-organ for the muscles of the body. It asserts that vibrations arriving in the internal ear affect the whole contents, including the organ for the perception of sound and the tonus-organ. Thus, sudden sounds like drum-beats or emphasized notes would stimulate the tonus-organ in unison, whereby corresponding impulses would be sent to the muscles. This theory has very much in its favor. It is undoubtedly true that such impulses are sent to the muscles. Thus at every loud stroke of a pencil on the desk I can feel a resulting

[1] Reprinted from Science, 1899 X 807.

contraction in the ear which I am inclined to attribute to the *M. tensor tympani.* Likewise a series of drum-beats or the emphasized tones in martial or dance music seem to produce twitching in the legs. Féré has observed that, in the case of a hysterical person exerting the maximum pressure on a dynamometer, the strokes of a gong are regularly followed by suddenly increased exertions. Nevertheless, these twitchings are not the origin of the movements in regulated rhythmic action. For many years I have observed that most persons regularly beat time just before the signal occurs; that is, the act is executed before the sound is produced. Records of such persons have been published,[1] but their application to the invalidation of the tonus-theory was first suggested by Mr. Ishiro Miyake. This does not exclude the use of muscle sensations, derived from tonus-twitches, in correcting movements in regulated rhythmic action, although they presumably play a small or negligible part as compared with sounds.

Another argument in favor of the subjective nature of regulated rhythmic action is found in the beginning of each experiment on a rhythm of of a new period; the subject is quite at loss for a few beats and can tap only spasmodically until he obtains a subjective judgment of the period. If the tonus-theory were correct, he should tap just as regularly at the start as afterward.

The conclusion seems justified that regulated rhythmic action is a modified free rhythmic action, whereby the subject repeats an act at what he considers regular intervals, and constantly changes these intervals to coincide with objective sounds which he accepts as objectively regular.

In free rhythmic action there is one interval which on a given occasion is easiest of execution by the subject. This interval is continually changing with practice, fatigue, time of day, general health, external conditions of resistance, and so on.

"It has long been known that in such rhythmic movements as walking, running etc., a certain frequency in the repetition of the movement is most favorable to the accomplishment of the most work. Thus, to go the greatest distance in steady traveling day by day the horse or the bicyclist must move his limbs with a certain frequency; not too fast, otherwise fatigue cuts short the journey, and not too slow, otherwise the journey is made unnecessarily short. This frequency is a particular one for each individual and for each condition in which he is found. Any deviation from this particular frequency diminishes the final result."

It is also a well-known fact that one rate of work in nearly every line is peculiar to each person for each occasion, and that each person has

[1] Scripture, New Psychology, 182, London 1897.

his peculiar range within which he varies. Too short or too long a period between movements is more tiring than the natural one in walking, running, rowing, bicycling, and so on.

It is highly desirable to get some definite measurement of the difficulty of a free rhythmical action. This cannot well be done by any of the methods applicable to the force or quickness of the act, but it may be accomplished in the following manner.

As a measure of the irregularity in a voluntary act we may use the probable error. When a series of measurable acts are performed they will differ from one another, if the unit of measurement is fine enough. Thus, let x_1, x_2, \cdots, x_n be successive intervals of time marked off by a subject beating time, or walking, or running, at the rate he instinctively takes. The average of the measurements,

$$a = \frac{x_1 + x_2 + \cdots + x_n}{n},$$

can be considered to give the period of natural rhythm under the circumstances. The amount of irregularity in the measurements is to be computed according to the well-known formula:

$$p = \sqrt{\frac{v_1^2 + v_1^2 + \cdots + v_n}{n - 1}}$$

where $v_1 = x_1 - a$, $v_2 = x_2 - a$, \cdots, $v_n = x_n - a$. The quantity p is known as the "probable error," or the "probable deviation." The quantity

$$r = \frac{p}{a},$$

the "relative probable error," expresses the probable error as a fraction of the average.

If all errors in the apparatus and the external surroundings have been made negligible, this "probable error" is a personal quantity, a characteristic of the irregularity of the subject in action. If, as may be readily done, the fluctuations in the action of the limbs of the subject be reduced to a negligible amount, this probable error becomes a central, or subjective, or psychological, quantity. Strange as it may appear, psychologists have never understood the nature and the possibilities of the probable error (or of the related quantities "average deviation," "mean error," etc.). In psychological measurements it is—when external sources of fluctuation are rendered negligible—an expression for the irregularity of the subject's mental processes. Nervous or excitable

people invariably have large relative probable errors ; phlegmatic people have small ones.

Thus a person with a probable error of 25% in simple reaction time will invariably have a large error in tapping on a telegraph key, in squeezing a dynamometer, and so on. I have repeatedly verified this in groups of students passing through a series of exercises in psychological measurements. I do not believe it going too far to use the probable error as a *measure* of a person's irregularity. This is equivalent to asserting that a person with a probable error twice as large as another's is twice as irregular, or that if a person's probable error in beating time at one interval is r_1 and at another interval r_2, his irregularity is r_1 times as great in the second case as in the first. This concept is analogous to that of precision in measurements. We might use the reciprocal of the probable error as a measure of regularity. The positive concept, however, is in most minds the deviation, variation or irregularity, and not the lack of deviation, the non-variability, or the regularity. In the case of the word " irregularity " the negative word is applied to a concept that is naturally positive in the average mind.

The irregularity in an act is a good expression of its difficulty. Thus, if a person beating time at the interval T has an irregularity measured by the probable error P and at the interval t a probable error p it seems justifiable to say that the interval t is $\frac{p}{P}$ times as difficult as T. If T is the natural interval selected by the subject, then the artificial interval t would be more difficult than T, and we should measure the difficulty by comparing probable errors.

It is now possible to state with some definiteness the law of difficulty for free rhythmic action. Let T be the natural period and let its probable error—that is, its difficulty—be P. It has already been observed (Science, 1896, N. S. IV 535), that any other larger or smaller period (slower or faster beating) will be more difficult than the natural one and will have a larger probable error. Thus any interval t will have a probable error p which is greater than P, regardless of whether t is larger or smaller than T.

Three years ago (Science, as above) I promised a complete expression for this law. Continued observations during this time enable me to give an idea of its general form. The results observed can be fairly well expressed by the law

$$p = P\left(1 + c\,\frac{[t - T]^2}{t}\right)$$

in which T is the natural period, P the probable error for T, t any arb
trary period, p the probable error for t and c a personal constant.

This may be called the law of difficulty in free rhythmic action.
curve expressing the equation for $T = 1.0'$, $P = 0.02'$ and $c = 1$ is give
in the figure.

FIG. 75.

It will be noticed that periods differing but little from the natural on
are not much more difficult and that the difficulty increases more rapidly
for smaller than for larger periods.

In plotting this curve I have assumed unity as the value for all personal
constants. The personal constants will undoubtedly vary for different
persons, for different occasions and for different forms of action ; an inves-
tigation is now in progress with the object of determining some of them.

In case it is desired to know what periods are of a difficulty 2, 3, ···,
n times that of T, a table of values for p may be drawn up in the usual
way and that value for t sought (with interpolation) which gives for
p a value 2, 3, ···, n times as great. Thus, in a table for the above ex-
ample it is found that the periods 0.38' and 2.6' are twice as difficult.

This law can be stated in another form which is of special interest to
the psychologist. To the person beating-time a period of 0 is just as far
removed from his natural period as one of ∞ ; both are infinitely impos-
sible. The objective scale does not express this fact ; objectively a period
of 0 is as different from a period of 1' as a period of 2' would be. Simi-
lar considerations hold good for the lesser periods ; the scale by which
the mind estimates periods is different from their objective scale. This
difference may be expressed by asserting that the following relations exist
between the two :

$$x = c \, \frac{(t - T)^2}{t}$$

where x is the measure on the mental scale, T the natural period, t any other period, and c a personal constant. By this formula the various periods may be laid off according to their mental differences from the natural period. Every difference from the natural period is mentally a positive matter. With the mental scale the law of difficulty becomes

$$p = P \, (1 + cx)$$

where p and P are the probable errors for t and T respectively, x is the measure on the mental scale and c is a personal constant. This is the equation of a straight line. The law states that the difficulty of any arbitrary period is directly proportional to its mental difference from the natural period. This is the statement which I tried to make in the note published in Science, 1896, N. S. IV 535.

This law of difficulty as depending on the period is, of course, only one of the laws of free rhythmic action. It is quite desirable that other laws of difficulty and of frequency should be determined. For example, observations on ergograph experiments tend to show that the irregularity and the natural period both change with the weight moved ; they also change with the extent of the movement.

Such a series of well established laws might be useful in regulating various activities to the best advantage. It is already recognized that it is most profitable to allow soldiers on the march to step in their natural periods ; it is also known that on the contrary sudden and tense exertion is favored by changing the free rhythmic action into regulated action by marching in step and to music. More definite knowledge might perhaps be gained concerning the most profitable adjustments of the rhythm and extent of movement in bicycle-riding to the person's natural period ; at present only average relations are followed in the adjustment of crank-length, gear and weight to bicycle-riders, individual and sex differences not being fully compensated. Other examples will suggest themselves.

Not only does every simple activity have its own natural rhythms ; combinations of activities have rhythms that are derived from the simpler ones. In fact, it may be said that the individual, as a totality, is subjected to a series of large rhythms for his general activity (e. g., yearly, monthly, weekly, daily, and so on), and also to a series of smaller rhythms for his special activities. The natural periods do not always correspond with the enforced periods. The daily rhythm is unquestionably too slow for some persons and too rapid for others ; the unavoid-

able enforcement of the 24-hour period works a loss to all who woul
naturally vary from it, and diminishes the total amount of work tha
could be produced by them. For large numbers of brain-workers th
24-hour period is too long ; for many of them the natural period is prob
ably about 18 hours. Although about one-quarter of the day is no
efficiently used, there is little relief in splitting up the day into parts, be
cause (1) the 12-hour period would be naturally even less advantageou
than the 24-hour one, and (2) the new rhythm cannot be made to fit the
environment.

The progress of civilization and the changes in life are undoubtedly
tending to shorten the natural period from 24 hours by encouraging a
greater discharge of energy at shorter intervals. Since the 24-hour
rhythm is a fixed one, there must be a constant effort at adjustment in this
respect by those individuals most susceptible to the new influences.
the survival of the fittest will, of course, tend to keep the natural rhythm
not far from the 24-hour period.

NATIONAL EDUCATION ASSOCIATION OF THE UNITED STATES

SPECIAL REPORT OF THE COMMITTEE OF THE DEPARTMENT OF SUPERINTENDENCE ON A UNIVERSAL SYSTEM OF KEY NOTATION

At the regular meeting of the Board of Directors, July 7, 1910, Director A. R. Taylor submitted the following:

The Committee on a Universal System of Key Notation for indicating pronunciation, appointed by the Department of Superintendence seven years ago, and which has kept at its problem persistently, has now reached what it hopes will prove an acceptable solution, and it desires for special reasons to file immediately a brief unanimous report, containing the key alphabet upon which it has agreed, with the President of the Department of Superintendence and with the General Secretary of the Association.

To facilitate the proper consideration of this report at the next meeting of the Department of Superintendence, President Davidson of the Department of Superintendence joins with the committee in requesting that leave be granted thus to place its report on file and to have it printed and sent to the active members of the Association at an early date so as to give them an opportunity to study it and be able to discuss it effectively when this important matter comes up for consideration in regular order.

Therefore, I move that leave be granted to the committee to file its report as desired and that the Secretary be instructed to print it and send it out as soon as convenient.

This motion, being duly seconded, was carried by unanimous vote, with the proviso that the expenditure involved be approved by the Committee on Investigations and Appropriations of the National Council.

This expenditure having been approved by said committee, the report has been printed and is now distributed to active members of the Association, as ordered.

IRWIN SHEPARD, *Secretary*

August 15, 1910

REPORT OF THE COMMITTEE

To the Department of Superintendence, National Education Association:

Your committee, appointed in 1903 to invite and join with like committees from the Modern Language Association and the American Philological Association to prepare and recommend a key alphabet for uniform use in indicating pronunciation in all our cyclopedias, dictionaries, gazetteers, text and reference books, begs leave to submit this special report at this time with the privilege of adding a supplementary report at the next meeting of the department:

We regret to be obliged to report that as yet the efforts made in accordance with your instruction in response to our report of February 25, 1909, to secure if possible the agreement of the other two societies to a compromise on the few remaining points of difference then existing between us, have not been successful. But all three committees are in such entire accord on so large a portion of the key, and your committee are so fully convinced as to the forms in the disputed cases which will most satisfactorily meet the practical, immediate demand for such a key, that it seems clearly best to lose no more time in seeking for complete harmony, so much to be desired, but that we should at once recommend for your adoption the key which in our judgment is the best solution, all things considered, of this perplexing problem possible at this time.

The key which we here submit for your approval is substantially the one contained in the Report of the Joint Subcommittee, which was distributed to the members of the Department at the Milwaukee meeting in 1905. This key was quite satisfactory to your committee, as we reported at that time. It had the cordial indorsement, indeed, it was the product, of the representatives on the joint committee of the other two societies, men of the highest standing and influence as experts in their field. But when it came up for approval in their societies changes were made which we could not indorse or advise you to indorse. On these disputed points the key we now recommend is exactly the same as in the Report of the Joint Subcommittee handed to you in 1905. However, during the subsequent years of effort to compromise on these points of disagreement, above referred to, your committee has become satisfied that the practical adoption and use of this key would be greatly facilitated by making four changes, adopting digraphs composed of present letters instead of the more ideal and logical single signs which the Joint Subcommittee, tho not without some hesitation and debate, decided to recommend. The practical advantage to be gained by these concessions so clearly outweighs the loss in theoretical consistency, in our judgment, that we do not hesitate to approve them, particularly as all the experts who prepared the alphabet in the first instance concur with us.

The key here submitted adopts the alphabet, so far as that alphabet went, recommended by the American Philological Association in 1877, under the lead of those eminent philologists Professors Whitney, March, and Haldeman, which has already gained some headway as a pronouncing key, and which we deem it important to adhere to. Nothing could be more fatal to the success of a uniform key alphabet than to have the expert recommendations of one generation overturn or discredit those of a previous generation. In this matter steadiness and stability are of prime importance.

The other items completing this key alphabet, including the four concessions above referred to, have been adopted with the full and careful consideration and approval of several of the most eminent scholars and workers in the field of linguistic science, and they indorse this eclectic key as being the most happy combination of the scholarly and the practical which it is possible for patience and compromise to evolve from the mass of mere personal opinion or prejudice that embarrasses this subject.

The limits of this special report permit of no explanation in detail further than to say that this key provides a separate sign for each of our forty-four generally accepted sounds, not one of the signs being a distinctively new letter or having a foreign look. Excepting the last two supplementary letters, the added letters are so formed as to obviate difficulties on the part of the type-maker and the practical printer, as well as to be easy to write and to connect with preceding and following letters.

The experts agree that the discrimination of sounds in this alphabet is sufficiently delicate and precise for all practical purposes. It should be noted that the last three letters are required only, and will be used only, by the lexicographers in order that they may carry out their too realistic theory that it is the dictionary's function to record the facts not merely of our precise, formal, more or less ideal speech, as approved by educated and cultured people regardless of their speech habits, but the literal facts of our ordinary rapid, or careless, or incidental colloquial utterance in which precision and distinctness are not thought of. It is important for the practical educator to realize that the sounds which these three last letters are intended to stand for are so confessedly lacking in distinctive character and quality that they cannot be clearly identified or be named. No experts attempt it. They merely describe these sounds as "obscure," or "weak," or "neutral," "tending toward *i* in *pin*" or "toward *e* in *set*," "intermediate between *a* in *art* and *a* in *am*," etc. Of course, such indefinite, indeterminate sounds, no matter how often they occur in our colloquial and hasty speech, cannot be taught to beginners in reading or be used in oral or syllabic spelling; nor is it necessary, and certainly it is not desirable, that they should be, even if it were possible. This alphabet without these last three letters is complete and fully adequate for common. everyday use and for the ordinary needs of the learner and the teacher. In such use these three letters are needless and should be wholly ignored.

This key discards all diacritic marks but one, the macron, which has one invariable use, viz.: to indicate the long sound of whatever letter it is used with.

In the main this key alphabet conforms to international usage. For the pupil who should become accustomed to it the task of learning to pronounce Latin and German and most other European languages would be a comparatively small matter. The foreigner among us would find great help in a re-spelling of our words in this alphabet. It would furnish the primary teacher who wishes to use the phonetic method in teaching beginners to read, an authorized and complete alphabet, simple and easy for the children to learn to use, a tool never furnished to her before.

In order to have this key find its way into general use, there must, of course, be a call for it. Publishers must discover that the teachers of the country, those who come most directly in contact with the children, and who realize most fully the embarrassments and difficulties attending the use of the present diverse and complicated systems of key notation, desire and would appreciate the adoption of a simple uniform key system in all our books, and especially in our schoolbooks. Publishers cannot be expected to introduce such an improvement without feeling sure that there is a demand for it sufficient to justify the expense and risk involved in adopting it. It is for the teachers of the country to say whether such a call for a uniform key alphabet shall be clearly heard, and whether the royal seal of the National Education Association shall be placed upon the alphabet here recommended so that it shall always remain common property, perfectly open and free for use by all who will, and leaving no ground for business jealousy to make changes in it or refuse to adopt it on the claim that some rival publisher by earlier use has preempted it and thus put his private stamp upon it.

Any request for information in regard to this alphabet or its use, and any suggestion that may add to the value and helpfulness of our forthcoming final report will be welcomed and carefully considered. The capitals and script forms will appear in that report.

It is understood, of course, that the name of a vowel is its sound uttered distinctly. The systematic name of an explosive consonant and of *h*, *y*, and *w* is its sound followed by *ĭ*; of any other consonants, its sound preceded by *e*. In the case of five consonants, however, the common names are submitted as optional because of the present advantage they may be in teaching beginners, particularly adults, to read by the phonetic method (in phonetic print) when they come to make the transition to common print.

RECOMMENDED KEY ALPHABET

Letter	Name	Key-word	Letter	*Name	Key-word
ā		art	ō		nor
a		artistic	ə		not
ai		aisle, find	ei		oil
au		out, thou	p	pi	pit
ā		air	r	er (or är)	rat
a		at	s	es	set
b	bi	be	sh	esh	ship
ch	chi	chew	t	ti	ten
d	di	day	th	eth	thin
ē		prey	th	eth	that
e		men	ū		mood
f	ef	fee	u		push
g	gi	go	ū		urge
h	hi	he	u		hut
ī		marine	v	ev (or vi)	vat
i		tin	w	wi	win
iu		mute	y	yi	yes
j	ji (or jē)	jaw	z	ez (or zi)	zest
k	ki (or kē)	kin	ʒ	eʒ	azure
l	el	let		————	
m	em	met	ɑ	for a in	ask
n	en	net	ʊ	{ " a " " e "	about over
ŋ	eŋ	sing			
ō		note	ɪ	{ " i " " e "	candid added
o		poetic			

Respectfully submitted,

E. O. VAILE, *Chairman*, Oak Park, Ill.
T. M. BALLIET, New York University, New York City
Committee H. H. SEERLEY, President State Teachers College, Cedar Falls, Ia.
MELVIL DEWEY, Lake Placid Club, N.Y.
WM. H. MAXWELL, Superintendent of Schools, New York City

July 6, 1910

THE PSYCHOLOGY OF A PROTOZOAN.

By H. S. Jennings.

The nature of the psychic activities of unicellular organisms has of late become the object of considerable interest, though little work dealing with the problems in a fundamental way has been published since the researches of Verworn. The writer has recently made a perhaps more thorough study of the life activities of a typical infusorian, *Paramecium*, than has ever been made heretofore of any unicellular organism; the results of this study have been published in a number of papers in physiological journals.[1] This work was not done primarily from the psychological standpoint, and the papers referred to give nowhere a full and connected account of the bearings of these studies upon the psychological problems presented by the behaviour of the Paramecia. Yet taken together they enable an almost complete presentation to be given of the psychology of this animal; while there is reason to believe that Paramecium is in this matter typical of nearly or quite the whole class to which it belongs. In the present paper an attempt is made to bring together succinctly the observations which bear upon the psychic powers of this organism, in such a way as to present a complete outline of its psychology.

Paramecium is well known in every biological laboratory, living by thousands in pond water containing decaying vegetable matter. It is a somewhat cigar-shaped creature, about one-fifth of a millimeter in length, plainly visible to the naked eye as an elongated whitish speck. The entire surface of the animal is covered with cilia, by means of which it is in almost constant motion.

Now what are the phenomena in the life of Paramecium which require explanation from a psychological standpoint? Examination shows that under normal conditions Paramecia

[1] Studies on Reactions to Stimuli in Unicellular Organisms. I. Reactions to Chemical, Osmotic, and Mechanical Stimuli in the Ciliate Infusoria. *Journal of Physiology*, May, 1897, Vol. XXI, pp. 258-322. II. The Mechanism of the Motor Reactions of Paramecium. *American Journal of Physiology*, May, 1899, Vol. II, pp. 311-341. III. Reactions to Localized Stimuli in Spirostomum and Stentor. *American Naturalist*, May, 1899, Vol. XXXIII, pp. 373-389. IV. Laws of Chemotaxis in Paramecium. *American Journal of Physiology*, May, 1899, Vol. II, pp. 355-379.

are usually engaged in feeding upon the masses of Bacteria
which form a thick zoogloea on the surface of the water in
which they are found. These Bacteria form almost or quite
their entire food. A first question then might be : How do they
choose their food, selecting Bacteria in preference to something
else ?

If Paramecia are placed on an ordinary slide such as is used
for examining objects with the microscope, together with a small
bit of bacterial zoogloea, and the whole covered with a cover-
glass, it will soon be found that almost all the Paramecia, which
were at first scattered throughout the preparation, have gathered
closely about the mass of zoogloea and are feeding upon it. It
will be seen even, that many Paramecia which cannot on account
of the crowd get near enough to the mass to touch it are push-
ing close and shoving their more fortunate brethren, all appar-
ently trying to get as near to the delicacy as possible. Some
may be ten times their own length from the mass, but never-
theless crowd in from behind, apparently with the greatest
eagerness. Here we have a related problem. How do the
Paramecia collect thus from a distance about the mass? And
what is the psychology of their crowding together thus, like a
human crowd about a circus door? In the human crowd
somewhat complex psychological qualities are involved; must
we say the same for the Paramecia?

If we mount the Paramecia in the manner above described,
but without the mass of bacterial zoogloea, we shall soon notice
another phenomenon reminding us of human beings under like
conditions. The Paramecia do not remain scattered as at first,
but soon begin to collect into assemblages in one or more re-
gions. It appears as if they did not enjoy being alone and had
passed the word along to gather and hold a mass meeting in
some part of the preparation; at least we soon find them nearly
all in a little area near one end of the slide, with perhaps another
smaller crowd off near the other end, while all the rest of the
space is empty. Sometimes such a crowd becomes very dense;
the Paramecia jam each other after the most approved human
fashion, crowding as if all were trying to get near some popu-
lar orator in the center. If we watch such an assembly for
some time, we find that the interest is apparently gradually lost;
the Paramecia begin to separate a little,—not leaving the crowd
entirely, but extending the area and wandering about its edges.
The assembly thus becomes more and more scattered, the area
in which the Paramecia swim back and forth being continually
enlarged; but a rather sharp boundary is nevertheless main-
tained on all sides, as if by common consent no Paramecium
was to pass farther out than all the rest.

Here we have what seems a decidedly complex psychological

problem,—the beginning, or perhaps even a high development, of social conditions. In the culture jars, also, we find the Paramecia gathered into swarms, and any proposed psychology of the Protozoa must account for these social phenomena.

Further, we find that Paramecia seem to have decided preferences in taste. They have a special predilection for sour, gathering with apparent eagerness into a drop of any solution having a weakly acid reaction, while their pet antipathy is toward anything alkaline in character. A drop of fluid having an alkaline reaction is therefore left severely alone and remains entirely empty when introduced into a slide of Paramecia. They also seem to show decided preferences as to heat and cold; they collect in regions having a certain temperature, leaving a colder or warmer area to gather in such an optimum region, just as human beings do. The whole question of how animals are attracted by certain influences and repelled by others is one of the most fundamental problems to be solved.

Thus the ordinary daily life of a Paramecium seems, on the face of it, to present many complex psychological problems. Apparently they feel heat and cold and govern themselves accordingly, have decided preferences as to the nature of the substances dissolved in the water, seeking some, fleeing from others; they live upon one definite sort of food and find ways of discovering a mass of such food even when scattered at a distance from it, and finally, they are social, being commonly found in swarms together and finding means of getting together even when scattered over a wide area.

From observations of this sort, some authors have concluded that such animals have a complex psychology, lacking few of the factors to be distinguished in the psychology of the higher animals. Thus, Binet says, in the preface to his book on *The Psychic Life of Micro-organisms* "We could if necessary, take every single one of the psychical faculties which M. Romanes reserves for animals more or less advanced in the zoölogical scale, and show that the *greater part* of these faculties belong equally to micro-organisms." Thus, it could be maintained from the brief summary I have given of the activities of Paramecium that these animals have *sensations* of various sorts, since they distinguish heat and cold, acids and alkalies; that they exercise *choice* in that they gather in the regions of certain agents, while they turn away from others; that such choice in itself implies *intelligence*; that the choosing and gathering about masses of food implies a *memory* of the qualities of this substance as compared with others; that they show such *emotions* as fear by fleeing from injurious substances (Binet expressly states this); that finally, acute senses, memory, choice, social instinct, intelligence, and a whole host of higher mental attributes, are

necessarily implied in the phenomenon of their seeking each other's society and gathering together even from a considerable distance into crowds.

Is it possible by a closer analysis of the phenomena to simplify this complex psychology which seems forced upon us by the observed facts?

First, we should examine a little more closely the structure of the animal to see what is here available for the production of these results. Often function depends upon structure to such an extent that what appears to be a complex activity is found to be only the automatic result of the simplest movements of a peculiarly constructed organ or set of organs.

Paramecium is an elongated animal, with one end (the anterior) narrower and blunter, while the other (the posterior) is broader and pointed. On one side of the animal (the oral side) a broad oblique depression, called the oral groove, runs from the anterior end to the mouth, in the middle of the body. Near the opposite side (the aboral side) are two contractile vacuoles imbedded in the protoplasm. The mouth is a small opening at the end of the oral groove in the middle of the body; from it a narrow ciliated tube, the gullet, passes into the internal protoplasm. In the center of the animal are imbedded the single large macro-nucleus and the single small micro-nucleus. The entire body is thus a single cell. Under ordinary conditions all the cilia of the body strike backward, which of course drives the animal forward. The stroke of the cilia is apparently somewhat oblique, for as the animal moves forward, it at the same time continually revolves on its long axis: in this way the oral and aboral sides continually interchange positions.

Now the structure and ordinary movements of the animal explain a certain activity which in higher forms may be associated with some degree of psychological complication, namely, the taking of food. Since the oral groove is ciliated like the rest of the body, when the cilia strike backward in the ordinary forward motion a current of water is produced running in the oral groove backward to the mouth. Small particles such as Bacteria, are thus carried automatically to the mouth. The mouth and gullet are ciliated and the cilia strike toward the interior of the animal, hence the particles arriving at the mouth are carried by the cilia into the interior, where they undergo digestion. The taking of food is thus purely automatic.

Moreover, as has long been known, Paramecia and similar animals seem not to exercise a choice as to the nature of the food which they take. Any small particles such as will pass readily down the gullet are swallowed with the same avidity as the Bacteria, it matters not how indigestible they may be.

But, as we have seen above, if a small piece of bacterial

zoogloea on which the animals feed is introduced into a prepa-
ration of Paramecia, the latter soon find it and crowd around
it. It seems possible, therefore, that the choice of food takes
place merely a step sooner than with higher animals, the Para-
mecia choosing the food by gathering around it,—then taking
whatever comes. To test this we introduce a bit of filter paper
into the preparation in place of the bacterial mass. The Para-
mecia collect about it exactly as about the zoogloea. They
gather from all parts of the preparation and crowd upon it with
the same apparent eagerness as previously upon the food mass.
The same results are gained with bits of cloth, cotton, sponge,
or any other loose or fibrous bodies. The Paramecia remain
assembled about such bodies indefinitely, the oral cilia working
away at bringing a current to the mouth, which current carries
no food particles whatever.

Thus it appears that Paramecia exercise no choice as to the
nature of the substances which they use for food, gathering in-
differently about loose fibrous bodies of any sort, and swallow-
ing particles of any kind or none at all, as chance may direct.
We may cut out, therefore, any psychological qualities deduced
alone from the supposed choice of food, putting in their place
merely the fact that Paramecia react in a peculiar way when
they come in contact with bodies of a certain physical texture.
The reaction consists essentially of a quieting of the cilia over
the greater part of the body, while those in the oral groove
continue to strike backward, causing a current toward the
mouth,—the body of the animal remaining nearly or quite at
rest. It is important to recognize, in calling this a reaction,
that it is not shown by a movement, but by a *cessation* of part
of the usual motion.

Having been so successful in reducing the matter of feeding
to simple factors, we may attack at once the most complex
problem of all—the social phenomena shown in the gathering
together of the scattered animals into a close group, as already
described. Is there any way of dispensing with the sharpened
senses, memory, social instinct, intelligence, and the like, which
seem to be involved in these phenomena?

The possibility suggested itself that these collections might
be due to the presence of some substance which was attractive
to the Paramecia, and into which all would gather with one
accord,—so that the fact that they approached each other
would be a secondary result. This led to an extended study
of the chemotaxis of Paramecia, the results of which are de-
tailed in the first of the papers above referred to. It was found
that Paramecia are attracted by all acids, and that in the case
of any unknown substance having marked attractive properties,
it can be predicted with a high degree of certainty that this

substance will be found to have an acid reaction. Carbonic acid (CO_2) especially was found to exercise a strong attraction on the infusoria.

Now these animals, like all others, of course excrete carbon dioxide, which must therefore find its way into the water. The quantity of CO_2 thus produced by one of the dense assemblages of Paramecia was shown to be distinctly appreciable by chemical reagents, by means of the following experiment: Paramecia were mounted in water to which a distinctly reddish color was given by mixing with it a small quantity of rosol. This substance has the property of being decolorized by carbon dioxide. The rosol does not injure the Paramecia, and they soon gather together in a dense collection, as in ordinary water. By observing the slide against a white background it is soon noticed that the solution is losing its color about the group of Paramecia. The colorless area after a time spreads, and at the same time the group of Paramecia begins to break up, as previously described. The Paramecia swim back and forth in the colorless area (that is, the area containing (CO_2), from one side to the other, but without passing its boundaries. The colorless area increases in size, and the area in which the Paramecia swim back and forth keeps exact pace with it; the two coincide throughout.

The same phenomena may be produced by introducing a small bubble of CO_2 into the slide. The Paramecia collect closely about the CO_2, pressing against the bubble. In this way a dense mass is soon formed. After a time, as the CO_2 diffuses, the mass loosens; the Paramecia swim back and forth in the area of diffusing CO_2, not overpassing its boundaries. The phenomena caused by the presence of a bubble of CO_2 are identical in every respect with those which are apparently spontaneous. There is no question but that the assembling of the Paramecia into crowds is due to the presence in these crowds of CO_2 excreted by the animals themselves.

Thus it appears that our social phenomena, with all their implications of higher mental powers, have evaporated into a simple attraction toward carbon dioxide.

But how do the animals succeed in collecting from a distance? At first they are distributed throughout the entire preparation; when we introduce the bit of bacterial zoogloea or filter paper, how do the Paramecia discover its presence, so as to collect about it? From the general wreck of higher mental qualities, can we not save at least the *acute senses* necessary to account for these phenomena?

To determine how the Paramecia succeed in finding and collecting about a small solid placed in the middle of a large slide, it is necessary to study the ordinary method of locomotion of the

animals. "If a preparation of Paramecia on a slide, containing in one spot a small bit of filter paper is closely observed, the Paramecia are seen at first to swim hither and thither in every direction, apparently without directive tendency of any sort. . . Soon a single individual strikes in its headlong course the bit of paper. It stops at once, often starts backward a slight distance, and whirls about on its short axis two or three times, then settles against the bit of paper and remains. Quickly another and another strike in the same way and remain. Now the excretion of CO_2 by the animals gathered together begins to take effect; the region becomes a strong center of attraction, and in ten to fifteen minutes, and often less, the paper is surrounded by a dense swarm of Paramecia, containing a large majority of all those in the preparation." (I, p. 299.) Thus, the finding of the bit of paper is due simply to the roving movements of the animals. Moreover, for gathering in an area containing CO_2 or other acid alone, a similar dependence upon chance motions appears. There is no swimming in straight radial lines to the area of CO_2 as a center; the Paramecia swim at random until they come by accident into the region of CO_2; there they remain. The precise place where a group of Paramecia is formed in some part of a slide into which nothing has been intentionally introduced that would act as a center of attraction is determined by chance factors. One or two individuals, perhaps, strike by accident a bit of solid matter suspended in the water, or a slight roughening of the cover glass; the thigmotactic reaction is set up, so that they stop, and as a result the region becomes a center for the production of carbon dioxide. The remainder of the collection is then due to CO_2, and takes place in the manner last described.

We must, therefore, along with the rest, dispense with specially acute senses. The Paramecia do not react until they are in actual contact with the source of stimulus, and for coming in contact with the source they depend upon roving movements in all directions.

Thus we find that all more complex psychological powers deduced from the "social phenomena," as well as those from the choice of food, must fall to the ground. For explaining all the phenomena with which we have thus far dealt, but three factors are necessary: (1) the customary movements of the unstimulated animal; (2) the cessation of these movements, except those in the oral groove and gullet, when in contact with solids of a certain physical character; (3) attraction toward CO_2.

We have still remaining to be accounted for psychologically the *attraction* toward certain reagents and conditions, as toward CO_2 and toward the optimum temperature, and the *repulsion* to-

ward other reagents and conditions, such as alkalies, and cold or great heat. This selective attraction and repulsion is a phenomenon of great importance, seeming in itself to imply a *choice* on the part of the organisms. If they move toward certain sources of stimuli and away from others, this seems to involve a perception of the localization of things, and this can hardly be regarded otherwise than as at least the beginnings of intelligence. Moreover, from its apparent general occurrence, much theoretical significance has been attached to it. Now *how* does this attraction and repulsion take place? Organisms usually move by means of certain organs of locomotion; attraction and repulsion cannot therefore be left as abstract ideas, but it must be shown how the attractive agent sets these organs in operation in such a manner as to bring the animal nearer; how the repellent agent succeeds in affecting the locomotor organs so as to carry the animal away. To apply this to the particular case in hand, when a drop of some attractive solution is introduced into a slide of Paramecia, how does it succeed in affecting the cilia of the animals in such a way that they turn toward and enter the drop?

Exact observation of the method by which the Paramecia enter such a drop shows that this question is based on a false assumption. *The animals do not turn toward the drop.* Such a drop diffuses slowly, so that its margin is evident, and the Paramecia may be seen in their random course to almost graze the edge of the drop without their motion being changed in the slightest degree; they keep on straight past the drop and swim to another part of the slide. But of course some of the Paramecia in their random swimming come directly against the edge of the drop. These do not react, but keep on undisturbed across it. But when they come to the opposite margin, where they would, if unchecked, pass out again into the surrounding medium, they react *negatively*—jerking back and turning again into the drop. Such an animal then swims across the drop in the new direction till it again comes to the margin, when it reacts negatively, as before. This continues, so that the animal appears to be caught in the drop as in a trap. Other Paramecia enter the drop in the same way and are imprisoned like the first, so that in time the drop swarms with the animals. As a result of their swift random movements when first brought upon the slide, almost every individual in the preparation will in a short time have come by chance against the edge of the drop, will have entered and remained, so that soon all the Paramecia in the preparation are in the drop. If, however, the drop is not introduced until the Paramecia have quieted down, it will be found to remain empty; this shows the essential part played by the roving movements in bringing the collection together.

Thus it appears that the animals are not attracted by the fluid in the drop; they enter it by chance, without reaction, then are repelled by the surrounding fluid. This is true for all apparently attractive reagents or conditions. *Paramecia are not directly attracted by any substance or agency;* the assembling in the region of certain conditions being due to the repellent power of the surrounding fluid, after the Paramecia have entered by chance the area of the conditions in question.

There remains then as a motor reaction only the *repulsion* due to certain agents and conditions. Is this repulsion an ultimate fact in the psychology of the animal, or is it possible to analyze it further?

The first thing which a Paramecium does on coming in contact with a drop of repellent solution is to reverse all its cilia, so as to swim straight backward,—at the same time revolving on its long axis in a direction opposite to that in which it was previously revolving. Next it turns to one side a certain amount, then swims forward again, on a path which lies at an angle to the path in which it was first swimming. Briefly stated, it adopts the very rational plan of backing off, turning to one side, and swimming on past the obstacle. We must apparently concede the Paramecium at least a modicum of intelligence for the very practical way in which it meets this emergency.

But suppose the animal touches the margin of the drop obliquely, or brushes it only on one side as it swims past it through the water; what course will it then take? From its sensible behavior under the previous conditions we shall expect it to sheer off, away from the drop, and keep on its way undisturbed or at a slight angle to the original path. But when we observe such a case, we find that the Paramecium backs off, swimming straight backward, as before, then turns through an angle, then swims forward, exactly as in the previous case. And curiously enough, it by no means turns directly away from the drop, but fully as often turns toward it, so as to strike it squarely the next time it moves forward. If this occurs, the whole operation is repeated; the animal tries, as it were, for a new opening. Sometimes it is necessary to repeat the operation several times before the Paramecium succeeds in getting away from the repellent object.

Under these circumstances the animal evidently gives much less indication of intelligence, and the fact that it reacts in exactly the same way under such different conditions is especially fitted to shake confidence in its mental powers. Apparently the swimming backward has no relation to the position of the source of stimulus, but occurs merely as a result of the fact of stimulation, without reference to its localization. Whether

this is true as a general statement can be tested by giving the animal a general shock without localizing the source of stimulus at all. This is easily done by immersing the Paramecia directly into solutions of such a nature that they act as stimuli. In such a case the stimulus acts upon the entire surface of the animal at once, so that there is no obstacle to be avoided and no reason for swimming backward.

Immersing Paramecia thus into solutions of different kinds, it is found that the first thing they do in every case is to reverse the cilia and swim backward. Nor is this all. The entire reaction is given, just as when the source of stimulus was at one end or one side; the animal first swims backward, then turns, then swims forward. This is true for all classes of stimuli,—chemical solutions of all sorts, water heated considerably above the optimum temperature, water at the freezing point, and solutions active only through their osmotic pressure. The duration of the different parts of the reaction varies much in different agents, but the essential features of the reaction are the same everywhere.

It therefore appears that not only the backward swimming, but also the turning to one side takes place without reference to the localization of the stimulus,—both occurring equally when the stimulus is not localized at all. But what determines the *direction* in which the Paramecium turns?

Careful observation of Paramecia under conditions which compel them to move slowly shows that after stimulation *they always turn toward the aboral side*,—that is, the side opposite the oral groove. The direction of turning is thus determined by the structure of the animal, and has no relation to the position of the source of stimulus. The mechanism of the turning is as follows: after the first reversal of cilia, those in the oral groove begin to strike backward again, tending to drive the animal forward, while the remainder of the cilia on the anterior half of the animal *strike transversely toward the oral side*. This results in turning the animal toward the aboral side.

We find, therefore, that the direction of motion throughout the entire reaction depends upon the structure of the animal and has no relation to the localization of the stimulus. The reaction may be expressed completely, omitting all reference to the position of the stimulus, as follows: after stimulation the animal swims with the more pointed end in front, turns toward the aboral side, then swims with the blunter end in front.

It is of course a matter of chance whether this turning toward the aboral side carries the animal away from the source of stimulus or toward it. Frequently the latter is true; in this case the operation is repeated when the animal comes again in contact with the stimulating agent. As the animal revolves

continually on its long axis, the aboral side will probably lie in a new position at the next turning, so that the animal will turn in a new direction. If this is repeated, the chances are that in time the obstacle will be avoided.

Thus, not only is it true that Paramecium is not attracted by any agent or condition, but also we cannot say, speaking strictly, that it is repelled by any agent or condition. Certain agents set up a reaction in the animal, the directive features of which depend entirely upon the structure of the organism,—just as certain stimuli cause an isolated muscle to react. We cannot say that the Paramecium is repelled by the stimulus, any more than we can say that the contraction of the muscle is due to the muscle's being repelled by the stimulus. It is true that the source of stimulus is more often at the blunt or "anterior" end, in the case of Paramecium, so that swimming toward the sharp end does, as a matter of fact, usually result in taking the Paramecium away for a short distance from the source of stimulus. But this usual position of the source of stimulus is from a physiological standpoint purely accidental, and the reaction produced is the same whether it occupies this position or another. If the animal is stimulated at the posterior end, it swims backward, therefore toward the source of stimulus; in this way it may enter a destructive chemical solution and be immediately killed, though the same chemical acting upon the anterior end would of course have caused the animal to swim away. This is seen in a particularly striking manner in the larger infusorian *Spirostomum ambiguum*, which is so large that it is easy to apply a stimulus to any desired part of the body. It is then found that the animal reacts in exactly the same manner whether stimulated at the anterior end, the posterior end, or the side, the direction of motion having absolutely no relation to the position of the source of stimulus. The same is true for Paramecium, though its smaller size makes the demonstration more difficult.

A strict parity is therefore to be observed between the reactions of Paramecium and those of an isolated frog's muscle. Paramecium responds to any stimulus by a definite, well characterized reaction. "The same may be said of the isolated muscle of a frog. The intensity of the reaction varies with the nature and intensity of the stimulus; this also is true for the muscle. Under certain influences the Paramecium remains quiet; likewise the muscle. The directive relations of the motions are determined both in the Paramecium and in the muscle by the structure of the organism, not by the position of the source of stimulus. There seems, then, no necessity for assuming more in order to explain the reactions of the Paramecium than to explain the reactions of the muscle. We need, there-

fore, to assume nothing more than irritability, or the power of responding to a stimulus by a definite movement, to explain the activities of Paramecium " (II). The long catalogue of psychical qualities required to account for the movements of Paramecium is thus reduced to simple protoplasmic irritability.

The method by which Paramecia collect in the regions of influences of a certain character and leave other regions empty, may be stated in general terms as follows: Certain stimuli cause in the animals random motions, in which the direction is frequently changed, especially at the moment when the stimulus begins to act. These random movements result, through the laws of chance, if continued long enough, in carrying the Paramecia out of the region of influence of the agent causing the stimulus. Coming thus by chance into a region where such movements are not caused, the Paramecia remain; if this ineffective area is small, the Paramecia are crowded together within it and give the impression of being strongly attracted by it.

" It is evident that we have in this case as near the reaction postulated by Spencer and Bain for a primitive organism—namely, random movements in response to any stimulus—as is likely to be found in any organism. The motions are strictly random in character so far as the position of the source of stimulus is concerned. . . . And by the repetition of the reaction the direction of movement is frequently changed,— always without reference to the localization of the stimulus. It appears not to have been foreseen theoretically that such random movements would of themselves, if continued, carry the animal out of the sphere of influence of the agent causing them and keep it from re-entering. To accomplish this result it is only necessary that the direction of motion should be changed at the moment when the stimulus begins to act and at intervals so long as it continues " (II).

An examination of the activities of a number of other unicellular organisms in the light of the observations above detailed shows that they react in essentially the same manner. For each organism a simple statement can be given for the reaction to any stimulus. For *Spirostomum ambiguum* the reaction is as follows: the animal contracts, swims backward, turns toward the aboral side, and swims forward. *Stentor polymorphus* contracts, swims backward, turns toward the *right* side, and swims forward. A number of flagellates also have been found to have such a fixed method of reaction. In all these cases the direction of motion has no relation to the position of the source of stimulus, and the conclusions to be drawn for Paramecium apply equally to these organisms.

In regard to the position in the psychological scale to be as-

signed to Paramecium the following may be said: The reactions of Paramecium are, as we have seen, comparable in all essentials to those of an isolated muscle. In neither case has the direction of motion any relation to the position of the source of stimulus. Reaction in such a manner as to show a relation to the position of the stimulating agent has rightly been regarded as a first and lowest step in perception; this lowest step is quite lacking in Paramecium. Moreover, Paramecium has no "life history" in the sense of a change in its reactions such as between the reactions of a young and an adult higher animal. An individual undergoing division reacts exactly like the ordinary Paramecium, as do likewise the halves immediately after division. In the words of Professor Baldwin, "the fact of life history is just what distinguishes an organism from what is a 'mechanical arrangement.'" While we cannot deny that Paramecium is an organism, this fact shows the machine-like nature of its activities. An animal that learns nothing, that exercises no choice in any respect, that is attracted by nothing and repelled by nothing, that reacts entirely without reference to the position of external objects, that has but one reaction for the most varied stimuli, can hardly be said to have made the first step in the evolution of mind, and we are not compelled to assume consciousness or intelligence in any form to explain its activities.

A STUDY OF ANGER.

By G. STANLEY HALL.

Psychological literature contains no comprehensive memoir on this very important and interesting subject. Most text-books treat it either very briefly or not at all, or enumerate it with fear, love, etc., as one of the feelings, sentiments or emotions which are discussed collectively. Where it is especially studied, it is either in an abstract, speculative way, as in ethical works, or descriptively as in books on expression or anthropology or with reference to its place in some scheme or tabulation of the feelings, as in many of the older works on psychology or phrenology, or with special reference to some particular and partial theory as in the Lange-James discussions, or its expressions are treated in the way of literary characterizations as in novels, poetry, epics, etc., or finally its morbid and perhaps hospital forms are described in treatises on insanity. Observers of childhood, like Darwin, Taine, Preyer, Perez, Baldwin, Mrs. Moore, Miss Shinn, Sully and many others sometimes ignore it as too painful a trait to be fully described by fond parents or relatives, or briefly characterize single outbreaks, or special features in a single child. The outlook and the reactionary stages are sometimes confused, and there is nowhere any conception of the vast diversities of its phenomena in different individuals; so that we find not only great divergence but the most diametrical contradiction in describing its typical physical expressions. In some, *e. g.*, Stanley, it is *sui generis* and unique from the start; and for others, *e. g.*, Mantegazza, it shades by imperceptible gradations over into fear and love with few characteristics solely its own. Its physiological basis may be blood composition, digestive or hepatic changes in vascular contractions, abnormal secretions, non-removal of waste or toxic products, over lability of central nerve cells, reflex muscle tension, etc. At present the general subject of anger is a tumbling ground for abstract analysis and *a priori* speculation, which must be gradually cleared up if psychology is to advance from the study of the will to the feeling. Just now the chief obstacle to this advance is strangely enough the Lange-James theory, the general acceptance of which, puerile as it is in view of the vastness and complexity of the field, would do for this general tendency of psychology a dis-service comparable only with that which Descartes's catchy

dictum, that animals were mere automata, did for the advance of comparative psychology in his day.

I have collected the following, far from exhaustive list of English bearing on this state, additions to which in English or other languages also rich in such terms, are invited.

Acrimonious: sharp, pungent, biting.

Aggrieved: made heavy, severe, looded.

Affronted: confronted offensively.

Angry: root *ang*=straightened, troubled. *Angor*, strangling. Angere, to choke, stifle. Arxio=throttle. Awe and ugly have the same root, and ache is related, as are anxious and anguish. Other etymologies closely relate it to fear.

Animosity: hostile spirit, more vehement and less lasting than enmity.

Antagonistic: to a foe or adversary opponent.

Antipathy: instinctive and involuntary dislike, repugnance, distaste, disgust.

Aversion: turning from.

Bitter: biting, cutting, sharp, referring to the sense of taste.

Boiling: as a fluid from heat. Temper has a boiling point.

Breakout: restraint or inhibition giving way. *Cf. ausgelassen*, not peculiar to anger.

Brood: to incubate, nurse, keep warm.

Chagrin: mortify, keenly vex as at disappointment.

Chafe: as when the epidermis is worn off to the quick.

Choleric: from Latin and Greek, cholera=gall, bile. The liver was long regarded as the seat of anger and of love.

Contempt: scorn, despise, mépris.

Crabbed: scratch, claw, wayward in gait, not letting go.

Cross=curly, crimped, crooked. *Cf.* a "crook" in body or mind, cross-grained.

Cruel: morally crude, and from the same root, pitiless, loving to inflict suffering.

Crusty: brittle, short.

Curt: short and sharp.

Dander up: dandruff, scurf, ruffled temper.

Defiant: renouncing faith or allegiance, and challenging.

Demoniacal: possessed by an evil spirit.

Displeased: designating all degrees of being offended.

Enmity: inimical to an enemy.

Evil: exceeding limits, bad, depraved, vicious, not peculiar to anger.

Fierce often used for anger. *Ferus* (wild savage) cognate with *fera* (wild beast). *Cf.* wild with rage, savage resentment, mad as a hornet, angry as a bull, cross as a bear.

Fight: fighty.

Flare up: *Cf.* blaze out, inflame.

Fit: spasm, convulsion, spell, not peculiar to anger.

Fractious: fret, rebellious, warmly restive, easily broken.

Frantic: phrenetic, very excited, not peculiar to anger.

Frenzy: same root as frantic.

Fretty: abrasion, corrosion, chafing.

Fume: to smoke. *Cf.* thumos, spirit, anger.

Fury: storm of anger, possessed by the furies.

Gall: ref. to liver as seat of anger.

Glum: frown, stare, sullen.

Grim: stern, forbidding, severe, angry.

Gritty: sharp, grains of sand, pluck.

Grouty: turbid as liquor, dreggy, roily, surly.

Grudge: crumble, crush, ill will and envy.
Gruff: rough.
Grumpy: *Cf.* grim and many Teutonic words. Gram=to rage, roar, akin to sorrow, and related to grin, groan, grumble, make a noise.
Haste: too quick wrath or temper.
Hate: aversion, extreme detestation, repugnance.
Hostile: with enmity, antagonistic.
Hot: warm, heated.
Huffy: puffed, swelled with rage.
Impatient: the opposite of patience and long suffering.
Indignant: at the unworthy or mean.
Inflamed: a thermal analogy, combustible. *Cf.* flare up.
Insane: unwell, anger is a brief insanity. *Cf.* mad.
Ire: irascible, iracund.
Irritable: excitable, chiefly applied to temper.
Mad: a mad state, furious.
Malevolent: willing or wishing evil.
Malice: malus, bad, with ill will, malicious.
Malignity: *Cf.* malign, producing malice.
Morose: fretful.
Mucky: like muck, nasty, of temper.
Nasty: used of bad temper.
Nettled: stung with nettles.
Obstinate: standing against.
Offended: struck against.
Old Adam: aroused.
Passionate: of any passion but prominently of anger.
Peevish: feebly fretful, literally crying as a child.
Pet: *Cf.* pettish, as a spoiled child or pet.
Petulant: in a little pet.
Piqued: pricked, stung, nettled, angered.
Possessed: as if by a bad spirit.
Provoked: called out, incited to anger.
Put out: as of gear, off his nut, trolley, etc.
Putchy: New England for touchy.
Quarrelsome: prone to contend, also querulous.
Rage: *Cf.* rabies: a furious degree of anger.
Rancid: spoiled, tainted, rank, applied to butter.
Rancor: *Cf.* rancid, something that rankles.
Raving mad: as a horse, also roaring mad.
Refractory: breaking away.
Repugnance: contradiction, fighting against.
Resent: to have strong feeling against or take offense.
Retaliate: pay back in like.
Revenge: requite, retribution.
Riled: as mud stirred up in water.
Ructious: (belching) is widely used in New England of angry states.
Ruffled: hair or plumage towsled or stroked the wrong way.
Savage: like beasts or barbaric men.
Scorn: literally mockery, disdain, despise.
Sharp: used of temper.
Snarly: as of a dog.
Snappish: short, crusty, tart, disposed to bite.
Sore: literally aching, morbidly tender or irritable.
Sour: acid, mordant, the sours.
Spite: petty ill will.
Spitfire: a hot tempered person.
Splenetic: the spleen was supposed by the ancients to be the seat of anger.

Spunk: tinder, sponge.
Stark mad: stiff, naked, strongly angry.
Stormy: violent, gusty.
Stern: austere, rigid, severe.
Stubborn: stubbed, strongly obstinate.
Sulk: refuse to act or respond.
Sullen: glum and gloomy.
Surly: doggedly rude, rough.
Tantrum: literally =sudden impulse.
Tart: acidulous.
Tear: *Cf.* Zorn =rend, destroy, rip, burst, tearing mad.
Tempestuous: *Cf.* stormy.
Temper: disposition, hasty of temperament.
Testy: snappish.
Tew: used in New England for the fretting of infants.
Touchy: like proudflesh.
Ugly: literally horrid, unsightly.
Up on his (or her) ear.
Vengeance: *Cf.* vindictive, retribution, revenge.
Vex: literally to shake, to badger, bother.
Vicious: *Cf.* vitiated, addicted to vice.
Vile: used of temper.
Violent: infuriate, vehement, impetuous, turbulent.
Volcanic: explosive, eruptive.
Waspish: sting on too little or no provocation.
Wild: untamed, undomesticated.
Wode, wood: Wut=mad, furious, frantic, stirred up. *Cf.* woden
 wütendes Heer.
Wrath=cognate with writhe, twist, turn to and fro, and with many
 words in other Teutonic languages with like meaning.

After a learned and valuable discussion, Chamberlain[1] sums
up the etymological meanings of words for anger as designating
(1) choking and strangling, Eng. *anger* and its cognates; (2)
writhing and twisting, *wrath;* (3) crookedness, curling, *cross*
and its cognates; (4) bursting and tearing, Ger. *zorn;* (5)
hasty movements, *fury,* Gr. θυμός; (6) seizing and grasping,
rage and derivatives; (7) making a noise, *yelling,* Ger. *Grimm,*
Tahitian *riri;* (8) malicious talk, slander, Ger. böse; (9)
mental excitement, Lat. *vates,* Gr. μῆνις; (10) swelling, Gr.
ὀργή, Samoan *huhu;* (11) based on the heart, Kootenay, *san-
illwine* and others; (12) on the liver, gall, bile, spleen, etc.,
and other words in various languages based on the stomach,
nose, forehead, etc. Helpful as it is, this classification, as will
be apparent from my list above, is not adequate. These words
are interesting reflections of the ancient volks' conception of
anger and are, as would be expected, nearly all physical.

Older medical writers, Gebhardus (1705), Slevoytius (1711),
Fickius (1718), Clavillart (1744), Bender (1748), Regenhertz

<hr>

[1] On Words for Anger in Certain Languages. A Study in Linguistic
Psychology. *Am. Jour. of Psychology,* Jan. 1895, Vol. VI, No. 4, pp.
585-592.

(1757), Estrevenart (1788), Beeker (1811) and Regenbogen (1820), discussed the physiological effects of anger, urged its occasionally beneficial and even therapeutic effects. A group of French writers: Hiver (1815), Bemont (1816), Bigot (1818), Sallemund (1823), Boscher (1833), gave more or less elaborate descriptions of its phenomena and therapeutic treatment; and Baunus, Gallot, Husson, Ponte, Schneider and others have described cases of sudden death, loss of consciousness, convulsions caused by it, or have discussed its relations to drunkenness,

H. L. Manning[1] reports a case of rupture of a cerebral artery due to anger at an animal in a stable; compares brooding to a mental canker; thinks it may cause cancer and is liable to foreclose a mortgage of weakness in some organs at any time, urges that anger has the same sense as angina and that people whose temper is very sensitive are very selfish. Pointé[2] shows how violent anger may cause icterus, hernia, syncope, apoplexy, mania, hysterical attacks, mutism, etc. Many records of similar cures could be gathered from medical journals.

Forensic medicine, since Platner's important treatise on excandescentia furibunda, in 1800, has dealt with anger.[3] Misers are inflamed by loss of gold, the proud by slights, lovers by petty offences by or against their mistresses. Morbid onsets of anger are manias of brief duration, and some forms of mania may be characterized as long-continued anger without objective cause. The impulse is irresistible and there is loss of psychic freedom. Again the provocation may be so strong as to break down all the inhibition that comes from restraining motives, and to cause the mind to be beclouded, or the outbreak may be too sudden for the slower, later acquired, and long circuiting apparatus of control to be set in operation, so that responsibility is lessened or indeed removed. Friedreich also thinks the storm of passion may temporarily obstruct the power of self-direction. Feuerbach says "Murder in a moment of passion is a crime possible for the noblest natures," and he goes on to describe conditions under which the act would not only be justifiable but noble. Rare as such cases are, he urges that crimes committed in sudden anger should have individual study.

The murder of her seducer, by Maria Barbellina (a case so well studied by Hrdlicka), committed in an automatic state not remembered afterwards, was essentially anger intensified to a full and typical epileptic attack.

Rush[4] urges that the term gentleman implies a command of

[1] Journal of Hygiene, 1895, p. 324.
[2] Gazette des Hospitaux, 1898, p. 273.
[3] Cf. Friedreich: Gerichtliche Anthropologie, 1859, Ch. III, p. 20, et seq.
[4] The Mind, pp. 331, et seq.

this passion above all others, cites Newton's mild words to his little dog, which set fire to the calculations of years: "thou little knowest the mischief thou hast done," mentions a clergyman who demonstrated a proposition of Euclid as a sedative, commends Thety's mode of allaying the anger of her son Achilles by exciting the passion of love, advises a milk and vegetable diet and avoidance of all stimulants, even the moderate use of which predisposes to anger, advises drinking cold water, and in extreme cases a douche with it, and suggests that if due to weak morbid action wine or laudanum may help.

Savage races often work themselves up to a transport of rage for their battles by dances and yells, and rush upon the foe in blind fury. Sometimes the real fighting begins over the division of the booty with sickening sights of savage ferocity, more men being killed thus than in the original capture of the plunder; and blood feuds may augment the horror of it all,[1] The warrior's face is made up in the most fiendish way, his weapons suggest torture more than death, as do even his ornaments, and his scars are eloquent of the most desperate encounters.

Running amok[2], common among Malays and in other Oriental lands, has been variously described. An athletic man, who thus gives way to either revenge, religious frenzy, acute mental or bodily suffering, or to the various other causes assigned, often shaves off all the hair on his body, strips every vestige of clothing, oils or greases his body from head to foot, and armed with a dagger or knife runs at the top of his speed, stabbing every living creature he can get at. He runs straight ahead, rarely turning corners, never entering houses, and like an enraged human tiger never stops in his career of destruction, often with his head bent low like a battering ram, slippery as an eel, smeared and dripping with blood, till some one kills or at least stuns him. Formerly, poles with prongs were kept in every village to ward off or pin the Amokers who were far more frequent than now. The attack is not due to intoxication nor are the Malays subject to ordinary epilepsy, but it occurs when pain, grief, gloom, and loss of hope nursed by brooding, bring on what their language calls heart-sickness. When Job was tempted to curse God and die, or when we are goaded to desperation and break out from all the control of prudence and speak or act with abandon, reckless of consequences, wounding friends and foes, the Malay rushes, slashes right and left, plunges into the sea, etc. When medically examined they are

[1] I. Thompson: Through Masai Land, p. 255.
[2] The Amok of the Malays, by W. Gilman Ellis, M. D. J. of M. Science, July, 1893.

in an excited state which lasts for hours or days, and sometimes with complete amnesia of the crisis. Its onset is very sudden and seems uncontrollable and paroxysmal.

In the Viking Age[1] each champion wanted to become a Berserker (fighter without a shirt). These bravest of men wrought themselves into such a frenzy at sight of their foe that they bit their shields and rushed forward, throwing away every weapon of defence. The berserk fury was utilized, not only for war but for performing hard feats beyond the power of common people. "In some cases this fury seems to have overcome the Berserks apparently without cause, when they trembled and gnashed their teeth." When they felt it coming on, they would wrestle with stones and trees, otherwise they would have slain their friends in their rage. In their greatest fury they were believed to take the outward shape of an animal of great strength and perversity. When great champions went berserking and were angry, they lost their human nature and went mad like dogs. They vowed to flee neither fire or iron, and in days of incessant warfare, died singing their brave deeds, and as they entered Valhalla could hear the lay of the scalds recounting their acts of prowess.[2] Sometimes in the acme of their rage, the mouth was open and frothing, and they howled like beasts and spared nothing in their course. Afterward they were weak, and calling their name often cured them.

At quarter races in some parts of the south, near the close of the last century, cock fights where the birds were armed with steel spurs with which they cut each other to pieces, wrestlings, quarrelings and often brutal fights occurred.. In the latter, for which there were rules, "gouging" was always permissible. Each bully grew a long thumb nail for this purpose, and if he got his opponent down, would take out his eye unless he cried "King's curse." Sometimes ears were bitten off, and the yet more terrible mutilation of "Abelarding" might occur. These practices, McMaster[3] tells us, long prevailed as far north as the Maryland border.

The Iliad is, as the world knows, the story of the results of the wrath and bitter verbal quarrel of Achilles with Agamemnon over the priest's captive daughter, Chryseis.

Orlando Furioso, in his long search for his pagan love, Angelica, coming suddenly upon conclusive evidence that she is false to him, becomes frantic, and seizing his arms, rushes to the forest with dreadful cries, breaking and cutting trees and

[1] Du Chaillu: The Viking Age, Chapter XXVI.
[2] Simrock: Deutsche Mythologie, p. 465.
[3] History of the People of the United States, Vol. II, p. 5. I am indebted for this and several other references to the Librarian of Clark University, Mr. Louis N. Wilson.

rocks, destroying a grotto, and often thus terrorizing the country for days, passes raving mad through France and Spain, swims the Straits of Gibraltar and continues his devastations in Africa. For 300 verses Ariosto describes in vivid terms his desperate deeds of supernatural strength. Orlando is insanely mad and is restored only after the paladin and the apostle arrive at the magazine of good sense in the moon to find his soul securely bottled and labeled, which they return and force him to inhale, when he is restored.

Modern literature abounds in description of anger, *e. g.*, the breaking of the bull's neck by Ursus in the amphitheater to save the life of Lygia in Quo Vadis; the fights of Prasper and Galors in the Forest Lovers; Mulvaney's story in Kipling's Soldier's Three, where the conflict was body to body, too close to use bayonet, and the men could only push, kick, claw, maul, and breathe and swear in each other's faces, and knives danced like sunbeams, and cleft heads went down grinning in sections, revolvers spit like cats and black curses slid out of innocent mouths like morning dew from the rose. The brutal killing of Nancy by Bill Sykes; the fight with Squeers in Nicholas Nickleby; the conflicts in Scott; and from ancient mythology to the modern stage, all shows how all the world loves fighters. Dante, M. D. Conway and many other description of demons and hell abound in descriptions of anger. Volumes could be easily filled with such characterizations.

In Ireland's characterization of the insanity of power,[1] there are interesting descriptions of extreme and morbid anger. When angry, Claudius Cæsar is said to have grinned and foamed at the mouth. Agrippa's rage at a rival was so great that after one of them was executed, she had the head brought and opened its mouth. Commodus, by the sight of blood in the arena was aroused like a tiger on the first taste of it. He fought 735 times in gladiatorial games, took pleasure in bleeding people with a lancet, and the companions of his anger often fell victims to his rage. Mohammed Toghlac had a passion for shedding blood, as if his object was to exterminate the human race. Executioners were always present to kill or torture on the instant those who offended him. His elephants were taught to throw his enemies into the air and catch them with their trunks, and to cut their bodies with knives fastened to their tusks. One who had provoked him was flayed alive, and then cooked with rice, and his wife and child forced to eat his flesh. Others were tied by the leg to wild horses,. which ran through forests till only the leg was left. Ivan the terrible was filled with tigerish impulses by every suggestion of restraint. His jester

[1] The Blot upon the Brain.

displeased him and he threw hot soup in his face at the table, and then rose and stabbed him. He forced people to kill their wives, fathers, mothers and children. Death did not appease his rage, and sometimes his enemies must sit at the table for days opposite the corpses of their nearest relatives, whom he had killed. He interrupted his devotions to massacre those who had provoked him. In one case some 27,000 inoffensive people were killed before his rage was placated. He killed his favorite son and heir in a fit of anger. Another son, who was killed young, had as a child a passion for seeing slaughter, and killed animals himself for the pleasure of seeing the blood flow.

Mantegazza assumes that man has far greater capacity for pain than for pleasure, and can hate more bitterly than he can love. Love and hate are not only often mixed and felt towards the same person, but may be different degrees of the same emotive force. Anger is an expression of egoism, and vanity and hyperself feeling intensify it. Infants hate most and most often if their feeding is interfered with, boys if play, youth if love, adults if pride, old age if conservatism, women if their affections are disturbed. Duels in their early stages as courts of honor, and lawsuits and courts of arbitration are attempts to restrain this passion which makes *homo homini lupus*. Religions at their birth are efforts to placate the anger of deities and mitigate the fires of their wrath, for God is conceived as angry daily with the wicked, and hell is hot with his vengeance. A long list of curses, perhaps elaborately formed and ceremoniously launched, and damnatory oaths and obscenities, insulting names, especially of animals, imputing deformities of soul or body may be vents. Anger may emit its own peculiar smell ; the first cry of the babe is perhaps anger, and anger may be directed toward self. In great haters the luxury of one moment of rage may be deliberately purchased by years of pain, and a city may be destroyed for a single man. Its strength is shown by the fact that while love is everywhere and always taught, and hate and anger everywhere repressed, the latter are yet so much stronger. It has all degrees from the most bestial fights for extermination up to irony, satire, criticism, coldness, neglect, teasing and many other forms. One can be angry without an object, but if we hate we must hate something. Pardon and its motivation are lightly touched upon, and placation of gods and men mark a higher stage, and the long strain of patience is a noble discipline for this *sæva animi tempestas*.[1]

O. Schwartzer describes a form of morbid transitory rage as follows : '' The patient predisposed to this, otherwise an entirely reasonable person, will be attacked suddenly without the

[1] Physiologie des Hasses.

slightest outward provocation, and thrown into a paroxysm of the wildest rage with a fearful and blindly furious impulse to do violence and destroy. He flies at those about him, strikes, kicks, and throttles whomever he can catch, dashes at every object near him which he can lay his hands on, breaks and crushes what is near him, tears his clothes, shouts, howls, and roars, with eyes that flash and roll, and shows meanwhile all those symptoms of vaso-motor congestion which we have learned to know as the concomitants of anger. His face is red and swollen, his cheeks hot, his eyes protrude and the whites are bloodshot, the heart beats violently, the pulse marks 110–170 strokes a minute. The arteries of the neck are full and pulsating, the veins swollen, the saliva flows. The fit lasts only a few hours and ends suddenly with a sleep of from 8 to 12 hours, on awakening from which the patient has entirely forgotten what has happened."

Kraepelin[1] describes morbid irascibility *iracundia morbosa* in born imbeciles of higher grade whose moral nature is somewhat developed and who have considerable school knowledge. On the very slightest occasion, they go off as if loaded into an utterly uncontrollable frenzy of rage, tremble all over, stammer out insults and curses, inarticulate cries, bite their lips and hands, run and butt their heads against the wall, try to choke themselves, tear their clothing and destroy everything within reach, till they are breathless, reeking with sweat, hoarse, and too exhausted to move. Upon the stimulus, the explosion follows with the certainty of a machine Often such cases maintain a certain orientation and avoid attacking persons, but vent their fury upon lifeless objects as in gestures. Such attacks may last an hour or days, sinking back with a long asymptotic curve of diminishing irritability to the normal. They often have no or slight memory afterward of what occurred, lament their infirmity, beg to be bound or shut up, have all objects with which they could do injury removed. Every even imaginary infraction of their hyperalgeric egotism and selfishness may provoke imperative actions perhaps of brutal passion.

Ziehen[2] describes the disposition to anger which is often associated with abnormal exhaltation of self-feeling as hyperthyaim. In paralytic dementia primary exhaltation is a very common intercurrent stadium and is a cardinal symptom of mania. In the characteristic cyclus, the depressive stage more commonly precedes. At the beginning and end of an anger fit the peripheral arteria are expanded, sometimes almost to the point of

[1] Psychiatrie, pp. 125 and 673.
[2] Psychiatrie, pp. 60 *et seq.*, 141 *et seq.*, 174, 242, etc.

congestion in the face; but at the acme of the explosion they are contracted and palor is most common. Respiration is prolonged and deep, the pulse wave low, the lapse of association is retarded, followed perhaps by an explosive acceleration, there is a decrease of motor-discharge, a stage of initial inhibition, succeeded by one of augmented intensity and perhaps restricted range. The play of motives is reduced, reflection drops out and sensation is applied directly to motives which are rather incoherent and unco-ordinated, and it is the shunting out of the association plexus that causes subsequent amnesia. *Furor epilepticus* is the most intense manifestation of anger. As a symptom of paralytic dementia excessive tearfulness is often associated with it, and may more or less take its place with increasing lability of mood and kind of action, and perhaps facial mimesis gestures and general agitation. Morbid irritability is not infrequent in chorea.

No one has described with such clearness and copiousness of casuistic material as Magnan[1] the slow accumulation of anger in paranoiacs, whom he agrees with Tardieu in calling the most dangerous of all the insane, who, on grounds of a purely hallucinatory nature, steal, insult, shout, without having given any one any intimation of the long evolution of their state of consciousness. Querulants complain of all, suspect all about them of changed feeling towards or of designs upon them. They imagine their friends look askance, are less constant in their feelings, are gossiping about them, or are fomenting plots to injure their business, reputation, etc. All is perhaps increased by auditory hallucinations and slowly the patient feels himself the victim of persecutions and surrounded by enemies with overt or covert designs upon him. Gradually reactionary impulses arise and gather force. The injuries must be resented, the guilty punished, and at length, the persecuted becomes a persecutor now entirely devoted to vengeance. Insults, denunciations, abusive letters, threatening, and perhaps written in red ink or in blood, slanders, murderous attacks and every other means are resorted to to gratify hate. No failure discourages, and then reason justifies all their acts as the inevitable retaliation to long accumulated and extreme provocation. He feels his case to be unprecedentedly and inexpressibly pathetic, one that cries to heaven for an avenger. For crimes thus motivated, when the patient has plainly lived completely into his morbid romance some authorities in forensic medicine recognize either partial or incomplete irresponsibility.

For the Herbartians, whose treatment of the feelings always must be very inadequate, anger burns outward from within,

[1] Paranoia, chronica, etc.

establishes a new apperception center, or *pointe de repère*, for a part of the mental content, shakes old concepts into wakefulness, and like a tide adds to one plexus of ideas what it takes from another, and has a long and slowly dying out, somatic after effect. Although perhaps at first "sweeter than honey," as Homer calls it, it belongs on the whole to the algesic and depressive group of emotions.[1]

Stanley[2] characterizes anger as more offensive than defensive, as aggressive, expansive, as peculiarly developed in the carnivora who are usually solitary because predacious habits require a wide subsistence area. Its origin marked a most important and epoch-making era, as important for psychic morphology as the vertebrate form, giving those animals that acquired it a great advantage over those which did not, and it is a great factor in the evolution of personality. Those creatures who can injure all their enemies, and men who make their acquaintances fear to make them mad, are more likely to survive. The greater and more formidable the foe the more fear expels anger and prevents its ebullition. In a certain stage it is wise to bear in mind that any friend may become a foe. The weakness, which instead of hitting back turns the other cheek, is at a certain stage a disadvantage. Weak people cannot hate or be very angry. It is a unique passion, complete, and a genus by itself from the start, and so must be known introspectively or not at all; is pure at first and its hybrid forms evolve later. Its organs are claws, fangs, horns, spurs, and weapons, and it tends to culminate in eating the adversary, sometimes even in anthropophagy. Hate is habitual anger and is retrospective, while anger is prospective. It represents a wild state before and below civilization which has domesticated man. Even lower animals are very sensitive to it in men. While it smoulders and even when it breaks out the intellect may look coolly on. It cannot be undirected, but must always have an object.

For Ribot[3] anger in the offensive form appears early (two months Preyer—ten months Darwin), and in its motor forms is the partial contraction of muscles, which are fully active in combat, involves fascination for the sight of and suffering, and in the depressed form passes over into hate and easily becomes morbid, and even epileptic and maniacal. Irresistible destructive impulses are disaggregated forms of anger, and show gradation separated from each other by imperceptible stages from pleasure in torturing and killing to satisfaction in reading of

[1] Volkmann: Lehrbuch der Psychologie, Vol. II, p. 390.
[2] Evolutionary Psychology of Feeling. Chapter X, p. 127.
[3] Psychology of Emotion. Chapter III. Anger.

imaginary murders in novels, etc. All destructive impulses
are at root one, and heredity and education, environment and
circumstances develop them into determinate, habitual, and
chronic directions. It may increase the ptomaines and cause
auto-intoxication, and in the lower animal forms whose bite
when angry is poisonous, and in human beings modifies the
lacteal secretions of nursing mothers. It is best inhibited by
fear, in some sense its opposite, and best seen in some carnivora.
Steinmetz[1] holds that revenge is a reaction to enhance lowered
self-feeling, and primordially it is not directed against the ag-
gressor, and Ree thinks it a reaction against the feeling of in-
feriority inflicted by another. At first there was no discrimina-
tion, and wrath might be wreaked upon any one, innocent or
guilty. In a later stage, upon this theory, it is less indiscrim-
inate, and some fitness is demanded in the victim, as in cases
of blood feud. Last of all it was found that the wrong doer
himself should bear the punishment. An Indian kicked out
of a store kills a family of pigs; a relative at a funeral cuts
himself "in a fit of revenge against fate" or kills some poor
or defenceless person; the Navajoes, if jealous of their wives,
kill the first person they meet; if one dies from an unknown
cause, a victim is selected by lot, or the friends of the dead man
kill the first person they meet, the bearer of bad news may suf-
fer. All these facts and theories are combated by Westermarck[2]
who urges many cases where carefully directed revenge is exer-
cised by animals. From the very lowest forms anger is aimed
at the cause of the pain. This weapon against injustice and
injury resents aggression by counter aggression, and is thus a
great aid in self-conservation and self-forbearance. Even com-
mon tribal responsibility is a protection against the tendency of
revenge to single out the guilty person. The forms and details
of punishment are often elaborated.

After teaching this subject many years and with increasing
dissatisfaction, I determined to try the questionnaire method
and accordingly, in October, 1894, the first of an annual series
of topical syllabi on Child Study, which have been continued
now for four years, was published on anger and sent to nearly
900 teachers, parents and others in this country and elsewhere.
It was as follows :

The phenomena wanted are variously designated by the following
words: wrath, ire, temper, madness, indignation, sulks, sours, putch-
iness, crossness, choler, grudge, fume, fury, passion, to be or fall out
with.

[1] Ethnologische Studien zur ersten Entwickelung der Strafe.
[2] Mind. N. S. VII, 1898, p. 289.

1. Add any other *terms* or any euphemisms, or phrases you know or can get from children indicating their feelings.

2. Describe every vaso-motor symptom, such as flushing, paling, about forehead, cheeks, nose, neck or elsewhere. Is there horripilation, chill, shudder, tremor, prickly feeling, numbness, choking, twitching, sweating, if so where and how long. Are there any accompanying sensations of color, flushes, taste, smell, noises, (question for each sense). Can blood pressure be tested?

3. Describe all changes of muscle-tension, scowling, grinding teeth, opening lips, setting of eye, clenching fists, position of arms and attitude of body. Is there nausea or a tendency to either contraction or relaxation of sphincter muscles which control anal or urinal passages.

4. Describe overt acts, striking (how, down, straight out, with fist or palm), scratching, biting, kicking. At what part are blows or attacks aimed.

5. What is the degree of *abandon* or loss of self control? Is it complete and is the rage entirely blind, or usually is some restraint shown in intesity of blows or some consideration in the place attacked?

6. Describe long delayed anger, the venting of secret grudges long nursed, and deliberately indulged.

7. Describe intensity curve of quick and slow children.

8. Describe reactions, afterwards physical, mental or moral, whether lassitude, contrition, and all verbal or acted signs of regret.

9. How do children speak of past outbreaks of anger in themselves, and of anger in others, and in general?

10. What treatment have you found good, and what palliatives do irascible children apply to themselves?

In description be photographically objective, exact, minute and copious in detail. Add to all a description of your experience with anger in yourself, and if possible get a few of your adult friends whether good or ill tempered, to write theirs, or organize a little circle of friends, mothers, teachers, neighbors, to talk over the subject and to observe in concert. Above all, get children of different age and temperament to talk confidentially, or better to write their own ideas in response to such questions as tell some things which make you angry; when do you get angry easiest? how do you feel and how act, how check it and how feel afterwards? write cases of others getting angry in detail, and state what you think about it generally.

This is a subject of obviously great importance for moral and even physical education, but there is almost no literature worth reading upon it. It is so vast that it can be best explored by concerted effort. The undersigned desires to investigate the subject and invites you to co-operation by sending him any notes, however incomplete, upon any aspect of the subject. Or, if preferred, you can start with these hints and work out your own data and print your conclusions.

Let us try the concerted method of work and in some way pool its results for the mutual benefit of teachers and for the good of the children we all live for.

In answer to the above questionnaire, a total of 2,184 returns have been received in season to be included in the following report. Miss Lillie A. Williams, of the Trenton (N. J.) Normal School, sent returns from 244 persons, of which 121 were original observations of children, 92 were reminiscences, 28 information received at second hand. Principal E. H. Russell,

of the Worcester (Mass.) Normal School, sent 109 returns; 35 of which were reminiscences, mostly by his pupils and teachers, and 63 were original observations on children. Mrs. Grace B. Sudborough sent 1,016 answers to the questions with opinions upon hyperthetical stories involving anger. From an anonymous source, 147 carefully written but brief essays upon personal experiences with anger were received. Miss Carlisle, of Norwich, Connecticut, sent 95 papers, partly studies by her normal class and partly answers by school children. From California, 65 papers were received; from an unknown source, 59 papers; from Miss Clapperton, of St. George's Training College, Edinburgh, 77; from Miss A. E. Wyckoff, of Brookline, 72 personal papers; from the Springfield Training School, 24 papers; from Dr. F. E. Spaulding, Superintendent J. A. Hancock, Miss Pedrick, Miss Flora J. White, a few papers each; and from Miss Hughes, then of the Cambridge (England) Ladies' College, 31 carefully prepared papers by students, with others from other sources. Besides this, a large list of literary references have been gradually accumulating during the past five years; the subject has been made several times a matter of discussion in my weekly seminary for the comparison of experiences; and I have several times worked over portions of the subject in the form of popular and class lectures. I am under special obligations to Principal M. H. Small, of Passaic, N. J., lately my student, for the compilation of a part of this material and the selection from the mass of material of some of the typical cases.

It need not be repeated, that, as I have already said, in compiling such material, too much caution cannot possibly be exercised. The returns are of all degrees of merit, from extremely good to worthless, and it requires great and constant critical acumen to sift the chaff from the wheat; and the value of the work depends chiefly upon how accurately and thoroughly this is done. The great advantages of this method are also obvious in the data upon this topic, for the range of individual differences is vast and the fecundity of human nature in so diversifying the expressions of this sentiment is perhaps nowhere more apparent and gives constant and often deep interest in reading over the returns. Concerning no subject have I felt more strongly the necessary limitations of individual experience and how absolutely necessary as the basis for any valid psychology of the subject, it is first of all to gather a vast array of facts and cases. This and the necessity of revising current theories upon anger will explain why I introduce so many condensed accounts of concrete cases. This tends to bring psychology back again into the closest contact with a large group of the most vital facts of life and to rescue it from the narrowing and

one-ended influences of theories from which that part of it which treats of the feelings and emotions and which now seems next in order for investigation, is now so gravely afflicted. The aspects of anger are very many sided and complex, but we see here the intensity and bitterness of the struggle for survival in the past by the traces that are left in modern life. So inadequate and partial are the text-book characterizations of it that it seems well to begin a closer look at this most intricate salient group of phenomena as particularly seen in self and others.

A. GENERAL.

1. Scotch, F., 20. When in a real passion a torrent seems to rush through me with terrific force, I tremble violently and feel quite faint. When the storm is not too deep for speech, I say the bitterest things that I can think of, though often aware that I shall repent them afterward. Yet I always want to be by myself, not to listen to reason, but to stamp, beat myself and think or say all sorts of wicked things. Above all I pity myself most intensely and end in a torrent of tears. A most aggravating fact, however, sometimes is that I cannot utter a word, no matter how eloquent I feel I ought to be. The storm within is too furious for speech, although it always ends with rain. The tears are a sign of exhaustion rather than repentance. The fits last a few moments, rarely half an hour, and to give them vent clears the air. By restraining it I feed on it and it lasts and rankles. If my anger is less violent I avoid speaking to the persons or ignore their existence, but my icy silence will melt despite my resolution. It kills love and admiration however.

2. M., 31. My capacity for anger is great and deepens into indignation, scorn and contempt. I can despise in a way impossible before. To think and to say inwardly that my antagonistic is a —— fool vent my feeling, sometimes I pity him and yet know I shall revert to feeling him a fine man. I am usually good natured, but can imagine causes of anger in those I love, but nothing less than their entire annihilation or that of the whole world, including myself, can satisfy. I believe I should have the courage, fatalism, criminality or whatever it be, to follow my impulse of the moment. My capacity for anger has increased with the breadth of my psychic life, but such periods are far rarer and it takes more to rouse it. Now I sometimes feel a sort of pleasure in bad treatment which was expected to enrage me.

3. English, F., 19. When angry I feel all of a sudden burning hot, stifled and compelled to make a noise. I used to strike people, now I strike things. I used to be promptly carried to my room, now I seek seclusion of my own accord. I used to shed tears, now I feel burning and choke till my nose bleeds, then I am better. Sometimes I grow icy cold and feel as if I was all blanc mange inside. This feeling is worse than the heat, for I seem to be a stone. People speak to me but I do not move; question me but I do not answer. They think I am sulky. I am not, but am simply frozen. I awake the next morning with a sense of shame; relief, however, predominates, then I can look at things in the right light and I go around apologizing and setting things right.

4. M., 30. When angry I feel as if my features were distorted, as if it were cowardly not to look the offender straight in the eye as pride impels, although another impulse inclines me to invert my eyes in an embarrassed way. I am conscious of my mouth and do not know

how to hold it, but this gesture makes me feel ashamed and restrained. I do not know how to hold my hands or to stand, but feel conscious of my whole body, want to be left alone, and when I am by myself I relax from this strain, then I seem to go all to pieces. I collapse, flop down all in a heap, suffer chiefly from mortified pride, feel that I could do almost anything rash, but from this state of utter abandon to later self control I get back in time. When angry I never can talk without crying.

5. Scotch, F., 22. I feel when irritable like a volcano liable to burst forth at any unconscious touch. I used to feel on fire inwardly. It is most painful and urges me to break or knock something down. A casual remark or even a most trivial happening increases it. I do not scold or rant but gather up all my force into a few cutting, cruel words. There is always a faint background of knowledge in the very height of the storm, that words remain forever and that the good Lord I profess to follow disapproves; but all these are beaten down and although I know that my words hurt both others and myself, I must utter them. From about 12 to 16 I would do almost anything to wreak vengeance, often striking people. I feel quite capable of killing a person. Even now I sometimes fear I shall do so, although as a rule my rage vents itself more and more inside. The humorous side of my anger often strikes me afterward, and then its sting is removed.

6. A girl of 10 became so angry because detained after school that she lost all control and gave up to a fit of passion. Her face became very pale, then flushed to a dark red, purple spots came and went on her cheeks and forehead, she writhed, twisted, screamed as though in bodily pain, and at times was almost bent double. At other times she would sit still a moment, gasp, shudder as if to choke, and then begin to scream again. She seemed to be sick to her stomach. She never showed any regret. She was once very angry at me and will always dislike me.

7. M., 44. When huffy or in a tantrum, a man I know has a vein in his forehead swell out large; a woman of 60 lengthens her upper lip; a woman of 25 pushes forward both lips; a college girl I know stiffens her under jaw, her eyes grow glassy, she raises her head, walks stiff and erect, talks in a jerky way which she calls sputtering. Hopping mad is a phrase literally correct for some.

8. M., 39. In some, I know, anger makes the face white, the features are set, then a chiselled look will appear beautiful in a way. Others pitch their voice low and speak more slowly and distinctly. The face of one child I know is completely changed. He looks wicked and like an animal. I have several times seen this, it haunts me and I hope I may never see it again. The cause in this case was unjust and ill judged punishment.

9. F., 21. I saw my little wiry music master, a man of 70, thoroughly angry once at my wrong and careless playing He danced all around the room, stamped, shouted, stammered, and left the house unceremoniously. Some friends passed him around the corner rushing and muttering. At his next visit, mother asked him how I was getting on. He said I was doing spendidly and was his favorite pupil, and that he liked to have me give him trouble, because it showed that there was something in me.

10. F., 20. A sensitive, overworked middle aged music teacher, with keen artistic nature, when angered by laziness or conceit in his pupils, becomes extremely and frigidly polite,—by this, by his sarcasm and a slightly strained laugh, his indignation can be detected. Strong as his temper is, he has it under such control that a spectator would not suspect it.

11. M., 31. A most tempery women, I know, with a tremendous.

will, which if crossed makes her talk rapidly and recklessly Her eyes flash and I have known her to kick people and strike them in the face. She seems like a dog run mad. If she really hurts people or they are quite upset, her rage instantly goes, and she is as tender as a mother, but afterwards she has a bilious headace. She often justifies her acts afterwards in cold blood.

12. M., 21. The best case I know is a woman, who overwhelms people with abuse, sometimes flies at them, becomes hysterical and then sulks for days. Once she resented her sister's language and destroyed every present she had ever received from her. She considers her temper a matter of course and seems to make no effort to check it.

13. F., 17. An ugly little Italian girl of 15, with beautiful hair like spun silk, of which she was inordinately vain, flew into a rage terrible to witness when it was towsled, which the girls took delight in doing. She said little but a terrible demon seemed to seize her and drive her into a passion. Every vestige of color left her face, her eyes glittered and her expression was almost inhumanly wicked and cruel. With one quick look at her tormentor, she would spring at her with feline alertness, and generally left distinct marks of nails and teeth. I never saw signs of regret. "It is to be hoped that her face was covered with blessed shame and that humanity suffused with cooling streams that fiery spirit."

14. F., 38. When angry my face grows pale, but dark about the mouth. I feel numb as if my circulation and physical functions had received a shock. The angrier I am the tighter grows the muscle tension everywhere. Every attack of anger is followed by constipation and urinal continence, also lack of appetite, thirst, nausea at the very sight of food, and also an acute bilious attack. Nausea once lasted six months because I had to sit at the table with the object of my anger; no monthly sickness in all that time. It is ten years since, but the sight of that person still brings on a feeling of anger. Of contrition I know nothing.

15. I saw a gypsy man and woman fighting, screaming, and using the most awful threats. They tried to bite, choke, seize each other in all tender parts of the body, and seemed not human but wild beasts.

16. F., 34. A South African girl, if told to do anything, instantly and ostentatiously disobeys, and calls a long string of names. She reminds me of Angelica in the Heavenly Twins; is honest, affectionate, generous, fond of mad pranks, is capable but hates work, and sits for hours doing nothing.

17. Am.; adult; female. "I do not remember getting violently angry but once. A friend of mine spoke unjust words of a neighbor of whom I was fond. I stood it for a few moments, then I commenced to talk. I could not say things sarcastic enough. There was a lump in my throat. My eyes felt as though they were open to their widest extent; my face was cold; breathing rapid; muscles contracted, and my hands were clenched. I scarcely heard anything. In an instant all this passed. The blood began to be pumped up through the arteries in the neck in powerful pulse-beats and my heart seemed to fairly jump. Gradually the muscles relaxed and a feeling of extreme fatigue came on. I could scarcely walk home I trembled so. When I was in my own room the tears flowed copiously. For a time I was almost afraid of myself. That night there seemed to be something pushing me on which I could not understand. I was very tired when this occurred."

18. F., 38. I teach a boy of fine American parentage who, when reprimanded, parts his lips slightly and looks me straight in the eye a little as though he were laughing at me. When I call him he comes, but sets his teeth, bends forward, clenches his fists, tries hard to speak but cannot uttter a word till he cools down and then he stutters,

which he does at no other time, and at length the tears come. He is very bright, excels in study, likes and quotes me on all occasions. He is much worse at home and his mother fears he may become a murderer. He never shows regret.

19. F., 19. A girl friend has a peculiar sneering smile, which curls her lips, and no rebuke or threat can alter her. There is a peculiar contemptuous expression in her eyebrows. Her silence is dogged for days, it is as firm as a rampart against friends or foes. It ends in some burst of defiance and is usually roused by blame. Severity increases it. This disease the poor patient seems to inherit from her father.

20. M., 30. I know a young man of 24 in the West, who is well, strong and sane, whom I have seen repeatedly go to the corner of a ball-room and lie on the floor and pound his head on it and roll from anger, because another man danced with his best girl. He drives cattle and sometimes literally cuts a pig open with his great two-handed hog whip, or rides up to it on his broncho, seizes it by the hind legs and dashes its brains out on the ground. He is generally voted a good fellow, says little and never attacks human beings, but only writhes when angry.

21. F., 24. My former chum was a well-born girl, but without discipline and could never be crossed. If this occurred, she seemed at first astonished and then frozen up with rage. She stood once two hours without moving hands or feet, her head thrown back and a fixed determined look in her eyes.

22. Pure anger makes me creep from head to foot. I never want to have it out with any one or be revenged, but feel haunted and discordant for days. I must be alone, and have my door locked, with no possibility of intrusion, and often pile all the furniture against the door and then sit or lie down to have it out, or perhaps cry myself to sleep.

23. F., 21. When I had once lost control of myself, I wanted to push away everything that happened to be near, to make myself alone, where I could muse on my wrongs and grumble to my heart's content. Whoever happened to come near had to bear the brunt of my growls and hear everything and everybody described in the blackest of colors.

24. Eng., F., 21. In rage some people undergo an entire change, and their eyes grow large and set, the face is rigid, they contract the brows. Some vent it in violent motions, in quiverings of the body, compression of the lips, or bad words.

25. F., 19. I have seen men ordinarily sensible speak with cruel sarcasm and grow absolutely infantile, diffusing bitterness all about, and at the smallest provocation in a game of croquet.

26. A lady of 40 occasionally loses all control. She slaps, dances, says the most cutting things, for she is a woman of remarkable intelligence, but never shows any compunction.

27. My girl when angry is almost insane and acts like one possessed. She attacks anybody, breaks windows. Her second dentition seemed greatly to aggravate her temper.

28. F., 39. A girl of 11 when provoked throws down whatever she has and rushes at her enemy. She is hot, her teeth are clenched, and she usually goes for their hair, and when carried away, she stamps and cries boisterously.

29. M., 22. When maddest I used to sulk, make faces, stamp upstairs, my neck and ears would burn, my teeth grind, my fists clench, and although I felt contrition sometimes, could never show it.

30. M., 29. A girl of 17, humored and sentimentalized can bear no cross to her inordinate conceit. Her anger makes her eyes set and glassy, and she does outrageous things and ends always in sulks with no remorse.

31. Eng., F., 23. Some show temper by being bearish and boorish, others swell up and strut, will say or speak to any one, or give snappy answers. I think that rage makes red people white, dark people browner, and pale people pink. The better the complexion, the greater the change of color.

32. F., 36. I can recall but three violent experiences of anger. I felt pent up and congealed, then the worst of my nature came out. I got dizzy and my head felt very full. I seemed to tremble inwardly.

33. F. 25. Anger makes me hot, sticky and sweaty. I talk fast and loud. In extreme cases only do I completely lose all self control. It always ends in a shower of tears.

34. M., 18. When very mad I used to shut my eyes. There are some people I long to maul unmercifully, also cats, of which I have a most particular hate. The boy I am maddest at has separated me and my best girl, probably forever, and I am laying for him, if I have to hang for it.

35. F., 20. The slightest provocation in the way of getting worsted in games, or being forced to do hated things, made me scarlet and crimson. I still long to break out but something restrains me. I cannot bear to have any one speak to me in this state, and if they do am likely to burst forth in a torrent of tears. My reactions are usually penitence and fatigue.

36. A colored deaf mute, a boy of 15, slow mentally but well developed physically, resents everything, but most of all, allusions to his color. He shakes his fists, his eyes bulge, his upper lip is drawn from his eye teeth, he grows blacker, draws his fingers significantly across his throat, and his gestures and threats are terribly in earnest, but it all goes off in this way and he harms no one.

37. F., 21. There are no special causes or times that put me in a temper, and yet I sometimes have to walk up and down on tip toe or march back and forth in the garden or brace myself to sit still, feel every nerve and muscle stretched to its utmost tension. Sometimes when I am angry at people, I incline to do all the little nasty things I can think of to them, and the more angry I am the more lacerating things occur to me. Sometimes I cannot say these things, but fear that I may do them.

38. One bonnie merry Irish girl has spells of mood, during which she hardly speaks, but her moods are so separate that in one she rarely refers to the others.

39. F., 19. When alone I roll, wriggle and weep, but keep up a kind of philosophizing all the time as to how the object should be treated when we met.

40. F., 23. When my hot and furious temper culminates, I tremble, am cold, and speak out recklessly the first and bitterest things I know.

41. F., 19. A girl I know bursts into a flood of passion and must make a noise in almost any way, then she passes into the sulky state, and it takes a day or two for all to vanish.

42. M., 31. I know an impatient person who first fidgets, nostrils begin to twitch, eyes glare, voice is raised to a crescendo and after the acme there is a diminuendo, as the rage subsides. I know some whose chronic state of mind is sour and nothing is right.

43. Am.; adult; female. When I get very angry my face grows white, and it seems as though a cold hand clutches my heart. I grow faint and dizzy, and see green and black and red all whirling together. My breath grows short and my body gets limp. There is a distressing feeling of nausea. If a person ill treats me further, I rouse up and feed him sand, whereupon these symptoms disappear.

44. A boy of 14, the terror and leader among the inmates of a State reform school, when angry looks the person, officer, superintendent,

or whoever it may be, firmly in the eye, calls him the vilest names, is outrageously profane and attacks them like a mad man.

45. F., 23. If I could not have my own way when I was a child, I would scream and jump up and down. There was no control until I was about 8, when the form of my outbursts became tears and angry words. I had to do something when in a pet if only to rush about.

46. F., 26. My temper takes the form of taking things amiss and not being pleased at anything, am silent and gloomy, with a feeling as if my head was fixed in a vise. This symptom is a warning and the sensations are so painful that I make a desperate effort to keep pleasant.

47. My mother is a most warm hearted and affectionate woman, but when angry says very cruel things, which one does not like to think of. She has not been the same person since my little brother was born, and imagines injury where there is none, and broods over and nurses her wrath to keep it warm. My father too is hasty and like a great child in the way he takes offence, but he does not brood like mother. I have inherited his type.

48. F., 30. I have no feeling and no mercy, but will have my own way and prevent others from having theirs if I can.

A few typical individual outbreaks:

1. A big girl in a country school told me to get up and give her my seat near the fire, and when I refused she sat heavily in my lap. I could not push her off, and soon without willing to do so, found my teeth set pretty deep in her back. How often I have wondered if I did right. The question loomed up into big proportions and haunted me. I thought over and over again, "she was biggest, I had the seat first, what else could I have done," etc. I cannot tell how great this question grew or how it hung like a pall over my life for years.

2. F., 45. Once I was angry with God. It was too dreadful to recall; a sense of helplessness, the futility of reviling or opposing him, and this added to the horror. I was ill and could not hold my peace, but had to look up to the sky and blaspheme. My brother had a similar experience and told me that he felt as if the foot of a giant was on his neck. I told a clergyman, who called, that the Bible was a volume of lies, and God was the worst liar, for he had deceived me all my life. I have repented since and trust I am pardoned.

3. M., 40. Once I was said to have pushed down my brother, who was badly hurt, although in fact I was at the other end of the garden. I would not say I had not done it, and so was kept in bed two days. During this time I read Gulliver with delight, but a strong background feeling of injustice was always associated with this book. I am still angry at every thought of this, although usually I am quick over my tempers.

4. About my last rage was at the age of 13. I was in bed, and my sister was long in undressing, and then left the lamp in the farthest corner for me to put out. We quarreled fifteen minutes; then I put it out, but when I got back to bed, pinched her, when a fight ensued, which resulted in both of us sleeping very uncomfortably at the opposite and cold edges of the bed with a bolster between us.

5. F., 48. In youth I took refuge from the very few crosses of my very guarded life in pride. The first real anger was at the age of 42 at an act of injustice to my son, which stirred me fathoms below all previously known soundings in my nature. Each time that I permitted myself in the sanctity of friendship to discuss the matter, a singularly vile taste would arise in my mouth followed by extreme nausea.

That mighty maternal instinct of protection, which runs through all higher animal creatures, has since then been far more clear to me.

6. F., 41. My older brother teased me until I said I wished he was dead. As soon as I had said this dreadful thing, I was terrified lest a judgment from heaven should fall upon me by causing his death that day. I watched anxiously when he returned from his work and recall my remorse far more distinctly than I do the anger.

7. M., 24. I began a boyish fight which lasted nearly an hour without anger. It ended by my enemy falling and pretending to be dead. I believed he was and felt exultant and perfectly satisfied and happy. Left him lying at the fence corner and went home. Knew I must suffer at the hands of the law, but was fatalistically resigned.

8. F., 46. When I was ill and the doctor came to tell me of my brother's death, I struck him with all my might; and all that is usually grief seemed for the moment turned into anger.

9. F., 24. My last great rage was eight years ago at my brother who hurt my cat. I rushed at him, screamed, thumped him with both fists as hard as I could, then I ran out of the room, cried, felt ashamed, pretended to act as though nothing had happened, and for a long time felt hot and miserable, for my brother kept alluding to the wounds he said he had received.

10 F., 45. A slum boy lately struck me in the face with his fists. My face grew icy cold and all my muscles got tense. I felt my lips white and wanted to hurt him physically. I could have done it, although he was a large boy, and should have done it but for my dignity as a teacher. I wanted to put him on the floor and pound him.

11. M., 37. My present temper is of three sorts—first, actual passion; second, impatience or ire; third, sulks. Of the first I can recall but two instances. One was when my little brother would not stop teasing me to show him something when I was very tired. I broke out in words and was checked by the look in his face. I could have cried as I could at this moment in remembering it. When a friend urges me to do something I abominate, I have several times measured strength with him.

12. M., 23. Once when I was about 13, in an angry fit, I walked out of the house vowing I would never return. It was a beautiful summer day, and I walked far along lovely lanes, till gradually the stillness and beauty calmed and soothed me, and after some hours I returned repentant and almost melted. Since then when angry, I do this if I can, and find it the best cure.

13. F., 43. When about 4 my brother shot an arrow at my candlestick, this made me so mad I ran out of the house and hid under a hay stack, resolving to make him miserable by being lost, and determined to die from starvation.

14. F., 20. I offered a doll to my little niece and when she reached for it, I took it away and told her she could not have it. It worked like a charm, and when she was brought up to the proper pitch, I took the following notes—face very red and swollen, two deep wrinkles between the brows, lips firmly pressed together but later open to their full extent, when she began to scream at the top of her voice. She stamped, kicked, tried to slap me in the face and clenched her fist. Later but not at first the tears came and she sobbed as if her little heart would break. Next time I shall study her laugh which will be a pleasanter task.

I. CAUSES.

The following cases selected and abridged from many are typical and suggest that women have more provocations than

men, but usually practice control better, and how courtesy, respect, sympathy, consideration, kind and fair treatment of others and even of animals may remove many of the incitements to it.

1. F., 20. The painful feeling at the time and the self scorn afterward make angry experiences hard to recall. The chief causes are contradiction, especially if I am right; slights, especially to my parents or friends even more than myself; to have my veracity questioned; the sight of my older brother smoking when we are poor; injustice, dislike or hate from those who fear to speak right out; being tired and out of sorts, etc. In the latter mood the least thing like finding books out of place; loss of step when I am walking with some one; indignity to a poor girl by the teacher; stupidity in people who will not understand—these make me feel as a cat must when stroked the wrong way. Injustice is the worst and its effects last longest. To be distracted at my work; unpleasant manners and books; hunger and cold; to be treated as if I were of no account; flies that will keep lighting or buzzing around me; to stub the toe or have it stepped on; to forget things that I want to remember or to be unable to find things; when my bicycle hits a stone; to have lost a button or have my hair come down; to have a pin come out or my clothes rip; these things make me more petulant.

2. F., 26. People more than things or events arouse my temper and some have far greater power to do so than others. Their mere presence is so irritating that it requires a great effort of control and my aversion is often apparent to others. Life with such persons would be intolerable, and would bring out the worst side of my character. Special causes are narrow mindedness, cruelty to animals, slander, obstinacy in thought and deed, want of sympathy or sometimes a trifle unnoticeable by others, touches the sore spot, times of ill health, being forced to do over what I had done as well as I could before, times of low spirits which with me alternate with high. I pay too much attention to details without grasping the whole, and this makes trifles irritate me. I jump at conclusions and hence am often angry without cause.

3. F., 29. Whatever limits my freedom of action or thought is the strongest stimulus to wrath. I was royally mad at my sister because she did not resent an injury. I can deny myself as much as others can, but cannot endure to have others cross me. I was never madder than when my brother would make a noise, when our mother was ill. My causes are girls talking out loud and distracting me in study hours; to be accused of idleness when I have studied my hardest; blamed for what I did not do or did, or my health being below par. Sometimes when I am happy, I am more easily angered than when melancholy, because in the latter case everything looks gloomy, so that one point more or less makes no difference.

4. English, F., 22. I have a great variety of tempers, especially of the irritable, jealous, sulky violent kinds. The violent kind is caused by injustice to others or extreme flat contradiction, or when my favorite, deepest feelings and will are thwarted. The irritable type comes from smaller stimuli like being kept waiting, being hurried, having my skirt trodden on, density in others, etc. Health also affects it. Jealousy is caused by those I dearly love preferring others. Sulks are due to neglect or injustice or impertinent coldness. All these types except the irritable are more under control than in childhood.

5. F., 20. If accused of doing what I did not, and especially what I abhor, I am so angry that I tell my accuser that she would do the

same. If I am hurrying in the street and others saunter, so that I cannot get by, or a person I like makes fun of me, or when given a seat in church behind a large pillar, I am provoked, and the more helpless I feel the more ungovernable my temper becomes. Opposition enrages me, so does a discordant note in music, especially if repeated.

6. F., 23. My lines have fallen in such pleasant places, that I hardly know how anger feels; yet injustice does rouse ire which I call righteous. Sometimes I take up cudgels in behalf of imaginary sufferers and work myself into a state of passionate fury. In such mental inflammations, epithets and phrases suggest and form themselves with dreadful facility, and I express myself far more easily than at other times. Sarcasm and criticism are such a relief. If people are perfectly unjust, I can treat them indifferently, but if there is a spice of truth in what they say, I am much more angry.

7. M., 34. When despondent the worst thing is to have made up my mind to do something and failed. Being angry at myself, I am consequently so to all who speak to me. Frivolity in others, asking needless questions, attempting to cajole or boot-lick the teachers, rouse me; so does doing what I do not want to when I vent rage by doing it in a slovenly and discouraged way. Self gratification at another's expense, cruelty, being deceived or trapped, or when dignity, self respect or common courtesy are outraged.

8. M., 28. Am often angry with myself caused by my own faults, my jealousy of friends, so that I can rarely rejoice at another's success. This is bad and I fight but cannot overcome it. An over tidy relative always slicking up my things, the necessity for hard cramming for examination, interruptions, being laughed at is perhaps the worst of all. Being asked to give or do things when I am just ready to do so of my own notion, having my school work soiled.

9. M., 19. My causes are being beaten in an argument, when I know I am right, being misunderstood, being kept waiting, and worst of all being told I am stupid and ought to know better, especially if it is true, being accused of cheating at games, although it takes many such little aggravations to bring me to the boiling point.

10. F., 48. In my teens very divergent opinions or beliefs made me angry. I blush, throb, grow stiff, and have a peculiar whirling sensation in the head. If I differ in argument and cannot convince my opponent, or if he says what is false or strained to prove his case, or worst of all jealousy makes me short, sharp, crusty, and pale and savage in looks.

11. F., 22. The causes of my anger are if people act against reason or their better knowledge, or lack moral courage, pandering of all sorts, seeing nobodies patronized, slovenly work, want of system, method and organization, being expected to do things without the means or conditions, sudden emotions and meanness.

12. F., 25. My causes of anger are slowness in others, being kept waiting and expectant, or being slow myself when I want to be quick, when I am angry at myself. Another cause is if others are dense and wooden, if my curiosity is aroused and not satisfied. Perhaps it may all be resolved into my not having my own way.

13. M., 27. I am angry at late risers in my own house, stupidity, disappointment in some fond hope and feeling pushed and hurried. Any kind of reproof is most irritating. To sharply deny people what they want is the best means of arousing their temper.

14. F., 14. My temper is worst when I see a girl put on airs, strut around, talk big and fine. I scut my feet and want to hit her, if she is not too big. Jealousy at hearing others praised as I think unduly as paragons, or having my own nature dissected or discussed, is most irritating to me.

15. F., 22. Aggression toward the weak, stupidity, obstinacy, lying, deceit, and a sense of impurity. A person I neither love or hate would have a hard task to put me in a temper.

16. F., 36. One chief cause of anger and even fear in children would be removed if we did not begin their training with dont's. Sympathetic and positive indications, if wisely administered, cure me.

17. F., 46. When a playmate said her mother was better than mine, I tipped over the table in her house, rushed home, and was so confused that I fell down stairs, was more controlled afterwards.

18. F., 14. If I am made to stop reading a story in the most interesting part to wash dishes or mind the baby, I have to squeeze something very hard or make faces, and sometimes when very mad, I laugh.

19. F., 14. What makes me mad is if I have a bad headache or my brothers and sisters get to fighting, or all turn and plague me when mother is gone. Sometimes I hit and sometimes say a prayer to myself, and try not to mind it.

20. F. With me it is the worst and the commonest cause to feel that I have more to do than I can, to hear gossip about neighbors.

21. F., 29. When tired, I am irritable and fret at little things, and all my life have felt that I was not understood. This causes me to brood. If I am excited from having enjoyed myself very much, then I am easiest angered.

22. F., 31. To be crowded or jostled, told to do something by people who have no right, to see slovenly work, to be ridiculed, spied, tattled about, be detected in wrong doing, is my chief provocative.

23. F., 19. Harping, nagging, gloating over one's own or others' wrongs, rouses me and I give my friends the benefit of my thoughts with a great deal of volubility.

24. F., 29. Term time with regular work is better for temper than vacation when all sorts of things may turn up, and when there is not system, yet some are most irritable when working hardest.

25. F., 30. Tittle-tattle, petty talk and gossips, flat contradiction, interference with my rights or affairs, impertinence, constant interruptions, practical jokes, idiotic laughter or anything unjust.

26. M., 26. The most provoking things to me are real or fancied slights to those near me or myself, for I have great pride which is easily wounded.

27. M., 22. If indigestion, which is a form of irritability, is temper, then I often feel it. I am easiest angered in the morning, but later in the day can face difficulties with far more equanimity.

28. F., 35. My childish tempests of wrath burned hottest when my grandfather used to trim or cut down trees or even shrubs. I told him God made them that way, and he had no right to hurt or change them.

29. F., 20. Teasing I never minded, but rather enjoyed, but to snub or talk down to me in a top-lofty way arouses all my ire.

30. F., 31. If people I care for say unkind things, it hurts me so I seem to turn to stone, and it seems as if I can never love them more. This rankles. I can recognize one distinct type of my threefold temper, which comes from my mother.

31. F., 21. To have to do a great deal of unnecessary work, which my people invent to occupy my holidays, makes me maddest. I speak sharply, and I have reasons, for I am not a naughty girl, who needs to be kept out of mischief.

32. F., 44. When boys use vile language in my presence, I want to smack them across the mouth. Cruelty to objects incapable of resistance and injustice to children rile me intensely.

33. F., 39. Familiarity, which I have not evoked, discussion with those who have not even tried to understand my point of view, to hear

myself talked about or discussed, even by my parents, is insufferable.

34. I am more indignant at what people say than at what they do. When nasty things are said, I lose control of my tongue and must say what comes into my head at the time. I hardly know what I am saying, but it all comes back later.

Spontaneous Anger. I think we must admit that sometimes this really occurs, although it is a very interesting and uncertain question. Prison and other records show that people in confinement sometimes break out into fits of destructive rage with no apparent cause. Of course dislikes may deepen to antipathy and aversion, till not only every act whatever but the very presence of certain individuals may irritate to the point of explosion, and there may be a long summation of petty vexations, but it would seem that our organism is so made that this form of erethic inflammation may reach its fulminating stage without any cause assignable by the subject or observable by others. Sometimes purely imaginary wrongs to imaginary people excite intense moral indignation. If there are spontaneous cases, they cannot be entirely explained by love of this kind of erethic state as such, but may be due to the necessities of growth or over lability of nerve cells or centers. The satisfaction and real physical pleasure too that sometimes follow anger suggests that it has its place in normal development. Running amuck is sometimes described as spontaneous, like rabies. The determination of this question is like the problem whether crying and some movements of infants and animals are reflex or due to purely efferent causes, is at present insoluble nor is it crucial for the Lange-James theory. Platner, as we saw, thought some forms of mania were best characterized as prolonged anger without observable cause, and the Berserk rage it was thought was sometimes unmotivated. Michael Angelo is described as chipping down a block of marble to the rougher outlines in a veritable rage, and I lately read of a man and wife in court for fighting who agreed that they were peaceable and affectionate but had to have a bitter quarrel every few weeks over nothing to clear the air. Play and mock fights often contain a little repressed anger and are good to vent it harmlessly.

1. F., 23. When I was 17 I had a long spell of irritability, was unhappy, and it gave me pleasure and satisfaction to make sarcastic remarks. My weakness is impulsiveness, which makes me unfit for a responsible position. I try to lay good foundations of belief and get more settled feelings for my own determination.

2. M., 41. A girl up to 17 in good health had fits of anger with great regularity; about once a month she was violent and lost all self control. No small vengeance was her desire, but no less than a passionate desire to kill the offender. Hatred shown by looks and gestures was intense, and the fit might last a week.

3. F., 7, whose mother calls her every endearing name, while describing her way of sitting, eating, speaking, etc., suddenly passes

to a rigid state, and she once on recovering from this vented her spite by cutting off all the leaves of a century plant.

4. Girl of 3 was eating lunch, when suddenly, without discernible cause, she cried out, tipped over her milk, rose, threw herself face down upon the floor, screamed, kicked, beat the boards.

5. A boy of 14 was sitting in school dreamily gazing out of the window when suddenly his face clouded, and scowled, and he struck his fist on his slate and broke it. The loud noise and the teacher and the school brought him to himself. He could give no explanation except that he felt mad and must strike something.

6. M., 31. When a schoolboy I was a great fighter and if I had not had a battle for some weeks was literally spoiling for a fight. Once I went to the barn and pounded a poor cow chained in her stall for relief. Teasing and bullying used to relieve it. I sometimes pounded a rock behind the corn-house with a sledge hammer.

7. M., 25. Anger often helped me out in my work. In chopping wood, mowing, and other things requiring great effort, I could scarcely help gritting my teeth and getting mad with the object. I used often to find myself helped on by anger at sums, knotty translations, etc.

8. M., 37. (Once assistant physician in a lunatic asylum.) I knew an epileptic case where the patient, a colored man of perhaps 25, had fits that seemed to be nothing but spells of blind rage. He would attack every one, destroy everything and injure himself till he became unconscious. He felt the symptom beforehand and was put in a padded cell.

Personal Antipathies Based on Physical Forms and Features.
While these dislikes sometimes are intense enough to generate anger, their chief effect is to raise the anger point, so that a far slighter stimulus is necessary to produce the explosion than in the case of those who instinctively attract each other. From very copious collections of questionnaire material for a very different purpose, it appears that children and young people are very prone to detect resemblances to animals in faces, and often see persons whose features suggest the monkey, dog, parrot, pig, cat, mule, sheep, rabbit, owl, fox, lion, etc., and therefore become objects of special aversion. In another series, prominent or deep set eyes, shortness of stature, cowlicks, ears that stand out, too prominent chin, brows that meet, large feet, high cheek bones, pug nose, Adam's apple, long nose, small chin, prominent, large, dirty or otherwise exceptional teeth, pimples, red hair, light eyes, thick lips, a stub thumb, bad breath, bleary eyes, freckles, fatness, leanness, birth marks, deformities, are features any one of which may evoke immediate antagonism and put the mind in a critical attitude, so that with reference to persons possessing these peculiarities irritability exists side by side with great good temper for those who are physically attractive. Girls in particular often single out some one peculiarity with respect to which they are especially sensitized, and in some cases are provoked to active hate in a way that suggests the converse of the fetishism common among sexual perverts. It is difficult often even for the subject to

analyze the cause of these repulsions and they are sometimes quite unconscious and instinctive.

F., 21. I am a great person to take likes and dislikes; and if the latter, can see no good points in the person. I often judge wrongly and sometimes can conquer my aversion, but it often recurs.

F., 22. My little brother is like me in taking unaccountable aversion to things and persons, especially the former, *e. g.*, a new suit. I have an insupportable aversion to share my room with certain people with whom I like to go around with well enough, so too I cannot see sick people without anger, unless I love them passionately.

F., 19. I believe some persons have elements about them that tend to always keep others bad and others in a temper. The more I like people, the more it takes to make me angry at them; and the better my health, the stronger must be the provocation. Examinations make me spiteful toward the very rooms where they are held, and here some of my worst scenes with Apollyon have occurred. Generally I can stand any amount of banter, but sometimes a little brings a storm on some luckless head.

Based on Peculiar Acts or Automatisms. In this list we have snuffling, lisping, making faces, swallowing, rolling the eyes, peculiarities of voice, accent, intonation, inflection, sighing, shrugging, the kind of smile or laugh, motions of the head and arms, gait in walking, posture and carriage, hiccough, stammering, and bad manners generally.

Dress and Ornament. Ear rings in men to 130 women out of 679, are objects of intense and very special abhorrence. Thumb rings, bangs, frizzes, short hair in women, hat on one side, baldness, too much style or jewelry, single eye glass, flashy ties, heavy watch chains, many rings, necklaces, and a long list in this class show how dominant unconscious forces are in mediating dislike, which in some souls needs little intensification to settle into permanent hate. Not a few young women state that they could never lead happy married lives with the possessors of these peculiarities, no matter how many good traits of body and mind atoned for them, and the presence of persons possessing them is described as a constant source of irritation, sufficient in itself to spoil the temper. Special aversions of this kind must, of course, be the results of considerable development due to frequent or continued exposure, and it is plain that in some cases the antipathy is created by association with other disagreeable qualities. It would be interesting to know, what our data do not show, whether these traits are conspicuously present or absent in those who detest them, for it might throw light upon the question whether similar or complimentary characteristics repel or attract.

Habits. Another class of instinctive aversions for which some minds develop sore, irritable spots, are certain habits like smoking, eating onions and garlic, untidiness in dress or toilet, want of punctuality in rising, meals, engagements, etc., too

rapid or too slow movements, gossip, cowardice, too great bash-
fulness or familiarity, lying, stupidity or density, selfishness,
cruelty to animals, injury to flowers, trees, property, etc., mean-
ness, flattery, affectation, disorderliness, too great primness and
preciseness, excessive poise and reserve or deliberation, imposi-
tion, laziness, pandering, criticism, cheating in games, and
bragging. While individual experience in many cases exposes
individuals more to one of the above chologenetic agencies than
to others, there are undoubted indications of a tendency to
rutty specialization here, so that if education may be defined,
as I suggest it may, in part, as learning to be most angry with
those things that most deserve it and maintaining a true per-
spective down the scale, most of our correspondents are not
thus educated, and we have here another example of the *res
augusta domi* of the mind for which heredity may in part ac-
count, but not wholly. The above miscellaneous qualities
might be classified as æsthetic and moral. The deliverances
of conscience and a good taste are, however, here particularly
interrelated. Righteous indignation at unethical acts shades
by imperceptible gradations into the milder verdict of bad taste,
but even the latter is not without significance as a predisposing
cause of anger.

Limitations of Freedom. Liberty is a precious possession and
sedulously guarded by instinct. It is the indispensable condition
of the completest and most all sided growth, and cannot be
too carefully cherished. In an atmosphere of repression and
of *dont's*, temper usually suffers, while one of the best cures
of habitual anger is liberty, and complete occupation is often
a preventive to it.

The Thwarting of Expectation or Purpose. When a story
breaks off at the most interesting point and the mind is left in
suspense, or when children are called away from stories just
before the dénouement or games before the crisis, when they
are kept waiting or if curiosity is especially aroused, or they
are fooled and deceived, which is one common form of teasing,
or if adults fail to realize the plans of their youth, the anger
diathesis is called into play. In fact science, which is prevision,
and consists largely in eliminating shock or the unexpected,
has as one of its functions the reduction of this chologenetic
factor. Sudden fright, the blocking of a path or doorway by
an obstacle, the stubbing of the toe or running into a post, are
perhaps physical analogues of the same thing. We might
laugh in some states, if Spencer's theory of a descending in-
congruity is correct, but we are more likely to be indignant.

Contradiction. Akin to the above cause is that of meeting
opposition of our sentiments or ideas. Even when very differ-
ent views are encountered in friends, especially if they are per-

sistently maintained, as well as when the direct lie is given, the conflict of mind, will or feeling arises, which may evoke the anger erethism. There are paranoiacs to whom not only the thought but the very word conflict[1] or even discussion excites painful symptoms, while the interest in a vigorous altercation or debate, although less than in a slugging match, is very great.

Invasion or Repression of the Self. Each personality hedges itself about with certain limits which, however widely they may vary for friends and enemies, are more or less fixed for each acquaintance or each mood. While many complain of not being understood, a frequent excitant of anger is being too well known. Hence, prominent among the assigned causes are being spied upon, tattled of, gossiped about, criticised, dissected, analyzed, detected or even reproved. One form of plaguing is to penetrate with undue familiarity, like nicknames, the adytum of selfhood, and mocking and ridicule find part of their effectiveness here. Here, too, belong most forms of impudence from our inferiors and insults from our equals.

Pride and a certain amount of self respect is one of the most irrepressible qualities of our nature, so that slights, contumelies and undue subjection or subordination, even slight wounds of vanity that are inflicted by ostentatious disregard of opinions, are keenly resented.

Injustice. Not only cruelty to animals or persons taking unfair advantage, but injustice to self, like being accused of deeds or words that are abhorred, abuse of friends, heroes, favorite authors, and in rare cases imaginary indignities to imaginary sufferers, are chologenetic.

Individual Causes of a Special Nature. Some describe with considerable detail not only as special provocatives but as causes of distinct deterioration of temper, frequent experiences like finding books, utensils, tools, etc., out of place, persistent attacks of flies and mosquitoes, the perversity of walking with those who will not keep step or habitually lose it themselves, of having the toe or dress stepped on, of being jolted in a vehicle, crowded or turning out the same way in meeting others in the street, or even being touched by strangers, having the hair come down or out of order, the approach of a dog or cat, etc., busy work, being given too much to do, taunts, meanness. Indeed most have sore points or anger zones which may be based on individual weaknesses, or on peculiarities of form or action, or on special experiences of provocation.

Jealousy. Jealousy in seeing others preferred by teachers,

[1] See the interesting case described by Dr. E. Cowles. Persistent and Fixed Ideas. *Am. Jour. of Psychology*, I, p. 222.

friends, acquaintances, or hearing them praised, may cause not only intense misery but angry outbursts.

SUBJECTIVE VARIATIONS.

Among these the changes from the general feeling of euphoria and well being connected with good health, which is the best preventive of anger, down to illness and pain, which are its surest promoters, are most important. Some forms of disease and early convalescence are particularly characterized by irascibility, and children who are in abounding health have, other things being equal, perhaps the best immunity from temper. Closely connected with this is the state of rest or fatigue. In the morning after a long vacation, provocation is, as every one knows, far less easy than in the state of exhaustion. Hunger and sleepiness, too, incline to anger, and satiety to good temper. The optimum of temperature helps the disposition, while excessive heat and cold make it fragile. Dentition and menstruation are very important sources of variation of the anger point, which from all these considerations seems to be even more fluctuating than has been supposed. General prosperity and a sense of doing well and getting on in the world, as contrasted with ill fortune and calamity, makes for exemption from anger, as does a general good conscience, settled and tranquil religious opinions, good friends, an optimistic philosophy, sufficient but not too much work or occupation, and in general absence or removal of all the chronic causes of frettiness. The states of irritable weakness and hysteria are characterized by fluctuating moods, *e. g.*:

Heredity. On general principles it would seem that a diathesis so marked should be as hereditary as anything in our psychophysic organism. While our data are far too few for inference, it would seem that inheritance has here a wide scope.

F., 39. My father was never even hasty, but my mother was of a cranky, tempery family. I am for months and for occasionally years, sweet and placid as my father, and then without provocation I have spells of great irritability like my mother's people.

Eng., F., 11. My aunt who brought me up has given me her quick temper. It came by contagion and I think not by heredity.

Eng., F., 18. My father is the calmest and most placid of men. My mother one of the most fiery of women. I am all mother in this respect.

Eng., F., 20. A young man of 20 I have known from childhood inherits great irritability which can brook no restraint, who suffers to the point of tears from wounded pride, can bear no teasing or reproof, directly from his maternal grandfather. It seemed to lie dormant for a generation.

Eng., F., 23. My mother is very irritable. Her father had a whirlwind temper and five of us seven children have it, and in two it seems quite absent.

Scotch, F., 26. One brother, one second cousin, and one maternal

ancestor are very hot tempered like me, the rest have more or less escaped.

Absence of Temper. Some seem born untempered, nothing flusters or ruffles them. They are passive, easy, lazy, inert, apathetic, and while often imposed upon are generally liked, rarely teased or abused. Such cases usually lack not only energy, but the power of enthusiasm and capacity for erethic states generally. Too good a temper not only precludes from the luxury of intense forms of manifesting life, but is usually associated with a certain insensibility, lack of self respect, ambition and will power.

F., 39. My provoking good temper has been my life-long reproach. I fear it is, as I am often told, apathy, for I am easy going in matters in which I should take more interest. Then, too, my shyness keeps me from showing what I feel deeply.

F., 21. I am by nature rather unimpassionate and indifferent, have little temper or impulsiveness and rarely get enthusiastic. I do not consider this a virtue, but it is not because I am too lazy to show temper.

F., 28. In good health and happy circumstances, I have yet to see a sour spirited child. I think it would be possible to rear many children in such a way that they would have no experience of anger.

F., 29. I know a girl who never in the world could by any possibility be roused to temper. Her temperament was so inert, she says she cannot get up anger when she knows she ought to. A world of such people, I think, would be very monotonous.

F., 27. I often liken myself to a happy, clear, busy, sparkling brook, rarely interrupted by any one stirring the mud at the bottom. I can be roused, however, and the time before normal conditions recur depends upon the depth to which the mud was stirred.

F., 18. I know a girl of very hot temper, who when provoked does not give way, simply and solely because she is too lazy to take the trouble. It fatigues her to control herself.

Teasing and the Cry and Anger Points. Hectoring, plaguing, baiting, worrying and tormenting in all their many forms are largely, though not wholly, motivated by what might be called the psychological impulse to see what another will do under these new conditions of strain or temptation. A German student told me he never felt acquainted with a new man enough to know whether he liked or disliked him, until he had seen him more or less intoxicated. This sentiment is very wide spread, and is akin to Plato's suggestion that counsellors should discuss topics at night, when drunk, and decide them in the morning, when sober; so for many anger removes masks, and what Nordau calls the conventional lies are thrown off and we seem to see the lower strata of what a person really is at bottom alone, or in the dark. Repulsive instincts and habits manifest themselves better sometimes to the common acquaintanceships of years. Temper is tested in many forms of hazing, fagging, etc., to see if the victim will retaliate, how much

provocation is necessary to bring him to that point and what form the reaction takes. If peculiarities of body, dress or manner are salient, these are likely to be sore chologenetic points of attack. Girls who blush easily or are so ticklish that even a pointed finger sets them off, have red hair or even deformities, are particularly tempting to constitutional teasers, who are usually, though not always, cooler and better tempered than their victims. These experiences are really very often educative and develop control in the victim, although sometimes exactly the reverse is true, and tempers may be thus spoiled. Teasers with a strong propensity for practical jokes, playing April fools, etc., who are usually older and stronger, often profess and sometimes really have the purpose of teaching control. When anger is once roused, the goal with some is attained. More commonly, ridicule is then applied which intensifies the rage, and other methods of fanning it to its utmost often give the keenest enjoyment to the provoker. This peculiar pleasure in witnessing manifestations of anger is partly due to a sense of superiority of poise, and no doubt partly to pleasure in witnessing primitive psychological forms of expression, while the factor of cruelty and sport with a victim in one's power is probably the strongest motive of all. The tormentor chuckles, his eyes sparkle with delight, he claps his hands, dances, jumps up and down, rubs his hands, slaps his leg, points his finger, taunts, jeers, yells, calls it fun, and all this tends to egg on the victim to extremes, the memory of which is well calculated to cause regret, mortification, and the resolve for better control next time.[1]

With the cry point, no less variable than the anger point, the case is very different. The tormentor often stops short at this point, and sometimes the mood reverts to pity, sympathy, and regret. This is especially the case if the cry is one of collapse, surrender or real grief, with no impotent anger in it; but the aggravation may be pushed still further with accusations of babyishness in quest of a deeper lying and later reaction, and particularly a boy that has no fight in him is despised.

II. Physical Manifestations of Anger.

Upon this topic our returns are fullest and have been carefully tabulated and compiled with the following general results:

Vaso-motor Disturbances. Eighty-seven per cent. of the best cases describe flushing, and twenty-seven per cent. describe pallor as one characteristic of anger. The heart is often immediately affected and sometimes with very painful cardiac sensations.

[1] See Burk: Teasing and Bullying. *Pedagogical Seminary*, Vol. IV, p. 336.

It pounds and bounds, there is a feeling of compression, and the literature elsewhere referred to describes several cases of death from cardiac lesion thus caused. Occasionally some pulsation is felt sometimes painfully in a particular part of the body. In one case in the palm of the hand, another specifies the wrist. In many cases severe headaches with rhythmic intensifications for each pulsation are caused by the general disturbance of vascular tonicity. One woman describes the enlargement and pulsation of the temporal artery as the sign by which she best recognizes temper in her husband and describes a peculiar whirling sensation in the head. Stigmatization over a large V shaped area in the forehead occurs in one case, the face may become mottled, certain local pains sometimes sharp, which attend anger, seem thus best explained as does the dizziness and faintness often mentioned. The nose grows red or blue in one case, the eye balls are blood shot, and erethism of the breasts or sexual parts may occur. In one case the first sign of anger is nose bleed, and if it is copious the anger fit is less violent. Menstruation may be arrested, sometimes suddenly, and other psychic weather signs indicate a more or less intensive vaso-motor storm.

Secretions. The glands are no doubt far more closely connected with psyche than has hitherto been supposed, and we shall have no doubt ere long a glandular psychology. Of course the most common secretion is that of tears, which are specified in about 35 per cent. of the returns. Tears may be shed when other symptoms of crying are repressed. Salivation is not only more copious, although in later stages of a long rage it may be repressed till the mouth is described as "bricky dry," but perhaps its quality may be modified from the stomach or otherwise, since in some cases a bad taste is characteristic of anger. Its effect upon mammary secretions in nursing women is very marked, sometimes by way of almost total and sudden suppression, often by some modification of the quality of the milk, so that the infant is made ill. Urinal secretion is often affected rarely by way of suppression, but is commonly more copious, paler and with less deposits. Popularly anger is thought to be closely associated with the liver, and a bilious temperament is supposed to be peculiarly irascible. In not less than a score of cases, attacks called bilious are ascribed as the direct effect of anger. No less frequent results are constipation and diarrhœa, which may at least belong in part here. There is no case in our returns that suggests any modification of the action of sebaceous glands, but in two cases a rash, once said to be all over the body, follows every fit of anger in a child; and in the case of one male sexual secretion attends every violent outbreak. It would be very interesting to know how common this

is, and a collection of facts here might throw valuable light upon Sadism and Marrochism. Sweating may be copious in cases where increased muscular action fails to account for it. Whatever may be true of other emotions, some of which we know to be closely associated with glandular action, there can be no doubt of the relation here.

Salivation, Swallowing and Nausea. The act of swallowing somewhat like that of winking is normally repeated at brief but varying intervals through the waking hours. Just how much is due to the summated stimulus of accumulating saliva and how much to the constantly increasing lability of the nervous center involved it is impossible to determine. Of these two factors, however, there is abundant reason to believe that each is independently variable. Many returns specify swallowing, often several times in succession, as one concomitant of the early stage of anger. Occasionally the impulse to swallow is strong but is inhibited, and gagging, lump in the throat, and temporary paralysis are described. This beginning of the peristaltic action that forces food through the many feet of the alimentary tract is, of course, far more under control than the latter stages. The will delivers the bolus of food to the back of the mouth, whence it is taken in charge and propelled by the more reflex mechanism. In carnivora the attack and slaughter of prey is the normal prelude to eating it, and like salivation this movement may be a residuum of an ancient association without assuming any earlier canibalistic stage. The question is how far the momentum of this paleo-psychic association enters into the psychoses of anger, which has as its tap root the quite different impulse of defense and resistance. That it enters, I think there can be no doubt.

Nausea with anti-peristaltic symptoms more commonly occurs near the end or in the reactionary stage of an anger fit, and sometimes acts as the chief inhibitory motive to the impulse to swallow. Its cause here seems to be mainly the fatigue from over excitement or exertion, any form of which may cause it. There seems reason for raising the query, whether these two contradictory functions are so related that if the first is overdone without sufficient stimulus, incipient nausea arises in a compensatory way. If one swallows as frequently and as long as possible without eating and when in the normal state, incipient nausea arises. Swallowing is the act of appropriating the material on which life is made, and nausea means the repulsion or even the regurgitation of it, so that its symbolic significance is great and has been well exploited in both language and in æsthetics.

Spilling. In common with other secretions, salivation is often increased in anger, sometimes as would appear with, and

sometimes without, chewing or biting movements. In some of our cases the saliva is copious and runs from the mouth upon the clothes in a profuse and offensive way, and in three cases it is described as frothing at the mouth, and in one as white froth. In the acme of the stress and strain of fighting, this is puffed or blown, sometimes it would appear purposively and at other times unconsciously, upon the clothes or in the face of the opponent. Just what all this phenomena involves is difficult to determine, but it would appear that at least in some cases the drooling in anger is partly due to temporary and partial paralysis of the lips and perhaps of deglutition. Local exhaustion may be carried so far that it would be no more possible to spit than to whistle. To associate the salivation of anger with primitive anticipation of savory food in such cases may seem a long cry, and yet it is not theoretically impossible. In creatures that kill their prey, especially if it is large and involves an erethism like anger, this association may have been established by very long and inveterate experience. Spitting proper begins consciously with what might be described as a t–p movement by slightly protruding the tongue, drawing it in rapidly between the lips and projecting its load of saliva by a slight explosion of air compressed in the mouth after the tongue has been withdrawn and before the lips have closed. Children in the second and third year learn and sometimes practice this. This movement has apparently little utility for the child and is essentially a sign of aggression. It requires much delicacy and co-ordination of labio-lingual movements, and would probably be impossible in a creature less highly endowed with articulatory capacity. It is therefore of special interest. Another mode of spitting, which appears to be later, is what might be called the p–t movement, in a sense the reverse of the preceding. It consists in thrusting out the saliva with the tongue with much breath pressure after the manner common among tobacco chewers. This movement is more difficult and is often practiced with unpleasant results. From the age of four or five years on to near puberty, spitting may be a prominent expression of anger. At first it commonly seems directed toward the face, then towards the shoes, clothes, hands, seat, etc. Contests are described among expert spitters, both as to greater distance and greater accuracy. The victor in a fight sometimes spits in the eyes, hair, mouth, etc., of his prostrate enemy. The folk-lore upon this subject is very voluminous and pertains to the number of times one spits ceremonially upon given occasions, the place, direction, etc. It is, of course, one of the most extreme expressions of contempt and excites correspondingly intense repugnance. Saliva, of course, is a very effective medium of contagion, but the extreme abhor-

rence of the act when contrasted with the attractiveness of kissing, which often involves exchange of saliva and may be contagious, is hard to explain. Of course we have no adequate evidence of sufficiently venomous ancestors of man to sustain an argument that this horror is a toned down fear of virus-bearing sputa. The most that can be said is that there is no positive disproof of it and that the possibility is open. That even the bite of normal man or his progenitors is poisonous to another member of his own species, is unknown. The other possibility is that this abhorrence has some of its roots in long accumulated experience of contagion of morbific germs through saliva without dermal rupture, and that we have here an instinctive prophylaxis against contagion, which has given the folk-lore its character and form.

Respiration. Modifications of breathing are among the marked accompaniments of anger. Sometimes deep inhalation, often through the nose with clenched lips, perhaps several times repeated, as the need of increased oxidization deepens ; sometimes rapid breathing, which may be through the mouth, and give the effect of panting and occasionally almost gasping, is described. Stutterousness, almost suggesting a snort, purring, snoring, choking, gagging, and sobbing noises that almost suggest hysterical globus—all these cannot adequately be accounted for by increased muscular activity. Whether the type of respiration changes from abdominal to pectoral or conversely, and what the form of the respiratory curves through a fit of repressed anger are, it would be interesting to investigate. Amphibian life requires periods of deep and rapid breathing, alternating with longer periods of rest, and it is not impossible that the preparatory stage of anger symptoms is analogous in some cases to preparation for a long dive with violent exercise.

Noises. In twenty-eight young children screaming is more or less fully described as the most characteristic expression of anger. Crying is a language all its own, and as it develops in the first year or two of life the mother or nurse readily distinguishes the cry of hunger, fatigue, wetness, pain, etc., but none is more characteristic than that of anger, which is loud, sharp and generally sustained. A little older children develop sometimes very characteristic snarls, growls, grumbles, whoops, bellows, chatters, bleats, grunts, barks, or noises that sometimes consciously, or more characteristically unconsciously, suggest the cries of animals. Later, occasionally, specific words of warning, threat, defiance, or specific oaths become habitual and characteristic of rising temper. In some children anger brings on a fit of stuttering or a peculiar tremor or staccato, or speech may be interrupted by a noise suggesting a

sob. In older people the voice is perhaps the most sensitive of all the registers of anger. It is loud, shrill or harsh, with variously modified rhythms. Later yet control and repression may develop a peculiarly slow, calm, low, precise utterance which is with difficulty, and not without considerable acquaintance, recognized as a danger signal. One woman almost whispers, with little phonation, but very intense labio-lingual expression, and unwonted relations of these two elements of speech are common. Many become exceedingly voluble, irrepressible and almost eloquent, while some are glum and monosyllabic. Not infrequent is the habit of soliloquy, and many seek solitude in order to find, perhaps in monologue and perhaps in other forms of loud vocalization, the readiest vent for passion. One woman is conscious of no modification of voice in anger except a slight tendency to be hoarse afterward, even when she has not spoken. Perhaps a dozen well-described cases cannot speak or make a noise, but are vocally paralyzed or they cannot speak without crying. Theories of the origin of language like those of Noire postulate a very close connection between the intense muscular tension and loud phonation. The characteristic cry of epilepsy shows the same, as does the battle cries of various savage races. College yells at athletic contests are toned-down cries of defiance.

The close association between anger and noise is seen in many ways. Some stamp, walk with heavy or with shuffling steps, must pound something with a stick or with the fist, or beat a loud tattoo with the fingers or feet. One young woman goes by herself and slams a particular door ; a girl pounds the gutter with a stone ; a boy throws stones against the loose boards of the barn or against the resonant surface of a large sugar pan. Several work off their anger by playing or even pounding the piano. The gratification in these cases appears to be not solely from making, but also from hearing a loud noise.

Involuntary Movements. Of these there is a long list, many of which fall under other captions. Changes of muscle tonus are seen in the changes of the voice elsewhere noted, and in the relaxation or, less often, the tonic contraction of the sphincters, which causes escape or retention of the excreta. Horripilation is sometimes described, the skin becomes rough, and shuddery, creepy, crawly sensations occur. In one case twitching of the skin on the right leg, in one upon the shoulder, and often tonic or clonic or choreic movements of the face and fingers are described. The relation of voluntary to the involuntary activities, which is always a variable one, suffers in anger, and the disturbance and the readjustment is best seen in weak persons with strong temper after it is over, in which

arterial and cardiac tension, respiratory rhythms, etc., are modified.

Attitudes and Postures. In anger the body often becomes more or less stiff and rigid, is drawn up to its full height, sometimes with an attitude of pride that suggests strutting, the legs are placed apart when standing, and all the antagonistic muscles are tensed up, so that there is a great expenditure of energy, sometimes with very little activity, along with which goes a feeling of great strength, a difficulty of making correct or quick movements which may otherwise be normal, and which reacts sometimes into the stage of collapse later. Some habitually assume a characteristic attitude when angry, usually erect. Two seek to place the back against a wall, post, or other firm background. Two are impelled to sit and eighteen to lie down, mostly upon the face, and perhaps to roll, writhe, squirm or wriggle. One must throw herself into a chair sideways, in a particular manner, with feet drawn up. The arms are more commonly held down by the sides with slight pronation or supination movements, with fists clenched; sometimes one or both hands are placed against the breast. One young man always thrusts one hand into his coat and the other into his pocket, and probably a large number of more or less characteristic positions could be collected.

Butting and Pounding the Head. Many infants when angry and powerless to hurt others, strike their heads against doors, posts, walls of houses, and sometimes on the floor. In this gesture the head may be struck so sharply as to cause pain and crying, but more often it is pounded several times with a violence which would in a normal condition cause weeping but does not now. In some children bruises and discoloration lasting for days results. Occasionally in older children headaches seem to be thus caused. This expression of anger rarely outlasts early childhood, but sometimes persists into adult years, as in one striking case elsewhere in our returns of a young man who habitually pounded his head on the floor when his best girl danced with another. Sometimes the head is struck violently with the fist and quite often, not only in infancy but in boyish fights, butting is a mode of aggression. Some boys love to butt and attain great ability. One is described as running a rod at full tilt and injuring a companion dangerously in the stomach. Another boy practiced butting hard objects to attain virtuoship. Blows with the head are often described as sideways; the forehead or particularly the corner of the forehead, being the point of contact. This is interesting when we reflect on the number of horned species in the human pedigree. Why should man hook like a cow or butt like a sheep or hammer with his head, and that, too, when the skull is thin and elastic,

and the brain so delicate an organ? Surely there is nothing in the present human environment to adequately explain why such an experience, which undoubtedly causes more or less of a shock, can give satisfaction or relief in anger save on the general theory that it demands augmented motor and sensory experiences. Early vertebrates, both aquatic and terrestrial move head first, and there is thus a long ancestral experience of removing obstacles and breaking way through the water with the head. That there is some relation between these manifestations of anger and previous phyletic experience, I think can at least not be denied. In children incipient anger often manifests itself by the threatening sideway nod which very clearly suggests danger and seems to be the residuum of an older mode of going at things. In anger the head is often thrown down and the eyes partly closed as if in preparation, and square nodding in front, especially if repeated and with accompanying pressure of the lips, is a threat. When the fore extremities were engaged in locomotion or otherwise, the head played a more important role in aggression than in bipeds. Often in children we have the opposite anger gesture, instead of going at things head first the head is thrown back out of reach and out of the way of attack. Several boys, however, in our returns seem to be proud proficients in having skulls unusually thick with which they hammer the heads of their more tender opponents, until they cry for mercy; whereas others particularly dread combats lest this part of the organism should be injured.

An occasional expression of anger is stamping upon the toes or feet of the opponent or upon other parts of his body, when he is down. This is sometimes done with the heel and with great cruelty and deliberation. One boy injured for life two fingers of his adversary in this way. Stamping perhaps really begins in the foot movements of infants before they can walk, who angrily kick out with the sole of the foot against persons, the wall or any other object. In older children to stamp the ground or floor is an admonition always to be heeded, for it is a menace of starting to go at the adversary. In many savage dances stamping the ground, sometimes with bare feet and with great force, is an expression of annihilating an imaginary foe. Sheep, some birds, and other animals do the same. In only one case does the child make a movement described as pawing to get at an antagonist; but the writer remembers a case in his boyhood where this was carried to a marked extent, although probably in imitation of bulls. Stamping suggests having the enemy under foot and thus complete triumph. A vigorous up and down movement can tread out life very effectively. Our returns show that soon after learning to walk,

children vent anger thus first with no reference to an adversary, but later looking or pointing to him and thus launching a threat, where often an attack would not be ventured. The first seems quite automatic and unconscious, possibly the noise itself may have been one factor. When there is no alternation but with one foot and repeated, the gesture surely has some unique significance.

Making Faces. Violent anger often distorts the features, both by engorgement of blood and changing muscle tension. Often this is described in the returns as bringing out strange, perhaps repulsive and even animal traits and resemblances, and it may extend to nearly every part and feature of the face, modifying its natural hue, bring out veins and wrinkles, and occasionally unilateral modifications. Not infrequently the subject is painfully conscious of looking unusual and of having strange facial sensations, and this and the instinctive corrective impulse often aggravate the difficulty. Although there is very great individual difference in this respect, the face sometimes betrays sentiments almost as delicately as the voice. Many facial movements, too, are unconscious. In early childhood the very common vent of anger is consciously making faces. Our returns do not permit reliable statistical inferences concerning the frequency of the different types of contortion. Opening the mouth and protruding and often moving the tongue, especially out and in, turning the end of it up to show the under side, running it down toward the chin, flattening it, wagging it sideways—are specified and suggest contempt and perhaps insult. Drawing back the upper and the under lip to show the teeth, especially pouting or protruding the lips, stretching the mouth laterally as far as possible, drawing down its corners, projecting the under lip and more rarely the upper one, twisting the jaw sideways, projecting the lower one, drawing in one or both lips, opening and shutting the mouth, sometimes in a gnashing way, a special kind of nasal sneer, and other movements hard to describe that suggest very repulsive smells, tastes, perhaps to the point of nausea, and movements that suggest the threat of biting, occur. The upper part of the face, is on the whole, less involved, and vast as the individual differences are in facial mobility, they are greatest of all for the forehead. Some have little power to raise the eyebrows or produce longitudinal wrinkles above them, and perhaps still less power to frown with vertical wrinkles, and fewer yet can produce both at once. There is less unilateral power of movement in the upper part of the face. The eyes may be open very wide, emphatic and frequent winking makes them flash and sometimes they are nearly or quite closed, but more often rolled up, down or sideways, to show the white. Some

children become almost virtuosos in making faces and this propensity seems to culminate shortly before the dawn of adolescence. The number of combinations of all the possible movements here is vast, and one cannot look over the literature upon the subject without being impressed with the fact that Darwin, Duchanne and the Delsarteans have as yet barely entered this interesting field. Head positions and movements are another factor which serves to bring out the effect, and children often use the fingers to intensify eye and mouth distortion, while gestures and noises aid to set them in relief. Interest in facial expression is deep and instinctive. All children study the face and especially the eye as an index of feeling and disposition, and the variously toned fear and pleasure in them suggest the strange passion of savages for masks as seen in their dances, many of which even introduce marked animal features. Pleasant expressions of the face are habitual for happy moods and for friends, and the principle seems to be that the degree of departure from one's best expression indicates the degree of dislike. Many facial expressions are no doubt directly intended to strike terror, but others are suggestive of various degrees of repulsion. Reverence and respect have their own characteristic physiognomy, while contempt even parodies or else seeks the contrary of it by the law of opposition. Very deep seated is the instinct of fear at very unusual expressions of face in those we know.

Biting. Sixty-eight females, forty-eight males. From our returns it would appear that this anger act culminates a few years before puberty and has perhaps a slight and brief increment at its dawn. Very young children, soon after the appearance of the first teeth which are small and sharp, not only try them on all sorts of things but in anger can make a painful impression upon fingers, nipples, skin, etc. Some children run up to an enemy, inflict a quick hard bite, and retreat with no other aggressive act. Others bite firmly and hold on with tenacity, and fewer in our returns chew what is bitten in anger. In their fights, biting often plays an important role with children. In a few cases children bite their doll, the foot or tail of dog or cat, sometimes the place to take hold is chosen with deliberation, and the grip is so firm that it is with difficulty that it is released. We have records of idiots that seek to tear flesh in their rage. In many a brawl in the lower classes, noses, lips, ears are chewed, and occasionally bitten off and other damage is inflicted elsewhere with the teeth. I once saw a man in a cheap show who earned his living by killing rats with his teeth in a small pen, with no aid from his arms. He seized and shook them near the back of the neck and was rarely bitten himself. In the sex aberration of masochism, biting

sometimes plays an important and even a dangerous role in the organism. The biting of anger shades off into gripping and grinding the teeth, which is so long a manifestation of it even in adults, connected with the act of retracting the lips to show them. Sometimes one method of control of anger is to bite the tongue or lips till they bleed, or to grate the teeth. A Baltimore murderer, under sentence of death, once told me that if he had had a little stick of wood, which he always carried in his vest pocket to bite when he was angry, he would not have inflicted the fatal blow for which he was to die. Of course the jaws in man are degenerating from the size and strength they had in his prognathic ancestors and in his rodent or carniverous relatives in the ancestral line, but just as his type of dentition is composite, so this function seems made up of factors from both ruminants and carnivora now almost inextricably mixed. A large, strong jaw still suggests firmness and a small one weakness of character, and in children as in adults, there are the greatest individual differences here. Some seem made to perform the gymnastic feats of sustaining their whole weight, lifting or swinging heavy objects by the teeth alone. Both the first and second teeth often pull unusually hard and we may have here the basis for a position in what may be called dental psychosis. A distinction is repeatedly noticed in our returns between the square, even biting of young children and the more dangerous side grip, which is preferred when the eye teeth appear. Our returns do not suggest whether the biting of anger shows an increment at this stage of development.

Two things seem certain. First, that even modern civilized man has more or less adjustment between dental structure and function, the latter being proportionately less than the former. The passion of children for biting sticks, chalk, rubber, pencils, slates, chewing gum, etc., suggests that the biting of anger may be intensified by the fact that this function is declining and is both vented and mitigated by such activities. If man ever approximates an edentate stage with less mandibular power it will no doubt coincide with modification in this respect. The other suggestion which I venture is while the sneer, the *spasmus cynnicus* of pathology, may no doubt be gestures which are relics of dental attack, the kiss seems to have a very significant and opposite function. Its meaning seems to be that where danger once was greatest, when we reflect that the maws of their enemies have been the grave of most species, that now not only a truce but complete trust, and even pleasure, reign. One feeble-minded child is described as making the gesture to kiss, but when the lips were presented set his teeth firmly into and almost through them, and, in the

opinion of the reporter, actually sucking with pleasure the blood that flowed.

In adults the mouth often twitches, the lips are white, pressed or cold, and in the reaction the teeth often chatter. In 650 well-described cases, grating the teeth is mentioned in 27 per cent.; showing them in 21, quivering lip in 18, compressed in 11, pouting in 9. Some describe a peculiar "mouth-consciousness," others chew the tongue or inner wall of the cheek, swallow, choke, cannot speak, etc. Such expressions as " Would like to devour," " feel like eating, tearing, rending, crushing," occur with dental experience. Whether these are the last vaso-motor or involuntary automatic residues of what was once a fully unfolded carnivorous psychoses we can only conjecture. M. D. Conway, in his demonology, describes the devils or ex-gods of most primitive peoples as having for their chief characteristic capacious maws and dreadful mouths, with great, sharp and cruel fangs. The marks of many dances and ceremonies of the North American aborigines [1] are thus distinguished, and the instinctive fear of big teeth, so characteristic of infants is a psychic indorsement of the same fact.

Scratching. This is mentioned in 142 cases as a characteristic expression of anger, and is described more or less fully as habitual in the cases of thirty-eight males and eighteen females. The age at which it is most common is from two to nine years; and at fourteen, judging from our meager data, it entirely stops in males and is greatly reduced in females. While boys predominate in early childhood, the proportion is apparently reversed in adolescents and adults, women with their conservative organism then predominating. Instead of being clenched, the fingers are hooked rigidly and the movement is from the elbow and more from the shoulder, and from up downward. The point of attack is generally the face, more often the eye, although neck, hands, arms, and even the clothes are often scratched. In several cases anger at dolls, animals, inanimate objects and even self are expressed by scratching. One child lacerates her own face when angry. Two scratch the paint off doors and articles of furniture against which their rage is excited. Several have inflicted serious laceration upon younger children and infants, but in most cases the favorite point of attack seems to center about the eye itself, into which it sometimes seems a strong childish instinct to stick a finger. Our data give no indications that there is here any trace of an old instinct to attack the throat or any covered parts of the body. Occasionally in anger the hands are so tightly clenched

[1] In My Study of Fears. *Amer. Jour. of Psychology*, Vol. VIII. note, p. 312.

that, either with design or incidentally, the nails are forced
into the palms. It would almost seem that some children have
a love of scratching the skin as a motor activity independently
of the sensation of stimulus or relief of itching along the
afferent tracts. In the felidæ and in other animals, both in
and near the conjectured line of human evolution where claws
are best developed in structure and function, these movements
seem among the first group to be acquired, especially by the
forelegs after and superposed upon their locomotor functions.
These movements are more specialized and accessory than
walking, and among the climbers have a great but very dif-
ferent role. This may be set down as one of the first uses, then,
not merely of the digits, especially of the pentadactyl hand,
and this psychic co-ordination with dental function is close.
The infant's finger nail is much sharper than the adults, is
more curved, and hence has more sustained rigidity, while the
skin of infants is thinner and more tender. Hence the greater
effectiveness of this mode of attack. Very interesting are the
few cases in which scratching is not mentioned, but in which
one of the marked signs of anger which our correspondents
describe in themselves is the purpling of the flesh under the
finger nails. Interesting, too, are four cases where in anger a
shudder which suggests scratching a file, rusty saw, or some
other object, is provocative of incipient horripilation or some
nervous spasm. This function is so co-ordinated with struc-
ture that careful and regular cutting of the nails may reduce
it, as does the enforced wearing of gloves or artificial tips
where the habit is abnormally strong. Some people shudder
whenever they hear a noise that suggests scratching hard
objects or the earth, and the very thought of scratching a
brick or stone causes ''sinking'' symptoms of a very marked
nature in F. 18. Long after this habit has passed away, many
people describe as a symptom of anger the feeling that they
would like to tear the flesh of the offending person. Again,
some children cultivate long nails, less for use than for orna-
mentation, as several Oriental religious sects make it a sin to
cut the nails, even if they penetrate the hand. Nails have
sometimes an important industrial use in occupations requiring
fineness and exactness. A few barefoot boys are described as
scratching the antagonist with their feet. Civilization has so
long required trimmed and shortened nails that it is possible
that this has had an effect upon their reduction. The habit of
biting the nails to the quick has very likely a kindred psychic
origin with the impulse to trim them. Very curious is the
survival in some of our cases, particularly females, of habitu-
ally trimming the nails to a point more or less sharp or obtuse.
How many modern industries that involve scratching, like

movements such as writing, have any relation with any such ancient function, it is impossible to tell.

Pinching and Pulling. This culminates relatively late in childhood and continues at least to maturity, and probably through life. The strength of the opposing thumb must become well developed before it can be effective. Small children pinch the skin, often without bringing the nails to bear; the ear and nose are thus attacked and pulled. The arm is often thus made black and blue; the back of the neck is seized and pinched till the victim obeys the command to say "Shakespeare" or some other words, or to do some ordered and unusually humiliating act. Strangulation is sometimes thus attempted and the sexual organs may be thus assailed. Along with this action often goes pulling and shaking, indeed infants often pull hair and beard before they learn to oppose the thumb, and the difficulty of disentangling these from the baby's grip suggests arboreal life, in which the young thus hold to the shaggy sides of their parents as they moved among the tree tops, an act which natural selection has developed by eliminating those that let go and fall. While the child rarely shakes an object grasped with its teeth, objects clenched with the hands are often shaken. Both ears are grasped and the head violently pulled, twisted and shaken. One or both arms are thus used as handles by which to shake the body, so that the pain may be either in the pinch, in the pull, or in the shake. Where nails are used, the flesh may be dented, bruised or occasionally cut, and two instances are cited where poisoning is believed to have been thus conveyed by bacteria under the finger nails. The ears are sometimes permanently mutilated or distorted in this way, and far more serious is the injury, and once the death, reported from "Abelarding." In some conflicts handfuls of flesh from the breasts or any other part of the body are clutched and grave internal injury done. In one case, hair is said to have been pulled out by the roots and the scalp torn. In two descriptions of a fight, the tongue was thus attacked. In one case, the mouth was forced open for this purpose, and Mantegazza tells us that it has been thus torn out and the lips and the alae of the nose torn. In some forms of fighting the antagonists seek to pinch the fingers of their opponents, and particularly to twist and double them up to the point of dislocation. Sometimes any part of the body is grasped for a hold as one would grasp the clothes or through them. The variety of tortures possible in this way is great, and all must have been developed since the hand acquired its biped strength and dexterity. Not only folk-lore, but popular tradition, describes hand power developed to such an extent that by a single favorable grip an enemy has been disemboweled.

Kicking. This we distinguish from stamping as a lateral movement at right angles to it. It begins later, is far more common, and lasts through life. In most children the movement is front, but in some the stroke is backwards with the heel when it is more downward. The front stroke must discriminate very carefully if the foot is unarmed with a shoe where the blow is applied, for if it were a hard place in the antagonist's body the agent suffers more than the patient. Hence, the abdomen or the posteriors are common points of attack, the latter particularly permits the infliction of greater force and the blow has less danger. With shoes or boots any part of the body can be attacked, and the injury and danger is far greater. Some oriental forms of wrestling might be described as almost solely made up of tripping and kicking, where the arms and hands have nothing to do. I once saw two boys fight solely by trying to scratch with the feet. Heavy foot gear makes this expression of anger almost approximate in prominence that which it holds among some of the ungulata. One object is here often to overthrow the adversary and is peculiar perhaps to bipeds, who have assumed the erect position and for whom balancing upon a few square inches of foot surface with the center of gravity so high above, is quite a feat of equilibrium, and makes a fall often dangerous and an upright position always a little precarious. The usual strong forward kick as, *e. g.*, in football, and which is susceptible of a good deal of culture, is a mode of aggression which must have been originated however distinctly after the erect position had given the posterior limbs their strength and weight. It, like many other primitive modes of anger, has an extremely rich symbolic and metaphorical philology.

Hugging, Striking and Throwing. Young children often vent anger by hugging, and it is especially common among girls. The offending person or even animal is thus punished. As an aggressive method, this movement may become very effective and makes for strangling, the compression of crushing, and bones, joints and tendons may suffer thus.

Anger, however, is essentially repulsive and the gesture of pushing away is more common. From the latter, it would seem from such data as are at hand, striking evolved. The first blow in infants is a literally repulsive or standing off gesture. Although animals kick, butt, and strike with paws, etc., man might almost be called in a peculiar sense, the striking animal. His blows, although at first, perhaps, scratching movements, and at any rate more likely to be from above downward, change later into slaps, and last of all comes the straight out blow with the fist. This can, as pugilism shows, be made exceedingly effective with the unarmed hand. The skill and

dexterity in choosing the place and time of a blow, throwing the whole momentum of the body into it, to say nothing of foreseeing and warding off the blows of the adversary, make the development of this very human mode of attack susceptible of great perfection, and constitute the charm of slugging and mauling contests according to fixed rules, which eliminate forms of onslaught phyletically lower.

With the use of weapons began a new era. Even a stone or stick gives greatly increased efficiency and adds to the danger. Clubs, axes, spears, and a great variety of savage implements of warfare enhance many fold the dangers of conflicts and have prompted the invention of shields and other defensive and protective implements. It would seem from our knowledge of apes to be well established that they can use clubs and stones at least for certain purposes, but it is doubtful if these have ever been a factor in their combats.

Throwing introduces yet another development from the striking out blow. A missile is propelled far beyond the reach of the body, and bows, guns, etc., have made this the most effective, as it is the last, mode of offensive warfare.

We have space for but a few cases.

1. M. Fits of anger are plain in a child 7 months. She holds her breath a moment, seems expectant, grows red in the forehead and cheeks, straightens out stiff and rigid, trembles, chokes, and laughs merrily.

2. M., 8 months. Throws himself on his back, lies rigid and still, but yells at the top of his voice.

3. M., 15 months. Strikes himself savagely in the face, pounds his head but never any one else, spits at us and cries "Go way."

4. M., 2. Was set down hard on a chair for disobeying. He grew pale, then red, sweat profusely, made mouths as though trying to talk, but his teeth chattered. I only saw this once and am sure it has not occurred within the past fifteen months.

5. F., 26. A boy of 3 began to bite when in a temper. He always bites and kicks, throws anything and flushes.

6. F., 21. A 3 year old girl of violent temper, once punished by being kept home from a ride, broke out in sobs that appeared uncontrollable. Suddenly she stopped short and calmly asked if papa was in. Being told no, and realizing that there was no possible restraint from that quarter, she resumed her sobs

7. Eng., F., 41. I know a boy of from 3 to 5 who had marked relaxation of all the sphincter muscles when angry.

8. F., 41. A delicate boy from 3 to 5, when angry, flushes all over his face, neck and ears. Anger so completely absorbs him that once he was undressed during a mad spell and did not know it.

9. F., 4. Prayed one night for the hired men. The next day one of them, a disagreeable tobacco user, kissed her; that night she prayed unctiously, "God bless papa, mamma, etc., but dear God, damn Mr.——."

10. M., 4. In a tempest of sudden anger strikes any one in the face with all his might. This he used to do when he was a year old, but in a moment he wanted to kiss.

11. Papa told M. to sit down. It was his evening play hour. He

drew himself up, looked his father full in the face and said "you dasshopper" three times, and then obeyed.

12. M., 4. In a passion has a blind rage, has thrown forks and knives at people, broken dinner plates and glass, etc.

13. F., 5. Is usually bubbling over with fun, but when crossed, rules the household, which has a terror of her tantrums. She screams, rolls on the floor, sticks out her tongue, turns up her nose, and takes it out in making up all manner of horrid faces.

14. Eng., F., 28. Children I have observed stand perfectly still, open the mouth wide, and begin to scream. Later they dance wildly, brandish the arms and hit anybody. Others lie on the floor and roll, pound their heads, roar, sit and rock; others bite and scratch; tears are a sign that the repentant mood has begun to react.

15. F., 19. Some children I have seen turn white or red, howl, strike blindly. Boys control their feelings far less. A little boy lay in the mud and screamed because I would not buy him candy. I had to pick him up and carry him home yelling.

16. F., 41. A little girl in a pet first seems pleased with herself and looks to her companions for admiration. She shakes herself, settles into stolid sulks, which sometimes last two days, then cries, relents, and is extra good.

17. Two little boys were set down to write, but there was only one pencil, which was given to the elder. The younger flushed, flashed, and said "Do you fink I can write wid my finger like God?"

18. F., 31. A little girl constitutionally obstinate, when in a temper would grow red as a turkey cock about face and neck, which would seem to swell with anger. Her eyes filled with tears, but she never cried. She readily asked forgiveness and never bore ill will. When people are slow, she wriggles, writhes, bites her lips, snatches your work, and wants to do it herself.

19. A girl of 6, who has ambition as her ruling passion, is most enraged by her jealousy. If she is excelled in writing, she will try to sponge out the work of others, and to scratch them, lie down in the grass and kick and cry, because she cannot jump as high as her mates.

20. M., 28. My temper was so dreadful that I did not mind what it cost, it must have way. As a child I would scream, kick, rush at things and throw objects in the fire or out of doors, if my plans were frustrated. To put me to bed disturbed the whole house, so that my nurse usually gave way to me. Every point I scored made me worse, I was often wild and utterly unreasonable.

21. F., 19. A sweet little girl of 6 I know has outbreaks of passion, that seem to pass beyond control, when she stands and howls quite unconscious of everything. When it is all over she often cannot recall the cause of her temper. The only thing that helped her was diversion or some soothing action, like stroking her hand. When it is all over she seems to have forgotten both it and the cause.

22. F., 28. When I am inwardly impelled to say unpleasant things to people, I tremble, am short of breath, my teeth chatter, and often have a pain in my stomach, which causes sudden diarrhœa.

23. M., 28. When angry for sometime I twitch painfully in the palm of my left hand and also in the veins of my left wrist. In both these instances the pain is very much like the shock from a strong battery. It seems as if the blood was trying to get out of the small vessels causing them to stretch and snap back with violence.

24. Eng., F., 27. I know a child who has fearful fits of temper, after which a rash breaks out all over her body. Once she rushed into a tub of cold water with all her clothes on.

25. F., 19. When angry with the cat I used to squeeze it tight,

pull its tail, stroke it the wrong way, put my finger in its eye, and through childhood my anger generally vented itself by hugging.

26. F., 22. I literally boil. The angrier I am, the more compressed and internal it gets and the more silent I become. If I speak, I cry. My intellect is confused or rather does not move under the pressure put upon it. If I thoroughly start crying, the fit wears itself out, but if the cause requires action, I can stop crying. The effort to deliberate sets my mind flying.

27. F., 23. When I am angry I feel as if a demon was inside me tearing me to pieces, and if it must come out before I can be happy. Commonly it is vented in vicious little speeches, and deeds, aimed not particularly at the object which caused it, but at every one and everything. I take a sort of pleasing misery in contemplating the pain I inflict.

28. F., 29. Some children are white with rage, but more are crimson. They pinch, bite, scratch, and stiffen themselves. One little girl is so rigid that she can be picked up by her waistband, and held perfectly horizontal in the air. The sulky kind that hold temper is the worst.

29. M., 34. Symptoms of anger as I have seen them suggest the etymology of the word, which means compression of the neck, strangling, etc. This expresses my experience of it better than the words, spleen, vexation, ire, wrath, rage, resentment, malice, hate, indignation or any others.

30. I know people who change color, contort the face and even body. The hands clench, the muscles stiffen, the eyes flash and flame, the voice changes its pitch, time and quality. Some strut and other children dance, fall, butt, etc.

III. Anger at Inanimate and Insentient Objects. Vents.

Every one is familiar with the disposition to kick the stone against which one inadvertently stubbed a toe, to pound or even kick a door against which we have hit the head between our groping hands in the dark, and our returns abound in cases of pens angrily broken because they would not write, brushes and pencils thrown that did not work well, buttonholes and clothes torn, mirrors smashed, slates broken, paper crushed, toys destroyed, knives, shoes, books thrown or injured, etc. These violent reactions by which often the individual is himself injured, and in several cases seriously, occur not only in children but in adult and cultivated men and women. A man finding that the blossoms of a favorite and much nurtured pear tree were blasted for the third time, hacked it and barked it in a fit of rage, until it had to be cut down. A man of over forty fell over a roll of barbed wire at night, and the next day threw the whole into a bonfire and dumped it in a fish pond with much satisfaction. A farmer laying a stone wall found the stones so round and smooth, that they slipped down several times, and in a fit of anger, as he says, and not to split them into better shapes, he mauled them till he was tired with a sledge hammer. In one case described at length, a young car-

penter injured many times and even spoiled his own expensive
tools, because he was so clumsy and inexpert that they would
not work right; and the destruction of one's own or others'
property by this impulse is frequently recorded. A few cases
are appended.

1. F., 20. When a door will not stay latched, my little brother of
6 bangs it very hard several times, sometimes kicks, strikes, and even
butts it.
2. F., 19. Boy of 4 grew often angry with his blocks, kicked and
threw them, saying every time "Take that and that."
3. M., 19. I once fell on a large stone and hurt myself badly and
vowed I would smash that stone sometime. Some weeks passed be-
fore I got a stone hammer, broke it to pieces, and threw the fragments
in a fire.
4. M., 25. If when cracking nuts or driving a nail, I hurt my
finger, I am so mad I have to smash something instantly with the
hammer. Once my boot, which had been wet over night, was so stiff
in the morning I could not get it on. In rage I pounded it well with
my hammer.
5. M., 9. Pinched his finger in the door. Cried a while, then
stopped and kicked the door, hurt his foot, cried again, kicked it again
less intensely, scolded it and dared it to hurt him again.
6. F., 20. My brother M., 5, became angry with his drum and
broke it into pieces. He fell on his rubber skates aged 7 and broke
them both.
7. F., 18. I have vented anger on nearly all my toys, and could
not keep them long if they were destructible. When angry I often
drum with my fingers, tap my feet or if alone pound and stamp around.
8. F., 16. If I cannot play my exercises right, I pound the keys.
If my sums go wrong, I throw and sometimes break my slate. I have
torn books, cloth that I could not cut right, and smashed wood and
sometimes bang the tools in the manual training room.
9. M., 17. When I could not learn something in my lessons, I
used to sling the book across the room. My toys have suffered a good
deal.
10. A boy of 8 cut himself with a knife, threw it in rage against a
stone, and finally broke it with another.
11. A boy of 4 hits every large object against which he hurts him-
self, and throws all smaller ones.
12. M., 28. As a boy if I spoiled what I was whittling, I would
throw or smash it if I could.
13. M., 18. When I used to bump my head, I wished with all my
soul that I could make the thing I hit suffer for it.
14. F., 19. When angry I used to kick rocking chairs. This made
them rock and this made me more angry, because they seemed alive.

Such things are often done with a kind of lurking, nascent
self pity, sometimes with a trace of self contempt, but more
often with a bottom feeling of the humorous absurdity of it all.
Where pain is caused, such reactions serve as a vent, but on
the whole we seem to have here a momentary lapse back to a
primitive animistic stage of psychic evolution in which the
distinction between the things that have life and feeling and
those that lack both was not established. At any rate our or-
ganism acts as if the offending brick, stubble or tool was capable

of feeling the effect of our resentment. This very strange group of phenomena can only be partially explained by urging that most causes of pain are animate objects, and that it is a second thought or long circuit reflection that does not have time to act, that this particular cause is lifeless; while the preponderance of the direct vent upon the object, as well as introspection in such cases, shows that it is not a case of stimulus and undirected reaction.

Vents. Besides the direct action upon the cause of the offence, very many indirect ways of working off anger are common, and this is often the beginning of control.

1. M., 24. Biting my lips until they ache and bleed is far more effective as a restraint for me than the puerile method of counting ten. Music helps me and if I can get at a piano, I can play off my rage. My aunt knits off her temper, and a cousin always plays Schumann's Schlummerlied, so that when we hear that we know she is angry, but will soon be pleasant. If a piano is not at hand, she suffers greatly.

2. F., Once I was so angry that I could not sleep until I got up, wrote the person a most violent letter, venting all my rage, and then tearing it up in the middle of the night. Then I went back to bed and slept sweetly. Girls, I think, are more angry, stay so longer, and do not forgive an injury as soon as boys. This is particularly true of girls from 12 to 15.

3. F., 24. I am reputed good tempered, but this is false, for I can fume and seethe within, when outwardly I am perfectly calm. I have a habit of giving inner vent to my anger by thinking cutting remarks; this relieves me, while the object of my indignation never suspects it.

4. F., 22. When my feelings are injured, I have now learned to be able to turn aside to something else. I cannot always do it, but this checks most outbreaks. I can often hold myself to my study.

5. M., 31. A cultivated lady of 25, wife of a well-known university professor, is sometimes so angry that she goes into the back shed and chops wood furiously, and says that something far worse would happen if she was denied this vent.

6. F., 23. When angry I used to pick up stones and throw them at something hard. The throwing relieved me some, but if they broke, the relief was much greater.

7. F., 9. Vents anger upon her hat and particularly her coat. Has sometimes broken things on the table in a pet, and in her tantrums is liable to seize almost anything anywhere.

8. F., 19. My youngest sister gets maddest if she cannot find things. She always pounds something. Her motto seems to be "Pound if not found."

9. F., 27. When I have been very angry I have just stood and pinched myself and bit my finger until I screamed. I used to want to tear something.

10. F., 16. When I am very angry or feel it coming on, I want to run to a particular place and pound the tin gutters for relief.

11. M., 10. Used always if possible to vent his anger upon stones; F., 7, on doors; M., 11, on bees.

12. F., 18. My anger is generally vented on my clothes. I go up stairs into my room and sling them around and sometimes dance on them.

13. American; Adult; Female. When violently angry would grind

her teeth, walk back and forth between two rooms so as to slam the door. Sometimes she would take a pillow and shake it until exhausted.

14. I always used to fly to the piano, or get my pet kitten to comfort me when I found my temper rising.

15. M., 26. I know a woman with a bad temper who when exasperated plays the piano or sings to herself, which latter is considered by her friends as a danger signal.

16. F., 28. When I was a girl and got angry, I used to shake my hair all over my face and make wry faces. It was very easy for me to speak out and tell very disagreeable truths. When trying hard not to talk, I play scales; and when very angry, octaves. To repress rage makes it far worse than to blurt it out.

17. I know a child who always relieves her ill temper by kicking a particular post. Her eyes are half shut and afterwards she shakes.

18. A nervous boy of 8 several times a day gets so angry he throws himself on the ground and screams as if he were being killed. He is growing thin and I think his temper will wear him out.

19 F., 27. For three years I had a pupil, nice in many ways, but addicted sometimes to say things quietly that nearly drove me mad. I always restrained myself, but once found that I had broken a new pencil that I had in my hand short off in my efforts to control.

10. M., 27. When slightly angry I can best let off my feelings harmlessly by swearing. If madder I feel like knocking out part of my wrath, and make awful vows of vengeance which I do not live up to.

21. F., 32. I can now generally control my naturally strong temper. I think volumes, but say nothing. It would be a luxury to wreak myself upon expression, but I refrain from prudential reasons. I know people would pay me back. I try to feel benevolently towards all, to make allowances when I feel injustice, to switch off my anger into a sort of philosophical indifference. Sometimes I get relief by working it off in an imaginary scene with the offender. My opponent says severe things and I answer still more severely, but always go off complete victor. This appeases rage, although I inwardly laugh at and despise myself, while giving this triumphant scene. I have invented an instrument of slight torture which I apply to myself, but which I shall not tell. It has helped me much. A plain two minute talk once by my older brother helped me.

22. F., 44. I get some relief occasionally by prancing about and ejaculating, especially if my heart thumps and my head aches too much. Sometimes I write a letter or even an essay on the subject, and then put it into the waste paper basket, and it has served its purpose of giving outward expression to inner wrath. If all anger has to be checked and I have to attend to conventionality, I sometimes have one of my fainting spells.

A man I know saws and chops wood in the cellar, some pound stones, children break toys, pinch themselves pound their own heads, bite their fingers, one child jumps into cold water, some tear their clothes, one must tear something, anything, one pounds the gutter pipe, another shakes a pillow, one bites a coin, several play the piano, one kicks a post, one pulls her hair over her face, some sing, take it out in imagining extreme retaliations, in inventing instruments of torture, in imaginary dialogues, fights, or other scenes in which the opponent is put at a great disadvantage. Profanity is a very common

vent, and many people have curious forms of expression, some comic, while in others it is simply round, honest swearing never heard at any other time. Scathing remarks are shouted, whispered, or perhaps merely thought. Some mutter, others walk it off, etc. This varies all the way from slight divergence from the object to something connected with it by some law of association or even utterly unrelated to almost inversion, as where excessive kindness or politeness to the enemy is the only effect observed. In some cases certain automatic movements like tapping, rocking, etc., sewer off the tension harmlessly. Just how far the pent-up energy of anger can be metamorphosed from malignant to benignant work is an interesting and practical problem for pedagogy, as well as for psychology. If education could transmute and utilize for good this great power, turning the wrath of man to praise, a great service would be done. The fact that some vents tend to become stereotyped and almost like a kind of ritual of rage suggests much plasticity, while the general fact that plenty of exercise and work, physical or even mental, provided it be not excessive, directly tends to lessen irascibility is full of suggestion in this respect.

Vents are resultants of two impulses more or less contradictory, one to react directly against the offending object and the other to struggle to inhibit that reaction. The consequence is increased psycho-physic tension and diversion to another point of escape, as a horse paws if it cannot go. Complete control would not be suppression, but arrest of all forms of expression for the rising pressure. Allbut thinks that what he calls tension, somewhat in this sense, is one of the chief psychometric criterions by which to measure both sanity and brain power. To check all vents of strong indignation would be, according to the current theories of the physical basis of emotion, to annihilate it, for if these are correct rage cannot exist without at least heightened tonicity and blood pressure, etc. These latter then, if necessary concomitants, are not vents, and control would be conceived as restricting it to these more involuntary tensions and preventing overt acts.

Change with Age. While infants scream, stiffen, hold the breath, strike, scratch themselves, chatter, kick, sob, throw, roll, etc., age almost always brings repression of these manifestations and increased control. The adult, instead of being impudent, may become sarcastic; instead of dancing up and down, may walk with heavy tread to and fro; instead of shouting, may talk to himself and use his tongue instead of fists; and while peevishness and irritability are less, remorse, reason, reflection, toleration of offences become dominant. As the mind grows there is more space for subjective expenditure of energy, and to think unutterable things that are not uttered

or to put into words the rising tide of indignation. It takes
longer for an attack to reach its apex and it subsides more
gradually; the effects are often less in the somatic and
more in the psychic sphere; while the fact that the home,
school, church and state repress by their various rules
and methods the grosser manifestations of wrath, tend to
make it rise to forms of expression that are more sanctioned
because more refined. Conscience in some becomes a helpful
deterrent, which is reinforced by religion. Physical causes are
less frequent, while a larger area is exposed to psychic causes,
and while capacity for anger often grows with strength and
years, its frequency is generally greatly diminished. At ado-
lescence it especially becomes more inward, while a new set of
causes becomes operative. In old age temper may become
serene and sweet, but if otherwise, anger grows impotent and
often contemptible in its manifestations as its characteristic
expressions become more limited and stereotyped. Middle life
is the period when, if once thoroughly aroused, it can be most
destructive, not only physically but in the world of worths.
But this is the age of most intense preoccupation, most
exhausting work for body and mind, hence on the whole,
because other interests are so absorbing, of greatest immunity.
A certain choleric vein gives zest and force to all acts, and
increased manifestation of temper is one of the signs of weak
wills and decaying intellectual powers.

1. M., 19. I used to abandon myself to anger, but since the age of 14
I have lived in circumstances which absolutely require self-control.
I have grown to philosophize more before letting go, and can sometimes
stop long enough to reflect whether I am really right or wrong. The
dominant thought is the effect of the acts. As a child I used to feel
that I could not act or squeal loud enough, and often wanted to kill
the offender. Temper, I think, first shows itself in acts and then in
words.

2. F., 31. As a child I must have been a perfect spitfire and would
fight, kick and strike like a little animal, and must have been as soul-
less as Undine. Another little girl as bad as I fought with me, and
we sometimes tore each other's hair for ten minutes. I usually came
off with a great deal of triumph. About 11, chiefly under the influ-
ence of an older girl, I began to unfold a little heart and soul, and to
realize that life was a little more than self-feeling and self-pleasing,
when my childish temper quite disappeared.

3. F., 20. In the morning before I am fully awake, my temper is
most ticklish. I am slow, but when thwarted and fully roused I am
so transported with rage that I can neither move nor speak. If I can
strike or throw something, my feelings are relieved as if a thunder-
storm cleared the air. I end with passionate crying. Now, when I
am beginning to feel these inner convulsions, I can control them
better, and my remorse afterwards is deeper than it was in childhood.

4. F., 21. I find it unexpectedly hard to analyze my temper. It is
bad, and I fight it constantly. When I feel myself going, I have
forced myself to read of the crucifixion of Christ. At first I was
unmoved, but soon tears came and I was all right. The old feeling of

fighting myself, as real as if with fists, has passed away. As a child I used to roll, to kick, and once bit my tongue. I now talk into myself. I still have the feeling that we have a right to stand up sometimes on our dignity, but still know that we should have more love and trust toward our fellow beings. I have a real sense of union with unseen powers and try to feel a oneness with the human race; and when I can, this helps me greatly.

5. F. I have diligently cultivated my natural bad temper, so as to give it the hasty, fiery form instead of the sulky one.

6. F., 21. I think I take offence quicker, but control it easier than when young. I feel temper to be childish and due to a slow, weak will.

7. F., 21. My temper has changed little since childhood. Perhaps it was then quicker and for different reasons, but not getting what I wanted has always been the chief provocative.

8. F., 22. From 12 to 16 my temper was so bad that my mother was in despair. Now the worst outbreaks have about ceased.

9. M. My temper is greatly improved since childhood. I am still quick to wrath, but it does not last. Small things trouble me most.

10. M., 18. Now I can control my fists, but not my tongue. When I do make a few remarks, I generally have the best of it. Father says I shall have to be knocked down a few times before I know enough to shut up.

11. M., 27. My disposition to passion has grown less because of a more favorable milieu.

12. F., 30. My anger confession is that when a child I slammed doors, made faces, was impudent; while now temper makes me irritable and, alas, that I must confess it, I scold.

13. F., 26. When small I would throw myself down; later clench my fists and stamp. Am far better tempered than I was, for much that once angered me does so no more. I have gained control over words and acts and feelings, and now can foresee causes of anger and thus avoid them.

14. F. My temper as a woman is so changed from that of childhood that they seem to belong to two different beings. Once explosive, I am now more morbid, peevish, and irritable. I believe it is because my life has been so unsuccessful.

15. F. As a child I rarely got into a violent rage with others of my own age, and think the reason was that I always spoke or struck out at once, and thus relieved my feelings before they had time to gather full force. With my superiors, however, fear kept my anger down until it would grow to an outburst. I always ran to an empty room, banged the door, raged and sobbed till I was tired out. Now, instead of crying, I clench my teeth and drive the nails into the palms; my heart beats so fast that I feel choked and my head seems as though it would split.

16. F., 29. I am less passionate than when younger, because I consider all sides and realize how easily people misjudge; try to be charitable, and think those with unpleasant or selfish ways worthier of pity than of blame. I want to help people struggle against their weak nerves, for I have my own.

IV. REACTION.

When the spasm or crisis of anger is passed, it leaves the system exhausted in exact proportion to the violence of the attack, and inversely as the strength of the victim. Many are faint, cold, tremble, feel weak, perhaps drop down

almost in a collapse of fatigue, and with symptoms of prostration. They have headaches, nausea, bilious attacks, tears, general mental confusion, restlessness, depression, a sense of growing old, perspiration. Many of these physical symptoms are direct reactions from an over-expenditure of energy. There are often peculiar and individual sensations, like bad odors, tastes, ringing in the ears, optical symptoms, prickling and twitching, palpitation.

The psychic reactions most frequent are mortification of having appeared at great disadvantage, humiliation for having showed low level and perhaps bestial traits, a sense of shame for lack of control, poignant regret, self pity, qualms of conscience for having broken through resolutions or other forms of restraint, renewed resolves for the future, etc.

In some cases, along with this, and still more rarely predominating over them, is a pleased sense of exaltation arising largely from the natural exhilaration due to an increased sense of vitality and probably from a sense that justice has been done, judgment executed, the truth spoken, the basis for new and better understanding laid, etc. In this case there is no question of regret or contrition unless for the physical results. Here belong some of those cases who profess to have never felt a sense of guilt, however strong the outbreak. This in some cases is due to the concurrence of emotional strength with intellectual weakness, which prevents forever complete reaction to a normal state. Some souls tend to remain with reference to the offending cases where the last wave of passion left them. and although a friendship has been broken forever, justify themselves. This occurs either where mental elasticity is less, or the power to cherish grudges greater, than normal.

Yet another type rushes precipitately to the opposite extreme of self humiliation and abasement. They are abject in apologies, take over much blame upon themselves, make it a virtue to claim more than their share of the fault, and pour out their souls in superlatives of confessional self immolation and pleas for precipitate forgiveness.

Another better poised type shuns all ostentatious reversion, and though perhaps feeling that they have been a bit brutish and treasuring the lessons of regret and even remorse, from disposition or conviction, never ask pardon but quietly ignore the outbreaks, are perhaps a little over sweet, but feeling that least said is soonest mended, glide back without a word to old relations. This steadier type does not usually go quite to extremes of manifesting temper, and this mode of atonement is no doubt on the whole sanest in some cases.

In some the reaction is chiefly moral and religious, and prayer

and other spiritual exercises, together with those of conscience, play a prominent reactionary role. Some are able to react into a sense of the humor and ridiculousness of it all. Instead of being bestial, vile, undignified, disgraceful or unhealthy, it is simply preposterous and absurd; and the penalties of ridicule and caricature self inflicted may become habitual, and very efficient as a means of restraint.

1. Irish, F., 27. I tremble all over sometimes for an hour when a temper fit is passed.

2. F., 21. When it is over, I am exhausted and cold and tearful.

3. M., 18. When reacting from a bad mad I cry, regular sobs choking me all over, although tears are less plentiful.

4. M., 31. A violent outbreak leaves me worn out in body and mind. I am strong and healthy, but after my last could hadly stand, and I felt as if I had grown older, sadder and changed.

5. F., 22. When the passion is spent, then comes the weeping fit, and then great prostration.

6. F., 22. After I have broken out badly, I am tired and restless for days. My mind whirls on its own way and takes in nothing.

7. F., 41. After a mad fit, I am pale and faint, my hands tremble so that I cannot use them and I have to sit or even lie down from sheer relaxation.

8. F., 31. Anger makes me feel worn out but peaceful. I am often frightened that I can get so angry, and often have a nervous headache later.

9. I am usually thought to be good tempered. The reason is that it takes the form of a sort of muddled wretchedness, which I can usually save up till night and fight out alone. I am always left weak physically, but mentally better.

10. M., 18. I once almost killed a tyrant boy in our school, who bullied, but did not feel half as bad as after whipping my horse. When I had done so, I would cry for an hour with my arms around its neck.

11. F., 33. I know a girl of 13 who whines, scolds and is cross all day and the next day she is abed with a bilious attack. These alarm her, and she is trying to control herself.

12. F. When a spell of rage had worn itself out, I always reflected that I would be out of favor and get no petting. Until 10 I had no other regret and did not know it was wrong. I remember vividly when first told it was a fault, and when I tried to stop I was corrected by being sent to a corner, and sobbed violently. Few things I ever did were harder than when I made myself pick up a book I had flung down, and go on with the interrupted lesson. I often try novel reading with success. Am very sympathetic with ill-tempered people.

13. F., 40. I react by feeling that I have been a brute, try to meet my enemy as if nothing had happened, think it rarely wise to apologize, on the principle "least said, soonest mended."

14. F., 17. I am generally very contrite and want to make up by taking more of my share of the fault, and find that sometimes prayer helps.

15. F., 21. Although in anger I feel very bitter and full of burning hate toward all mankind, my reaction is intense remorse, though I never speak of it.

16. F., 26. My feeling afterward is a misery too great to speak of or even write. I know it a most dreadful sin, and remorse is deeper in proportion as the object was dearly loved.

17. F., 24. When I give way to uncalled for or long cherished anger, I feel sore and angry at myself, afterwards realizing how horrid I am and how much sweeter others are. I rarely, however, think much about anger after it is all over.

18. F., 20. My reaction is shame, seeing the other side, difficulty in speaking to the person in a natural tone of voice, realizing how small the cause was and feel that I have been a great silly. It makes me wretched that I cannot take things more calmly.

19. F., 19. It is far harder to express contrition in words than in acts, and yet if others do not apologize, my liking for them cools in spite of myself.

20. F., 28. A storm that has long smouldered in me rages on often for a long time, especially if my sister, usually its cause, is thoroughly and at once subdued. I feel humiliated in my own eyes because I have failed in what I have most desired, namely, control.

21. F., 38. I easily forget causes of anger, but never the feeling, and my constant dread is lest I shall be stirred up anew.

22. F., 21. When I think it over afterwards and see how foolish it was, I see that I must forgive as I would be forgiven and resolve to be more sensible next time, but alas!

23. F., 24. My reaction is never referring or thinking of it, or perhaps saying I did not mean to hit or being a little more affectionate than usual, amending by extra docility and sweetness with much inward disgust with myself. Sometimes I overwhelm the object of my anger with kindness.

24. F., 20. My contrition is not very deep and I detest reconciliation scenes, but glide back to normal relations without a word. To say I am reconciled, before I feel quite so, helps.

25. F., 21. At the highest pitch of frenzy, I do not care what I say or do, only striving to make it the worse, but later my remorse is awful and aggravated by punishment from parents. At these periods all my wrong deeds, especially those known to my own self, would rise up and I would resolve to confess to my father. I never came to the point of doing so, because I feared the knowledge of them would break his heart and usually ended by resolving to wait until he was on his death bed.

V. CONTROL.

Some children grow on towards maturity with no instruction that it is well to control anger and feel that not to fight on every provocation is a sign of cowardice. These cases are very rare, and experience soon teaches every child the necessity of some restraint. The simplest method is to command the voice, to speak slow, low, after a pause, and with steady and, if possible, kindly tones. Another is to relax in the jaws, arms and elsewhere the instinctive muscle tension and to undo, step by step, the attitudes and facial expressions after first restraining acts. The mirror sometimes makes a sudden revelation of ugliness that is a great aid. Repulsive and extreme exhibitions of anger in others prompt good resolves by way of warning, as do examples of great control by emulation. If one can assume even approximately the muscular expressions of the opposite state, anger cannot long persist ; for its nature is very closely bound up with tensions, not all of which, how-

ever, are under control of the will. That effort in this direction is of very great psychic and pedagogic value there can be no doubt. This we may call, perhaps, the most direct way of control. ·

Next comes the presence of others, especially those who are respected, loved or not very well known. To have made an exhibition of temper before a stranger is so mortifying as to usually reinforce all the instincts of control. Some confess to having a very ugly or even dangerous temper, but declare that no person has ever seen its malignity. In other cases, persons with a reputation of good and even sweet tempers among their friends give way in the presence of one or two members of their own household to the vilest and ugliest outbreaks. In some families irascible children get on far better away from home, not only because their tempers are less likely to be spoiled by indulgence, but because of the constant pressure of restraint by the presence of those who do not know them well.

With the inflammable type, counting three. ten, turning around, any act or formula securing a little delay allows the slower acting powers of control to be heard from. Some temperaments can thus almost entirely burn the smoke of their own anger calentures, and for the flashy, petulant type of diathesis this alone may sometimes quite suffice.

Reflection of a moral or religious sort becomes more effective as maturity is approached. The repetition of a Bible text or some proverb not only secures delay, but brings in antagonistic motives. Recalling the compunction of conscience, the necessary acts and words of atonement, bringing in a vivid sense of divine watchfulness, the beauty of love and service even to enemies, remembering that they may have as much cause for anger as we. Sometimes ceremonies or prayerful exercises are effective.

Diversion is a great and most effective panacea. If the mind can be occupied with something else at once that absorbs it and prevents brooding, it soon glides imperceptibly into good nature and comes back to the standpoint from which offences can be regarded with equanimity.

By some or all of these methods, some bring themselves to a habitude of displaying and soon to feeling special kindness to those who injure them, although few learn to turn the other cheek to the smiter. Indeed, current ethical standards, even in the best people, hardly justify a literal fulfillment of this Christian prescript. Literature furnishes a few examples of ascetic ideals, according to which imperturbability is almost in a metamorphical and even literal sense, as if thus superogatory merit were accumulated or treasure laid up in heaven. A young convert at Orchard Beach once told the writer that he

ever knew such joy as when he was buffeted and insulted in
iis work of soul saving, and always indulged in ejaculatory
hanks to God when he was cursed, struck, pelted with mud,
now or otherwise foully treated as a result of the crude meth-
ds of slum work to which his zeal had impelled him. The
thics of this frame of mind may well be doubted, and the
vorld admires the Quaker, who at a certain point of provoca-
ion, lays aside his gray and his creed to drub an aggressor.

1. F., 18. I check rage by asking, is it right?—and try to weigh
he facts. Since I was 14 I have realized how wrong anger is and can
;enerally control it. It is very violent, but people do not know my
truggles to curb it. Above all things, I hate scenes. All our family
re :rritable and nervous, and we have to steady ourselves. We all
;et on better when away from home. I sometimes try to think of all
he times my enemies have been nice to me.

2. F. If I give way to my temper, I soon feel well and in love
vith the world and with every one in it again; but if restraint suc-
eeds, I am miserable, overcome, want solitude, and feel that a heavy
veight is hanging over me, or like a smothered volcano liable to burst
orth.

3. F., 30. I have but once or twice in my life let myself go, and
hen went off like a whirlwind and stopped when I was ready. I
.lmost never lose control. To restrain general irritability is far harder.

4. F., 15. A lot of girls last winter turned on me, threw snow and
alled me names. I wanted to pay them back, but something told me
iot to. I felt as if it were some one talking right to me. The girls
aid I was a coward, but still I did not hit them. The Bible, you
:now, says forget and forgive.

5. F., 40. If one I love angers me, I am simply benumbed. Bitter
peeches, which I know would rankle, occur, but are never uttered.
3etween love and this assertion of my words, self-conflict is short,
harp, and generally results in perfect silence. I have noticed that I
ap my foot and often open and shut my hands and perhaps my teeth.

6. F., 24. My temper has grown more tolerant of late, for I can
ometimes check it by reflecting that others may know better, may be
ight, or have a right to their own opinion, that it is useless to strive
ir will be all the same a month or 100 years hence.

7. F., 28. I find it hard to think before I speak or to control my
vords, but I try to turn my thoughts to something pleasant. If I
iave the chance to do a person with whom I have been angry a good
urn, and if I do it, which is not always the case, then all self feelings
;o. If my enemy makes advances by doing me a good turn, the
inger goes, but then I feel remorse.

8. M., 32. To aid children in self-control, they should be taught
ommand of the voice and hands, attitudes, and awards and punish-
nents should be meted out with great delicacy and tact.

9. F., 22. I find some help by holding my face in my hands and
mothering my screams, but must be alone where I can gesticulate and
ct out a little.

10. M., 27. When angry I am in a state of miserable tension all
>ver. I feel it first about the head, in the the temples and forehead.
am conscious of unwonted secretions in the stomach. I can lately
ielp myself a little by forcing my attention to the drawn muscles and
elaxing them. This makes me at least a little calmer.

11. F., 28. Control of anger I think comes largely from imitation.
f children see others check rage, they learn to do so.

12. F., 19. Once I chanced to look in the glass when I was angry, and I did look so perversely ugly, that I now think twice before letting go. My face gets broad, heavy, babyish, the corners of my mouth go down and I frown awfully.

13. F., 27. Once my favorite uncle dropped into the nursery and found me on the floor kicking and screaming. He was shocked and said I looked more like a beast than a little girl. I was so ashamed that it cured me entirely.

14. F., 20. The more strangers are about, the less my irritability troubles me. Their presence is the best control. I am far worse at home. When vexed I try hard to think of something else or say to myself how much better it is to control myself or recall possible outbreaks.

15. M., 50. A murderer, awaiting sentence for crime done in a flash of anger, whom I know, told me he always carried a stick in his pocket to chew when in a rage to prevent such an outbreak as that he was to die for. When the fatal provocation came, the stick was lost, and could he have readily found a substitute, he is sure he would have done no harm.

16. I rarely felt guilty for rage and perhaps did not use to recognize my feelings as anger. There was no such self-condemnation as when I had lied. I did not apply Bible sayings about my anger to myself. As I showed anger chiefly to brothers and sisters next me in age, no adult knew how bad my temper was except the governess, who was the only one who ever spoke to me of the wickedness of anger.

Abandon. In really rare cases, there is either no power of control whatever, or else what power there is can be easily broken down, so that the individual is entirely at the mercy of his anger. If this is great, he becomes literally insane or infuriated, like animals suffering from rabies. This is sometimes seen in idiots, degenerates, imbeciles and other defectives. All fear of persons. punishment and other consequences is lost, and the individual is absolutely helpless and blind in the storm of rage. In excessive and prolonged provocation, when man is brought to bay and knows his case to be hopeless, and that he can only sell his life dearly as possible, a somewhat similar condition supervenes. This is not courage but fury, and the destructive impulse may be so strong as not to stop at any manifestation of suffering, danger, or even death to the victim, but may impel to nameless mutilations of corpses and the impulse to annihilate even self and others in the highest pitch of frenzy. Boys, who easily and really become blind mad, are usually defective or morally insane, and all extreme manifestations are generally restrained before strength or knowledge enough is acquired to make them dangerous, or they become amokers. p. 521.

1. M., 40. My boy striked when angry never quite straight, chooses a safe place like the shoulder and often with pounding down blows. Girls I have noticed are more likely to strike down. A lady I know when very angry speaks with the sweetest face and voice. Her manner is more charming than at any other time, but the things she says sting bitterly.

2. **M., 29.** Up to 9 or 10 my brother was so passionate as to be almost dangerous, and no punishment or disgrace affected him. He would strike wildly without aiming his blows; has thrown stools, hammer, stones and various things at me. We all used to be terrified and I used to knock him down and sit on him till he was quiet, unless some came to the rescue.

3. **F., 38.** I have a strong and secret dread lest anything should excite my anger. It is dreadful and I am always in hopes nothing will occur to rouse it. I fear it like physical pain. It is mental pain which I believe leaves a scar.

4. **M., 30.** The mother of a 14 year old boy had always vented much anger upon him, when one day for the first time in his life, he broke out with an awful volume of oaths, which paralyzed his parents and made them feel that he must be very carefully dealt with or he would be dangerous. It was, however, all game which he had put up deliberately and over which he chuckled.

5. My boy of 8 is passing through an irritable period connected, I think, with second dentition. He flies into a fury, throws, strikes, says he is crazy, and his body feels drawn up. I can see, however, that he has sense enough left to avoid doing the worst. His father, who is very nervous, believes in using the whip in extreme cases. This makes the boy pale, cold in his extremities, and nauseated. His older half sister is aggressive with him, so that his provocations are strong and frequent.

VI. TREATMENT.

Worst of all is humoring and the over-indulgence by which too fond parents are prone to spoil the temper of only or sickly children by excessive indulgence. Even good dispositions degenerate to moroseness under this regimen and a vigorous application of Dr. Spankster's tonic in such cases may work wondrous and sudden cures.

For strong, healthy children, whose will is not absolutely diseased by balkiness, whipping, if judiciously administered, greatly reinforces the power of self control. With young children it must often be a blow on the instant and without a word of warning or moralizing, and if there is a little instinctive indignation, it is all the better; and if not felt anger should often be simulated by the parent or teacher. This gives a quick sense of the natural abhorrence with which such conduct is regarded and teaches the child limitations beyond which its conduct becomes outrageous to others. Dermal pain, which is not so bad as sickly sentimentality regards it, thus comes to be associated with moral pain, both in self and others, where outbreaks occur.

Another effective method is neglect. By this the child is simply ignored, set aside from ordinary relations of intercourse, perhaps isolated as disagreeable, troublesome or sick, and thus comes to feel by their temporary loss what the ordinary relations of love, in which they live, really mean and are. It is let alone, treated with silence and affected indifference or even coolness or sadness. The social instincts are so strong

that the child soon wishes to kiss or make other signs of desired atonement, and to be taken back to the hearts of its friends as before. This method can be well developed and sustained, but with some has its own peculiar dangers and must not be carried too far.

Some are best helped by being left to the natural consequences of their acts. If they break their toys in a pet, they go without them. If they injure their clothes, bed, books, pets, they must be left to feel a sense of loss after the ruffled temper is calmed. If they litter the nursery or playground, they must slick it up, or if valuable things are endangered, they are taken away. If they treat others badly, their friendship is ostentatiously cooled. Thus they are made to anticipate the penalties of adult life.

In some, especially in small children and in those with a keen sense of humor, the risibilities may be appealed to, and the child provoked to laugh by diversion to funny acts, by caricaturing its own deeds, words, tones, appearance, and thus rage may be suddenly neutralized by its opposite.

Plain, straight talk is often effective. Sharp, incisive, graphic descriptions of their conduct, its effects, how it is regarded, its consequences when they are adult, often brings a realizing sense which increases their self-knowledge in most wholesome directions. No one can read these returns without pleading for judicious scolding, provided the time, occasion, person, etc., be well chosen. All languages are far fuller of words describing bad than those applied to good conduct, and these drastic expletives, thus at hand, should be made good use of. Perhaps it would be injudicious to advocate even a mild use of profanity as a mode of clenching or rebuking certain manifestations of temper, but surely if there is anything in the world that merits damnatory and diabolical terms, it is the extreme manifestations of rage.

In some cases I believe anger should be worked off by legitimate and regulated fighting. There are certain states of mind, sometimes provoked by certain offences, for which no ordinary modes of treatment are adequate; and to stand up squarely in a give and take conflict, whether with fists or with straight out pieces of one's mind to each other, teaches a wholesome sense of responsibility and also gives a hearty man-making type of courage. Every irascible boy at least should know how to box. Nothing is a better school of control than to face an equal in a fistic contest, and know that the least loss of temper involves a wild blow, a loss of guard, and a bloody nose or a black eye; while victory, other things being equal, is sure to rest with him who can take a stinging blow in the face or anywhere without losing his head and thus missing an opportunity.

Prophylactics should not be forgotten in cases that require special treatment. These are first of all good health, which always makes for serenity, active and sufficient exercise with regular work, absence of which is one of the surest modes by which anger material is accumulated. Primitive man had no regularity of meals, working hours or occupation, but days and weeks of idleness alternated with and prepared for by periods of excessive strain in hunting, migration, warfare, etc. Into such life rhythms, criminals and degenerates still tend to lapse, and a balanced regulation of income and expenditure of energy is the best palliative of every infirmity of disposition; congenial stated occupation acts especially as an alterative for those types of anger that tend to spontaneous monthly or otherwise recurrent explosions. Removal from irritating causes like relatives with similar types of sulks or irritability, teasing children, and a general atmosphere of kindness, affection, and freedom often work great changes.

1. F., 18. If riled I must be left by myself, for every attempt of others to soothe my ruffled feelings increases my irritation.

2. F., 19. No fear of punishment ever had the least deterrent or restraining influence. I always wished as a child, when angry, that I was grown up and could lay out the unjust person.

3. F., 20. A serious talk to me about my bad temper, when I was 16, helped me very much to both self knowledge and self control. My grandmother, who was very bad tempered, came to live with us a few years ago, and she was such an awful lesson of what I should grow to be at her age, that I improved.

4. F., 27. I think children should have it out with their rages, and that when the reaction comes, considerable reproof or punishment has its best effect. To remove causes of anger and find change of games, or playmates, to give diverting occupations and high ideals are best.

5. F., 23. I was allowed to lead in playing with other children. If they did not do as I said, I always declared that I would not play and, unfortunately for me, this soon brought them to terms. This hurt my temper.

6. F., 21. As a child I had few playmates, was much alone, and so rarely lost my temper. I had most things that I wanted and so had occupation enough to keep me from wanting much that I could not have.

7. F., As a mother of three children, whose father's family is full of nervous disease, I think perfect health the only cure of bad temper. The world is at best abnormal and civilization especially so. To make happiness a habit is to bring in the Kingdom of Heaven. If this can be evolved from a psychological laboratory, all hail to the laboratory.

8. M., 31. My mother once whipped me and then kneeled down and prayed for me. The latter made me more angry, only in a silent way, than the former. A moral lecture of being talked good to, or talked at, rarely fails with me.

9. Once F., 5, threw a favorite toy against a shelf. I put it up there for two weeks. She cast stolen glances at it daily. I also ask her, when in a pet, to say quietly, "He that ruleth his spirit is greater than he that taketh a city," and "A soft answer turneth away wrath."

10. A very sunny-tempered boy about twice a year had fits of uncontrollable rage, destroying everything within reach. These spells nearly ceased when he was about 9, but after one of them his nursery looked as if swept by a small cyclone. We never alluded to it, but let the litter lie until he took an impulse to clean it up.

11. My little brother, when in a passion, gets red, stamps, sticks to his will to the end, and, if spoken to, hits out in all directions. He is usually locked up, but the poor door suffers. When calmer, he is let out, but no notice is taken of him until a few days later, when he is spoken to seriously.

12. F., 34. My little 4-year old girl inherits considerable temper, and when she shows it I tell her she is sick or disagreeable, and to go away by herself. She soon comes back smiling and I tell her the sun is shining again.

13. F., 21. Sulkiness was my chief trait, but I suddenly and forever left it off when I was 12, when I went to live with my grandmother, who gave me a new treatment of simply ignoring me when I was sulky. She seemed to forget that I existed at such times and this made me miserable.

14. M., 28. A boy of 9 I know, when angry, used to have real spasms. The physician long treated him for extreme nervousness, but he grew no better. Another physician said it must be whipped out of him. His parents followed this instruction, and although he was very stubborn, peevish and fretful, it was whipped out of him and he never had another spasm.

15. M., 41. When my children were crying angry, I used to say, you can scream ten minutes longer, and they would have sufficient relief. Often watching the clock would divert them. Neither I nor the nurse ever say don't to our children.

16. F., 21. We can cause in M., 11, the worst fits of rage by making him laugh against his will. Punishment brings on a headache; with uniform kind and sympathetic treatment, all goes well.

17. My 10-year-old brother once cut me with a knife in rage. We learned, however, that if we cried out, you have hurt my sore corn, he would always melt to laughter, and would soon become penitent and ask pardon. His passion rarely left any trace after five minutes.

18. M., 42. Two children were very ill when they and the doctor said they must not be allowed to cry. Hence they were indulged till their tempers were spoiled. Any cross drives them into an ungovernable fury. They shriek and rave until exhausted. Their face is so changed that one would not know them, and they seem ready for any black deed. Curiously, if at the worst stage of their passion some funny word can catch their attention, they are calmed and laugh, and it all goes in a moment.

19. F., 27. At the age of 8 or 10 I fell into a state of feeling injured when everything said or done seemed aimed at me. This state recurred at intervals for many years and died out only when a great friendship and love came into my life. When I say stupid things, forget or remember too late, or plans have to be changed, I still am likely to look down, pout, stamp, be silent, etc. The sick are irritable brooding over their imagined wrongs, and self-conscious. The best way to cure this state is to break out suddenly with some funny remark or read a letter or something interesting, and it is amusing to see the change. Troubles are forgotten and happiness returns thus quickly, especially if several are together.

20. F., 24. Sometimes I can watch myself all through a tantrum, contemptuously, and perhaps laugh at my own excitement.

21. F., 22. When disagreeable and provoking things are said, I now try to laugh it off, and I find this very often succeeds.
22. F., 26. When other people are angry, it makes me calm; while if I am angry and they are calm, it makes me far more angry.

The Long During Forms. Instead of exploding, some children sulk for hours and days with little power to work it off otherwise than by making themselves miserable and diffusing an unpleasant atmosphere. This corroding state is both cause and effect of narrowed psychic range and easily grows into suspiciousness and may pass from the passive over into active and aggressive manifestations. It is hard to maintain this state without heightened self consciousness, which is prone to imagine slights, inuendoes, neglect, dislike, and may even fancy hostile schemes and plots. With a little morbid taint, suspicions of persecution may arise, especially in weak natures, and from this the passage to overt acts of vengeance has been admirably described by Magnan. Most sulkers and brooders, however, while good haters do not pass readily over to vengeance.

The law of retaliation, an eye for an eye, etc., is deeply seated in the human soul, and is closely connected with both the sense and with all the institutions of justice. Ancient and mediæval law was based upon the conception of injury for an injury, and elaborate tables of equivalents were developed. While courts now take the administration of graver matters of justice under their charge, much is still left to private settlement. In the scores of minor matters, we see in society this instinct of paying back in the same coin and which safeguards so much that is precious in life. Do others who do you, rather than the golden rule, is more germane for the natural and even for the twice born man.

Hate may be conceived as prolonged and more mentalized anger which may or may not express itself in overt acts. Usually it awaits occasion before it is heard from and it is often a strong factor in tests of popular suffrage, where those who believed themselves surrounded by friends find to their chagrin veins of disfavor where least expected.

Revenge seeks more than justice and would pay back with interest. It may be long cherished, even in the animal world, where grudges are harbored until there spite can be vented. Here we find long cherished and matured plans, the results of accumulated malice perhaps of months or years often involving calamities far beyond merit and not infrequently involving others in the doom of the victim. Among lists of infernal machines, slow poisoning, well schematized and insidious detraction, slander, libel, alienation of dearest friends, destruction of financial credit, moral or religious repute,—of all this literature, court records and individual observation abound. There are those

who can give the entire energy of their lives for long periods and even spend their treasure and take very grave risks to taste the sweets of vengeance upon an enemy. They are incapable of forgetting or forgiving, and their souls are soils in which all seeds of injury grow to preposterous dimensions. Such natures are constitutionally secretive, taciturn or cryptobiotic, and hug or nurse trifles sometimes purely imaginary until they fill the whole field of their mental vision. Had such souls the same creativeness in art, literature or good deeds, they would be great benefactors, but their passion is malevolence and destruction is far easier.

1. M., 27. A boy of 9 bore a long grudge against a shop keeper and for weeks sought an opportunity to smash his $60 glass window. Pea blowers and small stones were often thrown and at last it was broken. The boy was glad, would not apologize and went to a reform school, although told that he would be released upon asking pardon. The worst children are those who harbor grudges and vent spite after a long interval, during which it seems to accumulate like compound interest.

2. M., 24. Boy of 12 saved his money and bought salt to put on the neighbor's lawn, and when asked why, gave a long list of mean things the neighbor had done to disturb his play. He said, " Now I am revenged, we are even, and I am happy."

3. M., 25. I know a man not of strong will but conceited, who is more discriminating and persevering in his revenge than in anything else. This he makes a holy thing and his chief object in life. He could wait for years to pay off his debts. He would even study the character of children, and relatives of his victims, to find the tender spot. Remorse he had none.

4. F., 21. In exceptional cases, as of insult, I recall and brood over every detail, holding long imaginary conversations with the person, giving her good chunks of my mind. In one case I kept doing this over and over, nursing my hate for two years. Then it suddenly went away, leaving only a half humorous contempt for the person. Even if anger fades, I never willingly have the slightest intercourse with such an one. I have always been thought to have an unforgiving character, and as a child, often did bodily harm.

5. F., 30. I know a woman who refused to speak to her husband or her daughter for a week, although living in the same house with them. She is glum, and thought all the time she was a paragon of virtue and controlled her temper because she did not speak.

6. F., 26. I believe in standing up for myself and in speaking with greater warmth and assurance of being right than I really feel sometimes. Years ago a friend spoke hotly to me and I coolly told her she was unjust. We agreed to part although I wanted to get right, but brooded over it for years. My subject of love was impaired by a sense of injury, but I have never been able to overcome it.

7. F., 30. A friend of mine is irritable, her spells lasting for days every month. She never smiles unless bitterly, contradicts everything. The world and all the inhabitants appear corrupt. Her lips are firmly set and her eyes are staring and freezing. This mood is followed by exaggerated mirth.

8. F., 18. When in temper I cannot be spoken to. I cherish a dislike, call up all previous misunderstandings, real or imaginary,

aggravate present case and make myself very wretched. I struggle to get out of these states but am more and more powerless to do so.

9. F., 42. When I was 16 a classmate lied to the teacher, saying she had helped me in an examination. I could not go to her without betraying the girl who told me, so I worked six months hard from sheer revenge, and got a higher grade certificate than hers at examination. This proved that she could not have helped me. All this time I could not say the forgiveness clause of the Lord's prayer, but she never knew I was angry.

10. F., 27. I would sulk if reproved and nurse my wrong, feeling that I was a martyr until I reached the point when I would weep. I would pout, refuse to smile, answer snappishly or not at all, and always strove to do the opposite of what was wanted.

11. M. I felt a certain triumph in sulking but do not then wish to be alone, as I do in anger. I imagine that the offender implores my pardon, which I take pleasure in refusing. Sometimes when I have sulked long enough and the person to whom I am sulking feels contrite, I sometimes wish I could force myself to the point of saying "forgive me," but I cannot.

12. M., 25. My father had terrible fits of anger, which occasionally went on for days during which he would be almost completely silent; while my mother, who is chiefly irritated by slowness as I am, is exceedingly voluble and loquacious when angry.

13. M., 25. If offended I often try to sulk in a very dignified way, but find it hard to keep this up long.

14. M., 31. My irritability, which I inherit from my father and which differs from strong passion, makes me feel as if I wanted to set everything and everybody around me flying, and then to be absolutely alone.

15. F., 32. I feel better if I can speak my mind. I have been so angry that I have felt I was possessed by an evil spirit, but it all seemed so senseless afterwards.

16. M., 25. If I dwell on things, anger grows, so I am usually angriest sometime after the cause, but rarely show it at the time.

17. F., 34. I never had but four outbursts of passion, and these were when 19, 21, 29, and 33. The cause was always unjustice to self or friends, and I felt a horrid pain at what caused the anger, and immense relief at giving vent to the storm within. I never felt ashamed but often sorry.

18. F., 28. Anger must have scope or it accumulates with me. Blame rouses it most, next comes interference, although I know that often when this is by friends, it is an expression of interest.

19. Scotch, F., 19. My nasty temper never smoulders, but it is ablaze and over. I feel I must do something or explode, and must either say bitter scathing things or take violent exercise.

20. M., 38. My boy of 11 when angry, screams, speaks fast or in a gruff tone, and likes to break things. His reactions are emphatic and take the form of asking pardon of superiors, and showing excessive kindness to his inferiors. If his anger has free vent, he shows no desire for revenge later.

21. F., 27. My tempers first simmer, then boil, then explode in way that make me shake from head to foot. I am so unsettled for a long time afterwards that I find a walk the best way to work off the effects.

22. F., 26. If I repress rage entirely, from shame or any other cause, it lasts much longer. I brood over it, exaggerate the injustice and find it harder to reason myself into a happy mood of kindness toward the offender.

23. F., 37. I most dread those people, who when angry are pre-

ternaturally cool, precise and impressive. This is really the most terrible kind of passion, for you fear it may break out in anything.

24. Smothered anger that is not allowed to effervesce may become lasting and warp character, so that it is often hard to choose between the much and too little control.

25. F., 21. I do not rage but am irritable, and love to appear indifferent and even cut my acquaintances. Injustice makes the most permanent resentment.

26. My daughter of 12 is saucy, impudent, when she is provoked, but rarely revengeful.

27. F., 28. Grumbling and fault finding is the worst; sometimes trials through the day come out in the form of petulance or fretfulness when children go to bed.

Different Ways in which Individuals regard their own Anger States. The condition of rage is almost always regarded as very distinct from that of normal consciousness. The natural untaught child has at first little sense of moral wrong in this state, but soon connects painful impressions with it in his own experiences, which make for control. The instinct of seclusion, strongest with girls, and the bearing a great deal before giving way, both attest the many fears connected with this state. Threats often imply peculiar dangers if this second personality once becomes ascendant. Boys, who boast how strong they are and the cruel things they might do if mad, as though their ange'· was a dangerous and concealed weapon; anger, which adds more or less consciously to its intensity by feigning impulses to do unutterable things—all these are often effective in intimidating not only comrades but often parents and teachers. The simulation of anger often so admirable as a pedagogic method, the dramatic assumption of many of the symptoms and expressions of rage, are sometimes very effective in preventing fights, and a due sense among adults in society of the danger to person, property, or reputation of making active enemies and intensifying dislikes, is wholesome and sanitary. To arouse this demon, which may carry away those about us in a frenzy of rapt passion, is a danger that should never be forgotten, for where abandon is complete, the dearest friend, the fondest wife, child or even parent, may suffer an almost complete reversion, and hate, as inverted love, may become the most intense and rancorous of all. A single spasm of anger has sometimes the power in some souls of expelling affection forever beyond the power of pardon or even truce, and perhaps this "old Adam," as a potentiality, exists in every soul and may break through every fetter.

1. F., 30. Righteous wrath makes my moral sense keener, but this, I find, is very wearing to the nerves. To have a strong feeling of "served him right," when a mean thing is done, is almost a part of conscience. During the first stage of venting anger upon an opponent there is a grim satisfaction, but fortunately for the race this soon leads to shame.

2. F., 19. After a mad spell I sometimes feel repentant, often indifferent, and always very glad that my temper helped me to do what I wanted to do but otherwise never should have done.

3. M., 29. I believe in causes of offence; it is better to have the matter out, for a good rage freely vented gives an easement like the " peace which passeth all understanding, which nothing else can give and which is not of this earth." I know people who will not speak to you for a week, when you are quite at a loss for the cause, and prefer hasty tempers to the sulks.

4. M., 30. I plead for more anger in school. There is a point where patience ceases to be a moral or pedagogical virtue, but is mere flabbiness.

5. M., 31. In my experience as a teacher it is often an excellent thing to simulate or pretend anger in dealing with young children. Some faults are better punished with a little heat of anger than in cold blood.

6. F., 29. I prefer to deal with fiery than with sulky people, and am sure that a pretty good temper is desirable if not in excess. It is sometimes well to speak out that we may know and be known, and avoid misunderstandings.

7. F., 22. A strong temper well under control is a great force, and may be used for good. Heaven knows I hope it may prove so in my case.

8. F., 19. I am so often in the wrong that I seldom have a chance for righteous indignation, but I look forward to it some day, for I really like to get into a passion.

9. M., 24. It is certainly a great relief to get in a rage once in a while, but I think it should be done in solitude.

10. F., 21. The excitement is the pleasant part of my temper, and I grumble, fume and scold.

11. F., 20. A girl of prickly, contradictory disposition, balanced by much judgment, if angry never speaks, but acts. Once when 17, and told to replace some trimmings she had scissored into 100 pieces from her hat because she did not like them, she was roused to higher spirits, the deeper the disgrace. Her merriest evenings were when she had been in trouble during the entire day, and so had thrown off all restraints and revelled in the freedom from responsibility of being good. All her moods were afterwards atoned by a storm of tears.

12. Scotch, F., 24. I can generally check temper at an unkind or sarcastic remark and occasionally do not show it at all. Only once within the last ten years do I remember giving entire vent to temper, when I suddenly flew up inwardly and boxed my brother's ears. He looked so astonished that, although I was trembling with rage, I could hardly help laughing. I have found it a not altogether unpleasant sensation to be in a great rage. It wakes me up and makes me feel very much alive. I do remember once more giving way, and I shook my bigger brother till I thought I could hear his teeth chatter. If unwell or busy, I often feel very bitter and cross.

13. F., 19. The satisfaction and relief that used to make the after feeling decidedly pleasant is less now than formerly, for now it often leaves me unsatisfied, which it never did before.

14. Scotch, F., 26. When I am angry, if any one is at hand, I speak with greater heat than I really feel in order to keep up my anger. It is a kind of luxury.

15. F., 28. I used to boast and be very proud of my hot temper. It left me revengeful, sulky and skulking. Now I regret it.

16. F., 22. If deeply offended, I feel dried up toward the person for weeks and mouths. If I speak to the object of my wrath, my voice sounds strange and abrupt to myself. I once stood for hours in

front of a teacher whose rules I had broken, with occasionally a long-ing impulse to give way, but something, I suppose false pride, pre-vented. I felt too strange and excited to be unhappy; the latter came later. Now rage is a sort of intoxication. I am exhilarated with a sort of unnatural happiness.

17. Many boys are as I was, fond of talking of their herculean strength if angered, warning others not to make them mad, lest they be annihilated when their rage is unchained. Such boys, if angry, often look, threaten or feign to atttempt the most murderous things for effect, having themselves, however, fairly well in command all the time.

18. "Don't get me mad," said M., 10, "for if I am I can lick K. S. and B. (boys of 16 to 18) and the teacher himself. I hit the old man just once in the nose and made him bleed. He has not licked me since."

19. "When I get mad," said M. 11, "I don't know what I am doing. I might take out my dirk (he only had a small pocket knife) and cut your throat or cut your heart out and eat it, or rip you any-where like a stuck pig. I should not know what I did till afterwards."

20. "Look out, don't do that, stop, or you will get me mad!" boys often say, speaking of this state as if it were a kind of demoni-acal possession in which they were no longer accountable.

21. When I am misjudged, as I often am (for this is the way I put to myself the fact that my sister is far more attractive than I and gets all the attention) I show my temper by pretending to show non-chalance. "I care for nobody if nobody cares for me" is the spirit, although I do care very much indeed. Often I never wished to set matters right, but gloried in being a martyr.

22. M., 28. I act on the impulse and speak straight out what I think, say how maddening it is, give others a piece of my mind, tell them how they should act. If they think I make too much fuss and keep cool themselves, I am all the madder. I always say all that I mean and feel easier for having spoken out, but always regret it later.

23. F., 24. If my temper is upset, I feel disobliging and disagree-able. I never had physical signs of it, and have learned to avoid those I cannot live pleasantly with. When passion rises I have to weep, and must hide lest the cause of my anger should think my tears are those of penitence, instead of righteous indignation.

27. Psychological observations, like charity, are best begun at home, and I have all my life been at home with almost nothing so much as temper, although I never spoke willingly about it before, save once to the clergyman who prepared me for confirmation at the age of 16. My confessions are not complete, but I do not know how to write some things.

Love and Dread of Seeing Conflict in Anger. Both our re-turns and common experiences show that many, and especially women, have great and sometimes morbid dread of any mani-festations of anger as of all other uncontrolled states. In an-imals, females are often described as watching with compla-cency the conflict of their rival males for their possession, and it seems probable that the intense horror of this state, which many females report, is associated more or less unconsciously with the sexual rage which has followed it.

The great interest and pleasure in a fight, which boys, men, and sometimes even women manifest, is well attested in the

history of gladiatorial contests, tournaments, the wager of battle, pugilistic encounters, duels, whether by students or according to codes, wrestling and many other popular diversions, the crowd that always gathers to see men, boys or even dogs fight, cock fights and bull fights, etc., are further attested. The spectator's first impulse is to see fair play, and to have the contest prolonged and continued until one or the other of the contestants is subdued, and sometimes the thumbs go down, and even death is postulated. The writer himself confesses in his own experience a quite unparalleled tingling of fibre and a peculiar mental inebriation, he has himself felt in experiences of this kind, which as a psychologist and especially as a student of this subject, he has felt justified in giving himself. The common experiences of life seem dull, there is a zest of heroic achievement, of staking all for the chance of victory, of doing and daring with the greatest energy and risk, and that despite the brutality and the sense of degradation which comes from defying the ban of social condemnation placed upon witnessing such scenes. They give a sense that is to a great degree true, that life is warfare, that the struggle for survival never intermits, is always intense and bitter upon whatever plane life is lived, that offensive and defensive resources must never be out of reach, and that in a sense every one must be either a good fighter or a coward. Compared with the utterly unregulated fights of quite barbaric human beings, all these forms of conflict are more or less refined by rules or by customs, and one moral which familiarity with them impresses is that muscular strength and agility and the power to use fists and other natural weapons, and even some kind of code by which under certain circumstances certain wrongs, which the law cannot reach, can be promptly and summarily dealt with, is a distinct advantage to the ethical nature of man and a real safeguard of the highest civilization.

1. The sight of anger in others causes an awe struck yet interested wonder in the spectator, and every one flocks to see a quarrel. A boy of 11 jigged, danced and leaped up and down on witnessing a quarrel between two girls, although they attempted no physical violence, but simply stared at each other and said bitter things in a low distinct voice. If the quarrel is by older people, spectators on the other hand retire in almost inverse proportion to their sex, age, and strength.

2. F., 26. My brother, 17, once was roused to a frenzy at his brother attacking him brutally and looking awfully. He was taken to his room, and I sat by all night fearing murder, or something else still more dreadful, to follow. The next day he was silent and sullen, but gradually became himself again. This experience I cannot even now think of without shuddering.

Alas for those who consume the power of arrest or control too frequently or too completely. Many are angels or demons just in proportion as they are rested or fatigued. The state called irritability is due to loss of inhibition, and when this is gone man is the victim of whatever morbid impulses may be evoked, and some forms of insanity consist essentially in the loss of this higher power of restraint and the liberation in unchecked violence of lower instincts. Not only anger but mania, acute and active melancholy and suicide are often thus explained. Intensity of impulse, like the power of control, varies through all degrees. Some have perhaps all the wild passions, hysterical impulses, and criminal propensities in great power, but keep them so in leash that their strength and perhaps their very existence is not suspected by their nearest friends till some unusual strain removes the power of repression for a brief interval when they break out with overpowering mastery. To have and to control them, however, in some cases seems to give the tension with which the best work of the world is done. One function of education and civilization is to restrain and tutor the too quick form of response we call temper. It is always a waste of energy which passes from the potential to the kinetic form, so that control is storage of strength for either endurance or for action. The irritable diathesis involves the loss of all sense of proportion as well as perfect dignity, and weakens discipline, and ''temper is a weapon we hold by the blade.'' We can see thus how irritability is often a stage in the recovery from disease. This lower power of reflex is restored before the higher power of control.

Lange's[1] theory of emotions, as is well known, makes vasomotor changes primary, even to those of the neuro-muscular system. Sadness and fear are at root vascular constructions with consequent diminution of voluntary innervation, while joy and anger are vascular dilation with augmented innervation. Joy, sadness, anger, etc., are not mysterious energies causing physical states and changes; but we must drop this psychic hypothesis and say conversely that sadness, e. g., is simply a more or less obscure feeling of the vascular phenomena which accompany it. If these latter could be eliminated, nothing would remain of anger save a memory of its cause. In every emotion there is an initial fact, idea, image or sensation, but the emotion itself is nothing but a sense of those organic changes which precede and condition it. To prove such a theory, as Dumas well says, we must suppress all the visceral and peripheral changes and see if this involves the loss of the emotion;

[1] Les Emotions. Paris, 1895.

but this can never be done, and hence the theory is safe from
experimental proof or disproof. Perhaps, however, some pro-
portion may be established between emotional intensity and
vascular instability. This view is essentially mechanical, basing
feeling on physiological reflexes. The view of James[1] is that
"bodily changes follow directly the perception of the exciting
fact and that our feeling of the same changes as they occur is
the emotion." "We are sorry because we cry, angry because
we strike, afraid because we tremble, etc." These bodily
changes are not merely vascular but are innumerable and are
all felt. For the finer as distinct from the coarser emotions,
weakened repetition of once useful acts, the Darwinian analo-
gous feeling theory and that of easiest drainage channels, which
are probably not the smaller muscles but by way of the pneno
gastric and sympathetic nerves, are the three explanatory prin-
ciples.

No one adequately informed on the physiological basis of
psychic life will for a moment question this general view of the
primacy of physical changes and no one who accepts the most
cardinal principles of modern epistemology will hesitate to
affirm another psychic element and to deny that the physical
changes are the feelings. Not only ought these two precepts
to be almost platitudes in psychology and have interest only
for those still numerous, as the discussion of the Lange-James
theory has shown, who hold that the soul is more or less enti-
tive, but the same principles apply to every form of intellection
as well, save only that instead of muscle tensions, blood pres-
sures, etc., we must substitute more subtile changes in the
highest nerve centers. This, too, is the only fruitful presup-
position of modern psychology, vague and general as it must
be in the present state of our knowledge. In all thought
brain changes must be postulated as preceding in time and as
all conditioning. A far better and fuller statement of this
principle, so far as the emotions are concerned, has just been
made, independently of and in entire ignorance of the Lange-
James view, by Sutherland,[2] who makes an admirable digest of
recent biological and psychological researches which seem to
point to the conclusion that henceforth we must conceive that
the emotions are to the intellect somewhat as the sympathetic
nervous system is to the cerebro-spinal.

In general terms, we may say that the brain begins with the
vertebrate series, and that the visceral ganglia that preside
over nutrition, circulation and perhaps vascular tone, and the

[1] Psychology. Vol. II, pp. 449-450.
[2] The Origin and Growth of the Moral Instincts. 1898. Vol. II,
pp. 210-307. The Nervous Basis of the Emotions.

involuntary and non-striated muscles affecting nutrition, temperature, sex, etc., are the twilight region where the keys to the solution of the psychology of feeling must be sought. Most of the history of life as recorded in the rocks since the amphioxus has been devoted to the development of muscles and to laying the basis of all that they presuppose for the soul; and the suggestion is irresistible that the roots of our emotional life must be traced back to those paleologic ages where prevertebrate life had its fullest development. The feelings, therefore, are indefinitely older than the will, as it is older than the intellect. Mosso and others have lately laid stress on the idea that the physical expressions of the most different emotions are often more or less similar, especially if they are intense. It is no doubt true that strong feelings are so widely irradiated as to affect every part and organ of the body; and although pleasure states are more closely related with expansion and extensor muscles, and pain with ameboid and cellular contractions and in the higher forms with the flexor muscles, it seems improbable that emotions so opposite as anger and love should not be as strongly contrasted in their expression. Probably our emotional psychology has now only advanced to a stage of development more or less corresponding to that stage in general psychology when it was first clearly seen that the brain and not the heart was the general organ of mentation, and perhaps we are now at the dawn of a period of ganglionic psychology.

PSYCHOLOGICAL LITERATURE.

Studien über Hysterie von DR. JOS. BREWER and DR. SIGM. FREUD.
This little book, although it appeared in 1895, is not so generally known by psychologists perhaps as both its interest and importance warrants. With a different purpose than the great work of Legrand Du Saulle, the present study limits itself to those cases of hysteria which are of psychic origin. These are much more numerous than has commonly been supposed, and can almost invariably be traced back to some lesion of the psychic sexual region. Psychical hysteria is defined as " der Erregung, welche abströmt oder abreagirt werden muss." The excitant is of a compulsory nature and being ideational in origin is frequently hidden from the individual himself. It may often be reproduced by the aid of a light hypnosis or by pressing the patient to the point of confession, and upon such possibility and the degree of its success rests the therapeutic procedure of the authors. The key note of the discussion lies in the endeavor to find the causes or occasions of hysteria in sudden, painful experiences, shocks of some sort, frequently sexual, apparently present for the first time but really originating in years past. The clearest dependence is established between psychic lesions or shocks and the resulting hysterias with their various sensory and motor disburbances.
The Inhalts-Verzeichniss enumerates the following topics:
Part I. The Psychical Mechanism of Hysterical Phenomena, a reprint from the Neurologischen Centralblatt for 1893.
Part II. A history of cases, carefully detailed and with much of psychological suggestiveness.
Part III. Restatement of the author's theory and an attempt to find a basis for the facts noted in cerebral dynamics.
Part IV. This section, not the least fruitful, deals with the psychotherapeutics of Hysteria.
Three propositions embrace the carrying power of the author's discussion. *First:* Hysteria is for the most part psychic and founded upon reminiscence. As is explicitly stated, the shock as agent does not immediately provoke the symptoms, but the memory of the psychic shock acts as a sort of strange or foreign body, remaining active for years after the first impress. *Second:* The emotional force and pathological effectiveness of such reminiscences are due to the fact that normal, adequate reactions, either instinctive or expressional, are denied them. Hysterias are conditioned upon hyperæsthesic memories. *Third:* Such memories and emotionally surcharged reminiscences tend to form separate groups, giving rise to the well known phenomena of distraction, double consciousness, sensory, motor, and organic disturbances.
The hysteric consciousness has a field of its own, its reactions multiform and varied, subject to no apparent laws. Completed in its course of development, it leads to a sundering of the soul itself. Herein it may be likened to the self of the hypnotic state, many of the phenomena of the former are paralleled in the latter. So the authors would place beside the formula, "Hypnotism is artificial hysteria," the other proposition, "The basis and conditions of hysteria are found in the existence of hypnotic Zuständen." Thus the problem